FUN

NEW SERIES

VOL II

LONDON

PUBLISHED (FOR THE PROPRIETORS) BY THOMAS BAKER,
80, FLEET STREET, E.C.

30358. 18.12.78. 1475. G1

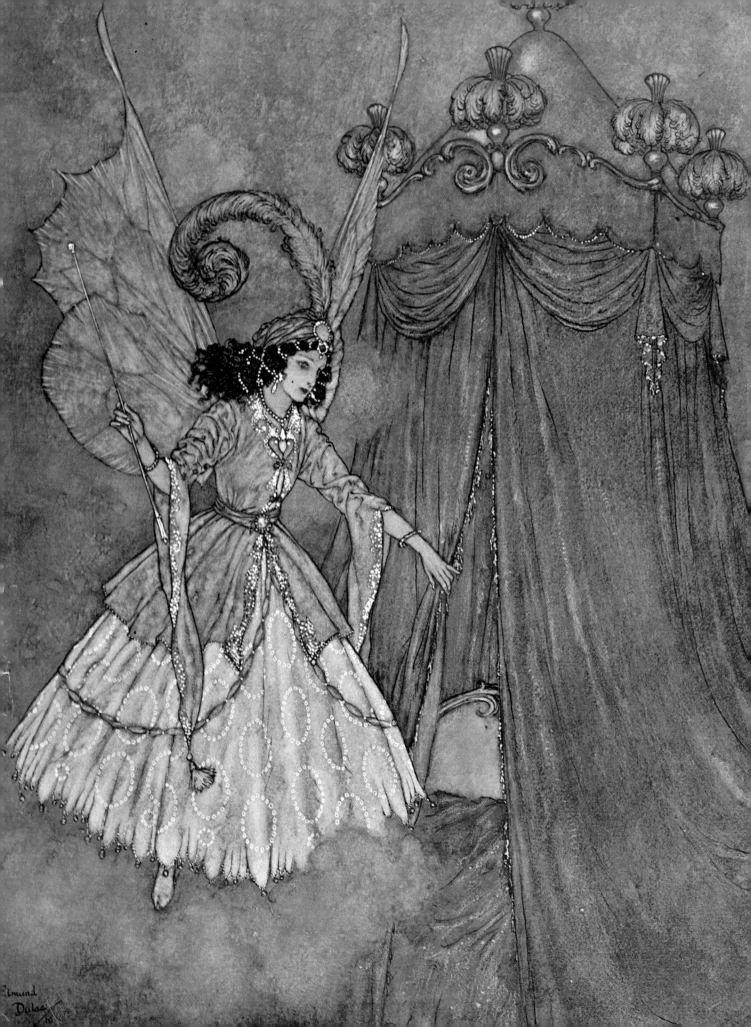

The Dictionary of British Book

ILLUSTRATORS and CARICATURISTS

1800~1914

With introductory chapters on the Rise and Progress of the Art.

Simon Houfe

Frontispiece:
EDMUND DULAC 1882-1953
'Beauty and the Beast'
Original drawing for Fairy Tales
by Sir Arthur Quiller-Couch, 1910
Pen, ink and watercolour
dated 1910

Victoria and Albert Museum

© Copyright 1978 Simon Houfe
World copyright reserved

ISBN 0 902028 73 1

British Library CIP data
Houfe, Simon
 Dictionary of British book illustrators, 1800-1914.
 1. Illustrators — Great Britain — Biography
 2. Illustration of books — Great Britain
 I. Title II. Antique Collectors' Club
 741'.092'2 NC978

 ISBN 0-902028-73-1

Printed in England by Baron Publishing
Church Street, Woodbridge, Suffolk

The Antique Collectors' Club

The Antique Collectors' Club, formed in 1966, pioneered the provision of information on prices for collectors. The Club's magazine *Antique Collecting* was the first to tackle the complex problems of describing to collectors the various features which can influence prices. In response to the enormous demand for this type of information the *Price Guide Series* was introduced in 1968 with **The Price Guide to Antique Furniture**, a book which broke new ground by illustrating the more common types of antique furniture, the sort that collectors could buy in shops and at auctions, rather than the rare museum pieces which had previously been used (and still to a large extent are used) to make up the limited amount of illustrations in books published by commercial publishers. Many other price guides have followed, all copiously illustrated, and greatly appreciated by collectors for the valuable information they contain, quite apart from prices.

Club membership, which is open to all collectors, costs £6.95 per annum. Members receive free of charge *Antique Collecting,* the Club's magazine (published every month except August), which contains well-illustrated articles dealing with the practical aspects of collecting not normally dealt with by magazines. Prices, features of value, investment potential, fakes and forgeries are all given prominence in the magazine.

In addition members buy and sell among themselves; the Club charges a nominal fee for introductions but takes no commission. Since the Club started many thousands of antiques have been offered for sale privately. No other publication contains anything to match the long list of items for sale privately which appears in each issue of the magazine.

The presentation of useful information and the facility to buy and sell privately would alone have assured the success of the Club, but perhaps the feature most valued by members is the ability to make contact with other collectors living nearby. Not only do members learn about the other branches of collecting but they make interesting friendships. The Club organises weekend seminars and other meetings.

As its motto implies, the Club is an amateur organisation designed to help collectors to get the most out of their hobby: it is informal and friendly and gives enormous enjoyment to all concerned.

For Collectors — By Collectors — About Collecting

The Antique Collectors' Club, 5 Church Street, Woodbridge, Suffolk

Contents

Acknowledgements

This opportunity is taken to thank the many people who have assisted in researches over the past three years. Among the families of the illustrators themselves must be included The Countess of Rosse, Miss O. Ault, L.F. Pape, Mrs. Eve Sheldon-Williams, Miss L. Wallis Mills and among collectors, C.R. Cone, Mrs. Christopher Day, Miss Julia Elton, Jeffrey Gordon, Dr. C. Lattimore, H. Newman and R.G. Searight, who gave enormous help from his unrivalled knowledge of Middle East illustrators.

The following trusts, foundations and art galleries have allowed works in their possession to be reproduced, The Trustees of the Bedford Settled Estates and The Most Hon. The Marquess of Tavistock, Birmingham City Art Gallery, The Garrick Club, The Paul Mellon Foundation and the Victoria and Albert Museum, Print Room and Library. Assistance has been received at various times from the staffs of the Print Rooms at the Ashmolean Museum, Oxford, the British Museum, The Fitzwilliam Museum, Cambridge, the Laing Art Gallery, Newcastle-upon-Tyne, as well as from the librarians at the British Library Manuscript Room, the London Library, the Westminster Public Library and the Witt Photo Library, Courtauld Institute, University of London.

Valuable help has been given by Eric Holder, Mr. and Mrs. Ronald Marshall, Christopher Mendez, Alister Mathews and Ben Weinreb in allowing access to original works in their possession.

Much information and advice has come from historians and collectors among whom should be mentioned, John Christian, Professor Robert Halsband, Professor Dudley Johnson, Lionel Lambourne, Lady Mander, Dr. Gerald Taylor and Lady (Micky) Reid.

A special note of thanks must go to Simon Richardson, who acted as research assistant during the summer of 1976 and did sterling service in many London libraries at various times in 1977 and 1978. Last but not least thanks are due to my publisher, John Steel, and to his able assistant, Mrs. Elizabeth Watson, who saw the book through its final stages.

Avenue House, Ampthill Simon Houfe
13th September, 1978

Introduction

The task facing any historian or lexicographer of the nineteenth century is a daunting one. The industry and energy of that century seems to have been almost uncanny and its capacity to record and document every detail of its tirelessness absolutely unprecedented. Lytton Strachey, writing sixty years ago when nineteenth century studies had only just begun, put the historian's predicament in this way. 'He will row out over that great ocean of material, and lower down into it, here and there, a little bucket, which will bring up to the light of day some characteristic specimen, from those depths, to be examined with a careful curiosity.'

The work of the book illustrators in the years 1800 to 1914 is certainly characteristic of its age but even one of Strachey's buckets would produce an embarrassing haul! No book setting out to cover this immense subject could hope to be fully comprehensive, but by including popular artists as well as significant artists, minor figures as well as great ones, it could go some way towards seeing the period as the Victorians saw it themselves. Illustration has always been the Cinderella among the fine arts, even in the nineteenth century, but in some ways in those years it comes closest of all to the normal, the average, the everyday in national taste; its steel engravings, wood engravings and lithographs tell us as much about the people who were looking at them as they tell of the artists themselves. The growth of literacy during the early part of the century, which was sealed with official approval after 1870, meant that more and more people could benefit from books and cheaper periodicals. The designs in them were a help to the learner and an entertainment to the leisured, to the working class and also to many of the middle class, images were associated with letter-press and 'painting' *was* the black ink impression of a wood block on the printed page. The impact of the illustrated magazine on the Victorian household must have been tremendous; for the first time people in remote places and of all backgrounds had their own art galleries of portraits, landscapes, caricatures, battlepieces, still-lifes and miniatures delivered by the postman weekly. For some people their only contact with the visual arts was through magazine illustration and a proper appreciation of that fact helps us to understand much about them, the seriousness with which they regarded book illustration, their love of narrative painting and their enthusiasm for the long novel.

Victorian illustrated pages travelled great distances. Readers of Samuel Butler's symbolical story *Erehwon* will remember that the walls of the hero's hut in the distant outback were 'pasted over with extracts from the *Illustrated London News* and *Punch. . . .*'. Nearer at home, but equally isolated, Flora Thomson describes in *Lark Rise*, the decoration of her 'privy' in deepest Buckinghamshire. 'On the wall of the "little house" at Laura's home pictures cut from the newspapers were pasted. These were changed when the walls were whitewashed and in succession they were "The Bombardment of Alexandria", all clouds of smoke, flying fragments and flashes of explosives; "Glasgow's Mournful Disaster: Plunges for Life from the Daphne", and "The Tay Bridge Disaster", with the end of the train dangling from the broken bridge over a boiling sea. It was before the day of Press photography and the artists were able to give their imagination full play.' It is these sort of comments that show most clearly what Victorian art was; sentimental, melodramatic, subjective perhaps, but also spontaneous and a medium in which everyone felt involved. The

present writer therefore makes no apology for having been biased towards magazine work in both the introductory chapters and in the accounts of individual artists.

For the purposes of this book, a book illustration has been defined as any pictorial subject in topography, architecture, genre or literature which aids a text, however slender. This does not include engravings of literary subjects separately issued or technical books of architecture or science. The definition of British is wide enough to take in foreign artists who published their work in this country or artists who studied here but only published work abroad. Although the limits of this book are really from the Regency to the Edwardian period, some artists have been included whose major contributions were made in earlier or later years, but whose style or direction seems relevant to the case. This is true of a number of topographers working in the 1800s and in most of these examples a bibliographical reference to J.R. Abbey's stupendous volumes is appended, AL (Abbey *Life*) or AT (Abbey *Travel*). The introductory chapters should be seen as a guide line to the Dictionary rather than as a full scale survey of the period, the sections are simply subjects that have caught the writer's attention as a collector and, in the compilation of the artists' names, have interested him. Where a particular illustration in the Dictionary is discussed in detail in these chapters, a smaller version has been provided for the reader's convenience as close to the reference as possible.

No attempt has been made here to deal with technical matters, information on this can be found in Ruari Mclean's masterly work *Victorian Book Design and Colour Printing,* 1963, and in the much smaller but equally useful *Victorian Book Illustration* by Geoffrey Wakeman, 1973. Children's books are not considered separately, although many illustrators of them are listed, neither is any individual history of the private presses given, although many illustrators ran them or worked for them. Anyone working in this field must acknowledge the debt they owe to the pioneers of illustration history who worked at the turn of the century. Gleeson White's *English Illustration, The Sixties,* published in 1897, is a classic if somewhat unmanageable volume, Forrest Reid's *The Illustrators of the Sixties,* 1928, is still a very helpful book and far more compact. James Thorpe's *English Illustration of the Nineties* is very wide in its approach, the same author's biographies of illustrators are a mine of information.

Simon Houfe

Chapter 1

Regency Background

Although both the eighteenth and the twentieth centuries have produced outstanding illustrated books, it is perhaps generally recognised that it was in the nineteenth century that this art form reached its zenith. A wave of national self-awareness and cultural enthusiasm after the Napoleonic Wars became a basis for establishing a taste for books, which laid the foundations of solid mid-Victorian publishing. The early years of the century were brim-full of new ideas, which were waiting to burst out on a newly industrialised society, once the 'Corsican Monster' was safely locked up on St. Helena. They were ideas that were frequently at variance with each other, sometimes diametrically opposed, but usually having in common a thirst for experiment and a fresh vision of the future. The admixture of romanticism, hot-headed liberalism, evangelicalism, mass-production, popular education, self-help and scientific investigation, proved a very potent brew, and the richness of this society in transition is displayed to good effect in their illustrated books.

It was an age of expanding knowledge and therefore of expanding opportunities for the bookseller, the publisher, and through force of circumstances, for the illustrator as well. Books of travel, topography, architecture, science and natural history, archaeology and engineering, poured from the presses to satisfy the growing private library owners, while plain but serviceable magazines for mechanics, manuals of instruction, exemplars for the craftsman were in more ready supply than ever before. At the lower end of the market the literature of the streets, broadsheet and ballad was having a revival and the singly issued caricature print was in its heyday. Books were produced with fine mezzo-tint engravings, occasionally with stipple engravings, and firms in the years following 1800 were discovering the new techniques of aquatinting, one at least making its name with them. There were a wide variety of magazines being published, some on specialist subjects, but also political, religious, sporting and domestic, increasingly relying on illustration to appeal to an audience.

The inheritance from the eighteenth century in the illustrating of poetry and fiction was small in scale and theatrical in content, typified by the art of Robert Smirke, 1752-1845, and Richard Westall, 1765-1836. The decorative softness of the English rococo, which had re-interpreted the classics, and set figures against the background of an idyllic landscape, was disappearing. James Thomson's *The Seasons,* 1730, the perfect English idyll, but more naturalistic than anything preceding it, had passed from pastoral allegory to romantic tension between the illustrated editions of 1730 and 1830. The work of the late eighteenth century men tends to be divided between the sentimental and the neo-classical. In the first, conventional figures in a sylvan English setting languish or pine, in the second overtly classical figures in the style of Barry and Fuseli dominate the page. The strong decorative sense which is apparent in the French-inspired books, illustrated by Gravelot and others, recedes decade by decade, although powerful ornament was designed by some men outside the mainstream such as Richard Bentley, 1708-1782, for *Gray's Poems,* 1753.

The fashion was for small engravings in the sets of illustrated novels by Richardson, Fielding, Sterne, Smollett and Burney, to be used as tableaux rather than as explanations of the printed story. Charles Lamb, a Georgian by upbringing if not wholly by sentiment, enjoyed reading Shakespeare in the cheapest editions so that the poor plates could serve as

'maps' to the text without in any way emulating it! This was clearly the influence of Hogarth, who being more of an illustrator of life than of books, claimed that his engravings were 'dumb shows' and expected them to be 'read' quite independantly of a text. Hogarth's connection with the stage re-inforces this impression and the fact that contemporary British painting was most lively in its portrayal of actors underlines it yet again. To open an engraved page of an illustrated Smollett or Richardson is to look straight into a scene of theatrical portraiture. Joseph Wenman's edition of *Count Fathom,* published in 1780, for example, has several plates by a minor illustrator, Dodd; in each case the figures are taken in gesture and in placing from the contemporary stage or the portraits of it by Johann Zoffany. Later theatrical painters were also to be illustrators such as de Wilde and Clint.

Book illustration moved another step away from its primary object as a visual stimulus to the reader when various wealthy booksellers began projects for lavish publishing at the end of the century. Alderman Boydell's unsuccessful venture in creating a Shakespeare Gallery, where the greatest artists were asked to contribute paintings of the plays which would then be sumptuously published, emphasises this discrepancy. The art of the book illustrator and the historical painter are quite different and the policy, which reduced a large painting to a page size, ignored that difference. Boydell's artists were not only unacquainted for the most part with book illustration, they came from different sides of the classical tradition and were experiencing in 1786 the beginnings of a divergence between neo-classic and romantic ideals. Henry Fuseli, 1741-1825, started a similar venture, The Milton Gallery, between 1790 and 1800, and Thomas Macklin had established a Poets' Gallery in 1788. The latter was also responsible for an illustrated *Holy Bible* with seventy-one plates and one hundred and twenty-five vignettes by eminent artists including P.J. de Loutherbourg, 1740-1812, and Thomas Stothard, 1755-1834. The work came out in parts and was issued to subscribers, the whole edition being completed between 1789 and 1800.[1] Other illustrated classics included *Harrison's Novelists Magazine,* 1780-83, *Cooke's British Classics,* 1796, *Bell's British Poets* and *Theatre* and later on Rivington's pocket poets and *Sharpe's Classics,* 1822. The most illustrated volumes outside the series continued to be *Gil Blas, Don Quixote, The Spectator* and *The Adventurer* with, as the romantic 1800s progressed, increasing interest in *The Arabian Nights* and *The Waverley Novels.*

This group included many excellent artists. Richard Westall RA, became an academician in 1792 on the strength of his painting, but is best remembered as an illustrator. He was capable of handling subjects as various as Crabbe, Gray and Goldsmith but is probably strongest in working on the classical histories (Colour Plate I). A good pen and ink artist with a fine sense of colour, the majority of his illustrations, even the pretty vignettes to Thomson's *Seasons* of 1816-17, lack individual lustre. E.F. Burney, 1760-1848, is another artist who deserves mention, his vignettes, borders and trophies are beautifully executed, his sense of design imaginative, perhaps fired by that separate career of his as caricaturist in watercolours. Thomas Stothard was another prolific illustrator who became an academician and Librarian of the Royal Academy in 1812. According to his biographer, Stothard undertook over five thousand illustrations for books during his lifetime, probably only a slight exaggeration.[2] But implicit in all these works is the history painter who had painted the staircase at Burghley House and exhibited yearly at the Academy until 1834. The better examples are more like relief sculpture than illustration and some of the most delightful things are for trifles like pocket-books and almanacks, the bacchanals are strongly decorative, the rural pieces rather weak. So the combination of theatricality, sentimentality and small format gives the productions of these men little chance to breathe and the same can be said for R. Corbould, T. Uwins, T. Kirk and many others (Figure 1).

J.H. Mortimer, 1741-1779, an important neo-classical artist but also an illustrator, seems to have appreciated the opportunities and limitations of the book. In his

contributions to the poems of Milton and Pope in *Bell's Poets of Great Britain,* 1776-82, the artist places the illustrations in roundels which are decorated with neo-classical features, festoons and medallions giving the effect of an architectural frontispiece to the works. It is only a small point that Belinda in *The Rape of The Lock* looks more like a Roman matron than a Georgian lady of fashion, but there is altogether more vitality about the drawing. This is true of most of the neo-classical illustrators who worked in that other fashionable style of the Regency, line engraving, the shadeless outline, the concentration on the two dimensional that had evolved from Roman friezes and Greek vases. The most famous artist to adopt this method was the sculptor John Flaxman, 1755-1826, whose first childish drawings had been illustrations to the poets. His ability in modelling attracted the eye of Josiah Wedgwood and he was employed by the firm from 1775, later being sent to Italy to supervise Wedgwood's Italian draughtsmen. While in Rome, Flaxman was commissioned by Mrs. Hare Naylor to illustrate *The Iliad* and *The Odyssey* and by Thomas

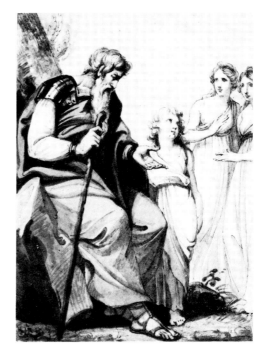

Figure 1. 'Youth and Age' by Thomas Kirk. Ink and wash.

Hope and the Countess Spencer to illustrate Dante and Aeschylus respectively. The set of four illustrated works were engraved by Thomas Prioli in Rome in 1793 and distributed throughout Europe, giving Flaxman a greater standing than any other British artist. *The Iliad* and *The Odyssey* were published in London by Longman, Hurst, Rees and Orme in 1805, and *The Theogony* in 1817. The drawings are sharp, almost stark in their linear purity, but beautifully placed on the page and accompanied by no other text than a few lines from *Pope's Homer.* These plates were very frequently re-issued and had a deep influence on certain artists of the 1830s and 1840s and in particular on Moritz Retsch and his Shakespearean illustrations. Flaxman, like Hogarth, was so big a figure that the reverberations of his art were still powerful fifty years after his death (Figure 2).

Line engraving appealed to Flaxman because he was a sculptor and it was ideal for showing the clear profiles of neo-classic architecture and ornament. An impressive example of its use is in the monumental three volumes of *Ancient Vases . . . in the Collection of Sir William Hamilton,* published by Tischbein in Naples, 1791-95. This fine set with English and French text was re-issued or reprinted four times between then and 1814 and certainly made line the medium for neo-classicism. The real doyen of line engraving however was a London artist, Henry Moses, 1782-1870. His list of books, all executed with great finesse, handsome lay-outs and border ornament, reads like a catalogue of Regency taste. He began by engraving *The Gallery of Benjamin West* in 1811, supplied the plates for Thomas Hope's *Modern Costume,* 1812, for three books on Greek vases between 1814 and 1820, and *Sculptures from the Museum of the Louvre,* 1828. Perhaps his most attractive work is the two volume *Works of Antonio Canova,* 1823-24, where Moses' status is given due recognition and the pages are packed with the artist's work, displayed with an almost French suavity. Thomas Hope's *Household Furniture,* with interiors of his own residence, was engraved in outline, so was *The Description of the House and Museum of Sir John Soane Architect,* 1835, and many guides to galleries and the fine arts in the intervening years. Some of the supplements to *The Repository of the Arts* were engraved in line, taking

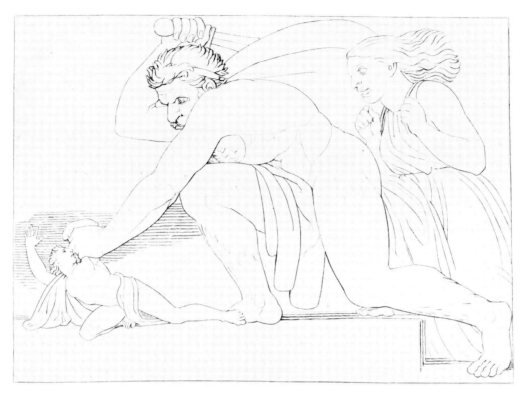

Figure 2. Illustration to The Odyssey *by John Flaxman, RA. Line engraving.*

their style and designs from the plates of Percier and Fontaine; the moving spirit behind *The Repository* was a dynamic German publisher living in London, Rudolph Ackermann.

Rudolph Ackermann, 1764-1834, was one of those remarkable figures who rise up on the shoulders of one particular fashion and dominate it for a generation; his contribution was to architectural and topographical illustration and his method was the aquatint. Ackermann was born at Stolberg in Saxony in 1764, and trained as a designer of carriages, moving first to Paris and then to London, working for various firms making equipages. He settled in London with an English wife and, looking round for a more permanent occupation, opened print shops at 96 and then 101, The Strand, taking in up to eighty pupils at a separate house run as a drawing school. Ackermann's gift for giving the art loving public a whiff of Continental air in his establishment, proved to be a very successful and lucrative idea. By 1806 he had closed the school and was concentrating on selling books and prints, artists' materials and fancy goods made by the impoverished French emigrés whom he employed. A contemporary report states that there were 'seldom less than fifty nobles, priests, and ladies of distinction at work upon screens, card-wracks, flower stands and other ornamental fancy works of a similar nature.'[3] The print seller was naturalised in 1809, and from 1813 established the first Art Library in London, where the latest publications on the arts in every European language were available for consultation or purchase. Ackermann saw his role as that of instigator of new ideas and his shop as a meeting place for artists and writers. This was a more usual form of trading in the 1800s, a guide of the time says 'English booksellers shops which are frequented as lounging shops ... are provided with all new publications, newspapers, etc.'[4] But Ackermann made his premises lavish, employed a well-known architect to design them and held receptions upstairs on Wednesdays, when drawings, lithographs and advances in book production were exhibited.

Ackermann's readers were the art conscious middle class who had been inspired by the cult of the picturesque and the cult of the Grecian. The picturesque had originated from

Edmund Burke's aesthetics of the 'Sublime' and the 'Beautiful'. The Rev. William Gilpin, while accepting the earlier idea that smooth landscapes and rugged mountains were the archetypal examples of sublimity and beauty, had further discovered the beauty of 'variety' which he termed 'the picturesque'. Landscape and buildings were picturesque if they had the qualities of composed paintings and perversely paintings were picturesque if they had the qualities of composed landscapes! The literature of this theory of design was stupendous; drawing-masters produced numerous books for the amateur student of the picturesque, writers of guide-books rewrote their texts to suit its teachings and topographical works and volumes on Gothic architecture abounded. Ackermann supplied a great deal of their wants both as artists' colourman and as publisher of sumptuous volumes on cathedrals and castles.

The first of these great volumes was *The Microcosm of London or London in Miniature, the Architecture by A. Pugin, the Manners and Customs by Thomas Rowlandson,* 1808. This was a part work, issued in twenty-six instalments at 10s. 6d. each, finally being offered in three elephant quarto volumes at fifteen guineas in

Figure 3. Tomb of the Duke of Richmond in Westminster Abbey by Thomas Uwins. Engraving.

1810. It was a new venture in that it treated the metropolis pictorially and ranged over new and ancient buildings and meeting places in an almost sociological way. Ackermann claimed in his introduction to have been disatisfied with the static quality of much architectural illustration and had therefore introduced Pugin for the buildings and Rowlandson for the crowds. The liveliness of the latter are certainly invigorating and the plates still bustle and jostle after a century and a half because of them. Rowlandson was given 'ample scope for the execution of his abilities', so the introduction runs, 'and it will be found that his powers are not confined to the ludicrous, but that he can vary with his subject, and wherever it is necessary descend "From grave to gay – from lively to severe".'

The next work to be issued was the famous *History of the Abbey Church of St. Peter's, Westminster,* published in sixteen monthly numbers and appearing in 1812 at £15 for two volumes. Here a variety of artists were used to bring out in page plates the glories of the stained glass windows and the 'dim religious light' of the chapels and the richness of the monuments in the national shrine. Thomas Uwins (Figure 3), Pugin, G. Shepherd, J. White, Frederick Mackenzie, Thomson and H. Villiers were extensively employed on a book that set out to 'give a history of this vast and beautiful fabric, this scene of human grandeur, this last repository of glory, in all its parts . . .' which would animate piety and awaken sensibilities.[5]

The next two books from 101, Strand were *The History of the University of Oxford,* 1814 and *The History of the University of Cambridge,* 1815. These are splendid works, real tributes to Ackermann's perfectionism, with glorious plates by Pugin, Nash, Mackenzie and Westall. They contained optional supplementary plates of the university costumes and the bound volumes were sold at £16. In 1816 he published *The History of the Colleges,* a survey

of the major public schools, using some of the same artists.

In 1809, Ackermann began his own magazine the *Repository of Arts, Literature, Commerce, Manufactures, Fashions and Politics,* published at four shillings a number and designed as an illustrated imitation of *The Gentleman's Magazine* and *The European Magazine* which was not extensively illustrated. The *Repository* included book reviews, theatrical notices, art criticisms and stories, but was distinguished for the variety of its plates in woodcut, line, stipple and lithography after 1817, as well as for the profusion of coloured aquatints. It was edited by Frederick Shoberl, 1775-1853, and was full of drawings by Ackermann's established artists as well as by new recruits to his team; within the first year it had gained a total of three thousand subscribers.

Aquatint was favoured not only because it was a perfected process but because it imitated the brushwork obtainable with watercolour. Aquatinting is intaglio printing from a copper plate, the hollows being bitten out with the ink squeezed on to damp paper under pressure. Whole areas are evenly hollowed out to give a uniform tint and by this method a variety of tones are achieved throughout the print, some imitating the highlights of watercolour, working from light to dark tones. The places that were to appear dead white were stopped out during the plate's successive immersions in the acid, resulting in a more and more contrasted effect. The plate might be printed in brown, olive, green or red, sometimes in two or three colours, before being tinted by hand. It is known for example that in Ackermann's last major work *The History of the Royal Residences,* 1829, the interior views of the palaces were printed in one colour and the exterior views in two, blue and brown, for the sky and buildings. The process from original drawings by C. Wild, J. Stephanoff or W. Westall would have run thus: when the watercolour was handed to the engraver an aquatint would be made of it, and a proof returned to the artist for colouring; this would then be used as a model by Ackermann's large staff of experienced colourists (Colour Plate II).

The publisher's other great discoveries were Thomas Rowlandson, 1756-1827, already referred to and William Combe, 1741-1823, whose talents he brought together. Rowlandson was connected with Ackermann from 1799 when he illustrated the eighty-seven plates to the *Loyal Volunteers of London and Environs.* Combe, a jobbing writer who was in and out of debtors' prisons, was an old man before he met Ackermann and agreed to write verses to Rowlandson's drawings of a travelling schoolmaster. In this way *Dr. Syntax in Search of the Picturesque,* 1812, was born and became one of the classic illustrated books of its period (Colour Plate III). The black-clad doctor on his awkward horse became the hero of a whole generation and started a fashion for aquatint engravings opposite rhyming texts. There followed *The Second Tour of Dr. Syntax in Search of Consolation,* 1820, and *The Third Tour of Dr. Syntax in Search of a Wife,* 1821. Ackermann had the distinction of not only paving the way for picturesque illustrating in this country, but of seducing the wayward Rowlandson into the covers of a book and holding him there. The same sort of flow of drawings and incidents take place in *Poetical Sketches of Scarborough,* 1819 and *The History of Johnny Quae Genus,* 1822, 'The Foundling of the Late Dr. Syntax'. Pursuing this further one would arrive at the episodic literature of the late Regency, Pierce Egan's *Real Life in London,* 1827, with coloured plates by Heath, Dighton, Alken and Rowlandson and the serial parts of early Dickens drawn for by H.K. Browne. Another notable Rowlandson and Combe partnership was in *The Dance of Death,* 1815, and *The Dance of Life,* 1817, where the artist's satirical powers are more in evidence. Another example of Rowlandson's work is shown in Colour Plate IV.

Ackermann's contribution was not just a nice mix of artists and authors but the raising of topographical and literary illustration on to a more fashionable plane. The foremost artists gathered at his rooms and we find that lion of the Royal Academy, Joseph Farington, there on April 26, 1813. After noting in his diary that he saw 'Pyne and Heaphy in

Right: Plate I
RICHARD WESTALL, RA
1765-1836
'Aeneas Triumphing over
Turnus.' Original drawing
for illustration to The
Aeneid. *c.1800*
Victoria and Albert Museum

Below: Plate II
CHARLES WILD 1781-1835
'The West Ante Room,
Carlton House.' Illustration for
Pyne's Royal Residences, *1819*
Hand-coloured engraving

Ackermann's Museum Room' he adds acidly that 'the printseller has gradually risen & become a publisher of Books with prints & is supposed to be worth £20,000'.[6] His relations with the illustrators seem to have been very good and his preservation of their work was remarkable. Retaining the original drawings, the publisher's right, he had all those for the *History of Westminster Abbey* bound up with the letterpress printed on vellum. Papworth 'prepared a special design, with Gothic details, for the brass mountings and clasps for the two volumes, which cost £120. This copy Ackermann valued so highly that he used to provide a pair of white kid gloves for the use of the person to whom was granted the favour of inspecting it.'[7]

Costume was not a speciality of Ackermann's except where it touched on the fine fashion plates in his magazine or in the university plates. There was however one notable book produced by an Ackermann author, W.H. Pyne, for another publisher, *The Costume of Great Britain,* 1808. William Miller of Old Bond Street published a series of six books on costume between 1801 and 1807 with English and French texts and pretty if anaemic single figure illustrations. Interest in costumes was generated by romantic novels and exotic architecture, so the countries chosen tended to be remote and colourful; China, an obvious choice, was illustrated by a Cantonese artist, Pu-Qua, Turkey by a Frenchman, Dalvimart, Russia and Austria being unattributed. Pyne designed, engraved and wrote the whole of the seventh volume on *Great Britain* and it is certainly far the most interesting. Pyne had cut his teeth in a remarkable drawing-book called *Microcosm or a Picturesque Delineation of the Arts, Agriculture and Manufactures of Great Britain.* In a series of groups which he subtitles as an 'Encyclopaedia of Illustration' issued from 1805, he shows how picturesque figures can be used for embellishing landscape for the artist. Aquatinted by J. Hill, these charming studies of cottagers, brewers, gardeners, basket makers and millers are now valuable as scenes of everyday life. A further series *Rustic Figures* appeared in 1814. It is not surprising therefore that *The Costume of Great Britain* has fine compositions of figures, superbly grouped and more in the tradition of narrative painting than costume illustration. Among the best are 'The Halfpenny Showman', 'The Lamp Lighter', 'Dustman' and 'Brickmaker', street scenes and trades having a greater sense of reality through Pyne's eyes than the more formal 'Baron' or 'Speaker of the House of Commons'.

A contemporary, Jerdan, leaves a picture of the restless and enquiring life of W.H. Pyne, so typical of the early nineteenth century artist. Through this ceaseless activity Jerdan writes 'his facile pencil so ready and true in seizing every quaint and characteristic form or feature, as illustrated in his Microcosm of London, and other productions which gave celebrity to Ackermann's Repository, were still more captivating proofs of his genius in the arts. It was delightful to lounge out with him on a summer day, imbibe his conversation, and watch the execution of a dozen humorous and most fanciful sketches, of beggars, brewers, milkmaids, children at play, animals, odd-looking trees, or gates, or buildings — in short, of all curious or picturesque objects and everything else.'[8]

The Napoleonic Wars, which had hemmed in the British artists for more than a decade, seem to have acted like a *camera obscura,* throwing the image of the outside world into sharper relief and giving them a more concentrated vision. After 1814, the full effect of this was felt in topographical books where the services of the artist were required in depicting every aspect of foreign travel for a public hungry for information. The British watercolourists who had built up a great reputation in their engraved views for *The Copper Plate Magazine,* 1792-1803, *Angus's Seats* from 1784 and *Watts' Seats,* 1779-1786, came to the fore as painters of Continental and Eastern scenery. The subtleties of watercolour, the softness of the colour range and the gentleness of the rendering were aspects that it had taken a generation to appreciate, and just as the medium was emerging from the tinted drawing into its richer form, here was the aquatint process to capture it for

a wider audience. A good example of this change from straightforward topography to a more powerful scenic style may be found in the *Selection of Twenty Views in Paris* published posthumously by Thomas Girtin in 1803, etched in outline and completed by F.C. Lewis in aquatint. The plates have no text, but this and other similar works showed the illustrator the way to a more picturesque rendering of buildings and a more poetically grand approach to landscape.

Just as Ackermann's contribution was chiefly in British topography, so the exploration of the Indian sub-continent was mostly the work of one publisher, Edward Orme. With his brothers, Daniel and W. Orme, all of them occasional illustrators, he succeeded in creating a library of Indian life that was second to none. The first book was *Twelve Views of Places in the Kingdom of Mysore* by R.H. Colebrook, 1794, which contained aquatints and was followed by *Picturesque Scenery in the Kingdom of Mysore*, 1805. But the most celebrated partnership began in 1808 with the publication of *Oriental Scenery* from the drawings of Thomas and William Daniell. Thomas Daniell RA, 1749-1840, was born at Kingston-on-Thames and studied at the RA Schools. In 1784 he left for India, taking with him his nephew William Daniell RA, 1769-1837, then aged fourteen, as his assistant. They spent ten years there, based in Calcutta, but travelling freely over the country and making a great number of oil and watercolour landscapes. Some of this material was published as *Views in Calcutta*, 1786-88, but most of it was issued by Orme of Bond Street, *Oriental Scenery* being followed in 1810 by *A Picturesque Voyage to India by the Way of China*. The success of the books enabled Thomas to retire, but William Daniell continued to issue fresh books, *Views in Bootan*, 1813, and the important *A Picturesque Voyage Round Great Britain*, 1814-25, many of the drawings for which are in the British Museum Print Room. He also shows his versatility in the uncoloured aquatint illustrations to *Memoir of Sicily*, 1824, by William Henry Smyth, including views and botanical drawings requiring a high degree of scientific accuracy. At a later date, 1836, he was providing the illustrations for *The Oriental Annual*.

Some other notable books contemporary with the Orme publications are Gold's *Oriental Drawings*, 1806, and Lord Munster's journal of a *Route across India*, 1819. Orme at first issued sporting subjects with his *Collection of British Field Sports* in 1807, a series of plates by Samuel Howitt, 1765-1822, later he augmented this with his Indian interests to produce *Oriental Field Sports* with illustrations by Howitt aquatinted by Havell and Merke. The introduction to this very beautiful work states categorically that the Englishman's domain is now much further extended than his own coasts. 'It is offered to the Public as depicting the Manners, Customs, Scenery and Costume of a territory, now intimately blended with the British Empire . . .' Howitt, a self-taught artist, never visited Bengal but worked up the watercolours from sketches made by the author, Captain Williamson, a tribute to the sort of co-operation that could exist between the amateur and the professional at this time (Figure 4).

Two artists who did travel abroad extensively however, were Sir John Carr, 1772-1832, whose *Stranger in France* was ridiculed by Byron in *English Bards and Scotch Reviewers*, and Sir Robert Ker Porter, 1777-1842. Carr, the typical amateur travelling for his health, went on to publish books on Holland, Spain and Scotland. Ker Porter was a much more substantial figure who was patronised by West as a battle painter and painter of panoramas and achieved success as Historical Painter to the Czar at St. Petersburg. His most representative work is found in two books *Travelling Sketches in Russia and Sweden*, 1809, and *Travels in Georgia, Persia, Armenia, Ancient Babylonia*, 1817-20. Greece was also a popular country for artists and travellers interested in archaeology and the Greek revival; Middleton's *Grecian Remains in Italy* appeared in 1812, Dodwell's *Views in Greece* in 1821 and P.F. Laurent's *Recollections of a Classical Tour* the same year. C.R. Cockerell,

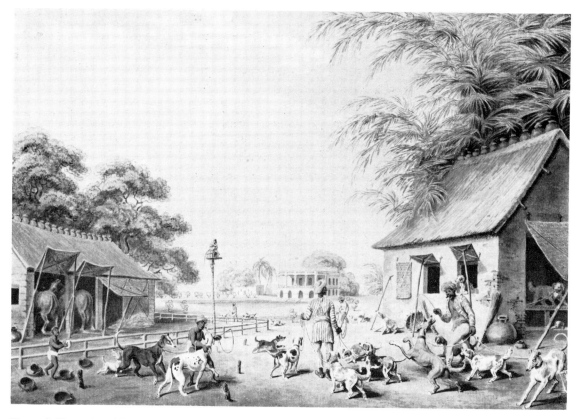

Figure 4. 'Dooreahs of Dog Keepers Leading out dogs, Plate XXXVII'. *Illustration to* Oriental Field Sports *by Samuel Howitt, 1805-07.*

1788-1863, contributed illustrations to *Travels in Sicily, Greece and Albania* by the Rev. T.S. Hughes in 1820 and another architect, Professor T.L. Donaldson, published his *Pompei Illustrated* in 1829. Sir William Gell, 1774-1836, another topographer, sent out a continuous stream of books after settling in Italy. These included *Pompeiana*, 1817-19, *The Walls of Rome*, 1820, *Narrative of a Journey to the Morea*, 1823, and *Topography of Rome*, 1834. Gell also penetrated to Troy and Barbary but with the exception of draughtsmen like Luigi Mayer, who worked in Egypt, 1801-04, much of the landscape drawing was in Western Europe.

A lucrative side to the illustrated book market was the trade in elaborate folios of the recent campaigns from the Nile to Waterloo, and in some cases views of St. Helena where Napoleon was residing. The volumes had begun to appear during the war as the public demanded immediate representations of the sites and evidence of battles and sackings as they happened. One example of this was from the pencil of the artist-chaplain to Lord St. Vincent, the Rev. Cooper Willyams, 1762-1816, who gave his own account of the Battle of the Nile in *Voyage up the Mediterranean in the Swiftsure*, 1802. There were many others, St. Clair's *Views of the Principal Occurences in Spain and Portugal*, 1812, and Jacob's *Travels in the South of Spain*. The small village of Waterloo became the most drawn in Europe, from the grand volume of the *Martial Achievements of Great Britain and her Allies*, 1815, to the *Historical Account of the Campaigns in the Netherlands* with some plates by Cruikshank, and the *Victories of the Duke of Wellington*, 1819, with Westall illustrations. R. Bowyer of Marlborough Place, Pall Mall, were offering their *Campaign of Waterloo* within the year, complete with portraits and biographical notes of the allied generals, reprints of despatches and an account of St. Helena. This was in addition to maps, several coloured aquatints and a folding plate in aquatint of the battle from Mont St. Jean.

The great interest in British topography which resulted from the cult of the picturesque was not confined only to the house of Ackermann. Another publisher and promoter of equal stature was John Britton, 1771-1857, who was also a rather mediocre illustrator in his own right. Virtually untrained, but working as an architectural draughtsman from about 1787, Britton began to produce surveys of the architectural antiquities of the English counties in 1801 under the title of *The Beauties of England and Wales,* 1801-1821. Similar things had been attempted but Britton brought with him an expertise in business, a thoroughness in history and accuracy in draughtsmanship, that had not been seen before. Along with his more scholarly co-author, E.W. Brayley, 1773-1854, Britton actually walked over much of the countryside described in the early books and according to one report, traversed as much as fifty miles in a day! For the first five volumes in the series, the authors travelled 3,500 miles and between June and September 1800 had walked 1,350 miles on a route from London to Hereford and Ludlow, then to North Wales and finally back to London again. 'In the long run it was the seven hundred illustrations which made the greatest impact,' writes J.M. Crook, 'and for this Britton justifiably claimed the credit. It was only towards the end of the series that he handed over responsibility to the ubiquitous J.P. Neale.'[9] Britton trained up a whole team of young men as topographical illustrators whom he housed under one roof in London, providing them with books and materials for study such as the earlier prints of Buck and Hearne and the drawings of Cotman, Girtin and Turner. Among these pupils were Samuel Prout, 1783-1852, Frederick Mackenzie, 1788-1854, and W.H. Bartlett, 1809-1854. Engravers who learned their craft in the Britton atelier included John and Henry LeKeux, the watercolourist George Cattermole, 1800-1868, and the architect Edward Blore, 1787-1879. Britton gave evening parties which were well known for their conviviality and the affection in which he was regarded by his pupils is shown in part of a letter written to him many years later by Bartlett:

'I have a vivid ... recollection of the awakening of the antiquarian spirit within me under your tuition; of drives and walks about the Wiltshire downs, and of the great gig-umbrella swaying to and fro, and the danger of all being capsized, of cromlechs, stone temples, old churches, and old gateways, and a host of other subjects.'[10]

Britton's generic name for his illustrators was 'scientific artists' suggesting the rigorous standards that he expected from them. At different times he employed Nash, Hearne, Wyatville, Buckler, Gandy, Wild, Westall, Dayes, Fielding, Turner, Shee and Repton. Even when he had ceased with *The Beauties,* he was busy producing other important series, *Cathedral Antiquities of Great Britain,* 1814-35, *The Dictionary of Architecture,* 1829 or individual guides to country houses, *Fonthill,* 1823, *Cassiobury,* 1837, and *Toddington,* 1841, which were still having a vogue. He completed his career by publishing a voluminous *Autobiography,* 1850, which shows how the seeds of the Gothic revival and of landscape illustration were sown in the Regency. Britton's importance lies not simply in this but in the fact that he understood the book as an art form and took pains with his design, his title pages, tail-pieces and headings. In many ways he was a forerunner of those industrious apprentices of the publishing trade who were to take the country by storm in the 1840s.

John Preston Neale, c.1780-1847, worked for both Ackermann and Britton at various times and published his own *Views of the Seats of Nobleman and Gentlemen,* 1818-24, and the second series from 1829, for which he executed over seven hundred drawings. He also drew for *Views of the Most Interesting Collegiate and Parochial Churches of Great Britain,* 1824-25, and *Jones's Views,* 1829-31. Original drawings for these works are seen on the market from time to time, beautifully finished, but often lacking the contrast or drama which one associates with the romantic movement. The urban counterparts to Neale were George Shepherd, fl.1800-1841, who drew for Wilkinson's *Londina Illustrata,* 1808, and *Architectura Ecclesiastica Londini* and his brother Thomas Hosmer Shepherd, fl.1817-1840.

The latter was a very prolific topographer, illustrating Bath and Bristol but most notably the new buildings of London in the 1820s. These were contained in *Metropolitan Improvements*, 1827-28, and *London and its Environs in the Nineteenth Century*, 1829, a show of confidence in the stuccoed terraces of Nash. These were published by Jones at his 'Temple of the Muses' in Finsbury Square and issued in parts at one shilling each. Each part contained a text by the architect James Elmes and four steel plates 'Engraved in The First Style of the Art' from Shepherd's drawings. The publisher offered subscribers special cheap rates during the progress of the work which would be doubled when the collected edition appeared. The artist depicted Regent Street, Regent's Park and the improved squares and crescents but also the smaller villas of Park Village and the Canal. Testimonials from famous architects were printed on the paper covers! A similar part work was issued for Scotland, *The Modern Athens! Or Views in Edinburgh: Exhibiting the Whole of the Splendid New Buildings and Modern Improvements*, 1830, priced at four shillings a section and containing sixteen steel engravings. A handsome two volume set by William Westall was *The Mansions of England*, 1830, a collaboration with Shepherd and Gendall of plates issued in *The Repository*. Another charming illustrated book is *Picturesque Rides and Walks with Excursions by Water, Thirty Miles Round the British Metropolis* by J. Hassell, 1817. With an eye for the remote and secluded, the artist shows the lesser-known country houses, churches and monuments of Hertfordshire, Kent and Surrey.

Among the growing number of topographers and view painters, many of whom were amateurs encouraged by Britton to draw their own localities, were one or two highly individual men whose work is on a different level. Georg Cuitt Junior, 1779-1854, was almost alone in using etchings for his antiquarian books on the North of England. A drawing-master at Chester, Cuitt used his vigorous and dramatic style, strongly influenced by Piranesi, to produce a remarkable series of plates including those to *Saxon and Other Buildings Remaining at Chester*, 1810-11, *Picturesque Buildings in Chester*, 1810-11, and *A History of Chester*, 1815. Cuitt used the deep contrasts possible in etching and the sketchy groups of figures among the old buildings of the city to lift topography out of the realm of mere hackwork (Figure 5).

Figure 5. Chester by George Cuitt. 1815. Etching.

Right: Figure 6. Monument in Hingham Church by J.S. Cotman. Etching.

Another artist to do this supremely well was John Sell Cotman, 1782-1842, a natural landscape painter whose hands were nevertheless tied by the publisher's demand for antiquarian views. Self-taught, but growing up in the fertile artistic ground of Norwich, Cotman had great advantages in being associated with watercolourists like John Varley and Thomas Girtin and having the encouragement of rich patrons. But recognition and worldly success did not come and he was thrown back on his own resources to become an illustrator of county histories and a teacher of drawing to young and not so young ladies. In 1804 Cotman came into contact with Dawson Turner, a scholarly amateur with a passion for medieval antiquities and particularly Gothic architecture and design. The artist was engaged almost at once on a long and tedious job of recording the historical monuments of Norfolk and Suffolk, the churches, castles, priories and brasses for which Turner felt such an enthusiasm. The sketches from which Cotman worked up his etchings are dated from 1805 to 1818 and were issued for circulation privately as *Specimens of the Architectural Antiquities of Norfolk,* 1812-18, in ten parts. The whole collection was published as *A Series of Etchings Illustrative of the Architectural Antiquities of Norfolk,* 1818, and *Specimens of Norman and Gothic Architecture in the County of Norfolk,* 1816-18. Besides these he produced ninety-seven plates and two ornamental title pages for *Excursions Through Norfolk,* 1818-19, which were badly engraved and lack any of the original brilliance as prints. It is rather depressing that such an individual genius as Cotman should have had to spend so much of his time on such unproductive book work, but his drawings and etchings show how personal his response was. As C.F. Bell wrote: 'It is paying him a very inadequate compliment to say that his touch transported the traditional "views of seats" so abundantly popular at that time, on to a plane which no other draughtsman dreamed of approaching.'[11] (Figure 6.)

Cotman was given greater scope when Turner sent him to Normandy in 1817, 1818 and 1820 to draw its Romanesque architecture as a comparative volume for the earlier work. The artist extended his range to the countryside and to its peasantry, although it was only the archaeological part of the tour that was published. This appeared as *The Architectural Antiquities of Normandy,* 1822 and 1832, a remarkable book in its scale and accuracy with a great deal of Cotman's unique vision. Some of the etchings are awe inspiring, the West Front of Rouen Cathedral for example which the artist called 'a work of more than twenty weeks hard labour'.[12] The most handsome set of the etchings is the one published by Bohn in 1838. But topographical illustration was not enough, disillusion produced in Cotman what has been described as 'self-tormenting melancholia'.[13] For long after his death in 1842, these drawings were still passing from collection to collection for only a few shillings, although a few discerning men, such as the Rev. Bulwer, had gathered them together, realising their merit.

Cotman eked out his living as a drawing-master and these years were notable for the great number of copy-books and exemplars produced by aspiring teachers for the amateur. The first books of this kind, as distinct from works on perspective, were really those by that herald of the Picturesque, the Rev. William Gilpin, 1724-1804, in the 1780s and 1790s. They included *Observations on the River Wye,* 1782, *Observations on . . . the Mountains and Lakes of Cumberland and Westmorland,* 1786, *Forest Scenery,* 1791, and *Picturesque Travel,* 1792, and several more. They were essays in aesthetics for the artist and the dilettante, but they were more than this for they were illustrated by Gilpin's own sketches in aquatint. These usually appear in ovals and have a yellowish tinge to the print, which the artist believed was preferable to the staring whiteness of paper; one of the books, *Forest Scenery,* had a series of 'picturesque animals' etched by Sawrey Gilpin on toned paper. This precedent brought a great flurry of similar books in the next twenty years, each claiming to show the most 'characteristic expression' of natural landscape. Among these might be

mentioned *An Essay on Trees in Landscape* by Edward Kennion, 1815, with a fine group of tree studies by the author, J. Hassell's *Aqua Pictura,* which came out in monthly parts, 1811-13, showing progressive stages in landscape drawing and the same artist's short-lived and rare *Drawing Magazine,* 1809-11. There were few artists of stature who did not publish something illustrated by themselves; Pyne, as we have seen, produced his *Groups,* John Varley issued an eight part work *A treatise on the principles of landscape paintings* between 1816 and 1821, Robert Hills etched plates of cattle and horses for example in the years 1798 to 1817. David Cox's *An Essay on Landscape Painting & Effect,* 1814, and reprinted regularly until 1841, is among the best of these works containing coloured aquatints of such beauty as to be barely distinguishable from watercolours. Samuel Prout's earlier drawing books were illustrated by soft-ground etchings, Francis Nicholson's *The Practice of drawing and painting landscape from nature,* 1820, has a careful explanation on colouring and George Brookshaw tackled another side of the growing interest in watercolour with his three books on *Groups of flowers, Groups of fruit* and *Six Birds,* 1819.

Brookshaw's most accomplished piece of illustrating was his *Pomona Britannica,* 1805, with ninety-three coloured plates in stipple and aquatint and this as well as other books prove it to have been a heyday for botanical illustration. William Jackson Hooker illustrated *The Natural History of Fuci,* 1819, for that same Dawson Turner who had helped Cotman and it was the late 1820s that saw the publishing of the grandiose plates for *Birds of America* by John James Audubon. Other titles of note are *Conchology, or the Natural History of Shells* by George Perry, 1811, with their drawings by John Clarke and the magnificent run of Maund's *Botanic Garden,* 1825-35, with the exquisite hand-coloured plates of plants by the miniature painter, Edwin Datton Smith.

The most exceptional talent of these years in book illustration was not however to be found in London or even in metal engraving, but in one of the most distant provincial cities and in wood engraving. Thomas Bewick, 1753-1828, was a Northumbrian who was trained as a copper plate engraver at Newcastle-upon-Tyne under Ralph Beilby. Within a year of his apprenticeship, he was asked to engrave on wood for the illustrations of a scientific work and the tools and boxwood blocks were procured from London; this started him on a career which not only transformed the art of wood engraving but gave Bewick national recognition. Bewick brought to the wood block the same skill and finesse that he used for copper and, instead of cutting away the non printing areas as the early wood engravers had done, he used white line cutting. This meant that the surface was treated as solid black and each stroke of the graver was a white line giving a greater delicacy and creative expression in the design. Over a number of years, the engraver perfected his technique, lowered his blocks to obtain greater evenness in the presses, printed them lighter and papered over the dark areas to bring out the highlights. There were many advantages in the process, it was simpler to print wood engravings and text together for a book, the effect was often more pleasing on the eye and, if the artists were skilful enough, great richness could be obtained for a reduced cost.

Bewick, the Northumbrian and the country man, was highly skilled and highly perceptive as an artist. A constant observer of nature, both human and animal, his soft grey and silvery tones seem exactly fitted for the task of depicting natural history subjects and the fancies and foibles of ordinary simple people. This was his main work from about 1776 until his death, beginning with the engravings for *Select Fables* and continuing with *Gay's Fables* and *Trip's History of Beasts and Birds,* 1779, on to the great classic *A General History of Quadrupeds* which occupied him from 1785 to 1790. Bewick's viewpoint is a very personal one, the animals, drawn in pen and ink and then traced on to the block for engraving, are beautifully alive within their settings and more naturalistic than anything that had gone before. This is even more true of *A History of British Birds,* 1797 and 1804, where

Figure 7. Vignette illustration of old country woman from Bewick's British Birds. *1797-1804. Wood engraving.*

the attention to detail in plumage and habitat could only have been achieved by someone who had roamed the countryside for information. The human interest is provided by the delicate little vignettes and tail-pieces, minute slices of country life which follow chapter by chapter, often with a Rabelaisian wit. We are treated to glimpses of clumsy yokels, huntsmen, angry old crones and mischievous boys, as the backdrop to the teeming, restless and fascinating rural life of Bewick's countryside (Figure 7). The same spirit emerges in the delightful *Fables of Aesop,* 1818, on which he was engaged for seven years. Further books were projected on *British Fishes* and although they were never completed many drawings and engravings survive for them in the British Museum.

Even Bewick's proficiency and personal supervision of the printers could not entirely outbalance the variableness of the impressions, and the engraver's own clients were invited to choose their own wood engravings before having the books bound up.[14] It is also uncertain how much of a hand the more talented pupils had in some of the vignettes, according to Bewick very little, but according to Jackson rather more; this again might account for some discrepancies among the engravings in the same book. Bewick had numerous pupils and some left him for London and great success, but he appears to have carried a rather jaundiced view of some of them into old age. Despite this, the association with Bewick was of great importance and it was this continuity in wood engraving that was to prove invaluable when the revival of the art set in during the 1840s. Names such as John Jackson, William Harvey, John Thurston and Charles Thomson were to carry Bewick's influence forward if their work never reached his heights. The celebrated Dalziel Brothers were also in the line of succession from this master engraver.

The Regency was not only the age of the lavish colour plate book but the golden age of British caricature. The cream of London life, its politics, its fashions, its social misdemeanours were constantly placed before the public by the artists, and if it was often rather sour cream, it helped to vent the irritation with weak governments and a self-indulgent Court. Many years later Charles Knight recalled the excitement generated by each new production of this very urban art. 'A daily Caricature? Yes; and a wilderness of Caricatures, issuing in endless succession out of shops round which crowds gathered from Piccadilly to Cheapside.'[15] When J.P. Malcolm published his *Historical Sketch of The Art of Caricaturing* in 1813, the first survey of the subject, he excused himself by referring 'to the number of persons employed in this way, and the number of shops appropriated to the sale of Caricatures . . . a proof of the importance the Publick has attached to them.'[16] Malcolm felt bound to define caricature as an art form and to some extent today it still needs that

definition. To some people it is any visual grotesque however far removed from portraiture, to others it is the world of diminutive figures with huge heads or the characters depicted on seaside postcards. Only an art as spontaneous and volatile as caricature could have slipped so easily into the language without explaining itself, so it is necessary to know a little of its background to appreciate the work of Gillray and Cruikshank, Dighton and Heath.

Caricature comes from the Italian word 'caricare' to overload and it was in the Italy of the early baroque that the art was born. Artists and sculptors had always interested themselves in the grotesque, Leonardo's heads are an example, and since the Renaissance had used emblems to make political or religious points in prints. But it was only with the painter, Annibale Carracci, 1560-1609, that it came to be realised that the pithy exaggerations of the most striking features of a man, were often more true to life than a portrait. Carracci made rapid sketches that 'overloaded' the characteristics of his friends and dubbed them 'caricature'. He claimed 'to grasp the perfect deformity and thus reveal the very essence of a personality'. Bernini and other artists were to develop this sideline to their more serious work.

By the early years of the eighteenth century, the Grand Tour was in full swing and the artistically-minded and the influential in British Society were making the journey to Italy. Not all of them were such serious connoisseurs and some no doubt agreed with Lord Chesterfield that it was not expected of a gentleman to do more than dabble in art. But caricature was different, it was witty and subtle and appeared to expend no energy; it exactly suited the dilettante who could show his flare for a likeness but remain an amateur, who could satisfy the urge to create something and yet know it would be ephemeral. So along with the opera, the ridotto and old master paintings, caricature entered this country in the baggage of returning *cicerones* and milords. One or two painters such as the Italians Zanetti and Pier-Leone Ghezzi became as celebrated for their thumbnail caricatures as for their history paintings, the English artist, Thomas Patch of Florence, specialised in caricature oil groups of his visiting fellow countrymen. The tourists and the artists saw these, were amused, and experimented for themselves, the Countess of Burlington, Lord Townshend and Sir Joshua Reynolds among them.

Alongside the growing interest in 'caricatura' was the much older tradition of portraying types. Leonardo had drawn contrasting faces much in the spirit of the medieval display of the different humours. Hogarth's prints are all of this kind, detections of passion, stupidity, grossness, cupidity and sloth in human countenances, but not caricatures. Hogarth has unfortunately been labelled 'the father of English caricature' but his work was quite alien to the light-hearted jottings of Court dandies. But Hogarth was far too powerful a figure in English draughtsmanship for his influence to escape the caricaturists. The 'caricatura' of types is a popular subject throughout the nineteenth century and this stems directly from him. A further boost to the character draughtsman was provided by the pseudo-scientific investigations of physiognomy and craniology. Johann Casper Lavater's writings were popular in England and in them he maintained that the virtues and vices of a man might be classified by his profile and salient features. The particular set of a nose or a mouth belonged inevitably to a certain type, craniology or the study of bumps led to similar conclusions about thirty years later.

So at the beginning of our period there were three branches of caricature, the amateur caricaturist who made lightning sketches for private circulation and occasionally had them published, the political and social caricaturist who drew portraits and mirrored current events and the draughtsman of types and characters. From the middle of the eighteenth century, caricature had come to occupy a more crucial place than as the mere doodlings of a dilettante, it became a sharp political weapon and crossed the threshold from the drawing-room to the club house. Malcolm believed that, 'Those Caricatures which apply to

political events and characters are now considered as the necessary consequence of holding a place under the Government, or wishing to obtain one.'[17] George Townshend, Lord Townshend, 1724-1807, was the earliest amateur to use his talent for a cause. Identifying military setbacks on the Continent with the Duke of Cumberland, Townshend began savagely and mercilessly to caricature his former commander and published an anonymous print of 'A Brief Narrative of the Late Campaign in Germany' 1751. From 1756 he was associated with the printsellers Matthew and Mary Darley, thus setting a pattern for the caricaturist in the next seventy years, the amateur supplying the engraver with ideas and the printseller financing them. From the 1770s the amateurs were still in the lead and one in particular, Henry William Bunbury, 1750-1811, typifies the ill-drawn but spontaneous life of these prints. A country squire with a taste for humour, Bunbury poked gentle fun at life and was commended by Malcolm for never 'having wantonly injured the feelings of individuals, who were not accountable to him for the singularities of their features, persons or manners . . .'[18] The example shown (Figure 8) is called 'The Salutation Tavern' and was published in March 1773 by the Darleys. Its free drawing of the figures and its Italian setting show the connection still existing between caricature, high society and the Grand Tour. These uncoloured prints with two figures were called 'Macaronis', a word for fashionable people and the sub-title 'Macaroni & other Soups hot every day' referred to the daily publications of satires. However inadequate Bunbury might seem to be as an artist, it says something for the status of caricature at this time that Reynolds owned the caricaturist's original drawing for his popular 'A Barber's Shop', 1785.[19]

Another crude but competent hand was Francis Grose FRS, 1730-1791, the antiquary and author, who actually published a pamphlet on the subject. *Rules For Drawing Caricatures,* 1788, is a delightful booklet which gives much of the flavour of amateur

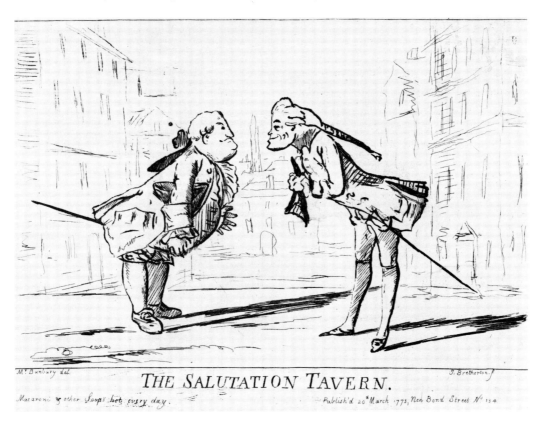

Mr Bunbury del. THE SALUTATION TAVERN. J. Bretherton f.

Macaroni & other Soups hot every day. Publish'd 20th March 1773, New Bond Street No 134

Figure 8. 'The Salutation Tavern' by H.W. Bunbury. 1773. Engraving.

draughtsmanship and must have accounted for many of the portfolios of scraps and albums of heads in country house libraries. Like Hogarth, Grose considers that caricature has a moral purpose and 'may be most efficaciously employed in the cause of virtue and decorum, by holding up to public notice many offenders against both, who are not amenable to any other tribunal.'[20] He instructs the reader to draw portraits from the antique or from plaster casts and then amuse himself by altering the proportions. But this is no substitute for observing the peculiarities of nature and with Georgian elegance he begins to rationalise the process, dividing the nose, the chin and the eyes into categories and giving each category names. A line should be drawn through a profile touching the extremities of the forehead, nose and chin, the general facial expression 'angular, concave, convex, right lined or mixed' being apparent from it. 'Mouths may be arranged under four different genera or kinds. Of each of these there are several species. The under-hung, the pouting or blubber, the shark's mouth and the bone box.'[21] Grose illustrates all these and goes on to point out that a caricature should be both spontaneous and a result of assimilation. 'Peculiarities of the eyes are best shown in a front face; those of the nose, forehead or chin [in profile] ; for by these distinctions the different features of a face may be described as to convey a pretty accurate idea of it; wherefore, when a caricaturist wishes to delineate any face he may see in a place where it would be improper or impossible to draw it, he may commit it to his memory, by parsing it in his mind (as the school-boys term it) by naming the contour and different species of feature of which it is constructed, as school-boys point out the different parts of speech in a Latin sentence.'[22]

Grose concludes that his appended caricatures 'are not to be considered in any other light than as mathematical diagrams, illustrating the principles here laid down.'[23] The germ of caricature is almost accidental and Grose can hardly have believed that anything so febrile could be achieved by a nearly mechanical process. Nevertheless such manuals kept amateur work alive in the long evenings and provided a continuous flow of new recruits to book illustration and later to the magazines. In 1813 it could be said with some truth that 'the Caricatures of the Continent seem all forced and unnatural and entirely destitute of that fire and freedom and invention, conspicuous in our own.'[24]

The happy band of amateurs, Townshend, Bunbury, Grose, Henry Wigstead, G.M. Woodward and John Nixon, prepared the ground for the professional caricaturists who were to follow. Among the most important names from the 1780s were James Sayers, Isaac Cruikshank and James Gillray, 1757-1815. After conventional training at the Royal Academy and as a stipple-engraver, Gillray turned to caricature with the Bond Street print-shop of Miss Humphrey as his outlet. A far better craftsman and a more instinctive artist than the others, he very soon simplified the art and brought greater expression to the subjects and stronger imagery to their meaning. His work hit very hard and as the artist was something of a political maverick, the politicians wooed him continuously. So did the Prince of Wales, who could not forget the bloated image Gillray produced of him as 'A Voluptuary under the horrors of Digestion' 1792. At various times the Prince and the ministers paid pensions and bribes to him to keep their features out of the daily prints!

Much of the pungency of Gillray's work can be accounted for by his cynicism and pessimism. 'For Gillray, as for any perceptive humorist,' writes Draper Hill, 'comedy and tragedy were the opposite sides of the same coin. In his eyes, human experience seems to resolve itself into a grim sort of carnival roller-coaster on which trial is inevitably followed by error and aspiration necessarily results in disillusion.'[25] J.P. Malcolm, who was not a great sponsor of Gillray referred to his 'unbounded spirit and fire of genius' glowing 'in every line of his work' which distinguished him from the previous generation. In his single figures and small groups, he continued the amateur style of caricature, but his elaborate compositions benefited from his training as a history painter which Bunbury and the others

had never had. A good pair of copper engravings of 1795 which show his talent in straight profile work are the 'Billingsgate Eloquence' and 'Pulpit Eloquence' (Figures 9 and 10). In 'Billingsgate Eloquence' he shows the scraggy features and bared arms of a Billingsgate fishwife, famed for their brutality and bad language. The gist of her argument is carried on the caption below, but the real humour lies in the fact that the caricature *is* a portrait of Lady Cecilia Johnston, well known for the bitterness of her tongue! In the other hand-coloured engraving 'Pulpit Eloquence', a fat and contented cleric preaches from a pulpit, but it is no ordinary cleric, but Archbishop John Moore, a frequent butt of Gillray's satire.

The sharp divisions along party lines which followed the French Revolution probably enabled Gillray to exercise his art with unprecedented asperity. Malcolm railed against faction and insisted 'that party spleen too often suggested a degree of severity which belongs only to crimes of the deepest dye.'[26] Charles James Fox's portrayal as a devil and Pitt's head rising out of excrement are rather overstating the case, even if the impact is powerful. It was in fact against the common enemy, the French, that some of Gillray's best work was done, in the same way as it was to be with that of Low one hundred and fifty years later. 'The Plum-Pudding in danger' of 1805 and 'Tiddy-Doll, the great French-Gingerbread-Baker' 1806, are unforgettable, as is 'The King of Brobdingnag and Gulliver, 1803 (Colour Plate V). The caricaturist has used an incident from Swift to show George III and Napoleon in a way that is practically visual alone. Gillray's original drawings are rare, but his surviving sketchbooks show that he worked 'in a lacy, delicate pencil to which ink (and occasionally colour) was later added'.[27] The wild maze of free penwork which typifies these studies is entirely different from that of Rowlandson, Dighton or any of his contemporary caricaturists.

Social caricature was at least as popular as political caricature under the Regency and the follies of society, connoisseurship, opera-going, military and sporting absurdities, medicine and the theatre, were ceaselessly ridiculed. The excesses of fashionable costume

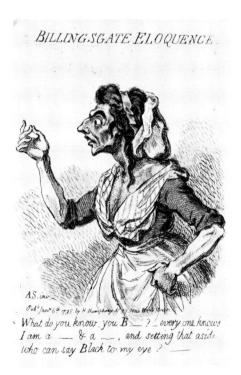

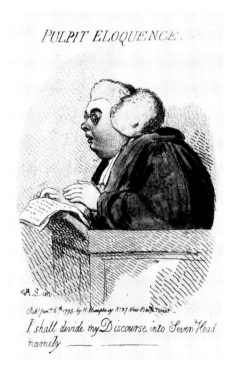

Figure 9. 'Billingsgate Eloquence' by James Gillray. 1795. Engraving.

Figure 10. 'Pulpit Eloquence' by James Gillray. 1795. Engraving.

were an early favourite of the caricaturists. 'Nothing affords greater scope for ludicrous representations than the universal rage with which particular fashions of dress are followed by persons of all ranks, ages, sizes and makes,' wrote Grose in 1788, 'without the least attention to their figures or stations. Habiliments also, not ridiculous in themselves, become so by being worn by improper persons, or at improper places.'[28] Gillray satirised superbly the elaborate coiffeurs, plumes, turbans and high-waisted dresses of his day and his followers relentlessly caricatured the sartorial coxcombery of the 1820s with its pantaloons, high collars and quizzing glasses for the men, enormous top-heavy hats, small waists and tiny feet for the women. The interaction between fashion plates and fashion comedies is touched on in a later chapter, but it was certainly this aspect of the art which was to find the most comfortable place in Victorian parlours. One of the earliest and most prolific of these artists concentrating on manners, was Robert Dighton, 1752-1814, an actor and caricaturist who took subjects from London life including those of

Figure 11. 'A Lesson Westward' by Robert Dighton. Pen and ink with watercolour. 1782.

parsons, barbers, ladies of the town and lamplighters. While not as bold in style or visual imagination as Gillray's, these engravings, usually charmingly coloured, give an interesting and detailed glimpse of late eighteenth century and early nineteenth century life.

In February 1978, Sotheby's sold the most important collection of original watercolours by Dighton that has so far come to light, a complete album of his work from the collection of the late Jeffrey Rose. The ninety-six drawings had belonged to the Carrington Bowles family, who were Dighton's publishers, and had been bound together in about 1830. The drawings were early, spirited, with both historical and literary content and in mint condition with their colours protected for a hundred and fifty years.[29] They covered the whole range of his work from the least caricatured of his groups 'Pheasant Shooting' and 'Snipe Shooting' to the macabre half skeletal watercolours of 'Life and Death Contrasted'. One which illustrated Dighton's delight in detail is 'A Lesson Westward' (Figure 11), poking fun at the fashion for ladies in high life to learn to drive phaetons. This one, expensively dressed and under instruction, has already killed a piglet and is terrifying the life out of an elderly gentleman! In the majority of cases, Dighton's pen line is harder than Rowlandson's and he is much less accomplished in the drawing; his figures stare rather stiffly out of the paper and their faces are usually grotesque.

The most important figure after Gillray was probably George Cruikshank, 1792-1879. He came from a caricaturing stable, the son of Isaac Cruikshank, and completed Gillray's last work for Miss Humphrey in 1811 and was the dying artist's natural successor. Satire became extraordinarily fierce again in the closing years of the Napoleonic campaign,

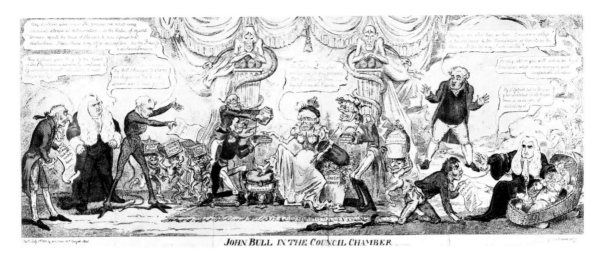

Figure 12. 'John Bull in the Council Chamber' by George Cruikshank. Engraving.

particularly in the turmoil surrounding the King's illness, Princess Caroline's misdemeanours and the Prince's extravagance; Cruikshank's eye was a match for all this. He inherited from Gillray the large scale of the latter's caricatures and to some extent his grotesqueness, devils, gremlins and exaggerated gestures are part of this. In other places, his imagery of a polluted countryside or a vision of future air travel, are more abstract. One of Cruikshank's typical productions is 'John Bull in The Council Chamber' drawn and issued by Jones of Newgate Street in 1813 (Figure 12). This engraving does demonstrate that Regency caricature was still something that had to be read as well as looked at, symbol and letter-press were still as important as recognisable portraiture. The central figure is that of Queen Charlotte, the German consort of George III, by 1813 the rather sad wife of the mentally disturbed King. Never a great beauty, she is shown by Cruikshank shrivelled and peevish, her elbow resting on a German sausage and her throne overflowing with sauer kraut. Various attendants offer up boxes of Royal Strasburgh to her, while Chinese figures holding money bags glare down at her from pillars, a reference to the royal extravagance at the Brighton Pavilion. A fat baby in a cradle, easily identified as the Prince of Wales, sleeps indulgently, while the Chancellor keeps a starving Irishman away. On the other side, the Liverpool administration refute the claims that the estranged Princess Caroline is worthy of censure. At the right-hand, John Bull, a fairly new recruit to the caricaturist's menagerie, looks on aghast and shouts out indignantly 'Is this the way I am bubbled?' That the artist should strike so many subtle nuances was a great test of his political awareness, Cruikshank scarcely left the drawing table when Parliament was in session. As Malcolm comments: 'He that would ensure success is aware that he is expected to draw with great correctness; which having attained, he flies to his pencil, and thence to etching; and thus he gives a spirit in every touch of the needle that could not be effected were he compelled to proceed with caution.'[30]

Neither Cruikshank nor his contemporaries Charles Williams, William Heath (Colour Plate VI), Newton or Rowlandson, spared their subjects and it is not surprising that Cruikshank was paid £100 on the new King's accession in 1820 'in consideration of a pledge not to caricature His Majesty in any immoral situation', the artist was indeed wielding power. The forerunners of the illustrated papers, they were sold at a penny plain and tuppence coloured but not yet in book form.

The art of caricaturing continued in the country houses where it had first flourished. Numerous sketchbooks are found with witty little drawings of house parties, shooting parties and amateur theatricals in broad caricature, but they are often difficult to identify. Two, who might be mentioned are Robert Browning Senior, 1782-1866, the father of the

poet, who made crude political caricatures in ink and the Hon. Henry Graves, 1806-1892. Graves was a society figure who moved in aristocratic circles and drew his fellow guests with charm and humour in brown ink and wash. His vein of fantasy is sufficient to make the private jokes of the Paget and Wellesley families seem funny even today with their monstrous luggage, animals in hats and cigars flying through the air with wings!

A more substantial figure however and one with a humorous eye was the Rev. Walter Sneyd, 1809-1888, of Keele Hall, Staffordshire. Sneyd had the conventional background of the younger son, he was educated at Oxford and destined for the church and the occupation of a family living. Perhaps as an undergraduate he developed an aptitude for caricature, for as a young man he was prolific in both pencil and crayons. In 1829, he privately printed a delightful little book called *Portraits of the Spruggins Family*, an imitation of a family history with witty little drawings (Figure 13). Sneyd carried out all the work himself with the exception of one plate[31] and utilised the new invention of lithography, which enabled the amateur to come to grips with printing as well as sketching. As can be seen, Sneyd was still working in the manner of Gillray and in fact his uncle had supplied drawings for Gillray's prints. There is therefore some evidence that the art of caricature was handed down in families as a 'polite' accomplishment along with drawing and dancing. Other skilful draughtsmen were Alfred, Count D'Orsay, and W.M. Thackeray who will be discussed later, the link between the professional artist who played with the human countenance and the amateurs who dabbled with it, provided a useful middle ground in the years that lay ahead.

Figure 13. Illustration to the Spruggins Gallery *by the Rev. Walter Sneyd. Lithograph.*

Footnotes

1. Mrs. Bray, *Life of Thomas Stothard R.A.*, 1851.
2. ibid.
3. S.T. Prideaux, *Aquatint Engraving*, 1909, p.113.
4. *Picture of London*, 1811, p.335.
5. *History of the Abbey Church of St. Peter's, Westminster*, 1812, p.xvi.
6. *The Farington Dairy*, Edited by James Greig, Vol. 7, p.168.
7. Wyatt Papworth, *The Life of J.B. Papworth*, 1879.
8. *Jerdan's Autobiography*, 1853, pp.78-79.
9. J. Mordaunt Crook in *Concerning Architecture*, 1968, p.108.
10. ibid. p.109.
11. C.F. Bell, *Walker's Quarterly*, Nos. 19-20, 1926, p.17.
12. Martin Hardie, *Watercolour Painting in Britain*, Vol. 2, 1967, p.87.
13. ibid. p.91.
14. *Thomas Bewick — Memoir*, Edited by Ian Bain, 1975.
15. Charles Knight, *Passages of a Working Life*, Vol.2, 1865, p.6.
16. J.P. Malcolm, *An Historical Sketch of the Art of Caricaturing with Graphic Illustrations*, 1813, p.iii.
17. ibid.
18. ibid. p.89.
19. ibid. p.92.
20. Francis Grose, *Rules For Drawing Caricatures*, 1788, p.4.
21. ibid. p.8.
22. ibid. p.10.
23. ibid. p.12.
24. Malcolm, op. cit. p.157.
25. Draper Hill, *Mr. Gillray The Caricaturist*, 1965, p.136.
26. Malcolm, op. cit. p.54.
27. Hill, op. cit. p.135.
28. Francis Grose, *Comic Painting*, 1788, p.2.
29. The sale on 23 February 1978 made a total of £50,960 and established caricatures as major works of art.
30. Malcolm, op. cit. p.157.
31. According to a note in the *Bodleian Library Record*, Vol. 8, No. 3, February 1969, states that all but the picture of the whole gallery were Sneyd's works, the exception being Lady Morley's.

Chapter 2

Albums, Annuals, Landscapes
and Lithographs

The most dominant feature of the Regency book market had been topography, the most obscure countries, insignificant cities and curious journeys were dutifully recorded and engraved on the copper plate; abbeys, castles and country houses had their own guides and even the novels of Scott and the adventures of Dr. Syntax became the excuse for loosely delineated topography and travel illustrations. The appetite of the public for such descriptions was insatiable and there seems to have been little concern whether the texts were very accurate or very lengthy provided that the engravings were of a good standard. The limitations of this sort of book were really the limitations of the copper plate itself, for in 1800, a publisher would not normally expect to get more than four thousand good impressions from one plate, a lamentably small edition considering the potential readership. A more durable material was sought and this proved to be the steel plate, introduced here in about 1822 by Albert Warren. As the years went by these were improved to gain absolute consistency for the artist, no warping and any degree of hardness that was required. From 1820 to 1835, a whole generation of artists were bred up to this new invention, who completed their work with the burin (a type of chisel) and became specialists in the interpretation of tones and gradations. For the first time, a large number of British artists saw an opening for their drawings to reach the greatest possible audience, by the 1840s editions of between 20,000 and 30,000 prints were quite usual from the leading London printsellers. Some engravers reached a high degree of proficiency by the 1830s and had a European reputation, among them George Cooke, E. Goodall, R. Wallis, Edward Finder, W. Miller, J.C. Allen and W.B. Cooke. Both topographical and architectural illustrators learned to draw for the engraver, to adapt to his skill and recognise his limitations. Among the men who formed part of the new landscape school were James Duffield Harding, Thomas Allom, W.H. Bartlett, Alfred Gomershall Vickers, James Holland and William Callow; immense prestige was gained for this medium when J.M.W. Turner began to work for it in the 1820s. We are of course still in the province of the separately issued print. Walter Crane dismissed the whole group eighty years later as outside the range of pure illustration: 'Book illustrations of this type which largely prevailed during the second quarter of the century – are simply pictures without frames.'[1] But these 'pictures' did find their way into collections with covers between 1820 and 1840 and do carry the story of the illustrated book forward if somewhat hesitantly. The watercolourists and draughtsmen whose names became famous in early Victorian households through steel engravings, had reached those hallowed surroundings by one direction only, the illustrated annuals.

The craze for annuals, which lasted for about three decades from 1820 to 1850, was a hardly surprising reaction to the austerities and masculine emphasis placed on society by the Napoleonic Wars. Once free of the books on battles and sieges in aquatint, the decade of the 1820s developed a very soft and highly decorative standpoint in everything from its villas to its cuisine. It could be described as a very feminine and pretty period, frilly and fluffy in its dress, modulated in its satirical prints, gently edging forward to the Victorian concept of art and ornament being synonymous. It was a time when the small and the ephemeral were very fashionable just as the 'new' and the 'artistic' were to be in the 1890s and the pocket-sized

annual, beautifully bound, exquisitely lettered 'full of sound and fury signifying nothing' became the touchstone of the moment. Pocket diaries and almanacks had been popular in the eighteenth century, often with an engraved frontispiece or a fashion plate. *The English Ladies Pocket Book For The Year 1795* for example has a folding plate of 'The most Fashionable Head Dresses of the Year'. *The London Almanack for the Year 1810* which is only thumb-size, has a diminutive engraving of 'the Naval Asylum Greenwich' as an introduction to a calendar and a table of lord mayors and current coins. Other illustrated almanacks included the *Ladies Polite Remembrancer* and the *Royal Repository,* and William Havell supplied many of the tiny illustrations for *Peacocks Polite Repository, 1813-17.* A number of these sheets have been seen on the market, usually done in sepia and wash with their locations written below, they are never more than one by two inches in size and must have proved some challenge to the engraver. Samuel Prout also supplied designs for these books and a large collection of proofs is in the British Museum.

It was the energetic Rudolph Ackermann who first spotted that this humble branch of book production could be a highly profitable enterprise. The firm of Rodwell and Martin of Old Bond Street were actually the first to lay plans for an annual and got as far as examining German models and deciding that they could surpass them in quality of engraving, before the financial outlay upset the project.[2] Ackermann was less diffident and knew well the German 'Taschenbucher' and the French 'Almanachs' which the others had no doubt consulted. Taking ideas from here and there, he produced this hybrid called *The Forget-Me-Not* in 1822, which was the first of the race 'the prototype of a new and splendid progeny'.[3]

It was an immediate success and was to last as a 'Christmas and New Year's Present' from then until 1847. The contents were always insubstantial, poems by minor bards and plates of minor thespians, all surrounded by borders and encased in covers that became more exotic every year. A few respectable literary figures began to grace the pages of the books after Alaric Watts started editing *The Literary Souvenir or cabinet of poetry and romance* in 1825-26, continuing in one form or another to 1842. Watts who had a circulation of six thousand copies for *The Souvenir* from its first years, prided himself on executing engravings from '*original* paintings and drawings by the first artists of the day'. Ackermann's and Watts' success led to a cascade of new titles, all rivals as Charles Knight recalled and with 'no lack of sentimental stories and verses, somewhat mawkish with their bowers and flowers'.[4] Over three hundred separate annuals are listed between 1823 and 1855,[5] many of them only reaching one edition, some like *Heath's Book of Beauty* having very long and popular runs, 1833 to 1849. Their names alone capture their trifling fascination and their perennial success, *Affections Keepsake,* 1836-46, *Apollo's Gift,* 1830, *The Bijou,* 1828-30, *The Christmas Box,* 1828-29, *Fisher's drawing-room scrap book,* 1832-38, *Gems of Loveliness,* 1843, *Juvenile Missionary Keepsake,* 1846, *Royal Repository and picturesque diary,* 1831. The flood had become a deluge after August 1834 when the stamp duty on almanacks was repealed. 'There were elegant bijou almanacks for the drawing-room table', Vizetelly records, 'Sunday almanacks for the prayer-book, miniature almanacks for the waistcoat pocket, circular almanacks for the crown of the hat and almanacks even printed upon pocket handkerchiefs.'[6] Where the almanacks led the annuals followed and there were annuals for children, young ladies, protestants, the military, naval and musical! 'Competition necessarily gave rise to prodigious efforts to obtain pre-eminence', wrote S.C. Hall, who was busy editing *The Amulet* from 1829 to 1836, 'In their earlier years, the Annuals were all bound up in tinted paper, and enclosed in a case. Paper yielded to silk, in which the majority of them soon made their appearance; then followed morocco — for the binding of which they had been accustomed to pay nearly as much as the cost of the whole work — illustrated by exquisitely engraved prints from

Above: Plate III. THOMAS ROWLANDSON 1756-1827
'Dr. Syntax and The Gypsies.' Illustration to
The Tour of Dr. Syntax in Search of the Picturesque
Hand-coloured engraving. 1812

Below: Plate IV. THOMAS ROWLANDSON 1756-1827
'The Stocks at Tetbury.' Ink, watercolour and wash
8ins. x 13ins. (20.3cm x 33cm)
Author's Collection

paintings by artists of the highest ability, any of which previously would have been valued at the charge demanded for the series, and containing prose and poetry, written for the several publications by leading popular writers of the age.'[7] A minor poet who wrote for *Friendship's Offering* was W.M. Praed who summed up the gossamer like pattern of these books in his verse 'Goodnight to the Season'.

> 'Good-night to the Season — the splendour
> That beam'd in the Spanish Bazaar;
> Where I purchased — my heart was so tender —
> A card case, — a pasteboard guitar —
> A bottle of perfume, a girdle
> A lithograph'd Riego full-grown
> Whom Bigotry drew on a hurdle
> That artists might draw him on stone
> A small panorama of Seville
> A trap for demolishing flies
> A caricature of the Devil
> And a look from Miss Sheridan's eyes.'

Miss Sheridan was Caroline Elizabeth Sheridan, afterwards the Hon. Mrs. Norton, 1808-1877, daughter of the playwright, who was editor of *The English Annual, Fisher's Drawing-room Scrapbook* and other journals. She was one of a number of society ladies who toyed with literature, the Countess of Blessington, Lady Emeline Stuart-Wortley and the Baroness de Calabrella were others, their portraits liberally spread through the pages among the pictures of J.R. Herbert, C.R. Leslie, G.S. Newton and H. Howard. Even if panoramas of Seville were included and full-grown Riegos, lithographs were never used for all the work was done in the medium of steel engravings. At the beginning of the period they were carefully engraved, but as time went on they were etched for speed and the later steel engravings in these books tend to have a rather mechanical appearance. 'There were Keepsakes', wrote Knight, 'and Gems and Bijous; but these delicate flowerlets of the literary hotbed had a brief existence. They did more for the arts than for letters.'[8] This statement is hardly corroborated by the books themselves. After looking at a great many their mild prettiness and embossed bindings do not seem to have anything very startling to say for book illustration at all. Beyond the title-pages, which were usually pleasantly designed (Figure 14) and gave the steel engraving an opportunity of cleverly showing medals by Wyon and sculpture by Flaxman, there was practically no use of the vignette and an

Figure 14. Title-page for The Keepsake, *1830.*

Figure 15. Illustration for Moore's Lalla Rookh *by J.M.W. Turner RA 1775-1851. Watercolour. Signed.*

Figure 16. Title-page of Heath's Picturesque Annual for 1832, *with illustration by Clarkson Stanfield, engraved by E. Goodall.*

unrelenting series of portraits and genre subjects. With titles like 'Lucy and Her Bird' or 'Do You Remember It', they were cabinet paintings encased in books. Obviously illustrations were commissioned directly for these books, small and highly finished grey and brown wash drawings that do appear by Fanny and Louisa Corbaux, F.P. Stephanoff, Alfred Chalon and the Corboulds were evidently destined for such plates, but the main commissions coming through the lady editors all seem to have gone to established oil painters. Absolutely no attempt was made by *them* to adapt their canvases for the small format. Thackeray ridicules this in *Pendennis,* 'it was the eminent poets who had to write to the plates and not the artists who illustrated the poem.'

J.M.W. Turner contributed regularly to *The Keepsake* from 1829 to 1837 and this influx of landscape engravings, though small in number in proportion to the book and always very small in scale, gave the annuals a more serious interest. Turner's involvement with book illustrations is almost a separate subject, his extraordinary powers and intellectual approach make them quite unlike anything else undertaken in the early nineteenth century. The artist had grown up very much in the topographical tradition but his first major attempt to codify his thoughts about the art and present 'a visual treatise on landscape' was his *Liber Studiorum* issued in fourteen parts between 1807 and 1819. This was inspired by Claude's *Liber Veritatis* and the project was carried out in mezzo-tint by Charles Turner, the engraver, although outlines of the designs were always etched on to the plate by Turner himself. Another large scale landscape work appeared between 1814 and 1826, *Picturesque View of the Southern Coast of England,* in which the master was joined by certain lesser stars like William Westall, Samuel Owen and William Havell, but had the lion's share of the

work. This series was a success, was issued as two volumes and was still being produced in large paper editions as late as 1849. Other illustrated books included a *History of Richmondshire,* 1823, *Picturesque Views of England and Wales,* 1832-38, and posthumous collections such as *Harbours of England,* 1856. Turner did venture into pure literary illustration with sketches after Tom Moore's lyrics (Figure 15). *Campbell's Poetical Works,* 1837, and *Rogers Italy,* 1830, and *Poems,* 1834. Probably greater attention to detail and finish of the engravings was applied to Turner's illustrations than to any comparable works by artists at the time; he personally supervised every stage and every work is an original in its own right. As sheer works of topography they are often of no interest at all but as the creations of a brilliant mind they repay careful study. As Percy Muir has written, 'The simple fact is that he was less interested in producing a faithful representation of a locality than in the creation of an original work of art, and if the natural ingredients of the landscape failed to conform with his requirements he changed them to suit his purpose.'⁹

Turner's example may have popularised the notion of having annuals that were solely filled with landscape engravings. *The Landscape Annual* began in 1830 and ran to 1837, and this was followed by *Heath's Picturesque Annual,* 1832-43, *The Continental Annual,* 1832, *The Landscape Album,* 1832, *Landscape Souvenir,* 1835-39 and *Landscape Wreath,* without date. In the case of the three best known ones, whole volumes were devoted to the work of one landscape artist, giving a pleasantly uniform appearance to the series, *The Continental Annual* was entirely illustrated by Prout, *The Landscape Annual* had J.D. Harding as its artist in 1832-34, David Roberts from 1835-38, and James Holland in 1839. Clarkson Stanfield's work was exclusively in *Heath's Picturesque Annual* from 1832-34 (Figure 16) and George Cattermole, A.G. Vickers, William Callow and J.D. Harding in succeeding years.

The only artist of the annuals to come anywhere near Turner's intensity of vision and grandeur of concept was John Martin, 1789-1854. Martin was born at Haydon Bridge, Northumberland, and after acting as heraldic painter and china decorator, finally established himself after 1812 as a painter of biblical and Miltonic subjects of enormous size and power. The more monumental and catastrophic the story, the greater the success Martin had with it, piling up huge and threatening edifices of rock and stone which topple and crush the struggling and wayward humanity below them. Among his favourite themes are 'The Fall of Nineveh', 'The Deluge', 'Belshazzar's Feast' and 'Pandemonium', all making use of the black ground and lowering aspect of the mezzotint. Martin therefore would seem the least likely candidate for the annuals, surely apocalyptic breezes blowing through *The Keepsake, The Amulet* and *The Forget-Me-Not* would overturn the tea-tray and bestir the drawing-room

Figure 17. 'Opening of the Seventh Seal' by John Martin 1789-1854, issued in 1837. Mellon Collection.

Figure 18. 'The Flight Into Egypt' by John Martin 1789-1854.

curtains? They do not seem to have done so, and his popularity and the high prices paid for his oil paintings are referred to by contemporaries. 'Sums of money that sound preposterous were lavished upon the several departments', writes S.C. Hall of *The Amulet,* 'five hundred pounds were given to Sir Walter Scott, and proportionable remuneration to other authors for articles contributed to a single volume of the Keepsake; amounts varying from twenty to one hundred and fifty guineas were paid to artists for the loan of pictures to be engraved; and it was by no means uncommon for the engraver to receive one hundred and fifty guineas for the production of a single plate. For one indeed, "The Crucifixion" after Martin, engraved by Le Keux, that gentleman received from me one hundred and eighty guineas (size 7 inches by 4), making the cost of the print, including the sum paid for the drawing, two hundred and ten guineas. The volume of The Amulet that contained this costly work had also two other engravings, which together cost two hundred and sixty guineas; the other nine prints amounted perhaps, to seven hundred guineas; so that for the embellishments alone the publishers had to pay nearly twelve hundred guineas. And yet, strange to say, that was the only volume of the whole series of The Amulet that yielded a profitable return upon the capital expended and the labour bestowed.'[10] As we notice, Martin was paid thirty guineas for his drawing, much less than the engraver, but one must remember that at exactly the same time Frank Stone was being paid five shillings each for his contributions to *Heath's Book of Beauty!*

Martin's cataclysmic visions appealed to the same audience that would today go to a horror film. The aspects of divine vengeance and natural disaster that were prevalent in all his paintings, lightning, raging seas, gigantic scale, seem to have touched a chord in the early Victorian breast which wanted to be a little discomforted and disconcerted in the face of growing prosperity. In some prints, such as 'Opening of the Seventh Seal', this disquiet and immense power are beautifully conceived, the tiny figure in the foreground silhouetted against the waves, being a typical Martin device (Figure 17). Some of his lighting and his structures have been convincingly linked to the influence of early industry, gas illumination and engineering in the 1820s and 1830s. A more gentle use of his prints is 'The Flight Into Egypt' (Figure 18) intended for *The Forget-Me-Not* of 1838.

The annuals and the albums are an intriguing sideline of book illustration, but not really a very important one. Their purpose obscure, their format constricted, they were pretty and ephemeral but had some lasting results in the gift-books of the 1850s and 1860s. While the fashion lasted however 'the returns were amply sufficient to requite writers liberally, to pay artists handsomely, and to satisfy publishers for their risks in advertising such heavy freights in such lightly built and showily painted vessels.'[11]

The public that had developed a taste for landscape illustrations from the engraved plates in the annuals and books of beauty were encouraged to take their scenery and architecture in a more personal way by the 1840s. The lithograph, which had been neglected since its first introduction to England by Senefelder in 1807, really came to the fore in the hands of C.J. Hullmandel, 1789-1850, who experimented with new processes and made it a commercial success. Hullmandel augmented the visual appeal of the lithograph by tinting it with one or as many as four lithographic tints, a method he called 'lithotint' and which he patented in 1840. The effects achieved were much richer than in pure lithography, the draughtsmanship of the chalk was now contrasted with toned areas and the use of white highlights. They were in essence tinted drawings and printed on toned paper with some colouring added by hand, they were very striking and convincing. With the graphic feel of the lithograph and gradations nearest to the watercolour, they were as close to autograph examples from the artist's sketch-book as the average art lover was likely to get outside aquatint.

This style was ideally suited to the more picturesque and romantic approach succeeding album art. Its subtle pencil technique softened the hard edges of topography and architecture and its pattern of colour gave all scenes a decorative uniformity as well as a sense of history and atmosphere. The medium exactly fitted the taste of the public which wanted a mood rather than a measured drawing, murky cavernous cathedrals and ivy-hung mansions rather than the trim squares and crescents of the metropolitan improvements. One associates with this time the impressive quartos and folios which show views of foreign cities on toned paper, the almost barren grandeur of Greece, India or Egypt, huge rugged monuments in stone, garrisoned by tiny ineffectual figures. Several artists travelled to the Near and Far East but others strayed no further than the Continent and its western coast. The volumes of lithotints that are most often seen in secondhand shops or framed singly on the walls of vicarages or hotels are views of Normandy, Brittany and Belgium.

The watercolour school was just beginning to discover French Gothic and Flemish Renaissance buildings, the dim religious light of Chartres, Beauvais and Amiens, the townhalls, market-places and burgher houses of Ghent, Bruges and Louvain. Although buildings, carvings, choir stalls and chimney-pieces were rendered with a feverish accuracy, the figures make these series a literary, almost narrative, form of illustration. Every market-place is thronged with people, every church with clerics, prelates and clouds of incense, cavaliers wander round the cloisters and here and there a hermit reads from a chained bible. It is a far remove from eighteenth century topography, but possibly because of their limited range of colour and their strongly graphic quality, the lithotinters are still among the most effective portrayers of old buildings.

Hullmandel was not slow to realise that this poetic treatment could be used for views of old manor houses and castles as successfully as Jones or Shepherd had used engraving for new buildings. He drew and published in 1833 a part work, *Ancient Castellated Mansions in Scotland* which captured the life and spirit of these great strongholds and may be said to have contributed to the Victorian idea of baronialism. But the most formidable work to appear was Joseph Nash's *The Mansions of England in the Olden Time,* 1839-49, subtitled as 'depicting the most characteristic features of the domestic architecture of the Tudor Age, and also illustrating the costumes, habits, and recreations of our ancestors.' Nash was trained under A.C. Pugin, the architectural draughtsman, but preferred a freer rendering of his subjects and a more secular choice of buildings. His chief interest was in Tudor domestic architecture and in *The Mansions* he illustrates nearly a hundred interiors and exteriors of the most famous sixteenth century houses. These include Hatfield, Burleigh, Haddon and Hardwick, the bedchambers and long galleries of Knole, the excesses of Wollaton and the glories of Hampton Court.[12] Nash was also sensible enough to include small houses,

Waterstone in Dorset, Levens and Ightham as well as the black and white manors of Speke and Moreton. 'The artists object', runs the 1869 edition, 'was not to exhibit these as many of them now appear — gloomy, desolate and neglected; but glowing with the genial warmth of their fire-sides.' The artist achieved this by avoiding anything in furniture or decoration that was not in accord with the period of the house; the rooms were peopled by ladies in ruffles and gentlemen in doublet and hose taken straight from the portraits on the walls. Apart from the too frequent appearance of Henry VIII and Queen Elizabeth, the result is reasonably convincing though his figures do not have the presence or power of George Cattermole's.

The Low Countries and Germany were well served by Louis Haghe, 1806-1885, a Frenchman who came to London as a young man. He was a painter in the lithographic firm, Day and Haghe, but made his reputation as a watercolourist and as an illustrator in '*A Portfolio of Sketches in Belgium, Germany,* 1840-50. Haghe's range was greater than that of Nash, the scenes were usually more vigorously drawn, the figures larger in scale and their relationship to the architecture and surroundings more important. Such scenes as the 'High Altar, St Martin's Church, Hal' or 'Townhall, Louvain' contain an incredible breadth of expression with only the slightest chiaroscuro effects. This type of treatment was much more influential on ink draughtsmen than on topographers, the swashbuckling cavaliers of Haghe's market-places became the stock in trade of Sir John Gilbert and the ancestors of boys' adventure story heroes.

Samuel Prout, 1783-1852, was another watercolour painter who excelled in lithography. He was a talented architectural draughtsman and figure artist who transmitted to paper his great affinity with the crumbling stonework and sunlit piazzas of old Swiss and Italian towns. His groups of washerwomen, fishermen and stall holders stand picturesquely beneath the west doors of cathedrals or at the foot of battered medieval crosses. The peasant costumes, the rather undefined faces and the high coifs of the women which gleam in his highlights, are almost the hallmarks of his books. Prout considered that the arrangement of his figures was the most important key to success. 'There should always be one principal group and smaller groups, with here and there detached figures, to express distances, and render the composition and effect more picturesque.' Perhaps this concentration on figures as well as his short sight caused him to illustrate features rather than complete buildings. There was no composer of crowds to equal him and Ruskin, a neighbour of the artist's in London, loved 'the half sad half sublime' buildings and more especially that they were drawn from nature. Prout produced eighteen books, all those after 1820 were in lithography and included *Illustrations of the Rhine,* 1824, *Facsimiles of Sketches made in Flanders and Germany,* 1833, *Sketches in France, Switzerland and Italy,* 1839. Some of the artist's early publications had been manuals of examples for the amateur. The idea was repeated in lithography which proved itself ideal for copying and for expressing the freedom of the pencil to the pupil in easy stages. *Prout's Microcosm,* 1841, is a typical example, it concentrates on the figure in an architectural setting, stresses the homogeneity of a composition but, says Prout, the eye should never rest 'but wander through the picture unconscious of the rules and principles that have influenced the painter'.

J.D. Harding, 1798-1863, was a pupil of Samuel Prout and specialised in the countryside and trees where his master specialised in buildings and figures. His greatest output was as a drawing-master, issuing copybooks and exemplars. He contributed to *The Landscape Annual* as we have mentioned and produced through the delicacy of stone three charming books, *Sketches at Home and Abroad,* 1836, *Harding's Portfolio* and *The Park and the Forest,* 1841.

Just as Haghe is associated with the Low Countries and Prout with the south, Paris was

the spiritual home of Thomas Shotter Boys, 1803-1874. Boys was a trained engraver but on going to Paris, came under the influence of the brilliant virtuoso watercolourist, R.P. Bonington. Boys' lucid renderings of ancient Paris, his marvellous light and rich colour are the nearest things to the actual work of that short-lived genius. Boys' greatest venture into lithography *Picturesque Architecture in Paris, Ghent, Antwerp, Rouen Etc Drawn From Nature on Stone,* is also the closest approach to watercolour art in the book. These twenty-six lithographs issued in 1839 were an opportunity for the public to have in their hands views treated with a personality and expression unparalleled in reproductive art. The introductory note did not let this unique character escape them. 'In developing the capabilities of Chromolithography, the artist has aimed at difference of style in his manner of treatment, as well as at variety in the aspects of nature. For example, the view of the Abbaye St Amand, Rouen, is intended to present the appearance of a crayon sketch heightened with colour; that of Ste Chapelle, Paris, a sepia drawing, with touches of colour; the Fish-Market, Antwerp, a slight sketch in watercolours; St Laurent, a finished watercolour drawing...' After this success, Boys produced in 1842 his *Original Views of London As It Is,* not in chromolithography but in monochrome lithography with a few copies coloured in by hand (Figure 19).

Two other artists ventured much further afield, David Roberts, 1796-1864, to Egypt and the Holy Land and Edward Lear to Greece and Syria. David Roberts, a Scottish artist who had made a reputation as a scene painter, began to travel abroad regularly in 1831 and published the fruits of a Spanish tour as *Picturesque Sketches in Spain during the years 1832 and 1833.* He contributed to *Jennings Landscape Annual,* 1835-38, but his greatest triumph was his visit to the Middle East in 1838. It was really the first time that an artist of Robert's calibre had visited Egypt and the Holy Land and with the new taste for archaeological accuracy, allied to mood, he came back with a portfolio of splendid results. Such hidden treasures as Aboo Simbel and Petra were suddenly within the grasp of ordinary people and the Holy Places of Jerusalem were drawn with a truth and directness that made these prints popular for a generation. Roberts' work was put on the stone by J.D. Harding and Louis Haghe and published in parts from 1842-1849 as *Views of the Holy Land, Syria Idumea, Arabia, Egypt and Nubia.* All the plates were finished in two tints but extra colour was added by hand from the originals, the whole project cost Moon, the publisher, £50,000, and the subscribers for the complete set of six volumes paid nearly £150 each.

Edward Lear, 1812-1888, is such a familiar figure on the Victorian scene, so appealing and yet so intangible that it is difficult to label him as a topographer. A brilliant ornithological artist, a wild humorist accompanying each zany verse of poetry with a more zany and surreal drawing, he nevertheless devoted much of his life to landscape watercolours. Published books of drawings played a large part in this and they were an important supplement to his income as

Figure 19. St. James's Palace by Thomas Shotter Boys 1803-1874 from his Original Views of London As It Is *1842. Lithograph.*

Figure 20. Frascati by Edward Lear 1812-1888. Illustration in Rome and Its Environs, *1841. Litho-tint.*

an artist. His three best-known landscape folios of drawings were *Excursions in Italy*, 1846, *Journals of a Landscape Painter in Greece and Albania*, 1851 and *Southern Calabria*, 1852. These are the ones most usually seen in bookshops, and sale-rooms frequently have sketches or studies that prove to be directly related to them. In Lear's very personal style of draughtsmanship, line predominated over watercolour and made his work ideal for lithography. In *Rome and Its Environs*, 1841, he is much more concerned for the overall balance of light and shade and is much less profligate with effects and highlights than some of his fellows. In his 'Frascati' view in this volume (Figure 20), Lear leans on no picturesque effects but just lets the weird shapes of the poplars outlined against the horizon of the campagna tell their own story. Figures are less important to him than the contour of the countryside, where they occur as in 'Cervara' or 'Collepardo' in the same volume, they stand to one side inviting the observer into the landscape where range upon range of mountains succeed each other into the distance.

The early Victorians were not so easily prepared to separate art and technology as we are and industry had its own sumptuous volumes in the new medium. Perhaps the most evocative of their period and the most interesting are the records of the building of railways by James Bourne, 1773-1854. Bourne brought from the world of architectural draughtsmanship a clear statement of what he saw, the complex world of the early engineers with their tunnels, embankments, earthworks and teams of navvies, all enlivened with his artist's eye but recorded with a scientific accuracy. The birth pangs of the railway age in the 1830s and 1840s, breathes again for us in his *London and Birmingham Railway*, 1839, and *The History and Description of the Great Western Railway*, 1846. His pencil transmits the excitement of machinery in such romantic plates as 'Engine and Tender emerging from Tunnel near Bristol' or 'Building retaining walls, etc. near Park St Camden Town'. From the original drawings for these in the Elton Collection it would appear that there were at least three stages before the completed compositions finally reached the stone. The first sketches of the people and objects were made in pencil, followed by inking over. At the same time broader watercolours were made of the whole scene and the view drawn on to the stone from this accumulated information. Bourne most resembles Prout and J.D. Harding and none of their delicacy is lost in these very different subjects; his accuracy in showing detail is amazing, especially as the larger sketches are all reduced on the stone and much of their finish is lost.

The major industrial event of the epoch, the Great Exhibition of 1851, is recorded in two lavish lithographic folios. The earlier *Recollections of the Great Exhibition* published in the same year contained selected views of the interior by various artists including John Absolom and W. Goodall. The twenty-five litho-plates were hand tinted and the volume was printed by Day & Sons. The second and more celebrated book was *Dickenson's comprehensive picture of the Great Exhibition of 1851* which has come to be associated with the names of its three artists, J. Nash, Louis Haghe and David Roberts. These illustrations, published in 1854 give a general survey of all the galleries and include fifty-five plates, all originally commissioned by the Prince Consort. The artists have given a pleasing spaciousness to the production, the plates are ample and crammed with detail, the blue and grey colours of the Crystal Palace's structure floats over the stands of rich red, the figures and groups animated and individual.

These are only a small fraction of the many decorative books produced during the zenith of litho-tint 1830 to 1856. It would be possible to mention two further well-designed works, *Eton College,* 1844 and *Memorials of Charterhouse,* 1844, drawn and lithographed by Charles W. Radclyffe. W.A. Delamotte, 1775-1863, published a similar series of studies in *Original Views of Oxford,* 1843 and George Barnard some plates of Germany at about the same time. Among the most charming of these is Douglas Morrison's *Views of Haddon Hall,* 1842, but almost every provincial town can claim one or two topographical books of this type, architectural, picturesque, but varying in quality from the masterly to the coarse. Many of them hardly qualify as illustrated books at all, and yet they form a substantial part of the nineteenth century story.

Although the impact of the lithograph was on landscape and architectural illustration, it had some slight success in the world of caricature. William Heath, 1795-1840, who was a prime caricaturist of social life as 'Paul Pry' 1827-29 (Colour Place VI) was the instigator of *The Glasgow,* later *The Northern Looking-Glass,* 1825-26, and *The Looking Glass,* 1830, which can claim to be the earliest caricature magazines, pre-dating even Charles Phillipon's French publications. They are rather flimsy things without much text but they have a rarity and curiosity value.

Figure 21. 'A Scene of Confusion' 1836 by 'HB' John Doyle 1797-1868.

John Doyle or 'HB' was in spirit if not in date the first political caricaturist of the nineteenth century. Trained as a portrait painter rather than in the strong satiric tradition of Gillray and Cruikshank, he brought to the art a need for likeness rather than for exaggeration, for reasoned argument rather than mud-slinging. Doyle was never a strong draughtsman and despite his Irish background no great wit either. His satire was in the line of Regency caricature, visual representations were adapted from the London stage and the rhetoric of politicians transferred to the print in gesture and stance, but the effect was weak (Figure 21). Perhaps it is not so much Doyle himself as the nature of lithography that is to blame; the soft pencilled effects that the process gives were a great contrast to the sharp, spiteful line of the copper-plate. The lithograph as a vehicle of satire needed strong draughtsmanship of the order of the French artists if it was to succeed and in England it never received this. Doyle's amateurishly composed pictures with their weightless figures are miles away from the stature of the Parisian artists. If one looks, for example, at a print of September 1831, a lead up to the Reform Bill controversy, one sees Doyle in his best and worst lights. Sketch No. 154 is entitled 'Another Sign of The Times or Symptoms of What Modern Architects, complacently term — Settling'. A pair of columns stand side by side supporting a collapsing cornice on which are chiselled the words 'The Bill The Whole Bill And Any-Thing But The Bill'. The column to the left is the Tuscan order of architecture, a Roman innovation and therefore a symbol of democracy and might, the right-hand one which is steady as a rock is a Greek Corinthian column in which the Crown features as the capital. The design like the title is not only a clever allusion to the two sides in the Reform debate but incidentally to the rivalry of Greek and Roman architecture at the time and the instability of late Regency building! Lord Brougham and others vainly try to steady the toppling mass with a pole inscribed 'The Times', needless to say the edifice is built on sand and the 'royal' column has emblazoned on it a pun on William IV, 'Reform Bill Alias The Kings Name'.

Although Doyle has achieved three or four strands of meaning in all this, the impact is not pungent and the drawing very thin. The figures are insubstantial and there is a lack of contrast, yet Doyle maintained a great following among the early Victorians who wished to be entertained not shocked or provoked as their forebears had been. 'You never hear any laughing at "HB" ', Thackeray wrote in 1840, 'his pictures are a great deal too genteel for that — polite points of wit, which strike one as exceedingly clever and pretty, and cause one to smile in a quiet gentlemanlike kind of way.'[13]

The postscript to this is that 'HB's' work never stirred any collectors after its period. Writing in 1893, Graham Everitt cites a projected sale of 'HB's' original drawings to have been held in about 1880. There were apparently no takers and only Disraeli was seen thumbing through the productions of a caricaturist who could never have done him any harm!

Footnotes

1. W. Crane, *Of The Decorative Illustration of Books,* 1901.
2. W. Jerdan, *An Autobiography,* Vol. IV, 1853, pp.241-242.
3. ibid.
4. Charles Knight, *Passages of a Working Life,* Vol. II, pp.53-54.
5. F.W. Faxon, *Literary Annuals and Gift Books,* Edited by Jamieson and Bain, P.L.A. 1973.
6. Henry Vizetelly, *Glances Back Over Seventy Years,* 1893, p.104.
7. S.C. Hall, *Retrospect of a Long Life,* Vol. 1, 1883, pp.306-311.
8. Knight op. cit.
9. Percy Muir, *Victorian Illustrated Books,* 1971, p.65.
10. Hall op. cit.
11. Jerdan op. cit.
12. Original watercolours for Speke, Knole and Hampton Court are in the Victoria and Albert Museum.
13. *Westminster Review,* June 1840.

Chapter 3

The Illustrated Magazine
Early Periodicals 1820~1840

Until 1820 the idea of an illustrated periodical in Great Britain was an impractical dream or a very rare novelty. A crude woodblock of Nelson's funeral car had appeared in *The Times* of 1806, the earliest newspaper illustration in the country, but an expensive curiosity rather than the vanguard of new things. The story does not fully begin until the 1820s with the rise of mechanisation, a wider reading public and a politically explosive decade. In 1814, *The Times* installed at their London office, a Konig printing machine which was powered by steam, a great advance over hand printing methods, in the number of impressions and the speed of their production. But this alone would not have caused the spate of illustrated journals from 1820 to 1840 if it had not been for two further factors; a tremendous thirst for information and the change from print to book of an earlier visual tradition.

Although it is usual to think of the Victorians and popular educationalists in the same breath, many of the most active were well to the fore by the great reforming year of 1832. Carlyle was beginning to establish himself, Ruskin's first effort was published in 1834 and Gladstone was already an MP. But the most outstanding figure in illustrated journalism, who might well rank with these great names, and crops up time and time again in books, pamphlets and periodicals, is Charles Knight, 1791-1873, newspaper proprietor and publisher. Knight was one of those indefatigible promoters of multitudinous schemes for the public good, as dexterous a canvasser as William Cobbett and as prolific as Charles Kingsley or Tom Hood, both incidentally involved in illustration. Born in 1791, the son of a Berkshire printer who had published *The Windsor Guide,* Knight was evidently destined for greater things than a provincial newspaper office. He was apprenticed to the editor of *The Globe* in London, returned home to run his father's *Windsor and Eton Express* in 1812, but was already by 1814 formulating plans to become a popular educator. In his breezy and self-confident autobiography *Passages of a Working Life,* 1865, Knight wrote: 'I had acquired a little familiarity with the general ignorance of the working classes, knew something practical of their habits, saw in some few a desire for knowledge, and felt how ill their intellectual wants could be supplied.'[1] Knight looked with horror at the literature of the book hawker 'the worst sort of temptations in sixpenny Novels with a coloured frontispiece'[2] and 'the lesson books with blotches called pictures, that puzzled the school-boy mind half a century ago . . .'[3] Knight published a paper on 'Cheap Publications' in 1819 but was not able to become a real agitator until he was established as first the publisher of *The Plain Englishman,* 1820-22, and concurrently of *The Guardian.*

One of Knight's principal concerns was to strike a midway course between scurrilous pamphlets with coarse woodcuts and the more learned magazines; both existed in total isolation. The religious and political tracts and squibs were to Knight's mind too inflamatory and the established publications like *The Gentleman's Magazine* and the newly-founded *Blackwood's Magazine,* 1817, too specialised, and the latter unillustrated. Knight had a healthy respect for the aspirations of a working population, now urbanised and estimated to be two-thirds to three-quarters literate. He was alarmed by the revolutionary spirit abroad in the 1820s and particularly in its more radical forms in magazines like *Twopenny Register, The Black Dwarf, The Republican, The Medusa's Head* and *The Cap of Liberty.* Para-

doxically, Knight picked up some of his most useful tips on a visit to anti-monarchist France from looking at a compendious publication of facts called *Le Bulletin Universal.*

Even so, Knight was not the first in the field, there were a few precursors though not on such a grand scale. *The Observer,* which can claim to be the earliest illustrated paper, ran a series of woodcuts in the mid-1820s, including one of Gurney's Steam Carriage, another of the Thames Tunnel accident and a third of the Ascot Races drawn by William Harvey. *The Observer* continued to illustrate events up to the time of Queen Victoria's Coronation in 1837 and her marriage in 1841, when it produced a complete supplement. Other newspapers to use illustrations included *The Weekly Chronicle, The Sunday Times, The Champion, Weekly Herald* and *The Magnet,* mostly in the 1830s. Rather earlier than these was a little magazine called *The Portfolio,* 1825, 'Comprising I. The Flowers of Literature. II. The Spirit of the Magazines. III. The Wonders of Nature and Art. IV. The Essence of Anecdote and Wit. V. The Domestic Guide. VI. The Mechanic's Oracle'. It had by 25 March 1825 already swallowed up a similar venture *The Hive* and contains on its title page a very crude woodcut of Eton College signed 'Blunt'. Another longer-lived magazine was *The Mirror of Literature, Amusement and Instruction,* edited by John Timbs, which according to Vizetelly was founded in 1822 and extensively illustrated by the late 1820s. It was priced twopence and published every Saturday until 1843 at the same price. Its cheapness would certainly have put it into the hands of the same artisans that Knight hoped to reach, his own comments on

it being that it was 'indifferently illustrated' and 'not crowned with success'.[4] Each issue had a page or half-page woodcut illustration under the heading, generally a view of a building, sometimes new sometimes old, but very seldom of an event or a news item. The only real departure from this was the coverage of George IV's death and funeral in 1830. *The Mirror* gave a full-page profile portrait of 'His Late Most Gracious Majesty' against a backdrop of a lake and Chinese temple, signed like others in the magazine, 'I Dodd' (Figure 22). Subsequent numbers showed interior views of Windsor Castle, the lying-in-state and the funeral at St. George's Chapel. Most of them are very hard and over hatched, crude representations of scenes, hardly conceivable only a decade after Bewick's triumphs.

It was this gap that Knight hoped to fill and from the late 1830s produced a whole series of journals of outstanding variety. He sowed some of his wild oats in the earliest and slightly scurrilous publication *Knight's Quarterly Magazine,* then followed *The London Magazine,* about 1828, *The Library of Entertaining Knowledge,* 1830, *The Quarterly Journal of Education,* 1831, *Gallery of Portraits,* 1832-34, *The Printing Machine — A Review For the Many,* 1834, and others. But he is best remembered for having established and run *The Penny Magazine,* the first number of which

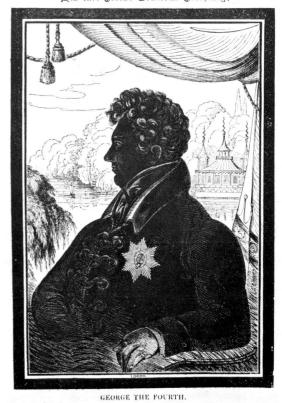

Figure 22. His Majesty King George IV from The Mirror, *1830.*

appeared on 31 March 1832. Knight's contacts with authors, artists and men of science gave him a wider sweep of the academic spectrum than any popular journalist had had before. *The Penny Magazine* had the promotion of a very Victorian-sounding body *The Society For The Diffusion of Useful Knowledge,* its eminent governors including Lord Brougham, Sir H. Parnell and Dr. Arnold of Rugby. Not surprisingly it was nicknamed 'The Steam Intellect Society'. The aims of the magazine were to capture the imagination of the ordinary readership in 'Striking points of Natural History — Accounts of the Great Works of Art in Sculpture and Painting — Descriptions of such Antiquities as possess historical interest — Personal Narratives of Travellers — Biographies of Men who have had a permanent influence on the condition of the world . . . '.[5] This formidable list which sounds pretty dry reading was liberally sprinkled with woodcuts. Fortunately Knight did not share the contemporary idea that something illustrated was something juvenile and his first year's figures thoroughly justified this piece of speculation. From March 1832 to the end of the year, the circulation of Knight's magazine rose to 200,000, an incredible figure for those days.

At the beginning *The Penny Magazine* relied on blocks from the other Knight publications, particularly *The Library of Entertaining Knowledge,* but as interest increased he was able to commission new work. Knight clearly saw the success as one of illustration and said as much in his printed preface to the first bound volume. 'It must not be forgotten that some of the unexpected success of this little work is to be ascribed to the liberal employment of illustrations, by means of Wood-cuts. At the commencement of the publication, before the large sale which it has reached could at all have been comtemplated, the cuts were few in number . . . But as the public encouragement enabled the conductors to make greater exertions . . . it became necessary to engage artists of eminence, both as draughtsmen and wood engravers to gratify a proper curiosity, and cultivate an increasing taste . . .'[6] Knight had a high opinion of illustrators, considered their derisory treatment by painters as unjustified and was among the first to print the names of both illustrator and engraver, though not in *The Penny Magazine.*

The chief difficulties in this illustrated mass journalism were technical ones. First of all there was a complete dearth of competent wood engravers, those that existed concentrating on the production of expensive books, to the mind of the populist Knight, a complete betrayal of what wood engraving was about! Then there was the machinery, capable of printing sixteen thousand impressions daily, but not of giving a very satisfactory balance or clarity to the engravings. Knight's woodcuts and text were transferred to stereotype-plates and the impressions were rapidly printed from the plates by his new cylinder machinery. The early results from *The Penny Magazine* were not very successful and publisher and printer continued to experiment for some years, consulting the artists, obtaining a clarity in his lights and a uniform application of ink, difficult with the cylindrical pressure of the printing machine. Knight's part works continued to be issued regularly until the middle 1840s. 'Price 4s. 6d. in Nine Monthly Parts. 6s. bound in cloth'. *The Gallery of Portraits* also appeared in parts, monthly numbers at half a crown, widening the circulation by reducing the initial outlay. The publisher himself proceeded to travel all over England, visiting factories, concerning himself with pauper lunatics, mechanics' institutes and providing cheap suppers for poor scholars near the British Museum. He was foremost in pressing for the repeal of duty on almanacks, but strangely enough against the similar lifting of stamp duty on newspapers, the signal for a mammoth illustrated press. With the unexpected success of *The Penny Magazine,* Knight proudly laid before the public details of his distribution, the agents in the provinces, the booksellers collecting their profits direct from him, the ease of communication being a sign of civilization. Knight's exertions were not without their admirers from abroad. Frederick Von Raumer, visiting England in 1835, went to see the steam presses of *The Penny Magazine* at Lambeth and published an account

of his guided tour. 'I learned many curious details,' he writes, 'for instance, how the single types are formed into stereotype plates: how plaster-casts are taken from the blocks of woodcuts, lead and antimony again cast into these matrices, and thus plates produced, which are used as substitutes for the blocks.'[7] Like Knight's, Von Raumer's view of illustrated books was clearly instruction rather than delight, but it was not coincidence that a German should be visiting the works for Knight claimed in 1836 to be supplying blocks to 'Germany, France, Holland, Livonia, Bohemia, Italy, the Ionian Islands, Sweden, Spanish America, the Brazils'.[8] Nevertheless something bigger was round the corner, the early 1830s were still after all, the era of the stage-coach.

The energetic Knight was not without his imitators; the Literature and Education Committee of the Society For Promoting Christian Knowledge were hard on his heels when in 1832 they published *The Saturday Magazine.* This was nearer to the earlier Knight schemes, except that it had a more distinctly religious nature, woodcuts of abbeys and churches and the history of saints. Other items included articles on plant growth, foreign lands, the manufacture of glass, Ancient Egypt, silk worms and the lives of famous painters, among them Rembrandt, Dürer and Richard Wilson. The woodcuts are often clearer than Knight's earlier work and those of buildings have a sort of obstinate chunky charm which excuses their shortcomings in accuracy. No reader confronted with a 'View of Jerusalem' in September 1833, would have any doubt what they were looking at! This could not have been said a decade earlier, but even *The Mirror* was now producing respectable views with passable figures. The run of *The Saturday Magazine,* which the writer has examined was from Woburn Abbey. It is hardly conceivable that the Duke of Bedford would have subscribed to it for himself and it seems likely that this cheap penny illustrated journal was reaching its right readership here in the library of the servants' hall.

Some of the earlier illustrated magazines had a similarity to the broadsheets, printed on poor paper and in small format, but idealists like Knight and the Chambers brothers made one mistake. Their uplifting penny papers contained no stories, nothing sensational and hardly any bones that the ordinary man could glamourise and romanticise with his lively imagination. The ballads with titles like 'The Taylor's Courtship', 'Death and The Lady' or 'The Fatherless Captain or Betray'd Virgin' were replaced with scenes of alpine villages and erudite articles on crabs! The restless and spontaneous world of the chapman, where every murder or public execution or scandal brought its fresh bundle of ballads, had not found a counterpart in the press. In the next ten years their vibrant, satirical and often bawdy outpourings were to be absorbed by a more official press, channelled by the restraints of Olympian editors into areas of more acceptable public taste. The cheaper end of the market persisted until it too was overtaken by the topical themes and songs of the music hall.

At the same time as the ballad sheet was in decline, the separately issued political caricature was ceasing to exist. Charles Knight, writing of the year 1810, gives a lively account of that trade as he remembered it which reminds one of Gillray's 'Very Slippery Weather' where idlers are seen gazing at the windows of Humphrey's print shop. 'I very often found myself staring into a window, if I could possibly get a look amidst the multitude which daily crowded about the shop of "T. McLean, 26 Haymarket, where Political and Other Caricatures are daily publishing" ', thus runs the imprint of one who was the chief patron of humourists for the age who were famous before *Punch.*[9] This teeming industry, which had lasted for nearly one hundred years, was the middle and upper class answer to the street ballad. Instant political and social comment came wet from the press daily, before the hue and cry had even died down. This amazing flurry of paper, caricature answering caricature, political party countering political party through rival engravers, the asperity and venom of faction bitten in to every line of print, acts like a daily diary of the reigns of George III and George IV. It bred several generations of rich artists, and in the

Cruikshanks, a whole dynasty of political caricaturists, Gillray at their head, but including Rowlandson, Newton, G.M. Woodward, William Heath and many others. The public were brought into direct touch with this work at such places as S.W. Fores Caricatura Exhibition Rooms, 3 Piccadilly 'the completest Collection in Kingdon, Admit 1s' where 'Folios of Caricatures' were 'lent out for the Evening'.[10] The approach of these artists was close to journalism and filled the gap left by the absence of any visual lampooning in the daily or weekly papers.

Book illustration was undoubtedly the respectable antidote to the virulent life of the caricature. By the end of the 1820s George Cruikshank had abandoned political satire for the art of the book and the same was true of Robert Seymour. The numerous draughtsmen and political caricaturists adapted their styles and were absorbed into the new world of illustrated papers. Something of their immediacy and personality was lost when an essentially ephemeral composition was the central point of a weekly or a monthly. Confined in the straight-jacket of covers, caricature took on much of the quality of book illustration proper, greatly invigorated the latter, but lost some of its separate identity and incidentally its colour.

Before the links with the old world were completely eclipsed, a number of minor illustrated weeklies and monthlies sprang up around the political excitement generated by the Reform Bill. The most important of them was *Figaro in London,* which had quite a long run from December 1831 to August 1839 and was less radical than some of its fellows. Its editors were Gilbert à Beckett and Henry Mayhew, both afterwards associated with the founding of *Punch. Figaro's* greatest claim to fame was that its centre focus was on a full-page drawing, an encapsulated caricature so to speak, drawn by Seymour and usually the subject of the leading article. This was to be a precedent and every great Victorian periodical was to follow its lead. A series of political woodcuts in serial form appeared in the years after the Reform Bill. *The Political Drama, John Bull's Picture Gallery* and the Chartist leaders, produced numerous unstamped penny newspapers with crude and anti-monarchial cuts by the artist C.J. Grant. Knight's self-improvement campaign was said to have killed off many of the more insubstantial squibs, but old habits die hard. When Mayhew made his survey of reading habits among Manchester operatives in 1849-50, he announced: 'That species of novel, adorned with woodcuts, and published in penny weekly numbers, claims the foremost place.'[11] This 'literary garbage' as Mayhew called it was selling six thousand copies weekly whereas *Chambers Journal,* a weekly, was only selling nine hundred copies. Knight himself blamed the eventual failure of *The Penny Magazine* on another publisher, as energetic as he but not so high principalled.

Edward Lloyd, 1815-1890, was a publisher whose aims were not very far removed from profit at any price, and who claimed to give the public what it wanted. The ballad printer and the caricaturist had made much coin out of sensational crime, Pitts and Catnach were famed for their circulation of 'dying speeches' and even Cruikshank had run a series like this entitled *Mornings At Bow Street,* 1824-25. Lloyd began in September 1841 a penny weekly called *The People's Police Gazette,* which exactly catered for this market. It was filled with lurid details of famous crimes accompanied by macabre illustrations as to how they were committed. Lloyd followed this with *The Weekly Penny Miscellany* and eventually *The Penny Atlas and Weekly Register of Novel Entertainment.* The high-flying titles were intentionally misleading and Lloyd claimed spuriously to be giving the public magazines that were 'elevated and impassioned'. Needless to say, Lloyd established the respectable-sounding *Lloyd's Weekly London Newspaper* in 1842 and died in 1890 as the proprietor of *The Daily Chronicle,* a sort of Victorian patriarch! It is curious however that the two great giants of the new illustrated era, discussed at length later, were to be founded on the basis of radical caricaturing and criminal reporting. Another magazine with less lofty

ambitions to educate was *The Illuminated Magazine,* 1845, edited by Douglas Jerrold. Its contents and its illustrations were a mixture of the serious and the humourous; its illuminated frontispiece in two colours was an introduction to a diet of ballads, book reviews, instruction on the fine arts and a description of Birmingham. Kenny Meadows contributed spidery figure subjects and both Leech and H.G. Hine added their talent to its pages, but the fear of stamp duty prevented it from being anything like a newspaper, even in satirical drawings. A little later on we come to *The Illustrated Magazine of Art,* a Cassell publication, with numerous items on industry and art, that twin-headed Victorian goddess worshipped by the reformers. *The Illustrated London Magazine,* edited by R.B. Knowles had a strong visual side including the work of 'Phiz', John Gilbert, Cuthbert Bede, W. McConnell and A.S. Henning, but both of these magazines date from the early 1850s, a little ahead of our period. Others with Knight's missionary zeal were the Scottish Chambers brothers, Robert and William who founded *Chambers Journal* in that same *annus mirabilis,* 1832, and *The Miscellany,* 1848, and *Repository,* 1852. Chambers' moralizing gave way sometimes to woodcut illustrations, giving the magazine a more popular appeal.

The second reason for the great vitality in the illustrated press of the 1830s and 1840s was its rich inheritance from the eighteenth century. The educationalists and the engineers were providing the aims and the means, but the man in the street was neither so gullible nor so disloyal to his past as to abandon hard worn ways of amusement over night. The 'illustrated magazines' of ordinary folk in the 1820s were not Knight's books or even Lloyd's penny dreadfuls, but the chapbooks and broadsheets that they bought at street corners, printed by the chapmen of St. Giles. This very ancient tradition of hawking songs, ballads and news at a half-penny a sheet, was having a revival under the Regency in the hands of two celebrated rivals, John Pitts and James Catnach. The trade had received a boost from the Newspaper Stamp Act of December 1819, which Knight called a 'tax on knowledge'. Ballad sheets were not affected by this and flourished among the poor who could not afford seven pence for a newspaper. Both Pitts and Catnach produced sheets with crude but often expressive woodcuts on them and Leslie Shepard in *John Pitts Ballad Printer,* 1969, quotes an early source as saying that the woodcut was half of the attraction. By the time Knight and his friends came on the scene, the street ballad was beginning to decline and the reformers made a concerted attack on it. In 1836, a Mr. E. Cowper gave evidence before a House of Commons Committee and was questioned on this subject. Amongst the leading questions or observations by the committee was this: "In fact the mechanic and the peasant in the most remote districts of the country, have now an opportunity of seeing tolerably correct outlines of form which they never could behold before?" His answer was "Exactly; and literally at the price they used to give for a song."[12]

But the Victorian poor accepted the illustrated ballad as a natural part of their background more readily than an illustrated magazine. As Victor Neuburg has pointed out in *The Victorian City,* its elements and attraction were almost those of a tabloid newspaper, it dealt with topical themes, satirised popular events, but its illustrations were not specifically topical or satirical. Printers frequently introduced woodcuts that had no bearing on the text, a trick which Vizetelly tells us was to find its way into early magazines. Although the sheets dealt with religious, commercial, free-thinking, political and temperance topics, they were carefully generalised to appeal to the largest sale. 'The political tone of street literature, then, was muted "The great battle for freedom and reform" is clearly reformist, but by no stretch of the imagination extremist,' writes Mr. Neuburg.[13] The radical writer and caricaturist were to find a new home in the magazines after the 1830s, although their strident voice was to gradually become as tempered as those of their brother ballad mongers.

Punch

Punch has become so much a national institution over the years, that its origins have always been hotly debated, leading almost to open controversy at the end of the Victorian era. When M.H. Spielmann sat down to write his monumental *The History of Punch* in 1895, the squabbling was at its height. 'It is not that his (Mr. Punch's) parentage has been lost to history in a discreet and charitable silence,' he wrote, 'on the contrary, it is rather that that honour has been claimed by over-many, covetous of the distinction.'[14] Spielmann is referring to the various families of the à Beckets, Jerrolds, Lasts and Landells who considered it to be their child and were saying so vociferously in the 1890s.

One of the clearest accounts of this complex business is given in R.G.G. Price's *A History of Punch,* 1957, and this summary is based on his conclusions. In late 1840 or early 1841, Joseph Last, the printer, and Ebenezer Landells, the engraver, proposed to start a periodical called *The Cosmorama.* Henry Mayhew, formerly of *Figaro in London* fame was introduced and he prepared a dummy, based on Phillipon's French paper and an abortive effort of his own called *Cupid.* Landells is believed to have had the first idea for the new paper, but Last claimed to have introduced Landells into the scheme and the Jerrolds maintained that the title and style of the magazine were based on Douglas Jerrold's *Punch in London.* Simultaneously, Mark Lemon, whose mother was licensee of the Shakespeare's Head in Wych Street, was attempting to start a weekly called *Pen and Palette.* The two projects came together and the name 'Punch', evolved from the beverage rather than the puppet, was finally agreed on when Douglas Jerrold relinquished his prior claim to the name. At this point a document was drawn up with a solicitor which described it as 'a new work of wit and whim, embellished with cuts and caricatures, to be called *Punch* or *The London Charivari*'. The printer and engraver were each to have a one third share and the three editors, Henry Mayhew, Mark Lemon and Stirling Coyne, the remaining share; Jerrold was to be the principal contributor.

Below and at heading: Original drawing and wood engraving for Punch's Almanack, *1849.*

The first months were not noticeably successful and three changes were made in the printers. The last printers, Bradbury and Evans were persuaded to buy the editors' share, Landells amid much bad blood sold his, and by the end of 1842, Bradbury and Evans were both printers and owners of *Punch*. It is significant that Bradbury's put their distribution into the hands of W.S. Orr and Co. from the beginning, the same firm that were agents for Chambers' magazines and presumably owners of lists of the better class of readership. Under the new regime Mark Lemon was sole Editor and Mayhew and Gilbert à Beckett wrote from time to time, the magazine settling down after its birth pangs to a period of unclouded success.

Those early numbers of *Punch,* witty and spontaneous though they are, leave an awful lot to be desired on the visual side. 'This Guffawgraph is intended to form a refuge for destitute wit,' reads the opening notice, 'an asylum for the thousands of orphan jokes – the superannuated Joe Millers – the millions of perishing puns, which are wandering about without so much as a shelf to rest upon!' Further facetious comments follow, but nowhere is there any reference to the illustrations and under 'Fine Arts' only to art criticism. The most striking features of the early pages are the bushels of tiny woodcuts, some of them in silhouette and known as 'blackies' which decorate the columns of the text. These were the work of William Newman who had worked for *Figaro in London,* 1841-49, and whose comic cuts were similar to the punning ones in Tom Hood's *Comic Annuals.* 'Returned by a Large Majority' showing a man kicked down the stairs by many boots or 'Real Irish Butter', a Pat with a shelalagh being attacked by a goat. All very simple stuff but at least providing continuity and better drawn than the main print of each issue by A.S. Henning. This artist took a social or political theme for his 'Pencillings' as they were called 'Candidates Under Different Phases' for example or 'Hercules Tearing Theseus From The Rock' or 'The Evening Party', all extremely weak in invention and drawing. Regrettably, *Pencilling* No. 4, 'Foreign Affairs', the first contribution of John Leech, is scarcely better. It was delivered so late that the artist was not asked again for a long time; Landells' hustle with the engraving may therefore account for its indifferent quality.

Punch is also responsible for having fathered the word 'cartoon' on satirical prints. In 1843, it published a series of mock entries for the mural decoration competition then taking place for the new Houses of Parliament. These replaced the usual 'Pencillings' and on 15 July 1843 appeared under the technical name for projected mural work 'cartoon'. This name gradually replaced 'Pencillings' and became the established term in Victorian England for the 'big cut' in a magazine.[15] Cartoon was never used in the nineteenth century as it popularly is now to describe almost any comic drawing.

The position of the artists on the paper was very anomalous to begin with. Lemon was out of his depth with artists, did not understand them and kept them quite separate from the writers who were his cronies. The illustrator worked with the text and there was no such thing as an individual joke illustration, there was indeed no artist strong enough had they been considered. Lemon eventually made some attempt to get acquainted with artists and enrolled Kenny Meadows, A.S. Henning's brother-in-law, for a series of cartoons up to 1844 and to illustrate 'Punch's Letters to His Son'. The young Birkett Foster began to contribute initial letters in 1841-3 and these little pieces of decoration, subtle and beautiful in execution, are as good a sign as any that *Punch's* draughtsmanship was speedily improving. Alfred Crowquill was recruited briefly, 'Phiz' joined the team but left when it was felt that *Punch* could not support two stars of the calibre of Leech and himself. W.M. Thackeray's influence on *Punch* was mostly literary, but scattered throughout the early numbers are his own contributions illustrated by himself in his inimitable untidy hand, signed by a pair of spectacles. One could mention 'Jeames's Diary' in 1845, 'The Snobs of England', 1846-47, 'Punch's Prize Novelists', 1847, as well as occasional cuts for Gilbert à Beckett or Percival

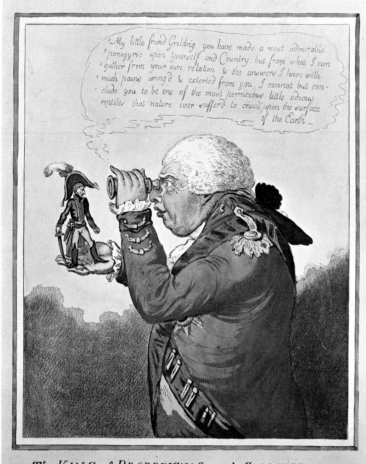

The KING of BROBDINGNAG and GULLIVER

Left: Plate V
JAMES GILLRAY
1757-1815
'The King of Brobdingnag
and Gulliver.' Political
caricature issued in
July 1803. Hand-coloured
engraving

Below: Plate VI
WILLIAM HEATH
'Paul Pry', 1795-1840
'Where Are You Going My
Pretty Maid?' Hand-
coloured engraving. c.1825

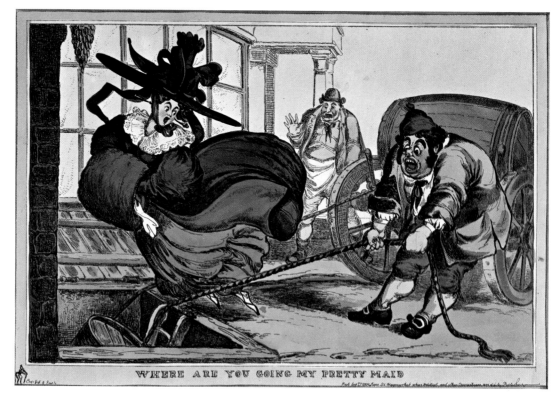

WHERE ARE YOU GOING MY PRETTY MAID

Leigh's writings, a grand total of three hundred and eighty.[16]

The constituents of early *Punch* were therefore a strange admixture of the old and the new as represented by the talented but very different men who ran it. Gathered together were the same strands discussed earlier in the chapter, that had come together in the crucible of the 1830s; a strong tradition of merciless caricaturing, an anti-monarchial vitality from the ballads and broadsheets, a Hogarthian chauvinism, a tremendous sympathy for the under-dog and a deep-seated but fair radicalism. Mark Lemon's connections with the stage, William Newman's coarseness and Albert Smith's racy writing numbered them among the old school of satirical journalism. Thackeray and Gilbert à Beckett in writing and Leech and Richard Doyle, when they joined, in drawing, represented a less savage and more light-hearted comment on the world around them. *Punch* was most modern, most sharply defined from the humours of the past when it took up the banner of middle-class life, depicted domestic scenes and involved 'the fair sex' increasingly in its pages. In the early issues the 'Pencillings' had been succeeded for a short time by 'Domestic Miseries', a clear inheritance from Heath and Alken but which R.G.G. Price suggests rightly are 'probably the ancestors of the independent joke drawing'.[17] The *Punch* men were most original where they worked as a team, bringing a precise and almost individual voice to its views, and probably thereby excluding artists like Cruikshank from its pages. This is most plainly seen in the *Punch* dinners on Wednesday nights, where members of the salaried staff met with the proprietor and printers round 'The Table' and decided on the big political cartoon for the ensuing week. These working meals, which Thackeray immortalised in his song of 'The Mahogany Tree', were lively, witty and punnish affairs, more boyish than business-like, but they worked because they brought authors and artists together and generated a feeling of mutual trust.

Punch had the great advantage over other magazines that it could appear to see things through the eyes of 'Mr Punch' himself. A point of view developed so personally that people could identify with *his* views and join *his* club, membership being the annual subscription to the magazine. Increasingly *Punch's* butts, pet aversions and recurring topics of satire became those people who were not members!

Thackeray was anxious from the start that the magazine should disassociate itself from tavern-shop wit and bumptiousness; Jerrold writing to Dickens in 1846 said: 'I am convinced that the world will get tired (at least I hope so) of this eternal guffaw at all things.'[18] If on the surface it appeared merely humorous, under-lying this was a strong vein of criticism. Both Henry Mayhew and Douglas Jerrold could be described as radical in some of their views but as Price says the generosity that accompanied Jerrold's radicalism was 'love of the ill-treated, not hatred of the powerful . . .'[19] It is all the same rather surprising to find in the early copies of the paper, articles and drawings attacking the Prince Consort, and the Crystal Palace, as well as more popular targets like Prince Louis Napoleon. The Queen came under some scrutiny, simply for being the wife of the Prince Consort and there were always references to the growing Royal Nursery! Spielmann writing in 1895 is at great pains to conceal this at a period when the Queen was at the height of her popularity. 'Towards the Queen herself,' he writes, '*Punch* has shown unswerving chivalry and reverence, even during the shouting days when democracy was more noisily republican than it is today.'[20] This is only half-true, for the disparity revealed in Disraeli's *Two Nations* was deeply felt by the first *Punch* men and was brought out in one of Richard Doyle's first cartoons for the paper in August 1844. 'Prince Albert's Bee Hives' provided a not very flattering cartoon of the Queen and an equally stony one of her consort. Doyle's composition takes as its theme the installations of new beehives at Windsor Castle by that ingenious and experimenting German Prince. The Royal Pair gaze down enchantedly on pretty, bell-shaped beehives, one of which is totally transparent for our benefit. Inside, tiny

Figure 23. 'Prince Albert's Bee Hives' by Richard Doyle.

busy figures, typically Doyleish, carry loads, scythe grass, hammer iron and, revealingly, work as artists. The caption, quoted from a newspaper report, reads 'These Hives are so constructed that the HONEY may be removed without DESTROYING THE BEES' (Figure 23).

Punch's outspoken views on foreign despotism resulted in it being banned in both France and Austria at various times and it was loud in its condemnation of sweat shops, the pollution of the Thames and the replanning of London that left many poor people homeless.

It had its rivalry during the first years from *The Squib, The Great Gun, Joe Miller The Younger* and later from *The Man in The Moon, The Comic Times, The Puppet Show* and *Diogenes. The Man in The Moon* was edited by Albert Smith, the writer who had been dropped from *Punch,* and was extremely hostile, although it only lasted for twenty-eight issues. In the 1860s and '70s it was to find competition in newer magazines built exactly like it, *Fun,* 1861, *Judy,* 1867, *Punch and Judy,* 1869, *Will o' The Wisp,* 1868, *Moonshine,* etc., but with the exception of a few brilliant cartoonists like Matt Morgan and John Proctor, their drawings never equalled those of the original.

The first great rise in circulation followed the publication of *Punch's Almanac,* when sales rose from 6,000 to 90,000 in the course of a week. There had been a great boom in the publication of almanacs since the repeal of Stamp Duty on them in 1834 and *Punch's* humorous one was a logical successor, though more packed with incident and anecdote than most. Highly decorative pages, calendaring the months, were contributed by H.G. Hine and Kenny Meadows and among the small print of the almanac's saints days, university terms and law sittings, sprang up puns and witticisms from the jolly dogs of the 'guffawgraph'. The drawings were much more full-blooded than in the main magazine, the head-pieces take on the substantiality of complete drawings and in the fourth and fifth almanacs in the hands of Leech and Doyle the metamorphosis of 'cut' to illustration is entire. *The Almanac* for 1848 was prepared in a luxurious coloured edition, price five shillings, an uncoloured version being half a crown, some indication that the artist was now on an equal footing with Grub Street.[21]

From 1843 to 1881, *Punch* published a *Pocket Book,* in many ways the counterpart to the almanac, but more useful in having twenty-five pages of diary in the centre, space for cash accounts, a pouch and a pencil. The whole book was neatly finished in red, blue or black leather and fastened with a tongue. This was supposed to reach a wider audience than the weekly *Punch* readership, part of its attraction being the folding coloured frontispieces by John Leech (Figure 24) and later by Charles Keene and Linley Sambourne as well as the vignettes by Tenniel and others. In some ways these books were an awkward compromise of fact and fancy but they remain, when they can be found, one of the most delightful pieces of *Punch* ephemera.

The career of John Leech, 1817-1864, is as much synonymous with early *Punch* as John Tenniel's and Richard Doyle's and this triumvirate must be considered individually. Leech's contributions to the magazine from 1841 to 1864 largely bridge the gap between

Figure 24. Punch's Pocket Book For 1857, John Leech.

Georgian and Victorian illustration and humour. One consciously avoids calling him a caricaturist, for though it would be unthinkable for a Regency artist to satirical papers to be anything else, Leech's work ushered in a more generous spirit of muted criticism. He can probably, as Ruskin wrote, be credited with having introduced this whole new genre of domestic satire which depended neither on verbal squibs or exaggerated drawing but on a greater naturalism of wit and draughtsmanship. Ruskin in *The Art of England* refers to that 'great softening of the English mind' which under Leech led to 'simplicity' and 'aerial space' in British humorous art.[22] This may not be so obvious to us today, but it was apparent to contemporaries.

John Leech was a Londoner and born in 1817, so that he came artistically of age in the 1830s, when illustration was uncertain in both aim and method. He had very little training, but did master etching, learnt drawing from the block from Orrin Smith and worked with lithography, one of the few English humorous artist to do so. His first published works, *Etchings and Sketchings* of 1835, were in lithography but he soon abandoned this for etching and the wood which were being used for books and magazines. All through his life he continued to contribute etched plates to more finished publications, but in many cases they lack the spontaneous touch which practice and speed had brought to his magazine work. It was above all the drawing on the wood that became Leech's natural medium of expression and it was perhaps that lack of academic training that left him with such a brilliantly sketchy effect. While his contemporaries produced harder and harder engravings, Leech danced rings round them with his rapidly drawn landscapes, seascapes and interiors, producing by a few lines of shadow or the skilful hatching of a hat or bonnet that wit and laughter which are free and immeasurable. Ruskin's admiration for the work was particularly directed to the flexibility and lightness of Leech's line, its condensation of elements, time, energy, thought and expression into a tiny area of paper and a few potent pencillings. Ruskin adds that the slightness of the sketches are their greatest strength because they have become slight, not through carelessness or cutting corners, but through studied realisation of the subject.[23] It is perhaps fortunate that most of the surviving drawings collected today have exactly that quality about them; they are preliminary jottings, rapid pencil sketches or a few more finished watercolours, the essence of Leech's talent. For the mid-Victorians they were unmechanical, individual and playful and if the subjects were undemanding, Ruskin could at least point out that this did not affect the purity of draughtsmanship which was like the silver points of the sixteenth century. The familiar 'JL' under a drawing or the sign manual of a leech in a bottle became almost the stamp of approval for bourgeois Victorian England.

Leech's art was like Leech himself. 'He was himself a typical middle-class British householder,' Spielmann writes, 'who liked to have everything nice and neat about him, including the pretty amiable, zealous h-less maidservant in nice white apron and clean print dress.'24 So that his world was not one where vice or hypocrisy were viciously exposed but where the follies of the ordinary domestic round got a decent airing. We find the master and mistress of this perfect household in trouble with burst water pipes after a thaw or facing an invasion of cockroaches in their kitchen; they are found entertaining their friends in the crinoline and swallow-tail of the period or déshabillé whispering sweet nothings to their own looking-glasses. They interview their servants for us, have consultations with sweeps and dustmen, they are barricaded in their houses by builders, tried to death by casual labourers, bored to death by barbers and horrified by nursemaids. We find them on trains, shut into claustrophobic little compartments, on steamboats feeling sick, rowing on the river, hunting and shooting, negotiating the discomforts of the bathing machine or the glories of the exhibition and the aquarium. At their most tranquil they gather round the family dinner table, the children on their high chairs, the parents ranged at either end, family portraits, pier glasses and ornaments surrounding them, while the master complains of 'cold mutton again' and the mistress mumbles not for the first time of her little 'housekeeping'. Leech, the affable, lovable *pater familias* puts a great deal of friendly chiding into these scenes, they are drawn with absolute familiarity and sympathy for the situations and people. Some of his themes have become fragments of history, but others like the climate, the exaggeration of sportsmen, the hen-pecked husband, the effects of cheap furniture, the temperamental artist, are still with us. Unlike many later Victorian satirists, one does not have to know a great deal about social or political history to appreciate his humour and respond to his pencil; his sketches are effervescently funny. The spectrum of nineteenth century life, provided by these hundreds of drawings in the first twenty years of *Punch,* is truly amazing; in sheer diversity of subject from political cartooning to social cuts and characterisations, novel illustrations, tiny thumbnail sketches, there is nobody to equal Leech. His statesmen and aristocrats may not be as convincing as his butcher boys, army sergeants, huntsmen and middle class matrons, because he did not know them so well, but all are gathered into his stiuations by his quick eye and deft line. Unlike his colleague Keene, Leech's wit was usually his own.

Leech did not slavishly adhere to any method of work and oddly enough was regarded as unreliable and unpunctual in business. He never used models but made notes of landscape backgrounds, buildings and props that might be adapted to a particular event. The sands at Ramsgate were utilised on one occasion for a joke and his travels round the country gave him other vital details. The artist had taken up hunting and frequently went out with the Puckeridge Hunt so that his numerous subjects concerned with the pack, the huntsmen and the followers, all have Hertfordshire as the basis for their backgrounds. His friendship with John Everett Millais had led him to undertake shooting holidays in Scotland where he found the perfect scenery for the grouse-shooting, salmon-fishing and deer-stalking exploits of his comic hero Mr. Briggs. His power of observation was acute. Frith, his chatty biographer, cites the action of a young man putting on his coat in 'The Derby Epidemic', a movement lasting a fraction of a second and yet perfectly captured. All through his graphic work there are examples of this spontaneous memorising, the man-about-town with one foot on a chair, the baby with something stuck in its mouth, the inflections from the way a cigar is smoked. In the same way he has the genius to hide a figure behind a newspaper and tell everything about him from the set of his ankles! If Leech had relied less on this memory and more on strict accuracy, it is unlikely that so many fascinating stereotypes would have evolved in his work. This was not the derogatory stereotype of infinite repetition, but the inventive and essential signal of this or that type of behaviour. Leech expanded his originality by varying

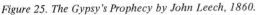

Figure 25. The Gypsy's Prophecy by John Leech, 1860.

Figure 26. The Gypsy's Prophecy by John Leech, wood engraving.

his own schemes, Doyle by extending his into fantasy.

The most famous of Leech's creations was the Leech young lady, as famous in her own time as America's Gibson Girl. Modelled on his wife, whom he had romantically seen in the street, followed and married, she pouts and simpers through hundreds of *Punch* pictures, a ringleted, rather bird-like creature with sharp nose, dark hair and sparkling lustrefull eyes. Sometimes she is the daughter of the house, sometimes she is the maid-servant taken advantage of by a guest or caught trying on her mistress's bonnet. She is seen in droves at balls, at the flower show or riding in Rotten Row, embroidering by the fireside or warming her very small feet on the fender. She is often the foil to Leech's more exaggerated creations, the foppish army officer, the precocious juvenile, elderly curmudgeons and cockney hunting gentlemen and even appears in the Surtees novels as the fair enchantress of Mr. Jorrocks or the seeker of a fortune teller in *Plain or Ringlets,* 1860. Figures 25 and 26, a drawing and an engraving, give one an opportunity of seeing Leech at work. The sketch of the Gypsy has been prepared by the artist in pencil and ink with a light wash here and there, for the steel engraver. On this first draft, Leech has pencilled in his instructions to 'Bite up with this vigorously' and indicated the positions. He has also requested a 'hard paper proof' so that he can add the final colour as an example to the hand painters. The result as it appears, the portion on the left of the plate duely treated and the distance clarified, shows the close co-operation then existing between artist and engraver.

The artist's other popular creations which the public found amusing through familiarity rather than novelty were 'The Rising Generation' series and 'Flunkeiana'. In the first, Leech hit that chord in the Victorians that so admired the diminutive, miniature objects, General Tom Thumb, bright children dressed like tiny adults. The usual format of these is for the miniscule infant in studied adult pose to refer to 'a jeuced fine gurl' across the room or for a creature the size and appearance of Bubbles to call for 'a toast to the ladies!' It is not a type of humour that has survived and is much funnier in Leech's repertoire when it emerges as the pretension of the undergraduate who wishes to cut a dash or the ensign working up his moustachios.

Flunkeiana, the counterpart of Servantgalism, was a chronicle of the thoughts and aspirations of cockaded metropolitan 'James's' and 'Thomas's' who waited at a thousand London tables and polished silver in a thousand London pantries. Leech's pencil often flew round at the expense of these powdered exotics complaining of too much 'fizzical exercise' or enquiring from their employers whether they were engaged for 'use or ornament'. The

London flunkey at Brighton asked if he likes the seaside, replies to the French maid 'Par Bokhoo Mamzelle' and his friend visiting Suffolk says 'I don't like your champagne, its all Gewsberry!'

With Leech's illustrations collected in his own lifetime into volumes of *Life and Character*,[25] it is easy to assume that he had no more serious comments to make than these. But he was a cartoonist of considerable ability and some of the best political work of early *Punch* came from him. 'The Agricultural Question Settled', 1845, 'The Poor Man's Friend' of the same year and 'The Irish Cinderella and Her Haughty Sisters' 1846, spring to mind. Nor was he above satirising the throne in 1845, when the Railway mania and subsequent crash had the Queen asking Prince Albert 'Tell me, oh tell me, dearest Albert, have *you* any Railway Shares?' Leech's portraits were not the careful likenesses of the photographic age, where everyone knows the features of the great, but good token images explicable by uniform or situation. He successfully used the theme of the school-mistress and the naughty boy to project the Queen and her ministers — Disraeli and Palmerston and even Sir Joseph Paxton fell into this rôle. One of his most celebrated full-page subjects was 'General Février Turned Traitor' of 1855, the gaunt skeletal figure of a Russian winter placing his boney hand on the form of the dying Tsar Nicholas, chief protagonist of the Crimean War. He shared with Doyle and Tenniel a favourite ploy of putting the politicians into Dickensian rôles, Trotty Veck, Mrs. Gamp and Fagin, the last a brilliant substitution of the scraggy thief for the corpulent form of Louis-Phillippe. Leech's own ideals were simple and English, he tended to be chauvinist and anti-Papist, show sympathy but not understanding for the poor and most of the causes he took up lacked objectivity. He developed an obsession against street musicians, was rather anti-semitic and much angered by unpatriotic loafers during the Crimean War. His greatest achievement was probably in the war against sweated labour and the famous 'Cheap Clothing' cut of 1845, where skeletons darn away under the eye of a prosperous proprietor, was a powerful image for change. However the full page was a rather large area to cover for Leech's decidedly domestic talent and the cartoons lack the impact of the smaller drawings.

As can be seen, Leech owed a great deal to the Regency despite his new approach. His famous 'characters' of 'Tom Noddy' and 'Mr. Briggs', instantly recognisable by the tall hat and large cigar of the one and the puffy indignant face of the other, are the descendants of Seymour's comic sportsmen and Alken's albums. But however many times Noddy loses his horse or Briggs his hat, there is a delight in their indomitable spirit totally lacking in Georgian savagery. Leech openly used Cruikshank's subjects of an earlier generation for his political cartooning, for example 'Where Ignorance is Bliss', 1846, smartened, brought up to date and reissued.

He was probably closest to the earlier men in his caricaturing of fashion, which despite growing conformity still showed excesses of display in the 1850s. The crinoline vogue, the cravat and collar mania, bloomerism, the great bonnet question, Dundreary whiskers, all come under the magnifying glass of his friendly satire. As good an example as any and a gallery of Leech's female beauties into the bargain appears in *Punch's Pocket Book*. Entitled 'Dressing For the Ball in 1857' (Figure 24), it shows a harem of soft-cheeked, soft-eyed girls waiting patiently for a maid to pump up the monstrous form of a crinoline like a glorified inner tube, a delightful combination of delicate penwork and modern fantasy! His belles and his fops, their skirts billowing out to impossible size, their shirts astonishing all beholders, are only one step away from the fantasies of Heath and Cruikshank, but that step is all important.

It is sad to think that as *Punch* veered away under Thackeray from Bloomsbury to Belgravia, Leech became more conservative, more jingoistic and more determined to be a gentleman. Like so many illustrators, his profession had made his social position a rather

ambiguous one and social standing was everything in Victorian England. Neither journalist nor artist, neither fish nor flesh, Leech adopted the life style of a country gentleman, hunting, fishing and attending parties, winning the sort of acceptance that his drawings alone could never gain him. As John Gilbert hid his insecurity behind piles of money, Leech and many others hid it behind respectability. It is rather tragic to find Leech at the end of his life in 1862, expending time and energy on pro-

Figure 27. The Knight and Jotun by Richard Doyle.

ducing oil paintings from his *Punch* drawings, hoping for the designation of 'painter'.[26] Tenniel, the mural painter of histories was to be remembered for *Alice,* Leech who fancied himself an oil painter, for the fat boys, flunkies and squires of *Punch.*

The second of the great triumvirate of early *Punch* was Richard Doyle. Doyle was the son of John Doyle 'HB' and came from a family of talented journalists and caricaturists, two of his brothers also having their drawings published. He was snapped up by Mark Lemon when hardly out of his teens, taught drawing on wood by Swain and was contributing his first border designs to Tom Hood's famous 'Song of the Shirt' on 16 December 1843. *Punch* was established in its drawings of political and social satire, Richard Doyle provided that other essential ingredient, fantasy. The legendary and fantastic were too integral a part of the Victorian scene in other literature to be excluded from a humorous magazine, and with Doyle's pen the allegories became whimsically funny, mythology impish and even the half sinister world of fairies and elves took on a wayward charm of its own (Figure 27). His most noteworthy successes in this line were the *Punch* covers, the first designed in January 1844, including a mock 'Triumph of Bacchus' and a border of tumbling figures, the second, a modification made in January 1849 and used for over a hundred years. Doyle really has two styles of drawing, the first used on the covers with such decorative effect was primarily ornamental, intricate and small of scale, superb groupings of tiny figures drawn with a sharp pen (Figure 28). The other method was

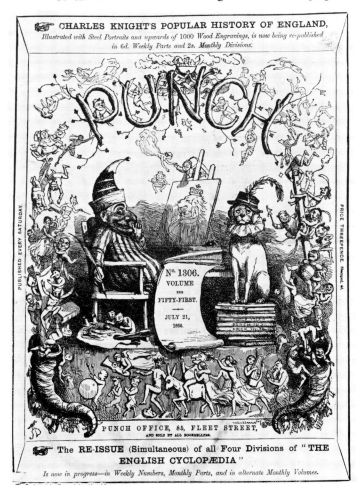

Figure 28. Punch *cover.*

developed later, a linear style of etched outlines, an obvious inheritance from Flaxman and the German classicists, where the same crowded figures were disposed like a frieze without shade or hatching. The artist used his more piquant decorator's style for the lovely initial letters, vignettes and head and tail pieces that are a feature of the 1840s. A recurring theme is the dream, either of Mr. Punch or some other character, who snoozes contentedly while the passions of past or present frolic above him in the air. The idea was well tried in the early Victorian period, 'Phiz' uses it in *Martin Chuzzlewhit* by Charles Dickens, 1844, and for the frontispiece to *Dombey and Son*, 1848. Doyle uses it again for Dickens in *The Chimes*, 1845, and *The Cricket On The Hearth*, 1846. Fairy illustration once established in *Punch*, remained a favourite until the turn of the century but usually in the Christmas issues. Doyle began this tradition in its pages which lasted until the beautiful drawings of Thomas Maybank in the 1900s and to Rackham and beyond in books.

Doyle's other great triumph was with his etched outlines. He used this medium for his long-running series of 'Manners and Customs of Ye Englyshe', later expanded in book form as *'Mr Pips Hys Diary'*, 1849. Doyle took as his starting point contemporary society as viewed through a medieval drawing or tapestry, scenes showing among other things 'Ye Fashionable Worlde Takynge Its Exercyse In Hyde Parke' and 'Ye National Sporte!!! of Steeple Chasynge'. Doyle's drawings were a development from Gilbert à Beckett's comic histories which Leech had illustrated from the 1830s. The humour may seem a trifle laboured now, but it caught on and became the first in a long series of humours of history, leading down to the 'Prehistoric Peeps' of E.T. Reed and the early British lunacies of George Morrow.

It was perhaps ironic that one of Doyle's 'Manners and Customs' should have shown 'A Prospect of Exeter Hall Showynge A Christian Gentleman Denouncynge Ye Pope'. This is a much harsher picture than the others and refers to the anti-Catholic rumpus of 1849-50 when Rome established bishops in this country. The anti-papal stand taken by *Punch* was too much for the gently and deeply Catholic Doyle, who resigned his position in 1850. He devoted the rest of his life to book illustration and in particular to books for children to which his talent was ideally suited.

If Leech's drawings represented the domestic side of Victorian Britain, Tenniel's pointed to her political and imperial role in the grandly classical guises of John Bull, Mrs. Bull, The British Lion, Father Thames and Brittania, seen week by week from 1862 in the principal cartoon. Like so many *Punch* artists, Tenniel's work was sought out by Mark Lemon for its range rather than its purity Doyle had left the 'Table' at an awkward moment, the Almanac and *The Pocket Book* for 1851 were uncompleted and there was no decorative artist on the staff to tackle the ornaments, initial letters and frontispieces which were the entrée of *Punch* to the drawing-room. John Tenniel, 1820-1914, was a serious artist, whose training at the RA Schools had left him greatly influenced by Flaxman and greatly enamoured of German draughtsmanship in the works of Menzel and Rethel. Lemon had seen his illustrations for the Rev. Thomas James's *Aesop*, published by Murray in 1848 and evidently been impressed, but it was certainly a new departure to have a representative of high art on his team, Gilbert having been dropped years before.

Tenniel's first work was the frontispiece to the second half-yearly volume for 1850, but he very soon graduated from initials and frontispieces to 'socials' and cartoons, taking over from John Leech, that onerous weekly job to which the latter was somewhat unsuited. But Tenniel was one of the new breed of political cartoonists, as far removed from Gillray or Cruikshank as possible. 'As for political opinions,' he told Spielmann, 'I have none; at least, if I have my own little politics, I keep them to myself, and profess only those of my paper.'[27] As the one Conservative among a Liberal editorship, Tenniel shows remarkable restraint in this, but it emerges that above all *his art* mattered more to him than the subject

picked for him by the *Punch* 'Table'. Tenniel felt that professionalism should rule over strong feelings, a stoically Victorian attitude, and his drawings are always finely executed, beautifully composed and fair in content. Mercifully he could be both stern and amusing on paper. This order and exactness in his dealings with *Punch,* the cartoon commissioned on Wednesday, sketched on Thursday, finished on the block on Friday, is in marked contrast to Leech! His perfectionism extended to working with a specially prepared six-H pencil, producing silvery grey strokes of a hair's breadth thickness on the paper, possibly the finest pencil work after Maclise of the Victorian era. He was also a fanatic for smooth blocks on which to draw and Swain, the engraver, had a hard job to keep him so supplied. Tenniel himself admitted that he traced the drawing on to the block and in his excellent study of this period, Percy Muir suggests 'that most of the old hands at drawing on wood habitually provided the engraver with no more than the bare essentials of a picture leaving him to supply the trimmings.'[28] This may be true, but does not quite account for the highly finished drawings on the wood that still exist in some collections, mostly by eminent artists of the 1860s. Despite the appearance of the half tone and improved reproductive processes, Tenniel continued to draw for or on the block for *Punch* until as late as 1892. After this it was his practice to draw on the chinese-whitened surface of cardboard, which was then photographed.[29]

His lightness of touch and feathery delicacy were not characteristics which the engraver could transpose at all. Swain had to interpret Tenniel's work into a thicker black line for the printed page without losing the areas of detail or the flat areas of white which gave the sketches their Germanic crispness. Spielmann mentions that Tenniel could never open the journal himself when the print was completed, it was handed to his sister who opened it to show him! This sort of squeamishness was very general among artists, who were less well-served by engravers than Tenniel was by Swain. But there is a tremendous contrast between the drawings and the printed page in the magazine, leaving a lot to be desired. The fact that so many finished drawings do survive to show Tenniel's mastery of the pencil line is left on record by the artist himself. 'The first sketch I may, and often do complete later on as a commission,' he told Spielmann, 'Indeed, at the present time I have a huge undertaking on hand, in which I take great delight — the finishing of scores of my sketches, of which I have many hundreds.'[30]

Another feature of Tenniel's method which links him more closely to John Leech is that he, like Leech, never drew from nature, only from observation. 'I never use models or Nature for the figure, drapery, or anything else,' he recorded, 'but I have a wonderful memory of observation, not for dates, but anything I see I remember.'[31] This was true of the whole generation of book illustrators raised before 1850. As with Leech this tended to lead to repetition in placing the figures in the cartoons and what was worse a slight air of unreality about the subjects. Under his pencil, politicians tended never to age at all and in the 1890s he was still depicting the bicycles and railway trains of his middle age!

Among the two thousand cartoons contributed to *Punch* by Tenniel, are some of the most famous of the century. In 1857 after the Indian Mutiny appeared his 'The British Lion's Vengeance on The Bengal Tiger', a dramatic but direct piece of political allegory showing the artist's fine handling of animal subjects. As late as 29 March 1890 came the celebrated 'Dropping The Pilot' a powerful interpretation of Bismark's dismissal by the German Emperor, suggested to Tenniel by G.A. à Beckett. The 1860s, such a great period for illustrations generally, were a golden era for Tenniel cartoons. We have 'The National Crinoline' in February 1863, where current fashion is used to satirise national extravagance, 'The American Juggernaut', where the American North is condemned for bloodshed in the Civil War, September 1863, and 'Where's The Irish Police?' with an inert Gladstone in volunteer's dress idly watching a bloody brawl. Like Leech, Tenniel resorts to themes from

Dickens, Shakespeare and the Classics for his armour (Figure 29) and on occasion goes back to earlier painters. It is amusing to find him using Henry Fuseli's 'Nightmare', paraphrased to such advantage by Gillray, as the basis of 'London's Nightmare' in March 1866. In this case the incubus is a parish beadle crouching on a contorted feminine figure of 'London', a cry against Vestry Government in the City. As the beadle is obviously Dickens' 'Mr. Bumble', the sources for the subject are deliciously mixed; even so one speculates as to who in 1866 would have recalled the original painting by Fuseli! He also uses a contemporary image, Frank Holl's celebrated oil painting of 'Newgate; Committed For Trial' and uses it with dramatic force to illustrate a bank failure of February 1869. The figures are always in large scale, almost muscular, well-handled and with a slight suggestion of fantasy. 'My drawings are sometimes grotesque,' Tenniel is recorded as saying, 'but that is from a sense of fun and humour. Some people declare that I am no humorist, that I have no sense of fun

Figure 29. 'The Press as Scare Monger', 1892, by Sir John Tenniel.

at all; they deny me everything but severity, 'classicality' and dignity. Now I believe that I have a very keen sense of humour, and that my drawings are sometimes really funny!'[32] Grotesque describes his drawings perfectly, because they are usually too hard on the page to be really comic. In some such as 'Before The Tournament', an election cartoon of November 1868, the weird stiff figures in armour have a lot of the innocent child's view that comes out so clearly in the 'White Knight' and other *Alice* characters.

Tenniel's association with Lewis Carrol on these books, *Alice in Wonderland*, 1865, and *Alice Through The Looking Glass*, 1871, form one of the most chronicled author-artist partnerships of our period, the wild imagination of Carroll stretching Tenniel's powers to the limit, but in the process creating some of the greatest comic characters of all time.

The Illustrated London News

As the 1840s dawned, there was seen to be a place for a general illustrated journal of news, current events and comment that would appeal to a wide middle-class readership. *Punch* had had a slow gestation period, but was now reaping the benefit of the literary tradition of Hogarth, the satiric tradition of Gillray and the essay tradition of Junius and others; but *Punch* unquestionably needed a 'straight man' to compliment him. The founding of *The Illustrated London News* in 1842, made it very nearly Mr Punch's twin and the two magazines, still happily with us, became the bastions of Victorian Britishness and an essential part of the mid-nineteenth century household. If *Punch's* birth was protracted, that of *The Illustrated London News* was highly coincidental, not to say bizarre.

In about 1841, Herbert Ingram, a young businessman from Nottingham, who had been trained as a printer in Boston, Lincolnshire, approached the printer Henry Vizetelly for an engraved portrait of 'Old Parr' the legendary long-lived man. This engraving was to appear in a fictitious life of the old man and help to promote Morrison's Vegetable Pills, a somewhat dubious concoction, which Ingram was then selling in the Midlands. Ingram had an instinctive feel for business and realised that the 'Old Parr' story would be a most effective enterprise if linked to some sort of medical comfort. According to Vizetelly he had 'a harmless aperient bolus' made up and marketed it among the Nottingham lace-makers as 'Parr's Life Pills', later publishing *Old Moore* in almanac form to testify to the miraculous qualities of his first product! The little piece of job-work engraving brought Ingram and Vizetelly together and, as a result, Ingram made a suggestion which Vizetelly clearly jumped at with alacrity.

Ingram told him that after a sensational trial, the Greenacre murder of 1837, he had felt that there might be a place for a popular illustrated journal full of police cases and assize hearings, but aimed at a fairly literate market. Vizetelly was very impressed by the idea and in his own words gives Ingram the credit for it. 'The suggestion of a newspaper,' he writes, 'with every number of it more or less filled with engravings, came as a sort of revelation to me, and I at once realised the vast field it opened up.'[33] There was very little love lost between Vizetelly and Ingram in later years and it is difficult to know how much of his *Memories,* dealing with subsequent meetings is to be wholly trusted. Vizetelly drew up an elaborate prospectus which went far beyond the scope of Ingram's original and rather grubby little crime magazine and, if it was entirely his own scheme, was truly remarkable. Vizetelly recalled that the new paper would include 'scenes of state ceremonial, the

important political gatherings [the agitation against the Corn Laws was then at its height] and the crowd of general public events, including every class of popular amusement, which were equally susceptible of illustration.'[34] He also emphasised the ease with which portraits could be drawn for the publication since the discovery of daguerrotypes and that the inclusion of drawings from war zones, such as the Chinese and Afghan conflicts then in progress, would arouse colossal public interest. This latter point was not taken up at once, but in other respects the structure of *The Illustrated London News* was forming. Mason Jackson, who was later in the employ of the Ingram family, took quite a different view of Herbert Ingram's intentions in *The Pictorial Press,* published in 1885. Jackson makes him out to be a high-minded and generous principalled philanthropist, in the style of Charles Knight. 'Though he had not himself received the advantages of literary or artistic culture, he was able to do much in diffusing a knowledge and love of art amongst the people,' he writes.[35] This was certainly to be the case, but taking into account what we know of the shrewd Nottingham businessman and quack medicine proprietor, it is likely to have been the promotion of the magazine rather than its scope for which *he* is to be congratulated. The perfect balance of text to pictures and the happy blending of current affairs with historical or natural interest must be laid at Vizetelly's door alone.

The title of the magazine, *The Illustrated London News,* was decided almost at once; F.W.N. 'Omnibus' Bailey was appointed the first Editor with Monahan as the sub-editor and John Gilbert as chief artist. The first issue appeared on 14 May, 1842 with sixteen pages, thirty-two woodcuts, the main one showing the destruction of Hamburg by fire. Ingram's innate business sense won, the magazine was an immediate success; by its seventh number it had reached a circulation of 20,000, and within a year 66,000, rising to 100,000 in 1851. Ingram performed feats of unprecedented promotion for Victorian England. He sent eight thousand free copies showing the Enthronement of the Archbishop of Canterbury to every beneficed clergyman in the land, boosting the circulation yet again, and assuring the respectability of the paper for the next fifty years! The main difficulties were the dearth of artists who were sure enough and quick enough for this sort of work, drawing rapidly on the block and returning the finished product in a matter of hours. Ingram adopted Knight's formula of having a number of staff engravers working under a chief engraver, in this case Landells, so that much of the work was undertaken on the premises. Landells' position was really that of Art Editor, although no acknowledgement was given to this position for many years. The other problem was that those artists who were competent, the book illustrators, felt themselves to be a profession apart, did not understand the magazine and according to Vizetelly 'looked with something like disdain upon the interloper'.[36]

If Knight had had a struggle to interest the mechanics in the printed word interspersed with drawings, Ingram did not at first capture the literary public although his page openings alternated text with cuts. The Victorian mind which 'read' pictures in other contexts, found it difficult to consider news and events seriously in illustrations, the Poet Laureate included. William Wordsworth saw in the illustrated press only the pictorial world of childhood and was prompted to write a sonnet on looking at *The Illustrated London News* in 1846.

'Discourse was deemed Man's noblest attribute,
And written words the glory of his hand;
Then followed Printing with enlarged command
For thought — dominion vast and absolute
For spreading truth, and making love expand.
Now prose and verse sunk into disrepute
Must lacquey a dumb Art that best can suit
The taste of this once — intellectual Land.
A backward movement surely have we here,

From manhood – back to childhood; for the age –
Back towards caverned life's first rude career.
Avaunt this vile abuse of pictured page!
Must eyes be all in all, the tongue and ear
Nothing? Heaven keep us from a lower stage!'

It is difficult today, on leafing through the magazine of the 1840s to see what had so affronted the septuagenarian poet. We find an undoubted paper of information and record, eight pages of wood engravings to eight pages of text, and that text divided into three columns and set for the most part in thickly inked Victorian 6 point type, a most daunting prospect! The unillustrated openings might be from any serious nineteenth century paper with their one and a half pages of Parliamentary Reports, the obituaries of 'Eminent Persons Recently Deceased', a column length of leading article, 'Court and Haut Ton' and 'Foreign Intelligence'. With records of Stock Market transactions, extracts from the *London Gazette*, reports on Tattersall's, national sports, chess problems and humorous verses, Ingram and Vizetelly had proved that an illustrated paper of popular appeal, could still be a paper for the whole family. The only quarrel possible with the infant *Illustrated* would seem to be its diversity, the textual pages so unremittingly solid, its wood engravings so surprisingly big, perhaps it was the magnitude of this contrast that upset a word-based audience.

The intention was of course that text and pictures should be closely followed together, not in isolation as might be the case with modern glossies with their long captions. One has to imagine the Victorian reader, thumb in the text page, finger on the print, minutely following the details of the picture as they are described. For most of Ingram's readers, the serial novel in parts, or magazines like *Ainsworth's Magazine,* were the natural diet, and in them close study of the illustrations was the only way to provide a continuity week by week. The text running with some rural scenes by Birket Foster, published in an early number of *The Illustrated London News,* does show how integral was this relationship.

'Each bears the aspect of the month – a sort of pictured climatology, with the natural appearances of the season, and the monthly phases of the farmer's life. Thus, in January, the ground and roofs are thickly mantled with snow, the effect of which, against the black wintry sky, and the bare bough trees, is very telling; the scene is a farmyard, where the feeding of poultry, pigs and cattle, seems to break the sleep and silence of the season; the contrast of the still and busy life is excellent. The tail-piece is a shepherd carrying one of his flock in a snowstorm. The business of February is ploughing and sowing; the rooks are building, and all nature is just astir. In March we have felling timber; in April, angling, the ferry, and harrowing; with the landscape just freshened by a shower, and the bow in the sky. May is exquisitely redolent of whitethorn, and budding boys and girls in the roads and hedges. In leafy June, we have the mowers at their work, and the heavy load of hay.'

The narrator goes on to evoke the picturesque spirit of Foster's pictures with quotes from Robert Bloomfield and Alfred Tennyson. We are informed that the writer is 'Mr Thomas Miller', who has 'evidently luxuriated in such kindred subjects; his descriptions teem with eloquent poetry and truthful nature.'[37] The reader was confronted by a map with references, rather than by an independant work of art.

So entirely new and alien to the instincts of publishers was this venture, that even the industrious Charles Knight had his doubts. It was the reporting of events rather than facts that confused Knight and brought him nearly to disbelief.

'In 1842,' he writes, 'having occasion to be in attendance at the Central Criminal Court, my curiosity was excited by an unusual spectacle – that of an artist, seated amongst the city dignitaries on the bench, diligently employed in sketching two Lascars on their trial for a capital offence. What was there so remarkable in the case, in the persons, or even in the costume of the accused, that they should be made the subject of a picture? The mystery

was soon explained to me. *The Illustrated London News* had been announced for publication on the Saturday of the week in which I saw the wretched foreigners standing at the bar. I knew something about hurrying on wood engravers for *The Penny Magazine,* but a Newspaper was an essentially different affair. How, I thought, could artists and journalists so work concurrently that the news and the appropriate illustrations should both be fresh? How could such things be managed with any approach to fidelity of representation, unless all the essential characteristics of a newspaper were sacrificed in the attempt to render it pictorial? I fancied that this rash experiment would be a failure. It proved to be such a success as could only be ensured by resolute and persevering struggles against natural difficulties.'[38]

Ingram was already employing a few artists for the paper but the roving 'Special Artist', dealt with in a later chapter was still a thing of the future. Vizetelly notes how primitive were the arrangements for collecting material: 'the system pursued with the majority of engravings of current events — foreign, provincial, and even metropolitan when these transpired unexpectedly — was to scan the morning papers carefully, cut out such paragraphs as furnished good subjects for illustration, and send them with the necessary boxwood blocks to the draughtsman employed.'[39]

The earlier volumes were certainly stronger in their decorative and allegorical pages, than in their news reporting. It was a considerable triumph for Ingram to have enlisted William Harvey, the foremost book illustrator of the period, for the magazine, and he was given full pages with titles such as 'Bringing in The New Year', 'Autumn' or 'To The Memory of O'Connell' where his talent for pathos or legend filled the space with weeping angels, dancing sprites or maidens with sheaves. John Gilbert was the other draughtsman in the classical mould who found a comfortable niche in these pages. He had begun life on *Punch*, designing the frontispiece to its second volume in 1842, which also served as its wrapper, but his statuesque men and beautiful women planting laurel leaves on their brows had not one ounce of humour in them. After Douglas Jerrold's famous witticism about him 'We don't want Rubens on *Punch*!', Gilbert migrated to the Ingram stable very readily.

Gilbert's popular appeal cannot be overestimated. After little formal training except some study with George Lance, he had emerged as a magisterial draughtsman, the doyen of the Christmas book market and the best-loved illustrator of the English poets. He was exactly what the Victorians respected, a history painter who happened to illustrate books rather than a book illustrator who struggled with historical subjects. His figure drawing was always faultless and his sense of majesty and grandeur on the printed page almost overwhelming. He was decidedly at his best in allegorical work where lofty sentiments and patriotism could be expressed through mythological deities, his work becoming a *sine qua non* of the Christmas issues. He was also a decorative artist of rare accomplishment and his page design for The Royal Agricultural Society of England's meeting at Northampton in July 1847 is one of many that must have delighted readers who did not want their pictures to be taken in at a glance. The opening motions of the meeting are contained within a tremendous ornamental frontispiece by Gilbert in which a richly foliated border, twined with crops and vines, includes the figures of a reaper and a scyther. Below is a delicate vignette of the town of Northampton and at the bottom of the composition a 'trophy' of agricultural implements, with sieves, sickles, a plough, hay fork, cider press and the inevitable symbol of Victorian endeavour — a beehive (Figure 30). Gilbert's heavy metaphor does pall, but his early works are among his best, and Ingram shrewdly realised that such visual symbols were good for business.

Although it was a novelty, *The Illustrated London News* had in it many seeds of earlier experiments with pictorial journalism. Its format was entirely that of the newspaper and yet its appearance in two cloth-bound volumes at the end of the year, blind stamped decoration

Figure 30. Northampton Agricultural Meeting by John Gilbert, July 1847.

at the corners, gilded cypher in the middle, gave it an air of permanence. This was not something to be discarded like a newspaper, but kept on the table in view of visitors, to be pored over like an album. There was much of the album in these volumes, with gilt edges, decorated spines, elaborate initial letters from the pen of John Gilbert and the lush treatment of the Fine Arts, usually a sentimental genre subject with a purple description below it. Even closer to the tradition of the albums, *The Gem* and *The Keepsake* was the inclusion of sheet music from time to time, seasonal lyrics such as 'Hymn For The Harvest' by 'A Lady' or patriotic songs by that arch-philanderer Sir Henry Bishop, all suitably embellished. Fashionable costumes were shown each month, most of them straight from French journals and by French artists but an equal coverage was given to the 'London Season' with graceful high life portrayed by Gilbert and evoked 'with a charming novelette'. Where fashion and current affairs joined forces, artists specialising in drawing objects were employed on page after page of Royal wedding presents, commemorative plate, race cups and in the case of the Marquess of Kildare, his wedding cake in every intricate detail!

From Charles Knight and the Penny Encyclopaedists there were borrowings of scientific investigation, astronomy and the charting of eclipses, home industry in 'A visit to Messrs Barclay and Perkins Brewery' or natural history, the 'Long-Eared Fox at the Gardens of the Zoological Society', each accompanied by an accurate drawing or diagram. These were often by technical or architectural artists, the earliest scientific draughtsman being one Thomas M. Hare. Ingram was also following Knight's lead in the way fiction was reduced to the barest minimum; in the 1850s there was practically none and in the 1840s only the occasional tale from the German translated by Miss Howitt with column measure blocks. It is also noticeable that sensational crime, which was supposed to have been the *raison d'être* for Ingram's first idea and was the mainstay of Reynolds' publications, appears here as a straight report of the police courts.

In its early numbers *The Illustrated* borrowed a style of satire which was very much that of *Punch* and continued to do so for many years, relying at the same time on a group of *Punch* artists. Comic drawings appeared about once every four or five weeks, usually in Kenny Meadows rather wooden but jolly hand, and Albert Smith ran an 'Everybody's Column' punctuated by tiny comic vignettes, quite anonymous. The targets were social or seasonal, dealing with railways or elections and the popular pastime of the Victorians in drawing grotesque 'Heads'. Richard Doyle supplied some of these, H.G. Hine was a frequent contributor and in the next few years, John Leech, Alfred Crowquill, 'Phiz', Cuthbert Bede, C.H. Bennett and Charles Keene were to play their part. After 1860 Du Maurier, Fred Barnard and William Ralston were to feature, the former two bringing with them a less boisterous humour and the latter by degrees the comic strip episode.

Another side of the magazine in the 1840s which became a consistent adjunct to the whole were the portraits, one would not dare say pictures, of prize bulls, cattle and poultry. For a paper that drew a lot of support from the shires and published a country edition, it was important that the agricultural scenes were life-like. Describing Edward Duncan's drawing of 'A Poultry Yard' on 20 March, 1847, the writer says: 'The busy group in the Illustration need not be individualized. Nor need we enquire how many of the pure Dorking breed there may be among them, or if the hand which scatters the food be that of a Dorking housewife . . . All these accessories combine in a very pleasing scene, not a painter's composition, but a picture of actual life.' Duncan's art could be implicitly relied upon and the reader clearly knew his hens!

Both J.F. Herring and Benjamin Robert Herring were active in these agricultural scenes, Harrison Weir drawing the Leicester, Hereford and South Down cattle. J.W. Archer assisted and later on J.W. Wood, Harry Hall and G.B. Goddard were to continue their work and Sam Carter drew cows for upwards of twenty years. These 'pictures of actual life' are of a

continuing high quality and stand apart in the early days when figures are poor and printing indifferent.

A feature that developed out of the Victorian cult of Christmas as the main celebration, as opposed to the Georgians' New Year, was an enlarged Christmas issue with strong illustrative contributions. Until the end of the century, outside artists of high calibre were imported for this one occasion although the 'house' artists were used as well. In the 1850s we find in one supplement, Birket Foster, Abraham Solomon, John Tenniel, C.H. Bennett and Edmond Morin, in the 1860s James Godwin, George Thomas and John Everett Millais, with his only contribution to the magazine. As allegory and myth became less usual outside political cartooning, much of the fantasy and legendary illustration became concentrated in this section; it was also the first part of the magazine to have coloured pages from wood blocks in 1857.

This pattern of publication, once settled, was almost unchanging until the 1900s. The size of the journal nearly doubled from an average of 850 pages a year in the mid-forties to an average of 1,300 pages in the mid-fifties, the two comparatively slender yearly bound volumes becoming as bulky as family bibles. The proprietors supplied 'supplements gratis' at certain times of the year and at moments of national rejoicing or national crisis. There were several during the Crimean War, some issues had two supplements which had to be paid for, doubling the price of the magazine to one shilling. On 4 February 1854, there were sixteen extra pages on the Opening of Parliament, on 25 February another, mostly on the arts and one on the British Institution on 11 March. 'The Baltic Fleet' supplement appeared on 18 March with a marine frontispiece by E. Weedon, the chief marine artist of the magazine from 1848 to 1872, and nine wood engravings of engagements and uniforms as well as a map and a patriotic song. The coverage of naval and military activity was always extensive and became more so as artists themselves became more involved.

The Illustrated London News was not without rivals and imitators in its early days. The indefatigible Henry Lloyd tried to compete with its success for a few months in 1842, when he produced *Lloyd's Illustrated London Newspaper,* a short-lived speculation that fathered numerous other papers including *Lloyd's Penny Sunday Times and Peoples Police Gazette,* 1840-44, and *Lloyd's Weekly News.* Another inexpensive rival was *The London Journal,* 1845, which despite its sub-title as 'Weekly Record of Literature, Science and Art' depended for its popularity on sensational stories of barbarity and crude and lurid woodcuts. Selling at a penny a week, it had a circulation of 100,000. Mason Jackson mentions as other serious competitors, *Pen and Pencil* with woodcuts by Linton, *The Penny Illustrated Paper, The Pictorial World,* which specialised in large lithographic portraits and *The Ladies Pictorial.*[40] *The Field,* founded in 1853, began life with a strong team of artists including Leech, 'Phiz', Richard Ansdell, Harrison Weir and Harry Hall, but after its acquisition by E.W. Cox illustrations were dropped for a number of years. Cox gave as one of his reasons, the cost, and the fact that 'much better ones can be procured for a penny in John Cassell's illustrated sheet'.[41]

John Cassell, a reformed drunkard turned grocer, and a publisher from 1850, was making a name in inexpensive popular journalism. His papers were wholesome, homely, teetotal and illustrated, sufficient to make a formidable contender with *The Illustrated.* The one Cox refers to was *Cassell's Illustrated Family Paper* which had grown out of this earnest educator's other triumphs like *Cassell's Magazine of Art,* brought out after the Great Exhibition of 1851. The *'Family Paper,* which like *The Illustrated London News* had a folio format, lasted until 1865, when it became a quarto, changing its name to *Cassell's Family Magazine* in 1867. From 1854-57 it was priced at a penny, appeared like its rival on Saturday and contained eight pages of which four were illustrated. At this time it had designs by John Gilbert, including its headpiece, and illustrations by George Cruikshank (the

teetotal lobby), T.H. Nicholson, Kenny Meadows and G. Sargent. Generally speaking the artists were less impressive than Ingram's team as well as being restricted in space. Cassell's psychology of keeping in the penny market while employing *The Illustrated* artists was good business. Although *they* had twenty pages per issue in 1854 and fourteen were of illustrations, the *'Family Paper* was publishing stories in serial form running week to week. Nor were the authors inconsiderable. In 1854 appeared the following notice:

'John Cassell, being determined that this Periodical shall stand pre-eminent for popularity, has resolved to give it the increased attraction of a NEW, POWERFUL AND DEEPLY INTERESTING HISTORICAL TALE, which will be exclusively furnished under the Copyright Act, for Cassell's Illustrated Family Paper, by that celebrated Author ALEXANDER DUMAS.'

There followed serial instalments of the Dumas novel, completed each week by a busy and rather inky woodcut by T.H. Nicholson, who had taught Count d'Orsay. With the exception of Christmas numbers, it was only in the 1870s that *The Illustrated London News* finally succumbed to serial stories.

The greatest threat of all came from within, when in 1843, Henry Vizetelly, who was always willing to play maverick, left the magazine and founded his own *Pictorial Times*. This had a staff of brilliant men, Douglas Jerrold as leader writer, Thackeray as critic and reviewer, Mark Lemon as drama critic and Gilbert à Beckett as humorist. It foundered in 1847 and the tireless Vizetelly began again in 1855 with *The Illustrated Times* a far more ambitious paper. Its folio format was still modelled on *The Illustrated*, though slimmer, it had W. McConnell as the resident comic artist and employed that great designer H. Noel Humphreys to design borders and decorations. 'Phiz' worked for it, so did Doré, and between 1856 and 1866 it probably used more Continental artists than any other comparable magazine. A surprising contributor was the young Matt Morgan who was first employed to decorate and then to draw political demonstrations, showing his characteristic bite. *The Illustrated Times* was too successful for old Ingram, who at first took a third part share in it, then bought it and finally closed it down altogether.

No survey of these illustrated magazines would be complete without some mention of the part they played in perpetuating a strong tradition of black and white art, of providing a forcing house for young talent and constant employment for the less successful painter. Writing in 1885, Mason Jackson says 'Both *The Illustrated London News* and *The Graphic* may claim to have done good service to art and artists in this respect. Their pages have always been open to young artists, and while they have helped forward struggling genius they have opened up new sources of enjoyment to the general public.'[42] Jackson goes on to elaborate and say that 'the production of works in black and white, whether as engravings or drawings, is no doubt good artistic practice in the study of light and shade, and the young artist who draws on wood as a means of helping him to live while he is waiting for fame, is at the same time pursuing a useful branch of his art education.'[43] He cites Luke Fildes, Birket Foster, William Small, Caton Woodville and C. Gregory in this category and among the artists of our period, Samuel Read, Edward Duncan and F.W. Topham. He does not however mention the far wider scope of subjects or specialities available to the artist in the news magazines than in book illustration or their persistent use of the amateur. Both *Punch* and *The Illustrated London News* used much amateur drawing, some of it original or of high quality, but much of it merely perpetuating that link between professional and gifted gentleman that had made Georgian caricature and topography so varied.

Footnotes

1. Charles Knight, *Passages of a Working Life,* 1865, Vol. 1, P.226.
2. ibid., Vol. 2, p.227.
3. ibid., Vol. 2, p.116.
4. ibid., Vol. 1, p.244.
5. *Penny Magazine,* introduction to Vol. 1, 1832.
6. ibid.
7. F. Von Raumer, *England in 1835,* Vol. 1, p.193.
8. Charles Knight, *Passages of a Working Life,* 1865, Vol. 3, p.223.
9. ibid., Vol. 2, p.6.
10. Etched details on a caricature of S.W. Fores February 1803.
11. Quoted in John W. Dodd's *The Age of Paradox,* 1952, p.126.
12. Charles Knight, *Passages of a Working Life,* 1865, Vol. 2, p.223.
13. *The Victorian City* (V. Neuburg), Vol. 1, 1977, p.197.
14. M.H. Spielmann, *The History of Punch,* 1895, p.10.
15. R.G.G. Price, *A History of Punch,* 1957, p.43.
16. M.H. Spielmann, op. cit., p.314.
17. R.G.G. Price, op. cit., p.43.
18. ibid., p.49.
19. ibid., p.36.
20. Spielmann, op. cit., p.214.
21. George Cruikshank produced Comic Almanacs from 1835 to 1853 and *Punch* probably borrowed the idea from these.
22. John Ruskin, *The Art of England,* 1884, p.179.
23. John Ruskin, preface to *Children of the Nobility,* 1875.
24. Spielmann, op. cit., p.422.
25. Numerous editions, mostly undated were issued by Bradbury and Agnew between 1858 and 1886.
26. These were a considerable innovation in their time. An impression from an engraved wood block was made on india rubber and then enlarged by stretching. This 'blow-up' was then transferred to a lithographic stone and printed on canvas. Leech then painted in the whole composition with thin oil colour. Six examples were lent to an exhibition at Leicester Art Gallery in October 1967, the finest being 'The Fair Toxopholites' from the Croft-Murray Collection.
27. Spielman, op. cit., p.463.
28. Percy Muir, *Victorian Illustrated Books,* 1971, p.110.
29. Spielmann, op. cit., p.464.
30. ibid., p.464.
31. ibid., p.464.
32. ibid., p.463.
33. H. Vizetelly, *Memoirs,* 1893, p.223.
34. ibid.
35. Mason Jackson, *The Pictorial Press,* 1885. p.307.
36. Vizetelly, op. cit., p.238.
37. *Illustrated London News,* 30 October, 1847.
38. Knight, op. cit., Vol. 3, p.244.
39. Vizetelly, op. cit., p.232.
40. Jackson, op. cit., p.314.
41. *The Field.* In 1853, the magazine was running 16 pages weekly, 24 pages with supplements and had a circulation of 3,800.
42. Jackson, op. cit., pp.356-357.
43. ibid.

Chapter 4

The Continental Connection
Cross Currents in Illustration 1840~1880

The assimilation of ideas from the Continent and particularly France, which had been something of a one way traffic in the eighteenth century, had become a more healthy cross-fertilisation by the second decade of the nineteenth. The rise of romanticism, particularly that of Byron, Goethe and Scott, made a deep impression on the French mind, so that illustration and caricature, the most literary sides of the visual arts, were bound to benefit. In passing one should mention the solid contacts already existing by the 1820s. R.P. Bonnington was established in France by 1818, shared a studio with Delacroix in 1825, and collaborated with Monnier on an illustrated book in 1828. Delacroix made his celebrated visit to London in 1825, the same year that Thomas Shotter Boys arrived in Paris. The latter had been the first Englishman to show his compatriots what the lithograph was capable of in his *Picturesque Architecture of Paris,* 1839, already dealt with elsewhere.

The revival of wood engraving in England which had stemmed from Bewick's work in the North East had caused considerable interest in France. The beautiful naturalism and earthy simplicity of Bewick's line, cut on the grain, struck a chord in the romantic spirit of the age. Charles Thompson, 1791-1843, a Londoner, who had studied under Bewick, established himself at Paris in 1816 and had won for himself considerable success by the 1830s. (Strangely enough it was his followers that cut the famous 'St. Paul's' headpiece for *The Illustrated London News* in 1841, see page 67, wood engravers being at a premium in England.) Vignette illustrations, a feature with Bewick, had been more common in France than in England in the eighteenth century and were ideally suited to the woodcut. They returned to this country in the 1840s with the popular landscape subjects of Birket Foster decorating poetry.

The most persistent influence from France in book illustration, was, and remained, the fashion plate. It was the only consistently well circulated medium for the British public to become acquainted with French draughtsmanship and figure studies, unsullied by English alteration or interpretation. The earlier frigid plates of the Empire that had appeared in *La Belle Assemblée* and other ladies' magazines were replaced in the 1820s by a more romantic approach, figures grouped gracefully together, scenes of the toilette or the promenade which included more props in the way of statuary, furniture and ornament. The people in these were no longer clothes pegs on which glorious apparel was hung, but stereotyped beings, moving with a sort of exaggerated realism. Even earlier, the French caricaturists of the Empire, had made play with the extremes and follies of fashion, in series like 'Le Supreme Bon Ton', and 'Mode du Jour'. In many like 'La Manie de la Danse' and 'Le Bon Genre', 1800-1827, Debucourt and other artists mimmick social manners, but provide a very accurate picture of dress scarcely distinguishable from fashion plates. By the late 1820s the two are very alike and become more so as the French caricaturists turn their attention to domestic and social satire. Even if French caricatures were not reaching English homes, French fashion plates *were* and it seems plausible that a public accustomed to them was more open to accept the work of Leech, Keene, F.M. Brown and Millais in the 1850s as a result. By the mid-century, the caricaturist could dispense with the grotesque in his art, that exaggeration which Baudelaire condemned from across the Channel, and substitute for it the comedy of manners.

Punch magazine was to be the chief vehicle for this new middle-class humour. As already mentioned, its founding in 1841 provided an important departure for English satirical journalism modelled on the French press. From the end of the Georgian phase, when prints ceased to be issued daily from the printsellers, the Continental style of ephemeral newspaper began to catch on. They were brief beauties that budded and flowered and disappeared within the year if not within the month, but they were spontaneous, topical, uninhibited and as slippery and elusive as the young men who ran them. *Punch* was in reality a successor to *Figaro in London* and had the sub-title of another great French publication, *Charivari*. As we have noticed, the first plans drawn up for the magazine had in fact included a separate lithographic cartoon by Leech with each issue, in the French manner.

But France could supply much more than a model for English journalists and artists, it could supply a different relationship between them and a new mode of expression. British comic artists had given full vent to their feelings in the penny plain and twopence coloured caricatures of the printsellers for fifty years. The foibles of monarchy, the scandals of society and the vagaries of every politician in the spectrum had been ruthlessly satirised from Gillray and Rowlandson to the last sketches of Cruikshank. But in France the situation was very different; a rigid censorship under the Empire and a controlled press under the restored Bourbons, gave the satirist no outlet for his brush. Without as strong a tradition of caricature and visual satire as in England, the French were far more open to new ideas when they came and far more inventive when the floodgates finally opened. The collapse of the Bourbons and the advent of Louis Philippe's July Monarchy was the watershed for French caricature. The pent up anger and frustration of the satirical artist was released on a public hungry for the blood of a corrupt government and a self-satisfied bourgeoisie; their medium was the lithograph.

Charles Philipon, 1806-1862, the editor, political agitator and artist, was the moving spirit behind this revitalisation of the humorous print and he founded the magazine *La Caricature,* a chief organ for freedom and later a factor in the birth of the Republic in 1848. In a very special way the drawing on stone spelled out an artistic freedom which the artists could identify with a political one. The work had the immediacy and the urgency of the sketch, the sense of the private message from the draughtsman to the public which copper or wood lacked, easy manoeuvrability and the advantage of being a break with the past. Psychologically it was ideal and the artists such as Grandville, Despret, Devéria, Monnier, Pigal and many more brought their searing wit to it, a wit which lay as much in the drawing as in the printed caption. The greatest of all Philipon's artists was Honoré Daumier, 1808-1879, who impressed himself on the national consciousness of French satire as strongly as Hogarth had on the British. Daumier's art is the new art of the nineteenth century as totally removed from the caricature of Cruikshank as anything could be. It is the lithe and elfin art of a sophisticated bohemian, who prefers the literary parry and thrust of the drawing room to the guffaw of the street corner; the former often being the more venomous.

The best commentator on the new age is Thackeray, himself an amateur illustrator and caricaturist and a keen follower of this branch of journalism. The vitality of the art that he found in France formed the subject of a whole chapter in *The Paris Sketchbook,* published in 1840. Thackeray, who considered that his own indefinite little drawings were ruined by the engravers, classified wood block and steel plate as mere 'art done by machinery'. In the direct drawing of the French lithographers he saw the only freedom. 'We get in these engravings the *loisirs* of men of genius, not the finikin performances of labored mediocrity, as with us; all these artists are good painters, as well as good designers; a design from them is worth a whole gross of Books of Beauty; and if we might raise a humble supplication to the

artists in our own country of similar merit — to such men as Leslie, Maclise, Herbert, Cattermole and others — it would be, that they should, after the example of their French bretheren and of the English landscape painters, take chalk in hand, produce their own copies of their own sketches, and never more draw a single "Forsaken One" "Rejected One" "Dejected One" at the entreaty of any publisher or for the pages of any Book of Beauty, Royalty or Loveliness whatever.'[1]

Thackeray could see that where lithography had strengthened the arm of French humour, it had weakened the keen edge of English. The British treated the stone as a vehicle for soft and delicate portraits or the caricatures of 'HB' which were scarcely caricatures at all, the French gave full vent to their feelings day by day. *Charivari* became a daily Parisian paper which says much for the appetite of the French for visual satire; *Punch* started and remained a weekly. French artists came to London and drew its foibles, Thackeray went to Paris and *wrote* about theirs; the difference was one of spirit and temperament more than anything else. It is completely in accord with Thackeray's views therefore to find the cosmopolitan writer Mrs. Frances Trollope, 1780-1863, employing a French-trained artist for her books *Paris And The Parisians in 1835* and *Jonathan Jefferson Whitlaw,* 1835 and 1836. No British figure artist of this date would have been free of the distortions deplored by Thackeray and she chooses the draughtsman August Hervieu, fl.1819-1858, who contributes six 'Embellishments' to the first book and fifteen to the second, all in a straightforward literal style. They include in the Paris volume a superb engraving of a crowded room at the Louvre with its pushing throng of visitors drawn with great naturalness, and other similarly realistic groups of soldiers in 'Pro Patria (Figure 31), high society at the 'Soirée' and art lovers attending a 'Lecture à l'Abbaye-Aux-Bois'. Hervieu's sketches were criticised in the English press for having nothing to do with the text but one suspects it was their original format that rankled.

Philipon's celebrated 'poire' which metamorphosed into the jowell and visage of Louis Philippe, expressed in the simplest way the feelings of a generation who had been hoodwinked into a corrupt monarchy. It was a simple enough symbol to be scattered around Paris, scrawled on walls, to cause indignation at Court and result in an unsuccessful action against Philipon in November 1831. It was the kind of vitality that had been Gillray's at the height of his fame and in later years had lost its force as the plates became more and more smothered in words. Thackeray appreciated that the Frenchmen saw themselves first as artists and wished for a similar range of vision in his English friends.

'Now in looking, for instance, at HB's slim vapory figures, they have struck us as excellent *likenesses* of men and women, but no more: the bodies want spirit, action and individuality. George Cruikshank, as a humorist, has quite as much genius, but he does not know the art of "effect" so well as Monsieur Daumier; and if we might venture to give a word of advice to another humorous designer, whose works are extensively circulated — the illustrator of "Pickwick" and "Nicholas Nickleby" — it would be to study well these caricatures of Monsieur

Figure 31. 'Pro Patria' by Auguste Hervieu. 1835.

Daumier; who though he executes very carelessly, knows very well what he would express, indicates perfectly the attitude and identity of his figure, and is quite aware, beforehand, of the effect which he intends to produce.'[2]

Thackeray criticises Cruikshank for being 'a practised artist', taking his ease, and 'Phiz' a clever one who ought to think more and exaggerate less. In the whole gamut of Daumier's 'Macaire et Bertrand' series, there is nothing gross or absurdly exaggerated. Thackeray really finds that in England the intellectual approach is missing. 'Nothing merely intellectual will be popular among us; we do not love beauty for beauty's sake, as Germans; or wit, for wit's sake, as the French; for abstract art we have no appreciation.'[3]

Until the late 1840s none of these artists had appeared in British publications and they were never to be seen in the subtleties of lithograph. But from about 1835, Monsieur Michel P. Delaporte had a print and book emporium at 37 Burlington Arcade, where Thackeray and the public at large could see and purchase the genuine Parisian article. *The Illustrated London News* pressed Gavarni into its service in 1848 and Tony Johannot in 1851 but they, with Lami and Guys, remained aloof from *Punch* and other journals.

Tony Johannot, 1803-1852, was probably the best known French artist who worked for British authors. He had first appeared briefly as illustrator of the first three parts of *Windsor Castle* by Harrison Ainsworth, 1843, after the author had quarrelled with Cruikshank. He later illustrated further classics in English, *Don Quixote*, the *Vicar of Wakefield* and *A Sentimental Journey,* 1851, all containing his characteristically wiry figures. Another illustrator who would have been equally well-known was Jean-Ignace Isidore Gerard Grandville, 1803-1847, who specialised in humorous animals and metamorphosed objects which have an uncanny attraction and an almost surreal quality to them. Several of his books appeared in English editions, notably *Gulliver,* 1840, *La Fontaine,* 1843, *Comical People* and *The Flowers Personified,* 1855.

Daumier's art developed along a certain theme which was highly successful and certainly not unique to France. He took as his starting point a forgotten play called 'Auberge des Adrets' which had been transformed by the actor Lemaitre into a popular drama and taken Paris by storm. Lemaitre's clever interpretation of the main character Robert Macaire, an unscrupulous villain, became legendary, and his green coat, crimson pantaloons and enormous whiskers were written about, burlesqued and caricatured. When this bizarre figure had passed into popular mythology, Daumier transformed him and his seedy friend Bertrand and made them speak for the topical issue of the day, ridiculing the rogueries and corruptions of everything from the Parliament to the Bourse. If there was the whiff of scandal in high places, Macaire and Bertrand are there to dabble in it; if sharp practices exist in the law, the two villains will be hot on its heals, neither the institutions of monarchy or business are exempt from their crafty schemes. A similar running episode had been produced in England by the 'Paul Pry' caricatures of the 1820s and later Victorian artists were to benefit from a 'cast' of characters from Leech's 'Mr. Briggs' to Du Maurier's 'Sir Gorgias Midas'. In Daumier's case the effect was instantaneous; Louis Philippe took on M. Philipon's army of artists in the Gallerie Vero-Dodat, and it is posterity that is the richer. There were prosecutions, seizures, fines and even bribes instigated by the King of the French as prints of his family and himself continued to pour forth, each more ludicrous than the last.

At one point only, Daumier overstepped the mark, landed himself in prison for six months and immediately became the darling of radicalism. Daumier had drawn a plate entitled 'Gargantua' in which a pompous personage with a pear-shaped head, sits on a throne of state. A plank extends upwards towards his mouth and on it trip a hundred little mignons, to-ing and fro-ing in various robes of state and feeding him with gold pieces. On the extreme right artisans and the poor drop their meagre savings into his treasury. Strangely

enough this suggests that Daumier was familiar with British caricature; the source for this seems to be Robert Seymour's 'The Great Joss and His Playthings', published in 1829, a milder version, satirising the Prince Regent's extravagance.

These attacks resulted in the 'law of September' which made it illegal to caricature the officers of state and changed the tenet of French humorous art. From the mid-1830s the artists had to confine themselves willy nilly to the *comédie humaine,* the fashionable dress shops, the café, the bar at the opera and the social indiscretions of the bourgeoisie behind their Brussels curtains. This had one dynamic result which never took place in England, it drove the illustrators and the caricaturists into the arms of the writers, who were just then exploring the same subjects in reaction to the academic and high-flown romantic. Hugo, the artist-writer held a salon for both his confreres: 'For a century and more, art had served the libretto, the novel, and the pamphlet; for almost as long, the writer had minded the artist's business, and had not been careful to hide his condescension. Now, when he began to show a new sympathy and respect, the yoke ceased to chafe and a pleasant partnership ensued.'[4]

The French artists were seeing what Thackeray hoped their counterparts across the Channel would see, the importance of social satire as an expression of the times. 'They form a very curious and instructive commentary upon the present state of society in Paris, and a hundred years hence, when the whole of this struggling, noisy, busy, merry race shall have exchanged their pleasures or occupations for a quiet coffin at Montmartre or Père la Chaise; when the follies here recorded shall have been superceded by new ones, and the fools now so active shall have given up the inheritance of the world to their children; the latter will at least have the advantage of knowing, intimately, exactly, the manners of life and being of their grandsires, and calling up, when they so choose it, our ghosts from the grave to live, love, quarrel, swindle, suffer and struggle on blindly as of yore.'[5]

It is curious to find Charles Baudelaire taking up this theme and developing it in an essay more than twenty years later. Baudelaire, the most compelling and lucid of French critics, was among the first to bother with the caricaturist and the illustrator and to rescue him from the relegation of a minor art. In his 'The Painter of Modern Life', which appeared in *Figaro* in November and December 1863, he outlined a philosophy for 'the painter of the passing moment' which was neither insignificant or ephemeral. He takes as his starting point the work of the mysterious and elusive artist, Constantin Guys, whose rapid pen sketches of Second Empire Paris have become classics of their type. 'Monsieur G', the artist's name is never spelled out, is referred to as a 'man of the world', one whose vision is not restricted but whose curiosity makes him want 'to know, understand and appreciate everything that happens on the surface of our globe.'[6] Guys' restless and ever changing vision of life, dashing horses, milling crowds, swaggering officers, are *felt* through his frenzied ink lines as the trembling vibrancy of a composite humanity. 'The crowd is his element,' Baudelaire writes, 'as the air is that of birds and water of fishes. His passion and his profession are to become one flesh with the crowd.'[7] Every age, Baudelaire argues, has its own 'gait and gesture' and the artist-recorders job is to set this down for posterity, at the same time loving the synthesis of modern life, which he distills, as heroic and exciting. Baudelaire like Guys, concentrates on subjects that are piquant and sensual, parades, battles, strollers, royalty, women of easy virtue, never on the humdrum and laborious middle class, whose object, one might say heroism, was money.

The connection here, which makes the Anglo-French flow of ideas important, is Baudelaire's identification of 'the painter of modern life' with dandyism. The contemptuous superiority of the artist, his disassociation from the vulgarity of money and gainful employment, were very much part of the romantic rebellion. In the mind of the French, dandyism was very much associated with the English, or at least with that part of the English character which was feudal and aristocratic. This must have had its roots in such

publications as Pierce Egan's *Real Life In London*, the literature of sport, and the caricatures of George Cruikshank and his fellows. But if these and George Brummel were the inestimable models for the cult of French dandyism, they left a lot to be desired, none of them had an idea to their names and the new dandyism in France was 'an aristocratic superiority of mind'. Dress, that rich field of caricature, became the outlandish and defiant front of the artist against conventional patronage and academicism. The students of Paris paraded in the costume of the Middle Ages, colourful cloaks and waistcoats, doublet and hose, the literary garb of revived plays, novels or old legend. All this conspired to throw the artist and writer together too, a common enemy, the state, a common source of inspiration, ordinary life, and a common pride in Gautier's art for art's sake, which set artists as people apart. Contact with Gavarni and Monnier reconciled Balzac to the artists and recommended them to him as a study for his numerous novels. In England it was to be fifty years before artists played a prominent part in novels of the French-inspired writers like Wilde and Bennett. It was also more customary for serious artists to act as illustrators in France, not the case in England; Delacroix is one example and even Millet produced chalk drawings with popular journals in mind.

Constantin Guys was an apostle of this dandyism, in essence if not in appearance, Gavarni had it too. The latter's contacts in England are mentioned elsewhere, Guys long connection with *The Illustrated London News* and stay in London in the 1840s is sketchy in the extreme. It seems unlikely that he had any direct influence on English draughtsmen, his sketches were seen by few and such illustrations as were published lost their impressionistic sparkle. He has nevertheless left us the finest rapid notes of early Victorian England that can be found anywhere, whether they are the Brighton coach in quick motion or idlers in the Park (Figure 32).

One of the moving spirits behind this dandyism in England was also a Frenchman, Eugène Lami. It needed a Gallic illustrator to give a fashionable gloss to this worn out image that had died with that gross and unpopular dandy, George IV. Lami, a Parisian who trained

Figure 32. 'The purple roans' by Constantin Guys.

under Baron Gros, Horace Vernet and the École des Beaux-Arts, arrived in England in about 1828. For him it was an enchanted island and in many ways his spiritual home. Not only was it the country of Scott and the romantic novel but the country of the descendants of the Plantaganets and Tudors who re-gothicised their castles and dispensed boiling punch rather than boiling oil from the battlements. Lami's captivation first saw fruit in his *Voyage en Angleterre*, 1829-30. This was only a prelude to his obsession with English high life, and hundreds of ink and wash sketches of the most sensuous loveliness, which mirrored a generation or at least handed it a glass to see what it wanted to! Lami's evident enjoyment and uncritical view of the English, gave him influential friends. Unlike Gavarni, no doors were closed to him and he is there at the most intimate scenes of social life as well as at fêtes, balls, the hunt breakfasts, the farewell performance at the theatre or in a country house drawing-room. It is on record that Lami was very proud of his connections with old families and was well acquainted with their pedigrees; Baudelaire, who considered him minor, called him 'almost an Englishman in virtue of his love for aristocratic elegance'.[8] Lami gave English life that nonchalance and languid ease which it saw in the fashion plate. Spanking horses and sumptuous equipages collect frail girls, as light as fluff, from houses in Belgrave Square; doors open to reveal glittering staircases filled with unruffled fan-fluttering beauties; parties are set down in cool parkland to enjoy overflowing hampers, nothing disturbs the serenity of Lami's *beau monde*.

Lami was most successful with military processions and reviews, the officer being the archetypal dandy, but even intimate figure studies have a swagger and panache of their own. There is a splendid dandified figure, standing in half contemptuous gesture near the staircase in 'Queen Victoria at the Chateau d'Eu', 1843, now in the Royal Collection at Windsor Castle.

Another fine example is his 'Repos' which is typical both as to the treatment of the subject and the medium used (Figure 33). A pair of huntsman of studied elegance sprawl on the ground in a forest glade and chat to a cigar-smoking companion who perches in exaggerated jockey pose on his horse; in the background a groom waits respectfully with the two spare horses. Lami has done a fluid pen drawing on toned paper, washing in the

landscape and foreground in brown or green shadow, concentrating the whole of his interest on the figures. The reds of the coats, the smudge of a blue cravat and a yellow waistcoat, the sunlight on patent boots, give life to the whole. Inspite of the English scene, it is not an English treatment, the watercolour is imprisoned in those wirey pen lines, however sensuous, which are the structure of the whole picture. This is not a party of countrymen, but Londoners or Parisians who wish to be seen hunting the fox, the landscape is a fashionable backdrop.

Lami's attitudinising about the English must have contributed to the image of military and social life in the 1840s and '50s, Lord Cardigan's obsession with uniform and the officerial lisping, satirised by many writers. By a strange quirk of fate, the caricature figure of the dandy returned to English pages from these foreign works in John Leech's 'Young Snobley' with his tiny feet, peg top trousers and enormous neckwear.

Apart from Thackeray, the only Englishmen to have regular and direct contact with the French illustrators and caricaturists were Blanchard Jerrold and the Mayhews. According to one writer they were frequent visitors in the 1840s at 'le Childebert' an infamous tenement in the Quartier-Latin, renowned for its avant-garde artists and caricaturists, one of whom was Tony Johannot. Henry Vizetelly, later Editor of *The Illustrated Times,* was another man with Gallic contact. He purchased blocks from Philipon's *Charivari* for his *Comic Nursery Tales* and illustrated 'Cham' alongside the home-grown Leech and Crowquill. He was also businessman enough to buy up old blocks from *L'Illustration* and sell his own clichés to Lillaud of *Le Journal Illustré.* Thackeray introduced 'Cham', Amédée, Comte de Noé, 1819-1879, to England in the 1840s, and though he dined with John Leech and Richard Doyle, was either ignored or missed by the Editor of *Punch.* There was still no salon for the illustrator and the author to meet on equal terms on this side of the Channel, although *Punch's* table and the 'boards' of the various magazines were to become their nearest equivalent. Thackeray's position as foremost novelist and creditable illustrator might have enabled him to play this part in England as Victor Hugo had done in France, both artists had progressed from clever caricatures in the 1830s to more serious ambitions, but Thackeray was less attuned to changes in the arts and his power as a draughtsman was more limited than the French writer's.

Baudelaire, in his essay on some foreign caricaturists, 1857, mentions besides Hogarth, both Cruikshank and Seymour, showing that English graphic satire was known there when the English School of painting was dismissed. It seems evident that Robert Seymour's sporting subjects were familiar to the French public as Baudelaire refers to them as 'excessive', 'simple' and 'ultra-brutal' without further attempt at explanation. A nice piece of cross-channel borrowing took place at about this time which shows the extent to which artists were relying on one another. H.K. Browne, whom Thackeray considered should 'study well these caricatures of Monsieur Daumier', did so for *Martin Chuzzlewhit,* 1844. Not only are the figures in this book drawn with greater characterisation and realism, but in the engraving of the nurse 'Mrs Sarah Gamp', Browne has translated one of Daumier's most witty female creations 'La Garde Malade' from a lithograph published in *Le Charivari* two years before in May 1842 (Figure 34).

Another strong link with the Continent was provided by the German artists, not only those who had influenced Pre-Raphaelitism but those who were illustrating fables, songs, children's stories and history in the 1840s and 1850s. Ludwig Richter was the most outstanding, producing a well-illustrated *Vicar of Wakefield* in German and English in 1841 and *The Black Aunt* and *The Book of German Songs* in 1848 and 1856 respectively. Some of the designs in the latter book are certainly by Charles Keene who was the most forthright exponent of German draughtsmanship in the decade; he had been fired by looking at the most celebrated German book of the time Kugler's *Frederick the Great* with

its illustrations by Adolf von Menzel, 1815-1905. Two English editions of this mammoth work were published in 1844 and 1845 and the date, as well as the quality of their hundreds of black and white illustrations, can be seen as a turning point for the art in Britain. Several artists such as Holman Hunt were later to claim that they did not know the work of either Adolf Menzel or Alfred Rethel 1815-1859. Gleeson White's comments on the *Frederick the Great* are as near to the truth as we shall ever get. 'It is quite possible that any one of the men of the time might have seen it by chance, and turned over its pages ignorant of its artist's name.'⁹ Charles Keene developed a correspondence with the German artist and they exchanged work. When an interviewer visited Menzel many years afterwards he was recorded as saying that 'He favoured the nocturnal cafés, where he hunted after the illustrated papers – amongst which he admired *Punch.*'¹⁰ Keene's knowledge of Continental draughtsmanship was probably greater than most British illustrators and the admiration was mutual. On his death in 1891, he received long obituaries in both *Arte Moderne* and *La Chronique des Arts,* the last comparing his work to that of Menzel and Degas.

Figure 34. 'Sarah Gamp' by H.K. Browne from Dickens' Martin Chuzzlewhit, *1844.*

German magazines were making important strides throughout this period, their artists evolving a free style of drawing, based partly on Menzel, partly on the wit of the amateur and developing new techniques and formats such as the strip cartoon. The best of these magazines was the *Fliegende Blätter* of Munich which had a formidable team of artists and issued small books of their work as it appeared in the magazine. The most important humorous illustrator associated with it was Wilhelm Busch, 1832-1908, whose books were finding their way to this country in the 1860s.

Busch was an original artist whose work consisted in vigorous nonsense, drawn with great sprightliness, a sort of German equivalent of Edward Lear. His shorthand is in some ways more similar to Caldecott than to Lear although his humour was more provincial and more coarse than either of them (Figure 35). His preposterous German peasants and country characters spill over the pages and demand attention. As Pennell says, 'Busch's work is a perpetual letter to the whole world, which one who runs may read.'¹¹ Busch seems to have been more influential on individual artists than on the reading public in this country, the development of the strip cartoon surely has his mark upon it. In 1868 the first strip joke is used in *The Illustrated London News* in the able hands of Fred Barnard and this genre was popularised in Caldecott's letter stories for *The Graphic,* ten years later. E. Morant Cox uses the same medium for his humour in *The Illustrated* in 1884-85 and is followed by similar

84

sketches from S.T. Dadd; *The Graphic's* strip cartoonists were A.C. Corbould, a nephew of Charles Keene, and W. Ralston who both worked in the late 1880s, but none of these men had the lightness of touch and mobility of subject found in Busch. Interest in Busch's homeland was sufficient however in early 1882 for *The Graphic* to run to several pages on the art of caricature in Germany.

The only illustrator to capture the mischievous humour of Busch and to some extent his drawing line was J.F. Sullivan, 1853-1936, whose work was mainly done for the magazine *Fun* from 1878 to 1901. He invented and ran for years a series of story strips called 'The British Working Man' which included comic incidents of labourers, doctors, chemists, builders, gas-men and many others (Figure 36). Sullivan, whose cartoons were issued by *Fun* in book form, comes closest to his German counterpart in the unshaded drawings such as 'Time Work' and 'The British Bumpkin' both included in the 1878 volume and comparable to Busch's *Der Maulwurf*. He also illustrated books about comic insects, a derivation of Busch's most popular English book, *Buss-a-Buzz*, 1872, a tale of a bee-hive, and there is a refreshing modernity about Sullivan when he does not overwork his subjects.

After 1880 there was a considerable deterioration in printing and publishing in France and many illustrators began to appear in English and American editions. The most influential Parisian magazine remained, *L'Art et L'Idée* which was edited by Octave Uzanne, an interesting figure, who edited two gift books for the English market and published articles in both countries. *The Graphic* was the periodical with the strongest Continental links at this time, although both it and *The Illustrated London News* had relied on the foreign Special Artists for many years. W.L. Thomas of *The Graphic* had acquired the

Figure 35. 'Der Maulwurf' by Wilhelm Busch.

Figure 36. A comic strip by J.F. Sullivan.

virtuoso French cartoonist 'Mars' Maurice Bonvoisin, 1849-1912, for the paper in about 1880 and he contributed spasmodically from then until 1903, sharing his talents with *The Illustrated* from 1883 and including English subjects in his repertoire. Caran d'Ache otherwise Emmanuel Poirée, 1858-1909, appeared once in *The Graphic* in 1887 and once in *Punch* seven years later, it was perhaps difficult to wean such an international figure from his home ground of *Vie Parisienne* and *Chat Noir*. 'Caran d'Ache always spoke with enthusiasm of our black-and-white artists.' wrote A. Ludovici after his death, 'such as Charles Keene, Phil May, Dudley Hardy and Raven Hill, who were all then working for the comic papers.'[12] Poirée was given an exhibition at the Fine Art Society in 1898 and familiarity with his drawings and the circulation of his periodicals did much to loosen the English pen drawing from the straight-jacket of the *Punch* style. *The Graphic's* reputation abroad was enhanced in 1889 when it published two special numbers for the Continent. In June it announced 'L'Été' described as 'An Edition of the Graphic Summer No. Published in the French Language Price 1s 8d'. The following Christmas it published a similar number called 'Noël'. French artists like 'Mars', Caran d'Ache and A. Guillaume often appeared in colour in these supplements and provided a useful key of the subtle tones achievable in print compared to the stridencies in some English work.

Paris had given birth to a number of remarkable pen artists in the mid-1880s among whom might be named Jeanniot, Vogel, José, Loir and Robida. But the outstanding figure of this group was Daniel Vierge, 1851-1904. Vierge or Daniel Urrabieta Ortiz y Vierge to give him his full name, arrived in Paris from Spain in 1869 and began to publish his exquisite pen and ink drawings in *La Vie Moderne, Le Monde Illustré* and other Continental papers. His pen line was much purer than anything that had gone before it in book illustration, there was very little hatching, a delicate precision in every stroke and a strong *sense* of colouring without the use of any colour. There is a refinement in his buildings and figures that is quite breath-taking, somewhat aided by his habit of drawing large and having the sketch reduced for the page. Vierge had the sort of life of which legends are made. Struck down by a paralytic stroke in the middle of his most ambitious work, an illustrated volume of *Pablo de Ségovie*, he painstakingly learned to draw with his unaffected left hand in order to complete the book. Vierge undertook a lot of illustration for the American journal *Scribner's Monthly* and developed a large number of devotees in the United States as well as the admiration of American students working in Paris. The result was a school of pen draughtsmen who took Vierge as their exemplar and it was through the American connection that the refined pen technique of Vierge seeped into this country. E.A. Abbey, later to be discussed more fully, C.S. Reinhart and Howard Pyle who were typical illustrators in the new style, were featured in the pages of *The Graphic* by 1883 as well as illustrating classics for British publishers. This is not to discount the direct links that Vierge had with this country. 'He was so keen on exhibiting in England,' wrote Ludovici, 'that he not only sent us wash and pen and ink drawings framed, but a number of albums I had never asked for and did not know existed.'[13] When the completed English edition of *Pablo* was issued in 1892, Joseph Pennell was enthusiastic in his praise. 'There is really very little to be said about Vierge's drawings, except to advise the student to study them in the most thorough manner, and to remind him that their cleverness and apparent freedom are the result of years of the hardest study, and, in each drawing, of days and sometimes weeks of the most careful work.'[14] The magnificent illustrations by Bernard Partridge, W. Dewar, Christine Hammond, Fred Pegram and H.R. Millar which followed in the 1890s show that such advice was not wasted.

Paul Renouard, 1845-1924, began to work for *The Graphic* in about 1884 and was a continuing and powerful reminder of French practice until the 1900s. His stature as an illustrator of ordinary life is covered in a later chapter, but his introduction of chalk drawing

to the English magazines was an important step towards more powerful graphics. F.L. Emanuel writing of the new school of illustrators in London and Paris in the 1890s makes mention of 'how much many of the most excellent of the younger artists – such as Steinlen, Léandre Malteste, Redon, Sabattier, Tilly and Huard in France, Lockhart Bogle, Hartrick, Almond and Gunning King in England, evidently owe to that giant among draughtsman – Paul Renouard.'[15] In France the rise of poster art and the influence of artists like Jules Chéret had greatly affected book illustration and turned the attention of younger illustrators from pen to chalk and charcoal. 'The perfection to which the photo-reproduction of drawings now attains,' wrote Emanuel, 'has been chiefly responsible for this, together with the praise-worthy attempt of the modern men to vie with the magnificent series of drawings on stone, done half a century ago by Gavarni, Daumier, De Beaumont, 'Cham' and other splendid draughtsmen.'[16] Chalk and crayon were used with greater frequency towards the turn of the century and there was a revival in lithography but the average illustrated book and periodical remained grey and unbending. The most original and most European blends still came from highly gifted individuals, Lucien Pissaro, 1863-1944, for example, who made a tentative visit to England in 1883 and settled here after 1890. Pissarro set up the Eragny Press in 1894 and the thirty or so titles issued by him are famous for their strong Normandy flavour in the illustrations and the use of colour wood engravings, unusual in England. Nevertheless these rare birds with their fresh impressionistic colours can only have been seen by the very few. Emanuel's comments on the cross-currents between the two countries might almost be read as an obituary of the whole subject. 'The fact that most of the papers in which these illustrations appear are unknown to, or unpalatable to the British public, renders it certain that, with but few exceptions, the accomplished work of these modern artists of black and white art will never be as widely appreciated in England as it deserves to be.'[17]

And what of the cross fertilisation in the field of caricature that Thackeray had spoken of so hopefully? The effects of French naturalism and the *comédie humaine* had done their work well in the 1850s and 1860s, allied to Victorian disapproval of anyting that was excessive or coarse. Frank Emanuel could look across to France at the end of the century and in the design of 'Ribot de Noël' by Charles Léandre, 1862-1930, see that 'in the largeness of the forms and the rollicking *abandon* of the whole scene we are reminded of our own Rowlandson, an artist whose work is thoroughly appreciated across the Channel.'[18] But ironically, for Augustin Filon, the French historian who published *La Caricature En Angleterre*, the essentially British exaggeration which he admires from Hogarth to Leech has evaporated. 'La caricature anglaise a cessé de vivre sa vie independante; elle a cessé d'être un genre.'

Footnotes

1. W.M. Thackeray, *The Paris Sketch Book*, 'Caricatures and Lithography', pp.152-153.
2. ibid. p.172.
3. ibid. p.155.
4. Malcolm Easton, *Artists and Writers in Paris – The Bohemian Idea 1803-1867*.
5. Thackeray, op. cit. p.173.
6. Charles Baudelaire, *The Painter of Modern Life*, etc., edited by Jonathan Mayne, 1964, p.7.
7. ibid.
8. ibid. p.5.
9. Gleeson White, *English Illustration The Sixties*, 1906, p.150.
10. 'Conversations with Menzel', *The Studio*, Vol. 34, 1905, pp.257-261.
11. Joseph Pennell, *Pen Drawing and Pen Draughtsmen*, 1894, p.155.
12. A. Lucovici, *An Artist's Life in London and Paris*, 1926, pp.51-52.
13. ibid. p.126.
14. Pennell, op. cit. p.42.
15. Frank Emanuel, *The Illustrators of Montmartre*, 1904, p.76.
16. ibid. p.58.
17. ibid. p.84-85.
18. ibid. p.78.
19. A. Filon, *La Caricature En Angleterre*, 1902, p.269.

Chapter 5

The Pre-Raphaelite Illustrators

(i) Lyric and Legend

he vigour and diversity which had characterised the illustration of books under the Regency was not sustained long after the 1820s. Blake and Rowlandson were dead by 1827 and Thomas Bewick, the bulk of whose work had been done in the previous decade, died the following year. The older tradition of caricatured illustrating was continued under George Cruikshank and to a lesser extent H.K. Browne, W.H. Brooke, Henry Alken, Robert Cruikshank, William Heath and a host of minor practitioners. As we have seen the romantic movement lived on in the apocalyptic visions of John Martin, engraved for albums like *The Gem, The Keepsake* and *The Literary Souvenir,* or in the more private world of Blake's follower, Edward Calvert. The best work being completed after 1830, as we have noticed, was by the topographers, in the generous folios of travel, architecture and engineering achievement which were bringing the new art of lithography to the fore under the names of T.S. Boys, Samuel Prout, J.S. Cotman, J. Bourne and Edward Lear.

A glance at the illustration of books during the 1840s gives an impression of dreary sameness, an increasing antiquarianism with artists like George Cattermole, or a cloying sentimentality as painters like John Gilbert, Myles Birket Foster and William Mulready reduced the miopic prettiness of their oils to the confines of the printed page.

Change was however in the wind. The young Alfred Tennyson had admired Bewick's woodcuts not only for their beauty but for their scientific accuracy. A new generation responded more readily to Flaxman's interpretation of *The Odyssey,* 1805, with its linear austerity than to the small scale work of Smirke, Corbould or Westall. A more critical approach to the arts was leading some painters back to the earliest printed sources of book illustrations, the German woodcuts of the early sixteenth century.[1] When William Bell Scott visited the exhibition of designs for the Westminster Hall Competition in 1843, he noticed a new style from the younger men, 'careful studies of form and design' not costume pieces or the elaborate effects of light and shade.[2] This trend was not long in appearing in the illustration and decoration of books, where epics, such as *The Pilgrim's Progress* and Kingsley's *Hereward The Wake,* 1844 and 1866, were depicted in outline by Henry Courtney Selous, 1803-1890. These were typical of the new school in which expression and gesture were investigated and the placing of the figures very carefully considered. They often have the appearance of toneless frescoes and these were frequently the source from German and French publications, no coloured versions being available.

Another brilliant exponent of the kind was Daniel Maclise, 1806-1870, whose debt to the German work of Retzsch and others can be seen in his decorative but rather harsh frontispieces to Dickens' Christmas books, *The Chimes,* 1845, and *The Cricket On The Hearth*, 1846. Predictably perhaps the artist used a German wood engraver. In 1845 he illustrated Moore's *Irish Melodies* (Figure 37), a particularly successful combination of text and designs which have worn better than his large scale canvases. This concentration on draughtsmanship, organisation of the picture space and detail, sowed the seeds of a great black and white tradition in this country.

A number of small illustrated books began to reflect this change, among them Bogue's

edition of Longfellow's *Evangeline,* dated 1850 but presumably published in 1849. This little volume was produced uniformly with *The Minor Poems of H.W. Longfellow,* but is not mentioned by either Gleeson White or Forrest Reid in their comprehensive lists. It is very much a drawing-room gift copy of the period, a hard papier mâché cover in cream-colour with bevelled edges, is overlaid with a design of trailing leaves, the title in pseudo-medieval German script. In the centre of the design is an oval picture of a couple standing by the sea shore, the man in profile, the woman turned away, erect, stern and tense. The initials 'J.E.B.' below are for Jane E. Benham, a professional artist and illustrator, whose main reputation depends on two editions of Longfellow and some contributions to *Beattie and Collins Poems,* 1854. *Evangeline* has thirty-one pages or vignettes by Birket Foster, three half pages by John Gilbert and eleven by Jane Benham. Although the book was clearly to be sold on the strength of Birket Foster's reputation, it is interesting to note that Jane Benham's work is on the covers and reflects

Figure 37. Page from Moore's Irish Melodies *by Daniel Maclise, 1846.*

perfectly the current mood. She was one of a group of English artists who had studied under Wilhelm Kaulbach at Munich and brought back with her some of the intensity of approach and earnestness of method that had gained the Nazarene School a wide following and brought them under the patronage of the Prince Consort. It is not that she is a particularly strong draughtswoman, the engraving illustrated shows that she is not (Figure 38). For pure technique she is outdistanced by the suavity of Gilbert and the decorative sense of Foster. Where she triumphs is that her illustrations are very personal statements, unconventional in their simplicity of outline and lack of modelling, a great deal is left to the imagination of the reader, evoking a mystical rather than literal response to the words.

In the middle of 1847, that redoubtable trio of John Everett Millais, William Holman Hunt and Gabriel Rossetti, joined themselves together to form the Pre-Raphaelite Brotherhood, a bold attempt to recreate in their own work the naturalism of early Renaissance paint-

Figure 38. Illustration to Longfellow's Evangeline *by Jane E. Benham, 1850.*

ing. In Millais' Gower Street home, the three of them pored over engravings of frescoes by Benozzo Gozzoli, Orcagna and others from the Campo Santo at Pisa. The productions of the Brotherhood between then and 1851 slipped imperceptibly at first into the Royal Academy exhibitions. Millais had exhibited his masterpiece, 'Lorenzo and Isabella' and 'Christ in the House of His Parents', Hunt his 'Valentine' and Rossetti his 'Girlhood of Mary The Virgin' and 'Annunciation' separately. But then amid a growing storm of wrath, the British public became enraged by their fresh vision and new approach, until John Ruskin came to the rescue as 'a graduate of Oxford' in his celebrated supporting letter to *The Times* in 1851.

The Pre-Raphaelite assault on book illustration was not so dramatic as that on painting. The Brotherhood was already in disarray before their first illustrations had been commercially published. The four or five artists surrounding Rossetti had no revolutionary ideas to bring to the book itself, they had no crede of typography like Morris or ethic of decoration like Walter Crane, they simply wished to express the idea of the poetry of the day or of the day before yesterday as they saw it.

It was hardly surprising that they chose lyric, legend and mythology to do it. Not the mythology of the classical world which had lost its lustre for them, but the northern mythology of German romanticism, mysterious, cloudy and easy to paraphrase. Then there was contemporary poetry, the work of Tennyson and Longfellow, of Christina Rossetti and Jean Ingelow, much of it highly tuned and painterly, but not too tightly written. The Pre-Raphaelites proper seldom strayed very far outside *their* literature, either the writers whom they knew personally or the poets contemporary with the early painters they admired. Rossetti, the foreigner, turned his thoughts to early Italian themes and Dante, Madox Brown illustrated passages from Byron and Arthur Hughes tales from Macdonald. Biblical scenes were a source of inspiration and several of the group drew for *Sacred Poetry* much of it seventeenth century or for *Watts' Divine Songs.* Subjects from Scott or Shakespeare do not seem to have interested them as far as the book was concerned, not a single one of them illustrated an historical novel, and the works of Bunyan, Milton, Defoe, Swift, Goldsmith and Thomson as well as Cervantes and La Fontaine were left to their followers.

What they were beginning to bring to the illustration was a recognition that it had the status of a work of art. The endless preparatory studies, the research, the changes in direction, the demands on their engravers were quite new to men like the Dalziels. They had been used to the professionalism of John Gilbert, whose boast was that not one line had to be altered. That was the way of successful commercialism not of great art, Pre-Raphaelite pride owed nobody a living, the illustrator was now to be on a par with the poet. As their position improved, artists began to have their names on the contents pages of books, often from the 1840s with that of the engraver alongside.

It is only possible here to deal with representative books from the two main themes of Pre-Raphaelite illustration, the designs for contemporary poets and the biblical and sacred subjects. The most important book of the first group, and the first to appear, in 1855, was *The Music Master* by William Allingham, also known as *Day and Night Songs.* Allingham, 1824-1889, was an Irish poet and collector of ballads, who later became Editor of *Fraser's Magazine* and the husband of the well-known illustrator and watercolourist, Helen Allingham. The success of Allingham's *Poems,* 1850, and *Day and Night Thoughts,* 1854, must have encouraged him to think of an illustrated edition of the latter. In the eventual preface of the book, he thanks 'those excellent painters who on my behalf have submitted their genius to the risks of wood engraving. . . ,' making it plain that the idea had been his rather than Messrs. Routledge's. The amateur status of the project meant that each artist only received three guineas for each block. In April 1854, Rossetti and Ruskin were reading the first edition of the poems and the latter pronounced them 'heavenly'.[3] They held for

the Rossetti circle exactly the right ingredients of romance, archaism and love of nature to make them irresistible. Practically the only one remembered today is 'Up the airy mountain, Down the rushy glen', a nursery song that seems to have become the perennial diet of every child's anthology. By May 1854, the scheme which had been nothing more than a vague idea was taking shape; Rossetti was already asking Allingham for two or three blocks to work on. The following month the artist again writes to him with customary vagueness about the commission in hand. 'I trust certainly to join Hughes in at any rate one of the illustrations of Day and Night Songs,' he writes, 'of which I hope his and mine will be worthy — else there is nothing so much spoils a good book as an attempt to embody its ideas, only going halfway.' The book was obviously taking on a coherent shape, Millais was enlisted and Arthur Hughes, closely associated with the Pre-Raphaelites was one of the best designers for the printed page.

Rossetti took the subject of 'The Maids of Elfen-Mere' for his wood engraving, a theme of unrequited love which he found congenial and gave him the opportunity of drawing three lovely but menacing women and a pining, dying figure from the world of mortal men (Figure 39). It was nevertheless January 1855 before the publishers had the completed block in their hands, following one unsuccessful attempt. Rossetti was unfamiliar with drawing on the wood and the first effort seems to have been untranslatable by the engravers. 'In this *second edition* of it,' Rossetti writes, 'I have tried to draw all the shadow in exact lines, to which, if the engraver will only adhere, I fancy it may have a chance, but hardly otherwise, as there is a good deal of strong shade — dangerous especially to the faces, but I could find no other way.' The cutting was given to the Dalziels, the most experienced of engravers but the resulting proofs horrified the sensitive Rossetti, he immediately requested Allingham to withdraw it from the book. The other side of the story was related to Arthur Hughes by the Dalziels themselves. 'How', they asked him, 'is one to engrave a drawing that is partly in ink, partly in pencil, and partly in red chalk?' Allingham's wishes prevailed and after some doctoring, Rossetti was prepared to let it stand in March 1855. A cover design was also prepared by him for the book but never used.

Of the other two contributors. Arthur Hughes had the lion's share, designing the frontispiece 'Crossing the Stile', vignette and ornaments and six page illustrations. The ornament is small stark and naturalistic and in that sense Pre-Raphaelite, the illustrations less so. 'Lady Alice' except for gesture and drawing is on the same level as Selous or Benham, 'Milly' is a more carefully observed subject, three separate figures, all concealed from each other but all expressing inward emotion. The best of his in the book is 'Under the Abbey Wall', in which the figure of a young man lies head in hand on a grave, a derelict gothic transept, festooned with ivy behind him. This is the first appearance of the subject that was to fascinate Hughes and bring him to fame as the painter of 'Home From Sea', 1856-62. The more decorative side of Hughes' work is found in 'Fairies' (Figure 40), a delightful roundel of elfish figures dancing in front of the moon, their girations reflected in the calm waters of a lily pond. The gentle fantasy of this is somewhat akin to Richard Doyle's fairyland, but the

Figure 39. 'The Maids of Elfen-Mere' by D.G. Rossetti.

design is much more organised and the flowers and lilies and reeds are preternaturally real. John Millais' single illustration 'The Fireside Story' is dealt with later.

The Music Master, with its nine illustrations and small duodecimo size, does not seem to compete with work like William Harvey's *Don Quixote* of 1839, with its three hundred wood engravings. But despite its size and lack of balance, it was an achievement for Victorian illustration and for Allingham in particular for introducing three great artists to the art of the book. Rossetti best expressed what he had done when he wrote later to Allingham that he preferred to illustrate those poems 'where one can allegorize on one's own hook on the subject of the poem, without killing for oneself and everyone a distinct idea of the poets.' His 'Maids of Elfen-Mere' had caught the idea of the poem, captured

Figure 40. 'Fairies' by Arthur Hughes, 1855.

the nervous rhythm, 'the pulsing cadence', but neither slavishly mirrors the verses or dominates them; the three spinning maidens and the doomed figure in the foreground exist quite independantly of the lines. In choosing to allegorize here, Rossetti was really liberating the most creative forces since Blake, forces that were to give the 1860s their most distinctive themes, symbols of passion, cruelty, hopelessness, that were to be used and abused and plagiarized for forty years. Even the small size of the block, which Rossetti disliked, worked for the best. It gives the print a more highly charged, crowded, sensual aspect, which was entirely new. Hughes' vignettes in the same book were the starting place of a whole generation of children's books where the child's senses and imagination were magically touched and developed.

If the *Music Master* proved to be too slight a production for convincing the public of the freshness, originality and poetry of the Pre-Raphaelite illustrators, *Moxon's Tennyson,* 1857 was too diluted to do so. The first was the personal idea of Allingham the poet in sympathy with his friends, the second the commercial undertaking of Moxon, the publisher and man of business! Rossetti still saw *this* book as he had the other as a declaration of Pre-Raphaelite principles with only the chosen few contributing. 'The right names would have been Millais, Hunt, Madox Brown, Hughes, a certain lady and myself', he wrote to Allingham, 'NO OTHERS. What do you think? Stansfield is to do *Break, break,* because there is the sea in it, and Ulysses, too, because there are ships. Landseer has Lady Godiva — and all in that way. Each artist, it seems, is to do about half-a-dozen, but I hardly expect to manage so many, as I find the work of drawing on wood particularly trying to the eyes.'[4] W.M. Rossetti mentions with what derision the older illustrators work was received by the young men when the book finally came out.

Over the years it has become Rossetti, Hunt and Millais' book, five illustrations by the former including some of his best work (see Colour Plates VII and VIII), seven by Hunt and eleven legendary subjects by Millais. This triumvirate certainly seized on those passages where it was possible to allegorize and extemporize in visual terms, 'The Palace of Art', 'A Dream of Fair Women' and the ballad stories like 'The Lord of Burleigh' and 'The Lady of Shalott'. William Holman Hunt emerges through these pages as a better composer than Rossetti, if without so fertile an imagination. His two designs for 'Recollections of The Arabian Nights' seem to have been tailor-made for him, the squatting figure of 'the Good Haroun Alraschid' no doubt sketched from a figure in the Holy Land. In the first drawing for 'The Ballad of Oriana', Hunt has brilliantly moved to medieval Europe, capturing in his drawings the inevitable, ruthless and doom-laden world of chivalry, the knight's lady struck

down by the arrow as she looks out from the battlements. The 'Shalott' pictures are divided between Hunt and Rossetti because the latter complained that all the good subjects had been taken. Hunt's fine and stylised and stormy 'Lady', her hair flowing like a cascade fore and aft along the top of the engraving is the archetypal Pre-Raphaelite image. It is in fact more typical of Rossetti than of himself. This lank, slightly stooping titan was constantly repeated in book illustration and caricatured by such artists as George Du Maurier, 1834-1896, in his 'Legend of Camelot' based on the Moxon edition. In *Tennyson and His Pre-Raphaelite Illustrators* G.S. Layard refers to Tennyson's reaction to this drawing. 'My dear Hunt,' said Tennyson, when he first saw this illustration, 'I never said that the young woman's hair was flying all over the shop.' 'No,' said Hunt, 'but you never said it wasn't.'

In his other work, Hunt shows enormous subtlety, the 'Godiva' though highly finished throughout, concentrates attention on the beautiful figure of the woman, 'The Beggar Maid' is as lightly drawn as the other is deeply etched.

Rossetti's drawings are the result of the same brooding idiosyncratic vision which gave Allingham's 'Maids' such power and they brought much the same striving after perfection and outbursts of indignation from the painter poet. 'What ministers of wrath', Rossetti wrote of his engravers, 'Your drawing comes to them, like Agag, delicately, and is hewn in pieces before the Lord Harry. I took more pains with one block lately than I had with anything for a long while. It came back to me on paper, the other day, with Dalziel performing his cannibal jig in the corner, and I have really felt like an invalid ever since. As yet I fare best with W.J. Linton, he keeps stomache aches for you, but Dalziel deals in fevers and agues'. The most important of Rossetti's works here, the first illustration to 'The Palace of Art', was in fact engraved by the Dalziels with very creditable results, though Ruskin considered otherwise. It shows the artist at his most precocious; literary and mystical allusions abound, distant ramparts, greens, trees, harbours full of ships, a dove and a sundial. In the midst of this 'lordly pleasure house' sits the beautiful organist, St. Cecilia, swooning backwards at the heady sounds of her own melody, backwards to be kissed sensuously and on the cheek by an angel, the kiss of death (Figure 41 and Colour Plate

VIII). Potent stuff this and whether it is suggested by Titian's organ player or the little masters of Germany, it remains indelibly Rossetti's in its glorious intensity and skilled eclectism. Neither 'Mariana in the South' or 'Sir Galahad', two others of his contributions, quite sustain this pitch of poetic allegory. His illustration for 'The Lady of Shalott' is an admirable square composition with some of the confined feeling of a missal painting. The bending figure of Lancelot was modelled by the young Burne-Jones. 'The Palace of Art' remains the triumph, Madox Brown called it 'jolly quaint but very lovely' and Tennyson could not make it out at all. 'The illustration of St. Cecilia puzzled Tennyson not a little,' wrote W.M. Rossetti, 'and he had to give up the problem of what it had to do with his verses.'[5] Rossetti himself believed that Tennyson loathed his designs!

Even in the realm of legend and allegory, Millais was the most natural book illustrator of the three. Despite Rossetti's great powers of invention and Hunt's religious zeal, the pure, seemingly

Figure 41. St. Cecilia by D.G. Rossetti from Moxon's Tennyson, *1857.*

93

effortless line of the unbookish Millais surpassed them. The first drawing chronologically in the *Moxon,* is 'Mariana', illustrating Tennyson's haunting poem of a girl's forlorn love as she waits by a window (Figure 42). The very writing of this poem with its 'rusted nails', 'ancient thatch' and 'cluster'd marish mosses' has a sort of Pre-Raphaelite colouring to it. Millais' prostrate figure on the window seat lies like a great arc across the picture, the drapery of her dress catching the light of the window before falling into deeper shadow. The idea was frequently used by later artists and one suspects that the delightful window embrasure was the inspiration for many an aesthetic inglenook!

Figure 42. *'Mariana' by John Everett Millais, 1857.*

Perhaps next in quality to this is the 'St. Agnes Eve', a drawing of great sensitivity and simplicity in which the young woman pauses on a turret stair and gazes out on a snow-covered moonlit landscape. The light on her gown, the stonework and even the warmth of her breath in the frosty air are given an almost ethereal delicacy. Two rather more severe subjects are his illustrations to 'The Sisters' and 'The Death of The Old Year', a step nearer than most to Dürer and his contemporaries. For 'The Sisters' he takes a dark and windswept castle tower directly from Tennyson's lines 'The wind is howling in turret and tree', a much more literal interpretation than Rossetti or Hunt. In the 'Death of The Old Year', we are in an empty bell turret based on that at Winterton church. The wheel and bell are still, but a quizzical owl perches in the shadows above the wooden frame. Forrest Reid considers that this may have been an illustration for Tennyson's unused poem 'The Owl'; it certainly bears no connection to the printed poem below.

Both the 'Sleeping Palace' illustrations are complex in composition and that of the king waking from his reverie, surrounded by the court, looks forward to the groups of *The Parables* a few years later. 'The Talking Oak' is disappointing, but with 'The Lord of Burleigh' at the end of the book, he returns to a tragic theme and produces a deathbed scene with astonishing control of the lights. Millais seems to have liked to minimise the whites and praised highly the cutting of this block.

Moxon was to remain a rich mine for Pre-Raphaelite followers. The 'Lady of Shalott' and other themes appear and reappear from Burne-Jones to Fortescue Brickdale. But closer in time and more relevant are the constant repetitions of the 1860s, linking the technical ability of that decade to the creative mastery of the Pre-Raphaelites. 'Mariana' for example turns up as a direct transcription, but reversed, in Arthur Hughes' 'Blessings in Disguise', published in *The Sunday Magazine* in 1869. The scene of leaded window and angle seat had already been utilised three years earlier by J.D. Watson in 'Too Late', an illustration for *London Society.* Frederick Sandys has raided Rossetti's 'Mariana in the South' for his own 'Rosamund Queen of the Lombards' in *Once a Week,* giving her a more slick and polished finish; the same artist's 'If' for *The Argosy* is a type of 'Lady of Shalott'. Turning to the work of M.J. Lawless, 1837-1864, we find that his 'Rung into Heaven', *Good Words,* 1862, is set in the same bell turret as 'The Death of The Old Year', the landscape glimpsed through the self-same opening, but he introduces figures of three orphans.

It would be possible to pursue this almost *ad infinitum,* but one further convention deserves to be looked at because it occurs so frequently, the deathbed. The only deathbed in the *Moxon Tennyson* is Millais' 'Lord of Burleigh'; the sombre tones of the bunched drapes

and the dark areas of closely engraved line give it an extraordinary grandeur. The dying woman lies in a bed, the length of her body dividing the picture area laterally into two, a window is in the right corner and four figures lean gently over her. Whether Millais was thinking of some specific painting such as Hugo Van Der Goes' 'Death of the Virgin' or not it would be difficult to say, but his solution to making the picture read well and yet remain unsentimental, worked. The scene is a symbol rather than a representation. The same arrangement was used for his modern subject 'Last Words' in *The Cornhill*, 1860, in Holman Hunt's 'At Night' in *Once a Week*, (Figure 43), the same year, and repeated by that 'dealer in magics and spells', Frederick Sandys, for his 'Sleep', *Good Words*, 1863, and his 'Sailors Bride', *Once a Week*, 1861. M.J. Lawless uses it for his 'One Dead' in *The Churchman's Family Magazine*, 1862. The young George Du Maurier contributed 'On Her Deathbed' to *Once a Week* in 1860, the bed swung round at an angle, perhaps suggesting a familiarity with the 'Death of St. Anne' by Quentin Massys which he might have seen in Belgium. The same treatment of the bed at an angle appears in Lawless's 'The Bands of Love' for *Good Words*, 1862.

Although the Pre-Raphaelites had brought pictorial power and invention to the book, sharp observation of nature and increasing sympathy for the medium, the bulk of the work is scattered and not numerous. The most considerable series of drawings which can be judged together and represent the mystical side of the movement are *The Parables of Our Lord* published in 1863.

The Dalziels had suggested the idea to Millais in 1857 and in agreeing to it, he had said that he intended to make it 'a labour of love like yourselves'.[6] The plan was to have had thirty drawings but the number was reduced to twenty and even then it was six years before the artist completed them. In a letter to the Dalziels, Millais explained his attitude to the drawings and his method of work. 'They are separate pictures, and so I exert myself to the utmost to make them as complete as possible. I can do ordinary illustrations as quickly as most men, but these designs can scarcely be regarded in the same light — each Parable I illustrate perhaps a dozen times before I fix, and the "Hidden Treasure" I have altered at least six times. The manipulation of the drawings takes much less time than the arrangement, although you cannot but see how carefully they are executed.'

The Dalziels played their crucial part in the cutting, giving an exactitude in the facsimile which won high praise from Millais. Twelve of the subjects appeared in *Good Words* in 1862 by special arrangement with Strahan, the publisher. They included 'The

Figure 43. 'At Night' by W. Holman Hunt from Once a Week, *1860.*

Leaven', 'The Ten Virgins', 'The Prodigal Son', 'The Good Samaritan', 'The Unjust Judge', 'The Pharisee and The Publican', 'The Hidden Treasure', 'The Pearl of Great Price', 'The Lost Piece of Silver', 'The Sower', 'The Unmerciful Servant' and 'The Labourers of the Vineyard'. These were followed by eight others when the completed book was published, 'The Tares', 'The Wicked Husbandmen', 'The Foolish Virgins', 'The Importunate Friend', 'The Marriage Feast', 'The Lost Sheep', 'The Rich Man and Lazarus' and 'The Good Shepherd'.

One has to remain astonished at Millais' fecundity of invention. With twenty subjects, many of them representing similar passions, cruelty, remorse, retribution, compassion, reconciliation and wonder, the artist has left no room for overlap and has created a complete world in each. Millais lets the teaching or moral of each parable stand out clearly from personal sentiment. The cloying subjective character of much Victorian religious illustration is completely absent because of the strength and independance of the draughtsmanship. Had these illustrations been in colour, it is doubtful whether even Millais would have escaped the mediocre.

Perhaps the most distinguished of the group representing reconciliation and compassion respectively, 'The Prodigal Son' and 'The Good Samaritan', were both first published in *The Cornhill*. In 'The Prodigal', the returned wayward son is locked in the arms of his father as they meet on a grassy slope. Sheep sit unconcernedly nearby and above them is the conical shape of a granary where harnessed oxen wait for the normal day's work to be resumed (Figure 44). The dark shapes of the cedars contrast well with the pyramidal barn and the contrasting hair of father and son is splendidly rendered. Millais has realised that to show the faces at such a moment would be to betray the depth of the emotion. 'The Good Samaritan' is likewise balanced by a calm and unconcerned animal, this time a donkey and a carefully realised landscape. Again the faces of the two figures, the one bending over the other, are partially obscured.

The composition of these pictures is exceedingly diverse, 'The Sower' for example is shown silhouetted against the skyline, scattering the seed on a steeply sloping rocky hillside; in 'The Hidden Treasure' the dark haunches of the oxen are contrasted with the bright

desert sky and the ploughman kneels in the shade to examine what he has found. In 'The Tares' an evil old man sows mischief among the crops with snakes and jackals around him, while the light in his unwitting neighbour's house burns brightly in the background. The most Jewish or Eastern in feeling of the series are 'The Pharisee and The Publican' and 'The Unjust Judge', not perhaps as accurate in Jewish detail as Simeon Solomon's work but with a powerful sense of ritual and the difference between inward and outward behaviour. In the first, the Pharisee stands in the full sunlight, his finely chiselled profile and beard gazing upwards; the Publican by contrast leans heavily on a pillar more twisted than himself in deepest shade. In the second, the more complex composition, an Eastern ruler, of incredible duplicity and cunning, turns aside from a pleading widow at his feet, while his various attendants try to restrain her (Figure 45). Millais has written here, in the indifference of the judge and the petulant movement of that tiny

Figure 44. 'The Prodigal Son' by John Everett Millais.

96

THE UNJUST JUDGE.

Figure 45. 'The Unjust Judge' by John Everett Millais from Good Words *1862.*

authoritative hand, reams about the abuse of power. The studies of the other heads are brilliant realisations of brutal ignorance in the man tugging at the woman, superiority and idle curiosity in the figures looking round the chair and subservient hostility in the scribe to the right. The heads in this and the earlier drawing suggest more than a passing debt to Bellini.

'The Lost Piece of Silver' is the most striking image of the set, Forrest Reid considers the line has 'the flowing elastic quality of a water weed streaming in a current'.[7] The background is in deep shade because it is night and the stooping figure of the girl is moulded out of this where the light from the candle catches her face, her arm or the edge of her broom, in her diligent search. In 'The Leaven', a woman works at the kitchen table while her daughter looks on. 'I send off by Post the Parable of "The Leaven which the woman hid in the three measures of meal",' Millais wrote to Dalziel, 'she is mixing the leaven in the last of the three. The girl at the back I have made near the oven with one of the loaves, and the other rests against the wall of the window.'[8] The clarity of this scene and Millais' description of it is reminiscent of the Flemish painters of the sixteenth century or even the work of his French contemporaries.

The Parables of Our Lord were no more a commercial success than *The Music Master* or *Moxon's Tennyson*. For Millais it was a triumph and for Victorian book illustration a break through to 'high art'. The impact that these designs made on artists if not on the public, led the way to a large number of illustrated biblical books of high quality during the 1860s, culminating in Dalziel's great *Bible Gallery* in 1881.

(ii) Millais and Modern Episodes

The years after 1860 saw a great explosion of illustrations of contemporary life, both in the magazines and the novels, the one often proving to be the testing ground for the other. Authors such as Charles Dickens, W.M. Thackeray, Anthony Trollope, Wilkie Collins, George Eliot, and later Mrs. Henry Wood and Henry James, provided an absorbing account of middle class life in which the artist could not easily escape into medievalism or sentimentality. The illustrator had to face the nineteenth century on its own terms, revealing as he did so its morality, its dilemmas, its conscience or lack of it, much as the social realists were to do in the 1870s and 1880s. But the scenario for most of them was the gentler more claustrophobic world of those lives lived behind thick velvet curtains. The innuendoes of the croquet lawn and the Hunt Ball, the savagery of the moneyed, the gossip of the London dinner table, lingering illnesses, deathbeds and the private but terrible ruin facing the respectable family that erred. The tensions were as great as in the slop shop but more dramatic by being more concealed.

As Michael Sadleir put it: 'A tide of royal principle and popular disgust, by engulfing the *ancien regime,* had transformed the middle classes from unimportant sandhills into the bulwark between land and sea'.[9]

A great number of artists worked in the contemporary idiom and verged from the masterly to the banal, although the quality was consistently high during the 1860s. The mental leap one has to make between say Phiz's illustrations to *Little Dorrit* of 1857 and the same author's illustrated edition of *Our Mutual Friend,* 1865, requires some explanation; the first is exaggerated, caricatured, the figures crowded into the picture area with generalised expression, the latter by Marcus Stone, though not the best of their type, clearly presented, the figures larger in scale, the treatment naturalistic. There is a more subtle difference than one of medium, Phiz sticking to the steel plate and Stone preferring the wood engraving, the vision that society has of itself has shifted from synthesis to objectivity. Where did so much unbiased reporting and beauty of line spring from in the simple depicting of every day events? The answer must lie with the greatest illustrator of the mid-century, John Everett Millais.

Millais' career from infant prodigy to President of the Royal Academy is too well known to be given here, but his work as a book illustrator is less familiar. Millais' extraordinary aptitude for drawing led him to be entered at Henry Sass's School at the age of nine and gained him a Society of Arts silver medal the same year. He entered the Royal Academy Schools at the age of eleven and remained there for six years winning most of the major prizes. In the middle of 1847, when he was barely nineteen, he joined Holman Hunt and Gabriel Rossetti to form the Pre-Raphaelite Brotherhood, and make a return to the principals of early Christian painting.

Millais was a born draughtsman and therefore a born illustrator. Some of his earliest sketches are title pages for books in the confident line of Flaxman or the slightly more decorative manner of Stothard. It was he who had presented a portfolio to the group in which black and white drawings could be circulated and criticised and it was he who had contributed illustrations to that short-lived organ of their movement *The Germ,* 1849.

The work of Millais the illustrator happily falls into the years 1857 to 1867, although a few were done in the 1870s. The dates have a certain significance, for they form a bridge between the early career of the idealistic Pre-Raphaelite and the later career of the successful academician and man of the world. The reason that these illustrations were such powerful insights into the Victorian mind and such accurate realisations of the contemporary novel was despite rather than because of the artist's growing popularity. These drawings

had their seeds in the early 1850s when Millais was still young and still outside the artistic establishment. If these ideas took some years to form themselves into a coherent pattern, they were well worth waiting for; from 1857 with the publication of *Moxon's Tennyson* to the conclusion of *Phineas Finn* a decade later, glorious images of what Hunt called 'modern episodes' spilled out from his pen.

The crucible for all this energy and draughtsmanship was the Pre-Raphaelite movement itself, its strongly felt but inexact aims, its mixture of poetry and painting and Millais' own turbulent life after his meeting with Mrs. Ruskin. At the back of the Pre-Raphaelite creed was a strong reforming zeal and a desire to be involved with great moral issues in contemporary life; in 1853 Holman Hunt's *The Awakening Conscience* and Rossetti's *Found* were on this theme and Millais' own contribution was a very remarkable series of highly finished drawings. In them Millais was working out for himself the strong emotions engendered by his love for another man's wife; 1853 was after all the *annus mirabilis* of his Associateship, but also of the famous visit to Scotland with the Ruskins.

The author of *Modern Painters,* his young wife and Millais, the most promising painter of the British School, spent a holiday together in the Highlands during the summer and autumn of 1853. Ruskin lionised Millais, but the young people were thrown together, Millais grew to resent the coldness and reserve of Ruskin to his wife, and Effie had confessed to him that her marriage to Ruskin was no marriage at all. The Ruskins remained in the North and Millais returned to London, his love for Effie a ferment, his sense of outrage and frustration almost unbearable. Christmas passed, Effie returned to London, but it was not until the end of April that she left Ruskin for her parents' home in Scotland. Millais had to wait till July of 1854 for the marriage to be annulled and a further year before his own marriage to Effie.

It was at this period of mental anguish and self-searching, between the winter of 1853 and the summer of 1854, that Millais drew his series of modern episodes, thirteen in all, excluding copies. They are crucial in the development of Millais' own work for contemporary literature and ultimately of the School of the 1860s. J.G. Millais in his *Life* [10] discusses them with his father's illustrations to Trollope, implying this link; their high finish, their strong moral interest, their frank criticism, make them illustrations in all but name, although only one was published. The theme in each case is dependance, the dependance of woman on man, the dependance of children on their parents, the dependance of the sick person on his nurses, the sense that no action is ever isolated from responsibility. The most domestic of the subjects is the group called 'Retribution' where the Victorian paterfamilias stands, head bowed, confronted by two wives and the family of one of them; the solid furniture and the watching domestic heightening for a moment the public success and the private failure.

'The Race Meeting' follows the same pattern; a pleasure carriage at the races is surrounded by touts and beggars, the spendthrift young owner is ruined but tries to put a brave face on it, only his kept woman, who sits behind him, buries her face in her hands knowing that he will no longer afford her. Millais' tight penwork, incisive detail and factual reporting were the best vehicles for expressing Victorian cruelty and injustice. 'Accepted', a more conventional lover's tryst shows the man on his knees to the girl on the lawn of a country house. A ball is in progress within, dancers can be seen through the arches of the terrace, the lawn is bathed in moonlight except for the pool of shadow cast by the lovers. Are they part of the dance or has he crept into the garden to meet her? Her anxious glance housewards suggest this is the case. The whole scene conjures up Tennyson's *Maud* but that was published two years later in 1855. 'Rejected' is less dramatic as a composition but no less tense, a woman in a riding habit turns away from her suitor, her riding crop trailing on the ground, while grooms hold their agitated horses behind. 'The Dying Man' shows a faded and

Figure 46. 'Fireside Story' by John Everett Millais from Allingham's Music Master, *1855.*

sick man gazing at the fire, while his young wife reads to him. In 'The Blind Man', a blind beggar is led across a busy street by a defiant but gentle young woman. It is easy to conjecture Millais as the blind man and Effie as the absent but ever compelling guide! This drawing, both in outline, washes and subject matter, suggests curious affinities with Richard Dadd, an obsessive and nearly pathological eye.

A significant step between the drawings of the early 1850s and the illustrations of the 1860s, is the delightful contemporary subject in Allingham's *Music Master* of 1855, the only one of its kind by Millais in the book. Entitled 'Fireside Story' (Figure 46), it shows a circular group of two adults and five children listening to a tale, the whole scene is concentrated on facial expression and gesture, particularly good in the small girl, buried in her mother's skirts, and the totally absorbed look of the nursemaid.

Millais may have taken up the idea of doing black and white work from his meeting with John Leech in 1851. Leech's position on *Punch* had become pre-eminent through his social cuts of sporting subjects. Ruskin credits him with bringing graceful subjects to the printed page.[11] The two artists were to become fast friends and hunting and fishing companions. According to J.G. Millais, his father's attitude to illustrative work was not one of snobbery, he believed 'that the few men quite at the top of the tree, both in line and wash, were entitled to rank with the best exponents of oil and watercolour'.[12] He admired Leech's drawings and through him was introduced to Bradbury and Evans in 1860; in August that year he was speculating that he might make £500 a year from black and white drawing. His son did not think it was a profitable exercise; Millais was painstaking and deliberate and made as many pencil studies as for an oil painting before drawing the composition out in pen. He would scrap the whole scheme, tearing the drawing to pieces if there was anything unsatisfactory. He was careful about locations too; the interiors for *Orley Farm* were copied from Trollope's boyhood home at Harrow[13] and he was in the habit of using models, actually borrowing a baby for the same book! All the work for the Trollope novels, the *Cornhill Magazine, Good Words* and *London Society*, excellently engraved as they were, can only be appreciated with reference to these earlier 'modern episodes'. As all his work was drawn on the block, the original was destroyed in the cutting and he alone among the artists of the 1860s has enough surviving finished work to point the way. The fact that most of them remained in the family surely shows what personal documents they were.

One of the series was actually published and is illustrated here (Figure 47). It is perhaps the best study of the artist's technique, those controlled pen lines and subtle washes that only the best engravers could translate. This is called 'Married For Money' or 'Woman in a Church watching her former Lover married',· and was engraved for *Moore's Irish Melodies* in 1856. Millais mentions in a letter, quoted in Mary Lutyens' *Millais and The Ruskins*[14] that he spent his time in early 1854, disconsolately looking at churches. Perhaps one of them gave him the idea for this ingenious composition; the dark shape of the woman cranes forward to look into the body of the church where the wedding party are congratulating each other. Her silhouette is marvellously thrown into relief by the bright light from the windows behind her, striking pillar and pew, nobody but Millais could be so brilliantly subjective and yet so devoid of sentiment.

This perfection of line owes something to the neo-classicists as well as to fresco painting and the flat effects of Dyce or the

Figure 47. 'Married For Money' by John Everett Millais.

Nazarene School. It is most obvious in 'The Ghost', another marriage subject where Millais' preoccupation with gesture is best seen. It is small wonder that Ruskin was later to refer to this School of illustration as closer to nature in the delineation of the faces than anything since Holbein.[15] 'They possess,' says Gleeson White, 'the immense individuality of a Velasquez portrait, which, as a human being, appeals to you no less surely, than its handling arouses your aesthetic appreciation. At this period it seems as if the artist was overflowing with power and mastery – everything he touched sprang to life . . .'[16]

The decision by Edward Moxon, the publisher, to use Millais and Rossetti as his illustrators for the 1857 edition of Tennyson was a daring step. His use of older and less controversial men like Creswick and Mulready as well, makes the book a specially queer melange and accentuates the new style of the Pre-Raphaelites. Rossetti's 'The Lady of Shalott' and 'The Palace of Art' were outstanding, as were Millais' historical subjects dealt with previously. But the *Moxon Tennyson* brought Millais to the fore as a portrayer of modern episode. There were seven of these out of his total of twenty-four. The Dalziels called it 'a landmark in the history of book illustration',[17] even after one hundred and thirty years these engravings have a freshness and clarity. It must have appeared startling to the mid-Victorians that any artist would dare to treat the poetry of the great Tennyson in such a direct manner, the almost Millet-like figures for *Edward Gray,* the engagingly plain couple kissing in *The Miller's Daughter* and the magnificently basic and unlyrical argument between Father Allan and William at the head of *Dora.* The novelty is only reinforced by the simpering drawings of J.C. Horsley for *Circumstance* and the repetitive landscapes of Myles Birket Foster. Ruskin would have supported him; in *The Art of England* he writes 'that literature has in all cases remained strongest in dealing with contemporary fact. The genius of Tennyson is at its highest in the poems of *Maud, In Memoriam* and *The Northern Farmer.*'[18] What was true of the poet was equally true of this illustrator.

A number of the illustrations relate to the earlier drawings. The family group of 'Retribution' is contracted into the circle of figures at the end of *Dora*, the baby drawn from the poet's son, Hallam.[19] 'Rejected' becomes the gentler parting of *Edward Gray* and 'Accepted' the deep embrace of *Locksley Hall;* the similarities are not striking but the spirit of them is there. Millais like the other artists, was paid twenty-five guineas, Rossetti to be different, thirty guineas. The book is quarto size sold at a guinea and a half and should have been a success, but it wasn't. Another edition from Routledge sold well, but its triumph was in its influence rather than the profit it put into the pocket of Edward Moxon.

Three years later in 1860, Millais was commissioned through George Smith to illustrate Anthony Trollope's *Framley Parsonage* for the *Cornhill Magazine.* Although Millais only entered at the third instalment, it was to be one of the most successful partnerships of author and illustrator, the artist once more drawing for his inspiration on the modern passions and completing eighty-seven designs for *Framley Parsonage, Orley Farm, The Small House at Allington, Rachel Ray* and *Phineas Finn.* Trollope, who took little interest in his illustrators was surprisingly enthusiastic. 'Should I live to see my story illustrated by Millais nobody would be able to hold me,' he wrote from Cambridge in February 1860.

Unaware of who his new illustrator might be, he had. written a month before to the publisher with a tedious list of instructions: 'I think the scene most suited to an illustration in Part 3 of Framley Parsonage would be a little interview between Lord Boanerges and Miss Dunstable.' He goes on to explain that the lord should be very old, the lady not very young and the artist would have to read his earlier novel *Dr. Thorne* to get a description of her. Although Trollope came to trust Millais' pen implicitly, this was to continue as their pattern of work; the novelist suggested the subject, the artist carried it out and the writer criticised the result. It was remarkable that Trollope could fault his collaborator on dress but never on character. 'There is a scene which would do well for an illustration', Trollope wrote to his publisher, 'It is a meeting between Lady Lufton and the Duke of Omnium at the top of Miss Dunstable's staircase. I cannot say the number or chapter, as you have all the proofs. But I think it would come in at the second volume. If Mr. Millais would look at it I think he would find that it would answer.' Mr. Millais did and it is one of the best groups in the book. Both artist and author were completely attuned to observing nature. 'The art practised by Millais and myself,' said Trollope, 'is the effective combination of details which observation has collected for us from every quarter.'[20]

Trollope wrote appreciatively of their work together in his autobiography, a rare honour for the working illustrator. 'An artist will frequently dislike to subordinate his ideas to those of an author, and will sometimes be too idle to find out what those ideas are. But this artist was neither proud nor idle. In every figure that he drew it was his object to promote the views of the writer whose work he had undertaken to illustrate, and he never spared himself any pains in studying that work, so as to enable him to do so. I have carried on some of these characters from book to book, and have had my own early ideas impressed indelibly on my memory by the excellence of his delineations.'[21] If Trollope's characters had very nearly become Millais' characters, it is arguable how much the inhabitants of Barsetshire owe to the artist in the popular imagination today. The Archdeacon and Mrs. Arabin, the Bishop and Mrs. Proudie, the Crawleys and Lady Lufton are Trollope's creations but we still remember them through Millais' exact and penetrating eye.

The most delightful of the illustrated books is *Framley Parsonage* the earliest and the freshest in concept. Outstanding in the second volume of the work is the group of the Crawley Family (Figure 48), one of the softest and most beautifully balanced domestic subjects to come out of Victorian fiction, it was particularly admired by the novelist himself. The placing of the figures on the page is always happy in Millais, as in the 'Miss Gresham and Miss Dunstable' or the later illustration of Mr. and Mrs. Robarts standing in

front of their chimney-piece. It is noticeable that in 'The Crawley Family' Millais harks back to those earlier groups of 1853, in particular, 'Married For Love', the hard pressed cleric surrounded by his family and writing a sermon. Similarly, the Duke of Omnium appears as a younger version of the same nobleman in 'Married For Rank', led along on the arm of his much younger and ambitious bride.

Rachel Ray, 1863, was followed by *The Small House at Allington* in 1864. This has a splendid frontispiece to the second volume 'Mr. Palliser and Lady Dumbello', some good rural subjects in which Millais excelled, especially His Lordship discovering the sleeping Eames and another 'And Have I not Really Loved You' reminiscent of the 'Rejected' of 1853. Orley Farm, 1866, has the sensitive landscape frontispiece of the farm, based on Julian's Farm at Harrow, some delightful trios like 'Over Their Wine' and tête-à-têtes such as 'Never is a very long word'. For some reason Millais lost the commission of *The Last Chronicle of Barset.* 1867, to G.H. Thomas, a far inferior artist, who was instructed to work from Millais' originals. Millais again appears as the illustrator of *Phineas Finn* with some excellent work 'Lady Laura's Headache' and 'The Fact is mama, I love him' being among the best. But there is a distinct falling off in quality towards the end of this volume, which appeared as late as 1869.

Trollope did not however have a monopoly on modern subjects and there were a number of these by Millais, such as 'Last Words' (Figure 49), which appeared in *The Cornhill Magazine* in November 1860, and are equal to any of the Barchester series.

Many of the most significant artists of the time, followed Millais in tackling contemporary literature with a similar intensity and power. Among them were Whistler, a rare illustrator, Fred Walker, M.J. Lawless, Frederick Sandys, J.D. Watson, J. Mahoney, Luke Fildes, G.J. Pinwell, Ford Madox Brown and J.W. North. The pages of *The Cornhill Magazine, Once a Week, Good Words* and *The Quiver* are full of the exquisite drawings, not

THE CRAWLEY FAMILY.

Figure 48. 'The Crawley Family' by John Everett Millais.

LAST WORDS.

Figure 49. 'Last Words' by John Everett Millais.

only confounding Ruskin's strictures that the turban was superior to the hat, but giving a beauty and significance to the top hat, the crinoline, the frock coat and the parasol. The nearest approach to Millais was in the superb work of Fred Walker, who had originally acted as 'ghost' for Thackeray's feeble designs to his own *The Adventures of Philip,* 1861, eventually taking over the job fully and signing with his familiar 'FW'.

Another deft black and white artist was G.J. Pinwell whose forte was in rural life. His 'The Sailor's Valentine' published in *The Quiver* in 1867 shows a Jack Tar with a woman and a little girl in the back garden of a London house. It is certainly not a grand London house, the woman wears a crumpled dress, the little girl's frock is not of the newest and the backs of other houses run across the top of the picture like a frieze. Pinwell, like North and Fred Walker, has gone among the people with a contemporary eye, not with the eye of romantic hindsight.

Ford Madox Brown's rare illustration in *Dark Blue,* 'Down Stream', shows the same questing after modernity; the young man grasps his love coarsely and vulgarly as the oars drag idly from the boat, emphasising the power of the moment, the 'now' triumphing over the restraint of the 'later'. Boyd Houghton's domestic scenes such as 'My Treasure' engraved in *Good Words* in 1862 echo the same feeling, the ugliness of the Victorian furniture giving a strong sense of the contemporary to the timelessness of a mother's love for her children.

Some of the early editions of Wilkie Collins' novels had illustrations by G.H. Thomas, Sydney Hall and F.W. Lawson that were not up to standard, and those of his later books, illustrated by Arthur Hopkins, are flagrantly bad. Marcus Stone's adequate but unremarkable work for Dickens' *Our Mutual Friend* has already been mentioned, Luke Fildes marvellous darkened interiors for Dickens unfinished novel, *Edwin Drood,* 1870, are easily the best of the later illustrations. A catalogue like this could go on to include work by T. Morten, Harrison Weir, F.W. Slinger, G.A. Sala, M. Ellen Edwards, who drew for Trollope's *The Claverings* and many more. Among these secondary artists, none is more charming than Kate Edwards, whose sensitive draughtsmanship of 'The June Dream', *London Society,* 1866, reflects the influence that the assured penwork of George Du Maurier was already having on a younger generation of artists.

Millais illustrations are however part of a long-standing graphic tradition even if that tradition was observed with new eyes. William Allingham, writing to the artist while he was on the threshold of his black and white career, recognised this: 'I wish you would master the art of etching, and make public half a dozen designs now and again', he writes. 'Surely one picture in a year, shown in London and then shut up, is not result enough for such a mine of invention and miraculous power of reproduction as you possess. This is the age of printing and a countless public, and the pictorial artist may and ought to aim at exercising a wider immediate influence. Be our better Hogarth . . .' That Millais achieved this end with his Trollope designs was the climax of a ten year study of modern episode.

Three of Millais' important series of 'modern episodes' came up for sale at Christie's on 12 December 1972 and fetched prices in excess of £2,500, a recognition of their considerable rarity in the artist's oeuvres. 'Accepted', from the collection of the artist's family, also made a high price at auction. Considering the wide circulation of Trollope's novels in the 1860s and the stature of the artist illustrating them, it is extraordinary that this side of his work is not better known and the books themselves more collected.

Right: Plate VII
DANTE GABRIEL
ROSSETTI 1828-1882
'King Arthur and the
Weeping Queens'
Design for Moxon's
Tennyson, 1856-57
Pen and brown ink
3¼ins. x 3³/₈ins.
(8.3cm x 8.6cm)
Birmingham City
Art Gallery

Left: Plate VIII
DANTE GABRIEL ROSSETTI
1828-1882
'St Cecilia'
Design for Moxon's Tennyson,
1856-57. Signed with mono-
gram. Pen and brown ink
3⁷/₈ins. x 3¼ins.
(9.8cm x 8.3cm)
Birmingham City Art Gallery

1. John Christian, 'Early German Sources For Pre-Raphaelite Designs' *The Art Quarterly*, Vol. XXXVI, Nos. 1 and 2, 1978.
2. William Bell Scott *Autobiographical Notes*, 1892, p.171.
3. This and following quotations taken from *Letters of Dante Gabriel Rossetti to William Allingham 1854-1870.* Edited by G. Birkbeck Hill, 1897, p.97.
4. ibid.
5. ibid, p.104.
6. *The Brothers Dalziel A Record of Work 1840-1890*, 1901, p.94.
7. Forrest Reid, *Illustrators of the Sixties*, 1928, p.75.
8. *The Brothers Dalziel,* op. cit., p.102.
9. Michael Sadleir, *Anthony Trollope A Commentary,* 1927, p.24.
10. J.G. Millais, *The Life and Letters of Sir John Everett Millais,* 1899, Vol. 1, pp.357-362.
11. John Ruskin, *The Art of England,* 1884, pp.178-179.
12. J.G. Millais, op. cit., Vol. 1, p.358.
13. ibid.
14. Mary Lutyens, *Millais and the Ruskins,* 1967, p.126.
15. John Ruskin, op. cit., p.179.
16. Gleeson White, *English Illustration of The Sixties,* 1906, pp.22-23.
17. The Brothers Dalziel, op. cit., p.83.
18. John Ruskin, op. cit., p.6.
19. Charles Tennyson, *Alfred Tennyson,* 1968, p.278.
20. Michael Sadleir, op. cit., p.278.
21. ibid.

Chapter 6

The Eighteen Sixties
Some Magazines and Some Artists

Nobody can deny that with the 1860s one has arrived at the golden age of Victorian illustration, a decade and a half from 1855 to 1870, when drawing on wood came to its maturity, and the best art ists in the country were engaged in it. A great deal has been written about this epoch and even before it closed, the works were legendary and the position of the artists almost sacrosanct. The tendency has always been to perpetuate the myth of this 'sudden' flowering as if it were entirely in the hands of a group of young artists, not in the hands of mid-Victorian society, its dictates, tastes and prejudices. The black and white art of the 1860s is principally remembered today through the pages of its magazines, endless publications with varying axes to grind, political, literary, religious, instructional, humorous and purely entertaining. The majority of these were run on strict business lines, earnestly improving perhaps, but unsentimentally meeting a demand from a vast reading public. The new magazines could follow the channels opened up by *The Illustrated London News* and benefit from the vast distributive organisation of W.H. Smith whose bookstalls were to be found at nearly every major railway station in England and Wales providing light reading for the journey.

Apart from Samuel Read of *The Illustrated London News*, there were no art editors on the magazines and therefore no pandering to the demands of the artists for their own sake. In fact the writer was still considered of greater value to the magazine than the illustrator, who was paid proportionately less by his editors, men totally unsympathetic to the visual arts. W. Tinsley, proprietor of the successful and fairly well-illustrated *Tinsley's Magazine*, grumbles in his memoirs that pictures 'cost from two to three pounds the square inch for drawing and engraving', a preposterous sum![1] Nevertheless by 1860, it would have been a foolhardy editor who did not liberally sprinkle his weekly or monthly with engraved illustrations. The public had become visually aware, printing and engraving were approaching a peak, literacy was spreading and punitive taxation was being repealed. The climate was ideal for magazines in this lull between the self-discovery of the Great Exhibition and the consolidation of the Queen as Empress after 1876. It was the heyday of family entertainment and the decorative covers of *Good Words* or *Once a Week* would be opened, read aloud and then passed from hand to hand for the designs to be examined. The editors were satiated with fiction and the middle class with leisure, the illustrators answered the call by improving the one without making too strenuous demands on the other.

The middle of the nineteenth century was a very art conscious period. Moral and social improvement joined with culture to form an Elysium of institutions. Institutions bred other institutions like rabbits, burgeoning government departments spread mutual benefit into the provinces, government schools of design were set up, literary and scientific societies established, architectural and archaeological institutes were born. The ground was well prepared for the book-conscious 1860s. The Art Union of London, which distributed engravings to its subscribers and bought and presented the works of modern artists by lottery, was flourishing. It had begun in 1836 with a capital of £489 and in 1857, at the beginning of our period, its assets stood at £13,218 -9s. with a largely middle class membership of twelve thousand. It became a patron of the book illustrator only

spasmodically, issuing to subscribers albums of line engravings such as Thomson's *Castle of Indolence* with William Rimer's designs in 1845 and the following year Campbell's *Gertrude of Wyoming* illustrated by George Elger Hicks. Sir Noël Paton was another artist employed by the Union to draw subjects from Shakespeare. Significantly enough the chief agents for the Art Union in the United Kingdom were booksellers. Other cities had their own Art Unions and the uniformity of the public they created and the homogeneity of its taste, must have encouraged publishers and printers to bring out larger editions, more lavishly illustrated.

'It is sometimes urged as an objection to the Art-Union,' ran its Report for 1857, 'that its productions, being issued to large numbers of persons, become in consequence common and valueless. This is not the feeling in which works of art should be viewed. It is not so in literature; a book is prized for the instruction it contains, or the delight it affords, and the value of it as a work of mind is in no degree lessened because copies are multiplied in thousands, and the book is placed within the reach of everyone.'[2]

The illustrators of the 1860s were part of a much larger revolution which placed the artistic print in the hands of everyone. The same zest for improvement that had created a readership had also created the talent to satisfy it, many of the draughtsmen now emerging were the products of those self-same government institutions. Never before had the decorative and industrial arts stood so high in the estimation of most men, and book illustration, perhaps the most artisan of the fine arts, shared in this glory of utility and mechanisation.

From the early 1850s, the vestries were allowed to build Free Libraries although they built very few. Such records of these as exist show that the working man was ravenous for tales and romances that took him far away from the grimy present, *The Arabian Nights, Ivanhoe, Robinson Crusoe* and *Moll Flanders* being the favourites. There is no indication but probably some of these cheap editions were crudely illustrated.[3] Mechanics Institutes were to be found in most large towns and these included libraries, news-rooms and reading rooms where journals and magazines could be found, although they were often most used by the tradesmen.[4]

There was also a revolution in the way people read, the more dignified habit of the eighteenth century, became the more cursory familiarity with books of the nineteenth. The age of the three volume novel turned into the age of the instalment, the part novel and the serial. W.H. Smith's had recognised as early as 1848 that a new means of transport needed a new kind of book. They had provided for the bookstall *The Railway Anecdote Book*, 1849, a collection of stories and jokes. The key was to occupy the reader rather than absorb him, to catch his attention between the covers, and hold him there for the fascinating moving landscape around him. The new literature presupposed that there was something else going on, and the 'yellow-backs' of the bookstalls carried the message 'For the Fireside, Steamboat or the Rail'. The illustrated magazine or novel was the natural companion for rapid transit where plates might hold the wandering attention in a way that prose could not.

The reformers of the Stamp Duty had likewise seen to it that the late 1850s and early '60s were the first tax free periods for the newspaper. Alterations were made to the levy on newspapers in 1853 and in June 1855, the duty was totally abolished except where the paper passed through the postal service. The effect was immediate. In July and August 1854, 19,115,000 newspaper stamps were issued and in the same months in 1855 only 6,870,000. Although not all magazines were subject to the tax, there was a great sense of liberation and euphoria in the press after the repeals and a boom in new papers and new publications.

The struggles of the artists over the previous ten years to master the art of book illustrating was really symptomatic of the slow progress towards a desired goal. Rossetti's

frantic consultations with J.R. Clayton, the engraver, and J.E. Millais' attempts to etch were only the birth pangs of a new movement. The desire to communicate with a wider public was there, but until that communication took the form of a happy partnership between illustrator and engraver, rather than a battleground, the vigour of creative ability and craft were not going to be united on the page. The engravers, Dalziel, Linton, Swain and their brethren continued to gain stature from the work fed to them by William Harvey, John Franklin, William Mulready, John Gilbert, Birket Foster and many more. The up-and-coming young men of the 1860s undeniably stood on the shoulders of such artists technically, even if they surpassed them in other ways; the younger group were to inherit the vision of the Pre-Raphaelites but to adopt a more craftsman-like approach to engraving. Until the middle of the 1850s the individuality of artists' work was virtually obliterated by the wood engravers. 'All that was to be recognised,' wrote Layard, 'was the composition and invention. There was not necessarily of the artist a line in the reproduction that corresponded to his pen and ink drawing. So we see in many illustrated books of the period the name of the engraver upon the title page, with no mention of the designer.'[5] It is important to note as one follows the course of the younger artists through the magazines and books of the time, how few of them were in any way architects of their destinies. Walter Crane, 1845-1915, the archetypal craftsman-illustrator had bought *Moxon's Tennyson* for 31/6d. while still an apprentice; Burne-Jones, the future apostle of poetic legend had raved at Oxford over Allingham's *Music Master;* du Maurier, the ascendant star of domestic manners, had given the same illustrated *Tennyson* to his bride! The 1860s were to flourish on their own account, but the seeds had been sown a long time before.

Gleeson White in his formidable book *English Illustration of The Sixties,* takes as his starting point the magazines of the period. He is correct to do so for not only were they pre-eminent, but from them stemmed the new role of the illustrator as a journalist. From then onwards until the demise of magazine draughtsmanship, the illustrator's staple diet was the weekly and the monthly, the periodical as opposed to the book. There were of course some magnificent books produced, but finance and caution among the publishers made the magazine the natural home for the pictorial journalist. 'For it must not be forgotten,' Gleeson White wrote, 'that every new books is, to a great extent a speculation; whereas the circulation of a periodical, once it is assured, varies but slightly. A book may be prepared for twenty thousand buyers, and not attract one thousand; but a periodical that sold twenty thousand of its current number is fairly certain to sell eighteen thousand to nineteen thousand of the next, and more probably will show a slight increase.'[6]

Just as the risk of a periodical was reduced over that of a book, so the problems of using one illustrator were reduced by employing many. The publisher who was unwilling to commit himself to an untried and inexperienced artist had the opportunity to give him minor work without any obligation to continue. From the point of view of the young illustrator, it was much easier to get his artistic foot in the door through magazine work than through the more prized book work. The first offered room for experiment and gradual improvement, the second greater discipline and an awesome sense of finality. Moreover the one led to continuous employment and the other to more patchy periods of activity punctuated by non-employment. The magazines therefore became the ateliers of students, amateurs and craftsmen who aspired to be painters. Just as the engraving establishments were the grammar schools, the editorial offices were the universities on the way to High Art. 'I shall always regard those early years in Mr Linton's office as of great value to me,' Walter Crane wrote at the end of his career, 'despite changes of method and new inventions, it gave me a thorough knowledge of the mechanical conditions of wood engraving at any rate, and has implanted a sense of necessary relationship between design, material and method of production, of art and craft in fact — which cannot be lost and has

had its effects in many ways.'[7] Similarly, Mason Jackson writing in the 1880s could make a strong case for the unique value of the magazines. 'Both *The Illustrated London News* and *The Graphic* may claim to have done good service to art and artists in this respect. Their pages have always been open for young artists, and while they have helped forward struggling genius they have opened up new sources of enjoyment to the general public.'[8]

The hierachy of the new magazines was as rigid as any old order of chivalry. The same sort of 'trade' specialists that had existed at Day's Lithographic Office in the 1840s were perpetuated in the 1860s. At the apex of this pyramid were those artists on the staff of the magazine, the members of 'The Table' at *Punch,* the Special Artists and the permanent men of *The Illustrated London News* and the chief cartoonists of the smaller magazines. Most of them held special positions in their respective papers, were paid salaries or retainers, and had privileged places within the pages. John Tenniel's principal cartoon in *Punch* for example was always placed in the middle opening and was always unbacked by print, Linley Sambourne's second cartoon also had a customary place and had to contrast with Tenniel's. Of equal importance with these regulars were the artists who drew only for special numbers at Christmas time, in the Season, or for royal weddings and funerals. The most famous of these was Sir John Gilbert, who had made a reputation out of grandiose history and patriotic allegory, and acquired a fortune to go with it. Du Maurier reported that Gilbert was making £3,000 a year out of illustrating in 1860 which was probably accurate; a bachelor and proverbially mean, he was continually pursued by less fortunate artists to become godfather to their numerous progeny! His greatest claim to fame is that he brought some dignity and objectivity to news reporting in the early days and made illustration respectable.

Further down in the scale were the outside contributors who would be featured regularly while not forming part of the inner coterie, illustrators working on the second serial, artists illustrating a poem or the seasons of the year. Beneath these were the scavenging hordes of students, amateurs and hacks hoping that an initial letter might fall from the rich man's table. There was enormous pressure to get commissions from more prominent journals and the enterprising would take on almost anything, drawing out another man's work, improving for the engraver and preparing tedious decorations and headings. The graduation from the drudgery to a quarter page cut was a red-letter day! The benefit of the system was that every man went through it. The RAs of the 1880s were the initial designers of the 1860s. Du Maurier, fresh from the Continent, set to work on initials, Herkomer had to learn to drawn on the wood and Fred Walker's lovely drawings appeared anonymously because he was ghosting them for W.M. Thackeray. Tenniel himself, A.B. Houghton, J.W. North, William Small, Luke Fildes, M.J. Lawless and Charles Green all came into the profession by that same door.

The more elaborate the magazine, the more complex its structure, and *The Illustrated London News* had of course specialists in every field. Artists were employed solely on portraits or animals, shipping, scientific drawing, bird's-eye views, comic cuts or ornament. T.R. Macquoid, their decorative artist, was in quite a different category from the casual decorator, his ornamental details appearing over a score of years with regularity.

George du Maurier, 1834-1896, who arrived in this country at the very turning point for black and white art, 1860, recognised at once the enormous competition. Brimming over with confidence and a certain self-importance, he was nonetheless forced to strain his capacities to the utmost to be accepted. His letters to his mother are full of the colour of the period and the *sturm und drang* of youthful enthusiasm. 'It is utterly impossible for me to give you an account of this last week,' he writes in June 1860, 'all the troubles, fatigues and vexations I have wiped — Clambering up the staircases and knocking at the doors of editors who are always busy and always in a bad temper. Sometimes treated rudely, sometimes put off with much politeness and slight hopes of future employment.'[9] 'If I got

as much work as I could do' he wrote more confidently in November 1860, 'I could make £800 or £1,000 a year.'[10] But the question was to get that work; there was no chance of the inexperienced man being taken on to the permanent staff although he sensibly realised that this should be his aim. 'My name hasn't yet sufficient weight to force on them drawings which they don't like, like Keene or Tenniel,' he remarks of *Punch* in April 1861, 'and I cannot illustrate all subjects with equal facility. This depending on one paper is certainly precarious . . .' Or again the following May he confides, 'Mark Lemon told me very kindly that as their artists, Leech, Tenniel and Keene received a yearly income, he could only take large sketches from me when they were very much better than theirs, which is sensible enough.'[11]

Du Maurier had set his sights on *Once a Week* and ultimately *The Cornhill Magazine*, but both were highly selective, *The Cornhill* had comparatively few illustrations and *Once a Week* cut down their number quite soon after he started contributing. 'There was no sketch of mine in this week's *Once a Week*,' he reported gloomily in October 1860, 'nor will there be in the next, as they are crammed full of drawings by Millais.' Late in 1862 he repeats much the same story – 'I went to see Smith about the Cornhill. No chance for a long time to come – Millais, Leighton and Sandys have the monopoly of that at present . . .' There were of course other tactics to be considered; the silly season was an ideal one for the aspiring illustrator. 'In August the Punch artists will be going out of town,' du Maurier wrote gleefully in the summer of 1861, 'and I shall be very necessary I fancy, and I will try and do my very best in the light comical line.'[12] Later he was using Keene's absences to get known 'such is everybody's advice'. In 1862 he was exercising his talents by dining with Miss Thackeray, the daughter of *The Cornhill's* editor. Du Maurier called her 'a tremendous jobber' and added, 'if I get on the right side of her I'm alright with the Cornhill.'

But the chief strength of book illustration in the 1860s was its emphasis on the syntax of draughtsmanship and its high degree of specialisation. The artists disciplined themselves to draw for a certain magazine or a certain public. Du Maurier recognised this at an early stage and made humorous social scenes, the comedy of high life, peculiarly his own. 'I do not see any others in the field against me,' he writes in June 1861, 'Little Walker who had the first start in *Once a Week* has cut me out there, his style is very much appreciated by the public and he has the knack of making his work easy to the engraver. But he is utterly without fun or humour of any kind, and so is Lawless, and therefore *Punch* is not for them.'

The prestige of magazine illustrating at this time can only be compared to the same status applied to the 'artistic' periodicals of the 1890s. As we have noticed the attraction of these publications was partly due to their growing technical excellence in reproduction, partly due to a more artistic readership and undoubtedly helped by the social position of editors like W.M. Thackeray, Mark Lemon, Edmund Yates and Dr. Norman Macleod. In the higher echelons of the arts they were also paying well; under no other circumstances would the great names have been persuaded to join this hitherto despised craft. 'Indeed the competition is becoming so pressing that it is only by unflagging industry that I can keep pace,' du Maurier wrote in 1862, 'There is Leighton drawing on wood now for *The Cornhill Magazine*, and other swells whom you have not heard of, who spare no expense in time, industry and models. There is little Walker who had greater talent than I and whom I can only hope to keep up with by straining every nerve so to speak . . .'[13]

A novel by George Eliot would have attracted Leighton no more than a novel by Trollope would have attracted Millais, if they had not embodied the ideals that swept the country in the 1850s. 'I am very anxious to be kept on O.A.W. as it is the swellest thing out,' du Maurier told his mother in 1861, 'and gets me known, and the more carefully I draw the better it will be for me in the end, as a day is coming when illustrating for the million à la Phiz and à la Gilbert will give place to real art, more expensive to print and engrave, and therefore only within the means of more educated classes, who will appreciate more . . .'[14]

It was particularly in their meticulous pen work and in their study of nature that the rising men most resembled the Pre-Raphaelite tradition. As soon as du Maurier came under the shadow of Frederick Sandys he came under that influence. He had been paying only £10 a year for a lay figure, even Leech had never used one, but with Sandys the study was nature or nothing. 'I never appreciated till now the full extent of Sandys' marvellous power of execution,' he wrote, 'but think it a thing to be acquired. Oh for the physical strength to work 10 or 12 hours a day like Sandys and not suffer.' Or again he admires the other artist's intensity of observation – 'If he has a path of grass to do in a cut, an inch square, he makes a large and highly finished study from nature for it first.' Something of this finesse and integrity comes over in du Maurier's drawings for *Once a Week* and *Good Words*, although more noticeably in the landscapes of Fred Walker, J. Mahoney, J.W. North and George Pinwell. If any further proof of the genesis of the new illustration was necessary it would be conclusively drawn from a remark by George Cruikshank. That irascible artist had burst out to the editor of *Once a Week* that du Maurier was 'a damned preraphaelite'. As du Maurier added delightedly, it was only likely to do him good and the other harm!

As the momentum of the new movement proceeded and three major magazines were founded, *Once a Week*, 1859, *The Cornhill Magazine*, and *Good Words*, 1860, it might have been expected that some support would come for the younger men from Rossetti and Ruskin. Rossetti's reactions were sweeping and perhaps ill-considered but not wholly unsympathetic. In a letter to William Allingham in November 1860 he says 'I quite agree with you in loathing *Once a Week* illustrations and all.' but he adds, that he would not mind opening a connection with the paper.[15] Ruskin's attitude, as might be expected, was much more mandarin in judgment.

Ruskin's antipathy was two-fold, a dislike of the cheapening effects of mass production and a mistrust of engravers that dated back to the time when he was writing *Modern Painters*. Of the first matter, Ruskin boiled over in the pages of *The Cornhill Magazine* in 1876, a splendid tirade of Victorian jargon and lofty sentiment.

'The cheap popular art cannot draw for you beauty, sense or honesty; but every species of distorted folly and vice – the idiot, the blackguard, the coxcomb, the paltry fool, the degraded woman – are pictured for your honourable pleasure in every page, with clumsy caricature, struggling to render its dulness tolerable by insisting on defect – if, perchance, a penny or two may be coined out of the cockneys itch for loathsomeness . . . These . . . are favourably representative of the entire art industry of the modern press – industry enslaved to the ghastly service of catching the last gleams in the glued eyes of the daily more bestial English mob – railroad born and bred, which drags itself about the black world it has withered under its breath.'[16]

The great critic's quarrel with the engravers was long-standing; there is scarcely a paragraph in *Modern Painters* that is not derisive of them and though much of this applied to steel rather than wood engraving, both came under much the same lash. The engravers of the earlier landscape books had altered his beloved Turner's landscapes on the plate, so his full fury was unleashed upon them. For Ruskin, facsimile engraving was too mechanical on the one hand and too subject to human error on the other. The engraving 'factories' and the dividing of blocks represented the hateful voice of the modern world and the interpretive rather than the craftsmanlike attitude of the engravers, a sort of tyranny. In his Oxford lectures he could speak with some reason – 'there is not one artist in ten thousand who can draw even simple objects rightly with a perfectly pure line; when such a line is drawn, only an extremely skilful engraver can reproduce it on wood; when reproduced it is liable to be broken at the second or third printing; and supposing it permanent, not one spectator in ten thousand would care for it.'[17]

Although this was probably over-stating the case, Ruskin's qualms about the result on

the printed page were natural. He could point to Albrecht Dürer's woodcut of 'The Dragon in the Apocalypse', where the line of the landscape was coarsely cut but was perfect in expressing the facts.[18] It was, he maintained, the engraver's job to express character not complexion, to use the softness of the substance to reproduce the light and shade drawn by the human hand, not to produce colour by varied line. 'All attempt to record colour in engraving,' he writes in *Modern Painters*, 'is heraldry out of its place; the engraver has no power beyond that of expressing transparency or opacity by greater or lesser openess of line, for the same depth of tint is producable by lines with very different intervals.'[19]

Ruskin could have been thinking of some of the early blocks for *Once a Week*; two spring to mind as typical of the insensitive approach of which he complained. J.E. Millais' first block in the new magazine 'Magenta' is so finely hatched and scraped as to be almost black, after staring at it one realises that the woman, if it is a woman, sprawled upon the bed, is reading a *newspaper*. Even if we take into account bad printing, it is inconceivable that Millais' original drawing could have been so totally lacking in contrast. Similarly, in December 1860, Holman Hunt's drawing 'Temujin' is handled with such awful coarseness by Swain that it is difficult to believe that the superfine draughtsman of 'The Lady of Shalott' could have had anything to do with it. Other examples could be quoted from the cheaper periodicals, but generally speaking Ruskin's strictures are over critical; the competent or excellent work seems to far outstrip the bad or mediocre. Without the original drawing, block and print side by side, it is however difficult to judge. But there was nevertheless a continuing tension for all artists except those who engraved their own work. As Philip James wrote: 'there could never exist that unity which Bewick gave to his books in which he, as the originator of the designs himself, cut the blocks and supervised the press work.'[20]

But it is only too easy to quibble over the deficiencies of such work without recognising the range, the quantity and the quality covered by artists and engravers in these brief dozen years. Gleeson White records nearly sixty magazines in his book and mentions two hundred and fifty artists, Forrest Reid considerably added to this list as well as classifying them more elegantly. The ones already mentioned, *The Cornhill Magazine* and *Once a Week* were the *sine qua non* of having reached the zenith as an illustrator and much the same could be said of *Good Words*. But the host of smaller publications catering for every taste and viewpoint must not be forgotten: *The Sunday Magazine* published by Strahan from 1865, *Belgravia* started by Miss Braddon, Mrs. Henry Wood's *Argosy*, 1868, *The Quiver*, with contributors like Robert Barnes, Paul Gray, A.B. Houghton and George Pinwell, *Tinsley's Magazine* already referred to, *The Broadway* which ran for seven years, *Saint Pauls* and *Dark Blue*, 1871-73. A noticeable advance which may reflect a change in the readership is the employment of women as contributors, illustrators, and even as editors in the 1860s. Some journals following earlier patterns were published entirely for women, the most famous of the newer sort being *The Queen*, 1860-61, containing fashion plates and samplers but not illustrated stories. Many other magazines ran articles on servants, cuisine and society, which must have been directed towards a feminine readership. The illustrator Miss Georgina Bowers, fl.1866-1880, made her début in the pages of *Punch* in 1866 and drew many vignettes, initials and socials for it in succeeding years. The woman as humorist was almost unheard of however and remained very rare indeed. Both Charles Keene and Harry Furniss shied away from caricaturing them and they did not emerge as caricaturists in their own right. At the end of the century M.H. Spielmann stated rather pompously, 'No woman has ever yet been a caricaturist, in spite of the fact that her femininity befits her pre-eminently for the part. That she has desisted is a mercy for which man may be devoutly thankful.'[21]

A number of magazines with excellent engravings in them were started for children, *The Boy's Own Magazine*, 1863, *Every Boy's Magazine*, 1863, *Aunt Judy's Magazine*, 1866,

Beeton's Annuals and the best of them all *Good Words For The Young*, 1869. In some ways the adult magazines were so charming and so comprehensive that any child might reach for them with delight, but in all cases they lacked colour, a powerful argument for returning to the nursery bookshelf. It was also some credit to the influence of artists of the 1860s that so many were employed by temperance societies, evangelical bodies and philanthropic institutions on tracts that would normally have been badly designed and badly printed. *The Band of Hope Review* was supported by Harrison Weir, L. Huard and John Gilbert and *The Leisure Hour,* an organ of the Religious Tract Society, contained an immense amount of illustrative work, some by Gilbert, George du Maurier and Simeon Solomon.

The least satisfactory side of these volumes was their overall design, the illustrations appear to be inserted without much consideration to the page and the types used for the text are often too small and hideous. Some of the original publisher's cloth bindings are very pretty and these are preferable to the re-bindings, even contemporary re-bindings in dull calf. *The Cornhill's* lovely cover design by Godfrey Sykes loses something from the red cloth being blind stamped. *The Churchman's Family Magazine* has gold stamped cloth in a gothic pattern by Bone and *London Society,* a maroon cover of the same by Burn, *Good Words* in blue cloth is stamped with gold only on the title and the spine.

The Cornhill Magazine

This publication was founded in 1860 with W.M. Thackeray as editor. Its aim was to maintain high standards in both literature and illustration and this it succeeded in doing during the forty-seven volumes of its first series. It was generally regarded to be at the zenith of magazine illustrating and du Maurier as we have seen was keen to enter its pages. The competition was increased by its policy of having fewer illustrations than its rivals and those mostly full page. The high standard of design runs through from the title-page and cover, commissioned from Godfrey Sykes, 1824-1866 (Figure 50). Sykes is best remembered today for his murals and decorations for the South Kensington complex of buildings, but here he has produced a vigorous Renaissance frontispiece, four vignetted figures in an architectural framework, owing something to the influence of Alfred Stevens. Sykes must also be credited with another unattributed classical design in illustration of 'Ariadne in Naxos' which appears in this first volume. It is surprising that although the artists employed were all in the first rank, neither this frontispiece nor any of the illustrations are given formal acknowledgement, though many are signed.

Figure 50. Cover of Cornhill Magazine *by Godfrey Sykes.*

Thackeray, the perennial illustrator of his own stories, is here, scratching through serial parts of *Lovel the Widower* and *The Four Georges,* but as his own editor, who could stop him! His figures seem weightless and scrappy, but he is too closely influenced by the Hogarthian tradition to adapt to the new drawing style. But in the same volume for July to December 1860 there were articles on William Hogarth, and the artists of the 1860s could feel that they were part of a school of British draughtsmanship.

The Cornhill Magazine did have a greater homogeneity about it than other publications such as *Once a Week,* all the illustrations were printed on higher grade plate paper and only initial letters on the text paper; initials and illustrations are usually by the same hand. The most remarkable feature of the magazine however was its power to attract the Victorian Olympians. Not only were Thackeray's novels appearing between its covers, but in successive volumes were the first appearances of works by Elizabeth Barrett Browning, Anthony Trollope, Matthew Arnold, George Eliot, Mrs. Gaskell and Wilkie Collins. It was clearly the attraction of such a team that persuaded Frederick Leighton, Frederick Sandys and John Everett Millais to contribute so regularly when so seldom illustrating elsewhere. But it was also in these pages that the young Fred Walker was first given his head as a black and white artist. Millais' formidable series of designs for the *Barchester* novels has been dealt with, Sandys and Walker will be considered separately, Leighton's illustrations for 1862-63 are exceptional, even in an oustanding decade.

Leighton's drawings for books are rare and it was a stroke of genius to combine his scholarly classicality with the texts of George Eliot's *Romola.* Without any doubt George Eliot's name gave the project an additional glamour to the thirty-two year old artist, only four years away from election to the Royal Academy. 'It is an Italian story,' wrote Leighton to his father in 1862, 'the scene and period are Florence and the fifteenth century, nothing could "ganter" me better. It is to continue through *twelve* numbers, in each of which are to be *two* illustrations.'[22] From the very first artist and author were on friendly terms and

George Eliot consulted Leighton, an acknowledged Italian expert on the meaning of words and on costume. 'I never saw anything comparable to the scene in Nello's shop as an illustration,' she wrote to him in the early numbers, 'There could not be a better beginning.'[23] Later on she criticised the position of a head but added as an afterthought, 'You have given her attitude transcendently well, and the attitude is more important than the mere head-dress.'[24] George Eliot had the advantage of seeing all of Leighton's highly finished pen drawings before they were engraved, we only have the results after the cutting. Probably the ones that most impress us today are those least redolent of Victoriana. 'The Blind Scholar and His Daughter', 'Suppose You Let Me Look At Myself' or 'The Escaped Prisoner' have that curious sense of pantomime that nineteenth century history painting usually brings. But when Leighton looks at the fifteenth century through the mind of its own painters as in 'The First Kiss', 'The Dying Message' or 'Coming Home' (Figure 51) the effects are marvellously structural, great play being made with the folds of materials and the contrasts of light and

Figure 51. 'Coming Home' by Frederick Leighton.

shade. Leighton is one of the few artists of the period to use shadow sparingly but really effectively, and he does so with the central figure in 'Niccolo at Work', the best classical model to emerge during the whole period. The corpus of this work was so highly rated that it was issued in a special edition of the novel in 1880. Leighton's first work for the magazine had been 'The Great God Pan' in the summer of 1860 but he was not satisfied with the engraving. The latter was a Dalziel block and he seems to have demanded a change to Swain for *Romola,* the results of those being wholly admirable.

Other notable contributions are in du Maurier's drawings for Mrs. Gaskell's *Wives and Daughters* in Volume 9 and Sir Noël Paton's only appearance 'Ulysses' in the same volume. That stalwart artist, Miss M. Ellen Edwards, at the outset of a long career, supplied eleven illustrations for Trollope's *The Claverings* in 1867 and F.W. Lawson makes his début with four drawings in the same year. In the 1864 volume we find G.J. Pinwell, Charles Keene and G.H. Thomas, a nicely contrasted trio, Robert Barnes, that most regular artist in later issues, arrive for the first time and Luke Fildes comes on the scene in 1870.

Two artists persist from the earlier tradition, Richard Doyle and C.H. Bennett, 1829-1867, bringing with them a facetiousness and whimsicality which suits the Thackeray ethos rather better than that of the other authors. Doyle continues his 'physiognomies' which began with 'Manners and Costumes of Ye Englishe' in *Punch* in 1849. Here they have become 'Bird's-Eye Views of Society' even more densely packed with figures than their predecessors and more sharply drawn. In the opening pull-out plate 'At Home Small and Early' the artist shows a nightmare of a party; overblown guests in the voluminous and constricting costume of the day jostle for position and food while the gasoliers burn hot overhead. Every face is carefully realised and shadow is almost excluded; no wonder the Pre-Raphaelites liked Doyle; he even includes an intense Rossetti female in the right foreground of the composition! We are then shown a 'Juvenile Party' no less crowded than the adult one, 'A Morning Party', 'A State Party' and 'A Country Ball', everywhere a profusion of food, a vivid motley of clothes and character and a revealing study of temperament. We then move on to the more public world of 'The Picture Sale', 'At The Sea-side' and 'A Popular Entertainment' with the same painstaking detail, nearly photo-graphic sweep of vision and mass of isolated narrative incidents. Doyle looks at life with a strange fanciful innocence like that of a child, his lack of gradations in colour reflect his ingenuous observation of character, everything is either black or white. Doyle's richly imaginative side is seen here in the initial letters to the series, especially in that to 'A Charity Bazaar' where 'C' (Figure 52) becomes a turmoil of mischievous sprites reliev-ing an elderly man of his money, his watch and everything!

C.H. Bennett's poorly drawn but expressive illustrations of passengers on 'The Excursion Train' and at 'Covent Garden Market', make even stranger company with the dexterous work of Fred Walker, but like Doyle's, their vein of comedy is refreshingly

Figure 52. Decorative initial by Doyle.

pungent. It was to be a long time before such direct almost surreal creations as Bennett's reappeared in books with all their delightful crudities. The initial letter 'F' (Figure 53) of a train, half snake, half child's toy, blowing its preposterous way across the page, was lost for many years to come in the high-minded factualism of the later illustrators.

The Cornhill Magazine did not fall off in quality as dramatically as its rivals at the end of the 1860s. There are still some fine drawings and interesting literary contributions in the 1870s, Helen Allingham produces good work for Thomas Hardy's *Far From The Madding Crowd* in 1874 and the following year du Maurier tackles the same author's *The Hand of Ethelberta* and Henry James' *Washington Square* in 1880. Initial letters for this serial show what a deft designer du Maurier still was until the early 1880s. Well into the decade there are interesting names, Harry Furniss, R.C. Woodville, G.G. Kilburne, Frank Dadd and Towneley Green. Arthur Hopkins, 1842-1930, produces fussier and fussier social subjects and William Small develops a slick smooth technique without the beauty of his early work. Curiously enough the magazine lists the artists for the first time in 1883, two years later it dispensed with them altogether.

Figure 53. Decorative initial by C.H. Bennett.

Good Words

This sixpenny religious publication edited by Dr. Norman Macleod, began in 1860 and had a meteoric rise to 1862, employing some of the best artists of the day. From 1863 with its change of venue from Edinburgh to London, there is a steady decline in its interest, drawings from photographs beginning to replace original work. Macleod, a chaplain to Queen Victoria and the son of a Moderator of the General Assembly, was more literary than visual but gave good scope to his evangelical leanings through the arts. During his early years, *Good Words* produced some outstanding things, in the *annus mirabilis* of 1862 came Millais' *Parables* already discussed but also fine work from lesser known artists. In that extraordinary year there is representative work by Millais, Sandys, Whistler, Keene, Holman Hunt, Burne-Jones and Boyd Houghton.

The greatest surprise of all are the two illustrations by the young Whistler, one showing the crouching figure of a girl by a fire and the other of a girl at a writing desk, both reflecting the vital line that was too powerful to contain this artist in book illustration. Edward Burne-Jones, who was to be one of the few artists to contribute to both the great periods of illustration, the 1890s as well as the 1860s, has two designs in 1862-63. The first is a rather grand composition to 'King Sigurd the Crusader', a poem by the Aberdeen poet, William Forsyth, and the second 'Summer Snow' a more typically lyrical subject of a girl bent over a letter, with the Pre-Raphaelite accessories of a full-flowing skirt, a brick wall and partly glimpsed tree branches. Burne-Jones seems to have disliked drawing on the wood and these are his only contributions to the magazines although he was later to draw for Dalziel's *Illustrated Bible.*

Both Sandys and Houghton are seen in 1862 in the height of their power and so are T. Morten and Holman Hunt. Morten is best represented by 'Pictures in the Fire' and 'The

Carrier Pigeon', Hunt by the distracted figure of 'Go and Come'. M.J. Lawless makes two splendid drawings 'Rung into Heaven' and 'The Bands of Love', rather softer than his usual mannered style. Works by H.H. Armstead, Fred Walker and J.D. Watson are scattered elsewhere and there is an infinite variety after 1863 in pictures by J. Wolf, R.P. Leitch, G. Pinwell, Florence Claxton and John Pettie. Two artists who sustain their early promise in the magazine from 1865 are Paul Gray and Robert Barnes, the first with some stirring costume subjects for Charles Kingsley's *Hereward the Last of the English* and the second in the protracted serial, *Alfred Hogart's Household,* by the now forgotten Alexander Smith. These are beautifully drawn and show in such plates as 'Come Along' and 'Puir Thing' a distinct debt to Millais' contemporary figures through the compositions of Fred Walker.

Until 1869 the quality of the magazine was maintained by the work of George Pinwell and Arthur Boyd Houghton, who will be dealt with separately. In April 1867, William Small illustrates Macleod's story, *The Starling,* with some very good country characters and Luke Fildes contributes an unusual scene 'In The Choir' for the following August. In 1868, Small is again very much to the fore with his domestic scenes for Mrs. Craik's story, *The Woman's Kingdom,* the initials for this

Figure 54. 'Macleod of Dare' by John Pettie.

being particularly charming, F.A. Fraser and J. Leighton also feature. Apart from the early work of Hubert von Herkomer, designs by J. Mahoney and Arthur Hughes, the later volumes tail off into the nondescript. There was an Indian Summer of the magazine's fortunes in 1878, when a group of 1860s men returned to draw for William Black's story, *Macleod of Dare.* The artists included G.H. Boughton, John Pettie (Figure 54), P. Graham, W.Q. Orchardson and J.E. Millais. Pettie in particular excelled himself in his portrayal of the Highlander.

Once a Week

This was the first major magazine to be extensively illustrated by the new group of 1860s artists. It appeared for the first time on 2 July 1859, an attempt by the publishers Bradbury and Evans to rival Charles Dickens' popular but unillustrated magazine, *All The Year Round.* They chose as their editor Samuel Lucas, 1818-1868, a well-tried

journalist with a strongly educational approach, accounting for the pictures of natural phenomena, archaeological specimens and topography in later numbers. His assistant and successor from 1867 was Edward Walford, a prolific journalist who was first an Anglican clergyman and then a convert to Rome. Both men benefited from sharing the same ownership as *Punch*, were frequent visitors to the *Punch* 'Table' and had the enormous advantage of being able to call on *Punch* artists. There is a very strong flavour of the other journal in early numbers,[25] especially in the contributions of John Leech, H.G. Hine and Hablot K. Browne, but it soon establishes its own identity with the younger men. Leech's socials are still marvellously vigorous and witty drawings but they do begin to date a little beside the subtlety of Fred Walker, M.J. Lawless and early Charles Keene.

It was probably Leech's influence that tempted Millais into *Once a Week,* with twenty illustrations in the first three volumes, July 1859 to December 1860. They vary a great deal in quality and in printing, the most enduring image being the engraving to Alfred Tennyson's poem 'The Grandmother's Apology', a sensitive study of the gentleness of age towards youth. But in 'A Wife', 'Practising', 'Musa', 'Violet' and 'A Head of Hair For Sale' we enter his most lyrical vein, lovely uncluttered outlines with superb light and shade. In 'La Fille Bien Gardée', a beautiful girl watched over by a dog, there is the gentlest hint that it is one of Leech's young ladies! There are several historical subjects too, less successful and less well interpreted by the Dalziels, although 'The Plague of Elliant' is very powerful.

Millais' contributions dwindle in 1861, the first half-year having like the second volume of 1860, only two works. In the last 1860 volume there is the warrior figure of 'Tannhauser' and 'Swing Song', a sentimental picture of childhood foreshadowing some of the later paintings. The illustrations for 'Thor's Hunt For His Hammer' and 'Iphis and Anaxarete' in the first volume of 1861 are in his most poetic style, perhaps a reaction from the amount of modern genre subjects he was doing for Trollope at this time.

Once a Week gave a prominent place to Charles Keene at the start of his brilliant career, as an illustrator of serials. He begins with half pages for Charles Reade's *A Good Fight,* most unsuccessful work in a jocular medieval style imitating German woodcuts. Fortunately the proprietors gave him his head and he produced sketches of contemporary life where his penchant for humour and fine penwork were combined. 'The Foundation of My Picture Gallery' (Figure 55), the study of a connoisseur, shows the artist at his best, the central figure carefully finished, the background merely suggested. The following year, 1860, the commission to illustrate George Meredith's *Ewan Harrington* brought thirty-nine exquisite drawings into the pages. Keene's work on these is uneven but sometimes they are equal in handling to the figure studies of Millais and Walker, though with that heavy characterisation of the faces that Keene made his own.

Another of the magazine's early contributors was Sir John Tenniel, seen to advantage in both illustrations of Old Norse legend and Goethe and in

Figure 55. 'The Foundation of My Picture Gallery' by Charles Keene.

the domestic scenes for Shirley Brook's story *The Silver Cloud*. Tenniel emerges as a very much more versatile draughtsman than *Punch's* cartoons would lead one to suppose, but he is happiest in his drawing of 'Eckhart The Trusty', a vision of elfland to a poem by Goethe. Tenniel of course is just one of a number of Victorian illustrators whose childhood fears and delusions seem to smoulder under the surface, only to burst out in zaney worlds where children and hobgoblins have complete control. The owls, bats and puckish denizens of the woods seem far more alive than the bewildered youngsters they surround. The treillage of rustic woodwork and twisting ivy that frames this very decorative page, points to Tenniel as the artist of the magazine's frontispiece. C.H. Bennett, that very fertile artist already mentioned, whose comic invention usually outstripped his drawing ability, has one very weird drawing, 'The Song of the Survivor', conceived with the same disturbing impersonality as Tenniel at his most fantastic.

W. Holman Hunt supplies three illustrations, 'Temujin' which has been referred to, 'Witches and Witchcraft' and 'At Night', a contemporary deathbed scene, very even in tone and full of the artist's religious intensity. *Once a Week* was also unique in having secured no less than four illustrations by J. McNeil Whistler, very free in their execution and quite unlike any of the other work; his kneeling girl in 'The Relief Fund in Lancashire' must have appeared very novel to the readers, looking forward as it does to the mastery of the pen line in reproduction at the end of the century.

Charles Green, George du Maurier, Edward Poynter, F.J. Shields, J.D. Watson, F.W. Lawson and Paul Gray all contributed to the first thirteen volumes of *Once a Week*. A new series began in January 1866 and another in 1868, but the standard of creativity and execution, so notable in the early days, declined until there was little difference between it and the cheaper magazines. That great triumvirate of George Pinwell, Fred Walker and M.J. Lawless did much of their early work for the publication, and the two former illustrators and Frederick Sandys are dealt with below.

The Churchman's Family Magazine

Although not as considerable as the 'big three' magazines, *The Churchman's Family Magazine*, founded by James Hogg in January 1863, is attractive and representative of the period. Its blue and gold cloth binding is very striking and like so many designs of the time is the work of John Leighton. The illustrative contents are surprisingly varied and exciting after that ominous sub-title that claims 'the Clergy and Distinguished Literary Men' as its contributors. J.E. Millais has two drawings of the 'Framley' type and similar domestic genre scenes are continued by J.D. Watson and A.W. Cooper, one of the best being the former's 'Sunday Evening' in Volume 1, page 191. Watson is equally at home in more dramatic company and two other works are 'The Christian Martyr', a free rendering of Sandys' 'Rosamund' in *Once a Week* a year or so before and 'The Hermit', a strong piece of figure drawing worthy of anything in Dalziel's biblical collection. E.J. Poynter makes an early appearance in two half pages that seem scratchy enough, but the poor paper probably accounts for it; his full page 'The Painter's Inspiration' is a fine thing (Figure 56), an artist with his back to the reader works on a Rossetti-ish canvas of a woman with a lute. F.R. Pickersgill is seen once again as the most interesting artist among the older generation; his 'Summer Evening Reverie' is boldly drawn, well composed and has a great sense of texture,

expressed through the wood engraving. The trees are in a beautiful shadow and the stonework lit by the setting sun. Thomas Morten has a pair of seascapes, 'Black Peter's Little Passenger' and 'The Moment of Danger', in Volume 1. He is one of those artists to whom an incident of pathos comes easily and an incident of humour hardly at all; his one attempt here on page 432, is completely stylised and wooden. But his last illustration in Volume 2, 'The Bell-Ringer's Christmas Story', gains by the superb characterisation of the old man whatever it may lose by the feeble drawing of the girls. The location is suspiciously close to Millais' *Moxon* bell chamber! An artist who appears fairly consistently in both Volumes 1 and 2 is Charles Green, later to find fame as a Dickens illustrator, here confined to one or two small half-page genre subjects and a surprising 'Henry II and Beckett'. The earliest two volumes seem to have a good balance between the old and new illustrators, including in this the amateurism of Cuthbert Bede and the idiosyncracies of M.J. Lawless. Lawless's most celebrated illustration here, published by Gleeson White, is 'One Dead', a death-bed scene that is among his strongest and least mannered works. 'Harold Massey's Confession', Volume 3, page 64, is much more vintage

Figure 56. 'The Painter's Inspiration' by E.J. Poynter.

Lawless, figures in dark outline, crowded together in the lower part of the picture space, the background almost frieze like.

Louis Huard's genre scenes 'Decorating the Church', 'Hooray', and 'Bring Home the May' are pleasantly handled, and in Rebecca Solomon's work there is a fine flow, especially in 'An Ambiguous Direction', Volume 1, page 564, where the figures of the women and their full skirts form a great elipse in the centre of the page. But the canker was already present. Although the magazine continued its High Church articles and had work by J.D. Watson, M.E. Edwards and A.B. Houghton in the following two years, it was relying already on far inferior artists. Florence Claxton's dreadful social subjects predominate and it is possible without visual aids to guess the sort of meal she would make out of a title like 'Murmur, murmur, rippled the Happy Child's low toned Monologue'. Like many of its competitors, editorial discrimination soon could not distinguish between the first and second rate and cut-price; gradually hackwork succeeded real talent and imagination in its pages.

London Society

Perhaps the most revealing way of looking at the problems of the magazines of the 1860s and of why such hopeful publications as *Once a Week* or *The Churchman's Family Magazine* declined in standard, is to examine their accounts. Few of these survive, but the papers and accounts of *London Society* from 1867 to 1873 do survive and provide valuable background information.[26] The magazine never had the prestige of *The Cornhill* or *Once a Week*, but it produced consistently good work in its pages and established artists as

well as promising ones were eager to appear. Towards the end of its best period, in 1870 in fact, the magazine was acquired by the firm of Richard Bentley and continued by them for a further three years.

London Society had been started in February 1862 under the editorship of James Hogg, ubiquitous proprietor, to be run as a popular illustrated shilling magazine. Hogg, 1806-1888, was a canny Edinburgh publisher whose experiences had taken him through at least two earlier periodicals. Its appearance was heralded enthusiastically by du Maurier. 'I have done the cover for this Periodical,' he wrote in December 1861, 'which will appear every month from the 1st February under the name of London Society, and I shall probably have to bring out a series of these sketches for which I get 6 guineas a piece, but shall charge more if they are twigged.'[27] Du Maurier's ideas were not over optimistic, he illustrated for the magazine consistently, but this first drawing of London Bridge was considered a 'shocking failure' and had to be redrawn at the artist's expense!

Whatever Hogg's hopes for *London Society,* it maintained a good circulation among the public until he sold it to Bentley. In the autumn of 1870 the magazine had a print order of nearly 15,000 copies, only a fraction of a giant like *The Illustrated London News,* but a healthy number for mid-Victorian England. The following year it started a steep decline to just over 13,000 copies in March 1871, picked up once more during the summer issues and finally sank to 11,750 copies at the end of 1871 and the beginning of 1872. It would probably be too simple an explanation to relate this to Bentley's management and his lack of sympathy for an illustrated periodical. The boom in magazine publishing was dying down after the euphoria of repealed legislation, the editors who typified the quality of the early 1860s had moved on and the draughtsmen of the period had graduated to being painters. Paradoxically the black and white men of this decade were too good to prevent a lowering of standards. 'It must not be forgotten,' writes Gleeson White, of Millais, 'that high prices are often responsible for the desire, or rather the necessity, of using second-rate work. When an artist attains a position that monopolises all his working hours, it is obvious that he cannot afford to accept even the highest current rate of payment for magazine illustration; nor, on the other hand, can an editor, who conducts what is after all a commercial enterprise, afford to pay enormous sums for its illustrations. For later drawings this artist was paid at least five times as much as for his earlier efforts, and possibly in some cases ten or twelve times as much.'[28]

There is therefore a noticeable falling off of artistic quality in *London Society* between James Hogg's proprietorship and that of Richard Bentley; the former ran between ten and twenty illustrations to each monthly issue and although Bentley did much the same, the names that his predecessor was able to command are no longer there. The one exception, who was Bentley's discovery and Bentley's alone, was Randolph Caldecott who first came into prominence through its pages in late 1871.

London Society was far too small an organisation to have a permanent staff of artists, none of the monthlies did, although *The Cornhill Magazine* had a small number of illustrators tackling long series. The editorial policy seems to have been to employ the more important professional men in full page for stories and at certain seasons of the year, leaving the text illustrating to the secondary man and the amateurs. There were always a few of these, varying from vicars to society ladies and differing in competence between the professional and the downright awful! There were obvious disadvantages in employing them, much of their work would have to be redrawn and often they were unable to draw straight on the wood, meaning extra engraving work, time and money.

Payment depended on the illustrator's place in the hierarchy mentioned earlier, but also to some extent on the size of the work undertaken, initials and tail pieces running at a very reasonable rate, double page illustrations and work involving colour being exceedingly

highly graded. The two special issues, the Christmas Number and the Holiday Number (June) carried higher honorariums, but for most illustrators there was no alteration to the standard rate and even this was often equal to some and more equal to others! The boasts of Millais and du Maurier, at the outset of the 1860s, about the sort of income they could make as illustrators were probably justified. £500 or £800 a year were the tokens of success and of great success when added to the prizes of fashionable landscape and portrait painting. The amateur artist was well pleased to make £100 out of his hobby. But for the majority of artists, unless it was a youthful stepping stone, the life of magazine illustrating must have been one of grind and frustration.

The usual fee for drawing a whole page illustration in *London Society,* usually a block of 7½ by 4½ inches, was five guineas. Between 1867 and 1870 the proprietorship seems to have erred on the side of generosity and increased it to six guineas. The rate for a half-page illustration was two guineas or three, depending on the quantity of work in it or the standing of the artist involved. For example George Pinwell received six guineas for drawing 'Beautiful Miss Johnson' in August 1867 and Charles Green seven guineas for 'All's Well That Ends Well' in September, slightly above the average price, presumably in recognition of their earlier work in illustrated books. Other artists to rate a higher price included William Small, eight guineas for an illustration to a poem in November 1867, J.D. Watson, ten pounds for a similar subject in March 1868 and Bouverie Goddard, six guineas for a full page animal subject in November 1867. Du Maurier who had drawn that first frontispiece in 1862 and hoped to get six guineas was getting ten guineas per drawing by January 1868 and his friend Charles Keene received twelve guineas for a full page in November 1868, both were by this time renowned *Punch* draughtsmen and to James Hogg the extra money would appear well spent. The most consistently highly paid illustrator in the magazine remained John Gilbert, who received ten guineas for every drawing quite irrespective of subject or issue. He was usually an indispensable part of the Christmas issue where his 'Spirit of Good Cheer' or 'The Old Year' gave him freedom to sentimentalise the feast, making it as much his own in line as Dickens had in print. The highest single price for a drawing on the block was fourteen guineas paid to H. Stacey Marks for a Christmas Number in 1870; Marks, who was elected an ARA the following year, had made a reputation out of rather conventional medieval subjects. In August 1868, when Hogg wanted a special cover for his Holiday Number, he commissioned it from John Leighton, the illustrator and book decorator, at a cost of seven guineas, a proportionately good figure when one considers it rated the same as a full page illustration and publishers thought of decorators as a minor branch of art.

It is amusing to find that a sensitive young draughtsman of twenty-four, who had trained as a Marine Engineer and had his first drawing published in *Punch* in 1867, was already on the books of *London Society* in 1868. His name was Linley Sambourne, 1844-1910, and he was earning three guineas for a full page illustration! Sambourne could have been described as an untried artist and his 'Sedan Chair' design of November 1869, for which he received the same sum, lacks assurance. Yet Sambourne was to gain a seat at the *Punch* 'Table' within a few years and live in considerable style at 18 Stafford Terrace, so for the successful artist there were attractive rewards. Sambourne would have thought of himself as a professional and yet T.S. Seccombe, an Indian army officer, and the Hon. Hugh Rowley were definitely amateurs. Seccombe drew for a hobby and Rowley, the son of Lord Langford, was a man of independant means with a house in Albert Gate, yet both received five guineas for their pages. Georgina Bowers, Florence Claxton, Louis Huard, J. Abbot Pasquier and Robert Dudley, professionals but not of the first rank, received from four to five guineas. M. Ellen Edwards, who was later to be the chief star in the Bentley galaxy as illustrator of all Mrs. Henry Wood's novels was not yet highly rewarded at five guineas per picture. Kate Edwards, that superb draughtsman of the single female figure, received four

Seven little Soldier Boys were playing funny tricks,
One, just in fun, let off his gun, and then there were but 6.

NEVER a word fpak' bonnie Jeanie
Roole,
But---"Shepherd let us gang :"
An' never mair, at a gloamin' buchte
Wad fhe fing another fang.

pounds for her 'Autumn Reverie' in 1867 and though no records show it, probably the same sum for the brilliant 'June Dream' of a year earlier illustrated here (Figure 57).

L. Straszynski received 15s. for a small initial letter and £2 5s. for a large one. Another contributor who was yet to make his name was W.S. Gilbert of Gilbert and Sullivan, who submitted an article illustrated by himself 'Thumbnail Sketches' in the middle of 1867 and a similar piece called 'Getting Up a Pantomime' at the end of the year. For the first he received £7 15s. and the second £10 4s., not princely for a man whose pen had two uses and was already known for the grotesque little sketches decorating the pages of *Fun*.

Figure 57. 'June Dream' by Kate Edwards.

A certain disparity is accounted for by those artists who drew directly on the block and those whose work was drawn on it for them by the engravers. It is surprising to find the veteran illustrator James Mahoney having his drawing put on the block for him in September 1870 at a cost of £11 5s. 9d. One of Gilbert's subjects, for which he was paid ten guineas, cost a further six guineas to be engraved by J.W. Whymper. If Whymper had had to put it on wood as well, the cost would have been over twenty pounds; small wonder that the artist who only produced a sketch was paid less. Most of the artists and engravers were prepared to produce work at a discount as J.W. Whymper wrote to the editor in 1871, 'it will be obvious for you that it is only a regular supply of work that makes men keep their prices at the lower figure.'[29] Hogg occasionally employed foreign artists like Jules Pelcoq, Gustave Janet and Moullin, apparently with that Francophile, Henry Vizetelly, acting as agent. Their remuneration seems to have been very much below the British average. Pelcoq being paid eight pounds for '6 dessins sur bois' in the same half year that Marks received fourteen guineas for one!

The new company which took over the magazine in the autumn of 1870 did not greatly alter its payments although some earlier contributors benefited. Alfred Crowquill, who was distinctly old-fashioned and had been poorly recompensed under Hogg, received eight guineas for a Christmas page and George Cruikshank Junior, a very weak artist, got a three-quarter page subject to do for three guineas. H. Tuck did some socials at £2 10s. a time and Sambourne has a frontispiece of Valentine for which he was paid five guineas. Many of the older men and more distinguished names have disappeared, all the more surprising because Henry Blackburn, art critic and writer on illustration, was editor for the next two years!

Blackburn's great *coup de main* was the discovery and recognition of Randolph Caldecott, 1846-1886. A parcel of drawings addressed to him from Manchester arrived at his office in late 1870 and he at once realised that he was in possession of wildly original work. Drawings of matchless freedom spilled out, they were not conventionally well drawn, but pen and ink sketches full of humour, presenting a world as seen by a jovial overgrown schoolboy. They were in fact not of the 1860s at all, but looking forward to colour books for children and the establishment of Routledge and Warne's picture books. In his life of Caldecott, Blackburn refers to this period. 'The freshness of fancy, not to say recklessness of style, in many of the drawings which came by post at this time, the abundance of the flow from a stream, the course of which was not yet clearly marked — raised embarrassing

thoughts in an editor's mind. What to do with all the material sent?'[30]

Blackburn bought it, or a lot of it and detailed accounts remain. Within the first year Caldecott was receiving £5 10s. for a full page drawing and a guinea for smaller subjects. His spirited work which really looked like pen work and not simply like an engraver's idea of it, depended a great deal on the minor items. Caldecott's spontaneous talent developed vignettes and jottings that were as important to the page as a full scale work. His accounts are therefore sprinkled with small items: '2 ball room sketches half page each £1-10-0', '1 small outline "Heigh ho the Holly" 15/-', 'Frieze — Irish landlord & tenants £2 : 2 : 0', '1 small outline Young Lochinvar 15/-'. During the first half of 1872, Caldecott earned £38 through the pages of London Society and by 1873 he was getting £10 14s. on every issue, thus giving him an income of £120 to £140 from this source alone. In addition of course he was working for the Manchester journals and was employed at his bank. As Blackburn rightly points out, it was *London Society* that gave him a London audience and the financial independance to migrate to the south and devote himself entirely to magazine and book illustration.

G.J.Pinwell

George John Pinwell, 1842-1875, is best remembered today for his highly finished watercolours of rural scenes, the colour applied with a jewel-like brilliance, the whole spectrum giving a kind of radiant peace. It is often forgotten that he began life as a black and white artist and that many of his most successful paintings are based on illustrated work in anthologies and magazines.

Pinwell was a Buckinghamshire man, born at High Wycombe in 1842, the son of a builder. His father's death left him in very straitened circumstances and at a young age he was employed by a firm of embroiderers to make designs for them. This unusual training gave him a keen sense of design, pattern and colour which was a great strength in his later work. Pursuing his own fortune, despite difficulties, Pinwell entered himself at St. Martin's Lane School and in 1862 joined Heatherley's. That year he produced his first batch of illustrations for *Lilliput Levee*, 'The Happy Home' and 'Hacco The Dwarf', as well as sending a few drawings to *Fun*. He gained more practical experience when he was apprenticed to J.W. Whymper, 1813-1903, succeeding Fred Walker as chief figure draughtsman at the firm.

During 1863 Pinwell widened his scope to include work for *Once a Week, Good Words, London Society, The Cornhill Magazine* and others, as well as being befriended by W.J. Linton and becoming closely associated with the Dalziels. It was in fact these industrious brothers (dealt with below), who gave him his first great chance in 1864, the illustrations for their own edition of *Goldsmith's Works.* It was this volume, that Williamson called 'a model of what an illustrated book should be',[31] and its forty pages of drawings proved Pinwell's maturity to have arrived, the vision poetic enough but literal and accurate too. The artist worked methodically at this, producing the illustrations week by week for the parts, completing it in about six months. More work followed from Dalziels, *A Round of Days, Wayside Posies, Poems by Jean Ingelow, North Coast and Other Poems,* all with that distinctive arrangement and lyricism that Pinwell made his own.

Pinwell was much more of a landscape artist than his contemporary Fred Walker and, where he shows landscape, there is a great deal in it to occupy the attention. He accurately

observes his backgrounds, they are never static like Walker's but filled with a continual flight of birds and movement of beasts. All the hedgerows are alive with activity and the figures are not intruders but merge naturally with the thickly growing grass and flowers. He returns frequently to Devon and Somerset for inspiration and the grey stone walls of a favourite manor house, Halsway Court, appear and re-appear in the drawings. They are the backdrop to the watercolour 'Away From Home' and also in 'The Unwilling Playmate' and 'The Dovecote' from *English Rustic Pictures*, 1865 (Figure 58). This variant, in the Victoria and Albert Museum, shows the same gables and chimneys framing the heads of the two rustic lovers, negligent of all around them, but so much a part of it, while inquisitive geese investigate the beautifully modelled basket. Every drawing is vibrant with this love of nature, some of the figures in *North Coast* are surrounded by a Noah's Ark, full of wild and domestic animals, decoratively placed, perfectly expressive of verse rather than prose. Even with his occasional sallies into urban life as with Dickens' *Uncommercial Traveller*, 1868, Pinwell searches out the passages that find people in relation to nature.

Figure 58. 'The Dovecote' by G.J. Pinwell, 1865.

The enduring memory of Pinwell is still as a watercolourist and not as an illustrator, so many of the former survive, so few of the latter. But they are really illustrations, these visionary fragments of the countryside, full of light, teeming with interest, Pre-Raphaelite in their hues but also looking forward to a more synthesised application of washes that would end with Wilson Steer. Walker, it is noted 'could not understand Pinwell's rough handling, or appreciate his touches of brilliant colour, and his experiments in the combined use of different colours and methods in the same picture.'[32] One leaves Pinwell with this impression of ethereal loveliness, hastily sketched women in the great bell-like dresses of the 1860s, parasols aloft, moving across meadows of yellow-green grass amidst a flurry of white birds. Even if Pinwell did not live long enough to develop his mature style, his influence on illustration was great. The *Goldsmith* series sowed the seeds of a simpler approach to historical illustrating and his bright colours found an echo in the sumptuous process books of the Edwardians.

Fred Walker

Fred Walker, 1840-1875, was perhaps the most classically academic of all the illustrators of the 1860s. Far less adaptable than a Millais, and far less dramatically accomplished than a Sandys, his gifts were nevertheless of an extremely high order. In thinking of Walker one turns one's mind more to the inhabitants of the countryside than to the countryside itself, the reverse of Pinwell; women sitting by their fireplaces, sewing or stirring the embers, children at cottage doors, men trudging home from the fields. Walker would seem to be the

perfect depictor of George Eliot or Thomas Hardy, in fact he missed the former and was too early for the latter, the long rural tales of which the Victorians were so fond seem to have eluded him. He served the Thackerays well, for W.M. Thackeray he illustrated *The Adventures of Philip in His Way Through The World* and for Miss Thackeray *The Story of Elizabeth* and *The Village on the Cliff.* But the first had a more or less metropolitan setting and the last consisted of only six designs, certainly Walker's short illustrating life, 1860-64, could have given him more opportunities.

Walker was born in Marylebone in 1840, the son of a designer of jewellery. The family were poor and the father's early death left them even poorer and gave little scope to the son in the choice of a career. But Walker was fortunate in being the first generation that had grown up with illustrated journalism and with his aptitude for drawing was able to copy engravings from Cassell's informative books and other plentiful and cheap periodicals. He was first of all placed with an architect, which lasted until 1857, and then entered Leigh's Newman Street Studio to learn drawing, studying the Elgin marbles in his spare time. This was followed by a spell as a student at the RA Schools from March 1858, but in all these places, Walker proved to be an original artist not a natural student. A more fruitful training opened up to him in November 1858, when he was apprenticed to the engraver J.W. Whymper, working in his establishment for three days a week for the next two years. Walker met J.W. North there and Charles Green, but more significantly he learnt the basic requirements that an artist needed to draw for the engraver, a knowledge that gave him pre-eminence as a technician.

Walker was small and slight and nervous, but had a disarming manner and generous nature that won him a wide circle of friends. Both the du Maurier and Millais circles referred to him affectionately as 'Little Walker' but this was not a disparagement, both recognised his great powers as an artist. Even before his name was established in 1859, he was clear about his intentions to use black and white work as a stepping stone only. 'I am busy now, and shall be; and for all the future shall look to making more by word drawing than painting, till I have advanced in practise to that extent, that I can *rely* on painting with safety.'[33]

His first important illustrations for *Once a Week,* beginning on 18 February 1860 with a characteristic subject 'Peasant Proprietorship', show no discernible strength in the drawing of country types. By April, Walker was contributing domestic genre subjects such as 'Apres' and 'Tenants At Number-Twenty-Seven' which are nicely balanced if unremarkable. With the second volume for 1860 we begin to recognise that gentle sympathy for the countryside by which he is most recognised. The first illustration for Eliza Cook's poem 'Once Upon a Time' has an elderly smocked rustic walking in front of a thatched barn with children in its shade and the more usual 'F.W.' signature superceding the full name. In October 1860 we find Walker promoted to the unusual position of illustrating a period story 'The Herberts of Elfdale', very strong figure drawing throughout, but what is more impressive, a real understanding of trees, grass and flowers. His tree trunks are especially convincing as not just examples of the genus but as individual trees; his gardens and old houses are not pasteboard but places he sees and interprets. It is on record that Walker would take his boxwood block into the countryside and finish backgrounds from nature, perhaps he was the first illustrator to do this.[34] Certainly Walker equated the study of nature with Greek art and this often gives his figures a sort of serenity. Those studies at the British Museum were deeply ingrained and Gleeson White rightly refers to his farm labourers as 'youths from the Parthenon in peasant costume'.[35]

The artist's best work was reserved for *The Cornhill Magazine,* every aspiring draughtsman's goal in the early 1860s. His entry into that august magazine is one of the legends of the illustrator. Swain, the engraver, who had the management of *Once a Week's*

illustrations had considerable influence with Thackeray. It was Swain's job to find draughtsmen who could put the great novelist's own sketches on to the wood and generally tidy up their deficiences. Walker, anxious to get on to *The Cornhill*, called on Thackeray with Swain and showed the jealous amateur artist some of his drawings. Thackeray promptly asked Walker to sketch his back while he was shaving in his dressing-room, and the result was so successful that Walker not only won the commission, but the block appeared in the journal in February 1861. But the object had been to get original work and the doctoring and 'ghosting' of Thackeray's designs would not satisfy him. After four ill-proportioned and wooden pages of Thackeray's own contributions to his *The Adventures of Philip*, Walker took over the compositions, though his presence was not acknowledged until June 1861. Thackeray's stepping down was unusual and the successful relationship was due to Walker's sensitive nature and great ability. The author gave his artist detailed verbal instructions, sometimes accompanied by a rough sketch, an indication of the expression of the passage rather than its exact rendering. In the last design of the 'Philip' series, 'Thanks giving', Thackeray specified which church he wanted depicted – 'the Church is the one in Queen Square Bloomsbury, if you are curious to be exact',[36] he wrote.

The influence of Millais is stressed by Gleeson White but not overtly referred to in the biography. Walker is known to have consulted Millais about his *Cornhill* work[37] and can hardly have failed to be impressed by the Trollope designs by Millais appearing alongside his own (Figure 59). But Walker's originality is unquestioned, and his study of children alone would win him a high place, as would such natural groups as 'Out Among the Wild Flowers' which appeared in 1862 in *Good Words*. But he was also an innovator, among the earliest artists to use photographs for the details of his pictures, the first artist to introduce brushwork into his drawings on wood and the creator of the first Victorian poster for Wilkie Collins' *The Woman in White*, 1872. The latter is such a fluid image of a woman escaping through a door that it is difficult to believe it was done before the 1890s. Walker's four productive years of illustrating were the groundwork for a further ten years as watercolourist and oil painter, the field, the lane and the cottage door recurring frequently in these fresh mediums. His tragic death at the age of thirty-five in June 1875 was a sad loss for British art which expected great things from the new ARA. But by this time, book illustration had long since ceased to be a major factor in his life.

Figure 59. 'In the November Night' by Fred Walker

A. Boyd Houghton

Arthur Boyd Houghton, 1836-1875, was a very different artist from those already mentioned. As fine a draughtsman, he was as well a painter, illustrator and Special Artist. His work for *The Graphic* is discussed later but his domestic and legendary work forms a major bulk in that working life that was so tragically short. Born into an Indian Army family in 1836, he returned with them to England and showing an aptitude for drawing was sent to the appropriate schools, Leigh's and the Royal Academy's. He benefited much more however from attending the Langham Art Society where he came under the influence of Charles Keene, a much older man and already well-established on *Punch*. Keene's bohemianism probably accorded with the unconventional in Houghton, that strain of compassion for the underdog which in the younger man's work became radical protest. A talented oil painter in small scale, Houghton turned in the later 1850s from historical subjects to those of everyday life, often the street and beach scenes that had attracted the Pre-Raphaelites and containing their bright palette. One of these, 'Holborn in 1861', has certain affinities with Madox Brown's 'Work', the sort of essay in realism that was to stand him in good stead as reporter-artist. A lack of success in selling paintings turned Houghton into an illustrator, as it did so many others. He was introduced to the Dalziel Brothers and began by doing domestic scenes for them on Wilkie Collins' novel *After Dark*. His domestic oil paintings owe rather more to Augustus Egg RA and the 1840s than to the Pre-Raphaelites, his illustrations based on his own happy family life, are more the descendants of Millais' 'Fireside Story' of 1855 and its aftermath. This connection is particularly noticeable in *Home Thoughts and Home Scenes*, 1865. The Brothers Dalziel continued to help the artist and in 1863-65 he illustrated for them with T.B.G. Dalziel, *The Arabian Nights*, contributing ninety-two designs. The Brothers record that he had an advantage for this work in having been born in the East and having access to 'articles of virtu, curios, costumes and every sort of thing invaluable for the illustrator's purposes . . .'[38] In his 'Three Blind Men', 'Aladdin in Despair' and other figure subjects, he produces some of the most powerful images of the whole decade. The masterly designs for the *Don Quixote* of 1866, another Dalziel commission, are better than the celebrated Doré ones, but neither book received proper recognition. The Dalziels talk of 'his fine sense of humour' being 'coupled with a pleasant tinge of satire, such as comes from a man who knows the world in its various phases of life, but always cultured and refined.'[39] It is this 'tinge of satire' that Paul Hogarth has suggested as the aspect of Houghton's work that middle class Victorians were not prepared to take.[40] Houghton was probably the right artist therefore to record the Paris Commune of 1870, which he did in a notable series in *The Graphic,* including those of the trial scenes after its collapse. Always a depressive man, Houghton became an increasingly persistent drinker and eventually died of his alcoholism in November 1875. He had been a meticulous worker, very professional, making several sketches before transferring the design to the wood block. Forrest Read found his most interesting style to be the early period, here he was closest to the idyllic artists, a more modern taste might prefer the dramatic and realistic quality of the later work.

Frederick Sandys

Of all the illustrators of the 1860s, there is no artist who carried the spirit of the Pre-Raphaelites forward with greater conviction than Frederick Sandys, 1829-1904. His black and white drawings for the magazines and the art books of the time are not numerous, they number about thirty in all, but they retain the fire, the atmosphere and the intensity which was apparent in the *Moxon Tennyson* several years earlier. Sandys could sustain this dynamism from the first appearance in *Once a Week* in 1860 to the *Dalziel's Bible Gallery* of 1882, and Gleeson White wrote of him as 'the most potent factor' in giving the former magazine a distinctive place in the arts,[41] but what essentially did the Sandys mastery consist of? He was certainly the most accomplished draughtsman of the period, nobody but Millais could possibly equal his graceful and easy line, his virtuosity in composition and decorative treatment, his tender portraits and soft studies from nature. However it is difficult to look at any of Sandys' works from our standpoint and feel that the penetration of character or literary interpretation is anything more than gently sensuous, that the haughty figures and crowded symbols are anything more than the trappings of poetry and lyric. This brooding dissatisfaction with a drawing is often present when the artist is very young or an inveterate copyist and as we know, Frederick Sandys was a brilliant and witty copyist from the famous 'Nightmare' of 1857 which caricatured Millais' 'Sir Isumbras at the Ford'.

Turning to the pages of *Once a Week* one is alternately amazed and bewildered by the artist's contributions, amazed at his range, dazzled by his performance, bewildered by the impertinence of his borrowings. It would be impossible to expect an artist of Sandys' ability to develop in the 1860s, a period of flux, without some recourse to borrowings, but the reliance on Rosetti revealed in these pages goes a good deal beyond the purely inspirational. This is not to say that Sandys was a pure copyist, his study of nature was meticulous and there are numerous drawings to prove it.

Frederick Sandys was born in Norwich in 1829 and, though his family were in rather unpromising circumstances, he received a good education and was trained at the Norwich School of Design and patronised by a local amateur artist. On coming to London he obtained work in drawing for wood engravers and there learnt the syntax that was to stand him in good stead when he had to draw for the printed page. Sandys got to know Rossetti and his friends after the satirical print of 1857 and they recognised his genius as a draughtsman. This was the year of the *Moxon Tennyson* which must have left a deep impression on him, but he was also making himself acquainted with the sixteenth century German masters of the woodcut and particularly Dürer. The Pre-Raphaelites' absorption in early German art stemmed from the Nazarene influence on the Brotherhood and several artists of the Rossetti circle had collections of these prints. Rossetti himself had a few examples, Ruskin a considerable collection and William Bell Scott a connoisseur's collection, as befitted the author of a *Life of Dürer,* 1869. A hazy juggling of motifs, symbols and backgrounds took place among these painters, many of them garnered from sixteenth century originals through the eyes of the more penetrating and poetic Rossetti. This influence has recently been highlighted in a revealing article on the sources of Pre-Raphaelite design.[42] It is evident though that Sandys was not quarrying from the originals, or synthesising the work of Rossetti, but rather working in a Rossetti mannerism as a vehicle for his own precocious line. In the catalogue of the Sandys exhibition at Brighton in 1974, this duplicity in Sandys is referred to as a weakness. 'Mystery is of the essence of Sandys themes', says the writer, 'but the pictures are made with an explicitness that precludes it.'[43] Surely this is because the highly charged, brooding and very poetic subjects belong to a Rossetti and the slick presentation of them only to a Sandys.

Figure 61. 'The Waiting Time' by Frederick Sandys.
Left: Figure 60. 'Manoli' by Frederick Sandys.

The most glaring example of this is the 'Rosamond Queen of the Lombards' which came out in *Once a Week* for 30 November 1861, only the third contribution by the artist to the paper. As mentioned briefly before, it is a reversed figure of Rossetti's famous *Moxon* subject 'Mariana in the South', the background of which had been taken from a Dürer woodcut.[44] Although a more accomplished work technically than the Rossetti, the Rosamond is awkwardly crowded with symbols and more ambivalent in meaning than its famous predecessor. The first important work for *Once a Week* 'Yet Once More on the Organ Play' contributed in March 1861, has similar memories of 'St Cecilia' in the instrument and the reclining figure, though more obvious links with Titian's 'Venus and Cupid with an Organ Player'. Other designs that follow, 'The Sailor's Bride', 13 April 1861,[45] 'From My Window', 24 August 1861, and 'The Three Statues of Aegina', 26 October 1861, are not so closely inspired. 'The Old Chartist' of 8 February 1862 is markedly Düreresque in style and the finest work he did for *Once a Week.* Pennell wrote ecstatically of this print in 1896 – 'the Chartist is a figure that Sandys has seen for himself; but it is this evidence of things seen which gives such force to his drawings; his illustrations are as carefully studied as any one else's paintings . . .' [46] Sandys was earning extremely good money for his illustrations at this time, receiving forty guineas from *The Cornhill* for his 'Portent' in 1860, but he was conspicuously profligate in his business affairs.

Dating from the same period are the contributions to both *The Cornhill Magazine*, classical studies like 'Manoli' (Figure 60) and *Good Words.* The last contains only two Sandys illustrations 'Until her Death' strongly influenced by Rossetti and Dürer and 'Sleep' appearing successively in 1862 and 1863. Sandys continued to work for *Once a Week* until 1866 but the most significant design ever produced by him was first seen in *The Churchman's Family Magazine* in July 1863. 'The Waiting Time' (Figure 61), an illustration to a poem by Sarah Doudney on the Lancashire cotton distress, exactly captures the spirit

of Victorian labour through the deliberate archaism of line and hatching found in Dürer prints; the over-hanging frames of the silent loom, the sunlight on the wall and the carefully observed wood grain on stool and machine. There is something implicitly Pre-Raphaelite here which wishes to interpret a current moral dilemma in terms of the past. Sandys illustrated two books, 'Life's Journey' a design with all the delicacy of 'The Chartist' was included in Willmott's *Sacred Poetry* in 1862 and his 'Little Mourner' appeared in the same work; further illustrations were used in *Thornbury's Legendary Ballads,* 1876. The muscular Biblical illustration 'Jacob Hears The Voice of the Lord' was drawn in the 1860s but was not used until *Dalziel's Bible Gallery* first came out in 1881. Hindsight may have slightly dimmed our appreciation of Sandys, his magnificent portrait drawings certainly redress the imbalance, but so does the remark of Swinburne that he wanted nobody else to design for his verse![47]

The Dalziel Brothers

The revival of wood engraving in the 1840s, its gradual perfecting in the 1850s and its flowering in the '60s greatly altered the status of the wood engraving workshops. In any less complicated time than the nineteenth century this trade might have remained a craft occupation as it had with Bewick, or the calling of a highly individual artist as it had in the late Renaissance, but the Victorians were at heart commercial and broadly based. By the middle of the century the facsimile wood engraver was sufficiently indispensable to command the respect of artist and publisher alike, his workshop was the meeting place of new talent with established names, his patronage was eagerly sought after and his advice taken. As we have already seen the Victorian artist diversified more than his predecessors; he was a designer as well as a painter, concerned himself with ornament, metalwork, stained-glass, as well as with history painting and landscape; he experimented with engraving and new methods of printing. The names of 'Landells', 'Swain' and 'Linton' printed prominently in the corners of otherwise unsigned wood engravings are often mistaken by the unwary for those of the artist. They were in fact the signatures of the leading engraving establishments, hives of industry from 1850 to 1880, the schools that made British black and white draughtsmanship pre-eminent for so long. The merchant princes of this trade were undoubtedly the Brothers Dalziel, whose name appears in almost every major book between 1840 and 1890.

The Dalziel Brothers have already been mentioned in connection with Rossetti for they were his dealers 'in fevers and agues' with their cutting! But less demanding artists than Rossetti fared better and their achievements are generally considered to be outstanding. The four brothers were born into that fertile ground for wood engraving, Northumberland, the three most prominent engravers being George Dalziel, 1815-1902, Edward Dalziel, 1817-1905, and John Dalziel, 1822-1869. Thomas Bolton Gilchrist Dalziel, 1823-1906, was the youngest brother and in many ways the most talented, combining like Edward, engraving with book illustrating, but also an active marine and landscape painter.[48] They were all the children of Alexander Dalziel, 1781-1832, a farmer who turned to painting late in life, but who nevertheless saw to it that his sons trained thoroughly and early. Both George and Edward Dalziel were apprenticed to Ebenezer Landells, a pupil of Bewick, and on their arrival in London in 1835 were befriended by William Harvey, 1796-1866, another Newcastle illustrator and pupil of Bewick, which accounts for the close connection with the

Bewick School that is mentioned in their memoir. John Dalziel joined the firm in 1852 and Thomas Dalziel arrived in London in 1857.

Although the firm was engaged on finely illustrated books from the 1850 Harvey edition of *Pilgrim's Progress* onwards, they only achieved real fame in the late 1850s, with their work on *The Music Master* by William Allingham, 1855 and the *Moxon Tennyson*, 1857. The convenience of wood engraving over its rivals, steel plates and lithography, was so obvious by the latter year that the Dalziels inaugurated a new side to their business. They established a printing works at 53 High Street, Camden Town, known as The Camden Press, which run together with the engraving shop, enabled them to commission their own books 'Dalziel's Fine Art Books' and superintend the production of them from start to finish. They were not their own distributors, but had agreements with publishing houses like Routledge, Longman and Warne, so that the titles could be retailed under their imprint. The 1860s were the Dalziels' heyday and they included among their employees and clients, the most astonishing list of Victorian giants, both artists and authors. The main part of their production was still in engraving blocks for the magazines, *Punch, The Cornhill Magazine* and *Good Words* among them, but since many of the serial stories were later reprinted in volume form, the book side to their business could expand simultaneously. Among the more attractive publications in which they had a hand are *Willmott's Poets of the Nineteenth Century*, 1857, Charles Mackay's *Home Affections,* 1858, *Montgomery's Poems,* 1860, *Wood's Natural History,* 1861-63, the *Barsetshire Novels,* 1861-64, *Alice in Wonderland,* with all its vicissitudes, 1865-66, and *Dalziel's Goldsmith,* already mentioned, 1865. Particular favourites of the present writer with which the Dalziels are associated are *A Round of Days* with its gentle rural illustrations, 1867, *Jean Ingelow's Fables,* 1867, and *Wayside Posies,* 1866-67, all contained in decorative art covers by John Leighton, Albert Warren, Owen Jones and others.

The Dalziel books are open to some criticism for being both melanges of various illustrators' work and insubstantial in text. The first problem was common to most of the books of the late 1850s and '60s, the second seems to have stemmed from a reluctance by the firm to commission from writers who were so much more expensive to use than artists. There was also a tendency to make anthologies pay their way in preference to new work and a not too scrupulous use of illustrative material when it was the firm's copyright. *Thornbury's Legendary Ballads* is a case in point, where eighty-two of the prime drawings for *Once a Week* are foisted on to the indifferent verses of G.W. Thornbury. Despite this, the advent of large illustrated volumes for the table, if not yet the 'coffee table', was a definite improvement on gift books and the Dalziels' record is an impressive one.

Gleeson White while emphasising their influence in engraving and in bringing forward the younger draughtsmen pays tribute to their own drawing. 'That these talented engravers were draughtsmen of no mean order might be proved in a hundred instances,' he writes, only a few of their own blocks 'establish their

Figure 62. Illustration for The Uncommercial Traveller, *Edward Dalziel.*

134

right to an honourable position as illustrators.'[49] These must include Thomas Dalziel's finely detailed illustrations to *The Arabian Nights,* 1864, and *The Arabian Nights Entertainments,* 1877, as well as his fourteen engravings in the Bible Gallery, 1881. After Thomas, the most competent artist in the family was Edward, his brother, a contributor to *Ballad Stories of The Affections,* 1866, and sole illustrator of *The Uncommercial Traveller* in Dickens' Household Edition, 1870 (Figure 62). E.G. Dalziel, 1849-1889, was Edward's eldest son and a strong figure draughtsman.

Had the Dalziel Brothers acquired or founded a magazine in the early 1860s it might well have been a great success. Their failure to do so, however, is probably explained by the fact that their real prosperity was after 1865 when the magazine market itself was starting to tail off. They did however acquire two magazines; *Fun* was bought by them somewhat later in 1870 and run by them until 1893 and *Ally Sloper's Half Holiday,* the paper that had been the brainchild of C.H. Ross, was run until 1903 by Gilbert Dalziel, 1853-1930, the journalist of the family and the most brilliant of Edward's sons.

Footnotes

1. W. Tinsley, *Random Recollections,* 1900, pp.62-63.
2. *Art Union Annual Report,* 1857, p.4.
3. G.M. Young (Editor), *Early Victorian England,* 1934, Vol. 1, p.232.
4. ibid.
5. G.S. Layard, *Pre-Raphaelite Illustrators,* pp.23-24.
6. Gleeson White, *English Illustration 'The Sixties',* 1906, p.9.
7. Walter Crane, *Of The Decorative Illustration of Books,* 1901, p.148.
8. Mason Jackson, *The Pictorial Press,* 1885, pp.356-57.
9. Daphne du Maurier, *The Young du M: A Selection of His Letters 1860-67,* 1951.
10. ibid.
11. ibid.
12. ibid.
13. ibid.
14. ibid.
15. *Letters of D.G. Rossetti to W. Allingham,* 1897, p.248.
16. John Ruskin, *Ariadne Florentina,* 1877, p.235.
17. John Ruskin, *The Art of England,* 1884, pp.166-67.
18. John Ruskin, *Modern Painters,* 1904, Vol. 4, p.228.
19. ibid., Vol. 1, p.182.
20. Philip James, *English Book Illustration,* 1800-1900, p.37.
21. M.H. Spielmann, *The History of Punch,* 1895, p.392.
22. Mrs. Ward Barrington, *Lord Leighton,* 1906, Vol. 2, p.95.
23. ibid., p.96.
24. ibid., p.97.
25. Like *Punch, Once a Week* was prepared to publish drawings independant of a story or a text.
26. British Museum, Add, MSS 46560-46682, Bentley Papers.
27. Daphne du Maurier, op. cit.
28. Gleeson White, op.cit., p.25.
29. Bentley Papers.
30. Henry Blackburn, *Randolph Caldecott,* 1886. pp.21-22.
31. George C. Williamson, *G.J. Pinwell And His Works,* 1900, p.12.
32. ibid., p.71.
33. J.G. Marks, *Life and Letters of Fred Walker,* 1896, p.12.
34. ibid., p.27.
35. Gleeson White, op. cit., p.165.
36. J.G. Marks, op. cit.
37. ibid., p.40.
38. *The Brothers Dalziel, A Record of Work, 1840-1890,* 1901, p.222.
39. ibid.
40. Paul Hogarth, *Arthur Boyd Houghton,* Catalogue of Victoria and Albert Museum exhibition, 1975, p.10.
41. Gleeson White, op. cit. p.173.
42. John Christian, *The Art Quarterly,* 1973, Vol. 36, pp.56-83.
43. Frederick Sandys exhibition catalogue, Brighton 1974.
44. John Christian, op. cit.
45. The original uncut woodblock of an earlier version of this subject is in the Birmingham City Art Gallery.
46. Joseph Pennell, *The Quarto, 1896, pp.33-37.*
47. Frederick Sandys exhibition catalogue, op. cit.
48. Thomas Dalziel was also instrumental in teaching the student wood engravers. Information communicated to me by Miss Ailsa Dalziel, 1978.
49. Gleeson White, op. cit., p.178.

Chapter 7

The Special Artists

Figure 63. 'The Trenches Before Sebastopol' by J.A. Crowe, Special Artist, 1855.

The founding and development of *The Illustrated London News* and its rivals in the 1840s led to a much greater sophistication on the part of the reading public and a much greater awareness of the possibilities and shortcomings of the then pictorial press. A mercantile and predominantly middle-class clientele demanded something more precise and direct than a sedentary artist's idea of a besieged citadel or an attempted assassination, worked up from maps in his Bloomsbury lodgings. The steamboat and the rail were contracting the confines of Europe and even the distances to India and America had shrunk within a generation. To the proprietors of the illustrated periodicals it was obvious that businessmen in an expanding Empire would require greater and greater authenticity in their illustrations; the shipbuilders of Tyneside, the locomotive engineers of the Midlands and the captains of iron in South Wales, would not be fobbed off with one bolt out of place. If the ordinary reader was less scrupulous, he at least required the realism of news, the sense of immediacy transcribed through the pencil by an eye witness. Perhaps the rather static repertoire of *The Illustrated London News* and other journals would have continued with their royal processions, ship launches, house fires and trials, if events had not overtaken them.

On 28 March 1854, Great Britain and France jointly declared war on Russia and troops were despatched to the Crimea. It was the first major military campaign for more than a quarter of a century, the public were aroused to a fever of patriotism and an insatiable appetite for information of any kind. They wanted first-hand news of their troops operating in this remote corner of Asia Minor, details of their every-day life, pictures of the terrain, its inhabitants, and their customs (Figure 63). It was up to the illustrated magazines to provide this information, but for the most part they were unprepared. It was true that they had used

SKETCHING IN CHINA.

Figure 64. Special Artists on location. R.P. Leitch and a colleague sketching for The Illustrated London News *in China in early 1857.*

French artists during the French Revolution of 1848, but Paris was a centre of illustrated journalism and the Crimea was not. The artist William Simpson, later called 'Crimean Simpson', described the ludicrous situation facing the home-based illustrators. 'When the news of the Battle of the Alma came home,' he writes, 'I made a sketch, principally from the newspaper accounts, and put it on stone.'[1] Simpson found even greater difficulty in tracing prints of Sebastopol as the siege approached; there were few maps and the British Museum had only a silhouette of the city in the corner of one of them from which a complete drawing had to be made. Simpson was then employed as a lithographer at the printers Day and Sons, and it was proposed to him that he should go to the Crimea and collect material for Messrs. Colnaghi, who intended publishing a folio of the war.

William Simpson left in September 1854 and became the first of the 'special artists' although not accredited to a newspaper. Later writers suggest that 'while the signs of the coming storm were yet distant',[2] *The Illustrated London News* sent Samuel Read to the seat of war. Read was certainly in Constantinople for the magazine in 1853 but saw no action. Vizetelly also records that *The Illustrated London News* sales slumped because they had no artist on the spot on the Bosphorus, so Simpson's claim to be the first of a new breed seems substantiated.[3]

What an amazing breed they were to be, these special artists. They were the princes among illustrators — hardy, resourceful and flamboyant, engaging in every kind of subterfuge and intrigue to ensure that their masters in Fleet Street received both copy and sketches hot from the action. They were the eternal wanderers of the magazine world, following campaign after campaign, from one continent to another (Figure 64), sometimes fêted by governments, sometimes imprisoned, one minute enduring awful privations, the next commanding a retinue of servants. The Special 'provides himself with an abundant supply of tinned meats and champagne,' says Mason Jackson, 'plenty of clothing, the latest improvements in saddlery; and when he arrives at the scene of action he buys as many horses as he wants for himself and servants. Acting on the experience of previous campaigns, Mr. Prior was able in the Zulu War to travel much more comfortably than any member of the staff, not even excepting Lord Chelmsford himself.'[4] At various times other artists had

their own covered carts, fitted up as 'studios' and sleeping quarters, but these luxuries were the exception in a very tough and rough life. Years after the Crimean campaign when the specials had developed a sort of rudimentary professionalism, the casualties were high. Melton Prior of *The Illustrated London News* caught sunstroke from which he never fully recovered, W.T. Maud of *The Graphic* died of syncope and, as late as 1906, C.E. Fripp collapsed and died from hardship. When the 'champagne' had run out and there were no more tins, Seppings Wright found himself eating bread that had gone into a hard brick in the Sudan campaign at a temperature of 130 degrees farenheit!

It is hardly surprising that René Bull, the war artist of *Black and White* at the end of the century, was also an illustrator of Anthony Hope's stories. Their lives were the pure stuff of Ruritania, of Rudolph Rasendel and 'Black' Michael, their feats of daring and disguise, ingenuity and escape would have made a splendid epic for the silent cinema. It is absolutely in character that G.A. Henty, the writer of more than seventy boys' stories, was a special for *The 'News* in the Abyssinian expedition of 1867. Such a life did not encourage the married man and many artists remained bachelors, adopting a sort of raffish bohemianism in dress and manner. Some like Melton Prior and Caton Woodville, despite illness, returned home to a distinguished old age of memoir writing, others like Frank Vizetelly vanished without trace.

William Simpson was not quite in this mould. A hard-working Scotsman from Glasgow, he had trained as a lithographer and risen from a salary of £2 a week in his native city to a commanding £8 a week in London. Simpson was an accomplished watercolourist, a talent he put down to the more painterly qualities of lithography as opposed to the more mechanical ones of wood or steel. He was, in fact, one of the few leading illustrators to spring out of the lithographic boom in the mid-century. As well as a competent hand and an eye for detail, Simpson possessed the unquenchable curiosity which make his drawings human documents that are fascinating to the historian. His intense interest in all the countries he visited led him to become an authority on eastern cultures and religions and publish several books.

On his arrival in the Crimea, Simpson was so much of a novice that he wandered about among the troops drawn up before Sebastopol like a kind of spectator and actually seated himself in front of the batteries and began to sketch! While working away with pencil and paper he records that he was dimly aware of objects falling around him from time to time, only to realise, when an officer shouted to him, that they were cannon balls. Simpson's work had value in showing the truth about the Crimea for he insisted in drawing actual situations under various conditions and including portraits, not the generalisations of later specials. In this way he spent long hours among the troops furnishing the publishers with a series of the trenches at different times of day, 'A Quiet Day in the Battery' or 'A Quiet Night in the Battery', etc.

The presence of an artist was as much of a novelty to the allied armies as their life was to Simpson. The only other correspondent in the field was the famous Dr. W.H. Russell, 'Russell of The Times', and the commanding officer, Lord Raglan, enjoyed showing off Simpson's work to his French opposite number because the great Parisian publications had no artists there. The fact that Lord Raglan approved of the work meant that the drawings could be sent home in his private letter bag with despatches. Every sketch that Simpson carried out had to be placed before the War Minister, shown to Queen Victoria and passed by both of them before going to the lithographers. This complicated procedure at least won Simpson and some later artists the Queen's patronage.

It was not always so easy to convince combatant officers of the accuracy of his drawings. An illustration of the Charge of the Light Brigade, composed from accounts given to Simpson was rejected time after time by the arrogant Lord Cardigan. It was only when

Simpson had the wit to place Cardigan in a gallant attitude in a prominent part of the drawing that the sketch was passed correct for the Foreign Office and Windsor!

The role of the special was being developed alongside that of the correspondent; sometimes the artist was called upon to write reports or letters, usually the functions were separate. Simpson considered perhaps rightly that the artist was rated lower than the correspondent by authority; less courted than the latter, he was also less hated in times of stress.

Simpson had no illusions about his function as a reporter. 'From the long peace that had existed before the Crimean War the technical terms belonging to seige operations had much the character of a foreign language to the British public,' he wrote. 'Gabions, fascines, sandbags, traverses, eparlements, etc., were words that conveyed no distinct meaning to the generality of readers and it was my function to make illustrations that would show what these things were.'[5]

It was unfortunately the great weakness of these draughtsmen that they had arrived on the scene at a time when British art had very little sense of direction. There was no tradition of news reporting; it was a new science. The strongest branches of local talent were landscape and topography, neither of which were suitable grafts for the febrile subjects of war painting. The nearest equivalent school was in history painting, almost non-existent since B.R. Haydon's tragic suicide in 1846, or in its near relation, battle painting, which had enjoyed some success in this country. It was this which was the starting point for much ensuing work. However much Simpson and his successors strove for a greater realism, a more objective and frank observance of the facts, the dead weight of historical battle painting was never far away. An illustrator such as T.H. Nicholson, who was special artist for *Cassell's Illustrated Family Paper* throughout the Crimean War, has a very heroic view indeed of the place and purpose of battles for the artist. His 'Battle of Alma' published on 11 November 1854, is an impressive and well-drawn full page woodcut, but the gesturing generals and serried ranks of soldiers do not leave a very striking impression of authenticity. The same artist's 'Death of Captain Vicars', 2 June 1855, where the officer staggers backwards on a pyramid of bodies, is hardly of its time and might almost be the work of Benjamin West or J.S. Copley. Caton Woodville, among the best of these men, developed a complete career as a battle painter and came to be known as 'the English Meissonier'. If these two identities became confused neither editors nor readers were dissatisfied; the same problem faced Frederick Remington in the 1890s when American publishers rejected his realism. In most cases the specials were not sufficiently strong as artists to develop their own individuality and resist the temptation to sentimentalise or dramatise their story. Nobody emerged of the calibre of Thomas Nast, whose American Civil War sketches affected a whole generation.

The results of Simpson's Crimean labours were eventually published in two folio volumes and were a great financial success. But by this time *The Illustrated London News* had a number of specials in the Crimea, *The Illustrated Times* one and, as mentioned, *Cassell's* one. By the middle of 1854, *The 'News* had W.O. Brierly stationed at the seat of war, supported by two naval officer artists, Lieut. Bredin and Lieut. Montagu O'Reilly of *The Retribution*. The concentration of the services on accurate draughtsmanship at this time was always a blessing to the harassed editor and officers were continually enlisted as illustrators in the course of these wars. At the beginning of 1855, Brierly had been recalled and replaced by E.A. Goodall, Samuel Read was at Scutari, and J.A. Crowe was officially designated 'Correspondent'. Local colour was provided by an army officer W.S.M. Wolfe and 'James Robertson of Constantinople', a resident with a useful pencil and also a photographer. The second half of this year saw the arrival of some first-rate illustrators, J.W. Carmichael, Constantin Guys, Gustave Doré and the return of Brierly. J.A. Crowe stayed on until 1856 perhaps as chief illustrator (Figure 63) and Landells arrived in the early part of that year as the war ended. Julian Portch had acted throughout for *The Illustrated Times*.

The Crimea was the last occasion on which the coverage was to be so haphazard; subsequently *The Illustrated London News,* later *The Graphic* and much later *Black and White, The Sphere* and their imitators, were to develop teams of artists, specialists in battles or naval engagements or simply explorers. *The 'News* relied on Marshall Claxton and W. Carpenter, both of whom happened to be in India during the Mutiny in 1857, but by 1870 it was relying more on its permanent staff. Nor was it easy to become a member of this august body. William Simpson noticing the change from lithograph to woodcut after 1865 determined to move with it; despite a life-time of experience he was not taken on to the permanent staff of *The 'News* until 1869, receiving a retaining fee with his services paid for in addition.

The circumstances of working were often hazardous in the extreme. Frank Vizetelly, who worked for his brother's *Illustrated Times* and was briefly editor of the Parisian *Monde Illustrée,* was sent by *The Illustrated London News* to Sicily in 1860. He landed with Garibaldi in Italy disguised as a sailor and managed to smuggle out some astonishing sketches of the thousand and their romantic leader. The following year he was sent to the United States to report on the Federal side of the American Civil War but not content with this decided to cross over the lines and draw the Confederates as well. After three days and nights on a river bank in the sights of a northern gunboat, he succeeded in his plan, once again bringing renown to *The 'News* which had failed before to get a correspondent into the blockaded southern ports.

Simpson encountered most difficulties in the France of the Second Empire, which, despite its glamorous reputation for Offenbach's music and café society was little more than a police state. The special, Vizetelly points out, was always at the mercy of the local populace and the local press ever ready to describe 'his pencils as stilettos, his india rubber as a pocket bomb, and his sketchbook as an infernal machine'.[6] He mentions in particular the artist Morin, whom he employed because he claimed relationship with the Emperor's chef. Later he discovered that this was a fabrication; Morin was actually one of the Emperor's agents. This double agent later redeemed himself in Vizetelly's eyes by sending a crucial sketch from the Battle of Sedan, drawn on the vellum of a drumhead! Simpson had an uncomfortable time during the same campaign in 1870, frequently under suspicion and once arrested, he nevertheless had to make sketches openly and then post them through the collapsing public service in the hopes that they would be in the Editor's hands for the Saturday after next! All the sketches for the build-up to the Battle of Forbach were drawn on cigarette papers which were then rolled and could be smoked in an emergency. The battlefield of Sedan was sketched on a strip of wallpaper removed from a deserted château, sealed up and sent to Mason Jackson in London.

The artists at the Franco-German front included not only Simpson but also G.H. Andrews, C.J. Staniland, Jules Pelcoq, G. Regamey and R.T. Landells, whose acquaintance with the Crown Prince gave him access to the German lines. After the fall of France, *The Illustrated London News* supported Pelcoq during the siege of Paris, paying for his hardship but none too generously. Pelcoq's and Regamey's sketches of the beleaguered capital were sent out to the world by balloon, first being photographed by Nadar and the prints sent out in another balloon to ensure that the precious work was not destroyed by one German gun. One of these is shown in Figure 65. During the five months not a single sketch was lost, making both the siege and the Commune among the most faithfully recorded nineteenth century events.

Later specials worked under even greater difficulties. The artist A.S. Hartrick records the sort of material he had to work from at *The Graphic* office, sent in by C.E. Fripp. 'I have handled volumes of sketches done by him during the Zulu War, which were ideal to work from. Some sketches made by him at the battle of Ulundi, drawn with a pen as he lay

Figure 65. G. Regamey's impression of German shells bursting at the Porte d'Auteuil during the Siege of Paris, 1871. Regamey worked for The Illustrated London News *throughout the sieges and his sketches were sent out by balloon.*

on the leather roof of a waggon, with Zulus charging close up armed with both assegais and rifles, were set out with full topographical details, as if executed in a chair at home.'[7]

Accuracy was often a criticism of the artist's work, even under these difficult circumstances, but a report in the *Morning Herald* of March 1855 gives a macabre insight into the draughtsman's truth to nature. 'I saw today the Sketching Correspondent of *The Illustrated London News,* who had been permitted to sketch amusing groups about the Camp. He has made a very clever and graphic sketch of the still unburied Russian bodies which have been lying in a putrid state, bordering the river Inkerman, ever since the 5th November. While engaged taking his sketch, the enemy fired a few shots upon him from the opposite side, but he succeeded in completing his work before he left the place.'

It was usual for these rapid sketches to be covered with notes and directions and to be sent back to competent home-based artists who could disentangle them and create a composition. But as one contemporary report of these artists put it, the special had to invest their drawings with something more than bare facts if they were to succeed. 'We are not moved by the accuracy with which a thousand and one details are realised; not by the material facts of masonry and cannon and armed men, though these in themselves are impressive; but by the intangible yet real idea they are made to express.'[8] The shorthand of the man in the field was a skeleton on which his colleagues could build a picture or a panorama, perhaps a 'two pager' double spread. As the century proceeded, the speed increased, but the mode of work remained the same, as Inglis Sheldon-Williams of *The Sphere* found in the Boer War; 'My Boer war drawings were, on occasion, the slightest sketches, but conveying the essentials to the artist at home. The drawings were always in outline, sketches sometimes from the top of my horse while the sergeant wasn't looking, the result could be slipped into an envelope and catch the first mail home to the office where, if considered advisable, it could be turned into a complete double page drawing in twenty-four hours by Wal Paget.'

Sometimes the drawing was divided into two for speed and two artists worked all night on the two halves, bringing them together in the morning. Gulich and Hatherell of *The Sphere* worked best on this kind of teamwork and it emphasises how vital the expertise of the supporting team was. The organisation behind the scenes was extensive; numbers of

artists were kept perpetually busy on the sketch notes of the specials, harmonising them for the page and drawing them on the boxwood blocks. Turkey boxwood was always used because of its close grain, hardness and lightness of colour, enabling the artist to use finer and sharper lines than on any other substance. These blocks were then transferred to the engravers, a handful of famous men – Orrin Smith, Landells, Whymper, Linton or Dalziel – whose services were retained by the better magazines over many years.

Ingram's hard business head had early appreciated the advantages of large blocks and quick engraving and he eagerly seized the idea of bolted blocks, developed at the time *The Illustrated London News* was founded. This process meant that the drawing covered an area of several blocks bolted together; the whole composition was sent to the engraver who set the lines across the joints of the block before dismembering it into individual pieces for the various engravers. The separated pieces therefore all had a small area of engraving prepared by the master engraver to act as a keynote in colour, texture and style for their particular fragment of the jigsaw. When this was followed, the woodcut came together again from various sources in perfect harmony and in a quarter of the time it would have taken one man to complete. A first proof would then be taken from the block and the supervising artist would add the retouching and corrections he thought necessary. After the block was finished it would be taken to the electrotyper, moulds made, overlays formed and the finished article would be ready to make 400,000 impressions from that first slight sketch of the artist on campaign.

Some of the magazines sent their work to outside artists and many younger men began careers in this way. George du Maurier notes in September 1861: 'The other day the *Illustrated Times* sent me a large block to do in a hurry, giving me 2 days. I did it in 6 hours; only three pounds, but that pays for it is coarse rapid work done anyhow.'[9] But most magazines had their own specialists, and Simpson's experience on coming to London in 1851 was typical. Day and Sons where he worked, had more than a dozen artists dealing with a variety of illustration. Edmund Walker concentrated on architectural subjects. T.G. Dutton on shipping, Lynch on elaborate portraits, Vintner on large figure subjects, Needham on trees, Haghe on interiors. All these artists worked in their homes, Simpson being considered unusual in working at the office. Vizetelly employed more than a score of artists during the nine years of his *Illustrated Times,* 1855-1864.

Speed was of the essence and later in the century some of the older men felt that it had lessened their control over their work. Simpson deputed to draw the Prince of Wales placing the last rivet in the new Forth Bridge, found it necessary to send Forrestier, a younger man, to fill in the background. The whole composition was more or less completed on the actual block before Simpson added a few touches and hurried it by rail to London.

'This was a Tuesday,' Simpson writes, 'and it was necessary to have the event in the paper on the Saturday following. This necessity indicates a great change in the history of *The Illustrated London News,* as well as in the history of illustrated journalism. When the paper was first started and for many years afterwards, what is called the "make up" was arranged on the Thursday week before the issue appeared. From improvements in the printing press, which produced greater speed in printing, events that took place on the Friday became possible. Later on events on a Saturday could be produced within the time. And at last, owing principally to greater speed in printing, important events taking place on the Monday were possible. Rivalry with *The Graphic* may have had something to do with these efforts at rapidity of production. One device which helped in such cases was to give the late event in a supplement, which being a smaller sheet than the body of the paper, could be run more quickly through the press. The floating of the *Daily Graphic* brought a new necessity for speed. It produced or intensified the feeling that if an event could not be given till the Saturday week after its occurrence, it had become "ancient history" which in these days of fast living would be all but forgotten.'[10]

The increase in mechanisation did not mean a fall in quality. Illustrated magazines burgeoned in the 1870s and those that had been founded in the 1840s like *The Illustrated London News* had doubled in size. The overseas readership had special colonial editions from 1880, printed on specially thin paper, but the proprietors did not recommend them for the best quality in the engravings.

On both *News* and *Graphic* there was a definite hierarchy with the 'Special War Artist' like R.T. Landells taking pride of place. But particular importance was attached to explorer artists designated 'Travelling Special Artist' such as J.M. Price, who was in Siberia in 1891. Maynard Brown that same year was called 'Special Artist at Public and State Ceremonies' — a very important recorder of the Victorian scene if less arduous than a war artist. He would be expected to 'fill up the intervals of waiting by making sketches of the various state costumes — perhaps "thumbnail" portraits of the functionaries who wore them — indicating little idiosyncracies of bearing and gesture and expression. He would make also, a variety of sketches of the broad general aspect of the scene, so as to get it thoroughly in his mind; thoroughly mastered and ready to hand as it were when the culmination of the ceremony should arrive.'[11] W.D. Almond, whose forte was in social realism, was also referred to as a 'Special Artist for Character Subjects' in 1887.

Figure 66. Parisians selling their pets for meat during the Siege of Paris by Fred Barnard, The Illustrated London News, *January 1871.*

The great strength of these men was not in their specialisation but in their versatility; any of them could be called upon at a moment's notice to fill in a background, giving authenticity to fragmentary pencillings. Although it might seem now to be pure hackwork, it produced a surprising degree of accuracy if not great art and very little rancour in the profession. The work of the war artists did need specialist treatment and was given to Caton Woodville, a veteran campaigner, who could render on the block the sketches of Joseph Bell high in the mountains of Armenia in 1877, or to John Schonberg, who worked on Melton Prior's drawings of the Zulu War in 1879. Necessity can make strange bedfellows and it is a surprise to find Fred Barnard, the illustrator of Dickens, working up drawings from the Paris Commune in 1871 (Figure 66) and F.H. Townsend, later the first art editor of *Punch,* redrawing Seppings Wright's sketches of the Greek War of 1897! From the same war and the same artist we find a scene in Larissa interpreted by Cecil Aldin in an idiosyncratic and almost too individual style!

One change in the artist's status had definitely taken place since the early days, he was no longer an anonymous artisan. From about 1877, when Mason Jackson, a talented illustrator, took over the editorship of *The Illustrated London News,* the work of the specials is more frequently acknowledged and their travels explained. In June 1877 the magazine published a series of war leaves from artists' sketchbooks, not the more impersonal finished product, but the action drawings reproduced in line. To our modern tastes these are

more exciting than the completed prints, their vigorous pen-line and dramatic excitement (Simpson even left the mud from a shell on his!) give us a blow by blow account of Queen Victoria's little wars from the Ashanti onwards. Furthermore they are likely to survive for the collector today when the full scale work would have been devoured by the engraver's tools. Simpson's drawings, the most commonly seen, are usually in pencil with light grey washes and squared up for division by the engraver. These facsimile sketches published by Mason Jackson were used from time to time, highlighting for the Victorian public 'the art' behind the special artist's rather mechanical prints. W. Luson Thomas, *The Graphic* editor came from a similar engraver background to Jackson and supported the artists by giving their work greater publicity.

Jackson kept his readers informed of the movements of his specials in the Turkish-Bulgarian campaigns of late 1877 with the pride of a general. Melton Prior, he tells us, was sent to Belgrade in 1875 to sketch preliminary skirmishing. When Servia declared war on Turkey, Chantrey Corbould joined the Servian forces and the *News* had Count Carriero as artist on the Turkish side. When Russia joined the war, John Schonberg was despatched to join them, but still there were not sufficient artists to supply the British public with news.

'In the meantime,' Mason Jackson writes, 'without delay or hesitation, we had despatched from London, solely and exclusively for the service of this journal, three more English artists: Mr. Bell, Mr. Irving Montague and Mr. E. Mathew Hale. The first named 'Special' proceeding to Constantinople, speedily found his way into Asia Minor, where he joined the army of Ahmed Moukhter Pasha, witnessed the battles of the road between Erzeroum and Kars, and was present at the raising of the Siege of Kars in the first week of July. Mr. Irving Montague who had likewise got a personal introduction to the Turkish naval and military authorities, sojourned for a time at Varna, which was the scene of great bustle in warlike preparations. He afterwards proceeded by sea to Armenia, where many of his sketches, with those of Mr. Bell, served to present a most complete set of pictures of travel and warfare in Asiatic Turkey ... Mr. Hale, was enabled ... to join the expedition of General Goucko across the Balakan ... We have much satisfaction in announcing that a selection of original Sketches of the War by the Special Artists of the *Illustrated London News* will shortly be placed on view at the Royal Aquarium, Westminster, by an arrangement with the directors.'

Exhibitions of finished drawings became a standard way of supplementing the meagre salaries of the specials, but not at first. There was always strong feeling on the artists' side about the publishers' right to the sketches once they had been drawn out and engraved. Simpson was indignant about his Crimean sketches. 'The publishers afterwards sold my drawings and no doubt received as much as they gave me for them, so that they had the copyright for nothing.'[12] Sir Charles Eastlake, PRA, had in fact advised the Government to buy Simpson's work in 1856 as an historical record but they had refused, adjudging mere watercolours as of no value! Simpson was among the earliest artists to get a contract from *The Illustrated London News* for the return of his sketches which were then exhibited annually in 'Mr. Thompson's Gallery' in Piccadilly.

It was not only the artistic personality of the specials that was being recognised by the 1880s, but their social position. The importance of the specials was tremendously advanced when Melton Prior was asked to lecture on his work and illustrate it before the Prince of Wales at the Savage Club in February 1883. Prior had drawn the Prince's tour of India in 1875 and like Vizetelly with Garibaldi, had struck up as close a friendship with his subject as protocol allowed. Frederick Villiers of *The Graphic* had had his portrait exhibited at the Royal Academy 'in uniform hung about with revolvers, in his hand the flaming scarlet envelope in which despatches for *The Graphic* might be franked without waiting for tiresome delays at post offices or such-like formalities'.[13]

The profession of special artist must have been the only area of book illustration in Victorian England where there was fierce competition to be chosen. A writer in 1883 talks of journals 'constantly pestered by people whose artistic powers are indescribably slight' ready to 'sketch very badly, anything and everything'.[14] Aristocratic amateurs flocked to these offices, some with talent got jobs, the well-connected Richard Wake was sent out to Suakim in December 1888 and shot in battle after sending home his first drawing.

It is reasonable criticism of the specials to see them as a pack of adventurers and fame-hunters, at their best mundane reporters turning out hundreds of illustrations for a fact-hungry but philistine readership. This ignores the real stature of men like Simpson, Caton Woodville, Melton Prior, J.W. Carmichael, Seppings Wright, Sidney Hall and W.T. Maud who had separate careers as painters and watercolourists, exhibiting regularly at the Royal Academy and other exhibitions. It is true that book illustration and genre subjects attracted more of the big names than the ardours of special work, London salons being more attractive than the solitary life of a campaigner. But at least one great name enlisted with the artist correspondents and his work gives some measure of the beauty and strength of line possible in a popular periodical of the 1870s, this was Arthur Boyd Houghton of *The Graphic.*

The founding of *The Graphic* in December 1869 presented *The Illustrated London News* with its first serious challenge since it had swallowed up *The Illustrated Times.* In 1868-69, *The 'News* had sent the artist and alpinist Edward Whymper to the United States, furnishing the journal with a series of views and descriptions like a travelogue. Whether or not as a direct competition to this, *The Graphic* sent A.B. Houghton on a seven month tour of the United States from October 1869 to April 1870 to depict the brash and prosperous land of plenty five years after the Civil War. Houghton was not a topographer, but a brilliant book illustrator and figure draughtsman, schooled in the pages of *Good Words* and *Once a Week* where his biblical and family themes rivalled those of Walker, Pinwell, Fildes and du Maurier. The series was called 'Graphic America' and as well as being an important opening for the publication, released the artist from the drudgery of magazine work, enabling him to investigate a young and virile nation with the sort of scrutiny that only Dickens and Thackeray had before attempted. Boyd Houghton's pen, tinged with a gentle Pre-Raphaelite radicalism, opened up the East Coast and the frontiers of the West for middle class England as well as causing a considerable stir in the States itself. He was both amused and disenchanted by the oldest republic in the world, amused to follow in the steps of Fenimore Cooper and Longfellow and appalled by the corruption and the greed of the new American. He was nevertheless able to extract from it all with consummate skill, the tiny incidents of city life, the Boston News Room, the barber's saloon and the trotting races that epitomised the vital razamataz of American cities. Also in the East, he produced strikingly contrasted sketches of the austere Shaker Community at Mount Lebanon, the synthesis of American extremes.

In the West, Houghton was dealing with themes that were as much of interest to the Bostonians as to the Londoners, so remote and detached were they from pioneering life. Some of Houghton's best work was done there where he found a greater sympathy with the rugged character of the frontiersman pitting his strength against unrelenting nature, craggy mountains and vast forests. Houghton's art, which was an art of contrasting balance of black with white, found full scope in the camp fires and dark woods of the West. A master of composition, his effects of light and shade in prints such as 'Crossing a Canyon' borrow a good deal from Doré's tricks of verticality and silhouette. He drew Indians, visited the Mormons and struck up an acquaintance with 'Wild Bill' Cody, accompanying him on a three day buffalo hunt, and despatched his drawings with his own pithy text to London. Paul Hogarth is probably near the mark when he writes that 'No other artist had been

given, or would be given again, the freedom to describe as well as to depict his impressions of such an important theme.'[15]

By the end of the century the role of the special was changing. He was far less independent, relied less on his own resourcefulness and was increasingly hampered by a panoply of red tape. 'The heyday of the war correspondent's adventurous life closed with the Boer War,' Sheldon-Williams wrote in an article during his old age.[16] At Ladysmith the relationship between military and artist was still informal. 'I do not care if you get a hole through your body as long as you don't go outside our lines,' Sheldon-Williams was told by Major Altham. On the same occasion, Bennet Burleigh of the *Daily Telegraph,* who was known for bluffing his way through anything, complained to the authorities half in jest, that Melton Prior's bald head was drawing the enemy's fire! Such camaraderie among the correspondents became less acceptable as the professionalism of scientific warfare increased. In the Russo-Japanese War of 1905, Melton Prior was forbidden to go to the front by the Japanese command as too old and too much of a liability. Sheldon-Williams says he wept, being unable to complete his work and therefore as good as finished. The First World War was like a new chapter for anyone like Sheldon-Williams who had worked under the old *ad hoc* methods of the specials. His position was officially recognised and he was provided with a chauffeur, a car and a batman, but was also expected to keep out of the way! The creation of official war artists in 1915 really swept aside the unique role of the artist correspondent and ended a profession that had lasted only a little more than sixty years.

Photography had much to do with the decline in the work of the artist reporter, but in this particular area the influence was very slow. In his introduction to *The Camera Goes to War, Photographs From the Crimean War 1854-6,* James Hannavy says that photographs exploded 'the lie that troops fought in dress uniforms — or for that matter any uniform at all — the war artist would rapidly become a dying breed'.[17] Although *The Illustrated London News* was using photographs as a basis for its engravings in the 1850s, there was no sense of rivalry at this early date and it was years before any process of printing photographs in acceptable form was developed. Mason Jackson used 'direct photo-engraving' in the magazine for 1886 and one illustration of a torpedo boat was photographed on to the block for an issue of 1889, but these were not yet substitutes for the action-packed drawings of Woodville or the spirited naval battles of J.R. Wells, the Fleet Special Artist. Many artists worked on photographs and had files of them for data. Apart from the technical problems, the photographer tended still to provide a static view of war, the artist on the other hand could give the sense and colour of action and continued to do so until well into the First War. The public craved for that 'instant when the scene resolves itself into a true picture, which remains for a minute perhaps, and then melts'.[18]

It was during the Russo-Japanese campaign of 1905 that artists like Sheldon-Williams felt the pressure of the camera really encroaching on their territory for the first time. It was a relentless progress from weekly to daily papers and then on to the early screens. Williams found himself in open competition with J. Hare, the official Japanese photographer, Bulla on the Russian side and R.S. Dunn of New York who had been sent out by *The Commercial Advertiser.*

But if the newspaper barons appreciated the use of photography it is clear from a strange story told by one of the specials that the public did not. Fred Villiers, who was always an experimenter, decided to take an early movie camera with him on the Graeco-Turkish campaign of 1897. Villiers had thought that if the artist's on-the-spot sketches were insufficient, here was the ideal substitute which was bound to be a commercial success. But it was a total failure. The flickering black and white impressions on the screen, in which it was difficult to make out either side, almost impossible to catch any dramatic moments and where there was practically no 'text', were useless to convey the

story. The public which had been brought up on fiery penwork, the swirling smoke of naval engagements, the defence of Majuba Hill or the Relief of Khartoum, were not prepared to knuckle down to actuality. In fact news films had to be set up in the tradition of 'battle painting' for the early cinema to be able to use them! It was an extraordinary back-handed triumph for the artist that he had dominated the pages for so long and gripped the imagination of his audience so successfully that they preferred his view to that of the camera. It was H.V. Barnett's remark in 1883 that the special's job was to invest 'bare facts with charm'[19] that was the making and undoing of their work. It put history in aspic, delicious for the taste of the Victorians but less palatable for us. Caton Woodville's great oil paintings are less true to us than his vital sketches covered with notes though it was the former that made him famous. But the battle-painter tradition that persisted among these gallant gentlemen died hard and it was only the unsentimental still photographs of rotting corpses in the trenches of the First World War that finally made the public familiar, if sickened, with reality.

Footnotes

1. William Simpson, RI, *Autobiography,* 1903.
2. Mason Jackson, *The Pictorial Press, its Origins and Progress,* 1885.
3. Henry Vizetelly, *Glances Back Over Seventy Years,* 2 Vols., 1893.
4. Mason Jackson, *The Pictorial Press, its Origins and Progress,* 1885, p.342.
5. William Simpson, *The English Illustrated Magazine,* Vol. 14, 1895-6, p.230.
6. Vizetelly, op.cit., p.236.
7. A.S. Hartrick, *A Painter's Pilgrimage Through Fifty Years,* 1939, p.71.
8. Harry V. Barnett, 'The Special Artist', *Magazine of Art,* Vol. 6, 1883, p.166.
9. Daphne du Maurier, *The Young George du Maurier: A Selection of his Letters, 1860-1867,* 1951, p.82.
10. William Simpson, RI, *Autobiography,* 1903.
11. Harry V. Barnett, op.cit.
12. William Simpson, RI, op.cit.
13. A.S. Hartrick, op.cit.
14. Harry V. Barnett, op.cit.
15. Paul Hogarth, *Arthur Boyd Houghton,* Victoria and Albert Museum, 1975, p.13.
16. Inglis Sheldon-Williams, 'The War Correspondent: Then and Now', *The Sphere,* November 20, 1937.
17. James Hannavy, *The Camera Goes to War,* Scottish Arts Council, 1974, p.13.
18. Harry V. Barnett, op. cit.
19. ibid.

Chapter 8

Social Realism 1850-1890

here was no question of the strongly didactic and moralising Victorian conscience leaving illustration as a purely informing or entertaining medium. In 1865, Charles Knight, who had been at the centre of popular illustrating from its beginnings, was criticising news illustration for its lack of serious reporting. 'The staple materials,' he wrote, 'for the steady-going illustrator to work most attractively upon are, Court and Fashion; Civic Processions and Banquets; Political and Religious Demonstrations in crowded halls; Theatrical Novelties; Musical Meetings; Races; Reviews; Ship Launches — every scene in short, where a crowd of great people and respectable people can be got together, but never, if possible, any exhibition of vulgar poverty. This view of Society is one-sided. We must look further for its "many coloured life". We want to behold something more than the showy make-up of the characteristics of the age. We want to see the human form beneath the drapery.'[1]

Had Knight examined the serial parts or even the bound volumes of the foremost novelist of the period, Charles Dickens, he would have noticed a change in the style of illustrations from 1840 to 1860, a change towards that reality he so wished to see in the press. We have deliberately avoided here in these chapters, the tangled web of Dickens' illustration, but even a cursory glance at the engravings of H.K. Browne (Phiz) to *Pickwick* and then to *Martin Chuzzlewit,* 1844, and *Bleak House,* 1852-53, show a progression away from caricature and towards direct statement. As John Harvey has written, there is a 'new sharpness and energy'[2] in Browne's drawing which is partly derived from Daumier and partly from the way the novelist was changing in the new Victorian world. In *Bleak House,* Browne uses the so-called dark plates to express the feeling of the time; probably a sense that both novelist and illustrator felt together and decided to use, a brooding sense where the figures are dominated by their surroundings. As Harvey writes — 'On Browne's part, the development of this mode shows the depth of his response to Dickens' writing at this time, for it is ideally suited to conveying the oppressive gatherings of fog and darkness in human affairs so powerfully presented in the novel.'[3] This was a far remove from Phiz's illustrations for Grant's *Sketches in London* of 1838, where convicts and lunatics became burlesques much as they had been in the eighteenth century. There were only twenty-three years between that book and the 'literal description' of Henry Mayhew's *London Labour and The London Poor,* 1861, but what a world passes between them. The cold charity of Mr. Bumble was gradually replaced by a greater compassion and understanding from writers and their artists, this was reflected in the Pre-Raphaelite work of the 1850s but there had been earlier precursors.

Charles Knight himself had been an important force in showing life as it actually was away from romanticism and cottage door sentimentality. His two volumes on *London,* 1841, showed some events that were neither topographical, sentimental or caricatured about the ordinary life of citizens. The woodcuts were small and generalised but they gave facts, those on the sewerage of the growing city are among the most interesting. Knight had gathered round him minor delineators like Tiffin, Timbrill and Fairholt, who could not be

expected to lift their work right out of the conventions of the time. In fact it was only after 1851 that the Victorian preoccupation with facts alone became dominant. Douglas Jerrold, writing in 1891, caught the spirit of the change from the earlier books, not simply the change in drawing techniques but the change in the way the new generation of 1851 looked at itself. 'Mr Knight's *London* of 1841,' he writes, 'is a book of the past. His streets and his Cockneys — even those of Dickens — are of another generation — the like of which we know no more. His picture of "a plug in a frost" is a part of London's history, it has ceased to be *our* plug in a frost — and the figures are less familiar to our sight than Chinaman.'[4]

Some earlier attempts had been made to depict the life of the metropolis in unvarnished form. A Regency book in which frankness vies with strangeness is John Thomas Smith's *Vagabondiana or Anecdotes of Mendicant Wanderers Through The Streets of London,* published in 1817. Smith, the morose Keeper of Prints at the British Museum, who brought out a barbed *Life of Nollekens,* filled his book with etchings after his own pen drawings. They present a dramatic survey of street folk, blind beggars, cripples, the indigent poor of all kinds, destitute sailors and hawkers of trifles, observed with objectivity

Figure 67. Beggars by John Thomas Smith. Etching, 1817.

(Figure 67). Smith has clearly taken Callot and Rembrandt as his models and some even mirror the prints of Goya. Although he was no great artist, Smith had the sense to perceive that it was more important to paint blindness, beggary and poverty than personifications of them. Smith worked for Knight at one time and in 1839 a posthumous book *The Cries of London* was published carrying much the same sort of illustrations but the threshold between curiosity and involvement between artist and subject had not really been crossed.

The suspicion of the truthfulness of the artist which was very much a part of the 'scientific' Victorian, stems from the strength of caricature and romanticism in the British School. It is certainly relevant that Mayhew, a founder of *Punch* and a friend of numerous illustrators, should choose daguerrotypes by Beard as the basis of the drawings in his three volume survey of *London Labour.* Nothing short of strict accuracy could be tolerated and no artistic humour or sentiment softens the confrontation of readers with these rejected individuals. *The Illustrated London News* had provided sketches of the Irish famine in 1847, which were not without social comment, and similar coverage was given to the Crimean veterans in 1856 and to the cotton distress in Lancashire in 1862 by a splendid series of illustrations of Manchester operatives' dwellings. Even George Cruikshank's temperance drawings such as the prints of *The Bottle,* 1847, have a stronger realism about them, but by and large the skill of artists was not equal to the situations shown. Irish sketches, Manchester sketches, only seem to tell half the truth and although from 1855 artists such as C.W. Sheeres, C.J. Durham, J. Palmer and R.C. Hulme were tackling industry, they were seldom getting behind the skin of the men who worked in it.

The political upheavals on the Continent between 1830 and 1848 produced a stream of disaffected artists who became temporary visitors to this country much as they did after 1870. Among the artists to come were Eugène Lami, already referred to, and H.G.S. Chevalier known as 'Gavarni', 1804-1866. Lami drew English high life with great panache, Gavarni, a more complicated figure, radical in outlook, bohemian in manner, left his

impressions of the capital in a volume called *Gavarni In London, Sketches of Life and Character*, published in 1849. This was a postscript to the artist's English years, he actually remained here from 1847 to 1851, a period of not unqualified success.[5] Fashionable London had taken the handsome Frenchman to its heart, had fêted him, had invited him to its houses, filled his desk with the cards of artists and men of letters. It was hoped that Gavarni would immortalise the high society of the most prosperous capital in the world, its receptions, balls, garden parties, political functions and historical ceremonies in a volume of magnificent lithographs. This may have been in Gavarni's mind to begin with, but as the life of London became more familiar to him, it was with the humdrum aspects of ordinary life that he identified. At home in Paris, he had hardly been the quiescent well-behaved illustrator of the bourgeois monarchy of Louis-Philippe; in London the artist who had struggled from poverty and imprisonment for debt, drew with fascination and feeling the inhabitants of the grimy streets. Gavarni had been introduced to *Punch* but was disdainful; he had been given permission to paint the Queen but had failed to turn up for the sitting. The British public were not prepared to tolerate such cavalier behaviour and though some of his work appeared in *The Illustrated London News* in 1848 it was dismissed as 'too French'.

Gavarni in London of 1849 remains an interesting book. As was the case with Doré, more than twenty years later, it needed an outsider, a foreigner, to look frankly at the problems of London and provide a dispassionate portrait of its people. Nearly three-quarters of Gavarni's subjects are what Mayhew came to call 'street folk', pavement entertainers, door to door traders, stall holders, labourers or working people in their habitats of Covent Garden or Greenwich. We have a wonderful frontispiece of street acrobats, supple and muscular figures divesting themselves of cheap clothing to reveal an almost Greek nobility; Gavarni found a nobility in the slums and was not afraid to reveal it. He shows us the Potato-Can seller, crying his wares defiantly while shadowy bundles of rags in the background, greedily gobble them up. Next to him are a pair of dandies bound for a fancy ball and before that the demi-monde of Vauxhall and the vulnerable world of the barmaid, a

Figure 68. 'The bar-maid' by Gavarni.

pretty figure surrounded by leering approving faces (Figure 68). Elsewhere a car man and a coal heaver talk together in a gin palace watched by the same pretty barmaid, a crossing sweeper pleads a tip from a haughty citizen and two beautiful women in bonnets and shawls make their way to church followed by a cockaded footman carrying the books. It is as if a sharp knife has been cut into the cake of Victorian society and its varying layers laid bare for the first time.

It can be no accident that each sketch remains so compartmented on its own page, so seemingly isolated from the others and from the text, it was precisely as the London of 1849 appeared to Gavarni. The artist brings a fluidity of line and softness in the pencillings and shadings only achievable in lithography. Besides this an extra dimension is given by the tinting of the lithographs, rare in this type of book. These are French illustrations par excellence, at their most English in the heads of the thieves, but still the productions of the Gallic temperament. In nearly the last illustration in the book 'Foreign Gentleman in

London' we see the be-whiskered features of Gavarni himself, a self-portrait, as he orders his menu in a chop house, defensive to the last of his right to be a foreigner and to have his own opinion of this strange paradoxical people.

A few attempts were made at an early date after this to draw the city as it actually was. George Godwin, Editor of *The Builder,* took graphic artists with him on his visits to investigate the slums in the early 1850s. This was to be 'a record of the curious – not to say frightful – condition of London and some of its denizens in the middle of the boasted nineteenth century.'[6] The choice of artists was strange, Alfred Concanen and William McConnell both being well-known humorous illustrators; the results were published as *London Shadows: A glance at the homes of the thousands,* 1854.

Perhaps the greatest piece of visual exploration in this sphere came not from the English illustrators but from another Frenchman, Gustave Doré, 1832-1883. Doré's background was that of many of the other visiting French draughtsmen, Gavarni included. A spell of working on Philippon's *Journal Pour Rire,* had been followed by a great success as the illustrator of classics by Rabelais and Cervantes. He had appeared briefly before the British public as the reporter of the Crimean War through the pages of *The Illustrated London News*, pages whose individuality and tortured humanity survived even the scalpels of the wood-engravers. The idea that this distinguished foreign artist should make a microcosm of London and follow more penetratingly in the steps of Rowlandson and Gavarni was not his own. It was suggested to him by Blanchard Jerrold, the playright and farceur, who offered to write an accompanying text. Neither was the idea brought to completion, but what was finished remains a masterpiece. Doré was a great enough artist to see that the way to understand a great city and to capture its spirit for the printed page was to synthesise. It was the distillation of the smokey, foggy, brutal and funny, hateful but engaging, poverty-stricken but luxury-laden city of four million people that he set out to capture.

Jerrold was later to write about his friend and the way *London A Pilgrimage* came to be written.

'We are pilgrims; not, I repeat, historians, nor antiquaries, nor topographers. Our plan is to present London in the quick to the reader – as completely as we may be able to grasp the prodigious giant, and dissect his Titan limbs, the floods of his veins, the iron beams of his muscles! We approach him by the main artery which feeds his unflinching vigour. We shall examine him at work and play; asleep and in his wakefullest moments. We shall pay court to him in his brightest and his happiest guises, when he stands solemn and erect in the dignity of his quaint and ancient state; when his steadfastness to the old is personified in the dress of a benefactor, or his passion for the new is shown in the hundred changes of every passing hour.'[7]

It is in fact 'the main artery' of the Thames which gives the book its symmetry, wherever our artist takes us we are conscious of the river producing the grime of the waterfront (Figure 69) as well as the luxuries of the drawing-room. In a large and generous piece of Victorian book production, Doré brings the contradictions and contrasts vividly into juxta-

Figure 69. 'The Pool of London' by Gustave Doré.

position, opening wide the London of Disraeli's two nations. Each nation is treated quite separately, The Docks, The Derby, The West End, Workaday London, divided territories, each totally ignorant of the other. And yet it is the similarities which make the irony for the artist; Jerrold perceptively remarks that only in London do the poor ape the rich in dress, becoming caricatures of the society that has rejected them. In both cases Doré's pictures are thick with humanity whether at the fashionable garden party at Holland House, or in the sleezy gaslight of a fourth rate music-hall; everywhere people are fighting for recognition in the anonymity of it all. The crowded full page illustrations are emphasised by the subtle inclusion of single figures in the opposite text; the chestnut woman or the blind beggar come struggling forward demanding our notice.

Doré's wit suffuses the book from the initial letter 'L' formed from oars pointing skywards and a boat jutting out from the bank, to the sinister rendering of the Lambeth Gasworks, an obvious allusion to Bosch or his followers with the *double entendre* of a Last Judgement! Throughout Doré has relied on foreign engravers which allied to his rather painterly flow of line gives the unique impression of figures on the streets and buildings being as much a part of the climate as the watery moon and the greyness. Doré is the prince of gaslight, both high and low are seen by its rays, the piled hair coils of society ladies come under its glow and so do the jigging bodies of wharfmen or children dancing to a barrel organ in a brick court.

With the founding of *The Graphic* in 1869, a more socially conscious epoch opened up to the illustrator. It was by no means solely *The Graphic* that reported the upheavals of the post industrial revolution cities or the drift from the land, although they fostered a group of artists who drew them with sensitivity, objectivity and great pictorial power. For the first time the illustrated journals became the vehicles of a passionate and persuasive point of view, whose purpose was to show the sufferings of the poor, the destitute and the ill, as they existed in the cold light of Victorian charity. In the hands of Luke Fildes, Hubert von Herkomer and Frank Holl, the homeless, the workhouse inmates and the flower girls, became actual voices demanding to be heard, to be understood, to be considered as part of that society. The unsentimental wood engraving was the ideal medium for this work, and the artist's skilful definition of a crowd as an individual, or a single person representing his whole group, could be seen with a detachment which excluded the morbid or banal.

These illustrators were partly influenced by the moralising of the Hogarth tradition, the novels of Dickens and George Eliot and the identification with work which was a feature of mid-Victorian radicalism. Such figures as John Cassell, the Ingrams and Walter Crane took a fairly vigorous line in social improvement and Crane like W.L. Thomas, 1830-1900, founder of *The Graphic,* had been apprenticed to the radical wood engraver W.J. Linton.

The catalyst in this whole development, from occasional realistic illustration to wholesale coverage of deprivation, seems to have been the Paris Commune in March to June 1871, very few pictures of strong social interest appearing before it. The Revolution exposed nerve ends which nobody recognised were there previously. French cartoonists displayed an amazing black humour in their illustrations of the siege and many French artists, with the tradition of Courbet behind them, flocked into England after the end of the Commune. There was already a great discipline in black and white art, a legacy from the 1860s and Regamey's sketches of Paris for *The Illustrated London News* and Boyd Houghton's powerful evocations of civic solidarity like the 'Women of Montmartre' in *The Graphic,* had a deep impact on the younger artists. Crane was not alone in reacting strongly to the executions of the communists that followed. 'The Commune, its ideals and its acts, were entirely misunderstood, or misrepresented in the English press, and it is only recently, after the lapse of years, that its true aims, with all its faults and almost superhuman difficulties, are beginning to be apprehended as an attempt to establish a true Civic

Figure 70. Illustration to Edwin Drood *by Luke Fildes, 1871.*

Commonwealth, on a basis of collective service and ownership.'[8] Fortunately the British artists preferred to extract the news of the moment from the heavy political theology of the time, making a visual comment outside faction and class rancour.

Fildes, Herkomer and Holl were not political animals. All were to be elected Royal Academicians and, though the third died comparatively young, the first two were to become influential figures in the artistic establishment. Luke Fildes, 1844-1927, a young painter who had already made his name as an illustrator in the mid-1860s, was showing some restlessness by 1869 at being confined to 'fancy' pictures. He was making it his habit to carry a notebook with him on his walks through London and when that year W.L. Thomas suggested he should illustrate a new publication that he was promoting, one of these sketches sprang to mind. It was a drawing that he had noted down of a group of homeless people waiting in the cold for admission to a Casual Ward. This was to be his first and most celebrated contribution to the new *Graphic.* It appeared on 4 December 1869 as 'Houseless and Hungry', a line of destitutes huddled against a bleak wall out of the wind, their heads bowed in subjection, their hands in their pockets and their meagre clothes wrapped inadequately round them. There is no trace of sentimentality anywhere, only a kind of stoical resolve in the adults, a weary inevitability in the figures of the children. The picture had immediate success, academicians praised it, the public were moved by it and Millais at once suggested Fildes' name as the illustrator of Dickens' new novel *The Mystery of Edwin Drood.* Fildes' work in social realism was to be limited; he translated this illustration into a canvas, 'Applicants for an Admission to a Casual Ward', 1874, and painted other subjects of a domestic rather than a social nature. But his enduring image of the queue as a symbol of social suffering was a powerful one and was used repeatedly by other realists, particularly William Small and E. Buckman for The Commune in *The Graphic,* 1870-71, and M. Fitzgerald in the *Illustrated* for the coal mining industry in 1875. Fildes' illustrations for the unfinished Dickens novel are fine and compelling (Figure 70) and provide a link between the novelist's frank expression and the artist's truth to nature which was a feature of the 1870s and 1880s, particularly in the designs for Hardy's novels by Helen Paterson (Allingham), M.E. Edwards, Fred Barnard, Robert Barnes and Charles Green.

Hubert von Herkomer, 1849-1914, some years Fildes' junior, came to illustrating rather late in the 1860s and his best work in black and white was done for *The Graphic,* 1871-79. His greatest strength was in his interiors with figures, observed with a Millet-like sense of form and compassion, melting into their surroundings. His illustrations of lodging

153

houses, workhouses and hospitals are measured by a particular sympathy for the frailties of age, for instance 'Old Age' a study at the Westminster Union, 1877, 'Sunday at Chelsea Hospital', 1871, 'Low Lodging House, St Giles', 1872 and 'Christmas in a Workhouse', 1876. For some reason his contributions to *The Illustrated London News* from 1871-73 are purely social.

Frank Holl, 1845-1888, was a Londoner and most at home with the depiction of ordinary life in town and country. He entered the RA Schools in 1860 at the age of fifteen and eight years later won the travelling scholarship. He resigned this while on tour abroad, partly because it was not benefiting his art, and partly because he was an invalid. His talents really lay in figure drawing and specially the figures of the quayside and the pavement, fisherwomen waiting for their husbands, soldiers ordered off to service overseas. Holl became the painter of working class uncertainty, the uncompromising realities of those who had to fish, had to fight for their country or had to deliver their all to the pawnbroker. Frith had made the platform a place of drama in his 'Railway Station', Holl makes it one of personal tragedy in 'Gone – Euston Station', a *Graphic* illustration of 19 February 1876, and 'Ordered Off', *Illustrated London News,* 13 September 1884. Other facets of the artist are the intensely observed interiors of 'Shoe-making at The Philanthropic Society's Farm, Redhill' *The Graphic,* 18 May 1872, and the subtle street groups of 'Sketches in London' in the same magazine for 22 June 1872. Holl was widely acclaimed for his 'Newgate: Committed For Trial', 1878, and 'No Tidings From The Sea', specially commissioned by Queen Victoria, but his later work is almost entirely in portraiture. Holl was not primarily an illustrator, only occasionally developed his magazine illustrations from canvases, rather than the reverse, and did not usually think in terms of black and white.

E. Buckman was a fairly regular contributor of the social illustration in the early 1870s, working for both the *Graphic* and the *Illustrated.* For the latter he tackled subjects as various as 'A Statute Fair For a Farm Servant', 2 November 1872, and scenes in a 'London Dockyard', 1873. His 'Homeless' in the Christmas *Illustrated London News* of 1876 verges on the sentimental. Michael Fitzgerald, a shadowy figure, contributed some staggeringly simple drawings to the *Illustrated* in the early 1870s showing the hopelessness and monotony of prison life in Newgate and the Clerkenwell House of Correction. A series of character studies run by *The Graphic* entitled 'Heads of the People' gave artists such as Herkomer, Mathew White Ridley and William Small, the chance to show the passions expressed through a trade or a calling, diligence in the head of the miner, watchfulness in that of the coastguard and sober devotion in that of the labourer. Small's contribution, 'The British Rough', is a most astonishing image of brute force, unsurpassed in his later work, with all the strength of Goya.

Mathew White Ridley and C.J. Staniland provided vivid illustrations of the coal mining industry and other artists like A.E. Emslie, W.B. Murray and later W.D. Almond, came to grips with the 'dark satanic mills' of the big cities with their poorly paid female labour. H. Towneley Green formed one of this same group with his brother Charles Green, the Dickens illustrator, so too did R. Caton Woodville, the battle painter and J.D. Linton, the watercolourist. Robert Barnes contributed to *The Illustrated* from 1872 and Fred Barnard, A.D. McCormick and Matt Morgan all submitted illustrations of the Irish distress and British unemployment in 1886. J.C. Dollman's factual look at an opium den in *The Graphic* of 23 October 1880 is a great contrast to Doré's theatrical treatment of ten years earlier.

An interesting sidelight on this group of illustrators in the early 1880s is the development of a mannerism by themselves and their successors. From about 1884, A.E. Emslie, Edward R. King, William Rainey, Sidney Paget, Percy Tarrant, Gunning King and a few more, veer away from the traditional pen line and attempt broken effects as if they were anxious to give a texture like oil paint. This is best seen in Edward R. King's

'Workman's Train' published in *The Illustrated London News* of 14 April 1883. The new processes for photographing a drawing directly on to the block and the increased use of heavy bodycolour over the ink, must account for this thick 'impasto' style, much decried by illustrators of the old school.

W.L. Thomas's interest in showing social problems continues in *The Graphic* throughout the 1880s although the artists employed tend to be less interesting. The middle years of the decade have illustrations of vaccinations in poor districts, board schools, common lodging houses and hospitals, Barnes providing many of them and the drawings for Hardy's *Mayor of Casterbridge* serialised at the same time. The work of C.S. Reinhart, H. Johnson and J.R. Brown is competent in accuracy but does not have that insight which lifts a scene out of the pages of journalism and into the realm of great art. Very different however is the work of the Frenchman, Paul Renouard, 1845-1924, one of the great stars of *The Graphic*.

Figure 71. 'Anarchist Oratory'. Front page of The Graphic *by Paul Renouard.*

He first appears in 1884 and was still working for the paper well into the Edwardian period. He is arguably the greatest artist in chalk ever to work for a British publication and he provides another link in the chain that Thomas forged with the Continental journals. Although he excelled in Parliamentary portraits, Renouard's greatest triumphs were in sketches of the London Police Courts, 1887, and the London prisons in 1889, followed by equally beautiful but less testing subjects in France in the 1890s (Figure 71). His extraordinary mastery of this very soft and caressing medium without tint, gave *The Graphic* a visual lead over its famous rival which was to remain until the First World War. No artist could succeed to him, but chalk replaced wash in the work of the Specials, and when David Wilson became cartoonist in about 1910, his medium was also chalk.

The greatest barrier to accurate social reporting was the fact that both *The Graphic* and *The Illustrated London News* pursued a very general readership. The work of the artists was required to be fairly objective, untainted and untrammelled by prejudice or polemic, simply putting forward a statement of fact. *The Graphic* artists could maintain a certain independence as narrative and genre painting swept agricultural and industrial subjects into the illustrator's net,[9] but the pressures on the draughtsmen as journalists kept their comments muted and there was little text accompanying the blocks. As has been pointed out, the situation with the Victorian comic weeklies was rather different. 'Traditionally', wrote Wolff and Fox in *The Victorian City*, 'graphic humour has always been closely connected with comment, individual bias and prejudice. It is recognised as being a distortion of reality to point an effect or achieve a purpose . . . In the small cartoons also, the contact between illustrator and audience did not involve the concept of impartiality, and in addition the artist rarely had to meet a topical deadline.'[10] The first cartoonist of *Punch* who had his subject chosen for him at a dinner on one day and had to produce a completed drawing three days later, would hardly endorse this, but *Punch* by the 1860s had become a paper of the *status quo* and Tenniel was not a political man. A more vital style of cartooning which must have had some social impact was that appearing in *The Tomahawk* between 1867 and 1870.

The Tomahawk was founded by A.W. à Beckett after he had been cold-shouldered by

Mark Lemon of *Punch*. A Beckett was twenty-one years old and determined to have a *Punch* of his own, which may account for the youthful verve of the paper and the great freedom of its one and only illustrator. It turned out to be very unlike *Punch*, 'a Saturday Journal of Satire' with a maximum of six pages of letter press and one 'big cut' for the price of twopence. With a staff of about six, mainly made up of young civil servants who were writers, it was more adaptable than its elder brother and more socially volatile. Its greatest strength was in having Alfred Thompson as writer and illustrator of its almanacs and Matt Morgan, 1836-1890, as cartoonist throughout its life.

Morgan is a rather shadowy figure but his work is amongst the most original of its time. He made rather conventional illustrations for *The Illustrated Times* and other periodicals before coming to *The Tomahawk* in 1867, and drawing for it with a fearlessness and conviction that had hardly been seen since Gillray. His draughtsmanship appears to have been very variable but the images that he produces are very modern, some deriving from French cartooning and some from the book illustrations of Doré. *The Tomahawk* made the innovation in political and social cartooning of printing from tinted wood blocks, the black outlines standing out from green, orange, yellow or blue tints, sometimes tremendously enhancing to a double page spread, sometimes creating 'an ultra-bilious effect to the jaundiced eye'.[11] The cartoons were decided by the staff much as those on *Punch* were chosen, but Morgan seems to have had great freedom and the editorial works very closely with his designs. *The Tomahawk* strongly criticised Disraeli, condemned the abuses of women by society, protested about the English attitude to Ireland and the misuse of money by city magnates. Morgan dared too on 14 November 1868 to criticise the Queen and her prolonged widowhood in 'Which Will It be?' A throne is shown on one side of the cartoon occupied by a serene Queen Victoria and on the other side it is empty and draped with black; around it are symbols of the corresponding prosperity or poverty that the sovereign's influence brings. This cartoon was strongly criticised and Morgan had to atone for it by a more loyal one when the Queen finally emerged from her hibernation at Windsor.

Morgan's bête noire was Napoleon III and his small, lithe presence, with carefully waxed moustache, is seen frequently in *The Tomahawk* pages as the ravisher and destroyer of France. Amongst the most memorable of the series leading towards the defeat of 1870 are 'Alone With The Dead, Or Liberty And Her Murderer', 30 January 1869, showing Napoleon rowing a boat with the corpse of *La France* in its stern, a subject from Doré and 'The Modern Mazeppa' where the Emperor is lashed to a runaway horse, 5 June 1869. The cartoon of 24 July 1869 is ominously prophetic, a sombre panorama of Paris is titled 'The Doomed City' and the lurid green of the tints breaks in only one piece of sky to reveal the words 'Revolution'. His most remarkable engraving appeared on 30 July 1870 under the title 'Vive La Guerre', a menacing skeleton dressed as a French soldier gives out a cry from its gaping jaws and holds a torch and a sword high in its bony hands. Not only is this an indictment of the Franco-Prussian War but a statement about war as a whole. Morgan was especially outraged by the dependence of the urban population on such frivolities as the London Season and he voiced this in a cartoon of 21 August 1869 where a family face starvation in a garret because Society has left town for the summer. Another outrage depicted by his pen was that of baby farming, shown as 'The Devil's Trade' in July 1870 (Figure 72).

Morgan's position on *The Tomahawk* is credited with winning greater freedom for the cartoonist in other fringe papers for which he worked, *Fun*, *Judy* and *Will o' the Wisp*.[12] He made some further important contributions to *The Illustrated London News* in 1886, showing the London unemployed but later settled in the United States where he died in New York in 1890.

A further pair of artists working in this strongly social pictorial tradition were William

Strang and Jack B. Yeats. William Strang RA, 1859-1921, used the recently revived etching to show the rugged and arduous life of poor country people, rather in the style of Millet. They can show great contrasts in atmosphere and in character, very often they depict that sort of stoical determination which is seen in the group of his etching 'The Fair Ground', 1892 (Figure 73). Jack Yeats, 1871-1957, reveals another aspect of late Victorian society in his East End drawings of 'A Push Halfpenny Match', 1898, or 'Gaff in the East End' of the same date. They show a crowd of heads, usually craning forward over a game, an incident or a boxing match, and are among the most sturdily vivid works being done in the 1890s.

THE DEVILS TRADE!

Figure 73. 'The Fair Ground' by William Strang, 1892.

Left: Figure 72. 'The Devil's Trade' by Matt Morgan, July 1870.

Footnotes

1. Charles Knight, *Passages of a Working Life*, 1865, Vol. 3, pp.246-47.
2. John Harvey, *Victorian Novelists and Their Illustrators*, 1970, p.134.
3. ibid., p.153.
4. Blanchard Jerrold, *Life of Gustave Doré*, 1891, p.175.
5. Gavarni must have been known to the British public by 1845 when W. Dugdale of Holywell Street, published sixteen woodcuts by the artist, price 2d.
6. Quoted by Dyos & Wolff in *The Victorian City*, 1973.
7. Blanchard Jerrold, op.cit., pp.175-76.
8. Walter Crane, *An Artist's Reminiscences*, 1907, p.102.
9. It was this aspect of the black and white artists that encouraged Vincent Van Gogh to collect their wood engravings from the magazines.
10. Dyos & Wolff, *The Victorian City*, 1973, p.567.
11. A.W. à Beckett, *The A Beckett's of Punch*, 1903, p.168.
12. Kemnitz, *Victorian Studies*, Sept. 1975, Vol. 19, No. 1.

Chapter 9

Fin de Siècle Magazines

Head-piece for The English Illustrated Magazine, *1883, by Heywood Sumner.*

The Victorian reading public was a magazine reading public and the originality and inventiveness of publishers and artists were kept in perpetual ferment by their demand to be entertained. After the rather dull days of the 1880s, the next decade produced a myriad of illustrated publications, some of them short-lived, some more hardy, but all of them self-consciously of the moment and determined to amaze, shock, delight and enthrall before the century ran out. Holbrook Jackson, writing in 1913 and almost within earshot of the 1890s, remarked that 'people felt they were living amid changes and struggles, intellectual, social and spiritual, and the interpreters of the hour — the publicists, journalists and popular purveyors of ideas of all kinds — did not fail to make a sort of traffic in the spirit of the times.'[1]

The words 'fin de siècle' were on everybody's lips as was the word 'new', there was the new art 'art nouveau', the new morals, the new socialism, the new drama and logically enough 'the new woman' who smoked, rode on a bicycle or had a career. Perhaps because of the entrenched academicism of the schools and galleries, perhaps because book work is the natural opening for a young artist, it was in the illustrations, in the decorations, in the posters and private presses, that the spirit of this new art flourished. 'In no other branch of pictorial art was there so much activity during the whole of the period,' wrote Holbrook Jackson, 'and, on the whole, so much undisputed excellence, as in the various pen and pencil drawings which blossomed from innumerable books and periodicals.'[2] It was after all the decade of Aubrey Beardsley and Phil May, of Walter Crane, William Morris, Charles Ricketts, Bernard Partridge, Linley Sambourne, Raven-Hill, S.H. Sime, J.F. and E.J. Sullivan to name only a few.

The decadent vision which has come to be associated with the period certainly stretches back to an earlier date than 1890, in fact to the aestheticism of the 1870s. The liberation of subject matter that had been won by the Pre-Raphaelites and continued by the

artists of the 1860s had not penetrated the book as a whole. It was only in the pioneering work of Walter Crane and his followers that the artist left his allotted pages and flowed over into the text, establishing his right to be considered and consulted over type faces, frontispieces, covers, initial letters and all manner of decoration. Crane had come to realise the importance of the quality of space and black and white areas in a book opening, his inspiration being partly in the tradition of medieval illuminations, partly inspired by Dürer and to some extent by latent Pre-Raphaelitism. But although Crane's discovery of the 'mechanical relation' of decoration to the page, and the page to printing, resulted in many fine art books, a large proportion of this creativity went into children's books and the production of magazines. Crane's training under the socialist engraver W.J. Linton places him firmly in the craft tradition and his populist feelings about illustration are summed up in a book written at about this time. Graphic art he says 'is the most vital and popular form of art at the present day, and it, far more than painting, deals with the actual life of the people; it is too, thoroughly democratic in its appeal, and associated with the newspaper and magazine, goes everywhere — at least, as far as there are shillings and pence — and where often no other form of art is accessible.'[3] Crane with his eye on new ideas and a new public was not so dogged by the precious archaism which taints some of Morris's book design and was so prevalent among his imitators. He did not resist mechanisation or disallow the value of photography but saw possibilities in both and praised their fidelity in the best processes.

Concurrent with the Utopian dream of Morris and the radicalism of Crane, was the doctrine of 'art for art's sake' which had been nurtured by Walter Pater and been brought to a wider audience through the writings of Oscar Wilde. It was in many ways the antithesis of the craft approach, it held that art was responsible to nobody, that it had no moral or political message beyond itself and that it was the territory of a cultured elite among whom the artist himself was a sort of natural aristocrat. The art of such a doctrine was necessarily self-conscious, brittle and precious, and whereas in the hands of Whistler or Beardsley it could reach great heights, its presence in the schools produced work that was often imitative and mannered. Because it was a distinctly decorative style, its range was well suited to the book and some of the finest productions of these years were in art nouveau books and magazines. The concept of the 'artistic person' and the 'artistic house' was very fashionable at the turn of the century and it was undoubtedly a middle-class readership, fired by Morris and seduced by the new art, that enabled so many *fin de siècle* magazines to flourish.

These magazines were sometimes weeklies, sometimes monthlies but were distinctive for their decoration, hand-made paper, beautiful type forms and carefully chosen subject matter, the spiritual heirs of the books of beauty that were nice to feel and handle as well as to read. The other magazines of political, social or general interest continued to be issued, *The Strand Magazine, The Pall Mall Magazine, The Pall Mall Budget, The Sketch, Pick-Me-Up* and many more, each employing their own teams of good artists. But the drawings were for the most part purely pictorial, purely illustrative and little more than accomplished entertainment; the *fin de siècle* magazines on the other hand clearly demanded a critical response and an intellectual comparison of design with design from their readers.

The resulting mixture of aims and aspirations between the arts and crafts movement on the one side and art nouveau on the other give the 1890s that fragile doomed extravagance which we have come to admire. The tensions within the art of the time seem to have been more than usually creative and they are nowhere better seen than in the pained pierrots, glowering satyrs, grotesque masks, arabesques and lotus flowers that spread across the pages of the magazines.

Line blocks had been used from 1876 and the first half-tone was used commercially in 1884, bringing in an epoch where the artist was no longer drawing for the engraver but

drawing for himself and gaining with it an independence of interpretation and a will to experiment. By the middle of the 1890s there were younger men on *The Graphic* who had never worked for the wood-engraver and whose vision was totally fresh. Another sign of the times was the rather tragic bankruptcy of the firm of Dalziel Brothers in the middle of 1893. The remarkable family of engravers and artists, who had been responsible for many of the finest art books of the mid-century, ceased trading with debts of £39,146. The Official Receiver commented of the famous brothers that they were 'over 70 years of age' and 'could not keep up with the times'.[4] But their own evidence was that their losses were due to 'the extinction of their wood-engraving business owing to the introduction of automatic processes; to loss by colour printing owing to foreign competition generally'. At the height of their fame in the 1860s, George, Edward and Thomas Dalziel had been the leading engravers and publishers of art books, their influence extending into magazines. For years they had supplied the engraved blocks for *Punch,* but in the 1890s even that magazine was changing, although it continued to be a forcing house for black and white art in the wood-engraved style until the 1920s.

For the more adaptable younger men like A.S. Hartrick, Charles Robinson, G.L. Stampa, Tom Browne, Jack B. Yeats and Reginald Cleaver, the half-tone was a spur to new things. As mass-production increased magazine coverage, and the process made illustration varied and cheap, the artist was more and more called upon to perfect his art and to extend his boundaries. The euphoria lasted out the decade. 'Gradually,' wrote James Thorpe, 'the development of the half-tone block facilitated the reproduction of photographs, and as the initial cost of these was far less, they began to take the place of drawings. Thus the new process, which had at first brought so much encouragement to the artist presently threatened to extinguish him.'[5] It was perhaps the constant presentiment of the camera breathing down their necks that drove so many of the best magazine artists of the day into areas where photography could not stray, pure decoration and pure humour.

The English Illustrated Magazine

The English Illustrated Magazine which was begun by Macmillan's in 1883 was a half-way house between the finely illustrated periodicals of the 1860s with little page design and the very 'aesthetic' publications of the 1890s. As its name suggests it was profusely illustrated, but not too heavily to frighten away Henry James as an early contributor or F. Marion Crauford, that steady favourite of Victorian fiction lovers. Travel articles were the mainstay with occasionally full-page, more usually half-page, illustrations or vignettes by T. Napier Hemy, W.J. Hennessy, R.W. Macbeth, A.D. McCormick, Lady Butler and J. Fulleylove. In almost all cases there was well-handled black and white or pen and wash, interspersed with chalk drawings, nothing very startling from the point of view of book production. But the aesthetic movement of the time was having its impact and there are some full-hearted contributions by Walter Crane, filling the page with his maidens, borders and cyphers, scarcely giving room for the scant verse it is intended to illustrate! This is at its best in 1884 and in 1887, Heywood Sumner takes up the clarion call with illustrations for Julia Cartwright's *Undine,* a double page spread of marvellously bold design, statuesque females, their long tresses mixing with a tightly meshed design of water-lilies and poppies. Sumner's inspiration is best seen in his headings and tail-pieces which are less

Burne-Jonesish in origin, more in the spirit of the woodcuts of Calvert and Palmer, small scale with an engaging lack of finish, one of a wagon veering across the page top is a small masterpiece (see the head-piece to this chapter, p.158).

An advance on the practice of many other journals was *The English Illustrated's* painstaking listing of all the artists appearing between its covers. Each illustrator is mentioned under the heading of 'artists' and again with the text he illustrates. Even the designers of the head-pieces, tail-pieces and initial letters come in for inclusion, a certain sign that the publishers were proud of their 'art for art's sake' approach. Some of this enterprise can be credited to the three Macmillan editors, J. Comyns Carr, Clement Kinloch-Cooke and Emery Walker, the first and the last in particular having close links with art and design. They managed to gather around them a very varied selection of talent. Sumner as has been mentioned contributed a great many wood engravings, but so did the Pre-Raphaelite artist Henry Ryland, the architect A.E. Sedding, the flower-painter Alfred Parsons and the lesser known S.R. Macquoid and A. Morrow. But even here there was no overall sense of design, not even that cohesion of 1860s magazines, head-pieces and borders come from different pens, illustrations from more than one artist per article, an *omnium gatherum* that does not sit easily together. One of Sedding's meticulous and delicate initials is placed immediately below a coarser, bolder design by R. Heighway. Elsewhere a mixture of original work and drawings based on photographs give an uncomfortable lack of direction to the whole venture.

The most homogeneous pages are those in which poetry is set into a free design and illustrations and text balance one another, as in Hugh Thomson's lyrical sketches to eighteenth century ballads. Hugh Thomson, 1860-1920, was principally a discovery of *The English Illustrated Magazine.* Arriving in London from Ireland, his work must have seemed like an answer to the editor's prayer after the tragic death of Randolph Caldecott in 1886. The two artists appear together in the same issue for 1885-86 making an interesting comparison. Thomson's art is in the straight tradition of Caldecott, superbly modulated pen and ink drawing, more meticulous perhaps, but not scratchy or unpleasantly hatched. His works for these numbers are as individual as Caldecott's, gentle humour pervading his huntsmen, dancers, dairy-maids and fishermen, as they did with the latter, but never becoming caricatures. Once Thomson was established as Caldecott's successor, and his frequent appearances after 1886 show this, the brilliantly versatile artist became the doyen of the eighteenth century pastiche. He had a collaborator of equal merit in Herbert Railton and during 1887-88, the two black and white artists gave readers a good piece of nostalgia, illustrating Outram Tristram's *Coaching Days and Coaching Ways,* dealt with later as a book. For their money, Macmillan's subscribers had Railton's tremulous drawings of old inns supported by Thomson's magnificent figures of grooms, coachmen and travellers.

If Thomson was very much the ascendant star, there were a number of exciting artists making their way through its pages. Louis Wain arrives in 1883 as a topographer and later as an illustrator of hunting scenes and dogs! W.D. Almond contributes superb figure studies, Harry Furniss comic scenes of low life, Holland Tringham and A.D. McCormick architectural studies. An amusing little pen artist is Harper Pennington who provides the thumbnail marginalia to Oscar Wilde's article on 'London Models' in 1889. Veteran illustrators like William Simpson RI and Harrison Weir worked for the magazine with sketches of campaigns and poultry respectively, but the editorship encouraged new blood such as the architectural drawings of Reginald Blomfield, the etchings of the young William Strang, and sketches to illustrate an article on 'Wolf Hunting' by a totally unknown student called Edmund J. Sullivan. From October 1888, there is a strong element of arts and crafts pervading the journal, this dates from the editorship of Emery Walker, lasting until about 1890. Younger artists are used for decorations, Annie Baker and Florence Ayling do Morrisy headings,

Matilda Stoker a very Celtic one, and A.C. Weatherstone a frieze in the style of Burne-Jones. The book itself is well covered by contributions on binding from Cobden Sanderson and on the *Punch* artists.

But after the first flush of interest, Macmillan's found the circulation dwindling and not even the talents of craft editors like Walker could do much about it. 'For a time the magazine prospered,' writes the official historian of Macmillans, 'but one cannot resist an impression that it never clearly made up its mind what its purpose was. The list of contributors is remarkable, but exceedingly mixed.'[6] The paper was sold to Ingram in 1893 and became for some years another arm of the great *Illustrated London News*. In succeeding years, particularly in 1893-96, the impetus was maintained and the new proprietors found Gilbert James as a good decorator for poetry and L. Bowley and C. May for headings and tail-pieces. E.J. Sullivan was employed again as an illustrator of stories, Phil May and Dudley Hardy appear infrequently, Laurence Housman designs for E. Nesbit's *Ballad of the White Lady*. It is pleasant to find Caran D'Ache making picaresque drawings in October 1895 and Cecil Aldin drawing animals in April 1896, but apart from

Figure 74. Illustration to The Century Guild Hobby Horse *by Selwyn Image, 1886.*

these it becomes 'run of the mill' work by *News* illustrators; W.H. Overend with his endless shipping, Caton Woodville's battling lancers and Montbard's stories. A delightful piece of light relief as always are the French influenced decorations by René Bull. The distinct character of *The English Illustrated Magazine* which made it the first of the 'artistic' magazines, has however completely vanished. Although it struggled on until 1909, its story is not that of a *fin de siècle* magazine.

Only three years after the birth of *The English Illustrated Magazine* in 1886, a publication of even greater artistic pretension had come on the scene. Herbert P. Horne and Selwyn Image produced *The Hobby Horse*, 1886-92, which was noted for its fine design and clear printing, a precursor of things to come (Figure 74). In 1888, the Arts and Crafts Exhibition was held which was to be an important step for the country. For the craftsman-printer and illustrator, the catalogue had a section on printing written by the ubiquitous Emery Walker. This influence bore immediate fruit in 1889 when Hacon and Ricketts founded their publication *The Dial*, and in 1891 William Morris opened his Kelmscott Press.

The Butterfly

A refreshing feature of the 1890s is its openness to new talent and the readiness of publishers to accept young artists as illustrators of magazines, handing over both design and editorship to them to show the work of their contemporaries. The Lane enterprises were highly commercial ones, the Charles Ricketts and Gordon Craig publications highly

personal, and between the two came periodicals like *The Butterfly*. Leonard Raven-Hill, 1867-1942, was only just twenty-six when he founded and edited this magazine in 1893. A Somerset man who had studied at the Lambeth School with Ricketts and Shannon, he had gone on to conventional atelier studies in France, concentrating on black and white drawing. Raven-Hill worked on *Judy,* and *Black and White* and was Art Editor of *Pick-Me-Up* before starting this new venture. His métier was the street scene and humours of society and both in style·and character he was the spiritual successor of Leech and Keene.

The Butterfly's sub-heading was 'A Humorous & Artistic Periodical Published on the 15th of each month', and its butterfly insignia on the front cover might easily have been mistaken for Whistler's signature, an association with aestheticism that cannot have been wholly unintentional! The informal note was struck by the 'Apology' in the first number which gave the impression that the readers were looking over a student's sketchbook, gleaned purely by chance. 'We propose to devote several pages of each monthly number to pictures of a really superior class,' it ran. 'These will be carefully done by some friends of ours who have learned drawing at school, and who have since devoted quite a lot of spare time to making sketches on odd pieces of paper and cardboard in order to acquire the pleasing facility in the use of the pencil which they now enjoy.'[7]

Chief among these friends were Maurice Greiffenhagen, 1862-1931, who illustrated stories and Edgar Wilson, an intriguing artist, who provided ·the decorations. The greatest strength of these little books is the pen drawing, but Greiffenhagen, a master of the lead pencil, reproduces superbly in the half-tone illustrations, making up about a quarter of the book. Raven-Hill fills these early numbers with sparkling cockney studies, some with the meticulousness of Keene, others more spare in line like Phil May or Tom Browne. E.J. Sullivan, 1869-1933, the greatest black and white artist of his day, appears briefly in the first volume as the illustrator of his own tale *The Story of Melloe's Play* in crisp inky lines. There are some reasonable genre scenes such as 'Bank Holiday at Brighton' by Oscar Eckhardt and other less known artists.

The contributor who most catches one's attention, presumably because so little is known about him, is Edgar Wilson, the principal decorator. It is his design on the cover and further penetration inside shows him to be a wildly enthusiastic follower of Whistler's and predictably of Japanese art. Wilson's eye for the page is excellent and his headings and tail-pieces lift the magazine out of the ordinary and place it in the forefront of design. In the early numbers there are some excellent Whistlerian drawings of jetties by Wilson, reproduced in silvery half-tones and in the final one of the first year an amusing piece of archaism in the decorations to the poem 'To My Garden'. Wilson shows here and in the drawings to 'A Wooden Waterloo' in 1894, his sensitivity to old woodcuts, anticipating the work of the Beggarstaff Brothers and Gordon Craig. In 1894 Wilson's work develops a slightly more grotesque dimension, and Greiffenhagen's story illustrations become more consciously French, Raven-Hill has a series of Jewish portraits, 'Ghetto Travesties', and there are some refined figure studies by a newcomer, Reginald Savage. Singularly enough, Raven-Hill's last series of drawings before the magazine closed down are illustrations to *Bab*, the story of a model, a neat piece of plagiarism from du Maurier's *Trilby.*[8]

The Butterfly began life again for a short spell in 1899-1900, altering its format and using not three or four artists as in its first flight but a large cast of black and white men, decorators and caricaturists. Half-tones are more widely used than in the first series to bring to life the animal drawings of G.D. Armour, the caricatures of G.R. Halkett and some mysterious lowering illustrations to *A Vision of Judgement* by S.H. Sime, 1867-1941. This artist is capable of straight pieces of impressionism, as in the 'Underground Railway Station' in one of these issues, but is best remembered for his disturbing black humour and insights into the uncanny. The best one in *The Butterfly* is probably 'The Edge of The Forest',

1900, which looks forward to the grimly menacing 'Wild Beast Wood' of a few years later and to his illustrations for Lord Dunsany's books. A bewildered group of figures cower around their diminutive cottages, dominated and crushed by the giant trees of the forest above them, Sime's personal vision of the inevitable power of nature. The timeless quality of these drawings and their power has seen to it that Sime is still remembered when other artists in these pages are forgotten. Gilbert James for example, another imaginative artist but a much weaker one, illustrates a Rackhamish medieval scene and decorative sentiment is found in a whole series of 'eighteenth century' portraits, 'The Virtuosos', 'The Sign-Painter', 'Violet', in the sensuous line of Dion Clayton Calthrop. The literary contributions to the pages are not particularly memorable but a *feuilleton* by Calthrop 'On The Prevalent Architecture of Hen Coops' typifies the satirical imitation of the essay style that little magazines seem to have attracted.

A more accomplished essayist is here as caricaturist, Max Beerbohm, 1872-1956, who took the germ of *portrait chargé* from *Vanity Fair* and invigorated it with brilliant feeling and wit, and is represented by two cartoons. The earlier one is an unkind but very funny portrait of Edward, Prince of Wales, entitled 'The Royal Box' from which the heir apparent leers through opera glasses, the second a sketch of M. de Sounal 'The Portugese Minister', the dandified sort of figure in whom Max delighted and who in many ways represented his own way of life. Raven-Hill continues to give the readers beautiful pen drawings and the Whistler influence of the early years persists in Joseph Pennell's etching of 'The Pool of London' and Frank Emanuel's charming drawing of Dieppe. Edgar Wilson's art has made great strides since 1894 and its decorative forms are much bolder, more symbolic and overtly Japanese than ever before. One superbly contrasted heading of a fish is so chunky and stylised that it could almost be taken for a piece of art deco rather than an explorative work by a young turn of the century artist. *The Butterfly,*[9] like most of its competitors, folded its wings for the last time in 1900. Raven-Hill had joined *Punch* and was filling its weekly pages with figure studies for which he was well suited and with political cartoons for which he was not; the student of 1893 had become the professional of 1900.

The Studio

If the trends in the arts of the 1890s were diverse with styles and ideals pulling in opposite directions, they came nearest to speaking with one voice in a neat little monthly magazine which began appearing in 1893. *The Studio* would have had no success before the art-conscious 1890s and to some extent lived on borrowed time after the decade was over, but during those years it was as decidedly of its time as Beardsley or May. In its pages jostled the two major influences on the art of the period, the crafts movement of Morris and the aestheticism stemming from Whistler, Wilde and their followers. The first provided scope for articles on potteries, tapestries, wall-papers, iron and metalwork, cottage homes and extensive coverage of the Arts and Crafts exhibitions; the second gave the magazine its Continental outlook, its love of posters, book illustrations, Gallé glass and international art nouveau. The publishers had cleverly succeeded in appealing to an audience wide enough to be popular and yet exclusive enough to retain the image of the artist as a special person. The magazine was neither the realm of the professional alone nor of the amateur alone, it contained works of new painters and old, balancing out the smart with the

established and giving the readership the aura of novelty and being in touch with experiments. It was the first attempt to tap the huge leisured middle-class which knew itself to be bored and suspected itself of being artistic, and the first attempt to involve that group principally with contemporary work.

The Studio was the brainchild of C. Lewis Hind, 1862-1927, who was its first promoter and who employed the very youthful Aubrey Beardsley to design the first wrapper, an outstanding design of tree stems and foliage with that signature of the new art, three open lilies in the left hand corner. Hind was succeeded almost at once by Gleeson White, 1851-1898, who was editor of the magazine for the first two years and stamped his personality and tastes on it in a quite remarkable way. White's background was more all-embracing than Hind's, he was not merely a critic, but a professional journalist and an amateur designer of talent. He had a more practical approach to the new art, having designed book covers for Elkin Mathews and the Bodley Head and was clearly most interested in the decorative side of designing, the side most in favour with his readership. The year he became Editor of *The Studio,* he published a book on *Practical Designing* and he brought with him to the post an immense amount of experience gained as Editor of the American journal *Art Amateur,* 1891-92. Perhaps most important of all he forged links with the art schools and the amateur sketching clubs, giving many column inches to their exhibitions and successes, publishing the work of unknown students and encouraging them through *The Studio* competitions, which were a great feature of the early volumes.

Besides this, White was an acknowledged authority on book illustration and particularly the artists of the 1860s. His book *English Illustration 'The Sixties' 1855-70,* was widely acclaimed on its first publication in 1897 and has been frequently quoted in this book. The fact that he should consider the artistic public of his own day as fertile ground for a book on illustration is borne out in its opening chapter 'The New Appreciation And The New Collector'. 'Today,' he writes, 'not a few people interested in the Arts find 'the sixties' a time as interesting as in the last century men found Praxiteles, or as still more recently, the Middle Ages appeared to the early Pre-Raphaelites.' White shows that the oil painters and the stained glass artists have been admired and the turn of the art of the book has come. 'Now, however, the humble illustrator, the man who fashions his dreams into designs for commercial reproduction by wood-engraving or 'process', has found an audience, and is acquiring rapidly a fame of his own.'[10] The re-appraisal of 1860s' work was undoubtedly coming from artists and critics like White and not from publishers and readers. Sir Seymour Haden and Joseph Pennell had both focussed attention on black and white work through etchings and drawings and Pennell had written about it in his formidable book of 1895.[11] The younger artists, particularly Laurence Housman and E.J. Sullivan, had looked over their shoulders at the earlier school and found kinship which greatly invigorated their work. Housman published an article on A.B. Houghton in *Bibliographica* for 1895 and then, such was his enthusiasm, produced a catalogue, *Forty Designs by A. Boyd Houghton* in 1896. Gleeson White understood how beneficial this cross-fertilisation could be. 'It is a healthy sign,' he wrote, 'to find that people today are interesting themselves in the books of the sixties; it should make them more eager for original contemporary work, and foster a dislike to the inevitable photograph from nature reproduced by half-tone, which one feared would have satisfied their love for black-and-white to the exclusion of all else.'[12]

It is hardly surprising therefore that *The Studio* began with a strong bias towards the art of the book generally and book illustration in particular. The first volume for April to September 1893 contained articles on 'Designing For Bookplates', 'The Collecting of Posters — A New Field For Connoisseurs' and a whole series on 'Drawing For Reproduction'. White's experience in the States is reflected in the contribution on 'The Art Magazines of America' and their strong emphasis on pen drawing, followed by an article on 'Pen Drawing

For Process'. But the article which set the seal of modernity on the whole venture was Joseph Pennell's celebrated essay on 'A New Illustrator, Aubrey Beardsley' which came out in the first month. Pennell like White wanted to see draughtsmanship that was working with, rather than fighting against, the new processes and in Beardsley he decided he had found it. 'The reproduction of the "Morte d'Arthur" drawing, printed in this number,' he wrote, 'is one of the most marvellous that I have ever seen, simply for this reason; it gives Mr Beardsley's actual handiwork, and not the interpretation of it by someone else. I know it is the correct thing to rave over the velvety, fatty quality of the wood-engraved line, a quality which can be obtained from any process-block by careful printing, and which is not due to the artist at all. But here I find the distinct quality of a pen line, and of Mr Beardsley's pen line, which has been used by the artist and reproduced by the process-man in a truly extraordinary manner.'[13] *The Studio* certainly became a continuing testimony to the Beardsley style although its pages also sheltered the woodcut style derived from Morris and Birmingham. White's catholic editing included the running of competitions for students, many of them devoted to illustration or other book craft.[14] The magazine organised prizes for 'all classes of decorative art', the designs being set by 'manufacturers, familiar with the purpose for which it is intended, who will also act as judges'. One of the earliest projects was to design a title-page for the new magazine and the variety of entries does show the eclectic influences from Crane to Kelmscott that prevailed in the art schools. In general the standard was high although frequent criticism came from the Editor about the inappropriateness of the lettering and the crowding of ornament. The competitions were continued long after White's death and must have had a marked effect on the art as a whole; for many aspiring illustrators it was the first time they saw their work in print. One finds the names of Evelyn Holden, Alfred Leete, Austin Osman Spere, Edmund Blampied and many others in this section.

The Studio gave an equal share of attention to photography, opened its columns to correspondence on such topics as 'Is the Camera the Friend or Foe of Art?' and published the work of Sutcliffe, Emerson and Henry Dixon. Artistic people were interviewed and artistic homes visited, pottery, sketching-grounds and Japanese art were discussed and the new movements spoken of with bated breath.

The second volume was less dramatic but continued White's themes with contributions on 'The Art of Book Binding', 'The Birmingham Municipal School of Art' with reproductions of the work of C.M. Gere, Winifred Smith, Sidney Heath, G.C. France and Florence Rudland, reviews of books and their decoration and fresh notices of the prodigy Aubrey Beardsley. The last were on the publication of *Morte d'Arthur* and *Salome*. In subsequent years it was *The Studio* which introduced that brilliant but soft-toned artist Charles Robinson to the public, and much the same was done for A. Garth Jones and Henry Ospovat in 1899 and the early work of Jessie M. King in the same year. In one number *The Studio* inserted a complete booklet printed by the Essex House Press entitled 'Beauty's Awakening' with decorations by C.R. Ashbee, Walter Crane, Harrison Townsend, C.W. Whall and H. Wilson, and bold penwork betraying its strong reliance on Morris. Phil May came to prominence here only after his death in 1903, but there were articles on animal illustrators such as Carton Moore Park and groups of illustrators such as The London Sketch Club. A tendency towards a more impressionistic genre is shown by an article on Constantin Guys in 1905 and to a more imaginative interpretation of children's books with A.L. Baldry's essay on Arthur Rackham later the same year.

Charles Holme's editorship from 1900 veered towards the crafts and architecture but the stamp of Gleeson White's concern for black and white art, the poster, the ex-libris, the book beautiful from the growing number of private presses, continued until after 1914. For the most informed criticism of E.H. New or Tony Sarg, George Sheringham or Hugh

Thomson, Kay Nielsen or Edmund Dulac, one still goes instinctively and confidently to the green and gold cloth volumes of *The Studio*. At the time of Gleeson White's premature death in 1898, the magazine published an appreciation stressing the wide scope of their first Editor's interests. 'The versatility and comprehensive knowledge which distinguished him have been exhibited here month by month in ways well fitted to appeal to the widest circle of art lovers; and to many readers of *The Studio* his death in the full tide of his ability will seem a personal loss.'[15] Magazines stand or fall by the quality of their editorship and White was unquestionably the right man for the job; but in the larger context of the *fin de siècle*, *The Studio* was the right magazine for the moment, it presented a more practical approach, a more pragmatic experience among the highly-polished and esoteric magazines of the 1890s.

The Yellow Book and The Savoy

Ephemeral publications in which literary squibs, minute poems and stories of a Firbankian intensity and obscurity vied with the 'new' illustrations were irresistible to a public fed on Whistler's 'Ten O'Clock Lecture' and aestheticism. *The Yellow Book*, begun in April 1894, was one of those ventures which become famous overnight, and is nearly synonymous with the cult of the 1890s and the death-wish tragedies of Wilde and Beardsley.

It was started by John Lane who, together with Elkin Mathews, seems to have cornered the market in aesthetic books. Lane himself was considered a sound businessman, lucky in his illustrators and authors, but not a man of very developed tastes. 'That poor fly in the amber of modernity' was what Max Beerbohm called him. He appointed Henry Harland as Literary Editor and Aubrey Beardsley as Art Editor, an explosive combination which produced exactly the reaction from conservative London that would have been expected. Each quarter from April 1894 to April 1895, the stumpy yellow bound cloth volumes, with covers designed by Beardsley, slipped out from Lane's Bodley Head office in Vigo Street to astonish the world. Harland kept a literary salon, his wife sang French songs and the conspirators of *The Yellow Book* were encouraged to attend, adopt their Editors Continental bias and thoroughly represent the avant-garde. Habitués of the Café Royal, imbibers of absinthe, unimpressed, dandiacal, ostentatiously dishevelled or studiously immaculate, they could be the harbingers of ridicule, satire and ennui but also the provokers of outrage.

Both the literary and the artistic contributions were of a high standard, the first number contained work by Henry James, Lord Leighton, George Moore and Edmund Gosse, the younger generation being represented by Richard Le Gallienne, Arthur Symons and Max Beerbohm with illustrations by Joseph Pennell, Laurence Housman, Will Rothenstein, Walter Sickert and Charles Furse. The furore on its first appearance was divided between Beardsley's designs and Beerbohm's essay 'On Cosmetics', which was delivered with mock seriousness and swallowed whole by a disapproving press. It is interesting to note that *Punch*, an old arch-enemy of aestheticism rushed into the attack, perhaps seeing all too clearly that the satire in Beardsley's line was a confrontation with its own image as the arbiter of black and white.

Aubrey Beardsley, 1872-1898, had been born in Brighton and from an early age had shown a precocious talent for drawing as well as for literature and music, he was one of a number of 1890s' artists who were writers and illustrators, Laurence Housman and E.J.

Sullivan being others. After juvenile contributions to school magazines and a bit of menu card decorating, Beardsley became a clerk in the Guardian Life Assurance Company in 1889. There he might have remained if he had not been befriended by a Queen Street bookseller who showed a remarkable pen and ink drawing to Messrs. Dent, the publishers, in 1892. The drawing in question called 'Hail Mary' was strongly in the manner of Burne-Jones, one of a number of formative influences on the young artist and won him the immediate commission to illustrate Malory's *Morte d'Arthur* from Dents in 1893. A meeting with Joseph Pennell led to that important article in the first number of *The Studio,* already mentioned, where the critic talked of Beardsley's work as showing 'decisively the presence among us of an artist, of an artist whose work is quite as remarkable in its execution as in its invention; a very rare combination'.[16] Beardsley was a lover of literature and of books and therefore an instinctive illustrator; the designs for *Morte d'Arthur* were probably his most derivative work, echoing as they did the work of Morris and Burne-Jones but the restlessness in them that was the essential Beardsley, caught the spirit of the moment and made him the great figurehead of the *fin de siècle.*

His post on the new magazine made his position even more influential. But it was his drawings in its pages that were the principal target for the captious critics, particularly in the first issue, with 'L'Education Sentimentale' and 'Night Piece', both mildly suggestive and full of that ruthless power that the artist, obtained in his clinical separation of black and white. Even the portrait of 'Mrs. Patrick Campbell', the most marvellously controlled piece of line drawing, is hardly flattering and seems full of a sort of sensuous contempt. What was true of the first number remained true of its successors; the pages were lightly interspersed with the work of more academic artists, younger men were included but Beardsley remained very much the star. In the second volume, P.G. Hamerton was allowed to criticise the first volume, making some of the points raised by the critics but in gentler mood. 'There seems to be a peculiar tendency in Mr Beardsley's mind,' he writes, 'to the representation of types without intellect and without morals. Some of the most dreadful faces in all art are to be found in the illustrations to Mr Oscar Wilde's *Salome.* We have two unpleasant ones here in l'Education Sentimentale. There is distinctly a sort of corruption in Mr Beardsley's art so far as its human element is concerned, but not at all in its artistic qualities, which show the perfection of discipline, of self-control.' He criticises the elongation in Beardsley, the exaggerations of perspective and the absence of beauty in the faces. But Beardsley's vision and world, however vivid, was not beautiful, it was the doomed vision of an artist who knew he was dying of consumption and the sardonic world of youth, the youth whose innocence is looking evil in the face for the first time.

Subsequent illustrations included the 'Portrait of Himself', a tiny cynical head in a sea of rich and smothering curtain, the chiaroscuro studies of 'Lady Gold's Escort' and 'Wagnerites' and the rather Burne-Jones influenced 'Mysterious Rose Garden'. He also produces two drawings under the pseudonyms of Philip Broughton and Albert Foschter as well as the famous 'Garçons de Café', arguably the most compelling image to emerge in *fin de siècle* illustration on this side of the Channel.

In fact Beardsley was the only one of *The Yellow Book* artists who came to terms with the new processes and one of the very few who saw the possibilities and limitation of the page. In the first volume, only Pennell's fantastic architectural drawing, Laurence Housman's 'Reflected Faun' and J.T. Nettleship's startling 'Head of Minos' look as if they were designed for a book. In the other issues there are some splendid decorative pen and ink drawings by Patten Wilson, especially 'Rustan Firing The First Shot' in Volume 2, an intricate composition in the manner of a Dürer woodcut. A.S. Hartrick supplies a slightly sinister 'Lamplighter' to the same volume and a spirited sketch of a boxing match in Volume 5. From Volume 4 onwards, *The Yellow Book* ran a series of so called Bodley Heads,

portraits of contributors, emphasising still further the close-knit circle of Harland's editorship. This gave a splendid opportunity for Will Rothenstein, fresh from the success of his *Oxford Characters*, to contribute a most lovely soft chalk drawing of John Davidson, others coming from the pencils and brushes of Walter Sickert, Sargent and E.A. Walton. Nothing could be a greater contrast to the tension of Beardsley's work than the refreshing and meticulous penmanship of Walter W. Russell's 'Westmorland Village' or William Hyde's open landscapes. Sickert's series of music-hall sketches give a delightfully raffish element to the volumes that might otherwise seem unnaturally precious in content. The cockney spirit of the 'Lion Comique' typifies the vitality of the halls, and 'Collins Music Hall' the French influence of Degas' stages, viewed across the orchestra. But as P.G. Hamerton points out Sickert's work, like that of C.W. Furse and Wilson Steer, is approached through the eyes of a painter not an illustrator.

In the October 1894 volume, Max Beerbohm had contributed only one drawing, a caricature of George IV, ringleted, double-chinned and gross and with an unaccountable look of Oscar Wilde. This presaged what was to come, because by the time the April 1895 volume was due to appear, Oscar Wilde was standing trial and the whole circle of decadents were under a cloud. Lane could not risk retaining an artist so strongly connected with Wilde in the public imagination as the illustrator of *Salome*, and though Beardsley was blameless he was immediately dismissed.

The mainspring of the exercise was gone, the elfin genius of the unpredictable Beardsley, but somehow the magazine managed to limp through eight further issues, not all lacking in interest. The design of the covers was now shared by various hands, J.D. Mackenzie, D.Y. Cameron, J. Illingworth Kay and Mabel Dearmer. Although the literary content remained high with Henry James and Arnold Bennett in July 1895, Baron Corvo, John Buchan and Richard Le Gallienne in April 1896, the graphic work did not equal it. The editor filled the first volume after the Wilde scandal with mediocrities like Fred Hyland, working in a sub-Beardsley manner, or wishy-washy amateurs like Sir William Eden, target

Figure 75. 'So the wind drove us on . . . ' by Patten Wilson for The Yellow Book, *1896.*

of one of Whistler's most searing attacks. Some fine pen drawings were obtained from Patten Wilson in these last three years, not only strongly reminiscent of German wood-cuts but like all Wilson's work, wild and Celtic, fighting to be released from the confines of the picture space (Figure 75). The October 1895 volume was devoted to the Newlyn School, that of January 1896 to the Glasgow School and the April 1896 issue to the Birmingham School. This was an interesting idea, giving added coherence to the magazine and focusing attention on the leading movements of the day. The first two volumes it must be confessed are very disappointing. The Newlyn School is not one that is strong on drawing and book illustration and the Glasgow School is treated entirely as a landscape group. By far the most valuable volume is that on the Birmingham School (culled from *The Quest*), which would have left no *Yellow Book* reader in any doubt as to where the strength in illustration really lay. The contributors include A.T. Gaskin, Sydney Meteyard, J.E. Southall and C.M. Gere

among the older men, and Mary J. Newill, Celia Levetus, Evelyn Holden (Figure 76), Bernard Sleigh and Florence M. Rutland among the younger students. E.H. New is represented by one of his fine architectural drawings and C.M. Gere shows a similar subject almost vying with it in its clarity of line. There are slight echoes of Burne-Jones in the allegorical subjects and E.G. Treglown's black and white work is Beardsleyesque, but otherwise the purity of draughtsmanship and the high quality of decoration is outstanding. The October 1896 volume contained the last Max caricature, an unusual coloured woodcut and the two succeeding issues were unremarkable except for the re-appearance of D.Y. Cameron and the emergence of Muirhead Bone.

Beardsley's highly indiviudal light was not easily extinguished and after *The Yellow Book* débâcle he flitted across from Lane to Leonard Smithers, the avant-garde publisher with whom he was to remain connected until his death. By

Figure 76. 'Binnorie O Binnorie' by Evelyn Holden for The Yellow Book, *1896.*

the end of 1895, both artist and publisher had decided to issue a new magazine of the arts, produced quarterly at 2/6d. and called *The Savoy*. It was in a slightly larger format than *The Yellow Book* but the paper was not so good and Beardsley returned to the medium of pure pen and ink. The move from Lane to Smithers coincided with a considerable shift in style, the curvilinear lines and black and white contrasts were replaced by rich decoration and stippling effects, mainly characterised by small dotted lines throughout the illustrations. The *Salome* of 1894, which predated even *The Yellow Book* was probably the most influential set of drawings that Beardsley ever created. The swirling lines, dramatic images and use of abstraction that runs through from the frontispiece to the 'Climax' plate at the end of the book were the most frequently copied by later illustrators and designers. His use of motifs from Whistler's Peacock Room, his tightly bunched borders of roses on the title page, but above all the very ascetic contrast of line to mass and black and white, recur again and again in the books of the 1900s and beyond.

The drawings of *The Savoy* period are finer compositions but give rise to the idea that Beardsley was principally a decorative illustrator. This was probably because of the artist's fascination with eighteenth century decoration, rococo detail, the hanging of lace and the forms of head-dresses which he used to such marvellous result in *The Rape of The Lock,* published by Smithers in May 1896. In an interview with Arthur H. Lawrence, Beardsley showed how much the current fashion for the eighteenth century had fired his imagination. Lawrence described how the artist always worked by candlelight with two old Empire ormolu candlesticks on the table, had Chippendale furniture and French Louis XV clocks as well as 'rare copies of last century *livres à vignettes* . . . and numerous pictures, engravings from Watteau, Lancret, Pater, Prud'hon and so on'.[17] It was these masterly plates for Pope's most elegant poem, 'The Dream', 'The Toilet', 'The Battle of the Beaux and The Belles' and 'The Cave of Spleen' which were to be a lasting memorial to the *fin de siècle* and an inspiration to the decorative artist for twenty years.

It is because *The Savoy* falls into Beardsley's richest period of illustrating that the eight volumes of the magazine have a special interest, demonstrating that the artist is a great

draughtsman as well as a great illustrator. The atmosphere is still highly charged, but this time in the mannered rococo lines of 'The Coiffing' or the delicate bending figure of 'Mrs Pinchwife', reminiscent of another consumptive artist, the equally doomed and sardonic Watteau. Among the most striking of the works are those on the theme of Wagner and particularly 'The Fourth Tableau of Das Rheingold' (Figure 77) completed amid increasing illness, giving an extraordinary sweep of oriental mysticism and an unsurpassed glimpse of the beauty of his control of line. This series of drawings for a projected book the *Story of Venus and Tannhauser* was never finished; Beardsley left England for the last time in April 1897 and died at Menton on 16 March 1898 while still trying to work on his drawings for Ben Johnson's *Volpone,* published posthumously in 1898.

Figure 77. *'The Fourth Tableau of Das Rheingold'*
by Aubrey Beardsley.

Holbrook Jackson, who did not much like Beardsley's art, wrote of his style as a sterile one. Too close to the period, he could not see the immense following the artist was to have, providing a rich inspiration to the gifted who could contain his manner without being overwhelmed by it, remaining a constant quarry to the hack and the amateur. In the following pages there are countless names who were grounded in the Beardsley discipline even if they failed to attain his literary vision or his finesse. Among them are Annie French, Harry Clarke, W.B. MacDougall, Austin O. Spare, H.H. Voight, A.E. Odle, W.H. Bradley, F.E. Jackson and George Plant.

The Quest

This magazine which ran from 1894-96 was the shop window for the Birmingham School of Illustrators and as such was one of the most unified little productions of the entire decade. It first appeared in November 1894, priced at half-a-crown and printed at the press of the Birmingham Guild of Handicraft. From the beginning it was strongly reminiscent of the newly founded Kelmscott Press, the grey paper cover with the wood engraved design on it was very Morrisy indeed and showed how much *The Quest's* promoters Gere and Gaskin were involved with him. The first frontispiece by E.G. Treglown is closer to Burne-Jones than Morris in manner, very long figures set against a floriate background, and this strong decorative feeling is carried through to the ballad borders by H.A. Payne and the flame-like flowers in the initial letters designed by Treglown and Sydney Meteyard. E.H. New illustrates the old Grange at Broadway and C.M. Gere provides beautiful Celtic head-pieces to 'The Life of Saint Silvester', much lighter in tone than Treglown's heavy blacks in the page illustrations for the same legend. The editors are obviously at pains to include the work of student artists wherever possible and to give full credit to the engravers who have cut the blocks.

The second number of the magazine contains more interesting work by H.A. Payne and C.M. Gere and a very illuminating article on 'the Guild of Handicraft' with illustrations of the craftsmen, printers and engravers at work by E.H. New; Mary J. Newill supplies an initial letter. The pictures for the romance of 'Sir Generydes' by Payne, Meteyard and Tarling, show the two aspects of the Birmingham illustrative school at this time, Tarling's style being fluid with flowing draperies and curving lines, Meteyard's much more angular deriving from his craft background in ceramics and stained-glass. The third number is a little more varied, a bold frontispiece by A.J. Gaskin, an architectural description of Evesham (his home town) illustrated by E.H. New with characteristic wide foregrounds and labels, and Meteyard's drawings for Morris's ballad 'The Defence of Guenevere'. E.G. Treglown's illustrations to 'A Stranger in Love's Place' are even more in the style of early woodcuts than his earlier contributions and have sixteenth century originals very much in mind.

Morris's seal of approval was on *The Quest* from the beginning, in fact imitation was for him quite definitely the sincerest form of flattery. In November 1895 he lent a frontispiece of Kelmscott House by C.M. Gere for the magazine and actually contributed an article to its pages 'Gossip About An Old House On The Upper Thames' with illustrations by E.H. New. This essay and the whole issue gives a pleasant echo of William Morris in his last phase as printer after the fires of youth had somewhat subsided. The number is greatly strengthened by the use of full page drawings and one particularly fine example by Mary J. Newill shows a frieze of children's heads at the top and a trailing plant dominating the foreground, white skilfully cut into a black ground. The fifth issue in March 1896 has C.M. Gere's frontispiece 'Summer is Icomen In', a predictably Kelmscott style of design to fit in with the poem of Old England, and an article on vernacular buildings with brilliant sculptural sketches by E.H. New, accompanying A.S. Dixon's text. E.G. Treglown goes back to Rossetti for his 'A Ballad Upon A Wedding' and 'The Book of Tobit'. Designs by Treglown and Tarling run through this volume and into the next.

The last of these little books appeared in July 1896 with a frontispiece of 'Rapunzel' by Sydney Meteyard and an article on the guilds by W.R. Lethaby, the heading for it by Gere. Gere's full page drawing of a city steam roller entitled 'A Detail of Today' is really welcome after all the ballads and medievalising, showing just how far the Birmingham School were prepared to go with modernity! Other features of interest are an illustration to 'Childe Roland' by Inglis Sheldon-Williams, perhaps inspired by seventeenth century etchings and an architectural look at Warwick by E.H. New. Treglown's full-page drawing to the 'Life of St Kenelm' has interest in being inspired by Rossetti and returning in handling to the 1860s' school. Though short-lived, *The Quest* gives a very fair representation of arts and crafts illustrating at its best and has the merit of showing the work of masters and students alongside one another.

The Quarto

The Quest was the magazine of the Birmingham School and the only other publication to exhibit mainly the work of one art school was *The Quarto*. This was begun in 1896 by J.S. Virtue & Co. and described itself as 'An Artistic Literary & Musical Quarterly'. It was formed from a mixture of modern talent, old masters and a rehabilitation of some of the great artists of the 1860s. Both Joseph Pennell and Gleeson White took a close interest

Right: Plate XII
KATE GREENAWAY, RI
1846-1901
'The Gaudy Flower'
Illustration to Little Ann,
A Book Illustrated By
Kate Greenaway, *1882.*

Below: Plate XIII
GEORGE SAMUEL ELGOOD
1851-1943
'Bowls in a castle garden'
Original drawing for illustration
Watercolour
Signed and dated, 1887
Lattimore Collection

in the venture and so the standard of draughtsmanship remained remarkably high. 'Our chief endeavour' runs the preface of the first number, 'is to bring before the world the work of young or unknown artists who have at some time or other received instruction at the Slade. This does not in the least preclude the work of others; our aims are broad and cosmopolitan, anything narrow or bigoted in Art, as in all else, being inimical to true progess, and therefore foreign to our intentions.'

From the beginning there was some very nice decorative work carried out by three talented artists, initial letters cut by Hugh Arnold, head- and tail-pieces by Alice B. Woodward and Cyril Goldie. One is struck at once by the tremendous sense of freedom and invention in these designs and by comparison some of the Birmingham designs seem stiff and contrived. Artists who were only just starting to emerge in 1896 are given some spectacular opportunities here, Robert Spence, the etcher, in a magnificent line drawing of 'The Legend of St Cuthbert' and Paul Woodroffe in his 'Nativity'. Something of a surprise is a ballad illustration by Ambrose McEvoy drawn completely in the style of the 1860s. In the second volume there is even stronger emphasis on the earlier illustrators with whom the new generation felt such obvious kinship. Millais' 'Foolish Virgins' is shown as well as Rossetti's 'Salutation of Beatrice', but the most astounding influence on a younger artist is Nellie Syrett's 'Time is short, life is short' which is based on A.B. Houghton's work. Other revealing drawings are 'The Brink' by Cyril Goldie, which shows him to have had nearly the imaginative temperament of a Rackham, and Alfred Jones' mixture of Celtic and Pre-Raphaelite symbolism in his illustration to Goethe's 'Der Erl König'.

In 1897 the pages are amplified by more Pre-Raphaelite work, Sir E.J. Poynter's 'Daniel's Prayer' and Burne-Jones' celebrated 'Parable of the Boiling Pot', both from the *Dalziel Bible* of sixteen years earlier. Robert Spence, who is still underrated, has a powerful work in his 'Legend of Fra Angelico And The Angels' and Paul Woodroffe a first class illustration to Bunyan's 'Holy War'. More of a curiosity than anything else is the oil painting by G.O. Onions 'Paolo and Francesca' showing the sort of thing Onions did as a student before going on to a career as a popular novelist. There is a single contribution by Rosie M.M. Pitman of 'Undine', a charming Pre-Raphaelite evocation by this delightful but minor Edwardian.

The Page and the Broadsheet Style

One aspect of the new processes and the advances in mass-production was to make the sophisticated public of the 1890s hanker after a more personal type of book, a rough image on the page and a more tactile quality to type face and paper. The private presses and Kelmscott in particular were catering for the more exalted type of library with limited editions on hand-made paper in limp vellum covers, but several artists looked back to the chapbook and the broadsheet for inspiration, rather than to the illuminated books of the Middle Ages or rare incunabula. There had always been an attraction for the illustrator in being the master of his own destiny, and the ephemeral artists of the streets who were their own designers, engravers and printers, appeared to have a freedom denied to other men. The cheap ballad sheets of the late eighteenth and early nineteenth centuries with their crude woodcuts, have a directness and a spontaneity which is almost a visual assault and nearly impossible within a book. Bewick was the artist particularly admired by the Victorians for

Figure 78. A chapbook by James Lumsden of Glasgow, c.1810.

the sensitivity of his natural studies, studies that came directly from his pencil to his block and from his block to the printed sheet. But there were other cruder artists of the Northumbrian School whose cutting was heavier and coarser and whose work had a primitive tang in the wood which the younger men of the 1890s began to find very appealing. Partly derived from the arts and crafts movement, partly from that cult of the eighteenth century shortly to be mentioned, the naïve style of the broadsheet swept through the studios of the more individual artists for a decade or more. Some of the productions of the printer W. Davison of Alnwick have this attractive earthiness about them in the 1800s, as do the chapbooks of the Glasgow and Paisley booksellers and the sixpenny tales of James Lumsden and Sons of Glasgow (Figure 78), but there was also a more recent link with the craftsman-like past.

The earliest artist to involve himself with the broadsheet style was Joseph Crawhall, 1821-1896, a provincial and an eccentric whose genius for book making almost defies classification. The son of a prosperous ropemaker at Newcastle-upon-Tyne, Crawhall's interest in books grew out of his dual passions for antiquarianism and angling. The one made him familiar with the chapbooks and ballad sheets of earlier periods, the other fed him with subjects for his witty pen; in Newcastle it was impossible not to be attracted to wood-engraving in the early nineteenth century! In 1859, Crawhall designed and printed his first book, *The Compleatest Angling Booke*, a mixture of old and new fishing lore but very much reflecting the artist's love of old printed texts and archaic language. It was decorated with woodcuts, cut by him in a 'rich black expressionist style',[18] as well as work by his brothers Thomas and George, all making as unusual a mid-Victorian book as could be found anywhere. More were to follow: *Ye loving ballad of Lorde Bateman To itte's owne Tune herin sette fforth* in 1860, *A Collection of Right Merrie Garlands for North Country Anglers* in 1864 and *Chaplets from Coquet side,* 1873. Crawhall uses both decoration and figurative cuts to embellish his tales and songs, the former reflecting the work of the old artists but the latter taken with considerably more punch and wit. In his decoration, Crawhall often used a stipple effect for a background, a flower or symbol standing out from a black area covered

with tiny white dots. In some of his more dramatic illustrations he cuts away the background to emphasise a bold black line, a technique which was to become popular with some of his imitators. Nineteen books were to come from this indefatigable angler and humorist, all printed from the original woodblocks and usually coloured by hand (Colour Plate XI p.124). From 1884 his work reached a wider public when it attracted the notice of Andrew Tuer, the printer, and the books were subsequently printed at the Leadenhall Press starting with *Old Aunt Elspa's ABC* and *Old Aunt Elspa's Spelling Bee,* 1884 and 1885. Tuer's commercialism and Crawhall's versatility extended the work to cards and posters, including some for Pears Soap and Brooke Bond Tea which have a refreshing sharpness for their date and actually bring humour to Victorian advertising. The level of fun and lightness of touch makes these books peculiarly desirable and popular with the collector. 'Although Crawhall's humour had a satire edge to it,' writes C.S. Felver, 'it reflects none of the Swiftian *saeva indignatio* that Hogarth, whom he admired greatly, often shows. And there is a happy freedom in most of it from didactic moralism which frequently sinks Victorian humour under a weight of religious piety.'[19]

Crawhall's books with their rough paper, often discoloured with the years, blue covers, idiosyncratic initials and woodcuts, succeeded in rebuilding a bridge between the reader and the designer. It is only necessary to read his imprint at the back of one of the part works to feel the engraver's uncomplicated joy in his work — 'Gathyrd and newlie sett foorth with Titles, hede and tayle-peeces, ande various Sculptures (othyr than those signed) curiously engraven by Joseph Crawhall of Newcastle-upon-Tyne'. Crawhall died in London on 7 July 1896, his unique works still ignored by all except a small circle of admirers; within a few years the dramatic force of them and the expressionistic quality of the cuts were to become increasingly influential.

William Nicholson, 1872-1949, first noticed Crawhall's books in the early 1890s and they strongly appealed to his decorative sense where otherwise he was looking towards French graphic art. Nicholson and his brother-in-law James Pryde, 1866-1941, became partners in designing and printing woodcuts for posters, cards and book illustrations from about 1894. Working from a country cottage they produced results that were powerful, fresh and almost revolutionary in their simplicity. An early article on the 'Brothers'[20] stresses their admiration for the posters of Toulouse-Lautrec, their fascination for the line of Phil May and their obvious delight in being craftsman-artists. They took great trouble with the placing of their lines on the page and equal care in the choice of their lettering which is always bold and clear, the prints being characterised by the squared off black line round the edge which seems to give them body. This partnership produced some remarkable illustrated works in the broadsheet style between 1898 and 1900, they include *An Alphabet,* 1898, *An Almanac of Twelve Sports* with a text by Rudyard Kipling, 1898, *London Types* with a text by W.E. Henley, 1898, *The Square Book of Animals,* 1899, and *Characters of Romance,* 1900. In a sense these books are more like folios of beautifully designed pages than books in the conventional form, indeed the last one, *Characters of Romance* is actually a folder of loose plates with only a list of titles as a text. Nicholson and Pryde managed to break through the convention that an artistic book was a complicated piece of design or crammed with extraneous ornament; the enduring images of *An Alphabet* or *London Types* are fixed on the retina because they are so simple. In the London scenes, the coster-girl, the policeman and the life-guardsman rely almost entirely for their effect on thick black outline and an almost Japanese sense of two-dimensional rhythm. The range of scale is remarkable, the delightful coloured woodcut of 'The Fisher' which appeared in *The Dome* for 1897 measures four inches by four inches (Figure 79), the amazingly free but sinister rendering of 'Mr Vanslyperken' in the *Characters,* thirteen and a half inches by ten and a half inches (Figure 80). Only a limited number of these books were printed from the woodblocks and coloured by hand, the majority were reproduced in lithography.

Figure 79. 'The Fisher' by William Nicholson

Right: Figure 80. 'Mr. Vanslyperken' by William Nicholson.

The only artist to embark on the production of a magazine in this distinctive style of cutting was Edward Gordon Craig, 1872-1966, the actor, theatrical designer and writer. Craig's family background was as varied as his talents, his father was the Victorian architect E.W. Godwin and his mother the celebrated actress Dame Ellen Terry. Craig only developed as an important designer after youthful experiences as an actor. He trained himself to become a first-class wood-engraver and graphic artist and as the promoter of three magazines acted as his own editor, author, illustrator and publisher. One writer has called *The Page*, which sprang to life in 1898 'a modest periodical'[21] but this is to miss the informality and camaraderie which Crawhall, the Beggarstaff Brothers and Craig were aiming at. The magazine which was brought out quarterly and only sold afterwards in yearly sets, had a high standard of design in type and illustrations and was an astonishing juggling act by Craig himself. He produced woodcuts (Figure 81) 'By the Editor' or 'By the Publisher' and even invented a fictitious artist called 'Oliver Bath' to spread the load more evenly; all of course were by himself! In the early volumes, however, there is some help from that beautiful but sombre artist J.J. Guthrie and from Charles Conder. Notable examples of Craig's work can be found in 'Waiting For The Marchioness' and 'The Horse' with its thick borders and dramatic darks, both in the first volume of 1899.

In the second volume of that year is the striking Puritan portrait subject 'Thoughts Apt, Hands Black' and the macabre and sardonically titled wood engraving of a hangman 'For what We are About to Receive'. The 'D'Artagnan in London 1649' is slightly looser than the others and the

Figure 81. 'Henry Irving', woodcut by E. Gordon Craig.

rather cloying effect of so much of the editor's work is relieved by a charming portrait drawing from Will Rothenstein. The third quarter for 1899 had fresh subjects by Craig on toned paper – 'Old Grimes, His Friend' and 'Mr Tom Peel', which was hand-coloured, as well as pen and ink drawings of Henry Irving and Sarah Bernhardt by J. Bastien Lepage.

The Page was also the advertising medium for Edward Gordon Craig's other designing projects, bookplates 'Designed, Engraved and Printed at the Sign of the Rose, Hackbridge, Surrey' and the famous *Gordon Craig's Book of Penny Toys – Twenty Original Colour Drawings of the most representative English, Dutch or German Wooden Toys and Twenty Verses. The Page Edition de Luxe* was sold to special subscribers and a pot pourri of contributions to the magazine, 1898-99, was issued in 1900. In the volume for 1901, Craig pays tribute to his predecessor in the broadsheet style by printing Haldane Macfall's article on 'Some Thoughts Suggested By The Art of Joseph Crawhall Illustrated With Woodcuts, The Presence of Which is Due To The Courtesy of The Leadenhall Press'. Some stage scenes in this number show the path Craig's art was going to take in the later magazines he edited, *The Masque* and *The Marionette.*

Craig's productions were too fresh and winsome to appeal to the heavy rhetoric of the Victorian critic and their very fragility came under attack. *The Dome* rather unfairly referred to the insubstantiality of the publication: 'To look at the cuts and read all the letter press took much less than ten minutes.' Some critics made comparisons with the Beggarstaff Brothers but not *The Weekly Sun,* which sums up the conventional disapproval with yet another side of *fin de siècle:* 'There is a charm in the work of an artist and also one in that of children but Mr. Craig is neither an artist nor a child, and why fair white paper should blush for his impertinences in line, or rather out of it, we do not see.' A great deal of *The Page's* influence however came much later in the 1900s and 1920s when Craig's shorthand began to be applied to scenery, books and posters. Pamela Colman Smith's illustrations such as that of 'The Wind' in 1901 certainly look towards the art deco designer and Claud Lovat Fraser's work is undeniably derived from Crawhall but through the deflecting glass of Edward Gordon Craig's *The Page.*

The Beam, The Dome and The Acorn

The *Beam* was a short-lived and rare bird, published bi-monthly in 1896 and foundering after the January, March and May issues. Its format was much the same as the earlier issues of *The Butterfly* although it employed a different set of contributors. It was edited by Alfred Jones and was published according to the title page by 'Some Students of the National Art Training School'. The illustrations are patchy, some inspired by Morris and some by the attraction of Beardsley and art nouveau, many are full of student promise but do not quite make the grade as single drawings. Among the more interesting things to be found are early decorations by Leon Solon, figure subjects by J.W.T. Manuel and woodcutty and Pre-Raphaelite subjects from W.R. Kean and W. Shackleton. The second number contained new art decorations by Arthur Orr and S. Stromquist, some tentative sketches by Oliver Onions and humorous sketches in the style of J.F. Sullivan from Alfred Jones. The May issue is perhaps the most coherent, the artists were obviously finding their feet and there are a number of new names. Edith Mason borrowing from Beardsley, Laurence Housman's refined illustrator's eye, more Oliver Onions' drawings of sturdy peasants in the

manner of Fred Walker and excellent things by Alice B. Woodward and A. Hugh Fisher. Although the student tempo is very obtrusive, there are some interesting articles showing the influences on black and white artists of the time. One by A. Hugh Fisher is on 'Angelo Colarossi' under whom many of these men and women would study in Paris, another is on Whistler and there is a 'Counterblast' to the teaching at the South Kensington Schools. The circulation for this attractive little publication must have been very small and valuable mostly for the opportunities it gave the ardent contributors.

A similar publication but one which was more commanding in its field was *The Dome.* On its first title page in 1897, it calls itself 'a Quarterly containing Examples of All the Arts' and that of illustration was given a high place. *The Dome* at one shilling set itself apart by giving prominence to coloured wood engravings, the second volume containing the admirable engraving 'A Fisher' by William Nicholson, printed from four blocks and already referred to (Figure 79). Later volumes have similar work by Gordon Craig (Figure 81), more poster-like and rendered with less craft and more theatricality. The diet up to the last volume in February 1900 is none too rich but is refreshingly varied. There are some typically forbidding landscapes from the pen of J.J. Guthrie, a Housman that leans heavily on the Pre-Raphaelites, 'The Troubling of the Waters', some sombre works by W.T. Horton, a strange Celtic melange from the sinister to the poetic suitable to accompany W.B. Yeats' work, and excellent if bloodless topography by H.W. Brewer, R.J. Williams and F.L. Emanuel. Bernard Sleigh of the Birmingham School makes two appearances, Charles Pears three, and there are some fine things by A. Hugh Fisher, particularly 'Thatching', a Millet type subject treated with unsentimental thoroughness. All these volumes show a renewed fascination with wood engraving, prints by the German masters are reproduced, particularly Dürer and Cranach, interleaved with modern work in busy imitation. *The Dome* was the only illustrated art magazine of its time except *The Chord,* 1899-1900, to devote a regular section to printed music.

The Acorn, published by the Caradoc Press, never grew into an oak. It began life in October 1905 and was dead by February 1906, although it still had that *fin de siècle* preciosity about it. This again was a quarterly dealing with literature and art, but except for some etched frontispieces by Frank Brangwyn, an etching by Alfred East and rather ordinary decorations by H.G. Webb, it is of little account.

Phil May's Illustrated Annuals

A hand-full of artists during our period were of sufficient popularity to have their own annuals, gift-books or journals,[22] easily the most famous of these was Phil May, 1864-1903. May was the obverse of the Beardsley coin, if the latter was the master of the refined line, the former was of the eliminated line. May was born in Leeds and on being left fatherless at the age of nine, took various jobs in offices and warehouses before joining the scene painters at Leeds' Grand Theatre. A natural artist with an instinctive sense of humour, he was quoted as saying in later life 'I can't remember a time when I didn't draw!'[23] May joined a touring theatrical company in 1879 and remained with them till 1882, gaining from this connection with the stage his delightful and unashamed bohemianism that became such a part of his life and his drawings. He made caricatures of his fellow actors and some of Irving, Toole and Bancroft, are in the manner of *portraits chargés,* perhaps

based on the work of Carlo Pellegrini, 'Ape' of *Vanity Fair*. Arriving in London in 1883, he had months of severe hardship before finding illustrative work with *Society* and *The St Stephen's Review* where he deputised for the political cartoonist Matt Morgan. In 1885 he was offered a three year contract with the *Sydney Bulletin* and accepted it, sailing for Australia in November and completing during this spell abroad nearly nine hundred drawings, cartoons, caricatures and joke illustrations.

By this time the May style was emerging. The artist was beginning to reduce dramatically the number of pen lines that he worked with, and found it difficult to explain to editors that the seemingly effortless strokes on a board were nevertheless part of a rigid concentration. Within the established order of elaborate detail, feverish hatching and controlled tones for the wood-engraver, May's breath-taking virtuosity was nothing short of revolutionary. The enforced work on *The Bulletin*, its regular flow of drawings and the contact with other artists made May's stay in Australia a beneficial one. From being a talented but haphazard artist, he became a professional artist, broadening his outlook and probably acquiring that air of casualness in drawing and freedom in humour more typical of the exile than the home-based illustrator. May was the worthy successor of Cruikshank and Leech in English graphic satire but was even more indebted to Charles Keene whose cast of metropolitan characters were so close to his own. Like Keene he concentrated wholly on black and white work and like him relied entirely on the pen for his effects. 'By his genius for observation and selection,' wrote James Thorpe, 'and the extreme simplification of his method of presentation, he showed that a pen drawing can be a very eminent form of art.'[24] He had too the advantage over Keene that his wit was greater and his drawings and their captions are more intrinisically funny and punchy than the earlier artist's. Keene's beautifully toned drawings require a time fuse, usually the time fuse of a lengthy explanation, May's are instantaneous and explode on one like a fire cracker. The situation of the drawings is often the same, barrow boys and street vendors, waiters, overbearing shopkeepers, drunken gentlemen, fussy old ladies and gossips. Keene looks backwards to a harsher and more Hogarthian England, May forwards to a humour free of manners and prejudices and without letter-press. He claimed to have learnt a great deal about the placing of lines and parallel shading from Linley Sambourne, the *Punch* artist, and from Caran d'Ache, the Frenchman who relied on so few masterly pen strokes.

Although one might expect such an engagingly social artist as May to be working directly from nature in his sketchbooks, this was not always the case. The sketch was only the beginning of a process that whittled down the figure from complexity to bare essentials, some of his sketchbooks were on transparent paper enabling him to trace the study back from page to page knocking out all but the relevant lines, working from back to front of the book. It was only by dint of concentration and a perfect eye that he managed to retain the spontanaiety and freshness in the finished result, even when models were used the result is lively, boyish and enjoyable. As May absorbed the pure essence of a figure, the details of dress, surroundings and background were entirely sublimated to it.

May was a splendid portraitist from an early age and this certainly helped him to capture the expressions of pearly kings, 'Arries and 'Arriets, topers and urchins from his Battersea and East End sketchbooks. Corner sketches such as the bedraggled female ejected from a gin palace and saying '*Next* time I goes into a Publickhouse, I'll go somewhere where I'll be *respected*' are unforgettable as is the bibulous retort of another inebriate 'I'll do ellythik you like in reasol,Mria (hic) But I won't come 'home'. Many of the drawings rely on the ludicrous juxtapositions of the street scene almost as the camera has come to do, a good example is the crisp 'Fair Woman' in the Garrick Club collection (Figure 82). To look at these spirited sketches is to stare straight into the London of the music-hall, the hansom cab and the Gaiety Theatre, the London of the posters and Dan Leno and Marie Lloyd. May's humour like his drawings is clipped, quick and urban, a type recognisable to any cockney.

On his return from Australia and a period of study in London and Paris, May was engaged once more by *The St Stephen's Review* and began to make his famous series of drawings *The Parson and The Painter,* 1890. This featured a country clergyman the Rev. Joseph Slapkins and his nephew, visiting famous theatrical and sporting resorts and having picaresque adventures. When the drawings were published in book form in 1891, the edition of thirty thousand copies was sold out at once and Phil May became a household name. He was snapped up in November 1890 to work for the newly-founded *Daily Graphic* and was sent by them to cover the World Fair at Chicago. This proved to be less than successful, for May could not get to grips with the American character and preferred to be among his beloved Londoners. From this date onwards the artist could choose his own work and most of the leading magazines were anxious to have it. He published it in *The Sketch, Black and White, The*

Figure 82. 'Fair Women' by Phil May.

Daily Chronicle and many more. In 1892, he launched his first *Annual* which appeared regularly from then until 1905, thirteen Winter issues and three Summer numbers at one shilling each. They contained a wide selection of May's drawings but had literary contributions from writers as various as E.F. Benson, Conan Doyle, Kenneth Grahame and H.G. Wells. May was also appearing in *Fun, Frolic and Fancy,* a little periodical where his fine pencil studies are featured alongside the rather crude decorations of his brother Charles May. The *Annuals* were a personal triumph because he had greater freedom to draw what he liked and did not have to obey an editorial policy of captioned jokes.

In 1895, May received the accolade of black and white draughtsmanship and was elected to the staff of *Punch.* It was very much the appointment of an outsider, for though he had been contributing to its pages since 1893, his drawing and his way of life were totally different from the sedate illustrators of Bouverie Street. They were still living in the world of du Maurier and the highly pictured joke; May's presumptuous urchins with few lines and no backgrounds were a visual shock to them, not to say an unpalatable reminder of the outside world. *Punch's* radicalism and realism had long since departed and it remained a pocket of 1860s black and white drawings long after May's death and practically into the 1920s. On the other hand May's influence probably loosened the line of some of the younger men and is discernible in such later practitioners as Bert Thomas and Frank Reynolds. F.C. Burnand, the lordly editor of the magazine, remained wary of this amiable bohemian artist whose deadlines were rarely met and whose spendthrift nature was always causing embarrassment; but much of his best work appeared there.

May's other strength was in his keen observation of children and particularly the children of the streets; he was quoted as saying that he could understand them because he had been one of them. A few of these usually decorated the pages of the *Annuals* and many of them were gathered together as *Guttersnipes* and *ABC* published by the Leadenhall Press in 1896 and 1897. He is far less snobbish in these scenes than any of the other *Punch* men, he laughs with the boys round the gin palace door and not at them, and can see the pathos of poverty as well as its ludicrous side. For our own day his studies of lunatics in humorous situations are far less acceptable, reflecting the great change between the late Victorians and ourselves, and his ethnic jokes have likewise lost some of their appeal.

This brilliantly versatile artist died of cirrhosis of the liver on 5 August 1903 at the early age of thirty-nine. His reputation was assured and he had many imitators, all attracted

by that deceptively easy line, few achieving any success with it. His monuments were the volumes of collected drawings and the *Annuals* which were continued for a year after his death. His spareness of line found its way most naturally into advertising and poster art in the early century, May himself had designed advertisements for Geradel's Pastilles and Player's Navy Cut. May qualifies as an artist of the *fin de siècle* not only because his work spanned that decade but because his approach to his art was so exclusive, so personal, so highly charged and nervous, filled with the self-conscious exuberance of those years. Like Beardsley, much of it was produced in the intervals between wracking illnesses, like Beardsley his last act was to be received into the Roman Catholic church.

The Idler

Of all the magazines discussed here, *The Idler* is the most nearly an intruder and the least consciously 'artistic'. It began in 1892 and was called 'An Illustrated Monthly Magazine' in the joint editorship of Jerome K. Jerome and Robert Barr. Although extensively illustrated from the first volume onwards, its appearance is often not much above that of *The Strand Magazine,* one of the nastiest productions of the period! The first

THE ART GALLERY.

Figure 83. The Strand Magazine Art Gallery, 1892.

volume began well however with drawings from Bernard Partridge, smart wash illustrations to a story from Dudley Hardy and some nice decorations to a poem by J.F. Sullivan. Some of the best Hardy's to be seen also feature in 1892, his drawings for Jerome's article 'Variety Patter', a survey of the music hall stage. These include brilliant sketches of Albert Chevalier, Jenny Hill, Lottie Collins, and Charles Coborn, showing both artist and author in relaxed mood in the midst of a world they loved. In 1892-93 fresh illustrators arrive such as Fred Pegram, J. Gulich, Louis Gunnis and Louis Wain with cartoons by the rather crude artist 'Cynicus'. But the format of the magazine and the quality of the printing do not merit much attention and even the excellent pen drawings of A.S. Boyd in 1895-96 seem rather lost on the page.

After Volume 8 in 1895-96, there is a change in the design and appearance of the magazine and an increase in quality and quantity of black and white work. In the pages from this date are excellent illustrations by Max Cowper, H.R. Millar and S.H. Sime as well as delightfully Beardsleyish pastiches by Alan Wright and good figures in the style of May by Hounsom Byles. A. Jules Goodman contributes and there is a great advance in the use of headings and tail-pieces for decoration. But the real contribution of the magazines for the collector of illustration is the excellent series of articles on black and white artists running from Volume 8 to Volume 12. They include in their number Louis Wain, Raven-Hill, H.R. Millar, Dudley Hardy, E.T. Reed, Caton Woodville, Bernard Partridge, Aubrey Beardsley, Fred Pegram and S.H. Sime. These alone and their accompanying reproductions single out *The Idler* from its fellows as a magazine very much of its time.

Although *The Strand Magazine* does not qualify for inclusion here, it made its own contribution to fostering black and white art in a very original way. George Newnes, its proprietor, had two rooms at the magazine's offices laid out as an art gallery of illustrators' works. These were all original drawings by Paul Hardy, W.J. Boot, H.R. Millar and others that had previously appeared in the magazine. 'All these drawings are offered for sale,' runs an article in the magazine, 'but whether a possible purchaser or not, the passer-by will not waste the time occupied by a look round these two pleasant rooms.'[25] (Figure 83.) In 1901, the Victoria and Albert Museum held a big exhibition of black and white drawings and summed up on a national scale the extraordinary fecundity and originality of magazine and book illustrators from 1890.

Footnotes

1. Holbrook Jackson, *The Eighteen Nineties*, 1913, p.21.
2. ibid., p.339.
3. Walter Crane, *Of The Decorative Illustration of Books*, 1901, p.208.
4. Dalziel family documents sold at Sotheby's Belgravia as *The Dalziel Family*, 16 May 1978.
5. James Thorpe, *English Illustration The Nineties*, 1935, pp.12-13.
6. Charles Morgan, *The House of Macmillan*, 1943, p.125.
7. *The Butterfly*, 1893, No. 1, p.6.
8. First published in *Harper's*, January to July 1894.
9. Some yardstick of its success may be gauged by the fact that the Victoria and Albert Museum Library copy is from the collection of Gleeson White.
10. Gleeson White, *English Illustration 'The Sixties'*, 1897, p.3.
11. Joseph Pennell, *Pen Drawing and Pen Draughtsmen*, 1895.
12. White, op. cit., p.11.
13. *The Studio*, 1893, Vol. 1, No. 1, p.17.
14. *The Studio* devoted a Winter No. to book illustration in 1900-01 and a further Special Number in 1914.
15. *The Studio*, 1898.
16. ibid., April 1893, p.14.
17. *The Idler*, Vol. 11, pp.188-202.
18. C.S. Felver, *Joseph Crawhall*, 1972, p.15.
19. ibid., p.80.
20. *The Idler*, 1895, Vol. 8, pp.519-528.
21. G. Nash, *Edward Gordon Craig*, Victoria and Albert Museum, 1967, p.15.
22. Other artists to have annuals were Kate Greenaway, Louis Wain, John Hassall and Cecil Aldin.
23. James Thorpe, *Phil May*, 1932, p.20.
24. ibid.
25. *The Strand Magazine*, July to December 1892, Vol. 4, p.597.

Chapter 10

The Return of the Eighteenth Century

From the third quarter of the nineteenth century onwards till well beyond 1914, there were a group of illustrators who had one major element in common, whatever else may have divided them. They were landscape illustrators as well as illustrators of novels and included decorators and the avant-garde in their number. In brief they had all been fired by the literature, art, costume or atmosphere of England in the eighteenth century and became dealers in nostalgia on a very large scale. Some writers have referred to these artists as 'the Cranford School' in an attempt to give some coherence to the main contributors to period novels from 1890 to 1914. It is the intention here to broaden this group still further and take the sources of Georgian revivalism back into the middle of the century as well as to include two important illustrators of children's books Randolph Caldecott and Kate Greenaway. In a sense Aubrey Beardsley's decorative debt from the eighteenth century might almost warrant his inclusion too, but this aspect of him has been touched on in the previous chapter.

The romantic novelists of the generation of Sir Walter Scott had tended to set their stories in the remote past or the remote orient, accounting for wild inaccuracies in drawing and costume. The early Victorians such as Thackeray, Dickens and his imitators, though not to the same extent as Lytton or Ainsworth, favoured the recent past for their finest stories. Although one might quibble about the exact date of *Pickwick Papers*, its setting is surely before 1837, the year in which it appeared; Mr. Pickwick himself is totally Georgian as a type, so is Weller and the attraction of both of them for us and surely for the Victorians was that they belonged to a world before the railways, before industrialisation. No more precise date could be pin-pointed for *David Copperfield* or *Martin Chuzzlewhit; Barnaby Rudge* is early eighteenth century and *Tale of Two Cities* late eighteenth century in date. But in approaching the illustrators of these books, one is aware how much they are slowing down the process of time.

In book illustration the overriding influence in black and white work remained the prints of William Hogarth. For most early Victorians he was a figure outside time, the founder of the British School, the model of what every great painter should be, a great moraliser. Charles Lamb and William Hazlitt were both powerful advocates for the study of Hogarth's graphic works and most significant of all the two novelists already mentioned, Dickens and Thackeray, borrowed extensively from the artist in words and pictures. In his brilliant study of this relationship, *Victorian Novelists and Their Illustrators*, John Harvey

argues convincingly that the elements of exaggeration, animism and the grotesque, find their way into the novels through the work of Hogarth. Dickens owned sets of some of the engravings and was clearly haunted by the artist's representation of 'Gin Lane', one of the most overtly allegorical of all Hogarth's prints. 'Dickens habitual mode of characterisation,' John Harvey writes, 'has the complexity we should expect to result from long immersion both in Hogarth's works and in the caricatures also. Although he brings a uniquely concentrated vision to bear on the physical details of his people, he does not submit these details to physical distortion; yet the reality is presented, none the less, through an elaborate play of far-fetched comparisons.'[1] This was a direct inheritance from the Georgian satirical print therefore, which outlawed by polite society had now taken refuge among the writers. An even stronger link is discernible in Thackeray, who as artist and writer clearly owed a lot to the great satirist. Thackeray was not only taught by George Cruikshank, the greatest exponent of the eighteenth century tradition, but Harvey traces one initial letter in his novel *The Virginians,* Chapter XXVII which is derived directly from Hogarth's 'Idle Apprentice' series.[2] A similar sort of connection can be seen in the delightful frontispiece which Thackeray drew for his own *Paris Sketchbook,* 1841 (Figure 84). A decorative frieze of heads which are satirical but not caricatured are grouped over the page, a succession of types that might have graced any eighteenth century work on physiognomy. But they are most akin to the compositions of heads which Hogarth liked to use as studies of character such as 'Arms of the Undertakers', 'The Chorus', 'The Laughing Audience' and 'Alma Mater' (Figure 85). For his highly successful book *The Four Georges,* serialised in *The Cornhill Magazine* in 1860, Thackeray made illustrations and initial letters from original eighteenth century material. In the published book, 1861, he acknowledges that the first initial letter 'is from an old Dutch print of Herenhausen', but he might also have added that

Figure 85. 'Alma Mater' by William Hogarth.

Figure 84. Frontispiece of The Paris Sketch Book *drawn by* W.M. Thackeray.

the initial in the fourth chapter is taken from Zoffany and the print of George IV and Queen Caroline comes from a popular stipple engraving. None of these have quite the Georgian feel of *The Paris Sketchbook* plate, but the initial of a drummer, at the head of the chapter on George II, is spirited and almost Hogarthian. With the money that he made on *The Four Georges,* Thackeray was able to build and furnish a new house in London where his enthusiasm for the 'Queen Anne' style could be given full rein.

It was perhaps significant that twenty years later it was Thackeray's works which gave a group of younger artists an opportunity of illustrating in the revived Georgian style. This was in the twenty-six volume Smith Elder Standard Edition of 1885 where Thackeray's original sketches were augmented by the works of Frank Dicksee, Linley Sambourne, Fred Barnard and G.A. Sala. The strongest period settings are by Fred Barnard who appears to go to original material for his inspiration and there is a splendid contribution by Fred Walker to 'Hogarth's Model' in *The English Humourists.* Linley Sambourne is weak as he often is with historical illustrating, but an added air of authenticity is introduced by the reproduction of eighteenth century engravings opposite each chapter in *The Four Georges.* For their 10/6d per volume, the readers of 1885 were receiving something that had not merely the sentiment of Georgian times about it, but a strong visual appeal as well.

By the middle of the 1860s there was a definite reaction against the sketchy, free and caricatured book illustrations that both Dickens and Thackeray had grown up with. H.K. Browne ended his partnership with Dickens after *Little Dorrit,* 1855-57, and the plates for *Tale of Two Cities,* 1859, and Fred Walker transformed Thackeray's pencillings for *The Adventures of Philip* into graceful and assured wood engravings for *The Cornhill.* It was a transition of style and temperament, a style which bade farewell to the copper-plate in a self-consciously progressive age and addressed itself to the greater subtleties of black and white art; a temperament which was as far removed from the volatile Regency as the pounding magazine presses were from the singly issued print of fifty years before. The French illustrators of the *comédie humaine,* the fashion plates, the middle-class novel and the softer characterisations of Leech, all had influenced the change. Ruskin, whose criticisms of book illustrations are curiously patchy saw fit to lampoon the illustrated edition of Dickens' *Barnaby Rudge,* 1841, in his *Ariadne Florentina,* natural perhaps that he should choose a period story with illustrators of the old school, H.K. Browne and George Cattermole. 'You have in that book,' writes Ruskin with marvellous over-statement, 'an entirely profitless and monstrous story, in which the principal characters are a coxcomb, an idiot, a madman, a savage blackguard, a foolish tavern-keeper, a mean old maid and a conceited apprentice – mixed up with a certain quantity of ordinary operatic pastoral stuff ...'[3] This edition of *Barnaby Rudge* was published in conjunction with *The Old Curiosity Shop* as an omnibus edition, under the title 'Master Humphrey's Clock'. The engravings are mainly half-page figure subjects with an occasional landscape illustration and some lively initial letters linking section to section (Figure 86).

Ruskin's outburst was untimely. In 1872 Browne was already elderly and neglected, Cruikshank, obsessed with teetotalism, was more an historical figure than a practising artist and George Cattermole had ceased to illustrate at all. It was the impact of Pre-Raphaelite illustration on the younger men that had swept the carpet from under the Georgian satirists, the energies of the illustrator were now concentrated on naturalism and realism in interpreting the text of books. As we have already seen, the portrayal of modern episodes became an absorbing passion of the novel and the magazine illustrator while his more imaginative side was poured into the legendary and symbolic preoccupations of poetry and myth. It seemed for a few years as if the visual continuity that stretched in illustration from 1740 to 1840 had been broken.

There were some exceptions among the artists of the 1860s, however, one of whom has

Figure 86. Illustration by George Cattermole for The Old Curiosity Shop.

already been dealt with in some detail, George Pinwell. We have seen him as the brilliant draughtsman of country scenes which he touches with a magical sympathy and innocence, but his reputation as a major illustrator rests on his work in the Dalziels' *Illustrated Goldsmith,* 1865. In this book, Pinwell had the opportunity to produce a large and sustained amount of work from the stories and plays of a writer with whom he obviously felt a great kinship. It is true that all the one hundred illustrations are costume pieces and are therefore not the usual stock in trade of the artist, but the characters of Goldsmith are mostly culled from country life and by accepting this and fitting them into the settings and groups he knew so well, Pinwell breathes on them a naturalism which has not dated. *The Vicar of Wakefield* engravings and those for *She Stoops to Conquer* are probably the most successful, the group on page 155 of the former being marvellously composed and modelled and the figures by the harpsichord a characteristically well-defined piece of drawing. Forrest Reid hits the correct note when he points to the admirable figure of Goldsmith wandering the streets of London as showing 'a touch of Hogarth'.[4] It is the authenticity of the drawings which is still their strength, the Victorian idea of Georgian London may be there, but it is happily subdued and clothes, furniture and settings would seem to have been modelled from paintings and prints as well as from sensitivity to the writer. Although it would be difficult to establish it definitely, one suspects that the high praise given by Gleeson White and others to this book at the turn of the century, made it widely influential.

Matthew Lawless, the Irish-born illustrator who died in 1864 at the age of twenty-seven, was another powerfully individual artist who made some successful contributions to the eighteenth century idiom. He has already been touched upon as a Pre-Raphaelite follower but in *Good Words* for 1864 he illustrates a poem 'The Player and The Listeners' with an attractive musical subject in which both costume and instrument are eighteenth century, though a little indeterminate because of lack of knowledge. The year before he had drawn for *London Society,* a full page illustration 'A Box on the Ears and Its Consequences' which gave him the chance to show a crowded Georgian Assembly Room with outlined figures. Another subject managed with equal facility was 'Doctor Johnson's Penance' in *Once a Week* of the same year. A book of 1867 which reflects the same spirit is *The Story of a Feather,* illustrated by George du Maurier, again recapturing something of the atmosphere of scenes set in the previous century and even imitating in the penwork a little of the period's caricature.

In the same decade as Ruskin's portentous grumblings, a spate of books were issued to the public which were to have a considerable effect on the return of the eighteenth century

to print. The publisher John Camden Hotten's list for 1871 included revived editions of *Hood's Whims and Oddities* of 1826, *Life in London* and *The Tours of Dr Syntax*, all Regency best-sellers. Cruikshank's *Comic Almanacks* were also on this list but by 1876 had migrated to Chatto and Windus, powerful supporters of caricature. Chatto's had been the publishers of the first major monograph on a Georgian figure with *The Works of James Gillray The Caricaturist* by Joseph Grego in 1873. Grego's thoughtful examination of the artist treats the caricatures in an historical and sociological fashion with passing references to 'HB', John Leech and Tenniel who he feels fulfill a similar function. This was followed by the yet more elaborate set of two volumes *Rowlandson The Caricaturist* by the same author in 1880. Thomas Wright had produced his *Caricature History of The Georges* in 1876 and a more general survey including chapters on the immediate past was available by 1893 in Graham Everitt's *English Caricaturists and Graphic Humourists.*

Such a wealth of illustrated material would have been of little use if it had not reached the notice of up and coming artists, but there is ample evidence that these books and the original drawings and prints were being re-discovered in studios and private collections. In 1883 a young girl visited the memorial exhibition of 'Phiz' (H.K. Browne) held in London. This was Beatrix Potter, the aspiring illustrator of flora and fauna, who found much in this unfashionable artist that was to her taste. She confided to her journal that she preferred his work to that of Leech and liked 'the wonderful difference in expression' of the original drawings in comparison with the published prints. Charles Keene, then at the height of his *Punch* fame, was the contributor who showed most clearly the free style of the magazine's early years. His figure work is incomparably the best of its kind in any illustrated journal but it was to Stothard that he claimed to look for inspiration and an obscure book illustrator of Polish extraction, Nicolas Chodowiecki, 1726-1801. This artist's scenes from Shakespeare, Lavater and others would seem to be the quintessence of good-mannered eighteenth century book illustration. Keene is on record as saying 'I consider him the most extraordinary demon of industry (and yet excellent art of its sort) I ever knew of.'[5] He also had a collection of Chodowiecki's originals. When Mr. John Jones left his outstanding collection of French eighteenth century furniture to the Victoria and Albert Museum in 1882, it contained a fine portfolio of hand-coloured caricatures of the same period, presumably collected in the 1850s and 1860s when interest in such things was supposed to be at its lowest.

The Household Edition of Charles Dickens Works that appeared between 1870 and 1879 reprinted all the major novels as well as fugitive pieces from *Household Words* and *All The Year Round* and a life of the author. The lion's share of this work went to Fred Barnard, the London born but French trained figure artist who had been working for *The Illustrated London News* since 1868. A good deal of Barnard's work had been in social realism, a good background for Dickens, but even with his considerable grasp of character and situation, the continuity of 'Phiz' and Cruikshank is not sustained through the volumes. A later edition of the illustrations only states that he took 'the types already created by his predecessors, preserved their characteristics, so that each was unmistakably himself and yet by the illuminating touch of genius transferred them every one from the realm of caricature to that of portraiture.'[6] This is only partially true for Barnard was a brilliant caricaturist and some of his creations in *Sketches By Boz* and *Martin Chuzzlewhit* are closer to caricature. It is only necessary to look at the wood engravings in *Nicholas Nickleby* and then at the steel engravings in the 1839 volume to see how closely Barnard follows the dress and fittings and manners of the epoch and yet how totally he has missed the spirit of the age. The *Boz* illustrations are better, the characters live within the context of their writer and their period and in the 'Cold Thin Rain' engraving to Chapter II, Barnard has used as his source Gillray's 'Windy Day' and elsewhere, the half page sketch of the actor 'Jem Larkins' is a masterpiece

but in reality a resurrected and re-moulded 'Jingle' from H.K. Browne.

Barnard's designs for *Tale of Two Cities* are very unconvincing, the costumes wildly inaccurate and the female revolutionaries looking more like the Parisians of 1870 than 1790. Charles Green, 1840-1898, was the other main contributor to this series, his best work being for *The Old Curiosity Shop* which gave him most scope for dramatic and atmospheric effects and strong characterisations. In drawings such as this, entitled 'A Consultation' one can see the strong influence of H.K. Browne's work (Figure 87). His surviving pen drawings show a freedom and a sprightliness one would not expect from the wood engravings, but the finished work for reproduction is often no longer linear but clouded with thick grey washes. The chief influence in this direction was William Small, 1843-1929, who also undertook period settings in some of his books. Artists like Barnard who remained loyal to line work, are not noticeably more accurate or close to the authors than those who experimented with washy effects on the wood engraving.

The most vigorous and spontaneous pastiches did not however come from established artists or amateurs but from an obscure bank clerk in Manchester, Randolph Caldecott. As mentioned in an earlier chapter, Caldecott was the discovery of James Hogg of *London Society,* 1871-72, and it was not long before he attracted the attention of W.L. Thomas of *The Graphic* and joined the recently founded magazine in October 1872. Caldecott's appeal was obviously in the freshness and vivacity of his drawing not in his accuracy. His tremendous capacity for humorous draughtsmanship and humorous story-telling was so effortless and attractive that it easily outbalanced the small blemishes natural in an untrained hand. An inveterate sportsman and lover of the country, Caldecott made the hunting party and the house party his school as Leech had before him. He also studied animals in the Zoological Gardens. There is still however some of the amateur's hesitancy and uncertainty in some of the earlier illustrations which in some ways give them their most enduring charm. Deriving some of his gentleness from Leech, Caldecott based his work directly on the spirit of the eighteenth century as it was found in the nostalgic Christmases and idylls of Dickens, Washington Irving and Thackeray, a pretty pastellish world, ideally suited for Victorians now living with industry, but dreaming of green countrysides and houses in blushing red brick (Figure 88).

Part of Caldecott's success was that he could convey the essence of a past age very easily but use his own texts. One of the ways he did this was to adopt the guise of a letter-writer or a diarist of the 'olden time' and illustrate with lively sketches his supposed

Figure 87. 'A Consultation' by Charles Green.

Figure 88. 'Three Jovial Huntsmen' by Randolph Caldecott.

adventures. *The Graphic* in those ten years between 1876 and 1886 contains numerous examples of this kind, 'Mr Carlyon's Christmas, Pictured by his Grandson', 'The Legend of the Laughing Oak', 'Diana Wood's Wedding', 'Christmas Visitors From My Grandfather's Sketches', 'The Cumudgeons Christmas' are some of them. A strangely fairy tale air of wonder fills the drawings to these stories, an unspoilt landscape stretches into the distance, great log fires seem to be perpetually burning and happy rustics are continually quaffing the health of the young squire in bright tankards. Yet these imaginary pieces were arranged in *The Graphic* for an adult readership who were enjoying to the full the greater use of colour printing in the magazines.

The artist happened to have arrived on the scene when what was needed was a humour of lightness, simplicity and verve, not too well drawn but adapted to colour work. Edmund Evans, the chief exponent of the new market, found ideal material for children's *Toybooks* in the designs of Walter Crane, Kate Greenaway and Randolph Caldecott, published by Routledges and Warnes from about 1865. Their simple black outlines and flat areas of subtle colours made them quite different from the crude and garish illustrations of other juvenile publications. (See Colour Plate X, p.124.) It was probably the whimsy of never-never land, combined with the sophisticated tonal range of the colours, that linked Caldecott and Kate Greenaway to the Aesthetic Movement. Their prettiness interested Ruskin and for him, Caldecott was 'dazzling' and most particularly for his landscapes, 'familiar landscapes, very English, interpreted with a bonhomie savante'.[7] Most of the artist's work has a remarkable economy of line which suggests comparisons with Phil May. The picture books had on average six coloured pages, the remaining openings being black and white or rather brown and white line drawings; only an artist of consummate skill could have linked the main plates with such slight and simple sketches so superbly. The artist certainly understood the world of childhood and the heroes and heroines of these *Toy Books* are always the children themselves.

In talking of the beauty of Caldecott's line, his biographer, Henry Blackburn, does say that the artist was not always well served by his engravers. This is certainly born out by the surviving pen drawings in letters and sketch-books and in the illustrations for *Old Christmas*, 1874, and *Bracebridge Hall*, 1877, both by Washington Irving. The drawing becomes much tighter in these illustrations, the compositions more considered and the figures more controlled, in some of them he would seem to have looked at Browne or Cruikshank with an affectionate eye. Drawings such as 'The Stage Coachman' and 'In The Stableyard' in the first book are marvellously evocative and in the second volume 'The Literary Antiquary' or 'Master Simon' only show a slight falling away. These two books were undoubtedly the most influential on the black and white artists of 1900, and from the amazing freedom of line and the imaginative use of vignettes, stems a great deal in Thomson, C.E. and H.M. Brock, Bernard Partridge and even E.J. Sullivan.

Caldecott's brief reign was not of course an entirely Georgian one. His French drawings were published as *Breton Folk* in 1878 and his *Graphic* contributions included light hearted views of contemporary life like 'The Strange Adventures of a Dog Cart' or 'Mr Chumley's Holidays'. But it is in the Georgian chronicles and the nursery books of Goldsmith's *Mad Dog* and Cowper's *John Gilpin* that the heart of Caldecott is to be found. There were numerous imitators but no single one could produce the magic of his parodies with the innocent child-like fun of his stories. In the year of his death, 1886, *The Graphic* published a pictured story by W. Ralston that was plainly an attempt to sustain the Caldecott manner, and another 'An Old Fashioned Christmas' followed in December 1889 with Arthur Hughes as the somewhat surprising Caldecott imitator. Others who caught this infectious style were W.B Wollen, Cecil Aldin in his *Jorrocks* series and Percy Macquoid. Frank Dadd and the Brock Brothers carried the spirit of Caldecott Christmases up to 1914 and and Edwardian

periodicals mercilessly aped the adventures of Regency bucks, even adopting the greens, browns and beiges of the coloured wood engraving for their own purposes. But it is some recognition of Caldecott's originality that while they have been forgotten, his evanescent picture books are still reprinted.

Kate Greenaway was a Londoner, born in Hoxton in 1846, a kinswoman of Richard Dadd and sister-in-law of the illustrator Frank Dadd. Like Caldecott, her urban background gave her a longing for the countryside and as he turned to the hunting field, she turned as readily to memories of childhood holidays in Nottinghamshire. Her aunt had a cottage at Rolleston near Newark and the young Kate spent summers there as well as much longer periods during a lengthy illness of her mother's. Rolleston with its haystacks and cornfields, country characters and farm animals, became mixed in her mind with the children's stories that were read to her, stories of the generation before last by the Misses Jane and Ann Taylor. An obvious aptitude for drawing led to her thinking of art as a career and she studied at both Heatherley's and the Slade School and shared a studio with Elizabeth Thompson, later Lady Butler. As early as 1868 she was specialising in legends and scenes from childhood and they began to bring her work from Marcus Ward for Christmas cards and valentines. In due course she was introduced to Edmund Evans and it was with his encouragement and expertise that she produced *Under the Window* in 1878, a book of her own verses, illustrated by herself. This was an immediate success in this country and also in Europe and America. Ruskin raved over her designs. 'The fairyland that she creates for you is not beyond the sky,' he told his Oxford audience, 'nor beneath the sea, but near you even at your doors.'

The 'fairyland' was 'olden time' in concept and Regency in dress as far as it could be. It corresponded to the Caldecott picturesque world perfectly. But the effect on the page was quite different; her garlanded children in bonnets and ribbons seem not only timeless but motionless as well, their waisted dresses and breached legs are as weightless and fleshless as feathers (Colour Plate XII, p.173). It is difficult to associate such robust tales as Red Riding Hood, Blue Beard and Puss in Boots with these solemn little girls, but she illustrated them all and the Victorian public loved them. The later nineteenth century was morbidly sentimental about children and here was an artist who not only treated them as serious little adults but gave them a period setting and an aesthetic costume! Kate Greenaway's sources were various, not only the children's books of the 1800s beautified, but the work of more considerable illustrators. Her friend Locker Lampson introduced her to the drawings of Thomas Stothard and she claimed elsewhere to have been influenced by Downman and certainly was by Reynolds in those finished watercolours of hers such as 'Winter', 1892, and 'Out For a Walk'. Her watercolours of country scenes are among her best work and are reminiscent in colouring of the art of Fred Walker and in their content, cottages and flower gardens, of her friend and contemporary Helen Allingham. She was unusual among the illustrators in attempting to create a genuinely historical representation. 'She did not merely pick up an old book of costumes and copy and adapt them second-hand to her own uses,' Spielmann records, 'She began from the very beginning, fashioning the dresses with her own hands and dressing up her models and lay figures in order to realise the effects anew.'[8] Whether copied or not, the garments have no genuine Regency counterparts, but the illustrations attracted the public who began to dress their children in Kate Greenaway costume. Du Maurier delightfully ridiculed the 'artistic couples' who decked their children out in flimsy dresses and monstrous bonnets aping *The Kate Greenaway Almanack* which came out nearly every year between 1888 and 1897.

The fact that so much was done in the studio from the lay figure surely accounts for the static quality in Kate Greenaway's art and its impression of decoration rather than illustration. It was precisely this aspect that most worried Ruskin. 'There is no joy and very,

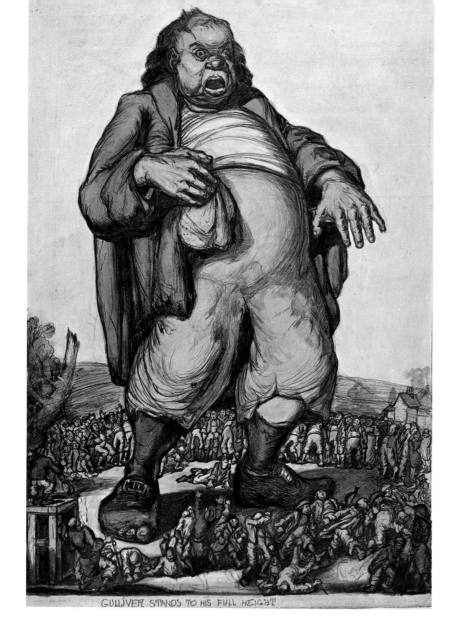

GULLIVER STANDS TO HIS FULL HEIGHT

ANNIE FREN

very little interest in any of these Flower book subjects,' he wrote to her in 1884, 'and they look as if you had nothing to paint them in but starch and camomile tea.'[9] Ruskin tried to persuade her to study from nature and considered her delicate colours were lost in the printing and should have been painted in by hand. 'What you Absolutely need,' he told her, 'is a quantity of practice from things as they are — and hitherto you have Absolutely refused to draw any of them so.'[10] But the books remained an overwhelming success. *Under the Window* was printed in an edition of 20,000 copies, at once sold out and reprinted, Evans eventually seeing it through to a total of 70,000 copies. The ones that followed, *The Birthday Book, Mother Goose, A Day in A Child's Life,* were equally popular and usually printed well over 10,000 copies. Her more conventional illustrating was not so individual, it harked back to the 1860s and in the case of *The Illustrated London News* included in Christmas 1874 'A Christmas Dream' which, with a sleeping child surrounded by elves and fairies, might have been a late work by Doyle. Her contributions to Charlotte M. Yonge's *The Heir of Redclyffe* in 1881 are very dry and reminiscent of M. Ellen Edwards at her least inspired.

But the essential Greenaway style of sugary sweetness, overlaid with Regency trappings, had it imitators well into the 1900s. It then became fused with the decorative motifs of 1890s work and died in the 1920s after a brief explosion of coy crinolined ladies. Among the better followers may be mentioned Mrs. Farmiloe, Winifred Graham, J.G. Sowerby, H.H. Emerson and R. André.

An illustrator who arrived from the United States in the late 1870s and who was to be widely influential here, was E.A. Abbey, 1852-1911, the American born and American trained draughtsman. Edwin Austin Abbey was born in Philadelphia and worked in a wood engraving office, studying art in the evening at the Pennsylvania Academy of Fine Arts, later moving to New York. His major American works were all for Harper Brothers' magazines, where the influence of German and French black and white art, already referred to, was transforming pen drawing. From the studio of Dietz in Munich, and Fortuny and others in

France, a whole generation of American artists had returned to revitalise the art of illustration. The leading exponents were all Harper's or Scribner's men and it was therefore in American magazines and through American draughtsmen that the strongest Continental influences came. The essence of these drawings was a high standard of technique, a remarkable control of the pen line and a direct working from nature; perhaps most significant of all they did not treat illustrations as a minor but as a major means of artistic expression.

Abbey's contact with England was a tremendous spur to his historical work. His familiarity with the literature of the sixteenth to eighteenth centuries in this country was such that direct contact with the places and the landscape of the stories drove him on to fresh inventiveness. Settling first in London and then at Fairford in Gloucestershire, he became successively ARA and RA in 1901-02 and over the years captured the imagination of many younger artists with his renderings of Shakespearean subjects, *Herrick's Poems*, 1882, and *She Stoops to Conquer*, 1885 (Figure 89). In the latter book, he breaks completely away from the decorative convention of period illustrating and conjures

Figure 89. Illustration by E.A. Abbey for She Stoops to Conquer.

193

up people of flesh and blood living in imaginable surroundings. 'In England of the eighteenth century he is as much at home as Austin Dobson,' wrote his fellow American Joseph Pennell, 'He can reconstruct its old rooms and village streets and fill them anew with beauty and life.'[11] The artist's work also contains greater historical accuracy; Goldsmith's and Sheridan's characters sit on chairs of a discernible date, drink from vessels of a plausible appearance and wear clothes of a recognisable cut. Abbey had a considerable collection of old master paintings and antique furniture and these were presumably marshalled for use in his illustrations, probably the earliest attempt at such for a purely Georgian scene.[12] He also possessed an extensive library of the illustrated books of the 1860s, and a well-thumbed copy of *A Round of Days* with his bookplate is ample evidence that there was a strong link with the earlier artists.[13]

The drawings of Abbey had a very refined quality which made them difficult to reproduce in wood engravings. The etchings and original sketches, such as the one shown (Figure 89), often have a delicacy and sparkle that surpasses the book illustrations themselves. *Old Songs,* 1889, and *She Stoops to Conquer,* 1885 and 1901, are probably the high points of Abbey's art, but it is important to remember how versatile he was, humorous drawing was also in his line and he collaborated in delightful but uncharacteristic illustrations with Alfred Parsons in *Quiet Life,* 1890. In a note to the 1894 edition of *Pen Drawing and Pen Draughtsmen,* Pennell comments 'one can see that a new school is arising, and this is the school of Abbey, who has at the present moment followers in every illustrating country in the world, men who are seeking to carry out his method of brilliant drawing carefully and seriously executed.'[14] How true this was is proved by the list of artists working on eighteenth century literature in the 1890s, and 1900s and in fact right up until Abbey's death in 1911.

Chronologically after Abbey comes Hugh Thomson, 1860-1920, who was directly influenced by him. He was born at Coleraine near Londonderry and like Kate Greenaway began his career on the design of Christmas cards. His arrival in London and early work for *The English Illustrated Magazine* has been discussed in an earlier chapter, but his contributions as an illustrator of books are important for combining two strands of Georgian revivalism. He assimilated the humour and freedom of Caldecott with the fine line and careful expression of Abbey, bringing out between 1886 and 1900 a whole succession of small classics with crisp well-tuned pen sketches for Macmillans and Kegan Paul. That he recognised his debt to these artists is recorded in a reference quoted by Spielmann; of Caldecott he said 'It was a revalation to us all, when we saw what could be done with a simple unshaded outline, provided there was humour and fun in it. Hugh admired Abbey's work in *Harper* and the fine lines took his fancy.'[15] Again he recalls 'Hugh was immensely pleased with *The Mad Dog, John Gilpin, The House That Jack Built'.*

The first of his books is *Days with Sir Roger De Coverley,* 1886, a very neat little volume with beautiful figure drawings and some excellent pastoral decorations in the shape of headings, initials and vignettes. There are strong hints of Caldecott throughout, even down to the eclectic styles of dress, but also echoes of Fred Walker's unused illustrations for *Henry Esmond.* Other titles included *The Vicar of Wakefield,* 1891, the same work that Walker had made famous, *The Ballad of Beau Brocade,* 1892, a real feast of Augustan sentiment and *Our Village,* 1893, and *Peg Woffington,* 1899. His greatest success, *Coaching Days and Coaching Ways,* was published in 1888 and reprinted in 1903, as J.F. Sullivan said of him – 'He was the roundest of round pegs in the roundest of round holes, and his spirit and style seemed to me to fit the works he illustrated to a degree unattained by any other draughtsman that occurs to mind.'[16] His peppery squires and rubicund coachmen perfectly capture this aspect of Edwardian nostalgia (Figure 90).

Thomson's path through the forty years of his working life was predictable. He was to

"THEN HE, HANDING HER INTO HER COACH, STEPS IN AFTER."
From a Drawing by Hugh Thomson.

The battle was over without any blows,

The heroes unharness and strip off their clothes;

The dame gives her captain a sip of rose-water,

Then he, handing her into her coach, steps in after.

John's orders are special to drive very slow,

For fevers oft follow fatigues, we all know;

Figure 90. Illustration by Hugh Thomson to poem in The English Illustrated Magazine.

illustrate, besides Goldsmith, Jane Austen, Fanny Burney, W.M. Thackeray, R.B. Sheridan, Hawthorne and Mrs. Gaskell. Any story in which costume illustration was appropriate was bound to persuade the publisher that Thomson should undertake it. The culmination was a series of handsome Edwardian volumes from Heinemann and Hodder in which Sheridan, Shakespeare and even J.M. Barrie were treated with a lush period sensuousness, fragile and beautiful interiors in pastel colours, lyrical decorations and vignettes, all between spacious margins. Although these caught the imagination of the public, they do not show Thomson at his best, because a black and white artist is usually diverted when he is engaged on colour work. The large plates are often flat and anaemic in tone and entirely lack the vigour of the pure pen drawings, neither do they make happy comparisons with the colour books of contemporaries like Rackham and Dulac. Thomson was also limited as an interpreter of legend and *The Illustrated Fairy Books,* 1898, lack the bite and the sinister element as well as the decorative appeal that made Rackham and Dulac so famous. Thomson's washy colours have most in common with the later watercolours of George Cruikshank and the surviving colour work of Leech and Doyle.

But Thomson had another side which is revealed in *The English Illustrated Magazine,* his love and sympathetic treatment of Londoners. In 1886-87 he illustrated an article 'In The Heart of London' filled with very lively cockney studies, gaiety as well as pathos. There is the germ here for a really great illustrator of the contemporary, a humourist of the streets like May, a forerunner of G.L. Stampa in his love of urchins. But it was not to be and Thomson always returned to the minuet, the pointed toe in the buckled shoe, the raised fan that his Edwardian admirers demanded.

A younger artist who must have been influenced by the Thomson manner was Sir J. Bernard Partridge, 1861-1945, better known as the cartoonist of *Punch.* Partridge, who in the 1880s was still making up his mind whether to be an actor or an artist was clearly struck by Thomson's work in *The English Illustrated Magazine.* He records this and elsewhere Thomson acknowledges a sort of friendly rivalry between them although they were little more than acquaintances. Partridge stressed Thomson's success in making the settings 'the compliment of his figures'[17] and he went on to achieve this in his own work. In 1893, he illustrated Austin Dobson's *Proverbs in Porcelain,* and made very accomplished pen drawings of the eighteenth century characters, somewhat dramatically gestured, but benefiting from his theatrical background in the knowledge of their costumes. Partridge's flirtation with the *dix-huitième* was brief and he was soon back in the weekly issues of *Punch* and illustrating the novels of F. Anstey.

The closest disciples of Thomson were definitely the Cambridge brothers, C.E. and H.M. Brock. These brothers (there were in fact three but the other was not a period illustrator) worked quietly in their Victorian house over a span of more than fifty years. Like a pair of latter-day Cheeryble Brothers, the Brocks worked away with tremendous industry and overflowed their benevolence into hundreds and hundreds of printed pages between 1891 and 1953. In some ways they were strangely isolated from other artists and unaffected by current trends, so that the pen drawings they were producing in the full

flower of the 1890s were largely the same as those coming from their boards in the 1930s. Although they used the Cambridge college libraries for picture research and the City obviously gave them inspiration, they remained totally outside the priggish academic circles there and indeed the Fitzwilliam Museum still contains not a single work by either of them.

C.E. Brock, 1870-1938, began to draw for books in the early 1890s and found his feet completely after illustrating *Gulliver's Travels* in 1894 and *Annals of The Parish* and *Pride and Prejudice* in 1895. The eighteenth century proved to be his métier, but this was only after considerable experience with contemporary subjects in magazines like *The Quiver, The Strand* and *Pearsons*. In 1898 he made sixteen full page drawings for *The Vicar of Wakefield* in the *Illustrated English Library* series and the same year saw the appearance of Dent's Novels of Jane Austen, a collaboration between the brothers. Although they are usually bracketed together, the brothers can be very different artists. Usually C.E. Brock's line is more delicate than his brother's, more refined on the page surface and closer to Thomson or Abbey. His compositions are always excellent but his range was probably not so great, he did far less *Punch* work than H.M. and nothing after 1910. The older brother's drawings are much scarcer than H.M.'s, a strange fact considering they so often worked and published together. They followed their more famous predecessors step by step, not only *The Vicar of Wakefield* like Abbey and Thomson, but *Jackanapes,* 1913, which Caldecott had made a best-seller and *Sir Roger de Coverley* and *Old Christmas,* the chestnuts of the period book market. Between 1903 and 1911 they worked on various stories by Charles Dickens, mostly the minor works where their benign drawings would most accord with the words. In the 1930s C.E. was to illustrate several Dickens novels but with the reduced number of plates that followed publishing economies. When one has mentioned Whyte-Melville's novels, Lamb's belles-lettres, the adventure stories of R.D. Blackmore and Baroness Orczy, the school stories of Ian Hay and Desmond Coke, one has covered the whole range of Brock illustrating. It could not be described as very powerful work but it is full of the quiet charm of England before 1914, when the leisured reader wanted his book well pictured but in a rather decorative way.

The Brocks certainly score over some of their forerunners and contemporaries in matters of accuracy. The brothers had clothes specially made up to provide examples for their costume subjects and they used the model to some effect in the mobility and action of their figures. There are also references to their working collection including a great many costume prints and fashion plates of the Regency period.[18] They both collected antiques and the 'props' in their houses, Georgian bureau bookcases, mirrors, chairs and candlesticks, recur again and again in their illustrations. The more authoritative note creeping in came not only from the more favourable climate in the country towards Georgian England, but from the more knowledgable approach of antique dealers. The Brocks were very friendly with a number of these and in 1906 their interest saw them jointly employed as illustrators on Mallett's *History of Furniture,* making ink drawings of the originals in the dealer's Bath shop. Extensive files were kept of furniture and interiors, carefully clipped from *Country Life* and entered under the appropriate date.

Another pair of illustrators whom the Brocks would surely have heard of, were led by *their* historical appetites into a completely different field, that of writing. Percy Macquoid, 1852-1925, the artist son of *The Illustrated London News* decorative illustrator, T.R. Macquoid, gradually turned from pictures with period settings to the history of furniture. Trained at Heatherley's and in France, Macquoid moved from equestrian illustrations in *The Graphic* and costume pieces illustrating Scott to the three-dimensional theatre stage and finally to the museum. His critical illustrator's faculties were brought to bear on the cabinet-making of the early Stuarts, Queen Anne and the first three Georges and he produced in 1905 the earliest modern history of English furniture. It was in the form of four large volumes dealing with oak, walnut, mahogany and satinwood furniture.

Fred Roe, 1864-1947, began his career as a black and white figure artist on *Fun* and *Judy,* but developed a fascination for historical genre painting. Working with Stuart and Georgian settings he became absorbed by their detail and began to draw each object for its own sake. The result of this research was a number of books including *Ancient Coffers and Cupboards,* 1902, and *A History of Oak Furniture,* 1920, and many articles in *The Connoisseur* incorporating his own sketches. Both these illustrators cum writers were avid collectors of antiques and this brings out yet another strand of influence in the return to the eighteenth century. The reproduction of art objects by photograph in sale catalogues and books, which had begun in the 1880s in earnest, was paralleled by a school of French still-life illustrators who represented the art of the *ancien régime* with amazing virtuosity. The chief of these was Jules Jacquemart whose tightly drawn lines and careful rendering of light effects on polished surfaces, made the boulle, Sèvres plaques and gilded bronze of Louis Quinze live with an astonishing brightness. Other artists of this school include C. David and E. Prignot, Charles Goutzviller and Henri Toussaint, all capturing the spirit of the age in their drawings. These books were not only aids to interior decoration and material for the artists' shelves but slowly established a more critical response in the reader who opened up a new volume of Molière's *Femmes Savantes* or Fanny Burney's *Evelina,* fully illustrated.

This historical awareness was a tribute to the sophistication of the public too, and might have been a step closer to the text, but it did not always work for the illustrator's advantage. From the 1890s onwards there was a taste for having the original illustrations wherever possible, the frank and caricatured etchings of George Cruikshank, the lively work of 'Phiz', not reproduced in their original medium it is true, but having enough of the irreverent Regency in them to be authentic! As mentioned, Thackeray led the way in 1885 with the *Standard Edition* and the same became true of John Leech's plates to R.S. Surtees' novels and the whole early cycle of Dickens' novels. Chapman and Hall's *Household Edition,* which should have been a pace setter with its fine wood engravings from drawings by Fred Barnard, Charles Green, J. Mahoney, G.B. Frost and E.G. Dalziel, came too late in the 1860s tradition to become a classic. In fact it was not published in the 1860s at all but in the 1870s with some weak work by 'Phiz' being the only contributions of an original collaborator. Macmillan's reprint of the first editions in 1892 contained the original 'Phiz' plates as did the succeeding *Gadshill Edition* of 1897, with the illustrations printed from the original steel plates. The early years of the century saw *The Biographical Edition,* 1902-03, *The Fireside Dickens,* 1903-07, *The Authentic Edition,* 1901-05, and *The National Edition,* 1906-08, all with their inimitable characters seen through the 'Georgian' eyes of 'Phiz'. In some editions, the *London Edition,* 1901-02, and *The Authentic Edition,* colour was applied to the 'Phiz' and Cruikshank illustrations, giving them the same weak and washy look as contemporary illustrators' works. *The London Edition* has alternate plates in colour only, a weird compromise.

It was hardly surprising that such a bout of nostalgia and antiquarianism should have its counterpart in landscape. Following the Caldecott and Greenaway vistas of unspoilt and sylvan countryside, a group of artists emerged who recorded actual places, old inns, castles and towns with the same touch of romance as if they had been part of an Austen or Goldsmith story. It is really Caldecott, this time as the painter of manor houses and old farmsteads, that lies behind this lichen-encrusted phase of illustration, but sentimental watercolourists like Samuel Read and illustrators such as Nash with his *Mansions of the Olden Time,* must have helped. Hugh Thomson's co-artist in the successful *Coaching Days and Coaching Ways* had been Herbert Railton and it was he that stood at the head of this particular group.

Herbert Railton, 1857-1910, was an extremely prolific black and white artist whose sensitive pen strokes seem to caress and enliven the odd shapes and textures of ancient

Figure 91. 'Old Tabard Inn' by Herbert Railton.

decaying buildings. He was, moreover, an artist who did not attempt portraits of his streets and buildings but presented a pavement-eye view of life, searching out little nooks and crannies, hens scratching in inn yards, curious vistas through narrow alley-ways, pumps and pub signs, but always somewhere the tremulous line and dark presence of ivy or virginia creeper, choking and covering the walls (Figure 91). Sometimes the artist gives an effect of sparkling light by using broken lines, an idiosyncracy that can become just a mannerism. *Coaching Days* remains his masterpiece, the backs of these old hostelries from Bath to Guildford and from Smithfield to Chester, really do breathe out an infectious enthusiasm for the travels of Pickwick and Weller. And yet the stable yards are empty and one has to look across the page for Thomson's group of ostlers or the departure of a four-in-hand to be completely convinced. Railton contributed to the *Jubilee Edition* of *Pickwick* in 1887 and illustrated *The Select Essays of Dr Johnson*, 1889, *The Poems and Plays of Goldsmith* in the same year and editions of Peacock and Leigh Hunt in 1891. The latter part of his career was given over to the illustration of old buildings in travel books and his reliability and expression of regional characteristics must have paved the way for many city and cathedral series in the 1900s. Although influential, he had only one outstanding pupil, Holland Tringham, who died in 1909. He worked principally for *The Illustrated London News* and *The English Illustrated Magazine* and his penwork is often much sharper than that of his teacher.

The highly evocative world of Cecil Aldin, 1870-1935, fits neatly into this story, for he was not merely an equestrian illustrator of great talent but a humourist and a lover of the eighteenth century who could set his scenes against a highly convincing background. He has few equals in creating the atmosphere surrounding old buildings and peopling the thoroughfares and squares with recognisable but untheatrical bustle. His studies of old houses and timber-framed inns grow naturally out of the coloured paper and chalks that he generally used. His chalk drawings of the transport of the day, the flying stagecoach or the crawling heavy waggon are more believable than most of his contemporaries, because he knew his horse flesh from first hand and had studied the prints of James Pollard, Henry Alken and W.H. Pyne. His student days with the animal painter Frank Calderon were of tremendous advantage to him, although their result can be rather mixed. Some early contributions of comic animals to *The English Illustrated Magazine* are sickeningly sentimental and he can be very cloying in his portraiture of dogs and cats. But he is the true

successor of Leech, even more than Caldecott was, and the full blooded hunting sketches and rapid line drawings balance perfectly with the knots of rustic figures to give a concentrated whiff of country air. Aldin's recognition after *Two-Well-Worn Shoes,* 1899, and a *Dog Day,* 1902, brought him a wider popularity than some of the other illustrators dealt with. He lent his strong outline work to advertising and produced a run of *Cecil Aldin Picture Books* from 1908; his *tour de force* in period genre is probably *The Romance of The Road,* a verbal and visual echo of Outram Tristram, which did not appear until as late as 1928. This has come to rely on contemporary engravings as much as on Aldin's own sketches of Georgian life. The present writer's favourites are four little books published by Heinemann in 1909, *Bachelors, Wives, The Widow* and *Jorrocks On 'Unting.* The texts are culled from various sources in Steele and Washington Irving as well as Surtees and the coloured plates show Aldin at his best, whimsical, mischievous and slight, some of the figures in pen-line and wash reminiscent of Hugh Thomson. The *Jorrocks* book has real affection in the sketches of this ebullient and over-weight sportsman, three years later Aldin illustrated *Handley Cross,* one of the most delightful of author-artist combinations before 1914. A similar rose-tinted view of the olden time came from the writer C.G. Harper, 1863-1943, who issued a number of coaching books between 1892 and 1900, the subjects usually well imagined and well drawn.

The most outstanding pencil artist in this group was probably Alfred Parsons, 1847-1920, a landscape painter with a great knowledge of flower and tree forms and with a strong sense of decoration. He was a natural partner with E.A. Abbey in *The Quiet Life* which has been mentioned and produced on his own the fine illustrations to *Old Songs,* 1889, and *The Sonnets of William Wordsworth,* 1891, his silver grey pencil drawings are quite unmistakable for softness and texture. Joseph Walter West, 1860-1933, is roughly comparable in the beauty of his draughtsmanship; he used his Quaker background for genre subjects and leaned heavily on the eighteenth century for both content and style in the book work that he undertook.

Probably the last and most important figure to come under this spell was Beatrix Potter, 1866-1943, whose enthusiasm for Georgian drawings was mentioned at the beginning of the chapter. Helen Beatrix Potter, the daughter of a wealthy Londoner, grew up from a rather lonely childhood to be a talented and painstaking amateur artist, mainly through her own exertions. She had the advantage of leisure, a book-filled house and at least some contacts with artists, provided by her father's wide circle of friends which included Millais. Beatrix's entry into illustration was through natural history; she soaked herself in the wood engravings of Bewick, pored over the illustrations of Mrs. Hugh Blackburn and kept tame dormice to make studies from. Visits to the Zoo resulted in accurate animal drawings and her preoccupation with making watercolours of fungi, gave her a colour discipline worthy of the Pre-Raphaelites. But there was another influence, as she confided to her biographer. 'I have always had the greatest admiration for Caldecott as an artist. At one time I tried in vain to copy him. We had all his picture books as they came out and my father bought many of his original drawings at a sale after Caldecott's death.'[19] In the secret journal that she kept from about 1882, the young artist shows an astonishing maturity in criticising the work of contemporary painters, she is rigorous in her search for good drawing and natural colouring, which she feels is lacking in all but the Pre-Raphaelites. Her solitary existence was relieved by letter writing and what was second nature to the Victorians, the illustrated letter, long, rambling histories of the household with amateur and not so amateur drawings in the margin. It is hardly surprising that when all these talents finally fused together, that uniquely fresh, translucent and charming art of Beatrix Potter came to be born. This innocent and inward world of childhood, only conceivable from a lover of nature and a secretive sketcher and writer, burst out onto the public in the series of books that

have become household names. From a tentative offer of Christmas cards in the 1890s, came the private printing of *Peter Rabbit* in 1900 and its acceptance by Warne & Co. in 1902. The stream of books that followed from *Squirrel Nutkin*, 1903, to *Little Pig Robinson*, 1930, show a faraway world which is nevertheless realisable, inhabited by recognisable animals in period settings. Beatrix Potter's eye was relentless in pursuing a world that children and even adults might believe in, the waistcoat in *The Tailor of Gloucester*, 1903, was copied from an eighteenth century embroidered one in the Victoria and Albert Museum, the kitchen scenes with their friendly antique articles and furniture were copied from her own cottage and the landscapes were those of her beloved Lakes.

Edmund J. Sullivan, 1869-1933, one of the most brilliant illustrators to appear during the Edwardian years, turned his attention to eighteenth century literature on a number of occasions. Sullivan's amazing versatility and stature as a black and white draughtsman is only just being recognised and his prolific but in some ways unfulfilled career is beginning to be charted. His father was an artist and his brother was the talented cartoonist who created the character of 'The British Working Man'. Sullivan's training was on *The Graphic* and *The Pall Mall Budget,* but in some senses his work was too large scale for magazine illustrations, it was too big in concept and too grand and generous in line and colouring to accompany anything but the strongest texts. In 1896 he illustrated *The School For Scandal* and *The Rivals* for Macmillans in his own individual style and in 1898 Thomas Carlyle's *Sartor Resartus* with its witty studies of dress. In this, as in the Tennyson *Dream of Fair Women,* 1900, he stylises and synthesises his historic costume leaving an impression of both the period of the writing and his own period. The ink drawing (Figure 92) accompanying the juvenilia poem 'Airy Fairy Lilian' is based on the style of 1830 in waistline and shoulder width, but the fine accordion pleating and the appearance of chiffons are typical of 1899, the year in which the drawing was made! Sullivan is on record as disliking books that were simply sought out by illustrators for their costume appeal alone. His commission for illustrating Carlyle's *French Revolution* in 1908 was greeted by a friend with the comment 'a fine chance for costume' which angered him.[20] The result is anything but window dressing, a powerful combination of fact and symbol in which the period staging, though clear, does not distort the meaning. Sullivan's oeuvres also included *A Citizen of the World,* 1904, and the inevitable *Vicar of Wakefield,* 1914, com-

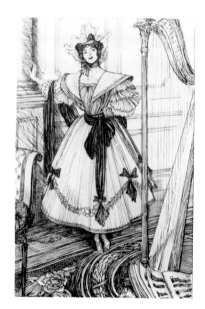

paratively straightforward tasks compared with many of the subjects he tackled. Sullivan's popular appeal seems to have wained after 1920, ironically enough at a time when his drawing skill was at its peak, and surviving sketches show this introspective man at his most interesting. He deserves to be better known and better understood for, as P.V. Bradshaw wrote of him, he was that rare thing among illustrators 'a literary Epicure and an Artist of distinction'.[21]

It would hardly be possible to think of a more different artist from Sullivan than Jack B. Yeats, 1871-1957, and yet he was engaged on illustrating similar subjects at about this time. The younger brother of W.B. Yeats, he started as a magazine illustrator in London before moving back to Ireland and becoming one of the country's most distinguished landscape painters. He was always involved with the illustration of character, both for comic journals like *Punch* and *Fun* and in the broadsheets issued under his own imprimatur. In 1895 he illustrated

Figure 92. 'Airy Fairy Lilian' by E.J. Sullivan.

200

for Messrs. Dent's *Pocket Series,* Defoe's *Life and Adventures of Captain Singleton* and five years later the same author's *Romance and Narratives.* Yeats' interpretation was sketchy, bold and rather hard, as unsentimental a view of the eighteenth century writer as one was ever likely to get in the 1890s.

A list of artists working in the eighteenth century idiom between 1880 and 1914 would be endless. It would include T. Blake Wirgman who imitated eighteenth century portraits, Lewis Baumer who revived the subtle effects of pastel in some of his books, Chris Hammond, the illustrator of Edgeworth, Frank Dadd, the gifted cousin of Kate Greenaway, F.D. Bedford, artist of Dickens and Barrie, W.J. Hodgson, producer of Regency children's books, Carl Scloesser, a follower of Thomson, H.M. Paget, A. Garth Jones, Margaret Jameson, Alan Odle (Colour Plate XIV) and George Belcher.

Such a brief glance over forty years of illustrating cannot hope to be all inclusive, especially as the period 1880 to 1914 proves to have been so rich. It has only been possible to pick up a few threads, which making themselves apparent in architecture, decorative art and fashion, are not always so obvious within the covers of a book. Changing attitudes to the eighteenth century not only reshaped the publisher's list of titles, but altered the artist's standpoint. What had been a highly expressive and individual period of history was softened and mellowed into pure decoration at its worst or into something quite new at its best. The least good artists compromised themselves for the sake of fashion or drew only with accuracy in view; the best, like Beardsley or Sullivan, took the germ of an idea but made the inspiration their own. The origins of the return to the eighteenth century stretched back a long way, but the Edwardians themselves tended to see no further back than the Caldecott and Greenaway *Picture Books.* These bright and charming productions were ideal for nursery ballads and songs, but by 1900 their direct descendants were expected to work alongside the prose of Fielding, Johnson and Scott. E.A. Abbey's drawings were serious and intellectual statements about the books that he was illustrating; E.J. Sullivan and Jack B. Yeats placed an individual interpretation on everything that they touched. In these men, that visual and verbal partnership that was so strong in the eighteenth century, lived on.

Footnotes

1. John Harvey, *Victorian Novelists and Their Illustrators,* 1970, p.63.
2. ibid., p.99, illus.
3. John Ruskin, *Adriadne Florentina,* 1872, p.235.
4. Forrest Reid, *Illustrators of The Sixties,* 1928, p.161.
5. G.S. Layard, *Charles Keene,* 1892, p.155.
6. *Scenes and Characters From Dickens,* 1908, p.x.
7. John Ruskin, *The Art of England,* pp.144-145.
8. M.H. Spielmann, *Kate Greenaway,* 1905, p.44.
9. ibid., p.128.
10. ibid., p.133.
11. Joseph Pennell, *Pen Drawing and Pen Draughtsmen,* 1894.
12. The Abbey Collection was sold at Sotheby's on 22 April and 13-14 June 1921.
13. In the possession of the author.
14. Pennell, op.cit., p.228, footnote.
15. M.H. Spielmann and Walter Jerrold, *Hugh Thomson,* 1931, p.15.
16. ibid., p.47.
17. ibid., p.230.
18. C.M. Kelly, *The Brocks: A Cambridge Family of Artists and Illustrators,* 1975, p.128.
19. Anne Carroll Moore, *The Art of Beatrix Potter With An Appreciation,* 1955, p.25.
20. Quoted by Gordon N. Ray, in *The Illustrator and The Book in England 1790 to 1914,* 1977, p.190.
21. Percy V. Bradshaw, *E.J. Sullivan The Art of The Illustrator,* c.1915, p.8.

Chapter 11

Collecting Original Illustrators' Drawings

The collecting of original book illustrations has always been a rather neglected subject in this country, a strange fact considering the tremendous diversity of talent in the last one hundred and fifty years and the reputation of the British as bibliophiles. With the exception of a few outstanding collectors such as Sir Harold Hartley, who have concentrated on one period, or scholars like Sir Geoffrey Keynes, who have concentrated on one artist, William Blake, there are no definitive collections of British book illustration. The Victoria and Albert Museum Print Room, which has the most comprehensive group of drawings, acquired them through two bequests, the Ingram Bequest in 1914 and the Harrod Bequest in 1948, rather than with a planned policy and other museums tend to hold isolated examples of home-grown talent or of artists working in a particular medium. These fortuitous acquisitions have netted some remarkable collections, the Dalziel Colection of proof engravings in the Print Room of the British Museum for example or the superb ink drawings for illustration by D.G. Rossetti in the Birmingham City Art Gallery illustrated in this book. But the omissions are even more extraordinary, very few examples of book illustration post 1900 at the British Museum, not a single cartoon by the well-known First World War artist, Captain Bruce Bairnsfather, at the Victoria and Albert.

In 1904, the illustrator and art critic Frank Emanuel summed up his feelings about illustrative work and its impact in Britain like this '. . . in London we are sadly in need of a National Watercolour and Black and White Gallery, for which the best obtainable examples of such work could be procured by gift or purchase, and thereafter exhibited. Stowed away in drawers and cupboards at the British Museum, at the National Gallery, and probably at South Kensington Museum and elsewhere, visible only in driblets after regulated application, is untold wealth of beautiful drawings which should rightly be *displayed* on the walls of such a gallery as is suggested. Beautiful examples of work by living illustrators, both British and foreign, could be obtained for a comparatively nominal sum, and would exemplify a powerful and fascinating development of modern art; which meets the requirements of the day, in its own line, as fully as did those early Italian masters in *their* time, which the nation's art buyers collect so assiduously and at so much cost.'[1] What was true of 1904 is still largely true of our own time, there is still no major comparative collection to help the amateur and foster interest in the subject, there are still no dealers who specialise exclusively in this field. Not for the collector of illustrations the carefully culled rows of watercolours lit by spotlights, rather the odd drawing in the darkest corner of a picture show or a portfolio brought in at the last moment! Given these factors, the enthusiast should not despair but develop his own innate sense of quality and discrimination and make the apathy and ignorance about the subject work to his own advantage. Contemporary illustration is well served by shows at the National Book League and other centres and local museums will sometimes devote a month or two to a particular artist.

The truth is that the book illustration, meaning the original drawing or watercolour by the artist, is neither fish nor flesh. Its apparent slightness eludes the hardened collector of English watercolours and its position outside the cover of a book bothers the librarian; collectors are notoriously conservative and if something does not fit into a category it can usually be ignored! Illustrations also have stiffer competition in their own sphere in Britain

than in most other countries, the Frenchman or German who cannot own oil paintings turns instinctively to drawings whereas his equivalent in this country turns automatically to watercolours. For the average British collector a move from the applied arts of antique pottery, glass, metalwork to the fine arts, generally means a move to watercolours and landscape watercolours in particular. It would be ridiculous to ignore this rich tradition stretching from Cozens to Cox with all its ramifications in the art of portraiture, still-life and architecture, but its roots are in the climate and in the strange, atmospheric, changeable and vari-coloured countryside that we all know. Most illustrations on the other hand are figurative, linear and monochrome, they have to rely on their forms alone to appeal to our eye, there is texture in the work but not colour, there is mood rather than atmosphere. The drawings are also intended to be seen in consort or in contrast to a text, so that one is not working alone with the artist in studying them, as would be the case with a landscape watercolour, but the story or poem or description is continually demanding attention. There is also a school of thought which I believe sincerely to be wrong, that does not rate any art associated with commercial ventures very highly. For them the full flow of artistic inspiration is lost if the draughtsman is constricted by publishers, authors and deadlines, the mode seems mechanical and somehow the magic is lost. The problem then is to wean ourselves away from watercolour to ink or wash, to step back from our pervading love of landscape and begin to look at the figure and above all to rid ourselves of the notion of book art as mechanical.

Fortunately our set ideas are beginning to change about all this. The suspicion that black and white art is a pedestrian medium should have been exploded years ago with Aubrey Beardsley and Phil May, but it is really only recently that drawings have gained by being connected with books or magazines rather than the reverse. The Victorian illustrators, who, with a few exceptions have long been out in the cold, are beginning to gain recognition. The last ten years has seen a meteoric rise in the price of minor works by the great names such as Millais, Leighton and Sandys, and a gradual increase of interest in secondary figures such as John Gilbert, John Leech and Richard Doyle in the mid-century and Arthur Rackham, E.J. Sullivan, Byam Shaw and Fortescue Brickdale at the end of it. It is partly a shift of taste but partly a lack of availability of major works to the serious collector who is not simply a broker! This is an acceptance long overdue, for the professional illustrator in the period from 1830 to 1890, not only interpreted, but often created a literary character that became a legend. Our view of Victorian literature is still an illustrator's one. It was the reputation of Robert Seymour, the comic draughtsman, which persuaded a publisher to ask Charles Dickens to write a text to his drawings, launching *Pickwick* on to the world. Although Dickens' description of the fat clubman is detailed, it is really Seymour's and later Browne's corpulent figure in tight gaiters and swallow-tail coat that lives on to the present day and is even continued by current illustrators and contemporary film producers. Similarly the world of *Alice* either in *Wonderland* or *Through The Looking-Glass* remains indelibly that of Sir John Tenniel, the toothy illogicality of the Mad Hatter, the sinister medievalism of the Duchess and the tip-toeing innocence of Alice herself. The visual impression of Sherlock Holmes, deer stalker, Inverness cape and spats, was very much the creation of Conan Doyle's illustrator Sidney Paget, whose wash drawings, recently re-issued, appeared in *The Strand Magazine* in serial form in the 1890s.[2] The best illustrators naturally worked closely with the author's text but it is undoubtedly true that characters such as Fagin, Mr. Jorrocks, the Duke of Omnium and the Lady of Shalott, remain as much the property of their first artists as their authors.

Apart from considering the intrinsic worth of a drawing's literary interest, and most collectors of illustrations are ardent readers, there is the great variety of work obtainable within the subject and its access to the collector. Because of their lack of popularity in the

past, illustrators' drawings are still grossly under-valued and have become the refuge of those with narrow purses. It is astonishing to think that a neat early nineteenth century design in pen and ink may be obtained for a tenth of the cost of a watercolour of the same period because it is an illustration and in monochrome. Sometimes a drawing can be obtained for a fraction of the amount of a watercolour by the very same hand and in this same perverse way a classical or religious theme may keep the price down for the modest collector. Book illustrations also have a built-in protection against pure investment collecting, they are rarely showy enough for this sort of buyer and their names are generally not eye-catching. Everybody has met name dropping collectors and it is essential in this as in other fields not to collect names; with illustrations one is in a jungle of minor figures and quality and individuality of style are all that matter.

There are three main periods of book illustration where it is still comparatively easy to collect, the first and last being much easier than that in between. The first one we might call the early Victorian phase although it actually stretches from the 1820s to the 1850s, the second is the great period of black and white art from the 1860s to the 1870s and the third is the heyday of ornament and book design from about 1895 to 1914.

One of the first questions an aspiring collector might ask himself is how do I identify a book illustration? Faced with a drawer of figure studies in a dimly-lit gallery it is not always easy to be certain, but a few general guide lines can be given period by period. All the illustrations of the early Victorian phase were for the copper-plate or the steel engraving and the illustrations to novels and annuals tended to be fairly restricted in size. Most of the designs for them by artists such as Smirke, Westall and Corbould are in pen and ink with grey or sepia washes, the finished drawing often squared up for the engraver (Figure 93). There are very clear indications of light and shade and very clear washed areas with hatching to indicate the latter to the engraver. Facial expressions and gestures are very exact and there is an overall balance in the finish of the drawing which makes it like the cartoon for an oil painting. Frequently you find pencil notes on the edge or on the verso of the drawing, indicating instructions to the engraver or making some comment to the printer about its place in the order of the book. The years 1820 to 1850 were plentiful ones for genre painting and even for genre paintings taken from literature. The distinction between a genuine drawing for illustration and a genre drawing is misleading, but the illustration tends to be more highly defined, more expressive in action and to contain details relative to the

Figure 93. Original pen and wash illustration by H. Corbould.

story which a more painterly approach would not have included. The riddle is usually resolved however by the small scale of the illustrations, 2 by 3 inches or 6 by 4½ inches; no genre painter would wish to work for those measurements if he was not engaged on a book.

Drawings from the first decade of the century which were intended for a book may have ornamental borders, swags, decorative cartouches, but this tended to die out before 1820. Illustrations in the following years were generally simple rectangles or landscape shapes but in the 1840s ornament returns in profusion and there is often a good deal of vignette illustration, that is small tightly drawn compositions for page decoration, often conceived in the round and often receding in definition towards the edges like a poorly exposed photograph. Myles Birket Foster was the greatest Victorian master of this in his numerous books of the countryside. Samuel Palmer, a rare enough illustrator, provides a charming example of decoration of this period for Charles Dickens' *Picture of Italy,* 1846 (Figure 94). Both these artists are prohibitively expensive today, but the joy about collecting the ephemeral output of the Victorian book designing world remains that these trifles, borders, initial letters, tiny vignettes by artists such as William Harvey, John Gilbert, H. Anelay, John Franklin and others can be found for reasonable sums, possibly a few pounds.

Figure 94. Vignette illustration and ornament by Samuel Palmer for Charles Dickens' Picture of Italy, *1846.*

The arrival of wood engraving as the most commercially viable form of illustration from the 1850s has advantages and disadvantages for the collector of drawings. Whereas the nature of copper and steel plate meant that the finished drawing was likely to survive its visit to the engraver, the advent of the woodblock meant that it was not. During the amazingly productive period from 1860 to 1870, many illustrators prepared their final version of a composition on the block and this was cut away when the engraving was made. By no means all the artists of the 1860s drew directly on the wood but as the facsimile wood engravers became more and more adept at their work, the artist was probably encouraged to indicate what he wanted by fewer and fewer directions. One author has argued convincingly on the basis of surviving drawings and versions for the Tenniel *Alice,* that the illustrators were able at this zenith of engraving to use a kind of shorthand when sending their sketches to Swain or the Dalziels, correcting discrepancies only at the first proof stage.[3] This would certainly be supported by the number of sketchy versions by Tenniel, Leech and others of otherwise important works and the occasional appearance of traced copies. The absence of finished drawings is obviously accounted for by the hungry graving tool on the block before the age of photographic reproduction.

In either case it means that completed designs for books and magazines in one of the greatest periods of black and white art are difficult to come by. There are exceptions of course where the artist made a finished sketch before transferring it to the block, where a version was finished but never used or where the block itself remained unused with the clear pen lines still standing out from a whitened ground. Some artists like Tenniel made carefully detailed duplicates of their celebrated cartoons for sale or for friends, men like Fred Walker and G.J. Pinwell often completed watercolours based on illustrative work, but if a collector is a purist, he will find this period a challenge to his time and his resources. Some of the finest drawings by the Victorian Olympians, Leighton, Burne-Jones, Ford Madox Brown,

Sandys, Poynter and Holman Hunt, are preserved because the Dalziel Brothers commissioned their Bible Gallery in the 1860s but did not prepare it until 1880 when drawings were already being photographed on the block. Some of these are illustrated here from the Victoria and Albert Museum, but it is noticeable that very few contemporary drawings exist now outside museums and are even absent from such recent collections as that formed by Gordon N. Ray.

The most important ink drawings which are forerunners of the 1860s group and which have been dealt with in Chapter 5, are Millais' modern episodes. At sales in December 1972, 'Married For Money' made 2,800 guineas, 'Married For Love' 2,200 guineas and 'Married For Rank' 1,100 guineas, the first was later offered for sale at 3,000 guineas. A work from exactly the same group, Millais' 'Accepted' signed and dated 1853, fetched £1,995 in 1967 so that in general terms their value has doubled as they have become scarcer and scarcer. A much earlier but less significant drawing of 'The Lempriere Family', 1845, made only £400 in late 1975, showing how much depends on the date of an artist's maturity even with the

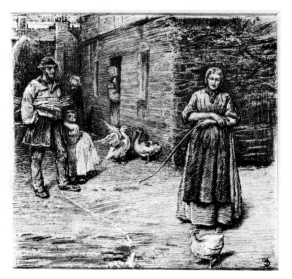

Figure 95. 'The Goose', by George Pinwell for Wayside Posies, *1866-67, 5¼ins. x 5½ins. (13.3cm x 14cm).*

greatest figures. Drawings by other hands during this key period are expensive if they are well-known, Rossetti's brilliant pencil and grey ink study of 'Dante in Meditation' made 2,100 guineas at Christie's in October 1975. At the recent sale of the Dalziel Family Collection at Sotheby's Belgravia on 16 May 1978, some works by a famous artist were undervalued. G.J. Pinwell's 'The Goose', the original pen drawing for *Wayside Posies*, 1866-67, made £280. Considering that this was a work for one of Pinwell's most important books, was very finished and such an opportunity is unlikely to recur again, it could not be thought of as expensive (Figure 95). The appearance of colour on a drawing greatly increases its price so that an excellent pencil sketch by Houghton, sold in 1976, made £120 because there were slight colour washes, pure pencil might have kept it below £100.

The drawings most commonly seen from this date are therefore preparatory studies in pencil, details worked up in ink over pencil and the penultimate compositions where elements of both are combined. The last stage is invariably missing as we see in the complete series of Luke Fildes' designs for 'The Duet' published in *Once a Week* for 30 January 1869. The subject was a domestic one so the artist begins by making a study of a standing female from the life, barely indicating the fireplace and the presence of a pianist (Figure 96). Then the pianist figure takes greater shape and the lines and the lights of the piano are indicated in a spirited sketch (Figure 97). The folds of the standing figure's dress are worked upon in greater detail in a larger scale than is necessary (Figure 98) and at last the composition is brought together in the page size (Figure 99). There is then a jump from the penultimate sketch to the completed wood engraving in reverse, the finished drawing having been cut away to complete it (Figure 100).

These sort of drawings in preliminary pencil or ink are readily found at auction and in galleries and are very nice to own. It is usually not too difficult to discover in a reference book the main magazines for whom these artists worked and to locate the wood engraving for which the studies were made. (A fairly exhaustive list of works is included after each biographical paragraph in the second section of this volume.) It would be useful to acquire studies that stand up as works of art in their own right as these obviously do, there are quite

Figures 96-100. Preparatory drawings and finished illustration for 'The Duet' by Luke Fildes 1844-1927, published in Once a Week, *1869.*

a number of very slight pencillings on gallery walls which are over-priced simply because of the names attached to them. Gleeson White, the first historian of this period who concentrated more on the wood engravings themselves than on the drawings, suggested that collections of the former should be made, removed from the books for comparative purposes! I have seen two such collections, presumably formed on this advice, Forrest Reid's files contained in boxes at the Ashmolean Museum, Oxford, and an anonymous collection on the London market with each print stamped with the artist's name. It would be a heinous crime to dismember these books and magazines today, but it is fascinating to form a library of reproduced works alongside ones own collection of originals and many of the books and specially the magazines are still easily obtainable.

The characteristic of this period is the very fine penwork and very exact statements of texture and 'colour' in black and white, prepared for engraving. Good examples of this are found in artists like Charles Keene and George du Maurier, both of whose drawings are still in good supply. Keene's sketchy designs have much charm but he is such a beautiful draughtsman that it is a pity to miss the more finished *Punch* jokes when they emerge; du Maurier's drawings fall short in composition after about 1880, his 'aesthetic' jokes of the 1870s are usually the most highly prized. John Leech has a looser pencil and his slight sketches are easy to find. More attractive than these are the finished watercolours from *Punch* subjects, large, airy and not too finished either, they seldom rise above £100 in price.

Between the 1870s and the 1880s great steps were taken in process printing which greatly alter the style and the abundance of the drawings. Although drawings were

photographed on the woodblock earlier, the idea was in general use from only about 1868 and was followed by line blocks and eventually the half-tone in the 1880s. As greater and greater demands were made on the illustrator to provide bigger and bigger blocks for the magazines, a system of parallel ruling was introduced which as well as taking away some of the slavishness of drawing for the engraver, enabled the artist to enjoy a greatly extended tonal range. This was increased by the half-tone process by which the picture on the page was made up of a great quantity of dots, screened from the original negative and varying in concentration between light and dark areas of the subject. This method meant not only that finished drawings were no longer slaughtered but that they changed from the meticulous pen strokes of the 1860s to a broader and more oily style reminiscent of painting. Artists like Charles Green, Seymour Lucas, William Hatherell and William Small painted their illustrations on stiff card, filling out their effects in thick grey washes with overlaid chinese white, giving the whole surface a creamy texture almost like impasto.

Some artists drew their illustrations in oil on board and the writer has seen one sketch prepared for illustration in oil on canvas, but this is unusual. It can be said that all these media are universally recognisable as illustrations because of their monochrome effects and their ample size for the pages of *The Graphic, Black & White, The Sphere* and *The Illustrated London News.* Although this period does not have the panache of the 1860s or 1890s, it is a good one to collect, the designs are superbly executed and much material can still be found. Comparatively recently a pair of William Hatherell *Graphic* drawings were seen for about £20 and a fine figure piece by Edward Killingworth Johnson for £18, grossly undervalued considering the pure draughtsmanship in them.

The 1890s saw an explosion of new black and white talent which was led by those champions of the art, Aubrey Beardsley and Phil May. The illustrators of that decade were the first to grow up with the half-tone and the line block and make it work for them, so the surviving drawings are typified by a purity of line and a sense of breathing space and air. This is a field that should be limitless for the collector, the fact that it is not, is due to the fashion for art nouveau which has attached itself to nearly everything produced at the time, irrespective of its real origins. The art nouveau book has always attracted attention and, perhaps because of this, the *fin de siècle* is one of those rare periods where the original illustrations have rivalled or surpassed the books themselves in price. The drawings of Aubrey Beardsley are now of extreme rarity and even the slightest sketches from his hand, initial letters, page decorations and tiny vignettes, make hundreds of pounds. A small grotesque figure from *Bon Mots* made over three hundred pounds in 1976, a price that would probably be doubled today. Any illustrators who imitate the Beardsley manner or are self-consciously of the 1890s in their subject matter, have steadily risen in price together with the master. This is particularly true of men like Charles Robinson and his brothers William Heath and Thomas, whose earlier works are decorative and elaborate and can be expected to fetch well over a hundred pounds. W.T. Horton's rather black studies are also making about the same and S.H. Sime at his most sinister can achieve £500-£600, but very much less for his single figure subjects. The magnificent pen drawing 'The End of All Knowledge' by this artist, which was being offered in a provincial gallery in 1975 for £200, was priced at £650 when exhibited in London in 1977, a quite remarkable jump for an illustrator's drawing in a period of two years. This may well presage a return to higher prices for the macabre and mystical side of black and white art which Beardsley engendered. The Glasgow School, which took some of its inspiration from the Beardsley idiom and is flagrantly art nouveau throughout, has gained tremendous success with collectors in recent years. Sotheby's sale of Miss Jessie M. King's studio on 21 June 1977 was a considerable eye opener to the seriousness beginning to be given to illustrations. A special catalogue was produced, every lot was illustrated and some of the items deserved such cosseted attention;

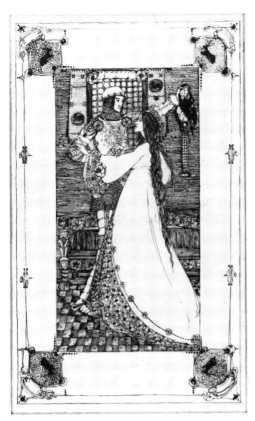

Figure 101. 'Percival and The Damsel', original drawing for the illustration in The High History of the Holy Graal, *1906 by Jessie M. King.*

a marvellously stylised bookplate design in ink on vellum fetched £2,000 and a collection of the artist's views of Paris reached £3,000, but the average for drawings was between £100 and £300 with many charming works below this. The drawing of 'Percival and The Damsel' for a 1903 edition of *The High History of the Holy Graal,* made £700 (Figure 101).

The designs discussed might be considered the cream of the market but there are many other examples which are noteworthy but undervalued. Phil May's illustrations are very variable in quality but the best are very good indeed. His extraordinary industry and amazing output must account for the fact that they are still so plentiful and still obtainable by the most modest collector. The apprentice work of the Australian years can be rather rough, but in his mature period in the 1890s he is supreme and little studies by this great figure artist can still be found for £25 to £50, an absolute necessity in a really comprehensive collection. The other magazine artists and caricaturists should fall into the same pattern but I have noticed that there are many ordinary men such as Lucien Davis and Maurice Greiffenhagen whose work is more expensive when it captures the feeling of the period in a very tangible way.

After 1900, when the Edwardian publishing houses began to turn their attention to grand gift-books, glorious travel books and elaborate children's books, the scene shifts from strong drawing and black and white to luscious effects and bright colouring. The change to colour printing is not always a satisfactory one, type and black and white drawings marry well together, strident colour less so, and even subtle colours compete rather than blend with the text. Apart from this the collector finds himself once more in the multi-tinted jungle of watercolour collecting where the price is immediately increased by one hundred per cent, or more. The world of Arthur Rackham, a very tempting mythical world, has ceased to tempt all but the most daring purchasers. The parchmenty watercolours with their sinewy lines that have frightened and captured the hearts of children for seventy years, have always remained relatively expensive. Ten years ago £60 might have gained you a very nice example of moderate size, in the early 1970s they could still be found for £150. When Sotheby's sold their large watercolour of 'Two Girls' in April 1976, an optimistic estimate placed the probable price at £800: the drawing made £1,232. Most of this artist's watercolour work is still in the £600 to £800 range and rising steadily, the black and white drawings have made a comparable progress. One has to remember when thinking about this artist's original illustrations that first editions of his books are now sold for £250 and upwards. Rackham's pencil sketches and contemporary subjects remain very much cheaper, a clear instance of the nonsensical idea that a designer's 'characteristic' sketches are the only ones that matter! The collector should be able to enjoy and appreciate the unusual in any illustrator's oeuvres, the investor cannot be expected to!

Edmund Dulac (Frontispiece) follows hard on the heels of Rackham in popularity and his watercolours of Eastern romance are very much in demand. A splendid 1906 drawing of

'The Forty Thieves' was sold at Sotheby's in late 1976 for well over £1,000. His cheeky little caricatures and less finished studies are often seen between £50 and £150 however and usually contain that spark of imagination that makes any Dulac work so special. The highly detailed animal watercolours of E.J. and C. Detmold are also among the nicest things in watercolour illustrations, the works by the latter are rarer, although a delightful subject of a panther for one of Kipling's books made only £68 in 1975.

A good example of how the expected element in an artist or a period disturbs its true price might be found in a work by an almost unknown Edwardian, Mrs. Averil Burleigh. A highly elaborate watercolour of 'Motherhood' was exhibited in London in 1977 at the astonishing price of £650; it was an extremely competent piece of work, wonderfully coloured and detailed, but selling on its archetypal Edwardian-ness rather than on its merits as an important illustration. The same exhibition had a series of four watercolours by Byam Shaw of Biblical subjects in modern dress most sumptuously framed, a sort of Rake's Progress in the dress of the *Forsyte Saga*. Period atmosphere breathed out a high price in every line, but a delightful study for a Chiswick Press book by Byam Shaw was only £45.

Colour is not such a barrier to the collector if the artist's work is less known or the subject matter is difficult to assimilate. A case in point is the brilliant watercolour painter of the 1900s and 1920s, Warwick Goble. His filmy translucent watercolours, with their subtle tints and Japanese compositions, are unique in British illustration, but are not noticed by the collectors of Rackham and Dulac. A fine watercolour by him for *Stories of the Pentamerone* was offered for sale by a suburban dealer at £65 in 1978 and two illustrations for his best book, *The Green Willow*, were sold by a bookseller for £140 each in 1975. This does incidentally highlight the fact that it is always best to buy from specialists, drawings from drawings dealers and books from book dealers, rather than vice-versa; unfamiliarity with a subject tends to slightly over-price the items. Another artist working in colour before 1914 was Alan Odle, whose immensely powerful figure study of 'Gulliver Standing to His Full Height' is illustrated here (Colour Plate XIV p.192). This drawing appeared on the market for £80 in 1976 and fulfils most of the requirements for a memorable illustration; it is very dramatically conceived, the drawing is powerful and the concept of Gulliver as a grotesque, everyman figure rather than a sleek mariner is entirely original. Odle and Goble are artists who are just being discovered and their qualities will be properly appreciated in the next few years.

There was still a lot of supporting black and white illustration for all this colour work and it has tended to be almost entirely overlooked. Where are the collectors of H.R. Millar's beautiful virtuoso pen drawings or the figures of Paul Hardy or the wash and ink work of W. Rainey, Dudley Hardy and Jacomb-Hood? They are still unconsidered and obtainable at a very low price indeed. E.J. Sullivan, whose draughtsmanship is stronger and more individual than Rackham's, seems to have remained loyal to pen in an age of colour. Henry Ospovat's short working life probably did not allow him to experiment in this direction. Neither illustrator is appreciated as he should be and their ink works pass through the sale-rooms for between £50 and £100, a negligible sum considering their stature as draughtsmen. Both men developed a very personal style, so did Lawrence Housman whose career as an illustrator stopped short in about 1900. His refined and sensitive pen drawings, inspired by Pre-Raphaelite illustration have a fatal fascination for those who would like an original Rossetti but cannot afford it. His works are therefore rather expensive and the best examples which are like contributions to *Moxon's Tennyson* seen through half-closed eyes, sell on the London market for £300 to £400.

The early 1900s were years in which animal illustration made great leaps and bounds. It is quite striking that between 1890 and 1910, a whole generation of nature artists grew up who combined accuracy with great decorative sense. Foremost among them are the

Detmolds, already mentioned, H. Seton Thomson, Carton Moor Park and Warwick Reynolds; G.D. Armour and Cecil Aldin were also excellent in straight animal studies. These artists are rather overshadowed by Archibald Thorburn, who is really just a careful painter of 'stuffed' birds, and J.G. Millais who brings a greater touch of life to his subjects. A slightly earlier illustrator, J. Wolf, who is comparable to Thorburn in every respect, continues to be totally neglected. Any sketches by Seton Thomson and Park should be eagerly acquired by the collector for their sheer perception of an animal's form and habitat and their break from the tyranny of showing every feather. J.A. Shepherd was a humorous draughtsman who knew his animals well and whose comic animals are nearly credible, never distorted. Louis Wain's cat subjects appeal to a special sort of audience and are grossly inflated in price for that reason. At a recent Sotheby's sale on 21 March 1978, a series of elaborate and large grisaille drawings 'The Seven Ages of Man', all comic cat subjects, made a total of £3,300, one single picture in the series making £550. 'A Quiet Game at Nap', a card party of cats, signed and dated 1894, was sold for £320. Both Cecil Aldin and Harry B. Nielsen do the same sort of drawings even if with less manic intensity and it is difficult to see why their works are not so valued.

The area in which one might begin a collection is so wide that it is a matter of some thought to choose a subject. Specific subjects, stemming from the collector's interests, spring to mind, illustrations of a particular sport, of hunting, fishing or golf, legal or medical topics, royal events, early industry and shipping, house interiors, trades or occupations. A possible line of development would be to take a certain fictional person such as King Arthur, Tom Thumb or Falstaff and try to collect different aspects of them through various artists' eyes. Important collections of *Pilgrim's Progress, The Seasons* by James Thomson and *The·Rape of The Lock* have already been made, but it would not be difficult to cull other subjects from literature; the resulting group of drawings would have great intrinsic value as a collection. One of the nicest small collections made recently in London, has taken politics as its theme and includes every sort of caricature and figure drawing from amateur work to the careful pencil of Tenniel. Another distinguished collector of Middle Eastern life has swept the illustrators into his net along with their more famous brothers, the watercolourists, to create an archive of national importance.

As has been mentioned earlier, the collector of illustrations is not primarily a house decorator or a fine art expert. His reasons for collecting at all are often twin-headed, a love of drawing, coupled with a love of literature, a curiosity about history joined with a wish to see it with the eyes of contemporaries, a fascination for a cause which has only been consistently chronicled by these humblest of all artists. It is obvious that such catholicity of taste will result in pictures that are not easy to display together or to display at all. Some drawings will be very small, designed to be seen on the closely-held printed page, others enormous as intended for double pages in Victorian weeklies. The one can hardly be seen against a wall-paper and the other is considerable enough to fight with oil paintings. The collector has to resign himself to having portfolios or presses of drawings that are not normally displayed, but there are plenty of good ink designs that will hold their own in any normal sized room.

A collector would be well-advised to know as much as possible about the method and technique of the drawings he is purchasing as well as the normal practice that illustrators worked by. This sort of information is found, not in their biographies, but in the manuals that they wrote for students. Two excellent books are *How To Draw In Pen and Ink* by Harry Furniss, 1905, which gives information on processes, papers, brushwork, scraping out and thumb shading, and a later publication *The Art of Illustration* by E.J. Sullivan, 1922; the same artist's book *Line An Art Study,* 1921, is also well worth looking at.

The main London auction·rooms hold regular sales of drawings but the items in our

category are usually included in watercolour sales at Sotheby's Belgravia, Christie's South Kensington and Bonham's. They are sometimes sold separately if they are considered important enough but more often are lotted together or even parcelled. Sotheby's Chancery Lane rooms are also an outlet for book illustrations and one should not assume that they only appear in the drawings catalogues. Chancery Lane holds twenty or more major book sales a year and at least two will generally include a good selection of original drawings. Several dealers run mailing lists and these are an invaluable guide to one's knowledge of the subject as well as a useful aid to collecting.

I have not touched on caricature specifically and this remains a very promising field for the enthusiast. It is if anything less fashionable than pure illustration, perhaps because people are squeamish about sharing their houses with grotesque heads! The successful sale of the large album of caricatures by Robert Dighton at Sotheby's, on 23 February 1978, certainly stimulated interest in this famous contemporary of the highly priced Rowlandson. Dighton, an infinitely less skilled draughtsman, scores on his pleasing colours and interior views, the sale totalled £50,000, indicating that caricatures must be considered a major part of British art. Victorian caricature drawings are still very virgin territory, the work of Tenniel, Sambourne, Partridge and Raven-Hill is to be found for well under £30, the slighter sketches even less. That serious people are starting to turn their attention to this area shows that recognition has been long overdue. One hopes that the breezes will not blow too hard through this backwater before a few collectors have been able to look long and carefully at these orphan children of the British School.

Footnotes

1. F.L. Emanuel, *The Illustrators of Montmartre,* 1904.
2. *The Sherlock Holmes Illustrated Omnibus,* 1978, Murray, pp.84-85.
3. Percy Muir, *Victorian Illustrated Books,* 1971, pp.110-111.

The Dictionary

SIR MAX BEERBOHM 1872-1956. 'Sir Henry Irving.' Signed. Ink and wash.
The Garrick Club

Abbreviations used in The Dictionary

AJ	*Art Journal*
AL	*Life* by Major J.R. Abbey
ARWS	Associate of the RWS
Ashmolean	Ashmolean Museum, Oxford
AT	*Travel* by Major J.R. Abbey
B	Birmingham
Barber	Barber Institute, Birmingham
BI	British Institution, 1806-67
Bibl:	Bibliography
BM	British Museum
CL	*Country Life*
Colls:	Examples of the artist's work can be found at the listed places
Colnaghi	Colnaghi's Gallery, London
Contrib:	Contributed illustrations to the listed publications
Dulwich	Dulwich College Picture Gallery
Exhib:	Exhibited paintings at the listed places
FAS	Fine Art Society, London
Free Society	Free Society of Artists
FRGS	Fellow of the Royal Geographical Society
FRS	Fellow of the Royal Society
G	Glasgow
GG	Grosvenor Gallery
Greenwich	National Maritime Museum
ICS	Indian Civil Service
Illus:	illustrated the listed books
ILN	Illustrated London News
L	Liverpool
Leicester Gall.	Leicester Galleries, London
Liverpool	Walker Art Gallery, Liverpool
London Salon	Allied Artists' Association.
M	Manchester
Manchester	City Art Gallery, Manchester
Mellon	Mellon Collection, Richmond, Virginia
Mercury Gall.	Mercury Gallery, London
NEA	New English Art Club
New Gall.	New Gallery
NG	National Gallery
NG, Ireland	National Gallery, Ireland
NG, Scotland	National Gallery, Scotland
NPG	National Portrait Gallery, London
NWS	New Watercolour Society
OWS	Old Watercolour Society
P	Royal Society of Portrait Painters
Paris	Paris Salon
Paris, 1900	Universal Exhibition
PRA	President of the Royal Academy
PRWS	President of the RWS
Publ:	Published but did not illustrated the listed books
RA	Royal Academy
RBA	Royal Society of British Artists
RCA	Royal College of Art
RCam.A	Royal Cambrian Society
RE	Royal Society of Painters & Etchers
RHA	Royal Hibernian Society
RI	Royal Institute of Painters in Watercolours
RIBA	Royal Institute of British Architects
RMS	Royal Miniature Society
ROI	Royal Institute of Oil Painters
Royal Coll.	Royal Collection
RSW	Royal Scottish Society of Painters in Watercolours
RWA	Royal West of England Academy
RWS	Royal Society of Painters in Watercolours
Soc. of Antiq.	Society of Antiquaries
SWA	Society of Woman Artists
Tate	Tate Gallery, Millbank, London
Tooth	Tooth's Gallery, London
V & AM	Victoria and Albert Museum
Walker's	Walker's Gallery, London
Witt Photo	Witt Photographic Library, Courtauld Institute of Art, London

The name of a town 'Chester', 'Lincoln' under Collections
denotes its Art Gallery unless otherwise specified.

ABBEY, Edwin Austin RA ARWS 1852-1911

Black and white artist and illustrator. Born in Philadelphia, 1 April 1852, and was educated at the Pennsylvania Academy of Fine Arts. After studying with a wood engraver, he began work with *Harper's* in New York in 1871 and was sent by them to England in 1878. With the exception of a brief visit to the United States, Abbey made his home in England from that date and became a very prolific draughtsman and illustrator. Specialising in costume and figure subjects, he established a reputation for fineness of execution and accuracy of detail; he was an important link with American drawing for British artists and was influential in introducing the taste for 18th century subjects and themes. He exhibited his first oil painting at the RA in 1890, was elected an Associate in 1901 and Academician in 1902. He worked in his later years at his home in Fairford, Gloucestershire, and died 2 August 1911.

Illus: *Herrick's Poems [1882]; The Rivals [1885]; Sketching Rambles in Holland [1885]; Old Songs [1889]; The Quiet Life [1890]; Comedies of Shakespeare [1896]; She Stoops to Conquer [1901].*
Contrib: *Scribner's Monthly, St. Nicholas [1875-1881]; The Graphic [1880,1883]; Longfellow's Portfolio [1887]; The Scarlet Runner [1899-1900].*
Exhib: RA; FAS, 1888, 1895.
Colls: Ashmolean; V&AM.
Bibl: The work of EAA, *The Artist*, Sept. 1900, pp.169-181 illus.; E.V. Lucas, *Life and Work of EAA*, 1921; R.E.D. Sketchley, *Eng. Bk. Illus.* 1903, pp.36, 64, 87, **144**.

EDWIN AUSTIN ABBEY RA 1852-1911. Study for illustration to Oliver Goldsmith's She Stoops To Conquer, *1901. Pen and ink, signed and dated, 1885.*
Victoria and Albert Museum

ABSOLON, John RI 1815-1895

Painter and illustrator. Born in Lambeth, May 1815, and studied under an Italian, Ferrigi, earning his living as a portrait painter. He then acted as an assistant to Grieve, the theatrical scene-painter for about four years, before going to Paris in 1835. He remained there some years and returned there again for a year in 1839, practising as a miniaturist. In 1850 he assisted T. Grieve and Telbin with their diorama 'The Route of the Overland Mail to India'. He went to the Continent about 1858, visiting Italy and Switzerland. He became a member of the New Water Colour Society in 1835, resigning in 1858 and rejoining in 1861 to become Treasurer. He made drawings of the battlefields of Crécy and Agincourt which were published by Graves, 1860. He died 26 June 1895.

Absolon stands midway between the illustrators of the old tradition like Mulready and the new generation of the 1860s. He was most successful in figure drawing and particularly so in his contemporary genre subjects and his illustrations to children's books, outlined and with very little shadow.

Illus: *Aunt Carry's Ballads For Children [Mrs. Norton, 1847].*
Contrib: *L'Allegro and Il Penseroso [Art Union, 1848] and The Traveller [Art Union, 1851]; Recollections of The Great Exhibition [1851]; Beattie and Collins Poems [1854]; Goldsmith's Poetical Works; Lockhart's Spanish Ballads; Longfellow's Poems [1856]; Rhymes and Roundelayes [1858]; The Home Affections [C. Mackay, 1858]; Favourite English Poems [1859]; Churchman's Family Magazine [1864].*
Exhib: BI; NW; RA; RBA.
Colls: Ashmolean; BM; Leeds; V & AM.
Bibl: Chatto and Jackson, *Treatise on Wood Engraving*, 1861, p.576.

ACKLAND, F.

Black and white artist contributing humorous figure subjects to *Fun*, 1901.

ADAM, Emil 1843-

Sporting painter and caricaturist. Born at Munich 20 May 1843, he was principally a painter of horses and came to London in 1885, where he was an instant success among the sporting fraternity. He contributed one cartoon to *Vanity Fair*, 1909.

Colls: Jockey Club.

ADAMS, H. Isabel

Decorative illustrator contributing to *The Yellow Book*, 1896.

ADAMS, W. Dacres 1864-

Landscape painter and occasional illustrator. Born Oxford, 1864, and educated at Radley and Exeter College, Oxford. Studied at the Birmingham School and at the Herkomer School, Bushey, before working in Munich. His most important illustrated work is *A Book of Beggars*, published by Heinemann about 1912-13, strongly influenced by the Beggarstaff Brothers. Worked at Lechlade, 1889-91, and Dorchester, Oxon, 1902-3.

Exhib: FAS, 1924, 1925, 1927, G; L, Paris, 1937-9; RA, 1892.

ADAMSON, Sydney fl.1892-1914

Painter and illustrator. Born in Dundee and working in London for the principal magazines in the 1890s. He designed a book cover for *The Idler* in 1895 and exhibited at the RA in 1908 and at Liverpool in 1914, at which time he was residing in Paris.

Contrib: *Fun [1892]; The Sphere [1894]; The Yellow Book [1894]; The Pall Mall Magazine; Illustrated Bits; The Idler; The Minister.*
Colls: V & AM.

ADCOCK, Frederick fl.1913

Topographical artist and brother of Arthur St. John Adcock, essayist and novelist, for whom he illustrated *The Booklover's London*, c.1913.

ADCOCK, George H. fl.1827-1832

Engraver and illustrator working in London. Best known as an engraver of portraits but also engraved an edition of *The Compleat Angler* after G. Hassell and *The Works of Sir Walter Scott*, 1832.

Exhib: RBA, 1827.

AIKMAN, George W. ARSA 1831-1905

Painter and engraver. Born in 1831 and began work as an engraver on leaving Edinburgh Royal High School. For many years he was engaged on engraving portraits for *The Encyclopaedia Britannica*, but also executed portraits, landscapes and etchings. The Victoria and Albert Museum has a series of architectural studies of Edinburgh for an unidentified book. Died 8 January 1905.

Illus: *A Round of The Links [J. Smart, 1893]; The Midlothian Esks, [T. Chapman and J. Strathesk, 1895].*
Exhib: L; RA; RHA, from 1874; regularly at RSA.
Colls: V & AM.

AIREY, F.W. RN

Amateur artist contributing drawings of China to *The Graphic*, 1901.

ALANDY, Sydney

Figure artist contributing to *Punch*, 1901.

ALBERT, Charles Augustus Emmanuel, HRH Prince 1819-1861

Consort of Queen Victoria, amateur etcher and draughtsman. Born at Rosenau, 26 August 1819, and married at St. James's Palace 10 February 1840. Prince Albert was an important patron of the arts during the mid-Victorian era, was largely responsible for the idea of the Great Exhibition of 1851 and established at Court a taste for idealistic German art. He is included here as the illustrator of his home country, Gotha. Sketches by him were engraved for *The Illustrated London News* and published in 1845.

Colls: BM; Windsor.

ALBERT, V. fl.1890-1899

Fashion Illustrator in watercolour, working for *The English Illustrated Magazine*, 1896-99 and *The Lady's Pictorial*, 1890.
Colls: V&AM.

ALDER, W. Brooke

Wash and pen and ink artists contributing to *The English Illustrated Magazine*, 1899.
Colls: V&AM.

ALDIN, Cecil Charles Windsor 1870-1935

Sporting artist and humerous illustrator. Born at Slough, 28 April, 1870, and educated at Eastbourne College before studying anatomy at South Kensington and animal painting under Frank W. Calderon. He published his first drawing in *The Graphic* in 1891, but continued to do much straight reporting work for the magazines before gaining a reputation for humerous hunting subjects. Aldin's activities as a countryman (he was MFH of the South Berkshire Foxhounds and a member of the Hunter's Improvement Society) enabled him to draw the funny side of horsemanship from inside that exclusive group. His brightly coloured books, the illustrations simply outlined, were the staple diet of country houses between the wars. His ability was in putting the spirit of an incident on to paper rather than the accuracy of it, in this he shared something with both Leech and Caldecott who clearly influenced him. He was the ideal illustrator for *Pickwick* and *Handley Cross*, which were issued in 1910 and 1912 respectively. He died 6 January 1935.

Illus: *Everyday Characters [W.M. Praed, 1896]; Two Well-Worn Shoe Stories [1899]; The Fallowfield Hunt [1899-1900]; A Dog Day [1902]; Cecil Aldin's Picture Books [c.1908]; White-Ear and Peter [N. Heiberg, 1911]; 12 Hunting Countries [1912-13]; The Romance of the Road [1928].*
Contrib: *Sporting and Dramatic News [1892]; Good Words; The Ludgate Monthly; The Boys Own Paper [1892]; Pall Mall Budget – Kipling's Jungle Stories [1894-5]; The Sketch [1894]; ILN [1892-1911 (X)]; Pick-Me-Up [1897]; Black and White [1899]; English Illustrated Magazine [1893-7]; Lady's Pictorial; The Gentlewoman; The Queen; The Windsor Magazine; Pearson's Magazine; Punch.*
Exhib. FAS, 1899, 1935.
Colls: V & AM.
Bibl: *CA, Time I Was Dead, 1934; Mr. Punch With Horse and Hound*, New Punch Library, 1930.
See illustration (right).

ALDRIDGE, Sydney

Illustrator. Contributed to *The Royal Magazine* and *The Windmill*, 1899.

ALEXANDER, Captain James Edward

Amateur artist, illustrated his own *Travels to The Seat of War in the East,* 1830, AT 229.

ALEXANDER, William 1766-1816

Travelling draughtsman and illustrator. Born at Maidstone in 1766, he became a pupil of W. Pars and J.C. Ibbetson before entering the RA Schools. He went to China in 1792, with Lord Macartney's embassy and his drawings of this were published in G. Staunton's official account, 1797. The sketches for this are in the British Museum. He was Professor of Drawing at the Military College, Great Marlow, 1802-8, and Keeper of Prints and Drawings at the British Museum from 1808. He died at Maidstone 23 July 1816.

Illus: *View of the Headlands, Islands etc. of China [1798]; The Costumes of the Russian Empire [1803]; The Costumes of China [1805, AT 534]; Engravings From The Egyptian Antiquities in the BM [1805]; Picturesque Representations of the Dress and Manners of the Austrians [1813]; Picturesque Representations of the Dress and Manners of the Russians [1814]; Picturesque Representations of the Dress and Manners of the Chinese [1814]; Picturesque Representations of the Dress and Manners of the Turks [1814].*
Contrib: *Travels in China [Sir J. Barrow, 1804]; Voyage to Cochin China [Sir J. Barrow, 1806]; Architectural Antiquities [J. Britton, 1804-14].*
Colls: Ashmolean; BM; Fitzwilliam; Leeds; Maidstone; V & AM.

ALFORD, W.

Architectural draughtsman, employed on *The Illustrated London News*, 1888-89.

CECIL ALDIN 1870-1935. A Street Scene in Larissa, ink and wash drawing fron sketches supplied by H.C. Seppings Wright for The Illustrated London News *1897.*
Victoria and Albert Museun

ALKEN, Henry Thomas **1785-1851**

Sporting artists, engraver and illustrator. Born in London in 1784 into a family which became celebrated for its sporting artists and engravers. He is said to have worked as a trainer for the Duke of Beaufort, before studying under J.T. Barker Beaumont, the miniaturist, and he exhibited miniatures at the RA in 1801-2. He moved to Melton Mowbray in 1810 to train horses and eke out a livelihood in decorating trays with hunting scenes. His success really began when he issued prints under the name of 'Ben Tally Ho' in 1813 and he was at his most prolific in the 1820s and 1830s. His work was less interesting after that date and he died in poverty on 8 April, 1851. His son H.G. Alken copied his father's work extensively.

Alken's illustrations and separate prints are lively and very colourful and are closer to the 18th century caricature than to the 18th century sporting print. He enlarged Gillray's idea that the mishaps of hunting could be depicted in the same format as scenes of the chase and his publisher was significantly Thomas M'Lean of 'The Repository of Wit and Humour'. Shaw Sparrow considers that he was most influential in creating a medium in which Phiz, Leech and Caldecott could flourish. His *Sketchbook*, 1823 and *Scrapbook*, 1824, with their pages crammed with nearly related but separated incidents, may have influenced strip stories in the Victorian magazines. His drawings are most often seen in soft pencil with colour washes.

Illus: *The Beauties and Defects in the Figure of the Horse comparatively delineated [1816]; National Sports of Great Britain [1821]; Humorous Specimens of Riding [1821]; Symptoms [1822]; Sketchbook [1823]; Sporting Scrapbook [1824]; Shakespeare's Seven Ages [1824]; Flowers From Nature [1824]; A Touch of the Fine Arts [1824]; Humorous Illustrations of Popular Songs [1826]; Don Quixote [1831]; Life and Death of John Mytton [1837]; Jorrocks Jaunts and Jollities [1837]; The Sporting Review [1842-6]; The Art and Practice of Etching [1849].*

Colls: BM; Fitzwilliam; Leeds; Leicester; V & AM.
Bibl: W.S. Sparrow, *British Sporting Artists*, 1922, with full bibliography, p.209; W.S. Sparrow, *HA*, 1927; A. Noakes, *The World of HA*, 1952; Arts Council, *British Sporting Painting 1650-1850*, 1974.
See illustration (below).

ALLEN, James **fl.1881**

Figure draughtsman probably working on children's books. A series of pen, ink and watercolour drawings, signed and dated 1881, are in the Victoria and Albert Museum.

ALLEN, Olive **fl.1900-1908**

Illustrator of children's books. Student at the Liverpool School. 1900. Illustrated *Grandmother's Favourites: Holiday House,* C. Sinclair, 1908, in a pretty and whimsical Regency style.

Exhib: Walker AG, 1900.
Bibl: *Studio*, Vol.20, 1900, p.196; *Studio*, Winter No.1900-01, p.78 illus.

ALLEN, Walter James **fl.1859-1891**

Genre painter and illustrator. He specialised in comic animals, humanised dogs and children. His work appears in *The Churchman's Family Magazine*, 1864 and in *The Illustrated London News*, 1888-91.

Exhib: RA and other exhibitions 1859-61.

ALLEN, Rear-Admiral William **1793-1864**

Amateur artist. Lieutenant, 1815, commander, 1836, captain, 1842, rear-admiral, 1862. A highly decorated officer who took part in the Niger expeditions of 1832 and 1841-42.

Illus: *Fernando Po [1838, AT 283]; Picturesque Views of the River Niger [1840, AT 284]; The Dead Sea [1855, AT 365].*
Exhib: RA and RBA, landscapes, 1828-47.

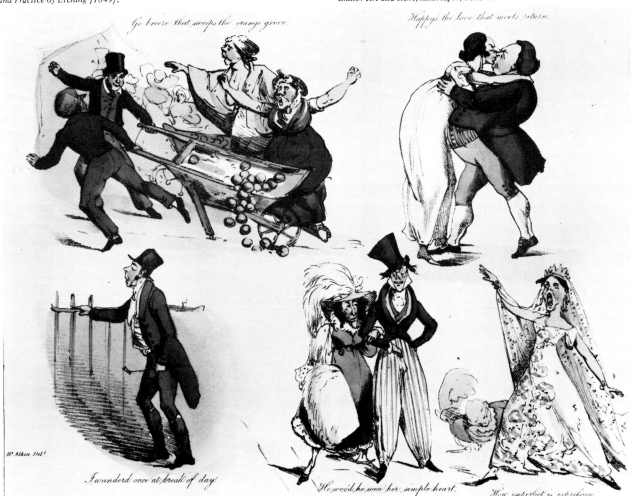

HENRY ALKEN 1784-1851. Hand coloured engravings to Illustrations to Popular Songs, *1826.*

ALLINGHAM, Helen RWS **1848-1926**

Watercolourist and illustrator. Born on 26 September 1848, the daughter of Dr. A.H. Paterson, M.D. She attended the Birmingham School of Design and the Royal Academy Schools from 1867, where she was influenced by the work of Fred Walker. She visited Italy in 1868 but between that time and 1874, drew extensively for the magazines. In 1874 she married the Irish poet, William Allingham, one of the earliest encouragers of the Pre-Raphaelites, and was elected ARWS in 1875 and RWS in 1890. Her scope as an illustrator was in cottage and rural life with some portraits. An early success was for the serial *Far From the Madding Crowd* by Thomas Hardy in *The Cornhill Magazine*, 1874. She died at Haslemere in 1926.

Illus: *A Flat Iron for a Farthing [Mrs. Ewing, 1872]; Jan of the Windmill [Mrs. Ewing, 1876]; Gentle and Simple [M.A. Paul, 1897]; Happy England [M.B. Huish, 1903]; The Homes of Tennyson [c.1905]; The Cottage Homes of England [1909].*
Contrib: *Once A Week [1868]; London Society [1870]; Cassells Magazine [1870]; The Graphic [1870-74]; ILN [1871-98].*
Exhib: FAS, 1886, 1887, 1889, 1891, 1894, 1898, 1901, 1904, 1908, 1913; RA; RWS.
Colls: BM; Manchester; V & AM.
Bibl: H.B. Huish, *Happy England as Painted by H.A.,* 1903; J. Maas, *Victorian Painters,* 1970, p.231; Arts Council, *English Influences on Van Gogh,* 1974-75, p.53.

ALLINGHAM, Wallace J. **fl.1898-1907**

Illustrator of stories for *The Illustrated London News,* 1898.
Exhib: RA, 1902.

ALLINSON, Adrian or Alfred Paul ROI RBA **1890-1959**

Painter, sculptor and caricaturist. Born 9 January 1890. Educated at Wrekin and studied at Slade School, becoming scenic designer to the Beecham Opera Company. Taught painting and drawing at Westminster School of Art and designed posters. He contributed occasional caricatures to magazines, always in black and white with

great economy of line, a good example is that to *The Gypsy,* 1915, of G.K. Chesterton
Exhib: FAS, 1919, 1939; London Salon, 1913; NEA, 1911-16; RA.
Colls: V & AM.

ALLISON, R. Gordon

Topographical illustrator, working for Ingram publications, 1898.
Colls: V & AM.

ALLOM, Thomas **1804-1872**

Architect and topographical illustrator. Born in London, 13 March 1804, and articled to the architect, Francis Goodwin in 1819. He was a founder member of the RIBA and was associated with Sir Charles Barry on various buildings. He carried out some of his own designs for buildings in the London area and died at Barnes on 21 October 1872. Works are mostly meticulous and in sepia washes.

Illus: *Devonshire Illustrated [1829]; Cumberland and Westmoreland, Scotland Illustrated, The Counties of Chester, Derby and Nottingham [c.1836]; France Illustrated [G.N. Wright, 1840]; China in a Series of Views [Rev. G.N. Wright, 1843]; China, Its Scenery, Architecture, Social Habits, Illustrated [c.1843]; Constantinople and Its Environs [1843].*
Contrib: *ILN [1851].*
Colls: BM; Chester; Fitzwilliam; G; Newcastle AG; V & AM.

ALLON, Arthur

Architectural illustrator, working for *The Illustrated London News* for which he supplied drawings of The Crystal Palace, 1851.

ALMA TADEMA, Sir Laurence **1836-1912**

Painter. Born at Dronryp, Netherlands, on 8 January 1836. He studied at the Antwerp Academy and under Baron Leys, but settled in London in 1870 and very soon became one of the Victorian Olympians, living in a lavish house in St. Johns Wood and having a wide circle of students and admirers. He became an ARA in 1873 and

WILLIAM DOUGLAS ALMOND RI 1868-1916. The Gas Workers' Strike. Chalk drawing for The Illustrated London News, *January 4, 1890.*
Victoria and Albert Museum

an RA in 1879 as well as Member of the OWS in 1875. Alma Tadema was knighted in 1899, received the OM in 1905 and many other honours. His reputation which suffered a decline after his death, has had a revival in recent years mainly due to the taste for slick and highly coloured classical subjects of which he was a master. He arrived too late in this country to benefit from the great period of illustration, but a few examples from the 1880s exist, most notably an India proof of Findusi's *Epic of Kings*, 1882 in the Victoria and Albert Museum.

Colls: BM; Manchester; V & AM.
Bibl: P.C. Standing, *Sir L. A-T.* 1905; J. Maas, *Victorian Painters*, 1970, pp.181-183.

ALMA TADEMA, Laura Theresa, Lady　　　　**1852-1909**
Artist and occasional illustrator. Born in 1852, the daughter of G.N. Epps, she was a pupil of Sir Laurence before she married him in 1871. She specialised in scenes of childhood, dressed up in the same classical guise as those of her husband.

Contrib: *The English Illustrated Magazine [1889, Vol. VII, p.625]*.
Exhib: FAS, 1910.
Colls: V & AM.

ALMOND, William Douglas　RI RBA　　　　**1868-1916**
Illustrator. Born in London, 28 April 1868, he was educated at King's College and became a Member of the Langham Sketching Club. He joined the staff of *The Illustrated London News* in 1887 and during the next decade did most of his best work for it while acting as an occasional contributor to other periodicals. He was designated 'Special Artist for Character Subjects' in 1891 and it is in social realism that his great strength lies. He was clearly influenced by the earlier generation of realists, Herkomer, Fildes and Holl, but his medium was

G. AMATO. *The Assasination of the King of Italy at Monza, wash drawing for* The Illustrated London News, *1900.*

chalk, adapted to new processes, and more lively than the old engravings. Almond's studies of the workhouses, sweat shops and hospitals of Victorian London have never been surpassed and it is strange that he has never received due recognition. He was also a topographical artist, but these works like his watercolours are much weaker in handling. RI, 1897.

Illus: *Sally Dows [Bret Harte, 1897]*.
Contrib: *ILN [1887-1894]; Good Words [1891-2]; The Sphere [1894]; Good Cheer [1894]; English Illustrated Magazine [1894-99]; Penny Illustrated Paper; Cassells Family Magazine; The Idler; The Pall Mall Magazine; The Windsor Magazine; The Strand Magazine.*
Exhib: Paris, 1900; RA; RBA; RI; ROI.
Colls: V & AM.
See illustration (p.218).

ALTSON, Abbey　RBA　　　　**fl.1892-1925**
Painter and illustrator. Working at Swiss Cottage, London, 1902, and at Bedford Park, London, 1903-1925. Worked for *The Illustrated London News*, 1897; *The Pall Mall Magazine; The Windsor Magazine*. His drawings are very clear and photographic.

Exhib: G; Salon, 1892-93; RA.

AMATO, G.　　　　**fl.1894-1901**
Special artist for *The Illustrated London News*, 1894-1901, for *The Graphic*, 1901 and for *L'Illustration*. Amato appears to have been a travelling artist for these papers, in Russia, 1894, in Crete, 1896 and in Rome, 1901. He specialised in royal events and did wash drawings in a mechanical, photographic and dull style.

Colls: V & AM.
See illustration (below left).

ANASTASI, Auguste Paul Charles　　　　**1820-1889**
French landscape painter. He was a pupil of Delacroix, Corot and Delaroche and specialised in views of Normandy, Holland and Rome. He abandoned painting due to blindness. Vizetelly says that he worked for *The Illustrated London News* in its early years.

ANDERSON, Martin　see 'CYNICUS'

ANDRÉ, R.　　　　**fl.1880-1907**
Illustrator of children's books. Worked at Bushey, Hertfordshire, 1890-1907. Designed covers for *Old Fashioned Fairy Tales*, Mrs. Ewing, c.1880 and the same author's *Grandmother's Spring* and *Master Fritz*, 1885.

ANDREWES, Miss D.
Illustrator of children's books. Working at Folkestone, 1902-1907. Drew illustrations for *The Little Maid Who Danced To Every Mood*, 1908, with Agnes Stringer.

ANDREWS, Mrs. E.A.　see CUBITT, Miss Edith Alice

ANDREWS, George Henry　RWS FRGS　　　　**1816-1898**
Marine painter and illustrator. Born at Lambeth in 1816 and trained as an engineer. Principal naval artist to *The Illustrated London News, 1856-1860* and to *The Illustrated Times*, 1859. Worked for *The Graphic*, 1870. OWS, 1878. Died 31 December 1898.

Illus: *Operations at the Pyramids of Gizeh [H. Vyse, 1840]; English Landscape and Views [J.C. Anderson, 1883]*.
Exhib: BI; OWS, 1840-50; RA, 1850-93; RBA.
Colls: Cardiff; Greenwich; V & AM.
Bibl: Chatto and Jackson, *Treatise on Wood Engraving*, 1861, p.598.

ANELAY, Henry　　　　**1817-1883**
Landscape painter and illustrator. Born at Hull in 1817 and lived at Sydenham from 1848. He was first of all a portrait illustrator and provided numerous plates for *The Illustrated London News*, 1843-1855 and may have been sent to Constantinople for the paper in 1853. He exhibited in London from 1845 and at the RA, 1858-73.

Contrib: *London [edited by Charles Knight, 1840]; Illustrated London Magazine [1853-54]; The British Workman [1855]; The Band of Hope Review [1861]; Sandford and Merton; Merrie Days of England; Favourite English Poems; Uncle Tom's Cabin [1852]*.
Bibl: Chatto and Jackson, *Treatise on Wood Engraving*, 1861, p.575.

ANTON VAN ANROOY RI fl.1897-1925. Illustration for 'The Observant Friar' by
F.H. Melville, wash drawing published in The English Illustrated Magazine, *1900.*

ANGAS, George French 1822-1886

Topographical illustrator. Born in Durham, 1822, the son of one of the founders of South Australia. He studied anatomical drawing and lithography in London and in 1841 travelled to Malta and Sicily, issuing the result of the journey in 1842. He went to Australia in 1843 and became director of the Sydney Museum in 1851. Returned to England, 1873, and published a book of poems, 1874.

Illus: *The New Zealanders Illustrated [1846-47, AT 588]; Savage Life and Scenes in Australia and New Zealand [1847]; Description of the Barossa Range [1849, AT 580]; The Kafirs Illustrated [1849, AT 339]; Gold Fields of Ophir [1851, AT 582]; Gold Regions of Australia [1851, AT 583]; South Australia Illustrated [1846-47].*
Exhib: RA; RBA, 1843-74.
Colls: BM; Sydney.

ANGUS, Miss Christine fl.1899-1900

Children's book illustrator. Student at City and Guilds, 1899, and at Liverpool, 1900. Her work shows a slight Greenaway influence. There is no record of published books.

Exhib: Walker AG, Liverpool, 1900.
Bibl: *The Studio,* Vol.17, 1899, p.188 and Vol.20, 1900, p.196.

ANNISON, Edward S.

Illustrator of stories for *The Graphic,* 1912.

ANROOY, Anton van RI 1870-

Born in Holland, but came to England at an early age and spent all his working life here. Principally a painter. Signs V. Anrooy or V.A.

Contrib: *The Dome [1897]; The Parade [1897]; The English Illustrated Magazine [1899]; The ILN [1901].*
Exhib: Brighton; Liverpool; RA; RI.
Colls: V & AM.
See illustration (p.220).

ANSDELL, Richard RA 1815-1885

Animal and sporting painter and illustrator. He was born at Liverpool in 1815 and was educated at the Blue Coat School and the Liverpool Academy. He practised in his native city but moved to London in 1847 and became one of the most successful Victorian sporting artists, collaborating on huge canvases with artists such as T. Creswick and W.P. Frith. ARA, 1861, and RA, 1870. He is a rare illustrator but contributed a few spirited designs to books.

Contrib: *The Illustrated Times [1855-56]; Once a Week [1867]; Rhymes and Roundelayes [1858].*
Exhib: RA from 1840; BI from 1846.
Bibl: Chatto & Jackson *Treatise on Wood Engraving,* 1861, p.598.

ANSTED, H.

Architectural illustrator. Worked during 1827 on *Britton's Cathedrals* 1832-36. He exhibited architectural subjects at the RA, 1826.

ANSTED, William Alexander

Landscape draughtsman, illustrator and etcher, working at Chiswick from 1888-99. He was one of a number of late Victorian artists who specialised in popular and inexpensive travel books.

Illus: *Rivers of Devon [1893]; The Riviera [1894]; The Coast of Devon [1895]; Episcopal Palaces of England [1895]; The Master of The Musicians [1896]; London Riverside Churches [1897]; English Cathedral Series [1897-98]; The Romance of our Ancient Churches [1899]; Life of Johnson [1899].*
Contrib: *Good Words [1894].*

APE See PELLEGRINI, C.

APE JUNIOR fl.1910-1911

Pseudonym of caricaturist working for *Vanity Fair,* 1910-11.
Colls: V & AM.

GEORGE DENHOLM ARMOUR 1864-1949. Illustration for Punch, *pen and ink. The Point to Point Season. Yokel (to persevering sportsman who in spite of several falls is doggedly completing the Course) " 'Urry up mister or the next race'll be catchin' you up!"* Author's Collection

ARCHER, John Wykeham ARWS **1808-1864**

Watercolourist and topographical illustrator. Born at Newcastle-upon-Tyne, 2 August 1808, coming to London in 1820 to serve his apprenticeship with John Scott, the animal engraver. He worked as an engraver in Newcastle in partnership with William Collard and then in Edinburgh. Finally in 1831 he returned to London to work for W. and E. Finden. He slowly abandoned engraving for watercolour, although he did a great number of wood engravings in the 1840s and carried out many drawings of old buildings for topographical works. He became an ARWS in 1842, and died in London, 25 May 1864.

Illus: *The Castles and Abbeys of England [W.Beattie, 1844]*.
Contrib: *Winkle's Illustrations of the Cathedral Churches [1836-37]; London [Charles Knight, 1841]; ILN [1847-49 (animals)]; Household Song [1861]; Vestiges of Old London; Douglas Jerrold's Magazine; William Twopenny's Magazine*.
Exhib: NWS, 1842-64.
Colls: BM; V & AM.
Bibl: Chatto and Jackson, *Treatise on Wood Engraving*, 1861, p.599.

ARIS, Ernest Alfred **1883-**

Watercolour artist and illustrator. Born 22 April 1883 and studied at the Bradford College of Art and the RCA; diploma at Bradford, 1900. Art master ICS School, 1909-12. His works were widely reproduced in America, Canada and Australia and he did much commercial work. Contributed children's illustrations to *The Graphic*, 1910.

Exhib: RA; RBA; RI; RWS.
Bibl: *Who's Who in Art 1964*.

ARMFIELD, Maxwell RBA **1882-1972**

Painter, watercolourist and etcher. Born at Ringwood in 1882, studied at the Birmingham School and in Paris under Collin, Prinet, and Dauchez. Armfield wrote and lectured extensively. As well as painting, he published *The Hanging Garden*, 1914, and *White Horses* and some books on technique. His only illustrated book is *Sylvia's Tales* by C. Armfield, 1911, which has vignettes of animals and elaborate colour plates.

Exhib: B, from 1902; FAS, 1970, 1971, 1973; L; NAC, from 1907; RA; RHA; RWA; Salon from 1905.
Bibl: *Modern Book Illustrators, Studio*, 1914.

ARMITAGE, Edward RA **1817-1896**

Historical and religious painter and illustrator. Born in London in 1817 and in 1835 went to the École des Beaux-Arts in Paris to study with Paul Delaroche. Entered the Houses of Parliament competition and in 1847 his prize-winning painting 'The Battle of Meeanee' was purchased by Queen Victoria. He visited Russia during the Crimean War and painted military subjects on his return. He became an ARA in 1867, RA in 1872, and was Lecturer on Painting at the RA, 1875.

Contrib: *Lyra Germanica [1861]; Pupils of St. John The Divine [1867-68]; Dalziel's Bible Gallery [1880]*.
Exhib: G; L; RA, from 1848-93; Salon, 1842.
Colls: BM; Royal Collection.
Bibl: J.P. Richter, *Pictures and Drawings of EA*, 1897.

ARMOUR, George Denholm OBE **1864-1949**

Black and white artist and illustrator. Born in Lanarkshire, 30 January 1864, and was educated at St. Andrews University, Edinburgh School of Art and the RSA, from 1880 to 1888. He worked in London from about 1890 as a painter and illustrator but only achieved wide recognition after his appearance in *Punch*, 1894. During the First World War, Armour commanded the depot of the Army Remount Service and served in Salonica, 1917 to 1919, being awarded the OBE in that year.

His drawings are almost exclusively of sporting and country subjects and many of them derived their humour from the Leech tradition. Armour's penwork was impeccable and he could seldom be faulted on his drawing of the horse. An unusual subject, a bullfight in the Victoria and Albert Museum is reminiscent of J. Crawhall, of whose drawings Armour had a collection. Nevertheless, the artist was criticised by Seaman of *Punch* for being too repetitive and of not introducing enough motor cars into his subjects!

Illus: *Handley Cross [1908]; Foxiana [L. Bell, Country Life, 1929]; Humour in the Hunting Field [1928]; Sport and There's the Humour of It [1935]*.

Contrib: *The Graphic [1892]; The Pall Mall Budget [1893]; Pick-Me-Up [1896]; The New Budget [1895]; The Unicorn [1895]; The Pall Mall Magazine [1897]; The Longbow [1898]; The Butterfly [1899]; Sporting and Dramatic News; The Windsor Magazine; Judge [New York]*.
Exhib: FAS, 1924; Leicester Gall.; RSA; RWA.
Colls: Glasgow; *Punch*; V & AM.
Bibl: R.G.G. Price, *A History of Punch*, 1955, pp.176, 205-206.
See illustration (p.221).

ARMOUR, Jessie Lamont

Student at Armstrong College, Newcastle, producing designs for illustration in Birmingham School style. No record of published books.

Bibl: *The Studio*, Vol.44, 1908, p.275 illus.

ARMSTEAD, Henry Hugh RA **1828-1905**

Sculptor and occasional illustrator. Born in London, 18 June 1828, and studied at the RA Schools. ARA, 1875, and RA, 1879. He was a prolific sculptor as well as a wood engraver and chaser; he carved the south and east panels of the podium of the Albert Memorial and part of the frieze of the Albert Hall. He was a frequent exhibitor of busts and reliefs at the RA from 1851. His illustrations, especially his religious subjects, were rather hard and Germanic, his modern genre subjects could be delightful with a good sense of composition. He died 4 December 1905.

Contrib: *Eliza Cook's Poems [1856]; Good Works [1861]; Sacred Poetry [1862]; Churchman's Family Magazine [1863]; Touches of Nature [1866]; Dalziel's Bible Gallery [1880]; Art Pictures from the Old Testament [1897]*.

ARMSTRONG, Francis Abel William Taylor RBA, RWA
 1849-1920

Landscape painter. Armstrong was born at Malmesbury, 15 February 1849, and although trained for a business career eventually devoted himself entirely to art. He drew for *The Art Journal* and *Portfolio*. He practised in Bristol and died there on 1 December 1920.

Contrib: *Lorna Doone [De Luxe Edition, 1883]*; an unrecorded edition of Mathew Arnold's Poems, n.d.
Exhib: Berlin; Cologne; FAS, 1923; Paris; RBA; RWA.
Colls: V & AM.

ARMYTAGE, J. Charles **fl.1863-1874**

Figure artist and illustrator. He contributed to *The Cornhill Magazine* and did architectural subjects — perhaps for books.
Colls: V & AM.

ARNALD, George ARA **1763-1841**

Landscape painter and topographer. He was born in Berkshire in 1763 and was a pupil of William Pether. Like his master he specialised in seascapes and moonlight scenes. He is best known as a watercolourist and travelled in North Wales with John Varley in 1798 or 1799. He won a prize for his painting 'The Battle of the Nile' and from 1825 did some commissions for the Duke of Gloucester. He died at Pentonville, 21 November 1841. ARA, 1810.

Illus: *The Border Antiquities of England and Scotland [Walter Scott, 1814-17]; Picturesque Scenery on the Meuse [1835, AT 95]; History and Topography of Essex [1836]*.
Exhib: RA, 1788.
Colls: BM; Greenwich Hospital; V & AM.

ARUNDALE, Francis Vyvyan Jago **1807-1853**

Architect and draughtsman. He was born in 1807 and became a pupil of A. Pugin (q.v.) and accompanied him to Normandy. He studied at the RA Schools in 1829 and in 1831 he went out to Egypt to assist Robert Hay in his archaeological works, later assisting Bonomi and Catherwood, 1831-40. Arundale made many fine architectural studies many of which were exhibited in London on his return, but his books were not a financial success. He married the daughter of H.W. Pickersgill, RA and died in 1854, probably as the result of a disease contracted in the Egyptian tombs.

Illus: *Illustrations of Jerusalem and Mt. Sinai [1837]; Operations Carried on at The Pyramids of Giza, 1837 [Howard Vyse, 1840]*.
Contrib: *Specimens of the Architectural Antiquities of Normandy [1826-28]; Britton's Union of Architecture [1827, AL 7]*.
Exhib: BI; RA.
Colls: Searight Coll.

ASHLEY, Alfred fl.1841-1853

Landscape artist and illustrator. Ashley was a draughtsman and etcher of figure subjects working in the style of 'Phiz' but less certain in his drawing and more scratchy in his line. He published *The Art of Engraving*, 1849.

Contrib: *Punch [1841]; Christmas Shadows [1850]; Old London Bridge [G.H. Rodwell, c.1850].*
Exhib: London, 1850-53.

ASHTON, G. Rossi fl.1875-1901

Australian artist and illustrator. He appears to have worked in Australia till about 1885 and was for some time a colleague of Phil May on *The Sydney Bulletin*. Came to England and did prolific humorous work for the magazines.

Contrib: *The Graphic [1875, 1885 (Australia)]; Daily Graphic [1890-95]; Lika Joko [1896]; Pearson's Magazine [1896]; St. James's Budget [1898]; Fun [1901]; Illustrated Bits; The Pall Mall Magazine; The Sketch.*

ASTOR

Pseudonym of unidentified caricaturist, *Vanity Fair*, 1913.

ATKINSON, Captain George Franklin 1822-1859

Son of the artist James Atkinson. Officer in the Bengal Engineers and amateur artist. He was present at the Indian Mutiny and supplied sketches for *The Illustrated London News*, 1857. Published *The Campaign in India*, 1859, AT 486; *Curry and Rice*, 1860, AT 487.

ATKINSON, John Augustus OWS c.1775-c.1833

Painter, etcher and illustrator. Born in London about 1775, he was taken to Russia by his uncle, James Walker, in 1784 and was patronised by the Empress Catherine and the Emperor Paul. He returned to London in 1801 and published books on costume and manners of Russia. Atkinson was an accomplished caricaturist and a battle painter, and he visited the site of the Battle of Waterloo in 1815 as a topographer. He was a Member of the OWS from 1808 to 1812. He remained in London until about 1818 but little is known of his subsequent life.

Illus: *Hudibras [1797 (Russian edition)]; Miseries of Human Life [1807]; A Picturesque Representation of the ... Costumes of Great Britain [1807]; A Picturesque Representation of ... the Russians [1812]; Voyage Round the World [1813, AT 1]; Foreign Field Sports [1814 AT 2].*
Exhib: BI; OWS; RA, 1803-33; RBA.
Colls: BM; Dublin; Greenwich; Leningrad; Manchester; V & AM.

ATKINSON, John Priestman fl.1864-1894

Humorous black and white artist. Official in General Railway Manager's office, Derby, 1864. Began to draw for *The Derby Ram* and later turned completely to art, studying in Paris and becoming a close friend of Harry Furniss. He was a regular contributor to *Punch* under the name 'Dumb Crambo Junior'. Specialised in comic genre subjects. Signs with monogram JPA.

Illus: *Thackeray's The Great Hoggarty Diamond, Paris Sketch Book, Ballads, [1894].*
Contrib: *ILN [1881, 1884]; The Cornhill Magazine [1883]; Moonshine [1892]; The St. James's Budget; The Backslider.*
Colls: V & AM.
Bibl: M.H. Spielmann, *The History of Punch*, 1895, pp.524-525.

ATKINSON, Thomas Witlam c.1799-1861

Architect, traveller and topographer. Born at Cawthorne, Yorkshire, of poor parents and began life as bricklayer and stone carver. In 1827 he settled in London and in 1834 moved to Manchester where he went into partnership with the architect, A.B. Clayton. He designed a number of churches and other buildings in the Manchester area and in 1844 he left England for Hamburg and St. Petersburg, where he abandoned architecture for the life of a painter and traveller. He visited Egypt and Greece and made an extensive tour through Russia, 1848 to 1853.

Illus: *Gothic Ornaments Selected from the different Cathedrals [1829]; Oriental and Western Siberia [1858, AT 530]; Travels in Upper and Lower Amoor [1860].*
Exhib: RA, 1830-42.
Bibl: *Art Journal*, October 1861; *Builder*, XIX, 1861, p.590; H.M. Colvin, *Biog. Dict. Eng. Architects*, 1954, p.47.

ATTWELL, Emily A.

Student competitor in *The Studio* book illustration competitions. Working from address in the Mile End Road, London E.

Bibl: *The Studio*, Vol.10, 1897, illus; and Vol.12, 1897, illus.

ATTWELL, Mabel Lucie (Mrs. H.C. Earnshaw) 1879-

Artist and illustrator, author of children's stories and verse. She was born in London 4 June 1879 and was educated at the Cooper's Company School. She studied art at the Regent Street Art School and at Heatherley's. In 1908 she married Harold Earnshaw (q.v.), the illustrator, and in 1925 she was elected SWA. She illustrated works by Charles Kingsley, Hans Andersen, Grimm, Lewis Carroll and J.M. Barrie.

Exhib: SWA, 1924.

AULT, Norman 1880-1950

Writer and illustrator. Born 17 December 1880 and attended West Bromwich Art School, 1895 to 1900. On leaving he obtained work with *The Strand* and other magazines and collaborated with his artist wife on children's books. He specialised in costume, architecture, furniture and landscape, giving great attention to period details. He worked for the children's annuals *Chatterbox* and *Sunday*. Did little for books after 1920. Close friend of H.R. Millar.

Illus: *Sammy and the Snarleywink [1904]; The Rhyme Book [1906]; The Podgy Book [1907] (all with his wife). The Mabinogion [Lady Guest, 1902]; The Story of an Old Fashioned Doll [J. Connolly, 1905]; Alice in Wonderland [1907]; England's Story for Children [M.B. Williams, 1908]; The Lays of Ancient Rome, [T.B. Macaulay, 1911]; Tennyson, The Children's Poets [1913]; The Seven Champions of Christendom [F.J.H. Darton, 1913]; Caravan Tales [W. Hauff, n.d.]; The Shepherd of the Ocean [G.I. Whitham, 1914]; New Tales of Old Times [W.E. Sparkes, 1914]; Chambers Dramatic History Readers [W.Hislop, 1914-15]; Life in Ancient Britain [1920]; Dreamland Shores [1920]; The Poet's Life of Christ [1922].*
Bibl: *The Artist*, c.1900.

AUSTIN, Henry

Topographical illustrator contributing to *The Pall Mall Budget*, c.1890.

AUSTIN, Samuel OWS 1796-1834

Watercolourist and topographer. He was born at Liverpool in 1796 and after working as a bank clerk, he took lessons from Peter de Wint. He was a founder member of the SBA and was elected AOWS in 1827 and OWS on his deathbed in 1834. He painted extensively in Lancashire and North Wales but also in Belgium, Holland and Normandy.

Illus: *Views in the East [Elliott, 1833].*
Contrib: *Lancashire Illustrated [1829].*
Exhib: OWS; RA; RBA.
Colls: Ashmolean; Fitzwilliam; Liverpool; Manchester.

AVRIL, Édouard Henri (called Paul) 1849-1928

Painter and illustrator. Born in Algiers, 21 March 1849, and studied under Pils and P. Lehmann in Paris. He exhibited at the Salon 1878 to 1884. Avril is included here because he illustrated three lavish books by Octave Uzanne, which were published in England. They are *The Fan*, 1884; *The Sunshade*, 1883, and *The Mirror of the World*, 1890. All the drawings are more French than English and are extremely eclectic and ill-assorted; they make an interesting comparison with contemporary English black and white work.

AYLING, Florence

Book decorator in the William Morris style. She contributed headings to *The English Illustrated Magazine*, 1888.

BACON, John Henry Frederick ARA 1865-1914

Portrait painter and illustrator. Painted the Coronation Portrait of King George V and Queen Mary, 1912. ARA, 1903. MVO, 1913. Died in London, 24 January 1914.

Illus: *Things Will Take a Turn [B. Harraden, 1894]; The Ravensworth Scholarship [H. Clarke, 1895]; The King's Empire [1906]; Celtic Myth and Legend [C. Squire, 1912].*
Contrib: *The Girl's Own Paper [1890-1900]; Black & White [1891-96]; The Quiver [1892]; The Ludgate Monthly [1895]; Cassell's Family Magazine [1896-97]; The Windsor Magazine.*
Colls: BM.

BADEN-POWELL, Robert, 1st Baron OM 1857-1941

General, Founder of the Scout Movement, sculptor and illustrator. Born 22 February 1857 and after attending Charterhouse, joined the 13 Hussars, 1876; served in India, Afghanistan and South Africa, Assistant Military Secretary in South Africa, 1887-89 and Malta, 1890-93. At the Defence of Mafeking, 1899-1900. Major-General, 1900. Lieutenant-General, 1908. CB, 1900; KCB, 1909; KCVO, 1909; Baronet, 1922. Like many army officers of his generation, Baden-Powell was a talented artist and sculptor. He contributed sketches to *The Graphic* from South Africa in 1891 and from Ashanti to *The Daily Graphic,* 1895. A further sketch of scouting appeared in *The Graphic* in 1910. Died in Kenya, 1941.

Publ: *Pig-sticking or Hog-hunting [1889]; Reconnaisance and Scouting [1890]; Vedette [1890]; Cavalry Instruction [1895]; The Downfall of Prempeh [1896]; The Matabele Campaign [1896]; Aids to Scouting [1899]; Sport in War [1900]; Sketches in Mafeking and E. Africa [1907]; Scouting for Boys [1908]; Indian Memories [1915].*
Exhib: RA, 1907.

BAINES, Thomas 1822-1875

Artist, explorer and illustrator. Travelled with the British Army during the Kafir war, 1848-51, and accompanied expeditions to North-West Australia, Victoria Falls, the Tati goldfields and the Zambesi under Livingstone. His drawings of African travel appeared in *The Illustrated London News,* 1869.

BAIRNSFATHER, Bruce 1888-1959

Illustrator, cartoonist and journalist. Born at Murree, India, in July 1888, the son of an army officer. He attended the United Service College and served with the Warwickshire Militia from 1911 to 1914. At the outbreak of war that year he returned to the Royal Warwickshire Regiment and served in France until December 1916. Bairnsfather was already becoming known to the public by his humorous sketches of trench life in the pages of *The Tatler* and other magazines. An amateur artist who worked in the poster style developed by Hassall and others, his individual view of the Front, its cockney humour, its unheroic fortitude and chauvinism, was exactly right for the grim period after the Somme. His pipe-smoking tommy 'Old Bill' typified British determination with his 'If you know of a better 'ole go to it!' Bairnsfather was Official War Artist to the U.S. Army Europe in the Second World War, 1942-44.

Publ: *Fragments From France [6 Vols.]; The Better 'Ole; Bullets and Billets; From Mud to Mufti; Old Bill; Wide Canvas [1939]; Old Bill Stands By [1939]; Old Bill Does It Again [1940]; Jeeps and Jests [1943]; No Kiddin' [1944]; C'est Pour La France; Back to Blighty.*
Coll: Imperial War Mus.

BAKER, Annie

Artist working at Egremont, Cheshire, and exhibiting at Liverpool, 1890. She contributed to *The English Illustrated Magazine,* 1888.

BAKER, Colonel Bernard Granville fl.1911-1930

Military painter and illustrator. He worked in London and Beccles, Suffolk and illustrated his own *The Danube with Pen and Pencil,* 1911.

Exhib: L.

BAKER, Sir Samuel White 1821-1893

Traveller and sportsman. Went to Ceylon in 1846 and remained until 1848. He established an English colony at Newera Eliya and travelled in Asia Minor, 1860-61, Abyssinia, 1861-62, Khartoum, 1862, and to the White Nile in 1864. He received the Gold Medal of the Royal Geographical Society and was knighted in 1866; FRS, 1869. He published in 1855 *Eight Years Wanderings in Ceylon,* AT 415, with his own sketches.

BAKEWELL, Robert

Illustrated *Travels in the Tarentaise [1823 (coloured acquatints),* AT 56].

BALCOMB, J.T.

Illustrator specialising in scientific and biological drawings. He worked regularly for *The Illustrated London News,* 1876-83.

RONALD E. BALFOUR 1896-1941. Drawing for illustration to Omar Khayyam, *published by Messrs. Constable, 1920. Pen and ink.*
Victoria and Albert Museum

BALFOUR, Maxwell fl.1896-1907

Painter and draughtsman. Working from an address in Cheyne Walk, Chelsea, 1901-2. He contributed to *The Quarto*, 1896, and exhibited at the NEAC, 1901-2.

BALFOUR, Ronald E. 1896-1941

Balfour appears to have been working as a book illustrator between about 1910 and 1925. In 1920 he illustrated an edition of *The Rubaiyat of Omar Khayyam* for Messrs. Constable. He frequently designs in pencil in an early art deco style and signs with monogram REB.

Colls: V & AM.
See illustration (p.224).

BALKIN, Lance

Portrait illustrator, working for *The Graphic*, 1887.

BALL, Alec C.

Illustrator of social realism for *The Graphic*, 1902-5 and 1906-10.

BALL, Fred H. fl.1899-1925

Black and white and decorative artist for books. Working in Nottingham, 1899, and at Mapperley, Notts., 1914-25. His style is based on that of the French poster artists and much influenced by designers such as Alphonse Mucha.

Exhib: RA, 1913.
Bibl: *The Studio*, Vol.15, 1899, p.68 illus; pp.144, 295 illus; and Vol.63, 1914, pp.62-63; *Modern Book Illustrators and Their Work*, Studio, 1914, illus.

BALL, Wilfred Williams 1853-1917

Illustrator, watercolourist and etcher. Born in London 4 January 1853. He was from a Lincolnshire family, settled in London, and was placed with a firm of accountants, devoting his spare time to painting and etching and studying at Heatherley's. In 1877 he gave up the City for professional painting, working from Putney, where he came into contact with Whistler undertaking his Thames views. He was a member of the Society of Painter Etchers from 1881 and a member of the Hogarth and Arts Clubs. His work was mainly topographical and landscape and it took him on tours abroad to Italy, 1877, Holland, 1889, Germany, 1890, Egypt, 1893. After 1895 he worked at Lymington and died at Khartoum on 14 February 1917 while working in a civil capacity for the army.

Illus: *Hampshire, Sussex [Varley, 1905].*
Contrib: *The Yellow Book [1895].*
Exhib: FAS, 1899, 1904, 1909, 1912, 1915, 1917; Leicester Gall.; New Gall.; RA, 1877-1903; RE.
Colls: V & AM.

BANNISTER, F.

Figure artist. He contributed to *The Strand Magazine*, 1892.

BARBER, C. Burton 1845-1894

Sporting and animal painter. Born in 1845 and worked latterly at Regents Park, London. He became a Member of the ROI, in 1883.

Contrib: *The Graphic [1882-86 (dogs)].*
Exhib: FAS, 1895; G; L; M; RA; ROI; Tooth.

BARBER, T. or J.

Engraver. He engraved views of Scotland and illustrated *Picturesque Illustrations of The Isle of Wight*, c.1830.

BARCLAY, Edgar 1842-1913

Landscape painter and illustrator. He studied in Dresden, 1861, and in Rome, 1874-75. He seems to have specialised in figure drawing and in illustrating stories of eastern life. Practised from Haverstock Hill, Hampstead, and died there in 1913.

Illus: *Orpheus and Eurydice [H.D. Barclay, 1877]; Mountain Life in Algeria [1882].*
Contrib: *English Illustrated Magazine [1888-91]; The Graphic [1899]; The Picturesque Mediterranean [1891].*
Exhib: G; L; M; New Gall.; OP; RA.

BARNARD, Frederick 1846-1896

Illustrator. Born in St. Martin's-le-Grand, London, 26 May 1846. He studied at Heatherley's in Newman Street in 1863 and at Paris under Bonnat. Barnard exhibited at the RA from 1866 to 1887, although he freely admitted that he never had the same confidence in oil as in black and white work. He began contributing the latter to *The Illustrated London News* in 1863 and remained until his death one of its most prolific artists. His *forte* was genre subjects and social realism which brought him the admiration of the young Vincent Van Gogh during his English years. He exhibited at the Paris Exhibition of 1878 and at home contributed to *Punch* and Furniss's *Lika Joko*. His Dickens illustrations are powerful, but his best work is perhaps the London sketches of *How The Poor Live* by George R. Sims, published in 1883, and also engraved for *The Pictorial Times*. His superb character drawing has only one fault, that it tends to be humerous when it is not required to be; the figures in the Paris Commune sketches of 1870, *Illustrated London News,* are a case in point.

Barnard was suffocated or burnt to death at Wimbledon on 28 September 1896. His work is usually in pen and ink, sometimes in chalk or wash, signed: F.B.

Illus: *Dickens Household Edition [1871-79], Barnaby Rudge, Bleak House, Sketches by Boz, etc.; Episodes of Fiction [1870]; All Sorts and Conditions of Men [Walter Besant]; The Four George's [Thackeray, 1894]; Armorel of Lyonesse [1890].*
Contrib: *ILN [1863-96]; Punch [1864, 1884]; The Broadway [1867-74]; Cassell's Illustrated Readings [1867-68]; London Society [1868]; Cassell's Family Magazine [1868]; Once A Week [1869]; Good Words [1869 and 1891-92]; Good Words For The Young [1869]; Fun [1869]; Judy [1887-90]; Boy's Own Paper [1890]; Black and White [1891]; Chums [1892]; Sporting and Dramatic News [1893]; Lika Joko [1894]; The Penny Illustrated Paper; Cassell's Saturday Journal.*
Exhib: Paris, 1878; RA from 1866.
Colls: V & AM.
See illustrations (below and p.143).

FREDERICK BARNARD 1846-1896. One of a series of 'London Sketches' in pen and ink, for George R. Sims' How The Poor Live, 1883.
Victoria and Albert Museum

ROBERT BARNES 1840-1895. A Welsh seller of lace, Llandudno, pen and ink for an unidentified magazine illustration. Author's Collection

BARNARD, George

Illustrator and drawing master. A pupil of J.D. Harding, he was a regular exhibitor at London galleries from 1832 to 1884 and became art master at Rugby in 1870. He published a number of books on technique, *Handbook of Foliage and Foreground Drawing*, 1853; *The Theory and Practice of Landscape Painting in Water Colours*, 1855; *Drawing From Nature*, 1856; *Barnard's Trees*, 1868.

Illus: *The Brunnens of Nassau and The River Lahn [1843, AT 61]; A Lady Tour Round Monte Rosa [Cole, 1859, AT 59].*
Contrib: *ILN [1858].*

BARNES, G.E

Illustrator. Working for *The Broadway*, c.1867-74 and exhibiting at the RBA, 1866. Specialised in architecture.

BARNES, Robert ARWS 1840-1895

Painter and illustrator. Worked first at Berkhampstead and later from Ormonde House, Cliveden Place, Brighton. Barnes was among the best of the second rank of illustrators of the 1860s; his drawing was always excellent if it lacks the originality of a Walker or a Pinwell. His range was very much theirs, because he was at his best in rural genre subjects and one of his most important commissions was to illustrate the first serialisation of 'The Mayor of Casterbridge' in *The Graphic*, January to June, 1886. He was elected ARWS in 1876.

Illus: *Sybil and Her Live Snowball [1866]; Gray's Elegy [1868]; A Prisoner of War [G. Norway, 1894].*
Contrib: *London Society [1862]; Churchman's Family Magazine [1863]; Once A Week [1864]; Cornhill [1864, 1869-70, 1884]; The Leisure Hour [1864]; British Workman [1865]; The Band of Hope Review [1865-66]; The Sunday Magazine [1865-66, 1869]; The Sunday at Home [1866]; Touches of Nature by Eminent Artists [1866]; The Quiver [1867-69]; Idyllic Pictures [1867]; Golden Hours [1868]; Christian Lyrics [1868]; Taylor's Original Poems [1868]; Good Words [1869, 1891]; Cassell's Magazine [1870]; ILN [1872-77]; The Graphic [1880, 1885-89]; Cassell's Family Magazine [1890]; Our Life Illustrated by Pen and Pencil [1865]; The Months Illustrated With Pen and Pencil [1864]; Pictures of English Life [1865]; Foxe's Book of Martyrs [1865].*
Colls: V & AM; Dorset County Museum.
Bibl: F. Reid, *Illustrators of The Sixties*, 1928, pp.256-258.
See illustration (above).

BARNETT, R.C. fl.1798-1831

Painter of landscape and draughtsman. Worked in London and exhibited there at the RA and BI, 1798 to 1821. Published at Manchester in 1831, *The Beauties of Antiquity*.

Colls: Ashmolean.

BARRAUD, Frances -1924

Painter of portraits and genre subjects. Son of Henry Barraud, artist, and nephew of William Barraud, the sporting artist. He studied at the RA Schools, where he won the silver medal, and afterwards at Heatherley's, the Beaux-Arts, Antwerp. Barraud worked from the St. John's Wood area of London and was a frequent contributor to exhibitions. His most celebrated work is probably the original advertisement of 'His Master's Voice'. He died 29 August 1924.

Contrib: *The Graphic [Christmas, 1912].*
Exhib: M; RA; RBA; RI; ROI; RWA.
Colls: Liverpool.
Bibl: *Who Was Who, 1916-28.*

BARRETT, C.R.B. fl.1889-1930

Topographical illustrator.

Illus: *The Tower [1889]; Essex Highways, Byways and Waterways [1892-93]. The Trinity House of Deptford Strand [1893]; Barrett's Illustrated Guides [1892-93]; Somersetshire [1894]; Shelley's Visit to France [C.J. Elton, 1894]; Chaterhouse in Pen and Ink [1895]; Surrey [1895]; Battles and Battlefields of England [1896].*
Bibl: R.E.D. Sketchley, *English Book Illustration*, 1903, pp.47, 48, 132.

BARRIAS, Felix J. 1822-1907

Distinguished French academic painter who won the *grand prix de Rome* in 1844. He contributed sketches of Italy to *The Illustrated London News*, 1847.

BARRIBAL, W.H. fl.1907-1925

Portrait illustrator. He worked through London agents from 1914 to 1925.

Contrib: *ILN, Christmas [1907]; The Graphic [1911].*

BARROW

Wood engraver and illustrator, working in a rather crude and old fashioned style in the second quarter of the 19th century. His chief interest lies in W.J. Linton's claim that he was Charles Dickens's uncle. Charles Knight says much the same: 'His uncle, Mr. Barrow, was the conductor of *The Mirror of Parliament* and sometimes meeting him at the printing-office of Mr. Clowes, he would tell me of his clever young relative . . .' *Passages of a Working Life*, 1865, Vol. 3, p.37.

Illus: *Gulliver's Travels [1864].*
Contrib: *ILN [1843, Queen Victoria's visit to the Midland counties].*

BARROW, Sir John 1764-1848

Amateur draughtsman. Traveller, secretary of the Admiralty and Founder of the Royal Geographical Society. He contributed to the Encyclopaedia Britannica and wrote his autobiography.

Illus: *A Voyage to Cochinchina [1806, AT 514].*

BARTLETT, William Henry 1809-1854

Topographical illustrator. Born in Kentish Town in 1809 and was apprenticed to the topographer, J. Britton. He travelled on the Continent in about 1830 and made visits to Syria, Egypt, Palestine and America. He died on board ship on his last tour, 1854.

Illus: *Britton's Cathedral Antiquities [1832-36]; Picturesque Antiquities of English Cities, Scotland Illustrated [1838]; American Scenery [1839-40, AT 651]; Walks About Jerusalem [1845]; Forty Days in the Desert [1848]; The Nile-Boat or Glimpses of Egypt [1849]; The Overland Route [1850]; Footsteps of our Lord and his Apostles in Syria, Greece and Italy [1851]; Pictures From Sicily [1852]; The Pilgrim Fathers [1853]; Scripture Sites and Scenes [1854].*
Exhib: NWS, 1831-33; RA.
Colls: BM; Fitzwilliam; Leeds; V & AM.
Bibl: W. Beattie, *Brief Memoir of WHB*, 1855; J. Britton, *A Brief Biography of WHB*, 1855.

BARTLETT, William H. ROI 1858-

Painter. Born in 1858 and studied at the École des Beaux-Arts under Gerome and then with Bouguereau and Fleury. Exhibited at Paris in 1889 and received a silver medal and the Legion of Honour. He published various photogravures and his work was reproduced in *The Art Journal*, 1894-97. His rare illustrations are strongly drawn with the use of thick black ink.

Contrib: ILN [1887, Vol.XC p.595].
Exhib: B; FAS, 1892; G; L; M; New Gall; RA; RI; ROI; RWA.
Colls: Auckland; Bradford; Brighton; Leeds; Liverpool; Reading Savage Club; V & AM.

BARTON, Rose M. RWS 1856-1929

Watercolourist. Worked in Dublin until about 1903 and then in London specialising in townscapes. She was elected ARWS in 1893 and RWS in 1911.

Illus: *Picturesque Dublin Old and New [1898]; Familiar London [1904]*.
Exhib: GG; RA; RBA; RWS from 1889.

BATEMAN, Henry Mayo 1887-1970

Comic artist in black and white and caricaturist. Born at Sutton Forest, New South Wales, Australia, 15 February 1887. Returned to England as a child and was educated at Forest Hill House School and at the Westminster and New Cross Art Schools. At a very young age, Bateman was encouraged to go ahead with his career by Phil May and was in the studio of Charles Van Havenmaet for several years before starting to draw for reproduction in 1906. Bateman's inimitable style of humour and line only developed after 1911, when, as he put it, he 'went mad on paper' and drew people how they felt rather than how they looked. His vigorous wholly visual approach was closer to the German work of *Simplicissimus* and Caran D'Ache than to anything in England. His infuriated colonels, gauche little men and haughty dames, spring out of the page with an extraordinary freshness. His art was an infusion to the stuffy pages of *Punch* which had been laughing at social indiscretions rather than with them. Bateman was a master at giving inanimate objects, palpable personality, the complete disintegration of a street in 'Love at First Sight' or the ricocheting chandeliers and twisting columns of 'The Man Who Asked for a Double Whisky in the Grand Pump Room at Bath'. Bateman revolutionised humorous art in Great Britain, making it spontaneous, hilarious and economical. Despite this his success and his failure is in stereotypes, he seldom moved away from Mr. Doolittle's 'middle-class morality' and the sequence of the faux pas. He contributed to almost all the leading weekly and monthly journals and designed several theatrical posters. In later life he was obsessed by Inland Revenue officials, an eccentricity in which he is not alone, and caricatured them mercilessly. Died in Gozo.

Illus: *Scraps [1903]; The Royal Magazine; The Tatler [1904]; London Opinion [1913]; Punch [1915]; The Graphic [1915]; Burlesques [1916]; After Dinner Stories [George Robey, 1920]; A Book of Drawings [1921]; Suburbia [1922]; More Drawings [1922]; Life [1923]; Adventures at Golf [1923]; Reed's The Complete Limerick Book [1924]; A Mixture [1924]; Our Modern Youth [Desmond Coke, 1924]; Colonels [1925]; Reed's Nonsense Verses [1925]; Bateman and I in Filmland [Dudley Clark, 1926]; Further Nonsense Verses and Prose [1926]; The Art of Drawing [1926]; Rebound [1927]; Brought Forward [1931]; Bateman's Booklets [1931]; Fly-Fishing For Duffers [1931]; Considered Trifles [1934]; The Art of Caricature [1936]; H.M. Bateman By Himself [1937]; Spinning for Duffers [1939]; On The Move in England [1940]; Art Ain't All Paint [1944]; Walton's Delight [1953]; The Evening Rise [1960]*.
Exhib: FAS, 1962; Leicester Galleries, 1919, 1921, 1936, 1974.
Colls: Annabels; Author; Guards Club; V & AM.
Bibl: Michael Bateman, *The Man Who Drew The Twentieth Century:* The drawings and cartoons of HMB., 1969; John Jensen, *The Man Who and Other Drawings, HMB.*, Eyre Methuen, 1975.
See illustration (right).

BATEMAN, James 1814-1849

Sporting artist and illustrator. Born in London in 1814 and exhibited at the RA, BI, RBA, 1840-50. Contributed to *The Sporting Review*, 1842-46. Died at Holloway, 24 March 1849.

BATEMAN, Robert

Painter of figures. Exhibited at the RA and Grosvenor Gallery, 1866-89 and illustrated *Art in the House*, 1876.

BATES, Dewey 1851-1899

Landscape painter and illustrator. He was born in Philadelphia, USA, in 1851, but settled in England by 1880 and died at Rye, Sussex in 1899.

Contrib: *The English Illustrated Magazine [1887 (figs.), 1888-91 (land.)]*.
Exhib: L; M; P; RA; RBA; RI; ROI.

BATES, Frederick D.

Illustrator for *The Sketch*, 1895. Worked from Grosvenor Chambers, Deansgate, Manchester, and specialised in chalk drawings of northern subjects. He signs his work F.D. Bates.

Colls: V & AM.

BATTEN, John Dixon 1860-1932

Painter and illustrator. Born at Plymouth, 8 October 1860. He studied at the Slade School under Alphonse Legros and began exhibiting pictures at the RA, New Gallery and Grosvenor Gallery in 1886. Batten was probably the best of that group of illustrators who took mythology as the keynote for their work and assisted such popularisers of it as Andrew Lang. His drawings derive partly from the German woodcuts that were admired by Pre-Raphaelites and partly from the arts and crafts book decoration of Morris and his followers. Batten was closely associated with the later Pre-Raphaelites and in particular with the amateur, George Howard, later Earl of Carlisle. Pennell considered that 'he has a keen appreciation of humour, and is

HENRY MAYO BATEMAN 1887-1970. 'The C.O. – A Man's Man', pen and ink illustration for Punch, *signed and dated 1917.* Author's Collection

very intelligent in his handling.' Batten took his inspiration from Celtic, Norse and even Indian legend and fairy tales, his penmanship has close affinities with the Birmingham School.

Illus: *English Fairy Tales [1890]; Celtic Fairy Tales [1892]; Fairy Tales From The Arabian Nights [1893]; Indian Fairy Tales [1893]; More Celtic Fairy Tales [1894]; More English Fairy Tales [1894]; More Fairy Tales from The Arabian Nights [1895]; A Masque of Dead Florentines [1895]; The Book of Wonder Voyages [1896]; The Saga of the Sea Swallow [1896]; Dante's Inferno [1933].*
Colls: Author; V & AM.
Bibl: J. Pennell, *Pen Drawing and Pen Draughtsmen*, 1894, p.316; *Studio*, Winter No. 1900-01, p.58 illus.; R.E.D. Sketchley, *English Book Illus.*, 1903, pp.109, 110, 158; *Modern Book Illustrators and Their Work*, Studio, 1914; B. Peppin *Fantasy Book Illus.*, 1975, p.185 illus.
See illustration (below).

JOHN D. BATTEN 1860-1932. Illustration of 'The Hunter Finds His Wife' for The Swan Maiden, pen and ink, c.1895. Author's Collection

BATTY, Lieutenant-Colonel Robert FRS **1789-1848**
Topographer and illustrator. He was the son of a surgeon who was also a landscape painter and was educated at Caius College, Cambridge. He entered the Grenadier Guards in 1813 and served in the Peninsular War and at Waterloo, where he was wounded. He spent the remainder of his life in travel and published numerous books illustrated from his own drawings.

At the Mentmore sale in May 1977, the unprecedented price of £40,000 was paid for more than sixty original drawings for Batty's *Hanoverian and Saxon Scenery*, 1829.

Illus: *A Sketch of the Late Campaign in the Netherlands [1815]; An Historical Sketch of the Campaign of 1815 [1820]; French Scenery [1822]; Campaign of the Left Wing of the Allied Army . . . [1823]; Welsh Scenery [1823]; German Scenery [1823]; Scenery of the Rhine, Belgium and Holland. [1826]; Hanoverian and Saxon Scenery [1829]; Six Views of Brussels [1830]; A Family Tour Through South Holland [1831]; Select Views of the Principal Cities of Europe [1832]; The Mutiny and Piratical Seizure of H.M.S. Bounty [1876].*
Exhib: RA, 1813-48.
Colls: Gibraltar Mus.; Nat. Mus., Wales; Wolverhampton.

BAUERLÉ, Miss Amelia R.E.
Illustrator of children's books and decorator. Working from Willesden, 1894-1907.

Illus: *Happy-go-lucky [1894]; A Mere Pug [1897]; Allegories [1898]; Sir Constant [1899]; Glimpses from Wonderland [1900]; Tennyson's The Day Dream [1901].*
Contrib: *The English Illustrated Magazine [1895-97]; The Yellow Book [1897].*
Exhib: L; RE; RI.
Bibl: R.E.D. Sketchley *English Book Illus.*, 1903, p.14.

BAUGNIET, Charles **1814-1886**
Painter, lithographer, engraver and illustrator. Born at Brussels, 27 February 1814, and after studying at the Brussels Academy he became a very succesful portrait painter and illustrator. He settled in London for some time after 1841 and had wide popularity, publishing a portrait of the Prince Consort. He contributed to *The Illustrated London News*, 1851. Died at Sèvres, 5 July 1886.

Exhib: BI, 1847-70; RA.
Colls: BM; Brussels.

BAUMER, Lewis C.E. **1870-1963**
Pastellist and illustrator. Born 8 August 1870, educated at University College School and studied at St. John's Wood Art School and Royal Academy School. Baumer is chiefly remembered for his black and white work during the 1920s and 1930s and he was a prolific contributor to *Punch* and other weekly magazines. He also painted portraits and flower pieces in oils, pastel and watercolour, was a member of the Pastel Society, the Royal Institute of Painters in Watercolours and regularly exhibited with them. All Baumer's drawings are beautifully executed in pen, even if they lack contrast and are in natural succession to Du Maurier, the humour lying in the letter-press rather than in the line; he is the classic suburban artist. Earlier Baumer drawings are often tinted and in softer line than his later work, all reveal an affinity with 18th century French drawings which he admired. He illustrated a number of children's books between the Wars.

Illus: *Jumbles [1897]; Hoodie [Mrs. Molesworth, 1897]; Elsie's Magician [1897]; The Baby Philosopher [1898]; The Story of The Treasure Seekers [E. Nesbit, 1899]; Henny and others [Mrs. Molesworth, 1898-1900].*
Contrib: *The Queen [1892]; The Pall Mall Magazine [1893]; Pall Mall Budget [1894]; The New Budget [1895]; The Unicorn [1895]; Pick-Me-Up [1895]; The English Illustrated Magazine [1896-97]; The Sketch [1896-1901]; St. James's Budget [1898]; Illustrated Bits; The Minister; The Royal Magazine; The Graphic [1910-11]; Punch [1912].*
Exhib: FAS, 1913, 1924; Liverpool; RA; RBA, 1892-93; RI.
Colls: Author; V & AM.
Bibl: *Studio*, Vol.30, 1902, pp.233-239; R.E.D. Sketchley *English Book Illus.*, 1903, pp.99, 159; R.G.G. Price *A History of Punch*, 1955, pp.206-207.

BAXTER, William Giles **1856-1888**
Caricaturist. He was born of English parents in the south of Ireland, where his father had a small business. The venture was not successful and the family moved to America but later returned to England where the father died leaving the widow in difficult circumstances. The young Baxter was apprenticed to a Manchester architect, but at the end of his indentures decided to give it up in favour of black and white work. His first attempt was produced at the age of twenty-one, a series of lithographed pictures entitled *Buxton Sketches*. Early in 1879, he established a satirical weekly in Manchester called *Comus* later changed to *Momus*, which featured among other things a remarkable series of life-size heads, 'Studies From Dickens'. This weekly was not long-lived and Baxter moved to London and with an artist friend concentrated on designing humorous and political Christmas cards. At this point, he met Charles H. Ross, newspaper proprietor and amateur cartoonist, who had started a journal *Ally Sloper's Half Holiday*, loosely written round an imaginary character 'Ally Sloper'. Baxter was able to take Ross's rather feeble drawings and turn them into the lovable but monstrous 'Sloper' who soon became a Victorian legend. He had added to Ross's spindly and bottle-nosed 'Sloper', the props of battered hat, enormous brolly and shaggy dog which were to go with him for a generation and make him instantly recognisable.

Baxter's penwork and detailing, the inheritance from the architectural days, were meticulous, his studies of politicians,

frequently introduced, brilliant. His great importance was that he foreshadowed 20th century cartoons, sustaining his public issue after issue with, in Pennell's words, 'a mystic and symbolic meaning . . . only to be comprehended by his constant followers'. Pennell adds that he was the most original caricaturist of his period and it was a sad day for British illustration when, after the first few numbers of a new publication, *Choodle*, Baxter died of consumption on 2 June 1888. He signs his work W.G. Baxter or WB (monogram).

Illus: *Comus* or *Momus [1879]; Ally Sloper's Half Holiday.*
Contrib: *Judy [1886]; The Graphic [1887-88]; Choodle [1888]; C.H. Ross's Variety Paper [1887-88].*
Colls: V & AM.
Bibl: *The Star*, July 1888; *The Graphic*, 4 August 1888, p.114 illus.; J. Pennell *Modern Illus.*, 1903; J. Pennell, *Pen Drawing*, 1895; J. Thorpe, 'A Great Comic Draughtsman', *Print Colls Quart.*, 1938.

BAYARD, Émile Antoine 1837-1891
Painter and draughtsman. Born at La Ferté-sous-Jouarre on 2 November 1837. He was a pupil of Cogniet and worked for most of the major French magazines including *Journal pour rire, L'illustration, Journal des Voyages, Bibliothèque rose*. In England he worked for *The Illustrated London News*, 1889 and *Cassell's Magazine*, 1887.

Exhib: Paris, 1853-61.
Colls: Pontoise; Rouen; Saintes; Saint-Étienne; V & AM.

BAYES, Alfred Walter RE RWS 1832-1909
Painter and draughtsman. Born at La Ferté-sous-Jouarre on 2 most of his life in London. Bayes was a second generation Pre-Raphaelite follower and specialised in illustrating fairy stories and children's books. He was killed by a motor cab in 1909.

Illus: *What the Moon Saw [1866-67]; Original Poems [Taylor, 1868]; Old Fashioned Fairy Tales [Mrs. Ewing, c.1880].*
Contrib: *Golden Light [1864]; London Society [1865]; The Sunday Magazine [1866]; A Round of Days [1866]; The Boys' Own Magazine; Aunt Judy's Magazine.*
Exhib: B; BI, 1859-67; G; L; M; RA; RBA, 1861-; RE; RHA; RI, 1890-1902; ROI; RWS.

BAYLE, Gertrude E.
Artist working in Margate, contributor to *The Studio* title page competition.

Bibl: *The Studio*, Vol.8, 1896, p.253 illus.

BAYNES, Philip
Humorous illustrator, specialising in comic strips. *The Graphic*, 1910.

BEACH, Ernest George 1865-
Portrait and landscape painter and lithographer. He lectured on art and worked in Holland, Belgium and France.

Contrib: *The English Illustrated Magazine [1890-91, 1897 (topography)].*
Exhib: G; L; NEA; RA; RI; ROI.

BEALE, Evelyn fl.1906-1925
Illustrator of children's books, watercolourist, working in Edinburgh in 1907 and at Glasgow, 1925.

Illus: *The Apple Pie [Jack, 1908].*
Exhib: G; RSA, 1906-24.

BEARD, Dan-Carter 1850-
American illustrator, who succeeded C. Dana Gibson as President of the Society of Illustrators, U.S. He studied under Sartrain and Carroll Beckwith at the Art Students' League, New York, and is included here as the illustrator of English editions of Mark Twain's works, notably *A Connecticut Yankee At the Court of King Arthur*, 1889, and *Tom Sawyer Abroad*, 1894.

BEARD, Frank-Thomas or Francis 1842-1905
American illustrator. He was born in Cincinnatti on 6 February 1842 and became one of the most celebrated illustrators of the American Civil War and a Director of *Illustration* and a frequent contributor to *Harper's Weekly;* he is included here as an occasional artist for *The Illustrated London News.*

BEARDSLEY, Aubrey Vincent 1872-1898
Book illustrator, caricaturist, poster-designer and novelist. Born at Brighton on 21 August 1872 and was educated at Brighton Grammar School. A close-knit family group consisting of a weak father, a dominant mother and a much-loved sister, gave Beardsley that strange love-hate relationship with women which tinges his pictures and gives his sexual allegiances a weird character. He was ailing at school, unable to play games, but developed his own aloof arrogance as a witty and spirited caricaturist. Beardsley's circumstances allowed for no formal training and on leaving school he became a clerk to the Guardian Life Insurance Company in London. He began to admire the prints of the Italian Renaissance and among contemporaries the work of Burne-Jones (q.v.). This led to a meeting with the painter and some encouragement resulting in his attending evening classes at the Westminster School of Art. A visit to Paris in 1892 brought him into contact with the mainstream of French art and the posters of Lautrec. Later the same year, he received a windfall commission from Messrs. Dent to illustrate their new edition of Malory's *Le Morte d'Arthur*, the job that gave him independance to work wholly as an artist. Lewis Hind, the architect of *The Studio* was so impressed by the artist's work that he asked Pennell to write about him ir the first number of it, 1894, publicity that immediately placed him in the front rank.

From 1894 to 1896, Beardsley was in his hey-day, these were the years of *The Yellow Book, The Rape of the Lock* and *The Lysistrata of Aristophanes*, and Wilde's *Salome*. Beardsley's identification with Wilde in the public mind was such that he was damaged by the Wilde scandal of 1895 and lost his art-editorship with *The Yellow Book*. But it was temporary, and in the following year he began on *The Savoy* a successor publication run by Arthur Symons and was engaged on Illustrations to *Mademoiselle de Maupin* and *Volpone*. From 1895, Beardsley's early diagnosed tuberculosis worsened, bringing discomfort and lassitude. After advice from London specialists, he was moved to Mentone where he died on 16 March 1898 at the age of twenty-five.

Beardsley's influence stretches a long way beyond his short life, its linear effects were to recur in architecture, textiles, in the applied arts right up to the 1920s and in a host of major and minor book illustrators' work. He received inspiration from various sources, Japanese prints, the Italian masters, the Pre-Raphaelites, 18th century books, but he remained quintessentially just Beardsley. He was the high priest of aesthetic black and white art, arriving at the moment when half-tone and photogravure were perfected, stretching them to the limit. It was part of the tension in the designs that made them at once astounding and repellant, the menacing presences of androgonous figures, the sickly appearance of over ripe rococo decoration and the melancholy of Harlequin, give his work its disturbing eroticism. In an interview he said, 'If I am not grotesque I am nothing', *The Idler*, Vol.11, p.198.

His various styles can be divided into three groups; an entirely linear style like that of a bas-relief with black and white contrast, a dotted effect as in *The Rape of the Lock* and the later mannerism of *Mademoiselle de Maupin* where line and wash are used with intermediate tones. Apart from his international reputation, Beardsley united book decoration and illustration in this country and gave it credibility with serious artists of the *avant-garde*.

Illus: *Past and Present [Brighton School magazine, 1887-89]; The Bee [1891]; Evelina [cov.]; Malory's Le Morte d'Arthur [1893-94]; Bon Mots [1893-94]; Pastor Sang [1893 (frontis.)]; The Wonderful History of Virgilius the Sorcerer of Rome [1893]; Keynotes series [1893-96 (frontis., cov. & tail)]; Young Ofeg's Ditties [Hansson, 1895 (tail)]; Lucian's True History [1894]; Pagan Papers [Kenneth Grahame, 1894]; Salome [Oscar Wilde, 1894]; The Barbarous Britishers [1895 (frontis. & tail)]; Plays [John Davidson, 1894, (frontis.)]; The Cambridge ABC [1894 (frontis.)]; Baron Verdegris [J. Quilp, 1894]; Today [1894]; The Works of EA Poe [1894-95]; Earl Lavender [John Davidson, 1895]; Sappho [1895]; The Thread and The Path [1895 (frontis.)]; A London Garland [1896]; The Rape of the Lock [1896]; The Life and Times of Madame Du Barry [1896]; Verses [Ernest Dowson, 1896]; The Parade [1897]; A Book of Bargains [Vincent O'Sullivan, 1896]; The Pierrot of the Minute [1897]; Scenes of Parisian Life [1897]; The Souvenirs of Leonard [1897]; Mademoiselle de Maupin [1898]; A History of Dancing [1898]; Volpone [Ben Jonson 1898 (illus., cov. & frontis.)]; The London Yearbook [1898].*
Contrib: *Pall Mall Pudget [1893]; The Studio [1893-95]; Pall Mall Magazine [1893]; The Idler [1894].*
Posthumous books: *The Early Work of Aubrey Beardsley [1899]; The Second*

Book of Fifty Drawings by Aubrey Beardsley [1899]; *Five Drawings Illustrative of Lucian and Juvenal* [1906]; *A Portfolio of Aubrey Beardsley's Drawings* [1907]; *The Later Work of Aubrey Beardsley* [1901]; *The Uncollected Work of Aubrey Beardsley* [1925].
Colls: Ashmolean; Barber Institute; Birmingham; Brighton; BM; Cecil Higgins Art Gallery, Bedford; Fitzwilliam; NPG; Reading Lib.; Sheffield; Tate; V & AM.
Bibl: *The Studio,* Vol.1, No.1, 1893; Vol.13, 1898, pp.252-263; Robert Ross *AB,* 1909; A.E. Gallantin, *AB Catalogue of Drawings and Bibliography,* 1945; Brian Reade, *B* Studio Vista, 1967; B. Reade and F. Dickinson, *AB, Exhibition at the V & AM,* 1966.
See illustrations (below and right).

AUBREY VINCENT BEARDSLEY 1872-1898. The fourth tableau of Das Rheingold, *1896, pen and ink.*
Victoria and Albert Museum

AUBREY VINCENT BEARDSLEY 1872-1898. Frontispiece to Walt Rudding's An Evil Motherhood, *1896.*

BEATRICE, H.R.H. The Princess **1857-1944**
Youngest child of Queen Victoria, born 14 April 1857, and married 1885 H.R.H. Prince Henry of Battenberg. She was an amateur artist and produced *A Birthday Book Designed by Her Royal Highness The Princess Beatrice* London, 1881. This has borders of flowers, insects and berries in colour lithography from her designs. She died 26 October 1944.

BEAUCÉ, Jean-Adophe **1818-1875**
Military painter. He was born at Paris on 2 August 1818 and went on many military expeditions to Algeria, Syria and Mexico and was present at the siege of Metz. He contributed to *The Illustrated London News,* 1859-60 and 1862, including sketches of Garibaldi. Died at Boulogne, 13 July 1875.

BEAUMONT, J. Herbert
Amateur bookplate designer, working at Hessle, East Yorkshire.
Bibl: *The Studio,* Vol.10, 1897, p.274, illus.

BECKEN, A.L.
Contributor to *The Ladies Pictorial,* 1895.

BEDE
Pseudonym of caricaturist contributing two cartoons to *Vanity Fair,* 1905-6.

BEDE, Cuthbert (The Rev. Edward Bradley) **1827-1889**
Author and illustrator. Born at Kidderminster in 1827 and was educated at University College, Durham, 1848, taking a licenciate in theology, 1849, ordained 1850. He held various Midland curacies before becoming Vicar of Denton, Peterborough, from 1859-71. He was subsequently in the livings of Stretton, Oakham, 1871-83, and Lenton with Harby, 1883-89. He learnt wood engraving from George Cruikshank but remained very much the amateur, illustrating his own books, *Mr. Verdant Green* and others in a jolly and careless style. He was one of the first humorous illustrators to satirise photography. He died at Lavington in 1889.

Illus: *The Adventures of Mr. Verdant Green, an Oxford Freshman* [1853-56]; *Little Mr. Bouncer* [c.1877 (child's book)].
Contrib: *Bentley's Miscellany* [1846]; *Punch* [1847-56]; *ILN* [1851 and 1856]; *The Month* [1852]; *The Illustrated London Magazine* [1855]; *Churchman's Family Magazine* [1863].
Colls: BM.
Bibl: M.H. Spielmann, *The History of Punch,* 1895, pp.191-195.

BEDFORD, Francis Donkin **1864-**
Illustrator. He was born in London in 1864 and trained as an architect at South Kensington and the RA Schools. He was articled to the church architect, Sir Arthur Blomfield RA, but turned his attention to illustration in the 1880s and gained a wide popularity in the realm of children's books and as a landscape illustrator. He practised in the

Kensington area until 1914 and was working at Wimbledon in 1925.

Illus: *Old Country Life [1890]; The Deserts of Southern France [1894]; The Battle of the Frogs and Mice [1894]; Old English Fairy Tales [1895]; A Book of Nursery Rhymes [1897]; The Vicar of Wakefield [1898]; Henry Esmond [1898]; A Book of Verses For Children [E.V. Lucas, 1898]; The Book of Shops [E.V. Lucas, 1899]; Four and Twenty Tailors [E.V. Lucas, 1900]; The Original Poems of Taylor and O'Keefe [1903]; Two are Company [Louise Field, 1905]; Old Fashioned Tales [E.V. Lucas, 1905]; A Night of Wonder [1906]; Forgotten Tales of Long Ago [E.V. Lucas, 1906]; Runaways and Castaways [E.V. Lucas, 1908]; Maggie, A Day Dream [Lady Algernon Percy, 1908]; Anne's Terrible Good Nature [E.V. Lucas, 1908 (cover)]; Peter Pan and Wendy [J.M. Barrie, 1911]; The Magic Fishbone [C. Dickens, 1921]; Billie Barnicole [G. Macdonald, 1923]; At the Back of the North Wind [G. Macdonald, 1924]; The Princess and The Goblin [G. Macdonald, 1926]; A Cricket on the Hearth [C. Dickens, 1927]; Count Billy [G. Macdonald, 1928]; A Christmas Carol [C. Dickens, 1931].*
Exhib: RA, 1892.
Bibl: R.E.D. Sketchley, *English Book Illus.*, 1903, p.106, 159; B. Peppin, *Fantasy Book Illustration*, 1975, p.185 illus.

BEDWELL, Frederick LeB.
Assistant Pay-Master on *H.M.S. Actaeon,* coast of China survey, 1862. Accompanied *H.M.S. Nassau* on Admiralty Survey of South America, 1869, contributed sketches to *The Illustrated London News.*

BEECHEY, Henry W. FSA 1870
Painter and explorer. He was the brother of Sir William Beechey and became Consul-General at Cairo, 1816. He explored the Nile with his brother, G.D. Beechey, and surveyed the coastline from Tripoli to Derna, 1821-22. He was elected FSA in 1825 and is believed to have died in New Zealand.

Illus: *Expedition to Explore The Northern Coast of Africa [1828, AT 305].*
Exhib: Sea pieces at RA and BI, 1829-38.

BEER, John-Axel-Richard 1853-1906
Illustrator. He was born at Stockholm on 18 January 1853, but went to America as a young man in 1869 and stayed there for five years. He travelled to Russia and worked as an artist at the Imperial Court, eventually settling in London where he worked for the principal magazines. Beer was an excellent figure artist, at his best in free pen and wash sketches with effective atmospheric backgrounds.

Contrib: *Journal Illustré de Leipzig; The Graphic [1886 (horses)]; Black and White [1891]; The Sporting and Dramatic News [1894]; ILN [1900].*
Colls: V & AM.

BEERBOHM, Sir Max 1872-1956
Caricaturist, novelist and broadcaster. Born in London on 24 August 1872, the youngest son of Julius E. Beerbohm and younger brother of Sir Beerbohm Tree, the actor. Educated at Charterhouse and Merton College, Oxford, the young Max was already cutting a figure in his undergraduate days as a wit, caricaturist and man-about-town. He referred to Oxford as 'the little city of learning and laughter' and this admirably sums up his attitude to life and to his art; he remained the perpetual impish undergraduate, cocking a snook at society and the philistines but never with very heavy artillery. From the circle of Oxford aesthetes, Max graduated to that of the Café Royal and Will Rothenstein, Oscar Wilde and Lord Alfred Douglas. But he remained on the edge of these groups like a good caricaturist, portraying his friends with an elfin touch and setting a seal on the 1890s as much as Beardsley or May. Max was a great admirer of the cartoons of Carlo Pellegrini (q.v.), for *Vanity Fair* and his own drawings are extensions of the type known as *portraits chargés.* He introduced his figures into situations, real or imagined, which gave an extra dimension to the cartoons as well as making them more literary than their proto-types. Max's range was wide but among his favourite targets were Edward, Prince of Wales, Rudyard Kipling, H.G. Wells, Edmund Gosse and the Rothschilds. They were usually drawn with pen, ink and wash, sometimes with a little colour added and always with a fastidious eye for detail. Max's talent was a small and brilliant one which he used with great care and the same miniature scale and perfection is found in his books, a stream of which appeared between 1896 and 1946. From 1910, the year in which he married, Max lived the life of an exile in Italy, his subjects and sources of inspiration remaining totally Edwardian to the end of his days. He died on 19 May 1956 at

Rapallo.

Publ: *The Works of Max Beerbolm [1896]; Caricatures of Twenty-Five Gentlemen [1896]; More [1899]; Second Childhood of John Bull [1901]; Poets' Corner [1904]; Book of Caricatures [1907]; Yet Again [1909]; Zuleika Dobson [1910]; A Christmas Garland [1912]; Fifty Caricatures [1913]; Seven Men [1919]; And Even Now [1921]; A Survey [1921]; Rossetti and His Circle [1922]; Things New and Old [1923]; Observations [1925]; The Dreadful Dragon of Hay Hill [Lytton Strachey]; Mainly on the Air [1946].*
Contrib: *Pick-Me-Up [1894]; The Yellow Book [1894-96]; The Unicorn [1895]; The Savoy [1896]; Vanity Fair [1896 and 1905-06]; Eureka [1897]; The Parade [1897]; The Butterfly; The Idler; The Sketch; The Strand; The Pall Mall Budget; John Bull [1903].*
Exhib: Leicester Galleries, 1925.
Colls: Ashmolean; V & AM.
Bibl: S.N. Behrman, *Portrait of Max,* 1960; David Cecil, *Max a Biography,* 1964; Rupert Hart Davis, *A Catalogue.*
See illustration (p.213).

BEEVER, W.A.
Topographer. He contributed to *Public Works of Great Britain,* 1838, AL 410.

BEGG, Samuel fl.1886-1916
Illustrator and sculptor working in Bedford Park. A prolific contributor to *The Illustrated London News* in the late Victorian and Edwardian periods. Begg seems to have preferred military subjects but also drew sport and the theatre. In many ways he represents the worst features of later illustration, technical perfection in representing almost photographic scenes with heavy use of body-colour but no imagination.

Contrib: *ILN [1887-1916]; Black and White [1892]; Cassell's Family Magazine [1895-96]; The Sporting and Dramatic News [1896].*
Exhib: RA, 1886-91, sculpture.
Colls: V & AM.
See illustration (below).

SAMUEL BEGG fl. 1886-1916. The Gordon Highlanders embarking for South Africa, published in The Illustrated London News, *1899. Grey wash heightened with white.*
 Victoria and Albert Museum

231

BEHNES, William 1794-1864

Sculptor. He was born in London in 1794 and studied in Dublin and at the RA Schools. He exhibited portraits at the RA from 1815-18 but then abandoned painting for sculpture, being commissioned to do many political and royal celebrities. In 1837 he became Sculptor in Ordinary to The Queen but this brought him little new work and he died in abject poverty in 1864. The Victoria and Albert Museum has a pencil drawing of *The Seven Ages of Man,* prepared for *The Saturday Magazine,* December 1832.

Bibl: R. Gunnis, *Dict. of British Sculptors, 1660-1851,* pp.45-48.

BELCHER, George Frederick Arthur RA 1875-1947

Black and white artist. Born in 1875, Belcher was educated at the Edward VI School, Berkhampstead, and at Gloucester School of Art. His *forte* was in charcoal drawing which he made very much his own in the *Punch* of the inter-war years. He was described by Kenneth Bird as 'Phil May in chalk' and R.G.G. Price says that he was 'A Regency buck in manner and a close observer of the appearance of low life by vocation'. Belcher's low life was different from May's in that it was more rural and less barbed, his favourite characters were the charladies, gossips and workmen whose speech he mimmicked so perfectly in his humorous touching figures. An early writer on Belcher in *The Studio* calls his humour 'intrinsic' adding that he had found charcoal the most sympathetic and responsive medium for rendering the subtleties of his models. His backgrounds are carefully observed but wholly atmospheric and a decided break with traditional *Punch* methods. His ability was recognised when he became an ARA in 1931 and an RA in 1945, a highly unusual distinction for an illustrator. He died in 1947.

Illus: *Portfolio of London Types and Characters [1922]; Members and Boxers of the National Sporting Club; Odd Fish [1923]; Potted Char; Taken From Life by George Belcher.*

GEORGE BELCHER RA 1875-1947. Illustration for The Tatler *c.1920, charcoal heightened with white. "Shall I open the other egg sir?" "Certainly not, open the window!"* Victoria and Albert Museum

ROBERT ANNING BELL RA 1863-1933. 'Ophelia', illustration probably for Lamb's Tales from Shakespeare, *1899, pen and watercolour.*
Victoria and Albert Museum

Contrib: *Punch; The Tatler, The Graphic.*
Exhib: FAS, 1924; Leicester Gall; RA from 1924.
Bibl: *The Studio,* Vol.52, 1911, pp.84-94 illus.; R.G.G. Price, *A History of Punch,* 1957, p.214.

BELL, J. fl.1874-1894

Special artist for *The Illustrated London News,* Russo-Turkish War and Constantinople, 1874-78, and Mombassa, 1890. He illustrated George Macdonald's *Phantastes,* Chatto, 1894.

BELL, Robert Anning RA 1863-1933.

Sculptor, illustrator, designer of mosaics and stained glass artist. Born in London in 1863 and educated at University College School and then at Westminster School of Art under Fred Brown and at the RA Schools. He later studied under Aimé Morot and visited Italy where he took part in exhibitions. Bell was associated with the Arts and Crafts Society and was Master of the Art Workers' Guild. He taught at Glasgow, 1914, and was Professor of Design at the RCA, 1918-24. Outside his numerous illustrations, Bell's best work is probably his mosaic in the Houses of Parliament and his tympanum over the west door of Westminster Cathedral.

Bell's early work as an illustrator lies heavily on the Crane style, rather long and angular figures without shading contained in decorative borders. All his work is reminiscent of the woodcut and its two-dimensional quality perhaps results from the large amount of

work undertaken in stained glass. He was elected ARA in 1914 and RA in 1922. Died 27 November 1933.

Illus: *Jack the Giant Killer, The Sleeping Beauty, Cinderella, Beauty and the Beast [1894]; After Sunset [G.R. Thomson 1894 (title and cov.)]; White Poppies [M. Kendall, 1894]; A Midsummer Night's Dream [1895]; The Riddle [1895]; Verspertilia [R.M. Watson, 1896]; An Altar Book [B. Updike, Boston, 1897]; Poems by John Keats [1897]; English Lyrics From Spenser to Milton [1898]; The Pilgrim's Progress [1898]; The Milan [1898]; The Christian Year [1898]; Lamb's Tales From Shakespeare [1899]; The Tempest [1901]; The Odes of John Keats [1901]; Grimm's Household Tales [1901]; Isabella and St. Agnes Eve [1902]; Poems by Shelley [1902]; Rubaiyat of Omar Khayyam [1902]; Shakespeare's Heroines [A.B. Jameson, 1905]; Palgrave's Golden Treasury [1907]; English Fairy Tales [E. Rhys, 1913].*
Contrib: *English Illustrated Magazine [1891-94]; The Yellow Book [1894-95]; Pall Mall Magazine.*
Exhib: B; FAS, 1907, 1934; G; L; NEA from 1888; RA from 1885; RHA; RSA; RWA; RWS.
Colls: V & AM
Bibl: *Studio*, Winter No.1900-01, p.21, illus.; *Modern Book Illustrators and Their Work*, Studio, 1914; R.E.D. Sketchley, *English Book Illus.*, 1903, pp.7, 121. *Who Was Who 1929-40.*
See illustration (p.232).

BELLEW, Frank Henry Temple 1828-1888

Humorous illustrator specialising in outline drawings. Born at Cawnpore in 1828. He emigrated to the United States and from there contributed comic genre subjects to *Punch*, 1857-62. He also illustrated more serious subjects of American character and the Civil War for *The Illustrated Times*, 1861. He died at New York in 1888, his son became 'Chip', cartoonist of New York *Life*.

BENDIXEN, Siegfried Detler 1786-1864

Painter, engraver and lithographer. He was born at Kiel on 25 November 1786 and studied under the Italian artist J.A. Pallivia at Enkendorf. He then travelled to Italy in 1808, to Dresden in 1810 and to Munich and Paris in 1811. Returning to Hamburg in 1813, he opened an art school there in 1815, finally settling in London in 1832. Bendixen produced *Preceptive Illustrations of the Bible*, in about 1840, a child's book of rather 'wooden' colour lithographs.

Exhib: BI; NWS, 1833-64; RA; RBA.

BENHAM, Jane E. (Mrs. Hay) fl.1850-1862

Painter and illustrator. She was a close friend of the artist daughter of William and Mary Howitt and of Miss Jessie Meriton White, a Garibaldi supporter. She studied for some years with the latter under Kaulbach at Munich, and then travelled in Italy. Vizetelly, who says that she married and lived in Paris, describes her as 'a grave and enthusiastic young lady'. There is little doubt that she was an interesting one, her few illustrations, notably those for *Longfellow's Evangeline*, 1850, show German influence, but also a familiarity with Blake, unusual for the date.

Illus: *Evangeline. A Tale of Arcady by Longfellow [1850 (with Birket Foster and John Gilbert)]; Longfellow's Golden Legend [1854]; Beattie and Collins' Poems [1854].* (Vizetelly records a further illustrated edition of Longfellow.)
Exhib: RA, 1848-49; other exhibitions 1859-62.
See illustration (right).

BENNETT, Charles Henry 1829-1867

Illustrator and caricaturist. Apparently untrained but was already contributing to the illustrated press by 1855 with cuts in *Diogenes* and *The Comic Times*. He worked for *Comic News* between 1863 and 1865 and achieved wide popularity with his 'Shadows' and 'Studies in Darwinesque Development' for Vizetelly's *Illustrated Times*. He joined *Punch* in 1865 but only contributed for two years before his death. He was sponsored by Charles Kingsley in producing illustrations for Bunyan and commanded the respect of a wide group of literary men. But his caricature portraits with big heads and tiny bodies were in the style of an earlier humour. White criticised his Bunyan figures for over characterization.

Bennett was a poor business man and left his family in distress. *Punch* staged a benefit night at Manchester for them in 1867 under the superintendance of Sir Arthur Sullivan. His earliest work is signed with an owl and later an owl with a 'B' in its beak for a phonetic pun on Bennett.

Illus: *The Fables of Aesop [1857]; Proverbs with Pictures [1858-59]; Pilgrim's Progress [1859]; Fairy Tales of Science [1859]; Quarles Emblems [1860]; Nine*

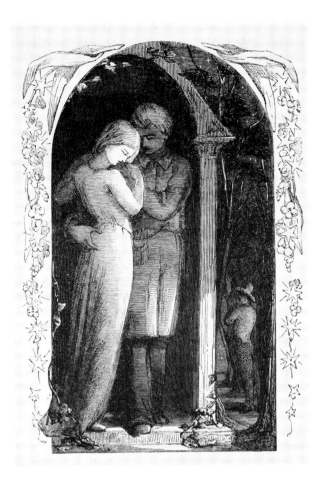

JANE E. BENHAM, MRS. HAY fl. 1850-1862. Vignette illustration for H.W. Longfellow's Evengeline – A Tale of Arcadie, *1850.*

Lives of a Cat [1860]; Stories little Breeches Told [1862]; London People [c.1864]; Mr. Wind and Madam Rain [c.1864]; Lemon's Fairy Tales; The Sorrowful Ending of Noodledo [1865].
Contrib: *ILN [1857 & 1866]; The Illustrated Times [1856]; The Cornhill Magazine [1861]; The Welcome Guest [1860]; Good Words [1861]; London Society [1862-65]; Every Boys Magazine [1864-65]; Beeton's Annuals [1866].*
Bibl: Gleeson White, *English Illus.*, 1895; M.H. Spielmann, *The History of Punch*, 1895; Chatto & Jackson, *Treatise on Wood Engraving*, 1861.
See illustration (p.117).

BENNETT, Fred

Contributor of vigorous and well drawn illustrations to *Chums*, first quarter of the twentieth century.

BENNITT, Colonel Ward

Amateur illustrator; officer in the 6th Inniskilling Dragoons who contributed social cartoons and initial letters to *Punch*, 1875.

BENSON

Working at Plymouth and contributing to *The Illustrated London News*, 1844.

BENSON, Miss Mary K. fl.1879-1907

Artist and decorator of books. Working in Hertford, 1879-90, at Dublin, 1890-1902 and in Bath in 1907. She drew a headpiece for *The Quarto*, 1896, and exhibited at the RA, RBA and RHA. She was the sister of Charlotte E. Benson, the artist, 1846-1893.

BENSON, Robert

Traveller and topographer. Published *Sketches of Corsica*, 1825, AT 76.

BENWELL, Joseph Austin

Painter, watercolourist and illustrator working in Kensington. He specialised in Eastern subjects but sometimes illustrated modern genre subjects with less assurance. He travelled to India and China prior to 1856 and to Egypt and Palestine, 1865-66. Mrs. Benwell was also an artist.

Illus: *Our Indian Army [by Capper]*.
Contrib: *The Welcome Guest [1860]; The Cornhill Magazine [1860]; ILN [1863-64]*.
Exhib: NW, 1865-86; RA; RBA.

BÉRARD, Evremond de fl.1852-1863

French landscape painter, born at Guadeloupe and exhibited at the Salon in 1852. He contributed illustrations of Madagascar to *The Illustrated London News*, 1863.

BERESFORD, Captain G.D.

Illustrated *Scenes in Southern Albania*, 1855, AT 46.

BERKELEY, Stanley fl.1878-1907

Painter and illustrator of animals. Berkeley was a regular contributor to magazines in the 1880s and 1890s either in fancy pictures or for serials. His work shows a heavy use of bodycolour but, though sentimental in character, is seldom ill drawn. He worked at Esher, 1890-1902, and at Surbiton to 1907; his wife Edith Berkeley was also an artist.

Contrib: *ILN [1882-96]; The Graphic [1886]; Black and White [1891]; The Sporting and Dramatic News [1896]; The Sketch [1896]; The Boys' Own Paper; Chums*.
Exhib: B, 1889; L, 1889; NWS; RA, 1878-92; RBA.
Colls: V & AM

BEWICK, Robert Elliot 1788-1849

Engraver and illustrator. Born at Newcastle in 1788, the only son of Thomas Bewick (q.v.), the reviver of English wood engraving. He went into partnership with his father in 1812 and assisted him with the illustrations for Aesop's Fables, 1818, and on the uncompleted *History of British Fishes*. Sketches by him for the latter book as well as some illustrations for *British Birds*, 1826, are in the BM. He died at Newcastle.

BRITISH BIRDS. 57

THE COMMON BUZZARD,

OR PUTTOCK.

(Falco Buteo, Lin.—La Buse, Buff.)

THOMAS BEWICK 1753-1828. The Common Buzzard or Puttock, wood engraving from A History of British Birds, *1816.*
Right: THOMAS BEWICK 1753-1828. The Domestic Cock, wood engraving from A History of British Birds, *1816.*

BEWICK, Thomas 1753-1828

Called the 'restorer of wood engraving in England'. Born at Cherryburn House, Ovingham, Northumberland, 10 August 1753 and was apprenticed to Ralph Beilby, the Newcastle-upon-Tyne copper plate engraver. The young Bewick found his work with Beilby unrewarding because it gave him little opportunity to develop as an artist, but he did find that wood engraving was more expressive. After working in London in 1776, he returned to Newcastle and in partnership with Beilby assembled material for a *History of Quadrupeds*, 1790, entirely illustrated by wood engravings. This was followed by a celebrated print of 'The Chillingham Bull' and his most famous work, *British Birds*, 1797 and 1804. Bewick died at 19 West Street, Gateshead, on 8 November 1828 and was buried at Ovingham..

Bewick's career runs parallel to the rise of the romantic school in painting and poetry. He was the first person to translate wood engraving from the crudities of the broadsheets to a fine art and the first person to recognise that naturalism was the vehicle rather than the enemy of book illustration. His first edition of *Quadrupeds* contained tailpieces borrowed from continental sources, but later editions and subsequent books had vignettes which in originality and observation are among his masterpieces. His miniature landscapes, his foliage, houses and animals are drawn with accuracy and his country folk with a humour and gentle truth. Chatto and Jackson, who were writing in 1838, only a decade after his death, express this well. 'Bewick was truly a *countryman*.....for though no person was capable of closer application to his art within doors, he loved to spend his hours of relaxation in the open air, studying the character of beasts and birds in their natural state; and diligently noting those little incidents and traits of country life which give so great an interest to many of his tailpieces.' *Treatise on Wood Engraving*, p.479. Bewick was a believer in a clean line and did not like cross-hatching, he liked to cut on the block from dark to light which was an innovation from old practice. His influence established Newcastle as the centre of wood engraving and he had a number of pupils; these include, John Bewick, Robert Johnson, Charlton Nesbit, Luke Clennel, and William Harvey (qq.v.).

Illus: *History of Quadrupeds [1790]; History of Birds [1797 and 1804]; Select Fables [1784]; Gay's Fables [1779]; Aesop's Fables [1818]; A Tour Through Sweden*.
Exhib: FAS, 1880.
Colls: BM (large collection); Newcastle; V & AM; Northumberland Nat. Hist. Soc.
Bibl: F.G. Stephens, *TB Notes on a Collection of Drawings and Woodcuts*, 1881; D.C. Thomson, *The Life and Works of TB*, 1882; D.C. Thomson, *The Watercolour Drawings of TB*, 1930.
See illustrations (below, left and p.235).

280 BRITISH BIRDS.

THE DOMESTIC COCK.

THOMAS BEWICK 1753-1828. Tailpiece wood engraving from A History of British Birds, 1816

THOMAS BEWICK 1753-1828. Vignette wood engraving from A History of British Birds, 1816.

BEWLEY, Miss
Landscape illustrator for *Good Words*, 1880.

BIDDARD, C.
Contributor of social subjects to *Punch*, 1902.

BIDDULPH, Major-General Sir Michael Anthony Shrapnel GCB
1823-1904
Soldier and artist. Born at Cleeve Court, Somerset, 1823. Major, 1854, and Colonel, 1874. Served throughout the Crimean War and was at the Siege of Sebastopol. Groom in Waiting to H.M. Queen Victoria and Keeper of the Regalia. Died 23 July 1904.
Illus: *Norway [Forester, 1849]*.
Contrib: ILN, 1880.
Exhib: RBA, 1889-90.

BILLINGS, Robert William **1815-1874**
Landscape painter and architectural illustrator. Born in London in 1815. Worked at Bath, 1834-37. Died at Putney, 4 November 1874. H.M. Colvin suggests that he was a member of the Billing family, who were builders in Reading.
Illus: *Britton's Cathedrals [1832-36 (vignettes)]; Architectural Illustrations...of Carlisle Cathedral [1840]; Architectural Illustrations....of Durham Cathedral [1843]; Architectural Illustrations....of Kettering Church [1843]; Baronial Antiquities of Scotland [1848-52]*.
Exhib: RA, 1845-72.
Colls: Bath AG.

BILLINGHURST, Percy J. **fl.1899-1900**
Illustrator, designer of bookplates. RA Schools, 1897. There is no biographical information about this talented animal draughtsman who did clever pen drawings in elaborate frames for children's books around 1900.
Illus: *A Hundred Fables of Aesop [1899]; A Hundred Fables of La Fontaine [1900]; A Hundred Anecdotes of Animals [Lane, 1901]*.
Bibl: 'P.J. Billinghurst Designer and Illustrator', *The Studio*, Vol.14, 1898, pp.181-186, illus; *The Studio*, Winter No. 1900-01, p.49, illus; R.E.D. Sketchley, *English Book Illus.*, 1903, pp.117, 160.

BILSBIE, Charles
Contributor of cockney figures to *Punch*, 1906. His style is broadly based on that of Phil May.

BINGHAM, The Hon. Albert Yelverton **1840-1907**
Landscape painter. He was born on 11 February 1840, the third son of Denis, 3rd Baron Clanmorris and was D.L. for County Mayo. He died on 31 March 1907.
Illus: *The Voyage of The Sunbeam [Lady Brassey, 1891]*.
Exhib: RA, 1878.

BINT
Contributed one cartoon to *Vanity Fair*, 1893.

BIRCH, Charles Bell ARA **1832-1893**
Sculptor and illustrator. Born in London September 1832 and studied at the RA Schools and in Berlin with Rauch, later becoming assistant to J.H. Foley, RA. His only illustrated work is *Lara, a Tale of Lord Byron*, Art Union of London Album, 1879. This is very hard and teutonic and quite out-moded for its date. Some further unidentified illustrations are at the Victoria and Albert Museum. ARA 1880.

BIRCH, Reginald
Illustrator of *Little Lord Fauntelroy* by Frances Hodgson Burnett, 1886, and *The One I Knew Best of All*, by the same author, 1894.

BIRD, John Alexander H. **1846-**
Painter of animals and illustrator. He specialised in horse subjects and exhibited at the RA, RI and Canadian Academy. He contributed to *Dark Blue*, 1871-73.

BIRD, W.
Pseudonym in *Punch* of Jack B. Yeats (q.v.).

BIRKENRUTH, Adolph **1861-1940**
Illustrator. Born at Grahamstown, South Africa, 28 November 1861. He was educated at University College School, at Frankfort and studied art in Paris. He settled in London by 1883 and from 1890 was a prolific contributor to the magazines, illustrating work by 'Q' and Walter Besant. Birkenruth handled plain chalk with greater mastery than he handled his washes and was more at home in social realism than in anecdotal subjects. He died on 15 September 1940. Signs with monogram AB.
Illus: *The Rebel Queen [Walter Besant, 1894]*.
Contrib: *Black & White [1892]; ILN [1892-99]; The Pall Mall Budget [1893]; The Butterfly [1893]; English Illustrated Magazine [1893-96]; The Sphere [1894]; Pick-Me-Up [1894]; The New Budget [1895]; The English Illustrated Magazine [1895]; The Idler*.
Exhib: Grafton Gall; L; RA from 1883; RBA; RI; ROI; RWS.
Colls: V & AM.
See illustration (p.236).

ADOLPHE BIRKENRUTH 1861-1940. 'A Hopper's Wife', black chalk and wash drawing for a story in The English Illustrated Magazine, *March 1895.*
Victoria and Albert Museum

BLACKBURN, Mrs. J. (née Wedderburn) 1823-1909

An important animal and bird illustrator. The daughter of an influential Scottish family, she showed an early ability for drawing animals and birds. She was influenced by the naturalism of Bewick's woodcuts and on a visit to London in 1840 became acquainted with Mulready and Landseer, the latter telling her that he had nothing to teach her about drawing. She married Professor Hugh Blackburn, Professor of Mathematics in the University of Glasgow and continued to paint and illustrate until the 1890s. She died at Edinburgh in 1909.

Mrs. Blackburn was strongly influenced by the Pre-Raphaelites and admired by both Millais and Ruskin. In a letter of 1861, George du Maurier wrote '. . . look at Mrs. Blackburn, who has monopolised the large page of Good Words, and is decidedly well paid for it too and courted much more for her talent than she ever could be for the title she possesses in common with some 2 or 500 other ladies'. *The Young George Du Maurier*, p.84.

Publ: *Scenes From Animal Life and Character [1858]; Birds Drawn From Nature [1862]; A Few Words About Drawing For Beginners [1893]; Birds From Moidart [1895].*
Illus: *The Instructive Picture Book [A. White, 1859]; Songs and Fables [W.J.M. Rankins, 1874].*
Contrib: *Good Words [1861].*
Exhib: RA from 1863.
Colls: BM.

BLACKWOOD, Lady Alicia

Lithographer and amateur illustrator. She published *Scutari, Bosphorus, Crimea*, 1857, at Bristol, AT 242, and exhibited landscapes at the RA from Box Wood, 1878-80.

BLAIKIE, F.

Contributor of silhouette cartoons to *Punch*, 1904.

BLAIKLEY, Alexander 1816-1903

Portrait painter. Born in Glasgow in 1816 and exhibited at the BI, RA and RBA, 1842-67. He was a contributor to *The Illustrated London News*, 1856.

BLAIKLEY, Ernest 1885-

Painter and etcher. He was born in London on 12 April 1885 and was educated at University College School, London, before studying art at the Slade School. He became Keeper of Pictures at the Imperial War Museum, 1919.

Illus: *The Artist's London [n.d.]*
Contrib: *Punch [1906].*
Exhib: RA; RBA; RI; RSA.

BLAKE, William 1757-1827

Engraver, poet, painter and mystic. Born in London at 28 Broad Street, Golden Square, on 28 November 1757, the son of a hosier. He joined William Pars's Drawing School at the age of ten and was writing poetry at fourteen. He was apprenticed to the engraver James Basire and made drawings of London churches for engraving, entering the RA Schools as an engraving student in 1779, and exhibiting there from 1780. From that date onwards he was engaged in commercial engraving to supplement his meagre income. This included plates after other artists in numerous publications like *The Wits' Magazine*, 1784; *Harrison's Novelists Magazine, Wollstonecraft's Works*, 1791 and various work by the minor author, William Hayley, 1800-09. He illustrated Lavater's *Essays on Physiognomy*, 1789, Young's *Night Thoughts*, 1793-1800, *Leonora*, 1796, *Hayley's Ballads*, 1805, Malkin's *A Father's Memories of His Child*, 1806, Thornton's *Virgil*, 1821, and wood engravings for Phillips *Pastorals*, 1820-21.

Blake's most powerful and individual contribution to illustration was in his Prophetic Books. Blake used his own printing method of relief etching for these, though some are intaglio etched, and then he or Mrs. Blake coloured the figures in imitation of drawings. As Bland says, 'Blake's calligraphy embraces the whole page – borders, figures, and words without distinction. The verse flows into the borders and the figures encroach on the verse. In this Blake goes back to the very earliest manuscripts of the Middle Ages before there was a division between scribe and illuminator and before the attempt was made to add a third dimension to the page.' The dating and printing of these mystic books, text and design, is very complex and can best be understood by reference to *A Bibliography of William Blake* by Sir Geoffrey Keynes, 1921, and the subsequent Blake studies by this author. They are as follows – *Songs of Innocence*, 1789; *Visions of the Daughters of Albion*, 1793-95; *The Gates of Paradise*, 1793; *The Argument*, 1793; *The Book of Thel*, 1789-94; *Songs of Experience*, 1794; *The Book of Urizen*, 1794; *Europe: A Prophecy*, 1794; *America: A Prophecy*, 1793; *Milton*, 1804; *Jerusalem*, 1804-18; *The Marriage of Heaven and Hell*, 1815-21; *Paradise Lost*, 1806; *Paradise Regained; The Song of Los; The Book of Ahania; Dante's Inferno* (incomplete); *The Illustrations of The Book of Job* (incomplete), 1825.

Blake was very influential but not until late in life. From 1818, he gathered round him a group of disciples including John Linnell, Samuel Palmer, Edward Calvert, George Richmond and F.O. Finch. To the Victorians he was a more substantial poet than artist, Ruskin admired his figures but not his colour, though David and William Bell Scott owe much to him (qq.v.). It was only at the end of the century that the growth of the private presses singled him out for praise as the precursor of the book as a total work of art.

Exhib: London, 1809.
Colls: Bedford; BM; Fitzwilliam; Leeds; Manchester; Tate; V & AM.
Bibl: W.B. Scott, *WB Etchings From His Works*, 1878; R.L. Binyon, *The Art of WB*, 1906; G.K. Chesterton, *WB*, 1920; W. Gaunt, *Arrows of Desire*, 1956; D. Bland, *A History of Book Illus.*, 1958, pp.242-246. M. Butlin, *Catalogue Tate Gallery*, 1978.
See illustration (p.237).

WILLIAM BLAKE 1757-1827. 'The Whirlwind of Lovers' from Dante's Inferno, *Canto V, 1824-27. Line engraving* Author's Collection

BLAMPIED, Edmund RE RBA **1886-**
Artist and caricaturist. Born in Jersey of a Jersey family, 30 March
1886. As a schoolboy he worked on farms and studied their animals,
especially horses, eventually going on to study at the Lambeth School
of Art. He exhibited book illustrations in the National Competition,
1905-6 and won an L.C.C. scholarship. Blampied was a witty and fluid
pen artist but concentrated on painting as a career. He took up
etching in 1913, becoming an Associate of the RE in 1920, and RBA,
1938. He lived in Jersey throughout the Occupation and designed the
liberation stamps, 1945.

Illus: *Peter Pan [Hodder, 1939].*
Contrib: *The Graphic [1915].*
Exhib: Leicester Gall., 1923; Salon.
Colls: V & AM.

BLANCHARD, F.L.
Marine painter. Contributor to *The Graphic*, 1905.

BLANCHARD, Ph. **fl.1853-1860**
Figure illustrator. He was chiefly employed on French illustrated
papers according to Vizetelly. He contributed French subjects to *The
Illustrated London News*, 1853.

BLATCHFORD, Montagu
Amateur cartoonist. By profession a carpet designer, Blatchford lived
in Halifax and contributed cartoons to *Punch* in the style of Linley
Sambourne from 1876-81.

BLAYLOCK, T. Todd **fl.1897-1925**
Artist and illustrator. Studied at Poole School of Art and exhibited at
National Competition, 1897. Worked in London in 1907 and at Poole,
1914-25. Exhibited at RA, 1906-13.

Bibl: *The Studio*, Vol. 11, 1897, p.260, illus.

BLOMFIELD, Sir Reginald RA FSA **1856-1942**
Architect, historian and draughtsman. Born in Kent on 20 December
1856 and was educated at Haileybury and Exeter College, Oxford.
Architect of many domestic and civil schemes and gardens. RIBA
Gold Medal. RA 1914, ARA 1905, PRIBA 1912-14. Knighted 1919.
Blomfield was an authority on French architecture and on
architectural draughtsmanship of which he was an accomplished
exponent.

Publ: *The Formal Garden in England [1892]; A History of Renaissance
Architecture in England [1897]; A Short History of Renaissance Architecture
in England [1900]; Studies in Architecture [1906]; The Mistress Art [1908];
History of French Architecture, 1494-1661 [1911]; Architectural Drawing and
Draughtsmen [1912]; History of French Architecture, 1661-1774 [1920]; The
Touchstone of Architecture [1925].*
Contrib: *The English Illustrated Magazine [1888-90].*
Colls: RIBA; V & AM.

BLORE, Edward FRS FSA **1787-1879**
Architect and architectural draughtsman. Born in Rutland, 1787, the
son of Thomas Blore, FSA. He lived as a youth in Stamford and
developed a passion for Gothic architecture and a talent for drawing
it. An introduction to Sir Walter Scott resulted in the chance
commission to rebuild Abbotsford in the Gothic style. He had a very
large practice in the early Victorian period, was a 'special architect' to
William IV and Queen Victoria and as such completed Buckingham
Palace, 1831-37. Surveyor of Westminster Abbey, 1827-49.

Illus: *History of Rutland [T. Blore, 1811]; History of Durham [Surtees,
1816-40]; Northamptonshire [Baker, 1822-41]; Hertfordshire [Clutterbuck,
1815-27]; Britton's Cathedrals [1832-36]; The Provincial Antiquities and
Picturesque Scenery of Scotland; The Monumental Remains of Noble and
Eminent Persons [1824]; Essay on Gothic Architecture [Sir J. Hall, 1813].*
Exhib: RA, 1813-36.
Colls: BM; RIBA; Soc. of Antiq.; V & AM.
Bibl: H.M. Colvin, *Biographical Dict. of English Architects*, **pp.**78-82.

BLOW, Detmar FRIBA **1867-1939**
Artist and architect. He was born on 24 November 1867 and was educated at Hawtrey's. He was a major domestic architect in the first quarter of the century, and specialised in the restoration of old buildings. He died 7 February 1939.

Contrib: *The English Illustrated Magazine [with E.H. New, 1891-92].*
Exhib: RA, 1924.

BLUM, Robert Frederick **1857-1903**
American illustrator who worked for *Scribner's Magazine.* Contributed pen, pencil and wash drawings to *Japonica,* Sir E. Arnold, 1892. Exhibited figures at the RA, 1888.

BLYTH, S.R.
Contributed figures in a posterish style with thick lines to *Fun,* 1900.

BOGLE, W. Lockhart **-1900**
Portrait painter and illustrator. Born in the Highlands and studied at Glasgow University followed by seven years apprenticeship to a lawyer. Abandoned law for painting and studied in Düsseldorf, specialising on his return in Highland subjects and subjects associated with Scottish history. Bogle was also an accomplished archaeologist and a champion wrestler. Died 20 May 1900. He signed his work 'Lockhart Bogle' or 'LB'.

Contrib: *ILN [1886-89]; The Graphic [1882-89]; Good Words [1891-94].*
Exhib: New Gall; RA, 1886-93.
Colls: V & AM.

BOND, A.L.
Illustrator. Nothing is known of this draughtsman who illustrated *The Miller's Daughter* by Alfred Tennyson in about 1855. This book contains fine vignette and page designs with large trees and flowers in juxtaposition with small landscape and in ornamental borders. It is possible that the artist was 'J.L.' Bond, a Welsh landscape painter.

BOND, H.
Draughtsman. He designed the frontispiece for *The Surrey Tourist or Excursions Through Surrey,* 1821, with H. Gastineau.

BONE, Herbert **fl.1882-1907**
Craftsman designer and illustrator. Working in Dulwich, 1902-7. Exhibited at the RA, RBA, RI, 1874-92, and contributed to *The Quiver,* 1882.

BONE, Sir Muirhead **1876-1953**
Etcher, draughtsman and painter. Born in Glasgow on 23 March 1876, the son of a journalist, he studied at the evening classes of the Glasgow School of Art. He moved to London in 1902 and in 1903 married Gertrude Dodd, the sister of Francis Dodd. Bone was a member of the New English Art Club from 1902, having exhibited there from 1898 and was a member of the Society of 12. He made extensive tours with his wife, she providing the text for a number of books illustrated by her husband. Bone did a great deal of his best work as Official Artist on the Western Front and with the Fleet, 1916-18; in the Second World War he was Official War Artist to the Admiralty, 1940-43. He was a Trustee of The National Gallery, 1941-48 and of The Tate Gallery.

Bone's early training as an architect's pupil led him to study buildings, and it is the structure and form of towns, cities and streets which appear most often in his work. But he was very far from being a mere topographer; his *Western Front,* best seen in the large paper edition of 1917, brings the contrasts and the anonymity of that First World War to life in chalk and pencil. Bone was particularly good at observing vast industrial activity and in showing myriad figures from above, a sort of Piranesi in reverse.

Illus: *Glasgow in 1901 [1901]; Children's Children [1908]; Glasgow, Fifty Drawings [1911]; The Front Line [1916]; Merchant Men-at-Arms [1919]; The London Perambulator [1925]; Days in Old Spain [1938]; London Echoing [1948]; Merchant Men Rearmed [1949]; The English and Their Country [1951]; Come to Oxford [1952].*
Contrib: *The Yellow Book [1897].*

Exhib: Colnaghi, 1930; FAS, 1953, 1974, 1975; G; L; Mercury Gall, 1974; NEA; RA; RSA.
Colls: V & AM.
Bibl: Campbell Dodgson, *Etchings and Dry Points of MB.*

BOOT, William Henry James RBA RI **1848-1918**
Landscape painter and illustrator. Born at Nottingham in 1848, he studied at the Derby School of Art. Moved to London and practised in Hampstead, devoting himself in his early years almost exclusively to illustration. He was Art Editor of *The Strand Magazine,* 1895-1915, and a contributor to the first numbers of *The Graphic.* He published two technical books, *Trees and How to Paint Them,* 1883, and *Tree Painting in Watercolours.* 1886. He became a member of the RBA in 1884 and was Vice-President, 1895-1915. He died on 8 September 1918.

Illus: *Picturesque Europe; British Battles; Our Village; Our Own Country; British Ballads; Royal River; Rivers of England; Greater London; Picturesque Mediterranean [1891].*
Contrib: *The Graphic [1870-81]; ILN [1884-86]; Good Words [1890]; The Quiver.[1890]; Boys' Own Paper; The Art Journal; The Magazine of Art.*
Exhib: B; RA, 1874-84; RBA, 1889-1913; RHA; RI; RWA.
Colls: Derby.
Bibl: *Who Was Who 1916-28.*

BOOTH, J.L.C.
Black and white artist contributing to *Punch,* 1896-1906. He usually draws hunting subjects and sometimes signs 'JC Booth'.

BOSSOLI, Carlo **1815-1884**
Painter and draughtsman. Born at Davesco, near Lugano, in 1815 and specialised in military and political subjects, many of which were undertaken in pen and ink. He travelled to Russia, Sweden, Spain and England where he was made a painter to Queen Victoria, finally settling at Turin.

Illus: *Views on the Railway Between Turin and Genoa [1853, AT 176]; The War in Italy [1859-60, AT 177].*

BOSTOCK, John **fl.1826-1859**
Portrait painter. He made a number of drawings for the Annuals, especially *The Chaplet,* c.1840. He exhibited at the RA, RBA, BI and Old Watercolour Society, 1826-69, at first from Regent's Park, later from Manchester and Kensington.

BOTHAMS, Walter **fl.1882-1925**
Landscape painter and illustrator of rural life. Working in London, 1882, Salisbury, 1885-1902 and Malvern, 1903-25. He contributed to *The Illustrated London News,* 1883-84 and 1894, (fishing and architecture).

Exhib: RA; RBA, 1882-91.

BOUCHER, William H. **-1906**
Illustrator. Cartoonist of *Judy,* 1868-87 in succession to J. Proctor (q.v.). Associate of the RWS. Died 5 March 1906.

Exhib: RA, 1888-91.
Bibl: Dalziel, *A Record of Work,* 1901 p.318.

BOUGH, Samuel RSA **1822-1878**
Landscape painter and illustrator. Born at Carlisle on 8 January 1822 and learnt engraving under Thomas Allom, in London. He was for some years in the Civil Service although he continued to associate with artists and in 1845 went to Manchester as scene painter to the Theatre Royal. This was followed by periods at the Princess Theatre, Glasgow, 1848, and the Adelphi Theatre, Edinburgh, 1849. An argumentative and individualistic man who became a well-established Edinburgh character and a popular landscape painter. ARSA 1856, and RSA, 1875. He died in Edinburgh, 19 November 1878.

Illus: *Poems and Songs [Robert Burns, 1875]; Edinburgh, Picturesque Notes [R.L. Stevenson, 1879].*
Exhib: RA, 1856-76; RSA.
Colls: Aberdeen; BM; Dundee; Fitzwilliam; Glasgow; Manchester; NG, Scotland; V & AM.
Bibl: S. Gilpin *SB,* 1905.

BOUGHTON, George Henry RA RI 1833-1905

Painter and illustrator. Born near Norwich on 4 December 1833, the son of a farmer. The family emigrated to the United States in 1839 and Boughton was brought up at Albany where he taught himself to paint. He returned to England in 1853, studying art in London and then went back to the States to practise as a landscape painter. He remained in New York, 1854-59, and then left for France to study under Édouard Frère. He finally settled in London in 1862 and became a regular exhibitor at the RA, being elected ARA, 1879 and RA, 1896.

Boughton established himself as a popular Victorian illustrator who specialised in strongly historical costume subjects with a decidedly literary setting. Van Gogh admired these when they appeared in *The Illustrated London News* and the artist's articles on Holland in *Harper's Magazine*, 1883. Boughton's figures derive a great deal from Fred Walker, but his historical revivalism is very much his own. He died 10 January 1905.

Illus: *Rip Van Winkle; Legend of Sleepy Hollow [Washington Irving, 1893]; The Trial of Sir Jasper [1878]*.
Contrib: *ILN [1870-82]; Good Words [1878]; The Pall Mall Magazine*.
Exhib: B; BI; FAS, 1894; G; GG; L; M; New York, 1857; NW; RA from 1862.
Colls: Ashmolean; V&AM.

BOURNE, James fl.1800-1810

Topographer. He exhibited at the RA, 1800-9, and published *Interesting Views of the Lakes of Cumberland, Westmorland and Lancashire*, n.d.

BOURNE, John Cooke 1814-1896

Topographer and illustrator. Although little is known of this artist, he was solely responsible for one of the most heroic illustrating achievements of the early Victorian period, the publication of two volumes on railway construction. Bourne's *Drawings of the London and Birmingham Railway*, 1839, with its 35 tinted lithographic plates on 30 leaves, united art and industry with the lithograph. *The History and Description of the Great Western Railway*, followed in 1846, with 43 tinted lithographs on 34 leaves with 3 maps. The series provide a unique insight into Victorian engineering stage by stage but, more than that, the artist's role is a new one. 'The revelation of the book is, not surprisingly, of an artist relatively unknown ... with his action pictures of the building of the London and Birmingham Railway ... He apparently foresaw the up-and-down and roundabout viewpoint of the cinema lense for he looks as up to date as Vertov and the most advanced of his documentaries'. John Grierson, *Scotsman*, 18 May 1968. Bourne stood unsuccessfully for election to the New Watercolour Society between 1866 and 1877 and exhibited there and at the RA and RBA. He visited Russia in about 1864.

In general the drawings resemble the work of Prout and J.D. Harding, his figures in particular being large, vigorous and very detailed in the preparatory sketches. He drew on stone for Hay's *Views in Kairo*, 1840, AT 270, and for *The Illustrated London News*, 1860.

Colls: BM; Elton Collection.

BOW, Charles

Contributor to *The Illustrated London News*, 1855.

BOWERS, Miss Georgina (Mrs Bowers-Edwards) fl.1866-1880

Punch's second woman cartoonist. She supplied initials, vignettes and social subjects for the magazine from 1866-76. A keen hunting woman, she lived at Holywell House, St. Albans, and was first encouraged to draw by John Leech. She exhibited in London, 1878-80.

Illus: *Canters in Crampshire [c.1880]; Mr. Crop's Harriers [c.1880]*.
Contrib: *Once a Week [1866]; London Society [1867]*.

BOWLER, Thomas William -1869

Landscape painter and illustrator. Born in the Vale of Aylesbury and lived in Brighton from where he exhibited at the RA and the RBA, 1857-60. In about 1860 he left for South Africa where he became an astronomer at the Cape of Good Hope. He drew many landscapes and drawings of the Cape Town area and contributed some to *The Illustrated London News* in 1860. He died in 1869.

Colls: Cape Town.

BOWLEY, A.L.

Book decorator. Contributing ornament to children's stories in *The English Illustrated Magazine*, 1895-97.

BOWRING, W. Arminger fl.1902-1922

Portrait and figure painter. He worked in London and was elected ROI in 1922.

Contrib: *Punch [1902-5 (children)]*.
Exhib: L; P; RA; ROI.

BOYD, Alexander Stuart 1854-1930

Illustrator. Born in Glasgow on 7 February 1854; practised in his home city until about 1890, contributing humorous drawings to *Quiz* and *The Bailie of Glasgow* under the pseudonym of 'Twym'. After moving to London, Boyd worked at St. John's Wood and drew for most of the leading magazines of the day. His parliamentary subjects were always very accurate and Spielmann considered that the drawings were 'executed with great care and with singular appreciation of the value of his blacks'. His wife, Mary Stuart Boyd, was a writer and they collaborated on a number of books. He emigrated to New Zealand after 1914 and died near Auckland on 21 August 1930.

Illus: *Peter Stonnor [Blatherwick, 1884]; The Birthday Book of Solomon Grundy [Roberts, 1884]; Novel Notes [J.K. Jerome, 1893]; At the Rising of the Moon [Mathew, 1893]; Ghetto Tragedies [Zangwill, 1894]; A Protegée of Jack Hamlin's [Bret Harte, 1894]; The Bell Ringer of Angels [Bret Harte, 1894]; John Inglefield [J.K. Jerome, 1894]; The Sketchbook of the North [1896]; Rabbi Saunderson [1898]; Lowden Sabbath Morn [R.L. Stevenson, 1898]; Days of Auld Lang Syne [1898]; Gillian the Dreamer and Horace in Homespun [1900]; Our Stolen Summer [1900]; A Versailles Christmas-Tide [1901]; The Fortunate Isles [Mrs. Boyd]; Wee Macgregor and Jess and Co. [Bell]; Cottars Saturday Night [Burns]; Hamewith [Murray]*.
Contrib: *Good Words [1890]; The Idler [1892]; Sunday Magazine [1894]; Black and White [1897]; The Graphic [1901-4]; Daily Graphic [1911]; Punch [1896-]; The Pall Mall Magazine; Pictures from Punch [Vol.VI, 1896]*.
Exhib: G, 1889-1906; RA, 1884-87 and 1913; RSA, 1889-1913; RSW.
Colls: Author; Glasgow; V & AM.
Bibl: M.H. Spielmann, *The History of Punch*, 1895, p.567.
See illustration (p.240).

BOYLE, The Hon. Mrs. Richard 'E.V.B.' 1825-1916

Illustrator of poetry and children's books. Born Eleanor Vere Gordon, youngest daughter of Alexander Gordon of Ellon Castle, Aberdeenshire, she married in 1845, the Hon. and Rev. Richard Boyle, MA, Chaplain in Ordinary to Queen Victoria, Vicar of Marston Bigott, Somerset. She received advice from Boxall and Eastlake and was admired as an illustrator by some of the Pre-Raphaelites. Her delightful little books appeared at intervals from 1853 to 1908 and are full of wide-eyed love of nature and a quirky charm of their own. Her inspiration is often in the work of Holman Hunt or Millais and her decorations and mystical pictures come directly from Arthur Hughes or are softened fantasies from Doyle. Her *May Queen* of 1861 is her most successful work, her *Story Without An End*, 1868, perhaps her most famous. At the close of her career, a writer to *The Bookman*, October 1908, p.54, said 'E.V.B. is an aesthete of Ruskin's school, a lover of beautiful things, of what is decent and quiet and old, of gardens, of nature in selections, and of art'. She is indeed the only woman illustrator of competence to emerge before the 1860s. She lived at Maidenhead in middle life and died on 30 July 1916. Signs with monogram.

Illus: *A Children's Summer [1853]; Child's Play [1858]; The May Queen [1861]; Woodland Gossip [1864]; The Story Without An End [1868 (coloured pls.)]; Andersen's Fairy Tales [1872]; Beauty and The Beast [1875]; The Magic Valley [1877]; The New Child's Play [1880]; A Book of Heavenly Birthdays [1894]; Seven Gardens and a Palace [1900]; The Peacock's Pleasaunce [1908]*.
Contrib: *ILN [Christmas, 1863]*.
Exhib: Dudley Gallery; Grosvenor Gallery, 1878-81.
Bibl: B. Peppin, *Fantasy Book Illus.*, 1975, pp.8, 11, 57, 60 illus.
See illustration (p.241).

BOYS, Thomas Shotter　　　　　　　　　　　1803-1874

Painter and lithographer. He was born at Pentonville on 2 January 1803 and articled to G. Cooke, the engraver. In 1825 he went to Paris where he worked for French publishers and met R.P. Bonington. This was the most important influence of his life, for the precocious young painter persuaded him to abandon engraving for watercolours and lithography. Boys grasped the importance of tinted lithographs and the fact that 'painting on stone' was the way to bring the effect of watercolours to the widest public. His masterpiece in this medium was *Picturesque Architecture in Paris, Ghent, Antwerp and Rouen*, 1839, AT 23, which was published at eight guineas. This was followed by *Original Views of London As It Is*, 1842, hand tinted this time and only a small number coloured.

Boys was the most sensitive colourist of the mid-Victorian topographers, his rendering of sunlight on massive building and his patches of local rich colour put him almost on a level with Bonington. But he was not successful and spent the latter part of his life on hack work, illustrating Blackie's *History of England*, and etching plates for Ruskin's *Modern Painters* or preparing lithographs for the *Stones of Venice*. He died at St. John's Wood on October 10 1874.

Exhib: NWS, 1832-73; RA, 1847-48; RBA, 1824-58.
Colls: Ashmolean; Bedford; BM; Fitzwilliam; Liverpool; Mellon, Richmond, Virginia; Newcastle; V & AM.
Bibl: E.B. Chancellor *Original Views of London*, 1926; E.B. Chancellor *Picturesque Architecture in Paris*, 1928; J. Roundell *TSB*, 1974; *Walker's Quarterly*, XVIII, 1926; M. Hardie *Watercolour Paint in Brit.*, 1967, Vol. III, pp.183-185, illus.
See illustration (p.242).

BRACEBRIDGE, Mrs Selina　née Mills　　　　　　　-1874

Watercolourist and traveller. She was born at Bisterne, Hampshire and became a pupil of Samuel Prout (q.v.). Her journeys included visits to Italy in 1824, Italy and Germany in 1825 and the Near East in about 1833. She was in Sweden in 1840 and in the Pyrenees in 1842. She was a friend and sponsor of Florence Nightingale at Scutari and may have been an acquaintance of Edward Lear who owned a sketchbook of hers, now in the Victoria and Albert Museum. Her style is like that of both Lear and W. Page and although her work was usually lithographed by others, she was apparently an amateur lithographer. She died in 1874.

Publ: *Panoramic Sketch of Athens [1836]*.
Contrib: *Finden's Landscape Illustrations of the Bible [1837-38]*.
Colls: Searight Coll; V & AM.

BRADDELL, Kyo

Contributor of two cartoons to *Vanity Fair*, 1891-92. The name is given in Puttick & Simpson's sale catalogue, 17 March 1916.

BRADDYLL, Lt.-Colonel Thomas Richard Gale　　　1776-1862

Amateur caricaturist. Presumably the owner of Conishead Priory near Ulverston, Lancs. He was the originator of Gillray's famous caricature of *Gulliver and the King of Brobdingnag*, 1803.

Bibl: M.D. George *English Political Caricature*, 1959, pp.69, 72, 83, 261.

BRADFORD, Rev. W.

Church of England clergyman of St. John's College, Oxford. He illustrated his own *Sketches of the Country, Character and Costume in Portugal and Spain*, 1809-10, AT 135.

BRADLEY, Basil RWS　　　　　　　　　　　1842-1904

Sporting painter and illustrator. He studied at the Manchester School of Art and was a consistent exhibitor in London and provincial shows He became chief equestrian artist to *The Graphic* in 1869 and his spirited pen did much to enliven its earliest and best years. He became an Associate of the RWS in 1867 and a full Member in 1881. He travelled to New South Wales.

Contrib: *Once a Week [1866]; Cassell's Magazine [1867]; The Graphic [1869-76]*.
Exhib: B; M; RA; RBA; RWS.
Colls: BM; Manchester; Sydney.

ALEXANDER STUART BOYD 1854-1930. A page of sketches in pen and ink for Immediate Parliament, *1898.*　　　　Author's Collection

BRADLEY, Cuthbert　　　　　　　　　　　fl.1885-1907

Equestrian illustrator. Working at Folkingham, Lincolnshire, in about 1907. Contributed to *Moonshine*, 1885, *The Graphic*, 1904 and *The Boy's Own Paper*.

BRADLEY, C.H.

Illustrator and decorative artist. He contributed initials, and social subjects to *Punch*, 1852-60, in a weak and watered-down Tenniel style. His monogram is easily mistaken for that of C.H. Bennett (q.v.).

BRADLEY, Miss Gertrude M.　　　　　　　　fl.1893-1902

Illustrator of children's books. She worked at Brocton, Staffordshire, and produced colourful story-books and fairy tales.

Illus: *Songs For Somebody [1893]; The Red Hen and Other Fairy Tales [1893]; New Pictures in Old Frames [1894]; Just Forty Winks [1897]; Tom Unlimited [1897]; Nursery Rhymes [1897-98]; Puff-Puff [1899]; Pillow-Stories [1901]*.
Bibl: R.E.D. Sketchley *English Book Illus.* 1902, pp.106, 160.

THE HON. MRS. RICHARD BOYLE 'E.V.B.' 1825-1916. Illustration for Alfred, Lord Tennyson's The May Queen, *1861.*

BRADLEY, William H. **1868-**

American illustrator, working at New York. He was Art Director of *Colliers Magazine, Metropolitan* and *The Century*. His work is one of the best examples of the Beardsley manner exported to the United States. Pennell writing in 1895 says, 'The decorative or decadent craze has also reached America and its most amusing representative so far, is W.H. Bradley.' *Modern Illustration*, p.124. He was a talented poster designer and is included here as an artist working for John Lane and exhibiting in this country.

Illus: *Fringilla [R.D. Blackmore, Cleveland, 1895]; The Romance of Zion Chapel [Le Gallienne, 1898]; War is Kind [Stephen Crane, New York, 1899]; Peter Poodle; Toy Maker to The King [1906]; The Wonderbox, Stories [1916]; Launcelot and The Ladies [1927].*

BRADSHAW, Percy Venner **fl.1905-1949**

Illustrator, writer and art teacher. He was born in London and after being educated at Askes School, he studied art at Goldsmiths and Birkbeck Colleges. He was an illustrator for the magazines for many years before developing an art correspondence course and founding the Press Art School at Tudor Hall, Forest Hill, in 1905. He issued portfolios on *The Art of the Illustrator* from about 1914. He had a large private collection of this work.

Publ: *Art in Advertising [1925]; They Make Us Smile [1942]; I Wish I Could Paint [1945]; The Magic of Line [1949].*
Contrib: *The Boys' Own Paper [c.1890].*

BRAGER, Jean Baptiste Henri Durand **1814-1879**

Marine painter and illustrator. Born at Dol, France, on 21 May 1814, and studied with Eugène Isabey. The artist was very adventurous and a keen traveller and ranged through most of Europe and Africa (including Algeria and Senegal), in search of subjects. He attended the expedition that brought back the Emperor Napoleon's body to France and published his drawings. Died at Paris in 1879.

Illus: *La Marine française; La Marine du commerce; Études de marine; Types et physionomie des armées d'Orient.*
Contrib: *The Illustrated Times [1859 (Piedmont campaign), 1860 (Palermo)].*

BRANDARD, Robert **1805-1862**

Landscape painter and engraver. Born at Birmingham in 1805, and came to London for a year in 1824 to study with E. Goodall. He was really a professional engraver and in this capacity worked on Turner's *Picturesque Views in England and Wales*, 1838, and engraved work by Stanfield and Callcott. He drew some illustrations for Knight's *London*, 1841-42. Worked mostly in Islington.

Exhib: BI, 1835-58; OW; RA; RBA, 1831-47.
Colls: Leicester; Manchester; V & AM.

THOMAS SHOTTER BOYS 1803-1874. The North Front of St. James's Palace from the set of twenty-six lithographs published as London As It Is, *1842.*

BRANDLING, Henry Charles fl.1847-1861

Watercolour painter and occasional illustrator. He was an Associate of the Old Watercolour Society from 1853-57, and exhibited at the RA from 1847-50. In 1848, he published *Views in the North of France,* tinted lithographs, AT 98, and in 1851, illustrated W. Wilkie Collins *Rambles beyond Railways;* sepia sketches for the latter were on the art market in London, 1976. Gleeson White records his illustrations to *The Merchant of Venice,* 1860.

Bibl: Chatto & Jackson *Treatise on Wood Engraving,* 1861, p.599.

BRANGWYN, Sir Frank RA 1867-1956

Born at Bruges in 1867, the son of a Welsh architect. Brangwyn was an all round figure, being painter, designer, etcher, lithographer and book illustrator, but basically self-taught. He worked with William Morris at Merton Abbey before going to sea, then travelled extensively in Asia Minor, 1888, Algeria and Morocco, 1889, South Africa, 1891, and in the same year to Spain with Arthur Melville. This is reflected in the very colourful mural and stained glass work which he undertook for town-halls and public buildings, his choice of subjects is in the tradition of the Newlyn School, but some of his wilder schemes are reminiscent of the northern symbolism of Ensor. In illustration, Brangwyn's range was equally wide; he gave full play to the Edwardian love of colour plate books of travel or romance but could hold his own with the best black and white work, preferring chalk to pen, but sometimes powerfully using black and white contrasts. He became an ARA in 1904, and an RA in 1919. He was knighted in 1941 and died in 1956. There are two museums devoted entirely to his work, that at Bruges, opened in 1936, and another is at Orange in the South of France.

Illus: *The Life of Admiral Lord Collingwood [1890]; The Captured Cruiser [Hyne, 1892]; The Exemplary Novels of Cervantes; The Wreck of the Golden Fleece [1893]; The Cruise of the Midge [1894]; Tales of Our Coast [1896];* *Arabian Nights [1896]; Don Quixote [1898]; Tom Cringle's Log [Scott, 1898]; Bread Upon the Waters [Kipling]; Devil and the Deep Blue Sea [Kipling]; Eothen [A.W. Kinglake]; The Book of Bridges [W. Shaw Sparrow, 1915]; Omar Khayyam [1920].* Contrib: *The Graphic [1891-1904]; Pall Mall Budget [1891]; The Idler; The Pall Mall Magazine; The Acorn [1905-6].* Exhib: FSA, 1908, 1910, 1912, 1915, 1916, 1924, 1948, 1952, 1958, 1967; G; New Gall; RA from 1885; RE; RWA. Colls: BM; Fitzwilliam; Glasgow; V & AM; Witt Photo. Bibl: W. Shaw Sparrow *FB and His Work,* 1910; H. Furst *The Decorative Art of FB,* 1924; *The Artist,* May 1897, pp.193-200, illus. See illustration (below).

BRANSON, Paul 1885-

American painter and illustrator, born in Washington in 1885. He illustrated Methuen's 1913 edition of *The Wind in The Willows.* This came in for adverse criticism at the time. 'The author tells the story of some obviously "fairy tale" animals, but in depicting the various characters with so much fidelity to nature . . . the artist seems to us to have entirely missed the spirit of this delightful romance.' *The Studio,* Vol.60, p.249.

BRANSTON, F.W.

Comic illustrator and watercolourist. Contributor to *Hoods Comic Annual,* 1830, exhibited at RBA, 1833, from address at the Old Mint, Tower of London.

BREDIN, E.G.

Army officer and amateur artist. Lieutenant, Royal Regiment of Artillery, 1847; acting Major 1855; Crimean War Medal. Contributed sketches of the Crimea to *The Illustrated London News,* 1854-58.

SIR FRANK BRANGWYN RA 1867-1956. Illustration for The Arabian Nights, *Gibbings Edition, 1896.* Victoria and Albert Museum

BRENNAN, Alfred
Decorative illustrator to *The Artist,* August 1897.

BRETON, William H.
Naval officer and amateur artist. Lieutenant RN, 1827; Reserve, 1862. He published *Excursions in New South Wales,* 1833, AT 575; *Scandinavian Sketches,* 1835, AT 255.

BREWER, Henry Charles RI **1866-1943**
Landscape painter and architectural illustrator. He was the son of H.W. Brewer (q.v.), and studied at the Westminster School of Art. He specialised in views of Spain, Venice and Tangier, all of which he visited. He practised in West London, 1902-25.
Contrib: *The Graphic [1887-1910].*
Exhib: FSA, 1908, 1911, 1932; L; RA; RI; RWA.

BREWER, Henry William **-1903**
Architectural illustrator specialising in panoramic views. He was born and educated at Oxford, though living most of his working life in North Kensington. He exhibited at the RA from 1858, and was in 1869 an unsuccessful candidate for the NWS. After his death in 1903, H.C. Brewer (q.v.), moved into his house.
Illus: *Old London Illustrated [1921].*
Contrib: *The Graphic [1870-1901]; English Illustrated Magazine [1887]; The Daily Graphic [1890]; The Pall Mall Magazine [1894-98]; The Girl's Own Paper [1897-98]; The Dome [1897-99].*
Colls: V & AM.
Bibl: *Art Journal.*

BREWER, J. Alphege
Possibly another son of H.W. Brewer (q.v.), practising at Acton, about 1925. Contributor to *The Graphic,* 1910, architectural subjects, and exhibited with the Royal Cambrian Academy, 1924.

BREWER, W.H.
Watercolourist. There are two drawings in the Victoria and Albert Museum, one for *Master Humphreys Clock* by Charles Dickens, 1840, and the other of fairies, the first signed 'W.H. Brewer delt'.

BREWTNALL, Edward Frederick RWS **1846-1902**
Landscape painter and illustrator. He was an early contributor to *The Graphic* supplying narrative pictures to that magazine and *The Illustrated London News.* He was a member of the RBA from 1882-86, having exhibited there from 1868, and a member of the RWS from 1883. He died at Bedford Park on 15 November, 1902. He signs his work 'EFB'.
Illus: *The Oceans Highway.*
Contrib: *Once a Week [1867]; Good Words For The Young[1869]; The Graphic [1870-74 and 1889]; Punch [1870]; The Illustrated London News [1873-74 and 1892]; Dalziel's Bible Gallery [1880]; Cassell's Family Magazine; English Illustrated Magazine [1887]; The Quiver [1890]; Black and White [1891]; Pall Mall Magazine [1892].*
Exhib: RA; RBA; RWS from 1875.
Colls: Sheffield; V & AM; Warrington.

BRIAULT, Sydney Graham **1887-1955**
Portrait painter and illustrator. He studied at the Regent Street Polytechnic, London, 1900 and at the St. Martin's School of Art.
Contrib: *Punch [1914].*
Exhib: RA.

BRICKDALE, Eleanor Fortescue RWS **1871-1945**
Illustrator, painter and designer. She was born in 1871, the daughter of a barrister and studied at the Crystal Palace School of Art, the RA Schools and with Byam Shaw. She won a prize for the best decoration of a public building in 1896 and began to exhibit at the RA the same year. She represents the last phase of Pre-Raphaelitism, her highly detailed and meaningful little pictures are crammed with medievalism and moral sentiment. She was the ideal illustrator of legend and particularly for those expensive coloured gift books of the 1900s where her bright colours and haughty figures were set off to advantage

on the ample pages. She was also a talented stained glass artist and designed windows for Bristol Cathedral. Her work was sometimes criticised for its confusion of black to white making outlines difficult to see and occasionally on scale 'piggies the size of white rats need a good deal of ingenious defence'. *The Studio,* Vol.13, pp.103-108. ARWS, 1902; RWS, 1919.
Illus: *A Cotswold Village [J.A. Gibbs, 1898]; Ivanhoe [1899]; Tennyson's Poems [1905]; Child's Life of Christ [M. Dearmer, 1906]; Pippa Passes [R. Browning 1908]; Dramatis Personae [R. Browning, 1909]; Beautiful Flowers [Wright, 1909]; Tennyson's Idylls of the King [1911]; Story of Saint Elizabeth of Hungary [W. Canton, 1912]; The Gathering of Brother Hilarius [M. Fairless, 1913]; The Book of Old English Songs and Ballads [1915]; The Golden Book of Famous Women [1920]; Fleur and Blanchefleur [1922]; Palgrave's Golden Treasury [1924]; Christmas Carols [1925]; A Diary of an Eighteenth-century Garden [D.C. Calthrop, 1926]; The Gentle Art [D.C. Calthrop, 1927].*
Exhib: Leighton House, 1904; L; RA; RWS.
Colls: Birmingham; Leeds.
Bibl: *The Studio,* Winter No., 1900-1 p.71 illus.; *Modern Book Illustrators and Their Work,* Studio, 1914, illus.; M. Hardie *Watercolour Paint in Brit.,* Vol. III, 1968 pp.130-131; G.L. Taylor *EFB Centenary Exhibition* Ashmolean, 1972-73.

BRIDGENS, Richard **fl.1818-1838**
Architect, practising in Liverpool, 1818, and later in London, in the gothic style. He published and illustrated *Manners and Costumes of France, Switzerland and Italy,* 1821, AT 21; *Sefton Church . . . ,* 1822; *West India Scenery,* 1836, AT 680; *Furniture with Candelabra and Interior Decorations . . . ,* 1838.
Exhib: RA, 1813-26, architecture.
Bibl: H.M. Colvin *Biog. Dict. of Eng. Architects,* 1954 p.97.

BRIERLY, Sir Oswald Walters RWS **1817-1894**
Marine painter. He was born in Chester in 1817, the son of a doctor, and studied at Sass's School and at Plymouth. In 1841, he made a voyage round the world, but settled in New Zealand for a time and then visited Australia and North and South America. He accompanied the British Fleet to the Baltic on the outbreak of the Crimean War in 1854, and then proceeded to the Black Sea, making drawings that were later published in two books. He travelled with various members of the Royal Family on tours, notably to Norway, 1867-68, and to the Crimea again in 1868. He was elected ARWS in 1872, and RWS in 1890. He became Marine Painter to the Queen in 1874 and was knighted in 1885.
Illus: *Marine and Coast Sketches of the Black Sea [1856, AT 240]; The Englis; and French Fleets in the Baltic [1858].*
Contrib: *ILN [1851, 1854 (Crimea); 1855 (Finland)].*
Exhib: Pall Mall Gallery, 1887.

BRIGHT, Henry of Thames Ditton
Painter of figure compositions, cartoons and an occasional book illustrator. A large gouache picture of humanised frogs was exhibited at the NWS, 1876. It probably had political implications, the two central frogs being identified as the German Emperor and Bismarck.
Bibl: *Country Life,* Nov. 29, 1956 illus.

BRIGHTWELL, L.R. **fl.1914-1938**
Animal painter and etcher. He studied at the Lambeth School of Art and at the Zoological Gardens.
Contrib: *Punch [1914 (figs.)].*
Exhib: L.

BRINE
An early cartoonist for *Punch.* He studied in Paris and in London at the same time as T. Woolner (q.v.), and A. Elmore (q.v.), and worked closely with A.S. Henning (q.v.). He is believed to have taught Birket Foster figure drawing.

BRISCOE, Arthur John Trevor **1873-**
Painter and engraver. He was born at Birkenhead on 25 February 1873 but spent most of his life in East Anglia. Exhibited at the NEA 1896 and 1900 and at the RA. His one attempt at illustration is 'The Mother', published in *The Quarto,* 1896, showing both the influence of Japan and the Birmingham School illustrators.
Exhib: FAS, 1926, 1928, 1930, 1934, 1936, 1940, 1943.

BRISCOE, Ernest Edward 1882-

Watercolourist and illustrator. He was born on 5 March 1882 and exhibited at the RA and RI from Caterham. He illustrated *By Ways of London,* 1928, and specialised in drawings of old houses.

BRITTAIN, I.G.

Contributor of agricultural subjects to *The Strand Magazine,* 1891. This may be identified with Miss Isabel Brittain of Scarborough who exhibited at Dowdeswell Galleries that year.

BRITTEN, William Edward Frank fl.1873-1901

Genre painter and illustrator. Britten was working in London from about 1873, the year in which he began to exhibit at the RBA. He was not a prolific illustrator but an eclectic one, his designs ranging from Victorian classicism to smokey Pre-Raphaelite chalk drawings. He excelled as a decorative artist, placing his subjects in elaborate frames, the Shaftesbury Tribute in *The Graphic* of 1885 is a good example. He was still working in Pimlico in 1890.

Illus: *Carols of the Year, Algernon Swinburne; The Elf Errant [1895]; Undine, [Baron de la Motte Fouqué, 1896]; The Early Poems of Alfred Lord Tennyson [1901].*
Contrib: *The Graphic [1885-86].*
Colls: V & AM.

BRITTON, John FSA 1771-1857

Architectural draughtsman and antiquary. He was born at Kingston St. Michael, Wiltshire in 1771 and after being apprenticed to a publican, became a hop merchant and ballad writer. He joined forces with Edward Brayley in 1801 to produce their first book, *The*

Beauties of Wiltshire, the first of a giant series which was to set the seal on romantic topographical guides for a generation. Britton gave up his interest in the project after Volume VII but was supplying illustrations for his successor J.C. Smith in 1814. A poor draughtsman, Britton was a brilliant self-made and irrepressible editor. For his works he gathered illustrative artists together calling them 'scientific artists' and showed a definite feel for book-making, highlighted by his use of Whittingham as his printer. He died in 1857 having published his mammoth *Autobiography,* 1850.

Publ: *Architectural Antiquities of Great Britain [1805-14]; Cathedral Antiquities of England [1814-35]; Specimens of Gothic Architecture [1823-25]; The Architectural Antiquities of Normandy [1825]; Dictionary of Architecture and Archaeology of the Middle Ages [1829]; Public Buildings of London [1825-28]; History . . . of the . . . Palace . . . of Westminster [1834-36, with Brayley]; Architectural Description of Windsor [1842].*
Exhib: RA, 1799-1819.
Colls: Ashmolean; BM; Devizes.
Bibl: *RIBA Papers,* 1856-57; *AJ* February 1857; J. Mordaunt Crook 'John Britton and the Genesis of the Gothic Revival', *Concerning Architecture,* Penguin, 1968, pp.98-119.

BROCK, Charles Edmund RI 1870-1938

Book illustrator and portrait painter. Born at Cambridge in February 1870 and spent the whole of his working life there. Educated at the Cambridge School and in the studio of Henry Wiles, sculptor. Like his younger brother, H.M. Brock, (q.v.), his metier was in the illustration of period books, the worlds of Jane Austen, Charles Lamb, Oliver Goldsmith, and Daniel Defoe, but also of Scott's classics and the stories of Whyte-Melville. His career began in earnest in the middle 1890s and he continued to produce a regular output until his death in

*Sang to him instead
of the cruelty of Barbara Allen*

CHARLES EDMUND BROCK RI 1870-1938. *Illustration for an 18th century story, pen and ink, signed and dated 1906.*

HENRY MATTHEW BROCK RI 1875-1960. Illustration for 'Mrs. Bellamy's Diamonds', c.1905, pen and ink. Author's Collection

1938. In general his pen drawings have a lighter touch than his brother's and are softer in their contrasts, the finished watercolours have an all over pastel hue which to the present writer is less successful than the black and white work.

The Brocks worked closely together in the same studio and gained stimulation from each other. One of their influences was undoubtedly the work of Hugh Thomson (q.v.), but their accuracy in period settings was greater than his, they collected Georgian furniture and clothing to study from. He became RI, 1908; and died at Cambridge 28 February 1938.

A full Bibliography of illustrated books is found in *The Brocks, A Family of Cambridge Artists and Illustrators,* by C.M. Kelly, 1975.

Contrib: *Good Cheer [1894]; Sunday Magazine [1894]; Good Words [1895-96]; Punch [1901-10]; Fun [1901]; The Graphic [1901-10]; ILN [1912] Tucks Annuals; Blackie's Annuals.*
Exhib: L; RA, from 1906; RI.
Bibl: *The Studio,* Winter No. 1900-01 p.37 illus.; *Modern Book Illustrators and Their Work,* Studio, 1914 illus.; C.M. Kelly, op. cit.
See illustration (p.244).

BROCK, Henry Matthew RI 1875-1960
Book illustrator and landscape painter. Born at Cambridge 11 July 1875, the younger brother of C.E. Brock (q.v.). He was educated at Cambridge Higher Grade School and at the Cambridge School of Art before joining his brother's studio. He married in 1912 his cousin, Doris Joan Pegram, sister of Fred Pegram (q.v.). There is little difference in the careers of the two brothers, except that H.M.'s was longer and in many respects more varied, he painted landscapes and was more gifted as a humorous artist. Although meticulous in signing

their drawings, H.M.'s can usually be told apart by their thicker ink lines and bolder handling. He was elected RI in 1906 and died at Cambridge in 1960.

A full Bibliography of illustrated books is found in *The Brocks, A Family of Cambridge Artists and Illustrators,* by C.M. Kelly, 1975.

Contrib: *Cassell's Family Magazine [1896-97]; The Quiver [1897-98]; Good News [1898]; The Captain; C.B. Fry's Magazine; Chums Annual; Blackie's Annuals; The Strand Magazine; Fun [1901]; The Graphic [1901]; Punch [1905-40, 415 drawings]; The Sphere [c.1912].*
Exhib: B; L; RA, 1901-1906; RI.
Colls: V & AM; Witt Photo.
Bibl: *Modern Book Illustrators and Their Work,* Studio, 1914 illus., C.M. Kelly, op. cit.
See illustration (above).

BROCK, Richard Henry fl.1902-1925
Landscape painter and illustrator. Brother of C.M. and H.M. Brock (qq.v.). He practised at Cambridge in the family studio but concentrated more on the illustrations of boys' annuals.

Contrib: *Punch [1916-17]; Chatterbox and Prize Annuals [1908-25]; Blackie's Boys' Annuals.*
Exhib: L; M; RA, 1901-13; RI.
Bibl: C.M. Kelly, op. cit.

BROMLEY, Clough W. fl.1880-1904
Landscape and flower painter, engraver and illustrator. He worked in London and contributed pastorals, architecture and decoration to *The English Illustrated Magazine,* 1885-87, 1896.

Exhib: B; L; M; RA; RBA; RHA; RI; ROI.

BROMLEY, Valentine Walter **1848-1877**
Painter and illustrator. Born in London in 1848 and exhibited at
London exhibitions, 1865-77. He married Miss A.L.M. Atkinson, the
landscape painter and was assistant on *The Illustrated London News,*
1873. He travelled to the United States in 1875, illustrating Lord
Dunraven's *The Great Divide* and died at Fellows Green, near
Harpenden in 1877. Member of RBA, 1871.

Contrib: *The Graphic [1872-73]; ILN [1873-79]; Punch [1876].*
Exhib: NWS; RA; RBA, 1867-74.
Colls: Shipley; Witt Photo.

BROOK, Ricardo
Illustrator of comic genre. He contributed to *Punch,* 1914.

BROOKE, Sir Arthur De Capel, Bt. **1791-1858**
Amateur artist, son of Sir R. De Capel Brooke, he travelled in Europe
and published several books illustrated by himself. These included *A
Winter in Lapland and Sweden,* 1827; *Winter Sketches in Lapland,*
1827; *Sketches in Spain and Morocco,* 1837.

BROOKE, E. Adveno
Topographer exhibiting at the RA, BI and RBA, 1844-64, from
addresses in Islington and Shepherd's Bush. He illustrated *The Book
of South Wales* by Mr. and Mrs. S.C. Hall, 1861.

BROOKE, Leonard Leslie **1863-1940**
Painter and illustrator. Born at Birkenhead and educated there before
being trained in the RA Schools, Armitage medal, 1888. Brooke's
talent lay in the illustration of children's books, his figure drawing is
strong, characterised by cross hatching and he is capable of
considerable humour. He is best remembered as the illustrator of Mrs.
Molesworth's works, 1891-97. He died at Hampstead, 1 May 1940.

Illus: *Miriam's Ambition [1889]; Thorndyke Manor [1890]; The Secret of the
Old House [1890]; The Light Princess [G. Macdonald 1890]; Brownies and
Rose Leaves [1892]; Bab [1892]; Marian [1892]; A Hit and a Miss [1893];
Moonbeams and Brownies [1894]; Penelope and The Others [1896]; School in
Fairyland [1896]; Mrs. Molesworth's Works [1891-97]; Pippa Passes [Robert
Browning, 1898]; A Spring Song [1898]; The Pelican Chorus [E. Lear, 1900];
The Jumblies [E. Lear, 1900]; Johnny Crow's Garden [1903]; The Book of Gilly
[Emily Lawless, 1908]; Johnny Crow's New Garden [1935].*
Contrib: *English Illustrated Magazine [1896]; The Parade [1897].*
Exhib: B; L; M; New Gall; NWS, 1887-1901; RA.
Colls: Manchester.
Bibl: *The Studio,* Winter No. 1900-01, p.74 illus.; R.E.D. Sketchley, *English
Book Illus,* 1902, pp.99, 160; *Who Was Who,* 1929-40.

BROOKE, William Henry **1772-1860**
Illustrator and caricaturist. Born in 1772, the nephew of Henry
Brooke, the historical painter. He exhibited portraits and figure
subjects at the RA, 1810-26, but is best known as an illustrator in the
style of Stothard. His comic cuts are in the manner of William Heath
(q.v.). He practised first in Soho, moving to the Adelphi and finally to
Bloomsbury. He died at Chichester in 1860.

Illus: *Moore's Irish Melodies [1822]; Hone's Every Day Book [1826-27]; The
Fairy Mythology [T. Keightley, 1828]; Greek and Roman Mythology [T.
Keightley, 1831]; Walton's Angler; The Humorist [W.H. Harrison, 1832];
Antiquarian Etching Club.*
Contrib: *Satirist [1812-14]; Britton's Cathedrals [1832-36, figures only].*
Colls: BM; V & AM.

BROOKES, Warwick **1808-1882**
Designer and illustrator. Born at Salford in 1808 and was one of the
first pupils of the new School of Design established at Manchester in
1838. He then became a leading figure among the group of artists in
the North-West who wished to study from the life and came together
as The United Society of Manchester Artists. Brookes made a
considerable local reputation and after the Manchester Exhibition of
1857, received encouragement from the Prince Consort and made
yearly visits to London. He was head designer of the Rossendale
Printing Company from 1840-66.

Illus: *Marjorie Fleming [J. Brown, 1884]; WB's Pencil Pictures of Child Life
[T. Letherbrow, 1889].*

Contrib: *A Round of Days [1866, heads].*
Colls: BM.

BROOKSHAW, George **fl.1818-1819**
Flower painter and drawing-master. He illustrated his own *New
Treatise,* 1818, AL 96 and *Groups,* 1819, AL 97.

Exhib: RA, 1819.

BROUGH, Robert ARSA **1872-1905**
Painter. Born at Invergordon, Ross, in 1872 and was educated in
Aberdeen and Glasgow. Studied art at Aberdeen Art School and at the
RSA, Edinburgh and later in Paris. In Edinburgh he gained the Watters
medal and Chalmers bursary. His first London success was with his
portrait of W.D. Ross of *Black & White* shown at the New Gallery. He
died 22 January 1905.

Contrib: *The Evergreen [1896].*
Exhib: Dresden, 1901; G; L; Munich, 1897; N; Paris, 1900; RA, 1897; RSA.

BROWN, A.
Contributed architectural subjects to *Illustrated London News,* 1847.

BROWN, Major Cecil MA RBS **1867-**
Equestrian artist and sculptor. Born at Ayr, 1867 and educated at
Harrow and Oxford. He designed the medal for the International
Medical Congress, London, 1913, and served in the First World War,
1914-18. Art master at Bedford School, 1925.

Illus: *The Horse in Art and Nature.*
Contrib: *ILN [1896].*
Exhib: Paris Salon; RA from 1895.

BROWN, Ford Madox **1821-1893**
Painter and occasional illustrator. He was born in Calais in 1821 and
studied art in Belgium and Rome. He came into contact with the
newly formed Pre-Raphaelite Brotherhood in 1848, when he took
D.G. Rossetti (q.v.), as a pupil. Brown remained on the edge of the
group, but his contact with them was mutually beneficial; it is
particularly marked in his illustrative work where an earnestness and
attention to detail is predominant. In 1857, he spent three days in a
mortuary getting accurate information on the decomposition of the
body for a woodcut illustration measuring 3¾ins. x 5ins.! Perhaps his
finest works were the two illustrations for Rossetti's poem 'Down
Stream' which combine technical mastery and an objective view of
love and nature. Brown taught at the Camden Town Working Men's
College from 1854 and was a designer for Morris, Faulkner and Co.,
1861-74. He signs his name 'FMB' or 'FMB/89'.

Illus: *The Feather [1892].*
Contrib: *Willmott's Poets of the Nineteenth Century [1857]; Lyra Germanica
[1868]; Once A Week [1869]; Dark Blue [1871]; Dalziel's Bible Gallery
[1880-81]; The Builder [1887]; Brown Owl [1891, title and illus.]; Dramas
in Miniature [Mathilde Blind, 1897].*
Exhib: BI, 1841-67; RA.
Colls: Ashmolean; Bedford; BM; Manchester; V & AM.
Bibl: F.M. Hueffer, *Memoir of MB,* 1896; Gleeson White, *English Illustration,
The Sixties,* 1906; F. Reid, *Illustrators of The Sixties,* 1928, pp.48-50; J. Maas,
Victorian Painters, 1969, pp.131-132.

BROWN, Isaac L.
Draughtsman. Contributor to *London Society,* 1868.

BROWN, James
Illustrator for *Judy,* 1887.

BROWN, John
Architect and County Surveyor of Norfolk. Contributed a church
genre subject to *The Illustrated Times,* Christmas, 1856. He exhibited
at the RA, 1820-44.

BROWN, J.D. or J.B.
Contributor to *Good Words,* 1860. Exhibited at the RBA, 1862.

BROWN, J.R. fl.1874-1890

Illustrator. Working at Sefton Park, Liverpool and contributing regularly to *The Graphic,* 1874-77 and 1885-88. The artist has a wide range, tackling comic and genre subjects as well as social realism. Among his best work here is 'Common Lodging House', 1888.

Exhib: L, 1889.

BROWN, M.

Landscape illustrator for *The Illustrated London News,* 1888. Presumably the same as artist practising in Edinburgh and exhibiting at the RSA, 1889.

BROWN, Oliver Madox

Painter. Son of Ford Madox Brown (q.v.). He illustrated with his father, Moxon's edition of the *Poetical Works of Lord Byron,* 1870.

BROWN, T.R.J.

Illustrator working exclusively for *Ally Sloper's Half Holiday,* c.1890.

BROWN, Thomas fl.1842-1856

Painter, sculptor and illustrator. He worked at Pentonville and exhibited at the RA and BI from 1842-55. He illustrated *The Complete Poetical Works of William Cowper,* for Gall & Anglis, Edinburgh, n.d., c.1840.

Colls: Witt Photo.

BROWN, Thomas Austen ARSA 1857-1924

Painter of genre and landscape, illustrator. Born at Edinburgh, 18 September 1859 and was educated there. He was an RA exhibitor from 1885 and a Member of the RI, 1888-99 and a member of The National Portrait Society. He exhibited abroad at Munich, Dresden and Barcelona and won many medals. He died at Boulogne.

Brown has a very individual style both in his watercolours and in the coloured woodcuts he undertook. The figures are sketchy and undefined, the buildings wavy in soft tints. He signs his name with a monogrammed TAB.

Illus: *Bits of Old Chelsea [1922, lithographs].*
Contrib: *ILN [1899].*
Exhib: FAS, 1900, 1903; NWS; RA; RSA.
Colls: BM; V & AM.
Bibl: *Who Was Who, 1916-28.*

BROWN, W.

Illustrator of *The Comic Album,* and contributor to *Punch,* 1844. The same artist may be William Brown exhibiting at the RBA from 1825-33 with an address in Chelsea.

BROWNE, Gordon Frederick RI 1858-1932

Painter and illustrator. Born at Banstead, Surrey, the younger son of H.K. Browne, 'Phiz' (q.v.). He was educated privately and then studied art at Heatherley's, following his father into book illustration as a profession. From about 1880, Browne illustrated a truly amazing quantity of boys' stories, tales and novels, among them works by Defoe, Swift, Bunyan, Scott, R.L. Stevenson, Andrew Lang, and E.F. Benson. In many ways he was the superior of his father as a figure draughtsman, but although very prolific never reached the latter's stature, principally because he had no one writer to collaborate with. He was clearly an artist who pleased editors and in this way there is a sameness about his work which dulls it; characters look much alike whether they are Besant's or Henty's! He was elected RI in 1896 and died 27 May 1932. He signs his name 'GB'.

Illus: *Stevenson's Island Nights Entertainments [1893]; Grimm's Fairy Tales [1894]; National Rhymes of the Nursery [1894]; Sintram and His Companions Undine [1896]; Dr. Jolliboy's ABC [1898]; Stories from Froissart [1899]; Mrs. Ewing's works including: Man's Meadow, Melchior's Dream, The Peace Egg, Dandelion Clocks; F. Anstey's Stories For Boys and Girls [1898, covers and illus.]; A Book of Discoveries [J. Masefield, 1910].*
Contrib: *ILN [1881-87, 1891-98]; The Quiver [1890]; Black & White [1891]; Good Words [1891-97]; Chums [1892]; The Captain; Lika Joko [1894]; The New Budget [1895]; The Sporting and Dramatic News [1899]; Cassell's Saturday Journal; Cassell's Family Magazine; The Boy's Own Paper; The Girl's Own Paper; The Pall Mall Magazine; The Sunday Strand [1906].*
Exhib: L; RA, 1886; RBA; RI, 1890-1925; RWA.
Colls: Author; BM; Doncaster; Hove; V & AM.
Bibl: R.E.D. Sketchley, *English Book Illus.,* 1902, pp.161-5, (this contains a full bibliography to 1901); *The Studio,* Winter No. 1900-01, p.27, illus.

HABLOT KNIGHT BROWNE 'PHIZ' 1815-1882. Illustration of a beach scene for unidentified book, pen and ink. Victoria and Albert Museum

TOM BROWNE RI 1872-1910. 'A Dispute with a servant.' Illustration for unidentified periodical, pen and ink and crayon. Author's Collection

BROWNE, Hablot Knight 'Phiz' 1815-1882

Watercolourist, book illustrator and humorous artist. He was born at Kennington in 1815 and after being educated in Suffolk was apprenticed to Finden, the engraver, subsequently opening a studio of his own and attending the St. Martin's Lane School. He was the artist who most benefited from the untimely death of Robert Seymour (q.v.), when he succeeded him as Dickens' illustrator for *Pickwick Papers*, 1836. The same year he had produced the illustrations for another Dickens work *Sunday As It is*, and he was to continue to do so with the major novels, until unseated by more modern illustrators in the 1860s. Browne's draughtsmanship was in the tradition of the Regency, verging on caricature, scratchy in execution and not always very assured in the penwork. His work would not perhaps have remained so stereotyped and old fashioned if he had not stuck to plates when the whole world was enjoying the woodblock. By the time that *Little Dorrit* appeared in 1857 he was moving towards a greater naturalism. Dickens seems to have found the artist companionable and took him on two trips to collect material. He became paralysed in 1867 and moved to Brighton in 1880, where he died in 1882.

Illus: *Sunday under Three Heads [Dickens, 1836]; Posthumous Papers of the Pickwick Club [Dickens, 1836-37]; Sketches of Young Ladies by 'Quiz' [1837]; Sketches in London [Grant, 1838]; A Paper of Tobacco [1839]; Nicholas Nickleby [Dickens, 1839]; Harry Lorrequer [C. Lever, 1839]; Master Humphrey's Clock – Old Curiosity Shop and Barnaby Rudge [Dickens, 1840-41]; Legendary Tales of the Highlands [1841]; Charles O'Malley [C. Lever, 1841]; Peter Priggins [1841]; Rambling Recollections [Maxwell, 1842]; Jack Hinton [C. Lever, 1842-43]; Irish Peasantry [W. Carleton, 1843-44]; Martin Chuzzlewit [Dickens, 1844]; Tom Burke [C. Lever, 1844]; St. Patrick's Eve [C. Lever, 1845]; Tales of the Train [C. Lever, 1845]; Nuts and*

Nutcrackers [1845]; The O'Donoghue [C. Lever, 1845]; Fiddle-Faddle's Sentimental Tour [1845]; Fanny the Little Milliner [1846]; The Commissioner [1846]; Teetotalism [1846]; Dombey & Son [Dickens, 1846-48]; The Knight of Gwynne [C. Lever, 1847]; The Fortunes of Colonel Torlogh O'Brien [1847]; Irish Diamonds [1847]; Old St. Paul's [W.H. Ainsworth, 1847]; Pottleton Legacy [Albert Smith, 1849]; David Copperfield [Dickens, 1849-50]; Roland Cashel [C. Lever, 1849-50]; Sketches of Cantabs [Albert Smith, 1850]; The Illustrated Byron [1850]; The Daltons [C. Lever, 1850-52]; Ghost Stories [1851]; Lewis Arundel [Frank Smedley, 1852]; Bleak House [Dickens, 1852-53]; Letters Left at the Pastrycooks [Horace Mayhew, 1853]; Crichton [W.H. Ainsworth]; Christmas Day [1854]; The Water Lily [H. Myrtle, 1854]; The Dodd Family Abroad [C. Lever, 1854]; Harry Coverdale's Courtship [Frank Smedley, 1854]; Martins of Cro' Martin [C. Lever, 1856]; Home Pictures [1856]; Little Dorrit [Dickens, 1855-57]; Spendthrift, Mervyn Clitheroe [W.H. Ainsworth, 1857-58]; Davenport Dunn [C. Lever, 1859]; The Minister's Wooing [H.B. Stowe, 1859]; Tale of Two Cities [Dickens, 1859]; Ovingdean Grange [W.H. Ainsworth, 1860]; Twigs for Nests [1860]; One of Them [C. Lever, 1861]; Puck on Pegasus [C. Pennell, 1861]; Barrington [1862-63]; Tom Moody's Tales [Mark Lemon, 1864]; Facey Romford's Hounds [1864]; Luttrell of Arran [C. Lever, 1865]; Ballads and Songs of Brittany [1865]; Can You Forgive Her? [A. Trollope, 1866]; Dame Perkin's and Her Mare [1866]; Phiz's Funny Alphabet [1883].

Contrib: *New Sporting Magazine [1839]; London Magazine [1840]; Punch [1842-44, 1861-69]; The Great Gun [1844]; ILN [1844-61]; Ainsworth's Magazine [1844]; The Illuminated Magazine [1845]; The Union Magazine [1846]; Life [1850]; Illustrated London Magazine [1853-55]; The Illustrated Times [1855-56]; New Monthly Magazine; Only a Week; Tinsley's Magazine; London Society; St. James's Magazine; Illustrated Gazette; Sporting Times; Judy; The Welcome Guest.*

Exhib: BI, 1843-67; FAS, 1883; RA; RBA, 1865-86.

Colls: BM; Manchester; V & AM.

Bibl: Chatto & Jackson, *Treatise on Wood Engraving*, 1861, p.599; F.G. Kitton, *Phiz a Memoir*, 1882; D.C. Thomson, *Life and Labour of HKB*, 1884; S.M. Ellis, *Mainly Victorian*, 1924.

See illustrations (pp.84 and 247).

248

BROWNE, N. Robert
Humorous illustrator for *Fun*, 1901.

BROWNE, Tom RI **1872-1910**
Painter and black and white artist. Born at Nottingham in 1872 into a
working class family and after attending the National School, left at
the age of eleven to work in the city's Lace Market. Browne had a
talent for sketching which led to his being apprenticed to a firm of
lithographers in 1886 where he remained until 1893. He had been
doing commercial illustration from 1889 and in 1895 settled in
London, where he exhibited at the RA in 1897.

Browne was one of the artists among whom can be counted
Beardsley and Phil May, who were young enough to be free of the
constraints of wood engraving by hand. They appreciated at once the
possibilities of photographic engraving and reproduction and
developed their style accordingly. Browne's was a linear style with
wide hatching and often a rather obvious contrast of areas of black
and white. His stage-door Johnnies and bottle-nosed footmen
sometimes have the feeling of May but rarely his subtlety. Browne's
humour was more earthy than that of *Punch* and he used convicts and
vicars and fat ladies with less discrimination than May and seems to
make little social comment. He was, however, enormously popular in
mid-Edwardian England and had his own *Tom Browne's Comic
Annual*. He made a trip to Korea in 1909 and the drawings completed
show a greater range than one would expect and an incredible facility
with pure pencil line. He died 16 March 1910.

Illus: *Tom Browne's Comic Annual; Tom Browne's Cycle Sketch Book; The
Khaki Alphabet Book; Night Side of London.*
Contrib: *The Graphic [1898-1911]; Pick-Me-Up [1898]; Eureka [1897]; Black
and White [1899]; Moonshine [1900]; Chums; Fun [1901]; Pearson's Magazine;
The Royal Magazine; The Sketch [1899].*
Exhib: FAS, 1899.
Colls: V & AM.
Bibl: *TB, RI Brush, Pen and Pencil,* c.1905.
See illustration (p.248).

BROWNE, Walter
Illustrator. Son of H.K. Browne and brother of G.F. Browne (qq.v.).
He contributed to *Punch,* 1875, and then worked on *Fun,* finally
devoting himself to news drawing and some book illustration.

Exhib: RBA, 1865.

BROWNING, Robert, Snr. **1782-1866**
Father of the poet, amateur caricaturist and draughtsman. For many

years a clerk in the Bank of England, he left an album of 172
caricatures, heads figure and groups, now in the Victoria and Albert
Museum Library.
See illustration (below).

BROWNLIE, R.A. 'R.A.B.' **-1897**
Illustrator and landscape painter. Born in England but worked for
most of his life in Scotland, principally in Glasgow. He was a talented
caricaturist, contributing spirited cartoons to many magazines. He was
influenced by Phil May, excelled in cockney subjects which he treated
either with broad grey washes or in a more linear posterish style. He
died at Edinburgh in 1897.

Contrib: *The Sketch [1893-95]; St. Paul's; Judy [1893]; The Pall Mall Maga: in
[1893]; The English Illustrated Magazine [1894-96].*
Exhib: G; L; NEA; RSA; RSW.
Colls: V & AM.

BRUCKMAN, William L. **1866-**
Landscape painter. Born at the Hague and worked in London and
Essex, 1904 to 1917. He contributed illustrations to *The Dome,* 1898.
Exhib: FAS, 1913.

BRUHL, Louis Burleigh RBA **1862-1942**
Landscape painter. He was born at Baghdad on 2 July 1862, and was
trained in Vienna; President of the British Watercolour Society.
Illus: *Essex [Hope Moncrieff, c.1905 (colour)].*
Exhib: RA, 1889-1924.

BRUNDAGE, Francis
Illustrated *Tales From Tennyson* by Nora Chesson, Tuck, c.1900. A
rather sugary artist not improved by chromo-lithography.

BRUNELLESCHI
Pseudonym of contributor to *The Illustrated London News,* 1913,
colour plates in the style of Poiret.

BRUNTON, William S. **fl.1859-1871**
Illustrator. He was of Irish extraction and was a founder member of
the Savage Club. Dalziel refers to 'Billy Brunton' as 'a constant
contributor of comic sketches dealing with passing events of everyday
life'. He has an unusual sign-manual of arrow-pierced hearts, or
monogram 'WB'.

Contrib: *Punch [1859]; The Illustrated Times [1861 (military), and 1866,
(comic)]; London Society [1863, 1865, 1868]; Fun [1865]; Tinsley's Magazine*

ROBERT BROWNING SENIOR 1782-1866. Amateur caricature in pen and ink.

Gordon Collection

[1867]; The Broadway [1867-74]; Moonshine, [1871].
Colls: V & AM.
Bibl: Dalziel, *A Record of Work*, 1901, p.314.

BRYAN, Alfred· **1852-1899**
Caricaturist and illustrator. Born in 1852 and worked chiefly for *The Sporting and Dramatic News* where he did weekly cartoons as 'our Captious Critic'. He worked also for *Entracte, The Hornet,* and *Judy,* 1890, but is best remembered as chief cartoonist of *Moonshine.*
Colls: Brighton Art Gallery.

BRYANT, Joshua
Landscape artist and topographer, exhibiting at the RA and BI, 1798-1810, from address in Oxford Street, London. He travelled widely in France and illustrated Thornton's *A Sporting Tour Through France*, 1806, AT 84.

BRYDEN, Robert RE **1865-1939**
Wood engraver, etcher and sculptor. He worked in Glasgow after studying at the RCA, RA Schools and in Belgium, France, Italy, Spain and Egypt. ARE, 1891; RE, 1899. Died 22 August 1939.

Publ: *Etchings of Ayrshire Castles [3 Vols, 1899, 1908, 1910]; Etchings in Italy [1894]; A Series of Burns Etchings [1896]; Etchings in Spain [1896]; Auld Ayr and Some Ayr Characters [1897]; Woodcuts of Men of Letters of the 19th century [1899]; Workers, or Wanting Crafts [1912]; Edinburgh Etchings [1913]; Glasgow Etchings [1914]; Ayrshire Monuments [1915]; Twenty Etched Portraits From Life [1916]; Ayr Etchings [1922]; Parables of Our Lord [1924].*
Contrib: *The Dome [1900].*
Exhib: G; L; RA; RE; RSA.

BUCHANAN, Fred
Humorous draughtsman, working for *Fun* 1900, *The Graphic,* 1906 and *The Strand.* He was a member of the Strand Club in 1906.

BUCHEL, Charles A. **1872-1950**
Portrait painter who made some illustrations of theatrical events and some posters. He practised in Hampstead, 1902-14, and in St. John's Wood, 1925.
Exhib: G; L; RA; RBA; ROI; RWA.
Colls: Witt Photo.

BUCK, Adam **1759-1833**
Portrait and miniature painter. He was born at Cork in 1759, the son of a silversmith and acquired a considerable reputation before coming to England in about 1795. Buck's drawings with watercolour finish over pencil, and the face usually given a miniature-like treatment, epitomise slick Regency neo-classicism. His engravings are often of family virtues 'Affection' etc., and frequently include Greek revival ornament and are very decorative. The drawings are much rarer and desirable.
Illus: *Sentimental Journey [Sterne, n.d.]; Paintings on Greek Vases [100 pls., 1812].*
Exhib: BI; RA; RBA.
Colls: Ashmolean; BM; Fitzwilliam.

BUCKLAND, Arthur Herbert RBA **1870-**
Painter and illustrator. He was born at Taunton on 22 January 1870, and studied at the RCA and at Julian's, Paris, 1894. He subsequently worked in London and Barnet, 1911-25. RBA, 1894.
Illus: *Anne's Terrible Good Nature [E.V. Lucas, 1908].*
Contrib: *The Pall Mall Magazine; The Windsor Magazine; ILN [1898 and 1907]; The Quiver [1900].*
Exhib: RA; RBA; RI; ROI.
Colls: Witt Photo.

BUCKLER, John Chessel **1793-1894**
Architect and topographical draughtsman. Born in 1793, the eldest son of John Buckler, FSA, the architect. Buckler was an antiquary like his father and his architectural practice was of houses in the gothic style. His meticulous drawings belong more to the 18th than to the 19th century.
Illus: *Views of Cathedral Churches in England [1822]; Observations on the*

Original Architecture of St. Mary Magdalen, Oxford ... [1823]; Sixty Views of Endowed Grammar Schools [1827]; An Historical and Descriptive Account of the Royal Palace of Eltham [1828]; Remarks Upon Wayside Chapels [1843]; History of the Architecture of the Abbey Church of St. Albans [1847]; Description of Lincoln Cathedral [1866].
Contrib: *Oxford Almanac [1816, 1817, 1820].*
Exhib: OWS; RA; RBA.
Colls: Ashmolean; BM; Bristol; Manchester; Norwich.
Bibl: H.M. Colvin *Biog. Dict. of English Architects*, 1954, p.106.

BUCKLEY, Walter
Illustrator of Sir H.M. Stanley's *My Dark Companions,* 1893.

BUCKMAN, Edwin **1841-1930**
Watercolourist and illustrator. Born on 25 January 1841 and, after being educated at King Edward's School, Birmingham, he acquired the rudiments of drawing at the Birmingham Art School. Buckman was one of the original staff of *The Graphic* and contributed to its reputation as a paper of social concern. His drawings of the poor and neglected in Victorian society and his illustrations of the Paris Commune are amongst the strongest works of their kind. Van Gogh admired his work in his London years and wrote of it as 'drawn especially broadly and boldly and in a whole-hearted manner'. He was later drawing master to Her Majesty Queen Alexandra. ARWS, 1877. He died 15 October 1930.
Contrib: *The Graphic [1869-71 and 1889]; ILN [1871-76].*
Exhib: RA to 1877; RWS.
Bibl: *English Influences on Van Gogh*, Arts Council, 1974-75 p.51.

BUCKMAN, W.R.
Illustrator contributing to *Good Words,* 1868, and *Cassell's Magazine,* 1870.

BULCOCK, Percy **1877-1914**
Illustrator specialising in ink drawing. Working at Burnley, 1899, and Liverpool, 1907.
Illus: *Blessed Damozel [Rossetti (Lane), 1900].*
Contrib: *The Dome [1899].*
Bibl: R.E.D. Sketchley, *English Book Illus.,* 1903, p.14, 122.

BULL, René **-1942**
Illustrator and special artist. He was born in Ireland and went to Paris to study engineering, but left this for art work in London, 1892. After working for various magazines, he was appointed 'special' for *Black and White,* 1896, attending the Armenian massacres and the Graeco-Turkish War as artist. He made trips for the paper to the North-West Frontier and to the Atbara and Omdurman campaigns. He served in the First World War in RNVR, 1916, and RAF, 1917.

Bull was one of the most versatile specials because his stature as an artist was above average. Not only an accurate reporter, he was a talented comic draughtsman and a brilliant illustrator of fairy stories. His most successful humorous sketches were in strip cartoon form and were the nearest things in England to the subtle line of Caran D'Ache.
Illus: *Fables [J. de la Fontaine, 1905 (with C. Moore Park, q.v.)]; Uncle Remus [J.C. Harris, 1906]; The Arabian Nights [1912]; The Russian Ballet [A.E. Johnson, 1913]; Rubaiyat of Omar Khayyam [1913]; Carmen [P. Mérimée, 1916]; Gulliver's Travels [J. Swift, 1928].*
Contrib: *Black & White [1892]; Chums [1892]; Pall Mall Budget [1893]; ILN [1893]; St. Paul's [1894]; Lika Joko [1894]; English Illustrated Magazine [1894-96]; Pick-Me-Up; The New Budget [1895]; The Sketch [1895-1918]; The Ludgate Monthly [c.1896]; The Bystander [1904].*
Colls: V&AM; Witt Photo.
Bibl: *Modern Book Illustrators and Their Work,* Studio, 1914, illus; B. Peppin *Fantasy Book Illustration,* 1975, p.186 illus.

BULTEEL, Lady Elizabeth **1798-1880**
Amateur illustrator. Daughter of the 2nd Earl Grey, and wife of John Crocker Bulteel of Flete and Lyneham, Devon. She produced several books for her grandchildren, illustrated by herself, one small volume being printed.

BUNBURY, Sir Henry Edward **1778-1860**
Soldier, military historian and amateur caricaturist. He was the son of Henry William Bunbury, 1750-1811, the amateur caricaturist who

published numerous satires at the end of the 18th century. His work strongly reflects the influence of his father.

BUNDY, Edgar ARA 1862-1922

Historical painter and illustrator. He was born at Brighton in 1862 and was largely self-taught. RI, 1891; RBA, 1891; ROI, 1892; ARA, 1915. One of his paintings acquired for the Chantrey Bequest, 1905. He died 10 January 1922.

Contrib: *The Graphic [1899].*
Exhib: B; G; L; RA, from 1881; RBA; RI; ROI.

BURCHELL, William John 1782-1863

Explorer, naturalist and artist. Born in 1782, he worked as a botanist at St. Helena, 1805-10, and then moved to Cape Town to study Cape-Dutch and travel in South Africa, 1811-15. He later explored the interior of Brazil, 1825-29, collecting plants and specimens.

Illus: *Travels in the Interior of Southern Africa [1822-24, AT 327].*
Exhib: RA, 1805-20.

BURGES, William ARA FRIBA 1827-1881

Architect. One of the most original Victorian designers, combining a brilliant understanding of structure with a wild imagination. He was the son of a wealthy engineer and in early middle age met Lord Bute who became his enthusiastic and faithful patron. For this eccentric peer he created Cardiff Castle and Castell Cock, both of which have such an air of gothic fantasy that they might easily be three dimensional extensions of *Moxon's Tennyson!* Burges is included here because of his powerful and exciting ink drawing in the Victoria and Albert Museum of 'St. Simeon Stylites'. This masterpiece inspired *by* rather than *for* literature, is signed and dated 1861, and is totally in the spirit of the grandest 1860s illustration with German woodcuts as its inspiration. ARA, 1881.

Exhib: RA, 1860-80.

BURGESS, Arthur James Wetherall RI 1879-1956

Marine artist and illustrator. Born at Bombola, New South Wales, 6 January 1879, and settled in England in 1901. He studied shipping in the Royal Dockyards and became Art Editor of *Brassey's Naval and Shipping Annual,* 1922-30. He contributed to many illustrated papers, particularly *The Graphic,* 1910. RI, 1916; ROI, 1913.

Exhib: B; G; L; RA, from 1904; RBA; RI; ROI.
Colls: New South Wales, Nat. Gall.

BURGESS, Ella

Illustrated P. Hay Hunter's *My Ducats and My Daughter,* 1894.

BURGESS, Ethel K. fl.1896-1907

Figure painter, illustrator, designer of bookplates. She was resident in Camberwell in 1896 and was a student at the Lambeth School in 1900, winning a first prize in the Gilbert Sketching Club. She was a good pen artist, basing her style on the rugged contrasts of the Newlyn School and capable of interesting period designs for children's books.

Exhib: L, 1901-07; RA.
Bibl: *The Artist,* 1897, pp.7-9 illus.; *The Studio,* Vol.10, 1897, p.113, bk. pl; Vol.20, 1900, pp.191-195 illus.

BURGESS, H.G.

American artist, working as an illustrator in Boston in about 1907. He contributed illustrations to *The Illustrated London News,* 1896-97; *English Illustrated Magazine,* 1897; *Cassell's Family Magazine,* 1898; *Pearson's Magazine.*

Colls: V & AM.

BURGESS, Walter William -1908

Etcher. He was elected RE in 1883 and, in 1894, published *Bits of Old Chelsea,* illustrated by himself.

Exhib: RA; RE.

BURLEIGH, Averil Mary -1949

Painter and illustrator. She studied at Brighton School of Art and

seems to have worked all her life in Sussex; she married the painter C.H.H. Burleigh. Her mannered medievalism is rather like that of E.F. Brickdale (q.v.), and she tackled the same sort of subjects, the works of Shakespeare and Keats. ARWS, 1939.

Exhib: FAS, 1925, 1934; GG, Arts & Crafts Exhib., 1913; RA; RI; RWS.
Bibl: *The Studio,* Vol.58, 1913.

SIR EDWARD COLEY BURNE-JONES RA 1833-1898. Caricature of William Morris, the poet and designer in a wooden bath tub.

BURNE-JONES, Sir Edward Coley Bt. RA 1833-1898

Artist, book illustrator, caricaturist and writer of illustrated letters. Born at Birmingham 28 August 1833 and after being educated at King Edward's School, Birmingham, went up to Oxford in 1833. There he met William Morris (q.v.), and in the succeeding year became influenced by the paintings of Rossetti and the writings of Ruskin, whom he met in 1856. Burne-Jones's position as a quasi-member of the Pre-Raphaelite group and his development as a major subject and decorative painter are not of primary importance here; his work as an illustrator falls into three categories. In 1857, he illustrated *The Fairy Family,* for his friend Maclaren, rather conventional designs and typical of the romantic school of the 1840s. In the 1860s he contributed a few illustrations to the magazines that were thriving on the revival in wood engraving. In the last years of his life, 1892 to 1898, he had a fruitful partnership with the Kelmscott Press in designing for books of high typographical quality. His influence in the latter venture lasted well into the 1900s in private press work. ARA, 1885; ARWS, 1886. Baronet, 1894.

Illus: *Good Words [1862-63]; Parables From Nature [1865]; Dalziel's Bible Gallery [1880-81];* design for title to one of Ruskin's lectures, 1865 (not used); *King Poppy [Lytton (title and frontis.)]; The Queen Who Flew: A Fairy Tale [Hueffer, 1894 (title and frontis.)]; The High History of The Holy Grail [1898]; The Beginning of the World [1903]; Letters to Katie [1925].*

Kelmscott Press Books: *A Dream of John Ball [frontis.]; A King's Lesson [1892 (frontis.)]; The Golden Legend [1892 (woodcuts)]; The Order of Chivalry [1893 (frontis.)]; The Wood Beyond the World [frontis.]; Sir Pereccyvelle of Gales [1895 (frontis.)]; The Life and Death of Jason, The Well at the World's End [1896]; The Works of Geoffrey Chaucer [1896]; Sire Degrevaunt [1897]; Syr Ysambrace [1897]; Love is Enough [1897]; The Story of Sigurd the Volsung [1898].*
Exhib: FAS, 1876; GG; New Gall; OW; RA.
Colls: Ashmolean; Bedford; Birmingham; Fitzwilliam; Manchester; V&AM.
Bibl: M. Bell, *Sir E B-J*, 1898; M. Harrison and B. Waters, *B-J*, 1973; *B-J*, Cat of Exhibition, Arts Council 1975 (J. Christian).
See illustrations (below, right and p.251).

BURNE-JONES, Sir Philip Bt. 1862-1926
Portrait painter. He was born on 2 October 1861, the only son of Sir E.C. Burne-Jones Bt. (q.v.). He was educated at Marlborough College and University College, Oxford. He died 21 June 1926.

Illus: *The Little Iliad [Maurice Hewlett, 1915].*
Exhib: B; G; L; M; P; RA; ROI; RSA.

SIR EDWARD COLEY BURNE-JONES RA 1833-1898. Pencil drawing for the frontispiece of Syr Percyvelle of Gales, *published by William Morris at the Kelmscott Press, 1895.* Victoria and Albert Museum

BURNEY, Edward Francis 1760-1848
Illustrator and caricaturist. Born at Worcester in 1760, the son of Dr. Burney, the composer, and brother of the novelist Fanny Burney. He studied at the RA Schools and exhibited there from 1780 both book illustrations and portraits. Among his earlier works were a set of illustrations for his sister's novel *Evelina*. But Burney's general run of illustrations give no indication of the inventive mind that lies behind his large caricature subjects 'An Elegant Establishment for Young

SIR EDWARD COLEY BURNE-JONES RA 1833-1898. Frontispiece for Syr Percyvelle of Gales, *published by William Morris at the Kelmscott Press, 1895. Wood engraving from the preceding drawing.* Victoria and Albert Museum

Ladies', 'The Waltz' etc. These superbly finished compositions of many figures are in direct succession to Hogarth and especially from their theatrical and literary standpoint. An album of drawings sold at Christie's on 5 March 1974 gave some indication of the artist's scope, including religious, classical, poetic and comic subjects. The smaller decorative subjects are not uncommon, he excelled in small groups, head and tail pieces.

Illus: *Buffon's Natural History [1791]; The Copper Plate Magazine [1792-1803]; Ireland's Avon [1795]; The Pleasures of Hope [Thomas Campbell, 1806]; Burney's Theatrical Portraits; Sporting Magazine [frontis.]; The New Doll [c.1825].*
Colls: BM; V & AM; Witt Photo.
Bibl: Iolo Williams, *Early English Watercolours*, 1952, pp.132-133; M. Hardie, *Watercolour Paint in Brit.*, Vol.I, 1966, pp.152-153.

BURNS, Cecil Lawrence c.1863-1929
Portrait and genre painter. He studied under Herkomer (q.v.), and at RA, becoming the Principal of Camberwell School of Arts and Crafts, 1897, and Principal of Bombay School of Art in 1899. He was curator of the Victoria and Albert Museum, Bombay, 1902-1918. He became a Member of the NEA, 1887 and RBA, 1899. He died 26 July 1929.

Illus: *Belle Dame Sans Merci [n.d.].*
Exhib: L; M; NEA; RA; RBA; ROI.
Bibl: *The Studio*, Vol.6, 1896, illus.

BURNS, M.J.
Marine artist. Contributed illustrations to *The Graphic*, 1910.

BURNS, Robert ARSA 1869-1941

Figure and portrait painter. He was born at Edinburgh in 1869 and after studying at South Kensington and in Paris, 1890-92, worked for the whole of his life in the city. Burns was specially successful with crowded figure subjects built up densely as in a medieval tapestry; a sketch-book of such subjects of Border legend was sold at Sotheby's in April 1976. The artist was President of the Society of Scottish Artists, ARSA, 1902, resigned 1920, and Director of Painting at Edinburgh College of Art, 1914.

Illus: *The Evergreen [1895]*.
Exhib: B; G; L; M; RA; RHA; RSA; RSW.

BURTON, E.J.

Contributor to *Punch*, 1847-49.

BURTON, Sir Frederick William RHA RWS FSA 1816-1900

Painter. He was born at Corofin House, County Clare, on 8 April 1816, the son of an amateur landscape painter. In 1828 he went to Dublin and studied under the Brocas brothers, attracting the attention of George Petrie, the landscape painter and archaeologist. He studied in Munich from 1851-1858 although he continued to exhibit in London. He was elected ARHA in 1837 and RHA in 1839; ARWS, 1854 and RWS, 1855, Hon Member, 1886. Burton was immensely successful as a miniature painter and watercolourist and became Director of the National Gallery in 1874, receiving a knighthood on his retirement twenty years later. He died at Kensington, 16 March 1900.

Contrib: *ILN, [1896]*.
Exhib: G; RA from 1842; RHA.
Colls: Ashmolean; BM; Nat. Gall., Ireland; V & AM.

BURTON, Sir Richard Francis 1821-1890

Scholar, explorer, translator and artist. Born in 1821 and was educated at Trinity College, Oxford, 1840. He followed an army career from 1842, was an assistant on the Sind survey. but abandoned this for a wandering life studying Moslem beliefs and customs. He explored Somaliland in 1854, the Nile in 1856-59, and travelled in North America, 1860. Burton served in the Crimean War, but from 1861 was in the diplomatic service as British Consul in Fernando Po, Santos, Damascus and finally Trieste, 1872. He was made a KCMG in 1885, but his fame really rests on his knowledge of Asiatic languages and his translation of classics like *The Book of The Sword'*, 1884 and *The Arabian Nights*, 1885-88.

Illus: *Falconry in the Valley of the Indus [1852, AT 479]; Personal Narrative of a Pilgrimage to El-Medinah and Meccah [1855-56, AT 368]*.

BURTON, William Paton 1828-1883

Landscape painter. Born in Madras in 1828, the son of an Indian army officer. He was educated in Edinburgh and proposing to take up architecture as a career, entered the office of David Bryce. He left Bryce for a life of landscape painting in oils and watercolours and travelled on the Continent and in Egypt in search of subjects. He died on 31 December 1883, near Aberdeen.

Contrib: *Willmott's Sacred Poetry of the 16th, 17th and 18th Centuries [1862]; Legends and Lyrics [1865]; Golden Thoughts From Golden Fountains [1867]*.
Bibl: Aberdeen; BM; Manchester; V & AM; Witt Photo.

BURTON, William Shakespeare 1830-1916

A minor Pre-Raphaelite who exhibited the 'Wounded Cavalier' at the RA in 1856. He studied at the RA Schools and won the gold medal there in 1851. His only known illustration is for *Once a Week*, 1865.

Exhib: RA; RI.

BURY, Rev. Edward John MA 1790-1832

Amateur artist. He was the son of Edward Bury of Walthamstow, Essex, and was educated at University College, Oxford, BA, 1811, MA, 1817. He was Rector of Lichfield, Hants from 1814 and married in 1818, the Lady Charlotte Campbell, daughter of the 5th Duke of Argyll, and died in May 1832. He illustrated his wife's *The Three Great Sanctuaries of Tuscany*, 1833.

Bibl: *Alumni Oxonienses 1715-1886*.

BURY, Thomas Talbot 1811-1877

Architect and artist. He was born in London and became a pupil of Pugin in 1824 although left him to set up his own practice in 1830. He was one of the draughtsmen of Pugin's *Paris*, 1831.

Publ: *Remains of Ecclesiastical Woodwork [1847]; Rudimentary Architecture [1849]*.
Colls: BM; Manchester.

BURY, Viscount See KEPPEL, William Coutts

BUSBY, Thomas Lord

Figure artist. He exhibited portraits at the RA from 1804-1837. He illustrated *Costumes of the Lower Orders in Paris*, c.1820, AT 107; *Costumes of the Lower Orders of The Metropolis*, 24 plates, 1818.

BUSHBY, Lady Frances 1838-1925

Amateur flower artist. She was born in 1838, the daughter of the 6th Earl of Guilford and wife of the Recorder of Colchester. In 1866 she illustrated *Early Rising by a Late Philosopher*, for private circulation.

BUSHNELL, A.

Contributed illustration to *Good Words*, 1861.

BUSS, R.W. 1804-1875

Painter and illustrator. He was born in London in 1804, the son of R.W. Buss, engraver and enameller. He studied drawing under George Clint, ARA, but began his career as an illustrator by working for Charles Knight. He was particularly closely associated with Knight in producing the *Penny Magazine* and an oil by him in the Victoria and Albert Museum shows the interior of the magazine office with a wood engraver at work. Buss's greatest test was to produce etched work of sufficient quality for use in *Pickwick*, 1836, but he failed in this and was succeeded by H.K. Browne (q.v.). He was Editor of *The Fine Art Almanack* and wrote a book *The Principles of Caricature*, 1874. He died at Camden Town, 1875.

Illus: *London [Knight, 1841]; Old England; Chaucer; Widow Barnaby [Frances Trollope, 1839]; Peter Simple [Marryat]; Jacob Faithful [Marryat, 1834]; The Court of King James II [Ainsworth]*.
Exhib: BI; RA; RBA, 1826-1859.
Colls: BM; Fitzwilliam; V & AM.
Bibl: Alfred G. Buss, *Notes and Queries*, April 24, 1875; G. Everitt, *English Caricaturists*, 1893, pp.363-366.

BUTLER, Lady (Elizabeth) née Thompson RI 1846-1933

Battle painter and illustrator. She was born in Lausanne in 1846 and studied at South Kensington, Florence and Rome. She was the sister of Alice Meynell, the poetess, and married in 1877 Lt-General Sir William F. Butler. Although she specialised in military and equestrian subjects, she did an extensive amount of black and white work and illustrated her sister's poems. She died 2 October 1933.

Illus: *Poems [Alice Meynell]; Ballads [Thackeray]; Campaigns of the Cataracts [W.F. Butler]; Letters From the Holy Land [1905]; From Sketch-Book and Diary [c.1905]*.
Contrib: *Merry England; The Graphic [1873 and 1889]*.
Exhib: B; FAS, 1877; G; L; M; RA from 1873.
Colls: BM.
Bibl: *An Autobiography*, 1923.

BUXTON, Dudley

Contributor of half tone comic sporting subjects to *Punch*, 1904.

BYLES, W. Housman RBA fl.1890-1925

Landscape and figure painter, practising in London, 1903, and at West Hamprett, Chichester, 1907-25. Byles contributed illustrations to *The Pall Mall Magazine* and *The Sketch* in the 1890s. RBA, 1901.

Exhib: B; L; New Gall; RA; RBA; ROI.

BYRNE, Claude

Painter working at Rathmines, Dublin. He contributed illustrations of Irish distress to *The Illustrated London News*, 1886, and exhibited at the RHA, 1884.

BYRNE, E.R.

Contributed marine subjects to *The Graphic*, 1873.

C

CADENHEAD, James ARSA RSW
1858-1927

Landscape painter and illustrator. Born at Aberdeen in 1858 and studied at the RSA School and then in Paris under Duran. He was elected ARSA in 1902 and RSA in 1921 and was a founder member of the NEAC, 1889. Cadenhead was a talented printmaker and in his few book illustrations the influence of the Japanese print on his work is very striking. He signs his work 🅒

Illus: *Pixie [Mrs. G. Ford, 1891]; Master Rex [Mrs. G. Ford, 1891]; Hell's Piper [ballad by Riccardo Stephens, n.d.]*.
Contrib: *The Evergreen [1894-96]*.
Exhib: G; L; M; NEA, 1899-1900; RSA from 1880.
Bibl: *The Studio*, Vol.10, 1897, p.67 illus.; Vol.55, 1912, pp.10-20 illus.

CALDECOTT, Randolph RI
1846-1886

Watercolourist and illustrator. Born at Chester on 22 March 1846, the son of an accountant and was educated at the King's School. He became a bank clerk at Whitchurch and Manchester, but had greater success as a draughtsman for local periodicals, 1868-69. His wish to reach a wider public was only realised in 1871, when sketches by him were published in *London Society;* this was his real début and in the next decade he became the most popular illustrator of children's books of the period published by Edmund Evans, and second only to Kate Greenaway (q.v.). Caldecott shared with Kate Greenaway a love of the past and especially the last days of the 18th century before industrialization. A keen sportsman, Caldecott's world is always rural, pretty and untroubled, a landscape of manor houses, hunts and skating parties loosely hung round a story. His costume subjects for *The Graphic,* often in the form of letters, are better than his contemporary cartoons and he is an artist who comes across more vividly in colour than in black and white.

Caldecott was a very finished artist, but his illustrations lack the humour of Leech and indeed of the period he depicts. His flat colour and slick outlines were to have many successors, in particular Phil May (q.v.), and Cecil Aldin (q.v.), his spiritual follower being Hugh Thomson (q.v.). Caldecott's promising career was cut short by illness and he died at St. Augustine, Florida, where he was seeking a cure on 12 February 1886.

Illus. and Contrib: *Will o'the Wisp [1867]; The Sphinx [1867]; London Society [1871-72]; Punch [1872 and 1883]; The Harz Mountains [1872]; Frank Mildmay [1873]; The Graphic [1873-86]; Pictorial World [1874]; Old*

Christmas and *Bracebridge Hall [Washington Irving, 1876]; North Italian Folk [1878]; The House That Jack Built* and *John Gilpin [1878]; Elegy on a Mad Dog* and *The Babes in the Wood [1879]; Aunt Judy's Magazine [1879]; Jackanapes, Daddy Darwin's Dovecote [1879]; Three Jovial Huntsman, Sing a Song of Sixpence [1880]; Breton Folk [1880]; What The Blackbird Said [1880]; The Queen of Hearts, The Farmer's Boy [1881]; Hey Diddle Diddle, Baby Bunting [1882]; Greystoke Hall [1882]; The Fox Jumps Over The Parson's Gate, A Frog He Would [1883]; A Sketch Book, Some of Aesop's Fables [1883]; Come Lasses and Lads, Ride a Cock Horse [1884]; The English Illustrated Magazine [1884-86 (initials)]; Mrs. Mary Blaize, The Great Panjandrum [1885]; The Complete Collection of Pictures and Sons [1887]; The Complete . . . Contributions; The Boys' Own Paper.*
Exhib: RA, 1872-85.
Colls: Ashmolean; Bedford; BM; Fitzwilliam; V & AM; Walsall.
Bibl: Henry Blackburn, *RC A Personal Memoir*, 1886; *The Artist*, June 1898, pp.65-69 illus.; M.G. Davis, *RC*, 1946; R.K. Engen, *RC*, 1976.
See illustrations (below and p.255).

CALDER, Scott

Amateur illustrator working at Chelsea. Winner of book illustration competition, *The Studio*, Vol.8, 1896, p.184, illus.

CALDERON, William Frank ROI
1865-1943

Figure, landscape and sporting painter. Born in 1865, son of P.H. Calderon. He studied at the Slade School and became founder and Principal of the School of Animal Painting, St. Mary Abbots Place, Kensington, 1894-1916. Calderon worked in London 1883-90 and then in Midhurst, 1889, and finally at Charmouth, Dorset. He was elected ROI in 1891 and married the daughter of H.H. Armstead RA (q.v.).

Contrib: *Black and White, 1891*.
Exhib: B; G; L; M; New Gall; RA; RBA; RHA; ROI.

CALDWELL, Edmund
-1930

Animal painter. He worked in Swanley and Guildford, 1887-90 and in Haverstock Hill, London, 1902-25. He contributed to *The Sporting and Dramatic News*.

Exhib: L; M; RA, 1880; RBA, 1881-83; RHA; RI; ROI.

CALKIN, Lance ROI
1859-1936

Portrait painter. Born 22 June 1859 and studied at South Kensington, Slade and RA Schools. He painted all the leading Edwardian figures including King Edward VII, Captain Scott and Joseph Chamberlain. He was elected RBA in 1884 and ROI in 1895. He died 10 October 1936.

Contrib: *The Graphic [1887-89 (portraits) and 1901-02 (genre)]*.
Exhib: B; G; L; M; New Gall; RA; RBA; ROI.
Bibl: *Who Was Who 1929-40*.

CALLAWAY, Rev. William Frederick

Amateur cartoonist. He was a Baptist minister at York and contributed to *Punch*, 1855. He exhibited at the RA, BI, and at other exhibitions 1855-61.

RANDOLPH CALDECOTT RI 1846-1886. 'The Three Huntsmen.' An illustration to The Complete Collection of Pictures and Songs, *1887.*

RANDOLPH CALDECOTT RI 1846-1886. 'Cupid in Society.' Outline drawing in pen and ink. Jeffrey Gordon Collection.

CALLOW, William **1812-1908**
Watercolourist. He was born at Greenwich in 1812 and his first art employment was in colouring prints for the Fielding brothers. He went to Paris in 1829 to help in engraving views of the city for a book, remaining there with a group of English artists until 1841. He was intimate with Turner and Bonington and shared a studio with T.S. Boys (q.v.) but his book illustrating is limited to the one work, Charles Heath's *Picturesque Annual: Versailles,* 1839, compiled in the years 1829-36. RWS, 1848. He died at Great Missenden, 20 February, 1908.

Bibl: *Autobiography,* Edited by H.M. Cundall, 1908; *Walker's Quarterly,* 1927 XXII; M. Hardie, *Watercolour Paint in Brit,* Vol.III, 1968, pp.35-42.

CALOR, Tom
Figure artist. He contributed to *Punch,* 1914.

CALTHROP, Dion Clayton **1878-1937**
Artist, writer and stage designer. Born on 2 May 1878, son of John Clayton, the actor. Educated at St. Paul's School and studied art at St. Johns Wood, Paris, with Julian's and Colarossi's. In early life he did a good deal of commercial work for magazines but then concentrated entirely on illustrating his own books. He served with the RNVR during the First World War and died 7 March 1937.

Illus: *History of English Costume; King Peter; Guide to Fairyland; The Dance of Love; Everybody's Secret; Tinsel and Gold; The Charm of Gardens; Perpetua; St. Quin; A Trap to Catch A Dream; Bread and Butterflies; A Bit of a Time; Beginners Please; All For the Love of A Lady; English Dress.*
Contrib: *The Dome [1897]; The Quartier Latin [1898]; Pick-Me-Up [1899]; The Idler; The Butterfly [1899]; The Connoisseur [1910 (décor)].*
Exhib: RA; ROI, 1900-03.
Bibl: *Modern Book Illustrators and Their Work,* Studio, 1914 illus; *My Own Trumpet,* 1935 (autobiography); *Who Was Who 1929-40.*

CALVERT, Edith L. **fl.1886-1907**
Flower painter and illustrator. Working in London 1893-1907.

Illus: *Baby's Lays [Elkin Mathews, 1897]; More Baby's Lays [Elkin Mathews, 1898].*
Contrib: *The Quarto [1898].*
Exhib: RBA; SWA, 1886-93.
Bibl: R.E.D. Sketchley, *English Book Illus,* 1903, pp.102, 165.

CAMERON, Sir David Young RA **1865-1945**
Painter and etcher. Born at Glasgow in 1865 and was educated at Glasgow Academy and studied at the Glasgow School of Art and at Edinburgh. Cameron was one of the outstanding group of print-makers who rose to fame before the First World War. He excelled in landscape but also did excellent illustrative work and even bookplates; his oils and watercolours are sensitive interpretations of his native Scotland, but the earlier work is purer. He served as War Artist for the Canadian Government, 1917, and in 1919 taugnt at the British School at Rome. He became ARA, 1911; RA, 1920 and RSA, 1918. He was knighted in 1924.

Illus: *Old Glasgow Exhibition [1894 (title)]; Charterhouse Old and New [1895]; Scholar Gipsies [John Buchan, 1896]; An Elegy and Other Poems [R.L. Stevenson, 1896 (title)]; Story of the Tweed [Sir Herbert Maxwell, 1905]; The Compleat Angler [1902].*
Portfolios: *The Clyde Set [1890]; North Holland [1892]; North Italy [1896]; The London Set [1900]; Paris Etchings [1904]; Etchings in Belgium [1907].*
Contrib: *Good Words [1891-92]; Black and White [1892]; The Ludgate Monthly [1895]; The Quarto [1896]; The Yellow Book [1896.(cover)].*
Exhib: Antwerp; Brussels, 1895; Chicago, 1893; Munich, 1905; NEA; Paris, 1900; RA; RE; ROI.
Colls: BM; V & AM.
Bibl: *The Studio,* Winter No, 1900-01, pp.34-5, illus.; R.E.D. Sketchley, *English Book Illus,* 1903, pp.41, 64, 133; F. Rinder, *An Illustrated Catalogue of . . . Etched Work,* 1912; *Modern Book Illustrators and Their Work,* Studio, 1914.

CAMERON, Hugh RSA RSW **1835-1918**
Portrait and genre painter. He was born at Edinburgh in 1835 and studied at the Trustees Academy. He worked partly at Edinburgh and partly at Largs, travelling on the Continent. ARSA, 1859 and RSA, 1869; RSW, 1878.

Contrib: *Pen and Pencil Pictures From the Poets [Nimmo, 1866]; Idyllic Pictures [Cassell, 1867]; Good Words.*
Exhib: GG; RA; RBA.

CAMERON, John
Etcher and dry-point artist. He was working at Inverness in 1917 and at Corstorphine, 1918-1925. A coloured illustration by this artist for *Treasure Island* is in Witt Photo Library.

Exhib: B; G; L; RHA; RSA.

CAMERON, Katharine (Mrs. Kay) RSW ARE **1874-1965**
Painter and etcher. Born in Glasgow, daughter of the Rev. Robert
Cameron and sister of Sir. D.Y. Cameron (q.v.). She was educated in
Glasgow and studied at Glasgow School of Art and in Paris at
Colarossi's. She was a prolific illustrator of children's books, giving
full vent to her gift for flower studies and in 1928 she married Arthur
Kay, HRSA. RSW, 1897 and ARE, 1920.

Illus: *In Fairyland; The Enchanted Land; Legends of Italy; A City Garden; Water
Babies; Idylls of the King; Aucassin and Nicolette; Undine; Rhyme of the
Duchess May; Flowers I Love; Haunting Edinburgh; Where The Bee Sucks; Iain
the Happy Puppy; Stories From the Ballads [Macregor, 1908].*
Contrib: *The Yellow Book [1897].*
Exhib: Berlin; L; Leipzig; RA; RSA; Venice.

CAMPBELL, John E.
Illustrator of the boys' story *Wulnoth the Wanderer,* H. Escott Inman,
1908.

CAMPBELL, John P. (Seaghan MacCathmhaoill) fl.1904-1912
Illustrator of Celtic legends. He illustrated *Celtic Romances; Irish
Songs; The Tain, Four Irish Songs,* all c.1909-1912. His penwork is
reminiscent of wood engraving and his figures usually have a strange
bending posture as if floating. No biographical details are known.

Colls: Witt Photo.
Bibl: *An Illustrator of Celtic Romance,* The Studio, Vol.48, 1909, pp.37-43;
Modern Book Illustrators and their Work, Studio 1914.

CAMPION, George Bryant NWS 1796-1870
Painter, topographical artist and lithographer. He specialised in
military subjects and was for some time a drawing master at the Royal
Military Academy, Woolwich. He emigrated to Munich where he died
in April 1870. NWS, 1834. Wrote *The Adventures of a Chamois
Hunter.*

Illus: *Virtue's View in Kent [1830].*
Exhib: NWS; RBA, 1829-31.
Colls: Ashmolean; BM; Witt Photo.

CANZIANI, Estella Louisa Michaela RBA 1887-1964
Portrait painter and illustrator. Daughter of the painter Louisa Starr,
was born 12 January 1887 and studied with Sir Arthur Cope, at
Watson Nichol's School and at the RA Schools. RBA, 1930.

Illus: *Round About Three Palace Green [1939]; Costumes Traditions and Songs
of Savoy; Piedmont; Through The Appenines and the Lands of the Abruzzi;
Songs of Childhood [Walter de la Mare]; Oxford in Brush and Pen; The Lord's
Minstrel [C.M.D. Jones, 1927]; Good Adventure [E. Vipont, 1931].*
Exhib: L; New Gall, 1906; RBA; RI, 1913-; RSA; SWA.
Colls: V & AM.

CAPON, William 1757-1827
Topographical artist and architect. He was born at Norwich in 1757,
the son of a painter. At a young age he began to paint portraits but,
on moving to London, he showed an aptitude for architecture and was
apprenticed to Novozielski as scene painter to Ranelagh Gardens and
the Italian Opera. Capon acted as scene painter to Kemble at Drury
Lane, 1794, and was generally associated with his productions. He was
able to establish a small architectural practice and in 1804 was
accredited architectural draughtsman to the Duke of York. He died at
Westminster in 1827.

Contrib: *Britton's Beauties of England and Wales [1808, 1815].*
Exhib: BI; RA; RBA, 1788-1827.
Colls: Bath; BM; Witt Photo.
Bibl: H.M. Colvin, *Biog. Dict. of English Architects,* 1954, p.121; *Views of
Westminster by William Capon,* London Topographical Society, 1923-24.

CARAN D'ACHE (Emmanuel Poirié) 1858-1909
French caricaturist. Born in Moscow in 1858 and studied there before
settling in Paris. He first came to fame as cartoonist on *Chronique
Parisienne,* but also with shadow pictures in *Chat Noir.* He was
particularly popular for his silhouette caricatures and for his historical
jokes; a vogue for both of these caught on in England, largely due to
his influence. Caran D'Ache contributed in his fluid outline to *Figaro,
L'Illustration, La Revue Illustrée* and drew for his own books,

*Comédie du Jour, Comédie de Notre Temps, Les Courses dans
L'Antiquité, Carnet de Chèques, The Discovery of Russia.* He played a
leading part in the Dreyfus affair and started the magazine *Ps'itt.* Died
in Paris in 1909.

Contrib: *The Graphic [1887]; Punch [1894]; English Illustrated Magazine
[1896].*
Exhib: FAS, 1898.
Bibl: J. Pennell, *Pen Drawing and Pen Draughtsmen,* 1894, p.112 illus.

CARLILE, Lieutenant W.O. RA
Contributor to *The Illustrated London News,* 1873.

CARLISLE, The 9th Earl of See HOWARD, George

CARMICHAEL, John Wilson 1800-1868
Marine painter and illustrator. Born at Newcastle-upon-Tyne in 1800
and went to sea at an early age, later being apprenticed to a
shipbuilder and employed in drawing and designing. He was really a
watercolourist, but from 1825 experimented with oils and became a
regular exhibitor in London. He moved to London in 1845 and was
employed by *The Illustrated London News* to make drawings in the
Baltic during the Crimean War, 1853-56. He left London in 1862, due
to illness and settled at Scarborough where he died on 2 May 1868.

Publ: *The Art of Marine Painting in Watercolours [1859]; The Art of Marine
Painting in Oil Colours [1864].*
Contrib: *Views on the Newcastle and Carlisle Railway [1839]; Howitt's Visits
to Remarkable Places [1841].*
Colls: BM; Greenwich; Newcastle; V & AM.

CARMICHAEL, Stewart of Dundee 1867-
Portrait painter, decorator and architect. He studied at Dundee,
Antwerp, Brussels and Paris, before practising in Dundee. He
produced three design in 1899, 'The Unhappy Queen', 'The Players of
the Jews Harp' and 'Disinherited', which show strong Beardsley
influence and may have been intended for a book.

Exhib: G; L; RSA.
Colls: Witt Photo.

CARNEGIE, Rook
Artist for *The Graphic* in Roumania, 1910.

CARPENTER, William 1818-1899
Painter and etcher of oriental subjects. He was born in London in
1818, the son of Mrs. M.S. Carpenter, the portrait painter. He spent
most of his life in India, sketching the country's manners and customs
and an exhibition of these works was held at South Kensington in
1881. He contributed to *The Illustrated London News,* 1857-59, his
Indian scenes being among the first reproduced in colour for the
magazine.

Colls: Ashmolean; BM; V & AM.

CARR, David 1847-1920
Figure and bird painter. Born in London, 1847 and was educated at
King's College, London. He was articled as a pupil engineer to W.H.
Barlow, CE, Consulting Engineer to The Midland Railway, and
worked there in civil engineering. He left this career and became an art
student for three years at the Slade School under Alphonse Legros,
finally going to Paris, 1881. Carr's interests were wide ranging and as
well as practising as a painter in Campden Hill, Kensington,
1890-1902, and at Bedford Park, 1902-14, he designed several
country houses in the West of England. He died 25 December 1920.

Contrib: *The Pall Mall Gazette; The England Illustrated Magazine [1884-87
(birds and landscapes)].*
Exhib: B; GG; L; M; New Gall; NWS; RA from 1875; RBA, from 1875; RI.
Colls: Witt Photo.
Bibl: *Who Was Who,* 1916-28.

CARR, Ellis
Illustrator of *Climbing in the British Isles,* Alan Wright, 1894. He
exhibited at the ROI, 1884.

CARR, Mrs. Geraldine fl.1896-1916
Sculptor and painter on enamel. She worked in London and supplied a decorative headpiece to *The Quarto*, 1896.

Exhib: L, 1901-16; RA.

CARR, Sir John 1772-1832
Miscellaneous writer, minor poet and illustrator. Carr was a gentleman of private means, who travelled for his health and was knighted in 1806. He was pilloried by Lord Byron in a cancelled passage of *English Bards and Scotch Reviewers*, 1809.

Publ: *The Stranger in France; A Tour From Devonshire to Paris; A Northern Summer [1805]; A Tour Through Holland [1807, AT 216]; Caledonian Sketches [1808].*
Illus: *Descriptive Travels . . . in . . . Spain [1811, AT 144].*
Colls: BM.

CARRICK, J. Mulcaster fl.1854-1878
Painter and illustrator. An extremely interesting minor Pre-Raphaelite who specialised in landscape painting. He illustrated *The Home Affections*, Charles Mackay, 1858, contributing four drawings, and in 1865 designed some for *Legends and Lyrics* by A.A. Proctor. At least one illustration 'An Episode From Life' was turned into an oil painting. Carrick uses great contrasts of light and shade, dappling the backs and clothing of his figures in sunlight, minutely hatching in the shadow.

Exhib: BI, 1854; RBA, 1856; RI.
Colls: Witt Photo.

CARROL, Lewis see DODGSON, Charles

CARSE, Alexander 'Old Carse' fl.1796-1838
Scottish genre painter. He was probably born in Edinburgh where he worked as a young man before going to London in 1812. There he exhibited at the RA and BI, 1812-20, before returning to Scotland for the last twenty years of his life. He designed title pages and vignettes for editions of Burns and Schiller, c.1830.

Colls: BM; Witt Photo.

CARTER, David Broadfoot fl.1905-1910
Illustrator and designer. He studied at Glasgow School of Art and afterwards in Paris, before settling in London as a professional lithographer. He undertook comic illustrations for books in strong pen line.

Exhib: G.
Colls: Witt Photo.

CARTER, Frederick ARE 1885-1967
Painter and etcher. He was born near Bradford in 1885 and studied in Paris and at the Académie Royale des Beaux-Arts, Antwerp. On his return to England he worked for poster printers, but went back to study at the Polytechnic, and won gold medals for book illustrations. He studied etching under Sir Frank Short (q.v.), ARE, 1910 and 1922.

Illus: *The Wandering Jew; The Dragon of the Alchemists; Eighteen Drawings; The Dragon of Revelation; D.H. Lawrence and The Body Mystical; Symbols of Revelation; Introduction and Drawings for Byron's Manfred; Florentine Nights [Heine]; decorations for Cyril Tourneur's works.*
Contrib: *various magazines about 1916.*
Exhib: L; NEA; RA; RE; ROI.
Colls: Witt Photo.

CARTER, Owen Browne 1806-1859
Topographical draughtsman and architect. He worked mainly at Winchester but travelled to Egypt in about 1829-30.

Publ: *Picturesque Memorials of Winchester [1830]; Some Account of the Church at Bishopstone [1845].*
Illus: *Illustrations of Cairo [Robert Hay, 1840].*
Exhib: RA, 1847-49.
Colls: BM.

CARTER, Reginald Arthur Lay 1886-
Black and white artist contributing humorous illustrations to magazines, c.1910-13.

Colls: V & AM.

CARTER, Rubens Charles 1877-1905
Painter and comic draughtsman. Born at Clifton in 1877 and studied at the Bristol School of Art. He worked for numerous magazines, his cartoons being in the style of Tom Browne (q.v.).

Illus: *Punch [1900]; Pick-Me-Up [1899].*
Colls: BM; Witt Photo.

CARTER, Samuel John ROI 1835-1892
Animal painter and illustrator. Born at Swaffham, Norfolk in 1835 and studied in Norwich. For many years he was the principal animal illustrator for *The Illustrated London News*, contributing many fine drawings of cattle, sheep and horse shows all over Britain. ROI, 1883.

Contrib: *ILN [1867-89]; The Graphic [1886].*
Exhib: BI, 1863-66; GG; RA; RBA, 1861-68; ROI.

CARTER, Z.A.
Contributor of 'Edwin and Angelina' social subjects to *Punch*, 1900.

CASELLA, Miss Julia
Sculptor. Contributing illustration to *The Graphic*, 1880, and exhibiting at Grosvenor Gallery, 1885.

CASTAIGNE, A. fl.1902-1910
Illustrator of royal events and social subjects for *The Graphic*, 1902-03 and 1905-10.

CATCHPOLE, Frederic T. fl.1897-1940
Landscape and figure painter. Worked in Chelsea and was elected RBA in 1913. He was drawing for *Judy* in 1890.

Exhib: GG; L; NEA, 1904; RA; RBA, 1914-25; RI; ROI.

CATHERWOOD, Frederick 1799-1854
Architect and topographer. He was born in London in 1799 and became a pupil of the architect, Michael Meredith. He travelled in Italy, Greece and Egypt from 1821-25 and again in 1831 up the Nile Valley to record its antiquities. He settled in New York after 1836 and made a celebrated voyage to South America with J.L. Stephens in 1839, the results appearing in *View of Ancient Monuments in Central America, Chiapas and Yucatan*, 1844. Lost on the steamer *Arctic*, 1854.

Exhib: RA, 1820-31.
Bibl: H.M. Colvin, *Biog. Dict. of English Architects*, 1954, p.129.

CATTERMOLE, Charles 1832-1900
Watercolourist. Born in 1832, nephew of George Cattermole (q.v.). He was elected RI, 1870; RBA, 1876 and ROI, 1883. He illustrated a number of books and died 21 August 1900.

Exhib: BI,1858-93; RBA; RI.

CATTERMOLE, George 1800-1868
Watercolourist and illustrator of romance. He was born at Dickleburgh, Norfolk in 1800, the youngest brother of the Rev. R. Cattermole (q.v.). He worked first as an architectural draughtsman, contributing largely to Britton's *English Cathedrals*, 1832-36. By the 1830s his emphasis was changing from historic buildings to historic incidents in which figures played a more important part than their backgrounds. Cattermole established a vogue for the swash-buckling 17th century where duels and sieges took place in accurate surroundings and alluring watercolours. His drawings were probably due to a mammoth edition of Scott which he undertook, *Poetical and Prose Works of Sir W. Scott* and *Landscape Illustrations of the Works of Sir W. Scott*, 1833. He had a great sense of history, his costumes were accurate and the figures drawn in with vivid spontaneous pen

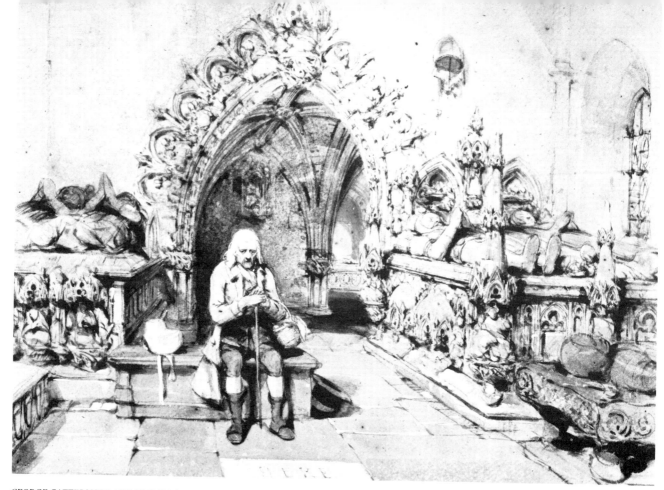

GEORGE CATTERMOLE 1800-1868. 'Little Nell's Grave at Tong church, Staffordshire.' Watercolour heightened with white. 14⅝ins. x 19⅜ins. (37.1cm x 49.2cm).
Victoria and Albert Museum

lines; sometimes individual illustrations were re-drawn as finished watercolours.

Cattermole enjoyed enormous success especially after illustrating *Barnaby Rudge* and *The Old Curiosity Shop* in Dickens's *Master Humphreys Clock,* 1841. Dickens was an intimate friend, called him 'Kittenmoles' and through him and others, the artist became part of the Kensington Gore set and a Member of the Garrick Club. Although he refused a knighthood in 1839 and was frequently patronised by Queen Victoria, his later life was clouded by unsuccessful attempts to establish himself as an oil painter. AOWS, 1822, and after a lapse, OWS, 1833. He died in London in 1868.

Illus: *Roscoe's North Wales [1836]; Cattermole's Historical Annual: The Great Civil War [R. Cattermole, 1841-45]; Cattermole's Portfolio [1845].*
Contrib: *Heaths Gallery [1836-38].*
Exhib: BI, 1827; OWS; RA, 1819-.
Colls: Ashmolean; BM; Glasgow; Leeds; Manchester; V & AM.
Bibl: OWS Club, IX, 1932; M. Hardie, *Watercol. Paint. in Brit.* Vol.III, 1968, pp.88-91.
See illustrations (above and p.259).

CATTERMOLE, The Rev. Richard c.1795-1858
Topographical artist. The eldest brother of George Cattermole (q.v.), studied under John Britton and drew nine illustrations for *Pyne's Royal Residences,* 1819, and *The Cathedral Antiquities of Great Britain,* 1814-35. He went up to Christ's College, Cambridge and took a BD in 1831, entering holy orders. He was minister of the South Lambeth Chapel from 1844 and Vicar of Little Marlow from 1849. He compiled the *Historical Annual,* illustrated by his brother and wrote *The Book of the Cartoons of Raphael,* 1837. He died at Boulogne-sur-mer, 1858.

Exhib: OWS, 1814-18.

CATTERSON, Albert fl.1895-1896
Illustrator. He specialised in coloured crayon drawings of sentimental subjects in a pretty posterish style. His work appears chiefly in *The Sketch,* 1895-96. He signs his work Bert Catterson.

Colls: V & AM.

CAWSE, John 1779-1862
Portrait painter and caricaturist. He published political caricatures with an anti-Foxite bias between 1799 and 1801. He was also a very talented personal caricaturist and the British Museum has a fine one by him of Joseph Witon, RA. Published *The Art of Oil Painting,* 1840.

Exhib: OWS; RA, 1801-45.
Bibl: M.D. George, *English Political Caricature,* 1959, Vol.II, p.261.
Colls: Witt Photo.

CECIONI, Adriano 1838-1886
Italian sculptor and caricaturist. He contributed twenty six cartoons to *Vanity Fair,* 1872.

CHALON, Alfred Edward RA 1780-1860
Portrait and history painter, caricaturist. He was born in Geneva in 1780, the son of a Huguenot refugee and the younger brother of J.J. Chalon (q.v.). The family moved to Kensington and the two brothers lived and worked there for the rest of their lives. He studied at the RA Schools, 1797, and began exhibiting at the RA in 1801. After working in Ireland, Chalon established himself as a fashionable painter of beauties and actresses, many of the portraits appearing in the albums of the period. He became Painter in Watercolours to Queen Victoria and it is his portrait of the Queen that appeared on many early issues of Colonial stamps. Chalon was a Member of the Association of Artists in Watercolours, 1807-08, and founded The Sketching Society in 1808. His caricatures in brown wash were done for private circulation only. He was elected ARA in 1812 and RA, 1816. He died

at Campden Hill, Kensington, 3 October 1860 and was buried at Highgate.

Illus: *Gallery of Graces [1832-34]; Portraits of Children of the Nobility [L. Fairlie, 1838]; The Belle of a Season [M. Gardiner, 1840]; A Memoir of Thomas Uwins [S. Uwins, 1858].*
Contrib: *Heath's Gallery [1836, 1838]; The Chaplet [1840]; ILN [1843].*
Exhib: BI, 1807-38; RA, 1810-60.
Colls: Ashmolean; BM; Leeds; NPG; Nottingham; V & AM; Witt Photo.
Bibl: *Art Journal,* January, 1862; M. Hardie, *Watercol. Paint in Brit.,* Vol.II, 1967, p.149.

CHALON, John James RA OWS 1778-1854
Landscape painter, genre painter and caricaturist. He was born in Geneva in 1778, the son of a Huguenot refugee and came to England with his family and younger brother A.E. Chalon (q.v.). He studied at the RA Schools, 1796, after giving up a commercial career and exhibited there from 1800. He travelled widely in the south and west of England making sketches and, after a visit to Paris in 1819-20, published a set of lithographs of the city, 1822. Associate of the OWS, 1805, and Member, 1807. He was elected ARA in 1827 and RA, 1841. Like his brother he practised caricature and had more success with it in a spirited and free style of wash. The Laing Art Gallery, Newcastle has a more conventional series of classical book illustrations in sepia, showing the influence of The Sketching Society which he helped to found in 1808. He died at Campden Hill, Kensington, 14 November 1854, and was buried at Highgate.

Illus: *Scenes in Paris [1820-22, AT 108].*
Exhib: BI, 1808-43; OWS; RA, 1800-54.
Colls: BM; Maidstone; Newcastle; V & AM.
Bibl: *Art Journal,* January, 1855; M. Hardie, *Watercol. Paint. in Brit.,* Vol.II, 1967, pp.149-150.

'CHAM' Comte Amedée Charles Henri De Noé 1819-1879
French draughtsman and caricaturist. He was born in Paris on 26 January 1819, and was intended to study at the École Polytechnique.

After several failures, he turned his talent for drawing into a career and began work under the caricaturist Charlet and with Paul Delaroche. He quickly became one of the leading lithographic caricaturists and published his first series in 1839. A friend of W.M. Thackeray, Cham was persuaded to complete some blocks overnight for Mark Lemon and these appeared in *Punch* in 1859. He died in September 1879.

CHAMBERLAIN, D. fl.1887-1914
Watercolourist and illustrator. Working in Glasgow from 1887 to 1914 and exhibiting there and at the RSW. This artist drew in the late *art nouveau* style of the Glasgow School and won the chapter heading competition in *The Studio,* Vol.12, 1898, illus.

CHAPMAN, C.H.
Comic illustrator. He was the principal illustrator of the 'Billy Bunter' stories from 1912 when he first met their author, Frank Richards. He was the first artist to give all the Greyfriars boys a distinctive character in the pen drawings, working closely to Richards' texts, but choosing his own subjects. He lived near Reading and died at the age of ninety.

Bibl: W.O. Lofts and D.J. Adley, *The World of Frank Richards,* 1975.

CHAPMAN, Captain E.F.
Amateur illustrator. He travelled to Asia on the Yakund Expedition, 1874, and his sketches appeared in *The Illustrated London News.*

CHAPMAN, George R. fl.1863-1890
Portrait painter who did some illustrations. He exhibited at the RA, 1863-74, and illustrated his own *The Epic of Hades,* c.1890. He also published a book *Songs of Two Worlds.*

Colls: Witt Photo.

GEORGE CATTERMOLE 1800-1868. 'Little Nell's Grave at Tong church, Staffordshire.' Original wood engraving from The Old Curiosity Shop *by Charles Dickens, published in* Master Humphrey's Clock, *1841.*

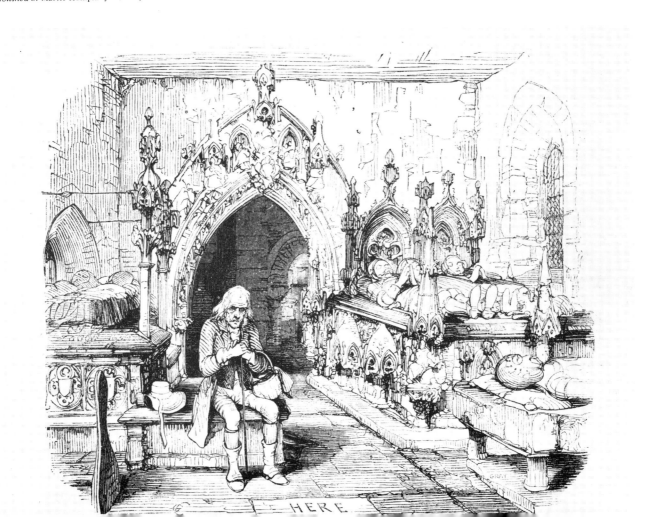

CHARLES, William -1820

A caricaturist who worked in England, 1803-04, and drew anti-British satires during the Anglo-American War of 1812. He died in Philadelphia in 1820.

Bibl: M.D. George, *English Political Caricature*, Vol.11, 1959, p.261.

CHARLTON, C. Hedley

Illustrator. He contributed drawings of children in a poster style to *Punch*, 1908.

CHARLTON, Edward William RE 1859-1925

Landscape painter. Working at Ringwood, Hants, 1890-99 and at Lymington, Hants, 1899-1925. ARE, 1892 and RE, 1907.

Exhib: L; RA; RE; ROI; RWA.
Bibl: *The Studio*, Winter No. 1900-1, pp.56-57 illus.

CHARLTON, Miss Gertrude

Portrait painter and illustrator of children's books. She worked in Chelsea, 1899-1902, and illustrated her own *Excellent Jane*, 1899. She exhibited at the NEA, 1901.

CHARLTON, John 1849-1917

Animal and battle painter and illustrator. He was born at Bamburgh, Northumberland in 1849 and after working in a bookshop, studied at the Newcastle School of Art under W.B. Scott (q.v.). He then went to South Kensington and worked for some time under J.D. Watson (q.v.), thereby forming an important link between the 1860s illustrators and those of the 1890s. He was at his best when drawing scenes from high life, particularly hunting subjects and royal occasions. He settled permanently in London in 1874 and his connection with *The Graphic* dates from two years later. His work for the magazine on the Egyptian Campaign of 1882 turned his attention to battle scenes, and he became one of the leading exponents of military paintings. He died in London, 5 November 1917. RBA, 1882 and ROI, 1887.

Illus: *Twelve Packs of Hounds [1891]; Red Deer [H.A. Macpherson, 1896]*.
Contrib: *The Graphic [1876-95]*.
Exhib: B; G; L; M; New Gall; RA; RBA, 1871- ; ROI; RSA.
Colls: Newcastle; V & AM; Witt Photo.

CHARTRAN, Théobald 1849-1907

Portrait painter. He was born at Besançon in 1849 and had a distinguished career painting state portraits and elaborate mural schemes. He exhibited regularly in Paris from 1872 and at the RA from 1881. He contributed several cartoons to *Vanity Fair*, 1878-88.

Colls: V & AM.

CHASEMORE, Archibald fl.1868-1901

A regular cartoonist for *Judy*, 1875-89. He was a contributor to *Punch* 1868-79, and supplied jokes for his friend Charles Keene (q.v.) to draw. His own work was in very finished pen and ink but tending to be rather stiff. His political subjects are amusing and collectable. Contributed to *Pick-Me-Up*, 1901; *Ally Sloper's Half Holiday; The Boys' Own Paper*.

CHATTERTON, Henrietta Georgina Marcia, Lady 1806-1876

Writer and artist. She married in 1824 Sir William Abraham Chatterton of County Cork, but lived in England from 1852. On his death she married Edward Heneage Dering in 1859. She published poems and travels, 1837-76.

Illus: *The Pyrenees with Excursions into Spain [1843, AT 211]*.

CHEESEMAN, Thomas Gedge fl.1890-1925

Painter of domestic subjects. He worked at Highbury, 1890, and at Battersea, 1908-25. Exhibiting at the RA, 1890-91, and ROI. He contributed to *The Cornhill Magazine*, 1885.

CHESTERTON, Gilbert Keith 1874-1936

Author, novelist and critic. He was born at Campden Hill in 1874 and studied at the Slade School. Before he established himself as a novelist, Chesterton reviewed art-books for *The Bookman*. He was a competent amateur artist and his chalks of humorous subject have considerable charm.

Colls: Witt Photo.

CHESWORTH, Frank

Prolific illustrator in the 1890s.

Contrib: *The Sketch [1894]; The New Budget [1895]; The Sporting and Dramatic News [1895]; Pick-Me-Up [1896]; Illustrated Bits; The Pall Mall Magazine*.

CHINNER, J.A.

Amateur illustrator. He contributed to *Punch*, 1908.

CHRISTIAN, W.F.D.

Illustrator contributing to *The Cambridge Portfolio*, 1840.

CHRISTIE, James Elder 1847-1914

Figure and portrait painter. He studied at Paisley School of Art and South Kensington. Visited Paris and worked in London, 1880-94, and at Glasgow, 1894-1914. He became a Member of the NEA in 1887.

Illus: *Susy [Bret Harte, 1897]*.
Exhib: B; G; GG; L; M; NEA; New Gall; RA; RSA.

CLARK, Christopher 1875-

Painter of military subjects and illustrator. He was born 1 March 1875 and was self-taught. He drew frequently for magazines from c.1900 and was also a poster artist. He served in the RNVR, 1917-19. RI, 1905.

Illus: *Lorna Doone [R.D. Blackmore, 1912]; Tales of the Great War [Sir H. Newbolt, 1916]*.
Exhib: L; RA; RI.
Colls: Witt Photo.

CLARK, John Heaviside 'Waterloo Clark' c.1771-1863

Landscape painter and book illustrator. He worked in London between 1802 and 1832, but died in Edinburgh in 1863. He earned his nickname from the series of sketches that he undertook immediately after the Battle of Waterloo.

Illus: *Foreign Field Sports [1814, AT 2]*.
Publ: *Practical Essay On The Art of Colouring and Painting Landscapes [1807]; Practical Illustrations of Gilpin's Day [1814]*.
Exhib: RA, 1801-32.
Colls: Glasgow.

CLARK, Joseph 1834-1926

Painter and illustrator. He was born at Cerne Abbas in Dorset in 1834 and was educated there by the Rev. William Barnes. He studied art at Leigh's School and was a student at the RA Schools. Two of his pictures were bought by the Chantrey Bequest and many were engraved. He died at Ramsgate 4 July 1926.

Contrib: *Passages From Modern English Poets [1862]*.
Exhib: NWS; RA, 1857-1925; RBA; RI.
Colls: Tate.
Bibl: *Who Was Who*, 1916-28.

CLARK, Joseph Benwell 1857-

Painter, draughtsman and illustrator. He was the nephew of Joseph Clark (q.v.) and specialised in interiors and animal painting. He was a pupil of Alphonse Legros and although much of his output is unremarkable, he was responsible for a handfull of exceptional book illustrations in the 1890s. In 1895, he drew the pictures for a Lawrence & Bullen edition of *The Surprising Adventures of Baron Munchausen*, pen and ink work in a bold and woodcutty style, very advanced and imaginative. The publishers clearly thought highly of his work, for he is one of the supporting illustrators in *Lucian's True History*, 1894, where Beardsley was the star. He worked for most of his life in North London, sometimes in conjunction with V.M. Hamilton.

Illus: *Ali-Baba [1896] Sinbad the Sailor [1896]*.
Contrib: *Judy [1889-90 (strip cartoons)]; ILN [1891]*.
Exhib: GG; RA; RBA, 1876-91.
Colls: V & AM.
See illustration (p.261).

JOSEPH BENWELL CLARK b.1857. Illustration to The Surprising Adventures *of Baron Munchausen, 1895. Ink and chinese white. Signed with initials and dated 1894. 6ins. x 5ins. (15.2cm x 12.7cm).* Victoria and Albert Museum

CLARKE, Arthur -c.1912

One of the original illustrators of 'Billy Bunter'. He succeeded Hutton Mitchell (q.v.), as artist on *The Magnet* and died about 1912. He also worked for *The Gem*.

Bibl: W.O. Lofts and D.J. Adley, *The World of Frank Richards*, 1975.

CLARKE, Edward Francis C. fl.1867-1887

Painter, architect and illustrator. He practised in London and exhibited there 1872-1887.

Contrib: *The Churchman's Shilling Magazine [1867]; Dark Blue [1871-73].*
Exhib: L; NWS; RBA, 1882-84; RI; RSA.

CLARKE, Harry 1890-1931

Illustrator and decorative artist. Born in Dublin in 1890 and was apprenticed to his father, head of a large firm of stained glass artists in 1906. Attended the Dublin Metropolitan School of Art, 1910-13, and was awarded three gold medals and one which took him to the Île-de-France. On his return he set up an independent stained glass workshop in Dublin and carried out a great deal of work in Ireland, England and abroad. As a book illustrator, he was one of the most successful followers of Beardsley, capturing a great deal of the latter's sinister atmosphere, although his finish was less polished. He died of tuberculosis in Switzerland in 1931. RHA, 1925.

Illus: *Fairy Tales [Hans Christian Andersen, 1916]; Tales of Mystery and Imagination [Edgar Alan Poe, 1919]; The Years at the Spring [Lettice D'O Walters, 1920]; The Fairy Tales of Charles Perrault [1922]; Faust [Goethe, 1925]; Selected Poems [A.C. Swinburne, 1928]; The Playboy of the Western World [J.M. Synge].*
Exhib: RHA; St. George's Gall.

Colls: V & AM; Witt Photo.
Bibl: *Modern Book Illustrators and their Work,* Studio, 1914; B. Peppin, *Fantasy Book Illustration,* 1975, pp.21-22, 186 illus.
See illustration (below).

CLARKE, Joseph Clayton 'Kyd' fl.1883-1894

Illustrator and caricaturist. He drew illustrations for an edition of Dickens in 1883 and made a caricature of Aubrey Beardsley (q.v.), in 1894.

Colls: Witt Photo.

CLARKE, Miss Maud V.

Horse painter. Contributor to *English Illustrated Magazine,* 1887, *The Illustrated London News,* 1889, and *The Sporting and Dramatic News,* 1890.

CLAUSEN, Sir George RA RWS 1852-1944

Landscape painter and painter of rural life. He was born in London in 1852, the son of a Danish sculptor and was much influenced by continental art and the French School in particular. Member of the NEA, 1888; he was elected ARA in 1895 and RA in 1908, having exhibited there since 1876. Clausen was Professor of Painting at the RA, 1903-06, and Director of the Schools. He was knighted in 1927. RWS, 1898. He provided a single illustration for *The Quarto,* 1897.

Exhib: L; M; RA; RWS.
Colls: Bedford; BM; Fitzwilliam; Manchester; V & AM.

CLAXTON, Adelaide (Mrs. George Turner) fl.1858-c.1905

Illustrator. The younger daughter of Marshall C. Claxton (q.v.), who was the first artist to take an exhibition of pictures to Australia. She accompanied her father there and afterwards to Ceylon, and India, 1860. Vizetelly says she 'satirized the social follies' and her pictures had great popularity, but the drawing was often very stiff and the proportions of the figures poor.

Illus: *A Shillingsworth of Sugar Plums [1867]; Brainy Odds & Ends [1900].*
Contrib: *ILN [1858]; The Illustrated Times [1859-66]; London Society [1862-65, 1870]; Judy [1871-79]; Sidelights on English Society [Grenville Murray, 1881].*
Exhib: RA; RBA, 1865-76; SWA, 1880-89.
Colls: V & AM.

HARRY CLARKE 1890-1931. Tail-piece for Goethe's Faust, *G.G. Harrap, 1925, limited edition.*

CLAXTON, Florence A. (Mrs. Farrington) fl.1855-1879

Illustrator. She was the eldest daughter of Marshall C. Claxton (q.v.), and sister of Adelaide Claxton (q.v.). Accompanied her father to Australia, Ceylon and India and made sketches of the last two countries which were later published. She was a more serious artist than her sister and specialised in historical drawings and the illustration of romantic stories rather than purely humorous subjects. Her work is, however, often poor in composition and coarse in execution.

Contrib: *The Illustrated Times [1855-67]; ILN [1860]; London Society [1862]; The Churchman's Family Magazine [1863]; Good Words [1864].*
Exhib: RA; RBA, 1865-73; SWA, 1896.
Colls: V & AM.

CLAXTON, Marshall C. 1811-1881

Historical painter and illustrator. He was born at Bolton in 1811 and was a pupil of John Jackson RA. He entered the RA Schools in 1831, won a medal in the Painting School, 1832, and a Society of Arts Gold Medal in 1835. He travelled to Australia in the 1850s with the idea of starting an art school and exhibiting pictures, the first man to do so. He returned through Ceylon and India and made sketches of life and scenery there. He signs his work *CM*

Contrib: *ILN [1852-58]; The Illustrated Times [1859]; The Churchman's Family Magazine [1863].*
Exhib: BI, 1833-67; RA; RBA, 1832-75.
Colls: V & AM (Designs for an edition of Pilgrim's Progress).

CLAYTON, Benjamin

Illustrator of military scenes. Contributed to *The Illustrated Times,* 1856-60.

CLAYTON, Eleanor 'Ellen' Creathorne c.1846-

Novelist and illustrator. She was born in Dublin and after studying at the British Museum began to contribute humorous drawings to magazines. She undertook the designing of calendars, valentines, etc. in the 1870s.

Illus: *Miss Milly Moss [1862].*

CLAYTON, John R.

Wood engraver and draughtsman, specialising in figure subjects. He was a High Victorian artist whose greatest claim to fame is that he was consulted by D.G. Rossetti (q.v.) about the wood engravings for the *Moxon, Tennyson,* 1857.

Contrib: *George Herbert's Poetical Works [1856]; Pilgrim's Progress [1856]; Course of Time [1857]; Poets of the Nineteenth Century [1857]; Dramatic Scenes and Other Poems [1857]; Lays of the Holy Land [1858]; The Home Affections [1858]; Krummacher's Parables [1858]; Architectural Sketches From the Continent [R. Norman Shaw, 1858 (border of frontis.)]; English Poets, Illustrated by the Junior Etching Club [1862]; Barry Cornwall's Poems.*
Colls: V & AM; Witt Photo.
Bibl: Chatto & Jackson, *Treatise on Wood Engraving,* 1861, p.599; Forrest Reid, *Illustrators of the Sixties,* 1928, pp.32-36.

CLEAVER, Dudley

Contributor to *The Penny Illustrated Paper,* c.1890.

CLEAVER, F.R.

Illustrator of genre subjects for *The Illustrated London News,* 1889.

CLEAVER, Ralph fl.1893-1926

Black and white artist. He was employed on many illustrated papers in the 1890s but regularly on *The Graphic* and *Daily Graphic* from 1906. He served in the RNVR throughout the First World War. Cleaver specialised in naval and military subjects, but also drew theatrical performances and cartoons. He enlivened his straight magazine reportage by introducing comic elements, and his drawing is always clear.

Illus: *Mating of Clopinda [James Bank, 1909].*
Contrib: *Judy [1893]; ILN [1895-1901]; The St. James's Budget; The Gentlewoman; Penny Illustrated Paper; The Temple Magazine; The Royal Magazine; Punch [1900].*
Colls: V & AM.
Bibl: *The Studio,* Winter No, 1900-01, p.84 illus.

REGINALD THOMAS CLEAVER c.1954. Study of a seated woman for an illustration in Punch, c.1900. Pencil and grey wash. 9½ins. x 6¾ins. (24.1cm x 17.1cm).
Author's Collection

CLEAVER, Reginald Thomas -1954

Black and white artist. He was employed on *The Graphic* staff from about 1893 and worked for that paper and *The Daily Graphic* until 1910. Spielmann calls his drawing 'somewhat hard but of great beauty in its own line', but this hardness wore off to make Cleaver, according to Thorp, the most important *Graphic* artist of the Edwardian era. His studies for drawings, where washes are subtly added to sensitive pencil lines, are among the most beautiful of their type. Cleaver was a marvellous portrayer of women and of the social scene as numerous *Punch* cuts testify.

Contrib: *The Graphic [1893-1910]; Punch [1894-1930].*
Colls: Author; V & AM.
Bibl: Spielmann, *The History of 'Punch',* 1895, pp.92, 565; J. Pennell, *Pen Drawing and Pen Draughtsmen,* 1894, pp.330-331; J. Pennell, *Modern Illustration,* 1895, p.106; *The Studio,* Winter No, 1900-01, p.84 illus.; *Mr. Punch With Horse and Hound,* New Punch Library, c.1930, p.115.
See illustration (above).

CLEGG, Ada

Book decorator. Contributing to *The English Illustrated Magazine,* 1896-97.

CLEGHORN, John fl.1840-1880

Painter of landscapes, wood carver and sculptor. He exhibited in London from 1840-80.

Contrib: *Winkle's Illustrations to the Cathedral Churches [1836-37]; Knight's London [1842].*

CLENNELL, Luke 1781-1840

Wood engraver, illustrator and watercolourist. He was born at Ugham, near Morpeth, on 8 April 1781, the son of a farmer. Although started in trade, Clennell was apprenticed in 1797 to Thomas Bewick (q.v.),

LUKE CLENNELL 1781-1840. Fashion illustration for La Belle Assemblée, *c.1805-6. Watercolour.*

and became one of his best pupils. He left Newcastle in 1804 and on becoming a wood engraver in London, was awarded the golden palette of the Society of Arts in 1806 and 1809. Chatto records that, 'Clennell who drew beautifully in watercolours, made many of the drawings for the Border Antiquities; and the encouragement that he received as a designer and painter made him resolve to entirely abandon wood engraving.' He became an Associate of the OWS in 1812 and won the 150 guinea premium offered by the BI for the best sketch of 'The Decisive Charge of the Life Guards at Waterloo'; it was published in 1821. In April 1817, he became insane and although he continued to make small sketches and write poems, his professional career was at an end. Clennell died in Newcastle Lunatic Asylum, 9 February 1840.

Clennell brought to book illustration some of the freedom which was associated with the Bewick School and the naturalness of head and tail pieces which characterised it. He designed some bookplates and in surviving designs looks backwards to French illustration and forwards to the insouciant charm of Kate Greenaway.

Contrib: *La Belle Assemblée or Fashionable Companion [1805-06]; Ackermann's Religious Emblems [1809]; Britton's Beauties of England and Wales [1814]; Border Antiquities of England and Scotland [1814-17]; The Antiquarian Itinerary [1818].*
Exhib: OWS; RA.
Colls: BM; Greenwich; Newcastle; V & AM.
Bibl: Chatto & Jackson, *Treatise on Wood Engraving,* 1861 pp.521-527.
See illustration (above).

CLIFFORD, Harry P. RBA fl.1895-1938
Black and white artist, specialising in architectural subjects. He worked in Kensington, 1902-25, and exhibited at many exhibitions. RBA, 1898.

Exhib: B; L; RA; RBA; RI.
Bibl: *The Studio,* Winter No., 1900-01, p.68 illus.

CLIFFORD, Maurice
Figure artist. Working in Bedford Park, London and winner of *The Studio* tailpiece competition, Vol.12, 1897-98, illus.

Exhib: L; M; RA; ROI, 1890-95.

CLINT, George ARA 1770-1854
Portrait painter and engraver. He was born in London in 1770 and after working as a decorator and a miniature painter, he began to paint personalities from the London stage. He was an ARA from 1821 to 1836.

Contrib: *The British Theatrical Gallery [1825, AL 418].*
Exhib: BI; OWS; RA; RBA.
Colls: BM.

CLUTTON, Henry 1819-1893
Architect. He was a pupil of Edward Blore and a friend of William Burges (q.v.). With Burges he won the first place in the Lille Cathedral Competition, and in the course of a long career designed many schools, houses and churches.

Illus: *Remarks ... On The Domestic Architecture of France [1853 (tinted liths.) AT 100].*

COBB, Ruth
Figure artist. She contributed to *Punch,* 1914.

COCK, Eianley
Perhaps E.C. Loveland Cock, recorded in *The Years Art,* 1909-30. He contributed a cartoon to *Vanity Fair,* 1913.

COCKERELL, Charles Robert RA 1788-1863
Architect, draughtsman and etcher. He was the son of Samuel Pepys Cockerell, the architect and was educated at Westminster. After studying with his father, he went on a prolonged tour of Greece, Asia Minor and Sicily, 1810-17, discovering the frieze of the Temple of Apollo at Phigaleia, 1812. He was the leading exponent of Victorian classical architecture, designing the Taylor Buildings at Oxford, 1841-52. RA, 1836; Professor of Architecture at RA, 1840-57.

Publ: *The Antiquities of Athens etc. [1830]; The Temple of Jupiter Olympus at Agrigentum [1830]; The Iconography of the West Front of Wells Cathedral [1851]; The Temples of Jupiter Panhellenus etc. [1860].*
Illus: *Ancient Marbles in the British Museum [1820-30 (frontis.)]; Travels in Sicily, Greece and Albania [Rev. T.S. Hughes, 1820, AT 203].*

263

Exhib: RA, 1818-58.
Colls: BM; RIBA; V & AM.
Bibl: A.E. Richardson, *Monumental Classic Architecture in Great Britain and Ireland*, 1914; David Watkin, *CRC, 1975.*

COHEN, Ellen Gertrude fl.1884-1905

Figure painter and illustrator. She worked in London and contributed to *The English Illustrated Magazine*, 1890-94.

Exhib: B; L; M; P; RA; RBA; RI; ROI; SWA.

COÏDÉ See TISSOT, J.J.

COKE, Thomas William Earl of Leicester 1752-1842

'Mr. Coke of Holkam', created 1st Earl of Leicester, 1837. He was a talented caricaturist in the style of Ghezzi, but his drawings were only for private circulation.

Colls: Windsor.

COLE, C.W. fl.1884-1905

Humorous artist. He contributed comic genre subjects to *The Graphic*, 1884-85, and collaborated with C.J. Staniland (q.v.) in views of Japan in the same magazine, 1887.

COLE, Herbert 1867-1930

Draughtsman, illustrator and engraver, designer of bookplates. There is little biographical material on this important artist. He appears to have worked for many magazines in the 1890s, either in a flamboyant art nouveau style or in comic illustrations in the manner of Charles Keene. By the 1900s, Cole was combining a fluid pen with the most sensuous colouring, his designs are always inventive if they lack the

Such was the dirge the violet-crowned Muses sang over the son of Thetis

HERBERT COLE 1867-1930. 'Sunset of the Heroes.' An illustration for a book published by W.M.L. Hutchinson in 1911. Pen and ink with watercolour. 12⅛ins. x 8⅜ins. (30.8cm x 21.3cm). Victoria and Albert Museum

dramatic force of a Rackham or a Harry Clarke, returning more perhaps to the book design of Crane.

Illus: *Gulliver's Travels [Lane, 1899]; The Rubaiyat* and *Flowers of Parnassus [1901]* and *A Ballade upon a Wedding [in the same series]; The Nut-Brown Maid [1901]; The Rime of the Ancient Mariner [1900]; The Poems and Songs of Shakespeare [1904]; Songs and Lyrics From the Dramatists, 1533-1797 [1905]; The Dragon Volant [Le Fanu, 1907]; The Sunset of the Heroes [W.M.L. Hutchinson, 1911]; Fairy Gold: A Book of English Fairy Tales [Ernest Rhys, 1926]; Rise of the Romantic School in France [C. Yriarte, n.d. (decor)].*
Contrib: *Fun [1901]; The Pall Mall Magazine.*
Exhib: RA, 1898 and 1900.
Colls: V & AM; Witt Photo.
Bibl: R.E.D. Sketchley, *English Book Illustration*, 1903, pp.13-14, 122.
See illustration (below left).

COLEMAN, Edmund Thomas fl.1839-1877

Landscape painter and topographer. He specialised in alpine scenery.
Illus: *Sketches on the Danube [1838, AT 79]; Scenes From The Snow Fields [1859, AT 68].*
Exhib: BI, 1852-59; RA; RBA, 1850-1877.

COLEMAN, William Stephen 1829-1904

Landscape and figure painter and illustrator. He was born at Horsham, Sussex in 1829, the son of a physician. He was a keen naturalist and this led him to the arts and the illustration of books. He illustrated the Rev. J.G. Wood's natural history books and worked in oil, pastel and etching. His landscapes are idealised and romantic although his scientific work is accurate. In later life he became associated with Minton's Art Pottery Studio for which he designed. He was on the committee of the Dudley Gallery until 1881 and died on 22 March 1904 at St. John's Wood.

Illus: *Our Woodlands, Heaths and Hedges [1859]; British Butterflies [1860].*
Contrib: *The Illustrated Times [1856]; ILN [1857]; The Book of The Thames [S.C. Hall, 1859]; The Book of South Wales [Mr. and Mrs. S.C. Hall, 1861]; Mary Howitt's Tales; The Field.*
Exhib: 1866-79; RBA, 175.
Colls: Blackpool; Glasgow; V & AM; Witt Photo.

COLEMAN-SMITH, Pamela fl.1899-1917

Painter and illustrator of children's books. She was working at Knightsbridge, London, 1907 and exhibited at the SWA and the Baillie Gallery, 1905-17. She illustrated *Widdicombe Fair* in a limited edition, 1899, the drawings done in stumpy black outline in the style of the Beggarstaff Brothers.

COLES, E.

Contributor to *Fun*, 1900.

COLLIER, The Hon. John 1850-1934

Figure, portrait and landscape painter. He was born in London, 27 January 1850, son of 1st Baron Monkswell. He was educated at Eton and the Slade School and then under E.J. Poynter (q.v.), and J.P. Laurens, Paris. He married successively two of the daughters of T.H. Huxley.

Although a very popular artist in the grand manner, Collier was a rare illustrator and reveals himself to be a weak pen artist. He illustrated Thomas Hardy's 'The Trumpet Major' for *Good Words* in 1880, which was not successful and in 1894 tackled *Thackeray's Ballads* in the Cheap Illustrated Edition, *English Illustrated Magazine*, 1890-91. He published various manuals on oil painting. Died 11 April 1934.

Exhib: GG; RA; RBA.
Colls: Blackburn; Sydney; V & AM.
Bibl: E.C.F. Collier, *A Victorian Diarist, Monkswell, 1873-95*, 1944.

COLLINGS, Arthur Henry -1947

Portrait and figure painter. He worked in North London, 1902-25, and won a gold medal at Paris Salon 1907. RBA, 1897; RI, 1913.

Contrib: *The Lady's Pictorial [1895].*
Exhib: L; RA; RBA; RI; ROI.

COLLINGS, J.P. or T.P.

Illustrator, specialising in ornament and works of art, contributing to *The Graphic*, 1875-1889.

COLLINGWOOD, Professor William Gershom MA FSA 1854-1932
Landscape painter and illustrator. He was born in 1854, the son of W. Collingwood, RWS, and was educated at Liverpool College and at University College, Oxford. He then attended the Slade School under Legros and followed a career in art teaching. He was Professor of Fine Art, University College, Reading and President of the Cumberland and Westmorland Antiquarian Society and President of the Lake Artists Society. He published a number of books but made a special study of Scandinavian art and lore. He illustrated *The Elder or Poetic Edda: The Mythological Poems,* by Olive Bray, in 1909. These are very beautiful Norse designs, based on the sculpture of Pre-Norman monuments in the north of England. He lived much of his life in the Lake District and died at Coniston on 1 October 1932.

Exhib: G; L; M; New Gall; RA; RBA; RI.
Bibl: Who Was Who 1929-1940.

COLLINS, Charles Allston 1828-1873
Pre-Raphaelite painter and brother of Wilkie Collins and son-in-law of Charles Dickens. He studied at the RA Schools and worked with Millais and was thus drawn into the Pre-Raphaelite circle. His output was small and imbued with tremendous religious sentiment as well as Pre-Raphaelite colouring and exactitude. He wrote articles for *Good Words* and *All The Year Round* and exhibited at the RA from 1847 to 1855, when he finally abandoned painting. He designed the wrapper of the first American edition of Dickens's *Edwin Drood,* 1870.

Colls: Ashmolean; BM.
Bibl: J. Maas, *Victorian Painters,* 1969, p.127.

COLLINS, William Wiehe 1862-1951
Painter of architecture and military subjects. He was the son of an army doctor and was educated at Epsom College, followed by study at Lambeth School of Art and at Julian's, Paris. He was in the RNVR, 1914-18, in the Dardanelles and in Egypt, which furnished him with material for pictures. He lived at Wareham, Dorset, 1903-25, and died at Bridgwater, Somerset, 1951. RI, 1898.

Publ: *The Cathedral Cities of England [1905]; Cathedral Cities of Spain [1909]; Cathedral Cities of Italy [1911]; The Green Roads of England.*
Contrib: *Black and White [1891].*
Exhib: FAS, 1901.

COLOMB, Wellington
Landscape painter who exhibited at the RA and RBA, 1865-70. He contributed an illustration to *Good Words,* 1864.

COMPTON, Edward Theodore 1849-
Painter and alpinist. Lived most of his life in Austria and Germany but exhibited regularly in London. He was interned during the First World War, but continued to work near the Italian frontier.

Illus: *A Mendip Valley [T. Compton, 1892]; Germany [J.F. Dickie, 1912]; Germany [G.W. Bullet, 1930].*
Contrib: *The Picturesque Mediterranean [Cassell, 1891].*

CONCANEN, Alfred 1835-1886
Music cover illustrator. He was born in London in 1835 of Irish descent and began designing covers for music in 1859. He was the most prolific of these artists and the best, giving his subjects great verve and clarity and specialising in what Ronald Pearsall has called 'London out-of-doors' subjects.

Illus: *Carols of Cockayne [H.S. Leigh, 1874]; Low Life Deeps [J. Greenwood, 1874]; The Queen of Hearts [Wilkie Collins, 1875]; The Wilds of London [J. Greenwood, 1876].*
Contrib: *Illustrated Sporting and Dramatic News.*
Bibl: Ronald Pearsall *Victorian Sheet Music Covers,* 1972.

CONDER, Charles Edward 1868-1909
Landscape painter and designer of fans. He was born in London in 1868 and spent much of his early life in India. He was educated at Eastbourne and then spent five years in Australia as a civil servant, 1885. While there he worked for the *Illustrated Sydney News* and attended Melbourne School of Art. In 1890 he went to Paris and studied at Julian's becoming an Associate of the Société Nationale

des Beaux Arts, 1893. He settled in London in 1897 and was elected to the NEAC in 1901. He died at Virginia Water in 1909.

Contrib: *The Yellow Book [1895]; The Savoy [1896]; The Page [1899].*
Des: *Impressionist Exhibition [1899 (cover)];* invitation card for Conder Exhibition, Paris, Dec. 1901.
Colls: Bedford; BM; Fitzwilliam; Leeds; Manchester; V & AM; Witt Photo.

CONDY, Nicholas Matthew 1818-1851
Marine painter. He was the son of Nicholas Condy, 1793-1857, the painter, and taught art at Plymouth.

Publ: *Cotehele . . . the seat of the Earl of Mount Edgecumbe [1850].*
Contrib: *ILN [1845-50 (naval subjects)].*

CONNARD, Philip RA CVO 1875-1958
Painter and illustrator. He was born at Southport in 1875 and after being educated at the National Schools, he studied at Julian's in Paris. Settling in Fulham in 1901, he became Art Master at the Lambeth School of Art and concentrated on book illustration. These works, principally for John Lane, were in a late Pre-Raphaelite style in the manner of Laurence Houseman (q.v.). Elected to the NEAC in 1909; ARA, 1918, and RA, 1925. Keeper of the RA, 1945-49; ARWS, 1933.

Illus: *Flowers of Parnassus [Browning, Lane, 1900]; Narpessa [Stephen Phillips, 1900 (frontis.)].*
Contrib: *The Idler; The Dome [1899-1900]; The Quartier Latin [1898].*
Exhib: G; L; M; NEA, from 1901; RA; RHA; ROI; RSA; RSW; RWS.
Colls: Aberdeen; Bradford; Cardiff; Dublin; Manchester; Southport; Tate.
Bibl: R.E.D. Sketchley *English Book Illus.,* 1903, pp.13-14, 122.

CONNELL, M. Christine fl.1885-1907
Painter of domestic subjects. She worked in Chelsea and Chiswick and contributed decorative subjects to *The English Illustrated Magazine,* 1896, and *The Sketch,* 1897.

Exhib: L; M; New Gall.; RA; RBA; ROI; SWA.
Colls: V & AM.

CONNOR, Arthur Bentley fl.1903-1925
Portrait painter. He worked in London, 1903, in Penarth, 1915, and Weston-super-Mare from 1918-1925. He illustrated *Highways and Byways in Hampshire.*

Exhib: P; RA.

COODE, Miss Helen Hoppner fl.1859-1882
Illustrator and watercolourist. She worked at Notting Hill, London, and Guildford, Surrey, and specialised in figure subjects. They are often brittle little drawings with large heads and rather weightless. She was the first woman cartoonist to work for *Punch,* 1859-61 and contributed small illustrations to *Once a Week,* 1859. She signs her her work HGH

Exhib: BI, 1859-66; M; RA; RBA, 1876-81.

COOK, Richard RA 1784-1857
Painter and book illustrator. He was born in London in 1784 and entered the RA Schools in 1800. He specialised in historical scenes and illustrated numerous works from poetry and classical literature. His handling of the drawings typifies the beautiful ink and grey wash approach which was a legacy from the 18th century but which often lacked punch. The BM has a fine album of his studies for *The Lady of the Lake* by Sir Walter Scott, published in 1811. He became ARA in 1816 and RA in 1822 after which date he ceased to paint.

Illus: *Inchbald's British Theatre [1802]; Young's Night Thoughts [1804]; The Pastoral Care [1808]; The Idler [1810]; Park's British Poets; Miller's Shakespeare etc.*
Exhib: BI, 1807-26; RA, 1808-22.
Colls: BM; Swansea; V & AM; Witt Photo.

COOKE, Arthur Claude 1867-
Figure and animal painter. He was born at Luton, Bedfordshire, in 1867 and studied at the RA Schools. He worked in London, 1890-92, and again from 1903-14, finally settling in Radlett in 1925. He supplied illustrations of dogs to *The Lady's Pictorial* in the 1890s.

Exhib: B; L; RA; RBA; ROI.

COOKE, Edward William RA FRS **1811-1880**

Marine watercolourist, topographer and illustrator. He was born at
Pentonville on 27 March 1811, the son of George Cooke (q.v.), the
engraver. He was making wood engravings of plants by the age of nine,
some of which were used in J.C. Loudon's *Encyclopaedia of Plants,*
1829, and Loddidge's *Botanical Cabinet* 1817-33. He married the
latter's daughter but after meeting Clarkson Stanfield (q.v.) in 1825,
began to draw boats for him and to study shipping. Cooke travelled
extensively in Europe, visiting Normandy in 1830 and Belgium and
Holland between 1832 and 1844. He went further afield to Italy,
1845-46, and Spain and North Africa. His watercolours are rare but
his fine pencil studies and leaves from his sketch-book, showing
picturesque groups of fishermen, crowds and shore-lines, are quite
common. He became ARA in 1851 and RA in 1864, dying at
Groombridge, Kent, on 4 January 1880.

Illus: *Coast Sketches: British Coast [1826-30]; Fifty Plates of Shipping and
Craft [1829]; Finden's Ports, Harbours and Watering Places [1840].*
Contrib: *Good Words [1863].*
Exhib: BI, 1835-67; RA; RBA, 1835-38, 1876.
Colls: BM; Glasgow; Greenwich; Leeds; Salford; Sheffield; V & AM.
Bibl: M. Hardie, *Watercol. Paint. in Brit.*, Vol. III, 1968, p.79.

COOKE, George **1781-1834**

Topographical illustrator and engraver. Born in London in 1781 and
engraved many works after Turner, Callcott and his son E.W. Cooke
(q.v.). Died at Barnes in 1834.

Illus. or contrib: *Britton's Beauties [1803-13]; Pinkerton's Voyages and Travels;
The Thames [1811]; The Southern Coast of England [1814-26]; History of
Durham [Surtees, 1816-40]; Hertfordshire [R. Clutterbuck, 1815-27]; Italy [J.
Hakewill, 1818-20]; D'Oyly and Mant's Bible; The Botanical Cabinet
[1817-1833]; London and Its Vicinity [1826-28].*
Exhib: RBA.
Colls: BM.

COOKE, William Bernard **1778-1855**

Topographical illustrator and engraver. Elder brother of George Cooke
(q.v.). He was a pupil of W. Angus, the topographer, and assisted his
brother in publishing *The Thames*, 1811, and *The Southern Coast of
England*, 1814-26.

Illus: *A New Picture of The Isle of Wight [1808]; Britton's Beauties [1808-16].*
Colls: Witt Photo.

COOKE, William Cubitt **1866-1951**

Watercolourist and book illustrator. He was born in London in 1866
and was educated at the Cowper Street Schools, City Road. At the age
of sixteen he was apprenticed to a chromo-lithographer, but taught
himself drawing and painting. He went later to Heatherley's and the
Westminster School of Art. Cooke had his first black and white
drawing published in 1892 and this was followed by a steady stream,
some for short stories with an eastern flavour and some for period
novels. He was a very competent figure artist indeed, although his
compositions lack great individuality.

Illus: *Evelina* and *Cecilia [Fanny Burney, 1893]; The Man of Feeling
[Mackenzie, 1893]; My Study Fire [1893]; The Vicar of Wakefield [1893];
Reveries of a Bachelor [1894]; The Master Beggars [1897]; The Singer of Marly
[1897]; The Temple Dickens [1899]; Novels of Jane Austen [1894]; British
Ballads [1894]; By Stroke of Sword [1897]; John Halifax [1898].*
Contrib: *The Quiver [c.1895]; The Idler; The Pall Mall Magazine; The English
Illustrated Magazine [1896-98]; The Windsor Magazine.*
Exhib: RA, from 1893; RBA, from 1890; RI.
Colls: V & AM.
Bibl: R.E.D. Sketchley, *English Illus.*, 1903, pp.84, 149.
See illustration (right).

COOPER, Abraham RA **1787-1868**

Sporting artist. He was largely self-taught although he had some
drawing lessons from Ben Marshall. His inclusion here rests solely on
some compositions that appeared in *The Sporting Magazine* and the
frontispiece that he designed for *A Treatise on Greyhounds*, 1819.
ARA; 1817, and RA, 1820.

Exhib: BI and RA, 1812-1869.
Colls: BM; Witt photo.

COOPER, Alfred W. **fl.1850-1901**

Illustrator of domestic subjects. One of the best of the second rank of
1860s artists about whom little is known. He was living in North
London, 1853-54, and had moved to Twickenham by 1866, where he
seems to have worked for the rest of his life. Cooper's earlier drawings
are his best. Those in sepia ink or black ink in the Laing Art Gallery,
Newcastle, come closest in feeling to Millais and are dated 1857-59.
His published work begins with *Good Words*, 1861, and this and
succeeding work such as 'On The Hills', *Churchman's Family
Magazine*, 1863, retain the quality of line and show an affinity with
Fred Walker's rustic illustrations. His later domestic and high life
drawings are contrived and the use of gesture is overplayed and almost
ludicrous. An early ink drawing by this artist would be very desirable
and very rare. He signs his early drawings, which are very rare, and
his later drawings

Illus: *Une Culotte [Digby, 1894]; Walton's Compleat Angler [n.d.].*
Contrib: *Good Words [1861]; London Society [1862-68]; Churchman's Family
Magazine [1863]; Tinsley's Magazine [1868]; Dark Blue [1871]; The British
Workman; Aunt Judy's Magazine; The Graphic [1870].*
Exhib: B; BI, 1853-66; RA; RBA, 1852-1880; RI; ROI.
Colls: Newcastle; V & AM.
Bibl: Gleeson White, *English Illustration: The Sixties*, 1897.

COOPER, Florence **fl.1886-1935**

Miniature painter. She illustrated with James Cadenhead (q.v.), two
children's books, *Master Rex* and *Pixie* by Mrs. G. Ford, 1890-91.

Exhib: L; New Gall.; P; RA; RI; RMS; SWA.

*WILLIAM CUBITT COOKE 1866-1951. 'Mystery of the Balkans.' An
illustration for* The English Illustrated Magazine, *Vol.16. 1896. Pen and grey
wash. Signed and dated 1890. 7¾ins. x 5¼ins. (19.7cm x 13.3cm).*
Victoria and Albert Museum

COOPER, Frederick Charles
Landscape painter and archaeological illustrator. He went to Nineveh in 1849 to work for H.A. Layard, and drew for the latter's *Nineveh and Babylon*, 1853.

COOPER, Will
Contributor to *Fun*, 1900.

COPE, Charles West RA 1811-1890
Historical painter, watercolourist and illustrator. He was born at Leeds, 28 July 1811, and was educated at Leeds Grammar School. He went to London in 1826 and studied at Sass's School in 1827 followed by some time at the RA Schools, 1828. He travelled to Paris, 1831, and to Italy, 1833-35, and again in 1845. He won a premium in the Houses of Parliament frescoes competition in 1843 and was an authority on Renaissance frescoes. He was a founder member of the Etching Club and was elected ARA in 1843 and RA in 1848. He represented the Academy at Philadelphia in 1876. Cope died at Bournemouth on 21 August 1890.

Contrib: *The Deserted Village [Goldsmith, Etching Club, 1841]; Songs of Shakespeare [Etching Club, 1843]; Poems and Pictures [1846]; Sacred Allegories [1856]; Favourite English Poems [1858-59]; A Book of Favourite Modern Ballads [1859]; The Churchman's Family Magazine [1863]; Cassell's Sacred Poems [1867]; Excelsior Ballads; Burns Poems; The Poetry of Thomas Moore.*
Exhib: BI and RA, 1833-82.
Colls: BM; Leicester; Liverpool; Melbourne; Preston.
Bibl: Chatto & Jackson *Treatise on Wood Engraving*, 1861, p.598; C.H. Cope, *Reminiscences of CWC*, Art Journal, 1869; J Maas, *Victorian Painters*, 1969, pp.28, 216, 238.

COPPING, Harold 1863-1932
Illustrator. He studied at the RA Schools and won the Landseer scholarship to Paris. He travelled to Palestine, Egypt and Canada, finally settling at Sevenoaks in 1902 and remaining there till his death, designing children's books and illustrating scriptural stories. He died 1 July 1932.

Illus: *Hard Lines [1894]; A Newnham Friendship; Toy Book; Mrs. Wiggs of the Cabbage Patch [A.H. Rice, 1908]; Canadian Pictures; The Gospel in the Old Testament; Scenes from the Life of St. Paul; Scripture Picture Books; The 'Copping' Bible.*
Contrib: *The Girls' Own Paper [1890-1900]; The Temple Magazine [1896]; English Illustrated Magazine [1897]; Black & White [1899]; The Windsor Magazine; The Royal Magazine.*

CORBAUX, Louisa NWS 1808-
Painter and lithographer. She was the elder sister of Fanny Corbaux (q.v.) and specialised in pictures of animals and children. She collaborated with her sister in gift books and annuals. NWS, 1837.
Illus: *Pearls of the East, Beauties From Lalla Rookh [Tilt, 1837].*
Exhib: RBA, 1828-50.
Colls: BM.

CORBAUX, Marie Françoise Catherine Doetter 'Fanny' NWS
 1812-1883
Watercolourist and illustrator. Born in 1812, she was recognised as an infant prodigy, and won silver medals at the Society of Arts in 1827 and 1830. She was a writer on oriental subjects and a biblical scholar but is best known for her illustrations to gift books. She was granted a Civil List pension in recognition of her work and died at Brighton 1 February 1883. NWS, 1839.
Illus: *Pearls of the East, Beauties From Lalla Rookh [Tilt, 1837, 'drawn on stone by Louisa Corbaux']; Cousin Natalia's Tales [T. Moore, 1841].*
Contrib: *Heath's Gallery [1836]; Finden's Byron Beauties; Le Souvenir [1848].*
Exhib: NWS; RBA, 1828-40.
Colls: BM.
Bibl: R. Maclean, *Victorian Book Design*, 1972, pp.26, 28, 53 illus.

CORBOULD, Aster Chantrey RBA -1920
Sporting artist and illustrator. He studied with his uncle Charles Keene (q.v.) who introduced him to *Punch*, in which magazine much of his work was afterwards published. Corbould was at his best in illustration when horses were involved, but his range did include social

and military drawings and cartoons. His sketches appear to lose a great deal in the printing. Sheets of sepia illustrations on the market in 1976, had the clarity of penwork and finesse of Keene, but on the magazine page they look coarse. Elected to RBA, 1893. He signs his work

Illus: *The Sword of Damocles [frontis.].*
Contrib: *Punch [1871-90]; The Graphic [1873-89]; ILN [1876 (acting Special Artist, Servia)]; Cornhill Magazine [1883]; Daily Graphic; Black & White [1891]; St. Paul's [1894]; Lika Joko [1894]; The New Budget [1895]; The St. James's Budget [1898].*
Exhib: B; L; RA; RBA; RHA; RI; ROI.
Colls: V & AM.
Bibl: R.G.G. Price, *A History of Punch*, 1957, p.120; *Mr. Punch With Horse and Hound*, New Punch Library, c.1930.

CORBOULD, Edward Henry RI 1815-1905
Painter, sculptor and illustrator. He was born in London 5 December 1815 and became a pupil of his father, Henry Corbould (q.v.), also a very prolific illustrator. He studied at Sass's and at the RA Schools. In 1851 he was appointed drawing master to the children of Queen Victoria, retaining the post until 1872. His illustration drawings are all in the conventional monochrome washes of the period with fine ink detail, many of them bear the stamp of the artist's studio sale. RI, 1838.
Illus: *Lalla Rookh [1839]; Scott's Works, 1825.*
Contrib: *The Sporting Review [1842-46]; L'Allegro and Il Penseroso [Art Union, 1848]; The Traveller [Goldsmith, Art Union, 1851]; Tupper's Proverbial Philosophy [1854]; ILN [1856 (decor.), 1866]; Willmott's Poets of the Nineteenth Century [1857]; Merrie Days of England [1858-59]; London Society [1863]; The Churchman's Family Magazine [1863]; Cassell's Magazine [1870]; Favourite Modern Ballads; Burns Poems; Poetry of Thomas Moore; Barry Cornwall's Poems; Thornbury's Legendary Ballads [1876].*
Exhib: BI, 1846; GG; NWS; RA; RBA, 1835-42.
Colls: Ashmolean; BM; Soane; V & AM.
Bibl: Chatto & Jackson, *Treatise on Wood Engraving*, 1861, p.598.

CORBOULD, Henry FSA 1787-1844
Illustrator, third son of Richard Corbould (q.v.), and father of E.H. Corbould (q.v.). Born at Robertsbridge in 1787, he studied with his father, later becoming a student at the RA Schools under H. Fuseli. He was a close friend of the leading neo-classical artists, Flaxman, Stothard, West and Chantrey, some of whose works he drew. J. Britton says that he was 'extensively employed by publishers to make drawings for engraving; and the number of his designs, which adorn many books, amount to several hundreds. He was one of the sufferers from an accident on the Eastern Counties Railway, when the train, falling off a lofty embankment, involved passengers in a smash . . . he was killed . . .' *Autobiography* Vol. 11, p.172. He spent thirty years on drawings for *Ancient Marbles*, published after his death. He illustrated the marbles at Woburn and Petworth.
Illus: *Paradise Lost [1796]; Rasselas [1810]; Swiss Family Robinson [1814]; Rosara's Chain [Lefanu, 1815]; Letters of Lady R. Russell [1826]; Cecilia [Burney, 1825].*
Contrib: *Heath's Gallery [1836-37].*
Colls: BM; Leeds; V & AM.
See illustration (p. 204).

CORBOULD, Richard 1757-1831
Painter of oils and watercolours, miniaturist, enamellist, portraitist. He was born in London in 1757 and most of his life was employed in the illustration of books, principally the series of miniature classics produced by Cooke, 1795-1800. His drawings were either in muted watercolours or monochrome washes, very gem-like and often within decorative frames or feigned ovals. Their quality is usually higher than those by the other members of the Corbould family. Much of his best work falls earlier than the scope of this book, but a selection of work is given below. He died at Highgate, 1831.
Illus: *The Adventurer; Tom Jones; Thoughts in Prison; Howlett's Views in the County of Lincoln [1800]; Broome's Works; Adventures of a Guinea.*
Contrib: *The Copper Plate Magazine [1792-94].*
Exhib: BI, 1806-17; Free Soc.; RA.
Colls: BM; V & AM.
See illustration (p. 268).

RICHARD CORBOULD 1757-1831. 'Pamela giving up her parcel of Papers to her Master.' An illustration for Richardson's Pamela, *c.1805. Oval vignette in ink and watercolour with decoration.* Victoria and Albert Museum

CORDINER, Rev. James 1775-1836
Traveller and topographer. Son of the Rev. Charles Cordiner of Banff. M.A., Aberdeen, 1793. Army chaplain at Madras, 1797, and at Colombo, 1798-1804. He was minister of St. Paul's Episcopal Church at Aberdeen, 1807-34.

Illus: A Description of Ceylon [1807, AT 409]; A Voyage to India [1820].

CORNILLIET, Jules 1830-1886
History painter. He was born at Versailles in 1830 and studied with Ary Scheffer and H. Vernet. Exhibited at the Salon from 1857. He contributed drawings of the Franco-Italian campaign to *The Illustrated London News*, 1859.

COTMAN, Frederick George RI ROI 1850-1920
Landscape and genre painter in watercolour and oil. He was born in Ipswich and was a nephew of J.S. Cotman (q.v.). After being educated at Ipswich, he went to the RA Schools in 1868, winning the gold medal for historical painting, 1873. He accompanied the Duke of Westminster on a Mediterranean tour and was employed to make watercolours of the places visited. His illustrative work is very rare but boldly handled in quite large scale, using a great deal of sepia and bodycolour. He became RI in 1882, ROI, 1883, and died at

Felixstowe on 16 July 1920.

Contrib: ILN [1876 and 1880]; The Yellow Book [1895].
Exhib: B; FAS, 1893; G; L; M; Paris, 1889; RA; RBA; RI; ROI; RSA.
Colls: Norwich; V & AM.
Bibl: The Studio, Vol. 47, 1909, p.167.

COTMAN, John Sell 1782-1842
Painter and etcher, a principal figure of the Norwich School of painters, he is included here as an architectural illustrator. After spending his boyhood in Norwich, he went to London and learnt a good deal about the world of engraving and publishing, acting as a colourer of aquatints for Rudolph Ackermann of the Strand. He collected material for a volume of Norfolk antiquities and visited Normandy in 1817, 1818 and 1820 for a similar project. He produced one hundred etchings for the latter, often arduous work but showing his own individual view of the subject. The 1820s were clouded by mental anxiety and financial problems, but in 1834 Cotman was appointed drawing master at King's College, London, a post he held until his death in 1842.

Illus: Miscellaneous Etchings of Architectural Antiquities in Yorkshire [1812]; Architectural Antiquities of Norfolk [1812-17]; Sepulchral Brasses in Norfolk [1813-16]; Architectural Antiquities of Normandy [1822]; Sepulchral Brasses of Norfolk & Suffolk; Liber Studiorum; Britton's Cathedrals [1832-36]; Eight Original Etchings [n.d.].
Exhib: BI, 1810-27; OWS; RA; RBA, 1838.
Colls: Ashmolean; BM; Glasgow; Manchester; Norwich; V & AM.
Bibl: S.D. Kitson, Life of JSC, 1937; M. Hardie, Watercol. Paint. in Brit. Vol. II, 1967, pp.72-96.
See illustration (below).

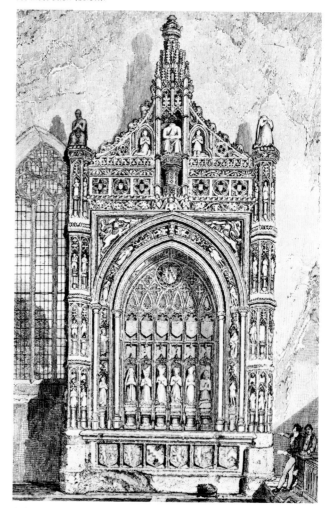

JOHN SELL COTMAN 1782-1842. The Morley Monument, Hingham church, Norfolk. An etching for Eight Original Etchings By The Late John Sell Cotman, *Norwich, n.d. 15½ins. x 10ins. (39.4cm x 25.4cm).* Author's Collection

COTTON, Lieutenant J.S.
Amateur caricaturist. He illustrated *The New Tale of a Tub* by F.W.N. Bayley, 1841, in lithography.

COULDERY, Thomas W. fl.1877-1898
Domestic painter and illustrator. He was working in London in 1882, at Pulborough and Chichester, Sussex, 1890-93, and at Brighton in 1897.
Illus: *A Woman Hater [Charles Reade, 1877].*
Contrib: *ILN [1888, 1894]; Cassell's Family Magazine; English Illustrated Magazine [1891-94].*
Exhib: B; L; M; RA; RBA; RI.
Colls: Sydney.

COWELL, G.H. Sydney fl.1884-1907
Domestic painter and illustrator of urban genre, sculptor. He worked in London and specialised in drawings for school stories and boys' and girls' novels. His work is competent but not exciting
Illus: *A Peep Behind the Scenes [Mrs. O.F. Walton]; Every Inch a Briton [1901].*
Contrib: *ILN [1889-92]; The Quiver [1890]; The English Illustrated Magazine [1891-92, 1896]; The Idler [1892]; The Sporting and Dramatic News [1893]; The New Budget [1895]; Pearson's Magazine [1896]; The Temple [1896]; The Minister [1895]; The Girls' Own Paper; The St. James's Budget; Cassell's Family Magazine; The Pall Mall Magazine; The Windsor Magazine.*
Exhib: B; M; RA; RBA; ROI.

COWHAM, Hilda Gertrude (Mrs. Edgar Lander) 1873-1964
Artist, author and book illustrator. She was born in 1873 and after being educated at Wimbledon College, attended the Lambeth School of Art. Miss Cowham had drawings published while she was still at school in *Pick-Me-Up* and *The Queen.* She later became a prolific contributor to magazines, designed posters and made dolls. Her claim to be the first woman to draw for *Punch* is quite incorrect, that honour going to Helen Coode (q.v.).
 Her drawings in pencil and ink for children's books are very decorative and whimsy. She usually signs: H. Cowham.
Illus: *Fiddlesticks; Our Generals; Blacklegs; Curly Locks and Long Legs; Kitty in Fairyland.*
Contrib: *The Sketch [1894-95]; Moonshine [1896]; The Royal Magazine [1901]; The Graphic [1902-05, 1908, 1912, (Christmas supps.)]; The Sphere; The Tatler.*
Exhib: G; L; RA; RWS; SWA; Walker's.
Colls: V & AM.

COWPER, Frank Cadogan RA RWS 1877-1958
Portrait and subject painter. He was born on 16 October 1877 at Wicken Rectory, Northamptonshire, and was educated at Cranleigh. He studied first at the St. John's Wood Art School, 1896, then at the RA Schools, 1897-1902, and worked for six months in the studio of E.A. Abbey, RA (q.v.). Cowper did numerous portraits but specialised in subject pictures of romantic type: 'French Aristocrat', 'Venetian Ladies' etc., etc. He was also responsible for painting panels and altar-pieces. He worked in London but died in Cirencester in 1958. ARA, 1907; RA, 1934; RP, 1921; RWS, 1911.
Contrib: *The Idler; The Graphic 1906.*
Exhib: B; G; GG; L; M; P; RA; ROI; RWS.

COWPER, Max fl.1892-1911
Figure painter and illustrator. He was working in Dundee in 1893, in Edinburgh in 1894 and in London from 1901. Cowper made illustrations for a large number of magazines, his ink drawing is very good and his grey wash drawings are delicate, but he sometimes swamps his fine line with wash.
Contrib: *Fun [1892-93]; St. Pauls [1894]; The Rambler [1897]; The Longbow [1898]; Pick-Me-Up; Illustrated Bits; The Quiver [1899]; The Idler; The Pall Mall Magazine; The Minister; The Strand Magazine.*
Exhib: G; L; RA; RSA.
Colls: V & AM; Witt Photo.

COX, David OWS 1783-1859
Landscape painter and watercolourist. He was born at Deritend, Birmingham in 1783 and began as a scene painter for the Birmingham Theatre. He moved to London in 1804 and in the next decade became highly influential as a drawing-master and practitioner. He travelled abroad between 1826 and 1832 and developed as a colourist and in his later years as a forerunner of impressionism. He is included here for his one recorded work of illustration *A Treatise on The Aeropleustic Art by means of Kites,* 1851, AL 395. He died at Harborne on 7 June 1859.
Publ: *Treatise on Landscape Painting and Effect in Watercolour [1814]; Progressive Lessons on Landscape for Young Beginners [1816]; A Series of Progressive Lessons [c.1816]; The Young Artist's Companion [1825].*
Exhib: BI; OWS; RA; RBA.
Colls: Ashmolean; BM; Birmingham; Nottingham; V & AM.
Bibl: Trenchard Cox, *DC,* 1947.

COX, Everard Morant fl.1878-1891
Black and white illustrator, working in London and producing comic genre and sporting subjects for the magazines.
Contrib: *ILN [1883-84, 1888, 1891]; Punch [1883].*
Exhib: RA, 1884-85.

CRAFT, Percy Robert RBA 1856-1934
Landscape and coastal painter. He studied at Heatherley's and at the Slade School under Legros and Poynter, where he was a gold and silver medallist. He worked in London until 1910 with a brief spell at Penzance in 1890. He was elected RBA, 1898, and died in London 26 November 1934.
Contrib: *ILN [1883 (Cornwall)].*
Exhib: B; G; L; M; New Gall.; RA; RBA; RE; ROI; RSA.

EDWARD GORDON CRAIG 1872-1966. Portrait of Henry Irving for The Dome, *October to December 1898. Woodcut.*

CRAFTY

Pseudonym of cartoonist to *The Graphic*, 1871.

CRAIG, Edward Gordon **1872-1966**

Designer, woodcut artist and propagandist for simplicity in the theatre. He was born 16 January 1872, the son of E.W. Godwin, 1833-1886, the Victorian architect, and Ellen Terry, 1847-1928, the actress. Although much of Craig's energy was concentrated on theatre design, he was a dynamic and original illustrator and typographer. After being educated at Heidelberg and Bradfield, he went on the stage for a short period. After moving to Uxbridge, he came under the influence of William Nicholson (q.v.) and James Pryde (q.v.), then living at Denham, and he was taught the rudiments of wood engraving by them. This contact proved a turning point and he immersed himself in Renaissance wood engravings and the study of architecture of the same period. The years 1893-98 saw the production of a number of splendid bold and chunky woodcuts, particularly character studies of Irving and Ellen Terry. Craig designed and produced *The Page* at The Sign of the Rose, Hackbridge, from 1898-1901. He was his own editor, illustrator and publisher for *The Mask* and *The Marionette*. In later years he produced numerous stage sets in Britain and Europe and wrote extensively.

Publ: *The Page [1898-1901]; The Art of The Theatre [1905]; The Mask [Florence, 1908-29]; On The Art of The Theatre [1911]; Towards a New Theatre [1913]; The Theatre Advancing [1921]; Scene [1923]; Woodcuts and Some Words [1924]; Books and Theatres [1925]; A Production [1926, 1930]; Fourteen Notes [1931]; Ellen Terry and Her Secret Self [1931].*
Contrib: *The Minister; The Dome [1898-99]; Book of Penny Toys [1899].*
Exhib: G; RHA.
Colls: BM; V & AM; Witt Photo.
Bibl: *EGC* Cat. of Exhibition. '' & AM, 1967; *EGC* Bibliography (Ifan Kyrle Fletcher).
See illustration (p.269).

CRAIG, Frank **1874-1918**

Black and white illustrator. He was born at Abbey, Kent, on 27 February 1874 and studied at the RA Schools. He began working on *The Graphic* in 1895, succeeding Gulich as collaborator with William Hatherell (q.v.). He was sent by *The Graphic* as Special Artist to the South African War, 1900. Craig was an accomplished illustrator of stories, using grey wash drawings to powerful effect and drawing in with the brush. He illustrated some of George Gissing's work, some of Rudyard Kipling's and a little of Arnold Bennett who disliked his style. One of his paintings was purchased for the Chantrey Bequest in 1906.

Contrib: *The English Illustrated Magazine [1894-95]; The Graphic [1895-1910]; The Quiver [1894-1900]; The Temple [1896]; Cassell's Family Magazine [1898]; The Pall Mall Magazine; The Sketch; The Strand Magazine.*
Exhib: G; L; M; RA; RBA, 1892-94; ROI; RSA.
Colls: Author; V & AM.
Bibl: *The Art Journal*, 1906, p.881; *The Studio*, Vol. 38, 1906, pp.4-11; *Arnold Bennett, Letters to J.B. Pinker*, Vol. 1, 1966, pp.168-169, (Edited by J. Hepburn).

See illustration (below).

CRAIG, William Marshall **c.1765-c.1834**

Illustrator, drawing master, painter of portraits. He was living in Manchester in 1788 and practising as a drawing master, exhibiting miniatures and landscapes at various exhibitions. He was established in London from 1790 and there became Water-colour Painter to the Queen in 1812 and Court Painter to the Duke of York in 1820. He may have travelled to Russia in 1814 and he gave lectures at the BI.

Craig's output as an illustrator was considerable, all his work was done in the meticulous neo-classic style of drawing favoured for books, charming but not individual. His work is occasionally seen on

FRANK CRAIG 1874-1918. 'A Group of Diners.' Illustration for unidentified story. Ink and grey wash. Signed and dated 1895. 7¼ins. x 8½ins. (18.4cm x 21.6cm)
Author's Collection

the market.

Illus: *A Wreath For The Brow of Youth [1804]; Scripture Illustrated [1806]; An Essay on Transparent Prints [1807]; The Economy of Human Life [1808]; Cowper's Poems [1813]; Foxe's Book of Martyrs.*
Contrib: *Britton's Beauties [1803-12]; Inchbald's British Theatre; Bell's British Theatre; Britton's Gallery of Contemporary Portraits.*
Exhib: BI, 1806-20; RA, 1788-1827; RBA, 1826-28.
Colls: Nottingham; V & AM.
Bibl: I. Williams, *Early English Watercolours,* 1952, pp.134-135, illus.

CRAMPTON, Sir John Twistleton Wickham Fiennes 1805-1886

Amateur artist and caricaturist. He was born in 1805, the son of Sir Philip Crampton and entered the Diplomatic service, acting as Secretary of the Legation at Berne, 1844 and Washington, 1845. He was recalled in 1856 after his attempts to recruit American citizens for the Crimea and became Minister at Hanover, 1857, and St. Petersburg, 1858. He finally retired in 1869 and died at Bushey Park, Co. Wicklow in 1886. His ink drawings of figures are very competent although they have a decidedly Georgian look to them.

Colls: BM.
Bibl: *Agnew . . . Exhib. of Watercolours,* Jan-Feb. 1975.

CRANE, T.

Designer. He was the elder brother of Walter Crane (q.v.), and was art director of the firm of Marcus Ward and Co. He designed ornament for Christmas cards, calendars and children's books, the figure work being by Mrs. Houghton of Warrington. He decorated *At Home,* in the style of Kate Greenaway, 1881.

Bibl: W. Crane, *An Artist's Reminiscences,* 1907.

CRANE, Walter RWS 1845-1915

Painter, decorator, designer, book illustrator, writer and socialist. He was born in Liverpool on 15 August 1845 and was self-taught as an

WALTER CRANE RWS 1845-1915. 'They saw a Knight in dangerous distresse.' An illustration for Spenser's Faerie Queen, *Book V, 1896. Pen and ink. Signed with monogram. 9⁵/₈ins. x 7⁵/₈ins. (24.4cm x 19.4cm).*

Victoria and Albert Museum

artist before being apprenticed in London to W.J. Linton (q.v.) in 1857. From this technical background, Crane was able to develop a much greater craftsmanship in the art of the book than any other contemporary artist. He had the great strength of being principally an illustrator and not merely a painter who illustrated books. In the following years he studied early printed books, medieval illuminations, Japanese prints and the work of the Pre-Raphaelites in order to adapt them to his own linear patterns. His children's books are the most famous and are characterised by strong outlines, flat tints and solid blacks, all ideally suited to colour wood engraving and the *Picture Books* produced for Messrs. Routledge by Edmund Evans. From 1867, Crane was associated with the Dalziels and in the years following his marriage in 1871, he travelled widely in Italy, later to Greece, Bohemia and the United States. The Paris Commune had a powerful influence on him in 1871 and after it he became associated with William Morris (q.v.) and with the socialist cause.

Crane was associated as well with every project in art education, he was examiner in Design to the Board of Education, to London County Council and the Scottish Board of Education. He taught design at Manchester, 1893-96, was Art Director at Reading College, 1898, and Principal of the RCA, 1898-99. He was first President of the Arts and Crafts Exhibition Society, 1888, and a Master of the Art Workers' Guild. Although direct followers are hard to pin down, Crane was widely influential and the Crane style appears in the Art School work of the 1890s and 1900s. He died at Kensington 14 March 1915.

Publ: *The Basis of Design [1898]; Line and Form [1900]; Of The Decorative Illustration of Books [1901].*
Illus: *Children's Sayings [1862]; Stories of Old [1862]; The New Forest [1863]; Stories From Memel [1863]; True Pathetic History of Poor Match [1863]; Goody Platts and Her Two Cats [1864]; Toy Books [1865-76]; Broken in Harness [Lemon, 1865]; Wait For The End [1866]; Miss Mackenzie [Trollope, 1866]; Poetry of Nature [1868]; Legendary Ballads [Roberts, 1868]; King Gab's Story Nag [1869]; Magic of Kindness [1869]; Merrie Heart [1870]; Labour Stands on Golden Feet [1870]; Mrs. Molesworth's stories from 1875; Songs of Many Seasons [1876]; Baby's Opera [1877]; The Baby's Bouquet [1879]; Grimm's Fairy Tales [1882]; Aesop's Fables [1886]; Flora's Feast [1889]; Queen Summer [1891]; The Old Garden [Margaret Deland, 1893]; Hawthorne's Wonder Book For Girls and Boys [1892]; Spenser's Mutabilitie [1896]; Spenser's Faerie Queene [1897]; Bluebeard's Picture Book [1899]; Don Quixote Retold [Judge Parry, 1900]; Last Essays of Elia [1901].*
Contrib: *Entertaining Things [1861]; London Society [1862]; Good Words [1863]; Once a Week [1863-65]; Every Boy's Magazine [1864-65]; Punch [1866]; The Argosy [1868-69]; Churchman's Shilling Magazine [1868]; English Illustrated Magazine [1883-88]; Black & White [1891]; The Quarto [1898]; The Art Journal [cover]; The Graphic [Christmas cover]; Pears Magazine.*
Exhib: Dudley; FAS, 1891; RI; RWS.
Colls: Ashmolean; Bedford; BM; Fitzwilliam; Glasgow; V & AM.
Bibl: Walter Crane, *An Artist's Reminiscences,* 1907; *The Studio,* Winter No., 1900-01, p.53, illus.
See illustrations (left, Colour Plate IX p.124, and p.272).

CRAWHALL, Joseph 1821-1896

Illustrator of chapbooks and ballads. He was born at Newcastle in 1821 and ran a family ropery business. Living in a city which was famous for its wood engravers and still basking in the glory of Thomas Bewick (q.v.), Crawhall enjoyed the spirit of book making and began to assemble material from various sources, writing, illustrating and putting the book together himself. The result is a unique kind of production, part archaism, part bibliomania and part wit. The crude woodcuts, coloured by hand, are in sympathy with the rough paper and the earthy ballads printed below them. Crawhall attempted to bring back the personality to books, dead since industrialisation.

He was a friend of Charles Keene and supplied many of his *Punch* jokes for the artist to work up. He was secretary of the Newcastle Arts Club.

Illus: *The Compleatest Angling Booke that ever was writ [1859]; Ye loving ballad of Lorde Bateman . . . [1860]; A Collection of Right Merrie Garlands . . . [1864]; Chaplets from Coquetside [1873]; Northumbrian Small Pipe Tunes [1877]; Border Notes and Mixty-Maxty [1880]; Chap-Book Chaplets [1883]; Olde Tayles . . . [1883]; Etc.*
Colls: BM; Glasgow.
Bibl: Charles S. Felver, *JC The Newcastle Wood Engraver 1821-96,* 1972 (complete bibliography).
See illustrations (Colour Plate XI p.124).

WALTER CRANE RWS 1845-1915. 'Simple Honesty.' An illustration to A Floral Fantasy Set Forth in Verses, 1899. Pen and watercolour. 10ins. x 14⁵/8ins. (25.4cm x 37.1cm). Victoria and Albert Museum

CRAWHALL, Joseph E. RSW **1861-1913**
Animal painter. The son of Joseph Crawhall (q.v.) and one of the most distinguished artists connected with the Glasgow School. His sketches of animals in action are particularly fine. He was a contributor to *The Pall Mall Magazine*.

Colls: V & AM.
Bibl: A.J.C. Bury, *The Man and The Artist* 1958.

CRAWSHAW, J.E.
Amateur artist. He contributed drawings of comic machines to *Punch*, 1906.

CREALOCK, Lieutenant-General Henry Hope **1831-1891**
Amateur artist. He was educated at Rugby and joined the Army in 1848, serving in the Crimea and China, 1857-58, the Indian Mutiny, New Brunswick, 1865, and Zululand, 1879. He was promoted Lieutenant-Colonel in 1861 and Lieutenant-General in 1884.

Illus: *Wolf-Hunting and Wild Sport in Lower Brittany [1875]; Katerfelto [G.J.W. Melville, 1875]; Sport [W.D.B. Davenport, 1885].*
Contrib: *The Illustrated Times [1855].*
Colls: BM.

CRESWICK, Thomas RA **1811-1869**
Landscape painter and illustrator. He was born at Sheffield in 1811 and studied at Birmingham with Joseph Vincent Barber before settling in London in 1828. His métier was the English landscape in high summer, his compositions are always good, many of them were done in collaboration with animal painters such as Ansdell and Goodall or figure painters like Phillip and Frith. He was an early member of the Etching Club and he was commended by Ruskin, rare distinction, for a book illustration to 'Nut Brown Maid' in the *Book of English*

Ballads. ARA, 1842 and RA, 1851. He died in 1869 and was buried at Kensal Green.

Illus: *Walton's Compleat Angler; Works of Goldsmith.*
Contrib: *Deserted Village [Goldsmith, Etching Club, 1841]; Gray's Elegy [Etching Club, 1847]; L'Allegro [Etching Club, 1849]; Songs and Ballads of Shakespeare [Etching Club, 1853]; Moxon's Tennyson [1857]; Favourite English Poems of the Last Two Centuries [1858-59]; Early English Poems [1863]; The Churchman's Family Magazine [1863].*
Exhib: BI, 1829-30; RA, 1828-
Colls: BM; Glasgow; Manchester.
Bibl: Chatto & Jackson *Treatise on Wood Engraving*, 1861, pp.588-589.

CRISP, Frank E.F. **-1915**
Artist working in St. John's Wood, who probably died on active service. He illustrated Edward Hutton's *The Cities of Romagna and The Marches*, 1913, with 12 colour plates.

Exhib: L; RA; RSA.

CROMBIE, Benjamin William **1803-1847**
Draughtsman, engraver and caricaturist. He was born in Edinburgh and published a set of caricatures for *Modern Athenians,* 1839, in a style akin to that of Dighton.

Colls: Edinburgh.
Bibl: Veth, *Comic Art in England*, 1930, p.41, illus.

CROMBIE, Charles **fl.1904-1912**
Cartoonist in black and white and watercolour. He worked for *The Bystander,* 1904, *The Graphic,* 1906, comic illustrations, and *The Illustrated London News* and *Graphic*, Christmas numbers, 1911 and 1912.

Colls: Witt Photo.

CROPSEY, Jasper F. **1823-1900**
American painter established in England. He worked in New York 1845-62 and then travelled to Turkey. He was a founder member of the Academy in New York, 1851, before settling in London in 1857.

Illus: *The Poetical Works of E.A. Poe [1857]; The Poetry of Thomas Moore [n.d.].*
Bibl: Chatto & Jackson, *Treatise on Wood Engraving*, 1861, p.598.

CROSS, A. Campbell **fl.1895-1898**
Illustrator, working in Chelsea for the magazines. His drawings are usually in black chalk with colour washes and are in a late Pre-Raphaelite style.

Contrib: *The Sketch [1895-98]; The Idler; The Quartier Latin [1896]; The Quarto [1896-97].*
Exhib: RA, 1897.
Colls: V & AM.

CROSS, Stanley
Black and white artist. He contributed to *Punch,* 1914 and specialised in drawings of hen-pecked husbands.

CROW
Comic illustrator to *Judy,* 1889.

CROWE, Eyre ARA **1824-1910**
Painter and illustrator. He was born in London on 3 October 1824, the son of Eyre Evans-Crowe, the historian. He studied with William Darley and at the Atelier Delaroche in Paris as well as at the RA Schools, 1844. He was secretary to his cousin W.M. Thackeray and lived in the United States, 1852-57. He was elected ARA in 1875 and died in London, 12 December 1910. He was an occasional caricaturist.

Illus: *With Thackeray in America [1893]; Haunts and Homes of W.M. Thackeray.*
Contrib: *ILN [1856-61].*
Exhib: BI, 1850, 1861; RA; RBA, 1854, 1856.
Colls: V & AM.

CROWE, J.A.
Artist. Described by *The Illustrated London News* as their 'Correspondent' in the Crimea, 1855-56.

See illustration (p.136).

CROWLEY, Nicholas J. RHA 1813-1857

Portrait painter. He was born in 1813, probably in Ireland, and lived and worked for the whole of his life in Dublin, visiting England briefly in 1838. He was elected RHA, 1838, and died in 1857.

Contrib: *ILN [1853-54]*.
Exhib: BI, 1839-57; RA, 1835- ; RBA, 1836.
Colls: NG, Ireland.

CROWQUILL, Alfred
pseudonym of Alfred Henry Forrestier 1804-1872

Writer and comic artist, caricaturist and illustrator. Born in London in 1804 and already contributing caricatures to the publishers by the age of eighteen. He worked for John Timbs on *The Hive* and *The Mirror*, before becoming associated with *Punch* from its earliest days, after its predecessor *Charivari* had foundered. Crowquill wrote extensively for *The New Monthly* and *Bentley's* magazines and was more widely regarded as a literary man than as an artist. Nevertheless his drawings are incisive and charming and have an element of fantasy at a time when grotesqueness was more usual. He left *Punch* in 1844 and found a highly successful career from the 1850s onwards as an illustrator of children's books. In his early career he sometimes drew social satires that were engraved by George Cruikshank (q.v.). His best work is found when he uses fine ink lines and pastel colours on toned paper. He signs his work

Illus: Ups and Downs [1823]; Paternal Pride [1825]; Despondency and Jealousy [1825]; Der Freyschutz Travestied, Alfred Crowquill's Sketch Book, Absurdities in Prose and Verse [1827]; Goethe's Faust [1834]; Pickwickian Sketches, Bunn's Vauxhall Papers [1841]; Sea Pie [1842]; Dr. Syntax Tour in Search of the Picturesque [1844]; Comic Arithmetic [1844]; Woman's Love [1846]; Wanderings of a Pen and Pencil [1846]; A Good-natured Hint about California [1849]; The Excitement [1849]; Pictorial Grammar, Pictorial Arithmetic; Gold [1850]; A Bundle of Crowquills Dropped by Alfred Crowquill [1854]; Fun [1854]; Griffel Swillendrunken [1856]; Aunt Mavor's Nursery Tales [1855]; Little Pilgrim [1856]; Little Plays For Little Actors [1856]; Fairy Tales [1857]; Merry Pictures [1857]; Bon Gaultier Ballads [with Leech and Doyle, 1857]; A New Story Book [1858]; Fairy Tales [C. Bede, 1858]; Baron Munchausen [1858]; Twyll Owlglass [1859]; Honesty and Cunning [1859]; Kindness and Cruelty [1859]; The Red Cap [1859]; Paul Prendergast [1859]; Strange Surprising Adventures of the Venerable Gooros Simple [1861]; Fairy Footsteps [1861]; Chambers Book of Days; Pickwick Abroad [G.W. Reynolds]; The Boys and The Giant [1870]; The Cunning Fox [1870]; Dick Doolittle [1870]; Little Tiny's Picture Book [1871]; Guide to the Watering Places.
Contrib: *Punch [1842-44]; ILN [1844-70]; The Illustrated Times [1859]*.
Exhib: RA, 1845-46.
Colls: Author; V & AM.
Bibl: G. Everitt, *English Caricaturists*, 1893, pp.368-371; M.H. Spielmann, *The History of Punch*, 1895, pp.449-450.
See illustrations (right and p.274).

CROWTHER, T.S.C. fl.1891-1902

Illustrator. His work is characterised by a very thin pen line.

Contrib: *The Daily Graphic; The Windsor Magazine; The Temple Magazine; The Idler; The English Illustrated Magazine [1891-92]; The Graphic [1902]*.

CRUIKSHANK, George, Snr. 1792-1878

Artist, etcher and polemicist on temperance, caricaturist. Born at Duke Street, Bloomsbury, on 27 September 1792, the second son of the caricaturist, Isaac Cruikshank. He worked with his father from an early age, engraving lottery tickets and chapbooks, his first published design appearing in 1806. From his father's death in about 1810, he developed as the foremost political caricaturist of the Regency, both spiritually and physically taking over the place of the insane Gillray at Mrs. Humphrey's establishment. As early as 1820 when the caricature boom was still at its zenith, Cruikshank had begun contributing to ephemeral journals like *The Wits' Magazine* and was establishing himself as a book illustrator. His first major work in this medium was the Regency best-seller, *Life in London*, by Pierce Egan. This was followed by similar publications, including *Life in Paris*, and then a number of smaller books which became little more than vehicles for his own lively drawings. By the 1830s he was the leading illustrator and was engaged on works by Charles Dickens, Harrison Ainsworth and Sir Walter Scott. At the same time yearly almanacks were issued from 1835 to 1853 under the artist's name and these were succeeded by *George Cruikshank's Magazine*, 1853-54.

ALFRED CROWQUILL (A.H. Forrestier) 1804-1872. Title page design for Music On The Waves, A Set of Songs *by The Honble Mrs Norton. Ink and watercolour. Signed. 12¼ins. x 8¼ins. (13.1cm x 21cm).*
Victoria and Albert Museum

Cruikshank's conversion to the teetotal cause in the late 1840s gave him a fresh zest for life at exactly the moment when his fame was starting to diminish. The next thirty years witnessed an incredible activity from his pen, mostly for the Temperance League and including his mammoth 'The Worship of Bacchus', the vast unmanageable canvas which took him three years to complete and is now relegated to the cellars of The Tate Gallery. This frenzied picture, with its hundreds of tiny figure groups in various stages of dissipation says a great deal about the artist. Strongly inventive and with a keen eye for the absurd and the pathetic, he had delusions of grandeur which were unsuited to his small scale genius. Although Ruskin gave him fulsome praise for his children's books, the vigour of his line and the bombast of his humour belonged to the 18th century rather than the 19th.

Cruikshank died at Mornington Crescent on 1 February 1878 and was buried at Kensal Green; his body was later removed to St. Paul's at the instigation of the temperance lobby rather than for his acknowledged importance as an artist.

Finished drawings by Cruikshank are rare, the most common items met with are pencil studies in small scale on white paper, the major figures drawn over in ink in preparation for the completed work.

Illus: Nelson's Funeral Car [1806, first illus.]; Life in London [1820]; Life in Paris [1822]; Peter Sclemihl [1824]; Greenwich Hospital [1826]; Phrenological Illustrations [1826]; Illustrations of Time [1827]; Punch and Judy, Scraps and Sketches [1828]; Three Courses and a Dessert [1830]; Hogarth Moralized, Roscoe's Moralists Library [1831]; Salis Populi Suprema Lex [1832]; Sundays in London [1833]; Cruikshankiana [1835]; My Sketchbook; Comic Almanack [1835-53]; Sketches by Boz [Dickens, 1836]; Waverley Novels [1836-38]; Oliver Twist [Dickens]; Jack Sheppard, Guy Fawkes [1838]; The Tower of London [Ainsworth, 1840]; George Cruikshank's Omnibus [1841]; The Bachelor's Own Book, Arthur O'Leary [1844]; George Cruikshank's Table

ALFRED CROWQUILL (A.H. Forrestier) 1804-1872. A page from the artist's Ramsgate sketchbook. Pen and ink. Signed and dated 1857. 6¾ins. x 9¼ins. (17.1cm x 25.5cm).
Author's Collection

Book, Maxwell's Irish Rebellion [1845]; Outline of Society [1846]; The Bottle [1847]; The Drunkard's Children [1848]; 1851 or The Adventures of Mr. and Mrs. Sandboys [1851]; Uncle Tom's Cabin [1852]; George Cruikshank's Fairy Library [1853-54]; The New Political House That Jack Built [1854]; Life of Falstaff [1857]; A Pop Gun Fired Off [1860]; The British Bee Hive [1867]; Our Gutter Children [1868]; The Brownies and Other Tales [Mrs. J.H. Ewing 1871]; The Trial of Sir Jasper [1873]; Peeps at Life [1875]; The Rose and The Lily [1877].
Contrib: Bentley's Miscellany [1837-43]; Ainsworth's Magazine [1842]; The Illustrated Times; ILN [1877].
Exhib: BI, 1833-60; RA.
Colls: BM (large collection); Manchester; Tate; V & AM.
Bibl: Chatto & Jackson Treatise on Wood Engraving, 1861, pp.595-596; J. Grego C's Watercolours, 1904; R. McLean, GC, 1949; William Feaver, GC, Arts Council, 1974.
See illustration (p.275).

CRUIKSHANK, George, Jnr. fl.1866-1894
Son of George Cruikshank (q.v.). His drawings are very weak imitations of his father, he contributed to magazines in the 1870s and 1880s and usually signs George Cruikshank Junior.

Contrib: Beeton's Annuals [1866]; London Society [1866, 1874]; Aunt Judy's Magazine [1866-71]; ILN [1882]; The Sphere [1894].
Colls: V & AM.

CRUIKSHANK, (Isaac) Robert 1786-1856
Caricaturist, illustrator and miniature painter. He was born in 1786, the eldest son of Isaac Cruikshank and brother of George Cruikshank, Snr. (q.v.). He served as midshipman with the East India Company until 1814, setting up as a miniature painter in London and changing to etching and caricatures in 1816. Between then and 1825 he attained almost as wide a popularity as his brother, issuing caricatures on the follies of fashion, the foibles of military life and those of the stage. He achieved great success with the illustrations for *Life in London*, the book adapted from the play which he had himself designed at the Adelphi Theatre, He also provided lively and well-executed illustrations for *The English Spy*, but after the 1820s he dropped out of favour and published slovenly uneven work. Everitt considers that the new forms of caricature adapted by HB and others

killed his not very original talent. He died in poverty, 13 March 1856.

Illus: Age of Intellect [J. Moore, 1819]; Lessons of Thrift [1820]; Nightingale's Memoirs of Queen Caroline [1820]; Radical Chiefs [1821]; Life in London [1821]; The Commercial Tourist [1822]; Annals of Sporting and Fancy Gazette [1822-25]; Ramsey's New Dictionary of Anecdote [1822]; My Cousin in the Army [1822]; Westmacott's Points of Misery [1823]; Spirit of the Public Journals [1823-24]; Life and Exploits of Don Quixote [1824]; Bernard Blackmantle's English Spy[1825]; Westmacott's Punster's Pocket Book [1826]; London Characters [1827]; Grimm's Fairy Tales [1827]; Thompson's Life of Allen [1828]; Smeeton's Doings in London [1828]; British Dance of Death [1828, frontis.]; Spirit of the Age [1828]; Universal Songster [1828]; London Oddities [1828]; The Finish to the Adventures of Tom, Jerry and Logick [1828]. Etc.
Exhib: RA, 1811-17.
Colls: BM; V & AM.
Bibl: G. Everitt, English Caricaturists, 1893, pp.89-124; W. Bates, GC the Artist, the Humorist and The Man, with some account of his brother Robert, 1878.

CRUIKSHANK, Percy fl.1853-1854
Probably the son of (Isaac) Robert Cruikshank (q.v.). Worked with his uncle and father and illustrated *Sunday Scenes in London and the Suburbs*, twelve illustrations on stone, May 1854.
Colls: BM.
See illustration (p.276).

CUBITT, Miss Edith Alice (Mrs. Andrews) fl.1898-1940
Flower painter and illustrator. She studied at the New Cross Art School and won the prize for black and white illustrations at the National Competition, South Kensington, 1898. She attended Goldsmith's College in 1909. She was working in London in 1900 and at Kent in 1909 and 1931.

Illus: A Book of Nursery Rhymes, Ernest Nister, c.1900.
Exhib: B; L; RA; RI.

CUCUEL, Edward 1875-
American painter and illustrator. He was born in San Francisco in 1875, but worked in Switzerland and Germany, 1924.
Contrib: ILN [1905].
Exhib: L; Salon, Paris.

JOHN BULL IN THE COUNCIL CHAMBER

GEORGE CRUICKSHANK, Snr. 1792-1878. 'John Bull in The Council Chamber.' A satirical print coloured by hand and published by W.N. Jones, 1 July 1813.
Author's Collection
Engraving. 7¾ins. x 19½ins. (19.7cm x 49.5cm)

275

PERCY CRUIKSHANK fl.1853-54. 'Sunday Evening at the Red Cross Gin Shop, Barbican.' Illustration for Sunday Scenes in London and the Suburbs, *May 1854. Lithograph.*

CUITT, George **1779-1854**

Topographical illustrator and etcher. He was the son of George Cuitt 1743-1814, the landscape painter, and was born at Richmond, Yorks in 1779. He followed his father as a painter, but specialised in etchings of buildings, ruins and landscapes in a dramatic Italianate style. He taught drawing at Richmond, then at Chester from 1804 to 1820 and it is that city with which he is usually associated. Cuitt was the only artist of his generation to apply the romantic view of buildings to practical illustration as in guides and histories, his crowded streets and small figures are influenced by Piranesi. Cuitt's books, which are very desirable, cannot be obtained easily, but his separate plates from these can be found. He died at Masham, 1854.

Illus: *Six Etchings of Saxon and Other Buildings Remaining at Chester [1810-11]; Six Etchings of Old Buildings in Chester Six Etchings of Picturesque Buildings in Chester [1810-11]; A History of Chester [1815]; Yorkshire Abbeys [1822-25]; Twenty-four Etchings of Select Parts of Yorkshire [1834]; Wanderings and Pencillings Among Ruins of the Olden Times [1848].*
Colls: BM; Leeds; Newcastle; V & AM; Witt Photo.

See illustration (below).

CULLIN, Isaac **fl.1881-1894**

Figure and portrait painter. He exhibited at the RA and Liverpool, 1881-89, and drew sporting subjects for *The Illustrated London News*, 1893-94.

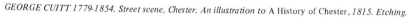

GEORGE CUITT 1779-1854. Street scene, Chester. An illustration to A History of Chester, *1815. Etching.*

CYNICUS (Martin Anderson). Political cartoon possibly for The Satires, *1890. Pen and ink.*

CUNEO, Cyrus Cincinnato ROI **1879-1916**

Painter and illustrator. He was born in San Francisco of Italian parents and came to Paris to study under Girardo, Prenet and Whistler, 1900. Settled in London in 1902 and died there in 1916. He became ROI in 1908. His illustrative work is unusual in often being in oil on board.

Illus: *The Lost Column [C. Gilson, 1908 (boys' novel)]*.
Contrib: *The Pall Mall Magazine; The Strand Magazine [1906]; ILN [1908-12]*.
Exhib: G; L; RA; RHA; ROI.
Colls: V & AM.

CURTIS, Dora

Figure painter and illustrator. She designed bookplates, one of which appeared in *The Quarto*, 1896, and exhibited at the NEA, 1899-1901.

CUTHBERT, E.S.

Contributing illustrations of Arabia to *The English Illustrated Magazine*, 1887.

'CYNICUS' Pseudonym of Martin Anderson

Political and social cartoonist, designer of postcards. Anderson seems to have originated from Dundee and produced satirical books, in limited editions from an address at 57 Drury Lane, London. The sketches are inventive if not very masterly in the drawing, according to Thorpe they were popular at the time.

Illus: *The Satires of Cynicus [1890]; The Humours of Cynicus [1891]; The Fatal Smile A Fairy Tale [1892]; Cartoons Social and Political [1893]*.
Colls: Gordon.
See illustration (above).

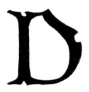

D, H.P.
Unidentified illustrator for *Fun*, 1887.

DA COSTA, John ROI 1867-1931
Portrait painter and illustrator. He was born in 1867 and after being educated in Southampton, studied art in Paris for three years. He did most of his illustrative work in the 1890s before becoming a fashionable portrait painter, elected ROI 1905 and RP 1912. He was living at Newlyn in 1880 and in London 1898-1931, except for a brief period at Clanfield, Oxon, 1908. He died 26 May 1931.
Contrib: *The Yellow Book; The Quarto [1896]; Eureka [1901]; The Graphic [1901].*
Exhib: G; GG; L; M; New Gall.; Paris, 1907; P; RA; RHA; ROI; RSA.

DADD, Frank RI 1851-1929
Black and white artist and figure illustrator. He was born in London on 28 March 1851 and educated at South Kensington and the RA Schools before starting work as an illustrator in about 1872. Dadd did much work for the magazines, particularly drawing for boys' adventure stories; he joined the staff of *The Graphic* in 1884. His style is very photographic with heavy application of bodycolour and clever uses of grey wash, but it is technically excellent and very accurate in detail. He became RI, 1884 and ROI, 1888 and in 1908 one of his pictures was purchased by the Chantrey Bequest. Dadd was a cousin

of Kate Greenaway (q.v.), and his brother married her sister. He died at Teignmouth, Devon, 7 March 1929. Dadd's pictures and drawings are models of Edwardian eloquence, if not of high art.
Illus: *Lead Kindly Light [J.H. Newman, 1887]; Dick O' the Fens [G.M. Fenn, 1888].*
Contrib: *Cornhill Magazine [1870-79]; The Graphic [1876-1910]; ILN [1878-84]; The Quiver [1882]; Boys' Own Paper; The Windsor Magazine.*
Exhib: B; G; L; M; RA, 1905; RI; ROI.
Colls: Author; BM; Exeter.
Bibl: *Who Was Who 1924-40.*
See illustration (below).

DADD, Philip, J.S. -1916
Painter and illustrator, killed in action 1916. There are two pen and ink drawings by this artist of war subjects in the Victoria and Albert Museum, one dated 1899. He worked in Hornsey and exhibited at the RA, RI, ROI and Liverpool, 1905-14. He signs his work 'PD'.

DADD, Richard, 1817-1886
Painter, draughtsman and illustrator. He was born at Chatham, the son of a tradesman and after being educated there, studied art at William Dadson's Academy. In 1834 his family moved to London and the young Dadd became friendly with notable artists, including David Roberts (q.v.) and Clarkson Stanfield (q.v.). He entered the RA Schools on their recommendation in 1837 and he specialised in the painting of fancy pictures in which fairies took a principle role. In 1840 he won the medal for life drawing at the RA and began to exhibit regularly in London.

Dadd was fortunate to be encouraged by Sir Thomas Phillips, the art connoisseur, and was taken on an extensive European tour by him in 1842, visiting, Italy, Greece and the Middle East. On this expedition he first showed unusual behaviour and delusions about the Pope and his patron, Sir Thomas, whom he was convinced were devils. Although he was clearly insane by his return, the symptoms were not recognised until, on August 28 1843, he brutally murdered his father

FRANK DADD RI 1851-1929. 'A duel.' Illustration for unidentified serial story. Ink and wash with Chinese white. Signed. 5½ins. x 7ins. (14cm x 17.8cm).
Author's Collection

in Cobham Park, Kent. He immediately fled to France, but was arrested and returned to this country in 1844 and confined in Bethlem Hospital. He was encouraged to continue painting in the asylum and Dr. W.C. Hood, who became physician at Bethlem in 1853, became a collector and admirer of his work. He was moved to Broadmoor in 1864 where he died in 1886. Dadd's work is interesting because of his isolation from the art world for so many years. His watercolours show a microscopic observation of detail and a fresh and rather disturbing use of colour. Some of his drawings might be compared to those of the Pre-Raphaelites, particularly the more intense visions of Millais and Rossetti in the early 1850s. Dadd's work as an illustrator was short-lived. He drew for *The Book of British Ballads*, 1842, contributing vignettes of 'Robin Goodfellow' and made a frontispiece for *The Kentish Coronal* 1840, which is remarkably bold for its date.

Exhib: BI, 1839; RA; RBA, 1837.
Colls: Bedford; BM; Fitzwilliam; Newcastle; V & AM.
Bibl: D. Greysmith, *RD* 1973. Tate Gallery RD Exhibition catalogue, 1974.

DADD, Stephen T. fl.1879-1914
Figure painter and illustrator. He worked at Brockley, South London, and contributed domestic and animal subjects to magazines.

Contrib: *The Graphic [1882-91, 1901]; ILN [1889]; Daily Graphic [1890]; The Quiver [1890]; Sporting and Dramatic News [1890]; Black and White [1891]; The Rambler [1897]; Chums; Cassell's Family Magazine.*
Exhib: L; M; NWS, 1879-92; RBA; RI.

DALE, Lawrence
Amateur artist. He contributed to *Punch*, 1909.

DALTON, F.T.
Perhaps 'Dallon' who contributed cartoons to *Vanity Fair*, 1895-1900.

DALZIEL, Edward 1817-1905
Engraver on wood and illustrator. He was born at Wooler, Northumberland, on 5 December 1817, the fifth son of Alexander Dalziel and brother of E. and T.B. Dalziel (qq.v.). He was in business at first, but spent much of his spare time studying art, finally joining his brother George in London in 1839 as a wood engraver. He formed part of the firm of Dalziel for over fifty years. Edward was the brother who took on the role of illustrator more earnestly than the rest of his family; he studied at the Clipstone St. Academy alongside Charles Keene (q.v.), and Sir John Tenniel (q.v.) and exhibited from time to time at the RA. He collaborated with his brother on their book, *The Brothers Dalziel, A Record of Work, 1840-1890*, and died 25 March 1905.

Illus: *The Hermit [Thomas Parnell].*
Contrib: *Bryant's Poems [1857]; Dramatic Scenes [1857]; Poets of the Nineteenth Century [1857]; The Home Affections [Mackay, 1858]; Dalziel's Arabian Nights [1865]; A Round of Days [1866]; The Spirit of Praise [1866]; Ballad Stories of the Affections [1866]; Golden Thoughts from Golden Fountains [1867]; North Coast [1868]; National Nursery Rhymes [1870]; The Uncommercial Traveller [Dickens Household Edition, 1871]; The Graphic [1873-74]; Dalziel's Bible Gallery [1881].*
Bibl: The Brothers Dalziel, *A Record of Work, 1840-90*, 1901; Gleeson White, *English Illustration The Sixties*, 1897; F. Reid, *Illustrators of the Sixties*, 1928, pp.252-258, illus.; Simon Houfe, *The Dalziel Family*, Sotheby's Belgravia, 1978.
See illustration (right).

DALZIEL, Edward Gurdon 1849-1889
Illustrator. He was born in 1849 and was the eldest son of Edward Dalziel (q.v.). For some years he was a contributor to *Fun*, 1878-80 choosing subjects of country life and manners, with figures in the tradition of Pinwell and Walker. In *The Brothers Dalziel* he is described as 'a young artist full of promise and great ability. Had he given continued attention to his oil painting he must undoubtedly have taken a very high position. He exhibited many pictures at the Royal Academy, the Grosvenor and other galleries, but the allurement of black and white became too much for him, and he laid aside his brush for the pencil.' *A Record of Work*, 1901, p.10. His work in this medium was much admired by Sir John Gilbert, but he died at the comparatively early age of thirty-nine in 1889.

Exhib: NWS, 1865-87; RA; RBA.

DALZIEL, Thomas Bolton Gilchrist Septimus 1823-1906
Illustrator and wood engraver. He was born at Wooler, Northumberland, in 1823, the son of Alexander Dalziel, painter. He joined his brothers George, Edward and John in the London engraving business in 1860. He was the only one of the brothers to be a noted draughtsman, he was a more accomplished figure artist than Edward, and he contributed to a number of books that were either augmented or financed by the firm. He was a fine landscape illustrator and some of his best work is in Dalziel's Arabian Nights.

Contrib: *Dramatic Scenes [1857]; Bryant's Poems [1857]; Poets of the Nineteenth Century [1857]; Gertrude of Wyoming [1857]; The Home Affections [Mackay, 1858]; Lays of the Holy Land [1858]; The Pilgrim's Progress [1863]; The Golden Harp [1864]; The Churchman's Family Magazine [1864]; The Sunday Magazine [1866-68]; Dalziel's Arabian Nights [1865]; The Arabian Nights [1866]; A Round of Days [1866]; Ballad Stories of the Affections [1866]; The Spirit of Praise [1866]; Jean Ingelow's Poems [1867]; Golden Thoughts From Golden Fountains [1867]; North Coast [1865]; National Nursery Rhymes [1870]; Christmas Carols [1871]; Dalziel's Bible Gallery [1881]; Art Pictures From The Old Testament [1891, etc.].*
Exhib: BI, 1858; RA; RBA, 1846, 1866.
Bibl: *The Brothers Dalziel – A Record of Work 1840-1890*, 1901; F. Reid, *Illustrators of the Sixties*, 1928, pp.251-252; Simon Houfe, *The Dalziel Family*, Sotheby's Belgravia, 1978.

DANCE, Sir Nathaniel, Bt. RA 1734-1811
Caricaturist. He was the eldest son of George Dance, the architect, and was born in London in 1734. He showed a talent for painting from an early age and studied with Francis Hayman, followed by nearly nine years in Italy, where he met and fell in love with Angelica Kauffmann. On his return to England he married a wealthy widow and enjoyed a comfortable life in which he was able to devote his time to politics, eventually being given a baronetcy as M.P. for East Grinstead. Dance was known in his day as a history and portrait painter and as a founder member of the RA, but ironically is best remembered now for the brilliant caricatures done for his own amusement and for

EDWARD DALZIEL 1817-1905. 'The Son of His Filthy Old Father Thames.' Illustration for The Uncommercial Traveller, *Dickens Household Edition, 1870.*

private circulation.

His style of pen drawing is close to Rowlandson (q.v.) in outline and like Hogarth in subject manner. Although it is very much in the tradition of Lord Townshend, it is softer in touch.

Exhib: RA.
Colls: NPG; Witt Photo.

DANIELL, Samuel c.1775-1811

Watercolourist and illustrator. He was born in 1775, the brother of William and the nephew of Thomas Daniell (qq.v.). He studied under Medland and travelled in Africa as secretary and draughtsman for the Bechuanaland mission, 1801. He returned to England in 1804 and travelled to Ceylon; in the following year he died of illness contracted there in the swamps.

Illus: *African Scenery and Animals [1804-05, AT 32]; Barrow's Travels Into The Interior of Southern Africa [1806, AT 322]; The Scenery Animals and Native Inhabitants of Ceylon [1808]; Scenery of Southern Africa [1820]*.
Exhib: RA, 1792-1812.
Colls: V & AM.
Bibl: Iolo Williams, *Early English Watercolours*, 1952, p.58 illus.

DANIELL, Thomas RA 1749-1840

Landscape painter. He was born at Kingston-upon-Thames in 1749, the son of an innkeeper. After being apprenticed to a coach painter, he began to work for Thomas Catton RA, and entered the RA Schools in 1773. During this period he worked as a landscapist in the English Shires, but in 1785 he made the journey that was to alter the course of his career, by travelling to India with his nephew, William (q.v.). He worked in Calcutta, 1788-89, then toured North India, returning to Calcutta in 1791. In 1792 they undertook a tour of Southern India and Ceylon, returning to Bombay in 1793 and leaving for home later the same year.

Much of Daniell's subsequent career was taken up with completing and publishing his Indian work. His drawings and watercolours are careful topographer's work, the colours more like tints than full-blooded watercolours. He became ARA in 1796 and RA in 1797. He was a Fellow of the Royal Society and of the Asiatic Society. He died at Kensington on 19 March 1840.

Illus. (with W. Daniell): *Oriental Scenery [1795-1808]; A Picturesque Voyage to India by the Way of China [1810]*.
Illus: *Views in Calcutta [1786-88, AT 492]*.
Exhib: RA, 1772-84.
Colls: BM; Fitzwilliam; India Office Library; V & AM.
Bibl: T. Sutton, *The Daniells*, 1954; M. Shellim, *The Daniells in Indias*, 1970; *Walker's Quarterly*, Vol.35-36, 1932; M. Archer, *Cat. of Drawings in the India Office Library*.

DANIELL, William RA 1769-1837

Landscape painter and topographer. He was born in 1769 and was trained as his uncle, William Daniell's assistant and accompanied him to India, 1785-94 (q.v.). On his return, Daniell concentrated on making topographical drawings and watercolours, specialising at first in Indian scenery and later in English and Scottish views. He was a very fine aquatinter and engraver and engraved most of the prints for his uncle and family from 1808. His greatest success was probably his *Voyage Round Great Britain*, produced in the years 1813 to 1823 and published 1814-25. He produced some of his best watercolours for this work although many of the studies for the prints are in sepia wash. Daniell was an early follower of Turner in wiping out highlights in his watercolours but otherwise belonged to the older tradition of watercolours. He died at New Camden Town on 16 August 1837. ARA 1807, and RA 1822.

Illus: *Oriental Scenery [1795-1808, 1812-16, AT 432]; Interesting Selections From Animated Nature [1807-12]; A Picturesque Voyage to India by the way of China [1810]; A Familiar Treatise on Perspective [1810]; Views in Bootan [1813]; A Voyage Round Great Britain [1814-25]; Illustrations of the Island of Staffa [1818, after S. Daniell]; Sketches of the Native Tribes . . . of Southern Africa [1820]; Views of Windsor, Eton and Virginia Water [1827-30]; The Oriental Annual [1838]; A Brief History of Ancient and Modern India [Blagdon, 1802-5]*.
Exhib: BI 1807-36; RA from 1795.
Colls: Bedford; BM; Fitzwilliam; Greenwich; India Office; V & AM..
Bibl: T. Sutton, *The Daniells*, 1954; M. Shellim, *The Daniells in India, 1970*; M. Archer, *Catalogue of Drawings in the India Office Library*.

DANIELS, George 1854-c.1917

Landscape painter, miniaturist, stained glass artist. He probably undertook some illustrations and a period subject dated '28 February 1874' is in the Victoria and Albert Museum.

Exhib: RA, 1884-93.

DARBYSHIRE, J.A. fl.1886-1893

Figure illustrator, working in the Manchester area at Flixton and Prestwick. His work is rather exaggerated and weak in drawing.

Exhib: M, 1886-93.
Colls: V & AM.

DARLEY, J. Felix RBA ACA -1932

Landscape and figure painter and illustrator. He contributed many competent landscape subjects to books in the 1860s and was elected RBA in 1901. He worked in London from 1886 and at Addlestone, Surrey, from 1898, he died at Woking on 17 October 1932.

Contrib: *The Poetical Works of Edgar Allan Poe [1857]; Poets of the West; London Society [1863]*.
Exhib: B; L; RBA; ROI.
Bibl: Chatton & Jackson *Treatise On Wood Engraving, 1861*, p.599.

DARRÉ, G. fl.1883-1889

French illustrator. He worked extensively for Parisian satirical publications including, *Charivari, Journal Amusant, Le Grelot, Le Carillon*. He illustrated a *Histoire de France* before coming to London in 1883. There he found work on *Punch*, 1888-89, and some work on *Judy*, 1889. After that date he abandoned illustration for commercial work in black and white.

DAVENPORT, W.

Topographer. He illustrated a *Life of Ali Pasha*, 1823, AT 206.

DAVEY, George

Illustrator and contributor to *Fun*, 1901, working in West Hampstead, London, 1901-2.

DAVEY, H.F.

Topograher. Working in Newcastle-upon-Tyne and contributing drawings to *The Illustrated London News*, 1887.

DAVID, S.

Illustrator of the 1822 edition of *Walton's Compleat Angler*.

DAVIDSON, Alexander RSW 1838-1887

Painter and illustrator who studied in Glasgow. He exhibited at the RA and at the RBA, 1873-92. He made drawings for an edition of Scott's *Waverley Novels*.

DAVIDSON, Thomas fl.1880-1908

Painter of history and genre. He worked in Hampstead from 1880 and specialised in figure subjects. He contributed the latter to *Good Words*, 1880.

Exhib: B; G; L; M; RA; RBA; RHA; ROI.

DAVIEL, Leon fl.1893-1930

Portrait painter, wood engraver and illustrator. In his earlier years he specialised in figure subjects for the magazines, 1897-1907; he worked in Chelsea, 1914-25.

Contrib: *Good Words [1897]; Black and White [1900]; Pearson's Magazine; The Temple Magazine; The Illustrated London News [1907, Christmas]*.
Exhib: NEA, 1912; New Gall; P; RA; ROI.

DAVIES, Edgar W. fl.1893-1910

Historical, mythical and architectural draughtsman. He was working in Manchester in 1893 and subsequently in London. He designed book covers and made studies of foreign towns possibly with a view to illustration. An important group of his drawings in a late Pre-Raphaelite style were sold at Sotheby's Belgravia on 24 January 1978.

Exhib: B; L; M; New Gall; RA; RBA.

DAVIES, Scrope
Figure artist. Contributed to *The English Illustrated Magazine*, 1897; *The Dome*, 1899.

DAVIS, A.L. fl.1899-1925
Figure painter. Probably the same artist who lived at Hither Green, Kent, from 1914-25 and exhibited at the RA, 1914. He contributed to Newnes edition of *The Arabian Nights*, 1899.

DAVIS, G.H.
Marine illustrator, contributing naval subjects to *The Graphic*, 1910.

DAVIS, Joseph Bernard 1861-
Painter of landscapes, genre and portraits, and illustrator. He was born at Bowness, Windermere, in 1861, and worked in London, 1890-1911, and from then until 1925 at Gerrards Cross, Bucks. He was a fairly regular illustrator in the 1890s and excelled in robust genre scenes, such as 'Bank Holiday at the Welsh Harp' for *The Graphic*.
Contrib: *The Temple Magazine [1896]; The Quiver [1900]; The Graphic [1903]; The Ludgate Monthly; The Pall Mall Magazine; The Windsor Magazine; The Royal Magazine.*
Exhib: B; G; L; NWS; RA; RBA; RCA; RI; ROI; RSA.
Colls: Witt Photo.

DAVIS, Louis RWS 1861-1941
Book decorator and illustrator. He worked at Ewelme, Pinner, 1897-1925, and designed borders and bookplates in the style of Morris and Burne-Jones. From 1886-87 he was designing decoration in the form of stylised birds for *The English Illustrated Magazine*, and in 1891-92 contributed topographical work. His drawings are delightful period pieces. He was elected ARWS, 1898.
Exhib: L; New Gall; RWS.

DAVIS, Lucien RI 1860-
Artist and illustrator. He was born at Liverpool in 1860, the son of William Davis, the Liverpool artist. He was educated at St. Francis Xavier's College, Liverpool, and entered the RA Schools in 1877 where he won several prizes. He began his career as an illustrator with Cassell's publications in 1878, but had his first important drawings published in *The Graphic*, 1880-81. He joined the staff of *The Illustrated London News* in 1885 and remained for the next twenty years as one of its chief artists, specialising in social subjects and in work for the Christmas numbers. He was described in the magazine in 1892 as 'singularly successful in representing the sheen of a silk or satin dress'; certainly his figures are rarely seen out of the ballroom or the drawing room! Davis was elected RI in 1893. His two brothers, W.P. and Valentine Davis, were also artists.
Illus: *Willow the King [1899 (child's book)]; Cricket, Lawn Tennis* and *Billiards* in the Badminton Library editions.
Contrib: *The Graphic [1880-81]; ILN [1885-1905]; The English Illustrated Magazine [1885]; Fun [1886-87]; The Quiver [1890]; Cassell's Family Magazine.*
Exhib: G; L; M; Paris, 1900; P; RA.
Colls: V & AM; Witt Photo.

DAVIS, Vaughan
Animal artist. Illustrated Cassell's *The Book of the Dog*, c.1870.

DAVY, C. fl.1833-1846
Architectural draughtsman. He contributed to *Public Works of Great Britain*, 1838, AL 410.
Exhib: RA.

DAWSON, Alfred fl.1860-1889
Landscape painter. He worked at Chertsey as painter and etcher and exhibited at London exhibitions from 1860. He made illustrations for a history of Dorset and contributed to *The Portfolio*, 1884-92.
Exhib: B; RA; RBA; RE; ROI.
Colls: V & AM; Witt Photo.

DAWSON, Charles Frederick fl.1909-1933
Painter and designer. He studied at Shipley School of Art and then in Bradford, Manchester and Newlyn Cornwall. He was for some years headmaster of the Bingley, Nelson and Accrington Schools of Art.
Contrib: *The Page*, 1899.
Exhib: L; M; RA.

DEAN, Christopher
Draughtsman, illustrator and book decorator. He was born in Glasgow and worked there until 1895, settling in Marlow, Bucks., in 1898 and in Chelsea from 1925. He designed illustrations and book covers in a bold Celtic style, using distinctive interlaced borders to the page plates.
Designs for: *Hans Sachs His Life and Work [c.1910]; The Odes of Anacreon [c.1910].*
Exhib: G and RSA, 1895-99.
Bibl: *The Studio*, Vol.12, 1898, pp.183-187, illus. Winter No.1900-01, p.64, illus.

DEAN, Frank RBA 1865-
Painter of genre and illustrator. He was born near Leeds in 1865 and studied at the Slade School under Legros and then at Paris with Lefevbre and Boulanger, 1882-86. He was a close friend of A.S. Hartrick (q.v.) and joined the staff of *The Graphic* with him in 1890, he later shared a flat with E.J. Sullivan (q.v.). Dean travelled to the Middle East and India in search of subjects and worked at Headingley near Leeds from 1914. He was elected RBA, 1895.
Exhib: L; M; NEA; New Gall; RA, from 1887; RBA; RCA; RI; ROI; RSA.
Bibl: A.S. Hartrick, *Painters Pilgrimage Through Fifty Years*, 1939.

DEANE, William Wood OWS 1825-1873
Painter, watercolourist and draughtsman. He was born in Liverpool Road, Islington, on 22 March 1825, the son of J.W. Wood, amateur watercolourist. He began his career in architecture, but gradually abandoned this for painting. He attended the RA Schools in 1844, where he won a silver medal and travelled to Italy, 1850-52. He was an intimate friend of F.W. Topham (q.v.) and visited Spain with him in 1866; he married the sister of Professor George Aitchison, ARA, the architect. He was elected ARIBA, 1848, Associate of the NWS, 1862, and Member, 1867, resigning in 1870 to join the OWS. He was a prolific painter of views of France, Spain and Venice, very colourful and moody compositions. He died at Hampstead, 18 January 1873.
Contrib: *The Illustrated Times, [Naples, 1856].*
Exhib: BI, 1859-64; OWS; NWS; RA; RBA, 1857-66.
Colls: V & AM; Wakefield.
Bibl: M. Hardie, *Watercol. Paint in Britain*, Vol.3, 1968, p.21 illus.

DEAR, Mary E. fl.1848-1867
Portrait and genre painter and illustrator. She worked in London and exhibited at various exhibitions through Messrs. Colnaghi, Pall Mall East; by 1867 she was working from Rottingdean, Sussex. Her figure drawing is always of high quality.
Illus: *The Scarlet Letter [Nathaniel Hawthorne, 1859].*
Contrib: *The Illustrated Times [1855, Christmas]; The Art Journal [c.1865 (a series of Seasons)].*
Exhib: RA; RBA, 1848-67.

DEARMER, Mrs. Percy (née Mabel White) 1872-1915
Writer, dramatist and illustrator. She was born on 22 March 1872 and studied art at the Herkomer School, Bushey. In 1892 she married the Rev. Percy Dearmer, Editor of the *English Hymnal*, and became one of the most popular illustrators of children's books, many of them written by herself and printed in bright colours. She was also engaged in poster work before her death and died at Primrose Hill, London, 10 July 1915.
Illus: *Wymps and Other Fairy Tales [Evelyn Sharp,1897]; Roundabout Rhymes [1898]; The Book of Penny Toys [1899]; The Noah's Ark Geography [1900]; The Seven Young Goslings [Laurence Housman, 1900].*
Contrib: *The Yellow Book [1896 (cover), 1897]; The Parade [1897].*

DE GRIMM see GRIMM

DE HAENEN, F. fl.1896-1910

War artist and illustrator. He was a Frenchman, working for the magazine, *L'Illustration*, and contributing to *The Illustrated London News*, 1896. He went to South Africa as correspondent for *The Graphic*, in 1900 and continued to work for the journal until 1910.

DE KATOW, Paul de 1834-1897

Battle painter and illustrator. He was born in Strasbourg on 17 October 1834 and became a pupil of Delacroix; he exhibited regularly at the Salon, 1839-82, and was war correspondent of *Gaulois* in 1870. He drew illustrations of the Siege of Paris for *The Illustrated London News*, 1870, and contributed to *The Graphic*, 1872.

Exhib: RBA, 1872-73.

DE LA BERE, Stephen Baghot RI 1877-1927

Figure and landscape painter and illustrator. He was educated at Ilkley, Yorks, and studied at Westminster School of Art. He worked in Kensington for most of his life, but at Bishop's Stortford, 1913-14. He was elected RI in 1908. De La Bere was an occasional illustrator, capable of very fine pen and ink work, he died in 1927.

Illus: *Lazarillo de Tomes [Hurtado de Mendoza, n.d.]*.
Contrib: *ILN [1911]*.
Exhib: FAS, 1912; L; RA; RI; RWA.

DE LACEY, Charles John fl.1885-1925

Landscape and naval artist and illustrator. He worked for *The Illustrated London News*, 1895-1900, and was Special Artist with the Russian Fleet, 1897. He later worked for *The Graphic* and acted as Special for the Admiralty and the Port of London Authority.

Illus: *A Book About Ships [A.O. Cooke, 1914]; Our Wonderful Navy, [J.S. Margerison, 1919]*.
Contrib: *The Pall Mall Magazine*.
Exhib: L; M; RA; RBA, 1885-1918.

DELAMOTTE, E.

Contributed decorative initials to *The Illustrated London Magazine*, 1855.

DELAMOTTE, William Alfred 1775-1863

Watercolourist and draughtsman. He was born at Weymouth 2 August 1775 and, through the interest of George III, was placed under Benjamin West in 1794. He studied in the life classes of the RA Schools and eventually settled in the Oxford area as a drawing master and topographer. In 1803, he gained the official appointment of drawing master to the Royal Military Academy, Great Marlow, and two years later, became an early member of the OWS. Our view of Regency Oxford and the Thames valley is generally taken through his soft pencil drawings with colour washes, many of which were engraved for books. He died at St. Giles's Field, Oxford, 13 February 1863.

Illus: *Thirty etchings of rural subjects [1816]; Illustrations of Virginia Water [1828]; Memorials of Oxford [J. Ingram, 1837]; Original views of Oxford, 1843 (liths)]; Windsor Castle [W.H. Ainsworth, 1843]; An Historical Sketch ... Hospital of St. Bartholomew [1844]; Smokers and Smoking [G.T. Fisher, 1845]; Journey to India [Broughton, 1847, AT 522]*.
Contrib: *Britton's Beauties of England and Wales [1813]*.
Exhib: BI 1808-46; OWS, 1806-8; RA; RBA, 1829-31.
Colls: Ashmolean; BM; Fitzwilliam; Manchester; V & AM.
Bibl: Iolo Williams, *Early English Watercolours*, 1952, p.63, illus.

DELFICO, Melchiorre 1825-1895

Draughtsman, musician and caricaturist. He was born at Teramo in 1825 and became well known in Italy for his caricature albums of celebrated people. He died in Naples in 1895. In 1872-73, he contributed 8 cartoons to *Vanity Fair*.

DELL, John H. 1830-1888

Painter of rustic subjects and animals. He worked in the London area and had addresses at various times in Hammersmith, Chertsey and New Malden. He was noted for the accuracy of his work and his masterpiece in book illustration was *Nature Pictures*, published in 1878, consisting of thirty plates in which were shown, as Gleeson

White put it, 'years of patient painstaking labour on the part of artist and engraver'.

Exhib: B; BI, 1851-67; M; RBA, 1851-86.

DE MARTINO, Commendatore Eduardo MVO 1834-1912

Marine artist and illustrator. Born at Meta, near Naples, in 1834 and trained at Naples Naval College for a career in the Italian Navy where he remained until 1867. He then travelled to Brazil and was engaged by the Emperor to make official sketches of the Paraguayan War. Settling in England in 1875, he was made Marine Painter in Ordinary to Queen Victoria and the Royal Yacht Squadron, MVO, 1898. He accompanied the Duke of York on his royal tour in 1901. He died at St. John's Wood, 21 May 1912.

Contrib: *The Graphic [1896-1905]*.
Exhib: GG; L.

DE MONTMORENCY, Lily fl.1895-1904

Landscape and figure artist. She was working in Streatham in 1895, and at Bushey, 1898, where she may have attended the Herkomer School. She was elected ASWA in 1898.

Illus: *Little Tales of Long Ago [1903 (child's book)]*.
Contrib: *The Parade [1897 (initials)]*.
Exhib: L; RA; SWA.

DE MORGAN, William 1839-1917

Artist, author and potter. He was born in 1839, and educated at University College and at the RA Schools, 1859. He came under the influence of the Pre-Raphaelite circle and experimented with stained glass and tile processes, founding a pottery at Chelsea in 1871. He is best remembered today for his re-discovery of coloured lustre, a craft he put to good use in making large chargers and vases. He was associated with William Morris (q.v.) in the Merton Abbey venture, 1882-88, and then on his own at Fulham. He retired in 1905 to Florence and became well-known as a novelist. He died in 1917.

De Morgan was a witty draughtsman of comic sketches and illustrated a book for children, *On a Pincushion and Other Fairy Tales*, 1877. His humorous drawings occasionally come on the market.

DE PARYS or DE PARIS, Alphonse G. fl.1902-1933

Figure painter and illustrator. He contributed to *The Graphic*, 1902-3, mostly crowded social subjects and in particular the Coronation of King Edward VII. He worked in Kensington.

Exhib: RA, 1933.

D'EPINAY see EPINAY

DEROY, Isidore Laurent 1797-1886

Architectural illustrator. He was well-known in France as a painter and lithographer and exhibited at the Salon. He drew views of churches and castles for some English publications, notably *The Illustrated London News* (Vizetelly).

DERRICK, Thomas C. 1885-1954

Artist in stained glass, mural painter and cartoonist. He was born in Bristol in 1885, and was educated at Didcot and studied at the RCA. He was instructor in decorative painting at the RCA for five years, but was best known as a cartoonist contributing to *Punch* and *Time and Tide*. His slick chalk drawings, more like the medium of advertising than the stateliness of *Punch*, typify the 1930s, but probably seemed very untypical at the time. His work was never straight reporting, but a synthesis and abstraction of an event. R.G.G. Price says, 'Reality was patterned and a social point that would be dull presented in a unitary setting gained enormously by being presented rhythmically and decoratively ...' *A History of Punch*, 1955, p.283, illus. Derrick married the daughter of Sir George Clausen, RA, (q.v.).

Publ: *The Prodigal Son and Other Parables; The Nine Nines [Hilaire Belloc]; Everyman [(72 wood engravings) 1930]*.
Exhib: FAS, 1910; G; NEA; RA.

DETMOLD, Charles Maurice ARE 1883-1908

Animal painter, illustrator and etcher. He was born on 21 November 1883, the twin brother of E.J. Detmold (q.v.), with whom he collaborated. He studied animals in the Zoological Gardens with his brother and exhibited watercolours from the age of fourteen. He was strongly influenced by Japanese art and produced with his brother, a portfolio of etchings of birds and animals of unusual technical ability in 1898. He committed suicide in 1908. Elected RE, 1905.

Illus: *Pictures From Birdland; The Jungle Book [Rudyard Kipling, 1908]*.
Exhib: FAS, 1900; G; NEA, 1899; RE; RI, 1897-

DETMOLD, Edward Julius 1883-1957

Animal painter, illustrator and etcher. The twin brother of C.M. Detmold (q.v.). He worked with his brother making sketches at the Zoological Gardens and exhibited with him from the age of fourteen. He was strongly influenced by Japanese art but also by the woodcuts of Dürer and became one of the best Edwardian animal illustrators. His sense of composition and the decorative placing of the animal in its natural habitat was much more subtle than the natural history painters or for example A. Thorburn (q.v.). E.J. Detmold's range was considerable and he published a number of books of fantasy drawing in the early 1920s which show a vivid imagination, fine drawing and warm colouring. Detmold settled at Montgomery in Wales and died there in 1957. He was elected RE in 1905.

EDWARD JULIUS DETMOLD 1883-1957. 'Dormice among brambles.' Illustration for a publication of Messrs. Dent. 19⁷⁄₈ins. x 13³⁄₄ins. (50.5cm x 34.9cm).
Victoria and Albert Museum

Illus: *Pictures From Birdland [1899 (with C.M.D.)]; Sixteen Illustrations of subjects from Kipling's 'Jungle Book' [1903 (with C.M.D.)]; The Jungle Book [R. Kipling, 1908]; The Fables of Aesop [1909]; The Life of the Bee [M. Maeterlinck, 1911]; Birds and Beasts [C. Lemmonier, 1911]; The Book of Baby Beasts [F.E. Dugdale, 1911]; The Book of Baby Birds [F.E. Dugdale, 1912]; Hours of Gladness [M. Maeterlinck, 1912]; The Book of Baby Pets [F.E. Dugdale, 1915]; The Book of Baby Dogs [Charles J. Kaberry, 1915]; Our Little Neighbours, Animals of the Farm and Woodland [1921]; Rainbow Houses [A.V. Hall, 1923]; Tales From the Thousand and One Nights [1924]*.
Contrib: *ILN [1912, Christmas]*.
Exhib: FAS, 1900; G; GG; L; M; NEA, 1899; RA; RBA; RHA; RI; ROI.
Colls: BM; Fitzwilliam; V & AM.
Bibl: 'A Note on Mr. Edward J. Detmold's Drawings and Etchings of Animal Life', *The Studio*, Vol.51, 1911, pp.289-296, illus; B. Peppin *Fantasy Book Illustration*, 1975, p.186, illus.
See illustration (below left).

DEVAMBEZ, André Victor Édouard 1867-1943

French book illustrator. He was born in Paris in 1867, and studied with Constant and Lefevrbre, winning the *prix de Rome* in 1890. He illustrated many books by French authors, including *La Fête à Coqueville*, Émile Zola, and *Le Condamnes à mort*, Claude Farrere. He contributed to *The Illustrated London News*, 1912-13.

DEWAR, William Jesmond fl.1890-1903

Figure artist and illustrator. A competent black and white artist in pen who uses bold hatching and outline in the manner of C.D. Gibson (q.v.).

Contrib: *Moonshine [1885]; Illustrated Bits [1890]; Pick-Me-Up [1894]; Black & White [1896-99]; The Ludgate Monthly [1896]; The Rambler [1897]; The Temple Magazine; Pearson's Magazine*.
Exhib: RA, 1903.

DE WILDE, Samuel 'Paul' 1748-1832

Dramatic portrait painter and illustrator. He was brought to England when a child by his widowed mother and apprenticed to a wood carver in Soho. His earliest works are a series of etchings and mezzotints after Steen, Van Loo, Reynolds, Vernet and Wright which were published under the pseudonym of 'Paul', 1770-77. From 1795, De Wilde was almost totally absorbed in theatrical portraiture, producing a long series of scenes with actors in character, mostly in oil but also in watercolour. He was also a political caricaturist and contributed anonymous plates to the Tory *Satirist*, 1807-8.

The Victoria and Albert Museum has a series of wash drawings of decorative designs for frontispieces, presumably dating from De Wilde's early years in illustration, c.1770; the Garrick Club has the finest collection of his theatrical portraits. He died 19 January 1832.

Exhib: BI, 1812; RA, 1782; SA, 1776.
Colls: Ashmolean; BM; Richmond, Virginia; V & AM.
Bibl: M.D. George, *English Political Caricature*, Vol. 2, 1959, p.106; Iolo Williams, *Early English Watercolours*, 1952, pp.148-149, illus.

DIBDIN, Thomas Colman 1810-1893

Painter and illustrator. He was born at Betchworth, Surrey on 22 October 1810, the son of Thomas Dibdin, the dramatist and probably the grandson of Charles Dibdin, the actor-dramatist. He began work as a clerk in the GPO at the age of seventeen, but after eleven years left it to paint. Dibdin travelled in Northern France, Germany and Belgium drawing their old towns and picturesque buildings. In later life he claimed to be the inventor of chromo-lithography. He died at Sydenham on 26 December 1893.

Publ: *Progressive Lessons in Water Colour Painting [1848]*.
Illus: *Heman's Works [1839]; Bacon's Oriental Annual; Rock Cut Temples of India [Ferguson, 1845, AT 467]*.
Exhib: BI, 1832-50; NWS; RA; RBA, 1831-83.
Colls: Ashmolean; BM; Nottingham; Sydney; V & AM.

DICKES, William fl.1841-1883

Illustrator, engraver and publisher. He was a prolific illustrator in the 1840s but turned his attention to publishing and was chief manager of the Abbotsford Edition of Sir Walter Scott's Works. Chatto records in 1861 that 'Mr. Dickes' attention is now turned to Colour-Printing'. He was living at Loughborough Park, London in 1881.

Illus: *Masterman Ready [Captain Marryat, 1841]; London [Charles Knight, 1841]; Glaucus or Wonders of the Shore [Charles Kingsley, 1855, (frontis.)]*.

SIR FRANCIS BERNARD DICKSEE, PRA RI HRSA, 1853-1928. 'An elderly couple.' Drawing for unidentified illustration, c.1873-80. Pencil.

Victoria and Albert Museum

Contrib: *ILN [1843]*.
Exhib: RA, etc, 1843-81.
Bibl: Chatto & Jackson, *Treatise on Wood Engraving,* 1861, p.599; M.H. Spielmann, *'The History of Punch',* 1895, p.248.

DICKINSON, F.C. fl.1898-1906

Black and white artist and watercolourist. He contributed to *The Quarto,* 1898, and *The Graphic,* 1899-1906. He does quite strong watercolours of figure subjects and may have illustrated an edition of Hans Andersen.

DICKINSON, J. Reed fl.1867-1895

Figure and portrait painter working in Regent's Park and Hammersmith.
Exhib: Dudley; L; M; RA, 1867-81; RBA, 1867-78.

DICKSEE, Sir Francis Bernard PRA RI HRSA 1853-1928

Painter and illustrator. He was born in London in 1853, the son of T.F. Dicksee, the portrait painter. He was trained at the R.A. Schools, 1870-75, and was influenced by Leighton and Millais. He became a very competent book illustrator in the best black and white tradition of the 1870s, illustrated Longfellow's *Evangeline* in 1882 and *The Four Georges,* W.M. Thackeray, 1894. But his success as a society portrait painter enabled him to abandon this side of his art. He was elected ARA, 1881; RA, 1891, and PRA, 1924. He died in London 28 October 1928.

Exhib: G; GG; L; M; RA; RHA; RI; ROI; RSA.
Colls: BM; Manchester; V & AM.
Bibl: E.R. Dibdin, FD, 1905.
See illustration (above).

DICKSEE, Margaret Isabel 1858-1903

Landscape and figure painter and illustrator. She was born in 1858, the daughter of T.F. Dicksee, the portrait painter and sister of Sir Frank Dicksee (q.v.). She drew ink illustrations for a number of magazines including *The Quiver,* 1890, and *The Girls' Own Paper.* She was also a good decorative artist and designed borders for some of Woolner's poems. She died in London 6 June 1903.

Exhib: L; RA; RBA; RWS.
Colls: V & AM; Witt Photo.

DIGHTON, Denis 1792-1827

Military painter and draughtsman. He was born in London in 1792, the son of Robert Dighton (q.v.), and studied at the RA Schools. He was patronised by the Prince of Wales and became Military Draughtsman to him from 1815, sometimes travelling abroad. He died at St. Servan, Brittany in 1827.

Illus: *Sketches [1821, 15 liths., AL 121].*
Exhib: BI; RA.

DIGHTON, Joshua fl.1820-1840

Caricaturist. A son of Robert Dighton and a brother of Richard Dighton (qq.v.). Like his brother he drew small full-length watercolour portraits in profile, concentrating on sporting celebrities.

Colls: Witt Photo.

DIGHTON, Richard 1795-1880

Caricaturist. Son of Robert Dighton (q.v.) whose successor he was. He was born in London in 1795, and on his father's death in 1814, he continued the series of portrait etchings, 1815-28. These were all in the 'Dighton style' of small full-length portraits in profile, coloured by hand, usually of sporting celebrities but also of politicians. The whole series of originals by father and son were purchased by King George IV. Dighton also etched some Anti-Radical caricatures between 1819-21 and died on 13 April 1880. His portrait drawings are still occasionally seen on the market, they are often in pencil and watercolour and well-handled. Work by other members of the family is stiffer and less convincing.

Colls: NPG; V & AM.
See illustration (p. 285).

DIGHTON, Robert 1752-1814

Painter, caricaturist and actor. He was the founder of the dynasty of Dightons that flourished in English caricature for a hundred years. Dighton began exhibiting as a watercolourist and etcher in 1769 at the Free Society of Artists and was an occasional exhibitor at the RA, 1775-1799. He worked for Carrington Bowles on humorous mezzotints or 'postures' between 1774 and 1794. In 1793, he brought out a *Collection of Portraits of Public Characters* which were an immediate public success and from this date he concentrated wholly on caricature. The series was something new in England as it was more natural than exaggerated and spelled the way for Regency and Early Victorian work. Dighton continued to do ordinary political caricaturing which Williams found coarse compared with the portraits. Dighton appears to have been a fairly reprobate personality and was discovered in 1806 to have removed prints out of the British Museum and replaced them with copies! He died in London in 1814.

Colls: Ashmolean; BM; Fitzwilliam; Manchester; V & AM.
Bibl: H.M. Hake, *Print Collectors Quarterly,* XIII, pp.136ff, 242ff.

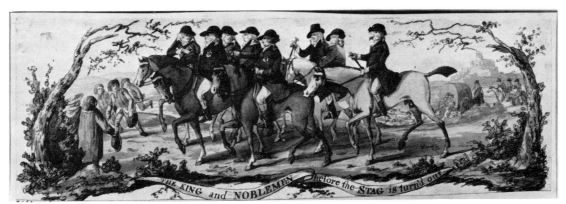

RICHARD DIGHTON 1795-1880. 'The King and Noblemen before the stag is turn'd out.' Vignette illustration. Ink and watercolour. Signed: Dighton del.

DINKEL, Joseph **fl.1833-1861**

Architectural and botanical illustrator. He was born in Munich and travelled widely in Europe for The Linnaen Society, the Royal, Geological and Palaeontological Societies. Chatto records that he was 'a very accurate draughtsman of subjects of Natural History, especially of Fossil remains; but though he has most practice in this department, he also undertakes Architectural and Engineering drawings.'

Illus: *Poissons Fossiles [Agassiz, 1833-43].*
Exhib: RA, 1840.
Colls: Neufchâtel.
Bibl: Chatto & Jackson, *Treatise on Wood Engraving,* 1861, p.593.

DINSDALE, George **fl.1808-1829**

Landscape painter and topographer. He was working in Chelsea, 1818, and Bloomsbury, 1828-9, and contributed illustrations to Griffith's *Cheltenham,* 1826.

Exhib: BI, 1808-29; RA.

DINSDALE, John

Figure artist working in Camden Town, 1884-90. He contributed humorous drawings to *Fun,* 1890. Exhibited at the RI.

DISTON, A.

Topographer. Illustrated *Costumes of the Canary Islands,* 1829, AT 75 (liths).

DIXON, Charles Edward **RI** **1872-1934**

Marine painter and illustrator. He was born at Goring in 1872 and after exhibiting at the RA from the age of sixteen, he became a prolific illustrator in *The Graphic,* 1900-10. He was a member of the Langham Sketching Club and was elected RI in 1900. His work is always very accurate, but he was able to create the atmosphere and mood of the great shipping lanes by skilful washes, careful uses of colour and sombre skies. He died at Itchenor, 12 September 1934.

Illus: *Britannia's Bulwarks [C.N. Robinson, 1901].*
Exhib: FAS, 1916; G; L; M; RA; RI; ROI.
Colls: Greenwich; V & AM.

DIXON, May

Amateur illustrator. Hon Mention in *The Studio* book illustration competition, Vol. 8, 1896, p.184, illus.

DIXON, O. Murray

Contributed colour illustrations of animals to *The Illustrated London News,* 1909.

DOBELL, Clarence M. **fl.1857-1866**

Figure painter and illustrator. He contributed to *Good Words,* 1860, and *Once a Week,* 1865, and illustrated *One Year,* 1862, for Messrs. Macmillan. He was working in London, 1857-65, and then at Cheltenham.

Exhib: BI, 1858-66; RA; RBA, 1857-66.

DOBSON, William Thomas Charles **RA RWS** **1817-1898**

Scriptural painter and illustrator. He was born at Hamburg in 1817 and entered the RA Schools in 1836, becoming a teacher in the Government School of Design in 1843. He left this work in 1845 and travelled abroad, mostly in Italy and Germany. He was elected an ARA in 1860 and RA in 1871 and RWS, 1875. Many of his pictures were engraved by Graves & Co. He died at Ventnor on 30 January 1898.

Illus: *Legends and Lyrics [A.A. Proctor, 1865].*
Exhib: OWS; RA; RBA.
Colls: Sheffield; V & AM.

RICHARD DIGHTON 1795-1880. Mr. Hobhouse. 1819. Etching.

DODD, A.W.
Illustrator. Made illustrations of 'The Four Elements', *The Studio,*
Vol. 34, 1905, p.350, illus.

DODGSON, Charles Lutwidge 'Lewis Carroll' 1832-1898
Writer and creator of 'Alice'. He was born at Daresbury, Cheshire, on
the 17 January 1832 and after being educated at Rugby, gained a
Fellowship at Christchurch, Oxford, where he remained for the rest of
his life. Carroll, as he was known from 1856, produced his own small
sketches to illustrate the first manuscript of *Alice in Wonderland,*
January 1863, but because of their weakness he approached Sir John
Tenniel (q.v.) in February 1864 to undertake the work. Carroll
remained a scrupulous critic of his illustrators till his death.
Bibl: G. Ovenden, *The Illustrators of Alice,* 1972.

DODGSON, George Haydock 1811-1880
Topographer, landscape painter and illustrator. He was born at
Liverpool on 16 August 1811 and was apprenticed to George
Stephenson, the railway engineer, from 1827 to 1835. He left this
employment due to the pressure of the work and began to paint,
moving to London in 1836 and drawing its architecture. He did a
great deal of illustration in the 1850s before turning his attention to
landscapes. He then drew extensively on the Thames and made visits
to Whitby and Wales. He was an ARWS from 1842-47 when he
resigned and became OWS in 1848. He died on June 4 1880 at 28
Clifton Hill, St. John's Wood.
Illus: *Illustrations of the Scenery on the Line of the Whitby and Pickering
Railway [1836].*
Contrib: *The Illustrated London News [1853-6]; The Cambridge Almanack;
Lays of the Holy Land [1858]; The Home Affections [C. Mackay, 1858].*
Exhib: BI; OWS; RA; RBA, 1835-39; RWS.
Colls: BM; V & AM.
Bibl: Chatto & Jackson, *Treatise on Wood Engraving,* 1861, p.598.

DODWELL, Edward FSA 1767-1832
Topographer and draughtsman. He was born in Dublin in 1767 and
after being educated at Trinity College, Cambridge, travelled in
Greece, 1801 and 1805-6. He died at Rome in 1832.
Illus: *Alcuni Bassi rilievi della Grecia [1812]; A Classical and Topographical
Tour of Greece [1819]; Views in Greece [1819-21, AT 130]; Views and
Descriptions of Cyclonian or Pelasgic Remains . . . [1834].*

DOLBY, Edwin Thomas fl.1849-1870
Landscape and architectural illustrator. He specialised in views of
churches and was a candidate for the NWS between 1850 and 1864.
Illus: *Great Britain as it is [E.H. Nolan, 1859]; A Series of Views . . . during the
Russian War [1854]; D's Sketches in the Baltic [1854].*
Contrib: *Recollections of the Great Exhibition of 1851 [1851]; ILN [1854,
Denmark]; The Illustrated Times [1855, Crimea]; The Graphic [1870].*
Exhib: RA, 1849-65.

DOLBY, Joshua Edward Adolphus fl.1837-1875
Landscape painter. He specialised in picturesque buildings and drew
for *Prague Illustrated,* 1845, AT 74 (liths.). He exhibited at RA and
RBA, 1840-46.

DOLLMAN, Francis Thomas 1812-1899
Architectural draughtsman. Illustrated his own *Examples of Ancient
Pulpits Existing in England,* 1849. Exhibited at the RA, 1840-78.
Colls: V & AM.

DOLLMAN, John Charles RI 1851-1934
Painter and illustrator of animals. He was born at Hove, 6 May 1851,
the son of a bookseller and after being educated at Shoreham, studied
art at South Kensington and the RA Schools, where he won prizes for
drawing from the living model. He practised black and white drawing
for the magazines until 1901 when he began to paint in watercolours,
specialising in historical genre subjects. He was elected RI, 1886; ROI,
1887; ARWS, 1906, and RWS, 1913. He died at Bedford Park 11
December 1934.
Illus: *In the days when we went Hog-Hunting [J.M. Brown, 1891]; Curly [John
Coleman, 1897]; Told by the Northmen [E.M. Wilmott Buxton, 1908].*

Contrib: *The Graphic [1880-88 (stories and theat.)].*
Exhib: B; FAS, 1906; G; L; M; Paris, 1900; RA; RHA; RI; ROI; RSA.
Colls: Glasgow; Manchester; Nottingham.
Bibl: *English Influences on Vincent Van Gogh,* Arts Council, 1974-75.

DONNELLY, W.A.
Contributed illustrations to *The Sporting and Dramatic News,* 1890
and *The Illustrated London News,* 1894.

DONNISON, T.E.
Illustrator, working at Rock Ferry, Cheshire, and contributing to the
The Boys' Own Paper in the 1890s. Exhibited at Liverpool, 1882.

DORÉ, Paul Gustave Louis Christophe 1832-1883
Painter, illustrator and sculptor. He was born at Strasbourg on 6
January 1832 and took up lithography at the age of eleven while
living at Bourg-en-Bresse. He then went to Paris and in 1848 attached
himself to Philippon's *Journal Pour Rire,* where he contributed a
weekly page. He showed pen and ink drawings at the Salon of 1848
and a painting in 1851 but really made his reputation in 1854 with his
illustrated *Rabelais,* followed by a whole series of classic titles in
English and French editions. He became known to the British public
with his contributions to *The Illustrated London News* from 1853,
and with Crimean sketches from 1855-56 and in 1858. Vizetelly
employed him even more extensively on *The Illustrated Times,*
1855-60, and there is no mistaking his crowded and wildly dramatic
battle scenes. His great projected work on London with a text by
Douglas Jerrold was prepared in the late 1860s but only came out in a
shortened version in 1872 as *London: A Pilgrimage.* A similar scheme
for Paris never materialised. Doré's success in England enabled him to
open his own gallery here for a number of years, but his obsessive
ambition to be recognised as a great painter rather than a great
illustrator clouded his later years.

Doré's earlier work tends to be linear and his later work tonal. By
the end of his career he was treating the page like a canvas and his
dominance of the illustrated book here and in France was not very
beneficial. His greatest works like the *Inferno* and *Don Quixote,* 1863,
are extremely dramatic; Doré plays on the horror of emptiness and
height very cleverly, but sometimes loses his hold with a
super-abundance of detail. His later books, where tone was all
important, did not have the drawings carefully inked out for the wood
engraver but were simply supplied as wash drawings. These are
occasionally seen on the market.

A further side to Doré's genius is provided by his caricature
sketches, many of these were published as *Two Hundred Sketches,
Humorous and Grotesque* in 1867; they show him as a brisk satirist of
society, the drawing is rather harsh and there is a tendency to adopt
the old tradition of caricature in enormous heads and skeletal bodies.
Illus: *The Wandering Jew [Sue, 1856]; Jaufry the Knight and the Fair
Brunissende [A. Elwes, 1856]; The Adventures of St. George [W.F. Peacock,
1858]; Boldheart the Warrior [G.F. Pardon, 1858]; the History of Don Quixote
[Cervantes, 1863]; The Ancient Mariner [S.T. Coleridge, 1865]; Days of
Chivalry [L'Epine, 1866]; The Adventures of Baron Munchausen [1866];
Fables of La Fontaine [1867]; Elaine, Guinevere, Vivien, Enid and Idylls of the
King, [Tennyson, 1867-68]; The Bible [1867]; Popular Fairy Tales [1871];
Poems of Thomas Hood [1872]; London: A Pilgrimage [1872].*
Colls: V & AM.
Bibl: Blanchard Jerrold, *Life of Gustave Doré,* 1891, (complete bibliography);
David Bland, *A History of Book Illustration,* 1958, pp.289-295.

See illustration (p. 287).

DORING, Adolph G.
German landscape painter and etcher, working at Bernbourg and
Ostsee, Germany. He contributed illustrations of animals to *The
Strand Magazine,* 1894.
Exhib: RA, 1897.

GUSTAVE DORÉ 1832-1883. 'Inside The Docks.' Illustration for London, a pilgrimage *by Douglas Jerrold, 1872.* Victoria and Albert Museum

DOUGLAS, Edwin 1848-1914

Sporting and animal painter. He was born at Edinburgh in 1848 and studied at the RA Schools, and the RSA. He spent most of his life working in the south of England, in Surrey, 1880-90, and then in Sussex until his death. His paintings are in the style of Edwin Landseer.

Contrib: *Poems and Songs of Robert Burns [1875].*
Exhib: B; G; L; M; RA; ROI.

DOWD, James H. 1884-1956

Painter, etcher and black and white artist. He was a regular contributor to *Punch* from about 1906, specialising in the humours of childhood and later in the illustrations for film criticism; R.G.G. Price calls him 'the Baumer of the nursery'. He was working at Sheffield in 1912 and in London from 1918. He must not be confused with L. Dowd, another *Punch* artist.

Contrib: *The Graphic [1915].*
Exhib: G; L; P; RA; RMS; RSA.
Bibl: R.G.G. Price, *A History of Punch*, 1957, p.210.

DOWNARD, Ebenezer Newman fl.1849-1892

History painter, engraver and illustrator. He specialised in genre subjects and contributed work to *The Illustrated London News*, 1873-79.

Exhib: BI, 1861-66; G; RA; RBA; RHA; ROI.

DOWNEY, Thomas fl.1890-1935

Figure painter and illustrator, caricaturist. He was a pupil of Alfred Bryan (q.v.) and worked for numerous magazines in the 1890s.

Illus: *Patsy [H. de V. Stacpoole, 1908 (frontis.)].*
Contrib: *Daily Graphic [1890]; Moonshine [1890]; The Sketch [1894-95]; Judy [1898]; The Idler; Chums; The Boys' Own Paper.*
Exhib: Arlington Gall., 1935.

DOWNING, Henry Philip Burke FRIBA 1865-

Architect, etcher and illustrator. He was born in 1865 and after studying at the RA Schools and at the Architectural Association, he was articled to Hessell Tiltman, FRIBA. He then became Chief Assistant to Joseph Clarke FSA, Canterbury Diocesan architect, and started in private practice in 1888. He served on the RIBA Council and was a member of the London Topographical Society. His pen and ink drawings of buildings are in the style of Herbert Railton and Holland Tringham (qq.v.).

Illus: *Architectural Relics in Cornwall [1888]; Monumental Brasses.*
Contrib: *St. Paul's [1894]; Black & White; Lady's Pictorial.*
Exhib: RA; RSA, 1904-32.
Bibl: *Who's Who in Architecture*, 1914.

DOYLE, Charles Altamont 1832-1893

Humorous and fairy illustrator. He was the fourth son of John Doyle (q.v.) and was born in London in 1832. He was a professional civil servant for most of his life but worked as an illustrator in an amateur capacity. His sketches of imaginary subjects often have a rather sinister quality somewhat akin to those of his brother Richard Doyle (q.v.). He was the father of Sir Arthur Conan Doyle and died at Dumfries in 1893.

Illus: *Our Trip to Blunderland [Jean Jambon, 1877 (60 illus.)].*
Contrib; *The Illustrated Times [1859-60]; Good Words [1860]; London Society [1863-64]; The Graphic [1877].*
Exhib: RSA.
Colls: Witt Photo.

DOYLE, Henry Edward RHA 1827-1892

Portrait and religious painter and caricaturist. He was born in Dublin in 1827, the third son of John Doyle (q.v.). He was trained in Dublin and on coming to London worked as a wood engraver and draughtsman for satirical journals. He made a number of small cuts for *Punch* in 1844, and was a contributor of caricatures to *The Great Gun*, 1845, and was cartoonist of *Fun*, 1867-69. His brother James Doyle (q.v.) rather dismisses this work as 'the merest child's play' but as Spielmann says, 'the spirit of humour was strong within him'. Doyle's public image was certainly very different (his illustrations to *Telemachus* were admired by Prince Albert) and in 1869 he became Director of the National Gallery of Ireland, formed an important collection there and carried out the decorations of a Roman Catholic chapel. He became ARHA in 1872 and RHA in 1874 and was awarded the CB in 1880. He died in Dublin, 17 February 1892.

Doyle's caricatures which are occasionally to be found, are usually diminutive full-length portraits in watercolour with large heads; he frequently signed with a hen or 'Fusbos'.

Bibl: M.H. Spielmann, *The History of Punch*, 1895, p.459.

DOYLE, James William Edmund 1822-1892

Heraldic artist and illustrator. He was the eldest son of John Doyle (q.v.) and born in London in 1822. He studied under his father but soon turned all his attention to historical research, although he made a few designs in pen, ink and watercolour. He wrote and illustrated *A Chronicle of England*, 1864, which has colour plates printed by Edmund Evans; some authorities consider it finer work than Baxter's. He was the author of the *Historical Baronage of England*, 1886, and died in London in 1892.

Colls: V & AM.
Bibl: M. Hardie, *English Coloured Books*, 1906; Ruari McLean, *Victorian Book Design and Colour Printing*, 1972, p.184.

DOYLE, John 'HB' 1797-1868

Lithographer, portraitist and caricaturist. He was born at Dublin in 1797 and studied there under an Italian landscape painter, Gabrielli, and under the miniaturist, W. Comerford. He attended the Dublin Society's Drawing Academy and in about 1822 travelled to London to work as a portrait painter. This proving unsuccessful, he set himself up as a portrait lithographer, publishing portraits of well-known people such as Wellington, George IV at Ascot, and the Princess Victoria in her pony phaeton. All of these were signed 'JD'. Doyle took to political caricature in 1827, publishing anonymous lithographs in that year and the next, and beginning in 1829 his famous series of *Political Sketches* signed 'HB'. The monogram was made up of two conjoined 'JD's, intended to hide the identity of the artist and excite curiosity, which it did! The series with its characteristically weightless but well observed figures, ran from 1829 to 1849 with a further plate in 1851, an astonishing output of nearly one thousand prints.

Doyle was fortunate to work during a period of reform and change ideally suited to his talents. Although there was intense political

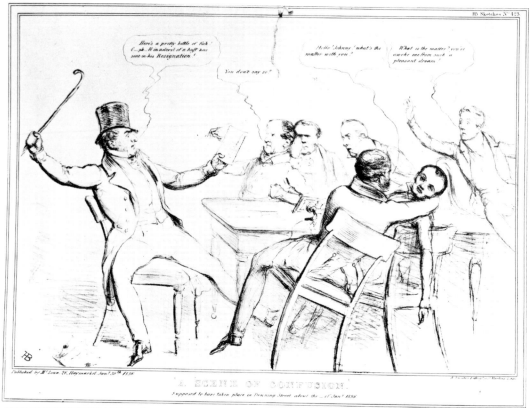

JOHN DOYLE 'HB' 1797-1868. 'A Scene of Confusion.' No. 423 in HB's Sketches, *published by McLean, 30th January 1836. Lithograph.*

activity, the public desired it to be treated with a gentler wit than the savage satire of the Gillray and Cruikshank era. Doyle therefore is less of a caricaturist than a political illustrator. The plates were issued by McLean in volume form, 1841 and 1844, with an *Illustrative Key*. Many of the pencil studies are in the British Museum. John Doyle died in London 2 January 1868.

Exhib: RA, 1825-35.
Colls: BM; Windsor.
Bibl: G. Everitt, *English Caricaturists*, pp.235-276; M.D. George, *English Political Caricature*, 1959; G.M. Trevelyan, *The Seven Years of William IV, a reign cartooned by John Doyle*, 1952.
See illustration (above).

DOYLE, Richard 'Dick Kitcat' 1824-1883

Humorous artist, cartoonist and fairy illustrator. He was born in London, September 1824, the second son of John Doyle (q.v.). He was the most gifted artist in a very gifted family and began from an early age to illustrate juvenilia, *Home for the Holidays*, a book for family circulation in 1836 (first published 1887) and *Dick Doyle's Journal*, 1840 (first published 1885). His first published work was the comic medieval book *The Eglinton Tournament*, 1840, which was widely acclaimed and the same year he collaborated with John Leech (q.v.) on the novel *Hector O'Halloran* by W.H. Maxwell; other book illustrating commissions followed from Dickens and Thackeray, Doyle working in wood and steel and sometimes signing 'Dick Kitcat'.

In 1843, Doyle was introduced to *Punch* and soon became a very regular contributor of decorations and initial letters, but did not graduate to cartooning until March 1844, eventually sharing about a third of the work with Leech. In January of the same year, Doyle designed *Punch's* sixth cover which remained in use until 1954, a spirited procession of tiny figures based on Titian's 'Bacchus and Ariadne'. By the middle 1850s, Doyle was almost a household name through his popular series 'Manners and Customs of Ye Englishe' and the later 'Bird's Eye Views of Society', and he had become a very proficient wood engraver after taking lessons from Swain. The source for much of Doyle's comedy remained the books of his childhood, the legends and the chivalry which gave him ideas but also an open-hearted naïveté in the drawing. It was probably this romance and

freshness, the lack of shadow, that recommended his work to an artist like Holman Hunt and a critic like Ruskin, whose work he illustrated.

Doyle's break with *Punch* came in 1850, when its attacks on the Papacy were more than Doyle, a devout catholic, could tolerate. He devoted the rest of his life to the illustration of books and in particular children's stories and fairy tales where his delight in the grotesque is given full rein and he reveals himself as a vivid and magical colourist. Perhaps his masterpiece was *In Fairyland* by William Allingham, 1870, a folio with colour wood engravings by Edmund Evans. Doyle continued to paint landscapes and died after a visit to the Athenaeum on 11 December 1883. He signed his work with:

Illus:. his own work: *Mr. Pip's Diary: Manners and Customs of Ye Englishe [1849]; An Overland Journey to The Great Exhibition [1851]; Bird's Eye Views of Society [1864]; The Foreign Tour of Brown, Jones and Robinson [1854]; The Doyle Fairy Book [1890]. Grimm's Fairy King [1846]; A Jar of Honey From Mount Hylba [Hunt, 1847]; Fairy Tales [Montalba, 1849]; The Enchanted Doll [M. Lemon, 1849]; Rebecca and Rowena [W.M. Thackeray, 1850]; The King of the Golden River [J. Ruskin, 1851]; The Story of Jack and The Giants [1851]; the Newcomes [W.M. Thackeray, 1845-55]; A Juvenile Calendar and Zodiac of Flowers [1855]; The Scouring of the White Horse [Hughes, 1859]; A Selection From the Works of Frederick Locker [1865]; An Old Fairy Tale [Planché, 1865]; Irish Biddy, The Visiting Judges, The Troublesome Priest [1868]; Lemon's Fairy Tales [1868]; In Fairy Land [W. Allingham, 1870]; Piccadilly [Oliphant, 1870]; The Enchanted Crow [1870]; The Feast of the Dwarfs [1871]; Fortune's Favourite [1871]; Snow White and Rose Red [1871]; Princess Nobody [A. Lang, 1884]; The Family Joe Miller.*
Contrib: *The Fortunes of Hector O'Halloran [W.H. Maxwell, 1842]; Punch [1843-51]; The Chimes [Charles Dickens, 1845]; The Battle of Life [Charles Dickens, 1846]; The Cricket on the Hearth [Charles Dickens, 1846]; ILN [1847]; L'Allegro and Il Penseroso [Milton, 1848]; Life of Oliver Goldsmith [J. Forster, 1848]; Gaultier Ballads [1849]; Merry Pictures By The Comic Hands of H.K. Browne and Richard Doyle [1857]; Puck on Pegasus [C. Pennell, 1862]; Disraeli in Cartoon,[1878]; Cornhill Magazine [1861-62]; Pall Mall Gazette [1885-87].*
Exhib: GG; L; RA, 1868-83.
Colls: Ashmolean; BM; Fitzwilliam; V & AM.
Bibl: G. Everitt, *English Caricaturists*, 1883, pp.381-394; Chatto & Jackson, *Treatise on Wood Engraving*, 1861, pp. 578-579; F.G. Kitton, *Dickens and His Illustrators*, 1899; Daria Hambourg, *RD English Masters of Black and White*, n.d.; B. Peppin, *Fantasy Book Illustration*, 1975. pp.9, 11, 20, illus.

See illustrations (pp. 63, 116 and 289).

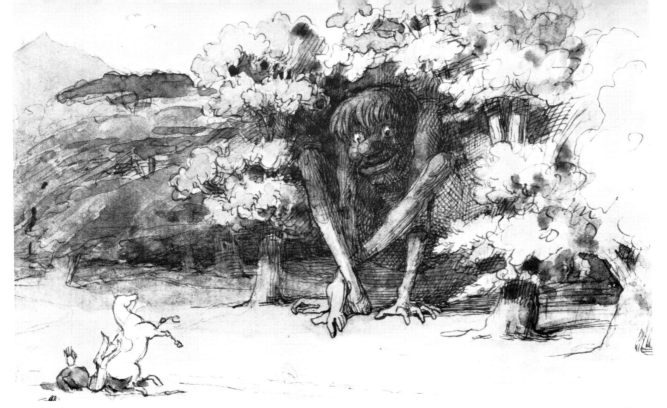

RICHARD DOYLE 1824-1883. 'The Knight and Jötun.' Illustration for a fairy story. Ink and watercolour. 4³/₈ins. x 7ins. (11.1cm x 17.8cm) Victoria and Albert Museum

PRINCE ALBERT'S BEE-HIVES.

"These Hives are so constructed, that the HONEY may be removed without DESTROYING THE BEES."—*Morning Paper*

RICHARD DOYLE 1824-1883. 'Prince Albert's Bees Hives.' Cartoon for Punch, *1844.*

D'OYLY, Sir Charles, 7th Bt. **1781-1845**

Amateur artist and illustrator. He was born in Calcutta in 1781 and served for the whole of his life in India, first as assistant to the Registrar, Calcutta Court of Appeal, 1798, and then as Collector of Dacca and Resident at Patna, 1831. He studied drawings under George Chinnery in Dacca and made sketches of Anglo-Indian life and society. He returned to Europe in 1838 and died at Livorno in 1845.

Illus: *The European in India [1813]; Antiquities of Dacca [1814-15]; Behar Amateur Lithographic Scrap Book [1828; AT 446]; Indian Sports [1828, AT 447]; Tom Raw The Griffin [1828, AT 450]; The Feathered Game of Hindoostan [1828, AT 451]; Extra Behar Lithographic Scrap Book [1829, AT 452]; Oriental Ornithology [1829, AT 453]; Sketches of the New Road [1830, AT 455]; Views of Calcutta [1848, AT 497].*
Exhib: RA, 1815.
Bibl: *The Connoisseur*, Vol.CLXXV, 1970.

DRAKE, William Henry **1856-**

American illustrator. He was born in New York on 4 June 1856 and studied in Paris at the Académie Julian. He is included here as the illustrator of *Stories of Child Life*, and *The Jungle Book*, by Rudyard Kipling, 1894. He was a noted still-life illustrator, specialising in black and white drawings of gold and silver antiquities and old armour.

Bibl: J. Pennell, *Pen Drawing and Pen Draughtsmen*, 1894, pp.242-243 illus.

DRAPER, Herbert James **1864-1920**

Portrait, subject painter and illustrator. He was born in London in 1864, and studied at the St. John's Wood School, RA Schools and in Paris at Julian's, 1890 and Rome 1891. His painting 'The Lament for Icarus' was bought by the Chantrey Bequest in 1898. He died in Hampstead on 22 September 1920.

Illus: *St. Bartholomew's Eve [G.A. Henty, 1894]; A Young Traveller's Tales [Hope, 1894].*
Contrib: *The Yellow Book [1895].*
Exhib: G; L; M; New Gall.; Paris, 1900; RA; RBA; RHA.

DRAW see WARD, Leslie

DRUMMOND, James RSA **1816-1877**

History painter. He was born in Edinburgh in 1816 and worked as a draughtsman for ornithological works. He then entered the Trustees Academy, Edinburgh, and studied with Sir William Allan, exhibiting at the RSA from 1835 and becoming ARSA in 1846 and Member in 1852. Drummond made a close study of archaeology and is noted for his historical accuracy in his large canvases of Scottish history.

Illus: *Ancient Scottish Weapons [J. Andersen, 1881].*
Contrib: *Good Words [1860].*
Exhib: RBA; RI.
Colls: Blackburn; Edinburgh; V & AM.

DUANE, William

Principal cartoonist of *Fun,* 1900.

DUDLEY, Ambrose **fl.1890-1919**

Portrait painter and illustrator. He worked in London and exhibited at the RA, 1890-1919. A pleasant ink and wash drawing of a pedlar, probably intended for illustration was in a London collection in 1976.

DUDLEY, Robert **fl.1858-1893**

Painter, lithographer and illustrator. He specialised in English and continental views and seascapes, but outside his landscape work was an interesting minor figure in illustration. He first appears contributing the topography of Birmingham to *The Illustrated London News* in 1858 and seven years later in 1865, the same paper sent him as correspondent on *The Great Eastern* when the Trans-Atlantic Cable was laid. The result of this was a handsome book of lithographs *The Atlantic Telegraph,* 1866, with text by W.H. Russell of *The Times.* A watercolour worked up from one of these subjects was shown by Dudley at the RBA in 1866. He was also well-known as a book decorator and drew designs for brass cut publishers' bindings, many of them signed. He worked in Kensington, 1865-75, and at Notting Hill from 1875 and died there about 1893.

Illus: *A Memorial of the Marriage of H.R.H. Albert Edward, Price of Wales and H.R.H. Alexandra, Princess of Denmark [W.H. Russell, 1863].*
Contrib: *ILN [1858-73]; The Illustrated Times [1861]; The Boys' Own Magazine [1863]; London Society [1864-71]; The Graphic [1869].*
Exhib: B; G; L; M; RA; RI.
Bibl: Ruari McLean *Victorian Book Design and Colour Printing,* 1973, pp.139, 220, 221.

DUFF, Sir C.G. 'G C D' or 'Cloister'

Contributing cartoons to *Vanity Fair,* 1899-1900 and 1903. Nobody of this name can be traced.

DUGDALE, Thomas Cantrell RA **1880-1952**

Painter and illustrator. He was born at Blackburn on 2 June 1880, and was educated at Manchester Grammar School, studied art at Manchester Art School and later in South Kensington and at Julian's, Paris. He served throughout the First World War mostly in the Middle East and the Balkans, being mentioned in despatches, 1915. In his student days, Dugdale designed some book decorations in a woodcut style and was an occasional illustrator in ink and watercolour. He later abandoned this for oil painting. He was elected ROI, 1910; ARA, 1936, and RA, 1943. He held a one man show at the Leicester Galleries in 1919.

Illus: *The Gateway to Shakespeare [Mrs. Andrew Lang, 1908].*
Contrib: *The Graphic [1910].*
Exhib: G; GG; L; M; NEA, 1910-13; P; Paris, 1921; RA; RHA; ROI; RSA.
Bibl: *The Studio,* Vol.12, 1897-98 p.137 illus.

DULAC, Edmund **1882-1953**

Artist and illustrator. He was born at Toulouse on 22 October 1882 and after attending the university there, he studied law and took up art, joining the drawing and painting classes of the Toulouse School of Art. He then went to Paris and studied at the Académie Julian for three weeks, concentrating from then onwards on work as a book illustrator, portrait painter, designer of costumes and stage sets and modeller. Dulac settled in London in 1906, and by the outbreak of war had established himself as one of the leading artists in the field. He became a naturalised British subject in 1912 and really cemented a

EDMUND DULAC 1882-1953. Caricature of Arnold Bennett, novelist and man of letters. An illustration for The Evening Standard, *c.1922. Pen and ink. 5ins. x 5½ins. (12.7cm x 14cm)* Author's Collection

popularity with his adopted country which has remained to the present day. Dulac was immensely versatile and had more sense of colour and design than most of his English contemporaries, excepting Rackham. He looked to the Middle and Far East for inspiration, his watercolours of legendary subjects have a gemlike brilliance found only in Mogul miniatures, their flat, stylised and sleepy beauty sometimes comes from the Japanese print, sometimes from the Pre-Raphaelites and even occasionally from the Renaissance. There are clearly a few borrowings from Rackham mannerisms but when he is depicting a tale like *Beauty and the Beast,* the repertoire is his own, the paper parchment, the colour vivid and thick and the design dominating the story. Dulac's early work is a precursor of Art Deco and in fact his middle period fell right into the 1920s when such highly-coloured and self-conscious work was in vogue. The artist played his own part in this, designing a smoking room for one of the great luxury liners, *The Empress of Britain.*

Dulac was also a remarkable caricaturist, a disciplined artist in black and white who could capture a personality or situation in very few lines, but remain sympathetic. He also brought to this country the very French tradition of caricature sculpture, many examples of this were in his studio at his death.

Illus: *The Arabian Nights [1907]; Lyrics Pathetic and Humours [1908]; The Tempest [1908]; The Rubaiyat of Omar Khayyam [1909]; Fairies I have Met [1910]; Studies from Hans Andersen [1911]; The Sleeping Beauty and Other Tales [1912]; Princess Badoura [1913]; Sinbad the Sailor [1914]; Edmund Dulac's Book For The French Red Cross [1915]; Edmund Dulac's Fairy Book [1916]; Tanglewood Tales [1918]; The Kingdom of the Pearl [1920]; The Green Lacquer Pavillion [1926]; Treasure Island [1927]; The Fairy Garland [1928]; Gods and Mortals in Love [1936]; The Golden Cockerel [1950].*
Contrib: *The Graphic [1906]; ILN [1911]; Princess Mary's Gift Book [1915]; The Outlook [1919].*
Exhib: L; Leicester Gall., from 1907; Paris, 1904-5; RI.
Colls: Author; BM; Fitzwilliam; V & AM.
Bibl: F. Rutter, *The Drawings of ED; The Studio,* Vol.45, 1908-9, pp.103-113 illus; *Modern Book Illustrators and Their Work,* Studio, 1914; D. Larkin, *Dulac,* Coronet Books, 1975; *Times Literary Supplement,* 29 October 1976.
See illustration (above, frontispiece and p. 291).

DU MAURIER, George Louis Palmella Busson **1834-1896**

Black and white artist, illustrator and novelist. He was born in Paris and came to London as a student to read chemistry at University College, 1851. He returned to Paris as an art student in 1856-57 to work under Gleyre and there made the acquaintance of J. McNeill Whistler and E.J. Poynter (qq.v.), a period of his life which was afterwards featured in his novel *Trilby.* Du Maurier moved on to

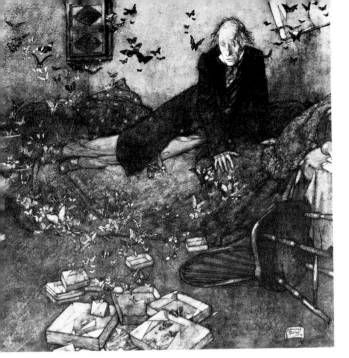

EDMUND DULAC 1882-1953. 'The Entomologist's Dream.' Pen and ink, and
watercolour. Signed and dated 1909. 10³/₈ins. x 11³/₈ins. (26.3cm x 28.9cm).
Victoria and Albert Museum

Antwerp from 1857-60 to study under De Keyser and Van Lerius, but
the loss of an eye precluded him from following the career of a
painter, and he decided to concentrate on black and white work
which was at a new peak at the beginning of the 1860s. A naturally
lazy man, although a very talented one, du Maurier returned to
London in 1860 and gradually broke into book and magazine
illustrating, developing as a fine figure draughtsman and the greatest
social satirist of the period. An occasional contributor to *Punch* from
1860, du Maurier became a regular part of the magazine from 1864
when he succeeded John Leech (q.v.) as the chief observer and
caricaturist of fashion and high life. His accuracy in depicting the
houses and habits of the rich bourgeoisie was astonishing and his ink
drawings remain a very complete chronicle of Victorian life. It is the
situations that are humorous in du Maurier's work rather than the
drawings, he satirises certain traits of the Victorians admirably, their
artiness and aestheticism in 'Mrs Cimabue Brown', a culture-loving
hostess, and their snobbery in the social-climbing 'Mrs Ponsonby de
Tompkyns'. It was only late in life that du Maurier emerged as an
important novelist with his three books, *Peter Ibbetson*, 1891, *Trilby*,
1894; and *The Martian*, 1896, all illustrated by himself. He died in
Hampstead, 8 October 1896.

Du Maurier's pen drawings for *Punch* in black or brown ink are
among the most delightful of the Victorian era, they are usually very
finished, carefully hatched with little shadow on the faces but a
concentration of black in hair and clothes. They are more usually
signed than dated. There is a definite falling off of quality after 1880
and his compositions are sometimes awkward after this date.

Illus: *The Story of a Feather [Douglas Jerrold, 1866]; Frozen Deep [Wilkie
Collins, 1875]; Poor Miss Finch [Wilkie Collins, 1872]; The New Magdalen
[Wilkie Collins, 1873]; Misunderstood [F. Montgomery, 1874]; Pegasus
Re-saddled [H.C. Pennell, 1877].*
Contrib: *The Welcome Guest [1860]; ILN [1860 (decor.)]; Once a Week
[1860-68]; Punch [1860-96]; Good Words [1861]; The Illustrated Times
[1862]; London Society [1862-68]; The Sunday At Home [1863]; The
Cornhill Magazine [1864, 1870, 1875-80]; English Sacred Poetry of The Olden
Time [1864]; Our Life Illustrated in Pen and Pencil [1865]; Divine and Moral
Songs [1866]; Legends and Lyrics [1866]; Foxe's Book of Martyrs [1866];
Touches of Nature by Eminent Artists [1867]; The Savage Club Papers [1867];
Lucile [1868]; Pictures From English Literature [1870]; The Graphic [1871,
1888]; Thornbury's Legendary Ballads [1876]; Sons of Many Seasons [1876];
Harper's Magazine [1889-94]; Black & White [1891].*
Exhib: FAS, 1884, 1887, 1895, 1897; OWS, 1870-93; RA.
Colls: Ashmolean; Bradford; BM; Fitzwilliam; Manchester; V & AM.

Bibl: T. Martin Wood, *G du M*, 1913; D.P. Whiteley, *G du M*, English Masters of
Black and White, 1948; Leonee Ormond, *G du M*, 1969; M.H. Spielmann, *The
History of Punch*, 1895, pp.503-516.
See illustration (p. 292).

DU MOND, Frank Vincent **1865-**
Painter of genre subjects, landscapes and illustrator. He was born in
Rochester, U.S.A., in 1865 and became a pupil of Boulanger and
Constant in Paris. He illustrated the English edition of *Personal
Recollections of Joan of Arc*, Mark Twain, 1897.

DUNCAN, A.
Figure painter. He was working at London from 1853 to 1862 and
illustrated *The Ancient Mariner*, 1856.
Exhib: BI, 1855-62; RBA, 1853-62.

DUNCAN, D.M.
Figure painter. He contributed illustrations to *Good Words*, 1880, and
exhibited in Glasgow, 1880-82.

DUNCAN, Edward RWS **1803-1882**
Marine and coastal painter and illustrator. He was born in London in
1803 and, showing artistic ability, was articled to Robert Havell and
his son, the aquatint engravers. He then worked for Fores, the
printsellers before giving up all engraving in favour of watercolours,
becoming a member of the NWS in 1834. He became interested in
marine subjects after making the acquaintance of William Huggins, the
marine artist, and subsequently married his daughter; it was this side
of his work that made him celebrated. He was a brilliantly clear
colourist and showed life at the water-front and in the harbours of
southern England with vividness and clarity. Duncan was specially
good at representing old jetties, nets drying and baskets piled with fish
and the general impedimenta of fisher life. These watercolour studies
for the exhibited pictures survive in abundance as do leaves from his
sketch-books showing boats, gear and busy figures, drawn in careful
pencil line. The artist resigned from the NWS and joined the OWS in
1847 and throughout the next twenty years made long sketching
tours in England, Scotland and Wales, once visiting Holland and once
travelling to Italy. Duncan was an accomplished illustrator of marine
subjects and his output was extensive. He died at his home in
Haverstock Hill, Hampstead, on 11 April 1882.

Duncan's watercolours and drawings are usually signed 'E.
Duncan', and many of the sketches have the red stamp of the artist's
studio sale at Christie's, March 11, 1885.

Publ: *Advanced Studies in Marine Painting [1889]; British Landscape and Coast
Scenery [1889].*
Illus: *Southey's Life of Nelson.*
Contrib: *Poems and Pictures [1846]; ILN [1847-58 and 1868]; Willmott's
Poets of the Nineteenth Century [1857]; The Home Affections [Charles
MacKay, 1858]; Lays of the Holy Land [1858]; Favourite English Poems
[1859]; Book of Favourite Modern Ballads [1860]; Montgomery's Poems
[1860]; Early English Poems: Chaucer to Pope [1863]; Once a Week [1866];
Book of Rhymes and Roundelayes; Moore's Poems; The Soldier's Dream.*
Exhib: BI, 1833-57; NWS; RA; RBA, 1830-82; RWS.
Bibl: Chatto & Jackson *Treatise on Wood Engraving*, 1861, p.583; M. Hardie,
Watercolour Paint. in Brit., Vol.III, 1968, pp.75-77 illus; F.L. Emanuel, *Walker's
Quarterly*, xiii, 1923.
Colls: Bradford; BM; Glasgow; V & AM.

DUNCAN, James Allen **fl.1895-1910**
Illustrator, decorator and type-face designer. He worked at Glasgow,
1895-97 and at Milngorie, 1902, and was a regular contributor to
magazines, an illustrator of children's stories and the designer of two
alphabets for the Chiswick Press, c.1899.

Contrib: *The Daily Graphic [1895]; The English Illustrated Magazine [1897];
Fun [1900]; The Graphic [1901-6]; The Connoisseur [1910 (decor.)].*
Illus: *Children's Rhymes [1899].*
Exhib: G and RSA, 1895-1901.
Bibl: *The Studio*, Vol.15, 1899, pp.184-189, illus.

GEORGE DU MAURIER 1834-1896. 'Appreciative Sympathy: Herr Bogoluboffski plays a lovely Nocturne. which he has just composed. To him, as he softly touches the final note, Fair Admirer, "Oh Thanks! I am so fond of that Dear Old Tune!" ' Illustration for Punch, *20 November 1880. Pen and ink. 5ins. x 8ins. (12.7cm x 20.3cm).*
Author's Collection

DUNCAN, John RSA 1866-1945
Painter of legend and history and illustrator. He was born at Dundee in 1866 and studied art there and in London and Düsseldorf before settling in Edinburgh and working in Edinburgh and Glasgow, where for a time he was on the staff of *The Glasgow Herald*. He drew for both magazines and books, his earlier work showing a strong influence from Japanese art and particularly Japanese prints. As a decorative artist, his main work was the scheme for the University Hall, Edinburgh, as a teacher, his main contribution was as Professor at Chicago University, 1902-4. He was elected ARSA in 1910 and RSA in 1923. RSW, 1930.

Contrib: *The Evergreen [1895].*
Bibl: *The Artist*, 1898, pp.146-152 illus.

DUNLOP, Marion Wallace fl.1871-1905
Portrait painter, figure artist and illustrator. She was working in London from 1871 and in Ealing 1897-1903. Her black and white work is extremely competent and heavily *art nouveau*.

Illus: *Fairies, Elves and Flower Babies [1899]; The Magic Fruit Garden [1899].*
Exhib: G; NEA; RA; SWA.
Bibl: *The Studio*, Vol.10, 1897, illus. (competitions); Vol.12, 1897, illus. (competitions); R.E.D. Sketchley, *English Book Illus.*, 1902, pp.106, 165.

DUNN, Edith (Mrs T.O. Hume) fl.1862-1906
Domestic painter and illustrator. She was working at Worcester, 1863, and in London, 1864, and exhibited at the RBA, 1862-67, and at the BI, 1864-67. She married the landscape painter Thomas O. Hume and lived after her marriage at South Harting, Petersfield, Hants.

Contrib: *The Quiver [1866].*

DURAND, Godefroy 1832-
Illustrator. He was born in 1832 at Düsseldorf but was of French extraction. After studying with Leon Cogniet, he settled in London in 1870 probably as a result of the French defeat of that year. He exhibited pictures of the Siege of Paris at the RBA in 1873. Durand joined the permanent staff of *The Graphic* in 1870 and remained on it for many years supplying the paper with military and horse subjects and foreign views. He was still there in 1890, when Hartrick joined the staff and he described him as 'an elderly Frenchman . . . permanently

on the paper to do hackwork'.

Illus: *La Guerre au Maroc [Yriarte, n.d.]; The Life of Christ [Ernest Renan, n.d.].*
Exhib: M, 1882; RA; RBA, 1873.

DURDEN, James ROI 1878-1964
Landscape and portrait painter. He was born in Manchester in 1878 and studied at Manchester School of Art and the Royal College of Art. He worked at Claygate, Surrey, 1909, London 1910 and 1927, finally settling at Keswick, Cumberland. He was elected ROI in 1927.

Illus: *The Five Macleods [C.G. Whyte, 1908].*
Contrib: *The Quartier Latin [1898]; The Graphic [1911-12].*
Exhib: G; L; M; P; Paris, 1927; RA; RI; ROI; RWA.

DURHAM, C.J. -1889
Figure painter and illustrator. He was a teacher at the Slade School and contributed drawings of industry to *The Illustrated London News,* very regularly, 1861-74.

Exhib: RA, 1859; RBA, 1872-80.

DUTTON, Thomas G.
Marine watercolourist. He worked in London and contributed drawings of shipping to *The Illustrated London News,* 1877.

Exhib: RBA, 1858-79.

DUVAL, Marie see ROSS, C.H.

DYSON, William Henry 1883-1938
Cartoonist. He was born at Ballarat, Australia, in 1883, was educated in Melbourne and came to England in 1909. He was chief cartoonist to the *Daily Herald*, 1913-25, and again in 1931-38, noted for his extreme radical outlook and as an ardent supporter of socialist change. Dyson was a talented etcher, but his drawings, scratchy penwork over pencil and dark shading, are more reminiscent of Daumier than of English caricature. Veth considered that Dyson in his 'wild extravagance' often overshot the mark. He died 21 January 1938.

Illus: *Collected Drawings.*
Exhib: Leicester Gall.; RHA; RSA.
Colls: V & AM.
Bibl: John Jensen, *WD: 20th Century Studies*, 1976.

292

EARLE, Augustus — 1793-1838

The son of Ralph Earle, the American painter. He studied at the RA, 1813, and began to travel, visiting the Mediterranean, Africa, Tristan da Cunha, the United States, New South Wales and New Zealand. He worked as a portrait painter in Madras before returning to England by way of France. His most famous voyage was made about 1833 when he acted as draughtsman to Charles Darwin on the expedition of H.M.S. Beagle. Earle was a skilled topographer but also drew caricatures and genre subjects.

Illus: *Journal of a Voyage to Brazil [M. Graham, 1824, AT 708]; Journal of a Residence in Chile [M. Graham, 1824, AT 714]; Sketches Illustrative of the Native Inhabitants and Islanders of New Zealand [1832, AT 587]*.
Exhib: RA, 1806-38.
Colls: BM.

EARLE, Percy

Contributed cartoons of horse subjects to *Vanity Fair*, 1909-10.

EARNSHAW, Harold — fl.1908-1926

Watercolour painter and illustrator. Husband of Mabel Lucie Atwell (q.v.). He specialised in the illustrating of boys' novels and exhibited at the RI.

Illus: *The Rebel Cadets Charles Gleig, 1908]; Princess Mary's Gift Book [1915]*.
Contrib: *The Graphic [1912]*.

EAST, Sir Alfred RA FRS — 1849-1913

Landscape painter and watercolourist. He was born at Kettering, Northants, 15 December 1849, and began life in business at Glasgow before attending the Glasgow School of Art, studying under Robert Greenlees. He then went to Paris and was strongly influenced by the Barbizon School. East was an etcher as well as a painter and was an early member of the Royal Society of Etchers, Painters and Engravers, President of the RBA in 1906, ARA, 1899, and RA, 1913. He visited Japan in 1909 and was knighted in 1910. He died in London 28 September 1913 and was buried at Kettering.

East is included here by virtue of the fact that his etchings and paintings were sometimes used for books, for example in *Cassell's Picturesque Mediterranean*, 1891. His *Brush and Pencil Works in Landscape* was published posthumously, 1914.

Exhib: RA, 1883-1913.
Colls: Ashmolean; BM; Leeds; V & AM; Wakefield.
Bibl: F. Newbolt, 'The Etchings of Alfred East' *The Studio*, Vol. 34, 1905, pp.124-137; A. East, 'Art of the Painter Etcher' *The Studio*, Vol. 40, 1907, pp.278-282.

EBBUTT, Phil

Figure and humorous illustrator. Working for magazines 1886-1903.

Contrib: *Fun [1886-87]; The Daily Graphic [1890]; The Quiver [1892]; Lady's Pictorial [1895]; The Graphic [1901-03]*.

ECKHARDT, Oscar RBA — fl.1893-1902

Painter and illustrator, working in Kensington. He worked for numerous magazines in thin pen and ink, 1893-1900. He was elected RBA, 1896. He signs his work Eckhardt.

Contrib: *The Butterfly [1893]; Black & White [1894]; St. Paul's [1894]; Daily Graphic [1895]; The Unicorn [1895]; The Windsor Magazine [1895]; The Sketch [1895]; Eureka [1897]; The St. James's Budget [1898]; Illustrated Bits [1900]; Pick-Me-Up; The Ludgate Monthly; The Idler; The Strand Magazine*.
Exhib: L; RBA; ROI.
Colls: V & AM.

EDMONSTON, Samuel — 1825-

Landscape and marine painter, occasional illustrator. He was a pupil of Sir William Allen and the RSA Schools and worked in Edinburgh, painting in watercolour and drawing in chalks.

Contrib: *Pen and Pencil Pictures from the Poets [Edinburgh, 1866]; Burns Poems [n.d.]*.
Exhib: RA, 1856-57; RSA.
Colls: N.G. Scot; Witt Photo.
Bibl: Chatto & Jackson, *Treatise on Wood Engraving*, 1861, p.599.

EDWARDS, Amelia B.

Illustrator and contributor to *The Girl's Own Paper*, c.1890.

KATE EDWARDS fl.1865-1879. 'The June Dream.' Illustration to London Society, *Vol. 9, No. 54, 1866. Wood engraving.*

EDWARDS, D. fl.1850-1857

Illustrator of poetry in a rather weak and sentimental manner. He contributed two drawings to *Willmott's Poets of the Nineteenth Century*, 1857.

Colls: Witt Photo.

EDWARDS, The Rev. E. 1766-1849

Amateur topographer. He was a Norfolk vicar and antiquary and founded the Kings Lynn Museum in 1844. He was a competent pen and wash artist and contributed views to *Britton's Beauties of England & Wales*, 1810.

EDWARDS, George Henry

Figure and landscape painter and illustrator. He worked in London for juvenile magazines and novels and specialised in fairy and romantic subjects.

Illus: *The Temple of Death [E. Mitchell, 1894]; The Crimson Sign [Keightley, 1894].*
Contrib: *ILN [1900]; The Boys' Own Paper; The Girls' Own Paper; The Royal Magazine.*
Exhib: L; RA; RBA, 1883-93; RI; ROI.

EDWARDS, Henry Sutherland 1828-

Author and minor illustrator. He was for some time Editor of the comic paper *Pasquin* and was engaged as a writer for *Punch*, 1848. He published *The Russians at Home*, 1858, *A History of the Opera*, 1862, *Malvina*, 1871. In 1867 he contributed some illustrations to magazines.

Colls: Witt Photo.

EDWARDS, Kate fl.1865-1879

Illustrator. Nothing is known of this outstanding figure artist who worked in the middle 1860s. Her drawings of women can only be compared to those by M. Ellen Edwards (q.v.) and George Pinwell (q.v.) by whom she was clearly influenced.

Contrib: *London Society [1865-66]; Once a Week [1867].*
Exhib: RBA, 1879.
See illustration (p. 293).

EDWARDS, Lionel Dalhousie Robertson RI 1878-1966

Painter, illustrator and writer on sporting subjects. He was born 9 November 1878, the son of Dr. James Edwards of Chester. He studied art under A. Cope and Frank Calderon (q.v.) at the School of Animal Painting, Kensington. Edwards worked extensively for the press, specialising in hunting subjects, first for *The Graphic* in about 1910 where he reported the Lisbon Revolution. He was the successor of Alken and Leech in his love of country pursuits, and eventually of G.D. Armour (q.v.), but his drawings lacked their humour. He worked for *Punch* before the First World War and regularly in the 1920s, but his black and white work is more scratchy than Armour's although his figures and landscapes are very authentic. Edwards was most at home in straight hunting sketches, ink and watercolour sometimes varied with colour chalk, or skilful smudges of bodycolour. The whole hunting field vividly realised, springing over fences or drawing a wood. In the inter-war years he made portraits of hunting celebrities, and there were few clubs or pubs at the time that did not possess a print of at least one of them. He was working in Wales, 1901-06, and Abingdon, 1909. He finally settled at Salisbury, Wiltshire, in 1923 and died there in 1966. He was elected RI in 1927.

Edward's work has always been popular with the hunting fraternity and both paintings and drawings have risen in demand.

Illus: *Hunting and Stalking Deer [1927]; Huntsmen Past and Present [1929]; My Hunting Sketch Book [1928 and 1930, 2 vols.]; Famous Fox Hunters [1932]; A Leicestershire Sketch Book [1935]; Seen From the Saddle [1936]; The Maltese Cat [Kipling, 1936]; My Irish Sketch Book [1938]; Horses and Ponies [1938]; Scarlet and Corduroy [1941]; Royal Newmarket [1944]; Getting to Know Your Pony [1947].*
Contrib: *The Graphic [1910-16]; Punch.*
Exhib: L; RA; RCA; RI.
Bibl: *Mr. Punch with Horse and Hound*, New Punch Library, c.1930; Autobiog. *Reminiscences of a Sporting Artist*, 1948.

EDWARDS, Louis

Illustrator of military subjects. Contributed to *The Illustrated London News*, 1889.

EDWARDS, Mary Ellen 1839-c.1910
(Mrs. Freer 1866-69; Mrs. Staples 1872).

Book illustrator and figure artist. She was born 6 November 1839 at Kingston-upon-Thames and became one of the most prolific secondary illustrators of the third quarter of the 19th century. Her drawings of domestic life never advanced much beyond the competent and pretty, but she did illustrate Anthony Trollope's *The Claverings* and the novels of Mrs. Henry Wood in serial and book form. She was particularly good at child studies and in handling groups of children in a natural way. She was also associated with *The Argosy*, a magazine run by Mrs. Henry Wood's son. She used her maiden name until 1869, then Mrs. Freer until 1872 and finally her second husband's name, Mrs. Staples, from 1872. She lived at Chelsea, 1865-66, and at Hedingham, Essex, 1875-76, finally settling at Shere, Surrey, 1892. She died about 1910.

Illus: *The New House That Jack Built [Mrs. W. Luxton, 1883]; The Boys and I [Mrs. Molesworth, 1883]; A World of Girls [L.T. Meade, 1887].*
Contrib: *Puck on Pegasus [1862]; Churchman's Family Magazine [1863-64]; Parables From Nature [1861 and 1867]; London Society [1864-69]; Family Fairy Tales [1864]; The Quiver [1864]; Once a Week [1865-68]; Watts Divine and Moral Songs [1865]; Legends and Lyrics [1865]; The Sunday Magazine [1865]; Good Words [1866]; Aunt Judy's Magazine [1867]; Cassell's Magazine [1867-70]; The Churchman's Shilling Magazine [1867]; The Broadway [1867-70]; Golden Hours; The Illustrated Times; Idyllic Pictures [1867]; The Illustrated Book of Sacred Poems [1867]; Argosy [1868]; Dark Blue [1871-73]; Graphic [1869-80]; Mother's Last Words; ILN [1880-]; The Quiver [1890]; The Girl's Own Paper.*
Bibl: F. Reid, *Illustrators of The Sixties*, 1928, pp.261-262; *English Influences On Van Gogh*, Arts Council, 1974-75, p.51.

EGERTON, M. fl.1824-1827

Social caricaturist. He worked in London in the 1820s in the manner of George Cruikshank.

Illus: *Humorous Designs [1824, AL 288]; Sponge [1824, AL 289]; Airy Nothings [1825 AL 290]; Collinso Furioso [1825 AL 291]; Matrimonial Ladder [1825 AL 292]; Cross Readings [1826 AL 293]; Olla Padeida [1827 AL 294].*

EGLEY, William Maw 1826-1916

History painter and miniaturist who undertook some illustrations. He was born in 1826, the son of William E. Egley, 1798-1870, the miniaturist. Egley worked as a book illustrator from 1843 to 1855, but thereafter concentrated on scenes of contemporary life and period subjects under the influence of W.P. Frith. A design for a frontispiece in the Victoria and Albert Museum, dated 1843, is in pencil, heightened with white, a charming mock Gothic drawing, the handling reminiscent of 'Phiz' or G. Cruikshank. The same museum has a manuscript catalogue of the artist's work in its library.

Exhib: B; L; M; RA; RBA; RI; ROI, 1843-98.
Colls: BM; Fitzwilliam; V & AM.

EHNINGER, John W. 1827-1889

American landscape painter and illustrator. He was born in New York in 1827 and travelled to Paris in 1847 where he became a pupil of Thomas Couture, 1815-1879. He visited many European countries and returning to the United States, became a member of the National Academy in 1860. He later published many engravings of his English drawings. He died in 1889.

Contrib: *Good Words [1864].*
Exhib: RA and RI, 1864.

ELCOCK, Howard K. fl.1910-1923

Figure artist and illustrator. He contributed sporting subjects to *Punch* and designed dust jackets, notably that for the 1923 edition of *The Prisoner of Zenda* by Anthony Hope.

ELGOOD, George Samuel RI **1851-1943**
Painter and illustrator of gardens. He was born in Leicester, 26
February 1851, and was educated privately and at Bloxham. He
studied art at South Kensington and specialised in very finished
watercolours of formal gardens, parterres and country house views,
often peopled by figures in historic costume. Elgood became an
authority on Renaissance gardens in England, Italy and Spain and
generally spent five months of every year abroad, painting them. He
worked in London, 1872-77, and afterwards in his two houses at
Tenterden in Kent and at Markfield in Leicestershire. He was
brother-in-law of J. Fulleylove RI (q.v.). RI 1882, ROI 1883.

Illus: *Some English Gardens [Gertrude Jekyll, 1904]; The Garden That I Love
[Alfred Austin, 1905]; Larnia's Winter Quarters [Alfred Austin, 1905]; Italian
Gardens [1907]*
Exhib: FAS, 1891, 1893, 1895, 1898, 1900, 1904, 1906, 1908, 1910, 1912,
1914, 1918, 1923; L; M; RBA, 1871-78; RI; ROI.
Colls: Brighton; Wakefield.
Bibl: 'The Garden And Its Art with Special Reference to the Paintings of G.S.
Elgood'; *The Studio*, Vol.V, 1895, p.51, illus.; 'George S. Elgood's Watercolour
Drawings of Gardens', *The Studio*, Vol.31, 1904, pp.209-215, illus.
See illustration (Colour Plate XIII p. 173).

ELLESMERE, Francis, 1st Earl of see GOWER, F. Leveson

ELLETT
Illustrator working c.1903. The Victoria and Albert Museum has one
example by this rather weak artist in watercolours and body colour.

ELLIOTT, Alma
Black and white artist, probably for illustration. She is recorded as
working in Leicester in 1926 and was a working member of the Design
and Industries Association. She made drawings of period subjects with
thin angular pen lines.

ELLIOTT, E.G.
Topographer. Draughtsman for *Travels in the Three Great Empires of
Austria, Russia and Turkey*, by Charles Boileau Elliott, 1838, AT 31.

ELLIS, Edwin John **1841-1895**
Landscape and marine painter and illustrator. He was born in
Nottingham in 1841 and worked in a lace factory before studying art
with Henry Dawson. He settled in London after completing his art
studies in France and became a popular landscape painter,
concentrating on the Welsh and Yorkshire coasts. He was a gifted poet
and a champion of the poetry of William Blake (q.v.) and a friend of
W.B. Yeats. RBA, 1875.

Publ: *The Real Blake, A Portrait Biography, 1907.*
Illus: *Fate in Arcadia [E.J. Ellis, 1868-69].*
Contrib: *Punch [1867]; London Society [1868-69]; Cassell's Magazine [1870].*
Exhib: RA; RBA, 1868-91.
Colls: Manchester; Nottingham.
Bibl: M.H. Spielmann, *The History of Punch*, 1895.

ELLIS, Tristram James ARPE **1844-1922**
Artist. He was born at Great Malvern in 1844 and was educated at
Queenswood College and King's College, London. He was articled to
an engineer and worked on the District and Metropolitan Railways
until 1868. He then went to Paris to study painting under Bonnat,
1874, travelling to Cyprus, 1878, and to Syria, Asia Minor and
Mesopotamia, 1879-80, Egypt, 1881-82, Portugal, 1883-84 and
Greece and Turkey, 1885-86. He made later tours to Spitzbergen,
1894, and Russia, 1898. He became ARE in 1887 and at about this
time undertook some competent but not exciting book illustrations.
Phil May shared his studio in London for some months. He died 25
July 1922.

Publ: *On a Raft and through the Desert [1881].*
Illus: *Fairy Tales of a Parrot [A.C. Stephen, CB, CMG, 1873].*
Exhib: GG; New Gall.; RA; RBA; RG.

ELLWOOD, George Montagu SGA **1875-1955**
Artist and writer. He was born at Eton in 1875 and studied at South
Kensington, Camden School of Art and in Paris, Vienna, Berlin and
Dresden. He was Designer of Applied Art at Holloway School of Art
and Design Master at Camden School of Art. He was also a member of
the Architectural Association, the Art Workers' Guild and the Society
of Graphic Art, and was Joint Editor of *Drawing and Design*, 1916-24.
Ellwood's interests were catholic and his work wide ranging from
interior schemes for houses and churches to posters, books and
pottery. He published handbooks for artists and died at Boscombe in
1955.

Publ: *English Furniture [1680-1800]; Some London Churches; Figure Studies
for Artists; The Human Form; Pen Drawing; Art in Advertising; English
Domestic Art; Human Sculpture.*
Contrib: *The Dome [1899].*
Bibl: *The Studio*, Vol. II, 1897, p.210, illus; Winter No.1900-01, p.69, illus.

ELMORE, Alfred RA **1815-1881**
History and genre painter. He was born at Clonakelty, County Cork,
on 18 June 1815, the son of an army doctor, and moved to London
with his family while still young. Showing an aptitude for art, he
began drawing from the antique at the British Museum entering the
RA Schools in 1834 and exhibiting regularly there from the following
year. He made an extensive tour to Paris, Munich, Venice and
Florence, finally settling in Rome for two years and returning to
England in 1844. He was elected ARA in 1846, and RA in 1857, and
RHA 1878. He died in Kensington on 24 January 1881.

Elmore contributed one illustration, the frontispiece to *The Home
Affections* by Charles Mackay, 1858; it is well drawn and decorative
in the medieval idiom of the period and it is a pity the artist did not
produce more work of this type.

Contrib: *Midsummer Eve [Mrs. S.C. Hall, 1842].*
Exhib: BI, 1835-47; RA; RBA, 1836-79.
Colls: Ashmolean; BM; Edinburgh; V & AM.
Bibl: S.C. Hall, *Retrospect of a Long Life*, 1883, pp.219-220; J. Mass, *Victorian
Painters*, 1870, pp.239-240.

ELTZE, Fritz **-1870**
The son of Mr. Eltze, private secretary to Sir Richard Mayne, Chief
Commissioner of Police. He spent his early life at Ramsgate but was
unable to live actively due to progressive consumption. He was
introduced to *Punch* in May 1864 when he submitted some sketches
to Mark Lemon. In the same year he took over the production of the
social illustrations that had been the responsibility of the recently
deceased John Leech (q.v.). Eltze was best when allowed to mirror the
follies of fashion, or the *bon mots* of childhood; his drawing was
slightly amateurish and very distinctive for its broad outline. In *Once
a Week*, 1869, Eltze perpetuates the vignette humour of the 1820s,
'Alteration in the Court Costume', 'A Siamese Twinge', etc.

Contrib: *Good Words [1864]; Punch [1864-70 (post: 1872 and 1875)];
Sunday Magazine [1865]; Once a Week [1866-67]; A New Table Book [Mark
Lemon, 1866]; ILN [1867]; Legendary Ballads [1876].*
Colls: Witt Photo.

ELVERY, Beatrice Moss (Lady Glenavy) RHA **1883-1970**
Painter, stained-glass artist and illustrator. She was born in 1883, the
elder daughter of William Elvery of Foxrock, Dublin, and married in
1912, 2nd Baron Glenavy. She studied at the Dublin School of Art
and the Slade School where she won the Taylor scholarship and then
became teacher at the Dublin Metropolitan School of Art. She was
elected ARHA, 1932, and RHA, 1934. She illustrated *Heroes of the
Dawn*, Violet Russell, c.1914, in a rather nationalistic Celtic style.

Exhib: RA; RCA; RHA; SWA.

ELWES, Alfred Thomas **fl.1872-1884**
Illustrator of animals and birds. He was working in London, 1872-77,
and was chief draughtsman of natural history subjects for *The
Illustrated London News* during those years.

Illus: *The Pleasant History of Reynard the Fox [Sampson Lowe, 1872].*
Contrib: *The Graphic [1875]; The Cornhill Magazine [1883-84].*

ELWES, Robert fl.1854-1871

Landscape artist. He worked at Congham, near Lynn, 1861-71, and illustrated *A Sketcher's Tour Round The World*, 1854, AT 9 (liths.).

Exhib: BI, 1861; RBA, 1872.

EMANUEL, Frank Lewis 1865-1948

Topographer, etcher and illustrator. He was born in Bayswater in 1865 and was educated at University College School, University College and studied art at the Slade School. He worked in Paris at the Académie Julian and first exhibited at the Salon in 1886. After travelling to South Africa and Ceylon, he worked as a town planner and taught etching at the Central School of Arts and Crafts; he was also President of the Society of Graphic Art and a member of the Art Workers' Guild. He acted as special artist for *The Manchester Guardian* and was art critic of *The Architectural Review* for many years.

Emanuel was a copious writer, historian and polemicist for the arts; he wrote monographs on W.R. Beverley, Edward Duncan, William Callow and Charles Keene and his picture 'A Kensington Interior' was bought by the Chantrey Bequest in 1912. He was most at home with drawings of old buildings, principally those of London and the northern cities, which he drew very effectively in chalk or pencil, the contours of the houses built up with close hatching. He also reveals himself as a very good figure artist, capturing the spirit of cockney humour and the bustle of city life and produced one or two humorous sketches in the style of the Beggarstaff Brothers. He died at St. John's Wood, 1948. His work is signed 'Frank L. Emanuel' or 'F.L. Emanuel' or monogram

Illus: *Manchester Sketches; The Illustrators of Montmartre.*
Contrib: *The Graphic; The Dome [1899]; The Butterfly [1899]; The Studio [1899]; The Bystander [1904]; The Manchester Guardian [1906-].*
Exhib: G; L; M; NEA; P; RA; RE; RI; ROI; RSA.
Colls: Author; London Museum; V & AM.

See illustration (below).

FRANK LEWIS EMANUEL 1865-1948. 'The Merry Month of May.' Unidentified illustration. Pen and ink. 7½ins. x 6⅜ins. (19.1cm x 16.2cm).
Victoria and Albert Museum

EMSLIE, Alfred Edward 1848-1918

Watercolourist, painter of genre and illustrator. He was born in 1848 and exhibited in London from 1867. He contributed many illustrations of social realism and industry to *The Illustrated London News* and *The Graphic*, 1880-85, and these were admired by Van Gogh during his London years. He was elected ARWS in 1888 and won a medal at the Paris Exhibition of 1887.

Exhib: B; G; GG; L; M; RA; RBA; RWS; FAS, 1896.
Colls: Manchester; V & AM.
Bibl: *English Influences On Vincent Van Gogh*, 1974-75, Arts Council, p.51.

EPINAY, Prosper Comte d' 1836

French sculptor and caricaturist who exhibited at the Salon des Humoristes in 1909. He contributed one cartoon to *Vanity Fair*, 1873.

ERICHSEN, Nelly fl.1883-1901

Figure painter and illustrator. She specialised in figures in landscape and did some architectural illustration. Signs with monogram NE

Illus: *The Novels of Susan Edmonstone Ferrier [1894]; The Promised Land [1896]; Emanuel or Children of the Soil [1896]; Mediaeval Towns, Dent [1898-1901]*.
Contrib: *The English Illustrated Magazine [1886 (North of England), 1896-97(figs.)]*.
Exhib: L; RBA; RA ; ROI; SWA, 1883-97.

EVANS, H.

Black and white artist, contributing to *The Rambler*, 1897.

EVANS, William fl.1797-1822

Engraver and draughtsman. He worked from Newman Street, London, and illustrated Boydell's publications and drew for Cadell's *Gallery of Contemporary Portraits*, 1822, and engraved plates for the Dilettanti Society's *Specimens of Ancient Sculpture*, 1799-1807, published 1808.

Exhib: *BI and RA, 1797-1808*.

EVANS, William, of Bristol AOWS 1809-1858

Landscape painter. He was born in Bristol in 1809 and spent his earlier years living in a remote area of North Wales, studying mountain scenery. He was elected AOWS in 1845 and lived in Italy from 1852. He illustrated an edition of Scott's works in 1834.

Exhib: OWS; RBA, 1844-59.
Colls: BM; Bristol.

EVERETT, Ethel Fanny fl.1900-1939

Portrait painter and illustrator of children's books. She studied at the RA Schools and worked in Wimbledon, 1900, and Kensington 1915-25. She specialised in goblin drawings with vigorous compact pen lines and in a very decorative style. She signs her work E F E.

Exhib: L; RA; SWA.

EVISON, G. Henry fl.1890-1925

Illustrator. He was working at Bootle, 1890, and in London, 1896-1925. He is a particularly good figure artist and uses pen and ink with heavy bodycolour often in conjunction with a spray giving a speckled effect to the finished drawing. He signs 'G. Henry Evison', or 'G. Henry Evison/oo'.

Contrib: *Judy [1896]; The English Illustrated Magazine [1900]*.
Exhib: L; RA.
Colls: Author; V & AM.

See illustration (above right).

EWAN, Frances fl.1897-1929

Figure painter. She was working at Cricklewood, London, in 1907 and at St. Ives, Cornwall, in 1929. She contributed illustrations to *The English Illustrated Magazine* in 1897.

Exhib: RA, 1906; SWA.

G. HENRY EVISON fl.1890-1925. Illustration for a story. Pen heightened with white. 8½ins. x 6ins. (21.6cm x 15.2cm). Author's Collection

EYRE, J.

Topographer. He illustrated Mann's *Picture of New South Wales*, 1811, AT 566.

EYRE, John RI ARCA -1927

Watercolourist and book illustrator. Born in Staffordshire and studied art at the South Kensington Schools. After designing for pottery he became a painter in watercolours and enamels and worked as a book illustrator. RBA, 1896, RI, 1917. He died at Cranleigh, 13 September 1927.

Illus: *English Poets*.
Exhib: G; L; M; RA; RBA; RHA; RI; RWS.

EYRE, Colonel Vincent, CB

Colonel in the Bengal Artillery, 1858. Contributed illustrations of India to *The Illustrated London News*, 1857.

FABIAN, J. fl.c.1900

Illustrator, specialising in figure subjects, usually in pencil.

Colls: V & AM.

FAHEY, Edward Henry RI 1844-1907

Oil and watercolour artist and illustrator. Born in London in 1844 and studied at South Kensington Schools, RA Schools and in Italy, 1866-69. ARI 1870, RI 1876, ROI 1883. He held a one-man show entitled 'English and Foreign Landscape', 1905. Died at Notting Hill, 13 March 1907.

Contrib: *The Graphic [1870 and 1877, (architecture)]*.
Exhib: GG; New Gall; NWS; RA; RBA; RHA; RI; ROI.

FAIRBAIRN, Hilda fl.1893-1925

Figure painter and illustrator. She was born at Henley-on-Thames and studied art at the Herkomer School, Bushey, and in Paris. She made a specialty of portraits of children in watercolour or pastel. ASWA, 1902.

Illus: *The Saga of the Sea Swallow [1896, with J.D. Batten (q.v.)]*.
Exhib: L; New Gall; RA; ROI; SWA.

FAIRFIELD, A.R.

Amateur illustrator and clerk to the Board of Trade. He was born into an artistic family and had only three months training at South Kensington in 1857 before he began drawing on wood for *Fun*, 1861. He started to draw for *Punch* and appeared regularly in 1864-65 and again in 1887, contributing both drawings and initial letters. He was a talented caricature portraitist, and a sketch of Austin Dobson dated 1874, is in the National Portrait Gallery. He signs his work with the symbol

Contrib: *The Leisure Hour; Once a Week [1860-65]; Thornbury's Legendary Ballads [1876]*.
Colls: NPG; Witt Photo.
Bibl: M.H. Spielmann, *The History of Punch*, 1895, pp.522-523.

FAIRHOLT, Frederick William FSA 1814-1866

Illustrator and engraver. He was born in London in 1814, the son of German immigrants, and won a Society of Arts medal at an early age. After working as a scene painter, he became assistant to S. Sly, the wood engraver, in 1835. He soon established himself as an authority on medieval heraldry and design and, as Chatto says, became 'distinguished for his knowledge of Costume and Medieval art, which he has exemplified in a considerable number of shaded outlines, mostly drawn and engraved by himself'. He was patronised by the Earl of Londesborough and accompanied him or his son to Italy and Egypt after 1856. Much of his work first appeared in *The Art Journal* of which he was assistant editor. He died in London in 1866.

Illus: *Lord Mayor's Pageants [1841]; Robin Hood [Gutch, 1847]; The Home of Shakespeare [1847]; Costume in England [1856]; Tobacco its History and Association [1859]; Gog and Magog [1860]; Up the Nile [1862]; History of Richborough [C.R. Smith]; Roman London [C.R. Smith]*.
Contrib: *London [Charles Knight, 1841]; Archaeological Album [1845]; The Book of the Thames [S.C. Hall, 1859]; Book of British Ballads; Arts of the Middle Ages [Labarte]*.
Colls: BM; V & AM.
Bibl: Chatto and Jackson, *Treatise on Wood Engraving*, 1861, p.592; S.C. Hall, *Retrospect of a Long Life*, 1883, pp. 360-362.

FAIRHURST, Enoch 1874-

Portrait and miniature painter, etcher and illustrator. Elected ARMS, 1918. He was working in London until 1918 and then at Bolton, 1924. A talented delineator of architecture in pen and ink. Fairhurst contributed a number of drawings to *The Ludgate Monthly* in the 1890s.

Exhib: L; M; RA; RCA; RMS; RSA; RWA.
Colls: V & AM.

FANE, Brigadier-General Walter 1828-1885

Amateur artist and illustrator. He was born 6 January 1828, the third son of the Rev. E. Fane of Fulbeck, and served for most of his career in India. His best works are of Indian landscape and architecture, with brilliant colouring and creamy impasto. He contributed sketches of Afghanistan to *The Illustrated London News*, 1880, which were completed by Caton Woodville (q.v.) and he was a friend of W. Simpson (q.v.). Died 17 June 1885.

Exhib: Dudley Gall.; OWS; RBA; RI.

FARMILOE, Edith

Children's book illustrator. She was the second daughter of Colonel the Hon. Arthur Parnell and second cousin of C.S. Parnell, and married the Rev. William D. Farmiloe, Vicar of St. Peter, Soho. Her fanciful sketches of a make-believe world were partly influenced by Caldecott and partly by Kate Greenaway. She was elected ASWA, 1905, and SWA, 1907.

Illus: *All the World Over [1898]; Rag, Tag and Bobtail [1899]*.
Contrib: *Little Folks [1895]; The Child's Pictorial [1896]*.
Exhib: SWA.
Bibl: *The Studio*, Vol.18, 1895 pp.172-179 illus.; Winter No. 1900-1 p.22.

FARREN, Robert

Etcher and illustrator. He was working in Cambridge in 1880 and at Scarborough in 1889 and contributed 26 etched plates to *The Graphic* and *The Cam*, Cambridge, 1880-1.

Exhib: L; M; RA; RE.

FATIO, Morel fl.1843-1859

Italian illustrator, contributing topographical works of France to *The Illustrated London News*, 1843, and of Italy to *The Illustrated Times*, 1859.

FAU, Fernand

French caricaturist. He contributed comic genre subjects to *Fun*, 1900.

FAUCONNET, Guy Pierre 1882-1920

Painter, etcher, designer for the theatre and book illustrator. Became a pupil of J.P. Laurens and Benjamin Constant. He worked in London as a miniaturist and book illustrator during the First World War, his style being influenced by Beardsley; his friendship with Poiret is also reflected in his work.

Illus: *Form and Substance [Charles Marriott, 1917]*.
Contrib: *La Gazette du bon ton [1914-20]*.

FAULDS, James

Painter and illustrator. He was working in Glasgow, 1896-1938, and contributed to *The Graphic*, 1903.

Exhib: G; RSA; RSW.

FAULKNER, A.M.

Illustrator contributing to *The Lady's Pictorial*, 1895.

FAUX, F.W.
Illustrator contributing to *The Quest,* 1894-96.

FAWKES, Francis Hawksworth 1797-1871
Amateur caricaturist. He was born in 1797, the eldest son of Walter Fawkes of Farnley Hall, Yorkshire, Turner's friend and patron. He was also a friend of Turner and did spirited caricatures in wash.

FAWKES, L.G.
Irish artist and contributor to *Punch,* 1875.

FELL, Herbert Granville 1872-1951
Artist, illustrator, journalist and Editor of *The Connoisseur,* 1935-51. He was born in 1872 and married the daughter of Sir J.D. Linton, PRI (q.v.). Fell was educated at King's College, London and studied art at Heatherley's, in Paris, Brussels and in Germany before joining the firm of George Newnes Ltd. as editor of its Art Library. In 1907 he became Art Editor of *The Ladies Field,* holding the post until 1919, and in 1910-12 he was Art Editor of *The Strand Magazine.* He was Editor of *The Queen* from 1924-28 and Director of Drawing, Painting and Design at the Royal Albert Memorial College, Exeter. Fell was a well-known art journalist but his name as an artist deserves more recognition. He was a prolific book illustrator before 1910, drawing competent black and white figure studies for biblical and allegorical books, all strongly influenced by the late Burne-Jones; his pencil studies of *The Song of Solomon,* reproduced in half-tone, have more of the quality of Alphonse Mucha and international art nouveau.
Illus: *Our Lady's Tumbler [1894]; Wagner's Heroes [1895]; Cinderella [1895]; Ali-Baba [1895]; The Fairy Gifts [1895]; The Book of Job [1895]; Poems [W.B. Yeats, 1895]; The Song of Solomon [1897]; Wonder Stories from Herodotus [1900]; Tanglewood Tales [Nathaniel Hawthorne]; Stories of Siegfried [1908].*
Contrib: *The Ludgate Monthly [1892]; The Pall Mall Magazine; The Windmill [1899]; The Ladies Field.*
Exhib: New Gall.; RA.
Colls: Witt Photo.
Bibl: *The Artist,* 1897 pp.97-105 illus.; *The Studio,* Winter No. 1900-1 p.70 illus.; R.E.D. Sketchley *English Book Illus,* 1902 pp.27, 126.

FELLER, F. 1848-1908
Painter and illustrator. He was born at Bumpliz, Switzerland, on 28 October 1848 and studied in Geneva under the enamellist Albert Feller and then at Munich, Paris and in London, where he settled. He specialised in book and magazine illustration and in comic genre subjects and depicting the humours of mountaineering. He died in London, 6 March 1908.
Contrib: *ILN [1880-84]; Black & White [1891]; St. Pauls [1894]; Good Cheer [1894]; Chums.*
Exhib: RA and RBA, 1878-95.

FELLOWES, William Dorset
Draughtsman and engineer. He illustrated *Antiquities of Westminster,* J.T. Smith, 1800 and *Historical Drawings,* 1828 by the same author and *A Visit to the Monastery of La Trappe,* 1818, AT 86.

FELLOWS, Henry
Amateur etcher who published privately *Etchings by H.E.,* 1866.

FENNELL, John G. 1807-1885
Landscape watercolourist and caricaturist. He studied with Henry Sass in London and became an intimate friend of H.K. Browne, 'Phiz' (q.v.) and also of Dickens and Thackeray. His best works in art are landscape studies and caricatures. He was a noted angler.

FENNING, Wilson
Figure artist. He contributed an illustration to *Punch,* 1914.

FERGUSON, James fl.1817-1866
Landscape painter and illustrator. He worked in London, Edinburgh, Darlington and Keswick and was an unsuccessful candidate for the NWS in 1850. He made vignette illustrations for an edition of Scott's *Gertrude of Wyoming* and was probably the illustrator of *Army Equipment,* 1865-66.
Exhib: BI, 1821-57; RA; RBA, 1827, 1849 and 1856.
Colls: Witt Photo.

FERGUSSON, James 1808-1886
Architectural writer. He was born in 1808 and started an indigo factory in India, at the same time devoting himself to the study of Indian art and architecture. He was elected a Fellow of the Royal Asiatic Society in 1840 and was awarded the Gold Medal of the RIBA in 1871. He published *An Historical Enquiry into the Five Principles of Beauty in Art,* 1844, *A History of Architecture in All Countries,* 1865-67, and *Fire and Serpent Worship,* 1868.
Illus: *Ancient Architecture in Hindoostan [1852, AT 480].*
Exhib: RA, 1850 and 1864.

FFOULKES, Charles John FSA 1868-1947
Curator and draughtsman. He was born on 26 June 1868, the son of the Rev. E.S. ffoulkes and great-grandson of Sir Robert Strange, the eighteenth century engraver. He was educated at Radley, Shrewsbury and St. John's College, Oxford, before becoming a student of Doucet and Duran in Paris. He was appointed lecturer on Armour and Medieval Subjects to Oxford University, became Master of the Armouries, Tower of London, 1912-38, the first curator of The Imperial War Museum, London, 1917-33. ffoulkes wrote numerous books on armour and a study of Sir Robert Strange. He was given the OBE in 1925.
Illus: *The Happy Wanderer [Percy Hemingway, 1895-96].*
Exhib: L; Paris, 1900; RA; RBA.

FICHOT, Michel-Charles 1817-1903
Architectural draughtsman, painter and illustrator. Born at Troyes in 1817 and exhibited at the Salon regularly, 1841-75, being awarded the Chevalier of the Legion of Honour, he contributed to *The Illustrated London News,* 1867.
Colls: Troyes.

FIDDIAN, Emmil
Figure artist, contributing colour illustration to *The Graphic,* Christmas, 1889.

FIDLER, Gideon M. fl.1883-1910
Figure painter and illustrator. He worked at Telfont-Magna in Wiltshire and contributed drawings for a story to *The English Illustrated Magazine,* 1893-94.
Exhib: B; L; RA; RBA; RI; ROI.

FIELD, G.C.
A very fine pen and wash drawing by this artist for an illustration to *The Ancient Mariner* appears in *The Studio,* 1911.

FILDES, Sir Samuel Luke KCVO RA 1844-1927
Painter of genre and English and Venetian subjects, illustrator. He was born in Liverpool on 18 October 1843 and studied at the Liverpool Mechanics Institute, the Warrington School of Art, the South Kensington Schools and the RA Schools. At the outset of his London career in 1866, Fildes entered the world of black and white art and magazine illustration, remaining an outstanding figure in it until 1872. During these years he concentrated primarily on social realism, images of the poor and destitute that came across very powerfully on the printed page. Many of them especially those done for *The Graphic,*

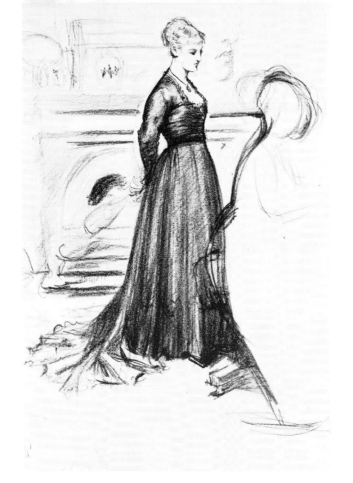

SIR LUKE FILDES RA 1844-1927. Study of a female figure for 'The Duet', an illustration in Once a Week, *30 January 1869. Pencil.*

SIR LUKE FILDES RA 1844-1927. Detail of a dress from studies for 'The Duet', an illustration in Once a Week, *30 January 1869. Pencil.*

SIR LUKE FILDES RA 1844-1927. Study of a piano for 'The Duet', an illustration in Once a Week. *30 January 1869. Pencil.*

Victoria and Albert Museum

SIR LUKE FILDES RA 1844-1927. Study of the whole group for 'The Duet', an illustration in Once a Week, *30 January 1869. Pencil and wash.*

SIR LUKE FILDES RA 1844-1927. Illustration for 'The Duet', Once a Week, *30 January 1869. Wood engraving.*

Victoria and Albert Museum

became famous and some like 'Applicants For Admission To a Casual Ward' were afterwards turned into large oil paintings. In spite of this, Fildes' genius as an observer of social need is much more satisfactory in black and white and his decision to concentrate on painting after 1872 was a loss to this side of book illustration. In 1869, he was chosen by Charles Dickens to illustrate his novel *Edwin Drood*, which was left uncompleted at the author's death in 1870. Fildes' reputation was increased by this work and by the drawing of Dicken's study at Gads Hill Place entitled 'The Empty Chair' done the day after the novelist's death. Published in *The Graphic* it was much admired by Van Gogh. Practically the whole of Fildes' archive of drawings, preparatory studies and proofs of wood engravings was presented to the Victoria and Albert Museum by his son, Sir Paul Fildes in 1971.

Fildes continued in his career as one of the foremost subject and portrait painters of the Edwardian era. He painted state portraits of King Edward VII, Queen Alexandra and King George V, was elected ARA in 1879 and RA in 1887. He was married in 1887 to the sister of H. Woods, RA (q.v.) and was knighted in 1906. He died 27 February 1927.

Illus: *Peg Woffington [Charles Reade, 1868]; Griffith Grant [Charles Reade, 1869]; Edwin Drood [Charles Dickens, 1870]; The Law and The Lady [Wilkie Collins, 1870]; Miss or Mrs. [Wilkie Collins, 1885]; Catherine [W.M. Thackeray, Cheap Illustrated Edition, 1894].*
Contrib: *Once a Week [1866-69]; Foxe's Book of Martyrs [1866]; Illustrated Readings [1867-68]; Good Words [1867-68]; The Sunday Magazine [1868]; Cassell's Magazine [1868-70]; The Quiver [1868-69]; The Sunday At Home [1868]; The Gentleman's Magazine [1869-70]; The Graphic [1869-74 and 1880]; The Cornhill Magazine [1870-73]; The Leisure Hour [1870]; Pictures From English Literature [1870]; ILN [1880]; Time [1880 (cover)].*
Exhib: B; G; L; M; RA, 1872-1927.

Colls: Glasgow; Holloway College; V & AM.
Bibl: L.V. Fildes, *LF, RA, A Victorian Painter*, 1868; *English Influences on Vincent Van Gogh*, Arts Council 1974-75 p.51.
See illustrations (below and pp.300 and 301).

FINBERG, Alexander Joseph 1866-1939
Art historian and illustrator. He was born in London in 1866 and after being educated at the City of London College and King's College, studied art at the Lambeth School and in Paris. In his early career Finberg alternated black and white illustration for the leading magazines with work as a journalist. For some years he was the art critic of the *Morning Leader, The Star, The Manchester Guardian* and *The Saturday Review*, and became a well known historian of the English romantic school. In 1905 he re-organised the Turner Collection at the National Gallery and made important discoveries among the paintings in the Turner Bequest, resulting in the building of the Turner Gallery. Finberg became the recognised Turner authority between the wars, and was Editor of the Walpole Society volumes, 1911-22 and lecturer in the history of painting at the London University. He died 15 March 1939.

Finberg's drawings in pen and ink or wash are quite common; he handles figure subjects well if not with great sparkle. Signs: AJF.

Publ: *English Watercolour Painters [1906]; The Drawings of David Cox; Ingres; The Watercolours of JMW Turner; Inventory of Turner's Drawings in the National Gallery [1909]; Turner's Sketches [1910]; The History of Turner's Liber Studiorum [1924].*
Contrib: *Fun [1890]; Lady's Pictorial [1890]; Puck and Ariel [1890]; The Ludgate Monthly [1892]; The Idler [1892]; The Sketch; Penny Illustrated Paper.*
Exhib: L; NEA; NWS; RA; RI.
Colls: V & AM.

SIR LUKE FILDES RA 1844-1927. 'Sleeping It Off.' Illustration for The Mystery of Edwin Drood, *by Charles Dickens, 1870. Wood engraving.*

FINCHETT, T.
Figure artist contributing to *The Illustrated London News*, 1896.
Perhaps a relation of D.R. Finchett, artist working in Manchester,
1885.

FINNEMORE, Joseph RI RCA **1860-1939**
Painter and illustrator. Born in Birmingham 1860 and studied at the
Birmingham Art School and in Antwerp with Charles Verlat. He
returned to England in 1881 and then went on an extended tour of
Malta, Greece, Turkey, South Russia and Bessarabia. He settled in
London in 1884 and specialised in book and magazine illustration and
black and white work. Finnemore was later to concentrate on colour
work for English and Continental colour printers in the 1900s. He was
elected RBA, 1893; RI, 1898. He died 18 December 1939.
Illus: *When London Burned [G.A. Henty, 1894].*
Contrib: *The Graphic [1886-1910]; English Illustrated Magazine [1887-88];
Black and White [1891]; The Strand Magazine [1891]; Chums [1892]; The
Wide World Magazine [1898]; Cassell's Saturday Journal; Cassell's Family
Magazine; The Boys' Own Paper; The Girls' Own Paper; The Windsor Magazine.*
Exhib: B; G; L; RA; RBA; RCA; RHA; RI; ROI; RWA.

FISH, Anne Harriet (Mrs Sefton) **-1964**
Black and white artist and magazine illustrator. She was born at
Bristol and after being educated at home, studied under C.M.Q.
Orchardson and John Hassall (q.v.), and at the London School and at
Paris. Her very individual style of drawing, which typifies the period
of Art Deco, is partly influenced by poster design and partly by
fashion drawing. Fish's art is the art of reduction, mouths, eyes or ears
are omitted in the pursuit of a harsh satire and the whole of society
becomes a symbol in a few black lines. Her greatest vogue was in the
inter-war years when her work appeared regularly in all the principal
magazines. She also designed textiles and worked in London from
1913 and then at East Grinstead, 1934, and latterly at St. Ives where
she died in 1964. Her drawings are not uncommon.
Illus: *The Rubaiyat of Omar Khayyam [1922];*
Contrib: *Eve; Punch; Tatler; Vanity Fair; Vogue; Harper's Bazaar;
Cosmopolitan.*
Exhib: FAS, 1916; RA.
Bibl: C. Veth, *Comic Art in England,* 1930 pp.196-197 illus.; *Caricature of
Today,* Studio 1928 illus.

FISHER, Alfred Hugh **1867-1945**
Painter, etcher, illustrator and writer. He was born in London on 8
February 1867 and was educated at the City of London and
University College Schools before going into business for nine years.
He then turned to art and studied at Lambeth School and South
Kensington before going to Paris to work under Laurens and
Constant. He travelled widely in Europe and the Near East for the
Visual Instruction Committee of the Colonial Office before settling at
Amberley, Sussex. ARE, 1898.
Publ: *The Cathedral Church of Hereford [1898]; Poems [1913]; The Marriage
of Ilario [1919]; The Ruined Barn and Other Poems [1921].*
Illus: *Through India and Burmah with Pen and Brush [1911].*
Contrib: *The Idler; The Dome [1899-1900]; The Windmill [1899].*
Exhib: L; NEA; New Gall.; RA; RBA; RE; RI; ROI; RWA.
Colls: Witt Photo
Bibl: F. Emanuel 'Exhib. of Works by Mr. A.H.F.', *The Artist,* Jan. 1901.

FISHER, Harrison **fl.1899-1906**
Figure artist and illustrator working until about 1906. He illustrated
The Market Place by H. Frederics, 1899.

FISHER, Henry Conway 'Bud' **1884-**
Contributor of strip cartoons to various children's comics, c.1917.
Colls: V & AM.

FISHER, Joshua Brewster **1859-**
Landscape and figure painter and illustrator. He studied at Liverpool
School of Art and spent the whole of his working life in the city.
Illus: *The Tyrants of Kool Sim [J. McLaren Cobban, 1896].*
Exhib: L; RCA, 1884-1933.

FITCHEW, Dorothy
Landscape and figure painter and illustrator. She worked at Bromley,
Kent and made large and elaborate watercolours of Shakespearean and
legendary subjects, particularly from 1911-15.
Exhib: L; RA; RI; SWA.

FITCHEW, E.H.
Portraitist and illustrator. Contributed studies of heads to *The English
Illustrated Magazine,* 1886.

FITTON, Hedley RE **1859-1929**
Editor and illustrator. He was born in Manchester in 1859 and worked
for *The Daily Chronicle,* specialising in etchings of architectural
subjects. Practising in Runcorn, Cheshire until 1890 he settled at
Haslemere, Surrey in 1902 and remained there until his death,
winning in 1907 the Gold Medal of the Société des Artistes Français.
He was elected ARE in 1903 and RE in 1908. Besides his book
illustrations Fitton produced a long series of etchings of London,
Florence, Edinburgh and Paris. He died on 19 July 1929.
Illus: *English Cathedral Scenes [Isbister, 1899-1901]; Aeschylos [1901].*
Contrib: *The English Illustrated Magazine [1887]; The Quiver [1894]; Daily
Chronicle [1895]; Good Words [1898].*
Bibl: R.E.D. Sketchley, *English Book Illus.,* 1902 pp.46, 133.

FITZCLARENCE, George Augustus Frederick, 1st Earl of Munster
 1794-1842
Amateur artist. He was born on 29 January 1794, the natural son of
King William IV by Mrs. Jordan. A professional soldier, he was the
Lieutenant of the Tower of London and Governor of Windsor Castle,
becoming a Major-General and ADC to Queen Victoria. He died 20
March 1842.
Illus: *Journal of a Route Across India [1819, AT 519].*

FITZCOCK, Henry **1824-**
History painter and illustrator. He was born at Pentonville in 1824
and studied at the RA Schools and with Benjamin Robert Haydon.
Fitzcock was a regular exhibitor in London from 1853, taking his
subjects from literature and chiefly from the works of Longfellow and
Cowper. He may have travelled to Sweden to make studies in about
1856.
Illus: *The Holy War [John Bunyan, 1864]; All About Shakespeare.*
Contrib: *ILN [1856-60 (Sweden)]; The Churchmen's Family Magazine [1864].*
Exhib: BI, 1853-64; RA; RBA, 1853-72.

FITZGERALD, Lord Gerald **1821-1886**
Amateur draughtsman and watercolourist. He was born in 1821, the
second son of the 3rd Duke of Leinster. A professional soldier who
served in the Scots Fusilier Guards, Lord Gerald became a member of
the Etching Club of Dublin, and engraved ten scenes to illustrate the
poems of Tom Hood.
Contrib: *Passages From Modern English Poets [1862].*

FITZGERALD, J. St M.
Contributor to *The Idler,* c.1890.

FITZGERALD, John Anster **1832-1906**
Figure and fairy illustrator. He was born on 25 November 1832 and
exhibited regularly at London exhibitions, 1845-1903 from
Newington. He contributed fairy subjects to the Christmas numbers of
The Illustrated London News, 1863, 1876-77.
Exhib: B; G; L; RA; RBA; RI; ROI.
Colls: Cardiff; Liverpool.
Bibl: J. Maas, *Victorian Painters,* 1969 pp.143-144 illus.

FITZGERALD, Michael **fl.1871-1891**
Figure painter and illustrator. He was working in London from 1875
and contributed Irish peasant subjects and middle class subjects to
various magazines. Van Gogh admired the former and considered his
prison illustrations as fine as Régamey (q.v.).
Illus: *The Irish Sketchbook; Ballads; The Roundabout Papers [W.M. Thackeray,*

HANSLIP FLETCHER 1874-1955. Charing Cross Hospital. Illustration for unidentified book. Ink and sepia wash. Signed and dated June 1914. 8¾ins. x 12ins. (22.2cm x 30.5cm).
<div align="right">Author's Collection</div>

Cheap Illustrated Edition, 1894].
Contrib: *Dark Blue [1871-73]; ILN [1872-86, 1891]; The Pictorial World [1874-75]; The Cornhill Magazine [1885].*
Exhib: D; L; RA; RBA; RHA.
Colls: V & AM.
Bibl: *English Influences on Vincent Van Gogh,* Arts Council 1974-75.

FITZMAURICE, Major The Hon. William Edward　　1805-1889
Amateur artist. He was born 21 March 1805, the second son of the Countess of Orkney and after serving as Major in the Life Guards he was MP for Buckingham, 1842-47. Died 18 June 1889.
Contrib: *ILN [1860 (Messina)].*

FITZPATRICK, Edmond　ARHA　　fl.1848-1872
Figure artist and illustrator specialising in Irish genre subjects. He contributed a series of drawings of the Irish Famine to *The Illustrated London News* in 1848 and further genre subjects, 1853-59. He was drawing for *London Society* in 1872. ARHA 1856.
Exhib: BI, 1867; RBA, 1856-70.

FITZPATRICK, Thomas　　1860-1912
Draughtsman and cartoonist. He was born at Cork in 1860 and after working as an apprentice to a printing and publishing firm there left for Dublin where he became a lithographer and cartoonist for the *Weekly Freeman* and the *Weekly National Press.* He started his own monthly *The Leprechaun* in 1905 and drew the cartoons for it.

FLAGG, E.
Contributor of cartoons to *Vanity Fair,* 1899 and 1902.

FLEMING-WILLIAMS, C.R.　　fl.1899-1925
Black and white artist and watercolourist. He was cartoonist of *Judy,* 1899, his drawings showing strongly the American influence of C. Dana Gibson (q.v.). He was working at Letchworth, Herts, 1920-25.
Contrib: *Sketchy Bits; The Graphic [1905-6]; ILN [1908].*
Exhib: RA, 1920.

FLÈRE, Herbert H.　　fl.1893-1903
Painter of genre. He was working in London in 1893. He contributed to *The Graphic,* 1902-3; *The Illustrated London News,* 1903.

FLETCHER, Hanslip　　1874-1955
Architectural draughtsman and etcher. He was born in London in 1874, the son of G. Rutter Fletcher, FSA, and was educated at the Merchant Taylors School and at the Birkbeck College, University of London. Fletcher concentrated his efforts on depicting vanishing corners of London and other old cities, drawing every detail of their architecture and street scenes with meticulous pen work. For many years he was artist for *The Sunday Times* and his weekly drawings were a feature of the paper, later being gathered together in book form as *Changing London,* 1925-28 and 1933. Fletcher was a close friend of many artists and writers including F.L. Emanuel (q.v.), James Bone, Sir Albert Richardson and Sir Muirhead Bone (q.v.). He was a member of the Art Workers Guild and served on the Committee for the Protection of Ancient Buildings. A large collection of his drawings of London was purchased by the Guildhall Library. He died at Northampton in 1955 after a long illness.
Contrib: *The Pall Mall Magazine; The Dome [1900]; The Architect and Builders Journal.*
Illus: *The Path to Paris [Frank Rutter, 1908]; London Passed and Passing [1908]; Oxford and Cambridge Delineated [1909]; Edinburgh Revisited [James Bone, 1911]; Bombed London [1947].*
Exhib: G; L; NEA; RA; RI; RSA.
Colls: Ashmolean; Author; Nat. Mus., Wales; V & AM.
Bibl: S.R. Houfe, *'Delineator of Change',* Country Life. Jan. 18, 1973.
See illustration (above).

FLETCHER, S.P.
Illustrator. He illustrated *Rowland Bradshaw, His Struggles and Adventures on The Way to Fame By The Author of The Raby Rattler* 1848. Fletcher's style is a clear derivative of the work of 'Phiz' (q.v.).

SIR WILLIAM RUSSELL FLINT 1880-1969. 'Then he blew three deadly notes . . .' Illustration to Morte d'Arthur, *Riccardi Press.*
Watercolour, signed and dated 1910. 11⅛ins. x 8¾ins. (28.2cm x 22.2cm).
Victoria and Albert Museum

FLINT, Sir William Russell RA PRWS **1880-1969**

Draughtsman, watercolourist and illustrator. He was born at Edinburgh, 4 April 1880 and was educated at David Stewart's College and the Royal Institute of Art, Edinburgh. He settled in London in 1900 and after studying at Heatherley's, he was on the staff of *The Illustrated London News*, 1903-7. From this period onwards, Flint turned increasingly to watercolour, particularly for the illustration of colour books. He was influenced strongly by the illustrations of *Rip Van Winkle* by Arthur Rackham (q.v.) and between about 1905 and 1924 produced a whole series of brilliant luxury editions for the Riccardi Press of the Medici Society. His figures are finely modelled and contain elements of a Burne-Jones influence by way of Byam Shaw. From the 1920s Flint became the unquestioned master of the watercolour nude and these, and the prints from them, made his reputation, even if they were less original than his illustrative work.

Flint served in the First World War with the RNVR Airship section and made the first Atlantic crossing by airship in the R34, 1918-19. He was elected ARWS in 1914, RWS, 1917 and was President of the RWS from 1936. He became ARA, 1924 and RA, 1933 and was knighted in 1947. He died in London in 1969.

Illus: *The Duel [Joseph Conrad]; King Solomon's Mines [Rider Haggard, 1905]; The Imitation of Christ [1908]; The Song of Solomon [1909]; Marcus Aurelius [1909]; The Savoy Operas [1909-10]; The Scholar Gypsy [1910, 2 vols.]; Morte d'Arthur [1910-11]; The Heroes [C. Kingsley, 1912]; The Canterbury Tales [1913]; Theocritus [1922]; Odyssey [1924]; Judith [1928]; Airmen or Noahs [1928]; The Book of Tobit [1929].*
Contrib: *The Studio [1899]; Opthalmological Society's Journal [1901]; The Pall Mall Magazine [1903]; Pearson's Magazine [1903]; Nash's Magazine [1903]; The Sketch [1903]; The Tatler [1903]; The Bystander [1903]; The Quiver [1903]; The English Illustrated Magazine [1903]; Black & White [1903]; The Idler [1903]; Illustrated Sporting and Dramatic News [1903]; Sunday at Home [1903]; The Sphere [1903]; The World and his Wife [1903]; The Graphic [1904].*
Exhib: FSA, 1909, 1911, 1914, 1919, 1922, 1923, 1925, 1932, 1937, 1950, 1975; G; L; M; RA; RE; RHA; RI; ROI; RSA; RSW.
Colls: BM; Glasgow; Leeds; V & AM.
Bibl: *Modern Illustrators and Their Work*, Studio, 1914; Arnold Palmer, *More Than Shadows - A Biography of WRF*, 1943; W.R. Flint, *Drawings*, 1950 (with prologue, descriptive notes and bibliography).
See illustration (p.305).

FLORENCE, Mary Sargant **1857-1954**

Decorative mural painter in tempera. She was born in London on 21 July 1857, and studied art at the Slade School under Legros and in Paris at the Studio Merson. She carried out the mural decoration of Chelsea Old Town Hall. In 1896, she illustrated *The Crystal Ball*, designs which Walter Crane found full of 'power and decorative feeling'. She became a Member of the NEA in 1911. Two of her pictures were purchased for the Chantrey Bequest in 1932 and 1949. She worked latterly at Marlow, Bucks.

Exhib: L; NEA; RA; SWA.
Bibl: K. Spence, 'A Country Refuge From Bloomsbury', *Country Life* November 15, 1973.

FLOWER, Clement **fl.1899-1908**

Portrait and figure painter. He was working at Bushey, Herts., 1899-1908 and contributed illustrations of social realism to *The Graphic* in 1901.

Exhib: RA, 1899-1908.

FOLKARD, Charles James **1878-**

Artist, illustrator and author of children's books. He was born in 1878 and after being educated at Lewisham, was apprenticed to a firm of designers but left them to become a professional conjuror. He later joined the *Daily Mail* staff as an artist, and invented the cartoon character 'Teddy Tail', but abandoned this career to follow that of book illustrator.

Illus: *Flint Heart [1910]; Swiss Family Robinson [1910]; Pinnochio [1911]; Grimms Fairy Tales [1911]; Aesop's Fables [1912]; Arabian Nights [1913]; Jackdaw of Rheims [1913]; Ottoman Wonder Tales [1915]; Mother Goose Nursery Rhymes [1919]; British Fairy and Folk Tales [1920]; Songs From Alice in Wonderland [1921]; Magic Egg [1922]; Granny's Wonderful Chair [1925]; The Troubles of a Gnome [1928]; Land of Nursery Rhyme [1932]; Tales of the Taunus Mountains [1937]; The Princess and the Goblin [1949]; The Princess and Curdie [1949].*

FOLKARD, W.A.

Artist, contributing comic illustrations to Tom Hood's *Comic Annual*, 1834.

FORBES, Elizabeth Adela (née Armstrong, Mrs. Stanhope Forbes)
 1859-1912

Landscape painter, etcher and illustrator. She was born in Canada on 29 December, 1859 and studied at the Art Students' League, New York. She married in 1889, Stanhope Forbes, RA, and with him founded the Newlyn School of Art, 1899. As an illustrator Elizabeth Stanhope Forbes worked in pen and ink, or in watercolour in a very broad and atmospheric way, reflecting her oil style. She became NEA in 1886 and RE, 1885-89, ARWS, 1899. She died at Newlyn, 22 March 1912. Signs early work: Elizabeth A. Armstrong, or with monogram:

Illus: *King Arthur's Wood [written and illus. by ESF, 1905]; Robert Herrick [Golden Poets, 1908].*
Contrib: *Black & White [1891]; The Yellow Book [1895].*
Exhib: B; FAS, 1900; G; L; M; NEA; RA; RBA; RI; ROI; SWA.
Colls: BM; V & AM.
Bibl: L. Birch, *SA Forbes and EF*, 1906; R. Pearsall, 'SF and the Newlyn School of Painting', *The Antique Collector*, Vol.44, August 1973 pp.213-216.

FORBES, Professor James David **1809-1868**

Scientist and draughtsman. He was elected FRSE at the age of nineteen and was one of the joint founders of the British Association in 1831 and FRS 1832. In 1833 he became Professor of Natural Philosophy at Edinburgh and Principal of St. Andrews in 1859.

Illus: *Travels Through The Alps of Savoy [1843]; Norway And Its Glaciers [1853, AT 257].*

FORBES, J.

Topographical artist. Contributed to Griffith's *Cheltenham*, 1826.

FORD, Henry Justice **1860-1941**

Artist and illustrator. He was born in London in February 1860 and was educated at Repton and Clare College, Cambridge; 1st Class Classical Tripos, 1882. He studied art under Alphonse Legros at the Slade and under Herkomer (q.v.) at Bushey. Ford was a friend of Edward Burne-Jones (q.v.) and was strongly influenced by the latter's iconography if not directly by his style of drawing. Ford concentrated on legend and folklore as subjects to illustrate and mixed carefully observed objects from the real world with fantasy creatures from an imagined world in a very convincing way. His penwork is assured and clear and placed on the page with great decorative effect; he often supplied borders and vignettes to his published work. A whole generation of Edwardians grew up on Ford's illustrations to Andrew Lang's fairy tales, the long series of little books appearing between 1889 and 1913. The black and white work owes something to Walter Crane and a great deal to *Moxon's Tennyson*, but it is really in the later colour picture books that Ford's debt to the Pre-Raphaelites emerges; their minute detail and brilliant colours show that they are his real source. He died in 1941. Ford's pen drawings are sometimes seen on the market.

Illus. for Andrew Lang: *The Blue Fairy Book [1889]; The Red Fairy Book [1890]; The Blue Poetry Book [1891]; The Green Fairy Book [1892]; The True Story Book [1893]; The Yellow Fairy Book [1894]; The Animal Story Book [1896]; The Blue True Story Book [1896]; The Red True Story Book [1897]; The Pink Fairy Book [1897]; The Arabian Nights Entertainment [1898]; The Red Book of Animal Stories [1899]; The Grey Fairy Book [1900]; The Violet Fairy Book [1901]; The Disentanglers [1902]; The Red Romance Book [1905]; Tales of King Arthur [1905]; Tales of Troy [1907]; The Marvellous Musicians [1909].*
Illus: *Aesop's Fables [1888]; When Mother Was Little [1890]; A Lost God [1891]; Early Italian Love Stories [Vera Taylor, 1899]; The Luck Flower [G. Walker, 1907]; The Book of Princes and Princesses [L.B. Lang, 1911]; The Book of Saints [L.B. Lang, 1912]; The Strange Story Book [L.B. Lang, 1913]; Old Testament Legends [M.R. James, 1913]; Pilot [H.P. Greene, 1916]; The Happy Warrior [H. Newbolt, 1917]; David Blaize and the Blue Door [E.F. Benson, 1918]; The Pilgrim's Progress [1921].*
Exhib: FAS, 1895; G; L; M; New Gall.; RA; ROI.
Colls: V & AM.
Bibl: R.E.D. Sketchley, *English Book Illus.*, 1902, pp.109, 110, 165; B. Peppin, *Fantasy Book Illus.*, 1975, p.187, illus.
See illustrations (p.307).

HENRY JUSTICE FORD 1860-1941. 'Bensurdatu Attacks the Seven-Headed Serpent'. Illustration to The Grey Fairy Book, *Andrew Lang, 1900.*

FOREST, Eugène Hippolyte 1808-

French painter and lithographer. He was born at Strasbourg, 24 October 1808 and studied under Roqueplan and exhibited at the Salon from 1847. He contributed to *The Illustrated London News*, 1848.

FORREST, Archibald Stevenson 1864-

Landscape painter and illustrator. He was born at Greenwich in 1869 and was educated at Roan School, Greenwich, and in Edinburgh. He studied art at the Westminster School, the City and Guilds College and Edinburgh School of Art. He worked in Blackheath, 1908, and at Lymington, Hants, 1926, specialising in black and white work in the 1890s, colour work in the 1900s, and pure landscape painting from about 1910. He designed a poster for *The Idler*.

HENRY JUSTICE FORD 1860-1941. Fantastic bird. Pen and ink. Signed. 8ins. x 7⅜ins. (20.3cm x 18.7cm). Victoria and Albert Museum

HENRY JUSTICE FORD 1860-1941. 'Udea Found Lifeless.' Illustration to The Grey Fairy Book, *Andrew Lang, 1900.*

Illus: *South America [W.H. Koebel]; Morocco [S.L. Bensusan]; The West Indies [John Henderson, 1905].*
Contrib: *Judy [1894]; St. Paul [1895]; Black and White [1899]; Moonshine [1900]; Illustrated Bits; The Idler.*
Exhib: L; RBA, 1893-1909.
Colls: Witt Photo.

FORREST, Isabelle

Illustrator. Contributed a frontispiece to *Twelve Moons* by Frances A. Baidswell, 1912.

FORRESTIER, Alfred Henry see CROWQUILL, Alfred

FORRESTIER, Amedée 1854-1930

Special artist and illustrator. He was probably born in Belgium but came to England to work for *The Illustrated London News* in 1882. He acted as Special Artist for that paper regularly until 1899, attending mostly royal occasions and ceremonial functions at home and abroad. He visited Morocco, Russia, Germany, Belgium, Italy and Scandinavia, attended the coronation of Nicholas II in Russia, 1896, and the Quebec Tercentenary of 1908. Forrestier was a very good portraitist in chalk and drew several members of the Royal Family from life. In later life he devoted himself entirely to the study and illustration of archaeology. He died 14 November 1930.

Illus: *Blind Love [Wilkie Collins, 1890]; Barker's Luck [Bret Harte, 1896]; The World Went Well Then, For Faith and Freedom, In Deacon's Orders [Walter Besant, 1897]; Pablo The Priest [Baring Gould, 1899]; Belgium [G.W.T. Ormond]; Bruges and West Flanders, Brabant and East Flanders [1905]; Liège and the Ardennnes.*
Contrib: *ILN [1882-99]; The Girls' Own Paper [1890-1900]; The Strand Magazine [1891]; The English Illustrated Magazine [1895-96]; Pearson's Magazine [1896]; The Quartier Latin [1898]; The Sporting and Dramatic News [1899]; The Lady's Pictorial; The Windsor Magazine.*
Exhib: RBA, 1882-83.
Colls: V & AM.
Bibl: W. Simpson, *Autobiography*, 1903.

FORSYTH, Adam

Landscape painter working at Harlesden, London, 1889-92. He contributed a topographical illustration to *The Illustrated London News* in 1891 and exhibited at the RA and RI.

FOSTER, Marcia Lane (Mrs. Jarrett) **1897-**

Wood engraver and illustrator. She was born at Bonn and studied at the St. John's Wood School of Art and at the Central School of Arts and Crafts. She specialised in figure painting and exhibited with the NEA in 1924.

Illus: *Canadian Fairy Tales [Cyrus Macmillan, 1922].*

FOSTER, Myles Birkett **1825-1899**

Pastoral painter and illustrator. He was born into a Quaker family at North Shields on 4 February 1825. His grandfather was an acquaintance of Thomas Bewick, the wood engraver, and from a very early age he was set on being an artist himself. He went to Quaker Schools in Tottenham and Hitchin after the family had moved to London and at the age of sixteen he was apprenticed to an engraver named Stone, who unfortunately committed suicide on the day the indentures were completed. Foster was then moved to Ebenezer Landells, 1806-60, who had been a pupil of Bewick. He left Landells in 1846 at the age of twenty-one and began a career of his own in book illustration. This very productive period of his life lasted until 1859, when success enabled him to abandon this kind of work. He made his name with the public through the vignettes to Longfellow's *Evangeline*, 1850, and thereafter followed commissions for most of the classics and many books of modern poetry. Foster supplied initial letters to *Punch* in 1841-43, but his work for the magazines was very limited in comparison with his output on books. The latter were much more suitable vehicles for his gentle and subtle art, much of it in a small scale and low key, tiny detailed landscapes with pretty vegetation, herds of sheep and cows and cottagers at their doors. He was elected ARWS in 1860 and RWS in 1862. He died at Weybridge, 27 March 1899. He was brother-in-law of J.D. Watson (q.v.).

Foster designed book covers as well as illustrations and was one of the first artists to have his work reproduced by colour block in *The Illustrated London News* of 1857. He was on friendly terms with the Pre-Raphaelites and travelled abroad with Fred Walker (q.v.) whose figure work his own landscapes complement. His watercolours are very sentimental but have always attracted a large following among collectors.

Illus: *Burns Poems and Songs [1846]; Longfellow's Evangeline [1850]; Gray's Elegy [1853]; Longfellow's Poems [1854]; Proverbial Philosophy [1854]; Cowper's The Task [1855]; Adam's Sacred Allegories [1856]; Herbert's Poetical Works [1856]; Rhymes and Roundelays [1856]; Ministering Children [1856]; The Ancient Mariner [1856]; Bloomfield's Farmer's Boy [1857]; Course of Time [1857]; Poets of the Nineteenth Century [1857]; Kavanagh [1857]; Moore's Poetry [1857]; Gertrude of Wyoming [1857]; Choice Series [1857-64]; Poe's Poetical Works [1858]; Lays of the Holy Land [1858]; Home Affections [1858]; Favourite English Poems [1859]; Odes and Sonnets [1859]; The Seasons [1859]; Montgomery's Poems [1860]; The Book of South Wales [1861]; Household Song [1861]; Merrie Days of England [n.d.]; Early English Poems [1863]; Poetry of the Elizabethan Age [n.d.]; Christmas with the Poets [n.d.]; Legends and Lyrics [1866]; Moore's Irish Melodies [1867]; Beauties of Landscape [1873]; The Trail of Sir Jasper [n.d.]; Pictures of English Landscape [1881]; Picturesque Mediterranean [1891].*
Contrib: *Punch [1841-43]; ILN [1847-57]; The Illustrated London Almanac For 1853; The Illustrated Times [c.1855].*
Exhib: G; L; M; RA; RE; RWS.
Colls: Aberdeen; Ashmolean; BM; Blackburn; Greenwich; Hitchin; Newcastle; Sydney; V & AM.
Bibl: Chatto & Jackson, *Treatise on Wood Engraving*, 1861, p.558; H.M. Cundall, *BF*, 1906.

FOSTER, William **1853-1924**

Landscape watercolourist and black and white and animal illustrator. He was born in 1853, the son of Myles Birkett Foster (q.v.). He lived near his father at Witley, Surrey, and later with him at Weybridge, 1899. He specialised in ink and wash illustrations to children's stories, including sketches of comic animals. He was a Fellow of the

Zoological Society.
Exhib: L; M; RA; RBA; RI; RSA.
Colls: V & AM.

FOTHERGILL, George Algernon **1868-**

Watercolourst and illustrator. He was born in 1868 and although trained as a doctor, he gave up the profession in order to become an artist. He was Medical Officer in charge of 1st Cavalry Brigade, 1918-19 and lived and worked principally in the north of England or in Scotland.

Illus: *Notes From The Diary of a Doctor, Sketch, Artist and Sportsman . . . 220 Illustrations . . . [York, 1901].*
Exhib: L; RSA; Walker's Gall.

'FOUGASSE' Cyril Kenneth Bird **1887-**

Black and white artist. He was born 17 December 1887 and was educated at Cheltenham College and King's College, London. He became Art Editor of *Punch* in 1937, succeeding George Morrow (q.v.), and had a great deal to do with modernising the paper's rather old fashioned image. He was Editor from 1949-52 and successfully steered the humour and drawing into the post-war world. Fougasse's own style was pithy and diagrammatic, due perhaps to the fact that he was trained as an engineer. His favourite form was the strip cartoon in which small outline figures, full of movement, but consisting of only the barest essentials for the story, raced along over the simplest of captions. He achieved great fame during the Second World War as a poster artist with his series 'Careless Talk Costs Lives'.

Illus: *A Gallery of Games [1920]; Drawn at a Venture [1922]; P.T.O. [1926]; E. and O.E. [1928]; Fun Fair [1934]; The Luck of the Draw [1930]; You Have Been Warned [1935]; Drawing the Line Somewhere [1937]; Stop or Go [1938]; Jotsam [1939]; The Changing Face of Britain [1940]; and the Gatepost [1940]; Running Commentary [1941]; Sorry No Rubber [1941]; Just a Few Lines [1943]; Family Group [1944]; Home Circle [1945]; A School of Purposes [1946]; You and Me [1948]; Us [1951]; The Neighbours [1954]; The Good-tempered Pencil [1956]; Between the Lines [1958].*
Exhib: FAS, 1966; RSA.
Bibl: R.G.G. Price, *A History of Punch*, 1957, pp.285-286, 300-301, illus.

FOXLEY, C.

Flower illustrator. Contributed decorative pages of the seasons to *The English Illustrated Magazine*, 1896-97.

FOX-PITT, Douglas RBA **1864-1922**

Watercolourist and illustrator. He was born in London in 1864, the fifth son of General Pitt-Rivers, FRS. He studied art at the Slade and became a member of the London Group and a friend of Walter Sickert (q.v.). He made extensive tours abroad to Canada, Poland, Greece and the Ionian Isles and Ceylon. He visited Morocco in 1905-6 for Count Sternberg. He lived at Brighton from 1911 to 1918 and died at Chertsey, 19 September 1922. RBA, 1906.

Illus: *The Barbarians of Morocco [Count Sternberg, 1908].*
Exhib: GG; Leicester Gall.; M; NEA; RBA; RI.
Colls: Brighton; Fitzwilliam; Imperial War.
Bibl: *The Studio*, Vol.64, 1914, pp.56-57, illus.

FRAMPTON, Edward Reginald ROI **1870-1923**

Painter and illustrator. He was born in 1870, the son of Edward Frampton, stained-glass artist. He was educated at Brighton and Westminster School and studied art in France and Italy. He was a member of the RBA, 1894, the Tempera Society, 1907, and the Art Workers Guild, 1910. Elected ROI, 1904. Frampton was for many years on the staff of the L.C.C. Higher Education Art Committee and published numerous papers on art. He is best known as a mural artist, he executed a number of designs for public buildings and most notably those in All Saints Church, Hastings, as well as designing stained glass and carrying out sculpture. His illustrated works were not extensive, they are in the black and white woodcutty manner which originates with Morris. Some of his drawings are very akin to those of Burne-Jones.

Illus: *The Poems of William Morris [n.d.].*
Exhib: B; FAS, 1924; G; L; M; New Gall.; P; Paris, 1910, 1920; RA; RBA; RI; ROI.
Colls: Bradford; V & AM.
Bibl: *The Studio*, Vol.58, 1913, p.21, illus.; *Who Was Who*, 1916-28.
See illustration (p.309).

REGINALD EDWARD FRAMPTON ROI 1870-1923. St. Brandon. Illustration for unidentified book. Pencil on card. Signed. 7ins. x 8¾ins. (17.8cm x 22.2cm).
Victoria and Albert Museum

FRANKLIN, John fl.1800-1861

Landscape, historical and architectural painter and illustrator. He was born in Ireland and studied at the RDS Schools before working in Dublin. He exhibited at the RHA from its foundation in 1826 but settled in London in 1828. S.C. Hall calls him 'an artist of prodigious capability, who never gave himself fair play, frittering away his marvellous talent in comparatively small things, and avoiding the great works in which he would undoubtedly have excelled'. He was a fairly regular book illustrator in the 1850s, and his work was much admired by the young Walter Crane.

Illus: *The Psalms of David; Midsummer Eve [Mrs. S.C. Hall, 1842]; Seven Champions of Christendom; Poets of the West; Ireland Its Scenes and Character [S.C. Hall, 1841]; The Irish Peasantry [Carleton, 1852].*
Contrib: *The Book of British Ballads*
Exhib: BI, 1830-68; RA; RBA.
Bibl: Chatto & Jackson, *Treatise on Wood Engraving*, 1861, p.599; S.C. Hall, *Retrospect of a Long Life*, 1883, Vol.1 p.332.

FRASER, Claud Lovat 1890-1921

Artist, book illustrator and decorator, theatre designer. He was born in London in May 1890 and was educated at Charterhouse, and afterwards studied with Walter Sickert (q.v.) for six months. He did some illustrating before the First World War but joined up in 1914 with the Durham Light Infantry and was severely shell-shocked and gassed at Loos, subsequently being invalided out of the army. He worked for two years in the Record Office but entered his most productive period after 1918, when he made a name as a theatrical designer, designing sets and costumes for *As You Like It* and *The Beggars Opera*, 1920. He developed a style of drawing and of illustration in the tradition of the chapbook with black outlines and flat areas of bright colour. There are hints of Crawhall in his work but also perversely, echoes of Nielsen. Fraser was an excellent decorator of pamphlets and among his most striking works are the rhyme sheets he drew for Harold Monro's Poetry Bookshop. Their self-conscious simplicity and unaffected charm make them very much a part of art deco mannerism. Fraser's active service had so damaged his health that he died after this short-lived success at Sandgate on 18 June 1921.

Illus: *Eve and Other Poems [Ralph Hodgson, 1913]; Nursery Rhymes [1919]; The Chapbook; Poems from the Works of Charles Cotton Newly Decorated by Claud Lovat Fraser [1922]; The Luck of the Bean-Rows [C. Nodier, 1921]; Peacock Pie [Walter de la Mare, 1924].*
Contrib: *Methuen's Annual, 1914, (cover).*
Exhib: International Soc., NEA, 1917; Memorial Exhibition, 1921.
Colls: Tate (Curwen Press Gift); V & AM.
Bibl: E. Craig and De La Mare, *Catalogue of the Lovat Fraser Memorial Exhibition*, 1921; D. Bland, *A History of Book Illustration*, 1958, p.374; Joy Grant, *Harold Monro and The Poetry Bookshop*, 1967, pp.113-114.

FRASER, Eric George 1902-
Painter and etcher. He worked in Westminster and exhibited at the RA in 1924.

FRASER, Francis Arthur fl.1865-1898
Figure painter and illustrator. He was working in London from 1867 and at Dorking and Shere, Surrey, from 1881-82. He was a very prolific artist, especially in the late 1860s and his work which is pleasantly ordinary, was considered decadent by Gleeson White. He was employed on *Fun* from 1878 and became cartoonist in 1898. His brother G.G. Fraser (q.v.) was also an illustrator.
Illus: *Great Expectations [Dickens Household Edition, 1871]; The Innocents at Home [Mark Twain, 1897].*
Contrib: *The Sunday Magazine [1865-69]; Once a Week [1867]; Cassells Magazine [1867-70]; St. Pauls [1868-69]; Good Words For The Young [1869-72]; Good Words [1870]; London Society [1870]; ILN [1874]; Fun [1878-98]; The Chandos Poets; Judy [1894].*
Exhib: RA; RBA.

FRASER, G.G. fl.1880-1895
Humorous illustrator. He was the brother of F.A. Fraser (q.v.) and specialised in comic figure subjects and strip cartoons. He was a regular contributor to *Judy* and died in 1895.
Contrib: *Fun [1890-92]; The Ludgate Monthly [1892]; The Strand [1894]; The Idler.*
Exhib: G; L; RA; RI.

FRASER, James Baillie 1783-1856
Traveller, writer and artist. With his brother W. Fraser, he explored Nepal and the sources of the Ganges and the Jumna in 1815. In 1821 he made the journey from Persia to Tabriz and rode through Asia Minor, 1833-34. He published a *Memoir of Lt-Colonel James Skinner*, 1851.
Illus: *Views of Calcutta [1824-26, AT 494]; Views in the Himala Mountains [AT 498].*
Exhib: BI and RBA, 1827-31.

FRASER, P.
Illustrator of genre. He contributed drawings of urchins to *Punch*, 1914.

FREDERICS, A. fl.1877-1889
Illustrator. He worked chiefly for *Harper's Magazine* in what Pennell considered the English tradition. He illustrated *Three Men in a Boat* by Jerome K. Jerome, 1889, and exhibited at the RBA in 1877.

FREER, Mary Ellen see EDWARDS, Mary Ellen

FRENCH, Annie (Mrs. G.W. Rhead) fl.1900-1925
Painter, etcher and illustrator. She was probably trained at the Glasgow School and made many watercolours and pen drawings to illustrate children's books. Her style is influenced by the Pre-Raphaelites with its vivid colours, languid figures and garlands, but also present is a Beardsley influence, particularly in the use of massed dots giving the drawings a speckled appearance. In 1914 she married the etcher and stained-glass artist, George Wooliscroft Rhead (q.v.). Her work has had a great upsurge of popularity in recent years.
Contrib: *ILN [1913].*
Exhib: B; G; GG; L; M; RA; RHA; RI; RSA; RWA.
Colls: V & AM; Witt Photo.
See illustration (Colour Plate XV p.192).

FRENCH, Henry fl.1868-1875
Domestic painter and illustrator. He was working at Kentish Town in 1872-75, and exhibited at the RBA.
Contrib: *London Society [1868]; The Sunday Magazine [1869]; Good Words For The Young [1869]; Our Mutual Friend [Dickens Household Edition, 1871]; The Chandos Poets.*

FRENZENY, Paul fl.1887-1899
Illustrator. He appears to have acted as a Special Artist for *The Illustrated London News* in the Spanish American War of 1898 and had worked for the paper since 1887. He also specialised in theatrical studies, his work usually being in grey wash.
Illus: *Fifty Years on the Trail [H. O'Reilly, 1889]; The Jungle Book [Rudyard Kipling, 1894 (with others)].*
Exhib: RI, 1898.

FRIEDENSON, Joseph T. fl.1899-1909
Landscape painter and illustrator. He worked in London and contributed some ink drawings of rural life to the magazines. He signs his work J.T F.
Exhib: NEA; RA.
Colls: V & AM.

FRIPP, Charles Edward ARWS 1854-1906
Watercolourist, Special Artist and illustrator. He was born in London in 1854, the son of G.A. Fripp, the landscape painter. Fripp was a war correspondent on *The Graphic* from 1878, and in that capacity covered a great number of Queen Victoria's 'little wars'. He was special artist in the Transvaal, 1881, Ceylon, 1881, South Africa, 1885 and China, 1895-1903. He visited Japan, but died at Montreal in 1906 as a result of the hardships endured during the Manchurian campaign of the Sino-Japanese War of 1905. Hartrick describes him as ' a little terrier of a man'. He was elected ARWS in 1891.

Illus: *Fairy Tales [B. Field, 1898].*
Contrib: *Black and White [1893]; The Pall Mall Magazine.*
Colls: V & AM.
Bibl: A.S. Hartrick, *Painter's Pilgrimage* 1939, p.71.
Exhib: L; M; RA; RHA; RWS.

FRISTON, David Henry fl.1853-1878
Figure painter and illustrator. He was working in Regent's Park in 1854 and in Kensington in 1863. Friston seems to have specialised in theatrical scenes and portraits in black and white.
Contrib: *The Churchman's Family Magazine [1863]; Tinsley's Magazine [1867]; ILN [1869-78 (theatrical)]; Dark Blue [1871-73].*
Exhib: BI, 1854-67; RA; RBA, 1863.

FRITH, William Powell RA CVO 1819-1909
Domestic and genre painter. He was born on 9 January 1819 and was educated at Knaresborough and Dover, before studying art under Sass and at the RA Schools. He began to exhibit at the RA in 1840 and from that period became the doyen of English subject pictures, including 'Ramsgate Sands', 1853, 'Derby Day', 1858, and 'The Railway Station', 1862. Frith tried unsuccessfully to be a moral painter in the manner of Hogarth and although he illustrates Victorian society in a very finished and photographic way, he did not penetrate its skin and remained a prosperous popular painter. He made one excursion into book illustration by contributing to S.C. Hall's *Book of British Ballads* in 1842, and there is a wash drawing in the Victoria and Albert Museum which may be a study for illustration. He became ARA in 1845, and RA in 1853, and was created CVO in 1908 in recognition of his long connection with the Royal Family as a painter of ceremonial events. He died at St. John's Wood, 2 November 1909.
Bibl: W.P.F. *My Autobiography ... Further Reminiscences, 1887-88; J. Laver and J. Mayne, Cat. of ... Paintings by WPF, RA, at Harrogate Art Gallery*, 1951.

FROHAWK, F.W.
Ornithological draughtsman who contributed illustrations to *British Birds Their Nests and Eggs*, 1891.

FRÖHLICH, Lorens 1820-1908

Painter, engraver and illustrator. He was born in Copenhagen on 25 October 1820, and studied in Denmark and at Munich, Dresden and Rome. In 1877, he was appointed professor of the Academy of Fine Art in Copenhagen but established his reputation more as an illustrator than a painter. He illustrated numerous Danish books of legend and contributed to English children's stories. He died at Copenhagen on 25 October 1908.

Illus: *What Makes Me Grow? [1875].*
Contrib: *Mrs. Gatty's Parables From Nature [1861]; Legends and Lyrics [A.A. Proctor, 1865]; ILN [1872].*
Exhib: FAS, 1883.

FROST, Arthur Burdett 1851-1928

Painter and draughtsman. He was born at Philadelphia on 17 January 1851 and was associated from an early date with *Harper's* for which he did many drawings serious and humorous. Pennell considered him to be the finest comic artist in the United States, but was even more impressed by his accuracy as a domestic illustrator. 'Mr. Frost's drawings of the farmer in the Middle States will later be as valuable records as Menzel's uniforms of Frederick the Great.' Frost was an exhibitor at the Paris Exhibition of 1900 and died in 1928.

Illus: *American Notes [Dickens Household Edition, 1871]; Phantasmagoria [Lewis Carroll, 1911].*
Contrib: *The Quiver [1882].*
Bibl: J. Pennell, *Pen Drawing and Pen Draughtsmen,* 1894.

FRY, Roger Elliott 1866-1934

Art critic and artist. He was born in 1866, the son of the Rt.Hon. Sir Edward Fry, one of the distinguished Quaker family. After being educated at Clifton and King's College, Cambridge, where he read science, Fry devoted himself to art and studied under Francis Bate and in Paris. After visiting Italy, he turned his attention to connoisseurship and writing and became the director of the Metropolitan Museum of Art, New York, 1905-10. He sponsored the first French Post-Impressionist exhibitions at the Grafton Gallery, 1910 and 1912, and founded the Omega Workshop in 1913. He wrote many books and articles, championing modern art and became Slade Professor of Fine Art at Cambridge in 1933. He died on 9 September 1934. Member of NEA, 1893.

Illus: *In a Garden [Rev. H.C. Beeching, 1896 (title)].*
Exhib: G; L; M; NEA; RSA.

FRY, Windsor

Contributor of domestic illustrations to *The English Illustrated Magazine,* 1897.

FULLEYLOVE, John RI 1845-1908

Landscape painter, watercolourist and illustrator. He was born at Leicester on 18 August 1845, and was at first apprenticed to an architect, Flint and Shenton of Leicester, before taking to painting as a profession. Fulleylove travelled abroad widely and painted architecture and gardens in Versailles, Florence, Rome and Athens and visited the Near East and the Holy Land. His work was published in a long series of late Victorian and Edwardian colour plate books and although attractive is often a too rich diet for today's taste. He was elected RI in 1879 and died in London on 22 May 1908. His brother-in-law was George S. Elgood RI (q.v.).

Illus: *Henry Irving [1883]; Oxford [Edward Thomas, 1889]; Pictures and Sketches of Greek Landscape [1897]; The Stones of Paris [1900]; The Holy Land [Rev. John Kelman MA, 1905]; Middlesex [Hope Moncrieff]; Edinburgh [Rosaline Masson]; In the Footsteps of Charles Lamb [c.1905].*
Contrib: *The English Illustrated Magazine [1886]; The Picturesque Mediterranean [1891]; Good Words [1891]; ILN [1894]; Pastorals of France [F. Wedmore, 1894 (title)].*
Exhib: B; FAS, 1886, 1888, 1890, 1894, 1896, 1899, 1902, 1906; G; Leicester Gall.; RA; RHA; RI; ROI.
Colls: Cardiff; Leicester; Liverpool; V & AM.
Bibl: 'Mr. Fulleylove's Drawings of Greek Architecture and Landscape', *The Studio,* Vol.7, 1896, pp.77-82, iillus.; R.E.D. Sketchley, *English Book Illus.,* 1902, pp.31, 39, 134.

FURNISS, Harry 1854-1925

Black and white artist, caricaturist and author. He was born at Wexford, Ireland, in 1854, the son of an English engineer. Furniss drew from an early age and first submitted work to A.M. Sullivan's Irish version of *Punch* and then to *Punch* itself, after he had settled in London in 1873. His sketches were rejected by *Punch's* editor, Tom Taylor, and only accepted after Burnand had taken over the editorship; he joined the staff in 1880, but was never on the salaried staff. Furniss was well-travelled, visited America, Canada and Australia, and was sent to the Chicago World Fair as Special Artist by *The Illustrated London News.* For the same paper he also tried his hand at social realism, but it is as a humorous illustrator that he is most widely remembered.

There is little doubt that Furniss was one of the most talented black and white artists of his time, certainly one of the quickest in executing work. His pen line, which looks effortlessly precise, was often worked up from pencil, but when he introduces washes, the effect is far less successful. A master of political caricature, of the silhouette caricature and of the inspired doodle, he lacked the consistency to become a great illustrator. He was notoriously argumentative and egotistical as is shown by obsessive use of self-portraits and his famous break with *Punch* in 1894 when he founded *Lika Joko* and *The New Budget.* He was at his most brilliant however in metamorphic caricatures such as 'Getting Mr. Gladstone's Collar Up' and subtly imitating the works of famous artists. His Parliamentary sketches are occasionally seen on the market. He died at Hastings, 14 January 1925 and signs his work 〰️

Illus: *Happy Thoughts; Incompleat Angler; The Comic Blackstone; Sylvie and Bruno [Lewis Carroll, 1889]; Thackeray's Ballads [Cheap Illustrated Edition, 1894]; All in a Garden Fair [W. Besant, 1897]; The Wallypug of Why [G.E. Farrow, 1900]; The Works of Charles Dickens [1910]; The Works of W.M. Thackeray [1911].*
Publ: *Royal Academy Antics [1890]; America in a Hurry [1900]; Peace with Humour; P and O Sketches [1898]; Confessions of a Caricaturist [1901]; Harry Furniss At Home [1903]; How To Draw in Pen and*

HARRY FURNISS 1854-1925. *Caricature of Lord Brampton.* Pen and ink. 3½ins. x 2¾ins. (8.9cm x 7cm). Author's Collection

HARRY FURNISS 1854-1925. 'The Race for the Country. Waiting for the Signal by our Americanised Artist.' Illustration for Punch, *18 June 1892. Pen and ink.*
Woburn Abbey Collection

Ink [1905]; Friends without Faces [1905]; Our Lady Cinema [1914]; More about How to Draw in Pen and Ink [1915]; Peace in War [1917]; Deceit a reply to Defeat [1917]; My Bohemian Days; The Byways and Queer Ways of Boxing [1919]; Stiggins, Some Victorian Women [1923]; Some Victorian Men [1924].
Contrib: *ILN [1876-86]; Punch [1880-94]; Vanity Fair [1881]; Cornhill Magazine [1883-85]; The English Illustrated Magazine [1883, 1890-91]; The Graphic [1889]; Good Words [1890]; Black & White [1891]; The Pall Mall Budget; The Sketch; The Windsor Magazine; Cassell's Family Magazine; Illustrated Sporting and Dramatic News.*
Exhib: FAS, 1894, 1898, 1925; RA; RHA.
Colls: V & AM.
Bibl: H.F. *Confessions of a Caricaturist,* 1901.
See illustrations (above and p.311).

FURSE, Charles Wellington ARA 1868-1904
Portrait painter. He was born in 1868, the son of the Ven. C.W. Furse, Archdeacon of Westminster. He was educated at Haileybury College and studied at the Slade School under Legros, winning a Slade Scholarship and then working in Paris. He was a member of the NEA in 1892 and was elected ARA in 1904. He died 17 October 1904.

Contrib: *The Yellow Book; The Autobiography of a Boy [G.S. Street, 1894 (title)].*

FUSSELL, Joseph fl.1821-1845
Landscape painter. He was probably the brother of A. and F.R. Fussell, and painted from addresses in Sadlers Wells and Bloomsbury, 1821-45. He contributed illustrations to Virtue's *Views of Kent,* 1829, and to Knight's *London,* 1841.

Exhib: BI, 1822-45; RBA, 1821-45.

FYFE, William Baxter Collier 1836-1882
Figure painter and illustrator. He was born at Dundee in 1836 and studied art at the RSA in Edinburgh. He specialised in Scottish genre subjects, exhibited his first picture in 1861, and settled in London in 1863, working latterly at St. John's Wood.

Contrib: *Good Words [1861].*
Exhib: G; RA; RI; RBA.

GAILDRAU, Jules 1816-1898

Figure artist and illustrator. He was born in Paris 18 September 1816, and worked for numerous French papers, principally for *L'Illustration* and contributed to *The Illustrated London News* (Vizetelly). He exhibited at the Salon, 1848-57, and died in Paris in January 1898.

GAILLIARD, François 1861-

Painter of genre and illustrator. He was born at Brussels on 30 November 1861 and exhibited at Berlin in 1886. He worked for *L'Illustration* and contributed to *The Illustrated London News*, 1900.

GALE, William 1823-1909

Painter of history and religious themes. He was born in London in 1823 and studied at the RA Schools before travelling to the Continent, the Middle East and North Africa for study. He was a frequent exhibitor at London exhibitions, 1844-1892.

Contrib· *Passages From The Modern English Poets [1862]*.
Exhib: B; BI, 1844-67; G; L; M; RA; RBA, 1844-92; RI; ROI; RSA.
Colls: Glasgow.

GALLAGHER, F. O'Neill fl.1901-1910

Landscape painter and illustrator. Working at Corbeil, France, in 1910 and exhibiting at the NEA the same year.

Bibl: *The Studio*, Winter No.1900-01, p.62, illus.

GALPIN, Will Dixon fl.1882-1891

Figure painter and illustrator. He was working at Roehampton, 1882-85, and at Bushey in 1884. In 1891 he contributed illustrations to Cassell's *The Picturesque Mediterranean.*

Exhib: B; G; L; RA; RBA.

GAMMON, Reginald 1894-

Watercolour artist, landscape painter and illustrator. He was born at Petersfield in 1894 and contributed black and white drawings to *Punch,* mostly of country subjects.

Exhib: NEA; RA; RBA; RI, 1938-40.
Bibl: *Mr. Punch With Horses and Hound,* New Punch Library, c.1930.

GANDY, Herbert fl.1881-1911

Figure and domestic painter. He exhibited regularly from 1881-1911 and contributed fairy illustrations to *The Illustrated London News,* Christmas, 1903.

Exhib: B; G; L; M; RA; RHA; RI; ROI.

GARDEN, G.M.

Book decorator, contributing endpieces to *The English Illustrated Magazine,* 1896.

GARDNER, W. Biscombe c.1849-1919

Landscape painter, wood engraver and etcher. He was born in about 1849 and painted in both watercolour and oil, but was best known as an engraver. He engraved work for *The Illustrated London News* and *The Graphic,* but specialised in work after such artists as Alma Tadema, Lord Leighton and G.F. Watts. He was working in London in 1880 and 1897, in Surrey, 1893 and 1883 and 1891, finally settling in Tunbridge Wells, 1906.

Contrib: *The Pall Mall Magazine; The English Illustrated Magazine [1887-88 and 1891-92]*.
Exhib: G; L; New Gall.; RA; RI; ROI; RSW.
Colls: Margate; V & AM.

GARLAND, Charles Trevor fl.1874-1907

Landscape, portrait and child painter and illustrator. He was working in London from 1874 and exhibiting regularly. He was living in Rome in 1880 and on his return to this country the following year, worked first in London and then in Penzance, 1892-1903. He was living in Colchester in 1907.

Contrib: *The Graphic [1874]; ILN [Christmas, 1882-86 (genre) and Christmas, 1892-93 (genre)]*.
Exhib: B; G; L; M; RA; RBA; RI; ROI.

GARLAND, Henry fl.1854-1892

Painter of landscape, genre and animals. He was born at Winchester and worked in North London from 1854 and in Leatherhead, Surrey from 1887, exhibiting regularly at the major exhibitions.

Contrib: *ILN [1868]*.
Exhib: B; L; M; RA; RBA; ROI.
Colls: Leicester; Sunderland.

GARLAND, Robert c.1808-

Draughtsman. He entered the RA Schools in December 1827 and drew views of London and its vicinity. He made the drawings for Winkle's *Cathedral Churches of England and Wales*, 1838.

Exhib: RA, 1826-31.

GARRATT, Arthur Paine 1873-

Portrait painter and illustrator. He was born in London on 17 July 1873 and was educated at the City of London School. He probably taught drawing at the Leys School, Cambridge and after some years portrait painting in America, returned to this country and settled in Chelsea. As a young man, Garratt was a prolific illustrator, and as a Londoner specialised in scenes of London life, crowded figure subjects such as the music hall and the riverside. A large pen and wash drawing of the Great Hall at Chelsea Hospital was recently on the market, the figures heavily built up in bodycolour.

Illus: *Lucian's Wonderland [St. J.B. Wynne Willson, 1899]*.
Contrib: *The Graphic [1899-1910]; Black & White [1899-1900]; The Quiver [1900]; The Pall Mall Magazine [1900]; Pearson's Magazine; The Royal Magazine; Punch; The Sphere.*
Exhib: FAS, 1911; L; P; RA; Salon, 1903.
Bibl: *Who's Who in Art 1927*.

GARRETT, Edmund Henry 1853-

Painter, illustrator and engraver. Although an American artist, born in Albany on 19 October 1853 and working in Boston, after studying in Paris, he is included here as the illustrator of English editions of Ouida's novels.

GASCOIGNE, John

Figure artist. Contributed illustrations to *London Society*, 1865.

GASKIN, Arthur Joseph 1862-1928

Painter, illustrator, portraitist, designer. He was born at Birmingham in 1862 and married in 1894 Georgie Evelyn Cave France, (Mrs. Arthur Gaskin, q.v.). He was educated at Wolverhampton Grammar School and then studied at the Birmingham School of Art, eventually teaching there. Gaskin became increasingly interested in the crafts after contact with William Morris (q.v.) and the influence of the Kelmscott Press, for which he designed, is discernible in his own work and those of his students. He became the Director of the Jewellers and Silversmiths School at Victoria Street, Birmingham and was a member of the Royal Birmingham Society of Artists, he died on 4 June 1928.

Illus: *Stories and Fairy Tales [Hans Andersen, 1893]; Good King Wenceslas [Dr. Neale, 1895-96]; The Shepheardes Calender [Spenser, Kelmscott Press, 1896]*.
Contrib: *The English Illustrated Magazines [1893-94]; A Book of Pictured Carols [Birmingham School, 1893]; A Book of Fairy Tales [Baring Gould, Birmingham School, 1894]; The Yellow Book [1896]; The Quarto [1897]*.
Exhib: B; G; L; M; New Gall.; RA; RBA; RE.
Bibl: R.E.D. Sketchley, *English Book Illus.*, 1902, pp.10 and 126; Joseph E. Southall, *The Drawings of AG;* The Studio, Vol. 64, 1914.

GASKIN, Mrs. Arthur (née Georgie Evelyn Cave France)
Illustrator of children's books. She married Arthur J. Gaskin (q.v.), in 1894, helped him to design jewellery and exhibited 1896-1930.

Illus: *An ABC Book Pictured and Rhymed by ... [1895-96]; Watts Divine and Moral Songs for Children [1896]; Horn-book Jingles [1896-97]; Little Girls and Little Boys [1898]; The Travellers and Other Stories [1898].*
Exhib: B; L; New Gall.; RMS.
Bibl: R.E.D. Sketchley, *English Book Illus.*, 1902, pp.101, 166.

GASTINEAU, Henry G. OWS 1791-1876
Landscape watercolourist and topographer. He was born in 1791 and studied at the RA Schools after being trained as an engraver. He travelled widely in Great Britain, painting picturesque scenery and was elected AOWS in 1821 and OWS in 1823. He worked as a drawing-master in Camberwell from 1827. He died there on 17 January 1876.

Publ: *Wales Illustrated [1829].*
Contrib: *The Surrey Tourist or Excursions Through Surrey [1821].*
Exhib: BI; OWS; RA.
Colls: BM; V & AM.

GATCOMBE, George fl.1887-1897
Black and white figure artist, specialising in theatrical illustrations.

Contrib: *Fun [1887-92]; Ally Sloper's Half Holiday [1890]; The Rambler [1897].*

GAUGNIET
French contributor to *The Illustrated London News,* 1848.

GAVARNI H.G.S. Chevalier 1804-1866
Caricaturist and lithographer. He was born in Paris at 5 Rue des Vieilles-Haudriettes on 13 January 1804, his father having been an active revolutionary and his mother a member of a theatrical and painting family. In 1818 he went to study at the Pension Butet and then at the Conservatoire des Arts et Métiers, concentrating on machinery design. The artist had a few plates issued in Paris about 1825 signed 'HG' or 'H. Chevalier' but his main work was as an architectural etcher for Jean Adam and later surveying in the Haute Pyrénées. He settled in Paris again in June 1828.

From 1829, 'Gavarni' as Chevalier now called himself, began to develop as a designer; his early productions were costumes and fashion plates and in 1830, during the Revolution of that year, he produced two satirical prints of the departing Bourbons. Gavarni's interests were always the study of humanity, faces, figures, groups on the Paris streets. A series of lithographs was published in the *Artiste* on the 'Physionomies de la Population de Paris' and followed by 'Travestissements' in a similar vein, both attracting enormous attention. He joined the staff of *Charivari* and from this time onwards, his work appeared there and in *Le Musée des Familles, Le Caricature, Le Figaro, La Renaissance, Le Bulletin de L'Amis Des Arts* and *La Sylphide.* He also contributed to *La Revue et Gazette Musicale, L'Illustration, Le Bossu, the Puppet Show* and *Paris.*

On November 21 1847, Gavarni left for England and spent the next four years there, travelling widely, making a journey to Scotland and meeting English artists. This resulted in *Studies: Rustic Groups of Figures,* published by Rowney. In 1850 he published a series of tinted wood engravings, *Gavarni in London* and on his return to Paris in 1851, *Les Anglais peints par aux-mêmes.* Gavarni profited by his visit to England by developing a much wetter and broader technique in watercolours. His work fell out of favour in the late 1850s and he died of consumption on 24 November 1866. Gavarni admired the work of his great contemporary Daumier, but unlike him was more of a humorist than a caricaturist.

Illus: *The Wandering Jew [Sue, 1845]; Dames Aux Camélias; Petits bonheurs de la vie; Mille et Une Nuits; Symphonies de L'Hiver; Gil Blas [1863].*
Contrib: *ILN [1848-55].*
Colls: V & AM.
Bibl: Edmond and Jules de Goncourt, *Gavarni,* Paris, 1924; Franzt and Uzanne, *Daumier and Gavarni,* Studio, 1904.

See illustrations (right and p.315).

GAVIN, Miss Jessie fl.1903-1914
Illustrator. She was working at Oxton, Cheshire from 1903-14 and contributed frontispieces to some of Messrs. Jack's publications. She was a good portraitist in solid outline and was clearly influenced by the Beggarstaff Brothers. She signs ⌐G⌐

Illus: *Stories of Hoffmann; Stories of Poe; Stories of Gautier [1908].*
Exhib: L, 1903-12.

GEAR, J.W. fl.1851-1852
Painter of portraits and engraver. He specialised in family groups in watercolours, in theatrical personalities and paintings on porcelain. Contributed to *The Illustrated London News,* 1848.

Exhib: RA; RBA, 1821-52.

GELL, Sir William 1774-1836
Topographical draughtsman and traveller. He was born in 1774 and after studying at the RA Schools and practising as an architect, he settled in Italy in 1820 and became Chamberlain to the exiled Caroline, Princess of Wales. He is best remembered by his series of illustrated books and he died at Naples in 1836.

Illus: *The Topography of Troy [1804, AT 399]; Geography and Antiquities of Ithaca [1807]; The Itinerary of Greece [1810, AT 129]; Views in Barbary [1815, AT 297]; Attica [1817]; Itinerary of the Morea [1818]; Pompeiana [1817-19]; The Walls of Rome [1820]; Narrative of a Journey to the Morea [1823]; Topography of Rome [1834]; A Tour in the Lakes [1797 (edited by W. Rollinson, 1968)].*
Colls: Barrow-in-Furness; BM.

GAVARNI (H.G.S. Chevalier) 1804-1866. 'The Bar-Maid.' An illustration for Gavarni in London, *1850. Tinted lithograph.*

GAVARNI (H.G.S. Chevalier) 1804-1866. 'The Queen's State Coachman.' An unpublished study for Gavarni in London, *1850. Pencil and chinese white.*
Victoria and Albert Museum

GENDALL, John 1790-1865
Topographical artist. He was born in 1790 on Exe Island, Exeter and after showing early talent was noticed by Sir John Soane and introduced by him to Rudolph Ackermann. He worked with him for many years as draughtsman, lithographer and manager, travelling all over Britain and to Normandy to make drawings. He settled at Exeter again in 1830 and taught drawing at Cole's School, dying in the city in 1865.
Illus: *Picturesque Tour of the Seine [1821, AT 90 (with A. Pugin)]; Westall's Country Seats [1823-28].*
Exhib: BI, 1818-63; RA.

GÉNIOLE, Alfred André 1813-1861
Painter of genre and portraits. He was born at Nancy, France on 1 January 1813 and became a pupil of Baron Gros, exhibiting in the Salon from 1839. He contributed illustrations to *The Illustrated London News*, 1853. Died at Bicêtre on 12 January 1861.

GERE, Charles March RA ARWS 1869-1957
Portrait painter and watercolourist, illustrator, decorator and designer of stained glass. He was born at Gloucester in 1869 and was educated at Birmingham and in Italy, training as an artist with the Birmingham School of Art, remaining for many years as a teacher. He was associated, like his colleague Arthur Gaskin (q.v.), with William Morris at the Kelmscott Press and later with C.H. St. John Hornby at the Ashendene Press. He was an accomplished decorative artist and designed for embroidery, but after settling at Painswick, Gloucestershire in 1902, began to specialise in landscapes of the Cotswolds and North Italy. He became a member of the NEA in 1911, ARWS, 1921,

RWS, 1927 and was elected ARA in 1933 and RA in 1939.
Gere's illustrations in black and white have the rather mannered angularity of the Birmingham School and his topographical work is very close in feeling to that of E.H. New (q.v.).
Contrib: *News From Nowhere [William Morris, Kelmscott Press, 1893 (frontis.)]; Russian Fairy Tales [1893]; A Book of Pictured Carols [The Birmingham School [1893]; The Imitation of Christ [1894]; The Quest [1894-96]; The Yellow Book [1896].*
Exhib: B; G; L; M; NEA, 1910-24; New Gall.; RA 1890-1956; RHA; RWS.
Bibl: R.E.D. Sketchley, *English Book Illus.*, 1902, pp.12, 50, 126.

GERMAN, Dick
Figure artist. He contributed to *Punch,* 1914.

GIBBS, Percy W. fl.1894-1937
Portrait and landscape painter and illustrator. He studied at the RA Schools and won the Creswick prize in 1895. Worked at East Molesey. Contributed to *The Graphic*, 1906.
Exhib: G; L; RA.

GIBERNE, Edgar fl.1872-1890
Sporting artist and illustrator. He worked from Epsom and drew Highland and Indian sporting subjects for magazines and illustrated children's books.
Illus: *Binko's Blue [H.C. Merivale, 1884].*
Contrib: *ILN [1889-90].*
Exhib: RA; RBA, 1872-88.

GIBSON, Charles Dana 1867-1944
Black and white artist and illustrator. He was born at Roxbury, Massachusetts, U.S.A. on 14 September 1867 and was educated at Flushing High School, followed by training at the Art Students' League, New York. Gibson studied with Augustus Saint Gaudens and attended Julian's in Paris. Within a year or so of his first drawing from life in 1888, Gibson had become an international figure and recognised on both sides of the Atlantic. He was the chronicler in visual terms of American high society, the world of luxury-laden and zestful New York and Boston where East Coast aristocrats hunted as a group and rigorously excluded all newcomers. Gibson did more than create a beautiful type of American girl 'the Gibson Girl', he created a fashion. As Pennell remarks, 'Not only has he countless artless imitators on both sides of the Atlantic, but Fifth Avenue today is like an endless procession of Gibsons.' Although his subjects were mostly American, he made visits to Europe and drew society in Paris and London. *The Studio*, in 1897, considered that they were unsuccessful, Gibson remaining a foreigner who could not capture a cockney or a society figure. His sister-in-law was Lady Astor.
His penwork was done on a very large scale which was greatly reduced, giving an incredible fineness and finish to the printed page. The execution is brilliant, but the compositions are often repetitive and a nauseating sentimentality creeps in from time to time. Gibson remains very much an American collecting field.
Illus: *Drawings by C.D. Gibson; Pictures of People [1897]; London As Seen By C. Dana Gibson [1897]; People of Dickens [1897]; Sketches and Cartoons; The Education of Mr. Pipp; Americans; A Widow and Her Friends; The Social Ladder; The Weaker Sex; Everyday People; Our Neighbours; Other People [1911].*
Contrib: *Life.*
Exhib: FAS, 1896.
Bibl: Joseph Pennell, *Pen Drawing and Pen Draughtsmen*, 1894, pp.244-245.
See illustration (p.316).

GILBERT, Frederick fl.1862-1877
Painter, watercolourist and illustrator. He was the brother of Sir John Gilbert (q.v.), and lived with him at Blackheath. He specialised in genre and history subjects and illustrations from Tennyson's works.
Contrib: *Cassell's Magazine [1866]; Aunt Judy's Magazine [1866]; London Society [1870].*
Exhib: RBA.

HIS SISTER

CHARLES DANA GIBSON 1867-1944. 'His Sister.' Illustration to Pictures of People, *1897.*

GILBERT, Sir John 1817-1897

Historical painter and illustrator. He was born at Blackheath in 1817 and after being apprenticed to an estate agent, he studied with George Lance and taught himself to draw on the block, engrave, etch and model. He was the first major figure to emerge alongside Harvey (q.v.) in the revival of wood engraving. Chatto & Jackson date his success from the publication of *Hall's English Ballads* in 1843, 'the first work of any consequence that presented a combination of the best artists of the time. Indeed it was the leader in what may be called the Illustrated Christmas Books of the present day. Since this period Mr. Gilbert has probably produced more drawings on wood than any other artist ...' Gilbert was the first serious artist to tackle news illustrating for *The Illustrated London News*, 1843 and remained as a major contributor until late in life. He made a reputation however, out of elaborate semi-allegorical pages, festive Christmas scenes and representations of the seasons for special issues of magazines, for which he was paid enormous sums of money. The acclaim with which Gilbert's work was met seems almost incredible, the Victorians considering his rather dull historical set-pieces as equal to the work of Doré! He became President of the Royal Society of Painters in Watercolours in 1871, was knighted in the following year and elected ARA in 1872 and RA in 1876. He died on 5 October 1897, having given a large collection of his works to various provincial art galleries in 1892.

Illus: *City Scenes [1845]; Children of the New Forest [Capt. Marryat, 1847]; The Pleasures of the Country, Stories For Young People [Mrs. Myrtle, 1851]; The Salamandrine [1853]; Hide and Seek [Wilkie Collins 1854]; Basil [Wilkie Collins, 1862]; Fairy Tales [Countess D'Aulnoy, 1881]; Shakespeare's Works [1856-58]; Adele [J. Kavanagh, 1862].*
Contrib: *Punch [1842(frontis.)-1882]; ILN [1843-79]; Sunday at Home [1852]; The Illustrated London Magazine [1853]; Proverbial Philosophy [M. Tupper, 1854]; Longfellow's Poems [1855]; Scott's Lady of The Lake [1856]; The Illustrated Times [1856]; Poets of the Nineteenth Century [Willmott, 1857]; The Book of Job [1857]; The Proverbs of Solomon [1858]; Lays of the Holy Land [1858]; The Home Affections [Charles Mackay, 1858];*
Montgomery's Poems [1858]; Poetry of the Elizabethan Age [1860]; Songs and Sonnets of Shakespeare [1860]; The Welcome Guest [1860]; Eliza Cook's Poems [1861]; The Leisure Hour [1861-63]; The British Workman [1862]; The Band of Hope Review [1862]; English Sacred Poetry [Willmott, 1862]; Boys' Book of Ballads [1862]; Early English Poems [1864]; Wordsworth's Poems [1865]; Legends and Lyrics [Proctor, 1866]; Foxe's Book of Martyrs [1866]; Once a Week [1866-67]; Cassell's History of England [1867]; London Society [1868-69]; Cassell's Family Paper [n.d.]; Choice Series [1857-64]; The Standard Poets and Standard Library; The Graphic [1877].
Exhib: B; L; M; RA, 1838-51 and 1867-97; RBA, 1836-1892; RWS.
Colls: Ashmolean; BM; Manchester; Nat. Gall., Scotland; V & AM.
Bibl: F. Reid, *Illustrators of The Sixties,* 1928, pp.20-23; *Who Was Who 1897-1916;* M. Hardie, *Watercol. Paint. in Brit.,* Vol. III, 1968, pp.94-96, illus. See illustration (p.71).

GILBERT, Sir William Schwenck 'BAB' 1836-1911

Journalist, playright and amateur illustrator. He was born at Southampton Street, Strand on 18 November 1836 and was educated at Ealing and London University. He was called to the Bar in 1864 and served as Clerk to the Privy Council, 1857-1902. From his first introduction to Sir Arthur Sullivan in 1869 developed the fertile production of Savoy operas up to the year 1896. Gilbert's earlier career and reputation was made as 'Bab' the contributor of humorous verse to *Fun* illustrated by the author's own grotesque thumbnail sketches. There were really two sides to his artistic productions, the monstrous and savage creatures of the *Bab Ballads,* very much in the tradition of Lear, and rather pretty fairy sketches and drawings of young girls. Although the sketches were slight, they won the admiration of that fastidious critic Max Beerbohm. Gilbert died at Harrow Weald 29 May 1911. He was knighted, 1907.

Contrib: *Juvenile Verse Picture Book [1848]; Fun [1861]; Magic Mirror [1867-68]; London Society [1868]; Good Words For The Young [1869]; The Graphic [1876].*
Colls: BM.
Bibl: Leslie Baily, *The Gilbert and Sullivan Book,* 1952, p.44; Philip James, Introduction to *Selected Bab Ballads,* 1955.

GILES, Alice B. fl.1896-1924

Illustrator. She was a student at the New Cross Art School in 1896-97 and was working at Surbiton, Surrey in 1924 and was a member of the Design and Industries Association. She specialised in the illustration of child's stories where animals were included.

Exhib: RA, 1903.
Bibl: *The Studio*, Vol.8, 1896, p.229, illus.; 1897.

GILES, Godfrey Douglas 1857-1923

Painter of horses and military scenes and illustrator. He was born in India in 1857 and served as a professional soldier there, and in Afghanistan and Egypt. He studied in Paris and was a regular exhibitor in London, 1882-1904. He was also a caricaturist.

Contrib: *The Graphic [1885, (horses)]; Black & White [1891, (sport)]; Vanity Fair [1899-1909, 1903]*.
Exhib: G; GG; L; M; RA; RBA; ROI; RSA.

GILKS, Thomas fl.1840-1876

Wood engraver, writer and illustrator. His bill head describes him as 'Draughtsman, Engraver, Ornamental Printer'. He was active from about 1840, engraved the plates for John Leech's *The Comic English Grammar*, and H. Fitzcock's *All About Shakespeare*. He illustrated his own *Study of the Art and Progress of Wood Engraving*.

Contrib: *ILN [1858, (Australia)]; London Society [1870]*.
Exhib: RBA, 1870.

GILL, Arthur J.P.

Contributor to *Judy*, 1889.

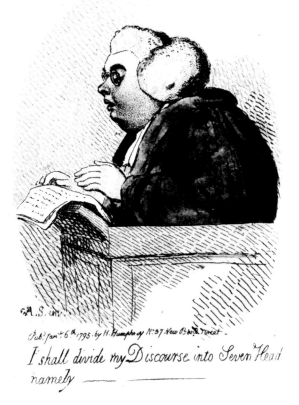

JAMES GILLRAY 1757-1815. 'Pulpit Eloquence.' Published 6 January 1795. Engraving. 5ins. x 3¼ins. (12.7cm x 8.3cm).

GILLETT, (Edward) Frank RI 1874-1927

Sporting artist and illustrator of equestrian subjects. He was born at Worlingham, Suffolk on 23 July 1874, son of the Rev. Jesse Gillett of Aldeby and was educated at Gresham's. He left school at sixteen and after six years as a Lloyds' clerk, joined the staff of the *Daily Graphic*, 1898, remaining on the paper until 1908. He was subsequently with *Black & White*, 1908-11 and with *The Illustrated Sporting and Dramatic News*, 1910-23. Gillett, who was elected RI in 1909, was working at St. Albans that year, in London 1911 and in Aldeby, Suffolk from 1918. His pen drawings of horses are always convincing but they can be stiff.

Contrib: *Fun [1895]; Judy [1898]; The Ludgate Monthly; The Idler*.
Exhib: G; L; RA; RI.

GILLRAY, James 1757-1815

Caricaturist and engraver. He was born at Chelsea in 1757 and after being educated by the Moravians at Bedford was apprenticed to a letter engraver and worked under classical engravers such as Ryland and Bartolozzi in stipple. He trained at the R.A. Schools and did some book illustrations for Macklin's *Tom Jones* before turning to caricature in about 1780. His earlier works were published by the printseller Robert Wilkinson of Cornhill, forsaking him for Fores in about 1787. Gillray finally came to rest as chief caricaturist to Mrs. Humphrey at New and Old Bond Street, where he lodged till his death. Gillray was the first professional caricaturist in this country, he simplified the art of the amateurs by replacing archaic symbols with forceful design and his art training enabled him to work on a more heroic scale than his predecessors. His work hit very hard and as the artist was something of a poltical maverick, he was assiduously courted by all parties. His frequent satires on Royal extravagance such

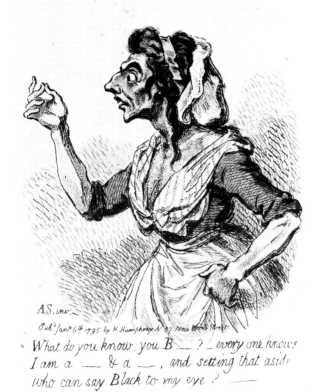

JAMES GILLRAY 1757-1815. 'Billingsgate Eloquence.' Published 6 January 1795. Engraving. 5ins. x 3¼ins. (12.7cm x 8.3cm).

317

as 'A Voluptuary under the horrors of Digestion' 1792 and the caricatures of Napoleon and Charles James Fox, created in their realism and savagery a whole new field for the caricaturist. Although much of his work dates from before 1800, a group of marvellous caricatures appeared in the early 1800s including 'Tiddy-Doll, the great French-Gingerbread Baker', 1806, 'Uncorking Old Sherry', 1805, 'The Plum-pudding in danger', 1805 and most famous of all 'The King of Brobdingnag and Gulliver', 1803. Gillray's last work was engraved in 1811 shortly before he became insane; his position was taken by the young George Cruikshank (q.v.). Original drawings by this artist are very rare, they show a very free pen line and strong influence of the Old Masters. He died on 1 June 1815 and was buried at St. James's Church, Piccadilly.

Colls: Ashmolean; BM; New York Pub. Library; V & AM.
Bibl: T. Wright, *The Caricatures of JG*, 1851; Joseph Grego, *The Works of JG*, 1873; Draper Hill, *Mr. G The Caricaturist*, 1965; Draper Hill, *Fashionable Contrasts: Caricatures by JG*; 1966; *Country Life*, 12 January 1967.
See illustrations (Colour Plates V p.56 and p.317).

GLAZIER, Louise M. fl.1900-1912
Wood engraver and illustrator. She was working at Mitcham in 1902 and at Bruges in 1906. Her domestic and village scenes recall the Newlyn School. She designed book plates and examples of her work occasionally come on the market.

Illus: *The Field Flowers Lore [1912]*.
Contrib: *The Dome [1900]*.
Exhib: Baillie Gall.; L.

GLENNIE, J.D. 1796-1874
Painter, etcher and amateur lithographer. He was born in 1796 and illustrated Maria Graham's *Letters On India* and *Views on the Continent* and contributed to *The Antiquarian and Topographical Cabinet*, 1811.

Exhib: RA, 1810-19.

GLICK
Contributor of cartoons to *Vanity Fair*, 1897. This has been identified as Count Gleichen, 1833-1891, who died in London or his daughter, Countess Feodora Gleichen who worked there as a sculptor.

GLIDDON, Charles fl.1865-1870
Illustrator. He apparently drew for an edition of Walter Scott's novels, studies for *Red Gauntlet* and *The Fortunes of Nigel* in pencil, brown ink and brown wash are in the Ashmolean Museum, Oxford.

GLOAG, Isobel Lilian ROI 1865-1917
Painter of romantic subjects, portraits and illustrator. She was born of Scottish parents in London in 1865 and studied at the St. John's Wood School, South Kensington and Paris and worked with M.W. Ridley (q.v.). She undertook poster design, flower paintings and stained glass work and was elected ROI in 1909. She died on 5 January 1917.

Illus: projected editions of: *William Tell* and *Loves Labour Lost*.
Contrib: *The Graphic [1910]*.
Exhib: B; G; L; RA; RBA; RI; ROI; SWA.

GLOVER, G.C.
Figure artist. He contributed illustrations to *Fun*, 1890-92, *Chums* and *Cassell's Saturday Journal*.

GOBLE, Warwick fl.1893-1925
Watercolour painter and illustrator. After being educated at the City of London School, he joined the staff of *The Pall Mall Gazette* and later *The Westminster Gazette* as artist. Goble was strongly influenced by Japanese art and by Chinese paintings, his colour washes are extremely subtle and stroked on with the brush, his compositions consciously oriental. He worked almost entirely for publishers like Messrs. Black and Messrs. Macmillan who were specialising in colour plate books. He made a tour of the French battlefields in 1919.

Illus: *Constantinople [A. Van Milligen, 1905]; The Water Babies [C. Kingsley, 1909]; The Green Willow and Other Japanese Fairy Tales [Grace James, 1910]; Folk Tales of Bengal; The Fairy Book [Mrs. Craik, 1914]; The Modern Readers, Chaucer; Treasure Island; Kidnapped [1924]; The Alhambra; The Greater*

Abbeys of England; The Book of Fairy Poetry.
Contrib: *The Minister [1895]; ILN [1897-98, 1912]; The World Wide Magazine [1898]; The Pall Mall Budget; The Windsor Magazine.*
Exhib: FAS, 1910, 1911; L; RA.

GODDARD, George Bouverie 1832-1886
Animal painter and illustrator. He was born at Salisbury in 1832 and after recognition as an infant prodigy, travelled to London in 1849 and spent two years studying at the Zoological Gardens. After this he returned to Wiltshire for a period and finally settled in London in 1857. Goddard made drawings for many magazines and contributed some humorous and sporting subjects. He died at Brook Green, London in 1886.

Contrib: *ILN [1865-84]; Punch [1865]; Once a Week [1866]; London Society [1868]; The Graphic [1880-84]*.
Exhib: B; G; L; RA; RBA, 1864-72.
Colls: Liverpool.

GODDARD, Louis Charles fl.1904-1921
Portrait painter. He worked at Stockport, Manchester and Wallasey, Cheshire. He contributed social subjects to *Punch*, 1904.

Exhib: B; L; N.

GODEFROY
French illustrator contributing comic genre strips to *Fun*, 1900, in the style of Caran D'Ache (q.v.).

Bibl: J. Pennell, *Pen Drawing and Pen Draughtsmen*, 1894, p.129, illus.

GODWIN, James -1876
Painter of genre, draughtsman and illustrator. Working in Kensington from 1846, having studied at the RA Schools. Godwin's draughtsmanship was very influenced by the German School and although his pencil work is extremely exact and delicate, it lacks real power. He was a regular exhibitor at London exhibitions and died there in 1876.

Illus: *The Dream Chintz [1851 (child's book)]*.
Contrib: *ILN [1853-67 (Christmas and decor)]; The Poetical Works of E.A. Poe [1853]; Poets of the Nineteenth Century [Willmott, 1857]; The Home Affections [Charles Mackay, 1858]; London Society [1863]*.
Exhib: BI, 1846, 1850; RA; RBA, 1846-51.
Colls: V & AM.

GOEDECKER, F.
Contributor to *Vanity Fair*, 1884-85, signing 'GD' or 'FG' in monogram.

GOLDIE, Cyril fl.1910-1925
Painter and illustrator, working in Liverpool. He contributed a headpiece and full page illustration to *The Quarto*, 1896, in a grotesque art nouveau style.

Exhib: L; NEA, 1910-22.

GOLDSMITH, J.
Amateur draughtsman. He contributed an illustration to Britton's *Beauties of England and Wales*, 1814.

GOODALL, Edward Angelo RWS 1819-1908
Landscape painter and illustrator. He was born on 8 June 1819, the son of E. Goodall, the engraver, and brother of F. and W. Goodall (qq.v.). He was educated at University College School, London and at the age of seventeen, won a Society of Arts silver medal for watercolour, 1836-37. In 1841 he was appointed artist to the British Guiana Boundary Expedition and travelled there with Sir Robert Schomburgh, remaining in South America for three years. In 1854-55, Goodall was artist correspondent to *The Illustrated London News* in the Crimea, and in succeeding years made study trips to France, Italy, Spain, Egypt, Tangiers, Turkey and Greece. He was elected ARWS, 1858 and RWS, 1864. He died on 16 April 1908 and was buried at Highgate.

Illus: *Twelve Views in the Interior of Guiana [Bentley and Schomburgh, 1840-41, AT 720]*.
Contrib: *ILN [1855]; Poets of the Nineteenth Century [Willmott, 1857]; Rhymes and Roundelayes*.

Exhib: BI, 1841; L; M; RA; RBA, 1841-60; RWS.
Colls: Ashmolean; BM; Dublin; Liverpool; Manchester; Sydney; V & AM.
Bibl: Chatto & Jackson, *Treatise on Wood Engraving*, 1861, p.598; M. Hardie, *Watercolour Paint. in Brit.*, Vol.III, 1968, pp.163-164 illus.

GOODALL, Frederick RA HRI 1822-1904

Landscape, genre and biblical painter and illustrator. He was born on 17 September 1822, the son of Edward Goodall, the engraver and brother of E.A. and W. Goodall (qq.v.). Studied engraving with his father and brother, encouraged by Ruskin and in 1837 won a Society of Arts silver medal. He travelled to Normandy in 1838, 1839 and 1840, to Brittany in 1841, 1842 and 1845 and to Ireland with F.W. Topham (q.v.) in 1843. He went to Egypt for eight months in 1858-59 and this to some extent changed his style; his earlier works followed the genre subjects of Wilkie, his later ones took the Nile and the Pyramids as their centre piece. He returned to Egypt again in 1870 with his brother E.A. Goodall. Goodall was elected RI, 1867, ARA, 1853 and RA, 1863 and became an Honorary Retired Academician in 1902. He died at Harrow, in the house designed for him by Norman Shaw, on 28 July 1904.

Contrib: *The Traveller [Goldsmith, Art Union, 1851]; Passages From The Poets [Junior Etching Club, 1862]; Rhymes and Roundelayes; Ministering Children.*

Exhib: B; FAS, 1894; G; GG; L; M; RA; RI; ROI.
Colls: BM; Leicester; Liverpool; Manchester; V & AM.
Bibl: *Reminiscences of FG*, 1902; Chatto & Jackson, *Treatise on Wood Engraving*, 1861, p.599; M. Hardie, *Watercol. Paint. In Brit.*, Vol.III, 1868, pp.163-164, illus.

GOODALL, Walter RWS 1830-1889

Painter and watercolourist. He was born in London in 1830, the son of Edward Goodall, the engraver and brother of E.A. and F. Goodall (qq.v.). He studied art at the Clipstone St. Academy, the Government School of Design and at the RA Schools. He was elected RWS in 1853 and spent the winter of 1868 in Rome making Venetian studies. He died at Clapham, Bedfordshire in 1889.

Contrib: *Recollections of the Great Exhibition of 1851 [1851].*
Exhib: RA; RWS.
Bibl: M. Hardie, *Watercol. Paint. in Brit.*, Vol.III, 1968, p.164.

GOODMAN, Arthur Jule fl.1890-1913

Illustrator and special artist. He was born at Hartford, Connecticut, U.S.A. and studied as an architect at the Institute of Technology, Boston. He worked as a lithographer with Matt Morgan (q.v.) and then left for Europe to study at Julian's in Paris and under Bouguereau. His

SIR FRANCIS CARRUTHERS GOULD 1844-1925. 'Birds of a Feather.' Caricatures of Kruger and the Duke of Bedford. Pen and ink. Signed with initials.
Woburn Abbey Collection

319

first published work was for *Harper's* in 1889 and on arrival in London, he became Special for *The Pall Mall Gazette* and contributed 'War Notes' making a considerable reputation as an illustrator of military subjects. He was working at Gedling, Nottinghamshire, from 1902 to 1913.

Illus: *Clarence [Bret Harte, 1897].*
Contrib: *The Girls' Own Paper [1890-1900]; The Pall Mall Magazine; The Pall Mall Budget [1893]; ILN [1893]; St. Pauls [1894]; Good Words [1894]; Good Cheer [1894]; The Minister [1895]; Pearson's Magazine [1896]; The English Illustrated Magazine [1895-97]; Madame; The Idler.*
Exhib: Nottingham; P.
Colls: V & AM.
Bibl: *The Idler,* Vol.9, pp.803-816, illus.

GOODMAN, Walter 1838-

Painter of portraits, genre and illustrator. He was born in London, 11 May 1838, the son of Julia Goodman, née Salaman, the domestic painter. He studied at Leigh's and travelled in Europe and in Cuba, 1864-69 and to North America. He exhibited regularly in London from 1859, including a portrait of Wilkie Collins. He was living at Brighton in 1889 and latterly at Henfield, Sussex in 1906.

Publ: *The Pearl of The Antilles or an Artist in Cuba.*
Contrib: *ILN [1877].*
Exhib: BI, 1859-61; RA; RBA, 1859-90; RSA.

GOODWIN, Ernest 'GEE' fl.1894-1903

Black and white artist in the style of Phil May. He was working at 20 St. Bride St., London E.C., 1902-03.

Contrib: *St. Pauls [1894]; Pick-Me-Up, [1895]; The Sketch; The Idler.*

GORDON, G.A.

Contributed illustration to *The Parade,* 1897.

GORDON, Godfrey Jervis (Jan) 1882-1944

Painter, etcher, lithographer and illustrator. He was born at Finchampstead, 11 March 1882 and was educated at Marlborough College and Truro School of Mines. He was art critic of *The New Witness,* 1916-19, of *The Observer* and *Athenaeum,* 1919 and of *Land and Water,* 1920. He collaborated with his wife on illustrated travel books. RBA, 1935. He signs his work 'J.G.' or 'Gordon'.

Illus: *Poor Folk in Spain [1922]; Misadventures with a Donkey in Spain [1924]; Two Vagabonds in the Balkans [1925]; Two Vagabonds in Languedoc [1925]; Two Vagabonds in Sweden and Lapland [1926]; Two Vagabonds in Albania [1927].*
Exhib: L; NEA; RA; RBA; RI.

GOSSE, Philip Henry 1810-1888

Zoologist and artist. He farmed in the United States and Canada before returning to England to devote himself to the study of insects in 1839. He illustrated many of his own books and was elected FRS in 1856; he was the father of Sir Edmund Gosse.

Publ: *The Canadian Naturalist [1840]; Introduction to Zoology [1843]; Birds of Jamaica [1847]; A Naturalist's Sojourn in Jamaica [1851, AT 688]; Rambles on the Devonshire Coast [1853]; The Aquarium [1854]; Manual of Marine Zoology [1855-56]; Actinologia Britannica [1858-60]; Romance of Natural History [1860].*
Bibl: E. Gosse, *Father and Son,* 1907.

GOSSOP, Robert Percy fl.1901-1925

Black and white artist, sometimes working in wash. He was a contributor to *Fun,* 1901, and was working at Henrietta St., Covent Garden, London in 1925.

Colls: V & AM.

GOUGH, Arthur J. fl.1897-1914

Landscape painter and illustrator. He was working at West Hampstead, 1903-14 and contributed black and white drawings to *The Rambler,* 1897.

Exhib: RA; RI.

GOULD, Elizabeth (née Coxon) 1804-1841

Ornithological painter. She was born at Ramsgate, the daughter of a sea captain and in 1829 married John Gould FRS, 1804-81, the author and publisher of *Gould's Birds.* She worked with the young Edward Lear in producing watercolours as guides to the finished illustrated works. She helped with *The Birds of Europe,* and *A Century of Birds From The Himalayan Mountains* and accompanied her husband to Australia, for his *Birds of Australia,* 1838-40. Her husband frequently took the credit for her work.

Bibl: *Country Life,* June 25 1964.

GOULD, Sir Francis Carruthers 1844-1925

Political cartoonist and caricaturist. He was born at Barnstaple on 2 December 1844, the son of an architect and after being educated in private schools, joined the London Stock Exchange. While working as a broker and jobber, he began to draw caricatures for his own amusement, eventually endowing them with his own brand of radicalism and publishing them. Gould illustrated for the Christmas numbers of *Truth,* became a member of the staff of *The Pall Mall Gazette* in 1890 and of *The Westminster Gazette,* 1893-1914, acting as assistant editor in 1896. He founded his own paper, *Picture Politics,* which ran from 1894-1914 and published numerous illustrated books. His reputation in the Edwardian period was considerable and Lord Rosebery was reported to have called him 'the greatest asset of the Liberal Party'. Gould was not a great artist, but he was a very political animal and had the talent to catch a likeness and develop a theme. His

PAUL MARY GRAY 1842-1866. Woman and child. Illustration study for The Quiver. *Pencil. 6⅜ins. x 4¾ins. (16.2cm x 12.1cm). Victoria and Albert Museum*

sketches of the sharp face of Joseph Chamberlain are amongst his best works and he introduced silhouette work into political satire. He was knighted in 1906 and died on 1 January 1925.

His cartoons are among the more attractive ephemera of the 1890s still obtainable.

Illus: *Michael's Crag [Grant Allen, 1893]; Who Killed Cock Robin? [1897]; Tales Told in the Zoo [1900]; Froissart's Modern Chronicles; The Struw-welpeter Alphabet [H. Begbie, 1900]; Political Caricature [1903]; Cartoons in Rhyme and Line [Sir W. Lawson, 1905].*
Contrib: *Vanity Fair [1879, 1890, 1897-99]; The Strand Magazine [1891]; Cassell's Family Magazine; Fun [1901].*
Exhib: Brook St. and Walker's Galleries, 1907-24.
Colls: BM; V & AM.
Bibl: *The Studio,* Winter No., 1900-01, p.40, illus.
See illustration (p.319)

GOURSAT, George See 'SEM'

GOW, Mary L. (Mrs. Hall) RI **1851-1929**
Figure artist and illustrator. She was born in London in 1851 and studied at the Queens Square School of Art and at Heatherley's. She married Sydney P. Hall, MVO, the painter and illustrator (q.v.) and was elected NWS in 1875 and RI in the same year.
Contrib: *The Quiver [1890]; The Graphic [1892]; Cassell's Family Magazine.*
Exhib: B; G; GG; M; New Gall.; RA; RI.

GOWER, Charlotte
Botanical illustrator. She provided the illustrations in colour and tail-pieces for *The Wild Flowers of Great Britain,* by R. Hogg and George W. Johnson, 1863-64.

GOWER, Francis LEVESON-, 1st Earl of Ellesmere KG 1800-1857
Amateur artist. He was born 1 January 1800 and is only known to have illustrated one work, his wife's *Journal of a Tour in the Holy Land.* 1841, AT 384. He died 18 February 1857.

GOWER, S.J.
Contributor to *The Illustrated London News,* 1860.

GRAHAM, J. **fl.1810-1840**
Contributor to *Bell's British Theatre* and *Cookes British Theatre.*

GRAHAM, Peter RA ARSA **1836-1921**
Landscape painter. He was born in Edinburgh and studied under R.S. Lauder at the Trustees Academy and with John Ballantyne. He settled in London in 1866, being elected ARA in 1877 and RA in 1881. He made a considerable reputation as a painter of Scottish scenery and was elected ARSA in 1860. He died at St. Andrews on 19 October 1921.
Contrib: *London Society [1878].*
Exhib: B; G; L; M; RA; RSA.
Colls: Worcester.

GRAHAM, Thomas Alexander Ferguson **1840-1906**
Figure and portrait painter. He was born at Kirkwall in 1840 and studied at the Trustees Academy, 1855 alongside Orchardson, J. Pettie, P. Graham and J. MacWhirter (qq.v.) under R.S. Lauder. On moving to London, he set up house with Pettie and Orchardson and exhibited there from 1863. He was elected HRSA in 1883 and received a commendation at the Paris Exhibition, 1900. He died in Hampstead, 24 December 1906.
Contrib: *Good Words [1861-63].*
Exhib: B; G; GG; L; M; New Gall; RA; RBA; RI; ROI; RSA.

CHARLES GREEN RI 1848-1898. 'Quilp in a Wherry.' Illustration for The Old Curiosity Shop, *by Charles Dickens 1871. Pen and wash with chinese white. 3⅞ins. x 5½ins. (9.9cm x 14cm).*
Victoria and Albert Museum

GRAHAM, Winifred

Illustrator of children's books. She was described in *The Studio,* Vol.18, 1899-1900, as an artist of 'poke-bonnetted and short waisted maidens . . . made familiar to us by Miss Greenaway'.

Illus: *Lamb's Poetry for Children [1898]; Mrs. Leicester's School [C. & M. Lamb, 1899].*
Bibl: R.E.D. Sketchley, *English Book Illustration*, 1902, pp.101, 166.

GRANBY, The Marchioness of See RUTLAND, Violet, Duchess of

GRANDVILLE, Jean-Ignace Isidore Gérard 1803-1847

Draughtsman, watercolourist, caricaturist and lithographer. He was born at Nancy on 15 September 1803 and went to Paris in 1823, where he had considerable success as a lithographer and produced a series of cartoons on domestic and political matters. He made many drawings for *La Caricature,* specialising in metamorphosed objects and animals, wildly fantastic and offering a nineteenth century foretaste of surrealism. His books were widely bought in England and many English versions appeared. He died insane on 17 March 1847.

Illus: *The Flowers Personified [1855]; Comical People [c.1860]; Vie Privée et Publique des Animaux [1867].*
Cols: Nancy; Rochefort; Tours.
Bibl: C. Baudelaire, *The Painter of Modern Life,* edited by J. Mayne, 1964, pp.181-182.

GRANT, Charles Jameson 'CJG' fl.1831-1846

Draughtsman, wood engraver and caricaturist. He was the leading artist of the penny Radical papers during the Chartist agitation, producing spirited if rather coarse work. He does not appear to be the same as Charles Grant, portrait painter, exhibiting at RA, 1825-39.

Cols: Witt Photo.
Bibl: M.D. George, *English Political Caricature,* Vol.II, 1959, pp.237-238, 245, 250, illus.

GRANT, William James 1829-1866

History painter, wood engraver and illustrator. He was born at Hackney in 1829 and attended the RA Schools in 1845. He concentrated on scriptural subjects, occasionally borrowing themes from modern poetry. He died at Hackney in 1866.

Illus: *Favourite Modern Ballads; Bloomfield's Farmers Boy.*
Exhib: BI, 1849-63; RA.
Bibl: Chatto and Jackson, *Treatise on Wood Engraving,* 1861, p.598.

GRAVE, Charles 1886-

Black and white artist, illustrator and watercolourist. He was born at Barrow-in-Furness in 1886 and was educated at Tottenham Grammar School. He began to draw for *Punch* in 1912 and was then successively on the staff of *Sporting Life, The Daily Chronicle,* and *The Daily Graphic,* serving in the First War with the Middlesex Regiment. Grave was at his best with low life characters, especially those of dockland and was a good draughtsman of shipping and boats although the situations are usually less funny than the sketches. For a time in the 1930s he was relief cartoonist of *Punch.* His work is not uncommon. He signs his work Chas Grave.

Contrib: *Lest We Forget, Illustrated Sporting and Dramatic News.*
Bibl: R.G.G. Price, *A History of Punch,* 1957, p.248.

GRAVES, The Hon. Henry Richard 1818-1882

Amateur caricaturist and portrait painter. He was the second son of the 2nd Baron Graves and was born on 9 October 1818. On marrying in October 1843 Henrietta Wellesley, Graves formed links with the Paget and Wellesley families whose members frequently feature in his sepia caricatures. They are very amateur works, but delightfully fanciful, the characters dramatised and cigars and other objects flying about with wings. An album of society portraits in pencil was sold at Sotheby's on 1 January 1976.

Exhib: RA, 1846-1881.

GRAY, Alfred

Contributor of comic strips and caricatures to *Judy,* 1887-89.

GRAY, D.B.

Black and white artist. He specialised in animal drawings, particularly horses and humanised dogs.

Contrib: *The English Illustrated Magazine [1895]; Punch [1902].*

GRAY, George Kruger fl.1915-1940

Painter, poster artist and sculptor, working in London. The Victoria and Albert Museum has a series of process engravings by him for book illustration.

Exhib: RA, 1919-40

GRAY, Millicent Ethelreda 1873-

Figure and portrait painter and illustrator. She was born in London, 12 September 1873, and studied at the Cope and Nicols School of Art and at the RA Schools.

Illus: *A Book of Children's Verse; Little Women [Alcott].*
Contrib: *The Queen's Gift Book [c.1915]; Princess Mary's Gift Book [c.1915].*
Exhib: G; L; Leicester Gall; P; RA; ROI; SWA.

GRAY, Paul Mary 1842-1866

Illustrator. He was born in Dublin on 17 May 1842 and after attending a convent, worked in Dublin as an artist. He taught drawing at the Tullabeg School and worked for Dillon, the Dublin printseller, at the same time exhibiting at the RHA, 1861-63. He worked in London from 1863, getting his earliest commissions from *Punch* for whom he drew initials and socials which were thought very attractive. By the middle 1860s he was quite successful, but was struck down by consumption and died in London on 14 November 1866. Spielmann considered that Gray's drawings lacked 'backbone' and Reid considered them rather overrated, but they are among the most gentle pastoral studies of the great black and white period.

Illus: *Medwyns of Wykeham; Kenneth and Hugh.*
Contrib: *Punch ·[1863-65]; Once a Week; Good Words; London Society; Shilling Magazine; The Argosy; The Broadway; Jingles and Jokes for Little Folks [1865]; A Round of Days [1866]; Idyllic Pictures [1867]; Ghosts Wives [1867]; The Spirit of Praise [1867]; The Savage Club Papers [1867]; Longfellow [The Chandos].*
Exhib: RBA, 1867.
Cols: BM; V & AM.
Bibl: M.H. Spielmann, *The History of Punch,* 1895, p.517; Forrest Reid, *Illustrators of The Sixties,* 1928, p.262.
See illustration (p.320).

GRAY, Mrs. Robert

Amateur artist. She was the wife of Bishop R. Gray and is believed to have designed churches in her husband's South African diocese. She illustrated *Three Months Visitation,* 1856, AT 346.

GRAY, Ronald RWS 1868-1951

Figure and landscape painter and illustrator. He was born in 1868 and studied at Westminster School of Art under Fred Brown and at Julian's. One of his oil paintings, 1908, was bought by the Chantrey Bequest in 1925. He was elected NEA, 1923, ARWS, 1934 and RWS, 1941.

Contrib: *Cassell's Family Magazine [1898-99]; The Pall Mall Budget; The Idler.*
Exhib: G; GG; L; M; NEA; P; RA; RHA; RI; RSA.
Cols: BM; Imperial War; Tate; V & AM.

GRAY, Tom

Subject painter, working from Howland Street, London in 1866. He exhibited at the BI that year and contributed illustrations to *London Society,* 1860, 1868; *The Graphic,* 1872 (rural).

GREAVES, R.B. Brook

Caricaturist in watercolours, working in art deco style, c.1920.

GRECO, J.

Wood engraver, who contributed illustrations to *The Book of the Sword,* Sir Richard Burton, 1884.

GREEN, Charles RI **1840-1898**

Painter and illustrator. He was born in 1840 and studied at Heatherley's and with J.W. Whymper (q.v.), thereby establishing himself as a master of figure and genre subjects and an accomplished draughtsman on the block. He was elected ARI in 1864 and RI in 1867, quickly establishing himself in the forefront of book illustrating, particularly in novels with a period setting. One of his major achievements was in illustrating *The Old Curiosity Shop* for Dickens *Household Edition*, in 1871, bringing a delicacy to the pen work and softness to the washes that made a great contrast with the earlier interpretations. Green was also involved in the early numbers of *The Graphic,* and his work was admired by Van Gogh there; this was yet another side of his character, the social realist, with sketches of street folk and factory workers. He exhibited oils at the RA from 1862-83. He died at Hampstead 4 May 1898.

The finest of Green's drawings date from the 1860s and 1870s and are rare. He signs his work CG.

Illus: *Playroom Stories [Craik, 1863]; Our Untitled Nobility [Tillotson, 1863]; Tinykins' Transformation [M. Lemon, 1869]; The Doom of St. Querec [Burnand, 1875]; The Old Curiosity Shop [1876]; Dorothy Forster [Walter Besant, 1897].*
Contrib: *Once A Week [1860]; Churchman's Family Magazine [1863-64]; ILN [1866]; Cassell's Magazine [1867]; The Graphic [1869-86]; London Society; Sunday Magazine; Good Words For The Young; Sunday at Home; English Sacred Poetry of the Olden Times [1864]; Life and Lessons of Our Lord [1864]; Choice Series [1864]; Watts Divine and Moral Songs [1865]; The Nobility of Life [L. Valentine, 1869]; Episodes of Fiction [1870]; Thornbury's Legendary Ballads [1876]*
Exhib: B; G; L; M; RA; RI; ROI.
Colls: BM; Cardiff; Leicester; V & AM.
Bibl: J. Pennell, *Pen Drawing and Pen Draughtsmen,* 1894, pp.279-300, 304, illus.; *English Influences on Vincent Van Gogh,* Arts Council, 1974-75.
See illustration (below and pp.321, 324).

GREEN, Henry Towneley RI **1836-1899**

Illustrator. He was born in 1836 and was the brother of Charles Green (q.v.). After a career in banking, he took up art and followed his brother into illustrating and watercolour work, though never with the same success. He was elected ARI in 1875, RI in 1879 and ROI in 1883.

Contrib: *Once A Week [1867]; The Sunday Magazine [1869]; Cassell's Magazine [1870]; Golden Hours [1869]; Good Words For The Young [1870]; Thornbury's Legendary Ballads [1876]; ILN [1872 and 1887]; The Cornhill Magazine [1885].*
Exhib: B; L; M; RA; RBA, 1865-67; RI.
Colls: V & AM.
Bibl: *English Influences On Vincent Van Gogh,* Arts Council, 1974-75.

GREEN, William Curtis RA ARIBA **1875-1960**

Architect. He was born on 16 July 1875 and was educated at Newton College, South Devon, and studied at the RA Schools. He is best remembered as the architect of the Dorchester Hotel, Park Lane, London. He was elected ARA in 1923 and RA in 1933. He won the RIBA Gold Medal in 1922.

Illus: *Old Cottages and Farmhouses in Surrey [1908].*
Exhib: G; RA; RSA.
Bibl: *The Drawings of W. Curtis Green,* foreword by A.E. Richardson, 1949.

CHARLES GREEN RI 1848-1898. 'A Consultation.' Sketch for unidentified illustration. Pen and ink. 4⅜ins. x 6ins. (11.1cm x 15.2cm). Victoria and Albert Museum

CHARLES GREEN RI 1848-1898. 'The Caledonian Market.' Pen and ink with chinese white. 12ins. x 20ins. (30.5cm x 50.8cm). Victoria and Albert Museum

GREENAWAY, Kate RI 1846-1901

Watercolourist and illustrator. She was born in London, the daughter of J. Greenaway, engraver to *The Illustrated London News* and was a cousin of Richard and Frank Dadd (qq.v.). She studied art at the Islington School, Heatherley's and at the Slade under Legros and began to exhibit at the RA in 1877. The same year, she began to work for Edmund Evans, the printer and publisher, who recognised her unusual talent for capturing an enchanted Regency world, and used it in the illustration of numerous children's books. Her style was loosely based on designs by artists such as Stothard, whom she admired, but endowed with a child-like innocence and charm which greatly appealed to the Victorians. Ruskin liked her work and encouraged her although he would have liked her to study directly from nature which she never did. Her popular books were being produced in editions of over ten thousand copies in the 1880s and beginning to sell widely in the United States. From 1883-1895 she produced a yearly almanack and at other times designed bookplates and painted portraits in oil. She was elected RI in 1889. She died in Hampstead in 1901.

Kate Greenaway's style had its effects on clothing and other accessories as well as on book illustration where it spawned a great number of copyists. Her meticulous pen drawings in outline, with no shadow, are charming if rather static studies; her watercolours are really the pen drawings lightly washed over with muted colours. Miss Greenaway's work was never very difficult to copy or imitate, and fakes abound.

Illus: *Aunt Louisa's London Toy Books: Diamonds and Toads [1871]; Madam D'Aulnoy's Fairy Tales [c.1871]; Fairy Gifts [Kathleen Knox, 1874]; The Quiver of Love [1876]; Poor Nelly [Mrs. Bonavia Hunt, 1878]; Topo [G.E. Brunefille (Lady C. Campbell), 1878]; Under The Window [K. Greenaway, 1878]; The Heir of Redclyffe [C.M. Yonge, 1879]; Amateur Theatricals [W.H. Pollock, 1879]; Heartsease [C.M. Yonge, 1879]; The Little Folks Painting Book [1879]; Kate Greenaway's Birthday Book [1880]; The Library [Andrew Lang, 1881]; A Day in a Child's Life [1881]; Mother Goose [1881]; Little Anne [1882]; Almanack [1883-95]; Fors Clavigera [John Ruskin, 1883-84]; A Painting Book [1884]; Language of Flowers [1884]; The English Spelling Book [W. Mavor, 1884]; Dame Wiggins of Lee [1885]; Marigold Garden [1885]; Kate Greenaway's Alphabet [1885]; An Apple Pie, The Queen of the Pirate Isle [Bret Harte, 1886]; Queen Victoria's Jubilee Garland [1887]; Rhymes For The Young Folk [William Allingham, 1887]; Orient Line Guide [1888]; The Pied Piper of Hamelin [R. Browning, 1888]; Kate Greenaway's Book of Games*

[1889]; The Royal Progress of King Pepito [B.F. Creswell, 1889]; The April Baby's Book of Tunes [1900].

Contrib: *The People's Magazine [1868]; Little Folks [1873-80]; Cassell's Magazines [1874-]; ILN [1874-82]; St. Nicholas; The Graphic; The American Queen; Every Girl's Annual [1882]; The Girls' Own Paper [1879-90].*

Exhib: FAS, 1894, 1898, 1902; RA; RBA, 1870-75; RI.

Colls: Ashmolean; BM; Manchester; V & AM.

Bibl: M.H. Spielmann, *KG,* 1905; H.M. Cundall, *KG Pictures From Originals Presented by Her to John Ruskin . . .,* 1921; A.C. Moore, *A Century of KG,* 1946; M. Hardie, *Watercol. Paint. in Brit.,* Vol.III, 1968, p.143, illus.

See illustration (Colour Plate XII p.173).

GREGORY, Charles RWS 1849-1920

Historical and genre painter and illustrator. He was born at Milford, Surrey and was working in London, 1880 and at Godalming, 1894, finally settling at Marlow, Bucks, where he died on 21 October 1920. He was elected ARWS in 1882 and RWS in 1884.

Contrib: *ILN [1876, 1877, 1879].*

Exhib: B; G; L; M; RA; RBA; RWS.

Colls: Bristol; Liverpool.

GREGORY, Edward John RA PRI 1850-1909

Painter and illustrator. He was born at Southampton on 19 April 1850, grandson of John Gregory, engineer to Sir John Franklin's Expedition. He was educated in Southampton and worked for some time in the P & O Company's drawing office, 1865, and with Hubert Von Herkomer (q.v.). On the latter's advice he went to London in 1869 and studied at the South Kensington Schools and at the RA Schools, 1871-75. Gregory was employed on the decorations of the new Victoria and Albert Museum and was employed by *The Graphic* to draw on the wood, often finishing the work of S.P. Hall (q.v.). He was elected RI in 1876 and became PRI in 1898. He was elected ARA in 1879 and RA in 1898. He settled at Great Marlow, Buckinghamshire and died there on 22 June 1909.

Gregory specialised in scenes of life aboard ship and did some illustrations of the Battle of Hastings for an unidentified edition. The former genre subjects were admired by Vincent Van Gogh.

Contrib: *The Graphic [1870-83].*

Exhib: B; G; L; M; RA; RI; ROI; RSA.

Colls: Ashmolean; Tate.

Bibl: *The English Influences On Vincent Van Gogh,* Arts Council, 1974-75.

GREGORY, Margaret

Irish illustrator and daughter of Lady Gregory of Coole Park. She contributed woodcut illustrations to *The Kiltartan Wonder Book* by Lady Gregory, c.1918, and is associated with the Cuala Press, Churchtown, Dundrum, County Dublin. Her brother, Robert Gregory contributed two designs for the Press including one for this book, before being killed in action, January 1918. She signs her work 🄼🄶

Bibl: Liam Miller, *The Dun Emer Press, Later The Cuala Press,* with a Preface by Michael B. Yeats. Dolmen Press, Dublin, 1973.

GREIFFENHAGEN, Maurice RA **1862-1931**

Painter and illustrator. He was born in 1862 and studied at the RA Schools, where he won the Armitage Prize. He became Headmaster of the Life School, Glasgow School of Art, in 1906, was elected ARA in 1916 and RA in 1922. His painting 'Women By A Lake' was purchased by the Chantrey Bequest in 1914 and 'Dawn' in 1926. The earlier part of Greiffenhagen's career was devoted almost exclusively to illustrative work for books and magazines. Throughout the 1890s he was producing high quality black and white work, some of it in its economy of line and free handling, clearly influenced by Phil May. He is particularly associated with the illustrations to Sir Henry Rider Haggard's novels and somewhat oddly appears to have been D.H. Lawrence's favourite artist. He died at St. John's Wood, 26 December 1931.

Illus: *Vain Fortune [George Moore, 1894].*
Contrib: *Judy [1889-90]; Black and White [1891-96]; Fun [1892]; ILN [1892-98]; The Butterfly [1893]; The Pall Mall Budget [1894]; Daily Chronicle [1895]; Pick-Me-Up [1895]; The Unicorn [1895]; Ally Sloper's Half*

MAURICE GREIFFENHAGEN RA 1862-1931. 'The Holy Flower.' Illustration to a book of the same name, by Sir H. Rider Haggard, 1915. Watercolour and chinese white. 19ins. x 13ins. (48.3cm x 33cm). Author's Collection

Holiday; The Sketch; The Lady's Pictorial; The Windsor Magazine.
Exhib: B; G; L; M; NEA; RA; RBA; ROI; RSA.
Colls: Author; V & AM.
Bibl: J. Stanley Little, *Maurice Greiffenhagen and his Work,* The Studio, Vol.9, 1897, pp.235-245, illus.
See illustration (below left).

GREIG, James RBA **1861-1941**

Painter and illustrator in black and white. He was born at Arbroath in 1861 and went to London to study art in 1891 and to Paris in 1895, settling in London in 1896. Greig became art critic of *The Morning Post* and a noted historian, publishing a monograph on Raeburn and editing *The Farrington Diaries,* 1922-28. RBA, 1898. His domestic and rustic figure drawings in Punch and elsewhere are attractive if a little weak.

Contrib: *Black & White [1892]; The English Illustrated Magazine [1893-96]; St. Pauls [1894]; The Sketch [1895-96]; The Temple [1896]; Good Words [1898-99]; Punch [1902-3]; Cassell's Family Magazine; The Ludgate Monthly; The Idler; The Pall Mall Magazine; The Windsor Magazine; The Quiver.*
Exhib: RBA, 1897-1907.
Colls: V & AM.

GREIG, John **fl.1807-1824**

Landscape painter. A draughtsman, engraver and lithographer, he was associated with J.S. Storer in publishing *The Antiquarian Cabinet,* and supplying many antiquarian drawings.

Illus: *Promenades Across London [D. Hughson, 1817]; Views of London [J. Hakewill]; Tours in Cornwall [F.W.L. Stockdale, 1824].*
Contrib: *Britton's Beauties of England & Wales; Border Antiquities of England and Wales [1817].*

GRIFFITHS, Tom **fl.1880-1904**

Landscape painter and illustrator. He was working for *The Graphic* from 1880-87, mostly military subjects. He may have acted as a Special in Africa in 1881, but it is more likely that he was an under-study to T.W. Wilson and worked up his sketches at home. He was living at Amberley from 1893 and at Bideford from 1901.

Exhib: B; G; L; M; RA; RBA; RHA; RI.

GRIGGS, Frederick Landseer Maur RA **1876-1938**

Draughtsman, etcher and book illustrator. He was born at Hitchin, Hertfordshire in 1876 and was educated privately. Griggs was one of the younger group of artists, who, influenced by Morris, brought to their art a great exactitude and a reverence for the work of past craftsmen. He had established himself by the early 1900s as the most sensitive of architectural illustrators, chiefly through his drawings to Messrs. Macmillans 'Highways and Byways' series, which appeared between 1902 and 1906 and then at longer intervals till 1928. Griggs removed to Chipping Campden, Gloucestershire before the First World War, and remained there till his death, strongly identifying himself with its Guild. 'Though his sympathies extended to Georgian and later architecture' ran The Times obituary, 'it can be said of Griggs, who was a Roman Catholic, that his spiritual home was in the Middle Ages and his works were full of a nostalgia for that period.' His meticulous work shows a direct sympathy for stone buildings, carving and the clean structure of regional styles from which a craftsman would be able to work stone by stone; his landscapes are akin to those of Samuel Palmer (q.v.). Griggs' range included the designing of two sets of Roman letters, known as Littleworth and Leysbourne in 1933 and 1934. He bacame ARA in 1922 and RA in 1931. He was made Hon. ARIBA in 1926. He died on June 7 1938 after being taken ill on a visit to London. A centenary exhibition was held at the Ashmolean Museum, March-May, 1976.

Illus: *The Collected Works of William Morris; The Life of G.F. Watts; Seven Gardens and a Palace [EVB, 1900]; Stray Leaves From a Border Garden [1901]; The Chronicle of a Cornish Garden [1901]; Highways and Byways in Hertfordshire [1901]; Memorials of Edward Burne-Jones [1904]; Highways and Byways in London; Highways and Byways in Berkshire [1906]; A Book of Cottages and Little Houses [C.R. Ashbee, 1906]; Highways and Byways in Buckinghamshire [1908]; Old Colleges of Oxford [1912]; Highways and Byways in Lincolnshire [1912]; Highways and Byways in Northamptonshire [1914]; Highways and Byways in Leicestershire [1918]; Highways and Byways in Nottinghamshire [1928]; Highways and Byways in Sussex; Highways and Byways in Oxford and The Cotswolds; Highways and Byways in South Wales; Highways and Byways in Cambridge and Ely; Essex.*

Contrib: *The Oxford Almanack [1922-23]*.
Exhib: G; L; RA; RE; RSA.
Colls: Ashmolean; BM; V & AM.
Bibl: *The Studio*, Winter No., 1900-01, p.63, illus.; R.E.D. Sketchley, *English Book Illus.*, 1902, pp. 54, 134; H. Knight, *The Work of FLG*, Print Collectors Club, No. 20, 1941; F.A. Comstock, *A Gothic Vision: FLG*, Ashmolean, 1966.

GRIMM, Constantine von 'Nemo' or 'C de Grimm'
German painter and illustrator. He contributed six cartoons to *Vanity Fair,* 1884.

GRIP pseudonym of Alfred BRICE c.1895-1896
Cartoonist for *The Sketch,* c.1895-96. Brice specialised in grey wash figures with large and detailed heads, highlighted with white on cheeks and hair. His range is usually political and literary, although the Victoria and Albert Museum has an admirable caricature of Aubrey Beardsley. He signs his work GRIP (with toucan), thus

Contrib: *The Ludgate Monthly [1893-94]*.
Colls: V & AM.

GRISET, Ernest Henry 1844-1907
Illustrator and comic draughtsman of animals. He was born at Boulogne-sur-Mer in 1844, and studied under Louis Gallait, presumably in Brussels. The latter had strong links with England and it may have been through him that Griset came to London in the mid-60s. Although intending to become a serious watercolourist, he was spiritually akin to Grandville (q.v.) in his delight in drawing animals and people and showing their basic similarities, not in caricature, but in behaviour. His mournful beasts and gangling half-savage hunters in pursuit of them, occupy a world of half legend, critical and comic. His work was exhibited first in a bookshop in Leicester Square and after attracting the notice of the Dalziel Brothers and Tom Hood, he was invited to join *Fun* and eventually *Punch.* Griset's style, delicate pen drawings, beautifully tinted with soft colours, are more French than English in their subtlety; one would not guess from the economic use of line and the precision of hand that the artist was a very rapid and hard worker, dashing off hundreds of such for *Griset's Grotesques,* 1867. Griset died on 22 March 1907, having outlived his popularity, but his sketches have a charm that has gained them a special place among collectors.

Illus: *The Hatchet Throwers [James Greenwood, 1867]; Legends of Savage Life [James Greenwood, 1867]; Among The Squirrels [Mrs. Deniston, 1867]; Vikram and The Vampire [1869]; Robinson Crusoe [1869]; The Rare Romance of Reynard The Fox [1869]; The Hunchback of Notre Dame [Hugo, 1879]*.
Contrib: *Fun; Punch [1867]; Once a Week [1867]; The Broadway [1867]; Good Words For The Young [1870-71]; The Graphic [1870-71]; Hood's Comic Annual [1878]*.
Exhib: RBA, 1871-72 (animals).
Colls: Author; BM; V & AM.
Bibl: Hesketh Hubbard, 'A Forgotten Illustrator'; *The Connoisseur,* 1945; L. Lambourne, *Country Life,* January, 1977.
See illustration (below).

GROB, Conrad 1828-1904
Painter of history and genre, lithographer, engraver and illustrator. He was born at Andelfingen, Switzerland on 3 September 1828 and did not begin his artistic career until he was thirty-eight, when he joined the Munich Academy and studied under Ramberg. He died at Munich 4 January 1904.

Contrib: *The Illustrated Times [1860. (Italian War)]*.
Exhib: Paris, 1900.
Colls: Basle; Berne.

ERNEST HENRY GRISET 1844-1907. 'Two Ragamuffins.' Pen and washes. 4½ins. x 6ins. (11.4cm x 15.2cm). Author's Collection

GROOME, William Henry Charles RBA fl.1881-1914

Landscape painter and illustrator. He was working at Ealing from 1881-1914 and became RBA in 1901.

Contrib: *ILN [1889-92 (rustic)]; Chums.*
Exhib: GG; RA; RBA; RI; ROI.

GROSSMITH, Walter Weedon 1854-1919

Painter and actor. He was born in 1854, the brother of George Grossmith and was educated at Simpson's School, Hampstead, before being trained at the Slade and RA Schools. He was the author of the Victorian classic, *Diary of a Nobody*, which first appeared in *Punch* in 1888. Grossmith was a talented black and white artist and landscape painter, but this increasingly gave way to his success as a comedy actor and later to his management of the Vaudeville Theatre, 1894-96 and the Avenue Theatre, 1901. He died 14 June 1919.

Exhib: B; GG; L; M; RA; RBA; RHA; ROI.
Colls: V & AM.
Bibl: WG *From Studio to Stage,* 1912.

GROVES, S.J.

Draughtsman. Contributed illustrations to *Pen and Pencil Pictures From The Poets,* Edinburgh, 1866.

GUERARD, Eugène Charles François 1821-1866

Painter and lithographer. He was born at Nancy 6 July 1821 and died there 6 July 1866. He studied with Paul Delaroche and exhibited at the Salon in 1842, 1848, and 1852. He contributed to *The Illustrated London News,* 1855.

GUILLAUME, Albert 1873-1942

Figure painter and humorous draughtsman. He was born in Paris on 14 February 1873 and studied in the Atelier Gérome and illustrated numerous French books. He died at Faux in the Dordogne in 1942.

Contrib: *The Graphic [1901-03].*
Exhib: L, 1910-24.

GULICH, John Percival RI 1865-1898

Illustrator, engraver and caricaturist. He was born at Wimbledon in 1864 and worked for many of the leading magazines in the 1890s, having begun with *The Graphic,* 1887 and *Harper's Magazine.* He was elected RI, 1897 and was a member of the Langham Sketch Club. He died of typhoid fever in 1898.

Illus: *Three Partners [Bret Harte, 1897]; John Ingerfield [Jerome K. Jerome, 1897].*
Contrib: *The Graphic [1887-97]; The Strand Magazine [1891]; Black & White [1892]; The Idler [1892]; Chums [1892]; The Quiver [1895]; Cassell's Family Magazine; The Pall Mall Magazine.*
Exhib: GG; L; Paris, 1900; RA; RBA; RI.
Colls: V & AM.

GUNNIS, Louis J. fl.1887-1897

Painter and illustrator. He worked in London 1887-97 and specialised in domestic scenes.

Contrib: *ILN [1889]; Judy [1889]; The Sphere [1894]; The Sketch [1895 (dramatic ports)]; The English Illustrated Magazine [1895-96]; The Ludgate Monthly; Chums; The Idler; The Royal Magazine.*
Exhib: L; RA, 1887-97.
Colls: V & AM.

GURNEY, Ernest T.

Landscape painter. He was working at Ampthill Square, Hampstead Road in 1900-02. He contributed to *The Idler* and exhibited at the RA in 1900.

GUTH, Jean Baptiste fl.1883-1921

French painter and caricaturist. He was a regular contributor to *Vanity Fair,* 1889-1908. He signs his work GUTH or JB GUTH.

GUTHRIE, James Joshua 1874-1952

Painter and illustrator and designer of bookplates. He was born in 1874 and although he had no formal training, studied as assistant to Reginald Hallward (q.v.). Guthrie was a talented hand printer and founded the Pear Tree Press at South Harting, Hampshire in May 1905. Guthrie was one of the leading wood engravers associated with the development of the private presses and the return to romanticism. His range extended from the illustrations to children's books to those of poets living and dead. His mood was a direct inheritance from the work of Blake, Palmer and Calvert (qq.v.) with his own idiosyncracies of curly trees, eddying water and wild sky, ideal for the brooding quality of Poe. The poet Gordon Bottomley has left an amusing description of his method of work. 'So far as I have seen he takes a piece of granulated cardboard and washes it over with a few brushfuls of a thin mixture of plaster of Paris. Then he digs into that with a pen and Indian ink. Then he puts on a film of Chinese White (Paris, India, China) what riches all at once.' This was in a letter to John Nash with whom some comparison might be found. Guthrie founded and illustrated a magazine called *The Elf* in 1895 and decorated rhymesheets for Harold Monro's Poetry Bookshop.

Illus: *Wedding Bells [1895]; The Elf [1895-1904]; The Little Man in Scarlet [1896]; An Album of Drawings [1900]; Virgil's Alexis [1905]; The Beatitudes [1905]; Midsummer Eve [Gordon Bottomley, 1905]; In Summer Time [Dorothy Radford, 1906]; A Second Book of Drawings [1908]; Echoes of Poetry [1908]; The Poems of E.A. Poe [1908]; The Riding of Lithend [Gordon Bottomley, 1909]; The Paradise of Tintoretto [1910]; The Blessed Damozel [1911 (decor)]; Six Poems [Edward Eastaway]; Trees [Harold Monro, 1916]; Root and Branch [1916]; Space and Man; The Castle of Indolence.*
Contrib: *The Yellow Book [1896]; The Quartier Latin [1896]; The Dome [1897]; The Windmill [1899]; The Page [1899]; The Idler.*
Colls: V & AM.
Bibl: *The Artist,* May-Aug., 1898, pp.238-241, illus; Sept., 1900, pp.197-202, illus.
See illustration (below).

DREAMLAND.

JAMES JOSHUA GUTHRIE 1874-1952. 'Dreamland.' Wood engraving. 9ins. x 7⅝ins. (22.9cm x 19.4cm).
Victoria and Albert Museum

CONSTANTIN GUYS 1802-1892. 'The Strawberry Roans.' Ink and wash.

GUYS, Constantin Ernest Adolphe Hyacinthe 1802-1892

Figure artist in pen and watercolour. The known facts about this great French draughtsman are scarce. He was born at Flushing, Holland of French parentage in 1802 and died in Paris in poverty at the advanced age of ninety in 1892. He is believed to have gone to Greece to fight in the War of Independence alongside Byron, action of any kind and particularly that of soldiers and horses always inspiring him. By the 1840s he was in England, acting as French tutor to the family of Dr. T.C. Girtin, son of Girtin the watercolourist. Guys gained employment with the newly-founded *Illustrated London News* in 1843 and appears to have worked for them until as late as 1860. He covered the Crimean War for the magazine in 1854-56, although his work is often unsigned though very recognisable, in the journal. He also went to Spain, Italy, Germany, Turkey and Egypt as their special correspondent. He seems to have been particularly associated with the English press, even by the French — the Goncourts mention him in their Journal in April 1858 as "the draughtsman of the ILLUSTRATED LONDON". Baudelaire brilliantly analysed Guys' style in his celebrated essay 'The Painter of Modern Life' (*Figaro*, 1863). Guys, characteristically mercurial and elusive, is referred to by his initials only. This and much else about his work, his casual attitude to completed drawings, his sketching from memory not life, his dismissal of the conventions, place him squarely in the literary bohemia associated with Balzac.

With little else to go on, the drawings speak for themselves about the originality and verve of Guys the artist. Baudelaire describes him as 'the painter of the passing moment' and links him to the vision of the moralist and the novelist. These rapid pen and ink sketches with light colour washes radiate their own period in a way that the finished illustrators could not attain. For Guys they are statements about society and leaves from the notebook of a reporter, in which the symbols of crowd or event matter more than their delineation. For Baudelaire they were living history, the documents on which the age would be judged, for him, a very valid role for a minor master. The drawings have remained time-less with the sparkle of life so vividly apparent, the tawdry mock heroic demi-monde, the glitter of soldiery in the Park, the vibrant rapidity of the Brighton coach. In later years Guys used less colour and his sketches became more synthetised, but he had left actual illustrative work far behind. Although he was not widely known in his own time (Thackeray mentions him, Gavarni copied him) he had a growing following by the early twentieth century when many of his values, freedom of expression and immediacy came to be recognised. He is now a much sought-after artist and his drawings are among the highest priced of illustrators work.

Colls: BM; Paris (Petit Palais); V & AM.
Bibl: Charles Baudelaire, 'Un peintre de la vie moderne' *Figaro* 3 December 1863; Armand Dayot, *Catalogue de l'Exposition de l'oeuvre de Constantin Guys*, 1904; Henri Frantz, 'A Forgotten Artist', *The Studio*, Vol.34, 1905, pp.107-112; Gustave Geffroy, *CG, l'historien du Second Empire*, 1904-20; *CG*, Collection Des Maîtres, 1949; *The Painter of Modern Life and Other Essays By Charles Baudelaire*, edited by Jonathan Mayne, 1964.
See illustration (above).

GWENNETT, W. Gunn fl.1903-1940

Landscape painter and illustrator. He worked in Richmond, Surrey, 1903 and London.

Contrib: *Punch [1909]*.
Exhib: L; RA; RI; RSA.

GYFFORD, Edward 1772-1834

Architect, draughtsman and illustrator. He was born in 1772 and studied at the RA Schools, winning the Gold Medal in 1792. He published *Designs For Small Picturesque Cottages and Hunting-Boxes*, 1807 and contributed illustrations to *The Beauties of England and Wales*, 1810.

Exhib: RA, 1791-1801.
Bibl: H.M. Colvin, *Biog. Dict. of English Architects*, 1954, p.256.

HAAG, Carl 1820-1915

Watercolourist and illustrator. He was born at Erlangen in Bavaria on 20 April 1820, the son of an amateur artist. He studied art at Nuremberg, 1834, and Munich, 1844-46 while working as a miniaturist and book illustrator. He worked in Brussels and then came to London in 1847 to study watercolour and attend the RA Schools. He visited Italy in 1847, travelled to Cairo with F. Goodall (q.v.) in 1858 and to Egypt in 1860, where he lived with the desert tribes. He ran studios in both London and Oberwesel, finally retiring to the latter in 1903 and dying there on 24 January 1915. He was elected AOWS in 1850 and OWS in 1853.

Contrib: *ILN [Christmas, 1869].*
Exhib: FAS, 1882; L; M; RA; RBA; RWS.
Colls: BM; Leeds; V & AM.
Bibl: M. Hardie, *Watercol. Paint. in Brit.,* Vol.III, 1968, p.67.

HACKER, Arthur RA 1858-1919

Portrait and genre painter and occasional illustrator. He was born in London on 25 September 1858, the son of Edward Hacker, the line engraver. He was educated in London and Paris and studied art at the RA Schools, 1876, and under Bonnat in Paris, 1880-81. He became a popular portrait painter and travelled widely in Italy and North Africa collecting material for classical and religious subjects. He was elected ARA in 1894 and RA in 1910. He died in London 12 November 1919.

Contrib: *The Graphic [1903 (story illus.)].*
Exhib: B; G; L; M; RA; RI; ROI.

HADDON, Arthur Trevor 1864-1941

Portrait and genre painter. He was born in 1864 and studied at the Slade School under Legros from 1883-86, winning the painting medal in 1885. He worked in Spain, 1887 and at the Herkomer School, Bushey. 1888-90, becoming a Fellow of it in 1891. He then studied in Rome from 1896-97 and was elected RBA in 1896.

Publ: *The Old Venetian Palaces; Southern Spain.*
Illus: *The Snow Garden [Elizabeth Wordsworth, 1897].*
Exhib: FAS; L; M; New Gall; P; RA; RBA; RHA; RI; ROI.

HADGE

Contributor of a cartoon to *Vanity Fair,* 1899.

HAGHE, Louis RI 1806-1885

Painter and illustrator of architecture with figures. He was born at Tournai, Belgium, in 1806 and studied lithography under de la Barrière and J.P. de Jonghe, afterwards coming to London where he went into partnership with William Day, the publisher. From the 1830s onwards, Haghe issued collections of lithographs of his travels and frequently lithographed the works of other artists, particularly David Roberts's *Holy Land.* He was President of the RI from 1873-1884 having been a member since 1835. Haghe's work is extremely accurate if lacking in imagination. He died in London in 1885.

Illus: *Sketches in Belgium and Germany [1840-50, AT 35 and 37]; Portfolio of Sketches [1850, AT 41].*
Contrib: *Bold's Travels Through Sicily [1827, AT 265]; Dickinson's Comprehensive Picture of the Great Exhibition of 1851.*
Exhib: NWS, 1835-
Colls: BM; Glasgow; Manchester; V & AM.
Bibl: M. Hardie, *Watercol. Paint. in Brit.,* Vol.III, 1968, p.93, illus.

HAITÉ, George Charles RI 1855-1924

Landscape painter and illustrator. He was born at Bexley in 1855, the son of a designer. After being educated at Mitcham College, he taught himself to draw and began work as a designer at the age of sixteen. He exhibited at the RA from 1883 and worked in black and white for a number of magazines, designing the covers of *The Strand Magazine* and *The Strand Musical Magazine,* 1891. He was the President of the Langham Sketching Club, 1883-87 and 1908. He was elected RI in 1901, and died at Bedford Park, 31 March 1924.

Illus: *Haité's Plant Studies.*
Colls: BM; Leeds; Manchester.
Bibl: *Who Was Who 1916-28.*

HAKEWILL, James 1778-1843

Architect, draughtsman and illustrator. He was born in 1778, the son of John Hakewill, painter and decorator, and trained as an architect and exhibited designs at the RA from 1800. He was however more of an antiquary than a practical designer and turned increasingly to the publications of tours undertaken by him and his wife, also a talented artist. Hakewill had some association with J.M.W. Turner (q.v.) who made finished drawings from his Italian sketches. He died on 28 May 1843.

Illus: *The History of Windsor and Its Neighbourhood [1813]; A Picturesque Tour of Italy [1818-20, AT 683]; Picturesque Tour in the Island of Jamaica [1825]; Plans, Sections and Elevations of Abattoirs of Paris [1828]; An Attempt to Determine the Exact Character of Elizabethan Architecture [1835]; Antiquarian and Picturesque Tour [1849].*
Bibl: H.M. Colvin, *Biog. Dict. of English Architects,* 1954, p.259.

HALCOMBE, Will fl.1897-

Black and white artist specialising in comic history subjects. He contributed pen and watercolour drawings to *The Sketch,* 1897, mostly signed and dated.

Colls: V & AM.

HALE, Edward Matthew ROI 1852-1924

Painter and illustrator. He was born at Hastings in 1852 and studied art in Paris under Cabanel and Carolus Duran. He was Special Artist for *The Illustrated London News* in the Russo-Turkish War, 1877-78 and in Afghanistan. He was a Colonel in the Middlesex Rifle Volunteers. Elected ROI in 1898 and died at Godalming, 24 January 1924.

Exhib: B; G; L; M; RA; RBA; RI; ROI.
Colls: Leeds.

HALKETT, George Roland 1855-1918

Artist, illustrator and writer on art. He was born at Edinburgh on 11 March 1855 and studied art in Paris. He later returned to Edinburgh and concentrated on making caricatures for the press and producing book illustrations. He was art critic of the *Edinburgh Evening News,* 1876, joined the *Pall Mall Gazette* as political cartoonist in 1892 and was successively art editor of *The Pall Mall Magazine,* 1897, and Editor, 1900-05. He was most celebrated for his caricatures of Mr. Gladstone which he issued in *New Gleanings From Gladstone* and a *Gladstone Almanack* and for *The Irish Green Book* produced during the Home Rule debates of 1887. His style is of the *portrait chargée* type adopted by 'Ape', but in the 1900s there is a definite Beggarstaff influence, chalky black lines on toned paper. He travelled extensively in the colonies and died in London, December 1918.

Contrib: *Edinburgh University Liberal Association [booklet, 1883 (frontis.)]; St. Stephen's Review [1885]; Pall Mall Budget [1893]; Pall Mall Magazine [1897]; Punch [1897-1903]; The Butterfly.*
Illus: *The Elves and The Shoemaker [child's book, n.d.].*
Exhib: G; RSA.
Colls: V & AM.

HALL, Basil fl.1886-1888

Black and white artist specialising in military subjects. He contributed story illustrations to *The Graphic* in 1886-87 and events in 1888.

HALL, E.

Black and white artist contributing genre and social subjects to *The Illustrated Times,* 1856-59.

HALL, Frederick 1860-1948

Figure and landscape painter. He was born at Stillington, Yorks, in 1860 and studied at Lincoln Art School and under Verlat at Antwerp. He worked for fifteen years at Newlyn, Cornwall and drew for *The Graphic* in 1902, and caricatured for *Black & White*, 1891, *The Sketch*, 1894.

HALL, Harry fl.1838-1886

Equestrian artist and illustrator. Hall worked first as a horse painter at Tattersall's in London, later moving to Newmarket where he became friendly with Mark Lemon, the Editor of *Punch*. He became chief artist on *The Field* and contributed only one drawing to *Punch*. He was the father of Sydney Hall (q.v.).

Contrib: *Tattersall's British Race Horses; Sporting Review [1842-46 (engs. and title)]; ILN [1857-58, 1866-67].*
Exhib: BI, 1847-66; RA, 1838-86; RBA, 1839-75.

HALL, L. Bernard 1859-1935

Portrait and figure painter. He was born in Liverpool, 28 December 1859 and was educated at Cheltenham College before studying art at South Kensington, Antwerp and Munich. He began his professional career in 1882, exhibiting at the RA from that year. In 1892, he was appointed Director of the National Gallery of Victoria at Melbourne, a post he held until his death on 14 February 1935.

Contrib: *The Graphic [1887]; Black & White.*
Exhib: L; M; NEA; RA; RBA; ROI.

HALL, Sydney Prior MVO 1842-1922

Painter, draughtsman and illustrator. He was born at Newmarket in 1842 and studied with his father Harry Hall (q.v.), with Arthur Hughes (q.v.) and at the RA Schools. Hall was a popular painter of military subjects and illustrated many stories, his most famous collaboration being on *Tom Browne's School Days,* 1869, with his teacher, Arthur Hughes. He was a favourite painter of the Royal Family and accompanied Lord Lorne to Canada in 1881. He was a *Graphic* contributor from its first year, 1870, and a Special Artist in the Franco-Prussian War. See E.J. Gregory.

Illus: *The Law and The Lady [Wilkie Collins, 1876].*
Contrib: *The Quiver [1869]; The Graphic [1870-1906]; Dark Blue [1871-73]; The Sketch.*
Exhib: G; L; M; New Gall.; RA; RHA; RI.

HALLIDAY, Michael Frederick 1822-1869

Amateur artist and illustrator. He exhibited at the RA from 1853-56 and at the RBA in 1853. The National Portrait Gallery has his portrait of Joseph Priestley; he died at Thurlow Place, London in 1869.

Contrib: *Passages From the Poems of Tom Hood [Junior Etching Club, 1858].*

HALLS, Robert fl.1892-1909

Miniature painter. He worked in London and Birkenhead and contributed to *The Yellow Book*, 1895.

Exhib: NEA; P; RA; RMS.

HALLTHORPE

Comic artist contributing to *Fun*, 1901.

HALLWARD, Cyril R. fl.1886-1890

Comic artist in pen and ink specialising in figure subjects. His drawings are poor and the penline rather scratchy.

Contrib: *Judy [1886-89]; ILN [1889]; Lady's Pictorial [1890]; Puck and Ariel [1890].*

HALLWARD, Ella F.G. fl.1896-98

Illustrator. Perhaps the daughter of Reginald and Adelaide Hallward, (qq.v.). She exhibited at the Arts and Crafts Exhibition Society in 1896 an illustration for an untraced book issued by Messrs. H.S. Nicholls. *The Studio* said: 'One can scarce recall any other attempt to work in white upon black which has mastered the problem so easily.'

Exhib: New Gall., 1898.
Bibl: *The Studio*, Vol. 9, 1897, p.283, illus.

HALLWARD, Reginald 1858-1948

Painter, stained glass artist, illustrator and designer. He was born 18 October 1858 and studied art at the Slade and at the Royal College of Art. He had J.J. Guthrie (q.v.) as an assistant for some time. Hallward ran The Woodlands Press at Shore near Gravesend from about 1895 to about 1913, printing various books of verse by Michael and Faith Hallward illustrated by his own chalk drawings. His wife, Adelaide (q.v.) was also an artist and illustrator.

Illus: *Vox Humana; Apotheosis; Wild Oats; Flowers of Paradise; The Babies Quest [1913, all Woodlands Press]; Rule Britannia; Quick March; The Religion of Art; The Next Step; Stories From The Bible [E.L. Farrar, 1897].*
Contrib: *Punch [1876]; Root and Branch [No. 4, 1916].*
Exhib: G; L; NEA; New Gall.; RA; RBA.

HALLWARD, Mrs. Reginald (née Adelaide Bloxam) fl.1888-1922

Artist and illustrator. She was married to Reginald Hallward (q.v.) and helped him with his various ventures. She illustrated *The Child's Pictorial* for The S.P.C.K. and exhibited five works at the RA between 1888 and 1890. She was still painting though not exhibiting in 1922.

HALSWELLE, Keeley ARSA 1832-1891

Landscape painter and illustrator. He was born at Richmond, Surrey, of Scottish parents on 23 April 1832. After studying at the British Museum and in Edinburgh, Halswelle started a career in book illustration from 1860 onwards, working for a number of leading magazines. Gleeson White comments that 'in these you find those water-lilies in blossom which in after years became a mannerism in his landscape foregrounds.' From 1869 he lived in Italy for some years painting peasant subjects, and he also worked in Paris. A new dimension to his art as an illustrator was revealed in November 1975, when Sotheby's Belgravia offered a remarkable ink drawing of 1858, entitled 'A Child's Dream of Christmas'. Centred on a sleeping child surrounded by many small fairy figures, it places him firmly in the tradition of Richard Doyle (q.v.). He was elected ARSA in 1865 and RI in 1882.

Illus: *The Princess Florella and the Knight of the Silver Shield [1860]; Six Years in a House-boat.*
Contrib: *ILN [1860]; Good Words [1860]; Pen and Pencil Pictures From the Poets [1866]; Scott's Poems [c.1866].*
Exhib: RA, 1862-91; RBA, 1875-79.
Colls: Dublin; Glasgow; Leeds; Tate.
Bibl: *The Art Journal*, 'The Works of KH', 1879, p.49.

HAMERTON, Robert Jacob RBA

Illustrator and lithographer. Born in Ireland, he was teaching drawing in a school in County Longford by the age of fourteen and then travelled to London to study lithography under Charles Hullmandel. He contributed to *Punch*, 1843-48 a number of cartoons of an Irish flavour, signing himself first 'Shallaballa' and then with a 'Hammer on the side of a Tun'. He continued to work on stone as a book illustrator until 1891 'when the drawings on the huge stones became too much for my old back' (Spielmann, pp.452-453). He was a close friend of H.G. Hine (q.v.). RBA, 1843.

Illus: *Comic Blackstone [G. a'Beckett]; Life of Goldsmith [Forster].*
Exhib: BI, 1831-47; RA and RBA, 1831-58.

HAMILTON, Lady Anne 1766-1846

Amateur artist. She was born in 1766, daughter of the 9th Duke of Hamilton and died unmarried in 1846. She contributed a drawing of Ashton Hall to *The Beauties of England and Wales*, 1807.

HAMILTON, James 1819-1878

American illustrator. He was born in Ireland in 1819 but went to America when young. He returned to England during the years 1854-56 and later became an art master in Philadelphia, where he died in 1878. He was most celebrated for illustrating an edition of the *Arabian Nights*.

HAMLEY, General Sir Edward Bruce 1824-1893

Amateur illustrator. He was born in 1824 and after entering the Royal Horse Artillery in 1843, became Colonel in 1855 and served in the Crimean War. He contributed articles to *Blackwood's* and *Fraser's*

magazines in 1858 and was Professor of Military History at Sandhurst, 1859-64. He was Commandant of the Staff College, 1870-77 and KCB, 1882, serving as MP for Birkenhead, 1885-92.

Illus: *The Campaign of Sebastopol [1855, AT 236].*

HAMMERSLEY, James Astbury　　　　　**1815-1869**
Headmaster of the Manchester School of Design, 1849-1862. He illustrated *The Shipwreck of the Premier*, G.R. Dartnell, 1845.

HAMMOND, Christine M. Demain "Chris"　　**fl.1886-1910**
Painter and illustrator. Sister of Gertrude E. Demain Hammond (q.v.). She lived with her sister in London, 1886-90 and with her was the principal illustrator to *St. Paul's*, 1894. Her penwork is rather free and she excels in costume subjects in a style not unlike that of the Brocks eighteenth century pastiches.

Illus: *Goldsmith's Comedies [1894-96]; Sir Charles Grandison; Castle Rackrent* and *Popular Tales; The Absentee [Maria Edgeworth, 1895]; Belinda* and *Helen [Edgeworth, 1896]; The Parents Assistant [Edgeworth, 1897]; The Charm [W. Besant]; Henry Esmond [W.M. Thackeray, 1897]; Emma; Sense and Sensibility [Jane Austen]; John Halifax Gentleman [Mrs. Craik, 1898]; Stories From Shakespeare [T. Carter, 1910].*
Contrib: *The Pall Mall Budget [1891-92]; The Ludgate Monthly [1891 and 1895]; The Idler [1892]; The English Illustrated Magazine [1893-96]; St. Paul's [1894]; The Quiver [1894-95]; Madame [1895]; The Temple [1896]; Pearson's Magazine [1896]; Cassell's Family Magazine [1898]; Pick-Me-Up.*
Exhib: RA, 1886-93; RBA, 1886-90; RI; ROI.
Colls: V & AM.
See illustration (below).

CHRISTINE HAMMOND fl.1886-1910. 'Lor! Ain't I glad!' Drawing for illustration in The English Illustrated Magazine. *Pen and ink. Signed.*
Victoria and Albert Museum

HAMMOND, Gertrude E. Demain　RI　　　**1862-1953**
Painter and illustrator. She was born in Brixton in 1862 and studied art at the Lambeth School, 1879 and at the RA Schools, 1885, gaining sketch and decorative design prizes there. From about 1892 she was engaged in illustrative work, becoming a very accomplished pen draughtsman particularly of female figures. She worked in oil and watercolour as well as in black and white and after her marriage in 1898, painted from West Kensington, 1902-14 and from Stow-on-the-Wold, 1925.

Illus: *The Clever Miss Foillett [J.K.H. Denny, 1894]; frontis. to novels by Robert Barr [1897]; The Virginians [W.M. Thackeray, 1902]; Martin Chuzzlewit; Our Mutual Friend [Dickens, 1903]; George Eliot [American edition, 1907]; Arethusa [Marion Crawford, 1907]; The Beautiful-Birthday Book [c.1907]; Fairies of Sorts [Mrs. Molesworth, 1908]. Colour illus. to Shakespeare [1902-03]; The Pilgrims Progress [1904]; Faerie Queen [1909]; Stories From Shakespeare [1910].*
Contrib: *The Quiver [1890]; The Ludgate Monthly [1891]; The Queen; The Idler [1892]; St. Paul's [1894]; Madame [1895]; The Yellow Book [1895]; The Minister [1895]; Lady's Pictorial; Pick-Me-Up.*
Exhib: L; M; RA; RBA, 1887-89; RHA; RI.
Colls: Gateshead; Shipley; V & AM.

HAMNETT, Nina　　　　　　　**1890-1956**
Portrait and landscape painter and illustrator. She was born in Tenby, South Wales in 1890 and studied at the London School of Art and became a member of the London Group, 1917. She contributed lively and linear figure sketches to *The Gypsy*, 1915.

Exhib: L; NEA, 1913-17.

HANCOCK, Charles　　　　　　**fl.1819-1868**
Sporting artist, illustrator and drawing master. He was teaching at Marlborough in 1819, Reading, 1827-28, Wycombe, 1829, Aylesbury, 1830, Knightsbridge, 1831-49 and Highbury, 1849-67. He was a very prolific artist, illustrated an edition of *Nimrod* and contributed to *Tattersall's English Race Horses* and *The Sporting Review*, 1842-46.

Exhib: BI, 1827-67; NWS; RA, 1819-47.

HANKEY, William Lee　　　　　　**1869-1952**
Landscape painter in oil. He was born at Chester on 28 March 1869 and educated at King Edward's School, Chester; he served in the First World War, 1914-18 and was a member of the RI from 1898-1906 and 1918-1924. He died in 1952.

Illus: *The Deserted Village [Goldsmith]; The Compleat Angler [Walton].*
Publ: *An Old Garden; At the Well.*
Exhib: Paris; RA; RBA; RI.

HANSCOM, Adelaide
Illustrator. She contributed drawings to an edition of *Omar Khayyam* published by Messrs. Harrap in 1908.

HARDING, Emily J.　　　　　　**fl.1877-1902**
Miniaturist and illustrator of children's books. She was married to the painter Edward William Andrews, worked closely with T.H. Robinson (q.v.) and was a translator as well as artist.

Illus: *An Affair of Honour [Alice Weber, 1892]; The Disagreeable Duke [E.D. Adams, 1894]; Fairy Tales of the Slav Peasants and Herdsmen; Hymn on the Morning of Christ's Nativity [1896].*
Exhib: RA, 1877, 1897-98; RMS.
Bibl: R.E.D. Sketchley, *English Bk. Illus.*, 1903, pp.112, 166.

HARDING, James Duffield　　　　　**1798-1863**
Watercolourist, topographer, lithographer and teacher. He was born at Deptford in 1788 and studied with Samuel Prout and Charles Pye, the engraver. Preferring drawing to engraving, he worked from an early age as a landscape artist, exhibiting at the RA from 1810. He was an excellent lithographer and worked for Hullmandel producing folios from the works of Bonington, Roberts and Stanfield. He visited the Rhine, Italy and Normandy in the 1820s, 1830s and 1840s, producing books of his travels and at the same time issuing copy-books for amateur artists. He was highly regarded by John Ruskin, whose drawing-master he had been. Finished watercolours and studies are seen with some frequency on the market, those prepared for the

books, in pencil with slight high-lighting.

Publ: *Lithographic Drawing Book [1832]; Art, or the Use of the Lead Pencil [1834]; Principles and Practices of Art [1845]; Lessons on Trees [1852].*
Illus: *Views in Spain [E.H. Locker, 1824, AT 147]; Britton's Cathedrals [1832-36 (figures)]; Sketches At Home and Abroad [1836. AT 29]; The Book of South Wales [S.C. Hall, 1861].*
Exhib: BI; OWS; RA; RBA.
Colls: Ashmolean; BM; Fitzwilliam; Glasgow; Manchester; Nottingham; V & AM.
Bibl: M. Hardie, *Watercol. Paint. in Brit.*, Vol. III, 1968, pp.24-27.

HARDWICKE, Elizabeth Yorke, Countess of -1858

Amateur artist. She was the daughter of 5th Earl of Balcarres and married Philip, 3rd Earl of Hardwicke in 1782. She died on 26 May 1858.

Publ. and Illus: *The Court of Oberon or The Three Wishes [1831, AL 421 lith.].*

HARDY, Dorothy fl.1908-1925

Illustrator of children's books. Contributed drawings to *In Nature's School* by Lillian Gask, 1908. Working at Long Eaton, Derby in 1925.

HARDY, Dudley RBA RI 1865-1922

Artist and illustrator. He was born at Sheffield, 15 January 1867, the son of T.B. Hardy, the marine painter. He was educated at Boulogne School and at University College School, London, and studied art at Düsseldorf, at Antwerp with Verlat, 1884-85 and in Paris. It was his period in Paris and his contact with French chalk drawings and poster art that had the most lasting influence on his style. On his return to England, he was able to give a panache to his illustrative work which was only surpassed by Phil May (q.v.), using his black lines economically and mastering the black and white spaces of the page. He is at his best when most dashing, the more careful sketches can sometimes verge on the pretty. A prolific magazine artist, he drew many theatrical posters, including most of the Gilbert and Sullivan operettas and other Savoy Theatre productions. His oil paintings, colourful and with strong impasto are often of oriental and biblical subjects. He became RBA, 1889 and RI, 1897.

Illus: *The Humour of Holland [Werner, 1894]; The Bell Ringer of Angels [Bret Harte, 1897]; Sensations of Paris [R. Strong, 1912].*
Contrib: *ILN [1889-94]; Illustrated Bits; Puck and Ariel [1890]; The Idler [1892]; The English Illustrated Magazine [1893-97]; The Pall Mall Budget [1894]; The Ludgate Monthly [1895]; Eureka [1897]; The Longbow [1898]; The Gentlewoman; The Sketch; The Minister; Punch [1900-02]; The Graphic [1902, 1910].*
Exhib: G; L; M; New Gall.; RA; RBA; RI; ROI.
Colls: Author; Leeds; Newport.
Bibl: E. Spence, 'Some Leaves From Mr. Dudley Hardy's Sketch Book', *The Studio*, Vol.8, 1896, pp.33-38; A.E. Johnson, edited by, *DH, RI, RMS Brush, Pen and Pencil Series*, c.1920; P.V. Bradshaw, *The Art of the Illustrator*, 1918.
See illustration (below).

HARDY, Evelyn

Contributed small military drawing to *The Illustrated London News*, 1889.

HARDY, F.C.

Brother of Dudley Hardy (q.v.). He contributed to *The Longbow*, 1898.

HARDY, Heywood RWA 1842-1933

Animal painter, etcher and illustrator, decorator. He came from Bristol but settled in London in about 1870 having exhibited landscapes and animal paintings from 1861. He was elected RE, 1880, ROI, 1883 and ARWS, 1885. He contributed illustrations to *The Illustrated London News*, 1876 (Christmas) and *The Graphic*, 1880 (Christmas colour). He worked in North London and latterly at Littlehampton.

DUDLEY HARDY RBA RI 1866-1922. 'Their College Boys.' Illustration for London Opinion, *1894. Pen and ink, and wash, 9½ins. x 15ins. (24.1cm x 38.1cm).*

HARDY, M.D.
Animal illustrator. Contributed to *The Strand Magazine,* 1891.

HARDY, Norman H. **fl.1864-1914**
Illustrator, etcher. He worked for most of his life in London, but in 1896 was attached to the *Sydney Herald,* New South Wales. He specialised in archaeological drawings for *The Illustrated London News,*1889-90.
Exhib: Dudley Gall.; RA, 1891.

HARDY, Paul **fl.1886-1899**
Historical painter and illustrator. Hardy worked at Bexley Heath, Kent and married the artist Ida Wilson Clarke. He is seen at his best in costume romances and adolescent series, like Jarrald's 'Books For Manly Boys', 1894. A prolific, competent but unexciting purveyor of adventure.
Illus: *Little Peter [L. Malet, 1888]; Children of the New Forest [1892]; A Jacobite Exile [G.A. Henty]; The Whispering Wilds [Debenham]; Afloat in a Gypsy Van [Thompson]; That Bother of a Boy [Stebbing]; Sayings and Doings in Fairyland; Lord Lynton's Ward [1892]; Barker's Luck [Bret Harte, 1897].*
Contrib: *The English Illustrated Magazine [1886]; Sporting and Dramatic News; The Quiver; The Boys' Own Paper [1890]; Black & White [1891]; Strand Magazine [1891]; Chums [1892]; St. Pauls [1894]; The Rambler [1897]; The St. James's Budget [1898]; Cassell's Family Magazine; Cassell's Saturday Journal; The Gentlewoman; The Ludgate Monthly; The Girls' Own Paper; The Wide World Magazine.*
Exhib: L; RA.

HARDY, Ruth **fl.1895-1898**
Portrait and figure painter. Contributed social illustrations to *The English Illustrated Magazine,* 1895.
Exhib: P.

HARDY, T.D.
An illustration by this untraced artist appears in Willmott's *Poets of the Nineteenth Century,* 1857. It seems unlikely to be an error for Thomas Bush Hardy 1842-1897.

HARE, Augustus John Cuthbert **1834-1903**
Writer of guide-books, illustrator and topographer. He was born in Rome in 1834 and, left an orphan, was adopted by his aunt and uncle. After an unhappy childhood, he was educated at Harrow and University College, Oxford. He travelled abroad in the 1860s and began to publish guide-books of the places he had visited. on his own admission he had visited every town and almost every village in Italy and France. He settled in England at St. Leonards, and died there in 1903.
Publ: *Epitaphs From Country Churchyards;* Murray's Handbooks for *Berks, Bucks, Oxfordshire, Durham* and *Northumberland; Memorials of a Quiet Life [1872-76]; Walks in Rome [1871]; Days Near Rome; Cities of Northern Italy; Cities of Central Italy; Cities of Southern Italy; Venice; Wanderings in Spain; Sketches of Holland and Scandinavia; Walks in London.*
Exhib: Leicester Gall., 1902.
Colls: Dundee; Leeds.

HARE, St. George RI **1857-1933**
Portrait and subject painter and illustrator. He was born in Limerick in 1857 and studied with N.A. Brophy and then at the South Kensington Schools, 1875. RI, 1892. Died 30 January 1933.
Illus: *The Dead Gallant [Tristram, 1894 (with Hugh Thomson)].*
Contrib: *The Graphic [1893, 1899 and 1912].*
Exhib: G; L; M; RA; RBA; RHA; RI; RWA.
Colls: V & AM.

HARE, Thomas M.
Scientific illustrator to *The Illustrated London News,* 1847-49.

HARGRAVE, John Gordon **1894-**
Artist and writer. He was born in 1894, the son of Gordon Hargrave, landscape painter. Educated at the Wordsworth School, Hawkshead, Hargrave produced illustrations for *Gulliver's Travels* and *The Rose and The Ring,* 1909 and was chief cartoonist of the *London Evening*

Times in 1911 at the age of seventeen. He joined the staff of C. Arthur Pearson in 1914.
Bibl: *Modern Book Illustrators and their Work,* Studio, 1914.

HARKER, E.
Contributed illustration to *The Illustrated London News,* 1860.

HARMSWORTH, Alfred Charles William **1865-1922**
Viscount Northcliffe
Millionaire newspaper proprietor and founder of *The Daily Mail,* 1896. Harmsworth apparently contributed sketches of the Arctic to *The English Illustrated Magazine,* 1895, perhaps in connection with exploration schemes that he was financing.

HARPER, Charles G. **1863-1943**
Artist, illustrator and author. He was born in 1863 and from the late 1880s was producing a steady stream of books on the English countryside, illustrated by himself. He specialised in coaching scenes and represented another nostalgic look backwards at the 18th century, a favourite Edwardian pastime. He died in Surrey on 8 December 1943.
Illus: *Royal Winchester [1889]; The Brighton Road [1892]; From Paddington to Penzance [1893]; The Marches of Wales [1894]; The Dover Road [1895]; The Portsmouth Road [1895]; Some English Sketching Grounds [1897]; Stories of the Streets of London [1899]; The Exeter Road [1899]; The Bath Road [1899]; The Great North Road [1900].*
Contrib: *The Pall Mall Budget [1891-92].*
Exhib: L, 1886.
Bibl: R.E.D. Sketchley, *English Bok. Illus.,* 1903, pp.47, 134.

HARPER, Henry Andrew **1835-1900**
Author and painter. He was born at Blunham, Bedfordshire in 1835 and specialised in landscapes of the Holy Land. He accompanied the Earl of Dudley to the Near East, but in 1874, failed to be elected to the NWS. He died at Westerham in 1900.
Contrib: *ILN [1872 (Christmas)].*
Exhib: L; RA; RBA; RI.

HARPER, H.G. "G G" **1851-**
Sporting journalist and artist. He was born in Cheshire in 1851 and lived for most of his life at Epsom, where he trained and rode his own race-horses. He hunted with the Surrey foxhounds and wrote several sporting novels and books.
Illus: *Romance of the Brighton Road [c.1892].*

HARPER, T. **fl.1817-1843**
Portrait painter and miniaturist. He exhibited at the RA from 1817-1843 and contributed illustrations to *Heath's Gallery* 1836.

HARRISON, Charles
Black and white artist and cartoonist. A very prolific contributor to *Punch* in the period 1896-1914, Harrison brought a rather more modern and jokey style into the paper during its formal years. His drawings are not carefully hatched black and white work, but vigorous and imaginative cartooning with the flatness of the Japanese print and the outline of French caricaturists such as Mars (q.v.). He was one of a number of artists who used comic ancients for his jokes. He was later cartoonist on *The Daily Express* and contributed work to American magazines. He sometimes signs his work Harry's Son.
Contrib: *The Strand Magazine [1891]; Chums; The St. James's Budget; Funny Folks; Cassell's Saturday Journal; Punch [1896-1914].*

HARRISON, Emma Florence **fl.1887-1914**
Figure painter and illustrator. She was working in London from 1887 and specialised in illustrating poetry and children's books in a later Pre-Raphaelite style deriving something as well from William Morris.
Illus: *In The Fairy Ring [1908]; Poems of Christina Rossetti [1910]; Guinevere [Tennyson, 1912]; Early Poems of William Morris [1914].*
Exhib: RA, 1887-91.

HARRISON, George L. fl.1881-1904

Figure and domestic painter, working in West Kensington. He contributed hunting subjects to *The Illustrated London News*, 1884-86.

Exhib: RA; RBA, 1881-1904.

HARRISON, Thomas Erat 1853-1917

Sculptor, painter, illustrator and engraver. Although not a very prolific illustrator, Harrison drew for books at various times and designed bookplates. Two examples of the latter, dated 1887 and 1907 are in the Victoria and Albert Museum.

Exhib: GG; L; RA; RHA.

HART, Dorothy

Possibly a member of the Birmingham School, clearly influenced by it. She was working at Heathdale, Harborne, Birmingham in 1897, when she won a *Studio* competition.

Bibl: *The Studio*, Vol.II, 1897, p.71, illus.

HART, Frank 1878-1959

Black and white figure artist. He was born at Brighton on 1 November 1878 and was drawing for magazines from the age of twenty. He was a regular contributor to *Punch*, most frequently in the 1920s, where his work is notable for fine penmanship and a carefully observed view of country life and ways. Hart was a lecturer on black and white art and gave many talks throughout the country, drawing directly on to the blackboard. He died in 1959.

Publ: *Dolly's Society Book [1902]; How The Animals Did Their Bit [1914-18]; Andrew, Bogie and Jack; One Long Holiday.*
Illus: *Master Toby's Hunt; Little Lass; Peter and Co.*
Contrib: *The Temple Magazine [1896-97]; The Graphic; Punch [1914].*
Exhib: RA; RI.
Colls: Brighton; Eastbourne.

HART, William fl.1823-1894

Landscape painter. He was born at Paisley, 31 March 1823 and emigrated to the United States. He worked first as a coach painter, then as a portrait painter, finally setting up a studio in New York in 1853. He became a member of the National Academy in 1858 and President of the Brooklyn Academy of Design. He made a number of illustrations for the books of John Gould.

HARTE, George C. fl.1885-1893

Genre painter. He was working at Bedford Park, 1885-86 and contributed boating subjects to *The Illustrated London News* in 1893.

Exhib: L.

HARTRICK, Archibald Standish RWS 1864-1950

Painter, black and white artist and illustrator. He was born at Bangalore on 7 August 1864, the son of an army officer and was educated at Fettes College and Edinburgh University. He studied art at the Slade School under Alphonse Legros, 1884-85, in Paris under Boulanger and Cormon, 1886-87 and joined the staff of *The Daily Graphic* in 1890. Although Hartrick was very prolific as a magazine artist and often worked as a special for *The Graphic*, his style remained consistently high and he was almost unsurpassed in chalk by any other British artists. It was perhaps typical of the man that he did not think of himself as an illustrator and went on to become an excellent watercolourist and a significant lithographer. He was at his best when depicting rural characters and many of them have an uncanny affinity with the rustic illustrators of the 60s. A whole set of these drawings called Cotswold types was acquired for the British Museum. He was a member of the NEA from 1893 and became ARWS in 1910 and RWS in 1920. He died in 1950.

Illus: *Soldiers Tales [Rudyard Kipling, 1896]; The Body Snatcher [R.L. Stevenson].*
Contrib: *The Graphic [1889-95]; Daily Graphic [1890]; The Pall Mall Budget [1893]; Daily Chronicle; The Quiver; The New Budget [1895]; Black and White [1899-1900]; The Butterfly [1899]; Cassell's Family Magazine [1899]; Fun [1901]; The Yellow Book; The Ludgate Monthly; The Strand Magazine; Pearson's Magazine; The Pall Mall Magazine.*

ARCHIBALD STANDISH HARTRICK RWS 1864-1950. 'Pulling Down The Strand.' Drawing for illustration, unpublished. Pen and ink. 16¼ins. x 11⅜ins. (41.3cm x 28.9). Victoria and Albert Museum

Exhib: B; G; L; M; NEA; RA; RBA; RHA; RSA; RWS.
Colls: Aberdeen; BM; Liverpool; Manchester; Melbourne; Sydney; V & AM.
Bibl: *The Studio* Winter No., 1900-1, p.72, illus.; *Apollo*, XXIV, 1936; A.S. Hartrick. *Painter's Pilgrimage Through Fifty Years*, 1939.
See illustration (above).

HARVEY, Sydney fl.1897-1907

Cartoonist for *Moonshine*, about 1901. He worked at Muswell Hill and contributed drawings to *Punch*, 1897-1902.

HARVEY, William 1796-1866

Wood engraver and illustrator. He was born at Newcastle-upon-Tyne on 13 July 1796 and was apprenticed to Thomas Bewick (q.v.) who employed him on the woodcuts for the famous edition of *Aesop's Fables*, published in 1823. Harvey left Bewick in 1817, retained contact with the engraver till his death, but became a pupil of B.R. Haydon in London. He studied anatomy under Sir Charles Bell and became associated with Charles Knight, the popular journalist and educator for whom he undertook work. Harvey did little wood engraving after his success in engraving Haydon's 'Dentatus' in the manner of a copper plate. This heralded a new style and expertise in wood engraving which was to result in elaborate Victorian compositions. Harvey gradually became the most popular illustrator of the 1840s, taking on work of such a scale, hundreds of vignettes in *The Arabian Nights* and three thousand illustrations in the decade 1828 to 1838, that it almost revolutionised the market. Harvey was one of the first to use numerous outside engravers on his work, thus opening the way for a less personal approach but also for speed. His shortcomings were his lack of success with modern subjects and his total lack of humour in drawing. He designed the third cover of *Punch* in July 1842 but it was considered too serious and his initial letters

were thought too graceful! By the 1860s his decorative pages, elegant figures and balanced foilage, was considered 'too mannered' but his influence on Gilbert and early Fred Walker was considerable. He died at Richmond on 13 January 1866.

Illus: *History of Wines [Henderson, 1824]; The Tower Menagerie [1828]; Northcote's Fables [1828]; The Garden and Menagerie of the Zoological Society [1831]; Children in the Wood [1831]; The Blind Beggar of Bethnal Green [1832]; Story Without An End; Pictorial Prayer Book; Thousand and One Nights [Lane, 1840]; London [Knight, 1841]; Metrical Tales [Samuel Lover, 1849]; The Pilgrim's Progress* and the *Holy War [1850]; Oriental Fairy Tales [1854]; The Fables of John Gray [1854]; Tales From Shakespeare [C. and M. Lamb, 1856]; The Queen of Hearts [Wilkie Collins, 1859]; Eugene Aram [T. Hood]; Natural History [J.G. Wood].*
Contrib: *The Observer [1828]; Bell's Life; Punch [1841-42]; ILN [1843-59 (decor and political)]; The Illustrated London Magazine [1854].*
Colls: BM; Fitzwilliam; V & AM.
Bibl: M.H. Spielmann, *The History of Punch*, 1895, pp.42-44; The Brothers Dalziel, *A Record of Work*, 1840-1890, 1901, pp.12-21; P. Muir, *Victorian Illustrated Books*, 1971, pp.28-33, illus.

HARWOOD, John fl.1818-1829
Architectural and landscape painter. He worked in London and contributed to *Lancashire Illustrated*, 1829.

Exhib: BI; RA; RBA.

HASELDEN, William Kerridge 1872-1953
Cartoonist and caricaturist. He was born at Seville in 1872 and began drawing professionally in 1903. He joined the staff of the *Daily Mirror* in 1904 and began to contribute to *Punch* in 1906, concentrating on theatrical caricatures. In the 1920s and 1930s he was well-known for his 'art deco' caricatures of Edith Evans, Gertrude Lawrence, Shaw, Ivor Novello etc.

HASSALL, John RI 1868-1948
Watercolourist, poster-designer and illustrator. He was born at Walmer in 1868 and educated at Newtown Abbot College, Devon and Neuenheim College, Heidelberg. He began life as a farmer in Manitoba, abandoning this for art and studying at Antwerp and Paris, 1891-94, in the former under P. Van Havermaet and in the latter with Bougereau. Hassall was an original and versatile designer of illustrations from 1895 onwards, contributing cartoons to many leading magazines, designing theatre posters, commercial posters for Messrs. David Allen and greetings cards, boys' books and nursery rhymes. His chief influence would seem to be the flat colours and two-dimensional decorative quality of Japanese prints, which he adapts to his own work with thick outline and careful patterning. He also executed fine watercolours for boys' adventure stories, the scene drawn in with the brush and the washes applied dryly and carefully. Hassall's work is synonymous with colour except for his First War booklets in line. He was elected RI in 1901, and RMS, the same year. A Centenary Exhibition was held at Leighton House 1-11 April 1968 He signs his work *Hassall* or *H*

Illus: *Two Well Worn Shoes [1899]; The Princess and The Dragon; John Hassall's New Picture Book [1908]; Ye Berlyn Tapestrie Wilhelm's Invasion of Flanders [1916]; Keep Smiling [c.1916].*
Contrib: *The Daily Graphic [1890]; The Sketch [1894]; Judy; Moonshine; Pick-Me-Up; The New Budget [1895]; The West End Review [1898]; The Graphic [1899-1911]; Illustrated Bits; The Idler; Eureka; ILN [1900, 1908 (Christmas)]; The Sphere.*
Exhib: B; G; L; RA; RI; RMS; RSW.
Colls: Author; V & AM.
Bibl: 'The London Sketch Club' *The Magazine of Art*, March 1899, p.229; 'The Poster Paintings and Illustrations of John Hassall RI' *The Studio*, Vol. 36, 1906, illus.; *The Studio*, Winter No., 1900-1, pp.44-47, illus.; A.E. Johnson (editor) *JH, RI*, Pen and Pencil Series, c.1920.

See illustrations (below and p.336).

JOHN HASSALL RI 1868-1948. 'Drunken Man and Teetotaler.' Pen and watercolour. 5ins. x 3½ins. (12.7cm x 8.9cm). Author's Collection

JOHN HASSALL RI 1868-1948. 'Diner and Waiter.' Pen and watercolour. 5ins. x 3½ins. (12.7cm x 8.9cm). Author's Collection

JOHN HASSALL RI 1868-1948. Gunfight. Illustration for a boys' magazine. Watercolour. 10ins. x 12ins. (25.4cm x 30.5cm). Author's Collection

HASSELL, Edward -1852

Topographical artist and lithographer. He was the son of John Hassell 1767-1825, the engraver and drawing master, and was awarded premiums by the Society of Arts, 1828-29. He was a member of the RBA from 1841 and held the office of Secretary. He died at Lancaster in 1852.

Illus: *Historical Account of the Parish of St. Marylebone [Thomas Smith, 1833].*
Exhib: BI; RA; RBA.

HASSELL, John 1767-1825

An engraver and drawing master and close friend of George Morland. He produced numerous guide-books with aquatints after his own drawings.

Publ: *Tour of the Isle of Wight [1790]; Picturesque Guide to Bath [1793]; Life of George Morland [1806]; Speculum or the art of Drawing in Watercolours [1808]; Aqua Pictura [1813]; Picturesque Rides and Walks [1817]; The Tour of the Grand Junction Canal [1819]; Camera or the Art of Watercolour [1823]; Excursions of Pleasure and Sports on the Thames [1823].*
Contrib: *The Antiquarian Itinerary [1816].*
Exhib: RA, 1789.
Colls: BM; Guildford; Manchester.

HASWELL

Landscape artist and designer of initial letters in the style of Richard Doyle. He contributed to *The Illustrated London Magazine,* 1853-54.

HATHERELL, William RI RWA 1855-1928

Landscape and figure painter and illustrator. He was born at Westbury-on-Trym on 18 October 1855 and was educated at private schools before entering the RA Schools in 1877. He was a regular contributor to magazines from about 1889, having done his first illustrative work for Cassell's. Hatherell was at his best with stories, where his moody wash drawings and his care to reflect accurately a town, country or historical period could be shown to the full. Thorp says that his flowing wash style was influential on younger men, it is certainly typical of the 1890s. He was one of the few artists to produce illustrations in oil on board, grey monochrome studies which often have a rather French appearance. He was elected RI in 1888, ROI, 1898 and RWA in 1903. He died 7 December 1928.

Illus: *Annals of Westminster Abbey [E.J. Bradley, 1895]; Tantallon Castle [E.R. Pennell, 1895]; Sentimental Tommy [J.M. Barrie, 1897]; Romeo and Juliet [1912]; Island Night's Entertainments [R.L. Stevenson, 1913]; The Prince and the Pauper [S.L. Clemens, 1923].*

Contrib: *The Graphic [1889-1912]; The Quiver [1890]; Black and White [1891]; The Picturesque Mediterranean [1891]; The English Illustrated Magazine [1891-92]; The Pall Mall Budget [1892]; Cassell's Family Magazine; Chums; Cassell's Saturday Journal; Harper's Magazine; Scribner's Magazine.*
Exhib: B; G; L; M; NEA; RA; RBA; RI; ROI.
Colls: V & AM.

HATTON, Brian 1887-1916
A promising young black and white artist who was killed in the First World War. He gained a Bronze Medal from the Royal Drawing Society at the age of eight and later studied at Oxford, 1905-6 and at South Kensington and Julian's in Paris. An extremely strong draughtsman of the country and its people, in thick ink lines.
Contrib: *The Graphic [11 Dec. 1915].*
Exhib: P; RA; ROI.
Colls: Witt Photo.
Bibl: W. Shaw Sparrow, 'BH' *Walker's Quarterly,* Feb. 1926.

HATTON, Helen Howard (Mrs. W.H. Margetson) 1860-
Watercolourist and pastellist. She was born in Bristol in 1860 and studied art at the RA Schools and at Colarossi's in Paris. She married the painter W.H. Margetson 1861-1940 (q.v.), and worked mainly in Berkshire.
Contrib: *The English Illustrated Magazine [1886 (architecture)].*
Exhib: B; G; L; M; RA; RI; ROI.

HAVELOCK, Helen
Amateur topographer and daughter of W. Havelock of Ingress Park. She contributed an illustration to *Britton's Beauties of England and Wales,* 1808.

HAVERS, Alice (Mrs. Frederick Morgan) 1850-1890
Watercolourist and illustrator. She was born in Norfolk in 1850, the daughter of the manager of the Falkland Islands, where she was brought up. She returned to England in 1870 to study at South Kensington and in 1872, married the artist Frederick Morgan. She exhibited at the Salon, receiving a special mention in 1888 and was patronised by Queen Victoria.
Illus: *Cape Town Dicky; The White Swans [1890].*
Contrib: *Cassell's Family Magazine.*
Exhib: G; L; M; RA; RBA; RHA; SWA.
Colls: Cardiff; Liverpool; Norwich; Sheffield.

HAWEIS, Mrs. H.R.
Wrote and illustrated *Chaucer For Children, A Golden Key,* 1877.

HAWKER, J. fl.1804-1812
Topographer and landscape painter. He exhibited at the RA 1804-09 and contributed to *Britton's Beauties of England and Wales* 1812.

HAWKER, Peter 1786-1853
Artist, soldier and author. He served in the Peninsular War with the 14th Light Dragoons and afterwards patented improvements to the pianoforte and wrote a sporting journal. He died in 1853.
Illus: *Instructions to Young Sportsmen [1824, AL 389].*

HAWKSWORTH, John
Topographer, working in London about 1820. He contributed to *The History and Antiquities of Islington,* 1823.

'HAY'
Pseudonym of caricaturist contributing to *Vanity Fair,* 1886, 1888-89 and 1893. His style is close to that of Pellegrini.

HAY, George RSA 1831-1913
History and subject painter and illustrator. He was born in Edinburgh in 1831 and studied in the RSA School and at the Trustees Gallery, entering the architectural profession at the age of seventeen. He later abandoned this for painting, specialising in pictures of Scottish life and history. He was elected ARSA in 1869, RSA in 1876 and

Secretary, 1881-1907. He died 31 August 1913.
Illus: *Pen and Pencil Pictures From the Poets [1866]; Poems and Songs by Robert Burns [1875]; Red Gauntlet [Walter Scott, 1894].*
Exhib: G; RSA.

HAY, Helen fl.1895-1940
Black and white artist. She was probably associated with the Glasgow School and contributed to *The Evergreen,* 1895-96. She was working in Paisley in 1933 and at Egglesham, 1937.
Exhib: G; RSA.

HAYDON, G.H. fl.1860-1892
Barrister, traveller and amateur artist. According to G.S. Layard, Haydon went to Australia as a youth to seek his fortune and made a number of sketches of the interior, later reproduced in the *Australian Illustrated* in about 1876. He was back in England by 1860 and became steward of Bridewell and Bethlem Hospitals. Haydon was a member of the Langham Sketch Club, became a friend of Charles Keene and John Leech, and was used by the latter as a model in some of his sporting drawings. He himself drew for *Punch,* 1860-62.
Bibl: G.S. Layard, *Charles Keene,* 1892, p.247.

HAYES, Frederick William ARCA FRGS 1848-1918
Landscape painter, illustrator and author. He was born at New Ferry, Cheshire on 18 July 1848 and was educated at Liverpool College and privately. He trained as an architect with a firm in Ipswich, but turned to painting and studied with H. Dawson. Returning to the North-West, Hayes helped to found the Liverpool Watercolour Society; he remained in the city until about 1880 when he moved to London. A socialist and historian, Hayes specialised in the scenery of North Wales and illustrated his own books. He died 7 September 1918.
Illus: *The Story of the Phalanx [1894]; A Kent Squire [1900]; Gwynett of Thornhaugh [1900]; The Shadow of a Throne [1904]; A Prima Donna's Romance [1905]; Captain Kirk Webbe [1907]; The United Kingdom Limited [1910].*
Exhib: B; L; M; RA; RBA; RCA; RI; ROI.
Colls: BM; Glasgow; V & AM.

HEAPS, Chris
Black and white artist. Contributor to *The Graphic,* 1915.

HEATH, Charles 1785-1848
Engraver and illustrator. He executed plates for popular works and engraved the pictures of Benjamin West. He is best remembered as the publisher of illustrated 'Annuals' during the 1830s.
Exhib: RA and RBA, 1801-25.

HEATH, Ernest Dudley fl.1886-1927
Painter and illustrator. He was the son of Henry Charles Heath, Miniature Painter to Queen Victoria. He studied at the RA Schools and became lecturer on art, University of London Extension, 1903-08, Principal of the Hampstead Garden Suburbs School of Arts and Crafts, 1914-26, and lecturer on Principles of Art Teaching, Royal College of Art, 1927.
Contrib: *The English Illustrated Magazine [1893-94 (cockney figures)].*
Exhib: L; M; RA; RBA; RMS; ROI.

HEATH, Henry fl.1824-1850
Probably the brother of William Heath (q.v.). He was a versatile and imitative artist, working in the loose and coarse Heath manner between the years 1824-30. He did imitation caricatures in the style of John Doyle 'HB' signed 'HH' for Messrs. Fores, 1831 and etched vignettes in the style of Cruikshank and lithographs in the style of Seymour from 1834. He was employed to make political caricatures by Spooner, the publisher and his work was collected and published by Charles Tilt. Heath undertook one cartoon for *Punch* in 1843 and his sets include *London Characters,* 12 pls., 1834 and *Domestic Miseries, Domestic Blisses,* 12 liths., 1850. He is believed to have emigrated to Australia.

HEATH, Thomas Hastead of Cardiff fl.1879-1905
Portrait and figure painter. He specialised in seascapes but did fine figure studies in sepia ink, reminiscent of Wilkie. He also designed a fixture card for the 'Cardiff Harlequins'.
Exhib: L; RA; RBA.

HEATH, William 'Paul Pry' 1795-1840
Watercolourist and caricaturist who worked mostly under the pseudonym of Paul Pry. He called himself 'Portrait and Military painter' and was reputed to be an 'ex-captain of dragoons' but is not recorded in the Army List. Heath began life as a draughtsman and his main claim to fame rests on his having produced the first caricature magazine in Europe, *The Glasgow* later *Northern Looking-Glass*, 1825-26. Although this was a provincial work and without much text, it does pre-date Charles Philipon's similar publication. The height of his popularity fell between the years 1809-34, after which his humour was displaced by that of Robert Seymour and John Doyle (qq.v.). After this period he concentrated on topography and straight illustration.
Illus: *The Looking-Glass [1830]; The Life of a Soldier [1823]; Minor Morals [Bowring, 1834-39]; The Martial Achievements of Great Britain and Her Allies* and *Historical Military and Naval Anecdotes.*
Colls: V & AM.
See illustration (Colour Plate VI p.56).

HEAVISIDE, John Smith 1812-1864
Engraver. He was born at Stockton-on-Tees in 1812 and worked in London and Oxford. He illustrated Parker's archaeological books and died at Kentish Town on 3 October 1864.

HEAVISIDE, T.
Brother of John Smith Heaviside (q.v.). He engraved portraits of Thomas Bewick and John Owen and contributed to *The Illustrated London News*, 1849-51.

HEBBLETHWAITE, H. Sydney
Black and white artist. Thorpe describes him as an artist of promise and invention who died young. He contributed drawings to *Pick-Me-Up* in 1899 and another drawing, perhaps posthumous appeared in *The Graphic*, 1908.

HEFFER, Edward A. of Liverpool fl.1860-1885
Decorative designer, architect and illustrator. He contributed work to *The Illustrated London News*, 1860-61.
Exhib: L; RA.

HELLÉ. André
French theatrical designer and illustrator. He was closely associated with the Opera Comique at Paris and did a great deal of work for children's books.
Contrib: *The Graphic [1910].*

HELLEU, Paul César 1859-1927
Painter and etcher. He was born at Vannes on 17 December 1859 and became a pupil of Gérome at the École Nationale des Beaux-Arts. Helleu was a talented painter of churches and of architecture but was best known in this country during the Edwardian period for his sensitive and charming etchings of society beauties. Among his subjects were Queen Alexandra, the Princess of Connaught and the Duchess of Marlborough. He became ARE, 1892, and RE, 1897. He died at Paris, 23 March 1927.
Contrib: *The Graphic [1901].*
Exhib: L; P; RE.

HELMICK, Howard 1845-1907
American figure painter and illustrator. He was born at Zanesville, Ohio, in 1845 and studied in Paris under Cabanel. He lived in London for some years and on returning to the United States became Professor of the History of Art at Georgetown University. He died on 18 April 1907. RBA, 1879, and RE, 1881.
Contrib: *The Graphic [1880].*
Exhib: B; G; L; M; RA; RBA; RE.

HEMING, Matilda (Miss Lowry) fl.1808-1855
Portrait painter. She was the daughter of the engraver Willson Lowry and exhibited at the RA, 1808-09 and 1847-55. She contributed an illustration to Britton's *Beauties of England and Wales*, 1807.

HEMY, Charles Napier RA RWS 1841-1917
Marine, landscape and still-life painter. He was born at Newcastle-upon-Tyne on 24 May 1841 and studied with William Bell Scott (q.v.). From 1850 to 1852, he sailed round the world developing a great knowledge of and interest in shipping, but on his return entered the Dominican order and studied for three years in monasteries at Newcastle and Lyons. He finally abandoned this life in 1862 and went to Antwerp to study art under Henri Leys, settling in London in 1870 and finally moving to Falmouth. Hemy's reputation is principally as a marine artist and he made many studies from his own yacht, the *Van der Meer,* which he kept at Falmouth. He was elected ARA in 1898 and RA in 1910, and RWS in 1897. He died on 30 September 1917.
Contrib: *The English Illustrated Magazine [1883-87].*
Exhib: B; G; L; M; New Gall.; RA; RI; RSA; RWS.
Colls: Birmingham; Bristol; Leeds; Newcastle.

HENDERSON, Keith OBE RWS 1883-
Writer and illustrator. He was born in 1883 and after being educated at Marlborough, studied art at the Slade School and in Paris. He served in the First World War and was War Artist to the Royal Airforce in 1940.
Publ: *Letters to Helen; Palmgroves and Hummingbirds; Prehistoric Man; Burns by Himself; Romaunt of the Rose [1911]; No Second Spring; Christina Strang.*
Illus: *Conquest of Mexico [Prescott, 1922]; Green Mansions [W.H. Hudson, 1931]; Buckaroo [E. Cunningham, 1934].*
Exhib: B; FAS, 1914, 1917; G; L; NEA; RA; ROI; RSA; RWS.
Colls: V & AM.
Bibl: *Modern Book Illustrators and their Work*, Studio, 1914.

HENDRY, Sydney
Black and white artist specialising in children. He contributed to *Punch* in 1903.

HENFREY, Charles
Contributed illustrations to *Public Works of Great Britain*, 1838, AL 410.

HENLEY, A.W. fl.1880-1908
Landscape artist working in West London. He contributed illustrations to R.L. Stevenson's *Fontainbleau.*
Exhib: GG; RHA; RSA.

HENLEY, Lionel Charles RBA 1843-c.1893
Genre painter. He was born in London in 1843 and studied art at Düsseldorf, making his début at exhibitions in Magdebourg. He returned to England and exhibited regularly from 1862, becoming RBA in 1879.
Contrib: *London Society [1865]; Fun [1865]; Foxe's Book of Martyrs [1867]; The Graphic [1870].*
Exhib: B; L; RA; RBA; ROI.

HENNESSY, William John ROI 1839-1917
Landscape and genre painter and illustrator. He was born at Thomastown, Ireland, in 1839 and emigrated with his family to America when very young, remaining there till 1870. He attended the National Academy in New York in 1856 and became a member in 1863, but in 1870 settled in England, alternating his residence from time to time between Normandy and Sussex. Hennessy was something of an expert on American art and his own drawing style, very finished and slick, owes a good deal to that school. Amongst his best work is probably the series of illustrations to Jean Ingelow's 'Sarah de Berenger' in *Good Words*, 1880. He became ROI in 1902.
Illus: *Broken Wings [Avery Macalpine, 1897]; Marriage [Susan Ferrier, 1895]; The Suicide Club; The Rajah's Diamond [R.L. Stevenson, 1913].*
Contrib: *ILN; Dark Blue [1871-73]; The Graphic [1872-76, 1880]; Punch [1873-75]; The English Illustrated Magazine [1884-92]; Black & White [1891]; The Girls' Own Paper.*
Exhib: B; G; GG; L; M; NEA; NG; RA; RHA; ROI.

HENNING, Archibald Samuel -1864

Comic illustrator. He was the third son of the sculptor John Henning and the brother-in-law of Kenny Meadows (q.v.). A rather slap-dash artist and bohemian character, he designed *Punch's* first wrapper and was rated 'a fair and prolific draughtsman on wood' by W.J. Linton. He may have undertaken medical and natural history illustrations in the 1850s.

Contrib: *Punch [1841-42]; The Squib; The Great Gun; Joe Miller The Younger; The Man in The Moon; The Comic Times; The Illustrated London Magazine [1854]*.

HENRY, Paul RHA 1876-

Landscape painter. He worked in Liverpool, Belfast, Dublin and County Wicklow, and was elected ARHA in 1926 and RHA, 1929. He contributed illustrations of children to *The Graphic*, 1910.

HENRY, Thomas fl.1891-1914

Painter and illustrator. He contributed to *Punch*, 1914.

Exhib: Dowdeswell Gall.

HENTY, George Alfred 1832-1902

Author, journalist and amateur artist. He was born at Trumpington, Cambridge, on 8 December 1832 and educated at Westminster and at Caius College, Cambridge. Henty went out to the Crimea in the Purveyors' Department of the Army and after being invalided home, served with the Italian Legion. From 1866, he was special correspondent for *The Standard* in the Austro-Italian, Franco-Prussian and Turco-Serbian Wars and the Abyssinian and Ashanti Expeditions. His illustrated reports attracted considerable attention, but for their writing rather than their drawing! Henty went on to use these experiences in numerous adventure books for boys. He died 16 November 1902.

Contrib: *ILN [1868]*.
Bibl: G.M. Fenn, *GAH The Story of an Active Life*, 1907, p.27.

HERALD, James Watterson 1859-1914

A landscape and coastal painter. He was born at Forfar in 1859 and studied under Herkomer (q.v.). His style is closely associated with the Glasgow School, he died at Arbroath in 1914. Some prints by this artist dating from about 1900, may have been intended as book illustrations.

HERBERT, John Rogers RA RHI 1810-1890

Portrait, romantic and religious painter. He was born at Maldon, Essex, in 1810 and studied at the RA Schools, 1826. He was an early teacher of art at the Government School of Design at Somerset House, Herbert was a regular book illustrator in the early part of his career, but after his conversion to Roman Catholicism, he gave this up to concentrate on large religious paintings. He was elected ARA in 1841 and RA in 1846, retiring in 1886.

Illus: *Legends of Venice [Edited by Roscoe, 1840]*.
Contrib: *The Keepsake [1836]; Heath's Gallery [1838]*.
Exhib: BI; NWS; RA; RBA.
Colls: BM; L; V & AM.

HERDMAN, Robert RSA 1829-1888

Portrait and history painter. He was born at Rattray on 17 September 1829 and after studying at St. Andrews University, became a pupil of R.S. Lauder at the Edinburgh Trustees Academy. He travelled to Italy, 1855-56 and established himself from 1861, when he became ARSA, as a leading portrait painter and painter of Scottish history. He left his large collection of artists' portraits to Aberdeen. He died at Edinburgh on 10 January 1888.

Contrib: *Poems and Songs by Robert Burns [1875]*.
Exhib: RA; RSA.
Colls: Edinburgh; Glasgow.

HERING, George Edwards 1805-1879

Painter and illustrator. Born in London in 1805, the son of a bookbinder of German extraction. He studied art and worked in Munich and then travelled in Italy and Turkey, Hungary and Transylvania, which were the most usual subjects for his pictures. He settled in London, but frequently travelled on painting expeditions.

Illus: *Sketches On The Danube, in Hungary and Transylvania, [1838]; The Mountains and Lakes of Switzerland, The Tyrol and Italy [1847, AT 63]*.
Exhib: BI; RA, 1836; RBA, 1838-
Colls: V & AM.

HERKOMER, Sir Hubert von RA 1849-1914

Painter and illustrator. He was born at Waal, Bavaria, on 26 May 1849, the son of Lorenz Herkomer, who settled in England in 1857. He studied art at South Kensington from 1866, founded the Herkomer School of Art at Bushey in 1883 and was Slade Professor at Oxford, 1885-94. Herkomer was one of the grandees of Victorian painting in the 1880s and 1890s, receiving many honours both at home and abroad. He became ARA in 1879, RA in 1890 and was knighted in 1907.

Herkomer's greatest strength was as a composer of pictures and as a figure painter. His principal achievement in book illustration was the series of social realistic subjects that he drew for *The Graphic*, 1870-79. These included his famous 'Heads of the People', 1875, and such famous images of Victorian society as 'Christmas in a Workhouse'. Herkomer's talent for expressing the plight of the under-privileged was again used when he illustrated Hardy's *Tess of the D'Urbevilles* for the same magazine in 1891. Herkomer died at Budleigh Salterton on 31 March 1914.

Contrib: *The Quiver [1868]; The Sunday Magazine [1870]; Good Words For The Young [1870]; The Graphic [1870-79]; ILN [1871-73]; London Society [1872]; The Cornhill Magazine [1872]; Fun; Black & White [title]. & White [title]*.
Exhib: B; G; GG; L; M; New Gall; P; RA; RBA; RE; RHA; ROI; RSA; RWS.
Colls: BM; Leeds; Manchester.
Bibl: *Autobiography*, 1890; *English Influences On Vincent Van Gogh*, Arts Council 1974-75, p.52.

HÉROND, L.J.

French artist, contributing illustrations of Paris to *Cassell's Illustrated Family Paper*, 1857.

HERRING, Benjamin -1871

Sporting artist. He was the son of J.F. Herring (q.v.) who looked upon him as his real successor in equestrian art. He was, however, a rather mediocre painter but contributed to *The Illustrated London News*, 1850-60 and 1864.

Exhib: BI; RBA, 1861-63.

HERRING, John Frederick 1795-1865

Sporting artist and illustrator. He was born in Surrey in 1795, the son of an American, and was inspired at an early age to draw horses. He worked as a coach painter and even for some time as a coach driver, later residing in Doncaster and setting up as a horse portraitist. He worked also at Newmarket, London and at Tunbridge Wells, where he died in 1865; he became a member of the SBA in 1841.

Contrib: *The Sporting Review [1842-46]; ILN [1844-45, 1864]; The Illustrated Times [1859]; Bell's Life in London*.
Exhib: BI; RA; RBA.
Bibl: W. Shaw Sparrow, *British Sporting Artists*, 1922, pp.215-227.

HERRING, John Frederick, Jnr. 1815-1907

Sporting artist. He was born in 1815, the eldest son of J.F. Herring (q.v.) and the brother of the B. Herring (q.v.). He made a speciality of farmyard scenes but was a less inspired painter than his father whom he mercilessly imitated. He died at Cambridge in 1907.

Contrib: *Old Sporting Magazine*.
Exhib: B; BI; RA; RBA.

HESTER, R. Wallace fl.1897-1913

Engraver and caricaturist. He worked at Tooting, 1897, and at Purley, 1901, and contributed to *Vanity Fair*, 1910-13.

Exhib: RA, 1897-1904.

HEWERDINE, Matthew Bede **1871-1909**
Cartoonist and book illustrator. He worked in Hull and Oxford and
illustrated *Lest We Forget Them*, Lady Glover, 1900, and *Cloister and
the Hearth*, C. Reade, 1904.

HEWETSON, Edward
Architectural draughtsman. He contributed illustrations to *Acker-
mann's Repository*, 1825.

HEWITT, John
Contributed illustrations to *Public Works of Great Britain*, 1838, AL
410.

HICKLING, P.B. **fl.1895-1914**
Illustrator. A very competent but unrecorded pen artist who worked
for magazines. Contributed to *Fun*, 1895; *The Boys' Own Paper* and
The Graphic, 1902-06; *Punch*, 1914. He also illustrated a novel *The
Three Clerks*, John Long, c.1908.

HICKS, George Elger **1824-1914**
Genre and portrait painter and illustrator. He was born at Lymington
in Hampshire in 1824 and trained as a doctor, abandoning this career
for one of a painter and training at the Bloomsbury and RA Schools.
Hicks was one of the most lush painters of Victorian life, such busy
subjects as 'The General Post Office - One Minute to Six', 1860 and
elaborate wedding pieces with every present shown in glittering oil,
are his. He was also a very competent illustrator of figures and did a
fair amount of this work in early life. He died in London in 1914.
RBA, 1889.

Publ: *A Guide to Figure Painting*, 1853.
Contrib: *Campbell's Gertrude of Wyoming [Art Union of London, 1846];
Sacred Allegories [1856]; The Farmer's Boy [Robert Bloomfield, 1857];
Favourite Modern Ballads [1859]*.
Exhib: B; GG; L; M; RA; RBA; RSA.
Colls: Ulster Museum.
Bibl: Chatto & Jackson, *Treatise on Wood Engraving*, 1861, p.598; J. Maas,
Victorian Painters, 1969, p.117.

HIGHAM, Bernard **fl.1895-1925**
Landscape painter and illustrator. He was working at Wallington,
Surrey, 1917-25. Contributed drawings to *The Idler*, c.1895; *The
English Illustrated Magazine*, 1897.

Exhib: RA, 1917-19.

HIGHAM, Sydney **fl.1890-1905**
Comic artist in black and white. His drawings are amusing but rather
coarse in execution, he worked for a number of magazines and may
have emigrated to Canada in about 1905.

Contrib: *Daily Graphic [1890]; Penny Illustrated Paper; The Graphic [1901
and 1903-05]*.
Colls: Author.

HIGHAM, Thomas **1796-1844**
Topographer and engraver. Contributed to *The Antiquarian Itinerary*,
1817. Exhibited at RA, 1824-30.

HILL, David Octavius RSA **1802-1870**
Landscape painter, illustrator and photographer. He was born at Perth
in 1802 and studied with Andrew Wilson at Edinburgh, making his
début in exhibitions in 1823. Hill specialised in Scottish life and
landscape pictures, but he was always an experimenter and worked
also in lithography. He was the first Secretary of the Royal Scottish
Academy, 1830-69, and ARSA in 1826 and RSA three years later. He
was one of the first artists to appreciate the potential of photography
when he used calotypes made by the Adamsons for his celebrated
painting 'The Disruption', commemorating a religious furore of the
1840s. From about 1843, he concentrated on photography and died
in Edinburgh 17 May 1870.

Illus: *Sketches of Scenery in Perthshire [liths.]; The Abbot, Red Gauntlet, The
Fair Maid of Perth [Scott]; Poems and Songs by Robert Burns [1875]; The
Land of Burns*.
Exhib: BI; RA; RBA; RSA.
Colls: Birkenhead; Edinburgh; Glasgow.
Bibl: D. Bruce, *Sun Pictures*, Studio Vista, 1973.

HILL, Leonard RAVEN- see RAVEN-HILL, Leonard

HILL, Rowland see 'RIP'

HILL, Vernon **1887-**
Illustrator, lithographer and sculptor. He was born in Halifax in 1887,
apprenticed to a trade lithographer at thirteen and was a student
teacher at seventeen. In 1908 he was working under John Hassall RI
(q.v.) and published his first illustrations the year following. Hill is
strongest as a figure draughtsman and his swirling bodies and large
wave and plant shapes, make him a classical equivalent of the
Beardsley eroticism. In November 1909, *The Bodleain*, referred to
him as 'a youth only just past his teens, his inventions have the eternal
quality of beauty, his imagination is so rich so astonishing in its
originality, and he is beside so gifted with rare humour, that his work
defies comparison with anything known to us . . .'

Illus: *The Arcadian Calendar for 1910 [1909]; The New Inferno [Stephen
Phillips Jnr., 1911]; Ballads Weird and Wonderful [Richard Chope, 1912];
Tramping with a Poet in the Rockies [Stephen Graham, 1922]*.
Exhib: Leicester Gall; NEA; RA; RSA; 1908-27.
Colls: V & AM.
Bibl: *The Studio*, Vol.57, 1912-13; *Modern Book Illustrators and Their Work*,
Studio, 1914, illus.; B. Peppin, *Fantasy Book Illustration*, 1975, pp.155-163,
illus.

HILLS, Robert **1769-1844**
Watercolourist. He was born in Islington on 26 June 1769 and
received drawing lessons from John Gresse. He is principally
remembered as a painter and etcher of animals and as a founder of the
OWS in 1804 and its first Secretary and Treasurer. He died in London
on 14 May 1844. Hills is included here for his book *Sketches in
Flanders and Holland*, 1816, AT 186.

Exhib: OWS; RA.
Colls: Ashmolean; BM; Fitzwilliam; Leeds; V & AM.
Bibl: M. Hardie, *Watercol. Paint. In Brit.*, Vol.II, 1967, pp.139-141, illus.

HILLS, W. Noel **fl.1889-1924**
Landscape painter and illustrator. He was working at Leyton, London
in 1920-24 and contributed comic genre subjects to *Judy*, 1889.

Exhib: RA.

HILTON, Robert **fl.1886-1907**
Architectural illustrator. He worked in Cricklewood in 1886 and in
Chester, 1902-07.

Exhib: RA; RBA, 1886.

HINDLEY, Godfrey C. **fl.1880-1910**
Figure and flower painter and illustrator. He became a Member of the
ROI in 1898. Specialised in boys' books.

Illus: *In The Heart of the Rockies [1894]*.

HINE, Henry George VPRI **1811-1895**
Watercolourist and illustrator. He was born in Brighton in 1811, the
son of a coachman and was largely self-taught. He was apprenticed in
London to Henry Meyer, the stipple engraver and after completing
indentures, worked for two years in Rouen, France, before joining the
Landell's firm as a wood engraver. During the 1840s and early 1850s,
Hine was a considerable illustrator, working in particular for *Punch*
and drawing for one of Wilkie Collins earliest stories in part works,
1843-44. Hone was like 'Phiz', a competent but not inspired humorous
artist. In later life, Hine became a serious landscape watercolourist,
concentrating on views of the Downs and coastal subjects showing the
influence of Copley Fielding. He became RI in 1864 and
Vice-President, 1888-95. He died in London on 16 March 1895.

Illus: *Change for a Shilling [H. Mayhew, 1848]*.
Contrib: *Punch [1841-44]; The Illuminated Magazine [1843-45]; ILN
[1847-55]; Illustrated London Magazine [1853-54]; The Welcome Guest
[1860]*.
Exhib: L; M; RA; RBA; RI.
Colls: BM; Fitzwilliam; Leeds; V & AM.

HIPSLEY, John Henry fl.1882-1910

Flower painter. He was working at Liverpool, 1882, and Hemel Hempstead, 1891, and at Birmingham in 1899. He contributed to *The Strand Magazine,* 1891.

Exhib: B; L; RBA; RI.

HITCHCOCK, Arthur fl.1884-1898

Watercolourist and illustrator. He illustrated *Hero and Heroine* by A.R. Hope, 1898 and exhibited at the RBA in 1884.

HODGSON, Edward S. fl.1908-1925

Landscape painter. He worked at Bushey, Herts., and exhibited at RA in 1922. He illustrated *A Middy in Command,* Harry Collingwood, 1908.

HODGSON, John Evan RA 1831-1895

Landscape and historical painter. He was born in London 1 March 1836 but spent the early part of his life in Russia, returning at the age of twenty-two to study at the RA Schools. He was a good military painter and specialised in oriental scenes after travelling in North Africa. He was elected ARA in 1873 and RA in 1880, becoming Librarian and Professor of Painting in 1882 until his death.

The Victoria and Albert Museum has a series of drawings by Hodgson for unidentified illustrations, one dated 1855. They are large figure drawings rather loosely handled in pencil, sepia, ink and watercolour.

Contrib: *The Graphic [1876].*
Exhib: B; G; L; M; RA; RE; ROI.
Colls: Cardiff; V & AM.

EVELYN B. HOLDEN fl.1894-1907 d.1920. 'Binnorie, O Binnorie.' Design for The Yellow Book, *Vol. 9, April 1896.*

HODGSON, William J. fl.1878-1903

Black and white sporting artist. He was working at Scarborough in 1878 and at Clovelly, Devon in 1891. His book illustrations for children are in the style of Caldecott and his *Punch* work, contributed most regularly from 1892-97 is in the best tradition of pen draughtsmanship.

Illus: *The Men of Ware [F.E. Weatherley, c.1884]; The Maids of Lee [F.E. Weatherley, c.1884].*
Contrib: *Punch [1892-97, 1900, 1902-3].*
Exhib: L; RA, 1891-93.

HOFFLER

Artist who supplied illustrations of Cuba to *The Illustrated London News,* 1869. Possibly the same as Adolph HOEFFLER of Frankfurt who travelled to North America in 1848.

HOGG, H. Arthur

Black and white artist, specialising in horses. Contributed to *Fun,* 1901, and *Punch,* 1906-7.

HOGGARTH, Arthur Henry Graham 1882-1964

Black and white artist and watercolourist. He was born at Kendal in 1882 and was educated at Kendal School and Keble, Oxford. He was Headmaster of Churcher's College, Petersfield, Hants., from 1911.

Contrib: *Punch [1904-06].*
Exhib: L; RA; RI.

HOLDEN, Evelyn B. fl.1894-1907 d.1920

Illustrator. She was closely associated with the Birmingham School and probably attended it in about 1894. She was strongly influenced by the work of Walter Crane (q.v.) and worked with her sister Violet M. Holden. She died by drowning in 1920.

Illus. with V.M. Holden: *The Real Princess [B. Atkinson, 1894]; The House That Jack Built [1895].*
Contrib: *The Quest [1894-96]; The Yellow Book [1896].*
Exhib: B; L; RA; SWA.
Bibl: *The Studio,* Vol.7, 1896; R.E.D. Sketchley, *English Book Illus.,* 1903, pp.102, 167; *The Diary of an Edwardian Lady,* 1977.
See illustration (left).

HOLDING, Frederick 1817-1874

Watercolourist. He was born in Manchester in 1817 and was the brother of H.J. Holding, landscape painter. There are two illustrations of Shakespearean subjects in the Victoria and Albert Museum collection.

HOLE, William ARSA 1846-1917

Painter and illustrator. He was born at Salisbury on 7 November 1846 and after being educated at the Edinburgh Academy, served an apprenticeship as a civil engineer. He abandoned this career for art in 1870 and travelled in Italy, studied at the RSA and took up etching and mural painting. He is best known as an illustrator of Scottish subjects. He was elected ARSA in 1878, RSA, 1889, and died 22 October 1917.

Illus: *A Widow in Thrums [Barrie, 1892]; The Heart of Mid-Lothian [Scott, 1893]; The Little Minister [Barrie, 1893]; Auld Licht Idylls [Barrie, 1895]; Kidnapped [R.L. Stevenson, 1895]; Catriona [R.L. Stevenson, 1895]; Beside the Bonnie Brier Bush [1896]; Poetry of Robert Burns [1896]; The Master of Ballantrae [R.L. Stevenson [1897].*
Contrib: *The Quiver [1882].*
Exhib: B; G; L; M; RA; RE; RHA; RSA; RSW.
Bibl: R.E.D. Sketchley, *English Book Illus.,* 1903, pp.92, 151; *Who Was Who 1916-28.*

HOLIDAY, Gilbert 1879-1937

Black and white artist. He was born in 1879 and studied at the RA Schools and served in the First War with the RFA. He worked in London and at East Molesey, Surrey.

Contrib: *The Graphic [1900-02 (military)]; Punch.*
Exhib: M; RA; RI; ROI; RSA.

HENRY JAMES HOLIDAY 1839-1927. 'The Beaver.' Illustration for The Hunting of The Snark by Lewis Carroll, 1876. Wood engraving.

HOLIDAY, Henry James 1839-1927

Painter, sculptor, illustrator and stained glass artist. He was born in London on 17 June 1839 of an English father but French mother. He went to Leigh's Academy, 1854, and RA Schools the same year, becoming deeply interested in the work of the Pre-Raphaelites and forming friendships with Holman Hunt and Burne-Jones (qq.v.). While at the RA he formed his own sketching club with Albert Moore, Marcus Stone (q.v.) and Simeon Solomon (q.v.). Holiday's chief importance lies in his work as a glass designer, he started his own glass-works in 1890, and as a decorative artist in murals and mosaics. He wrote extensively on techniques and invented a new form of enamel on metal in relief. He died on 15 April 1927.

As an illustrator, Holiday's fame rests on the drawings for Lewis Carroll's *The Hunting of the Snark,* 1876, which show a weird intensity of detail which is among the most disturbing aspects of Victorian literature. The source of this drawing is Pre-Raphaelite and an even more astonishing example of the artist's work was on the London market in 1977, 'Beethoven at the First Performance of His Ninth Symphony', dating from about 1860.

Illus: *The Hunting of The Snark [L. Carroll, 1876]; The Mermaid [Hans Andersen, n.d.].*
Exhib: GG; L; M; RA.
Colls: Liverpool.
Bibl: *Reminiscences,* 1914; A.L. Baldry, 'HH' *Walker's Quarterly,* 1930, No.32-32.

See illustration (above).

342

HOLL, Francis Montague
'Frank' RA ARWS 1845-1888

Portrait painter in oils, chalk draughtsman and illustrator. He was born in London, 4 July 1845, the son of Francis Holl, RA, the engraver. He studied at the RA Schools in 1861 and won a travelling scholarship which was not useful to him and which he never completed. He worked as an illustrator in the middle 1870s, chiefly on *The Graphic,* where he gained a great reputation for social realistic subjects, such as 'Sketches in London' which were admired by Van Gogh. Some of these compositions were taken from his oil paintings and others were developed into oil paintings, Queen Victoria bought 'Home From The Sea' in 1870 and Holloway 'Newgate – Committed For Trial', 1878. Holl worked almost entirely as a portrait painter from 1878, when he was elected ARA, becoming an academician in 1883. He died from heart disease on 31 July 1888.

Illus: *Phineas Redux [A. Trollope, 1874].*
Contrib: *The Graphic [1872-83]; ILN [1881, 1884].*
Exhib: B; GG; L; M; RA; RE; RHA; RI; RSA.
Colls: Birmingham; Bristol; Leeds; Royal Holloway College; Royal Collection.
Bibl: A.M. Reynolds, *Life and Work of FH,* 1912; A.L. Baldry, *FH; English Influences on Vincent Van Gogh,* Arts Council, 1974-75, p.52.

HOLLAND, Frank

Contributed strip cartoons to *Fun,* 1900-01.

HOLLAND, Henry T. fl.1879-1906

Figure painter and illustrator. He contributed humorous figure subjects to *Judy,* 1879-87, and to *Punch,* 1906. He worked in Bloomsbury and exhibited at the RI in 1887-90.

HOLLANDS, S.D.

Still-life and fruit painter. He made drawings and a tailpiece for *The English Illustrated Magazine,* 1888.

HOLLIDAY, F.

Figure artist, contributing to *Punch,* 1907.

HOLLOWAY, Herbert

An unrecorded artist who illustrated *Fairy Tales From South Africa,* 1908.

HOLME, C. Geoffrey fl.1906-1914

Artist and illustrator working at Fleet, Hants., 1911-14. He was elected RBA, 1912, and illustrated *The Old Man Book,* R.P. Stone, 1906.

Exhib: L; RBA.

HOLMES, George

Irish topographer and illustrator. He studied art in Dublin and worked as a landscape painter and engraver. He made a tour of Southern Ireland with J. Harden in 1797 and settled in London in 1799.

Illus: *Sketches of Some of the Southern Counties of Ireland . . . [1801].*
Contrib: *Sentimental and Masonic Magazines; Copper Plate Magazine; Antiquities of Ireland [Ledwich]; Beauties of Ireland [Brewer, 1825-26].*
Exhib: RA; RHA.
Bibl: D. Foskett, *John Harden of Brathay Hall 1772-1847,* 1974.

HOLMES, George Augustus RBA -1911

Genre painter. He worked at Chelsea and was elected RBA in 1869.
Contrib: *ILN [1882].*
Exhib: BI; RA; RBA.

HOLT, W.G.

Figure artist. Contributed to *Punch,* 1878.

HOMERE, Stavros

Engraver and illustrator. He studied at Paris with Jules Lefebvre and Robert Fleury. He was working at Bridgnorth, 1897, and at Étaples and Wallingford in 1907 and 1913.

Exhib: L; RA.
Bibl: *The Studio,* Vol.11, 1897, p.211, illus.

HOMEWOOD, Florence M.
Black and white artist.
Bibl: *The Studio*, Vol.8, 1896, p.227, illus.

HOOD, George Percy JACOMB- MVO 1857-1929
Painter, etcher and illustrator. He was born at Redhill, 6 July 1857, the son of an engineer. He was educated at Tonbridge School and studied art at the Slade School and under J.P. Laurens in Paris. For most of his career Hood worked in Chelsea and followed the calling of an illustrator while continuing to paint portraits. He was attached to *The Graphic* for many years and was sent by them to Greece in 1896 and to India for the Prince of Wales's tour, 1905-06. He was a founder member of the NEA, of the Society of Portrait Painters and a member of the ROI. A very dependable and accurate artist for the story or the event, his work lacks fire. He was created MVO in 1912 and died 11 December 1929. He signs his work ⊞

Illus: *Odatis, An Old Love Tale [Lewis Morris, 1888]; Lysbeth A Tale of The Dutch [H. Rider Haggard, 1900].*
Contrib: *ILN [1889-94]; Black & White [1891]; Daily Chronicle [1895]; The Graphic [1896-1911]; The Quarto [1896].*
Exhib: B; G; L; M; NEA; RA; RBA; RE; ROI.
Colls: V & AM.
Bibl: *With Brush and Pencil*, 1925.

See illustration (below).

HOOD, Sybil Eleanor JACOMB- 1870-
A sketchbook of designs for illustrations by the above artist is in the Victoria and Albert Museum collection and dated 1897 'Slade School'.

HOOD, Thomas 1799-1845
Poet and humorous draughtsman. He was born in London in 1799 and while living at Dundee during his adolescence, contributed sketches to local papers. Returning to London, he was apprenticed to an engraver called Harris, then to his uncle Robert Sands and finally to the Le Keux brothers. Hood worked on comic illustrations until his literary efforts such as 'The Song of The Shirt' made that unnecessary. He drew for *The Comic Annual*, 1830, 1834, 1837 and 1838, his humour and line being that of the punster, his drawing reflecting the savage, brutal and callous wit of the 18th century. Most biographies or notices of him neglect his work as an illustrator and even the 1869 edition of *The Works* with notes by his family, does not refer to it.

Publ: *Whims and Oddities [1826-27]; Comic Annual [1830-38]; Hood's Own [1838]; Up The Rhine [1839]; Hood's Magazine [1844]; Whimsicalities [1844]; Collected Works [1882-84].*
Colls: BM.
Bibl: Douglas Jerrold, *TH His Life and Times*, 1907; J.C. Reid *TH*, 1963.

GEORGE PERCY JACOMB-HOOD 1857-1929. 'The Heir.' An illustration to The Graphic, *6 January 1906. Chalk and wash. Signed with monogram.*
Victoria and Albert Museum

HOOK, Bryan fl.1880-1923

Landscape painter and etcher. He was the son of James Clarke Hook RA (q.v.) and travelled widely in Africa. He was working at Churt, Surrey, in 1880 and at Brixham in 1923.

Contrib: *The English Illustrated Magazine [1887 (animals)]*.
Exhib: L; M; RA; RI; ROI.

HOOK, James Clarke RA 1819-1907

Landscape and portrait painter. He was born in London in 1819 and after being educated at the North London Grammar School, studied art at the RA Schools in 1836. He travelled in France and Italy between 1845 and 1848 and worked in Cornwall and the Scilly Isles. Hook specialised in his early career in history and poetic subjects and his only illustrations date from this period. He was elected ARA in 1850 and RA in 1860, dying in Churt on 14 April 1907.

Contrib: *Songs and Ballads of Shakespeare Illustrated by The Etching Club [1853]; A Selection of Etchings . . . Etching Club [1865, 1872, 1879]*.
Exhib: B; G; L; M; RA; RE; RSA.

HOOKER, Sir Joseph Dalton OM FRS 1817-1911

Botanist, artist and author. He was born at Halesworth, Suffolk, on 30 June 1817 and was educated at the High School and the University, Glasgow. He was surgeon and naturalist on Ross's Antarctic Expedition, 1839-43, travelled in the Himalayas, 1847-51, Syria, 1860, Morocco, 1871, and the Rocky Mountains, 1877. Director of the Royal Gardens, Kew, 1865-85 and President of the Royal Society, 1872-77. He was made KCSI in 1877 and OM in 1907. He died 10 December 1911.

Publ: *Flora of Tasmania [1860]; Genera Plantarum [1862-83]; Handbook of the New Zealand Flora [1867]; Flora of British India [1883-97]*.
Illus: *The Rhododendrons of Sikkim – Himalaya [1849]*.

HOOPER, William Harcourt 1834-1912

Designer and engraver. He was born in London on 22 February 1834 and was a pupil of Bolton. He worked principally for magazines, but towards the end of his life was associated with William Morris (q.v.) at the Kelmscott Press and in particular with the production of *The Golden Legend of Master William Caxton*, 1892, and the *Kelmscott Chaucer*, 1896. Hooper was afterwards employed at the Essex House Press, 1902, and was engraving from the designs of C.M. Gere (q.v.) at the Ashendene Press in 1909 for *Tutte le opera di Dante Alighieri*. He died at Hammersmith, 24 February 1912.

HOPE, Mrs. Adrian C. (née Laura Trowbridge) -1929

Portrait and figure painter, illustrator. She specialised in children's books and worked in Chelsea 1893-1929.

Illus: *The Sparrow with One White Feather [Lady Ridley, 1908]*.
Contrib: *The English Illustrated Magazine [1891-92 (fairies)]*.
Exhib: L; New Gall; P; SWA.

HOPKINS, Arthur RWS 1848-1930

Watercolourist and illustrator. He was born in London in 1848, the brother of Gerard Manley Hopkins, poet and of Everard Hopkins (q.v.). He was educated at Lancing College and spent some years in the city before becoming an artist and entering the RA Schools in 1872. He painted in watercolour but was chiefly known for his social subjects contributed to the leading magazines. Hopkins' figure drawing is rather stiff and he has a very fussy pen line which works against him when he appears in *Punch* alongside Du Maurier. He died at Hampstead, 16 September 1930.

Illus: *Sketches and Skits [1900]; The Haunted Hotel [W. Collins]*.
Contrib: *ILN [1872-98]; The Cornhill Magazine [1875, 1884]; The Graphic [1874-86]; The Quiver [1890]; Cassell's Family Magazine; Punch [1893-1902]*.
Exhib: B; G; L; M; RA; ROI; RSW; FAS, 1900.
Colls: Ashmolean; BM; Exeter; V & AM.

HOPKINS, Everard 1860-1928

Watercolourist and illustrator. He was born in London in 1860, the brother of Gerard Manley Hopkins, the poet, and of Arthur Hopkins (q.v.). He worked extensively for the magazines and was a much more accomplished black and white artist than his more celebrated brother. He studied at the Slade School and was a Slade scholar in 1878 and

Assistant Editor of *The Pilot*. He died on 17 October 1928. He signs his work ℰℋ

Illus: *A Costly Freak [Maxwell Gray, 1894]; Sentimental Journey [1910]*.
Contrib: *The Graphic [1883-85]; ILN [1887-92]; The Quiver [1890]; Punch [1891-1904]; Black & White [1891]; Cassell's Family Magazine*.
Exhib: G; M; RA; RI.
See illustration (below).

EVERARD HOPKINS 1860-1928. 'Worth Knowing.' Pen and ink. Signed with initials. 9⅜ins. x 5¾ins. (23.8cm x 14.6cm). Victoria and Albert Museum

HOPKINS, Fritz

Contributor to *Fun*, 1900.

HORNE, Adam Edmund Maule 1883-

Figure artist. He contributed to *The Graphic*, 1908 and to *Punch*, 1913.

Colls: V & AM.

HORNE, Herbert P. 1864-1916

Architect, writer, designer and connoisseur. He was born in London on 18 February 1864. He designed a number of buildings including the Church of the Redeemer, Bayswater Road, Brewhouse Court at Éton College and part of St. Luke's, Camberwell. Horne retired to Florence in 1892 and became a writer, producing a number of notable books on the Rennaissance, among them, *Life of Leonardo da Vinci*, 1903 and of *Sandro Botticelli*, 1903. He devoted his time to collecting fine paintings and sculptures in the Palazzo Alberti, Florence, which he left to the Italian State as the Horne Museum on his death on 14 April 1916.

Publ: *Diversi Colores: Poems [1891]*.
Contrib: *The Hobby Horse [1886-93]*.
Exhib: RA, 1875.
Colls: BM.
Bibl: Carlo Gamba, *Il Museo Horne a Firenze*, 1961.

HORNEL, Edward Atkinson — 1864-1933

Genre painter of the Scottish School. He was born in Australia in July 1864 and studied at Antwerp under Professor Verlat. He visited Japan, 1892-94, and Ceylon and Australia, 1907. He died July 1933.

Contrib: *The Evergreen [1895-96].*
Exhib: B; G; L; M; NEA; RA; ROI; RSA.

HORWITZ, Herbert A. — fl.1892-1925

Portrait painter. He studied at the RA Schools and was working in North London until 1925. He contributed to *The English Illustrated Magazine,* 1896 (decor).

Exhib: G; L; New Gall; RI; RBA.

HORSLEY, John Callcott RA — 1817-1903

Painter and etcher. He was born on 29 January 1817, the great-nephew of Sir Augustus Callcott RA. A prolific artist, he studied at the RA Schools and concentrated on book illustration in the earlier part of his career, favouring in both oil and black and white, subjects from history or from Shakespeare. He was elected RA in 1864, became Treasurer in 1882 and was Professor of Drawing. He died at Cranbrook, 19 October 1903.

Illus: *The Beauty and The Beast, The King was in the Counting House, Puck Reports to Oberon, The Home Treasury series [Felix Summerly, 1843]; The Little Princess [1843]; Poems and Pictures [1846].*
Contrib: *The Deserted Village [1841]; Etch'd Thoughts [1844]; Gray's Elegy [1847]; L'Allegro [1849]; Songs and Ballads of Shakespeare [1853]; Etching Club; Etchings for Art Union [1857, 1865, 1872, 1879]; Moxon's Tennyson [1857]; A Book of Favourite Modern Ballads [1859]; The Churchman's Family Magazine [1863]; Adam's Sacred Allegories; Burn's Poems; The Poetry of Thomas Moore.*
Exhib: B; BI; G; M; RA.
Colls: Sheffield; V & AM.

HORSLEY, Walter Charles — 1867-1934

Figure and landscape painter. He was the son of J.C. Horsley RA (q.v.), and worked in London. He contributed to *The Graphic,* 1880.

Exhib: B; G; M; RA; RBA; RI; ROI.

HORTON, Alice M. — fl.1897-1911

Illustrator. Studied at Mount Street School of Art and contributed to *The Studio.* Working in Birkenhead, 1911.

Exhib: L.
Bibl: *The Studio,* Vol.13, 1897, pp.192-193, illus.

HORTON, William Thomas — 1864-1919

Black and white artist and illustrator. Born in Brussels in 1864 and was educated there and at Brighton Grammar School where he was a schoolmate of Aubrey Beardsley (q.v.). Studied architecture at the RA Schools, 1887, but abandoned architecture in 1894 for novel writing, drawing and mysticism. He was a member of 'The Brotherhood of New Life'. It is on record that Beardsley considered Horton to have some 'kind of talent' and he was clearly influenced by the younger man. His drawings are mannered, sharp and with strong contrasts of black and white, but miss the subtle nuances of Beardsley. Some of his drawings and their sources are influenced by William Blake's work.

Illus: *A Book of Images [Introduced by W.B. Yeats, 1898].*
Contrib: *The Savoy [1896]; Pick-Me-Up [1897]; The Dome [1898-99].*
Exhib: RA, 1890.
Bibl: *The Studio,* Vol.35, 1905-06, p.335; *Modern Book Illustrators and their Work,* Studio, 1914; Roger Ingpen, *WTH,* London, 1929.

HORWOOD, Arthur M.

Contributed comic strip illustrations to *The Graphic,* 1904.

HOSKINSON, E.

Contributed genre and figure subjects to *Punch,* 1903.

HOUGHTON, Arthur Boyd — 1836-1875

Painter and illustrator. He was born at Kotagiri, Madras, in 1836. He studied at Leigh's and entered the RA Schools in 1854 and through Charles Keene (q.v.) was probably introduced to J.W. Whymper (q.v.) and soon afterwards began work for the Dalziels. Financial circumstances forced Houghton to concentrate on book illustrations rather than on oil paintings and ironically drove into the field of black and white one of the most original geniuses of mid-Victorian England. He was a very powerful draughtsman and as an illustrator of romance, the *Arabian Nights* for example, was the only artist on this side of the channel to rival Doré in visual effects. He brought many aspects into his drawing, the composition of the Japanese print, the domestic humour of Leech and the imagination and accuracy of Rossetti and Holman Hunt. The founding of *The Graphic* in December 1869, gave Houghton a unique opportunity. He was sent to the United States for several months to draw the Americans and their way of life. The results are among his best work and perhaps the finest piece of pictorial journalism carried out by a Special Artist in the whole period. Houghton was elected ARWS in 1871 and died of progressive alcholism on 25 November 1875.

Houghton's drawings and oil paintings are tinged with Pre-Raphaelitism and often follow similar themes. A comprehensive exhibition of the artist's work was held at the Victoria and Albert Museum in May 1975.

Illus: *Dalziel's Arabian Nights, Victorian History of England [1864]; A Round of Days, Home Thoughts and Home Scenes, Don Quixote [1865]; Ernie Elton, The Lazy Boy, Patient Henry, Stories Told to a Child, The Boy Pilgrims [1866-67]; Ballad Stories of the Affections, Foxe's Book of Martyrs, Touches of Nature [1866]; Jean Ingelow's Poems; Idyllic Pictures; Spirit of Praise, Longfellow's Poems, Golden Thoughts From Golden Fountains, Savage Club Papers [1867]; Christian Lyrics, North Coast [1868]; The Nobility of Life [1869]; Novellos National Nursery Rhymes [1871]; Thornbury's Legendary Ballads [1876]; Dalziel's Bible Gallery [1880].*
Contrib: *Good Words [1862-68]; Churchman's Family Magazine [1864]; ILN [1865-66]; The Sunday Magazine [1865-71]; The Argosy, The Quiver, Every Boy's Magazine [1866]; Fun [1866-67]; Tinsley's Magazine, The Broadway [1867]; Golden Hours [1868]; The Graphic [1869-75].*
Exhib: BI; OWS; RA; RBA.
Colls: Ashmolean; BM; Fitzwilliam; V & AM; Witt Photo.
Bibl: Laurence Housman, introduction to *ABH A Selection From His Work in Black and White,* 1896; P. Hogarth, *ABH,* V & AM, 1975.
See illustrations (below and pp.346, 347).

ARTHUR BOYD HOUGHTON 1836-1875. 'The Meeting of the Prince and Badoura.' Illustration for Dalziel's Arabian Nights, *1865. Pencil. 6⅞ins. x 5⅛ins. (17.4cm x 13cm).*
Victoria and Albert Museum

THE MEETING OF THE PRINCE AND BADOURA.

ARTHUR BOYD HOUGHTON 1836-1875. 'The Meeting of The Prince and Badoura.' Completed illustration for Dalziel's Arabian Nights, 1865. *Wood engraving. 6⅞ins. x 5⅛ins. (17.4cm x 13cm).* Victoria and Albert Museum

HOUGHTON, Elizabeth Ellen **1853-1922**
Illustrator. She worked at Warrington, Lancashire, between 1886 and 1910 specialising in children's books. Her style owed a great deal to the influence of Randolph Caldecott both in line and tinting. She signs her work E.E.H.

Illus: *The Adventures of Little Man-Chester [1887].*
Contrib: *The Dome [1899].*
Exhib: L; M.
Colls: V & AM.

HOUGHTON, J.H. **fl.1886-1900**
Cartoonist for *Judy,* 1897. He also contributed to *Fun,* 1886-92 and 1900.

HOURY, J.J.
Amateur illustrator. Contributed to *The Studio* competitions, 1896, Vol.8, p.253, illus., from Bristol.

HOUSMAN, Clemence **1861-1955**
Woodcut artist. Sister of Laurence Housman (q.v.). Engraved many blocks after her brother's designs, including illustrations to *The Field of Clover, The Imitation of Christ,* 1898; *The Little Land with Songs from its Four Rivers,* 1899; *The Blue Moon,* 1904; *Maud,* 1905; *Prunella,* 1907, etc.

Exhib: Baillie Gall.

HOUSMAN, Laurence **1865-1959**
Painter, illustrator and author. He was born on 18 July 1865 and during the 1890s established himself as a leading book illustrator, basing his style on the traditional wood engraving of the 60s. He has been described as the last of the 'facsimile' engraver-illustrators and his wish to be in this line of succession, gives his work a marvellous purity of style and a freedom from *fin de siècle* mannerism. Housman was a great admirer of A.B. Houghton (q.v.) and published and edited his work in 1896. But it is not so much to this great black and white artist that Housman is in debt as to the Pre-Raphaelites and to artists such as Leighton. Housman paraphrases some of their best illustrative work, but with sufficient inventiveness and good manners to set himself well apart from the copyists. Like Rossetti, whose figures he imitated, Housman was a literary man as well as an artist and his books have a pleasant cohesion in design and text which was praised by contemporaries. He remained a rather isolated and nineteenth century figure and died at Street, Somerset, at a great age in 1959.
Signs: [⊢]

Illus: *Jump to Glory Jane [George Meredith, 1892]; Goblin Market [Rossetti, 1893]; Weird Tales From Nothern States [1893]; The End of Elfintown [J. Barlow]; A Random Itinerary [John Davidson]; A Farm in Fairyland; Poems [Francis Thompson]; Cuckoo Songs [Katharine Tynan, 1894]; The House of Joy [1895]; A Pomander of Verses [E. Nesbit]; Sister Songs [Francis Thompson]; Green Arras: Poems by Laurence Housman [1895]; The Were Wolf, All Fellows, The Viol of Love [C.N. Robinson, 1896]; The Sensitive Plant [P.B. Shelley]; The Little Flowers of St. Francis, Of The Imitation of Christ [1898]; The Little Land [1899]; At the Back of the North Wind [Macdonald, 1900]; The Princess and the Goblin [Macdonald, 1900]; The Blue Moon [1904]; Prunella or Love in a Dutch Garden [1907]; A Doorway in Fairyland [1923 etc.].*
Contrib: *The English Illustrated Magazine [1893-94]; The Pall Mall Magazine [1893]; The Yellow Book [1896]; The Pageant [1896]; The Parade [1897]; The Dome [1897-99]; The Quarto [1898].*
Exhib: Baillie Gall; FAS, 1901; NEA, 1894-1901.
Colls: V & AM.
Bibl: *The Studio,* Vol.19, 1897, p.220; *The Artist,* Feb. 1898, pp.99-103, illus; *The Studio,* Winter No., 1900-01, p.19 illus; R.E.D. Sketchley, *English Book Illus.,* 1903, pp.15, 127.
See illustration (p.349).

HOUSTON, Mary G.
Painter and decorative artist. She contributed to *The Studio* competitions (Vol. 8, 1896, p.184, illus.). She was working at Chelsea, 1901-04 and exhibited at the R.A.

HOWARD, Francis **1874-1954**
Painter and writer. He was born 1 January 1884, great-great-grandson of Benjamin Franklin. He studied art in Paris and London and was for many years art critic of *The Sun,* and a contributor on the arts to many periodicals. He founded the International Society of Sculptors, Painters and Engravers in 1898, and the National Portrait Society, 1910. He was Managing Director of the Grafton and the Grosvenor Gallery and arranged many exhibitions at home and abroad. He contributed a series of portrait drawings entitled 'Bodley Heads' to *The Yellow Book,* 1896. He died in 1954.

Exhib: G; L; New Gall; P.

HOWARD, George 9th Earl of Carlisle HRWS **1843-1911**
Watercolourist and illustrator. He was born on 12 August 1843, a grandson of the 6th Earl of Carlisle. He studied at South Kensington and was a patron of William Morris, Edward Burne-Jones, H.J. Ford and J.D. Batten (qq.v.). He was M.P. for East Cumberland, 1879-80 and 1881-85, but was more notable for the artists and radicals that he gathered round him at Naworth Castle, Cumberland. He travelled widely in Europe and Africa and was chairman of the Trustees of the National Gallery. He died 16 April 1911.

Illus: *A Picture Song Book by the Earl of Carlisle [1910].*
Contrib: *The English Illustrated Magazine [1895].*
Exhib: G; L; M; New Gall; RA; RHA; RWS.

FOR THE KING!

ARTHUR BOYD HOUGHTON 1836-1875. 'For The King.' Illustration to a story in Tinsley's Magazine, *1868. Wood engraving.*

HOWARD, Captain Henry R. -1895
Black and white artist. He was born at Watford, the son of a country gentleman and studied art under Ramburg in Hanover before being taught by John Leech (q.v.) to draw on the block. According to Spielmann he had the unusual practice of buying wood blocks from Messrs. Swain instead of having them supplied in his contract. He specialised in humanised beasts and birds and signed first with a manx emblem and then with a trident. He contributed to *Punch,* 1853-67 and died on 31 August 1895.

HOWELL, Charles A.
Amateur illustrator working in Upper Tooting. Contributed to *The Studio* competitions, Vol.15, 1899, p.144 illus.

HOWITT, Samuel 1756-1822
Sporting artist and illustrator. He was born in 1756, the son of an old Nottinghamshire family who were squires at Chigwell in Essex. Howitt was an amateur artist who turned professional after experiencing financial troubles. He worked as a drawing-master at a private academy in Ealing and began to exhibit at the Incorporated Society of Artists in 1783. He acquired great skill as an animal draughtsman, his studies usually taken from life at the Tower of London Menagerie. He married the sister of Thomas Rowlandson, whose penwork Howitt's sometimes resembles. He died at Somers Town, London in 1822.

Illus: *Miscellaneous Etchings of Animals [1803]; Oriental Field Sports [1805-07 and 1808, AT 427]; Fables of Aesop, Gay and Phaedras [1809-11]; The British Sportsman [1812].*
Exhib: RA, 1784-
Colls: BM; Fitzwilliam; Mellon; V & AM.
Bibl: M. Hardie, *Watercolour Paint. in Brit.,* Vol.1, 1966, p.225, illus.
See illustration (p.22).

HOYNCK, C. van Papendrecht 1858-
Dutch history and military painter and illustrator. He was born at Rotterdam on 18 September 1858 and exhibited in Munich and Berlin from 1888 and in Paris in 1900. He contributed to *The Graphic,* 1901-04.

Colls: V & AM (prints).

HUARD, L. -1874
Illustrator of genre. He was born at Aix-en-Provence and studied art at Antwerp. He worked in London for more than twenty years and contributed regularly to magazines. Gleeson White had a low opinion of this artist because he worked for the penny journals, his drawings are not inspired but he was thought good enough to succeed Sir John Gilbert on *The London Journal* in about 1859.

Contrib: *The British Workman [1855]; The London Journal [1859]; ILN [1861-63, 1875-76 and 1881]; London Society [1863]; Churchman's Family Magazine [1863]; Cassell's Magazine [1865]; The Band of Hope Review.*
Exhib: BI, 1857-72.

HUDSON, Gwynedd M. fl.1912-1925
Painter and illustrator of fairy tales. She studied at the Municipal School of Art, Brighton, and worked in Hove, Sussex.

Illus: *Peter Pan and Wendy [J.M. Barrie, c.1925].*
Exhib: RA, 1912.

HUGHES, Arthur 1832-1915
Painter and illustrator of genre and history, decorator and illustrator of children's books. He was born in London on 27 January 1832 and was educated at Archbishop Tenison's Grammar School, showing such ability in drawing that he was allowed to attend the Government

School of Design at Somerset House at the age of fourteen and work under Alfred Stevens. Entering the RA Schools in 1847, he won the silver medal for antique drawing in 1849. Shortly afterwards he came into contact with the Pre-Raphaelite Brotherhood, who particularly admired his paintings exhibited at the RA in 1851, 1854 and 1856. He posed for Millais in 1853 as 'The Proscribed Royalist' and was much admired as an artist by John Ruskin. He worked on the Oxford Union murals and painted a number of famous pictures including 'Home From Sea' in the Ashmolean Museum and 'The Long Engagement' in the Birmingham City Art Gallery. Hughes lived a rather withdrawn life at Kew Green and died there on 22 December 1915.

Hughes was alone among the Pre-Raphaelites in recognising that book illustration was more than the illustration itself. All his designs are conceived as part of the text and the ornament of the book and perhaps his classical study under Stevens, gave him this greater discipline. He is fond of placing his figures in a circle or a semi-circle, often gives them the arched neck of the Pre-Raphaelites and in his fairy drawings, the delicacy of Doyle. Although he is best-known for his black and white work, Hughes was a most brilliant colourist. He signs his work with gothic monogram .

Illus: *The Music Master* [W. Allingham, 1855 (with others)]; *My Beautiful Lady* [T. Woolner, n.d.]; *Enoch Arden* [Tennyson, 1866]; *Dealings with the Fairies* [George Macdonald, 1867]; *Five Days Entertainment at Wentworth Grange* [F.T. Palgrave, 1868]; *Tom Brown's Schooldays* [T. Hughes, 1869]; *Mother Goose* [1870 (with others)]; *At the Back of the North Wind* [George Macdonald, 1871]; *Ranald Bannerman's Boyhood* [George Macdonald, 1871]; *The Princess and The Goblin* [George Macdonald 1872]; *Parables and Tales* [T. Gordon Hake, 1872]; *Story of Elizabeth* [Anne Thackeray, 1872]; *Sing Song* [Christina Rossetti, 1872]; *Gutta-Percha Willie* [George Macdonald 1873]; *Sinbad the Sailor* [1873]; *Speaking Likenesses* [Christina Rossetti, 1873]; *Old Kensington* [Anne Thackeray, 1874-76]; *Four Winds Farm* [1887]; *Babies Classic* [1904]; *The Magic Crook* [Greville Macdonald, 1911]; *Trystie's Quest* [Greville Macdonald, 1912]; *Jack and Jill* [Greville Macdonald, 1913].
Contrib: *Poets of the Nineteenth Century* [Willmott, 1857]; *The Queen* [1861]; *The Cornhill Magazine* [1863]; *Good Words* [1864-72]; *London Society* [1865-70]; *Good Cheer* [1868]; *Sunday Magazine* [1869-72]; *Good Words For The Young* [1870-73]; *Novello's National Nursery Rhymes* [1870]; *The Graphic* [1887, 1889]; *London Home Monthly* [1895]; *The Girls' Own Paper*.
Exhib: B; G; GG; L; M; New Gall; RA; RI; ROI.
Colls: Ashmolean; BM; Manchester; V & AM.
Bibl: Forrest Reid, *Illustrators of The Sixties*, 1928, pp.83-95.
See illustrations (pp.350, 351).

HUGHES; Arthur Ford 1856-1914
Landscape painter and painter of windmills. He was born in 1856 and studied at Heatherley's and at the Slade and RA Schools. He was working at Wallington, Surrey in 1880 and in London in 1890. He contributed headpieces to *The English Illustrated Magazine*, 1886-87.
Exhib: G; L; RA; RBA; RI; ROI.

ELIZABETH ELLEN HOUGHTON 1853-1922. Illustration to The Adventures of Little-Man-Chester, *1887. Pen and ink, and watercolour. 8½ins. x 8⅞ins. (21.6cm x 22.5cm).*
Victoria and Albert Museum

LAURENCE HOUSMAN 1865-1959. 'King Bugdemagus Daughter.' Pen and ink. Signed L.H. 7⅝ins. x 4⅛ins. (19.4cm x 10.5cm).

Victoria and Albert Museum

HUGHES, Edward **1832-1908**

Portrait and genre painter and illustrator. He worked in Kensington, Chelsea and Notting Hill and contributed literary and historical subjects to the magazines.

Illus: *Poor Miss Finch [Wilkie Collins, 1872 (with Du Maurier)]*.
Contrib: *Once a Week [1864-66]; The Shilling Magazine [1865-66]; The Sunday Magazine [1866, 1869]; Cassell's Magazine [1870]; The Argosy [1866]; Hurst and Blackett's Standard Library*, etc.; *ILN [1870-75]; The Graphic [1871]*.
Exhib: BI; GG; RA; RBA.

HULL, Edward **fl.1827-1877**

Genre painter and illustrator, working in London. He contributed figure subjects to *The Illustrated Times*, 1859-61.

Exhib: RA; RBA.

HULLMANDEL, Charles-Joseph **1789-1850**

Artist and lithographer. He was born in London on 15 June 1789 and studied under Faraday. He travelled widely, experimented with lithography and perfected the litho-tint. He died on November 1850.

Illus: *Views of Italy [1818, AT 167]; The Art of Drawing on Stone [1824]; Ancient Castellated Mansions in Scotland [1833]*.

HULME, Frederick J. or E. **fl.1880-1940**

Flower painter and illustrator. He illustrated his own book *Flower Painting in Watercolours*, 1886, and a children's book *The Little Flower Seekers*, c.1880.

Exhib: NEA; RA.

HULME, Frederick William **1816-1884**

Landscape painter and illustrator. He was born in Swinton on 22 October 1816 and studied under a Yorkshire artist before going to London in 1844 to work for engravers. He died in London 14 November 1884.

Contrib: *The Illustrated London Magazine [1853]; The Poetical Works of E.A. Poe [1853]; The Book of South Wales [Mr. and Mrs. S.C. Hall, 1861]; Rhymes and Roundelayes*.
Exhib: B; BI; L; RA; RBA; ROI.
Colls: Leicester; Liverpool; Montreal.

HULME, Robert C. **fl.1862-1876**

Still-life painter and illustrator. He contributed drawings of ceremonies to *The Illustrated London News*, 1864-69 and 1873.

Exhib: RA; RBA, 1862-76.

HULSTROP, T.

Illustrator. A very competent pen draughtsman, inclined to spoil his work with heavy washes. He illustrated *The Refugees, A Tale of Two Continents*, by Conan Doyle, on its first appearance in 1891 and when reissued in 1912.

Contrib: *The Graphic [1889]; ILN [1895]*.

HUMPHREY, Miss K. Maude **fl.1883-1894**

Portrait and figure painter. She worked in London and illustrated *The Light Princess* by George Macdonald, 1894.

Exhib: B; M; RA; RBA; SWA.

HUMPHREYS, H. Noel **1810-1879**

Numismatist, naturalist and illustrator. He was born in Birmingham on 4 January 1810 and after working for some time in Italy, returned to England in 1843 to work as an illustrator. Humphreys was a very original designer in all the fields of art that he tackled, especially in that of illustration. A master of Chromo-lithography, he produced the finest illuminated gift-books of the Victorian age under the inspiration of Italian and Flemish illumination of the Middle Ages. He died intestate on 10 June 1879.

Illus: *The Illuminated Calendar [1845]; Parables of Our Lord, The Poets Pleasance, Insect Changes [1847]; The Coins of England [1846]; The Miracles of Our Lord, Maxims and Precepts of The Saviour [1848]; A Record of the Black Prince, The Art of Illumination and Missal Painting [1849]; The Book of Ruth [1850]; Sentiments and Similes of William Shakespeare [1851]; The History of Writing [1853]; Proverbial Philosophy [1854]; Coinage of the British Empire [1855]; Roman Anthology [1856]; River Gardens [1857]; Ocean Gardens [1857]; Rhymes and Roundelayes in Praise of Country Life [1857]; The Butterfly Vivarium [1858]; The Shipwreck [Falconer, 1858]; The Genera and Species of British Butterflies [1859]; Goldsmith's Poems [1859]; Thomson's Seasons [1859]; The White Doe of Rylstone [1858-59]; The Penitential Psalms [1861]; A Little Girl's Visit to a Flower Garden [Routledge Toy Books]*.
Contrib: *The Illustrated Times [1855 (decor.)]*.
Bibl: Chatto and Jackson, *Treatise on Wood Engraving*, 1861, p.599; R. McLean, *Victorian Book Design . . . 1972, pp.99-113*.

HUMPHRIES, A.

Illustrator. Contributing half tone work to *Punch*, 1905, in a poster style.

HUMPHRIS, William H. **fl.1881-1916**

Figure painter and illustrator of social realism. He worked in London, Wales and Cornwall and exhibited regularly.

Contrib: *The Graphic [1905-10]*.
Exhib: B; L; RA; RI; ROI.

HUNT, Alfred **fl.1860-1884**

Painter and illustrator. He was a student of the RA Schools and practised as a painter in Yorkshire until about 1860 when he returned to London and joined the staff of *The Illustrated London News*. He contributed large comic genre subjects to the paper, mainly for Christmas numbers at first and then more regularly. His double pagers present crowds of figures, usually rather wooden but interesting for their period details.

Illus: *Life and Lessons of Our Lord [Cummings, 1864]*.

ARTHUR HUGHES 1832-1915. Illustration for Tennyson's Enoch Arden, *Moxon Edition, 1866. Pen and ink. Signed with monogram.* Victoria and Albert Museum

HUNT, William Holman OM **1827-1910**

Painter and illustrator. He was born in Wood Street, Cheapside, London, on 2 April 1827, the son of a warehouse manager. He worked for some years as a clerk to an estate agent, but received lessons from the portrait painter, H. Rogers. He also studied at the British Museum, the National Gallery and after 1844 at the RA Schools. He began to exhibit at the Academy in 1846 and in 1848-49, he joined Millais and Rossetti in founding the Pre-Raphaelite Brotherhood. Thereafter followed a whole series of visits abroad, first to the Continent with Rossetti in 1849 and then as his ideas became more eastern and mystical, Egypt and Syria in 1854, a long stay in the Holy Land, 1869-71, and return visits to Palestine, 1875-78 and 1892. Hunt's greatest contribution was in portraying religious truth in terms of aesthetic truth as seen by the Pre-Raphaelites. His 'Light of The World' was to become a Victorian favourite and for his 'Finding of Christ in the Temple' he was paid the handsome sum of 5,500 guineas.

Hunt was not a prolific illustrator of books, but the work that he did was outstanding and highly inventive. His 'Lady of Shalott' in the *Moxon Tennyson*, 1857, set a seal on black and white drawing for a decade and his other contributions to magazines have a directness and mystery which makes them very compelling. He was awarded the OM in 1905 and died 7 September 1910.

Contrib: *Moxon's Tennyson [1857]; Once a Week [1860]; Parables From Nature [1861]; Willmott's Sacred Poetry [1862]; Good Words [1862]; Watt's Divine and Moral Songs [1865]; Macmillan's Golden Treasury Series; Studies From Life [Hurst and Blackett's Standard Library].*
Exhib: B; FAS, 1885-86; G; GG; L; M; NEA; New Gall; RBA; RHA; RSA; RWS.
Colls: Ashmolean; BM; Manchester; V & AM.
Bibl: W.H. Hunt, *Pre-Raphaelitsm and the Pre-Raphaelite Brotherhood*, 1905; F.W. Farrar, *WHH*, 1893; Diana Holman Hunt, *My Grandmothers and I.*

See illustration (p.351).

HUNTER, John Young **1874-1955**

Figure and portrait painter. He was born in Glasgow in 1874 and studied at the RA Schools. He married Mary Y. Hunter (q.v.), and became RBA in 1914.

Illus: *The Clyde [1908].*
Exhib: B; FAS, 1903, 1907; G; L; M; P; RA; RBA; RI; ROI; RWA.
Colls: Liverpool.

HUNTER, (George) Leslie **1879-1931**

Landscape and portrait painter, illustrator. He was born at Rothesay in 1879 and studied art in San Francisco and Paris. He worked in Scotland from 1906 and contributed to *The Graphic*, 1910.

Exhib: G; L; RSA.

HUNTER, Mary Young **fl.1900-1925**

Landscape and figure painter and illustrator. The wife of John Y. Hunter (q.v.), elected ASWA, 1901. She was working in Kensington 1902-14 and at Helensburgh, 1925.

Illus: *The Clyde [1908 (with JYH)].*
Contrib: *The Graphic [1912].*
Exhib: FAS, 1903, 1907; G; L; New Gall; P; RA; ROI; SWA.

HURST, Hal **1865-c.1938**

Painter, watercolourist, miniaturist and illustrator. He was born in London on 26 August 1865, the son of Henry Hurst, the African traveller. He began as an artist by drawing scenes of the Irish evictions and had work published at the age of twenty-three. He then went to America and worked as a special artist on the *Philadelphia Press* and several New York newspapers, covering the Atlantic City flood and other major events. He studied in the Art League in the United States

ARTHUR HUGHES 1832-1915. Illustration for The Music Master *by William Allingham, 1855.*

before returning to Europe to train under Bouveret and Constant in Paris. His drawing line is strongly American and influenced by the studies of Dana Gibson (q.v.). He claimed to be the 'Artist of the man and woman about town'. RBA, 1896 and ROI, 1900.

Illus: *The Sikh War [G.A. Henty, 1894]; Sou'Wester and Sword [St. Leger, 1894]; The American Claimant [Mark Twain, 1897]; various novels by Robert Barr, 1897.*

Contrib: *Fun [1890-1901]; The Idler [1892]; St. Paul's [1894]; Pick-Me-Up [1894]; The Minister [1895]; Vanity Fair [1896]; The Gentlewoman; Illustrated Bits; The Pall Mall Magazine; ILN [1912-13].*
Exhib: L; New Gall; RA; RBA; RHA; RI; RMS; RWS.
Bibl: *The Idler,* Vol.9, pp.657-670, illus.

HUTCHINSON, George W.C. fl.1881-1892
Figure and domestic painter. He worked in London, 1881, and in Bristol, 1889, and contributed the illustrations to Stevenson's 'Treasure Island' in *Chums,* 1892.

Contrib: *ILN [1889]; The Ludgate Monthly [1891]; Black & White [1892]; The Idler [1892]; Chums [1892]; The Pall Mall Budget; Puck and Ariel.*
Exhib: RA; RBA; RHA.

HUTTULA, Richard C. fl.1866-1888
Domestic painter. He contributed to *The Broadway,* c.1867-74.

Illus: *Hurricane Harry [W.H.G. Kingstone, 1874].*
Exhib: B; L; RBA; RI.

HYDE, Edgar
Artist working in Limerick, Ireland. He contributed drawings to *The Illustrated Times,* 1859.

HYDE, William Henry 1858-
Portrait painter and illustrator. He was born in New York on 29 January 1858 and studied under Boulanger in Paris and exhibited at the Paris Exhibition of 1900. Hyde was a mainstay of *Harper's Magazine,* producing fine ink studies in a gently humorous vein. He appears to have lived and worked in England for some considerable time and kept close contacts with British publishers.

Illus: *An Imaged World [E. Garnett, 1894]; Beyond the Dreams of Avarice [Walter Besant, 1897]; The Nature Poems of George Meredith [1897]; London Impressions [Alice Meynell, 1898]; London in Song [Whitten, 1898 (cover and end papers)]; The Cinque Ports [Blackwood, 1901]; The Victoria County Histories: Hampshire and Norfolk [1901]; The Poetical Works of John Milton [Astolat Press, 1904].*
Contrib: *The Yellow Book [1894-95]; The Pall Mall Magazine.*
Bibl: *The Studio,* June, 1894; *The Artist,* January, 1898, pp.1-6; R.E.D. Sketchley, *English Book Illus,* 1903, pp.39, 135.

HYLAND, Fred
Illustrator working in London, 1894. He contributed a drawing in the Beardsley idiom to *The Yellow Book,* 1895.

Exhib: RBA, 1894.

AT NIGHT.

WILLIAM HOLMAN HUNT 1827-1910. 'At Night.' Illustration to Once a Week, *Vol. 3, 1860. Wood engraving.*

ILLINGWORTH, F.W.
Figure artist. He contributed to *Punch*, 1914.

ILLINGWORTH, S.E.
Illustrator, contributing to *London Society*, 1868.

IMAGE, Selwyn 1849-1930
Watercolourist, illustrator and poet. Born at Bodiam, Sussex in 1849, the son of the Rev. J. Image. He was educated at Marlborough and New College, Oxford and then at the Slade School, Oxford under John Ruskin. He took Holy Orders in 1872, becoming curate at various London churches from 1875-80. He designed stained glass windows for the Paris Exhibition in 1900 and for St. Luke's, Camberwell and Morthoe Church, Devon. He was elected Master of the Art Workers' Guild in 1900 and was Professor of Fine Art at Oxford, 1910-16. He was an occasional illustrator, a designer of ex-libris, and died 21 August 1930.

Illus: *Lyric Poems [Laurence Binyon, 1894]; A London Rose and Other Rhymes [Ernest Rhys, 1894]; A Little Child's Wreath [E.R. Chapman, 1895-96]; Stephania [Michael Field, 1895-96]; Poems [Vincent O'Sullivan, 1895-96];* (in each case, title and cover).
Contrib: *The Century Guild Hobby Horse [1884-91].*
Exhib: FAS.
Colls: BM; V & AM.
See illustration (right).

IMARGIASSI, Mario
Contributor to *The Illustrated London News,* 1889.

INCE, Charles 1875-
Landscape painter and illustrator. He was educated at the Cowper School and at King's College, London, and studied art with Henry George Moon, the landscape painter. Ince was an accountant and a director of a family printing firm as well as an artist. He was for some years the auditor of the RBA, after being elected to it in 1912. He contributed to *Punch*, 1905-06, favouring chalk drawings reminiscent of Belcher's work.

Exhib: G; L; M; RA; RBA; RI; ROI; RWS.

INCE, Joseph Murray 1806-1859
Watercolourist and topographer. He was born at Presteign, Radnorshire in 1806 and became a pupil of David Cox in 1823, remaining with him for three years. Ince then lived in London and later lived in Cambridge, returning finally to Presteign in about 1835 on inheriting property there. He died 24 September 1859.

Illus: *Views Illustrating the County of Radnor [1832]; The Cambridge Portfolio [Rev. J.J. Smith, 1838-40].*
Exhib: RA; RBA.
Colls: BM; Fitzwilliam; V & AM.
Bibl: M. Hardie, *Watercolour Paint in Brit.,* Vol.III, p.19, illus.

INGLIS, Archie
Figure artist. Contributed a 'portrait' of Mr. Punch to *Punch,* 1904.

INGLIS, G.
Illustrator and book decorator. He illustrated *Ditties of the Olden Time,* c.1840, the ornamental work of a high quality, the figures less successful.

SELWYN IMAGE 1849-1930. Book illustration for The Century Guild Hobby Horse, *1884.*

INGLIS, Lionel
Humorous figure artist. He illustrated with R.A. Sterndale *The Lays of Ind* by Aliph Cheem, Calcutta, 1883, a satire of the British Raj.

INGRAM, Master H. -1860
Amateur artist. He was the son of Herbert Ingram, founder of *The Illustrated London News* and contributed illustrations to the paper in 1859 and 1860. He perished with his father in a steamer accident on Lake Michigan in 1860.

JACK, Richard RA 1866-1952

Portrait, figure and landscape painter. He was born in Sunderland in 1866 and studied at the York School of Art, winning a National Scholarship to South Kensington in 1886. He studied at the Académie Julian in Paris, 1890-91 and won medals at the Academy Colarossi and exhibited a prize-winning portrait at the Paris Exhibition, 1900. Jack was elected an ARA in 1914 and an RA in 1920, having become RP in 1900 and RI, 1917. He was working in Montreal, Canada in 1932.

Contrib: *The Windsor Magazine; The Idler [1892].*
Exhib: G; GG; L; M; New Gall; P. RA; RI.

JACKSON, Francis Ernest ARA 1872-1945

Portrait painter, lithographer. He studied in Paris and was for some time drawing instructor at the RA Schools. Jackson was very influential in bringing the art of lithography back into notice by serious artists and taught it at London County Council Schools in the 1900s. He ran his own lithography class in Camberwell and with Spenser Pryse (q.v.) he ran *The Neolith*, 1907-08, a magazine with both text and illustrations lithographed. His early work is clearly influenced by Beardsley and Mucha and with its candles and ironwork and 'coquettish' delicacy, looks forward to art deco. Jackson also carried out posters for the Underground Railway. ARA, 1944.

Exhib: G; L; M; NEA; P; RA; RHA; RSA.
Bibl: *The Studio*, competition, Vol.5, 1895, illus.; Vol.18, 1899-1900, pp.282-285.

JACKSON, Frederick Hamilton 1848-1923

Painter, illustrator and designer. He was born in 1848 and entered his father's wholesale book business, but gave this up to follow art. He studied at the RA Schools, later becoming master in the Antique School of the Slade under Poynter and Legros (qq.v.). He founded with E.S. Burchett the Chiswick School of Art in 1880, was lecturer on perspective at South Kensington and a member of the Art Workers' Guild from 1887. He also worked on schemes for ecclesiastical decoration and designed for mosaics. He was elected RBA in 1889 and died 13 October 1923.

Illus: *The Stories of the Condottieri; A Little Guide to Sicily [1904]; The Shores of the Adriatic [1906]; The Italian Side and the Austrian Side; Rambles in the Pyrenees [1912].*
Exhib: B; G; GG; L; M; New Gall; RA; RBA; RHA; RI; ROI.

JACKSON, J.

Illustrator, contributing drawings of Spain to *The Illustrated London News*, 1875.

JACKSON, James Grey

Artist. He wrote and illustrated *An Account of the Empire of Morocco*, 1809, AT 296.

JACKSON, Mason 1819-1903

Wood engraver and illustrator. He was the son of John Jackson, the wood engraver, who with W.A. Chatto published *A Treatise on Wood Engraving*, 1838. He was a pupil of his brother John Jackson 1801-1848 and became Art Editor of *The Illustrated London News* in 1860 and Editor in about 1875. He was the first historian of illustrated journalism. He died in West London in 1903.

Illus: *Walton's Compleat Angler [Bohn]; Ministering Children.*
Contrib: *Cassell's Illustrated Family Paper [1857]; ILN [1876-78].*
Exhib: RA.
Bibl: M. Jackson, *The Pictorial Press*, 1885.

JACKSON, Sir Thomas Graham, Bt. 1835-1924

Architect and draughtsman. He was born at Hampstead 21 December 1835 and was educated at Brighton College and Wadham College, Oxford. He was a pupil with Sir Gilbert Scott, 1858-61 and in 1864 became a Fellow of Wadham College, remaining at Oxford until 1880. He was a notable architect of collegiate buildings, mostly in Oxford and carried out many restorations of Tudor and Jacobean houses. He was elected ARA in 1892 and RA in 1896. He was created a Baronet in 1913 and died on 7 November 1924.

Illus: *Wadham College: Its History and Buildings [1893].*
Exhib: RA.
Colls: Ashmolean (book-plates).
Bibl: *Recollections of TGJ*, 1950.

JACOBS, Louise R. fl.1910-1938

Landscape and flower painter and illustrator. She was working in London in 1910 and in Hull, 1923-25.

Contrib: *The Graphic [1915 (allegory)].*
Exhib: L; RA; RBA; RCA; RHA; RSA; SWA.

JACOMB-HOOD, Percy See HOOD, Percy JACOMB-

JACQUE, G.H.

French figure artist. He contributed drawings to *The Illustrated London News*, 1851.

JALLAND, G.H. fl.1888-1908

Black and white artist specialising in equestrian subjects. He was a regular contributor to *Punch* from 1888 and was considered by M.H. Spielmann to be a natural successor to Leech with his humours of the hunting field and of sport. He did small free pencil sketches which are very lively. He signs his work ⚓

Contrib: *Punch [1888-1905]; ILN [1891-98]; The Sporting and Dramatic News [1892]; The Pall Mall Magazine; The Graphic [1908].*
Exhib: FAS, 1901.
Bibl: *Mr. Punch with Horse and Hound* New Punch Library, c.1930.

JAMES, Gilbert fl.1895-1926

Figure and still-life painter and illustrator. He was born at Liverpool and after working in commerce, turned to art and on moving to London began to contribute black and white drawings to the leading magazines. James worked mostly in a heavy art nouveau style, strong contrasts and very mannered and symbolic subjects often with an Eastern setting. His work is very variable in quality.

Illus: *Contes de Grimm [1908]; Contes de Anderson [1908]; The Rubaiyat of Omar Khayyam [1910].*
Contrib: *The Ludgate Monthly [1891]; The English Illustrated Magazine [1895-97]; The Sketch [1897]; Pick-Me-Up [1897]; The Quartier Latin [1898]; The Butterfly [1899].*
Exhib: L; NEA.
Colls: V & AM.

JAMES, The Rt. Rev. J.T. Bishop of Calcutta 1786-1828

Author and artist. He was born in 1786 and educated at Rugby, Charterhouse and Christ Church, Oxford. M.A., 1810. He lived at Barnet, 1810-16, was Vicar of Flitton-cum-Silsoe, Bedfordshire, 1816-27, and Bishop of Calcutta, 1827-28. He published some papers on painting, 1820-22.

Illus: *Journal of a Tour in Germany, Sweden and Russia, Poland [1816, AT 16]; The Semi-Sceptic [1825]; Views in Russia, Sweden, Poland and Germany [1826-27 (liths.) AT 23].*
Exhib: RA, 1810-16.

JAMES, Lionel

Special Artist for *The Graphic* in Russia, 1904, and during the Russian political outrages, 1905-10. This artist is not further recorded.

JAMESON, Margaret fl.1909-1920

Flower and portrait painter and illustrator. She worked in London and illustrated *The Vicar of Wakefield*, for Chapman and Hall in 1910 with lucid ink and watercolour drawings.

Exhib: L; RA; SWA.

JANE, Fred T. 1870-1916

Naval artist and author and originator of *Jane's The World's Warships,* 1915. He was born at Upottery, Devon, on 6 August 1870 and was educated at Exeter School. Jane was the inventor of the Naval War Game and a successful naval journalist, being correspondent for *The Engineer, The Scientific American* and *The Standard.* He contested Portsmouth as Navy Interest Candidate in the General Election of 1906. Lived at Havant, Hants and died 8 March 1916.

Publ: *The Imperial Russian Navy [1900]; The Imperial Japanese Navy [1904]; All The World's Aircraft [1910]; The British Battle Fleet [1912].*
Contrib: *ILN [1892-96]; The English Illustrated Magazine [1893-95]; The Penny Illustrated Paper.*
Exhib: RA, 1894.

JANET, Gustave 1829-

Draughtsman, lithographer and illustrator. He was born in Paris in 1829 and was the brother of Janet Lange (q.v.). He worked for most of the leading French magazines, particularly *Monde illustrée* and *Revue de la Mode.* He did a certain amount of fashion illustration and was employed by Henry Vizetelly on English publications. The latter writes of him that he 'excelled in depicting such scenes as a ball or reception at the Tuileries, his women always being very gracefully drawn although they were remarkably alike in face — being in fact so many portraits of the artist's handsome wife.'

Publ: *Caricatures Politiques [1849]; Souvenirs de L'Opera; La Mode artistique.*
Contrib: *Cassell's Illustrated Family Paper [1853]; The Illustrated Times [1855-66]; ILN [1867-71].*

JANOWSKI, C.

Illustrator of genre. A series of designs of French markets by this artist are in the Victoria and Albert Museum collection, signed and dated 1904. The book for which they were intended has not been identified.

JEHNE, Linton

Political cartoonist. He illustrated *Alice in Blunderland* by Louis Carllew, 1910.

JELLICOE, John fl.1865-1903

Figure painter and illustrator. He drew mainly domestic scenes for novels and popular magazine stories.

Illus: *Queen of Beauty [Mrs. Henry, 1894]; Cherry and Violet [Miss Manning, 1897].*
Contrib: *ILN [1889]; The Sporting and Dramatic News [1890]; Good Words [1891]; St Paul's [1894]; The Lady's Pictorial; The Windsor Magazine.*
Exhib: RBA, 1887-88.

JENKINS, Joseph John RSA 1811-1885

Genre painter, watercolourist and engraver. He was born in London in 1811, the son and pupil of the painter D. Jenkins. He became a member of the NWS in 1842 and an Associate of the OWS in 1849 and Secretary, 1854-64. He was a considerable historian of the progress of watercolour in this country, Roget basing his *History* on Jenkins notes. He was also the first artist to introduce the idea of private press views of exhibitions in this country. He died on 8 March 1885.

Contrib: *The Chaplet [c.1840].*
Exhib: BI; NWS; OWS; RA; RBA.
Colls: V & AM.

JENKINS, Will

Book decorator. He contributed borders and ornament to *The Connoisseur,* 1914.

JENNER, Stephen fl.1820-1830

Amateur caricaturist. He was a great-nephew of Dr. Jenner and drew portrait figures in pencil, usually signed 'S. Jenner del'.

JENNINGS, Edward fl.1865-1888

Landscape painter in watercolour and illustrator. He contributed to *Good Words,* 1880.

Exhib: NWS; RA; RBA; RI.

JENNINGS, Reginald George 1872-1930

Figure, portrait and landscape painter and illustrator. He studied at the National Art Training School and at the Westminster School of Art, becoming Instructor at King's College for Women and Instructor in Painting and Design to Middlesex County Council.

Contrib: *Fun [1900].*
Exhib: L; New Gall; RA; RI.

JENNIS, Gurnell Charles 1874-1943

Black and white artist and etcher. He specialised in country and horse subjects in an individual scratchy style which he contributed to *Punch* and other magazines. He worked in London and was elected ARE in 1914.

Contrib: *Pick-Me-Up [1896]; Punch [1913-22]; The Graphic [1916].*
Exhib: L; NEA; RA; RE.
Colls: V & AM.
Bibl: *Mr Punch with Horse and Hound,* New Punch Library, c.1930.

JESSOP, Ernest Maurice fl.1883-1907

Painter, etcher and illustrator. He worked in London and specialised in domestic subjects and children's books.

Illus: *The Knight and The Dragon [Tom Hood, 1885].*
Contrib: *The Girl's Own Paper [1890-1900]; The Idler [1892].*

'JEST'

Cartoonist contributing one caricature to *Vanity Fair,* 1903.

JEWITT, Thomas Orlando Sheldon 1799-1869

Architectural draughtsman and illustrator, engraver on wood. He was born in 1799, the son of Arthur Jewitt and worked with his father on the latter's newspaper *The Northern Star.* He established himself at Oxford in 1838 and later moved to London where he became well-known as an illustrator of Gothic architecture and ornament. According to Chatto he was 'one of the very few who continue to combine designing and drawing with engraving'. He died in London on 30 May 1869.

Illus: *Bloxham's Gothic Architecture [1829]; Bohn's Glossary of Ecclesiastical Ornament [1846]; Glossary of Architecture [J.H. Parker, 1849]; Brick and Marble Architecture of Italy [G.E. Street, 1855]; Murray's English Cathedrals [1861-69, 7 vols]; Baptismal Fonts [Van Voorst]; Westminster Abbey [Scott].*
Bibl: Chatto & Jackson *Treatise on Wood Engraving,* 1861, pp.584-585.

JOBLING, Robert 1841-1923

River painter and illustrator of panoramic views. He was born in Newcastle in 1841 and trained there as a glass-maker. He attended evening classes in art and after acting as the foreman painter at a shipyard, he became a full-time artist in 1899. He was married to a painter, Isa Thompson and died at Whitley Bay in 1923.

Illus: *Tales of the Borders [Wilson].*
Contrib: *Illustrated London Magazine [1885]; The Graphic [1889].*
Exhib: B; L; RA; RBA.

JOHANNOT, Tony & 1803-1852

French illustrator. He was born at Offenbach on 9 November 1803 and was the foremost illustrator of the 1840s in France, following the romantic tradition and introducing vignette work into his books. His popularity in England was not widespread although some English editions of his illustrated volumes did appear. He died in Paris, 4 August 1852.

Illus: *Don Quixote [1836-37, English edition 1842]; The Works of Molière [1835-36]; Sentimental Journey [Sterne, 1851]; Summer at Baden Baden [Guinot, 1853].*
Contrib: *ILN [1851].*
Bibl: Percy Muir, *Victorian Illustrated Books,* 1971, pp.221-222.

JOHNSON, Alfred J. fl.1874-1894
Figure and domestic painter and illustrator. Worked in North London
and was a very regular contributor to the magazines. He signs his
work ⅊

Illus: *Seven Little Australians [Ethel S. Turner, 1894].*
Contrib: *ILN [1874-93]; The Quiver [1890]; The Strand Magazine [1894];
The Wide World Magazine.*
Exhib: L; RA; RBA; RI.

JOHNSON, C.K.
Contributor of comic genre subjects to *The Graphic,* 1887.

JOHNSON, Cyrus RI 1848-1925
Genre painter and illustrator. He was born at Cambridge on 1 January
1848 and after studying at the Perse School, worked in London as a
domestic and portrait painter. He was elected RI in 1887 and died at
Baron's Court, 27 February 1925.

Contrib: *The Strand Magazine [1891].*
Exhib: RA; RBA; RWS.

JOHNSON, Edward Killingworth RWS 1825-1896
Rustic artist and illustrator. He was born at Stratford-le-Bow in 1825
and taught himself to paint, taking up the career of a painter in 1863.
He attended some classes at the Langham Life School but preferred to
study from nature in the countryside and moved to Essex in 1871,
remaining there for the rest of his life. He was a popular contributor
to *The Graphic* and in 1887, was described by that magazine as 'Our
Country Artist'. In 1855, Johnson was employed to draw illustrations
on the wood for the Cundall Edition of Goldsmith's *The Deserted
Village.* He was elected AOWS in 1866 and a full member in 1876. He
died at Halstead in 1896.

Contrib: *The Welcome Guest [1860]; London Society [1863]; The
Churchman's Family Magazine; The Graphic [1874-89].*
Exhib: OWS; RA; RBA.

JOHNSON, Ernest Borough RBA ROI RI 1867-1949
Lead pencil artist and illustrator, painter, etcher, lithographer. He was
born in Shifnal, Salop in 1867 and studied at the Slade School under
Legros and at the Herkomer School, Bushey. Johnson was Professor
of Fine Arts at Bedford College, University of London and
Headmaster of the Art Department at Chelsea Polytechnic. He also
taught at the London School of Art, the Byam Shaw School and the
Vicat Cole School. He was a writer, a collector of antiques and
porcelain and his drawings of 'Blitzed London' were acquired by the
Guildhall Museum in 1945. He collaborated with Sir H. Von
Herkomer (q.v.) in illustrating Thomas Hardy's *Tess* for *The Graphic*
in 1891. He was elected RBA in 1896, RMS, 1897, ROI, 1903 and RI,
1906.

Publ: *The Drawings of Michaelangelo; The Woodcuts of Frederick Sandys; The
Techniques of the Lead Pencil; Chalk and Charcoal; A Portfolio of Rapid
Studies From the Nude; The Art of the Pencil.*
Contrib: *The Graphic [1889-91]; Black & White [1891].*
Exhib: B; G; L; M; New Gall; P; RA; RBA; RI; RSA; ROI.
Colls: V & AM.

JOHNSON, Herbert 1848-1906
Figure and landscape painter and illustrator. He worked mostly at
Clapham, London, but was sent by *The Graphic* as Special Artist on
the Royal Tour of India, 1875 and to Egypt in 1882. He specialised in
military and ceremonial subjects.

Contrib: *The Graphic [1870-89]; The English Illustrated Magazine [1888]; The
Daily Graphic [1890]; The Girls' Own Paper; The Windsor Magazine.*
Exhib: G; L; M; RA; RBA; ROI.
Colls: Witt Photo.

JOHNSTON, Sir Harry Hamilton FRGS 1858-1927
Painter and explorer. He was born at Kennington on 12 June 1858
and was educated at Stockwell Grammar School and King's College,
London. He studied at the RA Schools, 1876-80 and was a medallist
at South Kensington Schools, 1876. Johnston travelled in North

Africa, 1879-80, West Africa and the River Congo, 1882-83, and led
the Royal Society's expedition to Kilimanjaro in 1884. He became
British Vice-Consul in the Cameroons in 1885, Consul General of The
British Central African Protectorate, 1891 and Consul General at
Tunis, 1897-99. He was created KCB, 1896 and GCMG in 1901, and
died in Sussex on 31 July 1927.

He was a very talented painter of African scenery and animals in
watercolours, which he contributed to various publications and
magazines.

Contrib: *The Graphic [1889-1906].*
Exhib: L; M; RA; RWS.
Bibl: *The Story of My Life,* 1923.

JOHNSTONE, Alexander 1815-1891
Genre painter and illustrator. He was born in Scotland in 1815 and
studied at the Edinburgh Academy and at the RA Schools, principally
painting history subjects. He died in March 1891.

Contrib: *The Home Affections [Charles Mackay, 1858].*
Exhib: BI; RA; RBA.

JONES
Various engravings to *The Illustrated London News,* 1843 are signed
'Jones del'.

JONES, Adrian 1845-1938
Sculptor. He was born on 9 February 1845, the son of James
Brookholding Jones of Ludlow and was educated at Ludlow Grammar
School. He served for twenty three years as a veterinary officer in the
regular Army before devoting his time entirely to sculpture. He
executed a large number of military statues and the Victoria and
Albert Museum has a drawing by him for illustration. MVO, 1907. He
died 24 January 1938.

Exhib: G; GG; L; RA; ROI.
Bibl: *Memoirs of a Soldier Artist,* 1933.

JONES, Alfred Garth
Landscape painter, illustrator and poster artist. He studied first in
Manchester and then at the Westminster School of Art and the Slade,
followed by working under Laurens and Constant in Paris, 1893 and a
period at South Kensington. He was influenced by the works of Dürer
and his pen drawings have a strong woodcut style that was sometimes
criticised. A very versatile artist, he was as much at home in
imaginative work as in political cartooning or pure decoration. He was
better known in France in the early part of his career, working for
Revue Illustrée, later establishing himself in this country as design
master at the Lambeth and Manchester schools.

Illus: *The Tournament of Love [Brentano, 1894]; The Minor Poems of Milton,
[1898]; Contes de Haute Lisse [Doucet, 1900]; Contes de la Fileuse [Doucet,
1900]; The Essays of Elia [Charles Lamb, 1902]; A Real Queen's Fairy Book;
In Memoriam [Tennyson, 1903]; Goldsmith's Works; Poems and Dramatic
Works of Coleridge; Journal to Stella [J. Swift]; Keat's Poems; The Voyage of
Marco Polo.*
Contrib: *The Quartier Latin [1896]; The Quarto [1896-97]; The Parade
[1897]; Fun [1901]; The Graphic [1910].*
Exhib: NEA; RA.
Bibl: *The Studio,* Winter No, 1900-01, p.82, illus; Vol.25, 1901-02, p.131;
R.E.D. Sketchley, *Eng. Bk. Illus.,* 1903, pp.14-15, 128; *Modern Book
Illustrators and their Work,* Studio, 1914.

JONES, E.A.T.
Illustrator. Four coloured ink drawings for a book, signed by this
artist and dated 1871-85, were on the art market in 1976.

JONES, F.
Contributed drawings to *Small Arms,* published by the War Office in
about 1900.

Colls: V & AM.

JONES, G. Smetham fl.1888-1894

Black and white artist, specialising in horses. Worked in North London and exhibited at the RA and RBA, 1888-1893.

Contrib: *Pick-Me-Up [c.1890]; Judy; St. Pauls [1894]*.
Colls: Witt Photo.

JONES, George Kingston fl.1890-1925

Illustrator. He worked in London and according to A.S. Hartrick (q.v.) was on the staff of *The Graphic*, 'established as toucher-up of photographs and general utility man'.

Contrib: *The Daily Graphic [1890]; The Windsor Magazine; The Graphic [1890-1910]*.
Exhib: RA, 1896-99.
Bibl: A.S. Hartrick, *A Painter's Pilgrimage*, 1939, p.67.

JONES, Maud Raphael fl.1889-1902

Landscape and rustic painter. She worked at Bradford and exhibited in London, 1889-93.

Colls: Witt Photo (illus.).

JONES, Owen Carter 1809-1874

Architect, designer and topographer. He was of Welsh descent and born in Thames Street, London on 15 February 1809. For six years he was a pupil of Lewis Vulliamy, the architect, and attended the RA Schools, 1830. Jones made extensive visits to France, Italy, Egypt and Spain in 1836, beginning a book on the Alhambra which was not completed for nine years and cost £24 a copy! He had also become interested by Sir Henry Cole's attempts to improve industrial design and contributed many illustrations to the latter's *Journal of Design and Manufactures,* 1849. He supervised the decoration of the Great Exhibition in 1851 and of the Crystal Palace at Sydenham, 1852. Jones was influential in opening up new possibilities for lithography and for applying new styles to wall-papers and textiles. He died on 19 April 1874.

Illus: *Ancient Spanish Ballads [J.G. Lockhart, 1841]; Alhambra [1836-42]; The Grammar of Ornament [1856]; The Victoria Psalter [1861]*.
Exhib: RA, 1831-61.
Colls: BM.
Bibl: Chatto & Jackson, *Treatise on Wood Engraving*, 1861, p.599; Ruari McLean, *Victorian Book Design*, 1972, pp.73-98, illus.; P. Muir, *Victorian Illustrated Books*, 1971, pp.154-155.

JONES, Sydney Robert 1881-1966

Painter, etcher and illustrator. He was born on 27 February 1881 and studied art at the Birmingham School. A very accomplished pen artist, he made tours of England, France, Belgium and Holland and published the results in a series of travel books. He worked for *The Studio* in 1912-13, designing for their special numbers and was associated with Messrs. J. Connell, publishers. He died at Wallingford in 1966.

Illus: *Old English Country Cottages [1966]; The Charm of the English Village [P.H. Ditchfield, 1908]; The Manor Houses of England [1910]; Old Houses in Holland; Cottage Interiors and Decoration; On Designing Small Houses and Cottages; The Village Homes of England [1912]; England in France [C. Vince, 1919]; Posters and Their Designers; Art and Publicity; Touring England; Old English Household Life; London Triumphant; Thames Triumphant*.
Contrib: *The Sphere*.
Exhib: L; RA; RI.
Colls: V & AM.
Bibl: *Modern Book Illustrators and their Work*, Studio, 1914.

JONES, T.W.

Figure artist. Contributed drawings to *Punch*, 1904.

JONES, Thomas fl.1836-1848

Caricaturist. He was active in the early Victorian period, drawing very much in the style of Bunbury.

Colls: Witt Photo.

JONES, V.

Contributor to *The Illustrated London News*, 1858.

JOPLING, Joseph Middleton 1831-1884

Painter, portraitist and caricaturist. He was self-taught and was elected ARI, 1859. He married Louisa Goode, the first woman to be elected RBA, 1902. He contributed two cartoons to *Vanity Fair*, 1883.

JOSEPH, George Francis ARA 1764-1846

Portrait and miniature painter. He entered the RA Schools in 1784 and won the gold medal, 1792. He was elected ARA in 1813 and died in Cambridge in 1846. He designed some illustrations for historical books.

Colls: BM.

JOUQMART, W.

Contributor of social subjects to *Punch*, 1900.

JOY, Thomas Musgrove 1812-1866

Historical painter and book illustrator. He was born at Boughton Winchelsea, Kent, in 1812 and studied art with Samuel Drummond ARA. He moved to London and became the teacher of John Philip RA, and was patronised by Queen Victoria, 1841-43. His illustrative work makes use of vignettes and elaborate borders. He died in London, 7 April 1866.

Exhib: RA; RBA, 1832-
Colls: York.

JUNGMANN, Nico W. RBA 1873-1935

Dutch artist who became a British subject, painter and illustrator. He was born in Amsterdam in 1873 and was apprenticed at the age of twelve to a church decorator. He then attended the Academy of Plastic Art in Amsterdam and won a scholarship to London to study its life. He settled in London but continued to paint Dutch scenes, much of the illustrative work being in large chalk drawings with pastel colours and very sculptural in effect. He is much influenced by the Japanese colour print, but also by Millet and his sympathy for the peasant at work. He was a close friend of the artist Charles W. Bartlett with whom he worked.

Illus: *Holland [Beatrix Jungmann, c.1905]; Norway [Beatrix Jungmann, c.1905]; Normandy [G.E. Mitton, c.1905]; The People of Holland [c.1905]*.
Contrib: *The Parade [1897]*.
Exhib: B; L; M; RA; RBA; RHA.
Bibl: *Some Drawings by Mr. NJ*, Studio, Vol. 13, 1898, pp.25-32, illus.

JUSTYNE, Percy William 1812-1883

Landscape painter and book illustrator. He was born at Rochester, Kent in 1812 and was principally a contributor to the magazines. Justyne specialised in architectural illustration and particularly church architecture, gothic buildings and the monuments of the East and Spain, where he lived from 1841-48.

Illus: *History of Greece [Smith]; Biblical Dictionary [Fergusson]; Handbook of Architecture [C. Kingsley]; Christmas in the Tropics*.
Contrib: *Cassell's Illustrated Family Paper [1857]; Churchman's Family Magazine [1863]; The Graphic [1873]; ILN; Floral World*.
Exhib: RA; RBA.
Colls: Nottingham.

K

KAPP, Edmond Xavier
1890-1978

Painter, draughtsman and caricaturist. He was born in London on 5 November 1890, and was educated at Owen's School and Christ's College, Cambridge before studying art in Paris and Rome. Although Kapp's training dates from before the First World War, in which he served with the BEF, his popularity as a caricaturist stemmed from his first one man show in London, 1919. He became one of the leading artists of the 1920s in this field, drawing most of the writers, musicians, artists and actors of the decade and publishing a number of books. He subsequently turned his attention to more serious painting and particularly abstract work. He died on 31 October 1978.

Illus: *Personalities, Twenty-Four Drawings [1919]; Reflections, Twenty-Four Drawings [1922]; Ten Great Lawyers [1924]; Minims, Twenty-Eight Drawings [1925]; Pastiche, A Music Room Book [1926 (with his wife)]; publications of original lithographs from 1932; The Nations at Geneva [1934-35, twenty-five portraits on stone].*
Contrib: *The Sketch; Trimblerigg [L. Housman, 1924]; The Law Journal [1924-25].*
Exhib: Leicester Gall; Wildenstein.
Colls: Ashmolean; Birmingham; BM; Manchester; V & AM.
Bibl: Charles Spencer, 'From Caricature to Abstraction', *Studio*, June 1961.

See illustration (below)

EDMOND XAVIER KAPP 1890-1978. Caricature of Wyndham Lewis at the Café Royal, 1914. Ink and watercolours, chalk. 10¾ins. x 8ins. (27.4cm x 20.5cm).
Victoria and Albert Museum

KAUFFER, Edward McKnight
-1954

Artist, poster-designer and illustrator. He was born at Great Falls, Montana, U.S.A. and educated at American public schools. He began his career as a theatrical scene painter, attending evening classes at the Art Institute, Chicago and then studying at Munich. He spent two years in Paris before settling in London in 1914, making his name there with his poster work for the Underground Railways. He was the first poster-artist in Britain to design advertisements where the visual and the verbal were totally integrated. He worked extensively for the private presses but his book illustration is less well-known. He became a member of the London Group, 1916.

Illus: *Anatomy of Melancholy [Robert Burton, Nonesuch, 1925]; Benito Cereno [Herman Melville, Nonesuch, 1926]; Elsie And The Child [Arnold Bennett, Curwen Press, 1929]; Don Quixote [Cervantes, Nonesuch, 1930]; Marina [T.S. Eliot, Ariel, 1930]; The World in 2030 A.D. [The Earl of Birkenhead, 1930].*
Contrib: *The Broadside [Harold Monro, Poetry Bookshop].*
Exhib: NEA.
Colls: V & AM.
Bibl: EMcKK, *The Art of the Poster*, 1924.

KAY, J. Illingworth
fl.1894-1918

Designer of covers and title-pages. He worked for Lane's Bodley Head and exhibited at the RA, 1917-18.

Illus: *Orchard Songs [Norman Gale, 1894]; Poems [Richard Garnett, 1894]; Romantic Professions [1894]; The Lower Slopes [Grant Allen, 1895].*
Contrib: *The Yellow Book [1896 (cover)].*

KAY, John
1742-1826

Caricaturist and miniaturist. He was born in Dalkieth in 1742 and apprenticed to a barber and print-seller at Edinburgh. In 1782, a customer left him a legacy which enabled him to live independantly as an artist. From that time until his death he produced nine hundred portrait caricatures and some political squibs. His drawings are in profile and spindly, rather like the work of Robert Sayer, but they were considered good likenesses and cover the whole of Edinburgh Society. *Kay's Edinburgh Portraits* were issued in 1837-38 and a further *Series of Original Portraits by John Kay, Edinburgh,* followed in 1877.

Colls: Witt Photo.

KEARNAN, Thomas
fl.1821-1850

Watercolourist and draughtsman. He worked in London and contributed to *Public Works of Great Britain*, 1838, AL 410. NWS, 1837.

Exhib: NWS; RA; RBA.

KEELING, William Knight RI
1807-1886

Portrait painter and watercolourist. He was born at Manchester in 1807 and was apprenticed to a wood-engraver there before moving to London to work under the portrait painter, W. Bradley. He returned to Manchester in 1835 and helped to found the Manchester Academy of Fine Arts of which he was President, 1864-77. He was elected AWS in 1840 and NWS the following year. Keeling made a voyage to Spain in middle life and died at Manchester 21 February 1886.

Contrib: *The Chaplet [1840].*
Exhib: BI; M; RA.
Colls: V & AM.

KEENE, Charles Samuel
1823-1891

Black and white artist, illustrator and etcher. He was born at Hornsea, London in 1823 and when a child moved with his family to Ipswich where he remained until his father's death in 1838. He was articled first to a solicitor and then to Pilkington, the architect, finally being articled to Charles Whymper, the wood-engraver. After leaving Whymper in 1852, he set up on his own in the Strand and worked for various publishers, especially for the nearby office of *The Illustrated London News*. Keene began to draw for *Punch* in 1852, a connection that was to last until the day of his death and bring him great celebrity. A rather withdrawn and slightly bohemian man, he relied principally on urban social life for his subjects, often taking his characters from the alley-way and the market where Du Maurier's folk

CHARLES SAMUEL KEENE 1823-1891. 'The Struggle.' Pen and ink. Signed with initials. 5½ins. x 4½ins. (14cm x 11.4cm). Author's Collection

would not be seen! He relied heavily on his friends for amusing situations and was supplied with many by his friend Joseph Crawhall (q.v.).

Keene's career as a draughtsman runs through several phases. His earlier works for Thomas Barrett's *Book of Beauty*, 1846, show an almost Georgian burlesque and caricature. By the 1850s he was under the influence of Menzel and develops a rather hard and Germanic drawing line, which gradually softens during the 1860s. In his last drawing, 'Arry on the Boulevard', published in *Punch* in 1891, his economy of line is such that he might almost be compared to the French draughtsmanship of a master like Lautrec. A memorial exhibition of the artist was held at the Fine Art Society in March 1891. He signs his early work: ⌐SK⌐ and his later work: ⫣

Illus: *Robinson Crusoe [1847]; Green's Nursery Annual [1847]; The Wooden Walls of Old England [1847]; The De Cliffords [Mrs. Sherwood, 1847]; The White Slave [1852]; A Story with a Vengeance [1852]; Marie Louise [1853]; The Giants of Patagonia [1853]; The Book of German Songs [W.H. Dulcken, 1856]; A Narrative of the Indian Revolt [Sir Colin Campbell, 1858]; The Boy Tar [Mayne Reid, 1860]; The Voyage of the Constance [1860]; Jack Buntline [W.H. Kingston, 1861]; Sea Kings and Naval Heroes [1861]; The Cambridge Grisette [H. Vaughan, 1862]; Tracks for Tourists [F.C. Burnand, 1864]; Mrs. Caudle's Curtain Lectures [1866]; Roundabout Papers [W.M. Thackeray, 1879]; The Cloister and The Hearth [Reade, 1890].*
Contrib: *Willmott's Sacred Poetry [1862]; Ballads and Songs of Brittany [1865]; Legends and Lyrics [A.A. Proctor, 1866]; Touches of Nature [1867]; Thornbury's Legendary Ballads [1876]; Passages From Modern English Poets [1876]; ILN [1850-56]; Punch [1852-91]; Once a Week [1859-65 & 1867]; Good Words [1862]; The Cornhill Magazine [1864]; London Society [1866-70].*
Exhib: FAS.
Colls: Ashmolean; BM; Fitzwilliam; Newcastle; V & AM.
Bibl: G.S. Layard, *The Life and Letters of CSK*, 1892.; G.S. Layard, *The Work of CK*, 1897; F.L. Emanuel, *CK*, Print Collectors' Club, 1935; D. Hudson, *CK*, 1947.
See illustrations (above and pp.119, 359)

KEENE, Thomas
Relation or follower of Charles Keene (q.v.). There are some prints of his work in the Witt Photo Library.

KELLER, Arthur L.
Illustrator of Winston S. Churchill's only novel *Mr. Crewe's Career*, 1908.

KELLY, Robert George Talbot RBA RI **1861-1934**
Landscape painter and illustrator. He was born at Birkenhead on 18 January 1861, the son of R.G. Kelly, the landscape painter. He was educated at Birkenhead School before studying art with his father. He specialised in oriental scenery and from 1882 onwards travelled abroad in Morocco, Egypt and Burma, undertaking the illustrations of travel books for Messrs. Black in the 1900s. He became RI in 1907, RBA, 1893, and died on 30 December 1934.
Illus: *Fire and Sword in the Sudan [Sir R.C. Slatin, 1896]; Egypt Painted and Described [1902]; Burma [1905]; Peeps at Many Lands [1908].*
Exhib: B; FAS, 1902, 1904, 1916, 1924; G; L; M; RA; RBA; RHA; RI; RSA.

KELLY, Tom **fl.1887-1901**
Landscape painter, topographer and flower illustrator. He was working in Newmarket, 1888, Bedford in 1892 and London in 1901. He travelled to South Africa in 1890-91 and exhibited at the New Gallery.
Contrib: *The English Illustrated Magazine [1887-91, 1896].*

KEMBLE, Edward Windsor **1861-**
American magazine illustrator. He was born at Sacramento on 18 January 1861 and is associated with pen drawings of the Deep South, a similar sort of realism to that of F. Remington (q.v.). He is included here as the illustrator of *Mark Twain's Library of Humour, The Adventures of Huckleberry Finn*, etc., Chatto, 1897. Pennell considers him a fine but uneven draughtsman, tending to carelessness.
Bibl: J. Pennell, *Pen Drawing and Pen Draughtsmen*, 1894, pp.236-240.

KEMP, Percy **fl.1890-1895**
Black and white artist showing the strong influence of Phil May.
Contrib: *Daily Chronicle [1895]; Pick-Me-Up.*

KEMP-WELCH, Lucy Elizabeth RI **1869-1958**
Horse and animal painter. She was born at Bournemouth in 1869 and studied at the Herkomer School, Bushey, Herts. She was Principal of the Kemp-Welch School of Painting at Bushey, was elected RBA, 1902 and RI, 1907. She was President of the Society of Animal Painters in 1914 and had paintings purchased by the Chantrey Bequest in 1897 and 1917. A one man exhibition of her work was held in London in 1938.
Illus: *The Making of Mathias [1897].*
Exhib: B; FAS, 1905; G; L; M; RA; RBA; RCA; RHA; RI; ROI; RSA; RWA; SWA.
Bibl: *The Studio*, Winter No., 1900-01, p.67, illus; *LK-W*, Antique Collectors' Club, 1976.
See illustration (p.362)

KENNARD, Edward
Illustrator. Contributed drawings of sport to *The Graphic*, 1888.

KENNION, Edward FSA **1744-1809**
Landscape painter and drawing-master. He was born in Liverpool in 1744 and travelled to Jamaica and Cuba as a young man from 1762 to 1769. He returned to England and worked in Bath, London and Malvern, making frequent visits to the North-West and the Lakes. He was a member of the Society of Artists and died in London in 1809.
Publ: *Elements of Landscape and Picturesque Beauty [1790]; An Essay on Trees in Landscape [1815, AL 147].*
Exhib: RA; SA.

CHARLES SAMUEL KEENE 1823-1891. 'A Soft Answer.' Illustration for Punch, 1879. Pen and ink. Signed with initials. 5ins. x 7½ins. (12.7cm x 19.1cm).
Victoria and Albert Museum

KEPPEL, William Coutts, Viscount Bury and 7th Earl of Albermarle
1832-1894
Artist and politician. He was born on 15 April 1832, the only son of the 6th Earl of Albermarle whom he succeeded in 1876. He exhibited in London from 1878-83 while living in Nuremburg. He died 28 August 1894.

Contrib: *Passages From Modern English Poets [1862].*

KERR, Charles Henry Malcolm RBA
1858-1907
Portrait and landscape painter. He worked in London and was elected RBA in 1890. He died at Campden Hill, Kensington on 27 December 1907.

Illus: *The Curse of Carne's Hold [G.A. Henty, 1890].*
Exhib: L; M; NEA; RA; RBA; RHA; RI; ROI.

KERR, Henry Wright RSA RSW
1857-1936
Genre and landscape painter, and character painter. He was born at Edinburgh in 1857 and studied in Dundee and at the RSA Schools. He travelled in Ireland in 1888 and was elected ARSA in 1893 and RSA in 1909. He died on 17 February 1936.

Illus: *Reminiscences of Scottish Life and Character [Dean Ramsay]; Annals of the Parish [M.R. Mitford, 1911]; The Lighter Side of Irish Life [G.A. Birmingham, 1911]; The Last of the Lairds [J. Galt, 1926].*
Exhib: G; L; RA; RI; RSA; RSW.
Colls: Dundee.

KERR-LAWSON, James
1864-1939
Figure and landscape painter, mural painter and lithographer. He was born at Anstruther, 28 October 1865, and was taken to Canada in early childhood. He was educated in Rome and Paris and studied art with Lefevbre and Boulanger, before returning to live in Chelsea.

According to Hartrick he was one of the early experimenters in the revival of lithography in the 1900s. He contributed to F.E. Jackson's *The Neo-Lith*, 1907-08. He carried out the decorations to the Senate in Ottawa and in later life retired to Italy.

Exhib: B; G; L; M; RBA; ROI.

KEYL, Frederich Wilhelm
1823-1871
Engraver and animal illustrator. He was born at Frankfurt on 17 August 1823, coming to London in 1845. He studied under Landseer and Verboeckhoven and began exhibiting in 1847. Several of his works were bought for the Royal Collection. He died 5 December 1871.

Illus: *Homes Without Hands [Rev. J.G. Wood]; Featherland: Or How The Birds Lived at Greenlawn [G.M. Fenn, 1877].*
Contrib: *ILN [1864-69]; Churchman's Family Magazine [1864]; Beaton's Annual [1866]; Gatty's Parables From Nature [1867].*
Exhib: BI; RA.

KIDD, John Bartholomew
fl.1807-1858
Contributor to *The Antiquarian and Topographical Cabinet*, 1808.

KIDD, Joseph Bartholomew RSA
1808-1889
Genre and landscape painter. He was born in Edinburgh in 1808 and studied with Thomson of Duddingston. He was a founder member of RSA in 1829, resigning from the institution when he settled in London in 1836. He practised as a drawing master at Greenwich, and died in May 1889.

Illus: *The Miscellany of Natural History [Sir T.D. Lauder, 1833]; West Indian Scenery [1838-40, AT 686].*
Exhib: BI; RSA.

359

KILBURNE, George Goodwin **RI ROI** **1839-1924**

Painter, watercolourist, engraver and illustrator. He was born in Norfolk on 24 July 1839 and was apprenticed to the Brothers Dalziel whose niece he married. He turned from engraving to painting and specialised in hunting scenes and genre subjects set in the 18th century. A very talented draughtsman, Dalziel records of his apprentice work that it was 'so perfect, that it was published with the set to which it belonged'. He died in London in September 1924. RI, 1868 and ROI, 1883.

Illus: *Thackeray's Ballads [Cheap Illus. Edit., 1894].*
Contrib: *ILN [1873]; The Graphic [1873-77 (domestic & theatrical)]; The Cornhill Magazine [1884].*
Exhib: B; G; L; M; RA; RBA; RI; ROI.

KIMBALL, Katharine **ARE** **fl.1906-1926**

Painter and illustrator. She was born in New England and educated at Jersey Ladies' College and at the National Academy of Design, New York, 1897. She specialised in pen illustrations of towns and cities for travel books. She was elected ARE, 1909.

Illus: *Paris [Okey, 1904]; Brussels [Gilliatt Smith, 1906]; Canterbury [Sterling Taylor, 1912]; Rochester [1912].*
Contrib: *The Century; The Studio; The Artist; Gazette des Beaux Arts; The Queen.*
Exhib: L; RA; RE.
Colls: BM; Congress Library; V & AM.

KING, Edward R. **fl.1883-1924**

Genre painter and illustrator. He was probably the brother of Gunning King (q.v.) and began contributing to *The Illustrated London News* in 1883. He was one of the group of artists who treated both rural and metropolitan subjects in a new and realistic way, giving through sensitive drawing and minute hatching, a sympathetic view of poor Londoners and country folk. He was one of the artists much admired by Van Gogh. He was still working at East Molesey, Surrey in 1924. He became NEA in 1888.

Contrib: *ILN [1883-87]; The Pall Mall Magazine; Punch [1905].*
Exhib: B; G; L; M; NEA; RA; RBA; ROI.
Colls: Witt Photo.
Bibl: *English Influences on Vincent Van Gogh,* Arts Council, 1974-75.

KING, Gunning **1859-1940**

Painter, etcher and illustrator. He studied art at the South Kensington and the RA Schools and became a member of the NEA in 1887. King was one of the most vigorous illustrators of rural life to emerge during the eighties, combining great human interest with fine quality penwork. He was an early advocate of chalk drawings and in his figure subjects owes something to the freedom of Charles Keene (q.v.). He worked for most of his life at Petersfield, Hants.

Contrib: *ILN [1882-99]; The Graphic [1883]; The Windsor Magazine; Punch; The Sketch; The Sporting and Dramatic News [1896]; The English Illustrated Magazine [1896]; Pick-Me-Up [1897]; The Quiver [1897].*
Exhib: B; G; GG; L; M; NEA; RA; RBA; RI; ROI.
Colls: V & AM; Witt Photo.
Bibl: R.G.G. Price, *A History of Punch,* 1955, p.158.

KING, H.W.

Illustrator. Contributed drawings of animals to *The Graphic,* 1871.

KING, Henry John Yeend **RBA RI** **1855-1924**

Landscape painter and illustrator. He was born in London on 25 August 1855 and was apprenticed to Messrs. O'Connors, glass painters of Berners St. He left after three years and studied painting with William Bromley, RBA, later going to Paris and working with Bonnat and Cormon. He began to exhibit at the RA in 1876 and was elected RBA in 1879, RI in 1887 and VPRI in 1901. King's work for the magazines is usually rural or domestic in character. He died on 10 June 1924.

Contrib: *The Graphic [1880-82]; ILN [1887-94].*
Exhib: B; G; GG; L; M; RA; RBA; RHA; RI.
Colls: Liverpool; Reading; Witt Photo.

KING, Jessie Marion (Mrs E.A. Taylor) **1876-1949**

Painter and illustrator. She was born in 1876 and studied at the Glasgow School of Art, where she won a travelling scholarship to France and Italy, in the latter coming under the influence of Botticelli's paintings. She was considered unsuccessful as a student because of her individuality, 'language of line' and imaginative sense, *The Studio,* Vol.26, p.177. Her style is inseparable from the angular *art nouveau* concepts of the Glasgow School and her decorative work in books is often the counterpart of C.R. Mackintosh's applied art. A great deal of her work was done on parchment, built up with carefully drawn thin pen lines and delicately coloured and tinted. Most of her designs have elaborate borders of stylised birds or foliage, suggesting metal-work rather than the printed page. It is not surprising to discover that she was in fact a jewellery designer and a painter of murals. Miss King lived in Paris from 1911 to 1913 and then at Kirkcudbright after her marriage to the artist E.A. Taylor. She died in 1949.

The drawings have become extremely popular in recent years and are among the more sought after illustrations. Sotheby's held an important sale of her work at the Charles Rennie Mackintosh Society in Glasgow on 21 June 1977, when the contents of her studio were auctioned by request of her daughter.

Illus: *The Light of Asia [Arnold, 1898]; Jeptha [G. Buchanan, 1902]; The High History of The Holy Graal [trans. by S. Evans, 1903]; The Defence of Guenevere [William Morris, 1904]; Comus [John Milton, 1906]; Poems of Spenser [intro. by W.B. Yeats, n.d.]; Budding Life [1906]; The Legend of Flowers [P. Mantegazza, 1908]; Dwellings of An Old World Town [1909]; The Grey City of the North [1910]; The City of the West [1911]; The Book of Bridges [E. Ancambeau, 1911]; Ponts de Paris [E. Ancambeau, 1912]; Songs of the Ettrick Shepherd [James Hogg, 1912]; Isabella and The Pot of Basil [John Keats, 1914]; A House of Pomegranates [Oscar Wilde, 1915]; The Little White Town of Never-Weary [1917]; Good King Wenceslas [1919]; L'Habitation Forcée [Rudyard Kipling, 1921]; How Cinderella Was Able To Go To The Ball [1924]; Mummy's Bedtime Story Book [1929]; Whose London [c.1930]; Our Lady's Garland [Arthur Corder, 1934]; Kirkcudbright [1934]; The Fringes of Paradise [Florence Drummond, 1935]; The Enchanted Capital of Scotland [I. Steele, 1945]; The Parish of New Kilpatrick [J. McCardel, 1949].*
Contrib. (covers): International Library Editions, *The Marriage Ring [Jeremy Taylor, 1906]; Everyman [1906].*
Exhib: G; L; RHA; RSA; RSW; SWA.
Colls: V & AM.
Bibl: *The Studio,* Vol. 26, 1901-02, p.177, illus; Vol. 36, 1906, pp.241-246, illus; Vol. 46, 1909, pp.148-150, illus. *The Studio Yearbook,* 1909, 1911, 1912, 1913, 1919; *Modern Book Illustrators and their Work,* Studio, 1914. *JMK.,* Scottish Arts Council Exhibition Cat., 1971.
See illustration (p.209).

KING, W.H. **fl.1808-1836**

Topographical illustrator. He worked at Edmonton and contributed to *Brittons Beauties of England and Wales,* 1808.

Exhib: RBA, 1836.

KINGSFORD, Florence **fl.1899-1903**

Figure and domestic painter. She worked in West London from 1899 and 1902 and designed initial letters for the Essex House Press.

Decor: *Tam O'Shanter [Essex House, 1902]; Rime of The Ancient Mariner [Essex House, 1903].*
Exhib: RA.

KINGSLEY, Charles **1819-1875**

Author and amateur artist. After leaving Cambridge in 1842, young Kingsley worked on a life of St. Elizabeth of Hungary, illustrated by his own pen and ink drawings. This was not intended for publication but as a present for his wife. He continued to sketch on holidays after his marriage and, as a lecturer illustrated all his points with chalk on a blackboard. In 1855 he tried to establish drawing classes for artisans at Bideford and later on was consulted by C.H. Bennett and Frederick Shields (qq.v.) over their editions of Bunyan. He died in 1875.

Illus: *The Heroes [1856 (eight illus. by the author)].*
Bibl: *CK His Letters and Memories,* Edited by His Wife, 1877.

KIPLING, John Lockwood **1837-1911**

Architect, sculptor and illustrator. He was born at Pickering, Yorks, in 1837 and was educated at Woodhouse Grove and South Kensington. He taught at the Bombay School of Art and was Principal of the Mayo School of Art, Lahore, 1865-75, and became Curator of the Central Museum, Lahore from 1875-93. He was related by marriage to Sir E.J. Poynter and Sir E. Burne-Jones (qq.v.) and was the father of Rudyard Kipling (q.v.). He died 26 January 1911.

Illus: *Beast and Man in India [1891]*.
Contrib: *The Jungle Book; The Second Jungle Book [1894 (with R.K.)]*.
Colls: India Office Lib.

KIPLING, Rudyard **1865-1936**

Author and occasional illustrator. He was born in Bombay in 1865 and clearly influenced by the study of Indian art and culture made by his father, J. Lockwood Kipling (q.v.). He was educated in England, living in the vacations with the family of his uncle Sir E. Burne-Jones (q.v.). He returned to India as a journalist from 1882-89 and after early success, travelled to the United States and settled at Bateman's in Sussex. Kipling's black and white illustrations to *Just So Stories*, 1902 show a good decorative sense, if not a very developed manner of execution.

See illustrations (below and right).

RUDYARD KIPLING 1865-1936. Initial letter for The Just So Stories For Little Children, *1902.*

RUDYARD KIPLING 1865-1936. 'The Elephant.' An illustration to The Just So Stories For Little Children, *1902.*

KITTON, Frederick George **1856-1903**

Author, artist and illustrator. He was born in Norwich on 5 May 1856 and was educated there before training as an engraver and draughtsman on wood with W.L. Thomas of *The Graphic*. From 1882, Kitton began to write on both illustration and English literature, eventually having a dozen works to his credit. He was a prolific if not very dazzling pen draughtsman and died at St. Albans on 10 September 1903.

Publ: *Phiz - A Memoir [1882]; John Leech, Artist and Humorist [1883]; Dickensiana [1886]; Charles Dickens by Pen and Pencil [1889-90]; The Novels of Charles Dickens [1897]; Dickens and His Illustrators [1898-99]; Zechariah Buck [1899]; The Minor Writings of Dickens [1900]; Charles Dickens, His Life, Writings and Personality [1902]; Autograph Edition of Dickens [Editor]*.
Illus: *Hertfordshire County Homes [1892]; St. Albans Historical and Picturesque [1893]; St. Albans Abbey [1897]; The Romany Rye [1900]*.
Contrib: *The Graphic [1874-85]; ILN [1889-90]; The English Illustrated Magazine [1891-92]; Black & White [1892]; The Sunday Magazine [1894]*.
Exhib: Norwich, 1886-87; RBA, 1880.
Bibl: R.E.D. Sketchley, *Eng. Bk. Illus.*, 1902, pp.48, 135.

KITTON, R. **fl.1832-1847**

Draughtsman at Norwich. He contributed illustrations to *Brittons Cathedrals*, 1832-36.

Exhib: RA, 1847.

KLEMPNER, E.G.

Contributor of military figure subjects to *Punch*, 1905.

KNIGHT, Captain Charles Raleigh

Amateur illustrator. He illustrated his own *Scenery on the Rhine*, 1850, AT 220.

KNIGHT, Henry Gally 1786-1846

Writer, traveller and amateur artist. He was born in 1786 and educated at Eton and Trinity College, Cambridge. He had independent means and an estate in Langold, Yorkshire, enabling him to travel throughout Europe and Palestine, writing about his journeys. He was a friend of J.M.W. Turner (q.v.) and illustrated his own books.

Illus: *An Architectural Tour of Normandy [1836]; The Normans in Sicily [1838]; Saracenic and Norman Remains to illustrate the 'Normans in Sicily' [1840]; The Ecclesiastical Architecture of Italy [1842-44].*

KNIGHT, J. Louis

Contributed scenes of Dockland to *The Illustrated London News*, 1889.

KNIGHT, John William Buxton 1843-1908

Landscape painter, watercolourist, occasional illustrator. He was born at Sevenoaks in 1843 and studied with J. Holland in Kent before attending the RA Schools, 1860. He was elected RBA in 1875 and RE in 1881.

Contrib: *The English Illustrated Magazine [1887 (figs. and lands)].*
Exhib: B; G; GG; L; M; RA; RBA; RE; RI.

KNOWLES, Davidson fl.1879-1902

Landscape painter, figure painter and illustrator. He worked in London and was elected RBA in 1890, specialising in country genre subjects and animals.

Illus: *Songs and Lyrics For Little Lips [W.D. Cummings, n.d.].*
Contrib: *The Graphic [1880]; ILN [1883-96]; The English Illustrated Magazine [1893-94].*
Exhib: B; G; L; M; NEA; RA; RBA.

KNOWLES, George Sheridan RI 1863-1931

Genre painter and illustrator. He was born in Manchester on 25 November 1863, and studied at the Manchester School of Art and the RA Schools, 1884. He was elected RI in 1892 and became Treasurer. He died on 15 March 1931.

Contrib: *The Quiver [1890]; ILN [1894-99, (short stories)].*
Exhib: B; G; L; M; NEA; P; RA; RBA; ROI.

KNOWLES, Horace J.

Decorator of books. Worked with his brother Reginald L. Knowles (q.v.).

KNOWLES, Reginald Lionel fl.1905-1925

Illustrator. A talented Edwardian artist of whom very little is known. He worked in the manner of Arthur Rackham, muted watercolours with highly decorative penwork and borders. He also designed book covers and book plates, and was responsible for Dent's *Everyman Library*.

Illus: *Legends From Fairyland [Holme Lee, 1908]; Norse Fairy Tales [P.C. Asborjornsen and J.I. Moe, 1910]; Marie de France - Old World Love Stories [1913].*
Bibl: *The Art of The Book*, Studio Year Book, 1914, illus; B. Peppin, *Fantasy Book Illustration*, 1975, pp.17, 188, illus.

KOEKKOEK, H.W.

Illustrator. Presumably one of the large family of Dutch painters of this name. He illustrated *Barclay of the Guides*, Herbert Strang, 1908.

KRETSCHNER, Albert 1825-1891

Genre painter and illustrator. He was born at Burghof, Germany on 27 February 1825, and studied at the Berlin Academy. He died in the same city on 11 July 1891.

Contrib: *The Illustrated Times [1859].*
Exhib: RA, 1852.

KRIEGHOFF, Cornelius 1812-1872

Painter of Canadian scenery and life. This very popular artist was active in the 1850s and 1860s. He illustrated *Construction of the Great Victoria Bridge*, 1860, AT 631.

'KYD' Joseph Clayton Clarke fl.1882-1899

Caricaturist and illustrator, who worked under the name 'Kyd'. His work is usually very delicate and in small scale with nice colour washes. He was employed on an 1889 edition of Dickens, and the drawings for this and a caricature of Whistler are in the V & A Museum.

Contrib: *ILN [1882]; Fun [1890-92].*

LUCY KEMP-WELCH 1869-1958. Original drawing for an illustration.

Messum Studio Collection

L, E.H. **late 19th century**
A watercolour for illustration by this artist is in the Victoria and
Albert Museum.

L, R.
Illustrator, contributing to *The Illustrated London News*, 1872.
Colls: V & AM.

LABY, Alexander **fl. 1840-1879**
History painter and illustrator. He was working in Paris and exhibiting
there, 1840-44. He contributed drawings of Flemish industry to *The
Illustrated London News*, 1879.
Exhib: RBA, 1864-66.

LADER, A.S.
Contributor to *The Illustrated London News*, 1889, topography.

LAMB, Henry **fl. 1826-1861**
Landscape painter. He worked at Malvern, Worcestershire, for most of
his life and contributed illustrations to *Griffith's Cheltenham*, 1826.
Exhib: BI; NWS, 1834-61.

LAMBERT, George ARA **1873-1930**
Portrait painter and illustrator. He was born in Russia in 1873 and
came to England in 1878. He went to Australia in 1891 and studied at
the Sydney School of Art, where he won a scholarship to Paris. He
taught at the London School of Art in 1910 and returned to Australia

in 1928, having been elected A.R.A. in 1922. He died on 29 May
1930.
Contrib: *The Graphic [1887-88]; The Strand Magazine [1891]; The English
Illustrated Magazine [1893-94]*.

LAMBERT, John **fl.1806-1814**
Topographer and traveller. He visited N. America to study the
cultivation of hemp in 1806 and travelled widely 1806-08. He
illustrated *Travels Through Canada and the United States*, 1814, AT
613.

LAMI, Eugène **1800-1890**
Genre painter, watercolourist, lithographer and illustrator. He was
born in Paris on 12 January 1800 and studied under Baron Gros, H.
Vernet and at the École des Beaux-Arts. Lami was an important
lithographer and watercolourist during the reigns of Louis-Philippe
and Napoleon III. His elegant ink drawings with watercolour washes
of courtly interiors and scenes of high life were popular both in
England and in France, typifying the artificial life of mid-19th
century France. Lami produced a series of prints of *Uniforms of the
French Army, 1791-1814*, in 1822 and *Uniformes français
1814-1824*, in 1825. His output was considerable, he produced 344
lithographs as well as numerous illustrations for books. He exhibited
regularly at the Salon from 1824 to 1878 and as well as becoming a
Chevalier de la Légion d'honneur in 1837, founded the French
Society of Watercolourists. He died in Paris, 19 December 1890.
Illus: *Voyage en Angleterre [1829-30 (with Monnier)]; L'Hiver et L'Eté
[Janin]; Les Ouevres de Alfred de Musset*.
Contrib: *ILN [1853]*.
Exhib: RA, 1850.
Colls: Author; Louvres; Royal Coll.; V & AM; Versailles; Wallace Coll.
Bibl: P.A. Lemoisne, *L'Oeuvre de EL*.
See illustration (below).

LAMONT or LA MONTE, Elish **1800-1870**
Miniature painter. She was born in Belfast in about 1800 and worked
in Belfast and Dublin. She contributed portraits to *The Court Album*
1857 and did some illustrations for Swain in the 1860s.
Exhib: RA, 1856-69; RHA, 1842-57.

EUGÈNE LAMI 1800-1890. 'Le repos.' Ink and watercolour on brown paper. 5¾ins. x 10½ins. (14.6cm x 26.7cm). Author's Collection, formerly Demidoff Collection

LAMONT, Thomas Reynolds ARWS 1826-1898

Landscape painter and illustrator. He was born in Scotland in 1826 and studied art in Paris with George Du Maurier (q.v.) who immortalised him as 'the Laird' in his novel *Trilby*. He was elected ARWS in 1866 but did little work after 1880.

Contrib: *London Society [1865]; The Shilling Magazine [1865-66]*.
Exhib: GG; OWS: RA.
Colls: V & AM.

LANCELOT, Dieudonné Auguste 1822-1894

Lithographer and illustrator. He was born at Sezanne in 1822 and became a pupil of J.F. Arnaud de Troyes. He exhibited at the Salon from 1853 to 1876 and illustrated landscapes and views in books. He died in Paris in 1894.

Illus: *Le Tour du Monde; Le Magasin pittoresque; Jardins [1887]*.
Contrib: *ILN [1857, Paris]*.

LANCON, Auguste André 1836-1887

Painter, engraver and sculptor. He was born at Saint-Claude in 1836 and studied art in Lyons and Paris, specialising in the painting and sculpting of animals. Lancon was implicated in the Commune of 1871 and imprisoned, but with the new regime he became a Special Artist for *L'Illustration* and went to the Balkans for them in 1877.

Contrib: *ILN [1870]*.

LANDELLS, Ebenezer 1808-1860

Engraver and illustrator. He was born at Newcastle-upon-Tyne in 1808 and worked as a pupil to Thomas Bewick (q.v.) and for a short time to Isaac Nicholson. He went to London in 1829 and became the right-hand man of John Jackson and William Harvey (q.v.) superintending the fine art department of the firm of Branston & Vizetelly. Landells was inventive and original as a projector of newspapers, but lacked business acumen. He was intimately concerned with the founding of *Punch,* but left it in 1842 to become Editor of the less successful *Illuminated Magazine,* 1843. He started *The Lady's Newspaper* in 1847, which was incorporated in *The Queen* and had M.B. Foster, the Dalziels and Edmund Evans (qq.v.) as his pupils. Landells was not a very strong artist, but acted as *The Illustrated London News* Special on Queen Victoria's first tour of Scotland. The Queen later bought the drawings, the first of their kind to be made for a newspaper on the spot. Landells died at Brompton on 1 September 1860.

Contrib: *The Sporting Review [1842-46]; ILN [1844-56]*.
Exhib: RBA, 1833 & 1837 (engravings).
Bibl: M.H. Spielmann, *The History of Punch,* 1895, pp.15-19; *The Brothers Dalziel, A Record of Work, 1840-1890,* 1901, pp.4-10.

LANDELLS, Robert Thomas 1833-1877

Illustrator and War artist. He was born 1 August 1833, the eldest son of Ebenezer Landells (q.v.). He was educated in France but studied drawing and painting in London, specialising in battles and military subjects. He was Special War Artist for *The Illustrated London News* from 1855 to 1871, covering the Crimea, Schleswig-Holstein, 1864, Austro-Prussia, 1866, and the Franco-Prussian compaign of 1870-71. He was awarded the Prussian Iron Cross on this occasion. Landells also acted for *The Illustrated London Magazine,* 1853-55. He died in London in 1877.

Exhib: RBA, 1863-76.

LANDER, Edgar 1883-

Black and white artist. He was born in 1883 and worked in North London. He regularly exhibited watercolours and etchings and married Hilda Cowham (q.v.).

Contrib: *Punch [1902, 1904-05 (social)]*.
Exhib: G: L: RA: RSA.

LANDSEER, Charles RA 1799-1878

History painter and illustrator. He was the second son of John Landseer, ARA, and brother of Sir E.H. and T. Landseer (qq.v.). He was a pupil of B.R. Haydon and studied at the RA Schools in 1816, afterwards travelling to South America. He became RA in 1845.

Illus: *Days of Deerstalking [W. Scrope, 1883]; Days and Nights of Salmon Fishing [1898]*.
Contrib: *Finden's Illustrations To the Life and Works of Lord Byron [1833-34]*.

LANDSEER, Sir Edwin Henry RA 1802-1873

Animal painter and caricaturist. He was born in 1802, the youngest son of John Landseer, ARA, and became the most popular painter of animals in Victorian England, his work widely engraved and admired from the Queen downwards. He is included here for his brown ink and wash caricatures which he often made while staying in country houses.

Colls: BM: Fitzwilliam; V & AM.

LANDSEER, Thomas ARA 1795-1880

Engraver and illustrator. He was the eldest son of John Landseer, ARA, and brother of Sir E.L. and C. Landseer (qq.v.). He was a pupil and assistant to his father and studied with B.R. Haydon, but became best known for his engravings from his famous brother's works. Early in his career, Thomas Landseer indulged in some humorous engraved caprices which are his most delightful works. They consisted of vigorous prints of animals, often in flight or fighting with men, mostly published by Moon, Boys & Graves in the 1820s or 1830s. Linton describes him as 'a short, broad-shouldered deaf man . . . evincing more originality and vigour of drawing than is to be seen in the excellently painted pictures of the more famous Sir Edwin'. He was elected ARA in 1868.

Illus: *Monkeyana or Men in Miniatures [1827-28]; The Devil's Walk [S.T. Coleridge, 1831]; Characteristic Sketches of Animals [1832]; The Boy and The Birds [Emily Taylor, 1840]*.
Contrib: *The People's Journal [1846]; ILN [1844]*.
Exhib: BI, NWS: RA: RBA.
Colls: BM: Witt Photo.

LANE, Richard James ARA 1800-1872

Engraver. He was born in 1800 and was a great-nephew of Thomas Gainsborough. Lane's career was mainly in making engravings after the work of Landseer, Leslie, Lawrence and Gainsborough and in teaching at the engraving school at South Kensington. He became ARA in 1827 and was made lithographer to the Queen in 1837. The Victoria and Albert Museum has three drawings for illustration by this artist, two of them of Shakespearean subjects.

LANE, Theodore 1800-1828

Painter and caricaturist. He was born at Isleworth in 1800 and was apprenticed to J.C. Barrow at Battle Bridge. Shortly after completing his time, he produced *The Life of an Actor,* 1822, six pls., which had some popular success. After meeting Pierce Egan as author, *Life of an Actor Peregrine Proteus,* 1825 with 27 colour plates, and many woodcuts. During the Queen Caroline scandals, Lane worked for the printseller Humphrey, 1820-21, and did several satirical prints probably in collaboration with Theodore Hook. He died tragically on 21 February 1828 by falling through a skylight, being so badly mutilated that he was only recognisable by his card case. The RA ran a subscription for his widow.

Exhib: RA, 1819-20, 1826.
Colls: BM.
Bibl: G. Everitt, *English Caricaturists,* 1893, pp.84-88, illus; D. George, *English Political Caricature,* Vol.II, 1959, pp.197-198.

LANGE, Janet fl.1855-1860

French illustrator. He was the brother of Gustave Janet (q.v.) and according to Vizetelly an artist 'whose reputation stood high as a delineator of military episodes, Court pageants, and the like . . .'

Contrib: *Cassell's Illustrated Family Paper [1855]; The Illustrated Times [1860]; ILN*.

LANOS, Henri fl.1886-1905

French genre painter and watercolourist. He contributed drawings of the Simplon Tunnel to *The Graphic,* 1902-03 and 1905. He was a member of the Artistes Français.

LARSEN, Carl Christian 1853-1910
Painter and illustrator. He was born at Viborg, Denmark on 16 March 1853 and studied at the Copenhagen School of Art. He was Special Artist for *The Illustrated London News* in Siberia in 1882. He died at Vienna on 6 June 1910.

LARUM, Oscar
Contributed drawings of comic animals to *Punch,* 1909.

LATHBURY, Mrs (née Miss M.A. Mills) fl.1807-1815
Amateur artist. She contributed topographical drawings of the West Country and Wales to *Britton's Beauties of England and Wales* 1812-15 and to *The Antiquarian and Topographical Cabinet,* 1807.

LAUDER, Sir Thomas Dick, Bt. 1784-1848
Amateur landscape artist. He was born in 1784 and succeeded his father as 7th Baronet of Fountainhall, County Haddington in 1820. He died 29 May 1848.
Illus: *A Voyage Round the Coasts of Scotland and the Isles [James Wilson, FRSE, 1842. Engraved by Charles H. Wilson].*

LAUGHLIN, J.E.
Illustrated *Three Boys in The Wild North Land* by E.R. Young, 1897.

LAURENS, Jules Joseph Augustin 1825-1901
Draughtsman and watercolourist. He was born at Carpentras, France, on 26 July 1825 and became a pupil of his brother J.J.B. Laurens. He exhibited regularly at the Salon and died at St. Didier 5 May 1901.
Contrib: *The Illustrated Times [1856 (Persia)].*
Colls: Angôuleme; Avignon; Bagnères; Carpentras; Metz; Montpellier; Narbonne, Orleans; Paris; Rouen.

LAVEROCK, Florence fl.1900-1915
Black and white artist working at Warrington. She did several pretty 'crinoline story-book' type illustrations in about 1900 which may have been published.
Exhib: L.

LAWLESS, Matthew James 1837-1864
Illustrator and etcher. He was born in 1837, the son of Barry Lawless, a Dublin solicitor. As a catholic he was educated at the Prior Park School, Bath and then at the Langham, Cary's and Leigh's Art Schools in London. He was for some time a pupil of Henry O'Neill, RA and was influenced by the Pre-Raphaelites and by the Dutch masters of the 17th century. Although often unequal in his compositions and his handling of figures, sometimes very large and sometimes very small, Lawless at his best ranks very high among the artists on the wood. He worked briefly for *Punch* but made his name in the more serious or poetic areas of illustration, particularly in *Good Words* and *Once a Week.* He was one of a number of the 1860s' illustrators who had tragically short working lives. He was ill from 1860 onwards and died at Bayswater in 1864.
Contrib: *Once a Week [1859-64]; Punch [1860-61]; Lyra Germanica [1861]; Life of St. Patrick [1862]; Good Words [1862-64]; London Society [1862-70]; Passages from Modern English Poets [1862]; Churchman's Family Magazine [1863]; Pictures of Society [1866]; Touches of Nature [1867]; Thornbury's Legendary Ballads [1876].*
Exhib: RA; RBA, 1857-63.
Colls: BM.
Bibl: Chatto & Jackson, *Treatise on English Wood Engraving,* 1861, p.599; G. White, *English Illustration The Sixties,* 1895; F. Reid, *Illustrators of the Sixties,* 1928.

See illustration (below).

MATTHEW JAMES LAWLESS 1837-1864. 'The Headmaster's Sister.' Illustration to Once a Week, *28 April 1860. Wood engraving.*

LAWSON, Cecil Gordon 1851-1882

Landscape painter in oil and illustrator. He was born at Wellington, Salop, in 1851, the son of William Lawson, the Scottish portrait painter. He came to London with his father in 1861 and in 1870 began to draw on the wood for the engravers. In some ways Lawson was a proto-impressionist and his oils of the Thames and the countryside of Kent and Yorkshire are having a revival among collectors. Lawson suffered from acute ill health and after travelling to the South of France in 1881, returned to London and died on 10 June 1882. He was the younger brother of F.W. Lawson (q.v.).

Contrib: *The Quiver; Good Words; The Sunday Magazine; Dark Blue [1871-72]; Poems and Songs by Robert Burns [1875].*
Exhib: GG; RA; RBA.
Colls: Birmingham; BM; Edinburgh; V. & AM.
Bibl: F. Reid, *Illustrators of The Sixties*, 1928 pp.266.

LAWSON, Francis Wilfrid 1842-1935

Painter and illustrator. He was born in 1842, the elder brother of Cecil G. Lawson (q.v.) whom he taught. He was a very versatile artist, specialising not only in the figure but in landscape work as well. Reid considers his best work to be that for *The Cornhill Magazine* and Foxe's *Book of Martyrs*. Charles Keene (q.v.) had a studio in Lawson's house.

Illus: *The Law and The Lady [Wilkie Collins, 1876 (with Fildes and Hall)].*
Contrib: *Once a Week; London Society; The Cornhill Magazine [1867-69]; Book of Martyrs [Foxe, 1866]; Heber's Hymns [1867]; The Shilling Magazine; The Sunday Magazine; Cassell's Magazine; The Broadway; Dark Blue; Aunt Judy's Magazine; Fun; The Graphic [1869-76]; Punch [1876].*
Exhib: B; G; GG; L; M; NEA; RA; RBA; ROI; RI; RSA.A.
Colls: Liverpool; V & AM; Witt Photo.

LAWSON, G.

Illustrator. The British Museum has drawings by this artist of Reading Room personalities, published in *Atlanta*, 1888.

LAWSON, John fl.1865-1909

Landscape painter and illustrator, working mostly in Scotland, but at Sheffield, 1892-93. He is rated by Reid and White as a very competent draughtsman of the second rank, producing excellent figure work for the magazines of the 1860s.

Contrib: *Once a Week [1865-67]; The Sunday Magazine; Cassell's Magazine; The Quiver [1865]; The Children's Hour [1865]; The Shilling Magazine [1866]; The Argosy [1866]; British Workman [1866]; Pen and Pencil Pictures from the Poets [1866]; Ballad Stories [1866]; Golden Thoughts from Golden Fountains [1867]; Roses and Holly [1867]; Ballads, Scottish and English [1867]; Nursery Time [1867]; Early Start in Life [1867]; The Children of Blessing [1867]; The Golden Gift [1868]; Original Poems [1868]; Tales of the White Cockade [1870]; The Runaway [1872]; The Childrens Garland [1873]; The Fiery Cross [1875]; The World Well Lost [1877]; Clever Hans [1883]; There Was Once [1888]; Childhood Valley [1889].*
Exhib: G; L; M; RI; RSA.
Colls: Witt Photo.
Bibl: F. Reid, *Illustrators of the Sixties* 1928, pp.228-229, illus.

LAYARD, Major Arthur fl.1894-1911

Watercolourist and illustrator. He worked in Hammersmith and at Pangbourne, 1902-03. He was principally a figure artist.

Illus: *The People of The Mist [H.R. Haggard, 1894]; The Winged Wolf [Ha Sheen Kaf, 1894].*
Contrib: *The Pall Mall Magazine; Fun [1901].*
Exhib: Bruton Gall; NEA.

LEAR, Edward 1812-1888

Topographical artist, ornithological and comic illustrator. He was born at Holloway on 12 May 1812 and by the age of fifteen was already making his living by bird drawings. In 1831 he became a draughtsman at the Zoological Society's Gardens and in 1832 published his first book of coloured plates of parrots. From 1832 to 1836, Lear was employed as drawing-master to the children of the Earl of Derby at Knowsley, where he continued to paint and drew and wrote *The Book*

EDWARD LEAR 1812-1888. 'Frascati.' Illustration to Views in Rome, *1841. Tinted lithograph.*

of *Nonsense* for the Earl's children. The result of his Knowsley years was the privately printed book *Knowsley Menagerie*, 1856 and an introduction to Queen Victoria to whom he gave lessons in 1846.

From 1831 onwards, Lear made extensive tours abroad, publishing the resulting drawings in albums of lithographs. His chief excursions were to Rome in 1837, where he remained and taught until 1848, to Greece, Albaniá and Malta in 1848 and Egypt in 1849. At this point Lear returned to England and studied at the RA Schools, meeting W. Holman Hunt (q.v.) before commencing another period abroad from 1853 to 1857, visiting Greence, Egypt and the Holy Land. From about 1860, he was living entirely abroad, based at Cannes, Corfu and finally at San Remo. He visited India and Ceylon in 1872-74 and returned to England for the last time in 1880 before settling in San Remo where he died in January 1888. Lear's sketches are unusual among the art of the Victorians for being principally pen and ink works with wash, rather than drawn in watercolours. Many of them have lengthy inscriptions about their locations and the date and time of day that they were done.

Illus: *The Family of Psittacidae, or Parrots [1832]; The Naturalists Magazine [n.d.]; Views in Rome [1841, AT 183]; Excursions in Italy [1846, AT 172 (two parts)]; A Book of Nonsense [1846 and 1861]; The Knowsley Menagerie [1846]; Journal of a Landscape Painter in Albania and Illyria [1851]; Journal of a Landscape Painter in Southern Calabria [1852, AT 175]; Views of the Seven Ionian Islands [1863]; Journal of a Landscape Painter in Corsica [1870]; Nonsense Songs, Stories, Botany and Alphabets [1871]; More Nonsense, Pictures, Rhymes, Botany Etc. [1872]; Tortoises, Terrapins and Turtles [1872]; Indian Pheasants [n.d.]; Laughable Lyrics, A Fourth Book [1877]; Nonsense Songs and Stories [1895].*

GILBERT LEDWARD RA 1888-1960. 'An aged enchanter.' Illustration to The Story of Princess Carena. *Indian ink. Signed with monogram. 9⅛ins. x 6ins. (23.2cm x 15.2cm).* Victoria and Albert Museum

Exhib: FAS, 1938; RA; RBA.
Colls: Ashmolean; BM; Glasgow; Greenwich; Mellon; V & AM; Witt Photo.
Bibl: Vivien Noakes, *EL, The Life of a Wanderer*, 1968.
See illustration (p.366).

LE BRETON, Miss Rosa
Domestic painter, exhibiting in 1865. She contributed similar subjects to *Cassell's Illustrated Family Paper*, 1857.

LEDWARD, Gilbert RA **1888-1960**
Sculptor. He was born in 1888, the son of the sculptor R.A. Ledward. He studied at the RCA and the RA Schools and was awarded the first sculpture scholarship at the British School of Rome in 1913, and the RA travelling scholarship. He was Professor of Sculpture at the RCA, 1926-29 and was elected ARA in 1932 and RA in 1937. He died in 1960.
Illus: *The Story of Princess Carena [n.d.].*
Exhib: G; GG; L; RA; RSA.
Colls: V & AM.
See illustration (below left).

LEE, Arthur
Humorous artist, working in Coventry and exhibiting at Birmingham 1910. He may have worked for *The Pall Mall Magazine*.

LEE, J.
Perhaps John Ingle Lee, a figure artist who exhibited at the RA and RBA, 1868-91.
Contrib: *Book of Martyrs [Foxe, 1866].*

LEE, Joseph Johnson **1876-**
Artist and author. He was born in Dundee in 1876 and studied at the Slade School and at Heatherley's. He served in the First World War 1914-18 in the Black Watch.
Publ: *Tales of Our Town [1910]; Fra Lippo Lippi [1914]; Ballads of Battle [1916]; Work-a-day Warriors [1917]; A Captive at Carlsruhe [1920].*
Contrib: *Punch.*
Colls: Witt Photo.

LEE, William NWS **1810-1865**
Watercolourist. He was born in 1810 and was a member and secretary of the Langham Sketch Club and elected NWS in 1848. He died in London on 22 January 1865.
Contrib: *London [Knight, 1841].*
Exhib: NWS; RA; RBA.
Colls: V & AM.

LEECH, John **1817-1864**
Artist and illustrator. He was born in London on 23 August 1817, the son of a vintner and showed a remarkable aptitude for drawing from an early age. After being educated at Charterhouse and then entering St. Batholmew's Hospital to study medicine, Leech abandoned it for the career of an artist. At Charterhouse he had become a friend of W.M. Thackeray (q.v.) and at St. Bartholomew's he had made the acquaintance of Albert Smith and Percival Leigh, the writers, all of whom were to further him in his profession. He produced his first book *Etchings and Sketchings,* caricatures of Londoners, in 1835 and followed this with a series of satirical and political lithographs. Leech was taught to draw on the wood by Orrin Smith and it was in this field of black and white work that he was to make his name. His humour was like his talent, gentle, warm-hearted and positive, his world, the ups and downs of middle class life, the sports of the squirearchy, and the peccadilloes of army officers and undergraduates. He became really established in 1840 when he joined the staff of *Bentley's Miscellany,* contributing over one hundred and forty etchings to the magazine. In August 1841 he contributed his first block to the newly-established satirical journal *Punch;* Leech's art was ripe for this type of pictorial satire and within a few months he had made it his own, establishing a convention of social humour that was to last until the 1920s. From 1843, Leech shared the cartoons with Tenniel, completing no less than seven hundred and twenty before 1864. But his strength was in the drawings of the hunting field and London fashion, epitomised in the characters of Tom Noddy and Mr.

JOHN LEECH 1817-1864. Frontispiece and title-page to Punch's Pocket Book For 1857. Wood engravings coloured by hand.

Briggs. Extravagantly praised by Ruskin, Leech's often careless but never crude drawings have survived in charm and humour to give us a refreshing glimpse of mid-Victorian society. He died after a short illness in 1864.

Leech prepared sketches in oil of some of his illustrations and exhibited them in the Egyptian Hall, Piccadilly, in June 1862. The pencil sketches for the *Punch* cartoons are more generally available, though often slight.

Illus: *Etchings and Sketchings [A. Pen, 1835]; Droll Doings, Funny Characters [1835]; The Human Face Divine and De Vino [1835]; Bell's Life in London [1836]; Jack Brag [T. Hook, 1837]; American Broad Grins [1838]; Local Legends and Rambling Rhymes [John Dix, 1839]; Pencillings By The Way [N.P. Willis, 1839]; The Comic English Grammar [Paul Prendergast, 1840]; The Comic Latin Grammar [G. à Beckett, 1840]; The Fiddle-Faddle Fashion Book [Percival Leigh, 1840]; The Ingoldsby Legends [1840]; The Clockmaker [T.C. Haliburton, 1840]; The Bachelors Walk in a Fog [Peter Styles, 1840]; The Children of the Mobility [1841]; Written Caricatures [C.C. Pepper, 1841]; Stanley Thorn [Henry Cockton, 1841]; The Porcelain Tower [1841]; Merrie England in the Olden Time [Daniel, 1842]; The Barnaby's in America [Mrs Trollope, 1843]; The Wassail Bowl [A.R. Smith, 1843]; Jack The Giant Killer [1843]; A Christmas Carol [Charles Dickens, 1843-44]; Jessie Phillips [Mrs Trollope, 1844]; Nursery Ditties [1844]; The Adventures of Mr Ledbury [Albert Smith, 1844]; The Comic Arithmetic [1844]; Sketches of Life and Character [George Hodder, 1845]; The Fortunes of the Scattergood Family [Albert Smith, 1845]; Hints on Life [1845]; The Quizzology of the British Drama [G. à Beckett, 1846]; The Battle of Life [Charles Dickens, 1846]; Mrs Caudle's Curtain Lectures [D. Jerrold, 1846]; The Comic History of England [G. à Beckett, 1847]; The Silver Swan [de Chatelain, 1847]; The Handbook of Joking [1847]; Hillside and Border Sketches [W.H. Maxwell, 1847]; The Haunted Man [Charles Dickens, 1847-48]; Life and Adventures of Oliver Goldsmith [Forester, 1848]; The Rising Generation [1848]; The Struggle and Adventures of Christopher Tadpole [Albert Smith, 1848]; Ballads of Bon Gaultier [1849]; A Man Made of Money [D. Jerrold, 1849]; The Natural History of Evening Parties [Albert Smith, 1849]; Toil and Trial [Mrs Crosland, 1849]; The Crock of Gold [M.F. Tupper, 1849]; Fun, Poetry and Pathos [W.Y. Browne, 1850]; Dashes of American Humour [Howard Paul, 1852]; The Comic History of Rome [G. à Beckett, 1852]; Picturesque Sketches of London [Thomas Miller, 1852]; Uncle Tom's Cabin [H.B. Stowe, 1852]; The Fortunes of Hector O'Halloran [W.H. Maxwell, 1853]; Mr. Sponge's Sporting Tour [R.S. Surtees, 1853]; The Great Highway [S.W. Fullom, 1854]; Handley Cross [R.S. Surtees, 1854]; Reminiscences of a Huntsman [The Hon. G. Berkeley, 1854]; The Paragreens [Ruffini, 1856]; The Militia Man At Home and Abroad [1857]; A Month in the Forests of France [The Hon. G. Berkeley, 1857]; The Encyclopaedia of Rural Sports [1858]; Ask Mama [R.S. Surtees, 1858]; The Cyclopaedia of Wit and Humour [1858]; The Path of Roses [F. Greenwood, 1858]; The Fliers of the Hunt [John Mills, 1859]; A Little Tour in Ireland [Reynolds Hole, 1859]; Newton Dogvane [J. Francis, 1859]; Soapey Sponge [1859]; Paul Prendergast [1859]; Mr Briggs and His Doings [1860]; Plain or Ringlets [R.S. Surtees, 1860]; Life of a Foxhound [John Mills, 1861]; The Follies of the Year [1864]; Mr Facey-Romford's Hounds [R.S. Surtees, 1864]; Carols of Cockayne [1869].*
Contrib: *The London Magazine [1840]; Bentley's Miscellany [1840-49]; Colin Clink [Hooton, 1841]; Punch [1841-64]; New Monthly Magazine [1842-43];*

The Sporting Review [1842-46]; Hoods Comic Annual [1844-46]; The Illuminated Magazine [1843-45]; The Cricket on the Hearth [Charles Dickens, 1845-46]; Jerrold's Shilling Magazine [1845-48]; ILN [1845-57]; The Month [1851]; Illustrated London Magazine [1854]; Merry Pictures [1857]; Once A Week [1859-64]; Puck on Pegasus [Pennell, 1861]; The Gardener's Annual [1863].
Colls: BM: Fitzwilliam; V & AM.
Bibl: John Brown, 'JL' *North British Review*, March 1865, pp.213-244; 'JL and Other Papers' *North British Review* Edinburgh, 1882; C.E. Chambers, *A List of Works containing Illustrations by JL*, 1892; Frederick Dolman, 'JL and His Method', *The Strand*, March 1903, pp.158-164; Graham Everitt, *English Caricaturists . . .*, 1893; W.P. Frith, *JL, his Life and Works,* 2 vols, 1891; F.G. Kitton, *Charles Dickens by Pen and Pencil*, 1890; F.G. Kitton, *JL Artist and Humourist*, 1883; R.G.G. Price, *A History of Punch,* 1957, pp.62-65; H. Saint-Gaudens, *JL, The Critic.* Oct. 1905, pp.358-367; H. Silver, 'The Art of JL' *Magazine of Art*, Vol. XVI; Russell Sturgis, 'JL' *Scribners*, Feb. 1879, pp.553-565; Harry Thornber, 'JL' 1890; Rev. G. Tidy, *A Little About Leech*, 1931; J.N.P. Watson, 'JL in the Hunting Field' *Country Life*, 20 Jan. 1977; Stanley Kidder Wilson, *Cat. of . . . Exhibition of Works by JL*, Grolier Club, New York, 1914.
See illustrations (above and pp.369, 370).

LEETE, Alfred Chew 1882-1933

Black and white artist and cartoonist. He was born at Thorpe Achurch, Northamptonshire in 1882 and educated at Weston-super-Mare Grammar School before starting work in printing at the age of fifteen. From 1905 to 1933, Leete was a regular contributor to *Punch* specialising in figure drawings in ink and some political cartoons and caricatures. His surviving drawings tend to be on a rather large scale. He died on 17 June 1933.

Contrib: *The Pall Mall Gazette; London Opinion [1913].*
Bibl: *The Studio*, vol. 18, 1900, p.72.
See illustration (p.371).

LE FANU, G. Brinsley fl.1878-1925

Landscape painter and illustrator. He worked in London and exhibited regularly at the RA and RBA.

Illus: *Nursery Rhymes [1897-98 (with Gertrude Bradley)].*
Contrib: *The Ludgate Monthly [1891].*

LEIGHTON, Edmund Blair ROI 1853-1922

Painter of genre. He was born in London on 21 September 1853, the son of Charles Blair Leighton, the artist. He was educated at University College School and studied art at the RA, exhibiting there from 1887. He became ROI in 1887. Leighton amassed a large collection of historical musical instruments, arms and furniture at his house in Bedford Park, where he died on 1 September 1922.

Contrib: *The Quiver [1887].*
Exhib: B; G; L; M; RA; RBA; ROI.
Colls: V & AM.

LEIGHTON, Frederic, Lord Leighton of Stretton PRA 1830-1896

Painter. He was born at Scarborough in 1830, the son of a doctor, and received a very wide visual education, travelling with his father on the Continent. He learnt drawing from F. Meli at Rome and attended the Florence Academy and studied under J.E. Steinle at Frankfurt after 1849. He set up his own studio in 1852 and spent three years working in Rome, settling in London in 1859. Leighton had great success with his 'Cimabue's 'Madonna' exhibited at the RA in 1855 and very quickly became one of the grandees of the Victorian art world. He was elected ARA in 1864, RA in 1868 and became PRA, 1878; this was followed by his creation as a baronet in 1886 and a peer in 1896, the only artist to be so honoured. He died on 25 January 1896.

Leighton was a very strong black and white artist and made contributions to *The Cornhill Magazine* which rank among the best work of the 1860s. Forrest Reid refers to them as having 'a kind of cold, formal dignity' rather underrating the power of the draughtsmanship in George Elliot's medieval story of *Romola*, ideally suited to the artist. These plates were brought together in a special limited edition in 1880.

Contrib: *The Cornhill Magazine [1860-63]; Dalziel's Bible Gallery [1881]; Black and White [1891].*
Exhib: B; FAS, 1896-97; G; GG; L; M; RA; RHA; RSA.
Colls: Ashmolean; BM; V & AM.
Bibl: Mrs. Barrington-Ward, *The Life, Letters and Work of FL,* 1906; R. and L. Ormond, *Lord L,* 1975.

See illustrations (pp.372, 373).

LEIGHTON, John FSA 'Luke Limner' 1822-1912

Artist, illustrator, book decorator and designer of ex-libris. He was born in London on 22 September 1822 and studied under Henry Howard RA. Leighton was a lecturer and polemicist on behalf of the arts and in pushing forward technical innovations, an early friend of the camera, he joined with Roger Fenton to found the Photographic Society in 1853, now the Royal Photographic Society of Great Britain. Leighton was best known for his designs for frontispieces and decorative borders, what Gleeson White refers to as 'a pioneer of better things' in their simplicity. He was a founder proprietor of *The Graphic* in 1869 and designed their title page which remained in use until 1930! Leighton designed bookbindings from about 1845 and also turned his hands to Christmas cards. He wrote extensively under the name of 'Luke Limner' and died at Harrow on 15 September 1912.

Illus: *Contrasts and Conceits [c.1850, 20 liths]; London Out of Town [c.1850, 16 liths]; Life of Man Symbolised [1866]; The Poems of William Leighton [1894].*
Contrib: *Lyra Germanica [1861 and 1868]; Moral Emblems [1862]; Good Words [1864]; Once a Week [1866]; London Society [(cover), 1868]; The Graphic [1869 (title)]; The Sunday Magazine [1871]; Dalziel's Bible Pictures [1881]; Puck and Ariel [1890]; Fun [1890-92]; Punch [1900-02].*
Exhib: L, 1898.
Bibl: Chatto and Jackson, *Treatise on Wood Engraving,* 1861, p.582; R. McLean, *Victorian Book Design,* 1972, pp.218-219.

JOHN LEECH 1817-1864. 'The Gypsey's Prophecy.' Original study for illustration to Plain or Ringlets *by R.S. Surtees, 1860. Pencil, ink and wash.* The Garrick Club

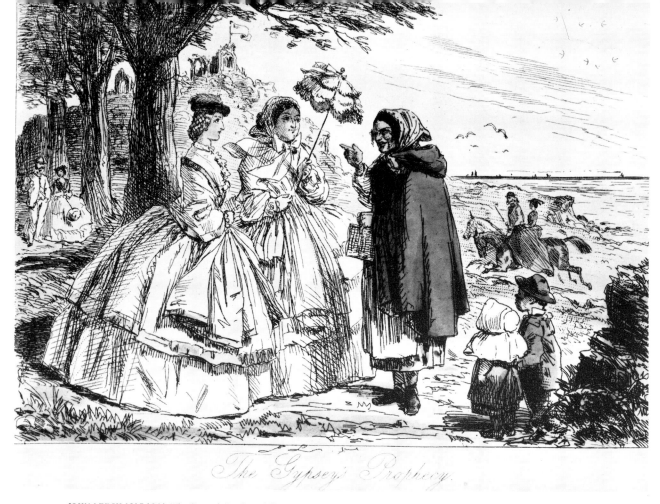

JOHN LEECH 1817-1864. 'The Gypsey's Prophecy.' Illustration to Plain or Ringlets *by R.S. Surtees 1860. Engraving coloured by hand.*

LEIST, Fred RBA **fl.1901-1930**
Portrait and figure painter and illustrator. He was elected RBA in
1913 and ROI in 1916. Working in Australia, 1901-02.

Illus: *The Gold-Marked Charm [B. Marchant, 1919].*
Contrib: *The Graphic [1901-10 (realism)].*
Exhib: L; P; RA; RBA; ROI.

LEITCH, Richard Principal **fl.1840-1875**
Drawing-master and illustrator. He was the brother of W. L. Leitch
(q.v.) and painted landscapes and wrote instructional books. He was
sent by *The Illustrated London News* to Italy in 1859 to cover the
Franco-Italian War.

Contrib: *ILN [1847-61]; Poets of the Nineteenth Century [1857]; Good Words
[1864]; The Sunday Magazine [1865]; Idyllic Pictures [1867]; The Quiver.*
Exhib: RA, 1844-60; RBA, till 1862.
Colls: BM; Maidstone; V & AM.
See illustration (p.137)

LEITCH, William Leighton RI **1804-1883**
Landscape painter. He was born in Glasgow on 22 November 1804,
the son of a manufacturer, and brother of R.P. Leitch (q.v.). He was
apprenticed to a lawyer after being educated at the Highland Society
School and later studied art with D. Macnee. After working for a sign
painter, he became scene painter at Glasgow's Theatre Royal in 1824,
later moving to London to work at the Pavilion Theatre where he
became a friend of D. Roberts and C. Stanfield (qq.v.). Leitch went to
Italy in 1833 and did not return for five years, having used his time in
extensive travel, teaching and sketching. He then set up in London as
a fashionable watercolourist and teacher being patronised by Queen
Victoria. He died 25 April 1883.

Contrib: *ILN [1859].*
Exhib: BI; NWS; RA; RBA.
Colls: BM; V & AM.
Bibl: A. MacGregor, *Memoir of WL,* 1884.

LE JEUNE, Henry L. ARA **1819-1904**
Painter of genre. He was born in London on 12 December 1819 and
studied at the RA Schools, becoming Drawing-master there in 1845
and curator in 1848. He was elected ARA in 1863 and died at
Hampstead 5 September 1904.

Contrib: *Ministering Children [1856]; Lays of the Holy Land [1858]; The
Poetry of Thomas Moore.*
Exhib: BI; RA; RBA.
Colls: Witt Photo.

LELONG, René **fl.1895-1912**
Painter. Born at Arrou, France, and exhibited at the Salon, 1895,
becoming a medallist, 1898. Contributed to *The Graphic,* 1912.

LE MAIR, H. Willebeek **1889-1966**
Baroness H. van Tuyll van Serooskerken
Dutch designer and illustrator. She was born in Rotterdam on 23
April 1889, the daughter of a wealthy family who were artists and
patrons of the arts. At an early age she was influenced by the French
illustrator Maurice Boutet de Monvel whom she met at her father's
and was advised by him to attend the Rotterdam Academy, 1909-11.
From 1911 she had growing contacts with London publishers and was
to remain very popular as an illustrator of children's books for the
British public throughout the 1920s and 1930s. Her style is rather flat
in the drawing with muted colours and decorative borders. A sideline
of her artistic life was making designs for children's breakfast sets for
the Gouda pottery, dating from about 1923. She lived the whole of
her married life in the Hague and died there on 15 March 1966.

 An exhibition of books and drawings by H. Willebeek Le Mair was
held at the Bethnal Green Museum, London, in October 1975.

Illus: *Premières Rondes Enfantines [1904]; Our Old Nursery Rhymes [1911];
Little Songs of Long Ago [1912]; Schumann Album of Children's Pieces
[1913]; Grannie's Little Rhyme Book; Mother's Little Rhyme Book; Auntie's*

Little Rhyme Book; Nursie's Little Rhyme Book; Daddy's Little Rhyme Book [c.1913]; The Children's Corner [1914]; What the Children Sing [1915]; Old Dutch Nursery Rhymes [1917]; A Gallery of Children [A.A. Milne, c.1925]; A Child's Garden of Verses [1926]; Twenty Jatka Tales [1939]; Christmas Carols; The Births of the Founders of Religion [1950-53].

LEMANN, Miss E.A. fl.1878-1889
Landscape painter and illustrator. She worked at Bath and specialised in children's books.

Illus: *The Gold of Farnilee [Andrew Lang]; King Diddle [H.C. Davidson]; Under the Water [Maurice Noel, c.1889].*
Exhib: RBA; SWA.

LENFESTEY, Gifford Hocart RBA 1872-1943
Landscape painter and illustrator of architectural subjects. He was born at Faversham on 6 September 1872 and studied art at the RCA and in Florence and Paris under Raphael Collin. He was elected RBA in 1898 and served on the Council. He died on 22 December 1943.

Exhib: M; RA; RBA; RI; ROI.
Bibl: *The Studio*, Vol.8, 1896, pp.142-148, illus.

LE QUESNE, Rose fl.1886-1895
Painter, sculptor and illustrator, working in London, but at Jersey in 1890. She contributed drawings of social realism, child workers etc. to *The Strand Magazine,* 1891.

Exhib: L; NEA; RA; RBA.

LESLIE, Charles Robert RA 1794-1859
Historical and portrait painter. He was born of American parents at Clerkenwell in 1794 and left with them for America in 1799 where he was brought up. He returned to England in 1811 to study art under Benjamin West and Washington Allston, becoming a student of the RA in 1813 and exhibiting for the first time in that year. He was elected ARA in 1821 and RA in 1826 and returned to the States in 1833 to become Drawing-Master at West Point. He settled in London finally the following year, becoming Professor of Painting at the RA, 1847-52 and as a painter specialised in very finished oil paintings of subjects from 17th and 18th century literature. He is included here for his series of illustrations for the novels of Washington Irving. Leslie, who became a notable art historian, died at St. John's Wood on 5 May 1859.

Pub: *Life of Constable [1845]; Life of Sir Joshua Reynolds.*
Exhib: BI; OWS; RA.
Colls: BM; V & AM.
Bibl: *Autobiographical Recollections,* Edited by Tom Taylor, 1865.

LESLIE, George Dunlop RA 1835-1921
Landscape and figure painter. He was born on 2 July 1835, younger son and pupil of C.R. Leslie, RA (q.v.). He was educated at the Mercer's School, before becoming a student at the RA in 1856. He was elected ARA in 1868 and RA in 1876. He specialised in views of the Home Counties and Thames Valley and White described his book illustrations as 'pretty half mediaeval, half modern . . .' He died at Lingfield, Sussex, on 21 February 1921.

Contrib: *Two Centuries of Song [1867]; ILN [1878].*
Pub: *Our River [1881]; Letters to Marco [1894]; Riverside Letters [1896]; The Inner Life of the Royal Academy.*

L'ESTRANGE, Roland 'Armadillo' 1869-1919
Amateur caricaturist. A member of the family of L'Estrange of Hunstanton Hall, Norfolk. He contributed cartoons to *Vanity Fair,* 1903-04 and 1907. He signs his work Ao for Armadillo.

LEVESON, Major A.H.
Amateur draughtsman. He contributed drawings to *The Illustrated London News* during the Abyssinian Expedition of 1868.

LEVETUS, Celia fl.1896-1901
Illustrator. She was born in Birmingham, the sister of Edward, Lewis and Amelia Levetus, writers and critics. She studied at the Birmingham School and published black and white work in the Morris manner but as Sketchley comments 'in a more flexible style'.

ALFRED CHEW LEETE 1882-1933. Black and white illustration for humorous magazine, c.1914. Pen and ink. Jeffrey Gordon Collection

Illus: *Turkish Fairy Tales [1896]; Verse Fancies [1898]; Songs of Innocence [1899].*
Contrib: *The Yellow Book [1896]; English Illustrated Magazine [1896].*
Bibl: *The Artist,* May 1896; R.E.D. Sketchley, *English Book Illustrations,* 1903, pp.12, 128.

LEVIS, Max 1863-
Portrait and figure painter. He was born in Hamburg, on 27 January 1863 and after studying at the Karlsruhe Academy and at Munich, worked in Vienna from 1888. He contributed an illustration to *The Illustrated London News,* 1892 (Christmas).

LEWIN, Frederic George fl.1902-1930
Humorous illustrator in black and white and colour. He worked throughout his life at Redland, Bristol, and specialised in rural figure subjects and children's books in the chap-book style.

Illus: *Rhymes of Ye Olde Sign Boards [c.1910].*
Contrib: *Punch [1902-08].*
Bibl: *Mr. Punch With Horse and Hound,* New Punch Library, c.1930

LEWIS, Arthur James 1825-1901
Landscape and portrait painter, working in London. He contributed illustrations to *Passages From Modern English Poets,* 1862.

Exhib: BI; GG; New Gall; RA.

LEWIS, F.
Animal artist, contributing illustrations to *The Graphic,* 1886 from Dublin.

LEWIS, Frederick Christian 1779-1856
Engraver and painter. He was born in London on 14 March 1779 and apprenticed to J.C. Stadler, the German engraver. He attended the RA Schools and was later appointed as engraver to Princess Charlotte of Wales, then successively to Leopold I, Geoge IV, William IV and Queen Victoria. He acquainted Plate 43 of Turner's *Liber Studiorum.* He died at Enfield on 18 December 1856.

Illus: *Scenery of the River Dart [1821]; The Scenery of the Rivers Tamar and Tavy [1823].*
Exhib: BI; OWS; RBA.

FREDERIC LORD LEIGHTON PRA 1830-1896. 'Coming Home.' Illustration for Romola *by George Eliot, published in* The Cornhill Magazine, *Vol. 6, July to December 1862. Wood engraving.*

LEWIS, George Robert **1782-1871**
Genre painter, landscape painter and illustrator. He was born in London in 1782, the younger brother of F.C. Lewis (q.v.). He was a pupil of Fuseli at the RA Schools and after working with his brother for Chamberlain and Ottley, made an extensive tour on the Continent in 1818. This journey made with the eccentric bibliophile Thomas Frognall Dibdin, was the start of a partnership which lasted some years, Dibdin writing reminiscenses and Lewis illustrating them. He died at Hampstead in 1871.

Illus: *The Bibliographical Decameron [T.F. Dibdin, 1817]; Muscles of The Human Frame [1820]; The Bibliographical Tour [T.F. Dibdin, 1821 & 1829, 3 vols.]; Illustrations of Kilpeck Church [1842]; Banks of The Loire Illustrated; Early Fonts of England [1843]; British Forest Trees; Description of Shobdon Church [1856].*
Exhib: RA, 1820-59.
Colls: BM; Leeds.
Bibl: E.J. O'Dwyer, *Thomas Frognall Dibdin*, Private Libraries Association, 1967.

LEWIS, John Frederick **1805-1876**
Painter of Figures and Eastern scenes. He was born in 1805, the eldest son of F.C. Lewis (q.v.) and began work as an animal painter in oils, exhibiting at the RA from the age of sixteen. His precocious talent attracted the notice of Sir Thomas Lawrence, who employed him as his assistant for a year. He published six mezzotints after his own work in 1825, which gained him a commission from George IV to paint sporting scenes at Windsor. His first visit to Spain in 1832 was of major significance to his work, his style became more assured, his

colours brighter and he developed an interest in the peninsular and the Middle East that soon became his hall-mark. Lewis lived abroad, first at Rome and then in the East from 1840 to 1851, basing himself at Cairo but visiting Greece and Albania. He was President of the OWS in 1855, having been elected in 1829, was elected ARA in 1859 and RA in 1865. Lewis's watercolours which are much sought after today are among the most brilliant Victorian achievements in the medium, brilliantly coloured and finely drawn. He died at Walton-on-Thames in 1876.

Illus: *Sketches and Drawings of the Alhambra [1835, AT 148]; Sketches of Spain and Spanish Character [1836, AT 149]; Sketches of Spain [1836, AT 150]; Illustrations of Constantinople [1838, AT 394].*
Exhib: BI; OWS; RA; RBA.
Colls: Birmingham; Blackburn; Fitzwilliam; V & AM.
Bibl: *Walker's Quarterly,* XXVIII, 1929; M. Hardie, *Watercol. Paint. in Brit.,* Vol.III, 1969, pp.48-55, illus.

LIGHT, Kate
Black and white artist. Contributed illustration and decor to a poem in *The Studio,* Vol.6, 1896.

LILLIE, Charles T. **fl.1881-1882**
Comic draughtsman. He trained as an engineer and travelled widely to Africa and America before settling at Haverstock Hill, London, as an author and artist. He contributed to *Punch* in 1881 and exhibited flower paintings at the RBA in 1882.

LINDSAY, G.
Contributed drawings of comic fashions to *Punch,* 1906

LINDSAY, Norman Alfred William **1879-**
Black and white artist. He was born at Creswick, Victoria, Australia, on 23 February 1879 and joined the art staff of *The Sydney Bulletin* in 1901. He was chief cartoonist of the paper for many years, developing a pungent satirical style and a virtuosity of pen line that makes him the greatest black and white artist Australia has produced. He illustrated a number of books in addition to his cartooning, most of his work being left-wing, pacifist and anti-clerical in subject.

Illus: *Theocritus; Boccaccio; Casanova; Petronius; Satyrs and Sunlight [Hugh McCrae]; Songs of a Campaign [Colombine and Geelert]; Norman Lindsay's Book No.1 [1912]; No.2 [1915].*
Colls: V & AM.
Bibl: *Pen Drawings of NL,* Sydney, 1918.

LINDSELL, Leonard **fl.1890-1907**
Illustrator. He was working in Bedford Park, London, during the 1890s and 1900s, contributing to the leading magazines.

Contrib: *The Girls' Own Paper [1890-1900]; The Lady's Pictorial [1895]; The Idler; The Royal Magazine.*
Colls: V & AM.

LINNEY, W.
Contributed a drawing to *Good Words,* 1861.

LINSDALE, J.
Contributed figure subjects to *Fun,* 1892.

LINTON, Sir James Drogmole PRI **1840-1916**
Historical painter and illustrator. He was born in London on 26 December 1840 and educated at Clevedon House, Barnes, before studying art at Leigh's in Newman Street. He exhibited at the Dudley Gallery and the RI from 1863, was elected RI in 1870 and became the first President, 1883-97. He was knighted in 1885. Linton worked in black and white during the early part of his career, his best work being done for *The Graphic.* He died in London on 3 October 1916.

Illus: *The Pilgrim's Progress.*
Contrib: *Good Words [1870]; Cassell's Magazine [1870]; The Graphic [1871-74].*
Exhib: B; G; GG; L; M; New Gall; P; RA; RHA; RI; ROI.
Colls: Ashmolean; V & AM.
Bibl: *English Influences on Vincent Van Gogh,* Arts Council, 1974-75, p.52.

FREDERIC LORD LEIGHTON PRA 1830-1896. 'Moses views the Promised Land.' Drawing for the illustration in Dalziel's Bible Gallery, *1881. Indian ink and black chalk. 8¼ins. x 5ins. (21cm. x 12.7cm).* Victoria and Albert Museum

LINTON, William 1791-1876

Landscape painter. He was born at Liverpool in 1791 and after being educated at Rochdale, entered a merchant's office in Liverpool. He spent much of his time in sketching the scenery of North Wales and studied the work of Claude and the Richard Wilson paintings at Ince Blundell Hall. He made extensive tours of Italy, Sicily and Greece in 1840 gathering information on classical antiquities which he incorporated in his pictures. Died in London in 1876.

Illus: *Ancient and Modern Colours [1852]; The Scenery of Greece [1856]; Colossall Vestiges of the Older Nations [1862].*
Exhib: BI; RA; RBA.
Colls: BM; Fitzwilliam; Woburn; V & AM.

LINTON, William James 1812-1898

Engraver, poet and socialist. He was born in London on 7 December 1812 and was apprenticed to G.W. Bonner, the engraver, before entering partnership with Orrin Smith in 1842. He established *The National* in 1839, which reprinted pieces from other papers for the benefit of the working man; in 1845 he became editor of *The Illuminated Magazine* and founded *The English Republic,* 1850-55. In 1857 he was responsible for engraving the blocks to the historic *Moxon Tennyson* and was brought into contact with the Pre-Raephalites, in the 1860s he engraved for many books and was influential on a great many black and white artists who were his pupils, particularly Walter Crane (q.v.). He emigrated to the United States in 1866 and was elected a member of the Academy in 1882. He died at Newhaven, Conn., 1 January 1898.

Contrib: *Poems and Pictures [1846]; Good Words [1866]; The Lake Country [1864]; Wise's Shakespeare; Book of British Ballads [1842].*
Exhib: RA; RBA.
Bibl: *A History of Wood Engraving in America,* 1882; *Masters of Wood Engraving,* 1890; *Memories,* 1895.

LINTOTT, Edward Barnard 1875-1951

Portrait and landscape painter. He was born in London in 1875 and studied at Julian's, the Sorbonne and the École des Beaux-Arts, Paris. He won a Carnegie Prize for work exhibited at the Salon and in the 1900s did a certain amount of illustrative work. He may have visited Russia in 1918 during the Revolution, was based in Chelsea after the First World War and died there in 1951.

Exhib: G; GG; L; M; NEA; P; RA.
Illus: *The Philharmonic-Symphony Orchestra of New York [W.G. King, 1940].*
Colls: V & AM.

LINVECKER, J.B.

Animal illustrator, contributing to *The Graphic,* 1872.

LIOTROWSKI

Russian artist, contributing drawings of the Revolution of 1905 to *The Graphic.*

LIVETT, Berte

Comic black and white artist. He contributed illustrations to *Judy,* 1899 and *Fun,* 1900.

LIVINGSTON-BULL, Charles

Illustrator of children's books. Drew for C. Lee Bryson's *Tan and Teckle,* 1908.

FREDERIC LORD LEIGHTON PRA 1830-1896. 'Moses views the Promised Land.' Illustration in Dalziel's Bible Gallery, *1881. Wood engraving.*
Victoria and Albert Museum

LIX, Frédéric Théodore 1830-1897
Genre painter. He was born in December 1830 and began to exhibit at the Paris Salon in 1859. He contributed equestrian subjects to *The Illustrated London News*, 1862-63 and died in Paris in 1897.

LLOYD, Arthur Wynell 1883-
Cartoonist and illustrator. He was born at Hartley Wintney in 1883 and after being educated at Rugby and Queen's College, Oxford, he served in the 25th Royal Fusiliers, 1916-17 and won the MC. He was chief cartoonist for the Essence of Parliament in *Punch* from 1914 and cartoonist of *The News of the World*. Signs: A.W.L.
Exhib: Cooling Gall., 1934.

LLUELLYN, Mrs Y.A.D.
Black and white artist, working for *The Longbow* and *The Ludgate Monthly* in the 1890s.
Exhib: ROI, 1889.

LOCK, Agnes fl.1905-1925
Black and white artist working at Frencham, Surrey, from 1918 to 1925. She illustrated *Haunts of Ancient Peace* by Alfred Austin, c.1905.
Exhib: RI, 1918-19.

LOCKE, William
Genre painter and etcher. He was a pupil and friend of Henry Fuseli and worked in Paris and Rome. An undated drawing for Pope's *The Rape of the Lock*, possibly intended for illustration, is in an American private collection.

LOCKWOOD, Sir Frank (Francis) 1847-1897
Amateur caricaturist. He was born in 1847 and was educated at Manchester Grammar School, St. Paul's, London and afterwards at Caius College, Cambridge. He was called to the Bar at Lincolns Inn and became Recorder of Sheffield in 1884, MP for York and Solicitor-General, 1894-95. He specialised in legal caricatures and contributed them to *Punch* for many years. R.G.G. Price says that they were 'worked up' by E.T. Reed (q.v.). He died 19 December 1897.
Contrib: *Punch; The Sketch; ILN [25 Dec., 1897]*.
Bibl: A. Birrell, *Sir FL.* 1898; R.G.G. Price, *A History of Punch*, 1955, p.168.

LODGE, George Edward fl.1881-1925
Figure and landscape painter. He specialised in natural history subjects and continental views, which he illustrated with great accuracy. He was working in London to 1917 and then at Camberley.
Contrib: *The English Illustrated Magazine [1886, 1893-94]; The Pall Mall Magazine*.
Exhib: B; L; M; RA; RBA; ROI.

LOEB, Louis 1866-1909
American illustrator. He was born at Cleveland in 1866 and became a member of the National Academy in 1906, dying at Canterbury, New Hampshire in 1909. He is included here as the illustrator of the English edition of *Pudd'nhead Wilson* by Mark Twain, 1897.

LOEFFLER, Ludwig 1819-1876
History painter and lithographer. He was born at Frankfurt-sur-Oder in 1819 and studied under Hensel and attended the Berlin Academy. He died at Berlin in 1876.
Contrib: *ILN [1868-74]*.

LOGSDAIL, William 1859-1944
Portrait, architectural and landscape artist. He was born at Lincoln in 1859 and was educated at the Grammar School and School of Art at Lincoln. He won Gold Medals in the National Competition, 1875-76 and began to exhibit at the RA in 1877. He made further studies at the Académie des Beaux-Arts in Antwerp and worked as a painter in Venice, Cairo and Sicily. He was elected to the NEA in 1886.
Contrib: *The Graphic [1889 (topog.)]*.
Exhib: G; GG; L; M; New Gall; RA; RBA; ROI.

LONGMIRE, R.O. fl.1904-1923
Black and white artist working in Liverpool. He contributed illustrations to *Punch*, 1904.
Exhib: L.

LORAINE, Nevison Arthur RBA fl.1889-1908
Figure and landscape painter. He was elected RBA in 1893 and contributed to *The Illustrated London News*, 1895.
Exhib: L; RA; RBA; ROI.

LORIOU, Felix
French illustrator. Contributed colour plates to *The Illustrated London News*, Christmas 1916, in the style of Poiret.

LORNE, The Marquess of 1845-1914
PC KG afterwards 9th Duke of Argyll.
Amateur artist. Born 6 August 1845, eldest son of George, 8th Duke of Argyll. He was educated at Eton and Trinity College, Cambridge and was MP for Argyllshire in 1868. In 1871, he married HRH Princess Louise (q.v.), fourth daughter of Queen Victoria, becoming successively Governor-General of Canada, 1878-83 and MP for South Manchester, 1895. Lord Lorne published numerous books including *Canadian Pictures*, 1885 and died 2 May 1914.
Contrib: *The Graphic [1883]*.

LORON, G.A. fl.1895-1914
Illustrator. The Victoria and Albert Museum has illustrations by this artist for *The Heptameron* by Margaret of Navarre, in pen, ink, black chalk and wash on primed canvas.

LORSAY or LORSA, Louis Alexandre Eustache 1822-
Portrait painter and draughtsman. He was born at Paris on 23 June 1822 and studied with Paris and Monvoisin, exhibiting at the Salon in 1847 and 1859. He contributed figure subjects to *The Illustrated Times* in 1855.

LOUDAN, William Mouat 1868-1925
Genre and portrait painter. He was born in London of Scottish parents in 1868 and educated at Dulwich College before attending the RA Schools for four years, and winning the travelling scholarship. He then worked in Paris under Bouguereau and returned to England where he was elected NEA in 1886 and RP in 1891. He later devoted himself entirely to portraiture and died in London on 26 December 1925.
Contrib: *ILN [1889-94]*.
Exhib: B; G; GG; L; M; NEA; New Gall; P; RA; RBA.
Colls: Leeds; Liverpool; V & AM.
Bibl: *The Artist*, 1899, pp.57-63, illus.

LOUGHRIDGE, E.G.
Amateur. Contributed some portrait into caricature subjects to *Punch* in 1903.

LOUISE, HRH 1848-1939
The Princess Louise Caroline Alberta, Marchioness of Lorne.
Artist, sculptress and writer. She was born at Windsor Castle on 8 March 1848, the sixth child and fourth daughter of HM Queen Victoria. She was married at Windsor on 21 March 1871 to the Marquess of Lorne, later 9th Duke of Argyll (q.v.). Princess Louise studied sculpture under Sir E. Boehm and was elected HRE, 1897, and RSW, 1884. She died at Kensington Palace in 1939.
Exhib: G; GG; L; M; RMS; RWS.

LOUTHERBOURG, Philippe Jacques de RA 1740-1812
Landscape painter, illustrator and inventor. He was born, according to the inscription on his tomb, on 1 November 1740 at Strasbourg, the son of a painter of Polish extraction. He studied at Strasbourg University and under F.G. Casanova and Carlo Vanloo in Paris, becoming a member of the Académie Royale in 1767. He settled in England in 1771, painting battle pieces and scenery for David Garrick

at Drury Lane. An incurable romantic, Loutherbourg invented in 1781 the Eidophusicon for Spring Gardens, a machine that gave the illusion of changing light and movement on a stage set. He began to exhibit at the RA in 1782, was elected ARA in 1780 and RA in 1781. He died at Hammersmith Terrace, Chiswick on 11 March 1812.

Between 1775 and 1780, Loutherbourg developed an interest in caricature based on a study of P.L. Ghezzi and a knowledge of Hogarth. In 1775 he published *Caricatures of the English* from the shop of G.M. Torre. From this period many of the subsidiary groups in his landscapes develop a slightly caricatured form like those of Rowlandson. Loutherbourg gathered together his topographical paintings to form *The Picturesque Scenery of Great Britain*, 1801, and *The Picturesque and Romantic Scenery of England and Wales*, 1805. In 1789, Loutherbourg agreed to contribute plates to Thomas Macklin's edition of *The Holy Bible*. He provided twenty two out of the seventy one plates, plus one hundred and twenty five vignettes. The project lasted from 1789 to·1800 and was based on subscription, Macklin holding annual exhibitions in his Poets' Gallery.

Illus: *Hume's England [Bowyer's Edition]; Nelson's Victories [frontis]*.
Colls: BM; Derby; Dulwich; Glasgow; Louvre; Stockholm; V & AM.
Bibl: Rudiger Joppien, *PJ de L, RA, 1740-1812*, Catalogue of exhibition at Iveagh Bequest, GLC, 1973.

LOW, Sir David 1891-196

Cartoonist and caricaturist. He was born in Dunedin, New Zealand on 7 April 1891 and educated at the Boys' High School, Christchurch. He became Political Cartoonist of *The Spectator*, Christchurch, in 1902 and joined *The Sydney Bulletin* in 1911. He became cartoonist of *The Star*, London, 1919, and from 1927 worked for *The Evening Standard*, where much of his finest work appeared, and on *The Daily Herald* from 1930.

Publ: *Low's Annual [1908]; Caricatures [1915]; The Billy Book [1918]; Man [1921]; Lloyd George & Co. [1922]; Low & I [1923]; Low & I Holiday Book [1925]; Lions and Lambs [1928]; The Best of Low [1930]; Low's Russian Sketch Book [1932]; Portfolio of Caricatures [1933]; Low and Terry [1934]; The New Rake's Progress [1934]; Ye Madde Designer [1935]; Politcal Parade [1936]; Low Again [1938]; A Cartoon History of Our Time [1939]; Europe Since Versailles [1939]; Europe at War [1940]; Low's War Cartoons [1941]; Low on the War [1941]; British Cartoonists [1942]; The World at War [1942]; C'est La Guerre [1943]; Valka Zacala Mnichovem [1945]; Dreizehn Jahre Weltgeschehnen [1945]; Kleine Weltgeschichte [1949]; Years of Wrath [1949]*.
Bibl: *Low's Autobiography*, 1956.

LOW, Harry (Henry Charles) fl.1914-1939

Landscape painter and black and white artist. He was working at Wimborne, 1939-40 and contributed figure subjects to *Punch*, 1914.

LOW, K.

Illustrator and designer. He supplied illustrations and initials to an edition of Oscar Wilde's *A House of Pomegranates*, c.1900-10. He signs his work 'KL'.

Colls: V & AM.

LOWELL, Orson

Illustrator. Contributed drawings to *The Choir Invisible* by James Lane Allen, c.1908.

LOWINSKY, Thomas Esmond 1892-1947

Painter and illustrator. He was born in London on 2 March 1892 and was educated at Eton and Trinity College, Oxford. He studied art at the Slade School and enlisted in August 1914, serving throughout the War and on active service in France. Lowinsky was closely associated with the private presses in the 1920s and worked as illustrator for The Nonesuch Press, the Fleuron Press·and The Shakespeare Head Press at various times. He specialised in coloured wood cuts, rather linear in style with strong art deco mannerism. He worked in Sunninghill, Berks., until 1914 and then at Kensington Square, London and Aldbourne, Wilts., where he died on 24 April 1947. He became a member of the NEA, 1926. He signs his work ⚹ ⚹

Illus: *Sidonia the Sorceress [William Meinhold, 1923]; Elegy on Dead Fashion [Edith Sitwell]; Paradise Regained [John Milton, 1924]; Dr Donne and Gargantua [Sacheverell Sitwell]; Exalt the Eglantine [Sacheverell Sitwell]; The*

Princess of Babylon [1927]; Plutrach's Lives [1928]; The School For Scandal [1929]; Modern Nymphs [Raymond Mortimer, 1930].
Exhib: G; L; NEA; RA.
Colls: Fitzwilliam.

LUARD, John Dalbiac 1830-1860

Genre painter and illustrator. He was born in 1830 at Blyborough and followed a military career, serving in the Crimean War. Luard then joined the Langham Sketching Club and studied under John Philip RA. White had little regard for his work which he felt 'shows . . . a pre-Raphaelite manner and promise which later years did not fulfill'. He died at the early age of thirty, at Winterslow.

Contrib: *Once A Week*.
Exhib: RA, 1855-58.
Bibl: Stacy Marks, *Pen & Pencil Sketches*, p.59.

LUCAS, Horatio Joseph 1839-1873

Amateur etcher. He was born on 27 May 1839 and exhibited at the RA, 1870-73. Died 18 December 1873.

Contrib: *Good Words [1863]*.

LUCAS, John Seymour RA RI 1849-1923

Historical and portrait painter and illustrator. He was born in London on 21 December 1849, the nephew of John Lucas, the portrait painter. He studied at the St Martin's School of Art and at the RA Schools, specialising in sculpture but later turning to painting. He began to exhibit at the RA, in 1872, was elected NWS and RI in 1877 and ARA and RA in 1886 and 1898 respectively; visitor at the RA, 1886. Lucas did a considerable amount of illustrating in the 1890s, mostly of historical stories for magazines, the sketches for these are in grey washes with heavy bodycolour. He died at Blythborough, Suffolk on 8 May 1923.

Illus: *The Cruise of the River [1882]; The Grey Man [S.R. Crockett, 1896]*.
Contrib: *The Graphic [1893, 1901-06]*.
Exhib: B; G; L; M; RA; RBA; RCA; RHA; RI; ROI; RSA.
Colls: Birmingham; Leicester; Sydney; V & AM; Witt Photo.

LUCAS, John Templeton 1836-1880

Portrait painter and author. He was born in 1836, the son of John Lucas, the portrait painter and cousin of J. Seymour Lucas (q.v.). He wrote a farce and published some fairy tales in 1871, but is included here for the contributions he made to *The Illustrated London News*, in 1865 and 1879 (genre subjects) and in 1876 (Christmas subjects). He died at Whitby in 1880.

Exhib: BI, 1859-76; G; RA; RBA.

LUCAS, Sydney Seymour fl.1904-1940

Portrait painter and illustrator. The son of J. Seymour Lucas, RA (q.v.) with whom he collaborated in illustrations. He worked in Bushey, Herts., in 1909 and at London and Blythborough, Suffolk in 1934 and 1936.

Contrib: *The Graphic [1904, 1905 (military)]*.
Exhib: P; RA; RSA.

LUDLOW, Henry Stephen 'Hal' 1861-

Portrait and domestic painter and illustrator. He was born in 1861 and studied at Heatherley's and Highgate College and worked in London from 1880. Ludlow was a very competent all round magazine illustrator, his subjects ranging from theatrical sketches to Parliamentary reporting, stories and cattle shows. He was chief cartoonist to *Judy*, 1889-90. He worked at Hanwell, 1902-25.

Contrib: *Fun [1879-87]; ILN [1882-89]; Judy [1889-90]; The Queen [1892]; The Rambler [1897]; The Sketch; Ally Sloper's Half Holiday; Illustrated Bits; Cassell's Family Magazine; Chums; The Strand Magazine*.
Exhib: B; G; L; RA; RI.
Colls: V & AM.
See illustration (p.377).

LUDLOW, S.

Contributed illustrations of birds to *The Graphic*, 1870.

LUDOVICO or LUDOVICI, Albert, Junior 1852-1932

Figure and landscape painter and illustrator. He was born on Prague on 10 July 1852, the son of Albert Ludovici Senior, the artist. He painted genre subjects and worked in London and Paris after studying in Geneva. He was elected RBA in 1881 and NEA in 1891. His Parisian years brought him into contact with many famous artists and he was influenced by J.M. Whistler (q.v.). He died in London in 1932.

Contrib: *The Strand Magazine [1891 (legal)]*.
Exhib: BI; G; GG; L; M; NEA; RA; RBA; RHA; RI.
Colls: Sheffield.
Bibl: *An Artist's Life in London and Paris,* 1926.

LUKER, William RBA 1867-

Animal and figure painter and illustrator. He was born in Kensington in 1867, the son of William Luker, the portrait, genre and animal painter. He was educated at private schools in London and Oxford before studying art at South Kensington and the RI Schools of Art. He worked for most of his life in London, but at Stanford-le-Hope, Essex, 1902-03 and at Amberley in Sussex after 1948. RBA, 1896.

Illus: *Kensington Picturesque and Historical; London City; London City Suburbs; Textile London; The Children's London [1902]*.
Contrib: *Souvenir of Indian Peace Contingent*.
Exhib: B; L; M; NEA; RA; RBA; RHA; RI; ROI.

LUMLEY, Arthur 1837-1912

American illustrator. He was born in Dublin in 1837 but emigrated to the United States where he worked as a painter in New York. He died there 27 September 1912.

Contrib: *ILN [1875-76, 1881]*.
Exhib: RA, 1876.

LUMLEY, Augustus Savile fl.1855-1899

Genre and portrait painter. He exhibited at the RA, RBA and BI as well as at Liverpool, and contributed illustrations to *Sketchy Bits*.

LUNT, Wilmot

Illustrator. He was born at Warrington, Lancs. and was educated at the Boteler Grammar School and studied art at the Beaux Arts and Julian's in Paris. Lunt was principally a figure artist in black and white and contributed to many magazines. He worked at Elstree, Hertfordshire from 1914.

Contrib: *Punch [1908-09]; The Graphic [1915-16]; The Bystander; The Tatler*.
Exhib: L; RA; RI.
Bibl: *Who's Who in Art,* 1927.

ILBERY LYNCH fl.1905-1925. 'Just Published.' An illustration in the style of Aubrey Beardsley. Pen and ink. Signed and dated 1909, and inscribed to Robert Ross 8¼ins. x 11¼ins. (21cm x 28.6cm).
Victoria and Albert Museum

LUTYENS, Sir Edwin Landseer PRA **1869-1944**

Architect and caricaturist. He was born in 1869 and studied at South Kensington under Sir Ernest George. He began to practise in 1888 and built country houses and later the brilliant New Delhi complex, 1913-30. Throughout his life, Lutyens was a talented and compulsive caricaturist and many of his letters and drawings are decorated in the margins with his humorous inspirations. He was elected PRA in 1938 and died in office in 1944; he had been knighted in 1918 and received the OM in 1942.

Colls: RIBA.
Bibl: A.S.G. Butler, *The Architecture of Sir EL*; C. Hussey, *The Life of Sir EL*, 1960.

LYDON, A.F. **1836-1917**

Engraver and illustrator. He worked at Great Driffield, Yorkshire, and specialised in ornithological and natural history illustration.

Illus: *Houghton's British Fresh-water Fishes [1879]*.
Contrib: *ILN [1890]; The English Illustrated Magazine [1891-92]*.
Exhib: RA, 1861.
Colls: Witt Photo.

LYNCH, F.

Caricaturist, contributing portrait chargés to *Fun,* 1901.

LYNCH, Ilbery **fl.1905-1925**

Black and white artist. Very little is known about this talented follower of Aubrey Beardsley. He illustrated *The Transmutation of Ling* by Ernest Bramah and designed a cover for *The Wallet of Kai Lung.* The Victoria and Albert Museum has an extremely fine pen drawing in pastiche of Beardsley, signed and dated 1909.

Exhib: FAS, 1913.
Colls: V & AM.
Bibl: Grant Richards, *Author Hunting,* 1960.
See illustration (p.376).

LYNCH, J.F.A.

Topographical artist. He contributed to. *The Illustrated London News* and *The Illustrated Times* in 1860.

LYNCH, J.G. Bohun **1884-**

Author and caricaturist. He was born in London on 21 May 1884 and was educated at Haileybury and University College, Oxford. Lynch was a popular caricaturist in the early 1920s, usually working in chalk and drawing large heads. He wrote a perceptive study of Max Beerbohm (q.v.).

Publ: *Glamour [1912]; Cake [1913]; Unofficial [1915]; The Complete Gentleman [1916]; The Tender Conscience [1919]; Forgotten Realms [1920]; A Perfect Day [1923]; Menace From The Moon; Max Beerbohm in Perspective [1921]; A Muster of Ghosts [1924]; Decorations and Absurdities.*
Bibl: *Caricature of Today*. Studio, 1928, pl.89.

LYON, Captain George Francis **1795-1832**

Naval officer and traveller. He was born in 1795 and entered the Navy in 1808. He travelled to Africa in 1818-20 and published a narrative account of this in 1821. He formed part of Parry's Arctic Expedition in 1821-23 and after visiting Mexico and South America died at sea in 1832.

Illus: *The Private Journal of Captain GFL of HMS Hecla [1824]*.

HENRY STEPHEN LUDLOW
'HAL' 1861- 'Scenes at
Smithfield Cattle Show'.
Signed and dated.

MACBETH, Ann fl.1902-1925
Watercolour artist. She may have been trained at the Glasgow School and was working in the city, 1902-7 and again in 1925. Her style of drawing in pen and ink heightened with bodycolour and stippled, is close to that of Jessie M. King and Annie French (qq.v.) who offer an interesting comparison. Her drawing of 'Sleeping Beauty' sold by Sotheby's on 15 November 1977, may be for illustration.
Exhib: G; L.

MACBETH, James 1847-1891
Landscape painter and illustrator. He was born in Glasgow in 1847, the son of Norman Macbeth, RSA and brother of R.W. Macbeth, RA (q.v.). He worked in London and at Churt, Surrey and died in 1890.
Contrib: *ILN [1872-73]; The Graphic [1872-74].*
Exhib: G; GG; L; M; RA; RBA; RI; ROI; RSA.
Colls: Norwich.

MACBETH, Robert Walker RA 1848-1910
Painter and illustrator. He was born in Glasgow on 30 September 1848, the son of Norman Macbeth, RSA, and was educated at Edinburgh and at Friedrichsdorf, Germany. He studied art at the RSA Schools and on coming to London in 1870, began to work as an illustrator for *The Graphic*, then in its first year. Macbeth drew a wide variety of subjects for the paper, including sketches of the Commune, but became well-known for his rustic scenes and his etchings. As an etcher he was much influenced by Velazquez and Titian and was elected RE on the foundation of the Society. Macbeth, who gave his recreation in *Who's Who* as 'sleeping when too dark to work', became ARA in 1883 and RA in 1903. He died in London on 1 November 1910.
Illus: *A Thousand Days in the Arctic [F.G. Jackson, 1899].*
Contrib: *The Graphic [1870-71, 1901-03]; Once a Week [1870]; The Sunday Magazine [1871]; The English Illustrated Magazine [1883-85].*
Exhib: G; GG; L; M; New Gall; P; RA; RBA; RE; RI; ROI; RSA; RWS.
Colls: Aberdeen; V & AM; Witt Photo.

MACBETH-RAEBURN, Henry Raeburn ARA 1860-1947
Artist and engraver. He was born in Glasgow on 24 September 1860, the son of Norman Macbeth, RSA and brother of R.W. and J. Macbeth (qq.v.). He was educated at the Edinburgh Academy and University and studied art at the RSA and at Julian's in Paris. He began his career as a portrait painter in London in 1884 and turned to engraving in 1890. In 1889, he made a visit to Spain and in 1896-97 etched a series of frontispieces for Osgood & Co.'s edition of *The Wessex Novels* by Thomas Hardy. Macbeth-Raeburn was best known in the 1920s for his engravings after the works of old masters, especially Raeburn. He was elected RE in 1899, ARA in 1921 and RA in 1933. He died in 1947.
Contrib: *ILN [1894-96].*
Exhib: G; L; M; P; RA; RBA; RE; RI; ROI; RSA.
Colls: V & AM.

McCLURE, Griselda M.
Illustrator, contributing drawings to *The Dawn at Shanty Bay*, a boy's story by R.E. Knowles, 1908.

McCONNELL, William fl.1850-1865
Cartoonist and comic artist. He was the son of a tailor of Irish extraction, learnt wood engraving from Swain and was a popular contributor to illustrated papers in the 1850s. He had two official appointments that of cartoonist to *Punch*, 1852 and cartoonist of *The*

Illustrated Times, 1855-56. His style is always exaggerated and grotesque with slight similarities to 'Phiz' or John Leech but never so well drawn. Spielmann says that he was a friend of G.A. Sala (q.v.) and was much commended by Mark Lemon for his *Punch* work which had included fierce attacks on Prince Louis Napoleon. According to Spielmann he 'revelled in beggars', 'swells' and 'backgrounds' and died of consumption soon after 1852. This must be incorrect information as he was still contributing to other periodicals in the 1860s.
Illus: *Twice Round The Clock [G.A. Sala, 1859]; The Adventures of Mr Wilderspin [1860].*
Contrib: *Punch [1850-52]; ILN [1851-58, 1860]; The Illustrated London Magazine [1855]; The Illustrated Times [1855-61]; The Welcome Guest [1860]; London Society [1864]; The Churchman's Family Magazine [1864]; The Sunday Magazine [1865].*
Bibl: M.H. Spielmann, *The History of Punch*, 1895, pp.460-461; Dalziel, *A Record of Work*, 1901, p.190.

McCORMICK, Arthur David RBA FRGS 1860-1943
Artist and illustrator. He was born at Coleraine on 14 October 1860 and was educated at Coleraine and Belfast, studying art at South Kensington, 1883-86. He accompanied Sir Martin Conway's expedition to Karakoram, Himalayas, as artist in 1892-93 and Clinton Dent to the Caucasus in 1895. He was elected RBA in 1897 and ROI and RI in 1905 and 1906 respectively. He was FRGS from 1895 and died at St John's Wood in 1943. An exhibition of his work was held at the Alpine Gallery in 1904.
Illus: *Climbing and Exploring in the Karakoram Himalayas [W.M. Conway, 1894]; Silent Gods and Sun-Steeped Lands [R.W. Frazer, 1895]; Climbs in the New Zealand Alps [E.A. Fitzgerald, 1896]; The Kahirs of the Hindu-Kush [Sir G.S. Robertson, 1896]; New Climbs in Norway [E.C. Openheim, 1898]; Prince Patrick [A. Graves, 1898]; From the Cape to Cairo [E.S. Grogan, 1900]; Wanderings in Three Continents [Sir R. F. Burton, 1901]; The Alps [Sir W.M. Conway, 1904]; The Netherlands [M. Macgregory, 1907]; New Zealand [R. Horsley, 1908]; India [V. Surridge, 1909].*
Contrib: *The English Illustrated Magazine [1885-88]; ILN [1886-97]; Good Words [1898]; Arabian Nights [1899]; Strand Magazine [1906].*
Exhib: B; G; L; RA; RBA; RHA; RI; ROI; RWA.
Bibl: *An Artist in the Himalayas*, 1895.

McCORMICK, Fred
Artist. Contributed sketches of China to *The Graphic*, 1902-03.

McCULLOCH, Horatio RSA 1805-1867
Landscape painter. He was born in Glasgow on 9 November 1805, the son of a weaver and studied art with W.L. Leitch and Daniel Macnee. He first worked with the latter, painting snuff boxes and then moved to Edinburgh where he became an engraver. He began to exhibit at the RA in 1829 and was elected ARSA in 1834 and RSA in 1838. He specialised in Highland scenery and was influential on the younger generation of Scottish painters. He died at Edinburgh on 24 June 1867.
Contrib: *Scotland Illustrated [1838].*
Exhib: BI; RA; RSA.
Colls: Edinburgh; Glasgow.
Bibl: A. Frazer, *H. McC.*, 1872.

MACDONALD, A.K. fl.1898-1925
Illustrator. Contributed to *The Longbow*, 1898 and was working in London, 1914-25.

MACDONALD, Margaret 1865-1933
Designer. She set up a studio with her sister in Glasgow in 1894 and married the architect Charles Rennie Mackintosh in 1900. One of the Glasgow 'Four', she was a highly original designer in the fields of textiles, brassware, leather, illumination and posters. Her only contribution to illustration was a geometric design which appeared in *The Yellow Book*, July 1896.
Bibl: *Charles Rennie Mackintosh, 1868-1928, Architecture, Design and Painting*, Scottish Arts Council Catalogue, 1968.

MACDOUGALL, William Brown -1936

Painter, etcher, wood engraver and illustrator. He was born in Glasgow and educated at the Glasgow Academy. He studied art in Paris at Julian's and under Bouguereau, J.M. Laurens and R. Fleury. Macdougall was a regular exhibitor at the Salon and became a member of the NEA in 1890. His style changes distinctly after his appearance in *The Yellow Book* in 1894 and contact with Aubrey Beardsley (q.v.). From this point his illustrative work is symbolic and sombre with a great emphasis on black and white contrasts, but he lacks the wit of his great predecessor. He died at Loughton, Essex, 20 April 1936.

Illus: *Chronicles of Streatham [1896]; The Book of Ruth [1896]; The Fall of the Nibelungs [Margaret Armour, 1897]; Thames Sonnets and Semblances [1897]; Isabella . . . [1898]; The Shadow of Love and Other Poems [Margaret Armour, 1898]; The Eerie Book [Margaret Armour, 1898]; The Blessed Damozel [D.G. Rossetti, 1898]; Omar Khayyam [1898]; Fields of France; St Paul [F.W. Myers].*
Contrib: *The Yellow Book [1894]; The Evergreen [1894]; The Savoy.*
Exhib: G; L; M; NEA; RA; RSA.
Bibl: *The Studio*, Vol.10, 1897, p.141; Vol.15, 1898, p.210; R.E.D. Sketchley, *Eng. Bk. Illus.* 1902, pp.26, 128.
See illustration (below).

WILLIAM BROWN MACDOUGALL -1936. 'The Mother and the Dead Child.' An illustration to The Eerie Book *by Margaret Armour, 1898.*

McEVOY, Arthur Ambrose ARA ARWS 1878-1927

Landscape and portrait painter, born at Crudwell, Wiltshire in 1878 and studied at the Slade School. He was strongly influenced by J.

McNeil Whistler (q.v.) worked with Augustus John and Walter Sickert, and developed a free style of watercolour portraits for which he is best known. He was commissioned to paint portraits of the naval VC's in the First World War and was elected ARA in 1924 and ARWS in 1926, having been a member of the NEA, 1902. An exhibition of his watercolours was held at the Leicester Galleries in 1927 and memorial exhibitions at the RA and Manchester in 1928 and 1933. He died in London on 4 January 1927 of pneumonia.

Contrib: *The Quarto [1896].*
Exhib: G; GG; L; M; NEA; RA; RHA; RSA; RSW; RWS.
Colls: Bradford; Leeds; Manchester; Paris.
Bibl: C. Johnson, *The Works of AM,* 1919; R.M.Y. Gleadowe, *AM,* 1924; OWS Club, VII, 1931.

McEWEN, D.H.

Illustrator. Contributed to *The Book of South Wales* by Mr and Mrs S.C. Hall, 1861.

MACFALL, C. Haldane 1860-1928

Figure, landscape and military painter. He was born on 24 July 1860 and was educated at Norwich Grammar School and Sandhurst before being gazetted into the West India Regiment in 1885. He retired in 1892 but served in the First World War. Macfall was a man of letters and a connoisseur and in the early part of the century published numerous books on literature, painting and collecting, he was an admirer of Whistler, Aubrey Beardsley and C. Lovat Fraser and wrote books on all three. He was awarded a Civil List Pension for his services to literature in 1914, and was increasingly known as an author rather than an artist, although he continued to design book covers. He died in London, 25 July 1928.

Contrib: *The Graphic [1891].*
Exhib: Int. Soc.; RA; RWA.

MacFARLANE, T.D. fl.1894-1908

Illustrator of children's books. He was working in Glasgow, 1894-97 and illustrated *Minstrelsy of the Scottish Border,* Noyes, 1908 and *Days That Speak,* 1908, both in colour.

Exhib: G.

MACGILLIVRAY, James Pittendrigh RSA 1856-1938

Sculptor. He was born at Inverurie, Aberdeenshire, in 1856 and studied art under William Brodie, RSA and John Mossman, HRSA. He became RSA in 1901, LLD, Aberdeen, 1909 and Kings Sculptor for Scotland, 1921. Macgillivray was a fine black and white draughtsman and some prints in the Witt Photo Library appear to be for book illustration. He died at Edinburgh, 29 April 1938.

Publ: *Verse Pro Patria [1915]; Bog Myrtle and Peat Reek [1922].*
Exhib: G; GG; L; M; NEA; RA; RSA.

MACGREGOR, Archie G.

Sculptor and illustrator. Working in London, 1884 to 1907 and exhibiting regularly.

Illus: *Katawampas [Judge Parry, 1895]; Butterscotia [Judge Parry, 1896]; The First Book of Klab [Judge Parry, 1897]; The World Wonderful [Charles Squire, 1898].*
Exhib: L; M; New Gall; NWS; RA; RHA; RI; ROI.
Bibl: R.E.D. Sketchley, *Eng. Bk. Illus.,* 1903, pp.107, 167.

MACGREGOR, G.

Probably G.S. Macgregor, working in Glasgow, 1891 and exhibiting at the RSA.

Contrib: *ILN [1887 (figures)].*

MacGREGOR, Jessie -1919

Portrait, genre and historical painter and illustrator. She was working in Liverpool from 1872 and in London from 1886 and was elected ASWA in 1886 and SWA in 1887.

Illus: *Christmas Eve at Romney Hall [1901].*
Exhib: B; G; L; M; RA; ROI; SWA.

McHUTCHON, F.

Humorous animal artist. Contributed illustrations to *Punch,* 1904-05.

Wreath the bowl
 With flowers of soul,
The brightest Wit can find us;
 We'll take a flight
 Tow'rds heaven to-night,
And leave dull earth behind us.
 Should Love amid
 The wreaths be hid,
That joy, th'enchanter, brings us,
 No danger fear,
 While wine is near,
We'll drown him if he stings us.

DANIEL MACLISE RA 1806-1870. 'Wreath The Bowl.' Illustration to Irish Melodies *by Tom Moore, London 1846.*

McIAN, Robert Ronald ARSA **1803-1856**
Genre painter and illustrator. He was born in 1803 and worked as a
professional actor as well as being a painter. He specialised in scenes of
the Highlands and after 1840 abandoned the theatre for the life of a
painter, having exhibited at the RA from 1836. He was elected ARSA
and died at Hampstead in 1856.

Illus: *The Clans of the Scottish Highlands, Illustrated by Appropriate Figures
[James Logan, 1845-47 (2 vols.)]; The London Art Union Prize Annual [1845]*.
Exhib: BI; RA; RBA; RSA.

MacINTOSH, John MacIntosh **1847-1913**
Landscape and view painter. He was born at Inverness in 1847 and
studied at Heatherley's, the West London School of Art and in
Versailles. He worked at Woolhampton near Reading, and died at
Shanklin in 1913. He illustrated E.G. Hayden's *Islands of the Vale*,
1908.

Colls: Reading; V & AM.

MACKAY, Wallis 'WV' **fl.1870-1893**
Black and white artist and caricaturist. He was a social cartoonist for
Punch, 1870-74 but offended Tom Taylor, the Editor and was
dismissed, although work by him was still appearing in 1877. He
became cartoonist of *Fun* in 1893.

Contrib: *Judy; ILN [1880]*.
Bibl: M.H. Spielmann, *The History of Punch*, 1894, pp.540-541.

MACKENZIE, Frederick OWS **1787-1854**
Topographical draughtsman. He was born in 1787 and became a pupil
of John A. Repton and began a career as an architectural draughtsman
for leading publishers such as Britton, Ackermann and Le Keux. He
became an Associate of the OWS in 1822, and a Member in 1823
holding the post of Treasurer from 1831 till his death. Mackenzie was
a very accurate delineator of gothic buildings at a time when clarity
was all important. His drawings in grey washes are small and feathery
and beautiful and have the definition that seems to be lost in the
prints after his works. In later life his work was superceded by early
photography. He died in London on 25 April 1854.

Illus: *Etchings of landscapes for the use of students [1812]; History of the
Abbey Church of St. Peter, Westminster [1812]; Britton's Salisbury Cathedral
[1813]; History of the University of Oxford [1814]; History of the University
of Cambridge [1815]; Illustrations of the Principal Antiquities of Oxfordshire
[1823]; Graphic Illustrations of Warwickshire [1829]; Memorials of
Architectural Antiquities of St Stephen's Chapel, Westminster [n.d.]*.
Contrib: *Britton's Beauties of England and Wales [1810-15]; The Oxford
Almanack [1822, 1827, 1838, 1848, 1850, 1851, 1853]*.
Exhib: OWS; RA; RBA.
Colls: Ashmolean; BM; Fitzwilliam; Lincoln; Manchester; V & AM; Witt Photo.
Bibl: M. Hardie, *Watercol. Paint. in Brit.*, Vol.3, 1968, pp.17-18 illus; Petter,
Oxford Almanacks, 1974.

MACKENZIE, John D. **fl.1886-1896**
Painter, black and white artist and illustrator. He was working in
London from 1886 and at Newlyn, Penzance from 1889. He supplied
a cover and title page to *The Yellow Book* in October 1895, and
exhibited at the RA and RBA.

Illus: *Sonnets and Songs [May Bateman, 1895-96 (title etc.)]*.

MACKEWAN, Arthur
Amateur contributor to *Punch*, 1907.

MACKIE, Charles Hodge RSA RSW **1862-1920**
Genre and landscape painter. He was born at Aldershot of Scottish
parents in 1862 and was educated at Edinburgh University before
studying at the RSA Schools. He travelled in Spain, Italy and France,
where he met Gauguin and Vuillard and settled at Murrayfield. Mackie
was a prolific and diverse artist and engaged in etching, mural
decoration, sculpture and colour printing as well as painting. He was
elected ARSA in 1902 and RSA in 1912, RSW, 1902. He died on 12
July 1920.

Contrib: *The Evergreen [1895]*.
Exhib: G; L; M; NEA; RA; RHA; RSA; RSW.
Colls: BM; Edinburgh; Leeds; Liverpool; V & AM; Witt Photo.
Bibl: *The Studio*, Winter No., 1900-01, p.48 illus; Vol.58, 1913, pp.66, 137,
295; Vol.68, 1913, pp.61, 122, 125; Vol.70, 1913, pp.107; *A.J.* 1900, p.287;
The Connoisseur, Vol.37, 1912, p.53.

McKIE, Helen Madeleine **fl.1915-1936**
Illustrator. She studied at the Lambeth School of Art and was for a
time on the staff of *The Bystander*. She contributed to *The Graphic*,
Christmas number, 1915.

Exhib: RHA; SWA.

MACKLIN, Thomas Eyre **1867-1943**
Painter and sculptor. He was born at Newcastle-upon-Tyne in 1867
the son of a journalist, and was educated privately before studying art
at the RA Schools and in Paris. Macklin became Special Artist to *The
Pall Mall Budget* from 1882 to 1892 and made many designs for
books, magazines and posters. He travelled in Italy and lived for some
time in France but also painted in his native Newcastle. He died in
1943. He was elected RBA, 1902.

Illus: *The Works of Nathaniel Hawthorne [1894]*.
Exhib: L; RA; RBA; RSA.
Colls: Gateshead.

McLEISH, Annie
Illustrator. Pupil of the Mount Street School of Art and contributed
illustration to *The Studio*, Vol. 13, 1897, pp.192-193.

McLEOD, Lyons
Artist. Illustrated *Travels in Eastern Africa and Mozambique*, 1860.
AT 277.

MACLISE, Daniel RA **1806-1870**
Historical and portrait painter. He was born at Cork in 1806, the son
of a former Scottish soldier and while attending the Cork Art School
was brought to public notice by a sketch he made of Sir Walter Scott,
1825. He travelled to London in July 1827 and attended the RA
Schools, winning the silver and gold medals in 1828. He exhibited at
the RA from 1829 and after a brief spell in Ireland that year, returned
in 1830 to make a career in book illustration. Maclise contributed
eighty caricatures to *Fraser's Magazine* between then and 1836. Most
of them were drawn with a lithographic pen and suited his linear style
and meticulous rendering. The caricatures were accompanied by biting
literary sketches from the pen of William Maginn and relied more for
their effect on their stylization than on their grotesqueness. Thomas
Carlyle sitting for his caricature described Maclise as 'a quiet shy man
with much brogue'. *Fraser's Illustrations*, the originals of which are
now in the BM, made the artist's name and he illustrated many books
of legend in the 1840s. Always concerned as an illustrator in fantasy
rather than reality, Maclise found his sources in contemporary
German illustration. He had been elected ARA in 1835 and RA in
1840 and became an immensely popular painter, declining a
knighthood and the Presidency of the RA in 1866. But by the time
his illustrations for *Moxon's Tennyson* were appearing in 1857 and
1861, these and his *Norman Conquest* for The Art Union, 1866, were
already in an outmoded style. He died at 4 Cheyne Walk, Chelsea on
25 April 1870.

Illus: *Fairy Legends [Crofton Croker, 1826]; Tour Round Ireland [John
Barrow, 1826]; Ireland its Scenery and Character [1841]; The Chimes: A
Goblin Story . . . [Charles Dickens, 1844]; The Cricket on The Hearth, A Fairy
Tale . . . [Charles Dickens, 1845]; Thomas Moore's Irish Melodies [1845];
Leonora [Gottfried Burger [1847]; Moxon's Tennyson [1857, 1861]; The
Princess [Tennyson, 1860]; Idylls of The King [Tennyson]; Story of the
Norman Conquest [Art Union, 1866]*.
Contrib: *Fraser's Magazine [1830-36]; The Keepsake [1835]; Heath's Gallery
[1836, 1838]; The Old Curiosity Shop [Charles Dickens, (Chap.55) 1841]*.
Exhib: BI; RA; RBA.
Colls: Ashmolean; BM; Ireland; Nat. Gall; NPG; V & AM; Witt Photo.
Bibl: Chatto & Jackson, *Treatise on Wood Engraving*, 1861, p.569; R. Ormond,
DM 1806-1870, NPG, 1972.
See illustration (p.380).

MACLURE, Andrew **fl.1857-1881**
Landscape painter and lithographer. This artist illustrated *Queen
Victoria in Scotland*, 1842 and *Highlands and Islands of The Adraitic*,
1849, AT 44.

Exhib: G; RA, 1857-81.
Colls: Witt Photo.

MACMICHAEL, William **1784-1839**

Amateur artist, physician and writer. He was educated at Christ Church, Oxford, MA, 1807 and became Radcliffe Travelling Fellow in 1811, MD in 1816 and FRCP in 1818. He was appointed physician to William IV in 1831.

Pub: *The Gold-headed Cane [1827]*.
Illus: *Journey from Moscow to Constantinople [1819, AT 20]*.

MACNAB, Peter RBA **-1900**

Genre painter and illustrator. Working in London and Woking, Surrey and exhibiting from 1864. He was elected RBA in 1879.

Contrib: *ILN [1882-83]; The Cornhill Magazine [1884]; The English Illustrated Magazine [1885]*.
Exhib: B; BI; FAS; G; L; M; RA; RBA; RI; ROI.

MACNEIL, H.

Illustrator. Contributed military subjects to *The English Illustrated Magazine*, 1896.

MACPHERSON, Douglas **1871-**

Illustrator. He was born in Essex on 8 October 1871 the son of John Macpherson, artist. After being educated at a private school, he studied art at Westminster School of Art and became a member of the original staff of *The Daily Graphic*, 1890-1913. He served as Special Artist at home and abroad for *The Daily Graphic* and *The Graphic* until he joined *The Sphere* in 1913, attending among other events, The Spanish-American War, 1898, The St Petersburg Revolt, 1905 and the Assasination of Don Carlos in 1908. He served with the RNVR, 1914-18 and was present for *The Sphere* at Tutankhamun's Tomb, 1923-24. Drew the Coronation of King George VI for *The Daily Mail*, 1937 and sketches of the Second World War for *The Sphere, Daily Telegraph* and *Daily Mail*, 1939-45.

Contrib: *The Daily Graphic [1890-1913]; St Pauls [1894]; The Ludgate Monthly; The Graphic [1901-10]; Punch [1906-09]*.
Exhib: L; RA.

MACQUOID, Percy T. RI **1852-1925**

Artist, illustrator, designer and historian of English furniture. He was born in 1852, the son of T.R. Macquoid (q.v.) and was educated at Marlborough and studied art at Heatherley's, at the RA Schools and in France. He worked for *The Graphic* from 1871, at first concentrating on animal subjects but later painting historical and genre pictures. He was elected RI, 1882 and ROI, 1883. He was a designer of theatrical costumes but in his later years concentrated wholly on the study of English furniture, publishing his four volumes *History of English Furniture*, 1905. He died on 20 March 1925.

Illus: *The Bridal of Triermain [Walter Scott, Art Union, 1886]*.
Contrib: *ILN [1874-82]; The Graphic [1871-90]*.
Exhib: B; FAS; G; L; M; RA; RI; ROI.
Bibl: *English Influences on Vincent Van Gogh*, Arts Council, 1974-75, p.52.

MACQUOID, Thomas Robert RI **1820-1912**

Painter, illustrator and ornamental designer for books. He was born in Chelsea on 24 January 1820 and after being educated in Brompton, studied art at the RA Schools and specialised in book illustration. He is specifically mentioned by Chatto for his work on 'ornamental Letters and Borders' and supplied much decoration of this kind to the early volumes of *The Illustrated London News*, all showing great architectural accuracy and delicacy of execution. He collaborated with his wife, Mrs K.S. Macquoid on a number of travel books. RI, 1882 and ROI, 1883, he died on 6 April 1912. A memorial exhibition of his work was held at the New Dudley Gallery, London in 1912.

Illus: *Little Bird Red and Little Bird Blue [M.B. Edwards, 1861]; The Primrose Pilgrimage [M.B. Edwards, 1865]; Through Normandy [K.S. Macquoid, 1874]; Pictures and Legends of Normandy and Brittany [K.S. Macquoid, 1897]; Pictures in Umbria [K.S. Macquoid, 1905]; The Paris Sketchbook [W.M. Thackeray, 1894]*.
Contrib: *Examples of Architectural Art in Italy and Spain [1850]; ILN [1851-61, 1863-69]; Favourite English Poems [1857]; The Welcome Guest [1860]; The Churchman's Family Magazine [1863]; The Graphic [1873]; Rhymes and Roundelayes; Burns Poems; Thornbury's Legendary Ballads [1876]; Good Words [1880]; The English Illustrated Magazine [1886-87 (architecture)]; The Pall Mall Magazine*.

Exhib: G; L; M; RA; RBA; κI; ROI; RSW.
Bibl: Chatto & Jackson, *Treaties on Wood Engraving*, 1861, p.599.

McTAGGART, William RSA, RSW **1835-1910**

Painter and Scottish impressionist. He was born at Aros, near Campbeltown, and began by painting portraits of the inhabitants of this Scottish burgh in his spare time. He attended the Trustees Academy at Edinburgh for seven years from 1852, studying alongside Sir W.Q. Orchardson (q.v.) and J. MacWhirter (q.v.). He became ARSA in 1859 and RSA in 1870. He was Vice-President of the RSW in 1878 and died at Broomieknowe on 2 April 1910.

Contrib: *Good Words [1861]*.
Exhib: G; L; NEA; RA; RHA; RSA; RSW.
Colls: Aberdeen; Glasgow; Nat. Gall., Scotland.

MacWHIRTER, John RA **1839-1911**

Landscape painter and illustrator. He was born at Slateford near Edinburgh in 1839, the son of a papermaker and was educated at Peebles School, the Edinburgh School of Design and the Trustees Academy. He was elected ARSA in 1867 and moved to London in 1869, where he attracted the notice of Ruskin and became a popular painter of Highland and Continental landscapes. He made extensive tours in France, Switzerland, Italy, Austria, Turkey and Norway and visited the United States. He was a strong advocate of drawing direct from nature and published a book on technique. Most of his book illustrations date from his early career in Scotland. He was elected ARA in 1879 and RA in 1893 and died at St John's Wood on 28 January 1911.

Illus: *Landscape Painting in Watercolours [1901]; The MacWhirter Sketchbook [1906]; Sketches from Nature [1913]*.
Contrib: *Good Words [1861]; The Golden Thread [1861]; Wordsworth's Poems for the Young [1863]; The Sunday Magazine [1869]; Pen and Pencil Pictures from the Poets [1866]; Poems and Songs of Robert Burns [1875]; The Picturesque Mediterranean [1891]*.
Exhib: B; FAS; G; GG; L; M; New Gall; RA; RE; RHA; RI; RMS; ROI; RSA; RSW.
Colls: BM; Dundee; Glasgow; Manchester; Nat. Gall; Scotland; V & AM.
Bibl: M.H. Spielmann, *The Art of J McW*, 1904.

MADOT, Adolphus M. **-1864**

Figure artist and illustrator. He was a pupil of the RA Schools and studied at Julian's in Paris. He exhibited figure subjects in London, 1852-64, but died young.

Contrib: *The Home Affections [Charles MacKay, 1858]; The Poetical Works of E.A. Poe [1858]*.
Exhib: BI; RA; RBA.

MAHONEY, J. **fl.1865-1876**

Illustrator and engraver. He was practically uneducated and spent some years as errand boy for the firm of Vincent, Son and Brooks, lithographic printers. He was said to be a natural artist and his drawings came to the notice of J.W. Whymper, to whom he had to deliver proofs. Whymper took him into his employ and he made quick progress as a draughtsman, being given small illustrations to do after a comparatively short time. He was later with the Dalziel Brothers, but in both cases had to leave because of drunkenness and disorderly behaviour, finally dying in a latrine in London in the same unhappy condition. He undertook some important commissions such as *Oliver Twist, Little Dorrit* and *Our Mutual Friend*, 1871, for Dickens 'Household Edition' and did a great deal of magazine work. Reid is however critical of his uneven style — 'A curious tendency to dwarf his figures is carried, one might fancy, into the very shape of many of Mahoney's designs, and into the square squat monogram with which they are signed.'

Illus: *Scrambles on the Alps [Whymper, 1870]; Oliver Twist, Little Dorrit, Our Mutual Friend [Dickens 'Household Edition', 1871]; Three Clerks [A. Trollope (frontis.)]; Little Wonder-Horn [Jean Ingelow, 1872]; Frozen Deep [Wilkie Collins, 1875 (with Du Maurier)]*.
Contrib: *Leisure Hour [1865-66]; Sunday Magazine [1866-70]; The Argosy [1866]; Cassell's Magazine [1867]; Touches of Nature [1867]; Cassell's Illustrated Readings [1867]; The Peoples Magazine [1867]; The Quiver [1868];*

The Nobility of Life [1869]; Good Words For The Young [1869]; National Nursery Rhymes [1870]; Little Folks [1870]; Judy; Fun; The Day of Rest.
Colls: V & AM.
Bibl: Forrest Reid, *Illustrators of The Sixties*, 1928, pp.255-256, illus.

MAHONEY, James 1816-1879
Watercolourist and engraver on wood. He was born at Cork in about 1816 and studied in Rome and other European centres, before returning to work in London, where he died on 29 May, 1879. He was a member of the NWS.
Contrib: *ILN [1847]*.
Exhib: RA, 1866-77.

MALCOLM, James Peller 1767-1815
Draughtsman and engraver. He was born in Philadelphia in 1767 and came to England in 1788-89, attending the RA Schools for three years. He was acquainted with Benjamin West and J. Wright of Derby, who patronised him, but he never made a success of painting and turned to engraving for a living. Malcolm was also a writer, a Fellow of the Society of Antiquaries and one of the first artists to write a treatise on caricature. He died in London in 1815.
Illus: *Twenty Views Within Ten Miles of London [1800]; Excursions in the County of Kent [1802]; The History of Leicestershire [Nichols]; Biographical Dictionary of England [Granger]; Londinium Redivivium [1902-07]; Manners and Customs of London during the XVIII Century [1808, 50 views]; Excursions in the Counties of Kent, Gloucester, Hereford, Monmouth and Somerset [1813]; An Historical Sketch of The Art of Caricaturing with Graphic Illustrations [1813]*.
Contrib: *The Gentleman's Magazine; Lyson's Environs of London [1797-1800]; The Beauties of England and Wales [1801-05]*.
Exhib: RA, 1791.
Colls: V & AM; Witt Photo.

MALLETT, R.W.
Artist. Contributing illustrations of industry to *The Illustrated London News*, 1875.

MANN, Harrington 1864-1937
Portrait painter and illustrator. He was born at Glasgow in 1864 and studied art at the Slade School and in Paris and Rome. He was a member of the Royal Society of Portrait Painters and of the International Society of Sculptors, Painters and Gravers. He was an important member of the Glasgow School of painters and an accomplished decorative artist, working as an illustrator for both *The Daily Graphic* and *The Scottish Art Review*. He is represented in most British galleries and died on a visit to New York, 28 February 1937.
Publ: *The Technique of Portrait Painting [1933]*.
Exhib: B; G; GG; L; M; NEA; New Gall; P; RA; RBA; RE; RI; ROI; RSA.
Bibl: *The Artist*, August 1897, pp.363-369, illus.

MANSEL, Miss afterwards Mrs Bull
Amateur artist. She contributed one drawing to *Punch* in 1863, which was touched up by John Leech!

MANTON, G. Grenville RBA 1855-1932
Portrait painter and illustrator. He was born in London in 1855, the son of Gildon Manton, gunmaker. He was educated in London and Paris and was an RA medallist, but left England for America in 1890 and worked there for some years as a portrait painter, exhibiting at The National Academy. On returning to London, he became a staff artist on *Black and White*. He was working at Bushey, Hertfordshire from 1895 till his death on 13 May 1932. He was elected RBA in 1899.
Illus: *True to The Core [Jarrold's Books for Manly Boys, 1894]*.
Contrib: *Black & White [1892]; The Quiver [1892]; Pearson's Magazine [1896]; The Ludgate Monthly; The Pall Mall Magazine; The Sphere*.
Exhib: B; L; P; RA; RBA; ROI.

MANUEL, J. Wright T. -1899
Illustrator. He worked in London from about 1894 and specialised in comic sporting subjects in black and white but also in chalk and watercolour. He became RBA in 1896 and died in 1899.

Contrib: *Pick-Me-Up [1894]; The Unicorn [1895]; ILN [1896]; Eureka [1897]; The Butterfly [1899]; The Idler; The Minister.*
Exhib: RBA; ROI.
Colls: V & AM.

MARGETSON, William Henry RI 1861-1940
Landscape and genre painter in oil and watercolour, illustrator. He was born at Denmark Hill, London, in December 1861 and after being educated at Dulwich College, studied art at South Kensington and at the RA Schools. He lived and worked in Berkshire from 1914, first at Blewbury and then at Wallingford and was elected RI in 1909. Margetson has a pleasing eye for colour and was most popular as an illustrator of adventure stories. He died 2 January 1940.
Illus: *The King's Pardon [Overton, 1894]; The Village of Youth [B. Hatton, 1895]; With Cochrane The Dauntless [G.A. Henty, 1897]; A Missing Witness [Frank Barrett 1897]; Aglyaine and Selysette [Sutro, 1898]; The Wild Geese [S.J. Weyman, 1908]; Humphrey Bold [H. Strang, 1908]*.
Contrib: *The English Illustrated Magazine [1885, 1891-92]; The Quiver [1890]; Black & White [1891]; Cassell's Family Magazine; The Idler; The Pall Mall Magazine; The Graphic [1904-06]*.
Exhib: B; G; GG; L; M; RA; RBA; RI; ROI.

MARIE, Adrien-Emmanuel 1848-1891
Painter and illustrator. He was born at Neuilly-sur-Seine on 20 October 1848, and was a pupil of Bayard, Camino and Pils. He was a regular exhibitor at the Salon from 1866 to 1881 and won a bronze medal at the 1889 Exhibition. His connection with England began in 1873, when he started to contribute French genre and social realistic subjects to *The Graphic*. A bold figure draughtsman, he was most prolific in the pages of the magazine from 1885-89, supplementing a rather weak period for English illustrators. He died at Cadiz in April 1891.
Exhib: FAS; M.
Colls: Calais; Tourcoing; Sydney.

MARKLEN, H.
Contributed illustrations to *Griffith's Cheltenham*, 1826.

MARKS, A.J.
Amateur caricaturist. Contributed cartoons to *Vanity Fair*, 1889. Signs his work AJM.

MARKS, Henry Stacy RA 1829-1898
Painter and illustrator. He was born in London on 13 September 1829 and studied art at Leigh's School, Newman Street and at the RA Schools, 1851. He spent some months in Paris with Calderon in 1852 and began exhibiting at the RA in 1853. Marks was very clearly influenced by the Pre-Raphaelites at this time and became a very brilliant pen and ink draughtsman and a masterly painter of animals. Marks seems to have been a very lazy artist and his drawings fall away dramatically after the 1860s into thick outline and clumsy handling. He was obsessed by the Middle Ages and painted many ludicrous subjects of them including 'Toothache in the Olden Time'. His best work is in his bird paintings and his stained glass design. He was elected ARA in 1871 and RA in 1878, and RSW in 1883.
Illus: *Sketching From Nature [T.J. Ellis, 1876]; The Good Old Days [E. Stuart, 1876]*.
Contrib: *Home Circle [1855]; Legends of the Cavaliers and the Roundheads [Thornbury, 1857]; Punch [1861 and 1882]; Willmott's Sacred Poetry [1862]; Passages From Modern English Poets [1862]; Once a Week [1863]; The Churchman's Family Magazine [1863]; Two Centuries of Song [1867]; Ridiculous Rhymes [1869]; London Society [1870]; National Nursery Rhymes [1871]; The Quiver [1873]; The Child's History of England [1873]; ILN [1876 and 1879]; The Graphic*.
Exhib: B; BI; FAS, 1889, 1890, 1895; G; L; M; RA; RCA; ROI; RWS.
Colls: Ashmolean; Exeter; Liverpool; V & AM.
Bibl: H.S. Marks, *Pen and Pencil Sketches*, 2 vols. 1894; Forrest Reid, *Illustrators of The Sixties*, 1928, pp.254-255; J. Maas, *Victorian Painters*, 1970, p.82, illus.
See illustration (p.384).

MARKS, Lewis fl.1814-1815
Amateur caricaturist, specialising in well-drawn figures of Napoleon and Paul Pry.
Colls: Witt Photo.

The Sleepy Porter

Knock, knock: Never at quiet! *Mark*

HENRY STACY MARKS RA 1829-1898. 'The Sleepy Porter.' An illustration for Shakespeare's Macbeth. Pen and ink, signed with monogram and dated 1859. 10½ins. x 7½ins. (26.7cm x 19.1cm). Author's Collection

MARRYAT, Captain Frederick CB FRS **1792-1848**
Novelist, draughtsman and caricaturist. He was born in Great George Street, Westminster on 10 July 1792, the son of an MP, and went to sea in 1806, serving throughout the Napoleonic Wars. He served in St Helena, 1820-21, and in North America, 1837-38. On his retirement he became celebrated as novelist and writer of books for children and died at Langham, Norfolk on 9 August 1848.
Publ: *The Children of the New Forest; The Naval Officer [1829]; Peter Simple [1834]; Midshipman Easy [1836]; The Metropolitan Magazine [Editor, 1832-35].*
Colls: V & AM.

'MARS' Maurice BONVOISIN **1849-1912**
Draughtsman, engraver and cartoonist of the Belgian School. He was born at Verviers on 26 May 1849 and became a regular illustrator in the French papers *Journal amusant* and *Charivari*. He was the only continental artist to be used consistently for cartoon work by British periodicals, his sketchy crayon style, based on the poster and anticipating May, being rather avant-garde here. He was a master of the purely visual joke without text and his books seem to have been popular in this country, some of his subjects being British ones. He died in 1912.
Illus: *Nos Chéris [Plon, Paris, 1886].*
Contrib: *The Graphic [1880-91]; ILN [1882-92]; The Daily Graphic [1890]; The Sketch [1894]; Illustrated Bits.*
Colls: V & AM.

MARSHALL, Benjamin Marshall **1768-1835**
Sporting artist. He was born in Leicestershire on the 8 November 1768 and went to London in 1791 to follow the career of a painter. He exhibited at the RA from 1801 and between 1812 and 1825 had his studio near Newmarket. He died in London on 24 July 1835. He is included here for the illustrations of his work that appeared in *The Sporting Review,* after his death, 1842-46.

MARSHALL, C.A. **fl.1889-1890**
Amateur artist and solicitor at Retford in Nottinghamshire. Contributed two drawings to *Punch,* 1889 and one to *Judy,* 1890.

MARSHMAN, J.
Artist working at Bangor, N. Wales. He contributed sporting subjects to *The Graphic,* 1876 and exhibited in the same year.

MARTEN, John II **fl.1808-1834**
Topographical artist and son of John Marten of Canterbury, the landscape painter. He contributed drawings to Britton's *Beauties of England and Wales,* 1808 and exhibited at the RA and NWS, 1822-34.
Colls: V & AM.

MARTENS, Henry **fl.1828-1854**
Battle painter in oil and watercolour. He worked in London and improved drawings by serving officers for engravings and published his own work.
Illus: *Yeomanry Costumes [1844-47, AT 369]; Costumes of the Indian Army [1846]; Costumes of the British Army in 1855 [1858, both for Ackerman].*
Exhib: BI; RBA.
Colls: Witt Photo.

MARTIN, Charles
Watercolourist and caricaturist. He was the son of John Martin, (q.v.) but according to Spielmann was too indolent to succeed as a painter. He contributed illustrations to *Punch,* in 1853.

MARTIN, John **1789-1854**
Historical and biblical painter and illustrator. He was born at Eastlands End, Haydon Bridge, near Hexham on 19 July 1789 and was apprenticed to a coach painter in Newcastle before running away and studying with an Italian artist, Boniface Musso. He reached London in 1806 and began to exhibit regularly, winning a prize at the BI in 1816 and a premium of 200 guineas for his 'Belshazzar's Feast' in 1821. Martin achieved great popular acclaim from this period onwards for his huge canvases of classical or biblical subjects, most of them featuring dramatic effects of earthquake, destruction and flight. S.C. Hall, the sober editor of *The Art Journal* considered that Martin 'possessed the genius that to madness nearly is allied', two of the artist's brothers were deranged. Martin's imagery was drawn partly from the mystical and partly from the industrial, while being an incurable romantic he was also a child of the Industrial Revolution and his vast palaces, gorges and subterranean caverns have a quality of fact and experimental engineering about them. His work was exhibited abroad and he was made a member of the Belgian Academy and St Luke's Academy, Rome. Although much of his work was prepared in small scale brown and black ink and wash sketches for album books, a great deal was for straight mezzotint and not book form at all. Martin's most lasting achievements were probably the *Last Judgement* series, on which he was still working, when he died in the Isle of Man on 17 February 1854.
Illus: *Characters of Trees [1817]; Imposing Edifice in the Indian Style [1817]; Paradise Lost [1823-27]; Illustrations of The Bible [1831-35]; The Poetical Works of John Milton [1836]; The Wonders of Geology [1838]; The Wars of Jehovah [1844]; The Imperial Family Bible [1844]; The Holy Bible [1861-65]; Art and Song [1867].*
Contrib: *The Amulet; Forget-Me-Not; Friendship's Offering; The Gem; The Keepsake; The Literary Souvenir [1826-37]; The Wonders of Geology [G. Mantell, 1838, (frontis.)]; The Book of the Great Sea Dragons [Thomas Hawkins, 1840 (frontis.)]; The Traveller [1840, Art Union].*
Exhib: BI; RA; RBA.
Colls: Glasgow; Liverpool; Manchester; Newcastle; Nottingham; V & AM.
Bibl: W. Martin, *A Short Outline of the Philosopher's Life. . . . and an Account of Four Brothers and a Sister,* 1833; W. Feaver, *The Art of JM,* 1975.

See illustrations (pp.40, 41).

MARTIN, Jonathan 'Mad' 1782-1838
Artist and fanatic. He was born at Hexham in 1782, the brother of John Martin (q.v.). He was unbalanced and was responsible for setting York Minster on fire in 1829, for which offence he was confined in St Luke's Hospital, London as insane. He was responsible for producing numerous strange caricature drawings.

MASON, Abraham John 1794-
Illustrator and wood engraver. He was born in London on 4 April 1794 and became a pupil of Robert Branston. He engraved the plates for George Cruikshank's *Tales of Humour*, 1824, exhibited at the RBA, in 1829 and emigrated to New York the same year. He became a member of the National Academy in the United States.
Contrib: *ILN [1851]*.

MASON, Ernold E. fl.1883-1902
Figure painter working in London. He contributed to *The Illustrated London News* in 1889, a series of comic sketches. Exhibited at the RA in 1883 and was living at Tilford, Surrey in 1902.

MASON, Frank Henry 1876-1965
Marine painter, etcher, illustrator and poster designer. He was born at Seaton Carew, County Durham in 1876 and was educated at private schools and on H.M.S. Conway. Worked at sea and later became an engineer in Leeds and Hartlepool and was Lietenant RNVR, 1914-18. He became RBA in 1904 and RI in 1929.
Illus: *The Book of British Ships*.
Contrib: *The Graphic [1910]*.
Exhib: B; G; L; M; RA; RBA; RHA; RI.

MASON, Fred fl.1893-1897
Black and white artist and illustrator. He belonged to the Birmingham School and illustrated a number of books in the 1890s, leaning heavily on the Morris style.

PHILIP WILLIAM MAY RI 1864-1903. 'Fair Women at the Grafton Galleries. Pen and ink. Signed and dated 1894. The Garrick Club

Illus: *The Story of Alexander, retold by Robert Steele [1894]; Huon of Bordeaux, retold by Robert Steele [1895]; Renaud of Montaubon, retold by Robert Steele [1897]*.
Contrib: *A Book of Pictured Carols [Birmingham School, 1893]*.
Bibl: R.E.D. Sketchley, *Eng, Bk. Illus.*, 1903, p.12, 128.

MASON, George Finch 1850-1915
Sporting painter and illustrator, caricaturist. He was the son of an Eton master and attended the school from 1860-64, painting a set of caricatures of Eton life, entitled 'Eton in The Sixties'. He died in July, 1915.
Publ: *The Run of the Season [1902]; Sporting Nonsense Rhymes [1906]*.
Contrib: *Punch [1881-83]*.
Exhib: London, 1874-76.
Colls: V & AM.

MASON, W.G.
Contributor to *The Illustrated London News*, 1850.

MASTERS
Illustrator, contributing to *London*, edited by Charles Knight, 1841.

MASTERSON, H.I.
Contributor of figure subjects to *Fun*, 1900.

MATANIA, Professor Eduardo 1847-
Painter and illustrator. The father of F. Matania (q.v.), he was born in Naples on 30 August 1847 and was an occasional contributor to *The Sphere*.

MATANIA, Fortunino RI 1881-1963
Historical and battle painter. He was born in Naples in 1881, the son of Professor Eduardo Matania (q.v.) and was trained in his father's studio, illustrating his first book at fourteen. He worked in Milan as Special Artist for *Illustrazione Italiana*, followed by work in Paris for *L'Illustration Française* and in London for *The Graphic*. He returned to Italy at the age of twenty-two in 1903 to do military service with the Bersaglieri and then settled in London where he joined the staff of *The Sphere*, becoming Special Artist in 1914 and seeing action on all fronts. He was elected RI in 1917. Matania's style of drawing was heroic rather than realist and his work has gone completely out of fashion. The greatest attention paid to the shape of a bridle or the cut of a uniform is useless when the picture itself is lifeless.
Contrib: *Illustrazione Italiana [1895-1902]; The Graphic [1902-05]; The Sphere [1904-26]; Britannia and Eve [1929-30]*.
Exhib: L; RA; RI.
Bibl: Percy V. Bradshaw, *FM and His Work*, The Art of The Illustrator, 1916-17.

MATANIA, Ugo 'M. Ugo' 1888-
Figure painter. He was born at Naples 1 December 1888 and was the nephew of Professor Eduardo Matania (q.v.) and cousin of F. Matania (q.v.). He trained with his uncle and contributed drawings to *The Sphere*.
Exhib: L; RA, 1909-18.

MATHES, Louis
Decorator of books. Contributing ornamental headpieces to *The English Illustrated Magazine*, 1883.

MATHEWS, Minnie fl.1886-1896
Flower and landscape painter. She drew the title and cover for *Pansies* by May Probyn, 1895-96.
Exhib: RA, 1886-87.

MATTHEWS, Winifred -1896
Painter and illustrator. She specialised in drawing children and some of her work was published by Cassell & Co.
Exhib: NEA, 1894.
Bibl: Prof. Fred Brown, 'WM' *The Quarto*, 1896, pp.9-14, illus.

MATTHISON, William fl.1885-1923

Landscape and coastal painter. He was living in Banbury, 1885 to 1902, and in Oxford, from 1905. He illustrated *Cambridge* by M.A.R. Tuker 1905.

Exhib: B; FAS; G; L; M; RA; RBA; RI.

MAUD, W.T. 1865-1903

Portrait painter and war artist for *The Graphic*. He was born in 1865 and became a pupil of the RA Schools, winning the Landseer Scholarship in 1893. He was appointed to *The Daily Graphic* the same year and succeeded A.S. Hartick on *The Graphic*, 1895. His campaigns as Special Artist for the magazine were considerable. He rode through Armenia from the Mediterranean to the Black Sea, 1895, was with the insurgents in Cuba, 1896, with the Greek Army in Thessaly, 1897; the Soudan, 1897, the North-West Frontier, 1897-98; he was at the Siege of Ladysmith and volunteered as A.D.C. to Sir Ian Hamilton, but was invalided home with enteric fever. He died during the Somali War on 12 May 1903. The Graphic obituary on 16 May 1903 referred to him as 'A Vigorous, capable artist, he had not only an eye for a good subject but the ability to transfer that sketch rapidly to his notebook.'

Illus: *Facey Romford's Hounds, Hawbuck Grange [R.S. Surtees]; Wagner's Heroines [Miss C. Maud, 1896]*.
Contrib: *Punch*.
Exhib: RA; ROI.

MAUND, Miss S. fl.1840-1873

Flower painter and illustrator. She illustrated *Flowering Plants*, 1873, and contributed to *The Botanist*, c.1840.

MAXWELL, Donald 1877-1936

Painter, illustrator and writer. He was born in London in 1877 and after being educated at Manor House School, Clapham, studied art at South Kensington, 1896, Slade School, 1897, and at Clapham Art School. From about 1910, Maxwell was Naval Artist to *The Graphic*, travelling widely and being appointed official artist by the Admiralty during the First World War, 1914-18. He accompanied the Prince of Wales on his Indian Tour and made numerous illustrations for travel books. He was working at Rochester, 1914-25, and afterwards at Harrietsham, Kent, where he died on 25 July 1936.

Illus: *The Enchanted Road; The Log of the Griffin [1905]; Adventures with a Sketchbook [1914]; The Prince of Wale's Eastern Book* etc.
Exhib: L; M; RA.
Bibl: *The Studio*, Vol.34, 1905, pp.113-117; *Modern Book Illustrators and their Work*, Studio, 1914.

MAY, Charles 1847-1932

Artist and decorator. He was the elder brother of Phil May (q.v.) and contributed to magazines as well as designing wall-papers.

Contrib: *Fun, Frolic and Fancy [1894]; Madame [1895]; The English Illustrated Magazine [1895-97]; Pearson's Magazine*.
Exhib: New Gall, 1896.

MAY, E.M.

Decorative designer for *The Connoisseur*, 1914.

MAY, Philip William 'Phil' RI 1864-1903

Black and white artist, caricaturist and illustrator. He was born on 22 April 1864, the son of a Leeds engineer whose family had been landowners. He was educated at St George's School, Leeds, and became assistant scene painter at the Grand Theatre there, gaining a reputation for caricatures of members of the company. He left for London in about 1883 and joined *Society* and *St Stephen's Review* as artist, before leaving for Australia for the years 1885 to 1888. There he worked for *The Sydney Bulletin* and on returning to Europe studied art in Paris for a time. He made a major success of the highly popular *Parson and Painter*, series of drawings, published in 1891 and continued it by issuing *Annuals* from 1892 to 1904. He was on *The Graphic* staff until 1903 and joined *Punch* in 1895 making an instant mark with the readership that had enjoyed the drawings of the recently deceased, Charles Keene (q.v.). He lived a raffish bohemian life, squandered his money and died of cirrhosis of the liver and tuberculosis at the age of thirty-nine, on 5 August 1903.

May was the most important black and white artist to emerge in the 1890s in the British tradition. In many ways he was the reverse of the Beardsley coin, the discovery of line which was easy to print and which was used with great economy. His *dramatis personae* were the same as Keene's, urchins, costers, cabbies and drunks, but he reduced the fine pen of the latter to a simplified language of strokes. His drawings are always lively but vary a great deal in execution, some include self-portraits and some are tinted with watercolour. He was elected RI in 1897 and his remaining drawings were exhibited at a memorial show in the Leicester Galleries in 1903.

Illus: *The Parson and the Painter, their Wanderings and Excursions among Men and Women [Rev. Joseph Slapkins (Alfred Allison) and illus. by Charlie Summers (Phil May), 1891]; Phil Mays Winter and Summer Annuals [1892-1904]; The Comet Coach [H.H. Pearse, 1894]; Fun, Frolic and Fancy [1894]; Guttersnipes, Fifty Original Sketches [1896]; Zig-Zag Guide [F.C. Burnand, 1897]; Songs and Their Singers [1902]; East London [Walter Besant, 1902]; Littledom Castle [Mrs. H.M. Spielmann, 1903]*.
Contrib: *The Yorkshire Gossip; The Busy Bee [Leeds, 1878]; St Stephen's Review [1883-85 and 1890-91]; The Penny Illustrated Paper [1883]; The Pictorial World [1883]; Society [1885]; The Sydney Bulletin [1886-94]; Puck and Ariel [1889]; The Daily Graphic [1890-96]; The Graphic [1891-92]; Black & White [1891]; Pick-Me-Up [1891-93]; ILN [1892-97, with advertisements]; The Sketch [1893-1903]; The Pall Mall Budget [1893-94]; The English Illustrated Magazine [1893-94]; Punch [1893-1903]; Daily Chronicle [1895]; The Unicorn [1895]; Eureka; The Savoy [1896]; The Mascot [1897]; The Century Magazine [1900]; The Tatler [1901]; The Jewish Chronicle [1903]*.
Exhib: FAS; G; RA.
Colls: BM; Bradford; Glasgow; Leeds; V & AM.
Bibl: J. Thorpe, *PM*, 1932; *The Studio*, Vol.29, 1903, pp.280-286 'Life and Genius of Late PM'; *The Graphic*, Dec. 19, 1903, pp.840-841.

See illustrations (below and p.387).

PHILIP WILLIAM MAY RI 1864-1903. The cover for the Christmas Number of The Graphic, *1893.*

MAY, Captain Walter William RI **1831-1896**
Marine artist and illustrator. He served in the Royal Navy from 1850
to 1870, retiring with the rank of Captain. He did rather accurate and
traditional work in the style of Clarkson Stanfield (q.v.) and
illustrated many books. He was elected ANWS in 1871 and NWS in
1874 and died in 1896.

Publ: *Marine Painting [1888]*.
Illus: *Fourteen Sketches Made During the Voyage Up Wellington Channel
[1855, AT 646]; Quedah [Osborn, 1857, AT 526]; Will Weatherhelm [\..H.G.
Kingston, 1879]; Sea Fishing [J. Bickerdyke, 1895]; In The Queen's Navee
[C.N. Robinson and J. Leyland, 1902]*.
Contrib: *The Book of South Wales [Mr and Mrs S.C. Hall, 1861]; ILN [1875
Discovery expedition]; The Graphic [1869-75]*.
Exhib: BI; L; M; NWS; RA; RBA; RI; ROI.
Colls: Greenwich.

MAYBANK, Thomas **fl.1898-1925**
Fairy illustrator and genre painter. He practised in Beckenham,
Croydon and Esher, contributing a number of startling fairy designs to
Punch between 1902 and 1904. These include 'A Bank Holiday in
Goblin Land', 'Coronation of Titania' and 'New Years Eve', all taking
their inspiration from Doyle's work, pages of meticulous little figures
drawn with pen and ink.

Contrib: *Punch [1902-09]; Pick-Me-Up [1899]*.
Exhib: RA; RBA; RHA; ROI.
Colls: V & AM.

MAYE, H.
Contributed illustrations to Wyatt's *Industrial Arts of the 19th
Century*.

Colls: V & AM.

MAYER, Henry **1868-**
Caricaturist and illustrator. He was born at Worms in Germany in
1868 and worked in New York.

Contrib: *Illustrated Bits; Punch [1906]*.

MAYER, Luigi **fl.1776-1804**
Watercolourist and draughtsman. He was of Italian origin and worked
as view painter to Sir Robert Ainslie, British ambassador at
Constantinople, 1776 to 1792. He was later employed in making
watercolours for aquatints, some of which were from sketches by the
Countess of Harrington. Mayer was the most accurate delineator of
the Near East before David Roberts (q.v.), most of the finished
watercolours are identified by inscriptions in classical lettering
running along the bottom; it is believed that he was assisted in some
of them by his wife Clara.

Illus: *Lyric Airs [Edward Jones, 1804, AL 417 (etched by Rowlandson)]*.
Colls: Searight Coll.

MAYSON, S. **fl.1850-1856**
Illustrator. An oil over pencil on millboard, presumably for a book is
in the Ashmolean Collection.

MEADOWS, Joseph Kenny **1790-1874**
Illustrator and caricaturist. He was born at Cardigan on 1 November
1790, the son of a retired naval officer. He was making a reputation in
London by the 1830s and was one of the first illustrators to
recommend wood engraving to publishers. In 1832, he collaborated
with Isaac and Robert Cruikshank in *The Devil in London*, and in
1840 illustrated *Portraits of the English*, published by Robert Tyas,
which achieved some success. In 1843, the same publisher issued his
Shakespeare, which was specially well received in Germany; Meadows
worked for *The Illustrated London News*, among his best work being
designs for its Christmas numbers. He also appears in the first seven
volumes of Punch, before being superceded by the stronger
draughtsmanship of Leech and Doyle.

Meadows was an unoriginal but competent hand whose designs
suffered most in mechanical figures with puffy faces and straight
arms. He was a kindly but temperemental artist and this shows clearly
in his uneven work. He was the brother-in-law of Archibald S.

Henning (q.v.). He died in London in August 1874.

Illus: *Costume of Shakespeare's Historical Tragedy of King John [1823];
Shakespeare's Works [1839-42]; Autobiography of Jack Ketch [1835]; Lalla
Rookh [Moore, 1842]; Palfrey, A Love Story of Old Times [Leigh Hunt,
1842]; Whist, Its History and Practice; Backgammon, Its History and Practice;
Leila; Calderon [E. Lytoon Bulwer, 1847]; The Family Joe Miller [1848];
Sketches From Life [Laman Blanchard, 1849]; Metrical Poems and Tales
[Samuel Lover, 1849]; The Magic of Kindness [The Brothers Mayhew];
Midsummer Eve [Mrs S.C. Hall]*.
Contrib: *Bell's Life in London; London [Charles Knight, 1841]; Punch [1841];
Book of British Ballads [S.C. Hall, 1842-44]; The Illuminated Magazine
[1843-45]; The Pictorial Times [1843-47]; The Illustrated Musical Annual
[F.W.N. Bailey]; The Man in the Moon; Cassell's Illustrated Family Paper
[1853]; The Book of Celebrated Poems; The Illustrated London Magazine
[1854-55]; The Illustrated Times [1855-59]; The Welcome Guest [1860]*.
Exhib: RA; RBA, 1830-38.
Colls: V & AM; Witt Photo.
Bibl: G. Everitt, *English Caricaturists*, 1893, pp.355-363; M.H. Spielmann, *The
History of Punch*, 1895, pp.446-449; The Dalziel Brothers, *A Record of Work,
1840-1890*, 1901, pp.38-41.

MARIANA.

"Mariana in the moated grange."—*Measure for Measure*.

*SIR JOHN EVERETT MILLAIS PRA 1829-1896. 'Mariana.' Illustration for
Moxon's Tennyson, 1857. Wood engraving.*

MEASOR, W. **fl.1837-1870**
Painter of scriptural and marine subjects, working at Exeter. He
exhibited at the BI, RA and RBA between 1837 and 1864 and
contributed to *The Illustrated London News*, 1848, and *The Graphic*,
1870.

SIR JOHN EVERETT MILLAIS PRA 1829-1896. 'A Fireside Story.' Illustration to The Music Master *by William Allingham, 1855. Wood engraving.*

MEIN, W. Gordon 'Will Mein' fl.1886-1925
Figure painter and illustrator. He was working in Edinburgh, 1894, and afterwards in London. Specialised in boys' stories.
Illus: *Hidden Witchery [Nigel Tourneur, 1898]; My Two Edinburghs [S.R. Crockett, 1913].*
Contrib: *The Dome [1899-1900].*

MELLOR, Sir John Paget, Bt. 'Quiz' KCB 1862-1929
Amateur artist and caricaturist. He was called to the Bar at the Inner Temple, 1886, and served as a barrister and assistant solicitor to the Treasury, 1894-1909, and as solicitor, 1909-23. He was created CB in 1905 and KCB, 1911, and died on 4 February 1929. Mellor's cartoons are usually *portraits chargés* and signed 'Quiz'.
Contrib: *Punch [1886-88]; Vanity Fair [1890, 1893, 1898].*
Bibl: M.H. Spielmann, *The History of Punch*, 1895, pp.558-559.

MELVILLE, Arthur ARWS, HRSA 1858-1904
Painter and watercolourist. He was born at the Loanhead of Guthrie, East Linton, Scotland on 10 April 1858 and was apprenticed to a grocer. He studied at the RSA and with J. Campbell Noble, before working his way round France and studying in Paris. He returned to Edinburgh, but left again in 1881 to tour in Egypt, Persia, Turkey and Asia, riding from Baghdad to the Black Sea. He made a special study of oriental subjects, became a friend of Frank Brangwyn (q.v.) and visited Spain with him in 1892. He died in London 29 August 1904.
Contrib: *The Graphic [1882].*
Exhib: B; BM; G; GG; L; M; New Gall; P; RA; RI; RSA; RWS.
Colls: Edinburgh; Glasgow; Liverpool; V & AM.

MELVILLE, Harden Sidney fl.1837-1882
Painter of landscapes, animals and sport. He worked in London for most of his life, but may have made tours abroad, possibly to Australia.
Illus: *Sketches in Australia [1849, AT 581]; The War Tiger [W. Dalton, 1859]; Wild Sports of the World [J. Greenwood, 1862]; Curiosities of Savage Life [J. Greenwood, 1864]; The Adventures of a Griffin [1867].*
Contrib: *London [Charles Knight, 1841]; ILN [1848 and 1865-66]; The Illustrated Times [1865]; The Welcome Guest [1860].*
Exhib: B; BI; RA; RBA.
Colls: BM.

Opposite: SIR JOHN EVERETT MILLAIS PRA 1829-1896. 'Married For Money.' Pen and black and brown ink, brown wash. Signed. 8¼ins. x 6ins. (21cm x 15.2cm).

MENPES, Mortimer FRGS 1860-1938
Painter, etcher, raconteur and rifle shot. He was born in Australia in 1860 and educated at a grammar school in Port Adelaide, but came to England in the early 1880s and was working with J.M. Whistler as a studio assistant by 1884. He became one of those disciples of the American master who scouted out streets and corners and alleys for him to paint and working alongside him, absorbed much of his style in their etchings and oil paintings. Menpes travelled extensively and was particularly influenced by the arts of Japan, but also by those of India, Mexico, Spain, Morocco and Venice. He was instrumental in holding an exhibition of coloured etchings, an attempt to revive this art. He was Special Artist for *Black & White* in South Africa, 1900. He was elected RE, 1881, RBA, 1885, NEA, 1886 and RI, 1897, and died at Pangbourne, Berks, 1 April 1938.
Illus: *War Impressions [1901]; Japan [1901]; World Pictures [1902]; World's Children [1903]; The Durbar [1903]; Venice [1904]; Brittany [1905]; India [1905]; Thames [1906].*
Publ: *Whistler as I Knew Him [1904].*
Exhib: FAS, 1901, 1902, 1908, 1911; G; GG; L; M; New Gall; RA; RE; RI; ROI.
Colls: V & AM.
Bibl: *The Studio*, Winter No., 1900-01, p.61, illus.

MERRITT, F.R.
Contributor to *The Graphic*, 1884.

MERRY, Tom 1852-1902
Caricaturist and cartoonist. Merry was for many years the chief cartoonist of *St Stephen's Review*, being most prolific in the period 1885-90. He became cartoonist of *Puck and Ariel* in that year. His style is rather wooden, although he has a good eye for portraiture and making his political points on a large scale. All his work appeared as two-pager coloured lithographs, often wittily taken from famous paintings of the day by Seymour Lucas, Stanley Berkeley, or parodies of Hogarth. He died in 1902.

METCALFE, Gerald Fenwick fl.1894-1929
Portrait painter, miniaturist, illustrator and modeller. He was born at Landour, India and studied art at South Kensington, St John's Wood School and the RA Schools. He was working in Chelsea, 1902-03 and at Albury, Surrey, 1914-25.
Illus: *The Wrecker [R.L. Stevenson].*
Contrib: *Punch [1906].*
Bibl: *Modern Book Illustrators and Their Work*, Studio, 1914.

THE CRAWLEY FAMILY.

SIR JOHN EVERETT MILLAIS PRA 1829-1896. 'The Crawley Family.'
Illustration to Framley Parsonage *by Anthony Trollope,* The Cornhill Magazine,
August 1860. Wood engraving.

METEYARD, Sidney Harold 1868-1947
Artist, stained-glass designer and illustrator. He was born in
Stourbridge in 1868 and is associated with the Birmingham School,
where he studied under E.R. Taylor. His paintings and drawings are
strongly influenced by Burne-Jones; he was elected a member of the
R.S.B.A., 1908.

Illus: *The Golden Legend [H.W. Longfellow, 1910].*
Contrib: *The Quest [1894-96]; The Yellow Book [1896].*
Exhib: B; L; New Gall; RA.

METEYARD, Tom B. 1865-
Painter and illustrator. He was born at Rock Island, U.S.A. on 12
November 1865 and worked as an artist at Fernhurst, Sussex.

Illus: *Songs From Vagabondia [Bliss Carmen and Richard Hovey, 1895-96].*
Exhib: FAS, 1922.

METTAIS, Charles-Joseph fl.1846-1857
French portrait painter and illustrator. He exhibited at the Salon from
1846-48 and contributed to *Cassell's Illustrated Family Paper,* 1857.

MICHAEL, A.C. fl.1903-1916
Painter and etcher, working in Bedford Park, London. He was artist
for *The Morning Star* and illustrated books.

Illus: *The Ghost King [H. Rider Haggard, 1908]; King Solomon's Mines [H. Rider Haggard, 1912].*

Contrib: *The Graphic [1903]; The Illustrated London News [1915-16].*
Exhib: RA; RI.
Bibl: M.A.C. *An Artist in Spain,* 1914.

MICHAEL, J.B.
Architectural illustrator on *The Illustrated London News,* 1873.

MICHAEL, L.H. fl.1845-1874
Architectural illustrator. He contributed drawings to Wyatt's
Industrial Arts of the Nineteenth Century, The Welcome Guest, 1860
and *The Illustrated London News,* 1865-66.

Exhib: RA; RBA.
Colls: V & AM.

MILES, Marie fl.1897-1914
Black and white artist, specialising in children.

Contrib: *The Parade [1897]; Cassell's Family Magazine [1898]; The Royal
Magazine; Punch [1914].*

MILLAIS, Sir John Everett, Bt. PRA 1829-1896
Painter, illustrator and President of the Royal Academy. He was born
in Southampton in 1829 and was brought up in Jersey and Brittany,
coming to London in 1838 to study at Henry Sass's Academy and at
the RA Schools, 1840. With Holman Hunt (q.v.) and D.G. Rossetti
(q.v.) founded the Pre-Raphaelite Brotherhood, 1848. From the first,
Millais was a masterly draughtsman and excelled in line drawings,
preparing some for *The Germ,* the magazine of the Pre-Raphaelites in
1850. His most powerful black and white work was done in the period
1851-55 when he was concerned with modern moral subjects, but

LAST WORDS.

SIR JOHN EVERETT MILLAIS PRA 1829-1896. 'Last Words.' Illustration to a
poem in The Cornhill Magazine, *November 1860. Wood engraving.*

these remained unpublished. His most influential work was published in Moxon's edition of *Tennyson*, 1857, where he showed two styles of drawing developing, a highly finished manner for the romantic subjects and a more sketchy modern style for the contemporary illustration. The latter is best seen in his fine series of drawings prepared for the novels of Anthony Trollope, which appeared in *The Cornhill Magazine*, 1860. Millais' brilliant groups grasp perfectly the underlining tensions and complexities of Victorian society and are arguably the best of their kind done for a novelist in the entire 19th century.

Millais ceased to do illustration after the 1860s, although he undertook some for his son, and his falling away in expression dates from the same time. Marriage with Effie Ruskin in 1855 was followed by election as RA in 1863 and increasing popularity as a portrait painter of the great. He was created a baronet in 1885 and was elected PRA in 1896, serving only six months before dying of cancer of the throat on August 13 that year.

The drawings prepared by Millais for his famous book illustrations were mostly lost in the cutting, but his Pre-Raphaelite sketches and finished drawings sometimes emerge on the market. A group 'Married For Money', 'Married For Love' and 'Married For Rank' appeared in the London galleries in 1972.

Illus: *Framley Parsonage [Anthony Trollope, 1860-62]; Orley Farm [Anthony Trollope, 1861-62]; Small House at Allington [Anthony Trollope, 1862]; Phineas Finn [Anthony Trollope, 1869]; Kept in the Dark [Anthony Trollope, 1882].*
Contrib: *The Germ [No. 5, 1850 (not used)]; Mr. Wray's Cashbox . . . A Christmas Sketch [Wilkie Collins, 1852]; The Music Master [W. Allingham, 1855]; Poems [by Tom Hood, 1858]; Moxon's Tennyson [1857]; The Poets of the Nineteenth Century [Rev. R.A. Willmott, 1857]; Lays of the Holy Land [1858]; The Home Affections [Charles Mackay, 1858]; Once a Week [1859-63 and 1868]; The Cornhill Magazine [1860-63]; Good Words [1861-64, 1878, 1882]; London Society [1862-64]; The Illustrated London News [1862];*

THE PRODIGAL SON.

SIR JOHN EVERETT MILLAIS PRA 1829-1896. 'The Prodigal Son. Illustration for The Parables of Our Lord, *1863. Wood engraving by the Brothers Dalziel.*

Cornhill Gallery [1864]; The Churchman's Family Magazine [1863]; Papers For Thoughtful Girls [Sarah Tytler, 1862]; Puck on Pegasus [Pennell, 1862]; Parables of Our Lord [1863]; Punch [1863 and 1865]; Lilliput Levee [1864]; Little Songs For Me To Sing Touches of Nature By Eminent Artists [1866]; St. Pauls [1867]; Gems of Poetry [Mackay, 1867]; Leslie's Musical Annual [1870]; Passages From Modern English Poets [1876]; The Memoirs of Barry Lyndon Esq. [W.M. Thackeray (Complete Works, Vol. XIX) [1879]; Game Birds and Shooting Sketches [J.G. Millais, 1892 (frontis)].
Colls: Ashmolean; BM; Bedford; Glasgow; Manchester; V & AM.
Exhib: BI; GG; G; L; M; New Gall; RA; RHA; RSA.
Bibl: J.G. Millais, *Life and Letters of JEM*, 1899. M. Lutyens, *M and the Ruskins*, 1967. M. Bennett, *M*, RA Exhibition Cat., Jan-April, 1967.
See illustrations (above, left and pp.387, 388, 389, 390).

MILLAIS, John Guille FZS 1865-1931
Animal painter and illustrator. He was born on 24 March 1865, the fourth and youngest son of Sir John E. Millais (q.v.). He was educated at Marlborough and Trinity College, Cambridge and after serving with the Somerset Light Infantry, 1883-86, travelled in Africa, Canada, America and the Artic as a big game hunter. Millais published numerous books on these subjects, many illustrated from his own drawings. He became FZS and died on 24 March 1931.

Illus: *A Fauna of Sutherland [1887]; A Fauna of the Outer Hebrides [1888]; A Fauna of the Orkney Islands [1891]; Game Birds and Shooting Sketches [1892]; A Breath From the Veldt [1895]; British Deer and Their Horns [1897]; The Wild Fowler in Scotland [1901]; Surface-Feeding Ducks [1902]; The Mammals of Great Britain [1904-06]; Newfoundland [1907]; British Game Birds [1909]; British Diving Ducks [1913]; Deer and Deer Stalking [1913]; European Big Game [1914]; American Big Game [1915]; Rhododendrons and Their Hybrids [1917]; Wanderings and Memories [1919]; Far Away up the Nile [1924]; Magnolias [1927].*
Contrib: *The Graphic [1886]; Pearson's Magazine.*
Exhib: FAS, 1901, 1919, 1923.
Bibl: R.E.D. Sketchley, *Eng. Bk. Illus.* 1903, pp.54, 135.

THE UNJUST JUDGE.

SIR JOHN EVERETT MILLAIS PRA 1829-1896. 'The Unjust Judge.' Illustration for The Parables of Our Lord, *1863. Wood engraving by the Brothers Dalziel.*

MILLAIS, William Henry 1828-1899

Painter, watercolourist and illustrator. He was the elder brother of Sir John E. Millais (q.v.) and was born in 1828. He worked at Farnham and specialised in landscapes.

Publ: *The Princess of Parmesan [1897].*
Contrib: *Parables From Nature [Mrs. Gatty, 1861, 1867]; Legends and Lyrics [A.A. Proctor, 1865].*
Exhib: FAS; M; RA; RI.
Colls: Ashmolean; BM; V & AM.

MILLAR, Harold R. fl.1891-1935

Painter and illustrator. He was born at Dumfries and intended to study engineering, but abandoned this for art and became a student of the Birmingham School. His earliest work was for Birmingham magazines such as *Scraps* and *Comus*, and he derived a very strong and free ink style based on the work of Vierge and Gigoux. A collector of ancient weapons and eastern works of art, Millar became known for his authenticity in illustrating eastern stories in the 1900s.

Illus: *The Golden Fairy Book [George Sand, 1894]; The Humour of Spain [1894]; Fairy Tales From Far and Near [1895]; The Adventures of Haji Baba [Morier, 1895]; The Silver Fairy Book [Bernhardt, 1895]; Headlong Hall, Nightmare Abbey [Peacock, 1896]; The Phantom Ship [Marryat, 1896]; The Diamond Fairy Book [Bellerby, 1897]; Untold Tales of the Past [B. Harraden, 1897]; Frank Mildmay [Marryat, 1897]; Snarleyow [1897]; Phroso [Anthony Hope [1897]; Eothen [A.W. Kinglake, 1898]; The Book of Dragons [E. Nesbitt, 1900]; Nine Unlikely Tales For Children [E. Nesbitt, 1901]; The Story of the Bold Pecopin [Hugo, 1902]; Queen Mab's Realm [1902]; The Phoenix and the Carpet [E. Nesbitt, 1904]; The New World Fairy Book [1904]; Oswald Bastable and Others [E. Nesbitt, 1905]; Kingdom Curious [Myra Hamilton, 1905]; Puck of Pook's Hill [Rudyard Kipling, 1906]; The Enchanted Castle [E. Nesbitt, 1917]; The Magic City [1910]; The Wonderful Garden [E. Nesbitt, 1911]; Wet Magic [E. Nesbitt, 1913]; The Dreamland Express [1927]; Hakluyt's Voyages [1929].*
Contrib: *Judy [1890]; The Girl's Own Paper [1890-1900]; Fun [1891-92]; The Strand Magazine [1891, 1905]; The English Illustrated Magazine [1891-92]; Chums [1892]; Good Words [1893]; Good Cheer [1894]; The Sketch [1898]; Black & White [1899]; The Quiver [1900]; Punch [1906-09]; The Ludgate Monthly; Pick-Me-Up; Cassell's Family Magazine; The Idler; The Minister; Eureka.*
Exhib: RA.
Colls: V & AM.
Bibl: *The Idler,* Vol. 8, pp.228-236; R.E.D. Sketchley, *Eng. Bk. Illus.*, 1903, pp.109, 112, 167; Brigid Peppin, *Fantasy Book Illustration*, 1975, pp.188-189, illus.
See illustration (right).

MILLER, F.

Book decorator. Contributed tail-pieces to *The English Illustrated Magazine* 1895.

MILLER, J.H. fl.1803-1829

Landscape painter and topographer. He contributed to Britton's *Beauties of England and Wales,* 1805 and exhibited at the RA, RBA and OWS from 1803 to 1829.

MILLER, William Edwards fl.1873-1929

Portrait painter. Worked in London and contributed one cartoon to *Vanity Fair,* 1896.

Exhib: B; G; L; New Gall; RA; RSA.

MILLER, William Frederick 1834-1918

Architectural draughtsman. He undertook some illustrative work for Messrs. T. Nelson & Sons, 1853-54.

Coll: V & AM.

MILLS, A. Wallis 1878-1940

Black and white artist. He was born in 1878, the son of the rector of Long Bennington, Lincolnshire, and trained at the South Kensington Schools, becoming a friend of F.H. Townsend, G.L. Stampa and G.K. Haseldon (qq.v.). He was working for illustrated magazines from about 1898, specialising in drawings of old country characters, many of them modelled on those he had known in Lincolnshire or who lived near him at Little Gransden, Hunts., in the 1920s. He served in the Royal Artillery in the First World War and made official war sketches, he died at his club in St. James's in April 1940.

Illus: *Novels of Jame Austen [n.d.]*

HAROLD R. MILLAR fl.1891-1935. 'The Amulet.' Drawing for illustration in The Strand Magazine, *Vol. 21, 1905. Pen. Signed and dated 1905. 7³/₄ins. x 6⁷/₈ins. (19.7cm x 17.4cm).* Victoria and Albert Museum

Contrib: *Judy [1898]; The Strand Magazine [1906]; Punch [1907-14]; The Humourist; The Ludgate Monthly; The Royal Magazine; The Graphic [1915].*
Exhib: Nottingham; RA.
Bibl: R.G.G. Price, *A History of Punch,* 1957, p.205.

MILLS, Charles A. ARHA -1922

Painter and illustrator. He worked in Dublin and contributed figure drawings to *Fun,* 1901 and to *The Graphic,* 1903-05. He was elected ARHA in 1913 and died in 1922.

Exhib: RHA.

MILLS, Walter fl.1880-1903

Painter and illustrator working in Dublin. He acted as *The Graphic* Special in Ireland, 1903.

Exhib: RHA.

MINNS, B.E. fl.1895-1913

Illustrator. He worked at Hendon, London and contributed to magazines in the 1890s.

Contrib: *The Idler; The Minister; Pearson's Magazine; Punch [1914].*
Exhib: G; L; RA; RI.

MITCHELL, Hutton fl.1892-1925

Illustrator and the original creator in line of Billy Bunter. He is recorded as being an able but dilatory artist who was replaced after thirty-nine issues of *The Magnet* by Arthur Clarke (q.v.). He was working at Paignton, S. Devon, 1920-25.

Contrib: *Fun [1892]; Daily Graphic [1893]; The Longbow [1898]; The Gem.*
Exhib: L.
Bibl: W.O. Lofts and D.J. Adley, *The World of Frank Richards,* 1975.

MOIRA, Gerald Edward RWS 1867-1959

Landscape, flower and decorative painter. He was born in London in 1867 as Giraldo de Moura, the son of a Portuguese miniaturist, and anglicized his name. He was elected ARWS in 1917 and RWS in 1932,

serving as Vice President from 1953. He died at Northwood in 1959.

Illus: *Shakespeare's True Life [J. Walter, 1890]*.
Colls: BM.
Bibl: J.H. Watkins, *The Art of GEM*, 1922.

MONCRIEFF, Robert SCOTT-
Amateur caricaturist. His drawings of Scottish lawyers of the years 1816-20 were published as *Scottish Bar*, 1871.

Colls: Witt Photo.

MONNIER, G.
French artist contributing to *The Illustrated London News*, 1870.

MONRO, A.
Illustrator of boys' stories. He contributed to *Chums*, c.1890 in a style like that of Gordon Browne (q.v.).

MONSELL, J.R.
Illustrator, who drew for *Grimms Fairy Tales*, 1908 and *The Buccaneers*, 1908, published by Cassells.

MONSON, Frederick John 5th Baron Monson 1809-1841
Amateur artist. He illustrated *Views in the Department of The Isère and The High Alps*, 1840. Lithographs by L. Haghe from Monson's drawings.

MONTAGU, H. Irving fl.1873-1893
Figure painter, illustrator and war artist. He was Special Artist for *The Illustrated London News* from 1874, when he was present during the Carlist uprising in Spain and later served in Hungary, Turkey and Russia.

Contrib: *The Sunday Magazine [1881]*.
Exhib: B; RA; RBA.
Bibl: H.I.M., *Wanderings of a War Artist*, 1889; H.I.M., 'Anecdotes of the War Path' *The Strand Magazine*, Vol. I, 1891, pp.576-585.

MONTBARD, G. Charles Auguste Loyes 1841-1905
Landscape painter, illustrator and caricaturist. He was born at Montbard on 2 August 1841 and took his professional name from the town. He worked first with O'Shea on *Chronique Illustrée* and had his introduction to the English public when he illustrated scenes at Compiègne for *The Illustrated London News* in 1868. Montbard was strongly political and after taking the side of the Commune in 1871, was proscribed from France and resided in England until his death. He very soon became a regular contributor to *The Illustrated*, making a series of drawings of country houses, usually devoid of figures at which he was very weak. He also undertook some flower paintings and died in London on 5 August 1905.

Illus: *The Land of the Sphinx [GM, 1894]*.
Contrib: *ILN [1868-99]; The Graphic [1871-73]; Judy [1871]; Vanity Fair [1872]; Good Words [1880-99]; The English Illustrated Magazine [1895]; St James's Budget; The Windsor Magazine; The Pall Mall Magazine*.
Exhib: L; M; RA; RBA; RI; ROI.
Colls: V & AM.

MONTEFIORE, Edward Brice Stanley fl.1872-1909
Landscape and genre painter, working in London and Newnham, Glos., 1909.

Contrib: *Sporting & Dramatic News [1894]*.
Exhib: M; RA; ROI.

MOODY, Fannie (Mrs. Gilbert King) 1861-
Animal painter and illustrator. She was born in London on 10 May 1861, the daughter of T.W. Moody 1824-1886, master at the South Kensington Schools. She studied under J.T. Nettleship and became well known for her sentimental dog subjects, beloved of the Victorians. She drew for advertisements and was still working in Battersea 1920. SWA, 1887.

Contrib: *ILN [1892-99]*.
Exhib: B; L; M; RA; RBA; RMS ROI; SWA.
Bibl: 'The Animal Sketches of Miss Fannie Moody' *The Artist*, 1899, pp.121-130.

MOODY, John 1884-
Painter, etcher and black and white artist. He was born 21 June 1884 and studied at the Regent St Polytechnic and then in Paris and Italy. He became a member of the Society of Graphic Art in 1920 and worked at Hampstead and Highgate from 1914 to 1925 and then at Burpham, Sussex. Principal of Hornsey School of Art, 1927. ARE, 1921; RE, 1946; RI, 1931.

Exhib: G; L; RA; RE; RI; ROI.
Bibl: *The Studio*, Vol. 38, 1906, p.317, illus.

MOORE, Albert Joseph 1841-1893
Figure painter and illustrator. He was born at York in 1841, the son of the portrait painter William Moore. On his mother's widowhood in 1855, he settled in London, travelling to Scotland and to France and visiting Rome in 1862. Moore was often employed by architects and worked as a mural painter. He was a frequent exhibitor at the RA from 1857 and developed a reputation for classical Greek studies which are the forerunners of Alma Tadema (q.v.). He died in London in 1893. RWS, 1884.

Contrib: *Specimens of Medieval Architecture [W. Eden Nesfield, 1862]*.
Exhib: B; FAS; G; L; M; NEA; New Gall; RA; RI; RWS.

MOORE, Alexander Poole 1777-1806
Topographer. He was born about 1777 and entered the RA Schools in 1792, winning the silver medal in 1794. He was a pupil of James Lewis, the architect, and was described as 'a young man of very eccentric habits but a clever Artist'.

Contrib: Britton's *Beauties of England & Wales*, 1802.
Exhib: RA, 1793-1806.
Colls: Witt Photo.
Bibl: H.M. Colvin, *Biog. Dict. of Eng. Architects*, 1954.

MOORE, C. Aubrey
Illustrator of the child's book *Adventures in Noah's Ark*, 1908.

MOORE, Henry 1776-1848
Topographer and drawing master at Derby. He was born in 1776 and won a Society of Arts medal for his process of etching on marble.

Illus: *Excursions from Derby to Matlock, Bath and its Vicinity [1818]*.
Contrib: *Beauties of England & Wales [Britton, 1802-13]; Antiquarian and Topographical Cabinet [Britton, 1806]*.
Colls: Derby; Witt Photo.

MOORE, Henry RA RWS 1831-1895
Marine painter and engraver. He was born at York on 7 March 1831, the son and pupil of the portrait painter William Moore and brother of Albert Joseph Moore (q.v.). He studied at the York School of Design and at the RA Schools, 1853, and after settling in London made a series of tours abroad to France, Switzerland and Ireland. He was principally a marine painter but did landscapes, the earlier works being influenced by the Pre-Raphaelites. He was elected ARA in 1885 and RA in 1893, RWS, 1880. He died at Margate, 22 June 1895.

Contrib: *ILN [1856]; Poems [Tom Hood]; Passages From Modern English Poets [1862, Junior Etching Club]*.
Exhib: B; BI; FAS, 1887; GG; G; L; M; New Gall; RA; RBA; RHA; ROI; RSA; RWS.
Colls: Birmingham; Tate; V & AM.

MOORE, R.H. 1875-1890
Animal and bird illustrator. He was a sculptor and black and white artist and worked extensively for *The Illustrated London News*, 1875-90.

Contrib: *Lady's Pictorial; Sporting & Dramatic News [1890]*.
Exhib: NWS; RBA.

MOORE, Thomas Sturge 1870-1944
Illustrator, wood engraver and poet. He was born on 4 March 1870 and studied wood engraving at the Lambeth School of Art under Charles Roberts. Moore had strong connections with the private presses and particularly with the Essex House Press and was a member

of the Society of Twelve. Moore's designs were not so consciously archaic as Morris's and extremely well balanced in light and shade. He was also engaged in decorations for the rhyme sheets produced by Harold Monro's Poetry Bookshop.

Publ: *The Vine dressers and Other Poems [1899]; Aphrodite Against Artemis [1901]; Absalom [1903]; Danae [1903]; The Little School [1905]; Poems Marianne [1911]; The Sicilian Idyll and Judith [1911]; The Sea is Kind [1914]; The Little School Enlarged [1917]; The Powers of the Air [1920]; Tragic Mothers [1920]; Judas [1923].*
Illus: *The Centaur, The Bacchante [de Guerin, 1899]; Some Fruits of Solitude [William Penn, 1901].*
Contrib: *The Dial [1895].*
Exhib: RSA.
Colls: Witt Photo.
Bibl: R.E.D. Sketchley, *Eng. Bk. Illus.* 1903, pp.18, 24, 129; *The Studio,* Vol. 66, 1916, p.28 and Winter, 1923-24, pp.34 and 105; *The Connoisseur,* Vol. 55, 1919, p.187; *Print Coll Quarterly,* No. 18 1921, No. 3 p.276.

MORCHEN, Horace **fl.1880-1890**
Humorous illustrator and caricaturist. He studied under Alfred Bryan (q.v.) and specialised in theatrical subjects.

Contrib: *ILN [1880-83]; Moonshine [1890]; Sporting & Dramatic News; Cassell's Saturday Journal.*

MOREL, Charles **1861-1908**
French draughtsman and illustrator. He was born in 1861 and became a pupil of Detaille. He contributed to the Graphic, 1904, and died in Paris, 27 July, 1908.

MORELAND A.
A cartoonist of *The Morning Leader,* c.1895. A book of 160 of these designs in colour was issued at the same date entitled *Humours of History.*

MORGAN, Frederick ROI **1856-1927**
Painter of genre and children. He was born in 1856 and married the painter, Alice Mary Havers. He worked in Aylesbury in early life and later in London and at Broadstairs, 1914-25. He became ROI in 1883.

Contrib: *The Sunday Magazine [1894].*

Exhib: B; BI; FAS; G; L; M; RA; RBA; RI; ROI.
Colls: Leeds; Liverpool; Sheffield.

MORGAN, Matt Somerville **1836-1890**
Painter of social realism, lithographer and caricaturist. He was born in London in 1836 and from the late 1850s gained a high reputation as a figure artist and decorator in the magazines. He went to Italy in 1859-61 and covered the campaigns there for both *The Illustrated London News* and *The Illustrated Times* as a Special, later travelling in Algeria. From about 1866, he became interested in social questions and drew powerful studies of reform demonstrations and the poor in London. On becoming cartoonist to *The Tomahawk,* a radical paper, in 1867, his talents for figure drawing and brilliant political images were brought together on the page. His sharp satire established for him a greater freedom than any other Victorian cartoonist and his work was marked by its individuality in being printed from tinted wood blocks. Morgan emigrated to the United States and painted panoramas of the Civil War, he died in New York in 1890.

Illus: *Miles Standish.*
Contrib: *The Illustrated Times [1859-66]; The ILN [1859-86]; London Society [1863]; The Broadway [1867-74]; The Tomahawk [1867]; Judy; Britannia [1869]; Arrow; Will o' the Wisp.*
Bibl: Chatto & Jackson, *Treatise on Wood Engraving,* 1861, p.599; Clement & Hutton, *Art of the 19th Cent,* 1893; Fielding, *Dict of American Painters,* 1926; *Victorian Studies,* Vol. XIX, No. 1, Sept. 1975.
See illustrations (below and p.157)

MORGAN, Walter Jenks RBA **1847-1924**
Genre painter and illustrator. He was born in 1847 and studied at the Birmingham School and at South Kensington. He worked for the magazines and Messrs. Cassell's, chiefly on domestic and children's subjects. He died at Birmingham on 31 October 1924. RBA, 1884.

Illus: *Spenser For Children [1897].*
Contrib: *The Graphic [1875-76]; ILN [1877-81].*
Exhib: B; L; RA; RBA; RI.

MORIN, Edward **1824-1882**
Watercolourist, lithographer and illustrator. He was born at Le Havre on 26 March 1824 and became a pupil of Gleyre, exhibiting at the Salon from 1857. He came to London to work for the illustrated magazines and was taught wood engraving by Sir John Gilbert (q.v.)

MATT SOMERVILLE MORGAN 1836-1890. 'The Unemployed at the East End of London.' Wood engraving in The Illustrated London News, *1886.*

394

and was described by Vizetelly as 'a spirited French artist'. Although Benezet says that he returned to Paris in 1851, his work was still appearing in English journals until 1861. He died at Sceaux on 18 August 1882.

Contrib: *Cassell's Illustrated Family Paper [1853-55]; The Illustrated Times [1855-61]; ILN [1856-57].*
Bibl: Vizetelly, *Memoirs*,1893.

MORRELL, G.F.
Draughtsman, contributed scientific drawings to *The Graphic*, 1910.

MORRIS, William **1834-1896**
Poet, designer and polemicist. He was born at Walthamstow in 1834 and after studying at Oxford was converted to craft design and socialism, founding manufactures for the production of textiles and tapestries, stained-glass and furniture, having a profound influence on Victorian design. Morris developed an interest in the decoration of books over many years, culminating in his illumination of some works by hand in the early 1870s. He supervised the production of *The House of Wolfings* at the Chiswick Press, 1888, and founded the renowned Kelmscott Press in 1890. During the last six years of his life, Morris concentrated most of his energies on book production, upwards of fifty books being produced at Kelmscott for which he had designed borders and initial letters. He believed that 'ornament must form as much a part of the page as the type itself' and in many of the books, the decoration based on early printed motifs, seems rather to impinge on the text than otherwise. Morris employed Sir E. Burne-Jones, Walter Crane and C.M. Gere as illustrators, the most famous production being the former's Kelmscott *Chaucer*, May 8 1896. Morris died at Hammersmith in 1896.

Colls: BM; V & AM; Walthamstow; Wightwick, Nat. Trust.
Bibl: Aymer Vallance, *WM His Art His Writings & Public Life*, 1897.
See illustration (right).

MORRISON, Douglas **fl.1842-1845**
Lithographer. He illustrated his own *Views of Haddon Hall*, 1842 and *Views of Saxe-Coburg and Gotha*, 1846, AT 121.

MORROW, Albert George **1863-1927**
Black and white and poster artist. He was born in 1863 at Comber, County Down, Ireland, the son of a decorator. He studied in Belfast and at South Kensington and began illustrating for magazines in 1884. He was the brother of George and Edwin Morrow (q.v.). He died at West Heathly, Sussex in October 1927.

Contrib: *The English Illustrated Magazine [1884]; Illustrated Bits [1890]; Good Words [1890]; Punch.*
Exhib: RA; RBA.
Colls: V & AM.

MORROW, Edwin A. **fl.1903-1914**
Landscape painter and illustrator. Brother of George and Albert Morrow (qq.v.).

Contrib: *Punch [1914].*
Exhib: RA.

MORROW, George **1869-1955**
Comic artist and illustrator. He was born in Befast in 1869, the brother of Albert and Edwin Morrow (qq.v.), and studied in Paris in the 1890s being greatly influenced by the work of Caran d'Ache (q.v.). He began to contribute to *Punch* in 1906 and soon bcame known for his humourous historical episodes, in which history was treated in light-hearted manner in subject and in line. He joined the staff of *Punch* in 1924 and was Art Editor from 1932-37 and continued to draw for the paper until a month before his death on 18 January 1955. *The Times* wrote of him on that occasion as 'probably the most consistently comic artist of his day'.

Illus: *Country Stories [Mary Russell Mitford, 1896].*
Contrib: *Pick-Me-Up [1896]; The Idler; The Windsor Magazine; Punch [1906-54].*
Exhib: RA; RBA.

MORROW, Norman **fl.1911-1916**
Irish illustrator. He contributed drawings to *The Graphic*, 1911-16.

XI.
LET the solid ground
Not fail beneath my feet
Before my life has found
What some have found so sweet;
Then let come what come may,
What matter if I go mad,
I shall have had my day.

2.

Let the sweet heavens endure,
Not close and darken above me
Before I am quite quite sure
That there is one to love me;
Then let come what come may
To a life that has been so sad,
I shall have had my day.

XII.

IRDS in the high Hall-garden
When twilight was falling,
Maud, Maud, Maud, Maud,
They where crying and calling.

2.

Where was Maud? in our wood;
And I, who else, was with her,
Gathering woodland lilies,
Myriads blow together.
26

WILLIAM MORRIS 1834-1896. Initial letters and page decoration for Maud! A Monodrama *by Alfred, Lord Tennyson, Kelmscott Press, 1894.*

MORTEN, Thomas **1836-1866**
Illustrator and occasional painter. He was born at Uxbridge in 1836 and studied at Leigh's of Newman Street from an early age, specialising in drawing on wood. He worked for most of the leading magazines of the 1860s and his finest illustrations were for *Gulliver's Travels*, 1866, where he brought to the subject a new wit and vision. In other works, Reid considered him to be rather a plagiarist, borrowing ideas from Doré, Sandys and J.D. Watson (qq.v.) among others. He died in the autumn of 1866, probably by committing suicide due to pecuniary difficulties.

Illus: *Gulliver's Travels [1866].*
Contrib: *Good Words [1861-63]; Once a Week [1861-66]; Entertaining Things [1861-62]; The Laird's Return [1861]; London Society [1862-69]; Every Boy's Magazine [186-63]; Churchman's Family Magazine [1863-64]; Dalziel's Arabian Nights [1863]; A Round of Days [1865]; Watts Divine and Moral Songs [1865]; Legends and Lyrics [1865]; Jingles and Jokes For little Folks [1865]; The Quiver [1865-66]; Aunt Judy's Magazine [1866]; Beeton's Annuals [1866]; Cassell's Family Paper [1866]; Idyllic Pictures [1867]; Two Centuries of Song [1867]; Young Gentlemen's Magazine [1867]; Foxe's Book of Martyres [1867]; Belgravia [1871]; Thornbury's Legendary Ballads [1876]; Cassell's History of England.*
Exhib: Bl; RA.
Colls: V & AM.
Bibl: Forrest Reid, *Illustrators of the Sixties*, 1928, pp.211-216.

MOSER, Oswald RI **1874-1953**
Painter and illustrator. He studied at St. John's Wood Arf School and worked in London until 1925 and afterwards at Rye. He exhibited at the Salon in 1907 and was elected RI, 1909 and ROI, 1908. He died 31 March 1953.

Illus: *John Halifax, Gentleman [Mrs. Craik, Black, 1905].*
Exhib: G; L; RA; RI; RSA.

MOSES, Henry 1782-1870

Draughtsman and engraver. He was born in London in 1782 and became the foremost outline engraver of his generation, specialising in antiquities and closely associated with the Greek Revival. He was engraver to the British Museum and died at Cowley, Middlesex on 28 February, 1870.

Illus: *The Gallery of Pictures Painted by Benjamin West [1811]; The Mausoleum at Castle Howard [1812]; A Collection of Vases [1814]; Picturesque Views of Ramsgate [1817]; Select Greek and Roman Antiquities from Vases . . . Gems . . . [1817]; Vases From the Collection of Sir Henry Englefield [1819-20]; Modern Costume [1823]; Sketches of Shipping [1824]; The Marine Sketchbook [1825-26]; The Works of Canova [1824-28]; Selection of Ornamental Sculptures From the Museum of the Louvre [1828]; Visit of William IV to Portsmouth [1840].*
Exhib: RBA.
Colls: Witt Photo.

MOULIN fl.1859-1860

French figure artist and illustrator. Vizetelly records that Moulin had access to the palaces of the Second Empire because he was related to Napoleon III's chef but in fact he was an informer of the secret police!

Contrib: *The Illustrated Times [1859-60]; ILN [1860].*

'MOUSE'

Contributed one cartoon to *Vanity Fair*, 1913.

MUCKLEY, Louis Fairfax fl.1889-1914

Painter, etcher and illustrator. He was born at Stourbridge and studied at Birmingham School of Art, contributing to various lavish books in a late Pre-Raphaelite style with Morris decoration. He was associated with the Birmingham School of Handicraft and designed for *The Quest*; he may have been a relation of W.J. Muckley, Art Director at Manchester and Wolverhampton.

Illus: *Fringilla [R.D. Blackmore, 1895-96]; Spenser's Faerie Queen [1897].*
Contrib: *Rivers of Great Britain [1889]; The Graphic [1889]; The Quiver [1890]; ILN [1893-96]; Cassell's Family Magazine.*
Exhib: B; New Gall; RA.
Bibl: R.E.D. Sketchley, *Eng. Bk. Illus.*, 1903, pp.12, 129.

MULREADY, Augustus Edward -1886

Genre painter. He worked with F.D. Hardy, G.B. O'Neill and T. Webster as a member of the Cranbrook 'Colony'. He concentrated on domestic subjects and died in London in 1886.

Contrib: *ILN [1886].*
Exhib: RA; ROI.
Bibl: *Cat. of Works of Art, Corp. of London*, 1910.

MULREADY, William RA 1786-1863

Genre painter and illustrator. He was born at Ennis, County Clare in 1786 and brought to London as a child where he early showed a talent for drawing. He received instruction from Thomas Banks, the sculptor, and entered the RA Schools in 1800. He formed a friendship with John Varley, whose sister he married in 1803, but the marriage ended after a few years. Mulready concentrated on oil paintings in the Wilkie style, but was also a very prolific illustrator, producing huge numbers of vignette designs in the period around 1810. He was elected ARA in 1815 and RA a few months later, but continued his illustrative work into late middle age, appearing under the same covers as the Pre-Raphaelites. Mulready is a charming but never a strong illustrator of fiction and his delicate drawings were best suited to the age before the wood engraving. He designed the first Penny Postage envelope for Sir Rowland Hill in 1840 and died at Bayswater on 7 July 1863.

Illus: *The Vicar of Wakefield [Goldsmith, 1843]; The Mother's Primer [1844]; Peveril of the Peak [Walter Scott 1846]; Frontispiece to Moore's Irish Melodies [1856]; Tennyson [Moxon, 1857].*
Exhib: BI; RA; RBA.
Colls: BM; Burnley; Glasgow; V & AM.
Bibl: F.G. Stephens, *Memorials of WM*, 1867; Chatto & Jackson, *Treatise on Wood Engraving*, 1861, p.598; Anne Rorimer, *Drawings of WM*, V & AM Cat., 1972.

MUNN, George Frederick RBA 1852-1907

American genre and flower painter. He was born at Utica in 1852 and studied under Charles Calverley at the National Academy and at South Kensington. He was elected RBA in 1884 and died in New York on 10 February 1907.

Contrib: *ILN [1891].*
Exhib: RA; RBA; ROI.

MUNNINGS, Sir Alfred PRA 1878-1959

Painter, sculptor and poet. He was born at Mendham, Suffolk on 8 October 1878 and studied at Framlingham School and Norwich School of Art. Munnings' great love of his native county and his knowledge of its life, made him one of the finest painters of the horse since George Stubbs. Although never strictly an illustrator, he began life in poster work at Norwich, designing wrappers for Caley's Chocolates and calendars for Bullard's Brewery. In later life he illustrated his own *An Artist's Life*, 1950. Elected RA in 1925, he was President of the RA from 1944 to 1949.

MURCH, Arthur fl.1871-1881

Black and white artist. He was apparently working in Italy, 1871-73, and Walter Crane says that he was a meticulous man who produced little. His wife was a frequent exhibitor at the Grosvenor Gallery 1880-90.

Contrib: *Dalziel's Bible Gallery [1881].*

MURDOCH, W.G. Burn fl.1882-1919

Painter, lithographer and etcher. He studied at the Antwerp Academy and under Carolus Duran in Paris, then in Madrid, Florence and Naples. He worked in Edinburgh and contributed to *The Evergreen*.

Exhib: G; L; New Gall; RA; RSA.

MURRAY, Sir David RA ARSA PRI 1849-1933

Landscape painter. He was born at Glasgow in 1849 and after studying at the Art School, moved to London and became a very fashionable painter in the tradition of Constable. He was elected ARA in 1891 and RA in 1905 and was President of the RI, 1916-17. He is included here for the illustrations he drew for *The English Illustrated Magazine* in 1887.

Colls: Birkenhead; Glasgow.

MURRAY, Charles Oliver RPE 1842-1924

Painter and etcher. He was born at Denholm in 1842 and was educated at Minto School and at the Edinburgh School of Design and the RSA. He gained medals there for his anatomical studies and drawings from the antique and the National Medallions Queens Prize. He worked as engraver and illustrator for the magazines but later devoted himself entirely to etching and worked on pictures after famous artists. He became RPE on its foundation in 1881 and was a member of the Art Workers Guild. He died 11 December 1924.

Illus: *Spindle Stories [Ascot R. Hope, 1880].*
Contrib: *Golden Hours [1869]; Good Words [1880]; The English Illustrated Magazine [1891-92].*
Exhib: FAS; L; M; RA; RE; RSA.
Colls: BM.

MURRAY, George fl.1883-1922

Painter and decorative designer. He was working in Glasgow in 1883, in London 1899 and 1903 and in Blairgowrie, 1902. A title page design by this artist appears in *The Studio*, Vol.14, 1898, p.71.

Exhib: G; L; RA; RI; RSA.

MURRAY, W. Bazett fl.1871-1890

Illustrator. This artist specialised in social realism and drawings of an industrial nature which are fine studies of the Victorian working class. His work was admired by Vincent Van Gogh during his English years.

Contrib: *The Graphic [1874-76]; ILN [1874-90].*
Exhib: RA, 1871-75.

MURRELL, Claire

Contributing decoration to *The Studio*, Vol.12, 1897, illus.

NAFTEL, Maud ARWS 1856-1890
Flower painter and illustrator. She was born in 1856, the daughter of
the artist Paul Naftel, a family of Guernsey origin. She studied at the
Slade School, then in Paris with Carolus Duran, and became a member
of the SWA in 1886 and was elected ARWS in 1887. She died in
London in 1890.
Publ: *Flowers and How to Paint Them [1886]*.
Exhib: B; FAS; GG; G; L; M; New Gall; RA; RI; RWS; SWA.
Colls: Liverpool.

NAIRN, Mr.
Illustrator contributing drawings of the New Zealand Gold Rush to
The Illustrated London News, 1863. He may be identified as the
father of J.M. Nairn, the New Zealand artist who died at Wellington
on 2 February 1904.

NANCE, Robert Morton fl.1895-1909
Illustrator, painter and ship modeller. He probably studied at the
Herkomer School at Bushey in 1895 and then lived in South Wales,
1903 and at Penzance, 1909 where he was associated with the St. Ives
artists.
Exhib: L; New Gall; RA.
Bibl: *The Studio*, Bk. Illus. Competition, 1897; Vol.14, 1898 pp.257-262, illus.

NANKIVELL, Frank Arthur 1869-
Painter, etcher and comic artist. He was born in Australia in 1869 and
studied in New York, London, Japan and China.
Contrib: *Punch [1903 (figures)]*.
Exhib: FAS, 1930.

NASCHEN, Doria fl.1910-1935
Figure artist and illustrator, working at Stamford Hill, London.
Exhib: RA; ROI.

NASH, Frederick OWS 1782-1856
Painter, watercolourist, lithographer and architectural illustrator. He
was born at Lambeth in 1782 and learned drawing with T. Malton,
Junior, and studied at the RA Schools. He exhibited at the RA from
1800 and began by working as an architectural draughtsman,
occasionally being employed by Sir R. Smirke RA. He contributed to
numerous publications and was one of a number of artists who gained
success by satisfying the early 19th century craving for extreme
accuracy. It was this which won him the post as artist to the Society
of Antiquaries in 1807, made Turner commend him and Ackermann
employ him. Nash was elected a member of the OWS in 1811 and five
years later began a series of foreign sketching tours to Switzerland,
France and Germany, some of the results of which were published. He
made tours in Great Britain, from 1827-41 and was accompanied on
some of them by Peter de Wint. His work becomes more moody in his
later years when he had almost ceased illustration and concentrated
on views of Windsor and Brighton, where he settled and died in 1856.
Illus: *The Collegiate Chapel of St. George at Windsor [1805]; Twelve views of
the Antiquities of London [1805-10]; Picturesque views of the City of Paris and
its Environs [1819-23]*.
Contrib: *Howlett's Views in the County of Lincoln [1802]; Britton's Beauties
of England and Wales [1801-15]; Ackermann's Oxford [1814]; Antiquarian
and Topographical Cabinet [1809]*.
Exhib: RA; RBA; BI; OWS.
Colls: Bradford; Nottingham; V & AM.
Bibl: Martin Hardie, *Watercol. Paint. in Brit.*, Vol.3, 1968 pp.16-17.

NASH, John RA 1893-1977
Artist, flower painter and illustrator. He was born in Kensington in
1893, the brother of Paul Nash (q.v.). He was educated at Wellington
College and on the advice of his brother took no formal art training
and thus developed a very personal style in his interpretation of
nature, both innocent and observant. He served in the Artists Rifles
1916-18 and was appointed an official War Artist in 1918. During the
1920s both brothers were very successful artists, notably in
landscape, where they led a school that sought out a more abstract
direction, based on its colour, structure and massing. Nash's talent as a
comic artist and writer, led him to the field of book illustration which
was having a revival at the time with the Cresset, and Golden
Cockerell presses. Although most of his work post-dates our period,
he is included here as an artist active before 1914. He was elected
ARA in 1940 and RA in 1951; he was a member of the London
Group and was an assistant teacher of Design at the RCA, 1934. A
one man exhibition of his work was held at the RA in 1967.
Illus: *Dressing Gowns and Glue [1919]; Drawings in the Theatre [1919]; The
Nouveau Poor [1921]; Directions to Servants [1925]; Ovid's Elegies and
Epigrams [Sir John Davies, 1925]; Bats in the Belfry [1926]; Catalogue of
Alpine and Herbaceous Plants [1926]; Poisonous Plants [1927]; Celeste
[1930]; The Shepherds Calendar [1930]; Cobbett's Rural Rides [1930]; When
Thou Wast Naked [T.F. Powys, 1931]; The New Flora and Sylva [1931]; One
Hundred and One Ballades [1931]; The Curious Gardener [Jason Hill, 1931];
Flowers and Faces [1935]; Wild Flowers in Britain [1938]; Plants with
Personality [1938]; The Contemplative Gardener [1940]; The Almanack of
Hope [1946]; English Garden Flowers [1948]; The Natural History of Selborne
[1951]; Parnassian Molehill [1953]; The Tranquil Gardener [1958]; The
Guinness Year Book [1959]; Thorntree Meadows [1960]; The Native Garden
[1961]; B.B.C. Book of the Countryside [1963]; The Art of Angling [1965]*.
Contrib: *The Broadside; Rhyme Sheets [Poetry Bookshop]; The Listener
[1933-34 (plant illus.)]*.
Bibl: *JN*, RA Cat., 1967.

NASH, Joseph 1808-1878
Draughtsman and illustrator. He was born at Great Marlow on 17
December 1808 and worked as an assistant to Pugin, who took him to
Paris in 1829 to prepare topographical sketches for *Paris and its
Environs*, 1830. Nash is best remembered however for his large
lithographed books of picturesque architecture which appeared in the
1830s and 1840s and are still regarded as the most accurate views of
medieval houses and castles. Nash's figures in the style of Cattermole,
brought the buildings to life, without detracting from the serious
antiquarianism of the book. He was elected AOWS in 1834 and OWS
in 1842, but his work declined in later years possibly due to illness.
He died at Bayswater on 19 December 1878.
Illus: *Architecture of the Middle Ages [1838]; Mansions of England in the
Olden Time [1839-49]; Views of Windsor Castle [1848]; Scotia Delineata
[Lawson, 1847]; Merrie Days of England [E.A. MacDermott]; Dickenson's
Comprehensive Picture of the Great Exhibition of 1851; Old English Ballads
[1864]*.
Exhib: BI; NWS; OWS; RA.
Colls: Fitzwilliam; Glasgow; Greenwich; Maidstone; V & AM; Witt Photo.

NASH, Joseph, Jnr. RI -1922
Marine and landscape painter and illustrator. He was the son of Joseph
Nash (q.v.) and worked in London from 1859, latterly at Bedford
Park. He undertook some magazine work, mostly shipping subjects
and is the artist of the amusing plate in *The Graphic* 1874, showing
Ruskin's navvies mending the Oxford Road! He was elected RI in
1886 and died in 1922.
Illus: *The Dash For Khartoum [G.A. Henty, 1892]*.
Contrib: *The Graphic [1872-1902]*.
Exhib: B; G; L; M; RA; RHA; RI; ROI.
Bibl: *The Studio*, Winter No., 1923-24, p.27; *Apollo*, 1925, p.126; *The
Connoisseur*, Vol.71, 1925, p.112.

NASH, Paul 1889-1946
Painter, wood engraver, illustrator and theatrical designer. He was
born in London on 11 May 1889, the elder brother of John Nash
(q.v.). He was educated at St. Pauls and studied at Chelsea Polytechnic
and the Slade School, 1909-10. He held his first exhibition of
drawings at the Carfax Gallery in 1911 and followed this with an
exhibition of work jointly with his brother at the Dorien Leigh

Gallery, 1913. Nash enlisted with the Artists Rifles in 1914 and after being transferred to the Hampshire Regiment was wounded at Ypres, 1917 and the same year appointed official War Artist on the Western Front. The war drawings, grey wash studies of tortured landscapes and crabbed humanity were the most significant contribution that Nash made to twentieth century art. The shapes and symbols from this time recur again and again in his later landscape paintings and drawings. An exhibition of the war work was held at the Leicester Galleries in 1918 and another was held in 1924. Nash was a member of the London Group, the Modern English Watercolour Society and the Society of Wood Engravers and founded a group of imaginative painters called 'Unit One'. He was author of *Room and Book,* a series of essays on decoration, published in 1932 and he died in July 1946.

Illus: *Loyalties [John Drinkwater, 1918]; Images of War [Richard Aldington, 1919]; Places, Prose Poems and Wood-Engravings [1922]; Genesis [12 engravings on wood, 1924]; Urn Burial [Sir Thomas Browne]; Abd-er-Rahman [Jules Tellier, 1928]; The Seven Pillars of Wisdom [T.E. Lawrence].*
Contrib: *The Graphic [1918]; The Broadside; Rhymesheets [The Poetry Bookshop].*
Exhib: FAS; L; M; NEA; P; RSA; RSW.
Bibl: *Poet and Painter,* Oxford, 1955, edited by Abbott and Bertram.

NASH, Thomas
Illustrator working for *The Broadway,* 1867-74.

NASMYTH, Alexander 1758-1840
Portrait and landscape painter. He was born at Edinburgh on 9 September 1758 and after becoming a pupil of Allan Ramsay, he worked in London and studied at Rome 1782-84. On his return to Edinburgh, he established a wide reputation for soft and sensitive oil landscapes in the manner of Claude. Nasmyth ran art classes in his house and five of his daughters and one son became distinguished artists. He died at Edinburgh on 10 April 1840.

Illus: *The Border Antiquities of England and Scotland [Walter Scott, 1817].*
Exhib: BI; RA; RBA.
Colls: Bristol; Edinburgh; Glasgow; Mellon; Nottingham.
Bibl: Peter Johnson, *The N Family of Painters.*

NAST, J. 1840-1902
American caricaturist. He was born at Landau on 27 September 1840 of American parentage, but left with his parents for the United States and settled with them in New York. He began his career as an artist for various American magazines but came to England in 1860 for *The New York Illustrated Newspaper* to cover the boxers Heeman and Sayers. A man who clearly preferred action to the newspaper office, Nast enlisted with Garibaldi and became a Special Artist to English, French and American magazines during the Italian campaign. On his return to the United States in 1861, he fought in the American Civil War with distinction and became the leading cartoonist of his generation, noted for the power of his images and his draughtsmanship. He died at Guayaquil on 7 December 1902.

Contrib: *The Illustrated Times [1860]; The Illustrated London News [1860-61]; Vanity Fair [1872].*
Bibl: A.B. Paine, *N His Period and His Pictures,* 1905; *American Art Journal,* Vol.4, 1903 p.143; T. Nast St Hill, *N Cartoons and Illustrations,* Dover, 1974.

NATTES, John Claude c.1765-1822
Topographer and drawing master. He was born in England in about 1765 and studied under Hugh P. Dean and was a founder member of the OWS in 1804, but was expelled in 1807 for exhibiting other artists' works under his own name. He travelled to Italy and the South of France in 1820-22 and specialised in Italian landscapes and topographical views. He died in London in 1822.

Illus: *Scotia Depicta [1801-04]; Hibernia Depicta [1802]; Bath and its Environs Illustrated [1804-05]; Versailles, Paris and Saint Denis [1810, AT 103]; Select Views of Bath, Bristol [1805].*
Exhib: RA, 1782-1814.
Colls: Barnsley; BM; Leeds; Lincoln; V & AM.
Bibl: Hardie, *Watercol. Paint. in Brit.,* 1967 Vol.2, pp.133-134 illus.

NEALE, Adam
Amateur artist who illustrated his own *Travels Through Germany, Poland, Moldavia and Turkey,* 1818, AT 19.

NEALE, Edward fl.1880-1899
Animal and bird artist and illustrator. Worked in London and contributed to *The Illustrated London News,* 1899.
Exhib: B; L; RA.

NEALE, John Preston 1780-1847
Architectural and topographical illustrator. He was born in 1780 and after working in the Post Office, turned to draughtsmanship and became one of the leading topographers of the gothic revival. His pen drawings which were exceptional for their accuracy, were often in monochrome washes and were used for numerous books as well as those published under his own name. He died at Tattingstone on 14 November 1847.

Illus: *The History and Antiquities of the Abbey Church of Westminster [1818]; The Seats of Noblemen and Gentlemen [1818-29]; Views of the Most Interesting Collegiate and Parochial Churches of Great Britain [1824-25].*
Contrib: *Britton's Beauties of England and Wales [1808-16]; London and Middlesex [Brayley]; Jones's Views [1829-31].*
Exhib: BI; OWS; RA; RBA.
Colls: Ashmolean; BM; Nottingham; V & AM.
Bibl: Iolo Williams, *Early English Watercols.,* 1952, p.225, illus.

NEIL, H. See O'NEILL, Hugh

NEILSON, Harry B. fl.1895-1901
Illustrator of comic animal subjects. He worked at Claughton, Cheshire and published books for children which *The Studio* called 'wild and domesticated beasts disporting themselves in human garb', Vol.12.

Illus: *Micky Magee's Menagerie [1897]; Droll Days [1901].*
Contrib: *The Sketch; Cassell's Family Magazine.*
Exhib: L.

NELSON, Harold Edward Hughes 1871-
Artist, illustrator and designer of bookplates. He was born at Dorchester on 22 May 1871 and studied at the Lambeth School of Art and the Central School of Arts and Crafts, London. Nelson made a speciality of medieval illustrations with elaborate borders and was particularly accomplished as a decorator of books. He was influenced by the books of Morris and by the Pre-Raphaelites, but made his mark as a designer of bookplates. He was also an early designer of Cadbury's advertisements.

Publ: *25 Designs by HN [Edinburgh, 1904].*
Illus: *Undine and Aslauga's Knight [F.H.C. de la Motte Fouqué, 1901]; Early English Prose Romances [W.J. Thomas, 1904].*
Contrib: *The Graphic [1915]; The Sphere; The Queen; Ladies Field; Royal Academy Pictures [cover, 1908]; Old Colleges of Oxford [Aymer Vallance, 1912 (frontis)].*
Exhib: L; RA; RI; RMS.
Bibl: H.W. Fincham, *Art of the Bookplate,* 1897; C.P. Horning, *Bookplates by HN,* New York, 1929; B. Peppin, *Fantasy Book Illustration 1860-1920,* 1975, p.189; *The Studio,* Vol.7, 1896, p.93; Vol.8 1896, p.226; Vol.24, 1902, p.63; Vol.63, 1915, p.148; Vol.73, 1918, p.67; Vol.81, 1921, p.19; Vol.83, 1922, p.96.

NESBIT, Charlton 1775-1838
Illustrator and wood engraver. He was born at Swalewell in 1775 and became a pupil for four years of Beilby and Thomas Bewick (q.v.), working on his *British Birds.* He began painting in about 1795 and established himself in London in 1799, where he gained a reputation for book illustrations. He died there in 1838.

Illus: *Shakespeare's Works; The Works of Sir Egerton Bridges; Hudibras; Ackermann's Religious Emblems [1809]; Northcote's Fables [1828-33].*
Colls: BM; Witt Photo.

NESBITT, Frances E. fl.1864-1934
Landscape, figure and marine painter. She was elected ASWA in 1899 and illustrated her own *Algeria and Tunis* for Messrs. Black in about 1905.

Exhib: L; New Gall; RA; RBA; RHA; RI; ROI; SWA.

NESFIELD, William Eden **1835-1888**

Architect and artist. He was the son of the artist William Andrews Nesfield and was closely associated with Richard Norman Shaw in the development of the romantic Victorian country house. He illustrated his own *Specimens of Medieval Architecture Chiefly Selected From Examples of the 12th and 13th Centuries in France and Italy*, 1862.

NETTLESHIP, John Trivett **1847-1902**

Animal painter, illustrator and author. He was born at Kettering on 11 February 1841 and was educated at Durham School before joining the staff of his father's law firm. He abandoned this career for art and studied at Heatherley's and the Slade School, working as an illustrator in pen and ink and making drawings in the Zoological Gardens. He visited India in 1880-81, but made his reputation from expressive paintings of animals in the style of Delacroix. He died in London on 31 August 1902, having been elected ROI in 1894.

Publ: *Robert Browning Essays and Thoughts [1890]; George Morland [1898].*
Illus: *An Epic of Women [A.W.E. O'Shaughnessy, 1870]; Emblems [Mrs. A. Cholomondeley, 1875]; Natural History Sketches Among the Carnivora [1885]; Ice-bound on Kolguev [A.R. Battye, 1895].*
Contrib: *The Boys' Own Paper.*
Exhib: G; L; M; New Gall; RA; RHA; RI; ROI.
Colls: Ashmolean.
Bibl: *The Magazine of Art,* 1903 pp.75, 79; *The AJ,* 1907, p.251.

NEW, Edmund Hort **1871-1931**

Landscape painter, architect and illustrator. He was born in Evesham in 1871, the son of a solicitor and was educated at Prince Henry's School, Evesham and at the Birmingham Municipal School of Art under E.R. Taylor and A.J. Gaskin (q.v.) 1886-95. New taught at a branch school of the School of Art and became well-known in the Midlands, spending much of his working life in Oxford. His black and white illustrations are characteristic of Birmingham, cleanly drawn in the woodcut style with large foregrounds and meticulous care in the delineation of each building and its materials. New was a member of the Art Workers Guild, was elected Hon. ARIBA, and died at Oxford on 3 February 1931.

Illus: *The Gypsy Road [Cole, 1894]; In the Garden of Peace [1896]; The Compleat Angler [1896]; The Vale of Arden [Alfred Hayes, 1896 (title and cover)]; White Wampum [Pauline Johnson, 1896 (title and cover)]; Oxford and Its Colleges [1897]; Cambridge and Its Colleges [1898]; Shakespeare's Country [1899]; Pickwick Papers [1899]; The Life of William Morris [1899]; The Natural History of Selborne [1900]; Westminster Abbey [1900]; Oliver Twist [1900]; Outside the Garden [1900]; Sussex [1900]; The Malvern Country [Windle, 1901]; The Wessex of Thomas Hardy; Some Impressions of Oxford [1901]; Haunts of Ancient Peace [1902]; Wren's Parentalia [1903]; Chester [1903]; Evesham [1904]; [Temple Topographies series, College Monographs series]; The Scholar Gypsy and Thyrsis [1906]; Poems of Wordsworth [1907]; Berkshire [1911]; Coleridge and Wordsworth in the West Country [Professor Knight, 1913]; Highways and Byways in Shakespeare's Country [1914]; Cranford [1914]; The New Loggan Guides to Oxford Colleges [1907-25, issued together 1932]; Prints issued of: The Towers of Oxford [1908]; High Street, Oxford [1912]; Firenze [1914]; The City and Port of London [1920].*
Contrib: *The English Illustrated Magazine [1891-92]; The Quest [1894-96]; Daily Chronicle [1895]; The Yellow Book [1896]; The Pall Mall Magazine.*
Exhib: B; FAS; RA.
Colls: Birmingham; V & AM.
Bibl: R.E.D. Sketchley, *Eng. Bk. Illus.,* 1903, pp.10, 38, 50, 136; *Modern Book Illustrators and Their Work,* Studio, 1914.
See illustration (right).

NEWCOMBE, Bertha **fl.1880-1908**

Landscape, figure and flower painter and illustrator. She worked in London and at Croydon and was elected NEA in 1888. She contributed illustrations of church and village life to *The English Illustrated Magazine,* 1895-97.

Exhib: FAS; L; M; NEA; RA; RBA; RI; ROI; SWA.

NEWELL, Rev. Robert Hassell **1778-1852**

Amateur artist and illustrator. He was born in Essex in 1778 and after being educated at Colchester and St. John's College, Cambridge where he was admitted Fellow in 1800, he became Rector of Little Hormead, Hertfordshire in 1813. He studied with W.H. Payne (q.v.) and illustrated his own works.

NEWHOUSE, C.B. **fl.1834-1845**

Artist and traveller. He illustrated his own *Scenes On The Road,* 1834-35. 18 aquatints, AL 406, and *Roadster's Album,* 1845, 17 aquatints, AL 407.

NEWILL, Mary J. **fl.1884-1925**

Black and white artist, illustrator and embroiderer. She studied at the Birmingham School of Art and worked in Edgbaston, basing many of her designs on the Morris style. She was particularly imaginative in her renderings of wood and foilage and *The Studio* in 1897 referred to her trees having 'the strength of those by a little master of Germany'.

Illus: *A Book of Nursery Songs and Rhymes [1895].*
Contrib: *The Quest [1894-96]; The Yellow Book [1896].*
Exhib: B; FAS.
Bibl: *The Studio,* Vol.5, 1895, p.56, illus; Vol.10, 1897, p.232.

NEWMAN, William **fl.1842-1864**

Comic artist. A friend of Ebenezer Landells (q.v.), he was much employed on *Punch* in the period, 1846-50. A talented humorist he was most versatile in small comic cuts in the manner of Tom Hood, but was rather despised for his coarse manners by the *Punch* Table and was poorly paid. He is believed to have emigrated to the United States in the early 60s.

Contrib: *The Squib [1842]; Puppet Show; Diogenes; Comic News [1864].*
Bibl: M.H. Spielmann, *The History of Punch,* 1894, pp.413-414.

EDMUND HORT NEW 1871-1931. 'Stanstead Abbots.' Illustration for The Yellow Book, *1896.*

NEWTON, Gilbert Stuart RA **1795-1835**

Painter and illustrator. He was born at Halifax, Nova Scotia in 1795 and began studies with his maternal uncle Gilbert Stuart, the American portrait painter at an early age. He visited Italy in 1817, and after spending some time in Paris, settled in London and studied at

the RA Schools, concentrating on painting in the style of Watteau. Newton had some success in painting genre and historical subjects and was patronised by the 6th Duke of Bedford. He was a friend of Washington Irving and died on 5 August 1835, having been insane since 1833. He was elected ARA in 1828 and RA in 1832.

Contrib: *The Literary Souvenir* [1826].
Exhib: BI; RA.
Colls: V & AM.

NEWTON, Richard 1777-1798
Caricaturist and miniaturist working in the manner of Gillray.

Illus: *Sentimental Journey* [Sterne, 1795, AL 250].
Colls: BM.

NIBBS, Richard Henry 1816-1893
Musician and painter. He was born in London in 1816 and worked principally in London with a studio in Brighton, settling permanently there after 1841. He travelled on the Continent and illustrated his own publications.

Publ: *Marine Sketch Book of Shipping Craft and Coast Scenes* [1850]; *The Churches of Sussex* [1851]; *Antiquities of Sussex* [1874].
Exhib: BI; L; RA; RBA.
Colls: BM; Brighton; Greenwich; V & AM.

NIBLETT, F.D. fl.1882-1884
Illustrator working at Edinburgh. He illustrated *Dulcima's Doom and Other Tales* by Willis, c.1880.

Exhib: RSA.

NICHOLL, Andrew RHA 1804-1886
Landscape painter. He was born in Belfast in 1804 and trained with a printer on the newspaper *The Northern Whig*. He was self-taught as an artist and worked in London, Dublin and Belfast, being elected ARHA in 1832 and RHA in 1837; he taught art in Ceylon during 1846, having previously illustrated S.C. Hall's *Ireland its Scenery and Character*, 1841. He died in London in 1886.

Contrib: *The Illustrated London News* [1851].
Colls: BM; V & AM.

NICHOLSON, George c.1795-c.1839
Topographer, working in Liverpool with his elder brother Samuel Nicholson. He published *Twenty-six Lithographic Drawings in the Vicinity of Liverpool*, 1821; *Plas Newydd and Vale Crucis Abbey*, 1824. He exhibited at Liverpool, 1827-38.

NICHOLSON, J.B.R. fl.c.1815
Illustrator. A series of watercolour drawings of soldiers and bandsmen one showing Edinburgh Castle, signed and dated by this artist 1815, were sold at Sotheby's in November 1976.

NICHOLSON, Thomas Henry -1870
Draughtsman, illustrator, engraver and sculptor. Nicholson worked in London and excelled in equestrian subjects, some of which he modelled in plaster, teaching the technique to Count Alfred d'Orsay. He was the principal artist for *Cassell's Illustrated Family Paper*, 1853-57 and worked for other magazines. Much of his work is busy and mannered in the style of H.K. Browne (q.v.). He died at Portland in 1870.

Illus: *Faces in the Fire* [1850]; *Works of Shakespeare* [n.d.].
Contrib: *ILN* [1848]; *The Illustrated Times* [1855-59].

NICHOLSON, William RSA 1781-1844
Portrait painter and etcher. He was born at Ovingham-on-Tyne in 1781 and after working in Newcastle, moved from there to Edinburgh in 1814. He was a Founder Member of the RSA and was its Secretary from 1826 to 1830. He published *Portraits of Distinguished Living Characters*, 1818.

Colls: Edinburgh; Newcastle.

NICHOLSON, Sir William 1872-1949
Painter and illustrator. He was born at Newark-on-Trent in 1872, the son of W.N. Nicholson MP. He studied at Julian's, Paris, and from about 1894, collaborated with his brother-in-law James Pryde (q.v.), on a series of posters and illustrated books. Their style was based on the French poster which they admired in the hands of Toulouse Lautrec and others and the designs were most different from contemporary work in their careful lettering and effects gained by massing of the shadows and bold outlines. The artists became known as 'The Beggarstaff Brothers' and their work, which was mostly in woodcut coloured by hand and then lithographed, became widely influential. The books produced were designed as a whole and have very little text, the lay-out and the squared illustrations give them the freedom and charm of the early chapbooks which both 'Brothers' had come to admire. After 1900, Nicholson's contributions to illustrations were spasmodic although he carried out a certain amount of it in the 1920s. His later career was almost entirely devoted to portrait painting. Nicholson was elected RP in 1909 and was knighted in 1936. He died in 1949.

Illus: *Tony Drum* [1898]; *An Alphabet* [1898]; *An Almanac of Twelve Sports* [R. Kipling, 1898]; *London Types* [W.E. Henley, 1898]; *The Square Book of Animals* [Arthur Waugh, 1899]; *Characters of Romance* [1900]; *Moss and Feather* [W.H. Davies, Ariel Poem, 1928]; *Memoirs of a Fox-Hunting Man* [Siegfried Sassoon, 1929]; *The Pirate Twins* [n.d.]; *Time Remembered* [Lady Horner, 1930 (end papers)].
Exhib: FAS; GG; G; L; M; NEA; P; RHA; ROI; RSA; RSW.
Colls: Fitzwilliam; Tate; V & AM.
Bibl: *The Idler*, Vol.8, pp.519-528, illus; *The Studio*, Vol.12, 1898, pp.177-183; Marguerite Steen, *WN*.

See illustrations (below and p.401).

Mr Vanslyperken.

SIR WILLIAM NICHOLSON 1872-1949. 'Mr. Vanslyperken.' Illustration to Characters of Romance, *Heinemann, 1900. Lithograph.*

NICKSON, Fred J. fl.1902-1903
Black and white figure artist contributing social subjects to *Punch* 1902-03.

SIR WILLIAM NICHOLSON 1872-1949. 'A Fisher.' Illustration for The Dome, *1897. Colour woodcut from four blocks.*

NICOL, Erskine ARA RSA 1825-1904
Painter of Irish genre subjects. He was born at Leith in 1825 and trained at the Trustees Academy at the age of twelve after being apprenticed to a house-painter. He worked as a drawing-master at Leith before moving to Dublin in 1846, where he began to gain a reputation for Irish peasant scenes. Although settling in London, he continued to make visits to Ireland; he was elected RSA in 1859 and ARA in 1868. He died at Feltham on 8 March 1904.

Illus: *Tales of Irish Life and Character [A.M. Hall, 1909]; Irish Life and Humour [W. Harvey, 1909].*
Contrib: *Good Words [1860].*
Exhib: G; RA; RSA.
Colls: BM; Edinburgh; Sheffield; Tate; V & AM.

NICOL, John Watson ROI 1856-1926
Genre painter and illustrator. He was born in 1856, the son of Erskine Nicol ARA (q.v.). He worked in Scotland and France as well as in London and was elected ROI in 1888.

Contrib: *Good Words [1890]; Black & White [1896].*
Exhib: B; G; L; M; RA; ROI; RSA.

NIELSEN, Kay 1886-1957
Illustrator and designer for the theatre. He was born at Copenhagen on 12 March 1886 and was a pupil of L. Find, before studying at Julian's in Paris and at Colarossi's, 1904-11. Nielsen worked in London from 1911 until 1916 which accounts for his inclusion here, it was an intensive period of work and he was strongly influenced by Aubrey Beardsley. In general Nielsen is a brilliant colourist and a highly decorative illustrator, his works formed into frieze-like patterns, are closest to Persian or Middle Eastern designs and therefore akin to Leon Bakst or Edmund Dulac (q.v.). He uses stippling effects and elaborate rococo motifs which are reminiscent of Beardsley, but also the swirling lines of Vernon Hill (q.v.) and the more sculptural lines of incipient art deco. Nielsen held a big exhibition in New York in 1917 and after acting as stage designer to the Theatre Royal, Copenhagen, 1918-22, he emigrated to the United States, living in California from 1939 and designing for the Hollywood companies. He died there in 1957.

Illus: *In Powder and Crinoline [A. Quiller Couch, 1912]; East of the Sun, West of the Moon [Asbjornsen and Moe, 1914]; Old Tales From The North [1919]; Fairy Tales by Hans Andersen [1924]; Hansel and Gretel [1925]; Red Magic [Romer Wilson, 1930].*
Contrib: *ILN [1912-13 (Christmas)].*
Exhib: Dowdeswell Gall., 1912; Leicester Gall., 1914.
Colls: V & AM.
Bibl: Marion Hepworth Dixon, 'The Drawings of KN', *The Studio*, Vol.60, 1914; B. Peppin, *Fantasy Book Illustration 1860-1920*, 1975, p.189 illus.; Keith Nicholson, *Introduction to KN*, Coronet Books, 1975.
See illustration (p.402)

NINHAM, Henry 1793-1874
Watercolourist and engraver. He was born at Norwich in 1793 the son of an heraldic artist and engraver. He was a topographical artist, specialising in street scenes and was a member of the Norwich School and friendly with J.S. Cotman. He died in the city in 1874.

Publ: *8 Original Etchings of Picturesque Antiquities of Norwich [1842]; Views of the Gates of Norwich made in 1792-93 by the late John Ninham [1861]; 23 Views of the Ancient City Gates of Norwich [1864]; Remnants of Antiquity in Norwich, Views of Norwich and Norfolk [1875]; Norwich Corporation Pageantry.*
Illus: *Castle Acre [Blome]; Eastern Arboretum [Grigor, 1841].*
Colls: BM; Norwich; V & AM.

NISBET, Hume 1849-1923
Painter and author, illustrator. He was born in Stirling on 8 August 1849 and studied art under Sam Bough RSA. At the age of sixteen he began to travel and spent seven years exploring Australia, being appointed on his return, Art Master at the Watt College and Old Schools of Art, Edinburgh. He resigned the post in 1885, when he was sent by Cassell & Co. to Australia and New Guinea, 1886; visited China and Japan, 1905-06. He concentrated on his work as novelist in the latter part of his life and died at Eastbourne in 1923.

Illus: *Her Loving Slave [1894]; A Sappho of Green Springs [Brett Harte, 1897]; The Fossicker [Ernest Glanville, 1897].*
Contrib: *The English Illustrated Magazine [1890-91 (ornament)].*
Exhib: G; RA; RBA; RHA; RSA.

NIXON, J. Forbes fl.1864-1867
Still-life painter working at Tonbridge. He designed the cover for *The Young Gentleman's Magazine*, 1867.

Exhib: RBA.

NIXON, James Henry fl.1830-1847
History painter and expert on heraldry. He was born in about 1808 and became a pupil of John Martin (q.v.).

Illus: *The Eglinton Tournament [Rev. J. Richardson, 1843, AL 388].*
Contrib: *Scott's Works [1834].*
Exhib: BI; RA; RBA.
Colls: Witt Photo.

NIXON, John c.1750-1818
Landscape painter and amateur caricaturist. He was born about 1750 and carried on the business of merchant in Basinghall Street, befriending many artists and going on sketching tours with some of them. Nixon had business connections with Ireland and visited the island frequently in the 1780s and 1790s, once in 1791 in company with Captain Grose, the antiquary. Some of his drawings were used in *Watt's Seats*, 1779-1786 and he visited the Continent in 1783-84 and in 1802 and 1804, when he was at Paris. Nixon was at Bath with Thomas Rowlandson (q.v.) in 1792 and a drawing of the Abbey by him, sold at Christie's in March 1974, shows strong similarities to this artist in pen outlines. Although Nixon remained a coarse draughtsman compared with Rowlandson, he has something of his bravura and sense of the grotesque and his best works are datable from this contact to the period after 1800. Nixon was Secretary to The Beefsteak Club and a member of the Margravine of Anspach's circle at Brandenburg House in Hammersmith. He died in 1818.

Contrib: *European Magazine; Journey from London to The Isle of Wight [Thomas Pennant, 1801]; Guide to The Watering Places [1803].*
Exhib: RA, 1781-1815.
Colls: BM; V & AM; Witt Photo.
Bibl: H. Angelo, *Reminiscences*, 1830.

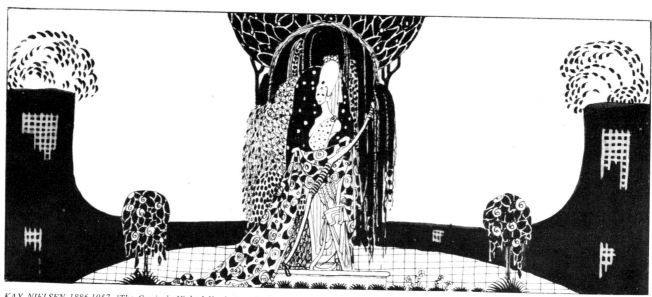

KAY NIELSEN 1886-1957. 'The Czarina's Violet.' Head piece for In Powder and Crinoline *by Sir Arthur Quiller-Couch, 1913. Pen and ink. 2³/4ins. x 6⁵/8ins. (7cm x 16.8cm).*
Victoria and Albert Museum

NOBLE, John Edwin RBA FZS 1876-
Animal painter and illustrator. He was born in 1876, the son of John Noble RBA 1848-96 and studied at the Slade, Lambeth and RA Schools. He worked in London and Surrey and at Milford on Sea, Hants from 1922; he was elected RBA in 1907 and FZS in 1908.
Bibl: *The Studio,* Vol.14, 1898, p.145, illus.

NORBURY, Edwin Arthur RCA 1849-1918
Painter and illustrator. He was born in Liverpool in 1849, the son of Richard Norbury, RCA. He was educated at Dr. Wand's School, Liverpool and at the age of fifteen began sending contributions to *The Illustrated London News* and *Illustrated Times,* later joining *The Graphic* as artist correspondent. He lived in North Wales 1875-90 and went to Siam in 1892 to teach at the Royal School of Arts and while there acted as *Graphic* Special Artist during the Franco-Siamese War, 1893. He was a Founder Member of the Royal Cambrian Academy and ran his own Norbury Sketching School and St James' Life School in Chelsea. He was Principal of the Henry Blackburn Studio and died in London, 16 October 1918.
Illus: *The Kingdom of the Yellow Robe [Ernest Young, 1898]; The Arabian Nights Entertainments [1899]; Animal Arts and Crafts.*
Exhib: L; M; RA; RCA; RHA; RI; ROI.

NORIE, Orlando 1832-1901
Military artist and illustrator. He belonged to a celebrated family of Edinburgh artists but worked in London and Aldershot where he kept a studio. He is notable for his great accuracy in depicting uniforms and military customs, but is not a particularly imaginative painter.
Illus: *The Memoirs of the 10th Royal Hussars [R.S. Liddell, 1891].*
Exhib: NWS; RA.
Colls: India Office Lib.; Nat. Army Mus.; V & AM; Royal Collection.

NORMAN, Philip FSA c.1843-1931
Draughtsman and antiquary. He was born at Bromley Common in about 1843, the son of a Director of the Bank of England and was educated at Eton and studied at the Slade School. Norman devoted his life to the study of old London buildings and made many hundreds of pencil drawings of its old courts and alleys during the last quarter of the 19th century. They are reliable records of vanished architecture, but not strong drawings, he was a rather weak figure draughtsman. A collection of these was presented to the Victoria and Albert Museum by the artist and an *Annotated Catalogue of Drawings of Old London* by the artist, was issued by the museum in 1900. He died in London 17 May 1931.
Publ: *The Inns of Old Southwark [1888 (with W. Rendle)]; Cromwell House, Highgate [1917].*
Illus: *London Signs and Inscriptions [1893]; Modern History of The City of London [C. Welch, 1903].*
Contrib: *The English Illustrated Magazine [1890-92 (taverns)].*
Exhib: L; M; NEA; New Gall; RA; RBA; RI; ROI.
Colls: V & AM.

NORMAND, B.
Artist contributing illustrations of Italy to *The Illustrated London News,* 1847.

NORRIS, Arthur 1888-
Landscape painter and teacher. He was born in 1888, the son of William Foxley Norris, Dean of Westminster, and studied at the Slade School, 1907-10. He contributed figure subjects to *Punch* in 1909 and 1914.
Exhib: FAS; NEA; P; RA.

NORRIS, Charles 1779-1858
Architectural draughtsman and amateur engraver. He was born at Marylebone in 1779, and though from a wealthy family became an orphan at an early age. He was educated at Eton and Christ Church, Oxford, before serving in the Army. After his marriage, Norris concentrated on the arts and made ambitious plans to publish antiquarian and picturesque views, teaching himself engraving in the process. He settled at Tenby in 1810 and died there in 1858.
Illus: *The Architectural Antiquities of Wales [1810]; Saint David's in a Series of Engravings [1811]; Etchings of Tenby [1812]; An Historical Account of Tenby [1818].*
Bibl: A.L. Leach *CN,* 1949.

NORTH, Lady Georgina 1798-1835

Amateur figure artist and illustrator. She was born in 1798, the third daughter of the 3rd Earl of Guilford and his second wife, Susannah Coutts. Since the appearance of some of this artists watercolours on the market in 1973, she has emerged as one of the most accomplished amateurs, working in the style of Fuseli. An illustration to *The Rape of The Lock*, dated 1831 was published and this together with a drawing of 'The Infancy of Wellington' are in an American private collection. She died unmarried on 25 August 1835.

NORTH, John William ARA RWS 1842-1924

Landscape painter, watercolourist and illustrator. He was born on the outskirts of London in 1842 and was apprenticed to J.W. Whymper's wood engraving workshop where he came into contact with Fred Walker and G.J. Pinwell (qq.v.). From 1862-66, North did a great deal of work for the Dalziel Brothers, and illustrated their *Wayside Poesies* 1867 and other books. North was a close friend of Fred Walker and they went on sketching tours together, Walker finding his subjects in the country folk and North in the landscapes. His work represents the best landscape work of the 1860s, a broad treatment of the countryside, superb detail showing up in the foreground, but as Reid has pointed out 'in his own day his work never attained popularity, and was underrated even by his fellow-artists'. North moved to Somerset in 1868 and the Halsway and Withycombe areas were to provide frequent subjects for his drawings. He was elected AOWS in 1871, RWS in 1883 and ARA in 1893. The later years of his life were spent in patenting and marketing a special watercolour paper which greatly impoverished him. He died at Washford on 20 December 1924.

Illus: *English Sacred Poetry of the Olden Time [1864]; Our Life Illustrated by Pen and Pencil [1864]; A Round of Days [1865]; The Sunday Magazine [1865-67]; Good Words [1866]; Once a Week [1866-67]; Touches of Nature by Eminent Artists [1866]; Longfellow's Poems [1866]; Poems by Jean Ingelow [1867]; Wayside Poesies [1867]; The Spirit of Praise [1867]; The Months Illustrated with Pen and Pencil [n.d.]; The Illustrated Book of Sacred Poems.*
Contrib: *The English Illustrated Magazine [1887].*
Exhib: B; FAS; GG; G; L; M; New Gall; RA; RHA; RSW; RWS.

Colls: Ashmolean; BM; Bristol; V & AM.
Bibl: Gleeson White, *English Illustration The Sixties*, 1906; Forrest Reid, *Illustrators of the Sixties*, 1928, pp.163-165; Martin Hardie, *Watercol. Paint. in Brit.*, Vol.3, 1968, pp.137-138; *Country Life*, 18 August 1977, 'A Somerset Draw For Painters' by R.M. Billingham.

NORTHCOTE, James RA 1746-1831

Painter and author. He was born in Plymouth in 1746, and was apprenticed to a watchmaker, before going to London in 1771 and being patronised by Sir Joshua Reynold's, whose assistant he became. He studied at the RA Schools and after a brief return to Plymouth, left for Italy in 1777 where he copied the old masters and particularly the works of Michaelangelo, Raphael and Titian. He returned to London in 1780 and became a successful portrait painter, contributing illustrations to various works. He was elected ARA in 1786 and RA in 1787. At the end of his career, Northcote devoted himself to animal painting and to writing, he published a standard life of Sir Joshua Reynolds in 1813 and his *Conversations* were published by William Hazlitt in 1830. In 1828, he produced an edition of *One Hundred Fables*, illustrated by himself, which includes 280 wood engravings of animal and landscape subjects which have almost the charm and romance of Bewick about them.

Contrib: *Boydell's Shakespeare [1792].*
Exhib: BI; RA; RBA.
Colls: Witt Photo; NPG; V & AM.
See illustration (below).

NORTON, Eardley B. fl.1895-1902

Caricaturist. He was working in London and contributed two cartoons to *Vanity Fair*, 1895 and 1902. Signs: E.B.N.

NORTON, Val fl.1902-1905

Contributor of figure subjects to *Punch*, 1902-05.

NYE, Herbert fl.1885-1927

Painter and sculptor. He was working at Walton on Thames, 1895-1902 and at Pulborough, 1923. He made nine etchings for Garnett's edition of *Vathek* by William Beckford, 1893.

Exhib: L; RA; RI; ROI.

JAMES NORTHCOTE RA 1746-1831. Vignette illustration for One Hundred Fables, *1878. Wood engraving.*

OAKES, John Wright ARA HRSA — 1820-1887
Landscape painter. He was born at Sproston House, Middlewich, Cheshire on 9 July 1820 and was educated at Liverpool College and at the Mechanics Institute under W.J. Bishop. Oakes concentrated on fruit paintings in the early part of his career but after 1843, worked with landscapes, especially the scenery of Wales, Scotland and Devon. He moved to London in 1859 and was elected ARA in 1876 and Hon. RSA in 1883. He was Secretary of the Liverpool Academy from 1839, and died in London on 8 July 1887.

Contrib: *Passages From The Modern English Poets [Junior Etching Club, 1862 and 1876].*
Exhib: BI; L; NWS; RA; RBA.
Colls: Birkenhead; V & AM.

OAKLEY, William Harold — fl.1887-1925
Architect and illustrator. He practised in Maiden Lane, Strand, 1881-88 and was still active in 1925. He contributed architectural drawings to *The English Illustrated Magazine*, 1887-92 and to *The Strand Magazine*, 1891.

ODLE, Alan Elsden — 1888-1948
Illustrator, black and white artist and caricaturist. He was born in 1888 and studied at the Sidney Cooper School of Art, Canterbury and at the St John's Wood Art School. Odle specialised in Black Comedy subjects and in the grotesque, his drawings are often in chalk or black ink and show crowded and tortured scenes of revelry, with a strong sinister element derived from Beardsley. He apparently sold few of his drawings in his lifetime and illustrated few books for an artist with so powerful and individual a vision. Two sales of his work, much of it unused, at Sotheby's in April and November 1976 have helped to put his art into perspective. He was married to the novelist Dorothy Richardson, and died in 1948.

Illus: *Candide [Voltaire, 1925]; The Mimiambs of Herondas [trans by Jack Lindsay, Fanfrolico Press, 1926].*
Contrib: *The Gypsy [1915]; The Golden Hind.*
Exhib: RSA.
Colls: Author; V & AM.
Bibl: John Rosenberg, *The Genius They Forgot*, 1973; *Drawing and Design*, Vol.5, July 1925, p.40; *The Studio*, Vols.89, 95.
See illustration (Colour Plate XIV p.192).

OFFORD, John James — fl.1860-1886
Figure painter and illustrator. He contributed drawings to *The Illustrated London News*, 1860.

Exhib: RA, 1886.

OGDEN, H.A. — 1856-
American illustrator. He was born at Philadelphia on 17 July 1856 and was a pupil of the Art Students League of New York. He specialised in military and historical subjects and contributed to *The Illustrated London News*, 1885.

OLIPHANT, Laurence — 1829-1888
Artist and war correspondent, traveller. He was born at Capetown in 1829 and travelled with his parents throughout Europe, 1846-48. He practised as a barrister in Ceylon and was secretary to Lord Elgin at Washington and in Canada, 1853-54. He represented *The Times* in Circassia, accompanied Lord Elgin to China, 1857-59 and worked with Garibaldi in Italy, 1860-61. He was *Times* correspondent again in the Franco-Prussian War of 1870 and was MP for Stirling, 1865-67. Oliphant was a contributor to *The Owl* and was associated with the spiritual teachings of T.L. Harris. He died in 1888.

Publ: *Journey to Khatmandhu [1852].*
Illus: *The Russian Shores of the Black Sea [1853, liths., AT 233].*
Contrib: *ILN [1855].*

OLIVER, Lieutenant Samuel P.
Amateur artist and Royal Artillery officer. He contributed to *The Illustrated London News*, 1867.

O'NEILL, Harry — fl.1902-1915
Painter and illustrator. He contributed figure and social subjects to *Punch*, 1902-03.

Exhib. RHA.

O'NEILL, Henry — 1798-1880
Artist and antiquary. He was born at Clonmel in 1798 and in 1815 entered the RDS Schools and worked for a Dublin printseller. He worked as an illustrator before settling in London for some time, but making little success, he returned to Dublin where he became known for his publications. He was elected ARHA in 1837 but resigned in 1844. He died in Dublin in 1880.

Illus: *Picturesque Sketches of some of the Finest Landscapes and Coast Scenery of Ireland [1835 (with Nicholl and Petrie)]; Fourteen Views in the County of Wicklow [1835 (with Nicholl)]; Ireland its Scenery and Character [Hall, 1841]; Descriptive Catalogue of Illustrations of the Fine Arts of Ancient Ireland [1855]; Illustrations of the most interesting of the Sculptured Crosses of Ancient Ireland [1863]; The Round Towers of Ireland, Part 1 [1877].*
Colls: Belfast.

O'NEILL, Hugh — 1784-1824
Topographer and illustrator. He was born in Lascelles Place, Bloomsbury on 26 April 1784, the son of an architect and was patronised by Dr Thomas Monro. He won a Society of Arts silver palette in 1803 and in 1806 applied for the drawing-mastership at the RMC, Great Marlow. He eventually became a drawing-master in Oxford, Edinburgh, Bath and Bristol and died in the latter city on 7 April 1824.

Publ: *Bristol Antiquities [1826, etched by Skelton].*
Contrib: *Britton's Beauties of England and Wales [1801-13]; Antiquarian and Topographical Cabinet [1807]; The Oxford Almanac [1809, 1810, 1811, 1812, 1814].*
Exhib: RA, 1800-04.
Colls: Ashmolean; BM; Manchester; Reading; V & AM.
Bibl: Martin Hardie, *Watercol. Paint. in Brit.*, Vol.3, 1968, p.219.

ONIONS, G. Oliver — 1873-1961
Author and illustrator. He was born in Bradford in 1873 and after studying art, worked as a draughtsman for the Harmsworth Press. He married Bertha Ruck, the novelist and artist. Onions devoted himself entirely to novels from about 1910, winning the Tait Black Memorial Prize in 1947. He died on 9 April 1961.

Contrib: *Lady's Pictoral [1895]; The Quartier Latin [1896]; The Quarto [1897].*

ONSLOW, A.G.
Amateur artist contributing illustration to *Punch*, 1903.

ONWHYN, Thomas — -1886
Illustrator. He was born in London, the youngest son of Joseph Onwyhn a bookseller and publisher of the magazine *The Owl*, 1864. Young Onwyhn produced 21 illegitimate drawings to an edition of *Pickwick Papers*, published by E. Grattan in 1837 and signed 'Sam Weller'. Further pirated examples followed, 40 for *Nicholas Nickleby* issued by Grattan in 1838 and another Pickwick set was begun but not published till 1893 by Albert Jackson. Onwyhn carried Dickens imitation to its logical conclusion by drawing in the manner of H.K. Browne and George Cruikshank (qq.v.). He never adapted to wood engraving and his best work is etched, but even that is rather wooden though he has an eye for the comic. He sometimes etched other people's work as in *Oakleigh* by W.H. Holmes, 1843 and drew for guidebooks and letter heads. He did no illustration for the last thirty years of his life and died on 5 January 1886.

Illus: *Memoirs of Davy Dreamy [1839]; Maxims and Specimens of William Muggins [Selby, 1841]; The Mysteries of Paris [Eugene Sue, 1844]; The Life and Adventures of Valentine Vox [Henry Cockton, 1849]; Etiquette Illustrated by an XMP [1849]; Marriage à la Mode, Mr and Mrs Brown's Visit to the Exhibition [1851]; Peter Palette's Tales and Pictures in Short Words For Young Folks [1856]; 300L a Year Or Single and Married Life [1859].*
Contrib: *Punch [1847-48].*

OPPENHEIM, E. Phillips 1866-1946
Illustrator. He began to work in 1887 and supplied ink drawings for *A Monk of Cruta*, c.1900.

ORCHARDSON, Sir William Quiller 1836-1910
Painter of subject pictures and portraits. He was born in Edinburgh in 1836 and entered the Trustees Academy there in 1850 where he was a fellow student with John Pettie (q.v.). He moved to London in 1863 and exhibited Shakespearean subjects at the RA, but he became increasingly known for his High Life paintings in the 1880s, where great play is made of dramatic figures in a large pictorial space. As a young artist he had undertaken a small amount of illustration for magazines in a competent unremarkable style. He became ARA in 1868, RA in 1877, and was knighted in 1907. He died on 13 April 1910. An exhibition was held at the RA in 1911 and at FAS, 1972.

Contrib: *Good Words [1860-61, 1878]; Touches of Nature [1866]*.
Exhib: B; GG; G; L; New Gall; P; RA; RHA; RSA.
Bibl: J. Maas, *Victorian Painters*, 1970, p.244 illus.

ORD, G.W.
Illustrator of children's books, illustrated *Tommy Smith's Animals*, Edmund Selous, 1899.

O'REILLY, Rear-Admiral Montague Frederick 1822-1888
Amateur artist and illustrator. He was born in 1822 and as a professional naval officer, he served in North Australia and Hong-Kong and took part in the Chinese war of 1841. From 1845 he served on the West coast of Africa and in the Mediterranean and between 1851 and 1852 was on the South African station. He joined H.M.S. *Retribution* at Sebastopol and during this time made numerous sketches and diagrams of the Fleet in action in the Crimea. In 1856 he was appointed commander and from 1862 was commander of *Lapwing* in the Mediterranean and was promoted rear-admiral in 1878. O'Reilly sent many sketches to *The Illustrated London News*, in the years 1854-56 and in the issue of October 21, 1854 appears a self-portrait of him explaining his sketches.

Illus: *Twelve Views in the Black Sea and Bosphorus [1856, AT 241]*.
Contrib: *Cust's Naval Prints [1911]; Moore's Sailing Ships [1926]*.
Colls: Greenwich.
Bibl: *ILN*, June 7, 1888.

ORFORD, H.W.
Amateur illustrator contributing to *Fun*, 1900.

ORME, Edward 1774-
Publisher, engraver and architectural draughtsman. He was the brother of Ernest and William Orme (qq.v.) and studied at the RA Schools in 1793. He published numerous books on drawing from his address at 59 Bond Street and was still active in 1820.

Publ: *A Brief History of Ancient and Modern India [1805]; Orme's Graphic History of ... Horatio Nelson [1806]; Essay on Transparent Prints [1807]; An Historical Momento [1814]; Bartolozzi Prints [1816 (a re-issue)]; Historic, Military and Naval Anecdotes [1819]*.
Colls: V & AM.

ORME, Ernest fl.1801-1808
Architectural draughtsman and illustrator. He was a brother of Edward and William Orme and shared the latter's London address when he exhibited portraits at the RA, 1801-03. He published a drawing-book and illustrated a *Collection of British Field Sports*, 1807-08.

Colls: V & AM (sketchbook); Witt Photo.

ORME, William
Landscape artist and illustrator. He was born in Manchester, the brother of Ernest and Edward Orme (qq.v.) and worked there as a drawing-master from about 1794 to 1797. He had been awarded a silver palette by the Society of Arts in 1791-92. From 1797 when he moved to London he exhibited regularly at the RA and worked closely with his publisher brother.

Illus: *The Old Man, his Son and the Ass [c.1800]; Costume of Hindustan [1800]; Twenty-Four Views of Hindustan [1805]*.
Contrib: *The Copperplate Magazine*.
Colls: Greenwich; V & AM.

ORMEROD, George fl.1801-1827
Amateur artist. Possibly George Ormerod of Charlton Hall, Cheshire, listed in *Patterson's Roads*, 1824.

Contrib: *Britton's Beauties of England and Wales [1801]*.

ORPEN, Sir William RA RI 1878-1931
Landscape painter and occasional caricaturist. He was born at Stillorgan in Ireland on 27 November 1878 and studied at the Dublin Metropolitan School of Art and at the Slade School, 1897-99. Although Orpen established his reputation in portrait painting and is remembered for very competent and slick studies of famous Edwardians in a lavish manner derived from Sargent, he made an impressive contribution as War Artist, 1917-18. These drawings which were exhibited as War Pictures in 1918 were later published as a book and many of them were presented to Government collections. Orpen was knighted in 1918, and elected RA in 1919 and was President of the International Society of Sculptors, Painters and Gravers from 1921. He was elected ARHA in 1904, RHA 1907 and RI in 1919, having been a member of the NEA since 1900. He died on 29 September 1931.

The Ashmolean collection has two caricatures by this artist, one of which is a self-portrait.

Illus: *An Onlooker in France [1921]; Stories of Old Ireland and Myself [1924]*.
Exhib: B; FAS; GG; G; L; M; NEA; P; RA.
Colls: Ashmolean; Imperial War Mus.

ORR, Monro Scott 1874-
Painter, etcher and illustrator. He was born at Irvine on 7 October 1874, the brother of Stewart Orr (q.v.) and studied at the Glasgow School of Art under Newbery. Orr's work is bold and rather posterish and is comparable in style to that of John Hassall (q.v.). He was also much influenced by William Nicholson as is clear from the thick border line to his drawings and his direct imitation of that artist in *Twelve Drawings of Familar Characters ... 1903*. A contemporary criticism was that his drawings seemed to be cramped into a space too small for them.

Illus: *Twelve Drawings of Familar Characters in Fiction and Romance [1903]; Ye Twelve Months; The Old Ayrshire of Robert Burns; Poems of Robert Fergusson; The Arabian Nights; Grimms Fairy Tales; Mother Goose; Jane Eyre*; Book covers for: *The Unchanging East; Our Naval Heroes; Towards Pretoria; The Blessings of Esau; Kidnapped*.
Exhib: G; L; RSA; RSW.
Colls: Witt Photo.
Bibl: *Art Journal*, 1900, p.310; *The Studio*, Vol.29, 1903, p.215-217; *Modern Illustrators and Their Work*, Studio 1914.

ORR, Stewart RSW 1872-1944
Watercolourist and book illustrator. He was born in Glasgow on 21 January 1872, the brother of Monro S. Orr (q.v.). He studied at the Glasgow School of Art and Glasgow University and after working in Essex in about 1902, lived chiefly in Glasgow or the Isle of Arran. He died in 1944, having been elected RSW in 1925.

Exhib: G; L; RA; RI; RSA; RSW.
Bibl: *Modern Book Illustrators and Their Work*, Studio 1914.

ORROCK, James RI 1829-1913
Landscape painter, collector and lecturer. He was born in Edinburgh in 1829 and was educated at Irvine, Ayrshire and at Edinburgh University where he read surgery and dentistry. He then studied art with James Fergusson and J. Burgess in Leicester and with Stewart Smith at the Nottingham School of Design until 1866, when he moved to London. He took lessons from W.L. Leitch (q.v.) in London and was elected ANWS in 1871 and NWS in 1875.

Orrock was however best known for the books that he published on the arts and for his fine collections of Chippendale furniture and Nankin china which he had in his home at Bedford Square, Bloomsbury. He presented watercolours and drawings to both the

Victoria and Albert Museum and the Glasgow City Art Gallery, 1899.
He died on 10 May 1913, at Shepperton, Middlesex.

Illus: *In the Border Country [W.S. Crockett, 1906]: Mary Queen of Scots [W.S. Sparrow, 1906]; Old England [1908].*
Exhib: B; G; L; M; New Gall; RA; RI; ROI.
Colls: Bradford; Maidstone; Nottingham; V & AM.
Bibl: B. Webber, *JO*, 1903.

OSBORNE, Walter Frederick RHA 1859-1903
Portrait painter. He was born in Dublin in 1859 and studied at the
RDS Schools, 1876 and then at Antwerp, 1881 to 1883. He made
extensive painting tours in England, France and Spain, was elected
ARHA in 1883 and RHA in 1886. Osborne was an accomplished
painter of animals and of town and country life; he died in London in
1903.

Contrib: *Black & White [1891].*
Colls: BM; Nat. Gall; Ireland.
Bibl: T. Bodkin, *Four Irish Landscape Painters*, 1920.

OSPOVAT, Henry 1877-1909
Painter, draughtsman and illustrator. He was born in Russia in 1877
and migrated with his family to Manchester where they settled.
Ospovat was trained at the Manchester School of Art in 1897 and was
perhaps encouraged by Walter Crane (q.v.) whose bookplate he
designed. He then attended the South Kensington School and received
some important commissions at a very early age and was much
influenced by the Pre-Raphaelites and the work of C.S. Ricketts
(q.v.). His drawing style might be compared to that of Laurence
Housman, another Rossetti devotee, but his line is much broader and
his effects altogether more powerful and sensuous. He was also a
brilliant caricaturist, particularly of the London music-hall and his
death in London on 2 January 1909 removed a significant figure from
English illustration. A memorial exhibition was held at the Baillie
Gallery in 1909.

Illus: *Shakespeare's Sonnets [1899]; The Poems of Matthew Arnold [1900];
Shakespeare's Songs [1901]; The Song of Songs [1906]; Browning's Poems
[projected but not issued].*
Contrib: *The Idler.*
Exhib: NEA.
Colls: V & AM.
Bibl: *The Studio*, Vol.10, 1897, p.111, illus; Vol.43, 1908, p.235; Winter No.,
1923-24, pp.37, 133; R.E.D. Sketchley, *Eng. Bk. Illus.*, 1903, pp.13-14, 129;
Oliver Onions, *The Works of HO With An Appreciation By*, 1911. Arnold
Bennett, *Books and Persons*, 1917.
See illustration (right).

OVEREND, William Heysman 1851-1898
Marine painter and illustrator. He was born at Coatham in Yorkshire
in 1851 and was educated at Charterhouse. He began principally as a
marine artist but increasingly from about 1872, undertook work for
The Illustrated London News and for book illustration. During the
next three decades his output was extensive and nearly every issue of
the magazine has pages of his coastal realism, fishermen and
trawlermen fighting the sea and anxious women waiting on shore. He
was elected ROI in 1886 and died in the U.S.A. 1898.

Illus: *The Fate of the Black Swan [F.F. Moore, 1865]: On board the Esmerelda
[J.C. Hutcheson, 1885]; One of the 28th [G.A. Henty, 1889]; Benin the City
of Blood [R.H.S. Bacon, 1897]; Devils Ford [Bret Harte, 1897].*
Contrib: *ILN [1872-96]; The English Illustrated Magazine [1891-94]; Good
Words [1894]; The Rambler [1897]; The Boys' Own Paper; Chums; The Pall
Mall Magazine.*
Exhib: G; L; RA; ROI
Colls: V & AM.
Bibl: Joseph Pennell, *Modern Illustration*, 1895 p.108.

OVERNELL, T.J.
Illustrator and designer and student of RCA working in an art
nouveau style and contributing programme covers and book plates to
the National Competition, South Kensington, 1897.

Bibl: *The Studio*, Vol.8, 1896, p.224, illus.

OWEN, Rev. Edward Pryce 1788-1863
Amateur artist and topographer. He was born in 1788 and was
educated at St John's College, Cambridge before becoming Vicar of
Wellington and Rector of Eyton-upon-the-Wildmoors, Shropshire in

HENRY OSPOVAT 1877-1909. 'Andrea del Sarto.' Illustration for Browning's
Men and Women. *Pen. 14ins. x 10ins. (35.6cm x 25.4cm).*
Victoria and Albert Museum

1823. He made extensive tours to the Continent, making sketches that
he used for watercolours and etchings. He died at Cheltenham in
1863.

Illus: *Etchings of Ancient Buildings in Shrewsbury [1820-21]: Etchings
[1826]; The Book of Etchings [1842-55].*
Exhib: RBA, 1837-40.
Colls: Shrewsbury Lib.

OWEN, Samuel 1768-1857
Marine painter. He was born in 1768 and is associated with
watercolour sketches of the south coast and the Thames estuary. He
published with W. Westall (q.v.) *Picturesque Tour of the River
Thames*, 1828 and illustrated W.B. Cooke's *The Thames*, 1811.

Exhib: RA, 1794-1807.

OWEN, Will RCA 1869-1957
Artist, caricaturist and lecturer. He was born in Malta in 1869 and
educated in Rochester and at the Lambeth School of Art. Owen
worked in a humorous poster style and did much commercial work,
his chief contribution to books was as illustrator of W.W. Jacobs
novels.

Publ: *Old London Town [n.d.].*
Contrib: *Pick-Me-Up [1895]: The Windsor Magazine; The Temple Magazine;
Punch [1904-07]: The Strand Magazine [1906]; The Graphic [1912]: ILN
[1915].*
Exhib: RCA;
Colls: V & AM.

PADDAY, Charles Murray RI fl.1889-1937
Marine and landscape painter and illustrator. He was a leading illustrator of shipping for *The Illustrated London News* from 1896 until about 1916. He worked in London from 1889-93 and then at Bosham, 1902, Hayling Island, 1914 and Hythe, 1925, he also travelled on sketching tours to Brittany. He was elected ROI in 1906 and RI in 1929.

Illus: *Gun Boat and Gun Runner [T.T. Jeans, 1915].*
Contrib: *Black & White [1899].*
Exhib: L; RA; RBA; RI; ROI.
Bibl: *A.J.,* 1906 p.168.

PADGETT, William 1851-1904
Landscape painter. He worked in Twickenham, 1881 and Campden Hill, London from 1882. He contributed one illustration to *Punch* in 1882.

Exhib: GG; G; L; M; New Gall; RA; RBA; ROI.

PAGE, P.N.
Architectural draughtsman contributing to *The Illustrated London News,* 1858 (col. block).

PAGE, William 1794-1872
Landscape painter and topographer. He studied at the RA Schools, 1812-13 and travelled in Asia Minor and Greece in the period 1818 to 1824. He was an accurate depictor of buildings and a competent figure artist and contributed drawings to *Finden's Landscape and Portrait Illustrations To The Life and Works of Lord Byron,* 1833-34 and to *Finden's Landscape Illustrations of the Bible,* 1836.

Exhib: RA, 1816-60.
Colls: BM; Coventry; Searight Coll.
Bibl: *Country Life,* September 26, 1968.

PAGET, Henry Marriott 1856-1936
Artist and illustrator. He was born in London on 31 December 1856, brother of Sidney and Walter Stanley Paget (qq.v.). He was educated at Atherstone Grammar School, the City Foundation Schools and entered the RA Schools in 1874. He made a series of foreign tours beginning in 1879 to Italy, Greece and Crete and was in Western Canada, 1909. He was sent as Special Artist by *The Sphere* to Constantinople to cover the Balkan War, 1912-13 and served with the BEF in the First World War, 1916. He was elected RBA, 1889 and died in London, 27 March 1936.

Illus: *The Bravest of the Brave [G.A. Henty, 1887]; The Talisman, Kenilworth [Walter Scott, 1893]; Quentin Durward [Walter Scott, 1894]; Pictures From Dickens [1895]; Annals of Westminster Abbey [Bradley, 1895]; The Vicar of Wakefield [Goldsmith, 1898]; The Black Arrow [R.L. Stevenson, c.1913].*
Contrib: *The Graphic [1877-1906]; The Quiver [1890]; The Illustrated London News [1890]; The Windsor Magazine.*
Exhib: B; FAS; GG; G; L; M; RA; RBA; ROI.
Colls: Bodleian.

PAGET, Sidney E. 1860-1908
Artist and illustrator. He was born in London on 4 October 1860, the brother of Henry Marriott and Walter Stanley Paget (qq.v.). He was educated privately and studied art at the BM and at Heatherley's and the RA Schools, where he was a bronze and gold medallist, 1884. Paget was a very prolific illustrator and was the first artist to draw Sherlock Holmes for Conan Doyle's short stories in *The Strand Magazine,* 1892-94. He was on the staff of *The Illustrated London News* and *The Sphere,* and died in London on 28 January 1908.

Illus: *The Adventures of Sherlock Holmes [1892]; The Memoirs of Sherlock Holmes [1892-94]; Rodney Stone [1896]; The Tragedy of Koroshko [1898];*
Old Mortality [Walter Scott, 1898]; Terence [1898]; The Sanctuary Club [1900].
Contrib: *ILN [1884]; The Quiver [1890]; The Strand Magazine [1891-94]; Cassell's Family Magazine; The Graphic.*
Exhib: L; M; New Gall; RA; RBA; RI.
Colls: Bristol.
Bibl: R.E.D. Sketchley, *Eng. Bk. Illus.,* 1903, pp.68, 152; *The Times,* 27 November 1976, Correspondence.

PAGET, Walter Stanley 'Wal' 1863-1935
Artist and illustrator. He was born in 1863, the brother of Henry Marriott and Sidney E. Paget (qq.v.).

Illus: *The Black Dwarf, Castle Dangerous, The Talisman, A Legend of Montrose [Walter Scott, 1893-95]; Robinson Crusoe [1896]; At Agincourt [G.A. Henty, 1897]; Treasure Island [1899]; Lamb's Tales From Shakespeare [1901].*
Contrib: *The English Illustrated Magazine [1891-92]; ILN [1892-98]; The Queen [1894]; The Quiver; Cassell's Family Magazine.*
Exhib: G; L; M; New Gall; RA; RBA; ROI.
Bibl: R.E.D. Sketchley, *Eng. Bk. Illus.,* 1903 pp.92, 152.

PAILLET, Fernand 1850-1918
French portrait, watercolour and enamel painter. He exhibited at the Salon from 1873 and illustrated *Persian Lustre Ware* by Henry Wallis, 1899.

Colls: V & AM.

PAILTHORPE, F.W. fl.c.1880-c.1899
Illustrator. A number of watercolours by this artist for an edition of Dickens are in the Victoria and Albert Museum. They are very Georgian in spirit and reminiscent of the work of H.K. Browne.

Illus: *Posthumous Papers of the Pickwick Club [1882]; Great Expectations [1885]; Oliver Twist [1886 (all issued by Robson & Kerslake)].*

PAINE, Henry A.
Black and white artist of the Birmingham School, contributed to *The Quest,* 1894-96.

PALEOLOGU, Jean de 'PAL' 1855-
Figure artist and caricaturist of Rumanian origin. He was a contributor to *Vanity Fair,* 1889-90 and to *The Strand Magazine,* 1892-94. Signs: PAL.

PALMER, John fl.1856-1887
Genre painter and illustrator. He specialised in industrial and theatrical scenes as well as in domestic subjects and contributed to *The Illustrated Times,* 1856-61 and *The Illustrated London News,* 1864-66.

Exhib: RA; RBA.

PALMER, Samuel RWS 1805-1881
Visionary landscape painter and watercolourist. He was born at Newington on 27 January 1805, the son of a bookseller and began painting at the age of thirteen. He started exhibiting at the RA in 1819 at the age of fourteen and soon after came under the influences of Varley, Stothard and Linnell, and that of William Blake (q.v.) whom he met first in 1824. Fired by Blake and forming one of his mystical circle of 'Ancients' at Shoreham, Palmer produced a series of watercolours of the area, outstanding for their poetic beauty and innocence. He married Linnell's daughter in 1837 and travelled in Italy for two years, returning to live near his father-in-law and to teach drawing. His later work is usually considered to have lost the intensity of his early vision of landscape. He was elected OWS in 1856 and died at Redhill in 1881.

Palmer's work as a book illustrator is very small. It was Blake's small wood engravings that first inspired him, but in his long life, only Charles Dickens' *Pictures from Italy,* 1846, has four tiny vignettes from his hand. Two important posthumous works were Virgil's *Eclogues,* 1883, and Milton's *Minor Poems,* 1888, issued by his son and filled with fine etchings. The Ashmolean has a print for an edition of *The Pilgrim's Progress,* 1848.

Exhib: BI; OWS; RA; RBA.
Colls: Birkenhead; Birmingham; Blackburn; BM; Manchester; V & AM.

Bibl: A.H. Palmer, *SP: A Memoir*, 1882; A.H. Palmer, *Life and Letters of SP*, 1892; R.L. Binyon, *The Followers of W. Blake*, 1926; G. Grigson, *The Visionary Years*, 1947; E. Malin's, *SP's Italian Honeymoon*, 1968; David Cecil, *Visionary and Dreamer*, 1969; R. Lister, *SP*, 1974.
See illustration (p.205).

PALMER, Sutton 1854-1933

Landscape painter and illustrator. He was born at Plymouth in 1854 and was educated at Camden Town High School before studying at the South Kensington School. He changed from being primarily a still-life painter to a landscape painter and illustrated a number of colour plate books. He was elected RBA in 1892 and RI in 1920. He died on 8 May 1933.

Illus: *Rivers and Streams of England [A.G. Bradley]; Bonnie Scotland [Hope Moncreiff]; Surrey [Hope Moncreiff]; The Heart of Scotland [Hope Moncreiff, 1905]; The Wye; Berks and Bucks.*
Exhib: FAS; G; L; M; RA; RBA; RI.
Colls: V & AM.

PANNET, R. fl.1895-1925

Figure artist and illustrator working in London.

Contrib: *The Lady's Pictorial [1895]; St. Pauls [1899]; Illustrated Bits [1900]; The Temple Magazine; The Royal Magazine; The Graphic [1908].*

PAPE, Frank Cheyne

Black and white artist and illustrator.

Illus: *Children of the Dawn [E.F. Buckley, 1908]; The Book of Psalms [1912]; The Story Without An End [1912].*

PAPWORTH, John Buonarotti 1775-1847

Architect and topographical illustrator. He was born in London on 24 January 1775 and studied architecture on the advice of Sir William Chambers, learning drawing from John Deare and working under the architect John Plaw. He entered the RA Schools in 1798 and by that date had already exhibited drawings there and designed his first house, in Essex, for Sir James Wright, 1793-99. Papworth was well established as an architect by the age of twenty-five and had a large practice in country houses and villas and designed such Regency landmarks as the Cheltenham Pump Room, 1825-26. As a draughtsman, Papworth was much employed by R. Ackermann and on his own books, many of them issued by Ackermann. He had public appointments as Architect to the King of Württemberg, 1820 and was Secretary of the Associated Artists, 1808-10. He died at Little Paxton, Huntingdonshire on June 16 1847.

Illus: *The Social Day [Peter Coxe, 1823]; Select Views in London [1816]; Designs For Rural Residences, consisting of a series of Designs for Cottages, small villas, and other Buildings, [1818, 2nd Ed., 1832]; Hints on Ornamental Gardening [1823]; Forget-Me-Not Annual [1825-30 (covers)].*
Contrib: *Ackermann's Repository [1809-28].*
Exhib: RA.
Colls: RIBA; V & AM.
Bibl: W.A. Papworth, *JBP*, 1879; *Arch Review*, Vol.79, 1936; H.M. Colvin, *Biog. Dict. of Eng. Arch.*, 1954 pp.436-443.

'PAQUE' see PIKE, W.H.

PARK, Carton Moore 1877-1956

Portrait, decorative and animal painter and illustrator. He was born in 1877 and studied at the Glasgow School of Art under Francis Newbery and his first efforts at illustration were published in *The Glasgow Weekly Citizen* and *St. Mungo*. Park was a talented book decorator and caricaturist, but concentrated on animal illustration which he was able to treat in a strong and unsentimental way derived from Japanese prints. In 1899 he was elected RBA, resigning in 1905, and he continued to exhibit in the UK before emigrating to America in about 1910. He was editor and illustrator for Messrs. George Allen's *Child's Library*. He died in New York on 23 January 1956.

Illus: *An Alphabet of Animals [1899]; A Book of Birds [1900]; A Book of Elfin Rhymes [1900]; A Book of Dogs; A Child's London [1900]; The Child's Pictorial Natural History [1901]; La Fontaine's Fables For Children; The King*

of the Beasts; Mural panels – The Zoo; The Farmyard; Lithographs – Uncle Remus; Tales of the Old Plantation; Breer Rabbit; For Allen's Child's Library – A Countryside Chronicle [S.L. Bensusan]; The Bee; Biffel; The Story of a Trek-Ox.
Contrib: *The Butterfly [1899]; The Idler.*
Exhib: G; L; NEA; RA; RBA.
Bibl: *The Studio*, Winter No., 1900-01 pp.16-17, illus.; R.E.D. Sketchley, *Eng. Bk. Illus.*, 1903 pp.118, 168; *Modern Book Illustrators and Their Work*, Studio 1914.
See illustration (below).

PARKES, David 1763-1833

Amateur artist and schoolmaster. He was born at Cakemore, Salop in 1763 and ran a school at Shrewsbury. He died there on 8 May 1833.

Contrib: *Britton's Beauties of England & Wales [1813-14]; The Gentleman's Magazine.*

PARKINSON, William fl.1883-1895

Figure artist and cartoonist of *Judy*, 1890. He worked in London and contributed to various magazines including, *Ally Sloper's Half Holiday*, 1890 and *Black and White*, 1891.

Exhib: RA.
Colls: V & AM.

PARNELL, R.

Illustrator of children's books. He was the brother of Mrs. E. Farmiloe (q.v.) and worked for *The New Budget, Lika Joko* and *Little Folks*. He made a speciality of comic animals.

Bibl: *The Studio*, Vol.21, 1900-01 pp.51-54.

PARRIS, Edmund Thomas 1793-1873

Portrait painter. He was born in London on 3 June 1793 and entered the RA Schools in 1816, exhibiting there from that year. He worked at Horner's Colosseum in Regents Park from 1824 to 1829 and became Historical Painter to Queen Adelaide in 1838. His restorations to the Thornhill paintings in the cupola of St. Paul's cathedral, 1853-56 were unsympathetic and his sentimental style and pretty washes were best suited to album illustration. He died in London on 17 November 1873.

Illus: *Flowers of Loveliness [Lady Blessington, 1836]; Confessions of an Elderly Gentleman [Lady Blessington, 1836]; Confessions of an Elderly Lady [Lady Blessington, 1838].*
Contrib: *The Keepsake,* 1833, 1836-37.
Exhib: BI; NWS; RA; RBA.
Colls: BM; Doncaster; V & AM.

CARTON MOORE PARK 1877-1956. 'Panthers.' Illustration for The Studio, *1900.*

PARRISH, Maxfield **1870-1966**
Painter and illustrator. He was born in Philadelphia on 25 July 1870
and studied at the Boston Academy of Fine Arts under Howard Pyle
(q.v.). Although principally an American illustrator, he made the
designs for *Dream Days* by Kenneth Grahame, 1906. He died 30
March 1966.
Bibl: *The Studio,* Vol.38, 1906 pp.35-43 (Herkomer on his illus.).

PARRY, James **c.1805-1871**
Landscape and figure artist at Manchester. He drew and engraved
some illustrations of topography for Corry's *History of Lancashire.*
Exhib: M, 1827-56.

PARRY, John **1812-c.1865**
Caricaturist. He was probably an amateur and the Victoria and Albert
Museum has two sheets of his work, one inscribed 'Whims' and dated
'1850'. He seems to have specialised in silhouette caricatures of men,
women and animals, often done on visiting cards.

PARSONS, Alfred RA PRWS **1847-1920**
Landscape painter, watercolourist and illustrator. He was born at
Beckingham, Somerset on 2 December 1847 and started his life as a
Post Office clerk before studying at South Kensington. Parson's made
a speciality of garden and plant drawings and was a masterly book
decorator in designs for initial letters. He did a great deal of magazine
work before turning his attention to books and was elected ARA in
1897 and RA in 1911. He became RWS in 1905 and was President in
1913. His meticulous pen landscapes have a slight similarity to Joseph
Pennell (q.v.), but his pencil drawing is quite special in its toned
softness. He died at Broadway on 16 January 1920. Signs: [AP]
Illus: *God's Acre Beautiful [W. Robinson, 1880]; Poetry of Robert Herrick
[1882]; Springham [R.D. Blackmore, 1888]; Old Songs [1889]; Sonnets of
William Wordsworth [1891]; The Warwickshire Avon [Quiller Couch, 1892];
The Danube [F.D. Millet, 1892]; The Wild Garden [Robinson, 1895]; The
Bamboo Garden [Freeman-Mitford, 1896]; Notes in Japan [1896]; Wordsworth
[Andrew Lang, 1897].*
Contrib: *The English Illustrated Magazine [1883-86, 1891-92]; The Quiet Life
[1890 (with E.A. Abbey)]; Harper's Monthly Magazine [1891-92]; The Daily
Chronicle [1895].*
Exhib: B; FAS, 1885, 1891, 1893, 1894; GG; G; L; M; NEA; New Gall; RA;
RHA; RI; ROI; RSW; RWS.
Colls: V & AM.
Bibl: *The Studio,* Winter No., 1900-01 p.73, illus.; R.E.D. Sketchley, *Eng. Bk.
Illus.,* 1903 pp.31, 35, 137; Martin Hardie, *Watercol. Paint. in Brit.,* Vol.3, 1968
p.96, illus.

See illustration (right).

PARTRIDGE, Sir J. Bernard RI **1861-1945**
Black and white artist and principal cartoonist of Punch. He was born
in London on 11 August 1861, the son of Professor Richard
Partridge, Professor of Anatomy to the RA and nephew of John
Partridge, Portrait Painter Extraordinary to Queen Victoria. Partridge
was educated at Stonyhurst College and then trained with a firm of
stained-glass artists, studying the design of drapery, 1880-84. He was
extremely interested in the theatre and acted for some time under the
name of 'Bernard Gould' appearing in the first production of Shaw's
Arms and The Man. Many of his early drawings are of theatrical
subjects or personalities and some of his finest caricatures in later life
were still drawn from the world of the stage. He was introduced to
Punch by F. Anstey and G. Du Maurier (q.v.) and joined the staff in
1891, becoming successively second cartoonist, 1901 and principal
cartoonist, 1909-45. An artist who was well suited to theatrical
sketches and book illustrations, he found himself having to do most of
the 'heavy' work of the magazine. Although he was trained with the
woodblock, he adapted his pen line to process quite easily, but some
of his cartoons are overworked and lack contrast. By the close of his
working life, the statuesque figures of symbol looked slightly out of
place on the magazines pages even when accompanied by excellent
portraits of Churchill, Hitler and Mussolini. Partridge also painted in
oil, watercolour and pastel, was elected a member of the NEA in 1893
and RI in 1896. He died in 1945.

*ALFRED PARSONS RA PRWS 1847-1920. The Old Mosque at Rustchuk,
Bulgaria. Illustration for* Harper's Monthly Magazine, *July 1892. Pencil. Signed
with monogram. 7⁷/₈ins. x 6¹/₄ins. (20cm x 15.9cm).*
Victoria and Albert Museum

Illus: *Stageland [Jerome K. Jerome, 1889]; Voces Populi [F. Anstey, 1890];
The Travelling Companions [F. Anstey, 1892]; My Flirtations [Margaret
Wynman, 1892]; The Man From Blankley's [F. Anstey, 1893]; Proverbs in
Porcelain [Austin Dobson, 1893]; Mr Punch's Pocket Ibsen [F. Anstey, 1893];
Under the Rose [F. Anstey, 1894]; Lyre and Lancet [F. Anstey, 1895];
Barrie's Works [1896]; Puppets at Large [1897]; Baboo Jabberjee B.A.,
[1897]; Lyceum Souvenirs; The Crusade of the Excelsior [Bret Harte, 1897];
The Tinted Venus [1898]; Wee Folk [1899]; A Bayard From Bengal [F.
Anstey, 1902].*
Contrib: *ILN [1885-89 (theat.)]; Judy [1886]; The Quiver [1890]; Punch
[1891-1945]; Black & White [1892]; The Idler [1892]; New Budget [1895];
Vanity Fair [1896]; Sporting and Dramatic News [1899]; Lady's Pictorial; The
Sketch; Lika Joko; Pick-Me-Up; Illustrated Bits.*
Exhib: FAS, 1902, 1946; G; L; NEA; RA; RI.
Colls: BM (Millar Bequest); V & AM; Mus. of London.
Bibl: Joseph Pennell, *Pen Drawing and Pen Draughtsmen,* 1894 pp.332-333;
M.H. Spielmann, *The History of Punch,* 1895 pp.564-565; *The Studio,* Winter
No., 1900-01 pp.11-13, illus.; R.E.D. Sketchley, *Eng. Bk. Illus.,* 1903 pp.58, 86,
153; R.G.G. Price, *A History of Punch,* 1957 pp.160-163, illus.; Martin Hardie,
Watercol. Paint. in Brit., Vol.3, 1968 p.96.
See illustrations (pp.410, 411).

PASQUIER, C.A.
Decorative illustrator contributing to *The Graphic,* 1911 (Christmas).

SIR BERNARD PARTRIDGE RI 1861-1945. 'The Wings of Victory.' A preliminary sketch for the cartoon that appeared in Punch *on 14 May 1912, marking the inauguration of the Royal Flying Corps. Pencil, pen and ink. 14^{1}/8ins. x 11^{1}/2ins. (35.9cm x 29.2cm).*
Victoria and Albert Museum

 The Comic Lovers ·

SIR BERNARD PARTRIDGE RI 1861-1945. 'The Comic Lovers.' A design for a music title cover, about 1895. Pen and ink. Signed. 9½ins. x 7¼ins. (21.4cm x 18.4cm).
Author's Collection

PASQUIER, J. Abbott fl.1851-1872

Genre painter, watercolourist and illustrator. Although very little is known about him, Dalziel credits him with being 'a clever artist in black and white, and a skilful painter in watercolours'. His drawings for illustration have a very soft line with nice washes and slight caricature reminiscent of Leech. His favourite subjects were London ones, crossing sweepers, rainy days etc.

Contrib: *The Home Affections [Charles Mackay, 1858]; ILN [1856, 1866]; The Illustrated Times [1860]; London Society [1865-68]; Foxe's Book of Martyrs [1865]; Aunt Judy's Magazine [1866]; Beeton's Annuals [1866]; The Broadway [1867]; The Sunday Magazine [1868]; The Quiver [1868].*
Bibl: Dalziel, *A Record of Work, 1840-1890,* 1901 p.190.

PATON, Frank 1856-1909

Figure painter and illustrator. He worked in London and Gravesend and contributed one cartoon of an equestrian subject to *Vanity Fair,* 1910.

Colls: BM.

PATON, Sir Joseph Noël 1821-1901

Religious and fairy painter and illustrator. He was born at Dunfermline on 13 December 1821 and educated there before entering the RA Schools in 1843. He was awarded a premium in the Westminster Hall Competition, 1845 and again in 1847, becoming ARSA, in 1847 and RSA in 1850. He was a very versatile man working as poet and sculptor as well as painter; he had close connections with the Pre-Raphaelites in his early days and retained their colouring, he remained a lifelong friend of J.E. Millais (q.v.). His most famous illustrated book was Kingsley's *Water Babies,* 1863 and though he was approached by Dodgson to illustrate the second

volume of *Alice,* he declined. Paton was most at home in the realm of fairyland where Celtic romance and myth mixed together in his powerful imagination. Such paintings as the 'Reconciliation of Oberon and Titania' in the National Gallery of Scotland are among the best works in this field. Some of this spills over into his books for The Art Unions. An immensely successful public figure, Paton was made Her Majesty's Limner for Scotland in 1866 and knighted in 1867. He died at Edinburgh on 26 December 1901.

Illus: *Compositions from Shakespeare's Tempest [1845]; Compositions from Shelley's Prometheus Unbound [1845]; Silent Love [James Wilson, 1845]; Coleridge's Life of the Ancient Mariner [1863]; Lays of the Scottish Cavaliers [W.E. Aytoun, 1863]; The Water Babies [Charles Kingsley, 1863]; Gems of Literature [1866]; The Story of Wandering Willie [1870]; The Princess of Silverland and other Tales [E. Strivelyne, 1874]; Rab and his Friends [John Brown, 1878].*
Contrib: *A Book of British Ballads [1842]; Puck on Pegasus [Pennell, 1861]; The Cornhill Magazine [1864].*
Exhib: GG; G; L; RSA.
Colls: BM; Glasgow; Nat. Gall; Scotland.
Bibl: J. Maas, *Victorian Painters,* 1970 pp.152-153, illus.

PATON, Walter Hugh RSA 1828-1895

Landscape painter and illustrator. He was born at Dunfermline on 27 July 1828 the brother of Sir J.N. Paton (q.v.). He began his career as an industrial designer in the textile industry until 1848 and then became a pupil of J.A. Houston. He was elected ARSA in 1866 and RSA in 1868. He died in Edinburgh on 8 March 1895.

Illus: *Lays of the Scottish Cavaliers [W.E. Aytoun, 1863 (with J.N. Paton)]; Poems and Songs by Robert Burns [1875].*
Exhib: G; L; M; New Gall; RA; RHA; RI; RSA; RSW.
Colls: Dundee; Glasgow.
Bibl: *Art Journal,* 1895.

PATTEN, Leonard fl.1889-1914

Painter. He contributed one humorous drawing in the style of Meryon to *Punch,* 1914.

Exhib: RA, 1889.

PATTEN, William

Topographer. He contributed illustrations to *Westminster* by Walter Besant, 1897.

PATTERSON, J. Malcolm fl.1898-1925

Black and white artist, etcher and illustrator. He was born at Twickenham in 1873 and educated at Clifton. He worked at St. Andrews, Scotland where he was art master at St. Leonard's School, and specialised in rustic genre subjects with finely detailed cottage interiors.

Contrib: *Fun [1896]; The Dome [1898]; The Quiver [1900]; Punch [1900-07]; Illustrated Bits; Sketchy Bits; The Idler; The Windsor Magazine; The Royal Magazine.*
Exhib: L; RSA.

PAUL, Evelyn fl.1906-1911

Illustrator. She studied at South Kensington in about 1906 and exhibited in the National Competition that year.

Illus: *Cranford [Mrs. Gaskell, 1910]; Stories From Dante [Susan Cunnington, 1911].*
Bibl: *The Studio,* Vol.38, 1906 p.316.

PAUL, Sir John Dean, Bt. 1802-1868

Amateur illustrator. He was born on 27 October 1802 and was educated at Westminster and Eton before joining the family bank of Snow, Paul and Paul, from 1828. He succeeded his father as second baronet in 1852 and in 1855 the bank stopped payment and its partners were tried for fraud and sentenced to transportation. He died at St. Albans in 1868.

Publ: *A.B.C. of Foxhunting [1871].*
Illus: *The Country Doctor's Horse [Sir J.D. Paul, 1847].*

PAUQUETTE, Hippolyte Louis Emile 1797-

French illustrator. He was the brother-in-law of Gustave Janet (q.v.) and was an occasional contributor to *The Illustrated London News* in about 1869. He exhibited at the Salon, 1821-49.

PAXTON, Robert B.M. fl.1895-1925
Portrait painter and illustrator. In his early years he shared a studio with A.S. Hartrick (q.v.) and later worked in Fulham and Putney.
Contrib: *The Daily Graphic [1895]; The Windsor Magazine; The Graphic [1902-07]; The Strand Magazine [1906].*
Exhib: G; RA.

PAYNE, C.N.
Contributed motoring sketches to *Punch*, 1906.

PAYNE, Charles J.
Contributor to *The Graphic*, 1915.

PAYNE, Dorothy M. fl.1910-1914
Illustrator. She was a student of the Lambeth School and shows a strong influence of Walter Crane in her work. She exhibited at South Kensington, 1910-11.
Bibl: *The Studio*, Vol.53, 1911 p.299; *Pen, Pencil & Chalk*, Studio, 1911; *Modern Book Illustrators and Their Work*, Studio, 1914.

PAYNE, Henry Albert RWS 1868-1940
Portrait and landscape painter, stained-glass artist and illustrator. He was born at Kings Heath, Birmingham in 1868 and studied art under E.R. Taylor at the Birmingham School and taught at it for eighteen years. He learnt the craft of stained glass and made many windows and painted frescoes for the chapel of Lord Beauchamp and for the House of Lords. He married the flower painter Edith Gere in 1903 and was elected ARWS in 1912 and RWS in 1920. He lived at Amberley, Gloucestershire from about 1912 and died on 4 July 1940.
Contrib: *The Strand Magazine [1891]; A Book of Carols [1893]; The Dome [1898].*
Exhib: B; FAS; G; L; M; New Gall; P; RA; RSW; RWS.

PEACOCK, Mildred A.
Illustrator working at West Bromwich and possibly a student of the Birmingham School.
Bibl: *The Studio*, 1897, p.273, illus.

PEACOCK, Ralph 1868-1946
Portrait and landscape painter and illustrator. He was born in 1868 and studied at the Lambeth School of Art, 1882, the St. John's Wood School and the RA Schools, 1887, where he won the gold medal and Creswick prize. He was a teacher at the St. John's Wood School for many years and died on 17 January 1946.
Illus: *Wulf The Saxon [G.A. Henty, 1894]; Both Sides The Border [G.A. Henty, 1897].*
Contrib: *The English Illustrated Magazine [1896]; The Graphic [1899].*
Exhib: B; G; GG; L; M; New Gall; P; RA; RBA; RCA; ROI.
Colls: Birmingham; Liverpool; Tate.
Bibl: 'Ralph P and His Work', *The Studio*, Vol.21, 1900, pp.3-15, illus.

PEAKE, Richard Brinsley fl.1816-1819
Figure and domestic painter. He illustrated *The Characteristic Costume of France*, 1819, AT 87.
Exhib: RA.

PEARS, Charles ROI 1873-1958
Marine painter, illustrator, lithographer and poster artist. He was born at Pontefract 9 September 1873 and was educated at Hardwick College. He served in the RM in the First World War and was Official War Artist to the Admiralty, 1915-18 and again in 1940. He was a regular magazine illustrator in the 1890s and 1900s and was elected ROI in 1913. He wrote extensively on sailing and yachting and died in 1958.
Illus: *Two Years Before The Mast; Saltwater Ballads [John Masefield]; Dickens Works; The Pedlars Pack [Mrs. Alfred Baldwin, 1904-05].*
Contrib: *The Yellow Book [1896-97]; Judy [1896]; The Quartier Latin [1896]; The Dome [1897-99]; Punch [1897-1914]; The Longbow [1898]; The Windsor Magazine; The Ludgate Monthly; The Sketch; Fun [1901]; The Graphic [1910].*
Exhib: FAS; L; NEA; RA; RI; ROI; RWA.
Colls: V & AM.

PEARSE, Alfred c.1854-1933
Painter, black and white artist and illustrator of boys' books. He worked in London from about 1877 and died in 1933.
Illus: *By England's Aid [G.A. Henty, 1890]; Westward with Columbus [Gordon Stables, 1894].*
Contrib: *ILN [1882]; Boys' Own Paper [1890]; The Girls' Own Paper [1890-1900]; The Strand Magazine [1891-94, 1906]; The Wide World Magazine [1898]; Cassell's Family Magazine [1898]; Punch [1906].*
Exhib: RA; RBA.

PEARSE, Susan B. fl.1898-1937
Watercolour painter. She studied at the New Cross Art School and exhibited book illustrations at the National Competition, South Kensington in 1898.
Exhib: RA; RI; SWA.

PEARSON, Mathew
Black and white artist. He drew 189 drawings for *An Inventory of the Church Plate of Leicestershire*, by the Rev. Andrew Trollope, 1890.
Colls: V & AM.

PEARSON, William fl.1798-1813
Landscape painter and topographer. He was a friend of the watercolour artist F.L.T. Francia and probably illustrated *Select Views of the Antiquities of Shropshire*, 1807. Contributed to Britton's *Beauties of England and Wales*, 1812-14.
Exhib: RA.
Colls: BM; V & AM (sketchbook); Witt Photo.

PEGRAM, Frederick RI 1870-1937
Black and white artist and illustrator. He was born in London on 19 December 1870 and was first cousin of H., C.E., and R. Brock (qq.v.). He joined the staff of *The Queen* and then *The Pall Mall Gazette* in 1886, having studied under Fred Brown and spent some time in Paris. From then onwards he became one of the most prolific and consistent of magazine illustrators, his pen work is always of a high standard and his own preference was for drawing subjects with a Georgian setting. He was also an etcher and did occasional advertisements for the papers. Elected RI, 1925, he died in London on 23 August 1937.
Illus: *Macmillans Illustrated Standard Novels – Midshipman Easy [1896]; Masterman Ready [1897]; Poor Jack [1897]; The Last of the Barons [Bulwer Lytton, 1897]; The Arabian Nights Entertainments [1898]; The Bride of Lammermoor [1898]; The Orange Girl [Besant, 1899]; Ormond [Maria Edgeworth, 1900]; Concerning Isobel Carnaby [1900].*
Contrib: *Pall Mall Gazette [1886]; Pictorial World [1888]; ILN [1889-1916]; Judy [1889-90]; Lady's Pictorial [1893]; Punch [1894-1917]; The New Budget [1895]; The Quiver [1895]; Daily Chronicle [1895]; The Rambler [1897]; Black & White [1897]; Pall Mall Budget; The Gentlewoman; The Idler; The Pall Mall Magazine; The Minister; Cassell's Family Magazine.*
Exhib: FAS, 1938; G; L; P; RA; RI.
Colls: V & AM.
Bibl: *The Idler*, Vol.11, pp.673-683, illus.; J. Pennell, *Pen Drawing and Pen Draughtsmen*, 1894, p.370, illus.

PELCOQ, Jules fl.1866-1877
French artist and illustrator. He was born in Belgium of an old family and studied art at the Antwerp School and then went to Paris to work as a caricaturist. He worked for *Charivari* and *Journal Amusant* and illustrated some of Dumas novels and specialised in subjects from Parisian life. He was employed by *The Illustrated London News* in figure drawing and was their chief artist in Paris during the Siege of 1870, his work being despatched by balloon. He visited Vienna for the magazine in 1873 to cover the International Exhibition.
Bibl: H. Vizetelly, *Glances Back Over Seventy Years*, 1893, pp.340-342.

CARLO PELLEGRINI 'APE' 1838-1889. Sir Charles John Forbes, Bt., of Newe. Original drawing for the illustration in Vanity Fair, *14 August 1880. Watercolour and bodycolour on grey paper. Signed. 12ins. x 7ins. (30.5cm x 17.8cm).*
Author's Collection

PELLEGRINI, Carlo 'APE' 1838-1889

Caricaturist, draughtsman and lithographer. He was born in Capua in 1838, the son of landed aristocrats, and made a considerable name in Neapolitan Society for his caricatures, which were directly inspired by the *portraits chargés* of Baron Melchiorre Delfico. The young Pellegrini was politically minded and before leaving Italy was associated with Garibaldi's liberation struggle to free Italy from foreign oppression. He moved to London in November 1864, where he soon became a central figure in the Prince of Wales' Marlborough House Set. He joined Thomas Gibson Bowles' *Vanity Fair* in 1865 and virtually made its name for the publisher, each issue having caricatures by the artist done in *portraits chargés* manner, quite new to an English public. He was later succeeded to some extent by James Tissot (q.v.) and then by his understudy Sir Leslie Ward (q.v.). Pellegrini had ambitions to be a serious portrait painter but his eccentricity and dilettante life style were against this; he exhibited some portraits at the RA and Grosvenor Gallery. He was very influential on Max Beerbohm (q.v.), who considered him his master and dedicated his first book to him in 1896. Pellegrini died in London on 22 January 1889.

Colls: NPG; Royal Coll., Windsor; V & AM.
Bibl: Eileen Harris, 'Ape or Man', *Apollo*, Jan. 1976, pp.53-57; *Vanity Fair*, NPG Exhibition Cat., July-August, 1976.

See illustration (above).

PELLEGRINI, Professor Ricardo 1866-

Genre painter and illustrator. He was born at Milan in 1866 and illustrated an edition of *Gil Blas*. He acted as Special Artist for *The Graphic*, 1905.

PENGUILLY L'HARIDON, Octave 1811-1870

French illustrator, watercolourist and engraver. He was born on 4 April 1811 and after serving as a professional soldier studied under Charlet. He was curator of the Artillery Museum in Paris and exhibited at the Salon, 1835-70.

Illus: *The Works of Scarron.*
Contrib: *ILN [1853].*

PENNELL, Joseph 1860-1926

Artist, illustrator and author. He was born in Philadelphia in 1860 and educated at the School of Industrial Art there and at the Pennsylvania Academy of Fine Arts. He married Elizabeth Robins Pennell, the authoress, and they settled in England in the 1880s swiftly becoming members of the circle surrounding James McNeil Whistler (q.v.). Pennell was an extremely competent topographer in black and white and with his wife illustrated numerous travel books which she wrote. He is perhaps most significant however as the chronicler of late Victorian illustration in a number of books which not only brought new names to the fore, but were powerful advocates for the new processes of mechanisation. He was Art Editor of *The Daily Chronicle*, 1895, and was elected RE in 1882 and was a member of the American Academy of Arts. He returned to New York about 1914 and died there on 23 April 1926.

Publ: *Pen Drawing and Pen Draughtsmen [1889]; Modern Illustration [1895]; The Illustration of Books [1896]; The Work of Charles Keene [1897]; Lithography and Lithographers [1900]; The Life of James McNeil Whistler [1907]; Etchers and Etching [1919]; The Whistler Journal [1921]; The Graphic Arts [1922]; Adventures of an Illustrator [1925].*
Illus: *A Canterbury Pilgrimage [1885]; An Italian Pilgrimage [1886]; Two Pilgrims Progress [1887]; Our Sentimental Journey Through France and Italy [1888]; Our Journey to The Hebrides [1889]; The Stream of Pleasure [1891]; The Jew At Home [1892]; Play in Provence [1892]; To Gipsyland [1893]; A London Garland [W.E. Henley, 1895]; The Alhambra [1896]; Highways and Byways Series, Devon and Cornwall [1897]; N. Wales [1898]; Yorkshire [1899]; Normandy [1900]; A Little Tour in France [Henry James, 1900]; Gleanings From Venetian History [1908]; Pictures of The Panama Canal [1912]; Pictures of War Work in England [1917].*
Contrib: *The English Illustrated Magazine [1884]; The Graphic [1888]; ILN [1891]; The Pall Mall Budget [1893]; The Yellow Book; The Savoy [1896]; The Pall Mall Magazine; The Quarto [1896-97]; The Butterfly; The Neolith [1907-08].*
Exhib: FAS, 1896, 1912, 1917, 1922; G; GG; L; NEA; RSA.
Colls: V & AM.
Bibl: E.R. Pennell, *Journal of JP*, 1931.
See illustration (p.414).

PENNINGTON, Harper 1854-

American illustrator. He was born at Newport in 1854 and while in Europe, 1874-86, was a pupil of Gérome, Carolus Duran and J.M. Whistler (q.v.). He contributed to *Punch* in 1886.

PETERS, C.W.

Contributor of railway sketches to *The English Illustrated Magazine*, 1896.

PETHERICK, Horace William 1839-1919

Painter and illustrator. He was working at Addiscombe in 1891 and at Croydon from 1919 and specialised in children's stories and particularly those with costume subjects. He did some work for the Kronheim 'Toy Book' series.

Illus: *Home For the Holidays [1880]; Among the Woblins [S. Hodges]; Among the Gibjigs [S. Hodges, 1883]; Cornet of Horse [G.A. Henty, 1892].*
Contrib: *ILN [1870-77, 1887, 1890].*
Exhib: L; RA; RBA.
Colls: V & AM.

PETHERICK, Rosa C. fl.1896-1903

Illustrator. She was probably the daughter of Horace William Petherick (q.v.) and competed in book illustration competitions run by *The Studio*, Vol. 8, 1896, p.184. She later illustrated *Mother Hubbard's Cupboard of Nursery Rhymes*, 1903.

JOSEPH PENNELL 1860-1926. 'Old Shops in Gray.' Original drawing for illustration in The Saône *by P.G. Hamerton, 1887. Pen. 7¹/₈ins. x 7¹/₄ins. (18.1cm x 18.4cm).*
Victoria and Albert Museum

PETHYBRIDGE, J. Ley fl.1885-1897
Figure and landscape painter and occasional illustrator. He was working at Lyndhurst, 1885 and at Launceston, 1889 and was described by Thorpe as 'a too infrequent contributor to magazines'.
Contrib: *The Ludgate Monthly; The Temple Magazine [1896-97].*
Exhib: L; RA; RBA.

PETIT, The Rev. John Louis 1801-1868
Amateur topographer. He was born at Ashton-under-Lyne in 1801 and educated at Trinity College, Cambridge, and was for many years curate of Bradfield, Essex. He moved to Shropshire in 1846 and died at Lichfield in 1868.
Publ: *Remarks on Church Architecture [1841]; The Abbey Church of Tewkesbury [1848]; Architectural Studies in France [1854].*
Colls: Lichfield; V & AM.

PETO, Gladys Emma 1891-1977
Black and white artist and illustrator. She was born in 1891 at Maidenhead and studied at the Maidenhead School of Art and the London School of Art. Her style was strongly influenced by the work of Aubrey Beardsley, and she worked for *The Sketch* from 1915-26. She married Col. C.L. Emmerson and died in Northern Ireland in 1977.
Illus: *The Works of Louisa M. Alcott [1914]; Malta, Egypt, Cyprus [1928].*

PETRIE, George PRHA 1789-1866
Landscape painter and topographer. He was born in Dublin in 1790 and studied at the RDS Schools and with his father, a miniature painter, before turning wholly to landscape. He made extensive tours in Ireland and Wales with fellow artists such as F. Danby and J.A. O'Connor in the years 1808-19. He was elected ARHA in 1826 and RHA in 1828, becoming Librarian in 1829 and President in 1856-59. He wrote antiquarian articles for the *Dublin Penny Journal*, 1832-33, and was Editor of the *Irish Penny Journal*, 1842. His ink drawings are reckoned to be more attractive than his watercolour drawings which are rather formal in composition. He died in Dublin on 17 January 1866.
Publ: *Ancient Music of Ireland [1855].*
Illus: *Excursions Through Ireland [Cromwell, 1819]; New Picture of Dublin [J.J. McGregor, 1821]; Historical Guide to Ancient and Modern Dublin [C.N. Wright, 1821]; Beauties of Ireland [Brewer, 1825-26].*
Contrib: *Guide to the County of Wicklow [C.N. Wright].*
Exhib: RHA.
Colls: BM; Nat. Gall., Ireland; V & AM.
Bibl: A. Stokes, *Life of G.P., 1868.*

PETRIE, Henry FSA 1768-1842
Topographer and antiquary. He was born at Stockwell, Surrey in 1768 and was patronised by Thomas Frognall Dibdin and Earl Spencer. In 1818 Petrie began editing the *Monumenta Historica Britannica* of which one volume appeared by Sir T.D. Hardy, 1848. He was also involved in making a survey of Southern English Churches from about 1800 which was not completed and not published. His watercolours for this work are clear and accurate if somewhat dead through lack of figures and anything but architectural interest. He died at Stockwell in 1842, having been Keeper of the Records at The Tower since 1819.

PETT, Norman
Amateur illustrator, contributed one rustic subject to *Punch*, 1914.

414

PETTIE, John RA 1839-1893

Painter and illustrator. He was born at East Linton, Scotland, on 17 March 1839 and showed early promise as a figure draughtsman. He studied with his uncle Robert Frier in Edinburgh and then at the Trustees Academy, 1856, under R.S. Lauder, where his fellow students were Orchardson, MacWhirter and McTaggart (qq.v.). In 1862 he moved to London with Orchardson and shared a studio with him, becoming an ARA in 1866 and an RA in 1873. He died at Hastings on 23 February 1893. Although Pettie's output in illustration is small it is among his most charming work; he excelled in costume pieces and produced figures of incomparable strength with subtle grey washes.

Illus: *The Postman's Bag [J. de Lefde, 1865]; The Boys of Axelford [L.G. Seguin, 1869]; Rural England [1881].*
Contrib: *Good Words [1861-63]; Wordsworth's Poetry for the Young [1863]; Pen and Pencil Pictures from the Poets [1866]; Touches of Nature by Eminent Artists [1866]; The Sunday Magazine [1868-69]; Good Words For the Young [1869].*
Exhib: B; G; GG; L; M; P; RA; RHA; ROI; RSA.
Colls: Ashmolean; Glasgow; V & AM.
Bibl: M. Hardie, *JP*, 1908.
See illustration (right).

PEYTON, A.

Illustrator of comic strips of sporting subjects to *The Graphic*, 1904.

PHILIPS, John fl.1832-1838

Illustrator. He worked in Soho and was an early contributor to *Punch* and collaborated with Alfred Crowquill (q.v.) in the illustrations of Reynolds' *Pickwick Abroad: or a Tour in France*, 1838.

Exhib: NWS; RBA.

PHILIPS, Nathaniel George 1795-1831

Landscape painter and topographer. He was born in Manchester in 1795 and was educated at Manchester Grammar School and Edinburgh University. He travelled in Ireland and the Lake District and visited Italy in 1824-25, where he was elected to the Academy of St. Luke in place of Henry Fuseli. He died at Liverpool in 1831, having published etchings in 1822-24.

Illus: *Lancashire and Cheshire [1893].*

PHILLIPS, John FRS 1800-1874

Lithographer and geologist. He was Keeper of the York Museum, 1825-40 and Professor of Geology at Trinity College, Dublin, 1844-53. He was Keeper of the Ashmolean Museum, Oxford, 1854-70, having been elected FRS in 1834. He published *The Geology of Yorkshire* and illustrated *The Rivers, Mountains and Sea Coast of Yorkshire*, 1853.

PHILLIPS, Paul

Fashion illustrator, contributing to *The Graphic*, 1871.

PHILLIPS, T.W. fl.1808-1826

Landscape artist and topographer. He contributed drawings to *Britton's Beauties of England and Wales*, 1808.

Exhib: BI; RA; RBA.

PHILLIPS, W. Alison

Illustrator of rustic genre subjects. Contributed to *Punch*, 1896-97.

PHILLIPS, Watts 1825-1874

Artist, illustrator and dramatist. He was born in 1825 and became the only pupil of George Cruikshank (q.v.). He was an early contributor to *Punch*, the founder of a short-lived periodical *Journal for Laughter* and was on the fringe of the arts and the stage in Paris and then in London where he settled in 1853-54. He brought out plays at the Adelphi, 1857-59 and published novels in the *Family Herald*.

Illus: *M.P. Drawn and Etched by Watts Phillips [c.1840, AI. 313].*
Contrib: *Punch [1844-46]; Puck; Diogenes; ILN [1852].*
Colls: Witt Photo.
Bibl: M.H. Spielmann, *The History of Punch*, 1895, pp.458-459.

JOHN PETTIE RA 1839-1893. 'Macleod of Dare.' Original drawing for illustration of a story by William Black, Good Words, 1878. Wash. Signed. 14³/₈ins. x 8¹/₈ins. (36.5cm x 20.6cm). Victoria and Albert Museum

'PHIZ' see BROWNE, H.K.

PHOENIX, George fl.1886-1935

Figure and landscape painter. He worked at Wolverhampton, 1889 to 1925 and contributed spirited black and white drawings of rustic and cockney genre subjects to *Punch*, 1902-03.

Exhib: B; L; New Gall; RA.

PICKEN, Andrew 1815-1845

Lithographer and illustrator. He was born in 1815, the son of the author, Andrew Picken, and studied with Louis Haghe (q.v.). Due to poor health, Picken settled in Madeira in 1837 and lived in London again from 1840 until his death in 1845. He lithographed Dillon's *Sketches in the Island of Madeira*, 1850, AT 193.

Illus: *Madeira Illustrated [1840, AT 191].*
Exhib. RA.

PICKERING, George 1794-1857

Landscape painter and illustrator. He was born in Yorkshire in 1794 and became a pupil and close follower of John Glover. He began as a drawing-master at Chester, taking over the practice of George Cuitt (q.v.) and opening a studio at Liverpool in 1836. He taught drawing at Birkenhead, where he died in 1857, having been for many years a non-resident member of the Liverpool Academy.

Illus: *History of Cheshire [G. Ormerod, 1819]; History of the County Palatine of Lancaster [E. Baines]; Traditions of Lancashire [J. Roby, 1928].*
Contrib: *Fisher's Scrapbook [1834].*
Exhib: L; OWS; RBA.
Colls: V & AM; Witt Photo.

PICKERSGILL, Frederick Richard RA 1820-1900

Historical painter and illustrator. He was born in London in 1820, nephew of H.W. Pickersgill, RA, and W.F. Witherington under whom he studied. He entered the RA Schools and exhibited there from 1839, being elected ARA in 1847 and RA in 1857; he was Keeper from 1873-87. Pickersgill was a beautiful colourist and much influenced by William Etty, his illustrative work is full of fine figure drawing even if with a characteristic German hardness in style. The finest collection of his drawings of this sort of work is at the Barber Institute, Birmingham. He died on the Isle of Wight on 20 December 1900.

Illus: *Virgin Martyr [P. Massinger, 1844]; Illustrated Life of Christ [1850]; Comus [Milton, 1858]; Poetical Works of E.A. Poe [1858].*
Contrib: *Book of British Ballads [1842]; Tupper's Proverbial Philosophy [1854]; Poets of the Nineteenth Century [Willmott, 1857]; The Home Affections [Charles Mackay, 1858]; Lays of the Holy Land [1858]; The Seasons [James Thomson, 1859]; Montgomery's Poems [1860]; Sacred Poetry [1862]; The Lord's Prayer [1870]; Dalziel's Bible Gallery [1880]; Art Pictures From The Old Testament [1897].*
Exhib: BI; RA.
Colls: Barber; V & AM.
Bibl: Chatto & Jackson, *Treatise on Wood Eng.*, 1861, p.598.

PIDGEON, Henry Clark 1807-1880

Landscape watercolourist, etcher and illustrator. He was a teacher of drawing in London until 1847, when he moved to Liverpool to become Professor of Drawing at the Institute and successively a member and Secretary of the Liverpool Academy, 1850. He was a founder of the Historic Society of Lancashire and Cheshire and is notable for the antiquarian details in his drawings and prints. In London, where he taught again from 1851, he was a member of the Clipstone St. Academy. He died there in 1880.

Contrib: *Recollections of the Great Exhibition of 1851; Wyatt's Industrial Arts of the Nineteenth Century.*
Exhib: BI; RA; RBA.

PIFFARD, Harold H. fl.1895-1903

Military painter and illustrator. He worked in Bedford Park, London, and was a prolific illustrator in the style of Caran d'Ache (q.v.).

Contrib: *Cassell's Family Magazine [1899]; The Quiver [1900]; The Windsor Magazine; Pearson's Magazine; Illustrated Bits.*
Exhib: B; L; RA.

PIKE, W.H. 'Oliver Paque' RBA 1846-1908

Landscape painter and illustrator. He was born at Plymouth in 1846 and painted in Devon and Cornwall until 1881 when he settled in London. He was elected RBA in 1889.

Contrib: *The Daily Graphic [1890]; The Sketch [1894]; The Graphic [1902].*
Exhib: L; RA; RBA; RHA; RI; ROI.

PILKINGTON, Major-General Robert W. 1765-1834

Landscape painter and soldier. He trained at the RMA, Woolwich and saw service in Canada and North America and was appointed Major-General in 1825 and Inspector-General of Fortifications in 1832. He painted in the manner of Richard Wilson and contributed a drawing to Britton's *Beauties of England and Wales*, 1814.
Exhib: RA, 1808-27.

PILOTELLE, Georges

Fashion illustrator to the *Lady's Pictorial*, c.1890.

PIMLOTT, E. Philip fl.1893-1940

Painter and etcher. He worked at Aylesbury and London and was ARE, 1901-11. He supplied an ink drawing for *The Yellow Book*, 1897.

Exhib: NEA; RA; RE.

PINWELL, George John 1842-1875

Painter and illustrator of rural life. He was born at Wycombe on 26 December 1842, the son of a builder and had his first employment as a designer for embroiderers. He entered the St. Martin's Lane Academy and in 1862 studied at Heatherley's, earning money to support himself by supplying drawings to *Fun* and designs to Elkingtons, silversmiths. He began to work for the Dalziel Brothers in 1864 and there met J.W. North and Fred Walker (qq.v.), the three of them becoming the outstanding rustic and landscape illustrators of the 1860s. He was elected AOWS in 1869 and OWS in 1870 and received important commissions such as the *Illustrated Goldsmith*, 1864, for which he made one hundred drawings, completed in six months. Pinwell's health began to fail in 1873 and he went to Tangiers in 1875 to recover but died in London on his return, 8 September 1875.

Pinwell was closely allied in style to Fred Walker but he was more of a figure artist and less of a landscape artist than the other. He was a brilliant colourist and Reid considered him to have greater decorative sense than Walker and to be at his best in contemporary subjects.

Illus: *Dalziel's Illustrated Goldsmith [1864]; The Happy Home [H. Lushington, 1864]; Hacco the Dwarf [H. Lushington, 1864]; The Adventures of Gil Blas [1866]; Jean Ingelow's Poems [1867]; The Uncommercial Traveller [C. Dickens, 1868]; It Is Never Too Late To Mend [Reade, 1868].*
Contrib: *Punch [1863]; Once a Week [1863-69]; Good Words [1863-75]; The Churchman's Family Magazine [1863-64]; The Sunday at Home [1863-64]; London Society [1863-67]; Lilliput Levee [1864]; The Cornhill Magazine*

GEORGE JOHN PINWELL 1842-1875. 'By The Dovecote.' Original drawing for illustration in Wayside Posies *by R. Buchanan, 1867. Pen and pencil. Signed with monogram and dated 1865. 7¹/8ins. x 5¹/2ins. (18.1cm x 14cm).*
Victoria and Albert Museum

[1864, 1870]; The Sunday Magazine [1865-72]; The Leisure Hour [1865]; Our Life Illustrated by Pen and Pencil [1865]; Dalziel's Arabian Nights [1865]; The Quiver [1866-68]; The Argosy [1866]; The Spirit of Praise [1866]; Ballad Stories of the Affections [1866]; A Round of Days [1866]; Wayside Poesies [R.W. Buchanan, 1867]; Golden Thoughts From Golden Fountains [1867]; Cassells Magazine [1868]; Good Words For the Young [1869]; Leslie's Musical Annual [1870]; Novellos National Nursery Rhymes [1870]; The Graphic [1870-73]; Fun [1871]; Judy [1872]; Sunlight of Song [1875]; Dalziel's Bible Gallery [1894].
Exhib: Deschamps Gall., Bond St., Feb. 1876; FAS, 1895.
Colls: Aberdeen; Bedford; BM; Nottingham; V & AM; Witt Photo.
Bibl: G.C. Williamson, G.P. and His Work, 1900; F. Reid, Illustrators of the Sixties, 1928, pp.152-163; 'English Influences on Vincent Van Gogh', Arts Council, 1974.
See illustrations (pp.206, 416)

PIOTROWSKI, Antoine
1853-1924

Painter and illustrator. He was born at Kunow on 7 September 1853 and studied at Warsaw and Munich. In 1877 he became a pupil at the Mateiko School in Krakow and worked there until his death in Warsaw on 12 September 1924. He was The Graphic Special Artist in the Servo-Bulgarian War of 1885-86.

PIRKIS
Figure artist contributing drawings in the manner of John Hassall to Punch, 1905.

PISSARRO, Lucien
1863-1944

Artist, landscape painter, wood engraver, designer and printer of books. He was born in Paris on 20 February 1863, the eldest son of the French painter Camille Pissarro. He was educated in France and studied with his father and the wood engraver Lepere, before coming to England to work in 1883. Here he met Charles Ricketts and C.H. Shannon (qq.v.) and came into contact with the revived interest in wood engravings and the new ideas in book design formulated by Kelmscott and other private presses. He contributed designs to The Dial and started the Eragny Press in 1894, producing a whole series of French classics in the next twenty years, most of them slightly illustrated but beautifully ornamented and designed. Pissarro stayed close to the Morris tradition in books, but his wood engravings do have a naturalism and flow that is not always present in Morris. Pissarro broke most new ground in his use of colour woodcuts and brought them to new heights in his Livre de Jade, 1911 and La Charrue d'Erable, 1912. Both his wife and Sturge Moore (q.v.) collaborated on these books. He designed the Brook type face for use in his books after 1902. As a landscape painter he provided an important bridge between English art and impressionism; he was also a talented caricaturist. He was a member of the NEA from 1906.

Illus: The Queen of the Fishes [1896]; Moralités légendaires [Laforgue, 1897]; Choix de sonnets [Ronsard, 1902]; Peau d'Ane [Perrault, 1902]; Areopagitica [1904]; Livre de Jade [Gautier, 1911]; La Charue d'Erable [1912].
Exhib: G; L; NEA; RA; RHA; RSA.
Colls: Ashmolean; Birmingham; Manchester.
Bibl: Colin Franklin, The Private Presses, 1969 (full bibliog.).

PITMAN, Rosie M.M.
fl.1883-1907

Illustrator of children's books. She worked in Manchester, 1883, London, 1894-1902 and at Ledbury, 1907.

Illus: Maurice or The Red Jar [Lady Jersey, 1894]; Undine [Fouqué, 1897]; The Magic Nuts [Mrs. Molesworth, 1898].
Contrib: The Quarto [1896].
Exhib: G; L; M; RA; RSA.
Bibl: R.E.D. Sketchley, Eng. Bk. Illus., 1903, pp.117, 168.

PITTMAN, Oswald ROI
1874-1958

Landscape painter. He was born in London on 14 December 1874, the son of Robert Pittman, ACA, and was educated at Palace School, Enfield and at the RA Schools. He took part in a number of The Studio book illustration competitions. He was elected ROI, 1916, and died on 25 October 1958.

Exhib: G; L; RA; RI; ROI.
Bibl: The Studio. Vol.13, 1897, p.64 illus; Vol.14, 1898, p.71 illus.

PIXELL, Maria
fl.1793-1811

Landscape painter. She may have been a pupil of S. Gilpin and she exhibited at the RA and BI, 1793-1811. She contributed a drawing to Britton's Beauties of England and Wales, 1813.

PLANK, George
Black and white artist who illustrated The Freaks of Mayfair by E.F. Benson, 1916, in the style of Aubrey Beardsley.

POCOCK, E.
Architectural illustrator, contributing to The Illustrated London News, 1875.

POGANY, William Andrew 'Willy'
1882-

Painter, etcher and illustrator. He was born at Szeged in Hungary on 24 August 1882 and educated at the Budapest Technical University and at the Art Schools of Budapest, Munich and Paris. Pogany settled in the United States where he designed many stage-sets and illustrated more than one hundred books. His art was very strongly decorative in character and has begun to return to favour with the advent of the cult of Art Deco. He is included here for the many books that he illustrated for the English market during the Edwardian years.

Illus: A Treasury of Verses for Little Children [M.G. Edgar, 1908]; Tannhauser [1911]; Goethe's Faust [1912], etc.
Contrib: ILN [1913].

POIRSON, V.A.
French artist and illustrator of comic genre subjects. He contributed to The Graphic, 1888-89.

PONT, J.
Topographer. He contributed drawings to Britton's Beauties of England and Wales, 1813.

POOLE, G.T.
Amateur artist. He acted as Special Artist for The Graphic in Russia in 1904.

POOLE, William
fl.1826-1840

Portrait painter. He worked in London, 1826 to 1838, and contributed to The Chaplet, c.1840.

Exhib: RBA.

'POPINI'
Name or pseudonym of artist contributing to Illustrated Bits, c.1890.

PORTCH, Julian
-1865

Illustrator and Special Artist. He came from a very poor background and was self-taught as an artist. He was a pupil of Henry Vizetelly (q.v.) who gave him a lot of work and sent him as Special Artist for The Illustrated Times to the Crimea in 1855. Portch caught rheumatic fever in the camps of the Crimea and was afterwards paralysed, although he continued to do theatrical illustrations, comic animals and decoration for the Punch Pocket Books. He died in September 1865.

Illus: The Illustrated Book of French Songs [John Oxenford, 1855].
Contrib: The Illustrated Times [1855-61]; Punch [1858-61, 1870]; The Welcome Guest [1860]; Puck on Pegasus [C. Pennell, 1861]; London Society [1862]; Poetry of the Elizabethan Age [1862]; Uncle Tom's Cabin; Boswell's Life of Johnson.

PORTER, J.L.
This is likely to be John Porter, the historical and landscape painter who worked in London and Folkestone and exhibited at the BI, RA and RBA, 1826-70.

Contrib: Good Words [1861].

PORTER, Sir Robert Ker 1777-1842

Historical painter and illustrator. He was born at Durham in 1777, the son of an army officer and spent his boyhood at Edinburgh, becoming a student in the RA Schools in 1790 through the influence of Benjamin West. He won a Society of Arts silver palette in 1792 and joined the Sketching Club in 1799. In 1800, Porter was engaged in scene painting at the Lyceum Theatre and in producing panoramas and battle subjects. In 1804 he went to Russia and was appointed Historical Painter to the Czar and married the Princess Marie Schertakoff. He was knighted in 1813 and then went on extensive tours that took him to Sweden, Spain and Persia and he acted as British Consul in Venezuela from 1826 to 1841 before returning to St. Petersburgh where he died in 1842. His important collections were sold at Christie's on 30 March 1843.

Publ: *Narrative of the Campaign in Russia [1812, 1813]; Travels in Georgia, Persia, Armenia and Ancient Babylonia [1821-22, AT 359].*
Illus: *Travelling Sketches in Russia and Sweden, 1805-1808 [1809, AT 13]; Letters From Portugal and Spain [1809, AT 130].*
Exhib: RA; RBA.
Colls: BM; V & AM.

POTT, Charles L. fl.1886-1907

Landscape painter and illustrator. He specialised in military and sporting subjects and worked at St. John's Wood, London. He was a regular contributor to many magazines but particularly to the pages of *Punch*, 1900-07.

Contrib: *Cassell's Saturday Journal [1890]; The Sporting and Dramatic News [1891]; Chums [1892]; Illustrated Bits [1900]; The Graphic [1902-03].*
Exhib: RBA; ROI.

POTTER, Helen Beatrix (Mrs. Heelis) 1866-1946

Illustrator of children's books. She was born in London in 1866, the daughter of a wealthy family who had connections in the arts and knew contemporary artists, among them J.E. Millais (q.v.). Beatrix Potter had a repressed girlhood, however, and found her chief solace in sketching fungi, fossils and animals on her Scottish holidays and in keeping a secret journal. She wrote illustrated letters to children and it was this that led to the creation of *Peter Rabbit*, a masterpiece that was quietly and privately printed in 1900. It was accepted by Warne & Co. and published in 1902, gaining instant success for its brilliant watercolours and interplay of text and pictures. Many books followed, which gave her independence from her family and eventually the opportunity to buy her own farm in the Lake District and marry William Heelis, a solicitor. She claimed to have been influenced by the Pre-Raphaelites and by Randolph Caldecott (q.v.) and is known to have admired the drawings of Mrs. Blackburn (q.v.) and the woodcuts of Thomas Bewick (q.v.). But she was essentially an amateur artist who loved children and wished to enliven their books with animals that were still recognisably animalish. She died at Sawrey in 1946 and left her home and farm to the National Trust. An exhibition was held at the V & A Museum in December 1972.

Illus: *Peter Rabbit [1902]; Squirrel Nutkin [1903]; The Tailor of Gloucester [1903]; Benjamin Bunny [1904]; Two Bad Mice [1904]; Mrs. Tiggy-Winkle [1905]; The Pie and the Patty Pan [1905]; Mr. Jeremy Fisher [1906]; A Fierce Bad Rabbit [1906]; Miss Moppet [1906]; Tom Kitten [1907]; Jemima Puddleduck [1908]; The Roly-Poly Pudding [1908]; The Flopsy Bunnies [1909]; Ginger and Pickles [1909]; Mrs. Tittlemouse [1910]; Timmy Tiptoes Rhymes [1922]; Little Pig Robinson [1930]; A Happy Pair [F.E. Weatherly, n.d.];* and posthumously *The Fairy Caravan [1952]; The Sly Old Cat [1971].*
Colls: BM; Nat. Bk. League; Tate.
Bibl: M. Lane, *The Tale of BP,* 1947; Anne Carroll Moore, *The Art of Beatrix Potter With An Appreciation.* 1955; *The Journal of BP,* 1966.

POTTER, Raymond fl.1893-1898

Illustrator. He specialised in theatrical subjects, current events and may have visited India in 1898.

Contrib: *The Ludgate Monthly [1892]; The English Illustrated Magazine [1893-97]; ILN [1897]; The Sketch; The Penny Illustrated Paper; The Windsor Magazine; Pearson's Magazine; The Royal Magazine.*
Colls: V & AM.

POWELL, Sir Francis PRSW 1833-1914

Marine and landscape artist. He was born at Pendleton, Manchester, in 1833 and studied at the Manchester School of Art, becoming OWS in 1876. He was first President of the RSW in 1878 and was knighted in 1893. He died at Dunoon on 27 October 1914.

Contrib: *Passages from Modern English Poets [1862].*
Colls: Dundee; Glasgow; V & AM.

POWELL, Joseph PNWS 1780-1834

Landscape painter and topographer. He was a drawing-master and specialised in views of the South Coast, Wales and the Lakes. He was first President of the NWS in 1832 and made etchings and lithographs as well as drawings.

Contrib: *The Antiquarian and Topographical Cabinet [1809].*
Colls: BM; V & AM.

POYNTER, Ambrose 1796-1886

Architect, still-life and landscape painter and illustrator. He was born in London in 1796 and became a pupil of T.S. Boys (q.v.), and of John Nash. He travelled in Italy during the years 1819-21 and on his return set up as an architect designing government schools and London

THE PAINTER'S INSPIRATION.
Drawn by E. J. Poynter. *See page 131.*

SIR EDWARD JOHN POYNTER, Bt. PRA 1836-1919. 'The Painter's Inspiration.' Illustration to a story in The Churchman's Family Magazine, *1862. Wood engraving.*

SIR EDWARD JOHN POYNTER, Bt. PRA 1836-1919. *'Joseph distributing corn.' Original drawing for illustration to* Dalziel's Bible Gallery, *1881. Pen and ink. Signed with initials and dated 1864. 8¾ins. x 10¼ins. (22.2cm x 26cm).*
Victoria and Albert Museum

churches and becoming a founder member of the RIBA in 1834. He retired from practice in 1858 due to failing eye sight and died at Dover on 20 November 1886; he was the father of Sir E.J. Poynter (q.v.). Poynter did a considerable amount of illustrative work for Charles Knight who referred to 'the most beautiful architectural drawings, which imparted a character of truthfulness to many scenes' in his *Pictorial Shakespeare.*

Publ: *An Essay on the History and Antiquities of Windsor Castle [1841].*
Illus: *Genealogical History of England [Sandford].*
Contrib: *Knight's London [1841-42].*
Exhib: RA
Colls: BM; Fitzwilliam; V & AM.
Bibl: H.M. Poynter, *The Drawings of AP,* 1931.

POYNTER, Sir Edward John, Bt. PRA 1836-1919

Painter and illustrator. He was born in Paris on 20 March 1836 the son of Ambrose Poynter (q.v.). He studied art in Paris under Gleyre, 1856-59 at the same time as Alma Tadema, Du Maurier and Whistler (qq.v.), having previously attended the RA Schools. He was elected ARA in 1868 and RA in 1877, having become the first Slade Professor of University College, 1871-75, and Principal of the South Kensington School, 1875-81. He was Director of the National Gallery, 1894-1904, and President of the Royal Academy from 1896 to 1918. He was knighted in 1896 and created a baronet in 1902. He died in London on 26 July 1919.

Poynter was very influential as a teacher in late Victorian Britain and especially through holding so many public appointments. His illustrations were all confined to the early part of his career but show a great aptitude for figure work and even a flare for handling modern subjects.

Contrib: *Once a Week [1862-67]; London Society [1862, 1864]; The Churchman's Family Magazine [1863]; Poems by Jean Ingelow [1867]; The Nobility of Life [1869]; ILN [1870]; Dalziel's Bible Gallery [1880].*
Exhib: B; FAS, 1903; G; GG; L; M; New Gall; RA; RE; RHA; RSA; RWS.
Colls: BM; Bradford; Manchester; V & AM.
Bibl: A. Margaux, *The Art of EJP.* 1905; M. Bell, *Drawings of EJP,* 1906; J. Maas, *Victorian Painters,* 1969, pp.183-184.
See illustrations (above and p.418).

PRATER, Ernest fl.1897-1914

Black and white artist and illustrator. He worked at London and Westcliffe-on-Sea and was on the staff of *Black & White, The Sphere* and *The Graphic,* acting as Special Artist for the first in the Sino-Japanese War of 1894.

Illus: *The Castle of the White Flag [E.E. Green, 1904].*
Contrib: *The St. James's Budget; The Boys' Own Paper; The Ludgate Monthly; The Idler; Chums; Pearson's Magazine; The Graphic [1905-10].*
Exhib: RA.

PRATT, Edward fl.1810-1812

Topographer. He contributed to Britton's *Beauties of England and Wales,* 1812.

PREHN, William fl.1862-1890

Sculptor. He was working in London in the last quarter of the nineteenth century and contributed to *Punch* in 1865.

Exhib: G; GG; L; RA.

PRENTIS, Edward 1797-1854

Genre painter and illustrator. He was born at Monmouth in 1797 and was an early member of the Society of British Artists. He specialised in domestic scenes of a humorous nature, many of which were engraved and he died in London in December 1854.

Contrib: *Layard's Monuments of Nineveh [1849, AL 29].*
Exhib: BI; RA; RBA.
Colls: Glasgow.

PRESCOTT-DAVIES, Norman RBA 1862-1915

Portrait, flower and miniature painter and illustrator. He was born at Isleworth in 1862 and educated at the London International College and at South Kensington, City Guilds and Heatherley's Art Schools. He worked in London and at Radway, Warwickshire, and was elected RBA in 1893 and ARCA in 1891. He died on 15 June 1915.

Illus: *Gray's Elegy [De Luxe Edition].*
Contrib: *The Strand Magazine [1891].*
Exhib: B; G; L; M; New Gall; RA; RBA; RCA; RHA; RI; ROI.

PRICE, Edward

Topographer. The son of the Vicar of Needwood, he was a pupil of John Glover and accompanied him on tours of North Wales and Dovedale. He corresponded with John Constable, RA, and was patronised by the Duke of Sutherland. He helped organise some exhibitions of Glover's work in London, 1820-24, and was living in Nottinghamshire in 1856.

Illus: *Norway Views of Wild Scenery [1834]; Dovedale, 12 Views in Dovedale and Ilam [1845]; Views in Dovedale [1868].*
Exhib: BI; RA; RBA.
Bibl: *John Constable's Correspondence,* Vol.4, 1966, pp.312-313.

PRICE, Julius Mendes -1924

Illustrator and Special Artist. He was born in London, the son of a merchant and was educated at University College School and in Brussels, before studying at the École des Beaux-Arts in Paris. He joined the staff of *The Illustrated London News* in about 1884, and was described as 'Travelling Special Artist' although his chief function was as war correspondent. He took part in the Bechuanaland Campaign of 1884-85, enlisting as a trooper in Methuen's Horse, visited Siberia, Mongolia and the Gobi Desert, 1890-91, and the Western Australian Goldfields in 1895. He represented the magazine at the Graeco-Turkish War, 1897, Klondike, 1898, at the Russo-Japanese War, 1904-05, and on the French front throughout the First World War. He was appointed a lecturer in the British Army of Occupation in Germany in 1919. He died on 29 September 1924.

Publ: *From the Arctic Ocean to the Yellow Sea [1892]; The Land of Gold [1896]; From Euston to Klondike [1898]; Dame Fashion [1913]; My Bohemian Days in Paris [1913]; My Bohemian Days in London [1914]; Six Months on the Italian Front [1917]; On the Path of Adventure [1919].*
Contrib: *ILN [1884-1919]; The Sporting and Dramatic News [1890]; The English Illustrated Magazine [1893-94].*
Exhib: Paris; RA; RBA; RHA; ROI.

PRIMROSE, Priscilla

Amateur artist. She contributed drawings of Rome to *The Illustrated Times,* 1859.

PRINCE, Val R. fl.1890-1893

Painter and illustrator. He was working in Kensington in 1890 and contributed to *The Pall Mall Budget* in 1893.

PRINSEP, James 1799-1840

Architect, orientalist and draughtsman. He was born in 1799, brother of Charles Robert Prinsep, the economist. He acted as Assistant Assay-Master at the Calcutta mint, 1819, was appointed Assay-Master in 1832 and carried out some architectural works there including the completion of the Hooghly Canal.

Illus: *Benares Illustrated in a Series of Drawings [1831].*
Colls: Witt Photo.

PRINSEP, Val C. RA 1838-1904

Painter and author. He was born at Calcutta on 14 February 1838 and educated at home. He studied art at the RA Schools and with Gleyre in Paris before spending some time in Rome. He was elected ARA in 1879 and RA in 1894, and was Professor of Painting from 1900 to 1903. He died on 11 November 1904.

Publ: *Imperial India, An Artist's Journal [1879].*
Contrib: *Once a Week [1869].*
Exhib: B; G; GG; L; M; New Gall; RA; RHA.
Colls: Hamburg; Sheffield; Tate.

PRIOLO, Paolo fl.1857-1890

Historical and biblical painter and illustrator. He worked in Stockwell, London, 1857-90, and contributed an illustration to *The Churchman's Family Magazine,* 1863.

Exhib: RA; RBA.

PRIOR, Melton 1845-1910

Special Artist and illustrator. He was born in London in 1845, the son of W.H. Prior (q.v.) and studied under his father in Camden Town. From about 1873 he was war correspondent of *The Illustrated London News,* and served in numerous campaigns. He followed the Ashanti War in 1873, the Carlist Rising, 1874, the Servian, Turkish, Kaffir, Zulu and first Boer Wars, the Egyptian Campaign, 1882, the Cretan Insurrection, the Siege of Ladysmith, 1900. He also went on a number of Royal Tours including the Prince of Wales's visit to Athens, 1875, the King of Denmark's visit to Iceland and the Marquess and Marchioness of Lorne's (qq.v.) visit to Canada. He was present at the Berlin Conference and drew for the magazine at the marriage of Tsar Nicholas II and later travelled with Prince George of Wales through Canada, 1901. He attended the Delhi Durbar of 1902, was on the Somaliland Expedition of 1903 and reported on the Russo-Japanese War of 1904. He died in London on 2 November 1910.

Contrib: *The Sketch; The English Illustrated Magazine [1893-94].*
Colls: V & AM.
Bibl: *The Idler,* Vol.8, pp.337-346; S.L. Bensusan (Editor), *Campaigns of a War Correspondent,* 1912.

PRIOR, William Henry 1812-1882

Landscape painter and illustrator. He was born in 1812 and worked in London and painted views in the South of England and on the Rhine. He was the father of Melton Prior (q.v.).

Illus: *Lyrics of a Life-Time [S. Smith, 1873].*
Contrib: *Knight's London [1841]; The Illuminated Magazine [1845]; ILN [1850]; Cassell's Illustrated Family Paper [1853]; The Illustrated London Magazine [1854]; The Illustrated Times [1866].*
Exhib: BI; RA; RBA.

PRITCHETT, Robert Taylor FSA 1828-1907

Illustrator and gunsmith. He was born at Enfield in 1828, the son of a gun manufacturer and was educated at King's College School. He became a partner in the family business and was the originator of the Enfield rifle and invented with W.E. Metford the 'Pritchett bullet' in 1853, and the three grooved rifle in 1854. As an artist he specialised in black and white work and watercolours of the sea and ships, accompanying Lord and Lady Brassey on their tours of 1883 and 1885 on the *Sunbeam.* He was an intimate friend of John Leech, Charles Keene and Birket Foster (qq.v.). He died on 16 June 1907.

Illus: *Brush Notes in Holland [1871]; Gamle Norge [1878]; Smokiana [1890]; Pen and Pencil Sketches of Shipping [1890].*
Contrib: *Punch [1863-69]; Once a Week; Good Words [1864-80]; The Sunday Magazine [1865]; Cassell's Magazine [1867]; The Leisure Hour [1867]; The Graphic [1887].*
Exhib: RA; RBA.
Colls: Glasgow; V & AM.
Bibl: M.H. Spielmann, *The History of Punch,* 1894, pp.520-521.

PROCTOR, J. James

Black and white artist and illustrator. He illustrated *Yarns On The Beach,* by G.A. Henty, 1885, and contributed to *Illustrated Bits.*

WHERE IS JOHN BRIGHT NOW?
WELL, PEACE PROFESSIONS HAVING PLUNGED US INTO ALMOST UNIVERSAL WAR, JOHN BRIGHT IS—HIDING.

JOHN PROCTOR fl.1866-1898. 'Where is John Bright Now?' A cartoon for Moonshine, *25 August 1885.*

PROCTOR, John fl.1866-1898

Cartoonist. Although little is known about his background or training, Proctor developed as one of the best political cartoonists of the end of the Victorian period, characterised by invention and strong drawing of animals. He was chief cartoonist for *Judy* 1867-68, following this with a period on *Will o' The Wisp* and *Moonshine*, 1868-85 and as chief cartoonist on *The Sketch*, 1893 and *Fun*, 1894-98. He was apparently employed by *The Illustrated London News* to act as Special Artist in St. Petersburg in 1874 and he also worked for *Cassell's Saturday Journal.*

Illus: *Dame Dingle's Fairy Tales [1866-67].*
Exhib: RBA.
Colls: Witt Photo.
See illustration (above).

PROSPERI, Liberio

Italian caricaturist. He contributed to *Vanity Fair*, 1886-94 and 1902-03.

PROSSER, George Frederick fl.1828-1868

Artist and topographical illustrator. He worked at Winchester and Eton and published a number of books.

Illus: *Select Illustrations of the County of Surrey [1828]; Select Illustrations of Hampshire [1833]; Scenic and Antiquarian Features . . . of Guildford [1840]; The Antiquities of Hampshire [1842].*

PROUT, John Skinner NWS 1806-1876

Architectural painter and illustrator. He was born at Plymouth in 1806, the nephew of Samuel Prout (q.v.) and was virtually self-taught but specialised in subjects similar to his uncle. As a young man he made a lengthy visit to Australia and lived in both Sydney and Hobart, forfeiting by his absence the membership of the NWS, which he had gained in 1838. He was re-elected on his return in 1849 and settled at Bristol where he became a close friend of the artist W.J. Muller. He died at Camden Town 29 August 1876.

Illus: *Sydney Illustrated [1842-44, AT 576]; Antiquities of Bristol [n.d.].*
Exhib: NWS; RI.
Bibl: M. Hardie, *Watercol. Paint. in Brit.*, Vol.3, 1968, pp.11-12.
Colls: BM; Fitzwilliam; V & AM.

PROUT, Samuel 1783-1852

Watercolourist, topographical illustrator and drawing-master. He was born at Diss, Norfolk on 17 September 1783 and was taught by J. Bidlake, master of the Plymouth Grammar School. He was friendly with B.R. Haydon, the historical painter and with him made sketching tours in Devonshire. In 1796, John Britton (q.v.) employed him to tour Cornwall for his *Beauties of England and Wales*, but his work proved unsatisfactory. By 1802 his work had improved and on sending fresh drawings to Britton, he was re-employed by him and lived with him at Clerkenwell for two years. Prout was continually dogged by ill health, but managed to finish work for Britton in Cambridgeshire, Essex and Wiltshire, 1804, and in Devon and Cornwall, 1805. From 1819 onwards, when he made his first visit to France, Prout became a frequent traveller on the Continent, visiting Belgium, the Rhine and Bavaria and Italy in 1824. He made his last tour to Normandy in 1846 by which time he was a sick man and unable to do much work between then and his death.

Prout's sympathy in rendering Gothic architecture with great accuracy and yet giving it mood and atmosphere was exactly suited to the romanticism of the 1820s and 1830s. His effects of light on crumbling masonry and flecks of colour on figures contrasting with the whites and greys of the buildings was widely copied for a generation. Perhaps this was partly due to the championship of John Ruskin who calls him in *Modern Painters* 'among our most sunny and substantial colourists'. He became a member of the OWS in 1819 and was Painter in Watercolours to George IV and Queen Victoria. He died at Denmark Hill on 10 February 1852.

Illus: *Rudiments of Landscape in Progressive Studies [1813, AL 170]; Rudiments [1814, AL 171]; New Drawing Book [1819, AL 172]; Series of Easy Lessons in Landscape Drawing [1819, AL 173]; Views of Cottages [1819, AL 174]; Illustrations of the Rhine [1824]; Facsimiles of Sketches made in Flanders and Germany [1833]; Hints [1834, AL 176]; Sketches in France, Switzerland and Italy [1839, AL 34].*
Contrib: *Beauties of England and Wales [1803-14]; Antiquarian and Topographical Cabinet [1809]; Jennings Landscape Annual [1831]; Microcosm [1841]; Sketches At Home and Abroad [1844]; Rhymes and Roundelayes; ILN [1850]; The Continental Annual [1832].*
Exhib: BI; OWS; RA.
Colls: Aberdeen; Ashmolean; BM; Birkenhead; Blackburn; Derby; Exeter; Fitzwilliam; Leeds; Manchester; V & AM.
Bibl: J. Ruskin, *Notes on SP and Hunt*, 1879; *The Studio*, Special No., 1914; J. Quigley, *Prout and Roberts*, 1926; A. Neumeyer, *Collection of Eng. Watercols. at Mills Coll.*, 1941; C.E. Hughes,' *O.W.S.* Vol.6; M. Hardie, *Watercol. Paint. in Brit.*, Vol.3, 1968, pp.4-11.

PROUT, Victor fl.1888-1903
Watercolour painter. He contributed an angling subject to *The Graphic*, 1903.

Exhib: Goupil Gall., 1888.

PROVOST, W.
French illustrator. He contributed views of Paris to *Cassells Illustrated Family Paper*, 1857.

PRY, Paul see HEATH, William

PRYDE, James Ferrierr 1866-1941
Painter and illustrator. He was born at St. Andrews on 30 March 1869 and was educated at George Watson's College, the RSA Schools and in Paris at Julians under Bouguereau. He married Mabel Nicholson, sister of William Nicholson (q.v.) and with his brother-in-law began to design and produce posters and illustrations as the Beggarstaff Brothers. Pryde claimed to be part of the Glasgow School but his work is closer to the French poster art of Toulouse Lautrec and of Phil May. Both artists experimented with woodcuts and produced a periodical, *The Page*, 1898, based on archaic chap-book printing. Pryde was less of a book illustrator than a designer and his later career was devoted to stage design and dramatic paintings of shadowy interiors. Pryde was elected HROI, 1934 and died in 1941.

Illus: *The Little Glass Man [Wilhelm Hauff, 1893].*
Contrib: *Tony Drum [1898]; The Page [1898-99].*
Exhib: G; GG; L; NEA; RHA; RSA.
Colls: V & AM; Witt Photo.
Bibl: Derek Hudson, *JP, 1866-1941,* catalogue, 1949.

PRYSE, Gerald Spencer 1882-1956
Painter and illustrator. He was born in 1882 at Ashton and was educated privately, studying art in London and Paris. He served in the First World War and won both the MC and the Croix de Guerre. Pryse was a member of the International Society and exhibited at Venice from 1907. He was working at Hammersmith from 1914 to 1925 but lived in Morocco after 1950. He died in 1956.

Publ: *Through the Lines to Abd el Karim's Stronghold in the Riffs; Four Days.*
Illus: *Salome and the Head; a Modern Melodrama [E. Nesbitt, 1909]; The Book of the Pageant [Wembley Exhibition, 1924].*
Contrib: *Punch [1903-04 (children), 1905]; The Neolith [1907-08]; The Strand Magazine [1910]; The Graphic [1910].*
Colls: V & AM.

PUGIN, Augustus Charles 1762-1832
Architect, antiquary and architectural illustrator. He was born in France in 1762 into an old family, and fled to England in about 1798 where he was befriended by John Nash, the architect. Pugin was extensively employed by Nash as a Gothic draughtsman and his accuracy and knowledge of it was influential in establishing a purer appreciation of the style. He had lessons in aquatinting from Merigot in London and attended the RA Schools, at the same time carrying out a great deal of work for Ackermann, the publisher. At about the same time he set up a school of architectural drawing and published his own works, visiting Normandy in 1825 and Paris in 1830. His drawings reflect the current fashion in architectural work, meticulous tinted penwork, the figures frequently added by other artists such as Rowlandson and Stephanoff (qq.v.). His son was A.W.N. Pugin (q.v.). He died in Bloomsbury on 19 December 1832.

Illus: *Ackermann's Microcosm of London [1808]; Specimens of Gothic Architecture From Oxford; Specimens of Gothic Architecture [1821-23]; Views of Islington and Pentonville [1823]; Illustrations of Public Buildings in London [1825-28]; Specimens of Architectural Antiquities of Normandy [1826]; Examples of Gothic Architecture [1828-31]; Views of Paris and Environs [1828-31]; Gothic Ornaments from Ancient Buildings in England and France [1831]; Ornamental Gables [1831]; Cassiobury Park [Britton, 1838].*
Contrib: *Ackermann's Repository of the Arts [1810-27].*
Exhib: BI; OWS; RA.
Colls: BM; Lincoln; Nat. Gall., Scotland; RIBA; V & AM; Witt Photo.
Bibl: B. Ferrey, *Recollections of Welby and his Father ACP,* 1861.

PUGIN, Augustus Northmore Welby 1812-1852
Architect, designer, draughtsman and polemicist. He was born in London in 1812 the son of A.C. Pugin (q.v.). He was educated at Christ's Hospital and studied architecture with his father, before being discovered by Rundell's the silversmiths and being employed by them and Jeffery Wyattville as a designer. He was received into the Roman Catholic church in 1835 and from then onwards had an extensive practice among wealthy co-religionists, notably the Earl of Shrewsbury and Ambrose March Phillips. He continued to design ecclesiastical buildings and ornaments until his death, his best work in illustration being the etchings for Ackermann which express in their fine lines an almost medieval mysticism. Pugin's large practice and obsessive pamphleteering caused him to lose his reason in 1851 and he died at Ramsgate in 1852.

Illus: *Gothic Furniture consisting of twenty-seven coloured engravings ... [1828]; Gothic Furniture in the style of the 15th century [1835]; Ornaments of the 15th and 16th centuries [1835-37]; Contrasts [1836]; Details of ancient timber houses of the 16th and 17th cent. ... [1836]; Designs for Gold and Silversmiths [1836]; Designs for Iron and Brass work in the style of the XV and XVI centuries [1836]; The True Principles of Pointed or Christian Architecture [1841]; An Apology For the Revival of Christian Architecture in England [1843]; Glossary of Ecclesiastical Ornament and Costume [1844]; Floriated Ornament, a series of thirty-one designs [1849]; Modèles d'orfèrerie, argenterie, etc. ... [1850]; A Treatise on Chancel Screens and Fonts [1851]; A series of Ornamental Timber Gables, from existing examples in England and France [1854].*
Exhib: RA.
Colls: BM; Maidstone; RIBA; V & AM.
Bibl: B. Ferrey, *Recollections of Welby and his Father A.C.P.,* 1861; *Victorian Church Art,* V & A Museum Cat., 1971-72.
See illustration (below).

Right: AUGUSTUS NORTHMORE WELBY PUGIN 1812-1852. Title page to Designs for Gold & Silversmiths, *1836. Etching.*

PURSER, William c.1790-c.1852

Architect and topographical draughtsman. He was born about 1790, the son of an architect at Christ Church, Surrey. He entered the RA Schools in 1807 and travelled in Italy and Greece in 1817-20 with John Sanders, undertaking major archaeological work. He may have visited India.

Illus: *Syria [J. Carne, 1836].*
Contrib: *Finden's Landscape and Portrait Illustrations To The Life And Works of Lord Byron [1833-34]; Fisher's Scrapbook [1834].*
Exhib: RA; RBA.
Colls: BM; V & AM; Witt Photo.
Bibl: H.M. Colvin, *Biog. Dict. of Eng. Architects,* 1660-1840, 1954 p.481.

PYLE, Howard 1853-1911

Author and illustrator. He was born at Wilmington, Delaware, U.S.A. in 1853 and after being privately educated, studied at the Art Students League, New York. Pyle was among the most assured black and white draughtsmen of the American School excelling in 18th century subjects and in drawings in the manner of Durer whom he studied closely. Pennell considered that his early works suffer from having no direct contact with Europe, which he did not visit until his early middle age. He was a prolific illustrator of books for English as well as American publishers and died in Florence on 9 November 1911.

Illus: *The Merry Adventures of Robin Hood [1883]; Pepper and Salt [1885]; Rose of Paradise [1887]; The Wonder Clock [1887]; A Modern Aladdin [1891]; Poems [O.W. Holmes, 1892]; Twilight Land [1895]; The Garden Behind the Moon [1895]; Rejected of Men [1903]; The Story of King Arthur and His Knights [1902]; The Story of the Champions of the Round Table; The Story of Sir Launcelot and His Companions; The Ruby of Kishmoor [1908]; The Story of the Grail [1910].*
Contrib: *ILN [1880]; The Graphic [1883].*
Colls: V & AM.
Bibl: J. Pennell, *Pen Drawing and Pen Draughtsman,* 1894, pp.232-234; J. Pennell, *Modern Illustration,* 1895 pp.124-125.

PYM, T.

Illustrator of children's books. Contributed illustrations to *Victoria Bess; The Ups and Downs of a Doll's Life,* c.1880.

PYNE, Charles Claude 1802-1878

Landscape and genre painter. He was the second son of W.H. Pyne, (q.v.) and brother of G. Pyne (q.v.). He travelled on the Continent and practised as a drawing master at Guildford, where he died in 1878.

Contrib: *Lancashire Illustrated [W.H. Pyne, 1829].*
Exhib: BI; NWS; RA.
Colls: Nottingham; V & AM.

PYNE, George 1800-1884

Topographical watercolourist. He was born in 1800, the elder son of W.H. Pyne (q.v.) and brother of C.C. Pyne (q.v.). He was an excellent architectural artist and specialised in views of the Oxford and Cambridge Colleges and Eton, but was a less competent hand than his father. He was elected AOWS in 1827 and married the daughter of John Varley but later separated from her.

Publ: *A Rudimentary and Practical Treatise on Perspective for Beginners [1848]; Practical Rules on Drawing for the Operative Builder and Young Student in Architecture [1854].*
Contrib: *Lancashire Illustrated [W.H. Pyne, 1829].*
Colls: BM; Coventry; V & AM; York.

PYNE, William Henry 1769-1843

Landscape and genre painter in watercolours, illustrator, etcher, caricaturist and author. He was born in London in 1769 and studied with H. Pars, before beginning a career in book illustration. He was a founder member of the OWS in 1804 and remained a member until 1809 when he resigned. His greatest successes were in his collaborations with the publisher Rudolph Ackermann, when they were jointly engaged in issuing colour plate books from about 1803 to 1819. Pyne produced several drawing books for amateurs which are notable for their fine groups of figures and it is probably this aspect of his contribution to the romantic school that is most significant. He

was an assiduous art critic, catalogued Benjamin West's collection in 1829 and Watson Taylor's in 1832 and was editor of *The Somerset House Gazette* under the pseudonym of Ephraim Hardcastle and author of *Wine and Walnuts,* an anthology of the former, in 1823. *The Microcosm,* 1803-05 is his largest undertaking and many of the original drawings for the illustrations are in the Leeds City Art Gallery. He was a poor businessman and spent the last years of his life in the King's Bench Debtors' Prison, before dying at Pickering Place, Paddington on 29 May 1843.

Illus: *Microcosm or a Picturesque Delineation of the Arts, Agriculture and Manufactures of Gt. Britain [1803-08, AT 177]; Nattes Practical Geometry [1805 (title and vignettes)]; The Costume of Great Britain [1808]; Rudiments of Landscape Drawing [1812, AT 178]; Rustic Figures [1815, AT 179]; The History of the Royal Residences [1819]; Microcosm [1822-24, AT 80]; Lancashire Illustrated [1831].*
Contrib: *Knight's London [1841].*
Exhib: OWS; RA; Witt Photo.
Colls: BM; Leeds.
Bibl: M. Hardie, *Watercol. Paint. in Brit.,* 1968, Vol.3 pp.280-281; A Bury, *O.W.S.,* Vol.XXVIII, 1950.

QUENNELL, Charles Henry Bourne 1872-1935

Architect, author and illustrator. He was born on 5 June 1872 and was educated at South Kensington, beginning practice in Westminster in 1896. Quennell worked as a church architect as well as carrying out numerous houses in the arts and crafts style before 1914. In later life he devoted himself principally to books on social history, most of them illustrated by himself and his wife Marjorie Courtney whom he married in 1904. He held many posts at the RIBA and died on 5 December 1935.

Publ: *Norwich Cathedral [1900]; Modern Suburban Houses [1906]; A History of Everyday Things in England [1918-34]; Everyday Life in the Old Stone Age [1921]; New Stone, Bronze and Early Iron Age [1922]; Roman Britain [1924]; Anglo-Saxon, Viking and Norman Times [1926]; Everyday Things in Homeric Greece [1929]; Everyday Things in Archaic Greece [1931]; Everyday Things in Classical Greece [1932]; The Good New Days [1935].*

QUESTED, George R. fl.1895-1901

Illustrator and book plate designer. He was working at St. John's Wood, 1895 and Edgbaston, 1897. He won prizes in *The Studio* book illustration competition, 1895.

Exhib: RA.
Bibl: *The Studio,* Winter No., 1900-01 p.59, illus.

QUINTON, Alfred Robert 1853-

Landscape and watercolour painter. He was born in 1853 and studied at Heatherley's and contributed to *The Illustrated London News,* 1884-86, 1894 and to *The Sporting & Dramatic News* 1890.

Illus: *Cycling in the Alps [C.L. Freeston, 1900]; The Historic Thames [J.H.P. Belloc, 1907]; The Avon and Shakespeare's Country [A.G. Bradley, 1910]; A Book of the Wye [E. Hutton, 1911]; The Cottages of Rural England [P.H. Ditchfield, 1912].*
Exhib: B; GG; G. L; M; RA; RBA; RHA; ROI.

'QUIZ' See MELLOR

R, N.
Unidentified illustrator of landscape subjects, dating from about 1900.

Colls: V & AM.

RACKHAM, Arthur RWS **1867-1939**
Illustrator and watercolourist. He was born at Lewisham on 19 September 1867 and after being educated at the City of London School, studied art at Lambeth School where he was influenced by his fellow student Charles Ricketts (q.v.). Rackham joined the staff of *The Westminster Budget* in 1892 and from that time forward concentrated on the illustration of books and particularly those of a mystical, magic or legendary background. He very soon established himself as one of the foremost Edwardian illustrators and was triumphant in the early 1900s when colour printing first enabled him to use subtle tints and muted tones to represent age and timelessness. Rackham's imaginative eye saw all forms with the eyes of childhood and created a world that was half reassuring and half frightening. His sources were primarily Victorian and among them are evidently the works of Cruikshank, Doyle, Houghton and Beardsley (qq.v.) but also the prints of Dürer and Altdorfer. He was elected RWS in 1902 and after 1922 he undertook oil painting and some stage designing. He was a member of the Langham Sketch Club, exhibited widely at home and abroad and died on 6 September 1939.

Illus: *The Dolly Dialogues [1894]; Sketchbook, Tales of a Traveller [Washington Irving, 1895]; Bracebridge Hall [1896]; The Money Spinner [1896]; The Grey Lady [Seton Merriman, 1897]; Two Old Ladies etc. [M. Browne, 1897]; Evelina [Fanny Burney, 1898]; The Ingoldsby Legends [1898]; Gulliver's Travels [1899]; Tales From Shakespeare [Lamb, 1899]; Grimm's Fairy Tales [1900]; The Argonauts of the Amazon [C.R. Kenyon, 1901]; Rip Van Winkle [1905]; Peter Pan in Kensington Gardens [J.M. Barrie, 1906]; Alice's Adventures in Wonderland [Lewis Carroll, 1907]; A Midsummer Night's Dream [Shakespeare, 1908]; Undine [Fouqué, 1909]; The Book of Betty Barber [M. Browne, 1910]; The Rhinegold and The Valkyrie [Wagner, 1910]; Siegfried and the Twilight of the Gods [Wagner, 1911]; Aesop's Fables [1912]; The Old Nursery Rhymes [1913]; Arthur Rackham's Book of Pictures [1913]; A Christmas Carol [Charles Dickens, 1915]; The Allies Fairy Book [1916]; Little Brother and Little Sister [1917]; The Romance of King Arthur and his Knights of the Round Table [1917]; English Fairy Tales Retold [Flora Annie Steel, 1918]; The Springtide of Life [A.C. Swinburne, 1918]; Cinderella [1919]; Snickerty Nick, Rhymes by Whitter Bynner [J.E. Ford, 1919]; Some British Ballads [1919]; The Sleeping Beauty [1920]; Irish Fairy Tales [James Stephens, 1920]; A Dish of Apples [Eden Philpotts, 1921]; Comus [Milton, 1921]; A Wonder Book [Nathaniel Hawthorne, 1922]; Where the Blue Begins [Christopher Morley, 1925]; Poor Cecco [M.W. Bianco, 1925]; The Tempest [Shakespeare, 1926]; The Legend of Sleepy Hollow [Washington Irving, 1928]; The Vicar of Wakefield [Goldsmith, 1929]; The Compleat Angler [Izaak Walton, 1931]; The Night Before Christmas [C.C. Moore, 1931]; The King of the Golden River [J. Ruskin, 1932]; Fairy Tales [Anderson, 1932]; Goblin Market [Christina Rossetti, 1933]; The Pied Piper of Hamelin [Robert Browning, 1934]; Tales of Mystery and Imagination [E.A. Poe, 1935]; Peer Gynt [H. Ibsen, 1936]; A Midsummer Night's Dream [Shakespeare, 1939]; The Wind in the Willows [K. Grahame, 1940].*
Contrib: *Pall Mall Budget [1891-92]; Westminster Budget; The Graphic [1901]; Punch [1905-06]; The Sketch; Black & White; The Gentlewoman; Cassell's Magazine; Cassell's Family Magazine; Chums.*
Exhib: B; FAS, 1917; G; L; RA; RBA; RI; ROI; RSA; RSW; RWS.
Colls: Bradford; Fitzwilliam; Tate; V & AM.
Bibl: *The Studio,* Vol.34, 1906 pp.189-201, illus.; F. Coykendall, *A Bibliography,* 1922; *O.W.S. Club,* XVIII, 1940; D. Hudson, *AR, Life and Work,* 1960; F. Gettings, *AR,* 1975; B. Peppin, *Fantasy Book Illustration,* 1975; Gordon N. Ray, *The Illustrator and the Book in England,* 1976 pp.203-206.
See illustration (pp.425 and 507).

RADCLYFFE, Charles Walter **1817-1903**
Landscape painter, watercolourist, lithographer. He was born at Birmingham in 1817 and worked there throughout his life specialising in views of old buildings in tinted lithographs and especially illustrations of the public schools. He came from a distinguished family of engravers and died at Birmingham in 1903.

Illus: *The Palace of Blenheim [1842]; Memorials of Shrewsbury School [1843]; Memorials of Charterhouse [1844]; Memorials of Eton College [1844]; Memorials of Westminster School [1845]; Memorials of Winchester College [1847].*
Exhib: B; RA; RI; ROI.
Colls: B; V & AM.

RAEMAKERS, Louis **1869-1956**
Cartoonist. He was born at Roermond, Holland on 6 April 1869 and educated there and in Amsterdam and Brussels and received many diplomas for drawing. He was Director of a drawing school at Wageningen in Gelderland and about 1908 began to produce political cartoons and posters. Raemakers first attracted the attention of the British public during the First World War with his powerful chalk cartoons of the European situation, 1914-18. His bold and unsparing criticism of German atrocities was something new and his style has been compared to that of Steinlen. He later worked for French newspapers and died in 1956. Elected HRMS, 1916.

Illus: *The Great War in 1916; The Great War in 1917; Devant L'Histoire [1918]; Cartoon History of the War [1919].*
Exhib: FAS, 1915, 1916, 1917, 1918, 1920.
Colls: V & AM.

RAFFET, Denis Auguste Marie **1804-1860**
Battle painter, illustrator, engraver and lithographer. He was born in Paris on 2 March 1804 and after being apprenticed to a wood turner he went to Cabanel as a decorator of porcelain. In 1824 he worked for Charlet who taught him lithography and on leaving in 1829 he became a pupil of Gros. He failed to win the Prix de Rome in 1831 and from then concentrated entirely on lithography and illustration, publishing a number of albums. Raffet followed the French army to Italy in 1849 and attended the siege of Rome. He was patronised by Prince Demidoff and visited England and Scotland with him during his later years. He died at Gênes on 11 February 1860.

Illus: *Musée de la Revolution; Histoire de France; La Revolution; Le Consulat et L'Empire; History of Napoleon; Voyage en Crimée.*
Contrib: *The Illustrated Times [1855].*

RAFTER, H.
Illustrator and sporting artist. He was working in Coventry in 1856 and contributed to *Wyatt's Industrial Arts of the 19th Century.*
Colls: V & AM.

RAILTON, Fanny (Mrs. Herbert Railton) **fl.1894-1902**
Illustrator of children's books. Wife of the black and white artist Herbert Railton (q.v.).

Illus: *Lily and Lift [Seeley, 1894]; A Midsummer Night's Dream [1902].*

RAILTON, Herbert **1857-1910**
Black and white artist and illustrator. He was born at Pleasington, Lancashire on 21 November 1857 and educated at Mechlin, Belgium and at Ampleforth. Railton's picturesque pen drawings of old buildings set a fashion in topographical draughtsmanship that lasted for many years, concentrating on the atmosphere and maturity of stone and brick. His drawings are characterised by an individual wriggly line and a strong decorative sense of the book page. Pennell considered him very influential, this is best seen in his follower Holland Tringham (q.v.). He died on 15 March 1911.

Illus: *Windsor Castle [1886]; Pickwick Papers [Charles Dickens Jubilee Edition, 1887]; Coaching Days and Coaching Ways [1888 (with Hugh Thomson)]; Westminster Abbey [1889]; Select Essays of Dr. Johnson [1889]; Poems and Plays of Goldsmith [1889]; Pericles and Aspasia [W.S. Landor, 1890]; Dreamland in History [1891]; The Citizen of the World [Goldsmith, 1891]; Beddoes Poetical Works [1891]; Collected Works of T.L. Peacock [1891]; Essays and Poems of Leigh Hunt [1891]; The Peak of Derbyshire [Leyland, 1891]; Ripon Millenary [1892]; The Inns of Court [Loftie, 1893]; Living English Poets [1894 (frontis)]; H. Kingsley's Novels [1894]; The Household of Sir Thomas More [1896]; The Haunted House [Hood, 1896]; Hampton Court [1897]; Cherry and Violet [Miss Manning, 1897]; English Cathedral Series [1897-99]; Travels in England [Le Gallienne, 1900]; Natural History of Selborne [White, 1900]; The Story of Bruges [1901]; Life of Johnson [1901].*

ARTHUR RACKHAM RWS 1867-1939. 'The Death of Balder.' Original illustration in pen and ink. Signed and dated 1904. 15ins. x 11¹/8ins. (38.1cm x 28.2cm).

HERBERT RAILTON 1857-1910. 'The Old Tabard Inn.' Original drawing for illustration. Pen. 7⅞ins. x 10⅜ins. (20cm x 26.3cm). Victoria and Albert Museum

Contrib: *The English Illustrated Magazine [1884-96]; The Graphic [1887]; ILN [1889-99]; The Sporting & Dramatic News [1890]; Good Words [1890-94]; The Pall Mall Budget [1891-92]; Daily Chronicle [1895]; The Sketch; The Idler; The Windsor Magazine; The Temple Magazine.*
Colls: Blackburn; V & AM.
Bibl: J. Pennell, *Pen Drawing and Pen Draughtsmen*, 1895 p.360, illus.; R.E.D. Sketchley, *Eng. Bk. Illus.*, 1903 pp.31, 38, 45, 74, 139.
See illustration (above).

RAIMBACH, Abraham 1776-1843
Miniature painter and engraver. He was born in London in 1776 of Swiss extraction and after being educated at Archbishop Tenison's Library School, he attended the RA Schools. He was then employed by J. Hall, the engraver and worked on Smirke and Forster's edition of the *Arabian Nights, Macklin's Bible, Hume's History of England, Woodmason's Shakespeare* and *Bell's British Theatre* . . . He engraved a number of plates after Wilkie's works and died at Greenwich in 1843. Although not principally an illustrator, Raimbach's *Memoirs and Recollections*, 1843, remain an important source for the history of the art.

Colls: BM.

RAINEY, William RBA RI 1852-1936
Artist and illustrator. He was born in London on 21 July 1852 and studied art at South Kensington and at the RA Schools before starting his career in book illustration. Rainey was much influenced by the 18th century revivalism of Thomson and others, was an assured pen artist and a fine wash artist. Much of his best work was done for the magazines but he illustrated a number of boys' stories. He was elected RI in 1891 and ROI, 1892, becoming HROI in 1930. He lived for the latter part of his life in Eastbourne and died on 24 January 1936.

Publ: *All the Fun of the Fair [1888]; Abdulla [1928]; The Last Voyage of the 'Jane Ann' [1929]; Admiral Rodney's Bantam Cock [1938]; Who's on My Side [1938].*

Illus: *Sweet Content [Mrs. Molesworth, 1891]; At Aboukir and Acre [G.A. Henty, 1898]; The Rebel of the School [L.T. Meade, 1902]; The Giant of the Treasure Caves [1908]; The Court Harman Girls [Meade, 1908].*
Contrib: *ILN [1884-94]; The Graphic [1884-1901]; The Quiver [1890]; Good Words [1891]; Black & White [1891-92]; The Strand Magazine [1891, 1906]; The Ludgate Monthly [1896]; The Temple Magazine [1896]; Cassell's Family Magazine; Chums.*
Exhib: G; L; M; RA; RBA; RI; ROI.
Colls: Leeds.
Bibl: J. Pennell, *Pen Drawing and Pen Draughtsmen*, 1894 p.352.
See illustration (p.427).

RALSTON, John Mc L. fl.1872-1880
Figure artist, illustrator and watercolourist. According to Dalziel this artist came from Scotland to work in London in about 1873. He worked for magazines and contributed to books.

Illus: *A Child's History of England [Charles Dickens, The Household Edition, 1873]; The Pilgrim's Progress [1880].*
Contrib: *ILN [1872-73, 1880-81].*
Exhib: Dowdeswell Galleries.
Bibl: The Brothers Dalziel, *A Record of Work, 1840-1890*, 1901.

RALSTON, William 1848-1911
Comic artist. He was born in Dumbarton in 1848 and probably studied under his younger brother after abandoning a career as a photographer. He contributed a great many drawings to *Punch* from 1870 to 1886, specialising in genre and military subjects. He later became a master of the episodic illustration and strip cartoon, making up in humour for a certain deficiency in his drawings. He died at Glasgow in October 1911.

Illus: *Barry Lyndon [W.M. Thackeray, 1894].*
Contrib: *Punch [1870-86]; ILN [1870-73]; The Graphic [1870-1911]; The Cornhill Magazine [1883-84]; The Daily Graphic; The Sporting and Dramatic News [1895].*
Exhib: G.
Bibl: M.H. Spielmann, *The History of Punch*, 1895 p.543.

RAMBERG, Johann Heinrich **1763-1840**
Painter, engraver and caricaturist. He was born in Hanover in 1763
and came to England in 1781 to study at the RA Schools. He was a
pupil of Sir Joshua Reynolds and Bartolozzi and after travelling to
Italy and Dresden was appointed Court Painter at Hanover in 1792.
His caricatures are mostly political ones dating from the later 1780s.
He died at Hanover on July 6, 1840.

Exhib: RA.
Colls: BM; Hanover; Nottingham.
Bibl: M.D. George, *English Political Caricature,* Vol.1, 1959 p.194.

RAMBLE, Fred
Illustrator. Contributed to *Public Works of Great Britain,* 1838 AL
410.

RANKIN, Andrew Scott **1868-**
Animal painter. He was born at Aberfeldy in 1868 and studied at the
Manufacturers School, Royal Institute and Life School, Edinburgh.
He was on the staff of *Today* and was caricaturist of *The Idler,*
c.1893. He worked at Strathtay, 1902-14 and at Pitlochrie, 1925.

Exhib: G; L; M; RA; RCA; RSA.

RANKIN, Arabella Louisa **1871-**
Painter and colour woodcut artist. She was born at Muthill, Perthshire
in 1871 and worked at Edinburgh, 1903, Crieff, 1914 and in London
1922-35.

Bibl: *The Studio,* Vol.8, 1896 p.252, illus.

RAVEN-HILL, Leonard RWA **1867-1942**
Black and white artist and cartoonist. He was born at Bath on 10
March 1867 and was educated at Bristol Grammar School and Devon
County School before entering the Lambeth School of Art where he
met Charles Rickettes and Charles H. Shannon (qq.v.). He then went
to Paris and studied with Bouguereau and Aimé Morot and exhibited

at the Salon from 1887. Raven-Hill's connection with *Punch* began in
1896, but he had had a varied career on the magazines before this. He
was appointed Art Editor of *Pick-Me-Up* in about 1890 and in 1895
founded his own illustrated publication *The Unicorn,* which had a
short run. Other notable successes included his drawings for Rudyard
Kipling's *Stalky & Co.* which first appeared in *The Windsor Magazine.*

Raven-Hill was one of the most versatile of the Edwardian *Punch*
artists. He was strongly influenced by Ricketts, admired Japanese art
and studied closely the work of Charles Keene (q.v.) with whose
delicate pencil line and superb washes his own work has the closest
affinities. He was second cartoonist and under-study to Partridge until
1935, but he was more at home in the domestic and genre subjects
which he handled simply and brilliantly.

Illus: *The Promenaders [1894]; Stalky & Co., [Rudyard Kipling, 1899];
Raven-Hill's Indian Sketchbook [1903].*
Contrib: *Judy [1889]; Pick-Me-Up [1890]; Daily Graphic [1890]; Black &
White [1891]; The Butterfly [1893-94, 1899-1900]; The Pall Mall Budget
[1893]; ILN [1893]; The Unicorn [1895]; Punch [1896-1935]; The Minister
[1895]; The Rambler [1897]; The Sketch [1897]; Fun [1901]; The Graphic
[1906]; St. Paul's; Pearson's Magazine; The Pall Mall Magazine; The Nutshell.*
Exhib: FAS, 1899; GG; G; L; NEA; RA; RBA; RI; ROI; RSA.
Colls: Author; Birmingham; V & AM; Witt Photo.
Bibl: J. Pennell, *Pen Drawing and Pen Draughtsmen,* 1895 pp.340-341; *The
Idler,* Vol.8 pp.124-132, illus; *The Studio,* Winter No., 1900-01 p.25, illus;
R.G.G. Price, *A History of Punch,* 1957 pp.217-218.
See illustration (pp.428, 429).

RAVERAT, Gwen **1885-1957**
Wood engraver. She was born at Cambridge in 1885, the daughter of
Sir George Darwin, Plumian Professor at Cambridge. She studied at
the Slade School and worked mostly in Cambridgeshire but also in
France, her style influenced by Eric Gill. ARE, 1920, RE, 1934. An
exhibition of her work was held at the Fitzwilliam Museum in
November 1977.

Illus: *The Bird Talisman, An Eastern Tale [H.A. Wedgwood].*
Exhib: G; L; NEA; RE; RHA; RSA.
Bibl: G. Raverat, *Period Piece,* 1952.

W. RAINEY RBA RI 1852-1936. 'A Regency skating party.' Original drawing for illustration. Grey wash and bodycolour. Signed and dated 1891. Newman Collection

LEONARD RAVEN-HILL 1867-1942. 'Edwin and Angelina find the only place they can meet in London!' Original drawing, probably intended as an illustration for Punch. Pen and ink. Signed and dated 1891. 8ins. x 9½ins. (20.3cm x 24.1cm). Victoria and Albert Museum

RAWLE, Samuel 1771-1860
Landscape painter in oil and watercolours. He drew a number of illustrations for *The Gentleman's Magazine* and for J. Britton's publications. He illustrated *The Arabian Antiquities of Spain* by Murphy and died in London in 1860.

Colls: V & AM.

RAWLINGS, Alfred 1855-1939
Landscape and flower painter and illustrator. He was born in London in 1855 and became an art master at Leighton Park School, Reading and a member of the Berkshire Art Society where he exhibited.

Publ: *Anthology of Sea and Flowers [1910, 1913]; Book of Old Sundials [1915].*
Illus: *Our Village [M.R. Mitford, 1910].*
Exhib: B; RA.
Colls: Manchester; Northampton; Reading.

RAWLINS, Thomas J. fl.1837-1860
Topographer and illustrator. Rawlins specialised in sporting subjects and was employed to illustrate works by Nimrod, Charles James Apperley, with H.T. Alken (q.v.). It seems that the artist visited India either in 1837 or in 1858-60.

Illus: *Gamonia or The Art of Preserving Game [L. Rawstorne, AL 392]; Elementary Drawing as Taught at St. Mark's College, Chelsea [1848].*
Contrib: *ILN [1858-60].*
Exhib: RA.

RAYNER, Samuel A. -1874
Architectural and historical painter and illustrator. Rayner began exhibiting in London in 1821, most of his work being in the style of George Cattermole (q.v.). He was a successful artist and prints were made after his drawings and he was elected AOWS in 1845. He was however struck off in 1851 after being convicted of fraud. He had five daughters who painted architecture in his style and he died at Brighton in 1874.

Illus: *Sketches of Derbyshire Scenery [1830]; The History and Antiquities of Haddon Hall [1836]; The History . . . of Derby [1838].*
Contrib: *Britton's Cathedrals [1832-36].*
Exhib: BI; OWS; RA; RBA.
Colls: Birkenhead; Coventry; Derby; Ulster.

READ, Edward Henry Handley 1870-
Portrait and landscape painter and illustrator. He studied at South Kensington, at the Westminster School of Art and at the RA Schools

where he won the Creswick prize. He was elected RBA in 1895 and was an Official War Artist for the Army, 1918.

Contrib: *The English Illustrated Magazine [1897]; The Graphic [1902].*
Exhib: FAS; G; L; M; RA; RBA; RI; ROI.
Colls: Bedford.

READ, H. Hope fl.1906-1928
Figure painter. He was working in London from 1908 and contributed subjects to *Punch*, 1905-07.

Exhib: M; NEA; RA.

READ, Samuel RWS 1815-1883
Landscape and architectural painter and illustrator. He was born at Needham Market, Suffolk in 1815 and was placed in a lawyer's office at Ipswich and then as an assistant to an architect. Neither professions suiting him, he went to London and learnt drawing on wood under J.W. Whymper (q.v.). He also studied with W.C. Smith and became an accomplished watercolour painter, sending many works to exhibitions. In 1844 he began to work as an illustrator for *The Illustrated London News*, a connection which lasted until his death. In 1853, just before the outbreak of the Crimean War, Read was despatched to Constantinople, the first occasion that the paper had sent an artist abroad on an assignment. He also travelled to Germany and North Italy and Spain as well as visiting and recording nearly every well-known ecclesiastical or manorial landmark in Great Britain. Over the years his pictures became an institution in *The 'News* and he was unofficially retained as Art Editor. His drawings of cathedrals, ruins and mysterious castles are delightfully dank and gloomy, always covered in thick undergrowth and with the appearance of having been painted in partly melted candle wax. He died at Sidmouth on 6 May 1883, having been elected OWS in 1880.

Illus: *Zoological Studies [S.P.C.K., 1844].*
Contrib: *The Home Affections by the Poets [Charles Mackay, 1858]; Willmott's Sacred Poetry of the 16th, 17th and 18th Centuries [1862]; Rhymes and Roundelayes.*
Exhib: OWS; RA; RBA.
Colls: Newcastle; Reading; V & AM.
Bibl: *Leaves From a Sketch-Book,* 1875.

REASON, Florence fl.1896-1914
Genre and flower painter. She studied at the Queen's Square School of Art and won a National Silver Medal and Gilchrist Scholarship. She contributed figures to *The English Illustrated Magazine,* 1896.

Exhib: B; L; M; RA; RBA; RI; SWA.

REDFARN, William Beales fl.1870-1916
Topographical artist. He made drawings of old buildings at Cambridge which were published as *Old Cambridge*, 1876 and he illustrated J.W. Clark's *Ancient Wood and Ironwork in Cambridge,* 1881.

Colls: Fitzwilliam.

REDGRAVE, Richard RA 1804-1888
Genre painter and illustrator. He was born in Pimlico on 30 April 1804, the son of a wire fence manufacturer, and worked with his father before studying at the RA Schools. Redgrave became a drawing master in 1830 and was always heavily committed to art education and art history. He was associated with the Government School of Design from 1847, was on the Paris Exhibition Committee in 1855 and was Director of the Art Division, South Kensington, until 1875. He was Surveyor of the Queen's Pictures from 1857 to 1880 and was made CB in that year. Redgrave returned to the Bible and the English poets for much of his inspiration and this was also true of the small body of illustrative work he undertook. He was elected ARA in 1840, RA in 1851 and died in London on 14 December 1888.

Publ: *An Elementary Manual of Colour [1853]; A Century of Painters of the British School [1866].*
Contrib: *The Deserted Village [Etching Club, 1841]; Book of British Ballads [1842]; Songs of Shakespeare [Etching Club, 1843]; The Song of the Shirt [Etching Club]; Favourite English Poems [1859]; Early English Poems, Chaucer to Pope [1863].*
Exhib: BI; RA; RBA.
Colls: BM; V & AM; Witt Photo.
Bibl: F.M. Redgrave, *RR, a Memoir,* 1891.

REDON, Georges **1869-1943**
Painter, lithographer, humorous illustrator. He was born at Paris on 16 November 1869 and exhibited at the Salon. He died in 1943.

Contrib: *The Graphic [1901]*.

REED, C.W.
Illustrator of *Jack the Fisherman*, E. Stuart Phelps, 1897.

REED, Edward Tennyson **1860-1933**
Cartoonist and illustrator. He was born on 27 March 1860, the son of Sir Edward James Reed, the naval architect and MP. He was educated at Harrow and then travelled to Egypt, China and Japan in 1880, before being appointed to the *Punch* staff in 1890 by Sir F. Burnand. He very soon became an established part of the paper, introducing his 'Prehistoric Peeps' series in 1893 and following Furness (q.v.) as parliamentary caricaturist in 1894, a post he held till 1912. He was also a talented lecturer and published a number of books.

Reed introduced the grotesque into *Punch* art once again after a long absence, he was also unusual in drawing principally in pencil with careful hatching and shading. A good portraitist and very inventive, his drawings are nevertheless rather angular and somewhat bizarre in quality. He died 12 July 1933.

Illus: *Mr Punch's Prehistoric Peeps [1896]; Tales With a Twist [1898]; Unrecorded History Mr Punch's Animal Land [1898]; Mr Punch's Book of Arms [1899]; The Tablets of Azit-Tigleth-Miphansi; The Scribe [1900]; The Unlucky Family [Mrs De La Pasture, 1908]*.
Contrib: *Punch [1889-1933]; The Sketch [1894]; The Graphic; The Bystander*.
Exhib: FAS, 1899; G; New Gall; ROI.
Colls: V & AM.
Bibl: M.H. Spielmann, *The History of Punch*, 1895, pp.560-563; *The Idler*, Vol.9, pp.493-508; *The Studio*, Winter No., 1900-01, p.23 illus; Shane Leslie, *ETR*, 1957.

REED, Ethel **1876-**
American illustrator. She was born at Newburyport in 1876 and specialised in babies and children's books which were published in the United Kingdom.

Illus: *Arabella and Araminta Stories; Verses [Mrs. L.C. Moulton]*.
Contrib: *The Yellow Book [1897 (cover and illus.)]*.
Bibl: 'The Work of Miss ER', *The Studio*, Vol.10, 1897, pp.230-236.

REES, F.
Amateur artist contributing to *Punch*, 1908.

REEVE, A.
Illustrator of comic genre subjects for *The Graphic*, 1886.

RÉGAMEY, Félix Elie **1844-1907**
Portrait and history painter, engraver and illustrator. He was born in Paris on 7 August 1844, the son and pupil of the artist L.P.G. Régamey. He started his career as a caricaturist on *Journal Amusant, la Vie Parisienne, au Monde Illustré, l'Illustration, l'Éclipse, La Lune, Paris Caprice, Monde Comique* and *La Guêpe*. He founded his own journal *Salut Public* in 1870. Régamey remained at Paris during the Siege and acted as reporter and Special Artist for *The Illustrated London News*, producing very strong and rugged work. He left France in 1873 and travelled to England and then to Japan and the United States where he made powerful sketches of American prisons. He became an inspector of drawings at the Paris Schools in 1881 and died there on 7 May 1907.

Exhib: London 1872.
Bibl: *English Influences on Vincent Van Gogh*, Arts Council, 1974-75.
See illustration (p.141).

REGNAULT, Henri Alexandre Georges **1843-1871**

Genre and history painter. He was born in Paris on 30 October 1843 and entered the École des Beaux Arts in 1860, winning the Prix de Rome in 1866 and studying in Italy until 1868. He travelled in Spain and Morocco but was killed with the 19th Infantry Regiment after enlisting in 1870.

Contrib: *The Graphic [1871 (carnival)]*.
Colls: Boston; Chicago; Marseilles; Louvre.

REID, Sir George **RSA HRHA** **1841-1913**

Black and white artist and illustrator. He was born at Aberdeen on 31 October 1841 and was educated at Aberdeen Grammar School. He studied art in Edinburgh, Utrecht and Paris and returning to this country became the leading landscape pen draughtsman of his time. Pennell regarded his powers very highly — 'he can, in a pen drawing, give the whole character of northern landscape . . . while his portraits contain all the subtlety and refinement of a most elaborate etching by Rajon.' Reid exhibited his work very widely, received many honours, was knighted in 1891 and was President of the RSA, 1891 to 1902. He died in Somerset on 9 February 1913.

Illus: *The Selected Writings of John Ramsay [1871]; Life of a Scotch Naturalist [Smiles, 1876]; George Paul Chalmers [1879]; Johnny Gibb [W. Alexander, 1880]; Twelve Sketches of Scenery [1882]; Natural History and Sport in Norway [1882]; The River Tweed [1884]; The River Clyde [1886]; Salmon Fishing on the Ristigouche [1888]; Lacunar Basilicae [1888]; St. Giles' Edinburgh [1889]; Royal Edinburgh [Mrs Oliphant, 1890]; Familiar Letters of Sir Walter Scott [1894]*.
Contrib: *The English Illustrated Magazine [1890-91]*.
Exhib: B; G; L; M; New Gall; P; RA; RHA; ROI; RSA.
Bibl: J. Pennell, *Pen Drawing and Pen Draughtsmen*, 1904, pp.277-279 illus; R.E.D. Sketchley, *Eng. Bk. Illus.*, 1903, pp.31, 141.

REID, John Robertson **RI** **1851-1926**

Genre, history and landscape painter. He was born in Edinburgh on 6 August 1851 and studied at the RSA Schools under Chalmers and McTaggert. He specialised in marine and coastal paintings, many of them of Cornwall and distinguished for their clarity and colour. He was elected RI in 1897 and died at Hampstead on 10 February 1926.

Contrib: *The Graphic [1892 (birds)]; The Sketch [1894]*.
Exhib: B; FAS, 1899; G; GG; L; M; NEA; New Gall; RA; RBA; RHA; RI; ROI; RSA.
Colls: Leicester; Liverpool; V & AM.

REID, Stephen **1873-1948**

Painter and illustrator. He was born at Aberdeen in 1873 and studied at the Grays School of Art, Aberdeen and at the RSA Schools. In his early years he was strongly influenced by the work of E.A. Abbey (q.v.) and favoured Georgian settings and costume pieces for his work, he was also a competent topographer in pen and ink. He was elected RBA in 1906 and died at Hampstead on 7 December 1948.

Illus: *The Magic Casement [Alfred Noyes, 1908]*.
Contrib: *The Windsor Magazine; The Temple Magazine [1896-97]; The Idler; The Strand Magazine [1906]; The Connoisseur [1910 (decor)]*.
Exhib: L; M; RA; RBA; RI; RSA.

REID, W.E.

Illustrator. Contributed drawings to *Embassy to the Court of Ava* by J. Crawford, 1829, AT 405.

REINAGLE, George Philip **1802-1835**

Marine painter. He was born in 1802 and was the younger son of R.R Reinagle and began his career by copying Dutch masters. He was present with the Fleet at the Battle of Navarino in 1827, the last battle under sail, and with the Fleet off Portugal in 1833.

Illus: *Illustrations of the Battle of Navarino [1829]; Illustrations of the Occurences at the Entrance of the Bay of Patras . . . [1828]*.
Colls: BM.

REINAGLE, Philip **RA** **1749-1833**

Sporting artist and animal painter. He was born in Scotland in 1749 and entered the RA Schools in 1769 after which he studied with Allan Ramsay. He made botanical and anatomical drawings for book illustrations and was elected ARA in 1787 and RA in 1812. He died in

London in 1833.

Illus: *Sportsman's Cabinet [Taplin, 1803]; Sexual System of Linnaeus [1799-1807]; Philosophy of Botany [1809-10]*.
Exhib: BI; RA; RBA.
Colls: BM; V & AM.
Bibl: *AJ*, 1898.

REINHART, Charles Stanley **1844-1896**

American painter and illustrator. He was born at Pittsburg in 1844 and studied art at Paris and in Munich with Strahuber and Karl Otto. He worked principally in New York but contributed to British publications. These included the illustrations to Thomas Hardy's 'Romantic Adventures of a Milk-Maid' in *The Graphic*, 1883. He died in 1896.

Exhib: L; RI.

REJCHAN, Stanislas

Polish artist and illustrator. He worked in Paris and contributed Belgian scenes to *The Graphic*, 1902.

RÉNAUD, G.

Humorous artist. Contributed to *Judy*, 1886-89.

RENÉ

Decorative artist contributing to *The English Illustrated Magazine*, 1895.

CHARLES PAUL RENOUARD 1845-1924. 'Anarchist Oratory in France.' An illustration to The Graphic, *24 February 1894.*

CHARLES PAUL RENOUARD 1845-1924. 'Recruiting the Sandwich Men.' Illustration for The Graphic, *1894.*

RENNELL, Joseph
Draughtsman. He contributed illustrations to *Public Works of Great Britain*, 1838, AT 410.

RENOUARD, Charles Paul 1845-1924
Painter, engraver and illustrator. He was born at Cour Cheverny on 5 November 1845 and studied at the École des Beaux Arts after which he worked as a mural painter. Renouard worked for the Parisian papers *l'Illustration* and *Paris Illustré* before starting work for *The Graphic* in 1884. Renouard's forte was in pencil and chalk drawings which had a power and expressiveness quite new in the pages of English magazines. For a decade he was the giant among illustrators and his flamboyant full page sketches of social realism, London life and Parisian fashion burst on the British public. For some reason this masterly artist who must have been widely influential on such Paris trained Englishman as Dudley Hardy (q.v.) has been almost forgotten. He exhibited at the Salon from 1877 and died in Paris on 2 January 1924. Elected RE, 1881.

Contrib: *The Graphic [1884-1910]; ILN [1886-89]; The Butterfly [1893]; The English Illustrated Magazine [1893-94]; Daily Graphic.*
Exhib: L; NEA; P; RE.
See illustrations (above and p.430).

RENTON, John 1774-c.1841
Figure and landscape painter. He lived in London and worked in the Thames Valley and Lake District. Contributed illustrations to *The Border Antiquities of England and Scotland*, Walter Scott, 1817.
Colls: BM.

REPTON, Humphry 1752-1818
Landscape gardener and watercolourist. He was born at Bury St Edmunds in 1752 and educated at Bury, Norwich and on the Continent. He became interested in botany and landscape design and from the 1780s developed a large practise in the new 'picturesque' style of gardening. Repton developed a habit of presenting elaborate Red Books to his clients in which projected improvements were set out in 'before and after' scenes in brilliant watercolours. He was not strictly an illustrator at all, but drew for some of his own works. He died at Romford on 14 March 1818.

Publ: *Sketches and Hints on Landscape Gardening [1794]; Observations on the Theory and Practice of Landscape Gardening [1803]; Odd Whims and Miscellanies [1804]; Fragments on the Theory and Practice of Landscape Gardening [1816].*
Exhib: RA.
Colls: BM; V & AM.
Bibl: J.C. Loudon, *The Landscape Gardening . . . of HR*, 1840; D. Stroud, *HR*, 1962.

REPTON, John Adey FSA 1775-1860
Architect. He was the eldest son of H. Repton (q.v.) and was born in Norwich on 29 March 1775. He became a pupil of the architect William Wilkins and made drawings of Norwich cathedral, but although he went into practice with his father, he was stone deaf and could only lead a retired life, but was the teacher of F. Mackenzie (q.v.). He was elected FSA in 1803 and died at Springfield, Essex on 26 November 1860.

Publ: *A Trewe . . . Hystorie of the . . . Prince Radapanthus [1820]; Some Account of the Beard and Moustachio [1839].*
Contrib: *Britton's Cathedrals [1832-36].*
Exhib: RA.
Colls: RIBA; Soc. of Antiquaries.
Bibl: H.M. Colvin, *Biog. Dict. of Eng. Architects*, 1954, p.491.

REYNOLDS, Ernest G.
Humorous artist. Contributed to *Judy*, 1886 and *Fun*, 1887.

REYNOLDS, Frank RI 1876-1953
Black and white artist and illustrator. He was born in London on 13 February 1876 and studied at Heatherley's before working for *The Illustrated London News* and *The Sketch*. He joined the staff of *Punch* in 1919 and was Art Editor from 1920-32, having been a contributor from 1906. Reynolds was most successful in urban genre subjects, interiors, street corners and where groups of people were included. His characters, portly policemen, charladies and drunks were not as individual as Belcher's, but Fougasse later considered that his fluid pen line had done a lot to alter the image of *Punch*. He was elected RI in 1903 and died in April 1953.

Illus: *Pictures of Paris and Some Parisians [Raphael, 1908]; The F.R. Golf Book [1932]; Hamish McDuff [1937]; Off to the Pictures [1937]; Humorous Drawings [1947].*
Contrib: *Pick-Me-Up [1896]; The Longbow [1898]; Judy [1899]; Sketchy Bits; Punch [1906-53]; ILN [1909-11]; The Sketch.*
Exhib: L; RI; Walker's.
Colls: Author; Fitzwilliam.
Bibl: *FR, RI*, Ed. by A.E. Johnson, Brush, Pen, Pencil series, c.1910; *Modern Book Illustrators and Their Work*, Studio, 1914.
See illustration (p.432).

REYNOLDS, H. fl.1882-1896
Artist and illustrator. He worked at Birmingham and contributed decoration to *The English Illustrated Magazine*, 1896.
Exhib: B.

REYNOLDS, J.H.
Humorous artist. Contributed illustrations to *Hood's Comic Annual*, 1830.

REYNOLDS, Percy T. fl.1890-1914
Humorous artist. He worked in London at Muswell Hill and contributed to *Fun*, 1890-92 and *Punch*, 1914.
Exhib: RA.

FRANK REYNOLDS RI 1876-1953. 'Sir Henry Irving and companion.' Pen and ink. Signed with initials. 9½ins. x 5½ins. (24.1cm x 14cm). Author's Collection

REYNOLDS, Warwick fl.1871-1879

Black and white artist. He contributed comic heads to *Judy*, 1871-79. He was a member of the NWS from 1864-65.

REYNOLDS, Warwick 1880-1926

Black and white artist and illustrator. He was born in Islington in 1880, the son of Warwick Reynolds (q.v.). He was educated at Stroud Green and studied at the Grosvenor Studio, St. John's Wood Art School and at Julians in Paris, 1908. He made a particular study of animals in the collection of the Zoological Society, 1895-1901, and began to work for the magazines in 1895. He died in Glasgow on 15 December 1926.

Illus: *Babes of the Wild [1912]*.
Contrib: *The Strand Magazine; Pearson's Magazine; Royal Windsor Magazine; The Quiver; The Idler; Ally Sloper's Half Holiday*.
Exhib: G; L; RA; RSA; RSW.
Colls: Glasgow; Witt Photo.

RHEAD, F.A.

Humorous figure artist. Contributed to *Punch*, 1914.

RHEAD, George Wooliscroft RE 1855-1920

Painter, etcher and illustrator. He was born in 1855 and won a National Art Scholarship and silver medals before studying with Alphonse Legros and Ford Madox Brown. Rhead designed for stained glass, wrote on ecclesiastical art and was a member of the Art Workers

Guild and Hon. ARCA. He was elected RE in 1883 and in 1914 married the illustrator Annie French (q.v.). He died on 30 April 1920.

Publ. his own etchings: *The Foundation of Manchester by the Romans; The Dream of Sardanapalus*.
Illus: *Bunyan's Pilgrim's Progress; Life of Mr Badman; Idylls of the King [Tennyson]*.
Exhib: G; L; New Gall; RA; RBA; RE; RI.
Bibl: *The Studio*, Vol.9, 1897, p.282 illus.

RICE

Illustrator contributing to *London Society*, 1868.

RICH, Anthony fl.1854-1914

Landscape painter and illustrator working at Croydon and Hassocks. He contributed to *Thornbury's Legendary Ballads*, 1876.

RICH, E.

Topographer. He was a pupil of J. Hawksworth and illustrated *The History and Antiquities of Islington*, 1823.

RICHARDS, Frank fl.1883-1925

Landscape and figure painter. He was probably born in Birmingham where he worked early in his career before settling in Dorset and the West Country from 1887. He was elected RBA in 1921.

Contrib: *Pick-Me-Up [1894]; The Graphic [1898]; The Queen; The Sketch; The Windsor Magazine*.
Exhib: B; L; M; RA; RBA.

RICHARDS, G.E.

Figure artist specialising in children. He contributed to *Punch* 1903 and may be the George Richards exhibiting at Liverpool in 1900.

RICHARDSON, Charles 1829-1908

Landscape and marine painter. He was born in 1829, the son of T.M. Richardson (q.v.) by his second marriage. He assisted his brother H.B. Richardson but moved to London in 1873, finally settling in Hampshire. He died in 1908.

Illus: *The Conquest of Camborne [Sir W. Lawson, 1903]*.
Exhib: L; RA; RI.

RICHARDSON, Charles

Animal and bird illustrator. He contributed comic sketches to *Punch*, 1905.

RICHARDSON, Charles James 1806-1871

Architect and draughtsman. He was born in 1806 and became a pupil of Sir John Soane and a specialist on Tudor and Jacobean buildings and ornament. He was Master of the Architectural Class at Somerset House, 1848-52.

Illus: *Architectural Remains of the Reigns of Elizabeth and James I [1838-40]; Studies from Old Mansions, their Furniture, Gold and Silver Plate . . . [1841]; Studies of Ornamental Design [1848]; Picturesque Designs for Mansions, Villas, Lodges . . . [1870]*.
Exhib: RA.
Colls: Soane Museum; V & AM (Lib.).

RICHARDSON, Henry Burdon 1811-1874

Landscape artist and topographer. He was born at Warkworth in about 1811, the son of T.M. Richardson (q.v.). He travelled widely before settling down as a drawing-master at Newcastle-upon-Tyne and undertaking the series of large views of the Roman Wall, illustrated in Sir Gainsford Bruce's *History of the Wall*. He died at Newcastle in 1874.

Exhib: RA; RBA.
Colls: Newcastle.

RICHARDSON, Ralph J. fl.1896-1925

Painter and illustrator. He specialised in comic genre subjects in black and white mostly associated with horsemanship.

Contrib: *Punch [1896-1907]; The Graphic [1901]*.
Exhib: RA, 1900.

RICHARDSON, Thomas Miles **1784-1848**

Landscape painter and watercolourist. He was born at Newcastle-upon-Tyne on 15 May 1784 and after being apprenticed to an engraver, became a drawing-master and devoted his time entirely to painting from 1813. He travelled widely and his work is chiefly associated with the more picturesque areas of Italy, Switzerland and France. Richardson was a fine colourist and by far the most distinguished watercolourist of the North East, founding the Newcastle Watercolour Society in 1831. He was ANWS from 1840 for three years and exhibited regularly. He began to publish a work on Newcastle in 1816 and in 1833 began to issue *The Castles of The English and Scottish Borders*. He died in Newcastle on 7 March 1848.

Contrib: *Howitt's Visits to Remarkable Places [1841]*.
Exhib: BI; NWS; OWS; RA, 1814-45; RBA.
Colls: BM; Bradford; Derby; Leeds; Manchester; Newcastle; V & AM.
Bibl: *Memorials of Old Newcastle on Tyne . . . with a sketch of the artist's life*, 1880.

RICHARDSON, Thomas Miles, Jnr. **RWS** **1813-1890**

Landscape painter and watercolourist. He was born at Newcastle-upon-Tyne in 1813, the son of T.M. Richardson (q.v.). He worked closely with his father, but moved to London in 1846 after being elected AOWS in 1843; he became a full OWS in 1851. Richardson made tours of the Continent and chose many of the same localities as his father for his exhibition works. These are always brightly coloured and highly finished, tending towards an over elaboration and a too great size for the medium. His smaller studies are often charming with an effective use of chinese white. He died at Newcastle on 5 January 1890.

Illus: *Sketches in Italy, Switzerland, France etc., [1837]; Sketches at Shotley Bridge Spa and on The Derwent [1839]*.
Contrib: *Howitt's Visits to Remarkable Places [1841]*.
Exhib: BI; L; M; RA; RBA; RWS.
Colls: Blackburn; BM; Cardiff; Manchester; V & AM.

RICHTER, Willibald **fl.1840-1856**

Watercolourist and illustrator. He worked at Vienna and travelled to England, Italy and Poland, exhibiting views of these countries at the Vienna Academy 1840-50.

Contrib: *ILN [1855-56 (Turkey)]*.

CHARLES DE SOUSY RICKETTS RA 1866-1931. 'Venus Bird Messenger.' Original drawing for wood engraving in The Marriage of Cupid and Psyche, *Vale Press, 1899. Circular pen and wash, touched with white. Diameter 3ins. (7.6cm)*
Victoria and Albert Museum

RICKARDS, Edwin A. **1872-1920**

Architect, draughtsman and caricaturist. He was born in Chelsea in 1872 and spent some time in the RA Schools and at the Architectural Association but chiefly taught himself from study in the museums. He entered the office of Richard J. Lovell in 1887 as an architectural assistant and later joined the firms of Howard Ince and George Sherrin. Toured Italy and made himself familiar with the baroque before returning to England to do competition work and enter partnership with H.V. Lanchester in 1897. He died as a result of war disabilities in 1920.

Illus: *Parisian Nights and Other Impressions of Places and People [Arnold Bennett, 1913]*.
Bibl: *The Art of EA with a Personal Sketch by Arnold Bennett, an Appreciation by H.V. Lanchester and Technical Notes by Amor Fenn*, 1920.

RICKETTS, Charles de Sousy **RA** **1866-1931**

Painter, printer, stage designer, writer and collector. He was born in Geneva in 1866, the son of the marine painter C.R. Ricketts (q.v.). He was brought up in France and Italy and studied at the Lambeth School of Art where he met his lifelong friend C.H. Shannon (q.v.). With him he owned and edited *The Dial*, 1889-97 and ran the Vale Press, 1896-1904, producing eighty-three volumes, many with type, bindings or illustrations by him. Among them were *Daphne and Chloe*, the first book of the new woodcut revival. Ricketts concentrated in later life on stage designing and sculpture, was elected ARA in 1922 and RA in 1928 and died in London on 7 October 1931.

Illus: *A House of Pomegranates [Wilde, 1891]; Poems Dramatic and Lyrical [de Tabley, 1893]; Daphne and Chloe [1894]; Hero and Leander [1894]; In the Key of Blue [J.A. Symonds; 1894 (cover)]; The Sphinx [Wilde, 1894]; The Incomparable and Ingenious History of Mr W.H. [Wilde, 1894]; Dramatic Works of Oscar Wilde [1894]; Nymphidia [1896]; Spiritual Poems [T. Gray]; The Early Poems of John Milton [1896]; The Poems of Sir John Suckling; Fifty Songs of Thomas Campion; Empedocles on Etna [Matthew Arnold]; Songs of Innocence [Blake, 1897]; Sacred Poems of Henry Vaughan [1897]; Cupide and Psyche [1897]; The Book of Thel [Blake, 1897]; Blake's Poetical Sketches [1899]; The Rowley Poems of Thomas Chatterton [1898]; Julia Domna [Michael Field, 1903]*.
Contrib: *Black and White [1891]*.
Exhib: FAS; G; GG; L; M; RA; RBA; RI; ROI; RSA.
Colls: Ashmolean; BM; Fitzwilliam; Leeds; Manchester; Reading; V & AM.
Bibl: T.S. Moore, *CR*, 1933; R.E.D. Sketchley, *Eng. Bk. Illus.*, 1903, pp.18, 129; C. Franklin, *The Private Presses*, 1969. For full bibliography of Vale Press see Franklin, C.
See illustration (below left).

RICKETTS, Charles Robert **fl.1868-1879**

Marine painter. He worked in London and contributed to *The Graphic* 1871.

Exhib: RA; RBA.

RIDCOCKS, E.F.

Black and white artist in New Zealand. Contributed to *Punch*, 1902.

RIDDELL, Robert Andrew **fl.1790-1807**

Landscape, painter and topographer who illustrated *A History of Mountains*, J. Wilson, 1807.

RIDLEY, B.

Black and white artist. He contributed to *London Society*, 1869.

RIDLEY, Mathew White **1837-1888**

Landscape painter, illustrator and engraver. He was born at Newcastle-upon-Tyne in 1837 and studied at the RA Schools under Smirke and Dobson. Ridley became the earliest pupil of James McNeil Whistler (q.v.) and a friend of Fantin Latour. He developed a very direct reportage in his illustrations of social realism in the 1870s and these were admired by Van Gogh. He contributed to numerous magazines and died on 2 June 1888.

Contrib: *Cassell's Family Magazine [1867]; The Quiver [1867]; Every Boy's Magazine [1867]; The Graphic [1869-77]; ILN [1872-81]*.
Exhib: G; GG; RA; RI.
Bibl: *English Influences on Vincent Van Gogh*, Arts Council, 1974-75; 'Artists Fruitful Friendship', V. Gatty, *Country Life*, 7 March 1974.

RIMER, William fl.1845-1888

Historical and subject painter and illustrator. His drawings are usually in pencil, very meticulous in execution and showing strong German influence. He worked in Westminster and London and illustrated *Thomson's Castle of Indolence* for the Art Union of London, 1845.

Exhib: BI; RA; RBA.
Colls: Witt Photo; V & AM.

RIMMER, Alfred 1829-1893

Black and white artist, woodcut artist and antiquary. He was born at Liverpool on 9 August 1829 and worked for some years as an architect, spent a period of time in Canada, finally settling at Chester as an artist and writer. He died there on 27 October 1893.

Illus: *Ancient Streets and Homesteads of England; Pleasant Spots About Oxford; Rambles About Eton and Harrow; About England with Dickens.*
Contrib: *The English Illustrated Magazine [1885].*
Exhib: L; M.
Colls: BM.

RIOU, Edouard 1833-1900

Landscape painter, designer and illustrator. Born at Saint-Servan on 2 December 1833 and exhibited at the Salon from 1859. He specialised in book illustration including the works of Jules Verne and the poetry of A. Riou. He died in Paris on 27 January 1900.

Contrib: *The Illustrated Times [1859]; ILN [1894].*
Colls: Witt Photo.

'RIP' Rowland HILL 1873-p.1925

Cartoonist. He was born at Halifax in 1873 and worked at Halifax before studying at Bradford School of Art and at the Herkomer School, Bushey. Travelled on the Continent and settled at Hinderwell, Yorks, 1908.

Contrib: *Black & White; Truth; The Sketch.*
Exhib: L; RA.
Colls: Leeds.

RISCHGITZ, Edward 1828-1909

Landscape painter. He was born at Geneva on 28 July 1828 and became a pupil of Diday and worked in Paris. He settled in London before 1878 and was elected RE in 1881. He died at the home of his daughter the artist Mary Rischgitz on 3 November 1909.

Contrib: *Good Words [1880].*
Exhib: GG; RE.

RITCHIE, Alick P.F. fl.1892-1913

Caricaturist and illustrator.

Contrib: *The Ludgate Monthly [1892]; St Pauls [1894]; The Pall Mall Budget [1894]; Sketchy Bits [1895]; Eureka [1897]; Penny Illustrated Paper; Vanity Fair [1911-13].*

RIVERS, A. Montague fl.1910-1915

Painter and illustrator. He worked in Hornsey, London and contributed to *The Illustrated London News,* 1915.

Exhib: M; RA; RI.

RIVIERE, Briton RA 1840-1920

Genre, landscape and animal painter. He was born in London on 14 August 1840, the son of William Riviere, drawing-master at Cheltenham College. He was educated at Cheltenham and St Mary Hall, Oxford, where he began making humorous pen drawings. These came to the notice of Mark Lemon of *Punch,* who gave him work and he then undertook drawing for American magazines. Riviere maintained that one of his eyes was permanently damaged by the strain of this drawing and he only painted after 1870. He became very well-known for his animal subjects and was elected ARA in 1878 and RA in 1881. He died in London on 20 April 1920.

Contrib: *Punch [1868-69]; Good Words [1868]; Good Words For The Young [1869]; ILN [1870].*
Exhib: B; FAS; G; GG; L; M; RA; RCA; RHA; RSA.
Colls: BM; Blackburn; Manchester; V & AM.
Bibl: *AJ,* 1878, 1891.

RIVIERE, Hugh Goldwin 1869-1956

Portrait painter. He was born at Bromley, Kent on 1 January 1869, the son of Briton Riviere (q.v.). He was educated at St Andrews and studied at the RA Schools, being elected RP in 1900 and ROI in 1907. He died in 1956.

Illus: *John Halifax Gentleman [Mrs Craik, 1897].*
Exhib: B; FAS; G; L; M; New Gall; P; RA; RHA; ROI; RSA.

RIVINGTON, Reginald fl.1908

Illustrator of children's books. He illustrated *The Snow King* and *Buffs and Boys,* Amy Sims, 1908.

ROBERTS, Charles J. Cramer 1834-1895

Landscape painter and illustrator. He was a professional soldier who joined the Army in 1853 and served in India and the Crimea retiring in 1887. He contributed portraits, social and military illustrations to *The Graphic,* 1872-77.

Colls: India Office Lib.

ROBERTS, David RA 1796-1864

Landscape and architectural painter. He was born at Stockbridge, Edinburgh on 2 October 1796, the son of a shoemaker and was apprenticed for seven years to a house painter, before working as scene painter at theatres in Carlisle, Glasgow and Edinburgh. In 1822 he went to London and while scene painting at Drury Lane formed his lifelong friendship with Clarkson Stanfield (q.v.). Roberts was very successful in what he undertook, became Vice-President of the SBA on its foundation in 1823-24 and President in 1830. He began travelling on the Continent in the 1820s and on Wilkie's recommendation visited Spain and Tangier in 1832-33, following this with trips to Egypt and Palestine in 1838 and Italy in 1851 and 1853. Roberts' great accuracy as a draughtsman, his strong sense of country and place, combined with his love of architecture, made his Middle Eastern views the touchstone of a fashion among the early Victorians. The temples and monuments brought to life for the first time were drawn on the stone by J.D. Harding and Louis Haghe (qq.v.) and issued in amazingly lavish form to subscribers. Roberts was elected ARA in 1838 and RA in 1841 and acted as a Commissioner for the Great Exhibition. He died in London on 25 November 1864, still at work on a series of Thames views.

Illus: *Picturesque Sketches in Spain during the years 1832 and 1833 [AT 152]; Views in the Holy Land, Syria, Idumea, Egypt, Nubia [1842-49].*
Contrib: *Jennings Landscape Annual [1835-38]; The Chaplet [c.1840]; Scotland Delineated [Lawson, c.1845]; Lockhart's Spanish Ballads.*
Exhib: BI; RA; RBA.
Colls: Aberdeen; BM; Fitzwilliam; Glasgow; Leeds; Manchester; Nat. Gall, Scotland; V & AM.
Bibl: J. Ballantine, *The Life of DR,* 1866; J. Quigley, DR, *Walker's Quarterly,* X, 1922; M. Hardie, 'DR' *O.W.S.,* 1947; M. Hardie, *Watercol. Paint. In Brit.,* Vol.III, 1968, pp.179-183 illus.

ROBERTS, Edwin fl.1862-1890

Genre and rustic painter. He worked in Chelsea and contributed figure illustrations to *Judy,* 1889.

Exhib: RA; RBA.

ROBERTS, Henry Benjamin 1832-1915

Genre painter and watercolourist. He was born in Liverpool in 1831, the son of a landscape painter and studied with his father. He closely followed the work of W.H. Hunt, was elected a member of the Liverpool Academy in 1855, of the NWS in 1867 and the RBA in 1878. He was living in Leyton, Essex from 1883 except for a period in North Wales. He died in 1915.

Contrib: *ILN [1871-75].*
Exhib: B; L; RI.
Colls: Birkenhead; V & AM.

ROBERTS, I.

Contributed a social illustration to *The Graphic,* 1870.

WALFORD GRAHAM ROBERTSON RBA ROI 1867-1948. 'The Man Whom The Trees Loved.' Illustration in The Studio, *1914.*

ROBERTS, J.H.
Black and white artist. He was an architect who had become a caricaturist, journalist and political versifier. He contributed to *Punch*, 1892-97; *Fun*, 1893; *Chums*.

ROBERTSON, George Edward 1864-
Portrait painter and illustrator. The son of a painter, he studied at St Martin's School of Art and worked in London.

Contrib: *The Graphic [1905]*.
Exhib: G; L; M; RA; RBA; ROI.

ROBERTSON, Henry Robert 1839-1921
Landscape, genre and figure painter and engraver. He was born at Windsor in 1839 and studied at the RA Schools. He worked in Hampstead and was elected RE, 1881 and RMS, 1896. He died on 6 June 1921.

Illus: *The Trial of Sir Jasper [S.C. Hall, 1870]; Life on the Upper Thames [1875]; The Art of Etching Explained and Illustrated [1883]; The Art of Painting on China [1884]; The Art of Pen and Ink Drawing [1886]; Plants we Play With [1915]; More Plants we Play With [1920]*.
Contrib: *ILN [1874, 1881]; The English Illustrated Magazine [1886]*.
Exhib: B; G; L; M; New Gall; RA; RBA; RE; RI; RMS; ROI.
Colls: Sheffield.

ROBERTSON, James of Constantinople
Amateur artist and photographer. He contributed an illustration of the Crimea to *The Illustrated London News* in 1855 and produced daguerrotype pictures of the War after Roger Fenton the photographer left the front. After the War he worked with Felice Beato and became an official British photographer. Drawings based on his photographs appeared in *The Illustrated Times*, 1856.

Bibl: *The Camera Goes to War*, Scottish Arts Council, 1974-75, p.58.

ROBERTSON, Walford Graham RBA ROI 1867-1948
Portrait and landscape painter, illustrator and designer. He was born in 1867 and educated at Slough and Eton. He studied art at South Kensington with Albert Moore and became a member of the NEA, 1891, the RBA in 1896 and the ROI in 1910. Robertson was part of the talented group of artists and illustrators who flourished in London in the 1890s, his portrait was painted by Sargent and he claimed to have been influenced by W. Crane and the Glasgow School and must have admired W. Nicholson (q.v.).

Illus: *Old English Songs and Dances [1903]; A Masque of May Morning [1904]; The Napoleon of Notting Hill [G.K. Chesterton, 1904]; Gold, Frankinsense and Myrhh and other Pageants for a Baby Girl [1906]; A Year of Songs; The Baby's Day Book; Wind in the Willows [Kenneth Grahame, 1908 (frontis)]; Old Fashioned Fairy Tales [n.d.]*.
Contrib: *The English Illustrated Magazine [1896]*.
Exhib: B; G. GG; L; M; NEA; New Gall; RA; RBA; ROI.
Bibl: 'The Illustrated Books and Paintings of WGR', by T.M. Wood, *The Studio*, Vol.36, pp.99-107 illus; *Modern Book Illustrators and Their Work*, Studio, 1914; *Time Was*, a book of Memories, WGR, n.d.
See illustration (left).

ROBINSON, C. -1881
Illustrator and engraver. He was born in London the son of a wood engraver and book binder and was apprenticed to the firm of Maclure, Macdonald and Macgregor, lithographers before joining *The Illustrated London News* in about 1862. He had attended Finsbury School of Art in about 1857, winning a silver medal in the National Competition. He contributed regular and rather wooden work to *The 'News* until his death and also to *The Illustrated Times* in 1865. He was the uncle of Charles, T.H. and W. Heath Robinson (qq.v.).

Bibl: L de Fretas, *Charles Robinson*, Academy Edit, 1976.

ROBINSON, Charles RI 1870-1937
Painter in watercolours, illustrator and decorator. He was born in London on 22 October 1870, the son of Thomas Robinson, wood engraver, and nephew of C. Robinson (q.v.). He was educated at Islington High School and Highbury School of Art, but spells at the RA Schools were abandoned for lack of finance, 1892. He was then apprenticed to Waterlow & Sons as a lithographic artist but came to the fore in 1895 when his drawings were published in *The Studio* and he was asked to design for R.L. Stevenson's *A Child's Garden of Verses*. Robinson in company with his brothers T.H. and W. Heath Robinson (qq.v.) became one of the most popular Edwardian black and white artists. His style was very decorative, flowing and imaginative scenes were surrounded by elaborate borders and in the faces and forms of his children he recaptured something of the innocence of childhood. His drawings were partly inspired by the prints of Dürer, partly by the Pre-Raphaelites, their space often suggestive of Japanese prints. But he was no copyist and his colouring and fantasy are often highly original, perhaps based on his lack of formal training. He was elected President of the London Sketch Club, and was elected RI in 1932. He died in Buckinghamshire on 13 June 1937.

Illus: *Come Ye Apart [Sunday School Union, 1894]; Aesops Fables; A Child's Garden of Verses [R.L. Stevenson]; The Infant Reader; The First Primer; The*

Second Primer [1895]; Animals in the Wrong Places [E. Carrington]; The Child World [G. Setoun]; Christmas Dreams [Awfly Weirdly]; Make Believe [H.D. Lowry]; Minstrel Dick [C.R. Coleridge, 1896]; Dobbie's Little Master [Mrs. A. Bell]; Lullaby Land [E. Field]; Cranford [Mrs. Gaskell, 1897]; King Longbeard [B. MacGregor]; Lilliput Lyrics [W.D. Rands]; Richard Wagner and The Ring [1898]; Fairy Tales From Hans Christian Andersen [With T.H. and W.H.]; The New Noah's Ark [J.J. Bell]; Pierrette [H. de V. Stacpoole]; The Suitors of Aprille [N. Garstin, 1899]; The Adventures of Odysseus [Homer]; Child Voices [W.E. Cule]; Jack of All Trades [J.J. Bell]; The Little Lives of the Saints [P. Dearmer]; The Master Mosaic Workers [G. Sand]; Sintram and His Companions [de la Motte Fouqué]; Tales of Passed Times [C. Perrault]; The True Annals of Fairyland [Ed. W. Canton, 1900]; A Book of Days For Little Ones [C. Bridgman]; The Farm Book [W. Copeland]; The Mother's Book of Song [J.H. Burn]; Nonsense! Nonsense! [W. Jerrold]; The Shopping Day [C. Bridgman]; Stories For Children [Charles and Mary Lamb]; The True Annals of Fairyland; [J.M. Gibbon, 1901]; The Bairns Coronation Book [C. Bridgman]; The Book of the Zoo [W. Copeland]; The Coronation Autograph Book [1902]; The Big Book of Nursery Rhymes [W. Jerrold]; Fireside Saints [D. Jerrold]; The New Testament of Our Lord . . . [1903]; Siegfried [Baring Gould, 1904]; The Black Cat Book [W. Copeland]; A Bookful of Fun; The Book of Ducks and Dutchies [W. Copeland]; A Book of The Dutch Dolls [W. Copeland]; The Book of the Fan [W. Copeland]; The Book of the Little Dutch Dots [W. Copeland]; The Book of the Little J.Ds [W. Copeland]; The Book of the Mandarinfants [W. Copeland]; The Cloud Kingdom [I.H. Wallis]; The Ten Little Babies [1905]; Awful Airship [W. Copeland]; Baby Town Ballads [Netta]; The Books of Dolly's Doings [W. Copeland]; The Book of Dolly's House [W. Copeland]; The Book of Dollyland [W. Copeland]; Bouncing Babies [W. Copeland]; The Child's Christmas [E. Sharp]; Fanciful Fowls; A Little Book of Courtesies [K. Tynan]; Mad Motor [W. Copeland]; Peculiar Piggies; Road, Rail & Sea [J. Pope]; The Silly Submarine [W. Copeland, 1906]; Alice's Adventures in Wonderland [L. Carroll]; Black Bunnies; Black Doggies; Black Sambos; The Cake Shop [W. Copeland]; Prince Babillon [Netta]; Songs of Love and Praise [A. Matheson]; The Story of the Weathercock [E. Sharp]; The Sweet Shop [W. Copeland]; The Toy Shop [W. Copeland, 1907]; Babes and Blossoms [W. Copeland]; The Book of Other People [W. Copeland]; The Book of Sailors [W. Copeland]; The Book of Soldiers [W. Copeland]; A Child's Garden of Verses [R.L. Stevenson]; The Fairies Fountain [Countess Cesaresco]; Songs of Happy Childhood [I. Maunder, 1908]; Babes and Birds [J. Pope]; The Vanishing Princess [N. Syrett, 1909]; Brownikins and Other Fancies [R. Arkwright]; Grimm's Fairy Tales; In The Beginning [S.B. Macy, 1910]; The Baby Scouts [J. Pope]; The Big Book of Fairy Tales [W. Jerrold]; The Secret Garden [F. Hodgson Burnett]; The Sensitive Plant [P.B. Shelly, 1911]; Babes and Beasts [J. Pope]; Bee: The Princess of the Dwarfs [A. France]; The Big Book of Fables [W. Jerrold]; The Four Gardens [Handasyde]; Longfellow [M. MacLeod]; Old Time Tales [Ed. L. Marsh]; Songs of Innocence [W. Blake, 1912]; A Child's Book of Empire [A.T. Morris]; Fairy Tales [C. Perrault]; The Happy Prince [O. Wilde]; Margaret's Book [Fielding-Hall]; The Open Window [E.T. Thurston]; Rainbows [M. Dykes Spicer]; Topsy Turvy [W.J. Minnion, 1913]; Our Sentimental Garden [A. & E. Castle, 1914]; Arabian Nights; The Open Window [E.T. Thurston]; Rip Van Winkle [W. Irving]; Robert Herrick; The Songs and Sonnets of Shakespeare; What Happened At Christmas [E. Sharp, 1915]; Bridget's Fairies [Mrs. S. Stevenson, 1919]; Songs of Happy Childhood [I. Maunder]; Teddy's Year With the Fairies [M.E. Gullick, 1920]; The Children's Garland of Verses [G. Rhys]; Father Time Stories [J.G. Stevenson, 1921]; Doris and David All Alone [E. Marc]; The Goldfish Bowl [P. Austin, 1922]; Wee Men [B. Girvin & M. Cosens, 1923]; Once On A Time [A.A. Milne, 1925]; The Saint's Garden [W. Radcliffe, 1927]; Mother Goose Nursery Rhymes; The Rubaiyat of Omar Khayyam [1928]; Granny's Book of Fairy Stories [1930]; Young Hopeful [1932].
Contrib: Black & White [1895]; The Yellow Book [1896]; ILN [1912]; The Graphic [1915]; The Queen.
Exhib: G; L; RA; RI.
Colls: V & AM.
Bibl: The Studio, Vol.63, pp.150-151 illus; R.E.D. Sketchley, Eng. Bk. Illus., 1903, pp.102, 114, 169; Modern Book Illustrators and Their Work, Studio, 1914; L. de Freitas, CR, Academy Edit., 1976.

ROBINSON, Frederick Cayley ARA 1862-1927

Painter, illustrator and poster artist. He was born at Brentford on Thames on 18 August 1862 and after being educated at the Lycée de Pau, studied art at the St Johns Wood and RA Schools. He lived on a yacht, 1888-90 and studied at Julian's 1890-92, later studying in Italy. He became Professor of figure composition and decoration at Glasgow, 1914-24 and was elected ARA in 1921. He had been RBA since 1890 and NEA since 1912. Robinson's style of work was based on Italian quattrocento sources and was not best adapted to the book. He did however, illustrate The Book of Genesis for the Riccardi Press in 1914. He died in London on 4 January 1927.

Exhib: G; L; M; NEA; New Gall; RA; RBA; ROI; RSA; RSW; RWS.
Colls: BM; Fitzwilliam; Manchester.
Bibl: FCR, FAS Cat., 1969, 1977; The Studio, Vol.31, 1904, pp.235-241 illus.

ROBINSON, Gordon fl.1905-1913

Illustrator of children's books. He illustrated Puss in Boots in about 1905 and contributed to The Illustrated London News, 1908-13 in the style of J. Hassall (q.v.).

ROBINSON, H.R.

Contributor of cartoon to Punch, 1864.

ROBINSON, Joseph fl.1882-1885

Landscape painter working in London. He contributed a view of Thanet to The Illustrated London News, 1885.
Exhib: RI.

ROBINSON, Ruth H.

Amateur illustrator. The Studio book illustration competition 1897 shows her work.

ROBINSON, Miss S.A.H. fl.1890-1902

Illustrator. She contributed to the Daily Graphic, c.1890 and to The Graphic, 1902.

ROBINSON, Thomas

Wood engraver and illustrator, probably the father of C., T.H. and W. Heath Robinson (qq.v.). Worked chiefly for The Penny Illustrated Paper, contributed to Dark Blue, 1871-73.

WILLIAM HEATH ROBINSON 1872-1944. 'Inspecting Stockings on Christmas Eve.' Original drawing for illustration in The Sketch. *Pen and ink and wash. Signed in full. 15¾ins. x 11¼ins. (40cm x 28.6cm).* Victoria and Albert Museum.

ROBINSON, Thomas Heath fl.1896-1902

Black and white artist and illustrator. He was the son of Thomas Robinson (q.v.) and elder brother of C. and W. Heath Robinson (qq.v.). He studied with his father and by 1896 had an extensive output among the magazines and was developing as a designer of bookplates.

Illus: *Legends From River and Mountain [1896]; Cranford [Mrs Gaskell, 1896]; Henry Esmond [W.M. Thackeray, 1896]; The Scarlet Letter [Hawthorne, 1897]; A Sentimental Journey [Sterne, 1897]; Hymn on the Morning of Christ's Nativity [1897]; A Child's Book of Saints [1898]; The Heroes [Kingsley, 1899]; Fairy Tales From The Arabian Nights [1899]; Fairy Tales from Hans Andersen [1899]; A Book of French Songs For The Young [1899]; Lichtenstein [1900]; The Scottish Chiefs [1900].*
Contrib: *Cassell's Family Magazine [1898-99]; The Windmill [1899]; The Quiver [1900]; The Idler; The Pall Mall Magazine.*
Bibl: R.E.D. Sketchley, *Eng. Bk. Illus.,* 1903, pp.114, 170.

ROBINSON, Will B. fl.1892-1902

Architectural draughtsman and illustrator. He was working in Lincoln's Inn, London in 1902 and specialised in industrial subjects, views of international exhibitions and decorations.

Contrib: *ILN [1892-1900]; The English Illustrated Magazine [1895-97].*

ROBINSON, William Heath 1872-1944

Black and white artist and illustrator, the only British illustrator to become a 'household name'. He was born in London on 31 May 1872, the son of Thomas Robinson (q.v.) and younger brother of C. and T.H. Robinson (qq.v.). He was educated in Islington and studied at the RA Schools before beginning to draw for the publishers. His earliest work was conventional book illustration very much in the idiom of his brother Charles and it was only with the approach of the First World War that the Robinson fantasy developed in him as a passion for mad machinery. His pen and ink drawings of inventions and contraptions were ideally suited to the industrial age and were in some ways the visual counterparts to Lewis Carroll's prose, having as their base, a kind of perverse logic. With his success, Robinson was imitated and taken into the language as the arch-priest of scatter-brained improvisation. He expanded into stage design and had a large following abroad.

Illus: *The Pilgrim's Progress [1897]; Don Quixote [1897]; The Giant Crab [1897]; Danish Fairy Tales [1897]; Arabian Nights [1899]; The Talking Thrush [Rouse, 1899]; Tales For Toby [1900]; Rabelais; Twelfth Night; A Song of the English [Rudyard Kipling]; Kipling's Collected Verse; a Midsummer Night's Dream [1914]; The Water Babies; Perrault's Tales; Peacock Pie [Walter de la Mare].*
Illus: *Uncle Lubin [1902]; Bill the Minder [1912].*
Contrib: *The Sketch; The Bystander; The Graphic [1910-]; The Illustrated Sporting & Dramatic News; London Opinion; Puck; The Strand Magazine; The Quiver; The Sportsman and Humorist [1931].*
Exhib: FAS, 1924; RA (Memorial Exhib, FAS 1945).
Colls: BM; V & AM.
Bibl: A.E. Johnson, *WHR,* Brush, Pen and Pencil series, 1913; *My Line of Life* by WHR, 1938; Langton Day, *The Art and Life of WHR,* 1947.
See illustration (p.436).

ROBLEY, Major-General Horatio Gordon 1840-1930

Amateur black and white artist. He was born at Funchal, Madeira on 28 June 1840 the son of Capt. J.H. Robley and served as a professional soldier in Burma, 1859-63, the Maori War, 1864-66, in Zululand, 1884 and Ceylon, 1886-87. He was one of a number of artists who sent suggestions to Charles Keene (q.v.) and some of his drawings were improved by Keene for *Punch.* Robley was well-known for his collection of preserved and tattooed Maori heads! He died on 29 October 1930.

Contrib: *Punch [1873-78]; The Graphic; ILN.*
Bibl: G.S. Layard, *Charles Keene,* 1892, p.179.

ROE, Fred RI 1864-1947

Genre painter and illustrator. He was born in 1864, the son of Robert Henry Roe, landscape and miniature painter and studied at Heatherley's and with J. Seymour Lucas (q.v.). He was elected RBA in 1895 and RI in 1909. Roe, who became a leading expert and collector of antique furniture, wrote many articles for art magazines and died in London in 1947.

Illus: *Ancient Coffers and Cupboards [1902]; Vanishing England [1910]; Old Oak Furniture; A History of Oak Furniture [1920].*
Contrib: *Fun [1892]; Judy [1895].*
Exhib: B; L; M; RA; RBA; RI; ROI; RWA.
Colls: Greenwich; V & AM.

ROE, John of Warwick

Landscape painter and topographer in watercolours. He worked chiefly in the Midlands and drew ruins, exhibiting at the RA and the Society of Artists. He was still active in 1812.

Illus: *Warwick Castle, a Poem [1812].*
Contrib: *Antiquarian and Topographical Cabinet [1811].*
Colls: BM; Coventry; V & AM.

ROFFE, F.

Illustrator. Contributed drawings of modern sculpture to *The Art Journal,* 1862-71 and 1891.

Colls: V & AM.

ROGERS, James Edward RHA 1838-1896

Architectural and marine painter. He was born in Dublin in 1838 and practised as an architect before giving this up to become a watercolourist. He was elected ARHA in 1871, RHA in 1872 and moved to London in 1876. He died on 18 February 1896.

Illus: *More's Ridicula; Ridicula Rediviva; The Fairy Book [Miss Mulock, c.1870].*
Contrib: *The English Illustrated Magazine [1893-94].*
Exhib: L; RA; RE; RHA; RI; ROI.
Colls: Nat. Gall., Dublin.

ROGERS, W.A.

Genre illustrator. Illustrated *City Legends* by Will Carleton, 1889 and contributed to *The Graphic,* 1887.

ROGERS, William Harry 1825-1873

Illustrator and designer. He was the son of W.G. Rogers and specialised in ornament, emblems and designs based on German books of the 16th century. He worked at Wimbledon and died there in 1873.

Illus: *Poems and Songs [Robert Burns, 1858]; Quarle's Emblems [c.1861]; Spiritual Conceits [c.1862]; Poe's Poetical Works [1858]; The Merchant of Venice [1860].*
Bibl: Chatto & Jackson *Treatise on Wood Eng.,* 1861, p.600; Ruari McLean, *Victorian Book Design,* 1972, pp.145-146, illus.

ROLLER, George R. RPE 1858-

Domestic and portrait painter and illustrator. He was born in 1858 and studied at Lambeth School of Art and in Paris under Bouguereau and Fleury. He was the designer of advertisements for Burberry's for thirty years and also picture restorer at the RA. He worked at Basingstoke, 1889 to 1914 and in London from 1925. He was elected RE, 1885.

Contrib: *Black & White [1894]; Pick-Me-Up; The Pall Mall Magazine; Fun [1901].*
Exhib: FAS; L; RA; RBA; RE; ROI.

ROLLESTON, D.

Marine illustrator. Contributed to *The English Illustrated Magazine,* 1895.

ROLLINSON, Sunderland 1872-

Painter, etcher and lithographer. He was born at Knaresborough in 1872 and studied at Scarborough School of Art and at the RCA. In his student years he contributed a number of landscape illustrations with enormous foregrounds to the National Competitions and *The Studio* book illustration competitions. He was working at Fulham, 1902 and at Cottingham, Yorks, 1914 to 1925, he married the artist Beatrice Malam.

Exhib: G; L; RA; RBA; RI; RSA.
Bibl: *The Studio,* Vol.11, 1897, p.261 illus.; Vol.14, 1898, p.144 illus.; Winter No., 1900-1, p.60 illus.

THE EARLY ITALIAN POETS
from Ciullo d'Alcamo to Dante Aligueri
translated by D. Gabriel Rossetti.

DANTE GABRIEL ROSSETTI 1828-1882. Design for frontispiece to The Early Italian Poets, *1861, unused. Pen and ink over pencil. 6ins. x 4⅞ins. (15.2cm x 12.4cm).*
Marshall Collection

ROLT, Charles fl.1845-1867
Figure artist working at Merton and in Bloomsbury. He illustrated *The Sermon on The Mount,* 1861 (chromo-liths).
Exhib: BI; RA; RBA.

ROOKE, Noel 1881-1953
Painter, engraver and book illustrator and decorator. He was born in 1881, the son of T.M. Rooke, portrait painter. He studied at the Slade School and at the Central School of Arts and Crafts, becoming the Head of the School of Book Production there. He was elected ARE in 1920 and died in 1953.
Illus: *An Inland Voyage [R.L. Stevenson, 1913]; Travels with a Donkey [R.L. Stevenson, 1913].*
Exhib: NEA; RA; RE.

ROPE, George Thomas 1845-1929
Landscape and animal painter. He was born at Blaxhall, Suffolk in 1849 and became a pupil of the landscape painter W.J. Webbe, visiting the Continent in 1882. He worked for most of his life at Wickham Market and excelled as a pencil artist. He died in 1929.
Illus: *Sketches of Farm Favourites [1881]; Country Sights and Sounds [1915].*
Exhib: L; RA.

ROSE, Robert Traill 1863-
Painter, designer and lithographer. He was born at Newcastle-upon-Tyne in 1863 and studied at the Edinburgh School of Art. He worked chiefly in Edinburgh and Tweedsmuir and produced a series of fine

symbolic illustrations to *The Book of Job,* c.1912.
Exhib: G; L; RSA; RSW.
Bibl: *The Studio,* Vol.55, 1912, p.312 illus.; *Modern Book Illustrators and Their Work,* Studio, 1914.

ROSS, Charles H. fl.1867-1883
Dramatist, novelist and illustrator. He was employed in the Civil Service at Somerset House and began to write and draw in his free time. He was brought to the notice of William Tinsley, the publisher who gave him two Christmas annuals to edit describing him as a 'very clever, but very nervous young man'. Ross's facility with writing and drawing won him the Editorship of *Judy* where many of his quips and drawings were published in the years 1867-78. Dalziel mentions that they were 'generally signed "Marie Duval", his wife's maiden name and the subjects often savoured somewhat of a French origin'. His small lively figures were full of humour but not great satiric art although they had in them the makings of real satire. One such was a large-headed man who became Ally Sloper and was taken to great heights by the artist W.G. Baxter (q.v.). Ross was also the proprietor of *C.H. Ross's Variety Paper.*
Illus: *Queens and Kings and Other Things, The Boy Crusoe; Merry Conceits and Whimsical Rhymes written and drawn by CHR [1883].*
Contrib: *Every Boy's Magazine.*
Bibl: W. Tinsley, *Random Recollections,* 1900, pp.267-268; The Brothers Dalziel, *A Record of Work, 1840-1890,* 1901, p.320.

ROSS, Sir John 1777-1856
Arctic explorer. He was born at Inch, Wigtonshire in 1777 and joined the East India Company in 1794 and the Royal Navy in 1805. He was commander in the Baltic and North Sea in 1812-17 and made his famous expeditions in search of the North-West Passage in 1818 and 1829-33. He was consul at Stockholm, 1839-46 and Rear-Admiral, 1834. He died in London in 1856.
Illus: *A Voyage of Discovery [1819, AT 634]; Narrative of a Second Voyage in Search of a North-West Passage [1835, AT 636].*
Colls: BM; Greenwich.

ROSSETTI, Dante Gabriel 1828-1882
Painter, poet and occasional illustrator. He was born in London on 12 May 1828, the son of Gabriel Rossetti, an Italian refugee and Professor of Italian at King's College. He was educated at King's College, studied drawing under J.S. Cotman (q.v.) and in 1845 entered the RA Schools, going in 1848 into the studio of Ford Madox Brown (q.v.). It was this meeting and later those with Millais and Holman Hunt (qq.v.) that caused the foundation of the Pre-Raphaelite Brotherhood of which Rossetti was the mainstay. The movement which lasted from 1848 until 1853 was to have repercussions right through the Victorian age, although it was first met with hostility. From 1857-58, when Edward Burne-Jones helped him with the decoration of the Oxford Union, Rossetti was much involved with the younger Pre-Raphaelite followers and poets and craftsman like William Morris (q.v.). His model, Elizabeth Siddal, whom he married in 1860, was the source of much of his inspiration in both painting and poetry, most of his important illustration was done prior to her death in 1862.

Rossetti can be seen as a larger than life influence on the later illustrators although his own contribution was small. He provided much of the hot imagery and passion in the decade following which made the 1860s memorable in book art. Rossetti lived for some time at 16 Cheyne Walk, Chelsea with W.M. Rossetti, A.C. Swinburne and George Meredith. He died at Birchington, Sussex on 9 April 1882 and was buried there.

Illus: *The Music Master [William Allingham, 1855]; Tennyson's Poems [Moxon Edition, 1857]; The Goblin Market [Christina Rossetti, 1862]; The Prince's Progress and other Poems [Christina Rossetti, 1866]; Flower Pieces [1888]; Early Italian Poets [n.d. (unused frontis)]; The Risen Life [R.C. Jackson, 1884 (cov. & frontis)].*
Exhib: London, 1849-50.
Colls: BM; Birmingham; V & AM.
Bibl: W.M. Rossetti, *DGR his Family Letters,* 1895; F.M. Hueffer, *R, A Critical Essay,* 1902; H.C. Marillier, *R,* 1904; Surtees, *DGR,* 1971; *DGR, Painter and Poet,* RA Cat., Jan.-March, 1973; Gordon N. Ray, *The Illustrator and The Book in England,* 1976, pp.101-103 illus.
See illustrations (above left, p.439 and Colour Plates VII and VIII p.105).

DANTE GABRIEL ROSSETTI 1828-1882. 'The Maids of Elfen-Mere.'
Illustration to The Music Master *by William Allingham, 1855. Wood engraving.*

ROSSITER, Charles 1827-c.1890
Genre painter. He was born in 1827 and taught painting. He married in 1860 Miss Frances Fripp Seares, the artist.

Contrib: *Passages From Modern English Poets [Junior Etching Club, 1862].*
Exhib: L; M; RA; RBA.

ROTHENSTEIN, Sir William 1872-1945
Painter and portrait artist. He was born at Bradford, Yorks in 1872 and educated at Bradford Grammar School and studied at the Slade School and at Julians, Paris, 1889-93. He made his debut as a draughtsman at Oxford in 1893, when he drew its celebrities. His portrait drawings are very French in treatment and some have a decidedly Whistlerish feel to them. Rothenstein travelled to India in 1910 and was Official War Artist, 1917-18 and to the Canadian Occupation, 1919. From 1917 to 1926 he was Professor of Civic Art at Sheffield University and Principal of the RCA, 1920-35. He was elected NEA, 1894, RP, 1897 and was knighted in 1931. He died in 1945.

Illus: *Oxford Characters, A Series of Lithographed Portraits by Will Rothenstein [1894]; English Portraits [1898]; Manchester Portraits [1899]; Liber Juniorum [1899]; The Fench Set and Portraits of Verlaine [1898]; Six Portraits of Sir*

Rabindranath Tagore [1915]; Twenty-Four Portraits [1920]; Twenty-Four Portraits, 2nd Series [1923].*
Contrib: *The Yellow Book; The Savoy ·[1896]; The Quarto [1898]; The Page [1899]; The Dome [1899].*
Exhib: B; FAS; G; GG; L; M; NEA; P; RA; RHA; RSA; RSW.
Colls: Liverpool; Tate.
Bibl: Robert Speaight, *WR, The Portrait of an Artist in His Time,* 1962.

ROUNTREE, Harry 1878-
Illustrator in black and white and colour. He was born in Auckland, New Zealand in 1878 and was educated at Queen's College, Auckland. He came to London in 1901 and studied with Percival Gaskell at the Regent Street Polytechnic before getting commissions through the Editor of *Little Folks.* Rountree's métier was always comic animals and books for children although he undertook a certain amount of poster work. His drawings are characterised by subtle colours and fluid washes with a great accuracy of natural background.

Illus: *The Magic Wand [1908]; The Wonderful Isles [1908]; Peep in the World [F.E. Crichton, 1908]; Alice's Adventures in Wonderland [1908].*
Contrib: *Little Folks; The Strand Magazine; Punch [1905-9, 1914]; The Graphic [1906, 1911]; ILN [1911].*
Bibl: *Modern Book Illustrators and Their Work,* Studio, 1914; *HR and His Work, The Art of the Illustrator,* P.V. Bradshaw, 1916.

ROUS, Eva
Illustrator contributing drawings to a story in *The Graphic,* 1910.

ROUSE, Robert William Arthur RBA fl.1883-1927
Landscape painter, etcher. He worked in Surrey, Buckinghamshire and Oxfordshire and was elected RBA in 1889. He illustrated a series of articles by W. Raymond in *The Idler* called 'The Idler out-of-doors' and contributed to *The Windsor Magazine.*

Exhib: G; L; M; RA; RBA; RHA; RI; ROI; RSA.

ROWLAND, Ralph
Humorous illustrator. Contributed golf sketches to *Punch,* 1905.

ROWLANDSON, George Derville 1861-
Sporting illustrator. He was born in India in 1861 and studied art in Gloucester, Westminster and Paris. He worked in Bedford Park and the majority of his contributions are military or equestrian. He signs his work GDR.

Contrib: *ILN [1897-1900]; The English Illustrated Magazine [1899-1900].*
Exhib: RI.

ROWLANDSON, Thomas 1756-1827
Watercolour painter, illustrator and social caricaturist. He was born in London in 1756, the son of a bankrupt merchant and was educated at Dr Barrow's School and at the RA Schools, which he entered in 1772. He made visits to Paris in 1774 and 1777 to visit relatives and the rococo delicacy of his pen and wash drawings probably owes something to this French connection. Rowlandson hereafter made extensive journeys on the Continent to France, Italy, Germany and Holland and in Great Britain, filling notebooks with a mixture of grotesque humanity and sylvan ideal landscapes. He often travelled with other caricaturists, notably, H. Wigstead and J. Nixon (q.v.). His work is always tinted pen drawing rather than full-scale watercolour, but he changed his humorous style to do drawings after the Old Masters and figures reminiscent of Thomas Gainsborough. He was one of the major caricaturists to become an extensive book illustrator, particularly in his work for Ackermann from 1798 in *The Tours of Dr. Syntax* and *The Microcosm of London,* 1808. In later life, Rowlandson's quality of work tailed off, a not surprising feature of someone who was a gambler, dissolute and naturally lazy. The later drawings often show a sloppiness and lack of interest in the subject and as countless versions of one subject exist this is not wholly surprising. The artist was extensively faked, but these copies tend to be wooden although the signature is often convincing. He died in London in 1827.

Illus: *Poems of Peter Pindar [1786-92]; Tom Jones [Fielding, Edinburgh, 1791 and 1805]; Joseph Andrews [Fielding, 1793]; Siebald [Smollett, 1793]; Humphrey Clinker [Smollett, 1793]; The Beauties of Sterne [1800]; Remarks*

On a Tour to North and South Wales in the Year 1797 [1800]; Matrimonial Comforts [1800]; Country Characters [1800]; Jones's Bardic Museum [1802]; A Compendious Treatise On Modern Education [1802]; Pleasures of Human Life [1807]; The Microcosm of London [1808]; Smollett's Miscellaneous Works [1809]; Poetical Magazine [1808-11]; Beauties of Tom Brown [1809]; Gambado [1809]; Baron Munchausen's Surprising Adventures [1809]; Antidote to The Miseries of Human Life [Beresford, 1809]; Advice to Sportsmen [1809]; Rowlandson's Sketches From Nature [1809]; Views in Cornwall, Devon . . .; The Art of Ingeniously Tormenting [1809]; Annals of Sporting [1809]; The Trial of the Duke of York [1809]; Chesterfield Burlesqued [1811]; The Tour of Dr Syntax in Search of the Picturesque [1812]; Petitcoat Loose [1812]; Poetical Sketches of Scarborough [1813]; Letters From Italy [Engelbach, 1813]; The Military Adventures of Johnny Newcome [1815]; Naples and the Campagna [Engelbach, 1815]; The Dance of Death [1815]; The Grand Master [1816]; Figure Subjects For Landscapes [1816]; Relics of a Saint [1816]; Vicar of Wakefield [Goldsmith, 1817]; The Dance of Life [1817]; Grotesque Drawing Book; World in Miniature [1817]; The Second Tour of Dr Syntax [1820]; Rowlandson's Characteristic Sketches of the Lower Orders [1820]; Voyage du Docteur Syntaxe [1821]; Journal of Sentimental Travels in the Southern Provinces of France [1821]; The History of Johnny Quae Genus [1822]; The Third Tour of Dr Syntax: In Search of a Wife [1822]; Die Reise des Doktor Suntax [1822]; Crimes of the Clergy [1822]; The Spirit of the Public Journals [1823-25]; Bernard Blackmantle, English Spy [1825]; The Humorist [1831].

Exhib: RA; Soc. of Artists.

Colls: Aberdeen; Ashmolean; Bedford; Birmingham; BM; Fitzwilliam; Leeds; Manchester; Mellon Coll; Wakefield; V & AM.

Bibl: Joseph Grego, *R, The Caricaturist*, 1880; A.P. Oppé, *TR, Drawings and Watercolours*, 1923; O. Sitwell, *TR*, 1929; F.G. Roe, *TR*, 1947; A.W. Heintzelman, *Watercolour Drawings of TR*, 1947; A. Bury, *R Drawings*, 1949; B. Falk, *TR, Life and Art*, 1949; J. Hayes, *R*, 1972; R. Paulson, *R, A New Interpretation*, 1972.

See illustrations (Colour Plates III and IV p.37).

ROWLEY, The Hon. Hugh 1833-1908

Flower painter and amateur illustrator. He was born in 1833, the son of the 2nd Baron Langford. He was educated at Eton and Sandhurst, taking a commission in 10th Lancers, 1852 and retiring in 1854. He lived at Westfield House, Brighton and was the author of various humorous publications and Editor of a short-lived magazine, *Puniana*. He died on 12 May 1908.

Illus: *Gamosagamnon or Hints on Hymen [1870].*
Contrib: *London Society [1867].*
Exhib: RA, 1866.

ROYLE, C. RN

Amateur illustrator. He contributed a drawing to *The Illustrated London News*, 1859.

RUDGE, Bradford 1805-1885

Landscape painter and teacher. He was the son of Edward Rudge, a competent Midlands artist who taught at Rugby School. He settled at Bedford in 1837, having been an unsuccessful candidate for the NWS that year, and became the first drawing-master on the staff of the Harpur Schools. His early work is more in the tradition of the romantics, his later work very flowery. He painted mostly on the Ouse, in Surrey and in North Wales and retired in 1875, dying at Bedford in 1885.

Illus: *A Short Account of Buckden Palace [1839].*
Exhib: L; RBA; RSA.
Colls: Author; Bedford; Coventry.
Bibl: *Bedfordshire Magazine*, Vol.7, 1960-61, pp.247-250.

RUSDEN, Athelstan

Cartoonist at Manchester. He worked for *Moonshine* and for *Punch*, 1879.

RUSKIN, John 1819-1900

Poet, painter and critic. He was born in London on 8 February 1819, the son of a Scottish wine importer with artistic inclinations. He studied at King's College, London and learned drawing under Copley Fielding and J.D. Harding (q.v.). He went up to Christ Church, Oxford in 1836 and won the Newdigate Prize three years later, then travelling in Europe, 1840-41. He had become acquainted with Turner in 1840 and paid his first visit to Venice in 1841, two events which were crucial to his writing career, his championship of Turner and his love of Venetian architecture. He published his first volume of *Modern Painters* in 1843 and the series continued until 1860, by which time he was the leading art critic in the country and a stout defender of the Pre-Raphaelites. In 1869 he was elected Slade Professor of Art at Oxford, where he gave regular lectures until 1884. Ruskin's reforming zeal was demonstrated by his founding of the Guild of St George in 1871 for the 'workmen and labourers of Great Britain'. He went to live at Coniston in 1871 and became more and more a recluse from recurring attacks of brain fever. He died there of pneumonia in 1900.

Inspite of his vast literary output, Ruskin did not neglect his own considerable talents as a watercolourist. His pencil drawings of buildings are accurate and delicate, owing something to the work of Harding and Prout, his watercolours very much in the style of Turner, his still-life pictures having a Pre-Raphaelite detail. He was elected HRWS, 1873.

Illus: *The Seven Lamps of Architecture [14 etched pls., 1849]; The Stones of Venice [1853]; The Poems of John Ruskin [Ed. W.G. Collingwood, 1891]; Poetry of Architecture [1893].*
Exhib: FAS, 1878, 1907; RHA; RWS.
Colls: Ashmolean; Birkenhead; Birmingham; BM; Brantwood; Fitzwilliam; Glasgow; Sheffield; V & AM.
Bibl: T.J. Wise and J.P. Smart, *Bibiography*, 1893; W.G. Collingwood, *The Art Teaching of JR*, 1891; J.H. Whitehouse, *The Painter and His Work at Bembridge*, 1938; P. Quennell, *JR*, 1949; J. Evans, *JR*, 1954; M. Lutyens, *Millais and the Ruskins*, 1967; P.H. Walton, *The Drawings of JR*, 1972.

RUSSELL, Sir Walter Westley RA RWS 1867-1949

Painter, teacher and illustrator. He was born at Epping in 1867 and studied at the Westminster School of Art under Fred Brown. He was Drawing Teacher at the Slade School from 1895 to 1927 and served with the Camouflage Corps in the First War, 1916-19. Russell was elected ARA in 1920 and RA in 1926. He was Keeper of the RA, 1927-42 and was influential in altering the teaching arrangements of the Schools and in bringing them up to date. He was an important link between the Academy and outsiders like P. Wilson Steer and Henry Tonks who were his friends. He was made CVO in 1931, knighted in 1935 and died on 16 April 1949.

Contrib: *ILN [1892-94]; Daily Chronicle [1895]; The Graphic [1895]; The Yellow Book [1895]; The Quarto [1898]; Lady's Pictorial; The Pall Mall Magazine.*
Exhib: G; GG; L; M; NEA; P; RA; RHA; RSW; RWS.
Colls: V & AM.

See illustration (p.441).

RUTHERSTON, Albert Daniel 1881-1953

Artist, stage designer and illustrator. He was born in Bradford on 5 December 1881, the son of M. Rothenstein and brother of Sir W. Rothenstein (q.v.). He was educated at Bradford Grammar School and studied at the Slade School, 1898-1902 and became Visiting Teacher at the Camberwell School of Arts and Crafts and Ruskin Master of Drawing at Oxford from 1929. He served in the First War with the Northants Regiment in Palestine, 1916-19. Rutherston did a considerable amount of designing for private presses in the 1920s and was responsible for some wrappers, all in the current craze for linear naivety in startling colours. He was a member of the NEA, 1905 and RWS, 1941.

Publ: *Decoration in the Art of the Theatre; A Memoir of Claude Lovat Fraser [with John Drinkwater]; Sixteen Designs For The Theatre.*
Illus: *The Children's Blue Bird [G. LeBlanc, 1913]; Cymbeline [1923]; The Cresset Herrick; The Soncino Haggadah; A Box of Paints [Geoffrey Scott, 1923]; Yuletide in a Younger World [Thomas Hardy, 1927].*
Contrib: *The Gypsy [1915]; The Broadside; The Chapbook [1921].*
Exhib: Carfax Gall; FAS; G; L; M; NEA; RSA; RWS.
Colls: Ashmolean; V & AM.

RUTLAND, Elizabeth Duchess of -1825

Amateur artist. She was the daughter of the 5th Earl of Carlisle K.G. and married the 7th Duke of Rutland in 1799 and became a leader of taste and fashion, extensively altering her husband's home Belvoir Castle. She died on 29 November 1825.

Illus: *Journal of a Short Trip to Paris, 1814, 1815 [AT 106, privately printed].*

RUTLAND, Florence M.

Illustrator. Student of the Birmingham School who contributed to *The Yellow Book*, April 1896.

SIR WALTER WESTLEY RUSSELL RA RWS 1867-1949. Mr. and Mrs. Gladstone at Gorebridge, 4 July 1892. Original drawing for illustration in The Illustrated London News, *Vol. 101, 1892. Black crayon. 8¼ins. x 7¼ins. (21cm x 18.4cm).*

Victoria and Albert Museum

RUTLAND, Violet Duchess of 1856-1937
Amateur artist. She was born at Wigan, Lancs in 1856, the daughter of Col. the Hon. C.H. Lindsay. She married the 8th Duke of Rutland. She concentrated on portrait drawings in pencil and chalks but also did sculpture. She died on 27 December 1937. Elected SWA, 1932.

Illus: *Portraits of Men and Women [1899].*
Exhib: FAS; G; GG; L; New Gall; P; RA; RMS; SWA.

RYLAND, Henry RI 1856-1924
Painter and illustrator. He was born at Biggleswade, Bedfordshire in 1856 and became a pupil of Benjamin Constant, Boulanger, Lefebvre and Cormon in Paris. Ryland was a versatile artist and after being strongly influenced by Pre-Raphaelite art, turned his attention to stained glass, decorating and book illustrations as well as to the painting of subject and legend. He was elected RI in 1898 and died in Bedford Park, London on 23 November 1924.

Contrib: *The English Illustrated Magazine.*
Exhib: B; G; GG; L; M; New Gall; RA; RBA; RHA; RI; ROI; RSW.
Colls: Manchester.
Bibl: *Cassells Mag.,* CXCIV; *The Artist,* September 1898, pp.1-9.

S., C.L.
Unidentified illustrator working about 1900.

Colls: V & AM.

S., M.H.
Unidentified illustrator working in the second half of the 19th century. Contributed to *The Gentleman's Journal and Youth's Miscellany.*

Colls: V & AM.

SABATTIER, Louis Rémy fl.1894-1910
French portrait painter. He was born at Annonay and studied with Gêrome and de Boulanger, exhibiting at the Salon from 1890.

Contrib: *The Graphic [1910].*

SACHS, William J.
Topographical illustrator. He contributed to *The Illustrated Times,* 1866.

ST CYR fl.1912
Fashion illustrator working in pen and ink and watercolour for magazines, about 1912.

Colls: V & AM.

SAINTON, Charles Prosper RI 1861-1914
Portrait, figure and landscape painter and silver point artist. He was born in London on 23 June 1861 and educated at Hastings, before studying at the Slade School and in Florence and Paris. He held a one man show of silverpoints at the Burlington Gallery in 1892 and exhibited at the Salon from 1889. He was elected RI, 1897 and RMS, 1904. Died on 7 December 1914, possibly at New York.

Contrib: *The English Illustrated Magazine [1893-94, portraits].*
Exhib: B; FAS; G; GG; L; M; RA; RI; RMS; ROI.
Colls: V & AM.

SALA, George Augustus Henry 1828-1896
Journalist, author and illustrator. He was born in 1828 and educated in Paris before studying drawing in London. He worked as a clerk and a scene painter at the Princess's and Lyceum Theatres before becoming a book illustrator and the Editor of *Chat.* Sala was sent by Dickens to cover the Crimean War on the Russian side in 1856 and contributed articles to *All The Year Round,* 1858. He founded and edited *Temple Bar,* 1860-66 and was a correspondent of *The Illustrated London News,* 1860-86 and of *The Daily Telegraph* in the American Civil War, 1863. In his early days he was a strong opponent of the youthful *Punch.*

Illus: *A Word With Punch [Bunn].*
Contrib: *The Cornhill Magazine [1860].*
Bibl: *The Life and Adventures of GS,* 2 vols., 1895; Ralph Straus, *GAS,* 1942.

SALMON, J.M. Balliol 1868-1953
Artist and illustrator. He was born on 1 June 1868, the son of a surgeon and barrister. He was educated privately and studied art under Fred Brown at the Westminster School and afterwards at Julian's in Paris. He was a teacher of drawing for a short time before becoming a full-time illustrator on *The Graphic* in about 1901. He was working in Glasgow in 1914 and at Bedford Park at the time of his death on

EDWARD LINLEY SAMBOURNE 1844-1910. *'Falstaff drinking from a tankard with Doll Tearsheet beside him.'* Original drawing for illustration. Pen and ink. Signed and dated 1886. 5⅝ins. x 9¼ins. (14.3cm x 23.5cm).

Victoria and Albert Museum

CLEAR AND COOL, CLEAR AND COOL,
BY LAUGHING SHALLOW, AND DREAMING POOL
COOL AND CLEAR, COOL AND CLEAR,
BY SHINING SHINGLE, AND FOAMING WEIR;

"The Water Babies"
Charles Kingsley. Page 51.

EDWARD LINLEY SAMBOURNE 1844-1910. Original drawing for illustration to The Water Babies *by Charles Kingsley, 1886. Pen, ink and bodycolour. Signed and dated 1881. 6¾ins. x 4¾ins. (17.1cm x 12.1cm).*
Victoria and Albert Museum

3 January 1953. He was one of the best pencil and chalk artists to work for the press in the Edwardian period.

Contrib: *The Quiver [1890]; The Pall Mall Budget [1893]; The New Budget [1895]; The Graphic [1899-1930]; The Sporting and Dramatic News [1900]; Cassell's Family Magazine; The Ludgate Monthly; The Pall Mall Magazine.*

SALT, Henry 1780-1827

Topographer. He was born at Lichfield in 1780 and took lessons from J. Glover, J. Farrington and J. Hoppner. He accompanied Lord Mountnorris to India in 1802 as secretary and draughtsman and returned via Egypt and Ethiopia in 1806. He was sent on a diplomatic mission to Ethiopia in 1811 and became Consul-General in Egypt in 1815. He died at Alexandria in 1827.

Illus: *Voyages and Travels to India [Lord Valentia, 1809]; Twenty-Four Views in St Helena [1809]; A Voyage to Abyssinia [1814].*
Colls: BM; India Office Lib.
Bibl: J.J. Halls, *Life of S*, 1834.

SAMBOURNE, Edward Linley 1844-1910

Black and white artist, cartoonist and designer. He was born in London on 4 January 1845 and was educated at the City of London School and Chester College. In 1860 he was apprenticed to a firm of marine engineers and continued in that career until his drawings began to be received by *Punch* in 1867. He under-studied Sir John Tenniel as cartoonist and succeeded him as first cartoonist of the magazine when he retired in January 1901. Sambourne was well-known for the great accuracy of his drawings and the care he took over details of dress and construction. He was an inventive artist who appreciated page design and fantasy although his ink sketches can show a Germanic hardness of line. He was considered by Du Maurier to be the only artist in London who could draw a top hat correctly! He died in Kensington on 3 August 1910.

Illus: *The New Sandford and Merton [1872]; Our Autumn Holidays on French Rivers [1874]; The Royal Umbrella [1880]; The Water Babies [Charles Kingsley, 1885]; Buz or The Life and Adventures of a Honey Bee [Maurice Noel, 1889]; The Four Georges [W.M. Thackeray, 1894]; The Real Adventures of Robinson Crusoe [1893].*
Contrib: *London Society [1868]; ILN [1876]; Good Words [1890]; Black & White [1891]; The Sketch [1893]; The Pall Mall Magazine [1893]; Daily Chronicle [1895]; The Minister [1895].*
Exhib: FAS, 1893; G; L; RA.
Colls: V & AM.
Bibl: M.H. Spielmann, *The History of Punch*, 1895, pp.531-537; *The Studio*, Winter No., 1900-1, p.85 illus.
See illustrations (pp.442, 443).

SAMBOURNE, Maud fl.1892-1895

Illustrator. She was the daughter of Linley Sambourne (q.v.) and contributed occasional drawings to *Punch*, 1892-94.

Contrib: *The Pall Mall Magazine; The Minister.*

SANDERCOCK, Henry Ardmore fl.1865-1907

Marine and landscape painter in watercolour, illustrator. He worked at Bideford, Devon and illustrated for children's stories. He signs his work ꟻ

Exhib: L; RA; RBA; RI; RWS.
Colls: Montreal.

SANDERSON, H. fl.1862-1865

Figure artist. He illustrated *Legends from Fairyland*, Holmeden, 1862 and contributed to *London Society*, 1862-63, *The Churchman's Family Magazine*, 1863, *Fun*, 1865.

SANDHEIM, May or Amy fl.1908-1929

Artist and illustrator. She illustrated *The Prince's Progress* by Christina Rossetti in 1908.

Exhib: L; SWA.

SANDS, J. fl.1862-1888

Minor Scottish poet and amateur draughtsman. He was a close friend of Charles Keene (q.v.) whom he first met in 1862. He subsequently went on expeditions in Scotland with Keene in 1869, 1871 and later in the 1870s. Although trained as a solicitor Sands fancied himself as an artist and at one time drew for a newspaper in Buenos Aires. He began to contribute to *Punch* in 1870 and continued to do so for a decade, also supplying Keene with material for his jokes. He finally broke with *Punch* because he considered that they were more interested in printing the work of Keene's nephew A. Corbould (q.v.) than his. He became a recluse at Walls, Shetland for the remainder of his life. Signs with an hour glass device.

Publ: *Out of this World or Life in St Kilda [1876].*
Colls: V & AM (album).
Bibl: G.S. Layard, *The Life and Letters of Charles Samuel Keene*, 1892, pp.123-128.

SANDY, A.C. fl.1897-1901

Illustrator. Contributed to *The Rambler*, 1897, *Moonshine*, 1898, *Fun*, 1899-1901, *Illustrated Bits*, 1900 and *The Sketch* and *Sketchy Bits*.

MANOLI.

FREDERICK AUGUSTUS SANDYS 1832-1904. 'Manoli.' Illustration to a poem in The Cornhill Magazine, *1862. Wood engraving.*

Drawn by Frederick Sandys. *See "The Hardest Time of All."*

THE WAITING TIME.

FREDERICK AUGUSTUS SANDYS 1832-1904. 'The Waiting Time.'
Illustration in The Churchman's Family Magazine, 1863. *Wood engraving.*

SANDYS, Frederick Augustus **1832-1904**

Portrait-draughtsman and illustrator. He was born at Norwich in 1832,
the son of a journeyman dyer who had set up as an artist. He showed
promise at an early age and was noticed by the Rev. Bulwer and was
enabled to attend Norwich Grammar School. He studied also in the
newly established Government School of Design there and by the time
that he arrived in London in about 1851, had already contributed
illustrations to *The Birds of Norfolk* and *The Antiquities of Norwich*.
He worked for wood engravers but showed his first picture, a portrait
at the RA that year. After 1857, Sandys became part of Rossetti's
circle at a time when the artists surrounding him were embarking on
the production of illustrated books. Sandys was to join them in this
and it is on these superbly finished designs that his reputation really
rests. His influences were Rossetti himself, but also the prints of Dürer
(he copied his own monogram freely from Dürer) and the work of
Alfred Rethel, 1816-59. From the late 1860s, Sandys concentrated
mostly on chalk drawings of women on toned paper, a surer medium
for his exquisitely fine draughtsmanship than oils had ever given him.
Despite some success, the artist remained largely unrecognised, partly
due to his lack of business sense and pecuniary troubles. He died at 5
Hogarth Road, London on 25 June 1904.

Contrib: *Once a Week [1861-67]; The Cornhill Magazine [1860, 1866]; Good
Words [1862-63]; Willmott's Sacred Poetry [1862]; The Churchmans Family
Magazine [1863]; The Shilling Magazine [1865]; The Quiver [1866]; The
Argosy [1866]; The Shaving of Shagpat [Meredith, 1865]; Christian's Mistake
[Mrs Craik, 1866]; Touches of Nature by Eminent Artists [1866]; Idyllic
Pictures [1867]; Thornbury's Legendary Ballads [1876]; The British Architect
[1879]; Cassell's Family Magazine [1881]; Dalziel's Bible Gallery [1881]; Pan
[1881]; The Century Guild Hobby Horse [1888]; The English Illustrated
Magazine [1891]; The Quarto [1896].*
Exhib: FAS; L; New Gall; P; RA.
Colls: Ashmolean; BM; Bradford; Fitzwilliam; Leeds; V & AM.
Bibl: *Woodcuts by FS,* Pub. by Hentchel, c.1904; *The Artist,* Dec. 1897,
pp.7-63 illus.; Gleeson White, *English Illustration 'The Sixties',* 1906,
pp.172-175; Forrest Reid, *English Illustrators of the Sixties,* 1928, pp.59-64;
FS, Cat. of Exhib. at Brighton, 1974; Gordon N. Ray, *The Illustrator and The
Book in England,* 1976, pp.107-108 illus.
See illustrations (left and p.**444**).

SANSOM, Nellie **fl.1894-1936**

Portrait painter and illustrator. She studied at the RCA and was
elected RMS in 1896.

Contrib: *ILN [1903].*
Exhib: B; G; L; M; RA; RBA; RCA; RI; RMS; SWA.

SARG, Tony **1880-**

American painter, illustrator and caricaturist. He was born in
Guatemala in 1880, worked for many magazines and executed mural
paintings in New York hotels. He became a member of the London
Sketch Club in 1914 and illustrated a number of English books.

Illus: *Children For Ever [J.F. Macpherson, 1908]; Molly's Book [1908].*
Contrib: *Punch [1907-12]; The Graphic [1908-10].*

SARGENT, G.F. **fl.1840-1860**

Illustrator. Lived in London and was a prolific illustrator of
topographical and antiquarian works. He was considered too poor an
artist to be seconded for the NWS in 1854.

Illus: *Polite Repository [T.L. Peacock].*
Contrib: *Knight's London [1841-42]; Shakespeare Illustrated [1842]; The
Pilgrim's Progress and the Holy War Illuminated [c.1850]; Cassell's Illustrated
Family Paper [1853]; The Illustrated London Magazine [1853-55]; The
Seasons and The Castle of Indolence [1857]; The Welcome Guest [1860]; ILN
[1860].*
Colls: Nottingham.

SARGENT, John Singer **1856-1925**

Portrait and landscape painter and watercolourist. He was born in
Florence in 1856, the son of an American doctor and travelled widely
in Europe and America, before studying in Rome, Florence and Paris,
under Carolus Duran. Although principally known as a portrait
painter of exceptional dexterity and sparkle in the Edwardian years,
he was also a fluid watercolourist, making great effects with rapid
washes and brilliant colours, particularly those undertaken during the
First World War. He received many honours, the Légion d'Honneur,
was elected ARA in 1894 and RA in 1897. He died in Chelsea on 15
April 1925 and his studio was sold at Christie's on July 24 and 27,
1925.

Illus: *Five Songs From a Book of Verses [W.E. Henley (title page)].*
Exhib: B; FAS; G; GG; L; M; NEA; New Gall; RA; RHA; ROI; RSA; RSW;
RWS.
Colls: Ashmolean; BM; Bradford; Fitzwilliam; Imperial War; Manchester; Tate.
Bibl: The Hon. E. Charteris, *JSS,* 1927; M. Hardie, *JSS,* 1930; R. Ormond, Cat.
of Exhibition, Birmingham, *JSS,* Sept-Oct., 1964; R. Ormond, *JSS,* 1970.

SARGENT, Waldo

Illustrator, contributing to *London Society,* 1863.

SARGISSON, Ralph M. **fl.1906-1937**

Artist and illustrator. He worked in Birmingham and contributed good
ink drawings of interiors with figures to *Punch,* 1906. He was elected
RBSA, 1935.

Exhib: B.

SATCHWELL, R.W. **fl.1793-1818**

Miniaturist and portrait painter. He designed frames and border
ornament for an edition of *The Rambler,* c.1795.

Colls: V & AM.

SAUBER, Robert RBA 1868-1936
Painter and illustrator. He was born in London on 12 February 1868, the grandson of Charles Hancock, the animal painter. He studied at Julian's, Paris and in Munich and was an exhibitor in both places. From about 1890, Sauber was living in London and working for most of the leading weekly and monthly magazines. He claimed to be most influenced by French 18th century art in his drawings, a particular mannerism of his work being heavy washes with busy pen work on top of them. He became RBA in 1891 and RMS in 1896, acting as Vice-President of the RMS, 1896-98. He lived at Hartwell near Northampton from about 1925 and died on 10 September 1936.

Illus: *Mrs Tregaskis [Mrs Praed, c.1894]*.
Contrib: *The English Illustrated Magazine [1893-96]; The Sketch [1894]; St Pauls [1894]; The Sporting & Dramatic News [1895]; The Minister [1895]; Pearson's Magazine [1896]; ILN [1897-99 (theat.)]; The St James's Budget; The Queen; The Windsor Magazine; The Idler; The Pall Mall Magazine; Fun [1901]*.
Exhib: B; L; New Gall; RA; RBA; RMS; ROI.
Colls: V & AM.
Bibl: 'An Illustrator of Note' *The Artist*, June 1897, pp.241-248 illus.

SAVAGE, Reginald fl.1886-1904
Portrait and figure painter and illustrator. He was a talented and imaginative designer and woodcut artist, closely associated with the Essex House Press. His subjects are usually from history and poetry and he was commended by Walter Crane (q.v.) for his 'weird designs'.

Illus: *Pilgrim's Progress [1899]; The Poems of William Shakespeare [1899]; Venus and Adonis [1900-01]; The Eve of St Agnes [1900-1]; The Journal of John Woolman [1900-1]; The Epithalmion of Spenser [1901]; Alexander's Feast [John Dryden, 1904]; (All Essex House Press)*.
Contrib: *Black & White [1891]; The Dial [1892]; The Butterfly [1893]; St Pauls [1894]; Madame [1895]; The Ludgate Monthly; The Pageant [1896]; Fun [1901]*.
Exhib: New Gall; RA; RBA; RI; ROI.
Colls: V & AM.
Bibl: *The Art of The Book*, Studio, 1914; R.E.D. Sketchley, *Eng. Bk. Illus.*, 1903, pp.18, 24, 130.

SAWYER, Amy 1887-1909
Figure and decorative artist. She worked at Bushey, 1887 where she probably attended the Herkomer School. She later worked from Ditchling, Sussex and was elected ASWA, 1901.

Contrib: *Black & White [1891]*.
Exhib: B; FAS; L; M; RA; ROI; SWA.

SCANNELL, Edith S.
Illustrator of children's books. She illustrated *The Child of the Caravan*, E.M. Green, c.1888.

SCHARF, George 1788-1860
Miniature painter, drawing-master and illustrator. He was born at Mainburg, Bavaria in 1788 and studied at Munich before travelling in Flanders and France. During the Empire, he was in the Low Countries and escaped from Antwerp during the siege of 1814. He studied in Paris at the Musée Napoleon after 1815 and came to England in 1816, where he learnt lithography and became an employee of Moser and Hullmandel. He was employed for many years to draw on stone for the illustrations of the Geological Society's *Transactions* and made topographical drawings of London. He was a member of the NWS from 1833 to 1836 and he died in London in 1860. He was the father of Sir G. Scharf (q.v.).

Exhib: RA; RBA; NWS.
Colls: BM; V & AM.

SCHARF, Sir George 1820-1895
Draughtsman and illustrator. He was born in London in 1820, the son of G. Scharf (q.v.) and was educated at University College School and studied at the RA Schools, 1838. In 1840 he accompanied Sir Charles Fellowes to Asia Minor as draughtsman, visiting Italy on the way and returning to Asia Minor again in 1843. He assisted Charles Keene in the scenery and costumes of his Shakespearean revivals, 1851-57 and became celebrated for his work as an art historian and cataloguer. He was made as a result of this the first Secretary and then Director of the National Portrait Gallery, 1857 and 1882. He was knighted in

1895.
Publ: *Catalogue of the Collection of Pictures at Knowsley Hall [1875]; Descriptive and Historical Catalogue of the Collection of Pictures at Woburn Abbey [1890]*.
Illus: *Recollection of Scenic Effects [1839]; Smiths Classical Dictionaries; Keats Poems [1866-67]*.
Exhib: RA; BI.
Colls: BM; Witt Photo.

SCHETKY, John Christian 1778-1874
Draughtsman and drawing-master. He was born in Edinburgh in 1778, the son of a Hungarian musician and Maria Reinagle. He took lessons from Alexander Nasmyth and from an early age taught drawing to support his family. He worked as a scene painter and in 1801, walked to Rome, returning through France. He was then drawing-master at Oxford, at the Military College at Marlow and after 1810 was appointed master at the Portsmouth Naval Academy where he remained until 1836. Schetky's official appointments included being Watercolour Painter to the Duke of Clarence and Marine Painter in Ordinary to George IV and Queen Victoria. He died in London in 1874.

Illus: *Sketches and Notes of a Cruise in South Waters [Duke of Rutland, 1850]; Court Martial [Hon. H.S. Rous, AL 343]*.
Exhib: BI; OWS; RA; RBA.
Colls: BM; Greenwich.
Bibl: S.F.L. Schetky, *Life of JCS*, 1877.

SCHLOESSER, Carl Bernhard 1832-1914
Portrait painter and etcher. He was born in Darmstadt in 1832 and studied under Couture and at the École des Beaux Arts, exhibiting at the Salon from 1861. He was living in London by 1890 and died there in 1914.

Illus: *Ormond [Maria Edgeworth, c.1895]*.
Exhib: B; FAS; G; GG; L; M; RA; RHA.

SCHNEBBLIE, Robert Blemmel -1849
Topographical draughtsman. He was the son of the celebrated topographer J.C. Schnebblie, 1760-92. He worked in his father's style and illustrated for *The Gentleman's Magazine* and Wilkinson's *Londina Illustrata*, 1808. He died of starvation in 1849.

Exhib: RA.
Colls: BM; V & AM.

SCHONBERG, Johann Nepomuk 1844-
Figure artist and illustrator. He was born in Austria in 1844, the son of the lithographer Adolf Schonberg, 1813-68. He studied at the Vienna Academy and then went to France where he worked for *Monde Illustré* and *Journal Illustré*. He was appointed Special Artist to *The Illustrated London News* in Roumania in 1877 and worked for the magazine until 1895, often improving drawings sent in by other artists. His style is characterised by heavy use of bodycolour with grey washes.

Illus: *History of the Popes [Patuzzi]; Universal History [Alvensleben]; The Young Buglers [G.A. Henty, 1880]; The Dash For Khartoum [G.A. Henty, 1892]*.
Exhib: RA, 1895.
See illustration (p.447).

SCHWABE, Randolph RWS 1885-1948
Watercolourist and illustrator. He was born in Manchester in 1885 and after being educated privately, studied at the Slade School and then at Julian's in Paris, 1906. Schwabe was a member of the NEA from 1917 and of the London Group from 1915, being elected ARWS in 1938 and RWS in 1942. In 1930 he was appointed Slade Professor of Fine Arts in the University of London. Schwabe was a fluid draughtsman with pen and ink and his views of cities in this medium are among his best works. He carried out some book illustration in the 1920s and died in 1948.

Illus: *Historic Costume, 1490-1790 [1929, with F.M. Kelly]; A Short History of Costume and Armour, 1066-1800 [1931, with F.M. Kelly]; Summer's Fancy [Edmund Blunden, Beaumont Press, 1930]; Costume in Ballet [Cyril W. Beaumont]*.
Contrib: *Oxford Almanac [1940]*.
Exhib: FAS; G; GG; L; M; NEA; RSA; RWS.
Colls: Ashmolean; V & AM.

JOHANN NEPOMUK SCHONBERG 1844- . 'Crossing the Citrol.' Original drawing for illustration, perhaps for The Illustrated London News. *Pen, grey wash and bodycolour. 20½ins. x 14ins. (52.1cm x 35.6cm).* Author's Collection

SCOTT, David RSA 1806-1849

Painter and illustrator. He was born at Edinburgh in 1806, the son of the engraver Robert Scott and elder brother of W.B. Scott (q.v.). He worked as an engraver before turning to painting, studied at the Trustees Academy and was one of the founders of the Edinburgh Life Academy Association in 1827. He worked for a short time in Italy in 1832-34 where he made anatomical studies in the Hospital for Incurables. His paintings are heroic in concept and his illustrations have considerable interest, deriving as they do in both symbol and style from William Blake (q.v.). He died at Edinburgh in 1849.

Illus: *The Ancient Mariner [S.T. Coleridge, 1837]; Architecture of the Heavens [Prof. Nichol, 1851]; The Ancient Mariner; Pilgrim's Progress [1860].*
Exhib: RA; RSA.
Colls: BM.
Bibl: W.B. Scott, *Memoir of DS*, 1850; W.B. Scott, *Autobiographical Notes of the Life of*, Vol.2, 1892, pp.216-219 and 259-268.
See illustration (p.449)

SCOTT, Georges 1873-c.1948

French portrait painter. He was born in 1873 and worked in Paris, contributing illustrations of events to *The Graphic*, 1901-11. He painted a portrait of King George V now in the Bristol City Art Gallery.

Exhib: L; RA, 1909-12.

SCOTT, J.

Figure artist. Contributed comic illustrations to *Thomas Hood's Comic Annual*, 1837-38.

SCOTT, Septimus Edwin 1879-

Landscape painter and poster artist. He was born at Sunderland on 19 March 1879 and studied at the RCA. He was elected ARBA in 1919, RI in 1927 and ROI in 1920.

Contrib: *The Graphic [1910].*
Exhib: B; L; RA; RBA; RI; ROI.

SCOTT, Stuart H.

Topographer. Contributed to *The Illustrated London News*, 1896.

SCOTT, Thomas D. fl.1850-1893

Portrait illustrator and miniaturist. He worked at Peckham and was described by White as 'a well-known portrait engraver' and by Chatto as an 'able reducer and copyist of pictures on wood'.

Illus: *The Gold of Fairnilee [Andrew Lang, c.1889 (frontis)].*
Contrib: *The Book of British Ballads [S.C. Hall, 1842]; The Illustrated London News [1850]; Examples of Ornament [Bell & Daldy, 1855]; Heber's Hymns [1867]; Once a Week [1867].*
Exhib: RA.
Bibl: Chatto & Jackson, *Treatise on Wood Engraving*, 1861, p.600.

SCOTT, William fl.1880-1905

Painter and etcher. He was elected RE in 1881 and lived much of his life in Italy, at Rome, 1882, Venice, 1884 and Bodighera 1896.

Illus: *Lamia's Winter Quarters [Alfred Austin, c.1905 (head and tail pieces)].*
Exhib: B; G; M; RA; RBA; RE; ROI.

SCOTT, William Bell 1811-1890

Painter, illustrator, critic and poet. He was born at Edinburgh on 12 September 1811, the son of Robert Scott, the engraver and younger brother of David Scott (q.v.). He studied art with his father and then attended the Trustees Academy in Edinburgh in 1831. He assisted his father in the engraving business and then in 1837 left for London where he hoped to earn a livelihood as an illustrator. This proved not to be a success and he turned to painting, making friends with W.P. Frith and Augustus Egg. In 1842 he entered an unsuccessful design for the Houses of Parliament Cartoon Competition and the next year was appointed master of the School of Design at Newcastle-upon-Tyne, where he remained till 1863. Scott developed a considerable facility as a mural painter and did major works at Wallington Hall, Northumberland for the Trevelyan family and at Penkill Castle, Ayrshire for his patron Mr. Boyd. A friend of Rossetti and the Pre-Raphaelites, Scott was often inspired in his compositions and clumsy in his executions, giving a slightly provincial echo of the Brotherhood. His watercolours are generally conceived on too large a scale, their symbolism often borrowed from Dürer or Blake. He died at Penkill Castle in 1890.

Publ: *Antiquarian Gleanings in the North of England [1851]; Half-hour Lectures . . . of the Fine and Ornamental Arts [1861]; Our British Landscape Painters [1872]; William Blake [1878].*
Illus: *The Ornamentist or Artisan's Manual [1845]; The Year of the World [1846]; Landon's Poetical Works; Pilgrim's Progress [1860, with D. Scott].*
Contrib: *Landscape Lyrics [c.1837]; The Observer [1842]; The Family Bible [1867].*
Exhib: BI; RA; RBA; RSA.
Colls: Author; Newcastle.
Bibl: *Autobiographical Notes on The Life of WBS*, 1892; M.D.E. Clayton-Stamm, 'Observer of the Industrial Revolution', *Apollo*, May 1969, pp.386-390; R. Trevelyan, *WBS*, Apollo, September 1977.
See illustration (p.448).

SEARLE, A.A.

Equestrian draughtsman. Contributed to *Punch*, 1907.

WILLIAM BELL SCOTT 1811-1890. 'The Rending of the Veil in the Temple.' Original drawing for illustration in The Family Bible, *1867. Ink. This version signed with initials and dated 1869. 10⅜ins. x 12¾ins. (26.3cm x 32.4cm).*

Author's Collection

SECCOMBE, Colonel Thomas S.　　　　　　**fl.1865-1885**

Military painter and illustrator. He joined the Royal Artillery in 1856 and retired with the rank of Colonel. He illustrated a considerable number of children's books and some period novels, his style of drawing being lively and humorous but often very wooden.

Illus: *The Poetical Works of Thomas Moore; The Poetical Works of William Cowper; The Poetical Works of James Thomson [c.1870 (all Moxon's Popular Poets)]; Miss Kilmansegg [T. Hood, 1870 (2 edits.)]; Army and Navy Drolleries [c.1875]; The Rape of the Lock [1873]; The Story of Prince Hildebrand and the Princess Ida — Related in Rhyme [1880].*
Contrib: *Punch [1864-66, 1882]; London Society [1865]; Fun; The Illustrated Times.*
Exhib: RBA.
Colls: Witt Photo.

SEDDING, A.E.

Designer of ornaments. This must be an error for the architect J.D. Sedding, 1838-91, contributing two geometric initial letters to *The English Illustrated Magazine,* 1887. Sedding was a member of the RIBA from 1874 and attempted to start a school of carvers and gilders.

SEELEY, Miss E.L.　　　　　　**fl.1873-1880**

Figure painter and illustrator. She worked in Camden Town and illustrated a child's book *Eva's Mulberry Tree,* c.1880.

Exhib: RA; SWA.

SELBY, Prideaux John　　　　　　**1788-1867**

Botanical and ornithological illustrator. He was born at Alnwick,

Northumberland in 1788 and after studying at University College, Oxford, he lived entirely in Northumberland and devoted himself to natural history. He became a member of the Royal Society of Edinburgh and of the Linnaean Society. He died at Twizell in 1867.

Illus: *Illustrations of British Ornithology [1821-34]; Illustrations of Ornithology [1825-43, with Sir W. Jardine]; British Forest Trees [1842].*

SELOUS, Henry Courtney　　　　　　**1803-1890**

Portrait and landscape painter and illustrator. He was born at Deptford in 1803, the son of George Selous, the miniature painter. He became a pupil of John Martin (q.v.) and was admitted a student at the RA Schools in about 1818. Selous entered the Westminster Hall Competition in 1843, having previously worked for a panorama painter and specialised in mural treatments. This background was to continue to influence his work, which though powerful, was always rather flatly conceived. He excelled in rather Germanic outline book illustrations and was an author of children's books under the names of 'Aunt Cae' and 'Kay Spen'. He died at Beaworthy in North Devon on 24 September 1890.

Illus: *The Pilgrim's Progress [Art Union, 1844]; The Life of Robert The Bruce; Hereward the Wake [1870].*
Contrib: *The Book of British Ballads [S.C. Hall, 1842]; Sintram and His Companions [Fouqué, c.1844]; Poems and Pictures [1846]; The Churchman's Family Magazine [1863]; Cassell's History of England; Our Life Illustrated by Pen and Pencil [1865]; Cassell's Shakespeare [1865]; Heber's Hymns [1867]; The Illustrated Book of Sacred Poems [1867]; The Man-Eaters of Tsaro [J.H. Patterson (1908 Edit.)].*
Exhib: BI; RA.
Colls: BM; Fitzwilliam; V & AM.
Bibl: Chatto & Jackson *Treatise on Wood Engraving,* 1861, p.599.

Coristian enters the Valley of the Shadow of Death.

DAVID SCOTT RSA 1806-1849. 'Christian enters the Valley of the Shadow of Death.' Illustration engraved by W. Bell Scott for The Pilgrim's Progress, *1860. Wood engraving.*

'SEM' George GOURSAT **1863-1934**

French portrait painter and caricaturist. He was born at Perigueux, Dordogne on 23 November 1863 and from the first had a talent for rapid sketching, giving the feel of his subjects faces rather than direct portraits of them. He epitomised the Paris of the Entente Cordiale and drew fashionable scenes in the style of poster art. He was a frequent visitor to England in the years 1905-10 when he sketched the celebrities of Newmarket and Cowes and left indelible images of Edward VII. He had an exhibition at the Baillie Gallery in 1907, and died in Paris in 1934.

Illus: *Messieurs les Ronds-de-cuir [G. Courteline].*

SETON, Ernest Thompson **1860-**

Animal illustrator in black and white. He was born at South Shields on 14 August 1860 and emigrated with his family to Canada. He studied in Paris under Gérome, Bouguereau, Ferrier and Mosler, 1878-81. He returned to America and worked as a writer and naturalist at Santa Fe. His drawings are notable for their accuracy but also for their strong decorative sense in the context of the book.

Illus: *Wild Animals I Have Known; Art Anatomy of Animals; Birds of Manitoba; Mammals of Manitoba; Trail of the Sandhill Stage; Biography of a Grizzly; Lives of the Hunted Containing a True Account of The Doings of Five Quadrupeds and Three Birds [1901]; Two Little Savages; Pictures of Wild Animals; Monarch, The Big Bear; Woodmyth and Fable; Animal Heroes; Birch Bark Roll of the Woodcraft Indians; Natural History of the Ten Commandments; Biography of a Silver-Fox [1909]; Life Histories of Northern Animals [1910];*

Manual of Scouting [1910]; Rolf in the Woods [1911]; The Arctic Prairies [1911]; The Forester's Manual [1911]; The Book of Woodcraft and Indian Lore [1912]; Wild Animals At Home [1913]; Wild Animal Ways [1916]; The Sign Language [1918]; The Preacher of Cedar Mountain [1917]; Sign Talk Dictionary [1918]; Woodland Tales [1921]; Bannertail [1922]; Lives of Game Animals [1925].

SEVERN, Joseph Arthur Palliser RI **1842-1931**

Watercolourist. He was born in Rome in 1830, the son of Joseph Severn, artist and consul. He studied in Rome and Paris and in 1872 accompanied John Ruskin (q.v.) to Italy and nine years later married his niece Joan Ruskin. He was responsible for Ruskin during the latter's derangement and lived with him at Brantwood, painting Lake District views. In later middle age, Marie Corelli, the novelist developed an embarrassing passion for Severn and he illustrated her book *The Devil's Motor* in 1910. RI, 1882.

Exhib: FAS; G; L; M; RA; RI; ROI.
Colls: BM.

SEVERN, Walter RCA **1830-1904**

Landscape and marine painter. He was born at Rome in 1830, the son of Joseph Severn, the artist and the brother of Arthur Severn. He was educated at Westminster and entered the Civil Service for a time before devoting himself to painting. He was interested in the applied arts, fostered needlework and embroidery designing and collaborated as a designer with Sir Charles Eastlake. He became President of the Dudley Art Society and RCA. He died in London on 22 September 1904.

Illus: *Good Night and Good Morning [Lord Houghton, 1859]; Golden Calendar; Deer and Forest Scenery; Morning and Evening Service.*
Contrib: *Passages From Modern English Poets [1862].*
Exhib: G; L; RBA; RCA.
Colls: V & AM.

SEWELL, Ellen Mary **1813-1905**

Drawing and school mistress, amateur artist. She was born at Newport, Isle of Wight and lived most of her life in the island where she ran a school, from 1851 to 1891.

Publ: *Sailors' Hymns [1883].*
Illus: *Sacred Thoughts in Verse [W. Sewell, 1885].*

SEYMOUR, George L. **fl.1876-1916**

Genre and animal painter and illustrator. He worked in London and illustrated architecture and topography for many of the magazines.

Illus: *Songs and Lyrics For Little Lips [W.D. Cummings, n.d.].*
Contrib: *Good Words [1880, 1890-95]; The Graphic [1886]; ILN [1887-92]; The English Illustrated Magazine [1888, 1897]; The Pall Mall Magazine.*
Exhib: FAS; L; M; RBA; RI; ROI.
Colls: Witt Photo.

SEYMOUR, Robert **1798-1836**

Humorous illustrator and caricaturist. He was born in Somerset in 1798 and apprenticed to a London pattern designer, where he slowly developed an interest in history painting. He had little success with this and turned his hand to caricature and comic illustration, where his talent for the grotesque and the absurd could be given full range. Seymour was a somewhat inadequate draughtsman, but modelled himself on the far stronger repertoire of George Cruikshank (q.v.) and even aped the latter's signature by signing himself 'Short Shanks'. Seymour learnt the art of copper engraving in about 1827 and used lithography in the 1830s, much of his work was in the form of folios of prints with little or no text. His greatest contribution was in creating the routine of comic sportsmen from London having adventures in the country, a theme that established itself for a hundred years. It was his fame in this field that led the publishers, Chapman and Hall to commission the text of *Pickwick Papers* from young Charles Dickens as an accompaniment to Seymour's sketches. Only two issues were produced before the sensitive Seymour committed suicide in London on 20 April 1836.

Illus: *Vagaries in Quest of the Wild and Wonderful [1827]; The Heiress [1830, AL 319]; New Readings [1830-35, AL 320]; Journal of a Landsman From Portsmouth to Lisbon [1831, AL 346]; Humorous Sketches [1834, 1836]; Pickwick Papers [1836].*

Contrib: *Friendship's Offering [1824-36]; The Looking Glass [1830-32]; The Comic Offering [1831-35]; Figaro in London [1831-36]; The Comic Magazine; Hood's Comic Almanack [1836]; The Squib Annual [1836]; Sayings Worth Hearing; Terrific Penny Magazine; Book of Christmas [Hervey].*
Exhib: RA, 1822.
Colls: V & AM; Witt Photo.
Bibl: Graham Everitt, *English Caricaturists*, 1893, pp.208-234 illus.; M. Dorothy George, *English Political Caricature*, 1959, illus.

SHACKLETON, William 1872-1933

Landscape, figure and portrait painter. He was born at Bradford on 14 January 1872 and educated at Bradford Grammar School and Technical College before studying at the RCA, 1893. He won a travelling scholarship to Paris and Italy in 1896 and worked in London from 1905 undertaking sketching tours with W.E. Stott. He was a dramatic colourist in the Turner tradition and was successful enough to have one man shows in London in 1910 and 1922. He became NEA in 1909 and died on 9 January 1933.

Contrib: *The Quartier Latin [1896]; The Parade [1897].*
Exhib: B; G; GG; L; M; NEA; New Gall; RA; RBA; RHA; RI.
Colls: Bradford; Manchester.

SHANNON, Charles Hazelwood RA 1863-1937

Portrait and subject painter. He was born at Sleaford, Lincolnshire in 1863 and studied wood engraving at the Lambeth School of Art in 1882, where he met his lifelong friend Charles Ricketts (q.v.). They joined together with Sturge Moore (q.v.) to form *The Vale Press*, 1894-1904, which produced forty-eight books conspicious for their fine design and unassuming quality. Shannon was principally an artist and Ricketts was the guiding hand in design and production. He was a member of the Society of Twelve, was elected an ARA in 1911 and an RA in 1921. He died in London on 18 March 1937.

Illus: *House of Pomegranates [1891]; Daphnis and Chloe [1893]; Hero and Leander [1894];* etc.
Contrib: *Judy [1887]; Black & White [1891]; The Savoy [1896].*
Exhib: FAS; G; GG; L; M; NEA; New Gall; RA; RBA; RE; RHA; RI; ROI; RSA.
Colls: BM; V & AM; Witt Photo.
Bibl: *Catalogue of Mr S's Lithographs*, Vale Press, 1900; E.B. George, *CS*, Benn Contemp British Artists, 1924; Colin Franklin, *The Private Presses*, 1969.

SHARPE, Charles Kirkpatrick 1781-1851

Portrait painter, caricaturist and antiquary. He was born at Hoddam Castle, Dumfriesshire on 15 May 1781 and was educated at Edinburgh University and Christ Church, Oxford. Although destined for the church, he became interested in painting and antiquarian research, spending most of his life in Edinburgh engaged in these pursuits. He also practised etching. He died in March 1851.

Contrib: *Witch of Fife [Hogg, 1820]; Fugitive Scottish Poetry [1823]; The Romances of Otuel, Roland and Vernagu [Abbotsford Club, 1836]; Flora's Fête.*
Colls: BM; Nat. Gall., Scot.
Bibl: A. Allardyce, *CKS's Letters*, 1868; *The Etchings of CKS*, 1869.

SHAW, A. fl.1826-1839

Architectural draughtsman. He was a friend of R.P. Bonington and illustrated for *Pugin's Paris,* 1831.

Exhib: BI; RA; RBA.
Colls: Witt Photo.

SHAW, Henry FSA 1800-1873

Architectural draughtsman, illuminator and antiquary. He was born in London on 4 July 1800 and concentrated on the research, decoration and production of a number of lavish Victorian heraldic books. Shaw was a perfectionist whose skills coincided with the beginning of the high Gothic revival culminating in the works of A.W. Pugin (q.v.). The books were usually published by William Pickering, printed by the Chiswick Press, and as McLean says 'are among the finest achievements of Victorian book design and illustration'. He was elected FSA in 1833 and died at Broxbourne, Herts on 12 June 1873.

Illus: *The History and Antiquities of the Chapel at Luton Park [1829]; Illuminated Ornaments [1833, AL 234]; Examples of Ornamental Metalwork [1836]; Specimens of Ancient Furniture [1836]; The Encyclopaedia of Ornament [1842]; Dresses and Decorations of the Middle Ages [1843];*

Alphabets, Numerals and Devices of the Middle Ages [1845, AL 235]; The Arms of The Colleges of Oxford [1855]; The Art of Illumination [1866].
Contrib: *Britton's Cathedrals [1832-36]; New Testament [Longman, 1864].*
Bibl: Ruari McLean, *Victorian Book Design*, 1972, pp.65-71 illus.

SHAW, James fl.1883-1902

Illustrator. He worked in Edinburgh and contributed to *Punch.*

Exhib: G; L; RSA.
Colls: V & AM.

SHAW, John Byam Liston ARWS 1873-1919

Painter, designer and illustrator. He was born at Madras on 13 November 1872 and came to England in 1878 and to London in 1879. He was educated privately and studied at the St John's Wood Art School, entering the RA Schools in 1889. Shaw was strongly influenced by the work of the Pre-Raphaelite painters and by the illustrators of the 1860s. His black and white drawings are more successful than his colour, his organisation of the page is usually good but his imagination weaker. He went into partnership with Rex Vicat Cole to found a School of Art at Campden Hill, which still continues today. He was elected RI in 1898 and ARWS, 1913. He died in London on 26 January 1919.

Illus: *Browning's Poems [1897]; Tales From Boccaccio [1899]; Chiswick Shakespeare [1899]; Old King Cole's Book of Nursery Rhymes [1901]; Pilgrim's Progress [1904]; Coronation Book [1902]; Ballads and Lyrics of Love [1908]; The Cloister and The Hearth [1909]; Tales of Mystery and Imagination [E.A. Poe, 1909]; The Garden of Kama [Laurence Hope, 1914].*

JOHN BYAM LISTON SHAW ARWS 1876-1919. Original drawing for an illustration in Reade's The Cloister and The Hearth, *1909. Pen and ink. Signed. 7¾ins. x 5¾ins. (19.7cm x 14.6cm).* Author's Collection

Contrib: *The Dome [1898]; Cassell's Family Magazine [1898]; The Graphic [1899-1905]; The Connoisseur [1902, decor]; Punch [1905-7].*
Exhib: B; G; L; M; New Gall; RA; RI; ROI; RSA; RWS.
Colls: Ashmolean; V & AM.
Bibl: *The Studio,* Vol.12, pp.173-176; Vol.13, p.129; Winter No., 1900-1, p.75 illus.; R.E.D. Sketchley, *Eng. Bk. Illus.,* 1903, pp.13, 130; *Modern Book Illustrators and Their Work,* Studio, 1914.
See illustration (p.450).

SHEERES, C.W. fl.1855-1859
Illustrator. He contributed views of industrial subjects to *The Illustrated London News,* 1855-59.

SHEIL, Edward 1834-1869
Figure painter. He was born at Coleraine in 1834 and worked in Cork where he died on 11 March 1869.

Contrib: *Once a Week [1867].*
Exhib: RA; RBA.

SHELDON, Charles M. fl.1891-1907
Figure artist and illustrator. He was, according to A.S. Hartrick, born in the United States and came to England to work as Special Artist for *Black & White.* He was sent by that magazine to the Sudan in 1897-98.

Illus: *Won By The Sword [G.A. Henty, 1900].*
Contrib: *The Pall Mall Budget [1891-92]; Black & White [1897-98]; The Ludgate Monthly [1895]; The Strand Magazine; Chums; The Wide World Magazine.*

SHEPARD, Ernest Howard 1879-1976
Black and white artist and cartoonist. He was born in St John's Wood, London on 10 December 1879, the son of an architect. He was educated at St Paul's School and then studied art at Heatherley's and the RA Schools, 1897-1902. He worked in Glebe Place, Chelsea, from 1901-3 and in 1904 moved to Shamley Green, Guildford. Shepard began drawing for *Punch* in 1907 and was elected to the *Punch* table in 1921, becoming chief cartoonist in 1945. His delicate caressing pen and ink style was more suited to episodes of childhood than political cartooning, but he managed to produce some striking subjects connected with the Second World War. His great success and chief celebrity came when he undertook the splendidly imaginative drawings for A.A. Milne's *Pooh* series, 1926. He died in 1976, when his last picture was exhibited at the RA, his first having been shown there seventy-five years previously.

Illus: *When We Were Very Young [1924]; Playtime and Company [1925]; Holly Tree [1925]; Winnie-the-Pooh [1926]; Everybody's Pepys [1926]; Jeremy [1927]; Little Ones Log [1927]; Let's Pretend [1927]; Now We Are Six [1927]; Fun and Fantasy [1927]; The House at Pooh Corner [1928]; The Golden Age [1928]; Everybody's Boswell [1930]; Dreamy Days [1930]; Wind in the Willows [1931]; Christmas Poems [1931]; Bevis [1931]; Sycamore Square [1932]; Everybody's Lamb [1933]; The Cricket in the Cage [1933]; Victoria Regina [Housman, 1934]; Modern Strewelpeter [1936]; Golden Sovereign [Housman, 1937]; Cheddar Gorge [1937]; As The Bee Sucks [E.V. Lucas, 1937]; The Reluctant Dragon [1939]; Gracious Majesty [Housman, 1941]; Golden Age and Dream Days [1948-49]; Bertie's Escapade [Grahame, 1948-49].*
Contrib: *The Graphic [1906-7].*
Exhib: B; G; L; M; RA.
Colls: BM; V & AM; Witt Photo.
Bibl: R.G.G. Price, *A History of Punch,* 1957, pp.210-212.

SHEPHEARD, George 1770-1842
Landscape painter and caricaturist. He was born in Herefordshire in 1770 and studied at the RA Schools before working chiefly in Surrey and Sussex. He visited France in 1816 and Wales in 1825, his caricature drawings are spirited and in the manner of Hogarth.

Illus: *Vignette Designs [1814-15].*
Colls: BM; Leeds; Witt Photo.

SHEPHERD, E.
Topographer. Contributed Herefordshire view to *Britton's Beauties of England and Wales,* 1808.

SHEPHERD, F.H. Newton fl.1898-1902
Figure artist and illustrator. He contributed to *The St. James's Budget,* 1898; *The Longbow,* 1898; *The Graphic,* 1902.

SHEPHERD, G.E.
Figure artist. He illustrated *Bubbles in Birdland* by H. Simpson, 1908.

SHEPHERD, George c.1782-c.1830
Architectural draughtsman and topographer. He had great success in the first decade of the 19th century and won the Society of Arts silver palettes in 1803-4 for draughtsmanship. He was principally an illustrator but did some landscape work.

Illus: *Londina Illustra [Wilkinson, 1808]; The History of the Abbey Church of St Peter's, Westminster [1812]; History of the County of Kent [1829-30].*
Contrib: *Beauties of England and Wales; Knight's London [1841].*
Exhib: BI; RA.
Colls: BM; Chester; Greenwich; Manchester; Nottingham; V & AM.
Bibl: M. Hardie, *Watercol. Paint. in Brit.,* Vol.3, 1968, pp.14-15.

CLAUDE ALLIN SHEPPERSON ARA ARWS 1867-1921. Original drawing for unidentified book illustration. Pen and ink. Signed. 10¾ins. x 6ins. (27.3cm x 15.2cm). Author's Collection

451

SHEPHERD, James Affleck 1867-c.1931

Comic animal draughtsman. He was born in London on 29 November 1867 and was educated at various private schools. He had no formal training, but worked with Alfred Bryan (q.v.) the cartoonist of *Moonshine* for two years on that magazine. Shepherd was a master draughtsman of animals and birds in pen and ink and this enabled him to do humorous drawings in which the creatures wore human attire and had human personalities. This became his speciality and he invented a series of caricatures called 'Zig-Zags' for *The Strand Magazine*, of which this was the main attraction. He was invited to join *Punch* in 1893 and contributed many drawings over the years, living latterly at Charlwood, Surrey.

Illus: *Zig-Zag Fables [1897]; Illustrated Uncle Remus [1901]; Wonders in Monsterland [1901]; Nights With Uncle Remus [1903]; The Three Jovial Puppies [1907]; The Life of a Foxhound [1910]; The Story of Chanticleer [1913]; The Bodley Head Natural History [1913]*.
Contrib: *Judy [1886-89]; Moonshine [1890-93]; The Sporting & Dramatic News [1892]; Chums [1892]; The Strand Magazine [1894]; Punch [1894]; Good Words [1894]; Black & White [1896]; Cassell's Family Magazine; The Boy's Own Paper*.
Exhib: G.
Colls: Witt Photo.
Bibl: M.H. Spielmann, *The History of Punch*, 1894, p.567; *The Studio*, Vol.12, 1898; Winter No., 1900-1, p.77 illus.

SHEPHERD, Thomas Hosmer c.1817-c.1842

Topographical illustrator. He was the son of George Shepherd (q.v.) and he was employed by Frederick Crace to make drawings of London which were outstanding for their skill and beauty.

Illus: *Metropolitan Improvements [1827]; London and Its Environs in the Nineteenth Century [1829]; Modern Athens Displayed or Edinburgh in the Nineteenth Century [1829]; Bath and Bristol [1829-30]; London Interiors [1841]*.
Exhib: RBA.
Colls: BM; Newcastle.
Bibl: M. Hardie, *Watercol. Paint. in Brit.*, Vol.3, 1968, p.15.

SHEPPARD, Raymond

Illustrator of bird subjects in about 1890.

SHEPPARD, W. fl.1801-1814

Topographer. He contributed illustrations to *Britton's Beauties of England and Wales*, 1801-14.

SHEPPERSON, Claude Allin ARA ARWS 1867-1921

Painter and illustrator. He was born at Beckenham, Kent on 25 October 1867 and was intended for the law, which he studied. He studied art at Heatherley's in 1891 and then at Paris, taking up principally illustration and lithography but also some watercolour. He is a graceful artist whose work is at its best when children and pretty young women are involved, he was a regular contributor of this sort of drawing to *Punch* from about 1905. He was elected RI in 1900 and ARWS in 1920, but was exceptional among illustrators in being elected ARA in 1919. He died in Chelsea on 30 December 1921.

Illus: *Shrewsbury [Weyman, 1898]; Merchant of Venice [1899]; The Heart of Mid-Lothian [1900]; Lavengro [Borrow, 1900]; Coningsby [Disraeli, 1900]; As You Like It [1900]; Magic Dominions [Arthur F. Wallis, 1912]; The Open Road [E.V. Lucas, 1913]*.
Contrib: *The English Illustrated Magazine [1893-96]; St Pauls [1894]; The Graphic [1895-1910]; The Idler; Pick-Me-Up; The Sketch; Illustrated Bits; Cassell's Family Magazine; The Queen; The Pall Mall Magazine; The Wide World Magazine [1898]; The Strand Magazine [1906]; The Windsor Magazine; ILN [1912-13]*.
Exhib: FAS; G; GG; L; M; RA; RI; RMS; RSA; RWS.
Colls: Birmingham; Leeds; V & AM; Witt Photo.
Bibl: R.E.D. Sketchley, *Eng. Bk. Illus.*, 1903, pp.68, 74, 154; *Cat. of CS Memorial Exhibition*, Leicester Gall., March-April 1922.
See illustration (p.451).

SHÉRIE, Ernest F.

Military illustrator. He worked for *The Royal Magazine* and *The Illustrated London News*, 1899-1900, supplying South African War drawings.

SHERINGHAM, George 1884-1937

Decorative designer, theatrical designer and illustrator. He was born in London in 1884 and was educated at the King's School, Gloucester before studying at the Slade School and in Paris. Sheringham's work is decidedly art deco in form, he uses primary colours and a rather sculptural line like that of Gill. He painted fans in the tradition of Conder (q.v.) and made studies for book covers and magazines and posters. A one man show of his work was held at the Brook Street Art Gallery in 1908. He died on 11 November 1937.

Illus: *The Happy Hypocrite [Max Beerbohm, 1918]; Canadian Wonder Tales [Cyrus Macmillan]; La Princesse Lointaine [Edmund Rostand]; The Duenna [R.B. Sheridan, 1925]*.
Contrib: *The Sketch [1933]*.
Exhib: FAS, 1937; L; M; RA; RMS; ROI; RSA.
Colls: Fitzwilliam; Manchester; V & AM.
Bibl: *The Studio*, Vol.53, 1911, pp.136-139 illus; Special Spring No., 1922, 'Pen and Pencil Drawings'.

SHERLOCK, William P. c.1780-c.1820

Landscape painter and topographer. He was the son of William Sherlock, the portrait painter and worked in London producing Wilson-like ideal landscapes. He was also an etcher and made prints after his own work and that of Cox, Prout and Girtin.

Illus: *Dickinson's Antiquities of Nottinghamshire [1801-6]*.
Contrib: *Howitt's Views in the County of Lincoln [1800]; Britton's Beauties of England and Wales [1808-14]*.
Exhib: RA.
Colls: BM; Birkenhead; Leeds; V & AM; Witt Photo.

SHERWILL, Captain George fl.1848-1856

Amateur artist. He was an officer in the Royal Marines from 1848 and contributed views of India to *The Illustrated London News*, 1856.

SHETKEY See SCHETKY, J.C.

SHIELDS, Frederick James ARWS 1833-1911

Landscape artist, mural painter and illustrator. He was born of poor parents at Hartlepool in 1833 and was educated at a charity school before beginning work for a commercial lithographer at Manchester from the age of fourteen. Shields was influenced by the Pre-Raphaelites from an early date and carried out a considerable number of frescoes which show their marked effect on him, among them the Chapel of the Ascension, Hyde Park Place and Eaton Hall. He was a very strong illustrator, his powerful drawings and fine washes only losing a little of their crispness in wood engraving. He was elected ARWS in 1865 and died at Merton in Surrey on 26 March 1911.

Illus: *History of the Plague of London [Defoe, 1862]; The Pilgrim's Progress [1864]*.
Contrib: *The Greyt Eggshibishun [Manchester, 1851]; Touches of Nature By Eminent Artists [1866]; The Sunday Magazine [1866]; Once a Week [1867]; Punch [1867-70]*.
Exhib: L; M; New Gall; RWS.
Colls: BM; Fitzwilliam; Hartlepool; Manchester; V & AM.
Bibl: E. Mills, *Life and Letters of FJS*, 1912; *The Chapel of the Ascension*, 1912; Ball, *The Eng. Pre-Raphaelite Painters*, 1901; M. Hardie, *Watercol. Paint. in Brit.*, Vol.3, 1968, pp.128-129; J. Maas, *Victorian Painters*, 1970, p.146.
See illustrations (pp.453, 454).

SHINDLER, H. fl.1900-1908

Illustrator of children's books. Worked in London and contributed rather weak drawings to *Fun*, 1900.

Illus: *Hullabulloos at Hucksters [W.A. Clark, 1908]*.

SHIRLAW, Walter 1838-1910

Landscape painter. He was born at Paisley and became the first President of the Society of American Artists. He died at Madrid in 1910. He designed initial letters for books.

Exhib: RA.

SHOUBRIDGE, W. fl.1831-1853

Topographical artist. He worked in Clapham, London and contributed to *The Cambridge Portfolio*, 1840.

Exhib: BI; NWS; RA; RBA.

FREDERICK JAMES SHIELDS ARWS 1833-1911. Study for scrambling figure. Original drawing for illustration in The Pilgrim's Progress, *1864. Pen and ink with chalk and bodycolour.*
Victoria and Albert Museum

SHURY, J.

Topographer. He contributed drawings of Oxfordshire to *Britton's Beauties of England and Wales,* 1813.

SHUTE, Mrs. E.L. fl.1883-1907

Portrait painter. She worked in London and illustrated a child's book *The Kelpie's Fiddle-Bow,* in 1892.

Exhib: G; L; RHA; RI; SWA.

SIBSON, Thomas 1817-1844

Painter, etcher and illustrator. He was born at Cross Canonby, Cumberland in 1817 and worked in Edinburgh before coming to London in 1838. According to W.J. Linton his first effort in illustration was a series of drawings to Dickens's *Old Curiosity Shop* and *Barnaby Rudge* which were not a success. He was then paid for by subscription to study under Kaulbach in Munich, 1842-44, but returned with consumption and lived with Linton. He died at Malta in 1844.

Illus: *Anatomy of Happiness [Ackermann, 1838]; The Old Curiosity Shop [Dickens, 1841 (frontis)]; Hall's British Ballads; The History of England.*
Colls: BM; V & AM (sketchbook).
Bibl: W.J. Linton, *Memoirs,* 1895, p.70.

SICKERT, Bernard 1862-1932

Landscape painter, architectural painter and engraver. He was born at Munich in 1862, the brother of W.R. Sickert (q.v.). He became a member of the NEA in 1888 and died at Jordans on 2 August 1932.

Contrib: *The Yellow Book [1894 (portrait)].*
Exhib: G; GG; L; M; NEA; New Gall; RA; RBA; ROI.

SICKERT, Walter Richard 1860-1942

Street, interior and genre painter, etcher and illustrator. He was born in Munich in 1860, the brother of B. Sickert (q.v.). He studied at the Slade School in 1881 and then with Whistler from 1882, who took him on etching expeditions in London and taught him discipline in colouring. Sickert's best period was that following the death of his master, 1905 to 1920. During this time he made the drab areas of North London and particularly Camden Town his very own haunt, inspiring young painters with his French technique and contemptuous of fashion. He also painted in Dieppe and in Venice but never flattered these places or the sitters who came to his house for portraits. Sickert was a highly individual and bohemian figure who had the strength as artist and man to carry with him a circle of friends including critics like Roger Fry and artists such as Henry Tonks, Wilson Steer and Matthew Smith. He was a member of the London Group, 1916, was elected to the NEA in 1888, RE, 1887-92 and ARA, 1924 and RA, 1934. He resigned from the RA in 1935. He died in Bath in 1942.

Contrib: *The Idler; Cambridge Gazette; The Yellow Book; The Savoy; The Pall Mall Pudget; Whirlwind; Vanity Fair;* all 1887-97, mostly portraits.
Exhib: FAS, 1973; G; GG; L; M; NEA; RA; RBA; RE; RHA; RI; ROI; RSA.
Colls: BM; Manchester; Tate.
Bibl: Osbert Sitwell, *Noble Essences,* 1950, pp.163-206; Marjorie Lilly, *S The Painter and his Circle,* 1971; Wendy Barron, *S,* 1973. Denys Sutton *WS* 1976.

FREDERICK JAMES SHIELDS ARWS 1833-1911. Initial letter C. Original drawing for decoration in The Pilgrim's Progress, *1864. Pen and pencil.*
Victoria and Albert Museum

SIME, Sydney Herbert 1867-1941

Draughtsman and caricaturist. He was born in Manchester of a poor family and went down the mines as a boy to work as a scoop pusher. He then worked for a linen draper and a barber, before turning to sign-writing and entering the Liverpool School of Art. He moved to London and began to work for *Pick-Me-Up* and various halfpenny papers, his style being influenced by Aubrey Beardsley and Raven-Hill (qq.v.). He was Editor of a paper called *Eureka,* and became Joint Editor of *The Idler* from Volume 15.

Sime was a master of the macabre and the sinister finished with a beautiful cold pen line. Thorp saw in him the influence of Doré as well as Beardsley and considered that 'Pattern and colour were introduced not as a cover but as an aid to capable draughtsmanship . . .'. Sime claimed to be influenced by the Japanese print and many of his more startling compositions have a distinctly eastern composition and penmanship. The quality of brooding menace had its admirers and he was extensively employed for Lord Dunsany's stories and much patronised by Desmond Coke and Lord Howard de Walden. He held a one man show at the St George's Gallery in 1927 and died at Worplesdon, Surrey in 1941.

Illus: *The Sword of Welleran [Lord Dunsany, 1908; A Dreamer's Tale [Lord Dunsany, 1910]; Tales of Wonder [Lord Dunsany, 1917]; The Gods of Pegana [Lord Dunsany, 1919]; Time and the Gods [1923]; The King of Elfland's Daughter [Lord Dunsany, 1924]; Bogey Beasts [1930].*
Contrib: *The Ludgate Monthly [1891]; The Boy's Own Paper [1891-93]; The Sporting & Dramatic News [1893]; The Minister; The Windsor Magazine; The Pall Mall Magazine; The Idler; The Unicorn [1895]; Pick-Me-Up [1895]; Eureka [1897]; The Butterfly [1899]; Black & White [1899]; The Tatler [1901]; The Sketch [1904].*
Exhib: L; RBA.
Colls: V & AM. Worplesdon Hall.
Bibl: *'Apotheosis of the Grotesque',* The Idler, Vol.12, pp.755-766 illus; *The Studio,* Winter No., 1900-1, p.79 illus; Desmond Coke, *Confessions of an Incurable Collector,* 1928, pp.222-225; B. Peppin, *Fantasy Book Illustration,* 1975, pp.7, 18 illus.
See illustration (below).

SIMKIN, Richard 1840-1926

Military painter and illustrator. He worked at Aldershot and specialised in watercolours of uniforms and in designing posters for military recruitment. He died at Herne Bay in 1926.

Illus: *The Boy's Book of British Battles [1889]; Our Armies [1891]; Where Glory Calls [1893].*
Contrib: *Army and Navy Gazette; Chums [1892].*
Colls: India Office Lib.

SIMMONS, Graham C. fl.1913-1919

Illustrator of comic genre subjects with bold hatching. He worked in London and contributed to *London Opinion,* 1913 and *Punch,* 1914.

Exhib: Inter Soc., 1916-19.

SIMMONS, W. St Clair **fl.1878-1917**

Portrait, landscape and genre painter. He worked mostly in London, but at Hemel Hempstead, 1883.

Contrib: *The Pall Mall Budget [1893]; The English Illustrated Magazine [1893-95]; The Temple Magazine [1896]; The Windsor Magazine.*
Exhib: B; G; L; M; NEA; New Gall; P; RA; RBA; RI; ROI.

SIMONSEN, Niels **1807-1885**

Painter, sculptor and lithographer. He was born in Copenhagen on 10 December 1807 and became a pupil of J.L. Lund, later visiting Italy and Algeria. He is described as 'Our Danish Artist' in *The Illustrated London News*, 1864.

SIMPSON, Joseph W. RBA **1879-1939**

Illustrator and caricaturist. He was born at Carlisle in 1879 and educated at Carlisle, studying art in Edinburgh. He became a close friend of D.Y. Cameron (q.v.) and was elected RBA in 1909. Simpson designed covers for Edinburgh publishers and was a prolific designer of bookplates, many of which were exhibited abroad. He died on 30 January 1939.

Publ: *Twelve Masters of Prose and Verse [1912]; God Save The King in La Grande Guerre [1915]; War Poems From The Times [1915].*
Illus: *Simpson His Book [1903]; The Book of Book Plates [1903]; Ibsen [1907];*

Lions [1908]; Literary Lions [1910]; Edinburgh in 1911.
Contrib: *The Student [Edinburgh]; London Opinion.*
Exhib: G; L; RBA; RSA; RSW.
Bibl: Haldane Macfall, *'JS Caricaturist'*, The Studio, 1905-6, pp.21-25.

SIMPSON, William RI FRGS **1823-1899**

Artist, special artist and illustrator. He was born at Glasgow on 28 October 1823. He was educated in Perth and Glasgow and after starting in an architect's office, was apprenticed to Glasgow lithographers and moved to Day & Sons of London in 1851. His first major commission was to prepare drawings for a lithographic folio of the Crimean War published by Colnaghi's, and he was sent to the Baltic and the Crimea itself. He can claim to be the first Special Artist to be in action. This was the beginning of a long series of tours, many of them for *The Illustrated London News* whose permanent staff he joined in 1866. He was in India for three years, visited Kashmir and Tibet, was on the Abyssinian campaign of 1868, at the Franco-German War of 1870 and witnessed the Paris Commune, 1871. He accompanied the Prince of Wales to India in 1875-76 and illustrated Dr Schliemann's excavations in 1877 and the work of the Afghan Boundary Commission in 1884-85. Simpson was not a great artist, but an able recorder in pencil, wash and watercolours. Many of his sketches are in pencil only with detailed colour notes and instructions added and usually accurately dated. He died in London

WILLIAM SIMPSON RI FRGS 1823-1899. 'The Mont Cenis Railway – Ascent from Lanslebourg.' Original drawing for The Illustrated London News, *1869. Watercolour and wash. Signed and dated 1869. 8⅝ins. x 9⅛ins. (21.9cm x 23.2cm).*
Victoria and Albert Museum

on 17 April 1899. RI, 1879.

Illus: *Illustrations of the War in the East [1855-56]; Meeting the Sun, a Journey Round the World [1873]; Picturesque People or Groups from all Quarters of the Globe [1876]; Shikar and Tamasha [1876]; The Buddhist Praying Wheel [1896]; The Jonah Legend [1899]; Glasgow in the Forties [1899].*
Contrib: *The Quiver [1890]; The Picturesque Mediterranean [1891]; The English Illustrated Magazine [1893-96].*
Exhib: G; L; RI; ROI.
Colls: Glasgow; V & AM; Witt Photo.
Bibl: *WS, RI*, Autobiography, 1903.
See illustration (p.455).

SIMSON, William RSA **1800-1847**
Portrait and marine painter. He was born at Dundee in 1800 and studied at the Trustees Academy and visited the Low Countries in 1827. He was elected RSA in 1830 and travelled to Italy to study in the 1830s. He died on 29 August 1847, in London.

Illus: *Sinbad the Sailor [n.d.].*
Exhib: BI; RA; RBA; RSA.
Colls: Birkenhead; V & AM.

SINCLAIR, Helen Mok **fl.1912-1917**
Miniature painter, black and white artist and illustrator. She illustrated children's books and worked in London.

Exhib: L; RA.
Colls: V & AM.
Bibl: *Modern Book Illustrators and Their Work*, Studio, 1914 illus.

SINGLEHURST, Mary
Student at Liverpool School of Art, 1906. A book illustration by her appears in *The Studio*, Vol. 38, 1906 p.77.

SINGLETON, Henry **1766-1839**
Historical painter. He was born in London in 1766 and after studying at the RA Schools, he became a very prolific and successful painter, but failed to be elected to the RA. He undertook a great many book illustrations, his later work verging on the sentimental. He died in London in 1839.

Exhib: BI; RA; RBA.
Colls: BM; V & AM.

SKELTON, Joseph Ratcliffe RWA **fl.1888-1927**
Figure painter and illustrator. He was born at Newcastle-upon-Tyne and was working in Bristol in 1893 and in London in 1925. Skelton's drawings are rather 1890s in style but the figures and drapery are North Country and solid. He was elected RWA.

Illus: *Our Empire Story [Jack, 1908].*
Contrib: *The Graphic [1885-1912]; The Sketch [1897]; The Bystander [1904]; ILN [1907].*
Exhib: M; P; RA; RI; ROI.
Colls: V & AM.

SKELTON, Percival **fl.1849-1887**
Landscape painter and illustrator. He was a relation of the 18th century engraver Joseph Skelton and a prolific illustrator of books. He was an unsuccessful candidate for the NWS from 1852 to 1861 and specialised in Scottish and coastal scenes in a detailed and sentimental mid-Victorian manner.

Illus: *The Tommiebeg Shootings [T. Jeans, 1860]; Harry's Big Boots [S.E. Gay, 1873].*
Contrib: *Metrical Tales [Samuel Lover, 1849]; The Poetical Works of Edgar Allan Poe [1858]; Childe Harold [1858-59]; ILN [1860]; The Illustrated Times [1860]; The Welcome Guest [1860]; The Churchman's Family Magazine [1863]; The Water Babies [Kingsley, 1863 (with Paton)]; Life and Lessons of Our Lord [1864]; Once a Week [1866]; Heber's Hymns [1867]; Episodes of Fiction [1870]; The Graphic [1870-76]; Thornbury's Legendary Ballads [1876].*
Exhib: RA; RBA.
Bibl: Chatto & Jackson, *Treatise on Wood Engraving*, 1861, p.569.

SKILL, Frederick John RI **1824-1881**
Landscape and portrait painter and illustrator. He was born in 1824 and trained as a steel engraver, working as a portrait artist on *The London Journal*. He lived in Venice for several years and acted as a Special Artist for *The Illustrated London News* during the Schleswig-Holstein affair. He may have been sent by the magazine to

China, but had little success with his work and committed suicide as a result of depression in London on 8 March 1881. He had been elected NWS in 1876.

Illus: *Holidays among the Mountains [M.B. Edwards, 1861].*
Contrib: *Metrical Tales [Samuel Lover, 1849]; ILN [1854-67]; The Illustrated Times [1860-65]; Cassell's Family Paper [1860-61]; The Welcome Guest [1860]; London Society [1862]; Foxe's Book of Martyrs [1866]; Beeton's Annual [1866]; The Graphic [1870-71].*
Exhib: NWS; RA; RBA.
Colls: BM; V & AM; Wallace; Witt Photo.
Bibl: *Art Journal*, 1881.

SKINNER, Edward F. **fl.1888-1925**
Portrait and landscape painter and illustrator. He worked in London, 1888, Lewes, 1891 and St Ives, Cornwall, 1925. He contributed to *The Royal Magazine* and *Black & White*, 1891.

Exhib: L; RA; RBA; RWA.

SKINNER, Captain H.F.C. **fl.1904-1915**
Figure artist. He worked in London and contributed to *Punch*, 1904 and 1914.

Exhib: RA; RI.

SLADER, Alfred **fl.1856-1866**
Landscape painter. He contributed to *The Illustrated Times*, 1856-66 and especially to its Christmas issues.

SLEIGH, Bernard **1872-**
Watercolourist, wood engraver, illustrator and decorator. He was born at Birmingham in 1872 and studied there, becoming associated with the Birmingham Guild of Handicraft. He was also connected with the Campden Guild of Handicraft and with the Essex House Press, for which he carried out work and cut blocks from the designs of William Strang (q.v.). His illustrations are characterised by a certain naïve charm combined with strength of design. He was elected RBSA in 1928.

Illus: *The Sea-King's Daughter [A. Mark, 1895]; The Faery Calendar [1920].*
Contrib: *A Book of Pictured Carols [Birmingham School, 1893]; The Yellow Book [1896]; The Dome [1899-1900].*
Exhib: B; FAS; G; L; New Gall; RA.
Colls: V & AM; Witt Photo.
Bibl: 'The Future of Wood Engraving', The Studio, Vol.14, 1898, pp.10-16 illus; R.E.D. Sketchley, *Eng. Bk. Illus.*, 1903, pp.12, 130; C. Franklin, *The Private Presses*, 1969, pp.78, 153.

SLEIGH, Henry
Book decorator. He contributed ornament to *Odes and Sonnets*, 1859 illustrated by Birket Foster (q.v.).

SLEIGH, John **fl.1841-1872**
Landscape painter and illustrator. He worked in London and was a close friend of Charles Keene (q.v.) with whom he went on a sketching tour of Brittany. A record of this is preserved in twenty-four drawings by Keene, contributed to *Punch* on 6, 13 and 20 September 1856.

Contrib: *The Home Affections [Charles Mackay, 1858]; Passages From Modern English Poets [1862]; Sacred Poetry of the 16th, 17th and 18th Centuries [c.1862].*
Exhib: RA; RBA.
Bibl: G.S. Layard, *C.K.* 1892, p.59.

SLINGER, F.J. **fl.1858-1871**
Genre painter and illustrator. He worked in London and was assistant at the Slade School to Alphonse Legros.

Contrib: *Once A Week; The Graphic [1871].*
Exhib: BI; RA.
Bibl: W. Shaw Sparrow, *Memories of Life and Art*, 1925.

SLOCOMBE, Alfred **fl.1865-1886**
Flower painter, etcher and watercolourist. He was a member of the RCA and did decorations for *The Illustrated London News*, 1866.

Exhib: BI; OWS; RA; RBA.

WILLIAM SMALL RI 1843-1929. Illustration to Amelia. *Ink and wash with bodycolour. Signed and dated 1882. 4¼ins. x 7ins. (10.8cm x 17.8cm).* Author's Collection

SLOCOMBE, Edward C. **-1915**
Painter and etcher. He was the brother of Alfred Slocombe (q.v.) and
worked at Watford, Hertfordshire from 1883. He contributed social
and military subjects to *The Graphic,* 1873.

Exhib: FAS; L; New Gall; RA; RE; RHA.

SLY, B.
Topographer. He contributed drawings to *Knight's London,* 1841.

SMALL, William RI **1843-1929**
Artist and illustrator. He was born in Edinburgh on 27 May 1843 and
studied at the RSA Schools before coming to London in 1865. He had
worked at Edinburgh in the art department of Messrs. Nelson, the
publishers, and was already a highly competent black and white artist
when he began to work for the leading magazines. Small was a very
quick worker, very powerful in conception and very prolific. His genre
subjects are drawn with a brilliance of detail and truth to line which is
among the best work of the 1860s, but it is this early period up to
1870 which contains his most attractive work. Afterwards, Small
begins to innovate and lose his way. He experiments with wash effects
and these gradually supercede the beautiful line work and because of
his reputation are copied by a whole generation of artists. He has
therefore been quite rightly condemned by both White and Reid. His
power was still expressed in the double pages that he was given in *The
Graphic* until about 1900, vast areas for which he was paid sixty
guineas, making him the most highly paid illustrator of his time.
Small's life span stretches amazingly from the early numbers of *Once
a Week* right up to the avant-garde *Gypsy* of 1915. For the last few

years of his life he lived at Worcester, having been elected RI in 1883
and HRSA in 1917. He died on 23 December 1929.

Illus: *Words for the Wise; Miracles of Heavenly Love; Marion's Sundays [all 1864];
Washerwoman's Foundling [1867]; A Protegée of Jack Hamilton's [Bret Harte,
1894].*
Contrib: *Shilling Magazine [1865-66]; Once a Week [1866]; Good Words
[1866-68]; The Sunday Magazine [1866-68, 1871]; Cassell's Family Paper
[1866, 1870]; Sunday At Home [1866]; Pen and Pencil Pictures From the
Poets [1866]; Touches of Nature by Eminent Artists [1866]; Ballad Stories of
the Affections [1866]; London Society [1867-69]; The Argosy [1867]; The
Quiver [1867]; Poems by Jean Ingelow [1867]; Idyllic Pictures [1867]; Two
Centuries of Song [1867]; Foxe's Book of Martyrs [1867]; Heber's Hymns
[1867]; The Spirit of Praise [1867]; Illustrated Book of Sacred Poems [1867];
Golden Thoughts From Golden Fountains [1867]; Ode on the Morning of
Christ's Nativity [1867]; North Coast and Other Poems [1868]; The Graphic
[1869-1900]; Pictures From English Literature [1870]; Good Words For The
Young [1871]; Novellos National Nursery Rhymes [1871]; Judy's Almanac
[1872]; Thornbury's Legendary Ballads [1876]; Dalziel's Bible Gallery [1880];
Chums [1892]; Fun; The Gypsy [1915].*
Exhib: B; FAS; G; L; M; RA; RHA: RI; ROI; RSA.
Colls: Birmingham (St George's Soc.); V & AM.
Bibl: Forrest Reid, *Illustrators of the Sixties,* 1928, pp.216-227 illus.
See illustration (above).

SMALLFIELD, Frederick ARWS **1829-1915**
Genre and portrait painter and illustrator. He was born at Homerton
in 1829 and studied at the RA Schools and was elected ARWS in
1860. He was a prolific watercolourist, worked in London and died
there on 10 September 1915.

Contrib: *Willmott's Sacred Poetry [1862]; Passages From Modern English Poets
[1862].*
Exhib: B; BI; G; GG; L; M; RA; RI; ROI; RWS.

SMALLWOOD, William Frome 1806-1834

Architect and draughtsman. He was born in London on 24 June 1806 and became a pupil of the architect D.N. Cottingham. He travelled to the Continent to make drawings of churches for *The Penny Magazine* and exhibited landscapes. He died in London on 22 April 1834.

Contrib: *Knight's London [1842].*
Exhib: RA; RBA.
Bibl: *Architectural Magazine*, Vol.1, 1834, p.184.

SMIRKE, Robert RA 1752-1845

Artist and illustrator. He was born at Wigton near Carlisle in 1752 and came to London in 1766, studying at the RA Schools in 1771. Smirke was one of the most prolific book illustrators of the early 19th century, working for all the leading publishers and specialising in the 'conversation piece' drawing within decorative borders which augmented so many three volume novels. His drawings are usually very fine in execution, the pen line clear, the shadows and modelling in washes sometimes with a trace of blue. He was elected an ARA in 1791 and an RA in 1793. He died in London in 1845.

Illus: *Bowyer's History of England; The Adventure of Hunchback [1814, AT 366]; Don Quixote [1818].*
Exhib: BI; RA; RBA; Soc. of Artists.
Colls: BM; V & AM.

SMITH, A.T. fl.1899-1914

Humorous figure artist. He contributed wooden doll subjects to *Punch*, 1902-14 and to *Fun*, 1899.

Colls: Witt Photo.

SMITH, Arthur Reginald RWS RSW 1872-1934

Landscape and figure painter. He was born at Skipton-in-Craven in 1872 and studied and taught at the Keighley School of Art and then at South Kensington. He travelled in Italy and had a one man show at Leighton House in 1907-08. He was elected ARWS in 1917 and RWS in 1925 and RSW in 1925. He died at Bolton Abbey in 1934.

Illus: *The Lake Counties [W.G. Collingwood, 1932].*
Exhib: B; FAS; G; L; M; RA; RI; RSW; RWS.
Colls: Bradford; Bristol; V & AM.

SMITH, Lieutenant-Colonel Charles Hamilton 1776-1859

Topographical draughtsman and antiquary. He was born in East Flanders in 1776 and was educated at Richmond, Surrey before training as an officer in the Austrian military academy at Malines and Louvain. He joined the British Army in 1797 as a volunteer and served in the West Indies and Holland before becoming quartermaster on the Walcheren Expedition. After a visit to the United States he retired in 1820 and settled at Plymouth where he formed an artists' club. For most of his life, Smith made watercolours of costume and natural history which he used to illustrate his books. He died at Plymouth in 1859.

Publ: *Selections of Ancient Costume of Great Britain and Ireland, 7th to 16th Century [with S.R. Meyrick, 1814]; Costume of the Original Inhabitants of the British Isles to the 6th Century [1815]; Natural History of the Human Species [1848].*
Colls: BM; Greenwich.

SMITH, Charles John 1803-1838

Engraver and antiquary. He was born in Chelsea in 1803 and became a pupil of Charles Pye, the engraver. He painted views of London buildings, illustrated antiquarian works and was elected FSA in 1837. He died in London on 23 November 1838.

Colls: BM.

SMITH, Edwin Dalton 1800-

Miniaturist and painter of flowers. He was the son and pupil of Anker Smith and was born in London on 23 October 1800. He made drawings for *The Botanic Garden*, B. Maund, 1825-35.

Exhib: NWS; RA; RBA.

SMITH, J.

Contributor of genre subjects to *The Illustrated London News,* 1873.

SMITH, J. Moyr fl.1885-1920

Decorative designer and occasional illustrator. After starting as an architect, he began to produce illustrations for *Fun* and other magazines in the 1870s. He was Editor of *Decoration*, 1880-89 and drew in a flat Etruscan style derived from his study of ancient art. The drawings are very often as flat as the jokes; there was one example of this artist in the Handley-Read collection.

Illus: *Shakespeare For Children: Lamb's Tales [c.1897].*
Contrib: *Fun; Doré's Thomas Hood [1870, decor]; Punch [1872-78].*
Exhib: B; G; L; RA; RBA; RSA; RSW.
Colls: Witt Photo.

SMITH, James Burrell 1822-1897

Landscape painter. He was born in 1822 and between 1843 and 1854, lived at Alnwick and studied under T.M. Richardson (q.v.) during his first years. He set up as a drawing-master in London in 1854 and made sketches in the manner of Richardson, particularly of waterfalls. He died in London in 1897.

Contrib: *ILN [1883-87].*
Exhib: RBA.
Colls: Alnwick Castle; Fitzwilliam; Newcastle; V & AM.

SMITH, Jessie Wilcox -1935

Artist and illustrator. She was born in Philadelphia and worked in New York, many of her books being published in this country. She studied with Howard Pyle (q.v.) at the Philadelphia Fine Art Institute and specialised in children's books. She died in New York on 4 May 1935.

Illus: *A Child's Garden of Verses [R.L. Stevenson, 1905].*

SMITH, John Thomas 1766-1833

Draughtsman and antiquary. He was born in London in 1766, the son of Nathaniel Smith, the sculptor and printseller. He studied art with Joseph Nollekens and J.K. Sherwin and then set up for himself as a portrait and topographical engraver. He worked at Edmonton from 1788 and was made Keeper of Prints and Drawings at the British Museum from 1816. Smith is better remembered as a writer on the arts than as an artist, he produced a number of books of memoirs which form important links between the 18th and 19th century schools and are valuable sources of facts. His own work as an etcher is incisive and reminiscent of Callot and sometimes even of Rembrandt. He died in London in 1833.

Publ: *Nollekens and his Times [1828]; A Book for a Rainy Day [1845, re-issued 1905].*
Illus: *Remarks on Rural Scenery [1797]; Antiquities of London [1800]; Antiquities of Westminster [1807]; The Ancient Topography of London [1815]; Vagabondiana [1817]; The Cries of London [1839].*
Contrib: *Knight's London [1842].*
Exhib: RA.
Colls: BM; Fitzwilliam.

See illustration (p.459).

SMITH, Joseph Clarendon 1778-1810

Topographical draughtsman. He worked in the Thames Valley and the Home Counties, touring in Warwickshire in 1805 and Cornwall in 1806. He died after a visit to Madeira which he had visited as a cure for consumption, 1810.

Contrib: *The Beauties of England and Wales [1803, 1814-15]; Topographical Cabinet [1811]; The Antiquarian Itinerary [1817].*
Exhib: BI; RA.
Colls: BM; V & AM; Witt Photo.

JOHN THOMAS SMITH 1766-1833. 'A Blind Man and his boy.' Plate in
Vagabondiana or Anecdotes of Mendicant Wanderers, *1817. Etching.*

SMITH, Percy John Delf 1882-1948

Painter, etcher and illustrator. He was born in London on 11 March
1882 and was mainly self-taught although he studied at the
Camberwell School of Art. After service in the First War, he worked
in the US, 1927, and in Palestine, 1932. Smith specialised in fine
lettering and the illumination of books but also designed alphabets
and worked for private presses. There is a bookplate by this artist in
the Victoria and Albert Museum.

Illus: *Quality in Life [1919]; The Dance of Death [1914-18]; Twelve Drypoints
of the War, 1914-18; The Bible in Spain [1925]; The Metamorphosis of Aiax
[Sir J. Harrington, Fanfrolico, 1927].*
Exhib: L; RI.
Colls: V & AM; Witt Photo.

SMITH, Robert Catterson fl.1880-1892

Landscape and figure painter. He worked in London and contributed
figure subjects and architecture to *The English Illustrated Magazine,*
1890-92.

Exhib: L; M; RA; RBA; RHA; RI.

SMITH, Thomas C.

Figure artist. Contributed to *Punch,* 1903.

SMITH, W.G. fl.1866-1880

Botanical illustrator. He contributed drawings to *The Wild Flowers of
Great Britain,* R. Hogg and George W. Johnson, 1866-80 and drew an
initial letter for *Punch* in 1878.

SMITH, W. Thomas 1862-

Portrait, figure and historical painter. He was working in London in
1890, but may have emigrated to Canada before 1925.

Illus: *The Wilds of the West Coast [Oxley, 1894].*
Contrib: *The Quiver [1890]; Good Cheer [1894]; The Boy's Own Paper.*
Exhib: L; M; P; RA; RBA; RI.

SMITH, Winifred fl.1890-1896

Illustrator of children's books. She won commendations at the Nat.
Competition, South Kensington in 1896 and was described by *The
Bookman,* in August 1894 as an artist 'whose designs in black and
white are witty, pretty and effective'.

Illus: *Childrens Singing Games [c.1890].*
Bibl: *The Studio,* Vol.8, 1896, p.228 illus.

SMYTH, Dorothy Carleton fl.1901-1925

Painter and illustrator. She studied at the Glasgow School, c.1901 and
worked in Glasgow, 1907 and at Cambuslang, 1925.

Exhib: G; L; RSA; RA.
Bibl: *The Studio,* Winter No., 1900-1, p.55 illus; Vol.25, 1901-2, pp.281-286.

SMYTHE, Ernest fl.1896-1899

Illustrator and watercolourist. He specialised in hunting subjects and
contributed to *The Sketch,* 1896 and *The Illustrated London News,*
1899.

Colls: V & AM.

SMYTHE, Lionel Percy RA 1839-1918

Figure and landscape painter in watercolours. He was born in London
on 4 September 1839 and was educated at Kings College School and
studied art at Heatherley's. Smythe worked in the warm colours and
genre subjects popularised by Fred Walker (q.v.) and worked chiefly
at the Chateau de Honvault, Wimereux, Pas-de-Calais. He was elected
ARA in 1898 and RA in 1911, having been RWS from 1894. He died
on 10 July 1918.

Contrib: *ILN [1874, 1879, 1880].*
Exhib: B; FAS; G; L; M; RA; RBA; RI; ROI; RWS.
Colls: Greenwich; V & AM.
Bibl: R.M. Whitlaw and W.L. Wyllie, *LPS, RA,* 1923; M. Hardie, *Watercol. Paint.
in Brit.,* Vol.3, 1968, p.140-141.

SNEYD, Rev. John 1766-1835

Amateur caricaturist. He was born in 1766, the son of Ralph Sneyd of
Keele Hall, Staffs, (now Keele University) and was Rector of Elford
for over forty years. He was a friend and patron of Gillray and died
unmarried on 2 July 1835. His nephew was the Rev. W. Sneyd (q.v.).

Bibl: M.D. George, *English Political Caricature,* Vol.2, 1959, p.263.

SNEYD, Rev. Walter FSA 1809-1888

Amateur caricaturist. He was born in 1809, the son of Walter Sneyd
of Keele Hall and his wife the Hon. Louisa Bagot, and nephew of the
Rev. John Sneyd (q.v.). He was educated at Westminster and Christ
Church, Oxford, taking his BA in 1831. He succeeded his brother at
Keele Hall in 1870 and died there on 2 July 1888.

Illus: *Portraits of the Spruggins Family [1829, privately printed].*
Bibl: *Walford's County Families; Alumni Oxoniensis.*
See illustration (p.34).

SNOW, J.W. fl.1832-1848

Horse painter. He worked in London and contributed illustrations to
Tattersalls British Race Horses, 1838 and *The Illustrated London
News,* 1848.

Exhib: RBA, 1832.
Colls: BM.

SNOWMAN, Isaac **1874-**

Genre and portrait painter. He was born in London in 1874 and studied at the RA Schools before becoming a pupil of Bouguereau and Constant in Paris. He painted state portraits of Edward VII and George V and eventually emigrated to Israel.

Contrib: *ILN [1897-98].*
Exhib: B; L; RA; ROI.

SOLOMON, Abraham **1824-1862**

Painter and illustrator. He was born in London in May 1824 and studied at Sass's Bloomsbury Art School in 1838, entering the RA Schools in 1839. Solomon painted a great number of subjects from literature but scored instant success with his railway carriage dramas of 1854, 'First Class — The Meeting' and 'Second Class — The Parting'. His work was well-known to the public through its popularisation in prints and he was a regular RA exhibitor. He died at Biarritz on 19 December 1862. He was the brother of Simeon and Rebecca Solomon (qq.v.).

Contrib: *ILN [1857]; Favourite Modern Ballads; Household Song [1861].*
Exhib: BI; RA.
Bibl: Chatto & Jackson, *Treatise on Wood Engraving,* 1861, p.599; J. Maas, *Victorian Painters,* 1970, p.238.

SOLOMON, Rebecca

Portrait and history painter. She was the sister of Abraham and Simeon Solomon and exhibited regularly between 1852 and 1869. She contributed illustrations to *The Churchman's Family Magazine,* 1864 and *London Society.*

Exhib: RA.
Colls: Witt Photo.

SOLOMON, Simeon **1840-1905**

Painter, draughtsman and illustrator. He was born in London in 1840, the brother of Abraham and Rebecca Solomon (qq.v.). He was a pupil of Cary's Academy in Bloomsbury and then entered the RA Schools, exhibiting at the exhibitions from 1858. Solomon became part of the Rossetti circle, was a friend of Burne-Jones (q.v.) and A.C. Swinburne and these contacts had a strong influence on his work. He travelled to Florence in 1866 and to Rome in 1869, but gradually sunk into a life of idleness and dissipation. His most vivid works are those featuring contemporary Jewish life such as the illustrations to *Jewish Customs* and they have an almost Rembrandtesque intensity. He was capable of evoking an air of eastern mystery in his drawings and fortunately his best work is his earliest and it was at this time that he was working for the book. He died in penury in 1905.

Publ: *A Vision of Love Revealed in Sleep [1871].*
Contrib: *Once A Week [1862]; Good Words [1862]; The Leisure Hour [1866]; Dark Blue [1871-73]; Dalziel's Bible Gallery [1880]; Art Pictures From The Old Testament [1897]; Lives of the Minor Saints [Mrs. Jameson, c.1860].*
Exhib: RA.
Colls: V & AM.
Bibl: A.C. Swinburne, *SS,* The Bibelot, XIV, 1908; B. Falk, *Five Years Dead,* 1937; Forrest Reid, *Illustrators of the Sixties,* 1928, pp.103-104; J.E. Ford, *SS,* 1964; J. Maas, *Victorian Painters,* 1970, p.146; L. Lambourne, *A SS Sketch-Book,* Apollo, Vol.85, 1967, pp.59-61.

See illustration (right).

SOLOMON, Solomon Joseph **1860-1927**

Portrait and figure painter and illustrator. He was born in London on 16 September 1860 and studied at Heatherley's and the RA Schools before going to the Munich Academy and the École des Beaux Arts in Paris, 1879. He travelled and worked in Italy, Spain and Morocco and became Vice-President of the Maccabeans Society and President of the RBA, 1918. He had been elected ARA in 1896 and RA in 1906, having been a member of the NEA since 1886. He was the first artist to initiate camouflage for the British Army in the First World War. He died in London on 27 July 1927.

Illus: *For The Temple [G.A. Henty, 1887].*
Contrib: *Black & White [1891]; The Graphic [1897-1904].*
Exhib: B; G; GG; L; M; NEA; New Gall; P; RA; RBA; RHA; ROI.
Bibl: J. Maas, *Victorian Painters,* 1970, p.232.

SOLON, Leon Victor **1872-**

Artist, sculptor and decorator. He was born at Stoke-on-Trent in 1872, the son of Louis M. Solon, artist and author. He was educated privately and then studied at the RCA where he was a scholar and medallist. Solon's connection with the Staffordshire potteries provides an interesting relationship between illustration and ceramics, many of his designs for Mintons for example, reflect the Symbolists and the work of Aubrey Beardsley (q.v.). Solon was the designer of one of the early posters for *The Studio,* but he emigrated to the United States early in the century and worked in Lakeland, Florida.

Contrib: *The Parade [1897]; Les Trophées [De Herdia, 1904].*
Bibl: *The Studio,* Winter No., 1900-1, p.65 illus.

SOMERVILLE, Edith Anna Œnone **1858-1949**

Author and illustrator. She was born at Drishane, Ireland in 1858, the daughter of Lt.-Colonel Somerville of a leading Anglo-Irish family. After being educated at home, she studied art in Paris under Colarossi and Delecluse and attended the Westminster School of Art. Edith Somerville returned to Ireland and set up house with her cousin Violet Martin, collaborating with her on a number of books on Irish life and character. Her knowledge of the country and particularly its sport gained from two spells as Master of the West Carbery Foxhounds, made her books both individual and popular. Most of them were illustrated by black and white sketches which typify the shabby genteel life of the Irish landowner before 1914. Edith Somerville

SIMEON SOLOMON 1840-1905. 'Jepthah and his daughter.' Original drawing for illustration probably intended for Dalziel's Bible Gallery, *1881, not used. Pen and ink. Signed. 6¼ins. x 4¼ins. (15.9cm x 10.8cm).*
Victoria and Albert Museum

continued to write after the death of Violet Martin and became a vociferous and ardent feminist, dying at her old childhood home of Drishane in 1949. She had one man shows at Goupil and Walker's Galleries in 1920 and 1923.

Illus: *The Real Charlotte [1894]; Clear As The Noon Day [E. Penrose, 1894]; The Silver Fox; Some Experiences of an Irish R.M. [1899]; Further Experiences of an Irish R.M. [1908]; Dan Russel the Fox [1911]; In Mr Knox's Country [1915].*
Contrib: *Black & White [1893].*
Exhib: FAS; L; RHA; SWA.

SOMERVILLE, Howard 1873-c.1940

Figure painter, illustrator and etcher. He was born at Dundee in 1873 and after being privately educated, studied science and engineering at Dundee but abandoned this for art. He settled in London in 1899 and began to contribute to *Punch* and other magazines. Somerville, who also specialised in interiors and still-life, worked for some time in New York and Glasgow and was elected RPE in 1917. His ink drawings of women are rather highly finished and mannered.

Contrib: *Moonshine [1900]; Punch [1903-6]; ILN [1911].*
Exhib: B; G; GG; L; NEA; P; RA; RSA.
Colls: Liverpool; Witt Photo.

SONNTAG, W. Louis 1870-

American illustrator. Born in New York in 1870. Contributor of railway drawings to *The English Illustrated Magazine*, 1896.

SOPER, George RE 1870-

Watercolourist, etcher, wood engraver and illustrator. He was born in London in 1870 and studied with the etcher Sir Frank Short. He worked at Harmer Green, Welwyn, Hertfordshire from about 1911 and was still exhibiting in 1930.

Illus: *The Water Babies [Charles Kingsley, 1908].*
Contrib: *ILN [1897 (S. Africa)]; Cassell's Magazine [1898]; The Boy's Own Paper; Chums; The Graphic [1901-4].*
Exhib: FAS; G; L; NEA; RA; RBA; RE; RHA; RI; RSA.

SOUTHALL, Joseph Edward 1861-1944

Painter, designer and engraver. He was born at Nottingham in 1861 and educated at York and Scarborough before serving an apprenticeship to an architect, 1878-82. In 1883 he came to realize that all fine art was architectural and that the architect must study art and therefore he spent some time in Italy studying tempera painting. He was also much influenced by John Ruskin and studied drawing and carving and interested himself in furniture design and embroidery. He painted frescoes at the Birmingham Art Gallery and was examiner at the Birmingham School of Art. He was elected RBSA in 1902, NEA in 1926 and RWS in 1931. Southall's work is often anaemic in colouring and lifeless in content but it had some popularity at the time. He died in 1944.

Illus: *The Story of Bluebeard [1895].*
Contrib: *The Quest [1894-96]; The Yellow Book [1896];* political pamphlets during the First World War, n.d.
Exhib: B; FAS; G; GG; L; M; NEA; New Gall; RA; RWS.
Colls: Birmingham; Witt Photo.
Bibl: *Modern Book Illustrators and Their Work,* Studio, 1914.

SOWERBY, James 1757-1822

Botanical illustrator. He was born in London in 1757 and studied at the RA Schools. He set up in practice as a portrait and flower painter in London but finally abandoned this for the study of botany. He issued and illustrated *English Botany*, 1790-1814, *English Fungi*, 1797-1815, *English Botany or Coloured Figures of British Plants*, 1832-40. He died in London in 1822, leaving a large family many of whom became botanical artists.

Publ: *An Easy Introduction to Drawing Flowers [1778].*
Exhib: RA; Soc. of Artists.
Colls: BM; Nat. Hist.

SOWERBY, John G. fl.1876-1925

Landscape and flower painter. He worked in Newcastle-upon-Tyne, Gateshead and Ross-on-Wye and contributed a number of illustrations to children's books, all showing the marked influence of Kate

Greenaway (q.v.). Father of Millicent Sowerby (q.v.).

Illus: *Afternoon Tea – Rhymes for Children [c.1880]; At Home [1881].*
Exhib: B; G; L; M; RA; RI; RSA.

SOWERBY, Millicent fl.1900-1913

Watercolourist and illustrator. She was the daughter of John G. Sowerby (q.v.) and was working at Colchester, 1900 and Abingdon, 1904. She illustrated *A Child's Garden of Verses*, R.L. Stevenson, 1913.

SPARE, Austin Osman 1888-1956

Painter, engraver, imaginary artist and illustrator. He was born at Snowhill on 31 December 1888 and studied at the Lambeth School and the RCA, exhibiting in the National Competition of 1903. Spare was a mystic and poetic draughtsman who was strongly influenced by Aubrey Beardsley's work in his early years. He was Editor of *Form*, 1916-17 and *The Golden Hind*, 1922-24 and illustrated in pen and ink as well as in chalk and watercolour and designed bookplates. He became unbalanced in later life and died in 1956.

Illus: *Earth Inferno [1905]; A Book of Satyrs [1907]; The Book of Pleasure; The Psychology of Ecstasy [1913]; Anathema of Zos; The Sermon of Hypocrites.*
Exhib: RA.
Colls: Ashmolean; Leeds; V & AM; Witt Photo.
Bibl: K. Grant, *Oracles of AOS*, 1975; *The Left Hand Path*, 1976.

SPECHTER, Otto

Illustrator. He contributed to *Parables From Nature* by Mrs Gatty, 1867.

SPEED, Harold 1872-1957

Landscape and portrait painter. He was born in London in 1872, the son of Edward Speed, the architect and was educated privately before studying at the RCA, 1887, at the RA Schools, 1890, and in Paris, Vienna and Rome, on a travelling scholarship, 1893. He was elected RP in 1897 and was Master of the Art Workers Guild in 1916.

Publ: *The Science and Practice of Drawing [1913]; The Science and Practice of Oil Painting [1924].*
Contrib: *The Graphic [1899-1902].*
Exhib: B; FAS, 1914, 1922, 1938; G; L; M; NEA; New Gall; P; RA; RBA; RCA; RHA; ROI; RSA.
Colls: Belfast; Birmingham; Bristol; Liverpool; Manchester.

SPEED, Lancelot 1860-1931

Coastal painter and black and white illustrator. He was born in London in 1860, the son of a barrister and was educated at Rugby and Clare College, Cambridge. Speed worked principally as a book illustrator from about 1890, concentrating on shipping subjects. He worked in Barnet and Southend-on-Sea and died there on 21 December 1931.

Illus: *The Red Fairy Book [c.1890]; The Limbersnigs [1896]; The Last Days of Pompei [Lytton, 1897]; Hypatia [C. Kingsley, 1897]; Novels of Robert Barr [1897]; The Romance of Early British Life [1908].*
Contrib: *ILN [1887-94]; The Sporting & Dramatic News [1892]; The English Illustrated Magazine [1895-97]; Good Words [1898]; The Sphere; Punch; The Windsor Magazine.*

SPENCE, Percy F.S. 1868-1933

Painter and illustrator. He was born at Sydney, N.S.W., in 1868 and spent his early career in Australia and Fijii, exhibiting his work with the Art Society at New South Wales. He came to London in 1895 and resided there for the rest of his life, working from Kensington and contributing to many magazines. Spence was a fine figure draughtsman, his pen work frequently used with colour washes. He was acquainted with R.L. Stevenson in the South Seas and drew portraits of him. He died in London in September 1933.

Contrib: *The Graphic [1900-6]; Punch [1903]; ILN [1905]; The Ludgate Monthly; The Pall Mall Magazine; The Windsor Magazine.*
Exhib: B; L; New Gall; RA.
Colls: V & AM.

SPENCE, Robert RE 1870-

Painter, etcher and illustrator. He was born at Tynemouth on 6 October 1870 and studied at the Newcastle School of Art, at the Slade School, 1892-95 and in Paris with Cormon. Spence is an important and original figure because of his use of the etched plate for both illustrations and text in the book, thus continuing the visionary tradition of William Blake (q.v.). His most notable achievement in this medium is the *George Fox His Journal*. He also etched scenes from Wagner and illustrated for magazines. His work was particularly commended by Walter Crane for its romantic feeling and dramatic force. He was elected ARE in 1897 and RE in 1902.

Contrib: *The Quarto [1896]*.
Exhib: FAS; L; NEA; RA; RE; RWA.
Bibl: *British Book Illustrators Yesterday and Today*, Studio, 1923.

SPILSBURY, Francis B. fl.1799-1805

Amateur artist and draughtsman. He was a naval doctor and made drawings on his voyages, some of which were used in publications. Some of these were published by Daniel Orme as *Picturesque Scenes in the Holy Land and Syria*, 1803, AT 381.

Colls: Searight Coll; Witt Photo.

SPOONER, Mrs. Minnie Dibdin (neé Davison) fl.1893-1927

Portrait painter and etcher. She drew for children's books and married the artist C.S. Spooner. She was elected RMS in 1901.

Illus: *The Gold Staircase [Wordsworth, 1906]*.
Exhib: L; New Gall; RA; RHA; RMS.

SPOTTISWOODE, William

Amateur artist. He published *Journey Through Eastern Russia*, 1857, AT 232, illustrated by lithos from his own drawings.

SPREAT, William fl.1841-1848

Landscape painter working in the Exeter area. He published *Picturesque Sketches of the Churches of Devon*, 1842.

Colls: Exeter.

SPURRIER, Steven ARA RBA 1878-1961

Painter, black and white and poster artist. He was born in London in 1878 and studied art at Lambeth School and Heatherley's being elected ROI in 1912, RBA in 1934 and ARA in 1943 and RA in 1952. In his early days he specialised in genre and social realistic subjects for the magazines, later undertaking theatre illustration. He died in 1961.

Contrib: *The Graphic [1910]; Radio Times [1936]*.
Exhib: G; GG; L; M; RA; RBA; RHA; RI; ROI; RSA.
Colls: RA; V & AM; Witt Photo.

SPURRIER, W.R. fl.1896-1905

Figure artist specialising in cockney children. He contributed to *Fun*, 1896-1900 and to *Punch*, 1902-5.

STACEY, Walter S. 1846-1929

Landscape and genre painter and illustrator. He was born in London in 1846 and studied at the RA Schools and was elected RBA in 1881 and ROI in 1883. He worked in Hampstead, 1890 to 1902 and then in the West Country at New Milton, Tiverton and Newton Abbot. His largest output of illustrations was for boys' books of adventure. He died at Newton Abbot in September 1929.

Illus: *Follow My Leader [T.B. Read, 1885]; Bible Pictures [1890]; In Greek Waters [G.A. Henty, 1893]; The White Conquerors of Mexico [Kirk Munroe, 1894]; In Press Gang Days [Pickering, 1894]; Bible Stories [L.L. Weedon, 1911]*.
Contrib: *The Cornhill Magazine [1883-84]; The Quiver [1891-95]; The Strand Magazine [1891-1906]; Good Words [1891]; Chums [1892]; The Temple Magazine [1896]; The Wide World Magazine [1898]; Cassell's Family Magazine; The Boy's Own Paper; The Girl's Own Paper; Black & White*.
Exhib: L; M; NEA; RA; RBA; RI; ROI.

STAFFORD, John Phillips 1851-1899

Painter and humorous artist. He was born in 1851 and acted as cartoonist for *Funny Folks* for a number of years and was also a contributor to *Punch*, 1894. He made stage designs for the theatre and died in March 1899.

Exhib: RA, 1871-86.

STAMP, Winifred L. fl.1899-1925

Figure and miniature painter. She worked in Stepney, London and was trained at the Regent Street Polytechnic. She exhibited some book illustrations in the National Competition, South Kensington in 1905-6.

Exhib: RA; RMS.

STAMPA, George Loraine 1875-

Black and white artist. He was born in London on 29 November 1875, the son of an architect, and was educated at Bedford Modern School. He studied at Heatherley's, c.1892 and at the RA Schools, 1895-1900. Stampa was a raffish bohemian who was the spiritual successor of Charles Keene and Phil May (qq.v.), preferring the London streets for his drawings to the salons of Mayfair. It was not surprising therefore to find him adopted as a *Punch* artist from 1895, contributing bushels of urchins, street arabs, cockney servant gals and drunken cabbies. He gave a touch of realism to *Punch* which was much needed, but his pen work was very traditional. He undertook some decorative work such as covers and initial letters and also made portraits.

Illus: *Easy French Exercises; Ragamuffins [1916]; Anthology – In Praise of Dogs*.
Contrib: *Punch [1895-1950]; Moonshine [1898]; The Graphic [1910]*.
Exhib: RA; Walker's Gall.
Bibl: R.G.G. Price, *A History of Punch*, p.249.

STANDFUST, G.B.

Draughtsman and illustrator. He illustrated *Shelley's Poetical Works*, 1844 and drew humorous subjects. There is a delightful study of Count D'Orsay by this artist in the Witt Photo Library.

Exhib: RA, 1844.

STANFIELD, William Clarkson 1793-1867

Marine and landscape painter and illustrator. He was born at Sunderland in 1793, the son of J.F. Stanfield, an Irish actor and anti-slavery writer. He was apprenticed to an Edinburgh heraldic painter but went to sea in 1808 and was pressed into the Navy in 1812. He made voyages on an East Indian ship to China, but left the service in 1818 to devote all his time to theatrical scene painting. He met and became a close friend of David Roberts (q.v.) and went to London with him in 1820, where they were employed on the stage work at Drury Lane Theatre. Stanfield soon had great success, became part of the Charles Dickens's circle and an intimate with Douglas Jerrold and Captain Marryat whose books he illustrated. He was a founder member of the SBA in 1823 and was elected ARA in 1832 and RA in 1835. He made tours to Italy, France and Holland and visited Scotland on a number of occasions in later life, settling from 1847 in Hampstead. Stanfield's seascapes are remarkable for their accuracy and his Continental views were much used in the Annuals of the 1830s. He died at Hampstead on 18 May 1867.

Illus: *The Pirate and The Three Cutters [Capt. Marryat, 1835]; Poor Jack [Capt. Marryat, 1840 (20 engrs.)]; Coast Scenery [1847]; American Notes [C. Dickens, 1850 (frontis)]*.
Contrib: *Heath's Picturesque Album [1832-34]; Heath's Gallery [1836-38]; Finden's Life and Poems of the Rev. G. Crabbe [1834]; Sketches on the Moselle, The Rhine and the Meuse [1838, AT 32]; The Chimes, A Goblin Story [C. Dickens, 1845]; The Cricket on The Hearth [C. Dickens, 1846]; The Haunted Man and The Ghost's Bargain [C. Dickens, 1848]; Moxon's Tennyson [1857]*.
Exhib: BI; RA; RBA.
Colls: Aberdeen; BM; Fitzwilliam; Greenwich; Leeds; Manchester; V & AM; Garrick Club; Witt Photo.
Bibl: *Gentleman's Magazine*, IV, July 1867; J. Dafforne, *CS Short Biographical Sketch*, 1873; C. Dickens, *The Story of a Great Friendship*, 1918; M. Hardie, *Watercol. Paint. in Brit.*, Vol.3, 1968, pp.68-70 illus.

See illustration (pp.39, 463).

WILLIAM CLARKSON STANFIELD 1793-1867. Charles Dickens in the character of 'Bobadil'. Watercolour and wash. The Garrick Club

STANIFORTH, J.M. fl.1895-1906
Cartoonist and humorous artist. He was chief cartoonist of the *Evening Express,* Cardiff and of *The Western Mail.* He contributed comic animals and figures to *Punch,* 1906.

Illus: The General Election 1895, Evening Express Political Cartoons; Cartoons of the Welsh Coal Strike [1898].

STANILAND, Charles Joseph 1838-1916
Marine painter and illustrator. He was born at Kingston-upon-Hull on 19 June 1838 and studied at the Birmingham School of Art, Heatherley's, South Kensington and the RA Schools, 1861. He was elected ARI in 1875 and RI in 1879, becoming ROI in 1883. Staniland's strength was in marine illustrations where the ships and tackle were seen at close quarters and the working seaman was observed in large scale. His many contributions to *The Illustrated London News* and *The Graphic* were a mainstay of those periodicals in the 1870s and 1880s, readers had practically to wipe the brine from their faces as they turned the pages. He was also an excellent portrait artist and painted still-life and bird subjects in watercolour. He was among the most prolific artists of the period and was much admired by Van Gogh during his English years. Staniland died in London in 1916.

Illus: The Gentleman Cadet [A.W. Drayson, 1875]; The Dragon and the River [G.A. Henty, 1886]; Traitor or Patriot [M.C. Rowsell]; Britannia's Bulwarks [C.N. Robinson, 1901].
Contrib: The Leisure Hour [1866]; Cassell's Family Magazine [1867]; Idyllic Pictures [1867]; The Quiver [1868]; Episodes of Ficton [1870]; ILN [1870-87]; The Graphic [1880-90]; The English Illustrated Magazine [1886-92]; The Boy's Own Paper [1892-93]; Chums [1892]; Cassell's Family Magazine [1895-96]; The Pall Mall Magazine [1896-97]; The Wide World Magazine [1898].

Exhib: B; FAS; G; L; M; RA; RI.
Colls: Greenwich; Sunderland; V & AM; Witt Photo.
Bibl: *English Influences on Vincent Van Gogh,* Arts Council, 1974-75.

STANLAWS, Penrhyn
Figure artist. He contributed drawings to *Punch,* 1903-4 in a spirited but scratchy style.

STANLEY, Lady See TENNANT, Dorothy

STANLEY, G. fl.1800-1817
Topographical artist. He may be the same artist who exhibited a landscape at the RA in 1800.

Contrib: *The Antiquarian Itinerary [1817 (Yorkshire)].*
Colls: Witt Photo.

STANLEY, Harold J. 1817-1867
Painter and illustrator. He was born at Lincoln in 1817 and went to Munich to work under Kaulbach. He travelled to Italy but returned to Munich to work and died there in 1867.

Exhib: BI; RA; RBA.

STANLEY, Sir Henry Morton 1841-1904
African explorer and amateur artist. He was born at Denbigh on 29 June 1841 with the name of John Rowlands, but being left an orphan was brought up in the St Asaph workhouse, 1847-56. As a boy he shipped to America and was adopted by Henry Stanley, a New Orleans cottonbroker whose name he took. Stanley served in the

463

Confederate army, 1861-62 and in the United States navy, 1864-65, afterwards adopting the life of a roving journalist in Asia Minor, Abyssinia and Africa. In October 1869, he was ordered by the *New York Herald* to mount an expedition to find Dr Livingstone in central Africa. He found Dr Livingstone at Ujiji on 10 November 1871 and published his account of the journey in *How I Found Livingstone,* 1872. He was Governor of the Congo and knighted in 1899, he served as MP for Lambeth, 1895-1900 and married on 12 July 1890 Dorothy Tennant (q.v.) the artist and illustrator. He died on 10 May 1904.

Contrib: *ILN [1878].*

STANLEY, L.
Topographer. He contributed illustrations of Palermo to *The Illustrated Times,* 1860.

STANNARD, Henry John **1844-1920**
Landscape and sporting artist and illustrator. He was born at Woburn, Bedfordshire in 1844, the son of John Stannard, 1795-1881. He studied at the South Kensington Schools and established his own Academy of Arts at Bedford in 1887, specialising in bird studies and publishing a number of country books illustrated by himself. He was elected RBA in 1894, was a member of the Dudley Art Society and died at Bedford on 15 November 1920.

Contrib: *ILN [1897-99 (decor and birds)]; Encyclopaedia of Sport; Bailey's Magazine; The Sporting & Dramatic News.*
Exhib: B; L; M; RA; RBA; RCA; RI.

STANNARD, Lilian (Mrs. Silas) **1884-1944**
Flower painter. She was born at Woburn, Bedfordshire in 1884, the daughter of Henry John Stannard (q.v.). She lived at Blackheath and specialised in flower and garden pictures, having one man shows at the Mendoza Gallery, 1906, 1907 and 1927. She died in 1944.

Illus: *Popular Garden Flowers [W.P. Wright, 1912].*
Exhib: B; L; RA; RBA; RCA; RI; SWA.
Colls: Newport.

STANNUS, Anthony Carey **fl.1862-1909**
Genre, landscape and marine painter. He drew views of Cornwall but also visited Ireland and Belgium for subjects and may have made a trip to Mexico in about 1867. He is probably the brother of the architect and writer H.H. Stannus, 1840-1908.

Illus: *The King of the Cats [1903].*
Contrib: *ILN [1867].*
Exhib: BI; L; RA; RBA; RHA.
Colls: V & AM.

STANTON, G. Clark RSA **1822-1894**
Sculptor, painter and illustrator. He was born at Birmingham in 1832 and studied as a designer for a commercial firm and attended the Birmingham School of Art. He visited Italy for some years and returned in 1855 to settle permanently in Edinburgh. He was a prolific painter of genre subjects with an 18th century tinge to them, popular in the third quarter of the century, but also designed stained glass windows and sculpted. He was elected ARSA in 1862 and RSA in 1883 and was also Curator of the RSA Life School. He died at Edinburgh on 8 January 1894.

Contrib: *Good Words [1860]; Poems and Songs by Robert Burns [1875].*
Exhib: B; G; L; M; RSA; RSW.
Colls: Dundee; Glasgow.

STANTON, Horace Hughes **1843-1914**
Landscape painter. He was born in 1843 and worked in Chelsea and Kensington until 1913 when he went to America. He died in New York on September 13, 1914.

Contrib: *London Society [1869].*
Exhib: B; G; GG; L; M; RA; RHA.

STAPLES, Sir Robert Ponsonby 12th Baronet **1853-1943**
Painter and illustrator. He was born on 30 June 1853, the third son of Sir Nathaniel A. Staples Bt. He was educated at home, and studied at the Louvain Academy of Fine Arts, 1865-70, with Portaels in

Brussels, 1872-74 and in Dresden, 1867. Staples visited Paris in 1869 and made tours to Australia, 1879-80 and was elected RBA in 1898. He was art master at the People's Palace, Mile End Road in 1897 and was a member of the International Union. He did a considerable amount of figurative work for magazines and died on 18 October 1943.

Contrib: *ILN [1893-96]; The Sketch [1894].*
Exhib: B; G; GG; L; M; NEA; P; RA; RBA; RHA; ROI.
Colls: Witt Photo.

STARR, Sydney **1857-1925**
Landscape and decorative artist and illustrator. He was born at Kingston-upon-Hull in 1857 and worked in St John's Wood until 1890 when he emigrated to the United States. He was a friend of Walter Sickert (q.v.) and worked up paintings after the latter's drawings. His black and white work is characterised by very pronounced vertical hatching, and some of it appeared in *The Whirlwind.* He was elected NEA and RBA in 1886 and died in New York on 3 October 1925.

Exhib: G; GG; L; M; NEA; RA; RBA; RI; ROI.
Colls: V & AM; Witt Photo.

STAYNES, Percy Angelo ROI **1875-**
Painter, designer and illustrator. He was born in 1875 and studied at the Manchester School of Art, at the Royal College of Art and at Julian's in Paris. He worked in Bedford Park, London, 1914-48 and was elected ROI in 1916 and RI in 1935.

Illus: *Roundabout Ways [Ffrida Wolfe, 1912]; Gulliver's Voyages [1912].*
Exhib: G; RI; ROI.

STEAVENSON, C. Herbert **fl.1900-1917**
Landscape painter at Gateshead. He published *Colliery Workmen Sketched at Work,* 1912.

STEELE, Gourlay RSA **1819-1894**
Animal painter. He was born in 1819 and studied at the Trustees Academy in Edinburgh under R.S. Lauder. He was appointed painter to the Highland and Agricultural Society and Animal Painter for Scotland to Queen Victoria. He became Curator of the National Gallery of Scotland and was elected ARSA in 1846 and RSA in 1859. He died at Edinburgh in 1894.

Contrib: *Poems and Songs by Robert Burns [1875].*
Exhib: L; M; RA; RSA.
Colls: Edinburgh; Witt Photo.

STEEPLE, John **-1887**
Landscape and coastal painter. He worked in Birmingham and London and specialised in subjects of Welsh, Midlands and Sussex scenery. He was an unsuccessful candidate for the NWS in 1868 and in subsequent years.

Illus: *Through Norway With a Knapsack [Williams, 1859, AT 258].*
Exhib: B; FAS; RA; RBA; RI; RSA.
Colls: Birmingham; Manchester; V & AM.

STEER, Philip Wilson **1860-1942**
Landscape, portrait and genre painter in oil and watercolour. He was born at Birkenhead in 1860 and studied at Gloucester School of Art and at Julian's in Paris, 1882. He was teacher of painting at the Slade School from 1895 and a member of the NEA from 1886. Steer was very impressionistic in his treatment of landscape and although it was usually the English countryside that he was painting, the feeling remains French. Most of his illustrative work is landscape although he contributed chalk drawings to the *Pall Mall.*

Contrib: *The Whirlwind [1890]; The Pall Mall Budget [1893]; The Yellow Book [1894-95]; Albermarle; Prose Fancies [Le Gallienne].*
Exhib: FAS; G; GG; L; M; NEA; P; RA; RBA; RHA; ROI; RSA; RSW.
Colls: BM; Bedford; Bradford; Exeter; Fitzwilliam; Gloucester; Leeds; Manchester; Tate; V & AM.
Bibl: R. Ironside, *PWS,* 1943; D.S. Macoll, *PWS,* 1945.

STEPHANOFF, Francis Phillip **1788-1860**

Painter and illustrator. He was born in London in 1788, the younger brother of James Stephanoff (q.v.). He exhibited with the AA from 1809 and with the OWS from 1813. He remained less well known than his brother with whom he is often confused. He contributed designs to Heath's Gallery, 1836-38 and died after suffering from poor health at West Hanham, near Bristol in 1860.

Exhib: BI; OWS; RA; RBA.
Colls: BM; Exeter; Nottingham; V & AM; Witt Photo.

STEPHANOFF, James OWS **c.1786-1874**

Historical painter and topographer. He was born in Brompton, London in about 1786, the elder brother of F.P. Stephanoff (q.v.). He studied for a short time from 1801 at the RA Schools and was a frequent exhibitor in London from about 1810. He concentrated principally on scriptural, poetic and legendary subjects which he treated realistically and with attention to costume and detail. He was made Historical Painter in Watercolours to King William IV in 1831 and was elected OWS in 1819. He retired from the society due to ill health in 1861, having moved to Bristol in 1850; he died there at Frederick Place, Clifton, in 1874.

Contrib: *Pyne's Royal Residences [1819]; Finden's Tableaux [1841]*.
Exhib: AA; BI; RA.
Colls: BM; Bradford; Nat. Gall; Edinburgh; V & AM.

STEPHENSON, James **1828-1886**

Engraver and lithographer. He was born in Manchester on 26 November 1828 and was described by Chatto as 'a skilful engraver on steel'. He engraved all the illustrations for *Manchester As It Is*, 1839 and contributed to *Clever Boys* and *Wide Wide World*. He died on 28 May 1886.

Bibl: Chatto & Jackson, *Treatise on Wood Engraving*, 1861, p.600.

STERNER, Albert Edward **1863-1946**

Genre and portrait painter, etcher and illustrator. He was born in London on 8 March 1863, the son of American parents and worked chiefly in New York. He studied at Julian's in Paris with Boulanger, Lefevbre and Gêrome, returning to the United States in 1879 and founding his own atelier in 1885. Sterner's pen drawing which was mostly done for *Harper's Magazine* is very typical of the American school, bold lines with concentration on the figures and little background detail. Sterner exhibited at the Paris Exhibition of 1900 and won a bronze medal.

Illus: *L'ennui Madame [D. Meunier]*.
Contrib: *Harper's Magazine; The Quiver [1895]; Pick-Me-Up; The English Illustrated Magazine [1896]; The Savoy [1896]; Black & White [1896]*.
Exhib: FAS.
Colls: V & AM.
Bibl: Joseph Pennell, *Pen Drawing and Pen Draughtsmen*, 1894, p.259.
See illustration (right).

STEVENSON, Robert Louis **1850-1894**

Author and amateur woodcut artist. He was born in Edinburgh in 1850 and studied engineering at the university there and was admitted an advocate in 1875. Stevenson's adolescent talent for writing rapidly developed in the 1870s and he published a series of best-sellers which rapidly became classics. They included *An Inland Voyage*, 1878, *Travels with a Donkey on the Cevennes*, 1879, *Treasure Island*, 1882, *Kidnapped* and *Dr Jekyll and Mr Hyde*, 1886. He travelled to America in 1887 to recover his health and after visiting Australia, settled at Samoa in 1890 where he died in 1894. None of his illustrations were ever published during his life time.

Bibl: J. Pennell, *RLS, Illustrator*, The Studio, Vol.9, 1897, pp.17-24 illus.

STEWART, Allan **1865-1951**

Military and historical painter and illustrator. He was born in Edinburgh on 11 February 1865, and educated at the Edinburgh Institution, studying art at the RSA Schools. He worked for *The Illustrated London News* from about 1895 and acted as their Special Artist in South Africa. He later accompanied King Edward VII on his Mediterranean tours for the same magazine and contributed fairy illustrations to its Christmas numbers. He worked at Kenley, Surrey

ALBERT EDWARD STERNER 1863-1946. 'My Unwilling Neighbour.' Original drawing for illustration in The English Illustrated Magazine. *1896. Signed with initials and dated 1896.* Victoria and Albert Museum.

till about 1925 and then at Castle Douglas, Kircudbright. He died on 29 January 1951.

Illus: *Red-Cap Adventures [S.R. Crockett, 1908]*.
Contrib: *ILN [c.1895-1908]*.
Exhib: FAS; G; L; M; RA; RSA; RSW.

STEYERT, Auguste **1830-1904**

French draughtsman and designer of book plates. He was born at Lyons in 1830 and died there in 1904.

Contrib: *The Illustrated Times [1856]*.

STOCK, Henry John RI **1853-1930**

Portrait, genre and imaginary painter and illustrator. He was born in Greek St, Soho on 6 December 1853 and studied at the RA Schools. He worked in Fulham until 1910 and then at Felpham, Sussex, being elected RI in 1880. He died on 4 November 1930.

Illus: *West Indian Fairy Tales [Gertude Shaw, 1912]*.
Exhib: FAS; L; M; RA; RI; ROI.
Colls: Witt Photo.

STOCKDALE, Frederick Wilton Litchfield **fl.1803-1848**

Topographer. He was assistant to the Military Secretary of the East India Company until forced to resign through ill-health. He was a prolific contributor to travel works.

Illus: *Etchings . . . of Antiquities in . . . Kent [1810]; A Concise . . . Sketch of Hastings, Winchelsea and Rye [1817]; Excursions in . . . Cornwall [1824]; The Cornish Tourist [1834]*.
Contrib: *The Beauties of England and Wales [1801-13]; Antiquarian Itinerary [1818]; Ackermann's Repository [1825-28]*.
Exhib: RA.
Colls: BM; Fitzwilliam; Nat. Mus., Wales; V & AM; Witt Photo.

STOCKDALE, W. Colebrooke fl.1852-1867
Draughtsman. He specialised in buildings and sporting subjects and
contributed to *The Illustrated London News* in 1852.
Exhib: RA, 1860-67.

STOCKS, Lumb RA 1812-1892
Portrait draughtsman, miniaturist, illustrator and engraver. He was
born at Lightcliffe on 30 November 1812 and became a pupil of
Charles Cope. He settled in London in 1827 and learnt the art of
engraving with Rolls for six years, becoming one of the most
competent of Victorian engravers. Chatto mentions that 'Mr Stocks
has considerable reputation as an engraver on steel'. He was one of
the few engravers to be elected on that art to the RA, becoming ARA in
1853 and RA in 1872. Many of his works are crayon portraits and he
was an assiduous engraver after Stothard's works. He died in London
on 28 April 1892. He was the father of the artists, Arthur, Bernard,
Katharine and Walter Fryer Stocks.

Contrib: *Ministering Children; Ministry of Life; English Yeoman*.
Exhib: RA; RBA.
Bibl: Chatto & Jackson, *Treatise on Wood Engraving*, 1861, p.600.

STOKER, Matilda fl.1880-1886
Book decorator. She worked in Dublin and London and contributed

Celtic ornament to *The English Illustrated Magazine*, 1886-88.
Exhib: RHA, 1880-84.

STOKES, Adrian Scott RA ARWS 1854-1935
Landscape painter in oil and watercolour and tempera, occasional
illustrator. He was born at Southport in 1854 and was educated at the
Liverpool Institute and studied at the RA Schools, 1872-75 and in
Paris under Dagnan Bouveret, 1885-86. Stokes travelled widely in
Europe and wrote extensively on Renaissance art, he exhibited work
at the major exhibitions of Paris, 1889 and Chicago and two of his
paintings were acquired by the Chantrey Bequest, 1888 and 1903. He
was elected ROI, 1888, ARA, 1910 and RA, 1919, his talent as a
watercolourist being recognised by his election as RWS in 1926 and
VPRWS in 1933. He died in London on 30 November 1935.
 His wife, Marianne Stokes (q.v.), née Preindlsberger, 1855-1927
was also an artist. A joint exhibition of their work was held at the
FAS in 1900.

Publ: *Landscape Painting [1925]; Pansy's Flour-Bin [1880]; Hungary [1909]*.
Illus: *The Three Brides [Charlotte M. Yonge]; The Clever Woman Of The
Family [Charlotte M. Yonge]; Tyrol and its People [C. Holland, 1909]*.
Exhib: B; FAS; G; GG; L; M; NEA; New Gall; RA; RBA; RHA; RI; ROI; RSA;
RSW; RWS.
Colls: V & AM.
See illustration (below).

ADRIAN SCOTT STOKES RA ARWS 1854-1935. 'Mackarel Lane.' Original drawing for illustration to The Clever Woman of the Family
by Charlotte M. Yonge. Indian ink. 3¹/2ins. x 4⁷/8ins. (8.9cm x 12.4cm).
 Victoria and Albert Museum

STOKES, George Vernon 1873-1954

Landscape and animal painter and etcher. He was born in London on 1 January 1873 and after a private education specialised in black and white illustration and was elected ARBA in 1923 and RBA in 1929. He worked at Carlisle, 1911-14 and latterly at Deal, dying there in 1954.

Publ: *Colour Etchings in Two Printings; How to Draw and Paint Dogs.*
Contrib: *The Gentlewoman [c.1890]; Punch [1905 (dogs)]; ILN [1915]; The Graphic; The Sphere.*
Exhib: FAS; New Gall; RA; RBA; RI; RMS.
Colls: Carlisle.

STOKES, Marianne (née Preindlesberger) 1855-1927

Portrait and biblical painter. She was born in Southern Austria in 1855 and studied under Lindenschmidt in Munich and worked at Graz. She married Adrian Stokes, RWS (q.v.) and died in London in 1927. She was elected NEA in 1887 and ASWA the same year, becoming ARWS in 1923.

Contrib: *The Graphic [1886].*
Exhib: B; FAS; G; GG; L; M; NEA; New Gall; RA; RBA; ROI; RWS; SWA.

STONE, Frank ARA 1800-1859

Figure painter and illustrator. He was born in Manchester in 1800 and began life as a cotton spinner before setting up for himself as a painter. He settled in London in 1831 and began to make illustrations for the albums and watercolours for the dealer Roberts. He was elected OWS in 1842 but resigned in 1846 in order to be elected an ARA in 1851. He was a close friend of Charles Dickens and his circle and acted with him. Stone's son Marcus (q.v.) was more successful than his father, who died in London in 1859.

Illus: *The Haunted Man [Charles Dickens, 1848].*
Contrib: *Heath's Gallery [1836].*
Exhib: BI; OWS; RA; RBA.
Colls: Manchester; NPG; V & AM; Witt Photo.
Bibl: *The Connoisseur,* Vol.62, 1922.

STONE, Marcus RA 1840-1921

Genre painter and illustrator. He was born in London on 4 July 1840, the second son of Frank Stone, ARA (q.v.). He studied art under his father and began exhibiting at the RA in 1858, specialising in figure subjects in interiors. He was elected ARA in 1877 and RA in 1887. He died in London on 24 March 1921.

Illus: *Great Expectations [Charles Dickens, 1860-61]; Our Mutual Friend [Charles Dickens, 1865].*
Contrib: *London Society [1863-64]; The Sunday Magazine [1865]; Touches of Nature by Eminent Artists [1866]; The Graphic [1872]; The Cornhill Magazine [1873]; ILN [1873].*
Exhib: B; FAS; G; L; M; RA.
Colls: BM; Manchester; V & AM; Witt Photo.
Bibl: *Art Annual,* 1896.

STONEY, Thomas Butler fl.1899-1912

Coastal painter and illustrator. He worked in London in 1899 and 1912 and at Portland, Co. Tipperary in 1910. With John Hassall (q.v.) he illustrated *The Princess and The Dragon,* 1908.

Exhib: B; L; NEA; P; RA; RHA.

STONHOUSE, Charles fl.1833-1865

Painter and engraver. He specialised in genre and literary subjects and worked in Bloomsbury from 1833 to 1865. He contributed to *The Deserted Village,* Etching Club, 1841.

Exhib: BI; RA.

STOPFORD, Robert Lowe 1813-1898

Marine and view painter and lithographer. He was born at Dublin in 1813 and became a drawing-master in Cork where he worked as Special Artist for *The Illustrated London News.* His son was W.H. Stopford, 1842-90. He died at Cork on 2 February 1898.

Contrib: *The Illustrated Times [1859 (Ireland)].*

STORER, Henry Sargant 1797-1837

Topographer, draughtsman and engraver. He was born in 1797, the son of James Sargant Storer (q.v.) with whom he collaborated on many books. He worked at Cambridge with his father but moved to London and died there on 8 January 1837.

Exhib: RA.

STORER, James Sargant 1771-1853

Topographer, draughtsman and engraver. He was born in Cambridge in 1771 and practised there, his chief works being illustrative surveys of the medieval buildings and the cathedrals of England. 'The Messrs Storer had not the artistic skill of the artists employed by Ackermann, and moreover their drawings are on a very small scale. On the other hand, the general accuracy of their representations of existing buildings induces us to conclude that those which have been destroyed were delineated with equal accuracy.' (Willis & Clark, *Arch. Hist. of Univ. of Cambridge,* Vol.1, p.128.) The elder Storer died in London in 1853.

Illus: *Cathedrals of Great Britain [1823-24]; Illustrations of Cambridge [1827-32]; Britton's Cathedrals [1832-36]; The Cambridge Almanac [1832]; Cantabrigia Illustrata [1835]; Collegiorum portae apud Cantabrigium [1837]; Delineations of Fountains Abbey; Delineations of the Chapel of Kings College; Delineations of Trinity College.*

STOREY, George Adolphus RA 1834-1919

Genre and portrait painter and illustrator. He was born in London on 7 January 1834 and educated in Paris, where he studied paintings and mathematics under Professor M. Morand. He returned to London and spent some time with an architect before entering J.M. Leigh's Art School in Newman Street. He subsequently became a student at the RA Schools in 1854 and came strongly under the influence of the Pre-Raphaelites. He worked in Hampstead and St John's Wood where he was a founder-member of the Clique. He was elected ARA in 1876 and RA in 1914, having been Professor of Perspective from 1900 to 1919. He died on 29 July 1919.

Publ: *Sketches from Memory [1899]; Theory and Practice of Perspective [1910].*
Illus: *Homely Ballads and Old-Fashioned Poems [1880].*
Contrib: *Punch [1882]; The Ludgate Monthly [1892]; ILN [1893].*
Exhib: B; G; L; M; RA; RI; ROI; RSA.
Bibl: *AJ,* 1875; A.M. Eyre, *Saint Johns Wood,* 1913, pp.181-199; *Apollo,* June, 1964; J. Maas, *Victorian Painters,* 1970, p.13.

STOTHARD, Charles Alfred 1786-1821

Painter and illustrator. He was born in London on 5 July 1786, the son of Thomas Stothard, RA (q.v.) and attended the RA Schools in 1807. He made a tour of Northern England in 1815, gathering material for illustrating Lyson's *Magna Britannia.* Having some skill as a classical draughtsman, he was made Draughtsman to the Society of Antiquaries and in 1816 visited Bayeux to draw the tapestry. He married the novelist Anna Eliza Bray who wrote biographies of both him and his father. He died at Beerferris, Devonshire on 27 May 1821 as the result of an accident in France.

Illus: *Monumental Effigies of Great Britain [1817]; Letters Written During a Tour Through Normandy, Brittany and Other Parts of France, 1820 [by Mrs CAS, AT 88]; Painted Chamber [J.G. Rokewode, 1842, AL 69].*
Contrib: *Lyson's Devonshire [1822].*
Exhib: RA.
Colls: BM.
Bibl: Mrs A.E. Bray, *Memoirs of CAS,* 1823; Mrs E.A. Bray, *Autobiography,* 1889.

STOTHARD, Robert T. FSA fl.1821-1857

Miniature painter. He worked in London and there is an undated illustration in the V & A Museum for Scott's *Lady of the Lake* by this artist.

Exhib: BI.

STOTHARD, Thomas RA 1755-1834

Illustrator. He was born in London in 1755 but on being left an orphan he was brought up in Yorkshire and educated in Tadcaster. He began his career as a silk pattern designer, but went to London and entered the RA Schools in 1777, where he attracted the notice of

John Flaxman (q.v.). He had already begun to design book illustrations by 1779, doing work for *The Town and Country Magazine,* on Bell's *British Poets* and Harrison's *Novelists Magazines.* In the period 1780-83, Stothard was engaged on shop-cards, pocket-books and other ephemera at the same time studying Dürer prints and becoming a friend of William Blake (q.v.). He was elected ARA in 1785 and RA in 1794, following this with an important mural commission at Burghley House for Lord Exeter. Stothard was by far the most successful and distinguished illustrator of his day, his total contributions are estimated to be over five thousand, most of them figure subjects which the artist took from nature. His work is usually well finished, generally in monochrome wash but sometimes in full watercolours. He died on 27 April 1834.

Illus: *Peregrine Pickle [1781]; Clarissa [1784]; Robinson Crusoe [1790]; Pilgrims Progress [1789]; Young's Night Thoughts [1802]; Shakespeare's Works [1802]; The Spectator [1803]; Poems of Burns [1809]; Tales From Landlord [1820]; Cupid and Pysche [1820]; The Songs of Burns [1824]; Walton's Angler [1825]; Dramatic Works of Shakespeare [1826]; The Surprising Adventures of Baron Munchausen [1826]; etc.*
Contrib: *The Novelists Magazine [1780-83]; The Poetical Magazine; Macklin's Bible [1791]; Boydell's Shakespeare; Bell's British Theatre; The Bijou [1828]; The Keepsake [1828-30]; etc.*
Exhib: BI; RA; RBA.
Colls: Ashmolean; Birkenhead; BM; Fitzwilliam; Manchester; Nottingham; Tate; V & AM; Witt Photo.
Bibl: Mrs A.E. Bray, *Life of TS,* 1851; *Memorial to TS,* 1867-68, V & AM MSS; A. Dobson, *Eighteenth Century Vignettes,* 1897; A.C. Coxhead, *TS,* 1906; I. Williams, *Early Eng. Watercolours,* 1952, pp.129-133; M. Hardie, *Watercol. Paint. in Brit.,* Vol.I, 1966, pp. 138-141 illus.

STOTT, William R.S. fl.1905-1934
Portrait and landscape painter and illustrator. He worked in Chelsea for most of his life, but worked at Aberdeen in 1909. He was employed by *The Graphic* from 1903 to 1923 to illustrate royal and public events.

Illus: *Kidnapped [R.L. Stevenson, c.1913].*
Exhib: G; L; RA; RHA.
Colls: Witt Photo.

STOWERS, Thomas fl.1778-1814
Illustrator. He may have been a friend of Rowlandson, but his figure work is more like that of J.H. Mortimer. He exhibited at the BI, RA and OWS.

STOWERS, T. Gordon fl.1880-1894
Portrait painter. He worked in London and contributed to *Punch,* 1880.

Exhib: B; RA; RBA.

STRANG, Ian RE 1886-1952
Painter and etcher. He was born in 1886, the eldest son of William Strang, RA (q.v.) and was educated at Merchant Taylors' School before studying art at the Slade School, 1902-6 and at Julian's, Paris, 1906-8. He travelled in France, Belgium, Sicily, Spain and Italy, where he became a member of the Faculty of the British School at Rome. He was elected ARE in 1926 and RE in 1930. He died at Wavendon, Bucks in 1952.

Publ: *The Students Book of Etching [1937]; Town and Country in Southern France [Frances Strang, 1937].*
Exhib: FAS; G; L; M; NEA; RA; RE; RHA; RSA.
Colls: V & AM.

STRANG, William RA 1859-1921
Painter and etcher. He was born at Dumbarton on 13 February 1859 and was educated at Dumbarton Academy and studied at the Slade School. He worked in London from 1875, carrying out some book illustrations but issuing a series of etchings notable for their imaginative power and insight and their concern with a wide range of subjects from poetry to social realism. He was elected RE in 1881 and ARA and RA in 1906 and 1921. He was President of the International Society of Sculptors, Painters and Gravers from 1918 to 1921, was LL.D. of Glasgow University, 1909 and a medallist of the Paris Exhibition of 1897. Strang's artistic debt is to the master engravers like Rembrandt, Forain and Daumier, but also to Alphonse Legros with whom he studied. He died on 12 April 1921.

Illus: *The Earth Friend [1892]; Death and the Ploughman's Wife [1894]; Nathan the Wise [1894]; The Ballad of Hadji [Ian Hamilton, 1894]; Baron Munchausen [1895]; Pilgrim's Progress [1895]; Christ Upon the Hill [1895]; Sinbad the Sailor and Ali Baba [1896, with J.B. Clark]; Milton's Paradise Lost [1896]; A Book of Ballads [Alice Sargant, 1898]; A Book of Giants [1898];*

WILLIAM STRANG RA 1859-1921. 'The Fair Ground.' Etching. Signed and dated 1892. 7¾ins. x 9¾ins. (19.7cm x 24.8cm).
Author's Collection

Western Flanders [Laurence Binyon, 1899]; Etchings From Rudyard Kipling [1901]; The Praise of Folie [1901]; Walton's The Compleat Angler [1902]; Tam o'Shanter [Burns, 1902]; The Rime of the Ancient Mariner [Coleridge, 1902]; Thirty Etchings of Don Quixote [1903].
Contrib: The English Illustrated Magazine [1890-91]; The Yellow Book [1895]; The Dome [1898-1900].
Exhib: FAS; G; GG; L; M; NEA; P; RA; RE; RHA; RSA.
Colls: Ashmolean; Leeds; V & AM; Witt Photo.
Bibl: F. Sedmore, Frank Short & WS, English Illustrated Magazine, Vol.8, 1890-91, pp.457-466; R.E.D. Sketchley, Eng. Bk. Illus., 1903, pp.58, 154.
See illustrations (below and p.468).

WILLIAM STRANG RA 1859-1921. Original drawing for illustration to The Surprising Adventures of Baron Manchausen, *1895. Ink and bodycolour. Signed with intials. 8⅝ins. x 6⅛ins. (21.3cm x 15.5cm).* Victoria and Albert Museum

STRASYNSKI, Leonard Ludwik **1828-1889**
Artist and lithographer. He was born on 11 January 1828 at Tokarowka, Poland and studied art at the St Petersburg Academy, 1847-55. He then travelled to Berlin, Paris, Brussels and Rome and was a member of the Academies of both Rome and St Petersburg. He appears to have been in London in 1867-68 when he designed initial letters for *London Society*. He died at Shitomir on 4 February 1889.
Contrib: *Punch [1867-68]; Once A Week [1867].*

STRATTON, Helen **fl.1892-1925**
Portrait and figure painter and illustrator. She worked in Kensington and Chelsea and specialised in children's stories and fairy tales.
Illus: *Songs For Little People [1896]; Tales From Hans Andersen [1896]; Beyond the Border [W.D. Campbell, 1898]; The Fairy Tales of Hans Christian Andersen [1899].*
Contrib: *Arabian Nights [1899].*
Exhib: L; RA; RBA; RHA; RI; SWA.
Colls: Witt Photo.
Bibl: R.E.D. Sketchley, *Eng. Bk. Illus.,* 1903, pp.116, 172.

STREATFIELD, Rev. Thomas FSA **1777-1848**
Topographer and heraldic artist and illustrator. He was born in London in 1777 and educated at Oriel College, Oxford, becoming curate of Long Ditton and Tatsfield, Surrey and Chaplain to the Duke of Kent. He lived at Westerham from 1822 and collected material for a history of Kent, he died there in 1848.
Illus: *The Bridal of Armagnac [1823]; Excerpta Cantiana [1836]; Lympsfield and its Environs [1839]; Hasted's History of Kent, corrected and enlarged [1886].*
Contrib: *The Copper Plate Magazine [1792-1802]; Britton's Beauties of England and Wales [1813].*
Exhib: RA, 1800.
Colls: BM; Greenwich.

STRETCH, Matt **fl.1880-1896**
Figure and humorous artist. He worked for *The Gentlewoman* and for *Fun,* 1886-96 and *Moonshine,* 1891.
Exhib: RHA, 1880.

STRINGER, Agnes **fl.1900-1908**
Illustrator. She worked at Sunbury and Putney and illustrated with D. Andrewes (q.v.) *The Little Maid Who Danced To Every Mood,* 1908.
Exhib: RBA; SWA.

STRONG, Joseph D. **1852-1900**
American illustrator. He was born at Bridgeport, Connecticut in 1852 and studied in California and Munich under Piloty before travelling in the South Seas. He died in San Francisco on 5 April 1900.
Illus: *The Silverardo Squatters [R.L. Stevenson, 1897].*

STRUBE, Sidney **1891-1956**
Artist. There is a pencil and watercolour caricature by this artist in the V & A Museum, signed and dated 1916.

STRUTT, Alfred William RE FRGS **1856-1924**
Animal, figure and landscape painter and illustrator. He was born at Tarahaki, New Zealand in 1856, the son of William Strutt, the genre painter, (q.v.) under whom he studied. He studied at South Kensington and exhibited in Paris and in Colonial exhibitions. He accompanied King Edward VII as official artist on a hunting trip to Scandinavia and was an occasional magazine illustrator. He was elected RBA in 1888 and ARE in 1889. He died at Wadhurst, Sussex on 2 March 1924.
Contrib: *ILN [1894 (rustic)].*
Exhib: FAS; L; M; RA; RBA; RCA; RE; RHA; RI; ROI; RSA; RWS.

STRUTT, Jacob George **1790-1864**
Painter of portraits and forests, etcher. He was born in 1790 and worked in London until 1831 when he moved to Lausanne and Rome. He died in Rome in 1864.
Illus: *Bury St Edmunds illustrated [1821]; Sylva Britannica [1822]; Deliciae Sylvarum [1828].*

STRUTT, William 1827-1915

Animal and genre painter. He was born at Teignmouth, Devon in 1827, the grandson of Joseph Strutt, the antiquary and artist. He studied in Paris and went to Australia in 1850 where he founded the *Australian Journal* and *The Illustrated Australian Magazine*. He worked in New Zealand from 1856 and returned to England in 1862 and died at Wadhurst, Sussex in 1915. His son was A.E. Strutt (q.v.). He was elected RBA in 1891.

Exhib: L; M; RA; RBA; ROI.

STUDDY, G.E. 1878-1925

Illustrator. He was born in Devonshire in 1878 and after studying at Heatherley's, specialised in drawings of children and contributed to *Punch*, in 1902 and to *The Graphic* in 1910 and 1912.

Colls: Witt Photo.

'STUFF' See WRIGHT, H.C. Seppings.

STURGESS, John fl.1875-1903

Sporting painter and illustrator. He worked in London and was the principal hunting and racing artist for *The Illustrated London News* for about ten years from 1875. His drawings are accurate though somewhat wooden and he was among the first black and white artists to go wholeheartedly into advertising with his hunting sketches for Ellerman's Embrocation.

Illus: *The Magic Jacket [Nat Gould, 1896]*.
Contrib: *ILN [1875-97]; The English Illustrated Magazine [1884]; The Sporting & Dramatic News [1890]*.
Exhib: RBA; RHA.
Colls: V & AM; Witt Photo.

EDMUND JOSEPH SULLIVAN RWS 1869-1933. 'Night and Morning.' Original drawing for unidentified magazine illustration. Chalk and wash. Indistinctly signed and dated 1 Jan 1903. 14ins. x 10ins. (35.6cm x 25.4cm).
Author's Collection.

HERR DIOGENES

EDMUND JOSEPH SULLIVAN RWS 1869-1933. 'Herr Diogenes.' Illustration for Sartor Resartus *by Thomas Carlyle, 1898.*

STYCHE, Frank fl.1913-1925

Black and white figure artist. He worked at Hendon and Golders Green and contributed to *London Opinion,* 1913.

SULLIVAN, Edmund Joseph RWS 1869-1933

Painter, watercolourist and illustrator. He was born in London in 1869, the son and pupil of M. Sullivan, an artist working at Hastings. He studied under his father and was in 1889, one of the new recruits along with Dean and Hartrick (qq.v.) for Thomas's new venture *The Daily Graphic.* From then onwards Sullivan established himself as one of the foremost illustrators of his time, although eclipsed by his contemporaries Rackham and Dulac. He was a superb figure draughtsman, especially in chalks and had a strong and inventive imagination. Hartrick later said of his colleague 'he could do anything with a pen and do it with distinction,' *Sullivan,* by Thorpe, p.14. Sullivan was a careful textual illustrator, his work on such books as *Sartor Resartus* are very accurately thought out, the decorative element in the design beautifully balanced. His preliminary sketches are very vivid and dramatic and sometimes they lose their greatest impact when completed as a finished drawing, but they never lack virtuosity. Sullivan had two main drawing styles, a very clear black and white one, used with most consistency about 1900 for books and a more atmospheric treatment with washes and swirling chalk lines, closer to the rough working notes. Less well known is his character study work, among the best of these being a series of Gloucestershire portraits which were purchased by the National Art Collections Fund for the BM.

Sullivan's lasting influence was probably not so strong in his books

EDMUND JOSEPH SULLIVAN RWS 1869-1933. 'Airy Fairy Lilian.' Original drawing for illustration to Dreams of Fair
Women by Alfred Tennyson, 1900. Pen and ink. Signed and dated '99. 9ins. x 6ins. (22.9cm x 15.2cm).

Author's Collection

as in his teaching. He was lecturer on Book Illustration and Lithography at the Goldsmith College for a number of years and was examiner in art for the Board of Education. He wrote two important text books on his subject. He was elected ARWS in 1903 and ARE in 1925. He died in London on 17 April 1933. His brother was J.F. Sullivan (q.v.).

Publ: *Line, an Art Study [1921]; The Art of Illustration [1922].*
Illus: *Lavengro [Borrow, 1896]; Tom Brown's School Days [1896]; The Compleat Angler [1896]; The Pirate and Three Cutters [Marryat, 1897]; Sartor Resartus [Carlyle, 1898]; Maud [Tennyson, 1900]; A Dream of Fair Women [1900]; The Pilgrim's Progress [1901]; Poems by R. Burns [1901]; A Citizen of the World [1904]; A Modern Utopia [H.G. Wells, 1905]; Sintram and His Companions [1908]; The French Revolution [1910]; The Rubaiyat of Omar Khayyam [1913]; The Vicar of Wakefield [1914]; The Kaiser's Garland [1915]; Legal and Other Lyrics [G. Outram, 1916].*

Contrib: *The Graphic [1889]; The Daily Graphic [1890-]; The English Illustrated Magazine [1891-94]; The Pall Mall Budget [1893]; The Yellow Book [1894]; The Daily Chronicle [1895]; The New Budget [1895]; A London Garland [W.E. Henley, 1895]; Good Words [1896]; The Lady's Pictorial [1898]; The Pall Mall Gazette [1899]; Black & White [1900]; Natural History of Selborne [Gilbert White, 1900-1]; The Old Court Suburbs [Leigh Hunt, 1902]; The Penny Illustrated Paper; The Pall Mall Magazine; The Gentlewoman; The Ludgate Monthly; The Windsor Magazine; Pearson's Magazine; Punch [c.1920].*
Exhib: FAS; G; L; NEA; RA; RE; RHA; RSA; RSW.
Colls: Ashmolean; BM; Bradford; V & AM; Witt Photo.
Bibl: *The Studio*, Winter No., 1900-1, pp.28-29 illus.; R.E.D. Sketchley, *Eng. Bk. Illus.*, 1903, pp.15, 74, 77, 155; *Modern Book Illustrators and Their Work*, Studio, 1914; J. Thorpe, *EJS*, 1948; B. Peppin, *Fantasy Book Illustration*, 1975, pp.98-99 illus.; Gordon N. Ray, *The Illustrator and The Book in England*, 1976, pp.186-193 allus.
See illustrations (pp.470, 471).

JAMES FRANK SULLIVAN 1853-1936. 'The Artist As He Should Be.' Original drawings for illustration to Fun, *10 June 1885.* Pen and ink. One signed with monogram. 4ins. x 10ins. (10.2cm x 25.4cm). Author's Collection

He had that sense of delicacy! His corn hurt him dreadfully, till he said "I will cut it". Then it flashed upon him that it would involve looking upon his toe in a state of nudity! He crimsoned to. the roots of his hair (an asterisk shows position of corn).

For a while he contemplates cutting the corn from the outside.

With a strong effort against the innate delicacy inseparable from the pure-minded, he forced himself to remove the slipper.

Then — but with what mental torture! the sock. But the sense of impropriety was fearful.

But he steeled himself, Ah, how easy it is to lose all shame when once we have overstepped the bounds! And as he was about to operate HIS LANDLADY CAME IN!

SULLIVAN, G.M.
Contributor of humorous figure subjects to *Punch*, 1908.

SULLIVAN, James Frank 1853-1936
Draughtsman, illustrator and author. He was born in 1853, the son of M. Sullivan, an artist working at Hastings, and elder brother of E.J. Sullivan (q.v.). He went to the South Kensington Schools and began to work for the leading periodicals from about 1878. His greatest success was through the pages of *Fun*, where he was resident illustrator for about twenty-four years. Sullivan favoured the strip story cartoon and created a popular character 'The British Working Man' who features in issue after issue of his magazines. The main character is conceived in traditional cartoon idiom of small body and large head but is always very well drawn. Sullivan died in London on 5 May 1936.

Contrib: *Fun [1878-1901]; Black & White [1891]; The Strand Magazine [1891]; The Idler [1892]; The Butterfly [1893]; Lady's Pictorial [1893]; Punch [1893-94, 1905]; The Sketch [1893]; St Pauls [1894]; The Minister [1895]; The New Budget [1895]; Pearson's Magazine [1896]; Lika Joko; Pick-Me-Up; Cassell's Saturday Journal; Cassell's Family Magazine.*
Exhib: FAS; RBA.
Colls: Author; V & AM.
Bibl: *The Studio*, Winter No., 1900-1, p.76 illus.
See illustrations (pp.85, 472).

SULMAN, T. fl.1855-1890
Architectural illustrator. This artist specialised in topographical views and panoramas and was architectural illustrator for *The Illustrated London News* from 1859 to 1888. His work was still appearing in 1890. He was described by Chatto as expert in 'Ornamental Borders and Vignettes'.

Illus: *Kalidasa-Sakoontala [Indian Drama, Monier Williams, 1855].*
Contrib: *Churchman's Family Magazine [1863]; The Illustrated Times [1860-65]; Once A Week [1867]; Good Words For The Young [1869]; The Boy's Own Paper [1882]; Lalla Rookh.*
Bibl: Chatto & Jackson, 1861, p.600.

SUMMERS, W.
Caricaturist. He published a series of illustrations entitled *Black Jokes*, 1834, AL 322.

SUMNER, George Heywood Maunoir 1853-1940
Etcher and archaeologist. He was born in 1853 and was a leading figure in the revival of wood engraving in the 1880s and 1890s. His work which is associated with the countryside, has a lyrical quality about it owing something to Blake and Palmer, his decorative illustration is somewhat akin to Morris. He died in 1940.

Illus: *The Itchen Valley [1881]; The Avon From Naxby to Tewkesbury [1882]; Epping Forest [1884]; Sintram and His Companions [1883]; Undine [1888]; The Besom Maker [1888]; Jacob and the Raven [1896].*
Contrib: *The English Illustrated Magazine [1883-86].*
Exhib: G; RA; RE.

Bibl: *The Studio,* Winter No., 1900-1, p.50 illus.; R.E.D. Sketchley, *Eng. Bk. Illus.,* 1903, pp.6, 130. Richard Bassett, *C.L.* 28 Sept. 1978.
See illustration (below).

SUMNER, Margaret L. fl.1882-1914
Landscape painter and illustrator. She was working at Grasmere in 1898 and contributed to *The Yellow Book* in 1895.
Exhib: L.

SUTCLIFFE, John E. -1923
Figure painter and illustrator. He worked in London, Bushey and Richmond and was married to the domestic painter E. Earnshaw. He contributed to *The Illustrated London News,* Christmas Number, 1916. He was elected ROI in 1920 and died in 1923.
Exhib: RA; RBA; RI; ROI.

SUTHERLAND, Elizabeth Duchess of 1765-1839
Amateur artist. She was born in 1765, the daughter and heir of the 18th Earl of Sutherland and married in 1785 the 1st Duke of Sutherland. Her claim to the title of Countess was allowed by the House of Lords. She was a pupil of Girtin and many of her watercolours of Continental scenes were engraved. Her *Etchings of the Orkney Isles* and *Views on the Northern and Western Coasts of Sutherland,* were privately printed in 1807.

SWAINSON, William 1789-1855
Zoological illustrator. He travelled widely in Europe and formed a natural history collection. He lived in Brazil from 1816 to 1818 and after returning to England in 1819, he finally emigrated to New Zealand in 1837, dying at Hutt Valley in 1855. He illustrated many of his own works.

Illus: *Zoological Illustrations [1820-23]; Ornithological Drawings, Birds of Brazil [1834-35]; Birds of Western Africa [Sir J. Richardson, 1837].*

SWAN, Mary E. 1889-1898
Fruit and flower painter. She worked in Bromley and London and drew the title page for *Poems by Emily H. Hickey,* 1895-96.
Exhib: B; FAS; L; New Gall; RA; ROI.

SWETE, Rev. John c.1752-1821
Topographer. He was educated at University College, Oxford and became Prebendary of Exeter in 1781, the majority of his drawings being of Devonshire. He settled at Oxton House near Exeter, but made sketching tours to Scotland and Cumberland as well as to Switzerland and Italy, 1816. An important group of his drawings of country houses was sold at Christie's on 15 July 1976.

Contrib: *Antiquarian and Topographical Cabinet [1808]; Britton's Beauties of England and Wales [1813].*
Colls: Exeter.

GEORGE HEYWOOD MAUNOIR SUMNER 1853-1940. Head piece for The English Illustrated Magazine, *1883. Wood engraving.*

SYDDALL, Joseph fl.1898-1910

Portrait and genre painter. He was trained at the Herkomer School, Bushey and worked from 1898 to 1910 at Chesterfield. He contributed illustrations with Sir H. von Herkomer (q.v.) to *Tess of the D'Urbevilles* when serialised in *The Graphic*, 1891.

SYKES, Charles 'Rilette' 1875-1950

Sculptor and illustrator. He was born in 1875 and worked in London as a poster designer and magazine illustrator, contributing to *The Sunday Dispatch* and *Woman* under the name of 'Rilette'. He also designed De Reske cigarette advertisements, fashion plates and in 1911 the mascot for the Rolls Royce car that is still in use. He was responsible for designing the Ascot race cups from 1926.

Exhib: G; L; RA; RI.
Colls: V & AM.

SYKES, Godfrey 1824-1866

Landscape and interior painter and designer. He was born at Malton in 1824 and studied at the Government School of Design at Sheffield, while serving his apprenticeship to an engraver. He subsequently became a teacher in the School under Young Mitchell and painted scenes of mills and forges. He worked with Alfred Stevens on coming to London and then with Captain Fowke on the decoration of the South Kensington Museum and the Horticultural Gardens. Linton who much admired his work says that he 'was starved on a low salary' and in consequence died of consumption in 1866. A memorial exhibition was held at South Kensington in the summer of 1866.

Contrib: *Cornhill Magazine [1860 (first cover design)]*.
Exhib: RA.
Colls: Manchester; V & AM.
Bibl: W.J. Linton, *Memoirs*, 1895, p.182.
See illustration (right).

SYMES, Ivor I. J. fl.1899-1937

Genre painter and illustrator. He studied at the Herkomer School, Bushey and married Mabel Gear, RI. He worked at Tadley, Hants.

Contrib: *The Graphic [1906]*.
Exhib: RA; ROI.

SYMINGTON, J. Aytòn fl.1890-1908

Illustrator. He specialised in adventure stories and contributed to numerous magazines.

Illus: *Tom Cringle's Log [Michael Scott, 1895]; Peter Simple [Captain Marryat, 1895]; The Wonderful Wapentake [J.S. Fletcher, 1896]; The Enchanting North [J.S. Fletcher, 1908]*.
Contrib: *The Sporting & Dramatic News [1890]; Good Words [1893]; Chums; The Windsor Magazine*.

SYMONS, William Christian 1845-1911

Portrait, genre, landscape and still-life painter and illustrator. He was born in London in 1845 and studied at the Lambeth School of Art and the RA Schools. He worked as a stained-glass designer and produced the controversial mosaics for the new Westminster Cathedral. He was elected RBA but resigned with Whistler in 1888 and later worked in Newlyn and Battle, dying in London in 1911. A memorial exhibition was held by the Goupil Gallery in 1912.

Contrib: *The Graphic [1885]; The Strand Magazine [1891]; Good Words [1898]; The Wide World Magazine [1898]*.
Exhib: B; G; L; M; NEA; RA; RBA; RHA; RI; ROI.
Colls: BM.

SYNGE, Edward Millington 1860-1913

Painter and etcher. He was born at Great Malvern in 1860 and educated at Norwich Grammar School and Trinity College, Cambridge. He became a land agent and practised etching in his spare time, being elected ARE in 1898. He devoted himself entirely to art from 1901 and travelled in Italy and Spain. He died in 1913.

Illus: *Romantic Cities of Provence [A.M. Caird, 1906]*.
Exhib: G; L; RA; RE; RHA.

GODFREY SYKES 1824-1866. Original drawing for the first cover of The Cornhill Magazine, 1860. Pen. 7½ins. x 4⁵⁄₈ins. (19.1cm x 11.7cm).
Victoria and Albert Museum

SYRETT, Nellie or Netta

Illustrator. Artist drawing in the black and white style of L. Housman (q.v.). She contributed to *The Yellow Book* and *The Quarto*, 1896.

Exhib: SWA.

TABER, I.W.
Illustrator. He supplied the drawings for *Captains Courageous* by Rudyard Kipling, 1908.

TADEMA See Sir L. ALMA- and Lady L.T. ALMA-

TAFFS, Charles H. fl.1894-1911
Black and white artist. He worked in Clapham, London and illustrated for the leading magazines.

Contrib: *St Pauls [1894]; Lady's Pictorial [1895-98]; The Quiver [1895]; The New Budget [1895]; Pick-Me-Up [1897]; Sketchy Bits; The Royal Magazine; The English Illustrated Magazine [1897]; ILN [1899, 1908]; The Graphic [1910-11].*
Exhib: RA.

TARLING, G.T. fl.1894-1907
Artist and illustrator. He was a member of the Birmingham Guild of Handicraft in 1907.

Contrib: *The Quest [1894-96].*

TARLTON, J. fl.1872-1875
Wood engraver and illustrator. He worked in London and contributed to *The Illustrated London News*, 1874-75.

TARRANT, Percy fl.1881-1930
Landscape, coastal and figure painter and illustrator. He worked in South London and then at Leatherhead and Gomshall, Surrey.

Illus: *Tom's Boy [Chambers, 1901].*
Contrib: *ILN [1884-89]; The Quiver [1890]; Black & White [1891]; Cassell's Family Magazine; The Girl's Own Paper; The Graphic [1911].*
Exhib: B; L; RA; RBA; RI; ROI.

TATHAM, Helen S. fl.1878-1891
Landscape painter and illustrator. She worked at Shanklin, Isle of Wight and illustrated a children's book *Little Margaret's Ride*, 1878.
Exhib: B; L; M; RA; RBA; SWA.

TATTERSALL, George 1817-1852
Architectural and sporting illustrator. He contributed to *Tattersall's English Race Horses*, c.1841, under the name of 'Wildrake'.

Exhib: RA, 1840-48.
Colls: Witt Photo.

TAVERNER, J.
Illustrator. Contributed railway scenes to *The Graphic*, 1870.

TAYLER, John Frederick RWS 1802-1889
Landscape and figure painter, etcher and illustrator. He was born at Boreham Wood, Hertfordshire in 1802, the son of an impoverished squire and was educated at Eton and Harrow. He was intended for the Church but instead attended art classes at Sass's and the RA Schools and studied in Paris under Horace Vernet, sharing rooms with R.P. Bonington. He worked with Samuel Prout (q.v.) and then lived in Rome before returning to London and achieving considerable fame as a watercolourist. He was elected AOWS in 1831 and OWS in 1834 becoming President from 1858 to 1871. Tayler was most fond of painting country scenes involving hunting and hawking and based on the landscapes of Scotland where he was a frequent visitor; these were also the most frequent subjects for his book illustrations. He died at West Hampstead in 1889.

Contrib: *The Deserted Village [Goldsmith, Etching Club, 1841]; The Traveller [Art Union, 1851].*

Exhib: BI; L; RA; RCA; RWS.
Bibl: M. Hardie, *Watercol. Paint. in Brit.*, Vol.III, 1968, pp.91-92.

TAYLOR, Edwin fl.1858-1884
Landscape painter. He worked in Birmingham and published *Pictures of English Lakes and Mountains*, 1874.

TAYLOR, Horace Christopher RBA 1881-1934
Painter, illustrator and poster artist. He was born in London on 10 January 1881 and was educated at Islington High School and studied at the Camden School of Art, 1898 and the RA Schools, 1902. He then worked in Munich, 1905 and was lecturer in commercial art at Chelsea School, 1931-34. Taylor worked as a caricaturist and cartoonist for *Pan* in about 1920 and also for *The Manchester Guardian*. He was one of the very few humorous artists to paint caricatures in oil. He died at Hampstead on 7 February 1934. He was elected ARBA in 1919 and RBA, 1921.

Illus: *Prehistoric Parables; The Second Show – Atta Troll.*
Exhib: RA; RBA; ROI.
Colls: Witt Photo.
Bibl: *The Studio*, Vol.48, 1909.

TAYLOR, Leonard Campbell RA 1874-1963
Portrait painter and illustrator. He was born at Oxford on 12 December 1874, the son of Dr. J. Taylor, Organist to the University. He was educated at Cheltenham College and studied at the Ruskin School, Oxford, the St. Johns Wood School and the RA Schools. He was working at Hindhead, Surrey in 1905 and at Odiham, Basingstoke in 1921. He was elected ARA in 1928 and RA in 1931. He died in 1963.

Contrib: *The English Illustrated Magazine [1900-1].*
Exhib: B; L; M; New Gall; RA; RHA; RI; ROI; RSA; RWA.
Bibl: Herbert Furst, *LCT, RA His Place in Art*, 1945; G.E. Bunt, *LCT, RA*, 1949.

TAYLOR, Thomas c.1770-1826
Topographer. He entered the RA Schools in 1791 and practised as an architect in the Leeds area, designing a number of churches. He illustrated Whitaker's *Loidis and Elmete* and his edition of Thoresby's *Ducatus Leodiensis*, both published in 1816. He died in March 1826.

Colls: BM.
Bibl: F. Beckwith, 'TT, Regency Architect', *Thoresby Society*, 1949.

TAYLOR, Tom fl.1883-1911
Figure and domestic painter and illustrator. He worked in Camden, London from 1883 and contributed to *The Illustrated London News*, Christmas number, 1895-96.

Exhib: B; L; M; RA; RBA; RHA; RI; ROI.

TAYLOR, Weld
Amateur artist. He belonged to the family of Mitford and contributed illustrations to *Howitt's Visits to Remarkable Places*, 1841.

TAYLOR, Zillah
Amateur illustrator. She lived in Nottingham and won a *Studio* book illustration competition, 1895-96.

TEALL, Gardner C.
Ornamental artist. He designed the Contents page for *The Quartier Latin*, Vol.3, September 1897. An artist called Miss E. Teall was working and exhibiting at Birmingham, 1920-25.

TEBBY, Arthur Kemp fl.1883-1928
Landscape, figure and flower painter and illustrator. He was working in Bloomsbury in 1883 and later moved to Heybridge, Essex; he acted as *The Graphic* naval artist for some time.

Contrib: *Daily Graphic [1890]; The Graphic [1903-5]; The Windsor Magazine; Pearson's Magazine.*
Exhib: RA; RBA; ROI.

SIR JOHN TENNIEL 1820-1914. 'The Press As Scare Monger'. A cartoon for Punch, *1892. Pencil. Signed with monogram and dated.* Gordon Collection

TEIGNMOUTH, Commander Henry Noel Shore 5th Baron
1847-1926
Painter of oriental subjects. He was born in 1847 and joined the Navy in 1868 becoming Lieutenant in 1872 and Commander in 1891. He died on 25 February 1926 at Clevedon, Somerset.

Publ: *The Flight of the Lapwing [1881]; Smuggling Days and Smuggling Ways [1892]; Three Pleasant Springs in Portugal [1899]; The Diary of a Girl in France in 1821 [1905]; The Smugglers [1923 (with C.G. Harper)].*
Exhib: RI.

TEL, S.
Contributed one cartoon to *Vanity Fair,* 1891.

TENISON, Nell Marion (Mrs. Cyrus Cuneo) fl.1893-1940
Figure painter and illustrator. She studied at the Cope and Nicholl School, London, 1879 and afterwards in Paris. She married Cyrus Cuneo (q.v.) and was elected SWA in 1918.

Contrib: *The Graphic [1904].*
Exhib: L; RA; RBA; RHA; ROI; SWA.

TENNANT, C. Dudley fl.1898-1918
Marine and sporting painter and illustrator. He worked in Liverpool, 1898 and Surrey, 1913 and contributed to *Punch,* 1907-8 and The

Graphic, 1910.
Exhib: L; RA.

TENNANT, Dorothy Lady Stanley -1926
Genre painter, illustrator and writer. She was the daughter of C. Tennant of Cadoxton Lodge, Glamorgan and studied at the Slade School and with Henner in Paris. She made a study of domestic subjects and children and in 1890 she married Sir H.M. Stanley (q.v.) the African explorer. She was RE from 1881 and died on 5 October 1926. Signs: ◿

Publ: *Autobiography of H.M. Stanley [1909].*
Illus: *London Street Arabs [1890].*
Contrib: *The English Illustrated Magazine [1885].*
Exhib: FAS; G; L; M; New Gall; RA; RE; RHA; ROI.
Colls: Tate; Witt Photo.

TENNANT, N.
Topographer. He was producing illustrations of Scotland for books in about 1849.

TENNIEL, Sir John 1820-1914
Cartoonist and illustrator. He was born in London in 1820 and studied at the RA Schools and the Clipstone Street Life Academy, rising to notice through his animal drawings in the 1840s. It was his edition of *Aesop's Fables,* 1848 that brought him to the attention of Mark Lemon of *Punch* and he joined the magazine as second cartoonist in 1851, graduating to principal cartoonist in 1864. Tenniel drew during his half century of association with the paper over 2,000 cartoons. They represented not only the essence of Victorian *Punch,* but of Victorian society, imperial, dignified and Olympian. Tenniel's superb draughtsmanship, meticulous silvery grey pencil strokes made with a special 6H pencil produced the household images of the period 'The British Lion Attacking The Bengal Tiger' and 'Dropping the Pilot'. Despite a serious vein in his work, Tenniel was a fine illustrator of fantasy and his greatest opportunity for really humorous drawing came with his work for Lewis Carroll's *Alice in Wonderland,* 1865, a singular example of painstaking professionalism for both artist and author. *Through The Looking Glass* followed in 1872. Tenniel was elected ANWS in 1874 and a full member the same year. He was knighted in 1893 and died in London in early 1914. *Punch* issued a special Tenniel Supplement on March 4, 1914 to mark his death.

Contrib: *Undine [1845]; The Juvenile Verse and Picture Book [1848]; Aesop's Fables [1848]; Pollok's Course of Time [1857]; Poets of the Nineteenth Century [1858]; The Poetical Works of E.A. Poe [1857]; ILN [1857, 1868]; The Home Affections [Charles Mackay, 1858]; Blair's Grave [1858-59]; Once a Week [1859-67]; Lalla Rookh [1861]; Parables From Nature [1861]; Good Words [1862-64]; Puck on Pegasus [Pennell, 1862]; Passages From Modern English Poets [1862]; Arabian Nights [1863]; The Ingoldsby Legends [1864]; English Sacred Poetry [1864]; Legends and Lyrics [1865]; The Mirage of Life [1867-68]; A Noble Life [c.1870]. (For full bibl. see Sarzano, F.).*
Exhib: FAS, 1895, 1900; NWS; RA; RBA.
Colls: BM; V & AM; Witt Photo.
Bibl: M.H. Spielmann, *The History of Punch,* 1895, pp.461-474; Frances Sarzano, *Sir JT,* English Masters of Black and White, 1948; R.G.G. Price, *A History of Punch,* 1957, pp.70-74.
See illustration (left).

TERRY, George W. fl.1854-1858
Ornamental artist. He contributed decorative work to *The Illustrated London News* in 1854 and initial letters to *Punch,* 1856-58.

TERRY, Herbert Stanley 1890-
Illustrator of comic genre subjects. He was born in Birmingham on 13 March 1890 and was educated at Bede College, Northumberland and at the Wolverhampton School of Art. He specialised in comic genre subjects and contributed to the major magazines from about 1914.

Contrib: *Punch [1914]; The Bystander; The Tatler; The Sketch; Illustrated Sporting and Dramatic News; London Opinion; Humorist; Passing Show; Windsor Magazine.*

THACKERAY, Lance RBA -1916

Painter, illustrator and writer. He worked in Notting Hill Gate, London and specialised in sporting subjects, often with a humorous side to them. He travelled extensively in the Middle East and had one man exhibitions at the Leicester Galleries, 1908, the FAS, 1910 and at Walker's Galleries, 1913. He was elected RBA in 1899 and died at Brighton on 11 August 1916.

Illus: *The Light Side of Egypt [1908]; The People of Egypt [1910].*
Contrib: *The Sphere [1894]; Sketchy Bits [1895]; The Graphic [1904-11]; Punch [1905-8].*
Exhib: FAS; RA; RBA; RI.

THACKERAY, William Makepeace 1811-1863

Novelist, illustrator and caricaturist. He was born in Calcutta in 1811 and after the family fortune was lost he turned to his aptitude for drawing for a living before his aptitude for writing. His pen drawing with light washes was always free and in the spirit of the amateur caricaturists of the 18th century and with undoubted borrowings from Hogarth. Despite a rather wooden appearance, Thackeray's figures have great value as being the only illustrations by a major writer for his own works. These began with the slight lithographs in *Flore et Zephyr,* 1836, made at a time when he was studying art in Paris and lead on to the more sustained work of *The Book of Snobs* and *Vanity Fair,* 1847-48. Thackeray was an able critic of caricature and humorous art both at home and on the Continent and his interest in artists was continued by his connection with *Punch,* 1842-54. His own attempts to illustrate his novel *Phillip* in the early numbers of *The Cornhill Magazine,* which he was editing, resulted in the young artist Fred Walker (q.v.) being employed. He died in London in 1863.

Illus: *Flore et Zephyr [1836]; The Paris Sketchbook [1840]; Comic Tales and Sketches [1841]; The Irish Sketchbook [1843]; Christmas Books [1846-50]; Vanity Fair [1847-48]; The History of Pendennis [1849-50].*
Contrib: *Figaro in London [1836]; Punch [1842-54]; The Cornhill Magazine [1860-61].*
Colls: BM; Fitzwilliam; V & AM; Witt Photo.
Bibl: Graham Everitt, *English Caricaturists,* 1893, pp.375-380; M.H. Spielmann, *WMT,* 1899; Melville, *T. As Artist,* The Connoisseur, March 1904; Gleeson White, *English Illustration,* 1906, p.18; *American Magazine,* Vol.28, 9 September 1935, p.555; Gordon N. Ray, *The Illustrator and the Book in England,* Morgan Library, 1976.
See illustration (p.185).

THIEDE, Edwin Adolf fl.1882-1908

Miniature portrait painter and illustrator. He worked in Lewisham and London and worked for the leading magazines.

Contrib: *The Queen [1892]; ILN [1893, 1900]; The Ludgate Monthly; The Windsor Magazine; The Temple Magazine.*
Exhib: RA; ROI.

THIELE, Reinhold

Illustrator. He illustrated *After School,* Robert Overton and *Lights Out,* by the same author in Jarrold's series 'Books For Manly Boys', 1894.

THIRTLE, John fl.1896-1902

Painter and illustrator. He worked at Ewell, Surrey and drew pen and ink illustrations in the style of the Birmingham School for *The Studio* competitions, 1896-97.

Exhib: RA; RI.
Bibl: *The Studio,* Vol.8, 1896, p.184 illus.; Vol.10, 1897; Vol.12, 1897.

THOMAS, Bert 1883-1966

Black and white artist and illustrator. He was born at Newport, Montgomery in 1883, the son of the sculptor Job Thomas and was educated at Swansea. He worked in London for many of the leading magazines, taking as his subjects a raffish metropolitan world of policeman, waitresses, soldiers and sailors, set down with a spontaneous broken line. He drew a number of posters and died in 1966.

Contrib: *Fun [1901]; Punch [1905-35]; The Graphic [1910]; London Opinion [1913-].*
Exhib: London Salon, 1909.
Colls: BM; V & AM.
Bibl: *Mr Punch with Horse and Hound,* New Punch Library, c.1930; R.G.G. Price, *A History of Punch,* 1957, p.221 illus.

THOMAS, George Housman 1824-1868

Wood engraver and illustrator. He was born in London in 1824, the brother of W.L. Thomas (q.v.). He worked from the age of fourteen with the wood engraver Bonner, and won a Society of Arts silver palette at the age of fifteen. He began his career as a book illustrator in Paris where he worked with Henry Harrison and had a small workshop with half a dozen assistants. During this period he was employed by an American journal and to engrave U.S. bank notes and went to New York in 1846, where he and his brother founded a magazine which was unsuccessful. On his return in 1848, Thomas went to Rome and was present at Garibaldi's defence of the city. illustrations of it being accepted by *The Illustrated London News.* His work for books and magazines was quite extensive after this date, but his drawing lacks the fire to make him a great illustrator, although his work was much admired by Queen Victoria. He died at Boulogne in 1868 after falling from his horse; a memorial exhibition was held at the German Gallery the following year.

Illus: *Uncle Tom's Cabin [1852]; Hiawatha [1855-56]; Vicar of Wakefield [1857]; Pilgrim's Progress [1857]; Robinson Crusoe [1865]; Armadale [Wilkie Collins, 1866]; The Last Chronicle of Barset [Anthony Trollope [1867].*
Contrib: *ILN [1848-67]; Punch [1851-52]; Merrie Days of England [1858-59]; The Home Affections [Mackay, 1858]; Thomson's Seasons [1859]; Household Songs [1861]; Early English Poems [1862]; London Society [1863]; The Churchman's Family Magazine [1863]; The Cornhill Magazine [1864-65]; Legends and Lyrics [1865]; Aunt Sally's Life [1866-67]; Foxe's Book of Martyrs [1866]; Cassell's Magazine [1867]; The Quiver [1867]; The Broadway [1867]; Idyllic Pictures [1867].*
Exhib: BI; RA.
Colls: Fitzwilliam; V & AM.
Bibl: *In Memoriam GHT,* n.d., Cassell; Gleeson White, *English Illustration,* 1906, pp.155-156; Forrest Reid, *Illustrators of the sixties,* 1928, p.248.

THOMAS, Inigo fl.1891-1903

Architectural illustrator. He contributed to *The English Illustrated Magazine,* 1891-92 and illustrated Reginald Blomfield's *The Formal Garden,* 1892.

Bibl: R.E.D. Sketchley, *Eng. Bk. Illus.,* 1903, pp.50, 142.

WILLIAM F. THOMAS fl.1890-1907. 'Ally Sloper canvassing for votes.' Original drawing for illustration in Ally Sloper's Half Holiday, *1906. Pen and ink. 10¾ins. x 9¾ins. (27.3cm x 24.8cm).* Author's Collection

THOMAS, Margaret **-1929**
Artist, illustrator, sculptor and author. She was born at Croydon and
emigrated with her parents to Australia. There she studied with
Charles Summers and returned to Europe to study in the RA Schools
and in Paris and Rome. She lived in Melbourne and London and made
extensive tours of the Mediterranean coasts, her researches being
published in a number of books. She died on 24 December 1929.

Illus: *A Hero of the Workshop [1880]; A Scamper Through Spain and Tangier
[1892]; Two Years in Palestine and Syria [1899]; Denmark Past and Present
[1901]; From Damascus to Palmyra [1905].*
Exhib: RBA; RHA; ROI; SWA.
Bibl: *Who Was Who,* 1929-40.

THOMAS, William F. **fl.1890-1907**
Landscape painter and cartoonist. He followed W.G. Baxter (q.v.) as
chief cartoonist on *Ally Sloper's Half Holiday* in 1890 and produced
meticulous and detailed pen drawings of this character until at least
1906. He lived from about 1901 at Lydstepp House, Southwold,
Suffolk.

Contrib: *Judy [1886-90]; Lika Joko [1894]; Punch [1895].*
Exhib: RA.
See illustration (p.477).

THOMAS, William Luson RI **1830-1900**
Wood engraver and newspaper proprietor. He was born in 1830, the
brother of G.H. Thomas (q.v.), and in 1846 left with him for the
United States where they founded the unsuccessful journals, *The
Republic* and *The Picture Gallery.* They returned to Europe in 1848
and lived in Paris and Rome and in 1855, W.L. Thomas married the
daughter of the watercolourist and illustrator J.W. Carmichael (q.v.).
Thomas's work for *The Illustrated London News* from about 1850,
gave him the idea of another illustrated periodical and *The Graphic*
was founded in December 1869. Mainly due to Thomas's dynamism
and first hand knowledge of the work, the new paper flourished in the
1870s and attracted a remarkable group of young social realistic
artists who published their best work in its pages. In 1890, he became
the first promoter of a daily illustrated paper *The Daily Graphic.*
Although principally a businessman, Thomas was an able water-
colourist and was elected ANWS in 1864 and NWS in 1875. He died at
Chertsey in 1900. His son, W. Carmichael Thomas, b.1856, was a
wood engraver on *The Graphic* and managing director from 1900-17.

Exhib: L; M; RI; ROI.

THOMPSON, Alfred **-1895**
Amateur painter, draughtsman and caricaturist. He was a cavalry
officer, who took the advice of Mark Lemon of *Punch* to abandon the
army and study art in Paris. He contributed to many periodicals, his
caricatures reflecting the delicate portraits chargés of Tissot (q.v.). He
finally became manager of the Theatre Royal at Manchester and
designed costumes and scenery and edited the magazine *Mask.* He died
in New York in September 1895.

Contrib: *Journal Amusant [Paris]; Diogenes [1854]; Punch [1856-58]; Comic
News [1865]; The Arrow [1865]; Vanity Fair [1862-76]; The Broadway
[1867-74]; ILN [1867]; Fun [1870].*

THOMPSON, George **fl.1892-1894**
Portrait painter. He worked in London and contributed to *The Yellow
Book,* 1894.

Exhib: London, 1892.

THOMPSON, Margaret **fl.1883-1923**
Figure and flower painter and illustrator. She was a student at the
New Cross School of Art and won a gold medal at South Kensington
in 1898. She won a *Studio* competition in 1899 and worked in
Hitchin and Hereford.

Exhib: B; RA; RBA; RI; RSA; SWA.
Bibl: *The Studio,* Vol.15, p.294 illus.

THOMSON, Emily Gertrude RMS **-1932**
Portrait painter, miniaturist, sculptor and illustrator. She was born in
Glasgow and studied at the Manchester School of Art and was elected
ARMS in 1911 and RMS in 1912. She worked at Brook Green,

London from 1908 and died in 1932.

Illus: *A Soldier's Children [1897 (with E. Stuart Hardy)]; Three Sunsets and
Other Poems with Twelve Fairy Fancies by EGT [1898].*
Exhib: G; L; M; RMS.
Colls: V & AM.

THOMSON, George **1860-1939**
Townscape painter and illustrator. He was born at Towie,
Aberdeenshire in 1860 and studied at the RA Schools and was a
lecturer at the Slade 1895 to 1914. He settled at Chateau Letoquoi at
Samer in the Pas-de-Calais in 1914 and died at Boulogne on 22 March
1939. He was elected NEA in 1891.

Contrib: *The Pall Mall Budget [1891-92].*
Exhib: B; G; GG; L; M; NEA; RA; RBA; RHA; RI; ROI.

THOMSON, Gordon **fl.1864-1886**
Figure artist and illustrator. He was originally a civil servant and then
cartoonist for *Fun,* 1870-78, having made his name with double page
illustrations of the Franco-Prussian War for *The Graphic.* Dalziel refers
to the 'large pictures for Christmas and other Holiday Numbers . . .
remarkable for the varied topical events he crowded into them, and
those who remember his "Academy Skits" will know what quaint
burlesques they were'. He signed his work

Illus: *Pictures From Italy [C. Dickens, 1870].*
Contrib: *Punch [1864]; London Society; The Graphic [1869-86]; Fun
[1870-78, 1890-93].*
Exhib: RA, 1878.

"THEN HE, HANDING HER INTO HER COACH, STEPS IN AFTER."
From a Drawing by HUGH THOMSON.

The battle was over without any blows,

The heroes unharness and strip off their clothes ;

The dame gives her captain a sip of rose-water,

Then he, handing her into her coach, steps in after.

John's orders are special to drive very slow,

For fevers oft follow fatigues, we all know ;

*HUGH THOMSON 1860-1920. '. . . Handing Her into Her Coach . . .' An
illustration to a poem, published in* The English Illustrated Magazine, *1883.*

THOMSON, Henry RA
1773-1843

Painter of history and allegory. He was born at Portsea on 31 July 1773 and studied in Paris before the Revolution, returning to this country to become a pupil of John Opie. He travelled to Italy and Germany, his main illustrative work being for Boydell's *Shakespeare* and portraits for *The Theatrical Recorder*, 1805. He was elected ARA in 1801 and RA in 1804, serving as Keeper from 1825-27. He died at Portsea on 6 April 1843.

THOMSON, Hugh
1860-1920

Watercolour artist and illustrator. He was born at Coleraine, Co. Londonderry in 1860 and first came to prominence with his series of drawings of 18th century ballads and stories in *The English Illustrated Magazine*, 1883. Thomson was an instinctive artist with little formal training. He had left Coleraine for Belfast in 1877 and started work in the factory of Messrs Marcus Ward, engaged in Christmas card colour printing. He attended a few classes at the Belfast School of Art, but his real teacher was the artist and designer John Vinycomb (q.v.). His contact with Carr of *The English Illustrated* gave him the opportunity for figurative work and the partnership with W. Outram Tristram, the author, provided him with an ideal text. His name was made with *Coaching Days and Coaching Ways*, by the latter, 1888 and in such delightful examples of nostalgia as *Days with Sir Roger de Coverley*, 1886. Influenced by Randolph Caldecott and the novels of Thackeray (qq.v.), Thomson created an idyllic world of stage coaches, sedan chairs, feasts and port wine, which was a little more convincing than the earlier artists but very pretty. From the late 1880s he was continuously in demand for the novels of Jane Austen, Fanny Burney, Mrs. Gaskell, Charles Reade and others as well as for contemporaries like J.M. Barrie and Austin Dobson. His studies of London life and the cockney poor are a notable achievement and show the diversity of this talented artist. Thomson was most prolific in the years 1900 to 1914 when his watercolour work was put to good use in the colour gift books, page plates of period scenes, their colour washed into a gentle ink drawing, usually pastellish and muted. He was elected RI in 1897 and retired in 1907. He died at Wandsworth on 7 May 1920. The artist was influential on the following generation especially on the work of C.E. and H.M. Brock (qq.v.).

Illus: *Days with Sir Roger de Coverley [1886]; Coaching Days and Coaching Ways [Outram Tristram, 1888]; The Vicar of Wakefield [1891]; Cranford [Mrs. Gaskell, 1891]; The Antiquary [1891]; The Bride of Lammermoor [1891]; The Ballad of Beau Brocade [1892]; Our Village [Miss Mitford, 1893]; The Piper of Hamelin [1893]; Pride and Prejudice [Jane Austen, 1894]; Coridon's Song [1894]; The Dead Gallant [Outram Tristram, 1894]; St. Ronan's Well [1894]; The Story of Rosina [1895]; Sense and Sensibility [1896]; Emma [1896]; The Chase [1896]; Highways and Byways in Devon and Cornwall [1897]; Mansfield Park [1897]; Northanger Abbey [1897]; Persuasion [1897]; Riding Recollections [1898]; Highways and Byways in North Wales [1898]; Jack the Giant Killer [1898]; Peg Woffington [Reade, 1899]; Highways and By-ways, Donegal and Antrim [1899]; Yorkshire [1899]; This and That [1899]; Ray Farley [1901]; The History of Samuel Titmarsh [1902]; Evelina [1903]; Scenes of Clerical Life [George Eliot, 1906]; Highways and Byways in Kent [Jerrold, 1907]; As You Like It [1909]; The Merry Wives of Windsor [1910]; The School for Scandal [1911]; She Stoops to Conquer [1912]; Quality Street [J.M. Barrie, 1913]; The Chimes [1913]; The Admirable Crichton [J.M. Barrie, 1914]; Tom Brown's School Days [1918]; The Scarlet Letter [Hawthorne, 1920].*
Contrib: *The English Illustrated Magazine [1883-92]; Pall Mall Budget [1890]; The Graphic [1890-1905]; Black & White [1891]; The New Budget [1895]; The Ludgate Monthly [1895]*. (See Spielmann and Jerrold for complete bibl.)
Exhib: FAS, 1887, 1893; Leicester Galls; Walker's Galls.
Colls: BM; Ulster Mus; V & AM.
Bibl: *The Studio*, Winter No., 1900-1, p.30 illus.; R.E.D. Sketchley, *Eng. Bk. Illus.*, 1903, pp.68, 79, 156; M.H. Spielmann and W. Jerrold, *HT*, 1931.
See illustrations (above right and p.478).

THOMSON, James William
c.1775-c.1825

Architectural draughtsman. He entered the RA Schools in 1798 and contributed illustrations to *The History of the Abbey Church of St. Peter's Westminster*, 1812 and *Ackermann's Repository*, 1825.

Exhib: RA, 1795.

HUGH THOMSON 1860-1920. 'The Gods — The Vaudeville Gallery.' Original drawing for The Graphic. *Pen, pencil and watercolour. Signed and dated 1899. 11⁷/₈ins. x 9³/₄ins. (30.1cm x 24.8cm).* Victoria and Albert Museum

THORBURN, Archibald
1860-1935

Painter of birds. He was born on 31 May 1860, the son of Robert Thorburn, RA, the miniature painter. He was educated at Dalkeith and Edinburgh and married the daughter of C.E. Mudie, the proprietor of Mudie's Libraries. Thorburn was a very scientific painter whose renderings of colour and texture in his ornithological books cannot be faulted, at the same time the works can be dull. He had a wide following among the sporting fraternity and lived latterly at Godalming, Surrey. He died on 9 October 1935.

Illus: *British Birds [1915-18]; A Naturalists Sketchbook [1919]; British Mammals [1920]; Game Birds and Wild Fowl of Great Britain and Ireland [1923]*.
Contrib: *The Sporting and Dramatic News [1896]; The Pall Mall Magazine; ILN [1896-98]; The English Illustrated Magazine [1897]; British Diving Ducks [1913]*.
Exhib: FAS; L; RA; RBA.
Colls: BM; V & AM; Woburn.
Bibl: *The Studio*, Vol.91, 1926.
See illustration (p.480).

THORIGNY, Felix
1824-1870

Landscape painter and draughtsman. He was born at Caen on 14 March 1824 and studied with Julian at Caen. He then went to Paris to work for *Monde Illustré; Magazin Pittoresque; Musée des Familles* and *Calvados Pittoresque*. He died in Paris on 27 March 1870.

Contrib: *ILN [1859-68]; Illustrated Times [1859]*.

THORNELY, H.

Equestrian illustrator. He contributed drawings to *The Penny Illustrated Paper*.

ARCHIBALD THORBURN 1860-1935. Original drawing for illustration to British Divine Ducks, *1913. Watercolour. Signed.* Woburn Abbey Collection

THORNTON, Alfred Henry Robinson **1863-1939**

Landscape painter. He was born in Delhi on 25 August 1863 and was educated at Harrow and Trinity College, Cambridge, then studying at the Slade and the Westminster School of Art. He was a member of the NEA from 1895 and Hon. Secretary from 1928 to 1939. He lived at Bath until 1914 and then at Painswick, Gloucestershire. He died on 20 February 1939.

Publ: *Fifty Years of the NEAC [1935]; The Diary of an Art Student of the Nineties [1938].*
Contrib: *The Yellow Book [1894-95].*
Exhib: FAS; L; M; NEA; RA; RBA; RSA.
Colls: BM; Cheltenham.

THORPE, James H. **1876-1949**

Painter and illustrator. He was born on 13 March 1876 and after being educated at Bancrofts School, studied at Heatherley's. He served in the First World War, 1915-19 and was the first designer of advertisements to the London Press Exchange, 1902-22. Thorpe's posterish style with heavy outline owes something to Hassall but is less competent in execution; his main contribution was as the historian of 1890s illustration and of monographs of two famous illustrators. He died in 1949.

Illus: *The Compleat Angler [Izaak Walton, 1911]; Over [de Selincourt, 1932].*
Contrib: *Punch [1909-38]; The Graphic [1908-15]; Windsor Magazine.*
Publ: *A Cricket Bag [1929]; Phil May [1932]; Jane Hollybrand [1932]; Happy Days [1933]; English Illustration The Nineties [1935]; Edmund J. Sullivan [1947].*
Exhib: RI.
Colls: Author; V & AM.

THRUPP, Frederick **1812-1895**

Sculptor. He was born at Paddington, London on 20 June 1812 and studied at Sass's Academy before working in Rome 1837-42. Thrupp won a Society of Arts silver medal in 1829 and designed statues for Westminster Hall. He died at Torquay on 21 May 1895.

Illus: *Paradise Lost [n.d.].*
Exhib: BI; RA; RBA.
Colls: BM; Winchester.
Bibl: R. Gunnis, *Dict. of Brit. Sculp.*, 1954, pp.394-395.

480

THURSTON, John 1774-1822

Watercolourist, illustrator and wood engraver. He was born at Scarborough in 1774 and specialised in copper plate and wood engraved book illustrations to stories. He was elected AOWS in 1805 and died in London in 1822.

Illus: *Rural Tales [R. Bloomfield, 1802]; Thomson's Seasons [1805]; Religious Emblems [1808]; Shakespeare's Works [1814]; Falconer's Shipwreck [1817]; Somerville's Rural Sports [1818].*
Contrib: *Hood's Comic Annual [1830].*
Exhib: OWS; RA.
Colls: BM; Greenwich; Nottingham.

TIDMARSH, H.E. fl.1880-1925

Landscape and figure painter. He worked in North London and at Barnet from 1914, specialising in architectural subjects.

Contrib: *The Graphic [1886-87]; ILN [1889-91].*
Exhib: B; M; RA; RBA; RI.

TIFFIN, Henry fl.1845-1874

Landscape painter. He worked in London and contributed to *Knight's London,* 1841.

Exhib: BI; RA; RBA.

TIMBRELL, James Christopher 1807-1850

Marine and genre painter. He was born at Dublin in 1807 and specialised in studies of sailors and shipping, contributing to *Knight's London,* 1841. He died at Portsmouth on 5 January 1850.

Exhib: BI; RA; RBA.

TISSOT, Joseph James Jacques 1836-1902

Painter of social genre, illustrator and caricaturist. He was born at Nantes on 15 October 1836 and studied art with Lamotte and Flandrin, exhibiting at the Salon from 1851. Tissot took an active part in the Franco-German War of 1870-71 and afterwards came to England and studied etching with Seymour Haden. In the 1870s he became the supreme genre painter of high life, the portrayer of balls and receptions, fashionable marriages and galas, transformed into luscious paint and correct in every detail. It was perhaps his observation that enabled him to be a good caricaturist for Vanity Fair, 1869-77, although Leslie Ward (q.v.) felt that the subjects in portrait chargé were too soft for caricature. In later life, Tissot became a convinced christian and devoted all his time to religious painting, some of this work is foreshadowed in his book illustrations of 1865. He died at Buillon on 8 August 1902. He was elected RE in 1880.

Illus: *Ballads and Songs of Brittany [1865]; The Life of Our Lord Jesus Christ [1897, 2 Vols.].*
Exhib: B; FAS; G; L; M; RA; RE.
Colls: V & AM.

TITCOMB, William Holt Yates RBA 1858-1930

Landscape, figure and flower painter. He was born at Cambridge in 1858 and studied at South Kensington and at Antwerp under Verlat and in Paris with Boulanger and Lefebvre. He also attended the Herkomer School at Bushey and was elected RBA in 1894. Titcomb worked at St. Ives, Cornwall and at Bristol and died in 1930.

Contrib: *The Graphic [1886 (story)].*
Exhib: FAS; G; L; M; NEA; New Gall; RA; RBA; RHA; RI; ROI.

TOD, Colonel James 1782-1835

Army officer and artist. He was sent to India in 1800 and carried out surveys, later acting as political agent at Rajput until 1822. He published and illustrated *Annals and Antiquities of Rajasthan,* 1829-32 and *Travels in Western India,* 1839. He died in London in 1835.

TOFT, Albert 1862-1949

Sculptor, modeller and designer. He was born in Birmingham in 1862 and studied at the Hanley and Newcastle-under-Lyme Schools of Art. He was at the RCA under Professor Lanteri for two years before being apprenticed to Messrs Wedgwood as a modeller. Toft undoubtedly designed Christmas cards and may have done some book illustration.

He died in 1949. FRBS, 1923.

Publ: *Modelling and Sculpture.*
Exhib: B; G; L; RA.
Colls: Birmingham; Glasgow; Liverpool.

TOMKINS, Charles c.1750-1810

Landscape painter and engraver. He was born about 1750, the son of William Tomkins, a landscape painter.

Contrib: *Britton's Beauties of England and Wales [1801-8].*
Exhib: RA.

TOMKINS, Charles F. 1798-1844

Landscape painter and caricaturist. He worked with David Roberts and Clarkson Stanfield (qq.v.) and was elected SBA in 1838. He contributed drawings for the early numbers of *Punch,* and died in 1844.

Exhib: RBA.
Colls: V & AM.

TOMKINS, Peltro William 1759-1840

Engraver and illustrator. He was born in London in 1759 and studied with F. Bartolozzi before working on *Sharpes's British Poets* and *The British Theatre.* He acted as a printseller in Bond Street and produced *The British Gallery of Art* by Tresham and Ottley and *The Gallery of the Marquess of Stafford.* He died in London in 1840.

Colls: BM; Manchester.

TONKS, Henry 1862-1936

Painter of interiors and caricaturist. He was born at Solihull in 1862 and educated at Clifton before training at the London Hospital and becoming Senior Medical Officer at the Royal Free Hospital and FRCS. He left medicine for art and studied under Fred Brown at the Westminster School, becoming his assistant at the Slade School, 1894. Tonks was Slade Professor of Fine Art at University College, London from 1917-30 and Emeritus Professor from 1930. He was elected NEA in 1895 and died in London on 8 January 1937.

Contrib: *The Quarto [1896].*
Exhib: G; L; M; NEA; RA; RHA; RSA.
Colls: Ashmolean; Manchester.

TOPHAM, Edward 1751-1820

Caricaturist. He was a Captain and Adjutant in the First Life Guards and was also a journalist and playwright. He made some Cambridge caricatures in 1771 and worked for W. Darly of the Strand in 1771-72, his most celebrated print 'The Macaroni Shop' appearing under his imprint on 14 July 1772. He was later caricatured by Rowlandson and Gillray. He died in 1820.

Colls: BM; Witt Photo.

TOPHAM, Francis William 1808-1877

Painter of genre subjects, illustrator and engraver. He was born in Leeds on 15 April 1808 and apprenticed to an uncle who was an engraver. He came to London in 1830 and became an heraldic engraver and then a line engraver, illustrating Moore's and Burns's works. He studied with the Clipstone Street Academy and gradually abandoned engraving for watercolour at which he was very proficient. He made a speciality of peasant scenes and figures and particularly those of Ireland, which he visited in 1844 and Spain where he travelled in 1852-53 and 1864. Topham was elected ANWS in 1842 and NWS in 1843, followed by OWS in 1848. He revisited Spain in 1876 and died there at Cordova on 31 March 1877.

Contrib: *Book of Gems; Fisher's Drawing Room Scrapbook; History of London [Fearnside and Harrall]; Midsummer Eve [Mrs. S.C. Hall]; Book of British Ballads [S.C. Hall, 1842]; The Sporting Review [1842-46]; ILN [1852]; Child's History of England [Dickens, 1852-54]; The Home Affections [Charles Mackay, 1858].*
Exhib: BI; NWS; OWS; RA; RBA.
Colls: BM; Reading; V & AM.
Bibl: Chatto & Jackson, *Treatise on Wood Engraving,* 1861, p.600; F.G. Kitton, *Dickens and His Illustrators,* 1899; J. Maas, *Victorian Painters,* 1970, p.240.

TOPPI, W.
Amateur figure artist. He contributed to *Punch*, 1902.

TORRANCE, James **1859-1916**
Painter and illustrator. He was born at Glasgow in 1859 and specialised in fairy books for children. He died in Helensburgh in 1916.
Illus: *Scottish Fairy Tales and Folk Tales [1893]; The Works of Nathaniel Hawthorne [1894].*
Exhib: G.
Colls: V & AM.

TORRY, John T. **fl.1886**
Landscape painter. He contributed social realism subjects to *The Illustrated London News*, 1886.
Exhib: RBA; RI.

TOVEY, John **fl.1826-1843**
Topographer. He contributed to *Griffith's Cheltenham*, 1826.
Exhib: BI, 1843.

TOWNSEND, Frederick Henry Linton Jehne **1868-1920**
Illustrator, black and white artist and etcher. He was born in London on 25 February 1868 and studied at the Lambeth School of Art. He was contributing figure drawings to *Punch* from 1903 and became the magazine's first Art Editor in 1905. Townsend's pen line is always assured and his compositions are good, but the subjects themselves lack humour and have little individuality in the *Punch* oeuvre. Before his connection with the magazine in the 1890s, Townsend was a prolific illustrator of books, having some claim to be influenced by Abbey (q.v.) and the draughtsmen of the 1860s. He died in London on 11 December 1920. His early work is sometimes signed 'Fin de ville'.
Illus: *A Social Departure [S.J. Duncan, 1890]; An American Girl in London [S.J. Duncan, 1891]; The Simple Adventures of a Memsahib [S.J. Duncan, 1893]; The Jones's and the Asterisks [Campbell, 1895]; Maid Marian and Crotchet Castle [T.L. Peacock, 1895]; Melincourt [1896]; Gryll Grange [1896]; Jane Eyre [1896]; The Misfortunes of Elfin; Rhododaphne [1896]; Shirley [1897]; Rob Roy [1897]; The Scarlet Letter [1897]; The House of the Seven Gables [1897]; Bladys of the Stewponey [1897]; The Blithedale Romance [1898]; The King's Own [Marryat, 1898]; For Peggy's Sake [1898]; The Cardinal's Snuff Box [1900].*
Contrib: *ILN [1889-99]; The Gentlewoman; Judy [1892]; The Pall Mall Budget [1893-94]; Good Words [1894]; The Unicorn [1895]; The New Budget [1895]; Daily Chronicle [1895]; The Quiver [1897]; Pick-Me-Up [1897]; Black & White [1897]; The Longbow [1898]; St. James's Budget [1898]; The Graphic [1899-1901]; Penny Illustrated Paper; The Lady's Pictorial; The Queen; The Idler; The Pall Mall Magazine; The Royal Magazine; Cassell's Family Magazine; The Windsor Magazine; Fun [1901]; The Sphere; The Tatler.*
Exhib: FAS, 1921; NEA; New Gall; RA; RBA; RE; RSA.
Colls: Author; BM; V & AM.
Bibl: *The Studio*, Winter No., 1900-1, p.52 illus.; R.E.D. Sketchley, *Eng. Bk. Illus.*, 1903, pp.68, 69, 72, 157; P.V. Bradshaw, *The Art of the Illustrator FHT*, 1918; R.G.G. Price, *A History of Punch*, 1957, pp.156-157.

TOWNSEND, G.
Ornamental artist. He supplied decoration for *The Illustrated London News* in 1860 and was then working in Exeter.

TOWNSEND, Henry James **1810-1890**
Surgeon, painter and etcher. He was born at Taunton in 1810 and between 1839 and 1866 taught art at the Government School of Design, Somerset House. He died in 1890.
Illus: *The Book of Ballads [Mrs. S.C. Hall, 1847].*
Contrib: *The Deserted Village [Etching Club, 1841]; Gray's Elegy [Etching Club, 1847]; Milton's Allegro [Etching Club]; The Illustrated Times [1855].*
Exhib: BI; RA; RBA.
Colls: V & AM.

TOWNSHEND, George 1st Marquess **1724-1807**
Soldier, politician and amateur caricaturist. He was born in 1724, the son of the 3rd Viscount Townshend and was educated at St. John's College, Cambridge, joining the 7th Dragoons in 1745, he fought at the Battle of Culloden, 1746. He had a distinguished career in the Army, acting as aide-de-camp to George II and as general under Wolfe at Quebec. He succeeded his father in 1764 and was made Lord-Lieutenant of Ireland in 1767 and created a marquis in 1786. Concurrently with this career, Townshend developed a superb hand for caricature and was the first amateur artist to publish his work in the country and the first caricaturist to apply caricature to political satires. He worked closely with Darly, the printseller from 1756, and may have learnt the art from Darly's wife, Mary. His drawings created many enemies and irritated both William Hogarth and Horace Walpole. He died on 14 September 1807.
Bibl: Eileen Harris, *The Townshend Album*, National Portrait Gallery, 1974.

TOY, W.H.
Amateur figure artist. He contributed to *Punch*, 1909.

TOZER, Henry E. **fl.1873-1907**
Marine painter and illustrator. He worked at Penzance and was a very extensive contributor of shipping scenes to *The Illustrated London News*, 1873-80.
Exhib: B; RA.
Colls: Cape Town.

TREGLOWN, Ernest G. **-1922**
Artist and illustrator. He was a student of the Birmingham School and contributed black and white work to *The Yellow Book*, 1896 in a strong Beardsley idiom, and to *The Quest*, 1894-96.
Exhib: B; L, 1891-1916.

TRESIDDER, Charles
Illustrator. He drew for *The Old Miller and His Mill* by M.G. Pearse, a child's story of 1881.

TRINGHAM, Holland RBA **-1909**
Painter and architectural illustrator. He was a pupil of Herbert Railton (q.v.) whose work his much resembles. He lived in Streatham and did a great deal of magazine work up to the time of his death, he was elected RBA in 1894.
Contrib: *The Quiver [1891]; Black & White [1891]; ILN [1892-1908]; The Gentlewoman; The Sketch; Cassell's Family Magazine; Chums; The English Illustrated Magazine [1894].*
Exhib: B; RA; RBA.
Colls: V & AM.

TRUE, Will
Poster designer and illustrator. He contributed to *Fun*, 1892.

TUCK, Harry **fl.1870-1907**
Landscape and genre painter and illustrator. He was on the permanent staff of *Fun*, 1878-1900 and worked at Haverstock Hill, London.
Contrib: *The Strand Magazine [1891].*
Exhib: B; G; L; M; RA; RBA; RI; ROI.

TUCKER, Alfred Robert, Bishop of Uganda **1860-1914**
Amateur artist. He was educated at Oxford and was curate at Bristol and Durham before entering the Colonial Episcopate as Bishop of Uganda from 1890 to 1911. He died after retiring to Durham in 1914.
Publ: *African Sketches [1892]; Toro [1899]; Eighteen Years in Uganda [1908].*
Bibl: J. Silvester, *ART*, 1926.

TUCKET, Elizabeth Fox
Black and white artist. She illustrated *Zigzagging Amongst the Dolomites* for Longmans in 1871.
Colls: V & AM.

TURBAYNE, Albert Angus 1866-1940

Designer and book decorator. He was born at Boston, United States in 1866 of Scottish parents and was educated there and at Coburg, Canada. From about 1900, Turbayne concentrated on the design of books, winning bronze medals in the Paris Exhibition of that year for his tool bindings for Oxford University Press. He was for many years Demonstrator in Design at the LCC School of Photoengraving and Lithography. He lived at Bedford Park, London and died on 29 April 1940.

Designed: *The Beautiful Birthday Book [Black, 1905 (borders)]; Prose Works of Rudyard Kipling [1908 (cover)].*
Publ: *Alphabet and Numerals; Monograms and Ciphers.*

TURNER, Joseph Mallord William RA 1775-1851

Landscape painter in oils and watercolours. He was born in London on 23 April 1775, the son of a barber and wig maker in Covent Garden. He entered the RA Schools in 1789, becoming a pupil of T. Malton and in 1791 and 1792 went on sketching tours in the Bristol and South Wales areas. He joined Dr. Monro's evening study classes in 1794 and in the following years visited the 'picturesque' landscapes of the Lake District and Wales and worked for William, Beckford at Fonthill Abbey. He was elected ARA in 1799 and RA in 1802, making his first Continental trip to France and Switzerland that year. Turner's tours increased after the Napoleonic Wars to include visits to Italy in 1819, Paris and Normandy in 1821, Holland, Belgium and the Rhine in 1825, the French rivers in 1826, France and Italy in 1828 and Northern France in 1829. These visits were interspersed with tours of England and stays with patrons like the Fawkes of Farnley Hall and Lord Egremont of Petworth. In the 1830s he was touring in the Baltic, Germany and Austria and paid his first visit to Venice in 1833 and made trips to the Rhine and Germany in 1840 and to Switzerland in 1841 and 1842 and again in 1844. He was in Normandy for the last time in 1845.

Turner's first move towards engraved work was in 1806 when W.F. Weils suggested that his paintings would reach a wider public if published. The result was the *Liber Studiorum*, a series of studies which were intended to classify his ideas about landscape. Turner etched the plates before they were mezzotinted and carefully superintended every stage under skilled engravers such as Lupton, Charles Turner and William Say. As Hardie has put it 'He trained a whole school of engravers and personally superintended their work'. In these inspired and harmonious productions the complete effect of a Turner drawing remains supreme. The fashion for the picturesque and for landscape annuals grew in the 1820s and the artist continued to work for these publications which were not so much books as plates between covers with a text. In many cases Turner, not principally a figure painter, had to crowd his foregrounds with interest to satisfy the public and his accuracy as a topographer was never a strong point. An extremely literary artist, Turner's pictures were full of allusions but he was too big an artist to sit comfortably in an ordinary volume and the *Liber* was never really surpassed. Turner acted as Professor of Perspective at the RA from 1807 to 1837 and died in London in 1851.

Contrib: *The Copper Plate Magazine; The Pocket Magazine [c.1798]; Cooke's Picturesque Views of the Southern Coast of England [1814-26]; Views in Sussex [1816-20]; The Rivers of Devon [1815-23]; Hakewill's Picturesque Tour of Italy [1818-20]; Whitaker's History of Richmondshire [1818-23]; Provincial Antiquities of Scotland [1819-26]; Picturesque Views in England and Wales [1827-38]; Roger's Poems [1834]; Byron's Life and Works [1832-34]; Rivers of France [1833-35]; Scott's Poetical and Prose Works [1834-37].*
Exhib: BI; RA; RBA.
Colls: Aberdeen; Ashmolean; Bedford; Birkenhead; BM; Derby; Exeter; Fitzwilliam; Glasgow; Leeds; Lincoln; Manchester; Nottingham; Tate; V & AM.
Bibl: W. Thornbury, *Life of JMWT*, 1862; A.J. Finberg, *T's Sketches and Drawings*, 1910; A.J. Finberg, *T's Watercolours at Farnley Hall*, 1912; A.P. Oppe, *Watercolours of T*, 1925; A. J. Finberg, *Life of JMWT*, 1939; J. Rothenstein, *T*, 1962; M. Butlin, *T. Watercolours*, 1962; L. Hermann, *JMWT*, 1963; J. Gage, *Colour in Turner*, 1969; Agnew *exhib. cat.*, Nov-Dec. 1967; RA *exhib. cat.*, Nov. 1974-March 1975.
See illustration (p.39).

TURNER, William 1792-1867

Diplomat and amateur topographer. He was attached to the embassy at Constantinople and was envoy to Columbia 1829-38. He illustrated his own *Journal of a Tour in the Levant*, 1820, AT 375.

TWIDLE, Arthur 1865-1936

Painter and illustrator. He worked at Sidcup, Kent from 1902-13 and then at Godstone, Surrey. He died in 1936.

Contrib: *The Quiver [1890]; The English Illustrated Magazine [1893-94]; The Temple Magazine [1896]; The Strand Magazine [1906 (Conan Doyle)].*
Exhib: RA.

TWINING, Louisa 1820-1900

Artist and writer. She was born on 16 November 1820 and published a number of books on art and social matters illustrated by herself. She was made a Lady of Grace of St. John of Jerusalem and died on 25 September 1911.

Publ: *Recollections of Life and Work [1893]; Workhouses and Pauperism [1898].*
Colls: BM.

TYNDALE, Walter Frederick Roofe RI 1856-1943

Architectural painter. He was born at Bruges in 1856 and came to England in 1871, later studying art at Antwerp and Paris. He began as an oil painter but after contact with Helen Allingham (q.v.) turned entirely to watercolour. He made tours of Morocco, Egypt, Lebanon, Syria and Japan and lived in Venice. During the First World War he acted as Head Censor for the Army at Boulogne. He died in 1943. He was elected RI in 1911, and one man shows were held at the FAS in 1920 and 1924.

Publ. or Illus: *The New Forest [1904]; Below the Cataracts [1907]; Japan and the Japanese [1910]; Japanese Gardens [1912]; An Artist in Egypt [1912]; An Artist in Italy [1913]; An Artist on the Riviera [1916]; The Dalmatian Coast [1925]; Somerset [1927].*
Exhib: B; FAS; G; GG; L; M; New Gall; RA; RBA; RHA; RI; ROI.
Colls: BM; Bradford; V & AM.

TYRER, Mary S.

Amateur illustrator. She was living at Cheltenham in 1896 and at Willesden in 1897 and won *The Studio* illustration competitions, Vol. 8 p.252 and Vol. 11 p.210 illus.

UBSDELL, Richard Henry Clements fl.1828-1856

History painter, miniaturist, illustrator and photographer. He worked in Portsmouth and drew watercolours of churches. He contributed to *The Illustrated Times,* 1856 (marine).

Exhib: RA; RBA.
Colls: Portsmouth.

UNDERWOOD, Edgar Sefton FRIBA fl.1898-1914

Architect and humorous draughtsman. He was a Fellow of the RIBA and practised at Queen Street, Cheapside.

Contrib: *Fun [1901].*
Exhib: RA.

UPTON, Florence K. -1922

Portrait painter and illustrator. She was working in Paris from 1905-7 and produced a whole series of children's books called the 'Golliwog Books' in the years 1899-1905. Her drawings of figures and toys are imaginative if rather stiff. She died in 1922.

Illus: *The Adventures of Two Dutch Dolls [1895]; The Adventures of Borbee and The Wisp [1908].*
Contrib: *The Strand Magazine [1894 (French ports)]; The Idler [1895].*
Exhib: FAS; L; P; RA.

URQUHART, Annie Mackenzie fl.1904-1928

Watercolour painter and illustrator. She studied at the Glasgow School of Art under F.H. Newbury and in Paris with M. Delville. She worked in Glasgow and specialised in drawings of children and foliage, often on vegetable parchment with the colour stippled on to an outline drawing.

Exhib: L; RA; RSA.
Bibl: *The Studio,* Vol.47, 1909, pp.60-63 illus.

UWINS, Thomas RA 1782-1857

Painter and illustrator. He was born at Pentonville on 24 February 1782, the son of a Bank of England official and was apprenticed to the engraver Benjamin Smith in 1797. He left this employ after a year to study at a Finsbury drawing school and at the RA Schools, making his living by book frontispieces and vignette illustrations. He was elected AOWS in 1809 and OWS in 1810, acting as Secretary from 1813-14. He resigned from this due to poor health in 1818 but money difficulties caused him to undertake another intensive round of book illustrating, 1818-24. He was employed as a topographer and visited France in 1817, and lived in Italy from 1824 to 1831. A commission to illustrate *Scott's Works* resulted in him living in Edinburgh for a time, but it was the copying of miniature portraits that was supposed to have ruined his eyesight and cost him his career. He later turned to oil painting and was elected ARA in 1833, RA in 1838 and served as Librarian to the Academy 1844 and Surveyor to the Queen's Pictures from 1845. He died at Staines on 25 August 1857.

Illus: *Nourjahad [Mrs. Sheridan]; Histoire de Charles XII [Voltaire]; Don Quixote.*
Contrib: *Ackermann's Repository [fashion pls.]; The History of the Abbey Church of St. Peter's, Westminster [1812]; History of the University of Oxford [1813-14]; History of the University of Cambridge; Britton's Cathedrals [1832-36].*
Exhib: BI; NWS; OWS; RA; RBA.
Colls: BM; Birkenhead; Fitzwilliam; V & AM.
Bibl: Mrs. T. Uwins, *Memoir,* 1858; M. Hardie, *Watercol. Paint. in Brit.,* Vol.1, 1966, p.157 illus.

See illustration (right).

THOMAS UWINS RA 1782-1857. 'The Duke of Richmond's Tomb'. An illustration to The History of the Abbey Church of St. Peter's Westminster, *1812. Engraving coloured by hand.*

V

VALENTIN, Henry **1820-1855**
Painter and illustrator. He was born at Allarmoint in the Vosges in 1820 and worked for *l'Illustration,* drawing figures in the style of Gavarni (q.v.). He was French correspondent of a number of British papers and died in Paris in 1855.

Contrib: *ILN [1848-56]; Cassell's Illustrated Family Paper [1855]; The Illustrated Times [1859].*

VALERIO, Theodore **1819-1879**
Painter, engraver, etcher and lithographer. He was born at Herserange on 18 February 1819 and became a pupil of Charlet, exhibiting at the Salon from 1838. He travelled widely and visited Italy, Switzerland, Hungary and England and made studies of the Crimea. He died at Vichy on 14 September 1879.

Contrib: *The Illustrated Times [1856, 1860 (Arabia and Austria)].*

VALLANCE, Aymer **-1943**
Flower painter, illustrator and designer. He worked in London and designed initial letters, endpapers and ornament for his own books and made playing card designs. He died in 1943.

Publ: *William Morris His Art, Writings and Public Life [1897]; Old Colleges of Oxford [1912]; Old Crosses and Lychgates [1919].*
Contrib: *The Yellow Book [1894].*
Exhib: RBA.

VALLENCE, William Fleming RSA **1827-1904**
Marine and landscape painter. He was born at Paisley on 13 February 1827 and apprenticed to a gilder in 1841 after which he studied at the Paisley School of Design and the Trustees Academy, Edinburgh. He was a full time artist from 1857 and was elected ARSA in 1875 and RSA in 1881. He died at Edinburgh on 31 August 1904.

Contrib: *Pen and Pencil Pictures From The Poets [1866].*
Exhib: RA; RSA.

VAN ASSEN, Benedictus Antonio **-1817**
Watercolour painter and engraver. He worked in England during the last decade of the 18th century and in the early 19th century. He engraved a portrait of Belzoni, 1804, J.H. Mortimer RA in 1810 and died in London in 1817.

Illus: *Emblematic Devices [1810].*
Exhib: RA, 1788-1804.
Colls: BM.

VANDERLYN, Nathan **fl.1897-1937**
Watercolourist, etcher, engraver and illustrator. He studied at the Slade School and at the RCA. He was Painting Instructor at the LCC Central School of Arts and Crafts and was elected RI in 1916 although his name was removed in 1937.

Contrib: *The English Illustrated Magazine [1897].*
Exhib: L; RA; RBA; RI; RMS.

VEAL, Oliver
Illustrator. Contributed drawings to *Sketchy Bits,* 1895.

VEDDER, Simon Harmon **1866-**
Painter, sculptor and illustrator. He was born in New York on 9 October 1866 and studied at the Metropolitan Museum School, N.Y. He studied in Paris at Julian's under Bouguereau and Robert Fleury and at the École des Beaux Arts. He settled in London by 1896 and married the painter Eva Roos.

Contrib: *Black & White [1900]; The Strand Magazine [1906]; Cassells Family Magazine; The Idler; The Pall Mall Magazine.*
Exhib: B; FAS; L; RA; ROI.

VENNER, Victor L. **fl.1904-1924**
Humorous illustrator. He contributed to *Punch,* 1904.

Exhib: L.

VERHAEGE, L.
Silhouette illustrator. He contributed scenes of Paris to *The English Illustrated Magazine,* 1896.

Colls: V & AM.

VERHEYDEN, Francois **1806-1890**
Genre painter and caricaturist. He was born at Louvain 18 March 1806 and studied in Paris before working at Antwerp. He contributed six cartoons to *Vanity Fair* in 1883 and died in Brussels about 1890.

VERNER, Captain Willoughby
Amateur artist. He was an officer in the Rifle Brigade, taking part in the Nile Expeditionary Force, 1884-85.

Illus: *Sketches in the Soudan [1885 (col. liths.)].*

VERNON, R. Warren **fl.1882-1908**
Painter, etcher and illustrator. He worked mostly in the South of England but in Dresden in 1903. He contributed a drawing to *Punch* in 1903.

Exhib: B; G; L; RA; RBA; RCA; RHA; RI; ROI.

VERPEILLEUX, Emile **1888-1964**
Portrait and landscape painter, engraver and illustrator. He was born of Belgian parents in London on 3 March 1888 and studied in London and at the Académie des Beaux Arts, Antwerp. He produced coloured wood engravings and views of London and was elected RBA 1914. He died in 1964.

Contrib: *The Graphic [1915].*
Exhib: L; NEA; RA; RBA; RSA.

VICKERS, Alfred Gomersal **1810-1837**
Landscape painter and illustrator. He was the son of the artist A. Vickers and was sent by Charles Heath to St. Petersburg to record the city for *The Picturesque Annual,* 1836 and *Heath's Gallery,* 1838. He died at Pentonville in 1837.

Exhib: BI; NWS; RA; RBA.
Colls: BM; V & AM; Witt Photo.

VICKERS, Vincent Cartwright **1879-**
Black and white artist. He was born in 1879 and was a member of the armament and shipbuilding family. He lived and worked at Royston.

Illus: *The Google Book [1913].*
Exhib: Arlington Gall; RA.
Bibl: *Strand Magazine,* Dec. 1926.

VIERGE, M. Daniel 'Vierge Urrabieta Ortiz' **1851-1904**
Genre painter, draughtsman and illustrator. He was born at Madrid on 5 March 1851, the son of a leading Spanish illustrator and studied at the Madrid Academy. In 1867 he was working for the *Madrid la nuit* and in 1869 left for Paris to find an opening in illustrated journalism but his plans were prevented by the Franco-Prussian War. After returning to Madrid he was recognised by Yriarte, editor of *Monde Illustré* and worked for the paper from that time. Vierge illustrated an important edition of Victor Hugo's works, 1874 to 1882 and Quevedo's *Don Pablo,* 1882 and *Cervantes,* 1893. The artist was severely crippled by a stroke in 1881 but recovered sufficiently to do much good work subsequently.

Pennell points out that Vierge's influence on illustration in France, Spain and the United States was very considerable. His pen line was very pure, there was little cross hatching and yet a great suggestion of colour without colour at all. Several of the Edwardian artists such as H.R. Millar (q.v.) owe a debt to him and Ludovici records that Vierge

was interested in his English public and wished to exhibit in London. Vierge won many honours including the Legion of Honour and died at Boulogne-surs-Seine on 4 May 1904.

Contrib: *ILN [1897]*.
Exhib: International, 1904.
Bibl: *The Century Magazine*, June 1893; J. Pennell, *Pen Drawing and Pen Draughtsmen*, 1889; A. Ludovici, *An Artist's Life In London and Paris*, 1926.

VIGNE, Godfrey Thomas **1801-1863**
Amateur artist and illustrator. He worked at Woodford and specialised in figure subjects. He travelled overland to India, 1833-39.

Illus: *A Personal Narrative of a Visit to Ghuzni, Kabul and Afghanistan [1840 AT 505]*.
Contrib: *ILN [1849]*.
Exhib: RA.
Colls: Searight.

VILLIERS, Fred **1851-1922**
Special Artist and illustrator of military subjects. He was born in London on 23 April 1851 and was educated at Guines in the Pas-de-Calais. He studied art at the BM and at South Kensington, 1869-70 and was a student at the RA Schools in 1871. He became Special Artist for *The Graphic* in 1876, being sent first to Servia and then to Turkey in 1877. He went on a world tour for the paper and was afterwards at Tel-el-Kebir, 1882, attended the Russian coronation in 1883 and saw action in Eastern Soudan, 1884, Khartoum, 1884, Bulgaria, 1886, Burma, 1887 and in the Graeco-Turkish War of 1897. Villiers was the earliest correspondent to be equipped with a cinematograph camera in the 1900s. He was present at the Siege of Port Arthur in 1904 and worked during the Great War, 1914-18. He was awarded twelve service medals. He died on 3 April 1922.

Publ: *Pictures of Many Wars [1902]; Port Arthur [1905]; Peaceful Personalities and Warriors Bold [1907]; Villiers, His Five Decades of Adventure [1921]*.
Contrib: *The English Illustrated Magazine [1883-84]; Black & White [1891]; The Idler; ILN [1900]*.
Exhib: M; RA; ROI.

VILLIERS, H.
Architectural draughtsman. He contributed to *The History of the Abbey Church of St. Peter's Westminster*, Ackermann, 1812.

VILLIERS, Jean Francois Marie Huet **1772-1813**
Miniature painter and draughtsman. He was born in Paris in 1772, the son of J.B. Huet and settled in London in 1801. He painted portraits and landscapes in oil and watercolours and was a member of the Sketching Society. He was appointed Miniature Painter to the Duke and Duchess of York and styled himself 'Miniature Painter to the King of France'. He died in London in 1813.

Illus: *Rudiments of Cattle [1805]; Rudiments and Characters of Trees [1806]*.
Contrib: *The History of the Abbey Church of St. Peter's Westminster [1812]*.
Exhib: BI; OWS; RA.
Colls: BM.

VINE, W.
Caricaturist. He contributed two cartoons to *Vanity Fair*, 1873. He signs 'WV' in monogram.

VINYCOMB, John Knox LRIBA **fl.1894-1914**
Architect, heraldic draughtsman and illustrator. He was probably born in Belfast and became a member of the Royal Irish Academy and a Fellow of the Royal Society of Antiquaries of Ireland. He was an authority on and a designer of bookplates and became Vice-President of the Ex Libris Society.

Publ: *On the Processes For the Production of Ex Libris [1894]; Fictitious and Symbolic Creatures in Art [1906]*.
Colls: Newcastle.

VIVIAN, George **1798-1873**
Amateur artist. He was born in 1798, one of the family of Vivian of Claverton Manor near Bath. He went to Eton and Christ Church,

Oxford, before travelling on the Continent and in the Near East where he met Lord Byron in 1824. He lived in Italy from 1844 to 1846 but contracted malaria from which he never fully recovered. He was a friend of J.D. Harding with whom his landscapes have some similarity. He died in 1873.

Illus: *Spanish Scenery [1838]; Scenery of Portugal and Spain; The Gardens of Rome [1848]*.

VIZETELLY, Frank **1830-1883**
Special Artist and illustrator. He was born in London, the younger brother of Henry Vizetelly (q.v.). He was trained as a wood engraver and worked with his brother on *The Pictorial Times* and was Editor of *Monde Illustré* in Paris, 1857-59. In 1859 he was sent by *The Illustrated Times* to cover the Italian Campaign as Special Artist and was subsequently engaged by *The Illustrated London News* as their permanent War Artist. He was with Garibaldi in Sicily in 1860 and saw action on both sides in the American Civil War, 1861 and was present during the Prusso-Austrian War of 1866. He founded a society periodical called *Echoes of the Clubs* and in 1883 was sent by *The Graphic*, to accompany Hicks Pasha to the Soudan. He never returned and was believed to have been killed at El Obeid.

Colls: Witt Photo.
Bibl: H. Vizetelly, *Glances Back Through Seventy Years*, 1893.

VIZETELLY, Henry **1820-1894**
Wood engraver, illustrator and editor. He was born in London on 30 July 1820, the elder brother of F. Vizetelly (q.v.). He was an engraver for *The Illustrated London News*, which he helped to found in 1842 and later established his own illustrated journals *The Pictorial Times*, 1843 and *The Illustrated Times*, 1855-65. In 1865 he became Paris correspondent of *The Illustrated London News* and lived there till 1872 when he settled in Berlin. He returned to London and worked on translations of Russian and French novels, dying at Fareham in 1894.

Publ: *Glances Back Through Seventy Years [1893]*.

VOIGHT, Hans Henning 'Alastair' **c.1889-1933**
Imaginative draughtsman and illustrator. He was born about 1889 of English, Spanish and Russian extraction. He was a self-taught artist and worked most of his life in Germany, interesting himself in decadence and transvestism. His black and white work is very sensuous and derivative from the work of Beardsley (q.v.), his colour illustrations have more the feel of the contemporary Russian school of ballet designers.

Illus: *Count Fanny's Nuptials [G.G. Hope Johnstone, 1907]; The Sphinx [Oscar Wilde, 1920]; Sebastian Van Storck [Walter Pater, 1927]; Manon Lescaut [Abbé Prevost, 1928]; Dangerous Acquaintances [Laclos, 1933 (Paris ed., 1929-30)]*.
Bibl: *Alastair: Forty-Four Drawings in Colour and Black and White With a Note of Exclamation by Robert Ross*, 1914; *Alastair: Fifty Drawings*, New York, 1925.

VON HOLST, Theodore M. **1810-1844**
Genre painter. He was born in London on 3 September 1810, the son of a music teacher and after studying in the British Museum, attended the RA Schools under H. Fuseli. The latter's strong influence in seen in his work, which can be rather hard and Germanic in line. He died in London on 14 February 1844.

Illus: *The Rape of the Lock [c.1825]*.
Exhib: BI; RA; RBA.

VOSPER, Sydney Carnow **1866-1942**
Watercolour painter, etcher and dry-point artist. He was born at Plymouth in 1866 and studied at Colarossi's in Paris, being elected ARWS in 1906 and RWS in 1914. He was working at Morbihan, France in 1904 and at Oxford from 1928. He died in 1942.

Contrib: *Punch [1902]*.
Exhib: B; L; M; RA; RI; RSW; RWS.

WADDY, Frederick
fl.1878-1897

Ornamental artist and illustrator. He contributed initial letters to *The Illustrated London News*, 1883-84 and exhibited pencil drawings in London from 1878.

Illus: *For Faith and Freedom [Besant, 1897 (with Forestier)].*

WADE, Charles Paget ARIBA
-1956

Architect, craftsman and illustrator. He was the son of a wealthy sugar planting family owning estates in the West Indies at St. Kitts and Nevis. He studied architecture and practised as an architect at Yoxford and Forest Gate, London before acquiring Snowshill Manor, Gloucestershire in 1925, which he totally restored and presented to the National Trust in 1951. He died in 1956.

Illus: *Bruges, A Record and Impression [Mary Stratton, 1914]; The Spirit of the House [G. Murray, 1915].*
Exhib: RA.
Colls: Nat. Trust, Snowshill Manor.
Bibl: *Modern Book Illustrators and Their Work*, Studio, 1914.

WADHAM, Percy
fl.1893-1907

Painter and illustrator. He was born at Adelaide, Australia and studied with T.S. Cooper and James Chapman. He was ARE from 1902-10.

Contrib: *The Pall Mall Magazine [1897].*
Exhib: FAS; RA; RE.

WAGEMAN, Thomas Charles NWS
c.1787-1863

Portrait and landscape painter and illustrator. He was born about 1787 and was a founder member of the NWS in 1831 and became Portrait Painter to the King of Holland. He specialised in portraits of famous actors. He died in 1863.

Contrib: *Annals of Sporting [1827].*
Exhib: BI; NWS; RA; RBA.

WAIBLER, F.

German illustrator. He contributed to *The Illustrated London News*, 1872.

LOUIS WILLIAM WAIN 1860-1930. 'A quiet game at Nap'. Original drawing for illustration. Grisaille, signed and dated, 1st Dec '94. 17ins. x 22½ins. (43cm x 56.5cm).

WAIN, Louis William **1860-1939**

Animal caricaturist and illustrator. He was born in London on 5 August 1860 of an English father and French mother. He was educated by the Christian Brothers and studied for a musical career until 1879. He then went to the West London School of Art, 1877-80 and was Assistant Master there, 1881-82. He joined the staff of *The Illustrated Sporting and Dramatic News* in 1882 and *The Illustrated London News*, 1886. From 1883, Wain began to draw cats as they had never been drawn before, cats in humorous guises in human situations but always beautifully handled. The titles speak for themselves, 'A Kittens Christmas Party', 'Nine Lives of a Cat' and 'Cats at Circus' although he was sometimes forced to draw dogs before he became well-known! His main success stemmed from his recognition by Sir William Ingram of *The 'News* who employed him regularly and included one picture of one hundred and fifty cats that took him eleven days to draw. Wain became popular in the United States and visited New York, 1907-10 where he was on the staff of the *New York American* for a time. He also turned his talents to the illustrating of short stories, published yearly gift books and was employed on postcards for Messrs Raphael Tuck. He was President of the National Cat Club and a member of many other committees connected with feline reform, but his obsession slowly turned to insanity and he died in poverty on 4 July 1939.

Illus: *Louis Wain's Annuals [1901-26]; Louis Wain's Summer Book [1906-7]; The Kitcats; 9 China Futurist Cats [1922]; Louis Wain Big Midget Book [1926-27].*
Contrib: *The Sporting & Dramatic News [1882]; ILN [1883-99]; The English Illustrated Magazine [1884-1900]; Moonshine [1893]; The Sketch; The Gentlewoman; Pall Mall Budget; The Boy's Own Paper; Judy [1898]; The Windsor Magazine; Lloyds Weekly News [1905].*
Exhib: RBA.
Colls: V & AM; Witt Photo.
Bibl: *The Idler*, Vol.8, pp.550-555; Rodney Dale, *LW The Man Who Drew Cats*, 1968, with bibliog. and chapter on Wain's illness by D.L. Davies.
See illustration (p.487).

WAITE, Edward Wilkins **fl.1878-1920**

Watercolourist and illustrator. He worked at Blackheath and then at Dorking, 1892, Fittleworth, 1919 and Haslemere, 1920. He was elected RBA in 1893.

Illus: *The Story of My Heart [Richard Jefferies, 1912]; The Roadmender [1911].*
Exhib: B; G; L; M; New Gall; RA; RBA; RCA; RHA; ROI; RSA.
Colls: Bristol.

WAKE, Richard **1865-1888**

Special Artist. He was born on 24 September 1865, the son of Hereward Crauford Wake, CB, Civil Magistrate of Arrah and a grandson of Sir George Sitwell. He was appointed artist for *The Graphic* at Suakim in 1888 and died there on 6 December after making his first drawings.

WAKEFIELD, T.H.

Amateur illustrator. Contributed design to *The Studio* competition, Vol. 8, 1896, p.252.

WAKEMAN, William Frederick **1822-1900**

Landscape and topographical artist. He was born at Dublin in 1822 and was attached to the Ordnance Survey through the influence of G. Petrie (q.v.). He later worked as a drawing master in Dublin and taught at St. Columba's College, Stackallan and at the Royal School, Portora. He died in Coleraine in 1900.

Illus: *Ecclesiastical Antiquities [Petrie]; Ireland Its Scenery and Character [S.C. Hall]; Catalogue of Antiquities in the Royal Irish Academy [Wilde]; Lives of the Irish Saints [O'Hanlon].*
Contrib: *The Irish Penny Journal; Dublin Saturday Magazine; Hibernian Magazine.*
Exhib: RHA.
Colls: RIA.

WALKER, Arthur George RA **1861-1939**

Sculptor, painter and designer in mosaics. He was born on 20 October 1861 and studied at the RA Schools and in Paris. He worked in Chelsea until 1914 and later at Parkstone, Dorset, he was elected ARA in 1925 and RA in 1936. He died on 13 September 1939.

Illus: *The Lost Princess [G. Macdonald, 1895]; Stories From The Faerie Queen [Mary Macleod, 1897]; The Book of King Arthur [Mary Macleod, 1900].*
Exhib: G; L; RA; RI; RMS; ROI; RSA.
Bibl: R.E.D. Sketchley, *Eng. Bk. Illus.*, 1903, pp.116,172.

WALKER, E.J. **fl.1878-1886**

Domestic painter. He worked at Liverpool, 1878-79 and then at Regents Park, London. He contributed to *The Illustrated London News*, 1886, Christmas Number.
Exhib: L.

WALKER, Francis S. RHA **1848-1916**

Landscape and genre painter, illustrator of social scenes and engraver. He was born in County Meath in 1848 and studied art at the Royal Dublin Society and at the RHA Schools. He obtained a scholarship there to study in London and came in 1868 to begin work with the Dalziel Brothers. He began to work for *The Graphic* in 1870 and *The Illustrated London News* in 1875. He was elected ARHA in 1878, RHA in 1879 and RE in 1897. He worked chiefly in North London and died at Mill Hill on 17 April 1916.

Illus: *Westminster [Walter Besant, 1897 (with others)].*
Contrib: *Cassell's Family Magazine [1868]; Good Words [1869]; The Sunday Magazine [1869]; Good Words For The Young [1869-72]; The Nobility of Life [1869]; London Society [1870]; Dalziel's Bible Gallery [1880]; Fun.*
Exhib: B; G; L; M; RA; RE; RHA; RI; ROI.
Colls: Witt Photo.

WALKER, Frederick ARA **1840-1875**

Painter and illustrator. He was born in Marylebone on 24 May 1840 and began to study art at the British Museum before being apprenticed to an architect named Baker. He returned to the Museum after leaving the architect, sketched the Greek sculpture and attended Leigh's Life School in Newman Street. He attended the RA Schools and then went, in 1858, to work for J.W. Whymper (q.v.) who taught him to draw on the wood, where he met J.W. North (q.v.). He began to draw for the magazines in 1860 and that year through the influence of Thackeray (q.v.), he started to work for *The Cornhill Magazine*. It was the latter's admission of failure in illustrating his own story that gave Walker a wider public through its pages in 1862. In some ways Walker's art was an inheritance from Millais, but it was also an inheritance from his studies of sculpture and his studies of nature. All his illustrations whether contemporary in subject or costume pieces show a familiarity with the figure and with movement that is outstanding. Although his name is usually linked with George Pinwell (q.v.) their acquaintanceship was slight, and Walker is more of a narrative painter than either Pinwell or North with whom he was sketching, 1868. Walker visited Paris in 1867, Venice in 1868 and 1870 and visited the Highlands with Richard Ansdell, RA (q.v.). From book illustration Walker stepped into watercolours, proving himself an exquisite colourist and with a superb eye for detail. Such paintings as 'The Harbour of Refuge' show the second mood of Pre-Raphaelitism in the 1870s with an increased naturalism. Walker's failing health caused him to winter in Algiers in 1873-74 but he returned to this country and died at St Fillan's, Perthshire on 5 June 1875. He was elected AOWS in 1864, OWS in 1866 and ARA in 1871.

Contrib: *Everybody's Journal [1860]; Leisure House [1860]; Tom Cringle's Log [1861]; The Twins and Their Stepmother [1861]; Hard Times, Reprinted Pieces [Charles Dickens, 1861]; Good Words [1861-64]; The Cornhill Magazine [1861-66]; London Society [1862]; Willmott's Sacred Poetry [1862]; The Cornhill Gallery [1864]; English Sacred Poetry [1864]; Punch [1865, 1869]; A Round of Days [1866]; Ingoldsby Legends [Barham, 1866]; Touches of Nature by Eminent Artists [1866]; Wayside Poesies [1867]; Story of Elizabeth [1867]; Village on the Cliff [1867]; The Graphic [1869]; A Daughter of Heth [1872]; ILN [1875]; Thornbury's Legendary Ballads [1876].*
Exhib: OWS; RA.
Colls: Ashmolean; BM; Fitzwilliam; Manchester; V & AM; Witt Photo.
Bibl: J. Comyns Carr, *FW An Essay*, 1885; Claude Phillips, *The Portfolio*, June 1894; J.G. Marks, *Life and Letters of FW, RA*, 1896; The Brothers Dalziel, *A Record of Work*, 1840-90, 1901, pp.193-205; Gleeson White, *English Illustration*, 1906 pp.165-166; Forrest Reid, *Illustrators of the Sixties*, 1928 pp.134-152.

See illustration (p.489).

Drawn by F. Walker.] [Engraved by J. Swain.

"IN THE NOVEMBER NIGHT."

Oswald Cray, page 371.

FREDERICK WALKER ARA 1840-1875. 'In The November Night'. An illustration to the story Oswald Cray, *in* Good Words, *1864. Wood engraving.*

WALKER, Jessica (Mrs. Stephens) **fl.1904-1932**
Painter, illustrator and writer. She was born in Arizona, USA and studied at the Liverpool School, winning the travelling scholarship to Italy and studying in Paris and Florence. She was for some years art critic of *The Studio.*
Contrib: *Women and Roses [Browning, 1905].*
Exhib: L; M; RCA.

WALKER, John
Topographer and illustrator. He is probably the same artist as the J. Walker exhibiting at the RA, 1796 to 1800.
Contrib: *The Copper Plate Magazine [1792-1802].*

WALKER, Marcella **fl.1872-1917**
Flower painter and illustrator. She worked at Haverstock Hill and contributed genre subjects to the magazines.
Contrib: *ILN [1885-94, 1903]; The Girl's Own Paper.*
Exhib: L; M; RA; RHA.

WALKER, T. Dart
Marine artist. He contributed illustrations of ships to *The Illustrated London News*, 1899.

WALKER, W.H. **fl.1906-1926**
Watercolourist and illustrator. He worked in pen with fresh colours in the style of Rackham and illustrated *Alice's Adventures in Wonderland* for Messrs Lane, in 1908. He was a member of the family who ran Walker's Galleries.
Exhib: L; RA.

WALL, A.J. **fl.1889-1897**
Illustrator specialising in animals and birds. He worked at Stratford-upon-Avon, but probably visited Australia in 1889-90 when he worked for *The Illustrated London News*.
Contrib: *The Sporting and Dramatic News [1891]; The Boy's Own Paper; The English Illustrated Magazine [1896-97].*
Exhib: B.

WALL, Tony
Figure artist. He contributed to *Punch*, 1902.

WALLACE, Robert Bruce **-1893**
Figure artist in watercolour and illustrator. He lived and worked in Manchester and assisted Ford Madox Brown (q.v.) with his Manchester frescoes. His illustrative work began with *Punch*, where he made contributions from 1875-78 after an introduction from Swain. He hoped to succeed Miss G. Bowers (q.v.) on the paper but when he failed to do so, he concentrated on serious illustration elsewhere. He was Secretary of the Manchester Academy of Fine Arts, a friend of Frederick Shields (q.v.) and died at Manchester in 1893.
Illus: *The Adventures of Phillip [W.M. Thackeray]; Catherine [W.M. Thackeray, Cheap Illustrated Edition, 1894].*
Contrib: *ILN [1898].*
Exhib: M; RBA.

WALLACE-DUNLOP See DUNLOP, Marion W.

WALLER, Pickford R. **1873-1927**
Amateur illustrator and decorator. He worked in Pimlico, was a friend of J. McNeil Whistler (q.v.) and patronised many artists including S.H. Sime (q.v.). He practised the decoration of manuscript and extra illustrated books with his own initial letters. His sketchbooks, including some designs for Guthrie's Pear Tree Press, were sold at Sotheby's in April and November 1976.
Illus: *Songs and Verses by Edmund Waller [Pear Tree Press, 1902].*
Contrib: *The Studio [Vol.8, 1896 pp.252-253 illus.].*

WALLER, Samuel Edmund **1850-1903**
Genre and animal painter and illustrator. He was born at Gloucester on 16 June 1850 and studied with the Gloucester artist John Kemp. He was educated at Cheltenham and went to the RA Schools in 1869, beginning regular work for the magazines from about 1874. Waller was a good painter of horses and developed a style of sentimental genre picture in which they were usually involved, but he also made

zoological studies and painted landscapes. He married the portrait painter, Mary Lemon Waller, and was elected ROI in 1883. He died at Haverstock Hill on 9 June 1903.

Publ: *Six Week's in the Saddle; Sebastian's Secret.*
Illus: *Strange Adventures of a Phaeton [William Black, 1874].*
Contrib: *The Graphic [1874-81]; ILN [1895]; The Sporting and Dramatic News [1899].*
Exhib: B; FAS; G; L; M; RA; ROI.
Colls: Tate; Witt Photo.

WALLIS, Henry RWS 1830-1916

Landscape and history painter and writer. He was born in London on 21 February 1830 and studied at Cary's Academy and then in Paris and at the RA Schools. He came under the influence of the Pre-Raphaelites at an early date and painted 'The Death of Chatterton', 1856 and 'The Stone-breaker'. His first flush of youthful talent did not last and he is included here for the academic illustrations that he made for his own books on ceramics. He was elected ARWS in 1878 and RWS in 1880. He died at Sutton, Surrey in December 1916.

Illus: *Egyptian Ceramic Art [1898]; Persian Lustre Vases [1899]; Nicola da Urbino at the Correr Museum [1905]; The Oriental Influence on Italian Ceramic Art [1900].*
Exhib: BI; G; L; M; RA; RBA; New Gall; RWS.
Colls: Birmingham; Tate; V & AM.
Bibl: J. Maas, *Victorian Painters,* 1970 pp.132-133 illus.

WALSH, Captain Thomas

Army officer and amateur artist. He illustrated *Journal of the Late Campaign in Egypt,* 1803, AT 266.

WALSHE, J.C. fl.1889-1909

Genre painter and illustrator. He worked in Birmingham and contributed figure drawings to *Punch,* 1903-9, specialising in strong interiors.

Exhib: B.

WALTERS, Thomas fl.1856-1875

Domestic painter and illustrator. He worked in London and contributed to *Punch,* 1867-75.

Exhib: BI; RA; RBA.

WALTON, Edward Arthur RSA 1860-1922

Landscape painter and genre artist. He was born in Glanderstone, Renfrewshire on 15 April 1860 and studied at the Glasgow School of Art and in Düsseldorf. He lived in London after 1894 but returned to Edinburgh in 1904. He was elected ARSA in 1889, RSA in 1905 and was President of the Royal Scottish Society of Painters in Watercolours, 1915. He died in Edinburgh on 18 March 1922.

Contrib: *The Yellow Book [1895-97].*
Exhib: G; L; M; NEA; New Gall; P; RA; RI; RSA; RSW; RWS.
Colls: Dundee; Glasgow; Leeds.

WALTON, Elijah 1833-1880

Landscape and genre painter in watercolour and illustrator. He was born at Birmingham in 1833 and studied in Birmingham and at the RA Schools. He visited Switzerland and Egypt in 1860-62 and spent much of his time on the Continent or travelling in the Near East in the succeeding years. He is at his best when drawing mountainous landscape. He died at Bromsgrove in 1880. Fellow, Royal Geographical Society.

Publ: *The Camel its Anatomy, Proportions and Paces [1865]; Clouds and their Combinations [1869]; Peaks in Pen and Pencil [1872].*
Illus: *The Peaks and Valleys of the Alps [T.G. Bonney, 1867]; Flowers from the Upper Alps [T.G. Bonney, 1869]; The Coast of Norway [T.G. Bonney, 1871].*
Exhib: BI; RA; RBA.
Colls: BM; Birmingham.

WALTON, George

Topographer. He contributed a view of Lichfield to *The Copper Plate Magazine,* 1792-1802.

WALTON, T.

Contributor to *The Illustrated London News,* 1860.

WARD, Charles D. 1872-

Landscape and portrait painter and illustrator. He was born at Taunton on 19 June 1872 and studied at the RCA. He married the portrait painter Charlotte Blakenay Ward and was elected ROI in 1915.

Contrib: *The Temple Magazine [1896-97]; The English Illustrated Magazine [1900-1].*
Exhib: D; G; L; NEA; RA; RBA; RI; ROI; RWA.
Colls: V & AM.

WARD, Edward Matthew RA 1816-1879

Historical painter. He was born in Pimlico in 1816 and studied at the RA Schools and in Rome. He carried out extensive decorations for the new Houses of Parliament and was elected ARA in 1847 and RA in 1855. He was the father of Sir Leslie Ward (q.v.) and died at Slough in 1879.

Contrib: *The Traveller [Goldsmith, Art Union of London, 1851].*
Exhib: BI; NWS; RA; RBA.
Colls: BM; Witt Photo.

WARD, Enoch fl.1891-1921

Landscape and figure painter. He worked in the London area, was RBA 1898, and contributed genre subjects including social realism to the magazines.

Contrib: *ILN [1891]; Black & White [1891]; The Queen [1892]; The Ludgate Monthly [1897]; The Pall Mall Magazine.*
Exhib: RA; RBA; RI.

WARD, Colonel Francis Swain c.1734-1805

Army officer and artist. He had two periods of service in India and retired as lieutenant-colonel in 1787. He died at Negapatam in 1805. Fellow of the Society of Antiquaries.

Contrib: *Twenty-Four Views in Hindustan [1805].*
Exhib: Society of Artists.

WARD, Sir Leslie Matthew 'Spy' 1851-1922

Portrait painter and caricaturist. He was born in London on 21 November 1851, the eldest son of E.M. Ward RA and the grandson of James Ward RA. He was educated at Eton and studied architecture with Sydney Smirke RA and at the RA Schools. He made caricature contributions to *The Graphic* from 1874, but is best remembered as the under-study and successor to Carlo Pellegrini (q.v.) on Vanity Fair, 1873-1909. Ward was the first English artist to develop the portrait chargé, but in a much gentler style than his predecessor. His likenesses are accurate and lively if lacking in insight, the watercolours are usually mixed with bodycolour and are often found on dove grey papers. Ward was a very popular artist and his range of characters from the turf, the army, the church, the stage and high life decorated the walls of many an Edwardian home. He was elected RP in 1891 and knighted in 1918. He died in London on 15 May 1922. Signs: *Spy*

Contrib: *Cassells Family Magazine.*
Exhib: G; P; RA; RE.
Colls: BM; Liverpool; NPG; V & AM; Garrick Club; Witt Photo.
Bibl: Leslie Ward, *Fifty Years of Spy,* c.1915; E. Harris & R. Ormond, *Vanity Fair,* NPG Cat. 1976.
See illustrations (p.491).

WARD, Martin Theodore 1799-1874

Animal painter. He was born in London in 1799, the son of William Ward and a pupil of Landseer. He worked in London at first and then in about 1840, moved to Yorkshire, dying there in poverty in 1874.

Contrib: *The Annals of Sporting [1826].*
Exhib: BI; RA; RBA.
Colls: Witt Photo.

but gradually turned his attention exclusively to watercolour, being elected NWS in 1835. He made many illustrations for the albums and annuals particularly those of a Spanish or Shakespearean flavour. He was also a musician and lithographer and was President of the NWS from 1839-73. He died in London in 1879.

Publ: Hints upon Tints [1833]; On the Fine Arts [1849]; Artistic Anatomy [1852]; Painting in Watercolours [1856]; Warren's Drawing Book [1867]; A Text Book of Art Studies [1870]; A Treatise on Figure Drawing [1871]; Half-hour Lectures on Drawing and Painting [1874].
Illus: Sketches in Norway and Sweden [Rev. A. Smith, 1847].
Contrib: The Book of British Ballads [S.C. Hall, 1842]; The Book of Common Prayer [1845]; ILN [1848]; Lays of the Holy Land [1858]; The Welcome Guest [1860]; A Winters Tale; Lockhart's Spanish Ballads; Wordsworth's Pastoral Poems; Moore's Paradise and the Peri; The Children's Picture Book of Scripture Parables [1861].
Exhib: BI; NWS; RA; RBA.
Colls: BM; V & AM; Witt Photo.

WARRY, Daniel Robert fl.1855-1913
Architect and illustrator. He worked at Lewisham and Eltham and specialised in architectural and antiquarian drawings.

Contrib: The Graphic [1881-82, 1884].
Exhib: RA.

SIR LESLIE WARD 'SPY' 1851-1922. Caricature portrait of the writer and traveller, A.G. Hales, Original drawing for Vanity Fair. *Watercolour. Signed. 21¼ins. x 15ins. (54cm x 38.1cm).* Author's Collection

WARDLE, Arthur 1864-1949
Animal painter. He worked in London, where he was born and was elected RI in 1922. A painting of his was purchased by the Chantrey Bequest in 1904. He died in 1949.

Contrib: The Queen.
Exhib: B; FAS; G; L; M; RA; RBA; RHA; RI; ROI; RSA; RSW.

WARING, John Burley 1823-1875
Landscape painter, watercolourist and architect. He was born at Lyme Regis on 29 June 1823 the son of a naval officer and was apprenticed to an architect and studied with Samuel Jackson. He travelled to Italy and wrote his autobiography, he died at Hastings on 23 March 1875.

Illus: Architectural Art in Italy and Spain [1850, AT 42]; Studies in Burgos [1852, AT 157].
Exhib: RA.
Colls; V & AM.

WARREN, Henry PNWS 1794-1879
Landscape and genre painter and illustrator. He was born in London on 24 September 1794 and studied under Joseph Nollekens, the sculptor, and at the RA Schools, 1818. Warren began as an oil painter

SIR LESLIE WARD 'SPY' 1851-1922. Caricature portrait of A.G. Hales, as reproduced in Vanity Fair.

WATERS, David B. fl.1887-1910

Marine painter. He acted as Special Artist to the Fleet for *The Graphic*, in 1910. He worked in Edinburgh and London.

Contrib: *The Graphic [1901-10]; Punch [1906-7].*
Exhib: RA; RSA.

WATERFORD, Louise, Marchioness of 1818-1891

Watercolourist and sculptress. She was born in Paris in 1818, the second daughter of Lord Stuart de Rothesay and inherited from him Highcliffe Castle in Hampshire. She married the 3rd Marquess of Waterford in 1841 and lived at Curraghmore in Ireland, becoming a friend and correspondent of John Ruskin (q.v.), Burne-Jones (q.v.) and G.F. Watts. She died at Ford Castle, Northumberland on 12 May 1891.

Contrib: *Story of Two Noble Lives [Augustus J.C. Hare].*
Exhib: G; M; RHA; SWA.
Colls: V & AM; Tate; Witt Photo.

WATERSON, David RE 1870-1954

Painter, etcher and engraver. He was born in 1870 and was elected ARE in 1901 and RE in 1910. He worked in Brechin, Scotland and undertook some illustration. He died on 12 April 1954.

Exhib: L; RE; RSA; RWA.
Bibl: *The Studio*, Vol.34, 1905 pp.346-348 illus.

WATHEN, James c.1751-1828

Traveller and topographer. He was born at Hereford in about 1751 where he was a glover. He became famous as a pedestrian traveller under the name of 'Jemmy Sketch', making tours of Britain and Ireland from 1787. Wathen travelled to Italy to visit Byron in 1816 and made a tour of the East in 1811; he visited Heligoland in 1827. He died in Hereford in 1828.

Illus: *Journal of a Voyage to Madras and China [1814, AT 517]; Views Illustrative of the Island of St Helena [1821, AT 314].*
Contrib: *The Copper Plate Magazine [n.d.].*
Exhib: RA.
Colls: Witt Photo.

WATKINS, Frank fl.1859-1894

Architectural illustrator. He was working at Feltham, 1875-76 and at Maida Hill, London, in 1890. He worked principally for *The Illustrated London News*, beginning in 1859, contributing in 1875, but featuring continously from 1884-94.

Exhib: M; RHA.

WATSON, Edward Facon fl.1830-1864

Topographical and landscape painter. He was probably a pupil of J. Barber and collaborated with Cox in illustrating *Wanderings in Wales* by Radclyffe.

Exhib: RBA.

WATSON, Harry 1871-1936

Landscape and figure painter. He was born in Scarborough on 13 June 1871 and was educated at Scarborough and in Winnipeg. He studied at the Scarborough School of Art, the RCA and at the Lambeth School of Art. He was Life master at the Regent Street Polytechnic Art School and was elected ARWS in 1915 and RWS in 1920. He became ROI in 1932 and died in London on 17 September 1936.

Publ: *Figure Drawing [1930].*
Contrib: *The Lady's Pictorial [1895]; The English Illustrated Magazine [1899].*
Exhib: B; G; GG; L; M; NEA; RA; RBA; RI; ROI; RSA; RSW; RWS; RWA.
Colls: Maidstone; Tate; V & AM.

WATSON, John Dawson 1832-1892

Figure painter in oils and watercolour and illustrator. He was born at Sedbergh on 20 May 1832 and entered the Manchester School of Art in 1847. He attended the RA Schools in 1851 and returned to Manchester in 1852 where he exhibited at the Institution and made friends with Ford Madox Brown, 1856. He eventually left the North-West for London in 1860 and at once succeeded in obtaining important commissions particularly the illustrating of *Pilgrim's Progress* for Messrs Routledge in 1861. Watson began to do work for the magazines and became one of the most popular of the 1860s illustrators with his dependable black and white figure work. He was clearly influenced by the Pre-Raphaelites and by the work of J.E. Millais (q.v.) in particular. His strongest subjects are those of rustic genre, where good penwork make up for his occasional lack of fire, his religious and historical drawings can be rather stiff. Watson's best work was done before 1865, after this he experimented more as a colourist and took up oil painting more vigorously. This move followed his election to the OWS in 1864 and full membership in 1869 and may be connected to his sister's marriage to Birket Foster (q.v.). He designed furniture and costumes for a production of Henry V at Manchester in 1872. He was elected RBA in 1882 and died at Conway, North Wales on 3 January 1892.

Watson's early illustrations and drawings are usually signed with one or other of his two monograms, the later work simply by his initials. A representative exhibition of his work was shown at Manchester in 1877. Signs: [monogram] [monogram] JDW

Illus: *Pilgrim's Progress [1861]; Eliza Cook's Poems [1861]; The Golden Thread [Dr. Norman Macleod, 1861]; Bennetts Poems [1862]; The Golden Harp [1864]; Robinson Crusoe [1864]; Old Friends and New [1867]; Wild Cat Tower [1877]; Princess Althea [1883].*
Contrib: *Once a Week [1861]; Good Words [1861-63]; ILN [1861, 1872]; London Society [1862-67]; Willmott's Sacred Poetry [1862]; The Churchman's Family Magazine [1863]; The British Workman [1863]; The Arabian Nights [1863]; English Sacred Poetry of the Olden Time [1864]; Our Life Illustrated by Pen and Pencil [1865]; The Shilling Magazine [1865]; A Round of Days [1866]; Legends and Lyrics [1866]; Ellen Montgomery's Bookshelf [1866]; Ballad Stories of the Affections [1866]; Foxe's Book of Martyrs [1866]; The Sunday Magazine [1867]; Touches of Nature by Eminent Artists [1867]; The Savage Club Papers [1867]; The Illustrated Book of Sacred Poems [1867]; Cassell's Illustrated Readings [1867]; Cassell's Magazine [1868-69]; Tinsley's Magazine [1868-69]; The Nobility of Life [1869]; Pictures From English Literature [1870]; The Graphic [1870-77]; Leslie's Musical Annual [1870]; The Quiver [1873]; People's Magazine [1873]; Thornbury's Legendary Ballads [1876].*
Exhib: BI; G; GG; L; M; RA; RBA; RCA; RWS.
Colls: Bedford; Manchester; Newcastle; V & AM; Worcester; Witt Photo.
Bibl: Chatto & Jackson, *Treatise on Wood Engraving*, 1861 p.600; The Brothers Dalziel, *A Record of Work 1840-1890*, pp.170-174; Forrest Reid, *Illustrators of the Sixties*, 1928 pp.166-171 illus.

WATT, T.

Illustrator and decorator supplying the head-pieces and initials to *The Pilgrim's Progress and The Holy War, Illuminated*, Lumsden Edition, c.1850.

WATTS, Arthur George 1883-1935

Artist and caricaturist. He was born in 1883 and was educated at Dulwich College and studied at Antwerp, Paris and the Slade School. He served in the First World War with the RNVR and won the DSO in 1918. He was a regular pen and ink contributor to the humorous magazines. He died on 20 July 1935. ARBA, 1923.

Contrib: *Punch; Life.*
Exhib: FAS; RA; RBA.
Colls: V & AM; Witt Photo.

WATTS, Louisa Margaret fl.1890-d.1914
(Mrs. J.T. Watts nee Hughes)

Landscape painter. She worked in Liverpool and London and married James Thomas Watts, the Birmingham painter. She contributed an illustration to *The Quarto*, 1896, in a slight woodcut style.

Exhib: B; L; M; RA; RCA; RI; ROI; SWA.

WATTS, William 1752-1851

Topographer and engraver. He was born at Moorfields in 1752 and studied with Paul Sandby and Edward Rooker. He took over the publication of the latter's *Copper Plate Magazine* and during the years 1779 to 1788, issued one of the finest series of topographical views *Views of The Seats of the English Nobility and Gentry*. He lived in Camarthen, Bath and Bristol at various times and was in Paris during the Revolution. He eventually retired to Cobham and died there on 7 December 1851.

Contrib: *The Copper Plate Magazine [1792-1802]; Britton's Beauties of England and Wales [1802].*
Colls: Witt Photo.

WAUGH, F.J. fl.1894-1906

Landscape painter. He worked in Sark, 1894 and London from 1899 and probably visited South Africa from 1901-4 where he contributed views of the Transvaal to *The Graphic*.

Exhib: L; RA.

WAUGH, Ida

Illustrator. She provided the drawings for *Twenty Little Maidens*, a child's book by Blanchard, 1894.

WAY, Thomas Robert 1861-1913

Landscape and portrait painter and lithographer. He worked in London and was a significant figure in the revival of lithography in Britain. He taught the medium to J. McNeil Whistler in 1878 and the artist became his intimate friend, working with Way on the printing of the Venice etchings for the Fine Art Society's exhibition in 1880. He was a regular exhibitor at London exhibitions and died there in 1913.

Publ: *The Art of James McNeil Whistler [1903]*.
Illus: *Reliques of Old London [H.B. Wheatley FSA, 1896]*.
Exhib: L; NEA; RA; RBA; RI; ROI.
Bibl: *The Studio*, Vol.34, 1905 pp.317-323 illus; E.R. and J. Pennell, *The Life of James McNeil Whistler*, 1908 p.157.

WAYLETT, F. fl.1895-1898

Painter and illustrator. He worked in Hampstead and contributed to *The Sketch*, 1898.

Exhib: NEA.

WEBB, Ernest fl.1907-1940

Sculptor and illustrator. He was working at Nottingham in 1923 and in London from 1927.

Contrib: *Punch [1906-7]*.
Exhib: G; L; RA.

WEBB, Harry George 1882-1914

Landscape painter, etcher and book decorator. He worked in London and specialised in architectural drawings and decorated *The Acorn*, 1905-6.

Exhib: L; M; RA; RBA; RE; ROI.

WEBB, John fl.1805-1816

Topographer. He contributed a view of Herefordshire to *Britton's Beauties of England and Wales*, 1805.

Exhib: RA, 1816.

WEBB, William J. fl.1853-1882

Animal and genre painter and illustrator. He studied in Düsseldorf and then worked at Niton, Isle of Wight, 1855-60, London, 1861-64 and Manchester, 1882. His work for magazines was mainly topography and travel, some influenced by the Pre-Raphaelites.

Illus: *The Great Hoggarty Diamond [Cheap Illustrated Edition, 1894]*.
Contrib: *ILN [1872-1874]*.
Exhib: BI; M; RA; RBA; Witt Photo.

WEBER, H.

Topographer. He contributed illustrations to *The Border Antiquities of England and Scotland*, Walter Scott, 1814-17. He may be synonymous with 'H. Webber' who exhibited scriptural subjects at the BI in 1830.

WEBSTER, George fl.1797-1832

Marine painter. He was based in London but travelled to Holland before 1816 and to Tripoli and the Gold Coast.

Publ: *Views of Various Sea-Ports [1831]*.
Exhib: BI; RA; RBA.
Colls: BM; V & AM.

WEBSTER, Thomas **RA** 1800-1886

Genre painter. He was born in London on 20 March 1800 and was a chorister of St George's Chapel, Windsor. He entered the RA Schools in 1821 and made a speciality of children or as Chatto puts it 'Infantine Subjects'. The most famous of these is 'The Village Choir' and this and similar paintings were popularised by engravings. He was elected ARA in 1840 and RA in 1846. He died at Cranbrook on 23 September 1886.

Contrib: *The Deserted Village [Junior Etching Club, 1841]; Book of British Ballads [S.C. Hall, 1842]; Favourite English Poems [1859]*.
Exhib: BI; RA; RBA.
Colls: Bury; Preston; V & AM; Witt Photo.
Bibl: Chatto & Jackson, *Treatise on Wood Engraving*, 1861 p.599.

WEBSTER, Tom fl.1900-1930

Designer of music title covers, c.1900. Cartoonist for *The Daily Mail*.

WEEDON, E. fl.1848-1872

Marine painter and illustrator. This artist of whom nothing is known, was chief marine illustrator for *The Illustrated London News* from 1848-72. His work could be classified as ship portraiture and is usually accurate and spirited. He may be a relation of A.W. Weedon 1838-1908, the landscape painter.

Exhib: RA, 1850.

WEEDON, J.F.

Illustrator of sporting subjects. He contributed to *The Graphic*, 1888.

WEEKES, William fl.1856-1909

Animal and genre painter. He was the son of Henry Weekes 1807-1877, the sculptor. He lived at Primrose Hill, London and was a regular exhibitor.

Contrib: *ILN [1883]*.
Exhib: B; FAS; G; GG; L; M; RA; RBA; ROI.

WEGUELIN, John Reinhard **RWS** 1849-1927

Painter and illustrator. He was born at South Stoke, Sussex on 23 June 1849, the son of a clergyman and was educated at Cardinal Newman's Oratory School, Edgbaston. He became a Lloyd's underwriter, 1870-73 and then entered the Slade School, where he studied under Poynter (q.v.) and Legros. He was a Victorian classicist and painted in the style of Alma-Tadema (q.v.), illustrating many books. He was elected ROI in 1888, ARWS in 1894 and RWS in 1897. He had worked in Sussex from 1900 and died at Hastings on 28 April 1927.

Illus: *Lays of Ancient Rome [Macaulay, 1881]; The Cat of Bubastes, A Tale of Ancient Egypt [G.A. Henty, 1889]; Anacreon [1892]; The Little Mermaid [Hans Andersen, 1893]; Catullus [1893]; The Wooing of Malkatoon [1898]*.
Contrib: *The Graphic [1888-1906]*.
Exhib: B; FAS; G; GG; L; M; New Gall; RA; RBA; RHA; ROI; RWS.
Bibl: R.E.D. Sketchley, *Eng. Bk. Illus.*, 1903 pp.29, 131; *The Connoisseur*, Vol.78, 1927.

WEHNERT, Edward Henry 1813-1868

Historical painter and illustrator. He was born in London in 1813, the son of a German tailor and was educated at Göttingen. He returned to England in 1837 after working in Paris and Jersey and settled in London where he made historical paintings and book illustrations. He was elected NWS in 1837 and was a competitor in the Westminster Hall Competition of 1845. Wehnert's art was strongly linear and Chatto describes it as 'essentially German'. He is known to have made one visit to Italy in 1858. He died at Kentish Town on 15 September 1868.

Illus: *History of the British Nation [Hutchinson, c.1835]; Grimm's Household Stories [1853]; Poe's Works [1853]; Longfellow's Poems [1854]; Eve of St Agnes [J. Keats, 1856]; Ancient Mariner [1856]; The Pilgrim's Progress [John Bunyan, 1858]; Grimm's Tales [1861]; Fairy Tales [Hans Andersen, 1861]; Robinson Crusoe [D. Defoe, 1862]*.
Contrib: *Art Union Annual [1845]; ILN [1848-49]; The Traveller [Art Union, 1851]; The Churchman's Family Magazine [1863]; Aunt Judy's Magazine*.
Exhib: BI; NWS; RA; RBA.
Colls: V & AM; Witt Photo.
Bibl: Chatto & Jackson *Treatise on Wood Engraving*, 1861 p.594.

WEHRSCHMIDT, Daniel Albert later Veresmith **1861-1932**

Portrait painter, engraver and lithographer. He was born at Cleveland, Ohio, USA on 24 November 1861 and studied at the Herkomer School, Bushey, Herts. He was Art Master at the Herkomer for 12 years, 1884-96, and was elected RP in 1915. He later lived at Doneraile, Co. Cork, 1921 and North Curry, Somerset, from 1927. He died on 22 February 1932.

Contrib: *The Graphic [1891].* (Illustrations for Hardy's *Tess.*)
Exhib: B; FAS; G; L; M; New Gall; P; RA; RHA; RSA.

WEIGALL, Charles Harvey NWS **1794-1877**

Landscape and genre painter and illustrator. He was born in 1794 and was elected a member of the NWS in 1834 and was Treasurer of the Society from 1839-41. Weigall was interested in technique and wrote a number of exemplars, also modelling in wax and making intaglio gems. He was a proficient draughtsman of animals and birds. He died in 1877.

Publ: *The Art of Figure Drawing [1852]; A Manual of the First Principles of Drawing, with Rudiments of Perspective [1853]; The Projection of Shadows [1856]; Guide to Animal Drawing [1862].*
Illus: *Juvenile Verse and Picture Book [1848].*
Contrib: *ILN [1844-50]; The Illustrated London Magazine [1853]; The Graphic [1873].*
Exhib: NWS; RA; RBA.
Colls: BM; Nat. Gall., Ireland; V & AM; Witt Photo.

WEIR, Harrison William **1824-1906**

Animal painter and illustrator. He was born at Lewes, Sussex on 5 May 1824 and was educated at Camberwell before learning colour-printing under George Baxter. He preferred painting and from an early date devoted all his time to studies of birds and animals. Weir was an independant minded artist with an amazing capacity for work; he started to draw for *The Illustrated London News* in 1847 and was still working for them at the turn of the century, their longest serving artist. He was elected ANWS in 1849 and NWS in 1851, but retired in 1870 because he preferred working on commission. He numbered among his friends Charles Darwin and among his hobbies pigeon fancying and natural history; a further link with the animal painters was provided by his marriage to the daughter of J.F. Herring (q.v.). Weir is characterised by an extraordinary accuracy and life in his drawings, his poultry live in the farmyard and his birds in the wild, rare among Victorians. He designed some race cups for Messrs Garrard and among his less successful ventures were sentimental fancy pictures of cats and dogs which may have influenced Louis Wain. He died at Poplar Hall, Appledore, Kent on 3 January 1906.

Illus: *Domestic Pets [Mrs Loudon, 1851]; Cat and Dog Memories of Puss and Captain [1854]; The Farmer's Boy [Bloomfield, 1857]; Wild Sports of the World [J. Greenwood, 1862]; The History of the Robins [Mrs Trimmer, 1868]; Animals and Birds [1868]; The Tiny Natural Histories [1880]; Our Cats and All About Them [1889]; Sable and White [Stables, 1894]; Shireen [Stables, 1894]; Poultry and All About Them [1903]; Animal Stories Old and New; Bird Stories Old and New.*
Contrib: *ILN [1847-1900]; The Poetical Works of E.A. Poe [1853]; Punch [1854]; Poets of the Nineteenth Century [Willmott, 1857]; Gertrude of Wyoming [Scott, 1857]; Dramatic Scenes [Cornwall, 1857]; The Home Affections [Mackay, 1858]; Comus [1858]; Montgomery's Poems [1860]; The Welcome Guest [1860]; The Illustrated Times [1860]; Sacred Poetry [1862]; Parables From Nature [1867]; Episodes of Fiction [1870]; The British Workman; The Band of Hope Review; Chatterbox [1880]; Wood's Natural History; The Field; Black & White; The Poultry and Stock Keeper; The English Illustrated Magazine [1887].*
Exhib: BI; NWS; RA; RBA.
Colls: V & AM; Witt Photo.
Bibl: Chatto & Jackson, *Treatise on Wood Engraving,* 1861 p.553; *AJ,* 1906.

WEIRD, R. Jasper

Probably a pseudonym of a figure artist contributing comic groups and animals to *Punch,* 1906.

WEIRTER, Louis **1873-1932**

Artist, lithographer and illustrator. He was born in Edinburgh in 1873, the son of a Professor of Music and was apprenticed to a lithographer while studying at the RSA and the Board of Manufacturers Schools.

He was elected RBA in 1902 and worked in London, 1907 and Baldock, 1914, specialising in pictures of current events, the Diamond Jubilee and the War in the Air, 1914-18. He died 12 January 1932. He signs his paintings 'Louis Weirter' and his etchings 'Louis Whirter'.

Illus: *The Story of Edinburgh Castle; Stories and Legends of the Danube.*
Contrib: *The Evergreen.*
Exhib: RA; RBA; RSA.
Colls: V & AM.

WELLS

Topographer. Contributed drawings for *Knight's London,* 1841.

WELLS, Joseph Robert **fl.1872-1895**

Marine artist. He was the principal marine artist of *The Illustrated London News* from 1873 to 1883, specialising in ship portraits. After this date he contributed occasional drawings till 1895, the figures usually by C.J. Staniland (q.v.).

Contrib: *The English Illustrated Magazine [1885].*
Exhib: B; G; L; M; RA; RBA; RI; ROI.

WELLS, Reginald Fairfax **1877-1951**

Sculptor and potter. He was born in Brazil in 1877 and studied at the RCA and under E. Lantieri. He was employed in the Chelsea Manufactory and acted as designer for Messrs Coldrum & Sons Pottery. He died in 1951.

Contrib: *The Sketch [1898].*
Exhib: FAS; G; GG; L; RSA; RA.
Colls: V & AM.

WEST, J.B. **fl.1804-1828**

Landscape painter and caricaturist. He published in 1804, *Design for Imperial Crown to be used at Coronation of the New Emperor.*

WEST, J.C.

Topographer. He contributed to *Griffiths' Cheltenham,* 1826.

WEST, Joseph Walter RWS **1860-1933**

Landscape and genre artist, illustrator and bookplate designer. He was born in Hull in 1860 and educated at Bootham School, York, by the Quakers and at the St Johns Wood and the RA Schools. He later studied in Paris and Italy and became proficient in many other mediums including tempera and lithography and practised mural painting. He used his Quaker background for many of his genre paintings, his illustrating is usually romatic. He was elected RBA in 1893, ANWS in 1901 and RWS in 1904. He worked at Northwood from 1902 and died there on 27 June 1933.

Illus: *Tryphena in Love [Walter Raymond, 1895]; Rosemary For Remembrance [Mary Brotherton, 1896 (title & cover); Ballads in Prose [Nora Hopper, 1896 (title & cover)]; Virgil's Georgics [frontis].*
Contrib: *The English Illustrated Magazine [1887]; The Pall Mall Magazine.*
Exhib: B; FAS; G; L; M; New Gall; RA; RBA; RHA; RSW; RWS.
Colls: Hull; Tate; V & AM.
Bibl: *The Studio,* Winter No., 1900-1 pp.87-100 illus; Vol.37, 1906 pp.158-159 illus; Vol.40, 1907 pp.87-100 illus; *Pearson's Magazine,* 1907.

WEST, Maud Astley **fl.1880-1916**

Flower painter. She was a student of the Bloomsbury School of Art and worked in London and Tunbridge Wells. She illustrated *Through Woodland and Meadow,* 1891, with M. Low.

Exhib: B; RA; SWA.

WESTALL, Richard RA **1765-1836**

Historical and figure painter and illustrator. He was born at Hertford in 1765 and apprenticed to a silver engraver in Cheapside, attending the RA Schools from 1785. He turned wholly to art on completing his apprenticeship in 1786 and became a popular and prolific book illustrator. He worked chiefly for publishers of poetry, decorating their pocket editions with vignettes and 'conversation piece' subjects within decorative borders. His drawings for these are firmly in the 18th century tradition, charming and delicate tinted drawings with

highly finished faces. He collaborated with Alderman Boydell in painting five Milton subjects for his *Shakespeare Gallery* 1795-96 and illustrated the works of Crabbe, Moore and Gray. He was elected ARA in 1792 and RA in 1794 and gave lessons in drawing to the Princess Victoria. He died in London on 4 December 1836.

Publ: *A Day in Spring [1808].*
Illus: *Paradise Lost [Sharpe's Classics, 1822]; Boydell's Shakespeare [1802]; Elizabeth [Madame Cottin, 1817]; Illustrations from the Bible [1822]; Vicar of Wakefield [1828]; Illustrations of the Bible [1835-36]; Reflections on the Works of God.*
Contrib: *The Keepsake [1829]; Heath's Gallery [1836-38]; National Portrait Gallery of the 19th century.*
Exhib: BI; RA; RBA.
Colls: Ashmolean; BM; Eton College; Hertford; Nat. Gall., Scot; V & AM; Witt Photo.
Bibl: M. Hardie, *Watercol. Paint. in Brit.*, Vol.1, 1966 p.150 illus.
See illustrations (Colour Plate I p.19 and p.32)

WESTALL, William ARA **1781-1850**
Topographical illustrator. He was born at Hertford in 1785, the younger brother of Richard Westall (q.v.). He studied with his brother and at the RA Schools and was chosen by Benjamin West PRA to accompany the Flinders expedition to Australia as artist. On his return voyage he visited China and India, 1803-4 and was in Madeira and Jamaica in about 1808. He was elected AOWS in 1810 and resigned in 1812 when he was elected ARA. He spent the rest of his life painting English topography and died in London on 22 January 1850.

Illus: *Views of Scenery in Madeira, at the Cape, in China and India [1811]; Views of Australian Scenery [1814, AT 567]; Views of the Yorkshire Caves [1818]; Victories of the Duke of Wellington [1819, AL 381]; Britannia Delineata [1822]; Scenery, Costumes and Architecture of India [Grindlay, 1826-30, AT 422]; Picturesque Tour of the River Thames [1828].*
Contrib: *Ackermann's History of Rugby School [1816]; Ackermann's Repository [1825]; Illustrations of Warwickshire [1829]; Great Britain Illustrated [Thomas Moule, 1830]; Landscape Album [1832].*
Exhib: BI; OWS; RA; RBA.
Colls: Ashmolean; BM; Glasgow; Leeds; Manchester; Nottingham; Witt Photo.
Bibl: *AJ*, April 1850; Iolo Williams, *Early English Watercolours*, 1952 p.59 illus.

WESTRUP, E. Kate **fl.1908-1927**
Sporting artist. She worked at New Milton, Hants, 1910 and in Cornwall, 1911-27. She was elected ASWA in 1923.

Illus: *The Rosebud Annual [1908].*
Contrib: *Punch [1914 (hunting)].*
Exhib: L; NEA; RA; SWA.

WHARTON, S. **fl.1810-1816**
Architect. He was an honorary exhibitor at the RA, 1810-14 and showed drawings of London improvements. He published and illustrated *Waterloo*, 1816, AL 382.

WHATLEY, Henry **1842-1901**
Landscape and genre painter. He was born in Bristol in 1842 and worked as a drawing-master there, teaching at Clifton College and other schools. He died at Clifton in 1901.

Illus: *Quiet War Scenes [J. Baker, 1879]; Pictures of Bohemia [J. Baker, 1894].*
Contrib: *ILN.*
Colls: Bristol.

WHEELER, Dorothy Muriel **1891-1966**
Watercolour painter and illustrator. She worked in Plumstead, Kent and Esher, Surrey, in the 1900s and 1920s, producing pretty figure studies in a late Greenaway style with shepherdesses and architectural ornament.

Exhib: RA; SWA.

WHEELER, Edward J. **fl.1872-1902**
Domestic painter and black and white artist. He began to work for *Punch* in 1880 and contributed figures for the theatrical pages, for the editorial and provided initial letters. He used an unusual sign-manual of a 'four-wheeler'.

Illus: *Tristram Shandy. [Smollett, 1894]; The Captains Room [W. Besant, 1897].*
Contrib: *Punch [1880-1902]; The Cornhill Magazine [1883].*

Exhib: London, 1872.
Bibl: M.H. Spielmann, *The History of Punch*, 1895 p.549.

WHEELHOUSE, Mary V. **fl.1895-1933**
Painter and illustrator. She was probably a student at Scarborough School of Art, 1895 and lived in Chelsea from 1900.

Illus: *Cousin Phillis [Mrs Gaskell, Bells Queens Treasures Series, 1908]; Six to Sixteen [Mrs Ewing, 1908].*
Exhib: M; New Gall; RA; SWA.

WHICHELO, C. John M. AOWS **1784-1865**
Watercolourist and topographer of marine and river subjects. He was born in 1784 and became a pupil successively of John Varley and J. Cristall. He became Marine and Landscape Painter to the Prince Regent in about 1812 and was elected AOWS in 1823. Whichelo drew mainly British subjects but travelled in the Low Countries, Germany and Switzerland.

Contrib: *Antiquarian and Topographical Cabinet [1806]; Britton's Beauties of England and Wales [1815].*
Exhib: BI; OWS; RA.
Colls: BM; Greenwich; V & AM; Witt Photo.

WHISTLER, James Abbot McNeil **1834-1903**
Painter, etcher, lithographer and caricaturist. He was born at Lowell, Massachusetts on 11 July 1834, the son of an army officer. He was brought up in Russia and England before entering West Point Military Academy, to begin an army career. He was later moved to the Navy as a cartographer, where he learned etching, but abandoned this for art and went to Paris in 1855 to study under Gleyre, where he met G. Du Maurier (q.v.), E.J. Poynter (q.v.) and was influenced by the work of Manet and Courbet. Whistler settled in London in 1859, remaining a leading figure in its art world but arrogant, temperamental and fiercely independant. His early years, particularly 1862, are the ones in which he undertook his few but very striking book illustrations for the magazines. They are very powerfully conceived and have a freedom of line which is unusual among the wood engravings of the 1860s, the finest is 'The Morning Before The Massacre of St Bartholomew', for *Once a Week.*

Whistler's libel action with Ruskin in 1879 and his subsequent bankruptcy divides a spectacular career into two. His return to London in 1880 resulted in a triumphant exhibition of Venetian etchings and a series of fine lithographs. As Gleeson White commented 'one might as well praise June sunshine as Mr Whistler's etchings' and the whole force of his genius appears in the plates. His later polemical books have some decoration in their pages, but otherwise his contribution in this direction was small. His caricatures are witty and sharp, those of his adversary F.R. Leyland executed with an almost pathological savagery. Whistler was President of the SBA from 1886-88 but resigned due to controversy. He died in London in July 1903.

Contrib: *Once a Week [1862]; Good Words [1862]; Passages From Modern English Poets [1862]; Thornbury's Legendary Ballads [1876]; Scribner's Monthly and St Nicholas [1880-81].*
Exhib: FAS; G; GG; L; M; NEA; P; RA; RBA; RSA; RSW.
Colls: Ashmolean; Fitzwilliam; Glasgow; Manchester; V & AM.
Bibl: T.R. Way and G.R. Dennis, *The Art of JMcN W*, 1903; H.W. Singer, *JAMcN W*, 1904; J and E.R. Pennell, *The Life of JAMcN W*, 1908; B. Sickert, *W*, 1908; J and E.R. Pennell, *The W Journal*, 1921; J. Laver, *W*, 1930; H. Pearson, *The Man W*, 1952; D. Sutton, *Nocturne*, 1963; D. Sutton, *JMcN W*, 1966; R. McMullen, *Victorian Outsider*, 1973; S. Weintraub, *W*, 1974; *W The Graphic Work*, Walker Art Gall. Cat. 1976.

WHITE, Edmund Richard **fl.1864-1908**
Landscape and genre painter in watercolour and illustrator. He worked in London and at Walham Green from 1880, and contributed comic genre subjects to *The Illustrated London News*, 1871.

Exhib: B; L; RA; RBA; RI; RSW.

WHITE, George Francis **1808-1898**

Professional soldier and watercolourist. He was born at Chatham in 1808 and served in India with the 31st Regiment until 1846 and sketched the landscape of the Himalayas. He was later a Chief Constable and DL of County Durham and died there in 1898.

Illus: *Views in India Chiefly Among The Himalaya Mountains . . . 1829-31-32,* Publ. in 2 pts., 1837.

WHITE, Gleeson **1851-1898**

Book decorator and editor. He was born at Christchurch on 8 March 1851 and was educated at Christchurch School before entering journalism. He was deeply involved with the arts and crafts movement and worked as Associate Editor on the New York magazine *Art-Amateur,* from 1891-92. He then became first Editor of *The Studio,* 1893-94, and was largely responsible for its international reputation and its encouragement of book illustration. Walter Crane recalled of White that his 'quick sympathy and recognition . . . extended to all young and promising designers in black and white.' He was himself a talented designer of book covers and the foremost historian of the art of the book of his period. He died in London on 19 October 1898.

Publ: *Ballads and Rondeaus, Canterbury Poets [1887]; Practical Designing [1893]; Salisbury Cathedral [1896]; English Illustration [1897]; Master Painters of Britain [4 Vols., 1897-98].*
Designed: *Hake, A Selection From His Poems [1894 (cover)]; Out of Egypt [P. Hemingway, 1895-96 (cover)].*
Bibl: *The Studio,* Vol. 15 1899 p.141 (obit.); *The Artist,* Nov. 1898 (obit.). *Apollo,* Vol. 108; October 1978, pp.256-261.

WHITE, William Johnstone **fl.1804-1812**

Illustrator. He worked in London and contributed drawings to Ackermann's *The History of the Abbey Church of St Peter's, Westminster,* 1812.

Exhib: RA.
Colls: BM; Nottingham.

WHITEHEAD, Frances M. **fl.1887-1929**

Landscape painter and etcher. She worked in the Birmingham area and illustrated a child's book *The Withy Wood,* Skeffington, 1903.

Exhib: B; RA; RI; SWA.

WHITELAW, George **fl.1907-1930**

Artist and illustrator. He worked in Glasgow, 1912 and London, 1920 and contributed cockney figure subjects to *Punch,* 1907.

Exhib: G; L.

WHITING, Frederic or Fred **1873-1962**

Portrait and figure painter and Special Artist. He was born at Hampstead in 1873 and was educated at Deal and St Mark's College, Chelsea and studied at the St John's Wood and RA Schools. He attended Julians, Paris, and was appointed artist on The Daily Graphic, 1890. He became Special Artist and War Correspondent on The Graphic in China, 1900-1 and during the Russo-Japanese War of 1904-5, he excelled in action subjects and equestrian scenes. He was elected RBA in 1911, ROI, 1915, RI, 1918 and RSW, 1921. Whiting was President of the Artists Society, 1919 and died on 1 August 1962.

Exhib: G; GG; L; P; RA; RBA; RHA; RI; ROI; RSA; RSW.
Colls: Brighton; Liverpool.

WHITTOCK, Nathaniel **fl.1828-1851**

Draughtsman and lithographer. He worked principally in London and Oxford and published drawing-books.

Illus: *The British Drawing Book [n.d.]; The Oxford Drawing-Book [1825]; History of the County of Yorks. [Allan, 1828]; The Art of Drawing and Colouring From Nature [1829]; A Topographical and Historical Description of Oxford [1829]; The Microcosm of Oxford [1830]; The Decorative Painter and Glaziers Guide [1837]; The Miniature Painters Manual [1844].*
Contrib: *Tallis's Illustrated London [1851 (frontis)].*
Colls: BM; Witt Photo.

WHYMPER, Charles H. RI **1853-1941**

Landscape and animal painter and illustrator. He was born in London on 31 August 1853, the son of J.W. Whymper (q.v.) and studied at the RA Schools. He spent the whole of his working life illustrating books on travel, natural history and sport and had a one man show at the Walker Galleries in 1923. He was elected RI in 1909. He worked in London and then at Houghton, Hunts. from 1915 and died on 25 April 1941.

Illus: *Wild Sports in the Highlands [1878]; The Game-Keeper at Home [Jefferies, 1880]; Siberia in Europe [Seebohm, 1880]; Matabele Land [Oates, 1881]; Birds of Wave and Woodland [P. Robinson, 1894]; Big Game Shooting [1895]; The Pilgrim Fathers of New England [1895]; Off to Klondyke [1898]; Bird Life in a Southern County [C. Dixon, 1899]; Egyptian Birds [1909].*
Contrib: *ILN [1887-89]; Good Words [1891-]; The English Illustrated Magazine [1883-].*
Exhib: B; FAS; L; M; New Gall; RA; RBA; RI.
Colls: Witt Photo.

WHYMPER, Edward J. **1840-1911**

Alpinist and illustrator. He was born on 27 April 1840, the second son of J.W. Whymper (q.v.) and brother of Charles Whymper (q.v.). He joined the family wood engraving business and was responsible for engraving and illustrating many books in the 1860s, but his fame really rests on his pioneer work as an alpinist. He wrote *Peaks, Passes and Glaciers,* 1862 and was a medallist of the RGS. He died on 16 September 1911.

Illus: *Scrambles Among the Alps [1870]; Travels Among the Great Andes of the Equator [1892]; Chamonix and Mont Blanc [1896]; Zermatt and the Matterhorn [1897].*
Contrib: *The Sunday Magazine [1865]; The Leisure Hour [1867]; The Graphic [1870].*

WHYMPER, F. **fl.1857-1869**

Landscape painter. He was working in London, 1857-61 and contributed illustrations of Russian America to *The Illustrated London News,* 1868-69.

Exhib: RA; RBA.

WHYMPER, Josiah Wood RI **1813-1903**

Landscape painter and engraver. He was born at Ipswich in 1813 and after being apprenticed to a stone mason, taught himself to draw. He settled in London in 1829 and studied with W.C. Smith, establishing himself as an illustrator after publishing an etching of London Bridge, 1831. Whymper's wood engraving business became one of the most thriving in London and did most of the work for Murrays, the publishers, and for the Religious Tract Society and the S.P.C.K., both at that time employing good artists. He had at various times Frederick Walker, Charles Keene, J.W. North, Charles Green, and G.J. Pinwell as pupils. He was elected ANWS in 1854 and NWS in 1857, and lived at Haslemere, where he died on 7 April 1903.

Illus: *The Child's History of Jerusalem [C.R. Conder, 1874]; Field Paths and Green Lanes [L.J. Jennings, 1877]; Tent Work in Palestine [C.R. Conder, 1878].*
Contrib: *Missionary Travels [David Livingstone, 1857].*
Exhib: L; M; RI; ROI.
Colls: V & AM.

WIDGERY, Frederick John **1861-1942**

Landscape and marine painter. He was born in 1861, the son of William Widgery, the Exeter painter, and studied at the Exeter School of Art and at South Kensington and Antwerp.

Illus: *A Perambulation of Dartmoor [S. Rowe, 1896]; Fair Devon Album [S. Rowe, 1902]; Devon [Lady R. Northcote, 1914]; Torquay [J. Presland, 1920].*
Exhib: L; RA; RI; ROI.
Colls: Exeter.

WIEGAND, W.J. **fl.1869-1882**

Figure artist. He worked in London and illustrated *Elliott's Nursery Rhymes* for Novello, 1870, and contributed to *Good Words For The Young,* 1869-73 and *The Sunday Magazine,* 1870.

WIGHTWICK, George **1802-1872**

Architect and draughtsman. He was born at Mold, Flintshire on 26 August 1802 and was educated at Wolverhampton Grammar School. He failed to gain entrance to the RA Schools in 1818 but was given £100 by his stepfather to visit Italy, a tour he undertook from 1825-26. On his return he became an assistant to Sir John Soane and began illustrating and publishing, but success eluded him in London and he finally moved to Plymouth in 1829 and set up an architectural practice. He retired to Clifton in 1851 and to Portishead in 1855 and died there on 9 July 1872.

Illus: *Select Views of Roman Antiquities [1827]; Remarks on Theatres [1832]; Sketches of a Practising Architect [1837]; The Palace of Architecture [1840]; Hints to Young Architects [1846]*.
Contrib: *Public Buildings of London [Britton]; Union of Architecture [Britton, 1827, AL 7]*.
Exhib: RA.
Bibl: *Bentley's Miscellany*, Vol. 1852-54 pp.31-35; Vol. 1857-68 pp.42-43.

WIGRAM, Sir Edgar Thomas Ainger, 6th Bart. **1864-1935**

Amateur artist and illustrator. He was born on 23 November 1864, and succeeded his cousin in the title 1920. He was educated at Kings School, Canterbury and Trinity Hall, Cambridge and was Mayor of St. Albans, 1926-27. He died on 15 March 1935.

Illus: *Northern Spain [1906]; The Cradle of Mankind [1914]; Spain [J. Lomas, 1925]*.
Colls: Hertford.

WILD, Charles OWS **1781-1835**

Architectural and topographical illustrator. He was born in London in 1781 and was articled to the younger Thomas Malton. Wild was a careful delineator of Gothic cathedrals and colleges and was very influential through the engravings after his work in spreading the enthusiasm for Gothic art. He concentrated mainly on Britain but travelled abroad in the 1820s. He was elected AOWS in 1809 and OWS in 1812 and was Treasurer and Secretary in 1833. Increasing blindness caused his resignation in that year and he died in London on 4 August 1835.

Illus: *Twelve Views of Canterbury Cathedral [1807]; Twelve Views of York [1809]; An Illustration of Chester [1813]; An Illustration of Lichfield [1813]; An Illustration of Lincoln [1819]; An Illustration of Worcester [1823]; Foreign Cathedrals [1826, AT 93]; Select Examples . . . of Architecture . . . in England [1832]; Twelve Outlines . . . [1833]; Selected Examples of Architectural Grandeur [1837]*.
Contrib: *History of the Western Division of the County of Sussex [Rev J. Dallaway, 1815-30]; Royal Residences [W.H. Pyne, 1819]; Oxford Almanac [1815, 1818, 1819, 1829, 1831, 1845]*.
Exhib: BI; RA; OWS.
Colls: Ashmolean; BM; Chester; V & AM.
Bibl: M. Hardie, *Watercol. Paint. in Brit.*, Vol.3, 1968 pp.15-16 illus.
See illustration (Colour Plate II p.19).

'WILDRAKE' see TATTERSALL, G.

WILES, Frank E. **fl.1899-1925**

Portrait painter. He was working in Cambridge, 1899, when he entered for the South Kensington Competitions and in London, 1914-25.

Exhib: RA.
Bibl: *Modern Book Illustrators and Their Work*, Studio 1914.

WILEY, H.W.

Probably a student of the Birmingham School. Watercolour illustrations for a child's book in a Dutch whimsy style appear in *The Studio*, Vol.29, 1903 pp.69-70.

WILKIE, Sir David RA **1785-1841**

Genre and portrait painter and caricaturist. He was born at Cult, Fifeshire on 18 November 1785, the son of a Scottish minister. He studied at the Trustees Academy and at the RA Schools from 1805. Wilkie exhibited at the RA from 1806 and caused considerable interest with his domestic genre subjects which were based on Dutch genre paintings but had an obstinate Scottishness of their own. He was elected ARA in 1809 and RA in 1811, later being appointed King's Limner for Scotland, 1823, and Painter in Ordinary to the King,

1830. He travelled to Paris in 1814, to Scotland in 1817 and 1822 and ventured further afield for his health after 1825. He went on an extensive tour of the East in 1840, but died at sea on his return, 1 June 1840. He had been knighted in 1836.

Illus: *Old Mortality [Scott, 1830]; Sketches in Turkey, Syria and Egypt [1843, AT 379]; Sketches Spanish and Oriental [1846, AT 39]*.
Contrib: *The Keepsake [1830]; Heath's Gallery [1836]*.
Exhib: BI; RA.
Colls: Aberdeen; Bedford; BM; Fitzwilliam; V & AM; Witt Photo.
Bibl: D. Cunningham, *Life of DW*, 1843; A.L. Simpson, *The Story of Sir DW*, 1879; Lord G. Gower, *Sir DW*, 1902; W. Bayne, *Sir DW*, 1903; RA Exhibition Cat., 1958.

WILKINS, Frank W. **c.1800-1842**

Portrait painter, miniaturist and engraver. He was born in about 1800 and was a pupil of Charles Wilkins. He died in London in 1842.

Contrib: *British Gallery of Contemporary Portraits [1822]; National Portrait Gallery of the Nineteenth Century [c.1830]; Burke's Female Portraits [1833]*.
Exhib: BI; RA.
Colls: Witt Photo.

WILKINSON, Charles A. **fl.1881-1925**

Painter of landscapes and ships. He worked in London from 1881 and at Farnborough, 1916.

Contrib: *Black & White [1891]*.
Exhib: G; L; M; RA; RBA; RHA; RI; ROI; RSA.

WILKINSON, G. Welby **fl.1900-1925**

Decorative artist. He worked at Haverstock Hill, London and contributed to *Fun*, 1900.

Exhib: London Sal.

WILKINSON, Rev. Joseph **1764-1831**

Amateur landscape painter and illustrator. He was born at Carlisle in 1764 and educated at Corpus Christi, Cambridge, where he became a Fellow of the College. He became Rector of Wretham, Norfolk in 1803, having been a minor canon of Carlisle. He died at Thetford in 1831.

Illus: *Select Views in Cumberland [Wordsworth, 1810]; The Architectural Remains of Thetford [1822]*.
Colls: V & AM.

WILKINSON, Norman PRI **1878-1971**

Marine painter and etcher. He was born in Cambridge on 24 November 1878 and was educated at Berkhampstead School and St. Paul's Cathedral Choir School. Wilkinson worked as an artist and illustrator on the magazines until 1914 when he entered the RNVR and invented camouflage for the shipping of the Allies, 1914-18, known as Dazzle painting. He was made OBE for this work in 1918. Wilkinson became Marine Painter to the Royal Yacht Squadron and was elected RBA in 1902 and ROI in 1908; he was RI from 1906 and President, 1937. He died in London in 1971.

Publ: *Virginibus Puerisque and other Papers [1913]; The Dardanelles: Colour Sketches from Gallipoli*.
Contrib: *ILN [1898-99]; The Graphic [1902-3]; The Idler*.
Exhib: FAS, 1907, 1915, 1953, 1958; G; GG; L; New Gall; RA; RBA; RI; ROI; RWA.

WILKINSON, Tom **fl.1895-1925**

Black and white artist. He lived at Ipswich, 1914 to 1925, and drew figures in the style of Phil May (q.v.).

Contrib: *Judy [1895]; Fun [1895]; Punch [1897, 1903]; Illustrated Bits [1900]*.

WILKINSON, Tony

Illustrator of children. He contributed to *Punch*, 1897-1902.

WILLES, William **-1851**

Landscape painter. He was born in Cork and studied at the RA Schools, becoming Master at the Cork School of Design, 1849. He died there in 1851.

Contrib: *Ireland [S.C. Hall, 1841]*.
Exhib: BI; RA.

INGLIS SHELDON-WILLIAMS 1871-1940. 'The Coronation Durbar in Delhi, 1903.' Original drawing for illustration. Ink and watercolour. Signed and dated.

WILLIAMS, Captain RA
Army officer and amateur artist. He contributed illustrations of Canada to *The Illustrated London News,* 1860.

WILLIAMS, Alexander RHA **1846-1930**
Landscape painter in oil and watercolour. He was born in County Monaghan in 1846 and educated at Drogheda Grammar School and was in the choir of Trinity College, Dublin. He studied art at the RDS and was elected ARHA in 1883 and RHA in 1891. He wrote many articles on ornithology. He died in Dublin on 15 November 1930.
Illus: *Beautiful Ireland [S. Gwynn, 1911].*
Exhib: B; RHA.

WILLIAMS, Alfred SHELDON- **fl.1871-1875**
Farmer and illustrator. He lived and worked at Winchfield and specialised in equestrian subjects. He was the father of Inglis Sheldon-Williams (q.v.).
Illus: *The Book of The Horse [Cassell, 1875].*
Contrib: *The Graphic [1871]; ILN [1874-75].*
Exhib: RA; RBA.

WILLIAMS, Alice Meredith see WILLIAMS, (Gertrude) Alice Meredith

WILLIAMS, Ann Mary
Genre painter and illustrator. She was the sister and collaborator of Samuel Williams (q.v.).

WILLIAMS, Charles **fl.1797-1830**
Illustrator and caricaturist. He was the chief caricaturist for Fores, the printseller and was a follower and copyist of James Gillray. His early work is published under the name 'Ansell' but the later is usually anonymous.
Illus: *Dr Syntax in Paris [1820, AT 109].*
Colls: BM; Witt Photo.
Bibl: M.D. George, *Eng. Pol. Caricat.,* Vol.2 1959.

WILLIAMS, Mrs Crawshay **fl.1890-1912**
Artist and illustrator. She was working in London in 1890 under her maiden name as Miss C. Crawshay.
Illus: *Oddle and Iddle [Lily Collier, 1912].*
Exhib: L.

WILLIAMS, F.A.
Illustrator of comic animals. He contributed to *Punch,* 1903-7.

WILLIAMS, (Gertrude) Alice Meredith **-1934**
Decorative painter and sculptor, stained glass artist. She was born at Liverpool and studied at the Liverpool School of Architecture and Applied Art, before going to Paris, 1904-7. She exhibited book illustrations at the Walker Art Gallery in 1900. She married the painter Morris Meredith Williams (q.v.) and died in 1934.
Exhib: G; L; RA; RSA; RSW.
Bibl: *The Studio,* Vol.20, 1900 p.196 illus.

WILLIAMS, Hamilton
Figure artist. He was working at Buckhurst Hill, Essex, 1913-14.
Contrib: *Punch [1909]; London Opinion [1913]*.
Exhib: RA; RSA.

WILLIAMS, Hugh William 'Grecian' 1773-1829
Landscape painter. He was born in 1773, the son of a sea captain and soon orphaned, being brought up at Edinburgh. He was a founder of the Associated Artists in 1808 and published engravings of Highland views. He made his reputation and earned his name from a Mediterranean tour he undertook through Italy and Greece in 1818. He retired to Edinburgh and died there on 23 June 1829.
Illus: *Travels in Italy, Greece and the Ionian Islands [1820]; Select Views in Greece [1827-29]*.
Contrib: *Scots Magazine; Britton's Beauties of England and Wales [1812]*.
Exhib: Edinburgh, 1808-9.
Colls: Aberdeen; BM; V & AM.

WILLIAMS, Inglis SHELDON- 1871-1940
Painter and Special Artist. He was born in 1871, the son of Alfred Sheldon-Williams (q.v.) and after the death of his father he emigrated to Canada where he farmed from 1887 to 1891. He returned to Europe and studied at the Slade, at the École des Beaux-Arts, Paris and with Sir Thomas Brock. He returned to Canada, 1895-96 and in 1899 after settling in London was appointed Special Artist to *The Sphere* to cover the Boer War in South Africa. The magazine sent him to cover the Russo-Japanese War in 1903 and the Fine Art Society commissioned him to make watercolours of the Delhi Durbar, 1902-3. He married in 1904, Ida Maud Thomson, the flower painter who had been a Slade student. Sheldon-Williams worked at Stroud, Gloucestershire in 1908 and later at Sharnbrook, Bedfordshire, 1934. A one man show was held at the Regina Art Gallery, in Canada in October 1969.
Illus: *After Pretoria, The Guerilla War [1902]*.
Contrib: *The Quest [1894-96]*.
Exhib: B; FAS, 1903; G; L; NEA; RA; RI; ROI.
Colls: BM.
Bibl: *The Studio,* Vol.41, 1907 pp.111-115; *Country Life,* 15 May 1975.
See illustration (p.498).

WILLIAMS, J. Scott fl.1909-1921
Painter and illustrator. He worked in London, 1921 and contributed story illustrations to *The Illustrated London News,* 1909, with A.H. Buckland (q.v.).
Exhib: RA.

WILLIAMS, Joseph Lionel c.1815-1877
Painter, watercolourist and engraver. He worked in London and drew architectural subjects and machinery for the magazines. He was an unsuccessful NWS candidate, and died in London in 1877.
Contrib: *ILN [1848-51]; The Art Journal*.
Exhib: BI; RA; RBA.
Colls: Sheffield.

WILLIAMS, Morris Meredith 1881-
Painter, illustrator and stained glass artist. He was born at Cowbridge, Glamorgan, in 1881 and studied at the Slade School and in Paris and Italy. He worked in Edinburgh, 1914-25 and afterwards at North Tawton, Devon. He married the decorative artist (Gertrude) Alice Meredith Williams (q.v.).
Contrib: *Punch [1906-7 (rustic)]*.
Exhib: G; L; P; RA; RSA; RSW.
Colls: Liverpool.

WILLIAMS, Penry 1798-1885
Landscape and view painter. He was born at Merthyr Tydfil in 1798 and studied at the RA Schools and won a Society of Arts silver medal in 1821. He settled in Rome in 1826 and remained there until his death painting pictures of the city for the tourist market. He was AOWS from 1828-33.
Publ: *Recollections of Malta, Sicily and the Continent [1847]*.

Contrib: *Britton's Union of Architecture [1827, AL 7]*.
Exhib: BI; OWS; RA; RBA.
Colls: BM; Fitzwilliam; V & AM.

WILLIAMS, Richard James 1876-
Painter and illustrator of children's books. He was born at Hereford in 1876 and studied at Cardiff University College, Birmingham and London, becoming Headmaster of the Worcester School of Arts and Crafts. He also worked as a wood engraver. ARCA.
Exhib: RCA; RI.

WILLIAMS, Samuel 1788-1853
Draughtsman, wood engraver and natural history illustrator. He was born on 23 February 1788 at Colchester and was apprenticed to a house-painter before learning the art of wood engraving. He settled in London in 1819 and became a popular and prolific illustrator, engraving much of his own work. He was assisted by his sister Ann Mary Williams (q.v.) and died in London in 1853.
Illus: *Robinson Crusoe [Daniel Defoe, 1822]; Natural History [Mrs Trimmer, 1823-24]; Hone's Everyday Book [1825]; British Forest Trees [Selby, 1842]; Pictures of Country Life [Miller, 1847]; The Poetical Works of John Milton [1854]; Wit Bought [Peter Parley, 1868 (reissue)]*.
Contrib: *Thomson's Seasons, The Castle of Indolence [1851]*.
Exhib: BI; RA.
Colls: BM.
Bibl: Chatto and Jackson, *Treatise on Wood Engraving,* 1861 p.572.

WILLIAMS, Thomas H.
Illustrator and engraver. He worked in Plymouth and Exeter and made topographical views of West Country subjects.
Illus: *Picturesque Tours in Devon and Cornwall [1801]; The Environs of Exeter [1815]; A Tour in the Isle of Wight [n.d.]; A Walk on the Coast of Devonshire [1828]*.
Exhib: NWS; RA; RBA.
Colls: Fitzwilliam.

WILLIAMSON, F.M.
Illustrator. He contributed comic animal drawings to *Punch,* 1903-6.

WILLIAMSON, Isobel B.
Illustrator. She may have been a Liverpool student and contributed drawings for *The Studio* competitions in 1897.
Bibl: *The Studio,* Vols.11 and 12, 1897 illus.

WILLIAMSON, John fl.1885-1896
Portrait and figure painter and illustrator. He was working in Edinburgh, 1885-90 and in London from 1893, specialising in costume subjects.
Illus: *Kilgorman [Reed, 1894]*.
Contrib: *The English Illustrated Magazine [1895-96 (social)]*.
Exhib: RA; RBA; RSA.

WILLIAMSON, Captain Thomas George c.1758-1817
Amateur artist. He contributed drawings which Howitt engraved for *Oriental Field Sports,* 1807.
Colls: Witt Photo.

WILLIS, J.B.
Amateur artist. He contributed figure subjects to *Punch,* 1908.

WILLOUGHBY, Mrs. Vera fl.1905-1927
Watercolour painter, poster artist, book illustrator and decorator. She worked at Slindon, Sussex until 1913 and then in London. Her work is inspired by 18th century decoration, transformed by incipient art deco into pretty but stiff fantasies. Some of her soft pencil work dating from the 1920s is pleasantly cubist in feeling.
Illus: *The Humours of History [c.1914]; The Memoirs of a Lady of Quality, being Lady Vane's Memoirs [1925]; A Vision of Greece [1925]; Horati Carminum [1926]; A Sentimental Journey [1927]*.
Exhib: L; P; RI.
Colls: V & AM.

WILLSON, Beckles
Domestic painter. He contributed to *The Strand Magazine,* 1894.

WILLSON, Harry fl.1813-1852
Townscape painter. He worked in the style of Samuel Prout (q.v.).
Publ: *The Use of a Box of Colours [1842].*
Illus: *Willson's Fugitive Sketches in Rome, Venice etc. [1838].*
Colls: BM.

WILLSON, John J. fl.1875-1902
Landscape and sporting painter. He worked at Headingley, Leeds, and
was married to the painter E. Dorothy Willson.
Contrib: *The Graphic [1875].*
Exhib: L; RA.

WILLYAMS, Rev. Cooper 1762-1816
Artist and topographer. He was born in Essex in 1762 and entered
Emmanuel College, Cambridge, 1780, being ordained in 1784. He held
the living of Exning, near Newmarket, 1788 and St. Peter, West Lynn,
1793. He became chaplain to Admiral Earl Jervis in 1793 and
accompanied him to the West Indies and with the Mediterranean
Fleet, 1798-1800, being present at the Battle of the Nile. He later held
livings at Kingston, Canterbury and Stourmouth. He died in London
in 1816.
Illus: *A History of Sudeley Castle [1791]; An Account of the Campaign in the
West Indies in 1794 [1796, AT 672]; Voyage up the Mediterranean [1802, AT
196]; A Selection of Views in Egypt, Palestine, Rhodes, Italy, Minorca and
Gibraltar [1822, AT 198].*
Contrib: *The Topographer.*
Colls: Witt Photo.

WILMSHURST, George C. fl.1897-1911
Portrait painter and illustrator. He worked in London and contributed
pen and ink drawings to magazines.
Illus: *The Cardinal's Snuff Box [Henry Havland, 1903].*
Contrib: *ILN [1905, 1908, 1911 (Christmas Nos.)].*
Exhib: M; RA.

WILSON, Alexander 1766-1813
Ornithologist and engraver. He was born at Paisley on 6 July 1766 and
illustrated and engraved his own works, most notably *The American
Ornithology,* 1808-14. He died at Philadelphia on 23 August 1813.
Colls: Witt Photo.

WILSON, Andrew 1780-1848
Landscape painter. He was born at Edinburgh in 1780 and studied
under Alexander Nasmyth (q.v.) and at the RA Schools. He made
several extensive tours of Italy, and on the second in 1803-5, he acted
as a dealer and brought a number of masterpieces back with him. He
was Professor of Drawing at the RMA, Sandhurst for ten years until
1818 and in 1826 he returned to Italy and settled there for twenty
years. He died in Edinburgh in 1848.
Contrib: *Britton's Beauties of England and Wales [1813-15 (Wales and
Oxford)].*
Exhib: BI.
Colls: BM; V & AM.

WILSON, Charles Heath 1809-1882
Landscape painter and illustrator. He was born in London in 1809,
the son of the landscape painter Andrew Wilson (q.v.), with whom he
toured Italy, 1826. He went to live in Edinburgh in 1834, was elected
ARSA in 1835 and continued membership until 1858. He was Master
of the Trustees Academy, 1843-48, and he finally settled in Florence
in 1869. He died there in 1882.
Illus: *Viaggio Antiquario [P. Pifferi, 1832]; Voyage Round the Coasts of
Scotland [1842].*
Exhib: BI; RA.
Colls: Nat. Gall., Scotland.

WILSON, David fl.1895-1916
Draughtsman and caricaturist. He worked for various magazines
beginning with the *Daily Chronicle* in 1895. He was chief cartoonist
to *The Graphic,* 1910-16, specialising in full page drawings in chalk,
often strongly symbolic and fantastic.
Contrib: *Punch [1900-14]; Fun [1901]; The Graphic [1910-14]; The Sketch;
The Temple Magazine.*

WILSON, Dower fl.1875-1897
Domestic illustrator. He may be the same as 'D.R. Wilson' exhibiting
at the RA from Bushey, 1884-86.
Contrib: *ILN [1875]; Judy [1878-79]; Punch [1879, 1897]; Moonshine
[1891].*

WILSON, E. fl.1792-1802
Landscape painter and topographer. He contributed to *The Copper
Plate Magazine,* 1792-1802.
Exhib: RA.
Colls: Witt Photo.

WILSON, Edgar W. -1918
Painter and illustrator. He worked in London from 1886 and
specialised in the design of covers, initial letters and head and tail
pieces for books. He usually works in pen and ink or pen and wash
and is strongly influenced by Japanese art.
Contrib: *The Strand Magazine [1891]; Black & White [1891]; The Butterfly
[1893, 1899 (covers)]; St. Pauls [1894]; Madame [1895]; The Sketch;
Pick-Me-Up; Daily Chronicle [1895]; The English Illustrated Magazine [1896];
The Pall Mall Magazine [1897]; Pall Mall Gazette [1897]; The Windsor
Magazine; The Unicorn.*
Exhib: RA; RI.
Colls: V & AM; Witt Photo.

WILSON, Godfrey
Figure artist. He contributed to *Punch,* 1904.

WILSON, H.P. fl.1890-1895
Figure painter in watercolour, illustrator. He worked in London and
contributed to *The Sporting and Dramatic News,* 1890 and *Black and
White,* 1891.
Exhib: RA.

WILSON, Helen Russell RBA
Painter and etcher. She studied at the Slade School and at the London
School under Frank Brangwyn (q.v.) and then went to Tokyo to learn
Japanese painting. She was elected RBA in 1911, settled at Tangier in
about 1913 and died there 22 October 1924.
Illus: *Angling and Art in Scotland [1908].*
Exhib: RA; RBA; RI.

WILSON, John
Amateur. He contributed illustrations of humorous insects to *Punch,*
1903.

WILSON, Leslie fl.1893-1934
Figure artist. He worked in London and contributed extensively to
magazines.
Contrib: *Judy [1886-93]; The English Illustrated Magazine [1893-94]; St. Pauls
[1894]; Madame [1895]; The Sketch; Pick-Me-Up; The Royal Magazine.*
Exhib: RBA.

WILSON, Oscar 1867-1930
Portrait painter and illustrator. He was born in London in 1867 and
studied at South Kensington and Antwerp under Beaufaux and Verlat.
He was elected RMS in 1896 and ARBA in 1926, he died on 13 July
1930.
Contrib: *St. Pauls [1894]; The Sketch [1894-95]; Madame [1895]; ILN
[1897].*
Exhib. G; L; M; RABA; RCA; RI; RMS; ROI; RSA.

PATTEN WILSON 1868-1928. 'So the wind drove us on to the cavern of gloom...' Illustration to The Yellow Book, Vol. 9, April 1896.

WILSON, Patten 1868-1928

Black and white artist and illustrator. He was born at Cleobury Mortimer in 1868 and studied under Fred Brown. Wilson was a very competent and original illustrator of fantastic subjects and a talented decorator of books. His talents led him to be employed by Messrs. Lane on book covers and title pages, and he completed the Keynote series for the firm after Beardsley's dismissal and was technical adviser for the later numbers of *The Yellow Book*, 1895-96. His greatest failing was over-invention and his drawings, which are rich in imagery and finely executed, lack a degree of clarity essential to textual illustration. He worked principally in London and died in 1928.

Illus: *Miracle Plays [1895]; Life in Arcadia [J.S. Fletcher, 1896]; A Houseful of Rebels [1897]; God's Failures [J.S. Fletcher, 1897]; Selections From Coleridge [1898]; King John [1899]; The Tremendous Twins [Ernest Ames, 1900]; A Child's History of England [1903].*
Contrib: *The Pall Mall Magazine.*
Exhib: L; RA.
Colls: V & AM.
Bibl: *The Artist,* Jan. 1898, pp.17-24 illus; *The Studio,* Winter No, 1900-1 p.51 illus; R.E.D. Sketchley, *Eng. Bk. Illus.,* 1903 pp.28, 131.
See illustration (above).

WILSON, Thomas Harrington fl.1842-1886

Landscape, genre and portrait painter and illustrator. He studied art at the National Gallery in company with Sir John Tenniel (q.v.) and

Charles Martin, later specialising in theatrical portraiture and being introduced to *Punch* by Swain, the engraver. He also made drawings of military subjects and contributed to *The Punch Pocket Books,* 1854-57.

Contrib: *Punch [1853]; ILN [1854-61 (theatre, 1855-60, objects 1876, 1890)]; The Illustrated London Magazine [1855]; The Graphic [1871].*
Exhib: BI; RA; RI; ROI.
Colls: Witt Photo.

WILSON, Thomas Walter RI 1851-1912

Landscape painter and illustrator. He was born in London on 7 November 1851, the son of T. Harrington Wilson (q.v.) and was educated in Chelsea, before studying at South Kensington Schools, 1868 and winning their scholarship, 1869. He was sent by the Department of Science and Art to study at Bayeux and then worked in Belgium and Holland. Wilson undertook a great deal of magazine work and as a *Graphic* artist was one of the finishers of drawings sent in by Fred Villers (q.v.), the Special Artist. He was elected ARI in 1877 and RI in 1879 and ROI in 1883. He died in 1912.

Contrib: *The Graphic [1880-85]; ILN [1888-99]; The English Illustrated Magazine [1895]; Good Words [1898-99]; The Sketch; The Minister; The Idler.*
Exhib: L; M; RI; ROI.
Colls: V & AM.

WIMBUSH, Henry B. fl.1881-1908

Landscape painter. He painted in Scotland and Wales and illustrated *The Channel Islands,* (E.F. Carey, 1904).

Exhib: B; FAS; L; M; RA; RI.

WIMBUSH, John L. -1914

Painter and illustrator. He was working in London from 1890 to 1902 and then at Dartmouth. He died in 1914.

Contrib: *The Strand Magazine [1891-]; The World Wide Magazine [1898]; The Idler; The Boy's Own Magazine.*
Exhib: B; L; M; RA; RBA.

WIMPERIS, Edmund Morrison VPRI 1835-1900

Landscape painter and illustrator. He was born at Chester on 6 February 1835 and after being put in a business there, he was apprenticed at the age of fourteen to Mason Jackson (q.v.), the London wood engraver. He studied with Birket Foster (q.v.) and did a great deal of work for *The Illustrated London News* and other publications before turning almost wholly to landscape watercolour. His best work is of Suffolk, Wales and the Home Counties, much of the work being drawn directly from nature. He was elected ANWS in 1873 and NWS in 1875, becoming Vice-President in 1895. He died on Christmas Day 1900.

Contrib: *The Book of South Wales [Mr. and Mrs. S.C. Hall, 1861]; Gray's Elegy [1869].*
Exhib: B; FAS; L; M; New Gall; RBA; RI; ROI.
Colls: BM; Bradford; Manchester; V & AM; Witt Photo.
Bibl: *Walker's Quarterly,* 4 1921.

WINGFIELD, James Digman 1800-1872

Historical painter. He worked in London and specialised in costume subjects, often with Hampton Court Palace as their background. He made drawings of the 1851 Exhibition and was almost certainly an illustrator, two poetic works of his being engraved by Dalziel.

Colls: Nottingham; Witt Photo.

WINZER, Charles Freegrove 1886-

Painter and illustrator. He was born at Warsaw on 1 December 1886 and worked in Morocco, Spain and Britain. He later travelled to India, Nepal and Ceylon, where he became Inspector of Fine Art. He contributed illustrations to a number of books in the 1920s and decorated the rhymesheets of Harold Monro's Poetry Bookshop.

Illus: *Sixteen Poems [J.E. Flecker]; The Chinese Drama [Johnson].*
Exhib: Toothe Gall.
Colls: Cambridge; Cardiff.

WIRGMANN, Charles 1832-1891

Figure artist and caricaturist. He was born in 1860, the brother of
T.B. Wirgmann (q.v.). He worked in London before settling in
Yokohama, Japan in 1860 and painting Japanese life. He contributed
drawings of Manila, 1857 and China, 1860, to *The Illustrated London
News*. He died in 1891 and an exhibition of his work was held in
London in 1921.

Colls: BM.

WIRGMANN, Theodore Blake 1848-1925

Portrait painter and illustrator. He was born at Louvain, Belgium on
29 April 1848 into a Swedish family and entered the RA Schools,
winning a silver medal there in 1865. He went to Paris to study with
Hebert and on his return, worked extensively for *The Graphic* and as
an assistant to Sir John Millais (q.v.). Perhaps his most notable
achievement is the series of brilliant chalk portraits that he carried out
for the magazine in 1884 to 1889, including politicians, writers and
royalty. Wirgmann worked in London where he had an extensive
practice, was elected RP in 1891 and died there on 16 January 1925.

Contrib: *Cassell's Family Magazine [1868]; The Graphic [1875-1901]; Daily
Chronicle [1895].*
Exhib: B; G; GG; L; M; New Gall; P; RA; RHA; RI; ROI.
Colls: Bradford; Middle Temple; NPG; Witt Photo.

WITHERBY, Arthur George fl.1894-1919

Caricaturist. He was a painter, draughtsman and writer of Newton
Grange, Newbury, who was a keen sportsman and for some time the
proprietor of *Vanity Fair* to which he contributed illustrations,
1894-95 and 1899-1901.

Exhib: Walker's Gall.

WITHERINGTON, William Frederick RA 1785-1865

Landscape painter. He was born in Goswell Street, London on 26 May
1785 and studied at the RA Schools, 1805. Although he first
exhibited landscapes, he gradually turned his attention to genre
subjects and painted a scene from *The Rape of the Lock*, which may
have been used for illustration, 1835. He was elected ARA in 1830
and RA in 1840. On account of ill health he spent many of his later
years in the country, but died in London on 10 April 1865.

Exhib: BI; RA.
Colls: V & AM.

WITHERS, Alfred ROI 1856-1932

Landscape painter, architectural painter and etcher. He was born on
15 October 1856 and worked in Kent and Surrey before settling in
London in about 1903. He was elected ROI in 1897 and was a
member of the Society of 25 Artists. He was also a member of the
Pastel Society and received the Royal Order of Alfonso XII of Spain.
He died on 8 August 1932.

Contrib: *ILN [1896].*
Exhib: B; FAS; G; GG; L; M; New Gall; RA; RBA; RE; ROI; RSA.

WITHERS, Augusta Innes fl.1829-1865

Botanical illustrator. She was a member of the RBA and of the
Society of Lady Artists and contributed to *The Botanist*, c.1840.

Exhib: NWS; RA; RBA.

WODDERSPOON, John fl.1812-1862

Landscape painter. He worked at Norwich, where he was sub-editor of
The Mercury.

Publ: *Historic Sites of Suffolk [1841]; A New Guide to Ipswich [1842];
Picturesque Antiquities of Ipswich [1845]; Notes on the Grey and White Friars,
Ipswich [1848]; Memorials of the Ancient Town of Ipswich [1850].*
Colls: Norwich.

WOLF, Joseph RI 1820-1899

Animal and bird painter and illustrator. He was born at Mors, near
Coblenz in 1820 and studied lithography and Darmstadt before
entering the Antwerp Academy. He came to England in 1848 under
the patronage of the Duke of Westminster and through the friendship
of D.G. Rossetti and was employed at the BM on Gray's *The Genera*

of Birds. He illustrated extensively for the Zoological Society and
visited Norway in 1849 and again in 1856 with John Gould, the
ornithologist and illustrator. He was elected RI in 1874 and died in
London on 20 April 1899.

Illus: *Life and Habits of Wild Animals [D.G. Elliott, 1873].*
Contrib: *ILN [1853-57, 1872]; Eliza Cook's Poems [1856]; Wordsworth's
Selected Poems [1859]; Montgomery's Poems [1860]; Band of Hope Review
[1861]; Good Words [1861-64]; Willmott's Sacred Poetry [1862]; Wood's
Natural History [1862]; The Sunday Magazine [1866-68]; Once a Week
[1866]; Poems by Jean Ingelow [1867]; North Coast and Other Poems
[Buchanan, 1868]; Gould's Birds of Great Britain.*
Exhib: BI; RA; RI.
Colls: BM; V & AM; Sir John Witt.
Bibl: Chatto & Jackson, *Treatise on Wood Engraving*, 1861 p.573; *The Artist,*
May 1899 pp.1-15 illus.

WOLFE, Major W.S.M. fl.1855-1862

Amateur illustrator. Royal Artillery officer, who was promoted
Captain in 1856 and Major of Artillery Brigade at Aldershot, 1862. He
held the Crimean War medal and contributed drawings of the War to
The Illustrated London News, 1855.

WOLLEN, William Barnes RI 1857-1936

Military painter and illustrator. He was born at Leipzig on 6 October
1857 and was educated at University College School and studied at
the Slade. He was intended for an army career but took up painting as
a professional and was sent as Special Artist for *The Graphic* to South
Africa in 1900. He was elected RI in 1888, ROI in 1897 and HROI in
1934. He lived for most of his life in Bedford Park, West London and
died there on 28 March 1936.

Illus: *Rex [L. Thompson, 1894].*
Contrib: *ILN [1882-99]; The Strand Magazine [1891-94]; Black & White
[1891]; Chums [1892]; The Boy's Own Paper [1892-93]; Daily Chronicle
[1895]; The Penny Illustrated Paper; Cassell's Family Magazine; The Wide
World Magazine [1898]; The Graphic [1900-6].*
Exhib: B; G; L; M; RA; RHA; RI; ROI; RSA.
Colls: Witt Photo.

WOMRATH, Andrew K 1869-

Painter and illustrator. He was born at Frankfurt on 25 October 1869
and studied at the New York Academy and with L. O. Messon in
Paris, before working at Mentone.

Contrib: *The Evergreen [1896]; The Savoy.*

WOOD, F.W.

Animal and bird illustrator. He contributed extensively to *The
Illustrated London News*, 1855-58 and again in 1865-75.

WOOD, Fane

Figure artist. He contributed to *London Society*, 1868.

WOOD, John George fl.1793-1838

Topographical illustrator. He contributed to Britton's *Beauties of
England and Wales*, 1810.

Exhib: RA.

WOOD, Lawson 1878-1957

Black and white artist and illustrator. He was born at Highgate in
1878, the grandson of L.J. Wood, the landscape painter. He studied at
the Slade School and at Heatherley's and was for six years the chief
artist on the staff of C.A. Pearson Ltd. He served in the RFC during
the First World War. Wood's work is usually in ink and watercolour
and most of it is humorous in drawing and content, his repertoire of
characters including peppery army officers, namby-pamby men and
dominating old dames. The figures are heavily caricatured and he was
one of the group of artists who made capital out of imaginary
pre-historic scenes. He died in 1957.

Contrib: *Pearson's Magazine; The Royal Magazine; ILN [1905, 1908, 1912];
The Graphic [1907-11]; London Opinion [1913].*
Exhib: D; L; RA; RI.
Colls: V & AM; Witt Photo.
Bibl: *LW*, Brush, Pen and Pencil Series, Ed. by A.E. Johnson, c.1910.

See illustration (p.503).

LAWSON WOOD 1878-1957. 'Remarkable Escapes'. Original drawing for illustration. Wash. Signed and dated 1903. 7½ins. x 13ins. (19.1cm x 33cm).

WOOD, Margery

Amateur illustrator. She was a student at the Lambeth School and won a prize at the National Competition, 1904 for an illustration of Cranfordesque type.

Bibl: *The Studio,* Vol.32 p.327.

WOOD, Olive **fl.1914-1933**

Miniature painter and illustrator of children's books. She studied at the Clapham and Camberwell Schools of Art and worked in Dulwich Village.

Exhib: RA.

WOOD, Stanley L. **1866-1928**

Military painter and illustrator. He was born in 1866 and worked in London for the leading magazines and was employed almost continuously by Messrs Chatto's as an illustrator of boys' adventure stories. He died in 1928.

Illus: *The Arabian Nights Entertainments [1890]; A Waif of the Plains [1890]; Maid Marian and Robin Hood [1892]; Romances of the Old Seraglio [1894]; Mr Sadler's Daughters [H.C. Davidson, 1894]; Rujub the Juggler [G. A. Henty, 1894]; A Protegée of Jack Hamlin [Brett Harte, 1894]; A Fair Colonist [1894]; The King's Assegai [B. Mitford, 1894]; A Ramble Round the Globe [T.R. Dewar, 1894]; The Lost Middy [G. Manville Fenn]; Rough Riders of the Pampas [Capt. F.S. Brereton, 1908]; In Empire's Cause [E. Protheroe, 1908].*
Contrib: *ILN [1889-90]; The Sporting and Dramatic News [1890]; Black & White [1891]; The Graphic [1903]; The Strand Magazine [1906]; Cassell's Family Magazine; The Idler; The Windsor Magazine; Pearson's Magazine; Wide World Magazine [1927].*
Exhib: L; M; RA; ROI.
Colls: Witt Photo; V & AM.

WOOD, Starr **1870-1944**

Caricaturist and black and white artist. He was born in London on 1 February 1870 and was educated privately before being entered in a chartered accountant's office in 1887. He left in 1890 and began to draw for the magazines, having sufficient success to found his own magazine *The Windmill,* a quarterly, and later to run *Starr Wood's*

Magazine, from 1910 until at least 1935. The latter is filled entirely with his illustrations, à la May, à la Belcher and à la everyone else! Wood's humour is seldom above that of the seaside postcard but he can be a funny draughtsman, many of his works appear under the name of The Snark. He died on 2 September 1944.

Illus: *Rhymes of the Regiments [1896].*
Contrib: *Puck and Ariel [1890]; Fun [1892]; The Sketch [1893]; Judy [1895]; Pick-Me-Up [1895]; The Idler; Chums; The Parade [1897]; The English Illustrated Magazine [1898]; Punch [1900-2, 1908, 1914].*
Exhib: L.
Colls: V & AM; Witt Photo.

WOOD, T.W., Jnr. **fl.1867-1880**

Illustrator. He was the son of the animal artist Thomas W. Wood, and he illustrated *The Common Moths of England* by Rev. J.G. Wood, c.1880.

Contrib: *Punch [1865].*
Exhib: RA.

WOOD, William **1774-1857**

Doctor and amateur topographer. He was born at Kendal in 1774 and practised in Calcutta. In 1833 he published *A Series of Twenty-eight Panoramic Views of Calcutta,* 1833.

Colls: BM.

WOODHOUSE, F.W.

Artist. He illustrated *Representation of the Brigade Field Day in Ware Park,* 1853, AL 383.

WOODROFFE, Paul Vincent **1875-1945**

Painter, illustrator and stained glass artist. He was born in Madras, India in 1875 and was educated at Stonyhurst and studied at the Slade School. Woodroffe specialised in book decoration, covers and end-papers as well as in illustration, he was also a poster artist. He settled in Campden, Gloucestershire in about 1904 and was associated

with the Arts and Crafts movement there and particularly in the design of stained glass. He was a member of the Art Workers Guild and of the Society of Master Glass Painters. He died in London in 1945.

Illus: *Ye Booke of Nursery Rhymes [1897]; Herrick's Hesperides [1897, 1907]; Shakespeare's Songs [1898]; The Little Flowers of St. Francis [1899]; The Confessions of St. Augustine [1900]; The Little Flowers of St. Benet [1901]; The Tempest [1908]; Alls Well [Robert Browning, 1913 (cover)].*
Contrib: *The Quarto [1896]; The Parade [1897]; ILN [1909].*
Exhib: FAS; G; NEA; RA; RHA; RMS.
Colls: V & AM; Witt Photo.
Bibl: R.E.D. Sketchley, *Eng. Bk. Illus.*, 1903 pp.13, 14, 131.

WOODS, Henry RA 1846-1921
Genre and landscape painter and illustrator. He was born at Warrington on 22 April 1846 and studied at Warrington School of Art, winning a travelling scholarship. He attended the South Kensington Schools and joined *The Graphic* as an illustrator in 1870 with his brother-in-law, Sir Luke Fildes (q.v.). He did a considerable amount of work for the paper, often in collaboration with S.P. Hall (q.v.). He became ARA in 1882 and RA in 1893, having settled in Venice since 1876. He died there on 27 October 1921.

Illus: *Miss or Mrs? [Wilkie Collins, 1885 (with Fildes)].*
Exhib: B; FAS; L; M; RA; ROI.
Colls: Liverpool; Tate; Warrington; Witt Photo.

WOODS, William
Military illustrator. He contributed drawings to *The Illustrated London News*, 1860.

WOODVILLE, Richard Caton, Snr. 1825-1855
Painter of battle scenes. He was born at Baltimore in 1825 and died in London in 1855. He contributed a drawing to *The Illustrated London News*, 1852.

Exhib: BI; RA.

WOODVILLE, Richard Caton, Jnr. 1856-1927
Painter of battle scenes, Special Artist and illustrator. He was born in London on 7 January 1856, the son of R.C. Woodville Senior (q.v.). He studied art in Düsseldorf under Kamphussen after being brought up in St Petersburg, and lived in Paris before settling in London in 1875. He began to work almost at once for *The Illustrated London News* and went as artist to the Turkish War of 1878 and the Egyptian War of 1882, also serving in Albania and the Balkans. He turned increasingly to oil painting in the 1880s and finally abandoned black and white work altogether in 1897. Woodville's war drawings were always accurate and highly finished if somewhat lacking in the realities of action. The high gloss and glamour earned him comparisons with Meissonnier. He was elected RI in 1882 and ROI in 1883. He died in North London on 17 August 1927.

Illus: *Ravenstones [H. Kingsley, 1894].*
Contrib: *ILN [1876-1911]; The Cornhill Magazine [1883]; The Sketch; The Boy's Own Paper; The Windsor Magazine; The English Illustrated Magazine [1895-97]; Pearson's Magazine [1896].*
Exhib: FAS; G; L; M; New Gall; RA; RHA; RI; ROI.
Colls: Royal Coll., Windsor; BM; V & AM.
Bibl: R.C.W., *Random Recollections*, 1913; *The Idler*, 1897, Vol.10 pp.758-775; *The Illustrated London News*, 7 December 1895.

WOODWARD, Alice Bolingbroke fl.1885-1920
Illustrator of children's books. She worked principally in pen and watercolours but also in pencil, her designs have something of Rackham about them but lack his atmospheric and sinister elements. Her work was greatly admired by *The Studio*.

Illus: *Eric, Prince of Lorlonia [Lady Jersey, 1895]; Banbury Cross [1895]; To Tell The King The Sky is Falling [1896]; Bon Mots of the Eighteenth Century [1897]; Bon Mots of the Nineteenth Century [1897]; Brownie [1897]; Red Apple and Silver Bells [1897]; Adventures in Toyland [1897]; The Troubles of Tatters [1898]; The Princess of Hearts [1899]; The Cat and the Mouse [1899]; The Golden Ship [1900]; The House That Grew [Mrs. Molesworth, 1900]; Nebula to Man [H.R. Knipe, 1905]; The Pinafore Picture Book [W.S. Gilbert, 1908]; Alice's Adventures in Wonderland [n.d.]; Lost Legends of the Nursery Songs [M.S. Clark, 1920].*
Contrib: *ILN [1895]; Daily Chronicle [1895]; The Quarto [1896].*
Exhib: G; L; M; NEA; RA; RBA; RI; RSW.

Bibl: *The Studio*, Vo.9, 1897 p.216; Vol.10, 1897 p.232; Vol.15, 1899 p.214; Winter No. 1900-1 p.31 illus.; R.E.D. Sketchley, *Eng. Bk. Illus.*, 1903 pp.104, 172.

WOODWARD, George Moutard 1760-1809
Amateur caricaturist. He was born in Derbyshire in 1760 and came to London about 1792. Between 1794 and 1800 he produced numerous political caricatures, some of them in strip form of his own innovation. His work is usually coarse and crude and was often etched by Rowlandson, Isaac Cruikshank, Roberts and Williams (qq.v.). He lived a dissolute life and died in a tavern in 1809.

Illus: *Elements of Bacchus [1792]; Familiar Verses from the Ghost of Willy Shakespeare to Sammy Ireland [1795]; The Olio of Good Breeding [1801]; The Musical Mania for 1802; The Bettyad [1805]; The Fugitive [1805]; Caricature Magazine [1807]; Eccentric Excursions [1807]; Chesterfield Travestie... [1808]; The Comic Works, in Prose and Poetry [1808].*
Colls: BM; Leeds; Witt Photo.

WOODWARD, Mary fl.1890-1914
Miniaturist. She worked in London and designed invitation cards and may have illustrated books.

Exhib: B; G; L; RA; RBA; RHA; RI; RMS; RSA; SWA.

WOOLEY, Harry fl.1912-1920
Figure artist. He worked in Bristol, 1912-13 and specialised in comic sketches in colour after the manner of Starr Wood (q.v.).

Exhib: L; RA; RMS.
Colls: Witt Photo.

WOOLNER, Thomas 1826-1892
Sculptor and draughtsman. He was born at Hadleigh, Suffolk on 17 December 1825 and after showing early promise he was apprenticed to the sculptor William Behnes. He entered the RA Schools in 1842 and won a silver medal of the Society of Arts in 1845, two years later meeting Rossetti and becoming a member of the Pre-Raphaelite Brotherhood. In the next few years Woolner concentrated on producing medallions, but in 1852, he set sail from Gravesend to try his fortune on the Australian goldfields, thus inspiring Ford Madox Brown's picture 'The Last of England'. He returned in 1854 and soon made a success of his portrait sculpture, being elected ARA in 1871 and RA in 1874. He died in London on 7 October 1892.

Contrib: *The Golden Treasury [1870]; Book of Praise [C.H. Seers].*
Exhib: M; RA.
Bibl: Amy Woolner, *TW, Life and Letters.*

WOOLNOTH, Thomas 1785-c.1836
Painter and engraver. He worked in London as a pupil of Charles Heath and contributed to *Heath's Gallery*, 1836.

Exhib: BI; NWS; RA; RBA.
Colls: NPG.

WORMS, Jaspar von 1832-1924
Painter, etcher and illustrator. He was born in Paris on 16 December 1832 and studied at the École des Beaux-Arts from 1849, exhibiting at the Salon from 1859. He specialised in Spanish genre subjects and died in 1924.

Contrib: *Cassell's Illustrated Family Paper [1853-57 (Crimea)].*

WORTLEY, Mary Stuart (Countess of Lovelace) -1941
Portrait painter and illustrator. She was the daughter of the Rt. Hon. J.A. Stuart Wortley and married 2nd Earl of Lovelace in December 1880. She died on 18 April 1941.

Illus: *Zelinda and The Monster [1896].*
Exhib: B; G; M; New Gall.

WRAY, A.W. fl.1830-1840
Figure artist and illustrator. He was a follower of George Cruikshank and 'Phiz' and made illustrations in their style for an unidentified novel.

Colls: Witt Photo.

WRIGHT, Alan fl.1889-1925

Painter, illustrator and poet. He was working in Kensington in 1890 and at Burghfield Common, Berkshire after 1914. Wright was an illustrator of children's books and a book decorator of talent. Much of his work is in the style of the woodcut with strong Celtic and Gothic emphasis, he also made designs for eastern subjects. His book, *Climbing in the British Isles,* was illustrated by Ellis Carr (q.v.).

Illus: *Queen Victoria's Dolls [1894]; The Wallypug in London [G.E. Farrow, 1898]; Adventures in Wallypug Land [1898]; The Little Panjandrum's Dodo [1899]; The Mandarin's Kite [1900].*
Contrib: *The Girl's Own Paper [1890-1900]; The Strand Magazine [1891-94, 1906]; The Pall Mall Magazine; The Parade [1897]; The Dome [1897-99]; The Windmill [1899]; Punch [1905].*
Exhib: L; NEA; RA; RBA; ROI.
Bibl: R.E.D. Sketchley, *Eng. Bk. Illus.,* 1903 pp.107, 173.

WRIGHT, Frank fl.1905-1911

Landscape painter. He worked in London and contributed illustrations of rustic figures to *Punch,* 1905.

Exhib: RA.

WRIGHT, Gilbert S. fl.1900-1911

Figure painter. He worked in Forest Hill, South London and contributed drawings to *The Graphic,* 1910-11, Christmas numbers.

Exhib: RA.

WRIGHT, Henry Charles Seppings 1850-1937

Painter and Special Artist. He was born in Cornwall in 1850, where his father had a parish and after studying in Paris, worked for *The Pictorial World* from 1883. He joined the staff of *The Illustrated London News* in about 1888 and attended the Ashanti, Grecian, Spanish-American and Balkan wars on behalf of the paper. He was the representative of Armstrong-Whitworth in the Russo-Japanese War of 1904-5 and was on the Russian front in the First World War, 1915-16. He is believed to have contributed caricatures to *Vanity Fair,* 1891-1900 under the name of 'Stuff'. He died on 7 February 1937.

Publ: *The Soudan [1896]; With Togo [1906]; Two Years under The Crescent.*
Contrib: *ILN [1888-1900]; The Graphic [1887]; Black & White [1891]; The Boy's Own Paper [1892-93]; The Idler; Chums [1892]; The Pall Mall Magazine; The Sketch; The English Illustrated Magazine [1893-94]; The Sporting and Dramatic News [1896].*
Exhib: L; M; RA; RBA; RI.
Colls: V & AM; Witt Photo.
Bibl: *The Idler,* Vol.11, pp.89-101.

WRIGHT, John Massey OWS 1777-1866

Historical painter in watercolours. He was born at Pentonville on 14 October 1777, the son of an organ builder and worked as a piano tuner for Broadwoods. He was acquainted with Thomas Stothard (q.v.) and on settling in London he was introduced to a number of artists and was commissioned to paint scenery for the Strand Panorama and for Covent Garden. He was elected AOWS and OWS in 1824 and set up a fashionable drawing-master's practice in London, also working for the Annuals. He died on 13 May 1866.

Contrib: *The Literary Souvenir [1825-26]; The Amulet [1826-27]; Heath's Gallery [1836].*
Exhib: BI; OWS; RA; RBA.
Colls: Leeds; Manchester; V & AM; Witt Photo.
Bibl: Martin Hardie, *Watercol. Paint. in Brit.,* Vol.3, 1968 pp.87-88.

WRIGHT, John William OWS 1802-1848

Figure and portrait painter. He was born in London in 1802, the son of the miniature painter John Wright, and was apprenticed to Thomas Phillips, RA. His main work was in supplying historical portraits and scenes to the Annuals, he was elected AOWS in 1831 and OWS in 1841. He died in poor circumstances in 1848.

Contrib: *The National Gallery of Contemporary Portraits [1822]; Heath's Gallery [1836]; Finden's Gallery.*
Exhib: OWS; RA.
Colls: BM; Witt Photo.

WRIGHT, Louise Mrs John W. Wright 1875-

Fashion illustrator. She was born at Philadelphia, USA, in 1875 and married the watercolourist and etcher John Wright, 1857-1933. She also painted portraits, landscapes and still-lifes.

Exhib: Beaux Arts Gall; RA.
Bibl: *LW, The Art of The Illustrator,* ed. P.V. Bradshaw, 1916.

WRIGHTSON, J. -1865

Engraver and illustrator. He worked at Boston and New York between 1854 and 1860 and drew three illustrations for Roscoe's *North Wales,* 1836.

Colls: Witt Photo.

WYATT, Henry 1794-1840

Portrait painter. He was born at Thickbroom, Lichfield, on 17 September 1794 and entered the RA Schools in 1812. He studied with Sir Thomas Lawrence before opening his own studio as a portrait painter in Birmingham, Manchester and finally London in 1825. He died at Prestwich on 27 February 1840.

Contrib: *Heath's Gallery [1836-38].*
Exhib: BI; RA; RBA.
Colls: V & AM; Witt Photo.

WYATT, Thomas Henry FSA 1807-1880

Architect. He was born in 1807, the brother of Sir Mathew Digby Wyatt. He was President of the RIBA, 1870-73 and Gold Medallist in 1873. He designed theatres and barracks and died in 1880.

Contrib: *Britton's Cathedrals [1832-36].*

WYBURD, Francis John 1826-

Genre painter. He was born in London in 1826 and was educated at Lille and studied with the lithographer, T. Fairland. He entered the RA Schools in 1848 and travelled in Italy in the 1850s. His only illustrations were the highly romantic and decorative ones for *The Poetry and Pictures of Thomas Moore,* c.1845. He died after 1893. RBA, 1879.

Exhib: BI; L; RA; RBA; ROI.
Colls: Witt Photo.

WYLD, William RI 1806-1889

Landscape painter. He was born in London in 1806 and became Secretary to the British Consul at Calais, where he took lessons in watercolours from F.L.T. Francia. He was a friend of Horace Vernet and travelled with him to Italy, Spain and Algiers, and settled in Paris. He was elected ANWS in 1849 and NWS in 1879. He died in Paris in 1889.

Illus: *Voyages Pittoresque dans La Région d'Alger [1833].*
Colls: BM; Fitzwilliam; Searight Coll; V & AM.

WYLLIE, Charles William or Charlie RBA 1859-1923

Marine painter and illustrator. He was born in London on 18 February 1859, the brother of W.L. Wyllie, RA (q.v.). He studied at Leigh's and the RA Schools and concentrated on coastal and genre subjects. He was elected RBA in 1886 and ROI in 1888. He worked in St John's Wood and died there on 28 July 1923.

Contrib: *The Graphic [1881-90]; The Picturesque Mediterranean [1891]; ILN [1893-96]; The Sunday Magazine [1894].*
Exhib: B; G; GG; L; M; New Gall; RA; RBA; ROI.
Colls: BM; V & AM; Witt Photo.

WYLLIE, William Lionel RA 1851-1931

Marine painter, illustrator and etcher. He was born in London in July 1851, the brother of C.W. Wyllie, RBA (q.v.) and half-brother of Lionel Percy Smythe (q.v.). He was brought up at Wimereux and studied at Heatherley's and the RA Schools and learnt the art of boat building. His pictures of the Thames Estuary and the shipping of Britain at the height of its Empire are among the most evocative and accurate existing. He was on the staff of *The Graphic* for some years as their marine illustrator and was sent to the United States by them in 1893. He was Marine Painter to the Royal Yacht Squadron, was elected NEA in 1887, ARA in 1889 and RA in 1907. He died on 6 April 1931.

Contrib: *The Graphic [1880-1904].*
Exhib: B; FAS, 1884, 1889, 1892, 1907; G; GG; L; M; NEA; RA; RBA; RE; RHA; RI; ROI.
Colls: BM; Fitzwilliam; Liverpool; Tate; Witt Photo.

YRIARTE, Charles **1832-1898**

Architectural painter and writer. He was born in Paris on 5 December 1832 and became a pupil of Constant-Dufeux. He died in 1898.

Contrib: *The Illustrated Times [1860 (Spain)]; ILN [1876 (Turkey)].*

YEATS, Jack Butler **RHA** **1871-1957**

Painter, illustrator and caricaturist. He was born in Ireland in 1871, the son of J.B. Yeats, RHA and the brother of W.B. Yeats. He was educated in County Sligo and studied art at South Kensington and at the West London and Westminster Schools of Art. He lived in England from about 1890 to 1898 and concentrated on figure drawing for illustrations. His work at this period is highly inventive and free and among the best of it is the social realism of the East End of London captured magnificently in chalk or ink. His drawing was often criticised at the time for its lack of precision but its ruggedness looks forward to the 1920s and the humour of his sketches for *Fun*, 1901, is very modern in quality. Yeats returned to Ireland in about 1902-3 and concentrated for the remainder of his life on oil paintings. He was elected ARHA in 1915 and RHA in 1916. He sometimes illustrated under the name 'W. Bird'.

Illus: *The Life and Adventures of Captain Singleton [Defoe, 1895]; Romance and Narratives [Defoe, 1900]; Life in the West of Ireland [1912].*
Contrib: *Puck and Ariel [1890]; Chums [1892]; ILN [1892]; The Sketch [1894]; Judy [1895]; The New Budget [1895]; Lika Joko; Punch [1896-1914]; Cassell's Saturday Journal; The Quartier Latin [1898]; The Longbow [1898]; Fun [1901]; The Broadsheet [1902-3]; The Manchester Guardian [1905]; The Broadside [1908-15].*
Exhib: G; L; RA; RHA; ROI.
Colls: Bat. Gall., Ireland; V & AM; Witt Photo.
Bibl: *Modern Book Illustrators and Their Work,* Studio, 1914; C. Neve, *JY; Rider to The Sea,* Country Life, July 30, 1970; *The Dun Emer Press Later The Cuala Press,* 1973; Catalogue of *JBY, Early Drawings and Watercolours,* Victor Waddington Gallery, 26 Oct.-18 Nov. 1967.

See illustration (right).

YENDIS, M.

Illustrator. He contributed to *Fun,* 1901.

YOHN, Edmond Charles or **YON** **1836-1910**

French landscape painter. He was born in Paris on 2 February 1836 and became a pupil of Pouget and exhibited at the Salon from 1865. He was a talented wood engraver and worked on the illustrations for an edition of Victor Hugo. He died in Paris on 15 March 1897.

Contrib: *The Graphic [1905-6].*
Exhib: G.

YORKE, Hon. Eliot Thomas **1805-1885**

Landscape painter. He was the son of Admiral Sir J.S. Yorke and nephew of Elizabeth, Countess of Hardwicke (q.v.). He was taught watercolour by de Wint and sat as MP for Cambridgeshire, 1854-65.

Illus: *The Wanderer in Western France [G.T. Lowth, 1863].*

'YORRICK'

Pseudonym of illustrator of children's books. He illustrated *A Knowing Dog,* Greening, 1908 and contributed to *The Minster* and *The Idler,* 1895.

YOUNG, Austin

Book decorator. He contributed the cover design and title page to *The Sonnet in England and Other Essays* by J.A. Noble for the Bodley Head, 1894.

YOUNG, William Weston **fl.1797-1835**

Topographer. He was originally a corn-merchant who settled at Neath in 1797, moving to Newton Nottage in 1806. He was also a coal owner and associated with the Swansea porcelain works.

Illus: *Guide to the Scenery of Glyn Neath [1835].*
Bibl: *The Connoisseur,* Vol.96, 1935 No.407.

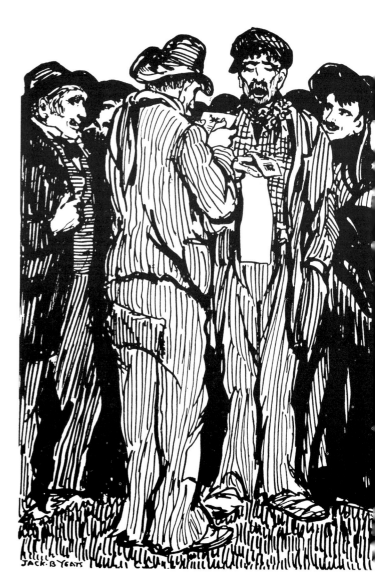

JACK BUTLER YEATS 1871-1957. Illustration to Life in The West of Ireland, *1912.*

ZANGWILL, Mark fl.1890-1896

Rural and domestic illustrator. He may have been a relation of I. Zangwill, the Editor of *Puck and Ariel*, to which he contributed in 1890. He also made drawings for *The English Illustrated Magazine*, 1896.

ZORNLIN, Georgiana Margaretta 1800-1881

Portrait painter. She was born in 1800 and became a pupil of Benjamin Robert Haydon.

Contrib: *Dennis's Landscape Gardener [1835, AL 13 (liths)]*.
Exhib: RA; RBA.
Colls: NPG.

ZWECKER, Johann Baptist 1814-1876

History painter, illustrator and etcher. He was born at Frankfurt on 18 September 1814 and became a student of the Institute Stadel and worked in Düsseldorf. He settled in London in about 1850 and made numerous illustrations for books and magazines, many of them of natural history subjects. He died in London on 10 January 1876.

Illus: *Wild Sports of the World [J. Greenwood, 1862]; Out on the Pampas [G.A. Henty, 1871]; The Child's Zoological Garden [1880]; The Rifle and The Hound in Ceylon [S.W. Baker, 1892]*.
Contrib: *ILN [1860-66, 1872 (animals)]; Good Words [1861, 1868]; Wood's Natural History [1862]; The Churchman's Family Magazine [1863]; London Society [1864]; Krilof and His Fables [1867]; North Coast and Other Poems [Buchanan, 1868]; Good Words For The Young [1869-72]; The Graphic [1875]*.
Exhib: BI; RA; RBA.
Bibl: Chatto and Jackson, *Treatise on Wood Engraving*, 1861 p.600.

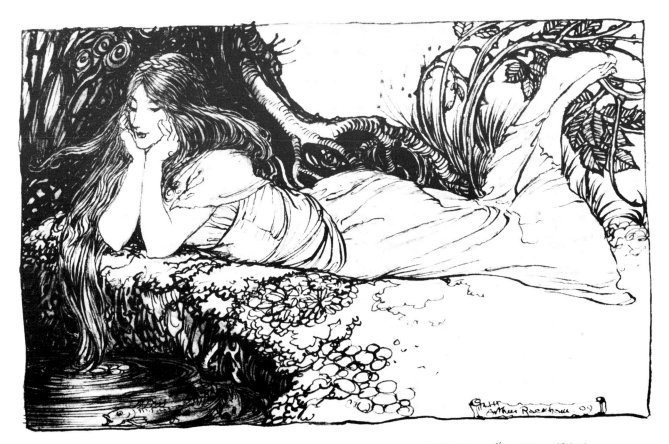

ARTHUR RACKHAM RWS 1867-1939. 'A Girl By a Pool.' Pen and ink. Signed and dated 1909. 3½ins. x 5⅜ins. (8.8cm x 13.6cm).

Appendix A
Schools of Illustration*

ARMOUR, Jessie Lamont
BATTEN, John Dixon
BRADLEY, Gertrude M.
BRISCOE, Arthur John Trevor
DAVIS, Louis
FAUX, F.W.
FRANCE, G. Cave (see A. Gaskin)
GASKIN, Arthur
GASKIN, Mrs. Arthur
GERE, Charles March

BIRMINGHAM

HOLDEN, Evelyn
HOLDEN, Violet M.
JONES, S.R.
LEVETUS, Celia
MASON, Fred
METEYARD, Sidney H.
MILLAR, Harold R.
MUCKLEY, L.F.

NEWILL, Mary J.
PAYNE, Henry A.
PEACOCK, Mildred A.
ROBINSON, F. Cayley
RUTLAND, Florence M.
SLEIGH, Bernard
SMITH, Winifred
SOUTHALL, J.E.
TARLING, G.T.
TREGLOWN, E.G.

GLASGOW

CAMERON, Katharine
CARTER, D.B.
CHAMBERLAIN, D.
DUNCAN, J.A.
FRENCH, Annie

HAY, Helen
HORNEL, E.A.
KING, Jessie M.
MACBETH, Ann
MACDOUGALL, W.B.
ORR, Monro S.

ORR, Stewart
PARK, Carton Moore
PRYDE, James
SMYTH, Dorothy C.
URQUHART, Annie

ARTISTS INFLUENCED BY AUBREY BEARDSLEY

BRADLEY, W.H.
CARMICHAEL, Stewart
CLARKE, Harry
FRENCH, Annie
HYLAND, Fred

JACKSON, F.E.
JAMES, Gilbert
KETTLEWELL, John
MACDOUGALL, W.B.

NIELSEN, Kay
ODLE, A.E.
PLANK, George
SPARE, Austin O.
VOIGHT, H.H.

ARTISTS INFLUENCED BY GREENAWAY AND CALDECOTT

ANDRE, R.
ANGUS, Christine
EMERSON, H.H.

FARMILOE, Edith
GRAHAM, Winifred

HODGSON, William J.
HOUGHTON, Elizabeth Ellen
SOWERBY, J.G.

ARTISTS INFLUENCED BY THE CHAP BOOK STYLE

ADAMS, W. Dacres
COLMAN-SMITH, Pamela
CRAIG, E. Gordon
CRAWHALL, Joseph

GAVIN, Jessie
HALKETT, George R.
HARDY, Dudley
KAPP, E.X.

NICHOLSON, William
PRYDE, James
ROBERTSON, W. Graham
SIMPSON, Joseph

*Artists listed may have been in-
fluenced by the Schools rather than
have attended them as students.

508

Appendix B

Specialist Illustration

ARMFIELD, Maxwell
BILLINGHURST, P.J.
BOYLE, The Hon. Mrs. E.V.
BROCK, H.M.
BRUNTON, W.S.
CALTHROP, Dion Clayton
COLLINGWOOD, W.G.
CRUIKSHANK, George
DEARMER, Mrs. Percy
DOYLE, Charles Altamont
DOYLE, Richard
DULAC, Edmund
EDWARDS, K. Ellen
FITZGERALD, J. Anster
FORD, Henry Justice
GANDY, Herbert
GASKIN, Arthur J.
GERE, Charles March

FAIRY ARTISTS

GILBERT, William Schwenk
GOBLE, Warwick
GREENAWAY, Kate
HALSWELLE, Keeley
HILL, Vernon
HASSALL, John
HARRISON, Florence
HOLLOWAY, W. Herbert
HOPE, Mrs. Adrian C.
HUDSON, Gwynedd M.
HUGHES, Arthur
JAMES, Gilbert
KNOWLES, H.J.
KNOWLES, R.J.
LANDSEER, Thomas
MAYBANK, Thomas
MILLAR, Harold R.

MONSELL, J.R.
PATON, Sir J. Noel
RACKHAM, Arthur
RAILTON, Fanny
RIVINGTON, Reginald
ROBERTSON, W. Graham
ROBINSON, Charles
ROBINSON, Thomas
ROBINSON, W. Heath
ROUNTREE, Harry
SANDERSON, H.
SAVAGE, Reginald
SPEED, Lancelot
STEWART, Allan
STRATTON, Helen
TORRANCE, James
UPTON, Florence K.
WOODWARD, Alice B.

ANDREWS, G.H.	ILN
BELL, Joseph	ILN
BULL, René	Black and White
CARMICHAEL, J.W.	ILN
CORBOULD, Chantrey	ILN
GOODMAN, A. Jules	
	Pall Mall Gazette
HALE, E.M.	ILN
HALL, Sidney	Graphic
HENTY, G.A.	Standard
HOUGHTON, A. Boyd	Graphic
LANDELLS, Ebenezer	ILN
LANDELLS, R.T.	ILN
LARSON, Axel	ILN
LARSEN, C.C.	ILN
MACPHERSON, Douglas	Sphere
MATANIA, F.	Sphere
MAUD, W.T.	Graphic

SPECIAL ARTISTS

MAXWELL, Donald	Graphic
MENPES, Mortimer	
	Black and White
MONTAGU, Irving	ILN
MORGAN, Matt	Illus. Times
NAST, J.	Various
NORBURY, E.A.	Graphic
PAGET, H.M.	Sphere
PELCOQ, Jules	ILN
PELLEGRINI, Ricardo	Graphic
PORTCH, Julian	Illus. Times
PRATER, Ernest	Black and White
PRICE, Julius M.	ILN
PRIOR, Melton	ILN
READ, Samuel	ILN
RÉGAMEY, F.E.	ILN

SCHONBERG, John	ILN
SIMPSON, William	ILN
SHELDON, C.M.	Black and White
SKILL, F.J.	ILN
TEBBY, A.K.	Graphic
VALENTIN, Henry	Various
VIZETELLY, Frank	ILN
VIZETELLY, Henry	ILN
WAKE, R.	Graphic
WATERS, D.B.	Graphic
WHITING, Fred	Graphic
WILLIAMS, I. SHELDON-	
	Graphic and Sphere
WILSON, T. Harrington	ILN
WILSON, T.W.	ILN
WOLLEN, W.B.	Graphic
WOODVILLE, R.C.	ILN
WRIGHT, H.C. Seppings	ILN

Monograms

 CADENHEAD, James

 HOUSMAN, Laurence

 CLAXTON, Marshall C.

 HUGES, Arthur

 FORBES, Elizabeth Adela née Armstrong, Mrs. Stanhope Forbes

 COODE, Miss Helen Hoppner

 JALLAND, G.H.

 COOPER, Alfred W.

 CORBOULD Aster Chantrey

 FURNISS, Harry

 JOHNSON, Alfred J.

 GAVIN, Miss Jessie

 KEENE, Charles Samuel

 LLOYD, Arthur Wynell

 CROWQUILL, Alfred

 GREGORY, Margaret

 LOWINSKY, Thomas Esmond

 DOYLE, Richard

 PARSONS, Alfred

 'GRIP' pseudonym of Alfred BRICE

 SANDERCOCK, Henry Ardmore

 EMANUEL, Frank Lewis

 HASSALL, John

 TENNANT, Dorothy, Lady Stanley

 ERICHSEN, Nelly

 HOOD, George Percy JACOMB-

 THOMSON, Gordon

 FAIRFIELD, A.R.

 HOPKINS, Everard

 WARD, Sir Leslie Matthew 'Spy'

WATSON, John Dawson

510

Bibliography

GENERAL 1800-1850

Abbey, J.R.
Scenery of Great Britain and Ireland In Aquatint And Lithography 1770-1860 . . . from the library of J.R. Abbey. 1952.
Life in England in Aquatint and Lithography 1770-1860 . . . from the library of J.R. Abbey, 1953.
Travel In Aquatint And Lithography 1770-1860 . . . from the library of J.R. Abbey, 2 vols., 1956-57.

Beck, Hilary
Victorian Engravings, Victoria and Albert Museum, 1973.

Darton, F.J. Harvey
Children's Books in England, 1932.

Faxon, F.W.
Literary Annuals and Gift Books, a Bibliography, edited by E. Jamieson and I. Bain, Private Libraries Assoc., 1973.

Harvey, J.R.
Victorian Novelists and Their Illustrators, 1970.

Jerdan, W.
An Autobiography, 4 vols., 1853.

Kitton, F.G.
Dickens and his Illustrators, 1899.

Leslie, C.R.
Autobiographical Recollections, 2 vols., 1860.

Linton, W.J.
Memories, 1895.

Pye, John
Patronage of British Art — An Historical Sketch, 1845.

Raimbach, A.
Memoirs and Recollections . . . , 1843.

Spielmann, M.H.
The History of 'Punch', 1895.

Vizetelly, Henry
Glances Back Over Seventy Years, 2 vols., 1893.

GENERAL 1860-1875

Dalziel Brothers
A Record of Work, 1840-1890, 1901.

Freedmann, W.E.
Pre-Raphaelitism A Bibliographical Study, 1965.

Layard, G.S.
Tennyson and His Pre-Raphaelite Illustrators, 1894.

Reid, Forrest
Illustrators of the Sixties, 1928.

Sparrow, W.S.
Book Illustration of the Sixties, 1939.

Tinsley, W.
Random Recollections, 1900.

White, Gleeson
English Illustration 'The Sixties' 1857-70, 1897.

GENERAL 1890s

Franklin, Colin
Private Presses, A Bibliography, 1969.

Hartrick, A.S.
Painter's Pilgrimage Through Fifty Years, 1939.

Jackson, Holbrook
The Eighteen-Nineties, A Review of Art and Ideas At the Close of the Nineteenth Century, 1913.

Krishnamurti, G.
The Eighteen-Nineties — A Literary Exhibition, National Book League, 1973.

Ludovici, A.
An Artist's Life in London and Paris, 1926.

Pennell, Joseph
Pen Drawing and Pen Draughtsmen, 1889.
Modern Illustration, 1895.
The Illustration of Books, 1896.

Sketchley, R.E.D.
English Book Illustration of Today, 1903.

Taylor, John Russell
The Art Nouveau Book in Britain, 1966.

Thorpe, James
English Illustration of the Nineties, 1935.

CARICATURE

Ashbee, C.R.
Caricature, 1928.

Ashton, John
English Caricature and Satire on Napoleon I, 1888.

Brinton, Selwyn
The 18th Century in English Caricature, 1904.

Buss, R.W.
English Graphic Satire, 1874. Privately printed.

Davies, Randall
Editor. *Caricature of Today,* Studio, 1928.

Everitt, Graham
English Caricaturists and Graphic Humorists of the Nineteenth century, 1893.

George, M. Dorothy
British Museum Catalogue of Political and Personal Satires, Vols. V-XI, 1935-1954.
English Political Caricature, 2 vols., 1959.
Hofmann, Werner
Caricature from Leonardo to Picasso, 1957.
Klingender, F.D.
Hogarth and English Caricature, 1944.
Low, David
British Cartoonists, Caricaturists and Comic Artists, 1942.
Lynch, Bohun
History of Caricature, 1927.
Malcolm, J.P.
Historical Sketch of the Art of Caricaturing, 1813.
Parton, James
Caricature and Other Comic Art, 1878.
Paston, George
Social Caricature in the 18th Century, 1905.
Veth, Cornelis
Comic Art in England, 1930.
Wright, Thomas
Caricature History of the Georges, 1867.

TECHNICAL

Hardie, Martin
English Coloured Books, 1906.
McLean, Ruari
Victorian Book Design and Colour Printing, 1963.
Lewis, C.T.C.
The Story of Picture Printing in England during the Nineteenth Century, 1928.
Sullivan, E.J.
Line An Art Study, 1921.
The Art of Illustration, 1922.
Wakeman, Geoffrey
Victorian Book Illustration — The Technical Revolution, 1973.

SURVEYS

Bland, David
A History of Book Illustration — The Illuminated Manuscript and The Printed Book, 1958.
Bliss, D.P.
A History of Wood Engraving, 1928.
Chatto, W.A. & Jackson
A Treatise On Wood Engraving, 1839, enlarged 1861.
Crane, Walter
Of The Decorative Illustration of Books Old and New, 1896.
Dyos H.J. & Wolff
The Victorian City, 1973.
Du Maurier, G.
Social Pictorial Satire, 1898.
Hogarth, Paul
The Artist As Reporter, 1967.
Jackson, Mason
The Pictorial Press Its Origins and Progress, 1885.
James, Philip
English Book Illustration 1800-1900, 1947.
Muir, Percy
Victorian Illustrated Books, 1971.
Peppin, B.
Fantasy Book Illustration, 1975.
Price, R.G.G.
A History of 'Punch', 1957.
Ray, Gordon N.
The Illustrator And The Book in England From 1790 to 1914. Pierpoint Morgan Library, 1976.
Slythe, R. Margaret
The Art of Illustration 1750-1900, Library Association, 1970.

* Bibliographies of individual artists will be found in their Dictionary entries.

Index

This index covers pages 13-212 but not the 'Dictionary'. It has been divided into two parts to facilitate use: an index of persons and an index of general subjects, including book titles.

Index of Persons

515

General Index

THE COMIC ALMANACK

MAY JUNE JUL AUG APR SEP MAR OCT FEB NOV JAN DEC

EDITED BY HORACE MAYHEW & Illustrated BY George Cruikshank

1848.
ONE SHILLING.

DAVID BOGUE, 86 FLEET STREET.

Vizetelly Brothers and Co Printers and Engravers, 135 Fleet Street